American Paintings in the Metropolitan Museum of Art

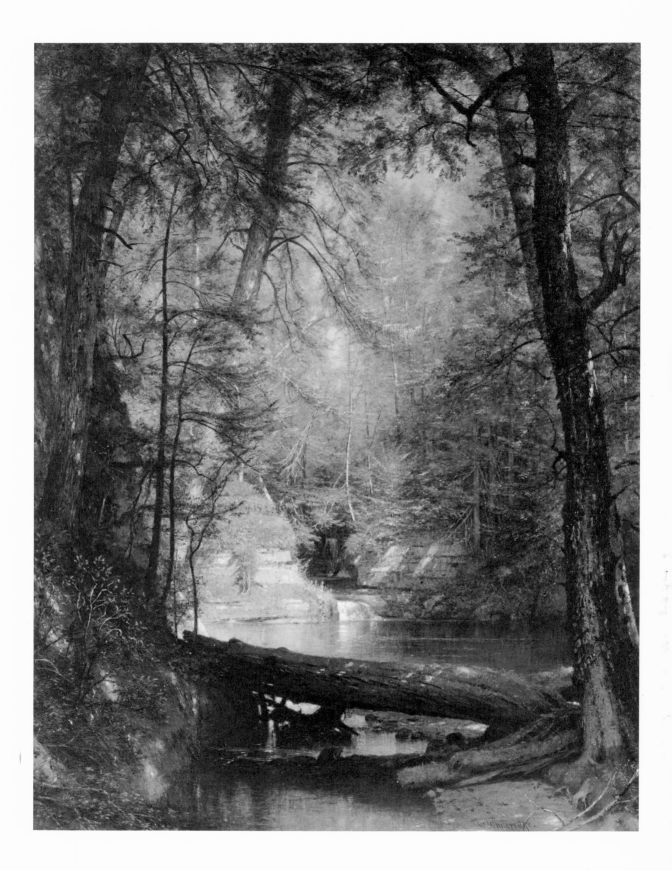

American Paintings in the Metropolitan Museum of Art

Volume II

A Catalogue of Works by Artists
Born between 1816 and 1845

By NATALIE SPASSKY

With Linda Bantel, Doreen Bolger Burke,
Meg Perlman, and Amy L. Walsh

Edited by Kathleen Luhrs
Assisted by Jacolyn A. Mott

 THE METROPOLITAN MUSEUM OF ART
IN ASSOCIATION WITH PRINCETON UNIVERSITY PRESS

JACKET ILLUSTRATION:
The Rocky Mountains, Lander's Peak by Albert Bierstadt.
Photograph by Geoffrey Clements.

FRONTISPIECE:
The Trout Pool by Worthington Whittredge.

ADDITIONAL PHOTOGRAPHY CREDITS:
pp. 276 (top), 485 (bottom), Geoffrey Clements;
p. 230, Nicolai Cikovsky, Jr.

LIBRARY OF CONGRESS CATALOGING IN PUBLICATION DATA
(Revised for v. 2)

Metropolitan Museum of Art (New York, N.Y.).
American paintings in the Metropolitan Museum of Art.
Includes bibliographies and indexes.
Contents:
v. 2 Spassky, N. A catalogue of works by artists born between 1816 and 1845—v. 3.
Burke, D. B. A catalogue of works by artists born between 1846–1864.
1. Painting, American—Catalogs. 2. Paintings—New York (City)—Catalogs.
3. Metropolitan Museum of Art (New York, N.Y.)—Catalogs.
I. Luhrs, Kathleen, 1941– II. Burke, Doreen Bolger, 1949–
III. Spassky, Natalie. IV. Title.
ND205.N373 1980 759.13′074′01471 80–81074
ISBN 0–87099–439–5
ISBN 0–87099–440–9 (pbk.)

Printed in the United States of America

TABLE OF CONTENTS

vii Foreword

ix Preface

xi Acknowledgments

xvii Introduction

xlix Reader's Guide to the Catalogue

lv Abbreviations and Short Titles

3 The Catalogue

655 Index of Former Collections

661 Index of Artists and Titles

667 Index of Authors

669 Cumulative List of Artists in Volumes I, II, & III

FOREWORD

A$_N$ essential part of the museum's mission is to provide information on numerous levels and in varying degrees to its widespread and diverse public. One of the most effective means for such communication is through publications, more specifically, complete and detailed assessments of the permanent collections. The Department of American Paintings and Sculpture has for some time been involved in such an endeavor. This three-volume catalogue is the realization of such work. Not only will the catalogue be of special use to the general public in its direct and easily comprehensible style and informative text but also it will be an invaluable tool for scholars because of the references and scholarly substance. In turn, the catalogue, the definitive and comprehensive publication of the museum's holdings in American paintings, gives the most current overview of the collection, its strengths and weaknesses.

The publication auspiciously marks the opening of the Metropolitan Museum's new American Wing, which includes the installation of American painting and sculpture galleries and provides visitors with an indispensable record of its collection of American paintings. Additional information is conveyed by such other means as audioguides, explanatory labels, gallery lectures, guidebooks, lecture programs, symposia, and similar projects. Such programs give recognition and rightly celebrate this long-awaited and immensely important installation of the museum's finest American paintings and sculptures.

We are deeply indebted to the Ford Foundation for the funding that initiated the project and to the Surdna Foundation for the generous support that has made this publication a reality.

Philippe de Montebello, *Director*

PREFACE

THE Metropolitan Museum of Art was established in 1870 following lengthy discussion and dedicated, organized activity by a diverse group of New York's social, religious, mercantile, academic, and artistic leaders. These men arranged the public and political support which allowed formation of the first general museum of art in this country. An early committee report of that year stated that the primary goal of the pioneering institution was to bring together and display "a more or less complete collection of objects illustrative of the history of Art from the earliest beginnings to the present time." Subsumed within this broader aim was the firmly held idea, stated by the leading spokesman for the founders, William Cullen Bryant, that New York City and the nation required "an extensive public gallery to contain the greater works of our painters and sculptors." In the meetings which led to the museum's foundation, the idea found ready support from a numerous group of painters, many of whose names are familiar today and most of whose works are represented in the museum's collection: George A. Baker, Albert Bierstadt, Walter Brown, Frederic E. Church, Vincent Colyer, Christopher Pearse Cranch, R. Swain Gifford, Sanford Gifford, Henry Peters Gray, William Hart, Daniel Huntington, Eastman Johnson, John F. Kensett, John La Farge, Louis Lang, Thomas Le Clear, Jervis McEntee, Aaron Draper Shattuck, Oliver William Stone, Arthur F. Tait, and Worthington Whittredge. Of these Church, Johnson, and Kensett became original trustees of the museum, insuring that the institution would actually collect and display paintings by American artists. The first American painting to enter the collection, Henry Peters Gray's *Wages of War*, was received in 1872. Since then over 1600 American paintings by about 800 artists have entered the collection through purchase, gift, and bequest. Of these, some 950 paintings by approximately 400 artists born before 1876 are the holding of the Department of American Paintings and Sculpture. The museum's collection of American paintings, given its overall quality and comprehensiveness, is perhaps the finest that exists in public or private hands.

The importance of the collection, and the fact that no scholarly catalogue of it existed, induced the Metropolitan, under the directorship of the late James Rorimer, to prepare one. The Ford Foundation awarded a grant in support of the project in 1963. The late Albert Ten Eyck Gardner, who had previously compiled *A Concise Catalogue of the American Paintings in the Metropolitan Museum of Art* in 1957, and Stuart P. Feld began the project aiming to produce a three-volume publication that would incorporate all American painters represented in the collection who were born before 1876. *American Paintings: A Catalogue of the Collection of the Metropolitan Museum of Art*, Volume I, which included painters born by 1815, prepared by Gardner and Feld, was published in 1965. Subsequently the staff and volunteers in the Department of American Paintings and Sculpture continued to do research and write entries, but with the steady growth of the collection and the rapid acceleration of research, publication, and revision of ideas in the field of American art history, it was determined some years ago to completely revise the existing Volume I and to select a new larger format for the three volumes

projected. The museum received two generous grants from the Surdna Foundation in 1976 and 1978, which made this major undertaking possible. Additional staff was hired to allow the publication of the books in conjunction with the opening of the American Wing.

The three-volume *American Paintings in the Metropolitan Museum of Art* is arranged chronologically by the dates of the artists. Paintings by artists born before 1816 can be found in Volume I. Volume II consists of paintings by artists born from 1816 through 1845. Volume III is a catalogue of paintings by artists born from 1846 through 1864. We hope that a catalogue of the subsequent material, paintings by artists born after 1864, can be prepared at a later time. Meanwhile some information on works in the museum by such painters from that period as Robert Henri, John Sloan, George Luks, William Glackens, and Ernest Lawson can be found in Henry Geldzahler's *American Paintings in the Twentieth Century* (1965). Paintings by American artists born from 1876 on are presently in the care of the Twentieth Century Art Department.

We are extremely grateful for the generosity of the many people who assisted us in the preparation of these volumes. A publication of this size and scope reflects the work of many people in the field and to a great extent the present state of scholarship. We hope that these volumes will add to the knowledge of American art and that where there are gaps, scholars will be inspired to fill them.

John K. Howat
Lawrence A. Fleischman Chairman
of the Departments of American Art

ACKNOWLEDGMENTS

THIS VOLUME of the museum's catalogue of American paintings could not have been produced without the generous help of many people and the cooperation of the staffs of numerous institutions. Although many have been cited in references in the body of the catalogue, a great number of people deserve special thanks. First of all, for his vision and unflagging support of this project, we wish to thank John K. Howat, chairman of the American Art Departments. We are grateful to the museum's director, Philippe de Montebello, and deputy director, James Pilgrim, for their support of the project; Ashton Hawkins, vice-president, secretary and counsel, Penelope K. Bardel, former associate secretary and counsel, and Linden Havemeyer Wise, assistant secretary and associate counsel, for legal advice; Richard Dougherty, former vice-president for Public Affairs; Emily K. Rafferty, vice-president for Development; Bradford Kelleher, vice-president and publisher, and John P. O'Neill, editor in chief and general manager of publications, for their continued assistance. The curatorial staff of several departments in the museum shared their expertise in their special fields: Marilyn Johnson, Alice Cooney Frelinghuysen, Morrison H. Heckscher, and R. Craig Miller of American Decorative Arts identified furniture and decorative objects; Stella Blum and K. Gordon Stone of the Costume Institute provided information on costumes and dating; Jessie McNab of European Sculpture and Decorative Arts helped with heraldic descriptions, and Alice Zrebiec of the same department, with textiles; Dietrich von Bothmer of Greek and Roman Art reviewed material in the entry on Luigi Palma di Cesnola by Jacob D. Blondel; Laurence Libin of Musical Instruments provided descriptions of instruments represented in several paintings; David W. Kiehl of Prints and Photographs unstintingly shared his knowledge of American prints. All our colleagues in European Paintings have supplied us with information.

We are especially grateful to John M. Brealey of Paintings Conservation, his staff, and Wynne Beebe, formerly of that department. A special debt is owed Dianne Dwyer, who examined every painting in this catalogue, provided incisive condition reports, and generously shared her perceptive insights on style and technique. Pieter Meyers, formerly of the museum's Research Laboratory, and Maryan W. Ainsworth, now of Paintings Conservation, in cooperation with the Brookhaven National Laboratory made and interpreted radiographs and autoradiographs of Thomas Eakins's painting *The Artist's Wife and His Setter Dog*. Merritt Safford, Helen K. Otis, Marjorie N. Shelley, and Margaret Holben Ellis of Paper Conservation carefully examined and explained condition problems relating to the works on paper.

Patricia F. Pellegrini, the museum's former archivist, and her successor Jeanie M. James and their colleagues patiently checked and made available museum records, provided information on provenance, and were tireless in verifying facts relating to acquisitions, loans, and exhibition history. Similar information was provided by Marceline McKee and Frederick John Gordon of the Department of Loans, Herbert Moskowitz and Laura Rutledge Grimes of the Office of the Registrar, and Marica Vilcek and her staff in the Catalogue Department.

We thank Mark D. Cooper, Walter J. F. Yee, and the entire staff of the Photograph Studio for their care with photography. William B. Walker, chief librarian of the Thomas J. Watson Library of the museum, and the dedicated library staff constantly assisted in facilitating our research.

Over the years many interns, apprentices, and fellows worked on various aspects of this catalogue. We are indebted to Anne Rorimer, who researched and wrote early drafts on James McNeill Whistler, Sandra K. Feldman, who did the same on Sanford R. Gifford and William Stanley Haseltine, and Lisa Larimore Wilson, who worked on Jervis McEntee. For their work on this catalogue we also thank: John Adler, Claudia Allen, Kevin Avery, Linda Cedargreen, Mary Dougherty, Diane Forley, David Gilbert, Caroline Kane, Marysia Laraud, Mary Davis MacNaughton, Matthew Marks, Linda Martin, Caroline Mortimer, Patricia A. O'Connor, Cathy Peck, Marjorie Gail Reich, Elizabeth Jean Russell; Gail Schechter, Virginia Volterra, Marcia Wallace, Patricia Anne Walsh, Austin Wilke, and Barbara A. L. Woytowicz.

A particular debt of gratitude is owed to a group of dedicated volunteers whose selfless work over many years has provided immeasurable help. For their tireless and extensive work on this project, we thank Marilyn Handler and Jo-Nelle D. Long, who in addition to research, directed volunteers and interns, Barbara Buff, Katherine Cary, Elizabeth Quackenbush, Shelby Roberts, Miriam Stern, Leslie P. Symington, Rebecca Tennen, and Virginia Thors.

Descendants of artists and their families who have generously shared information with us include: Richard G. Coker on Edward Gay, Sanford Gifford on Sanford R. Gifford; Mrs. Edna L. Hazelton on Severin Roesen; Henry La Farge on John La Farge; Henry Frederick Marsh and Emma Tait Marsh on Arthur Fitzwilliam Tait; James A. Richards on William Trost Richards; Mrs. Frank H. Rossiter on Thomas P. Rossiter; and Peggy Macdowell Walters on Thomas Eakins. Several people who have been helpful in providing material on the subjects of portraits in the collection include: Mrs. Harmar Brereton on Daniel Huntington's portrait of Anna Watson Stuart; William Cullen Bryant II on Thomas Le Clear's portrait of Bryant; Mrs. Frederick T. Cumerford on the Carter family by Nicholas Biddle Kittell and an unidentified artist; Mrs. Robert Merritt Gregg on the MacFarlan family portraits by Theodore Pine; and Eric Hatch, Mrs. Robert P. Hamilton, Mrs. James Wood, and other descendants of the Hatch family painted by Eastman Johnson.

Many scholars provided information on artists, their works, and collectors and in some instances reviewed and corrected catalogue entries. For their help we thank: Henry Adams on William Morris Hunt and John La Farge; Nancy Anderson on Albert Bierstadt, Thomas N. Armstrong III on the Pennsylvania almshouse painters; Madeleine Fidell Beaufort on Samuel P. Avery; Maurice E. Bloch on George Inness; John W. H. Boon on Winslow Homer; Jeffrey Brown on Alfred Thompson Bricher; Gerald L. Carr on Frederic E. Church; James W. Cheevers on James Guy Evans; Nicolai Cikovsky, Jr., on Winslow Homer and George Inness; Lois Dinnerstein on Thomas Eakins; the late Edward H. Dwight on Robert S. Duncanson, James McNeill Whistler, and Worthington Whittredge; Linda S. Ferber on William Trost Richards; Richard Frenier on Thomas Waterman Wood; Lloyd Goodrich on Thomas Eakins and Winslow Homer; Frank H. Goodyear, Jr., on George Fuller and

on the collections of the Pennsylvania Academy of the Fine Arts, Philadelphia; David Heiser on Johan Mengels Culverhouse; Patricia Hills on Eastman Johnson; David C. Huntington on Frederic E. Church; Ann Hawkes Hutton on Emanuel Leutze; Peter Kemp on William Magrath; Joseph D. Ketner on Robert S. Duncanson; Margaret MacDonald on James McNeill Whistler; Kenneth W. Maddox on Jasper F. Cropsey; Maybelle Mann on Thomas Hovenden; Clark S. Marlor on Seymour Joseph Guy and the Brooklyn Art Association; Lois Goldreich Marcus on Severin Roesen; Peter C. Marzio on Enoch Wood Perry; Michael J. McAfee on Jacob D. Blondel and Winslow Homer; Howard S. Merritt on John F. Kensett; Maurice A. Mook on Severin Roesen; Nancy Dustin Wall Moure on William Louis Sonntag; Ellwood Parry on Thomas Eakins; Clifford Schaefer on the collection of Edgar William and Bernice Chrysler Garbisch; the late Helen Burr Smith on Nicholas Biddle Kittell; Theodore E. Stebbins, Jr., on Martin Johnson Heade; Raymond Louis Stehle on Emanuel Leutze; William S. Talbot on Jasper F. Cropsey; William H. Truettner on the collector William T. Evans; Bruce Weber on Henry Peters Gray; H. Barbara Weinberg on John La Farge and the collector Thomas B. Clarke; Fran Weitzenhoffer on Samuel Colman; William D. Wilkinson on sea vessels in Winslow Homer's works; Richard N. Wright on Johan Mengels Culverhouse; and the late Andrew McLaren Young on James McNeill Whistler.

The records collected, preserved, and made available by the Archives of American Art, Smithsonian Institution, have been invaluable for this project. For their generous help with the vast resources of the archives, we are deeply indebted to William E. Woolfenden, Garnett McCoy, Arthur Breton, Judy Throm, William McNaught, and other staff members in the Washington, New York, and Boston offices. The Inventory of American Paintings, National Museum of American Art, Smithsonian Institution, has also been a valuable source of information.

Many New York institutions greatly facilitated research for this catalogue. We thank the staff of the Frick Art Reference Library, who were of constant assistance. We are indebted to the National Academy of Design, particularly John Dobkin, Abigail Booth Gerdts, and Barbara Kulick for providing information from the records of this early New York institution and its collections. We are grateful to the New-York Historical Society and its staff, especially Thomas Dunnings, Mary Alice MacKay, Richard J. Koke, John Lovari, Wendy J. Shadwell, and Barbara Shikler for their assistance. We thank the staff of the New York Genealogical and Biographical Society, especially Mary Lou Thomas, for their help. Numerous research problems were resolved in the New York Public Library. We are grateful to the staff of that institution, particularly those in the Local History and Genealogy Division, Manuscript Room, Newspaper Division, and Art Division. Robert Rainwater, curator of prints, was a constant source of information. The staff of the New York Society Library was of considerable assistance. We also thank: Gerald T. MacDonagh of the Association of the Bar of the City of New York, Mark Davis and Andrew Zaremba of the Century Association, Jane Reed of the Union League Club, the staffs of the New York Chamber of Commerce, New York Hospital, the New York Stock Exchange, the New York Botanical Gardens, the Museum of Natural History, and the New York Yacht Club. We are also grateful to: Sarah Faunce, Linda S. Ferber, Annette Blaugrund, and Dianne H. Pilgrim of the Brooklyn Museum; Edward L. Kallop, Jr., Elaine Evans Dee, and the staff of the Department of

Drawings and Prints of the Cooper-Hewitt Museum, the Smithsonian Institution's National Museum of Design; Albert K. Baragwanath and Margaret Stearns of the Museum of the City of New York.

Many museums and historical societies throughout the country provided assistance. We are particularly grateful to: Linn Hardenburgh and Anselmo Carini of the Art Institute of Chicago; Lucretia Geise, Galya Gorokhoff, Laura Luckey, Carol Troyen, and Theodore E. Stebbins, Jr., of the Museum of Fine Arts, Boston; Helen Cooper of the Yale University Art Gallery. We are also indebted to the following: Wilmont B. Bailey, Biddeford Historical Society, Maine; Mrs. Walter R. Britten, city historian, Saratoga Springs; William Crowley, Adirondack Historical Association; James B. Casey, Western Reserve Historical Society, Cleveland; Edward Crott-Murray, keeper of prints and drawings, British Museum; Alan Dages and James A. Ryan of the Olana State Historic Site; John H. Dryfhout of the Saint-Gaudens National Historic Site; Donald P. Fangboner of the Lake George Historical Association; Peter L. Fisher of the Glens Falls Historical Association; Florence M. Hill, town historian, Poestenkill, New York; Sona Johnston of the Baltimore Museum of Art; Richard C. Kugler of the New Bedford Whaling Museum; the late Blake McKelvey, city historian, Rochester, New York; Norman S. Rice of the Albany Institute of History and Art; Darla H. Rushing, New Orleans Museum of Art.

For providing information and answering inquiries we are grateful to the staffs of the other following institutions: Abby Aldrich Rockefeller Folk Art Center, Williamsburg, Virginia; Addison Gallery of American Art, Andover, Massachusetts; Adirondack Museum, Blue Mountain Lake, New York; Albright-Knox Art Gallery, Buffalo; Allentown Art Museum, Pennsylvania; American Academy and Institute of Arts and Letters, New York; Amon Carter Museum of Western Art, Fort Worth; Arizona Museum, Phoenix; Art Museum, Princeton University, New Jersey; Baltimore Museum of Art; Bennington Museum, Vermont; Berkshire Museum, Pittsfield, Massachusetts; Birmingham Museum of Art, Alabama; Boston Athenaeum; Bowdoin College Museum of Art, Brunswick, Maine; Bruce Museum, Greenwich, Connecticut; Butler Institute of American Art, Youngstown; Cape Ann Historical Association, Gloucester, Massachusetts; Charles H. Macnider Museum, Mason City, Iowa; Chicago Historical Society; Cincinnati Art Museum; Cincinnati Historical Society; Sterling and Francine Clark Art Institute, Williamstown, Massachusetts; Cleveland Museum of Art; Colby College Museum of Art, Waterville, Maine; Columbus Museum of Art, Ohio; Connecticut Historical Society, Hartford; Corcoran Gallery of Art, Washington, D.C.; Cummer Gallery of Art, Jacksonville, Florida; Currier Gallery of Art, Manchester, New Hampshire; Dayton Art Institute; De Cordova and Dana Museum, Lincoln, Massachusetts; Delaware Art Museum, Wilmington; Denver Art Museum; Des Moines Art Center; Detroit Institute of Arts; Everson Museum of Art, Syracuse; Fine Arts Museums of San Francisco; William A. Farnsworth Library and Art Museum, Rockland, Maine; Robert Hull Fleming Museum, Burlington, Vermont; Fogg Art Museum, Cambridge, Massachusetts; Folger Shakespeare Library, Washington, D.C.; Free Library of Philadelphia; Freer Gallery of Art, Washington, D.C.; Gibbes Art Gallery, Charleston; Grey Art Gallery and Study Center, New York University Art Collection; Guild Hall Museum, East Hampton, New York; Heckscher Museum, Huntington, New York;

Henry Art Gallery, Seattle; High Museum of Art, Atlanta; Hirshhorn Museum and Sculpture Garden, Washington, D.C.; Hudson River Museum, Yonkers, New York; Hyde Collection, Glens Falls, New York; Iowa State Historical Department Division of Historical Museum and Archives, Des Moines; Joslyn Art Museum, Omaha; Katonah Gallery, Katonah, New York; Library of Congress, Washington, D.C.; Long Island Historical Society, Brooklyn; Los Angeles County Museum of Art; Louisiana State Museum, New Orleans; Joe and Emily Lowe Art Gallery, Syracuse; Lowe Art Museum, Coral Gables, Florida; Lycoming County Historical Society and Museum, Williamsport, Pennsylvania; Lyman Allyn Museum, New London, Connecticut; Mariners Museum, Newport News, Virginia; Mead Art Museum, Amherst, Massachusetts; Memorial Art Gallery of the University of Rochester; Milwaukee Art Museum; Minneapolis Institute of Arts; Montclair Art Museum, New Jersey; Mount Vernon Ladies' Association of the Union, Virginia; Munson-Williams-Proctor Institute, Utica; Museum of Art, Carnegie Institute, Pittsburgh; Museum of Art, Rhode Island School of Design, Providence; Museum of Art, Pennsylvania State University, University Park; Museum of Fine Arts, Springfield, Massachusetts; Museum of Fine Arts, Houston; National Gallery of Art, Washington, D.C.; National Museum of American Art, Washington, D.C.; National Portrait Gallery, Washington, D.C.; William Rockhill Nelson Gallery and Atkins Museum of Fine Arts, Kansas City, Missouri; New Bedford Whaling Museum, Massachusetts; New Britain Museum of American Art, Connecticut; New Jersey Historical Society, Newark; New York State Historical Association, Cooperstown; New York State Museum, Albany; Newark Museum, New Jersey; Oakland Museum, California; Olana State Historic Site, Hudson, New York; Onondaga Historical Association, Syracuse; Oswego County Historical Society, Oswego, New York; Parrish Art Museum, Southampton, New York; Pennsylvania Academy of the Fine Arts, Philadelphia; Philadelphia Museum of Art; Putnam County Historical Society, Cold Spring, New York; Roberson Center for the Arts and Sciences, Binghamton, New York; Rochester Historical Society; Rutgers University Library, New Brunswick, New Jersey; Saint Louis Art Museum; Saint-Gaudens National Historic Site, Cornish, New Hampshire; Santa Barbara Museum of Art, California; Saratoga County Museum, Ballston Spa, New York; Seattle Art Museum; Slater Memorial Museum, Norwich, Connecticut; George Walter Vincent Smith Art Museum, Springfield, Massachusetts; Society of the Four Arts, Palm Beach, Florida; Staten Island Institute of Arts and Sciences, New York; Sheldon Swope Art Gallery, Terre Haute, Indiana; Taft Museum, Cincinnati; Toledo Museum of Art; United States Naval Academy Museum, Annapolis, Maryland; University Art Gallery, Binghamton; University of Maryland Art Gallery, College Park; University of Michigan Museum of Art, Ann Arbor; Utah Museum of Fine Arts, Salt Lake City; Vassar College Art Gallery, Poughkeepsie, New York; Virginia Museum of Fine Arts, Richmond; Wadsworth Atheneum, Hartford; Walters Art Gallery, Baltimore; West Point Museum, West Point, New York; Whatcom Museum of History and Art, Bellingham, Washington; Whitney Museum of American Art, New York; Wichita Art Museum, Kansas; Williams College Museum of Art, Williamstown, Massachusetts; Wood Art Gallery, Montpelier, Vermont; Worcester Art Museum, Massachusetts; and Yale University Art Gallery, New Haven.

Many auction houses and art galleries generously provided assistance. For their help, we

thank: Michael St. Clair of Babcock Galleries; Charles D. Childs of Childs Gallery; Thomas Colville; France Daguet and Charles Durand-Ruel of Durand-Ruel; Sandra Leff of Graham Galleries; Stuart P. Feld and Jane L. Richards of Hirschl and Adler Galleries; Lawrence A. Fleischman, F. Frederick Bernaski, and Cynthia Siebels of Kennedy Galleries; Ann Fernandez Wiegart and Nancy C. Little of M. Knoedler and Company; Maurice Glickman of Lewison Gallery; Thomas E. Renn of Samuel L. Lowe, Jr., Antiques; Kenneth M. Newman of the Old Print Shop; Harold and Peggy Samuels; Grete Meilman formerly of Sotheby Parke Bernet; Victor D. Spark; and Robert C. Vose, Jr., of Vose Galleries.

This catalogue, originally begun by Stuart P. Feld and the late Albert Ten Eyck Gardner, is the culmination of the work of many people over a long period of time. For their contributions in research and writing early drafts, we thank Robin Bolton-Smith, Carol Gordon, and John K. Howat. We are also grateful for the editorial expertise of Joan K. Holt in the early stages of the project.

We are deeply indebted to Klaus Gemming, the designer of the catalogue, for providing advice on production, for his thoughtful handling of the design, and constant attention and encouragement throughout all phases of production. For their careful typesetting, we are grateful to Martino Mardersteig and his staff at Stamperia Valdonega in Verona. David Lasko and Stephen Stinehour at the Meriden-Stinehour Press were generous with their assistance over a long period that often involved difficult problems of scheduling.

The authors owe a debt of great gratitude to their colleagues in the Department of American Paintings and Sculpture. For resolving numerous problems and lending his warm support to this project, we thank Lewis I. Sharp. For sharing their expertise in American art, we are profoundly grateful to John Caldwell and Oswaldo Rodriguez Roque. Barbara Pollard, Kathryn Greenthal, and Catherine Hoover provided assistance in several areas. For several years, the late Margaretta M. Salinger generously shared with us her experience and broad knowledge. For their role in seeing this catalogue to fruition, we are grateful to past and present departmental assistants: Sally Muir, Margaret Lawson, Marilyn Handler, Dale T. Johnson, Kristine Schassler, Sheila Newbery, Pamela Hubbard, and Nancy Gillette. We would also like to thank George Asimakis, Gary Burnett, Vito Luongo, Don E. Templeton, William P. Waelder, Jason Weller, and Benjamin Zibit, the department's former and current technicians who facilitated the examination of each painting.

The authors are deeply grateful to Kathleen Luhrs, the editor of this catalogue. Besides the expected work of editing and coordinating such a large project, she continued to keep account of the constantly changing scholarship regarding the paintings in the collection. We were also very fortunate to be able to rely on Jacolyn A. Mott's keen eye and wonderful sense for clarity. Together, their dedicated efforts, incisive editing, care and patient perseverence with endless details made the production of this catalogue possible.

Natalie Spassky

INTRODUCTION

THIS VOLUME catalogues the museum's collection of American paintings by artists born between 1816 and 1845. The works produced by these artists date from the late 1830s to the first decade of the twentieth century. During these years, many developments affected the course of American painting. One of the principal objectives of this introductory essay is to examine the diversity of content and style in this period. Another is to discuss the art publications, criticism, and organizations that reflected the progress of art in the United States.

During the nineteenth century American artists explored a vast new range of subject matter. A growing sense of national identity found its chief expression in history, landscape, and genre painting as well as likenesses of the nation's heroes, allegorical representations, and subjects drawn from literature. The assimilation and adaptation of native, European, and oriental traditions created a diverse range of styles. Artists pursued the classical heritage, studied the old masters, and sought training abroad. The influence of the Nazarenes, the Pre-Raphaelites, the Barbizon school painters, the realists, and the impressionists were part of the European contribution. The neoclassical work of John Vanderlyn, Benjamin West, and later Henry Peters Gray; the romantic work of Washington Allston, William Morris Hunt, George Fuller, Robert Loftin Newman, and Albert Pinkham Ryder; the realistic work of Winslow Homer and Thomas Eakins; and the impressionistic work of Mary Cassatt constituted some of the major stylistic currents of the nineteenth century.

The formation of various organizations—the National Academy of Design, the Art Students League, the Society of American Artists, the Ten American Painters, and the Eight— reflected changing intentions and the desire for the recognition of common interests. The founding of art unions encouraged a market in American art, while the establishment of museums and galleries provided showplaces for native artists. Meanwhile the wide dissemination of prints and art periodicals educated the public and promoted art. Contemporary criticism served as an indication of the changes in patronage, public opinion, and taste. The increased participation of the country's artists in international exhibitions showed their developing cosmopolitanism and willingness to measure their talents against those of their European counterparts.

From its beginnings in the seventeenth century, easel painting in America was determined both by the unique and rapidly changing nature of American life and the persistent influence of European art. Portraiture dominated colonial painting in the new world. Imported prints, paintings, and the work of immigrant painters from Europe provided the models for aspiring American artists. The single most important figure in the early history of American painting was Benjamin West. The first native of this country to study in Europe and to achieve international recognition, he became historical painter to George III in 1773 and in 1792 succeeded Joshua Reynolds as president of the Royal Academy in London. West's early exploration of neoclassicism and romanticism placed him in the forefront of the two major revolutionary currents in Western art. It was West's role as the founder of the first "American

school" of painting that was crucial to the development of sophisticated painting in America. From the mid-1760s to the early decades of the nineteenth century, he served as teacher and adviser to generations of American artists who traveled and studied abroad. Imported aesthetic concepts like Edmund Burke's the "Beautiful and Sublime," William Gilpin's "Picturesque," and Joshua Reynolds's "Grand Style," best realized in paintings of historical and religious subjects and styles like neoclassicism and romanticism, found enthusiastic adherents among American artists. The country, however, was not ready to support these foreign modes of expression. Artists like Washington Allston, who studied with West and was the leading proponent of romanticism in the United States, John Vanderlyn, who was trained in the French neoclassical tradition, and Samuel F. B. Morse, a student of Allston and West and an advocate of both neoclassicism and romanticism, found on returning to the United States that their aspirations and commitments to high ideals in art had little public backing. Those who were able to accommodate their art to the prevailing taste were more successful.

The first half of the nineteenth century was a period of unprecedented expansion in the arts. American artists, however, continued to look to Europe as a training ground and a source for styles and techniques. The art of England, France, Germany, and Italy was vital to the growth of academic painting in the United States. Portraiture and history painting continued to play a major role in providing a livelihood for artists, but they now produced landscapes, genre scenes, and still lifes as well. Commercial growth, economic prosperity, and geographic expansion stimulated support for a diverse group of artists. The first important art institutions were founded during the first quarter of the nineteenth century—the American Academy of the Fine Arts in New York (1802), the Pennsylvania Academy of the Fine Arts in Philadelphia (1805), and the Boston Athenaeum (1807). The National Academy of Design in New York was founded in 1826 in reaction to the restrictive character of the American Academy of the Fine Arts. Offering instruction and allowing artists more control over their own professional interests, it became the country's most prestigious art organization. Later in the century other schools were founded: the Brooklyn Institute (1843), the Graham Art School in Brooklyn (1852), the Cooper Union for the Advancement of Science and Art (1857–1859), and the Brooklyn Art Association (1861). Similar schools were organized in other major cities as well, notably in Buffalo, Cleveland, and Cincinnati. In New York, beginning in the mid-1830s, one of the main places where artists worked was the New York University Building at Washington Square. The increasing need for artists' studios was partly met in 1857 by the construction of the Studio Building on West Tenth Street. Besides studio space, this building also included a large exhibition gallery where artists could display their works. Receptions were held, and artists had the opportunity to exchange ideas easily in this new artistic community. In Boston, the Studio Building on Tremont Street served a similar purpose.

During the 1840s and 1850s, patronage of American art from individuals, cities, and the federal government was supplemented by the establishment of numerous art unions. Devoted to serving its subscribers through the acquisition and distribution of paintings and engravings, the art union was basically modeled after its successful European predecessors—the art unions founded in Munich in 1823, in Berlin in 1825, and in London in 1837. Encouraging representations of American scenery, history, genre, and ideal subjects, the art union was instru-

mental in popularizing the work of America's artists. The most effective and influential of these was New York's American Art-Union. Originating in an exhibition organized by James Herring at the Apollo Gallery in New York in 1838, it was reorganized in 1839 on the model of the "Edinburgh Association for the Promotion of Fine Arts in Scotland" as the Apollo Association for the Promotion of the Fine Arts in the United States and subsequently renamed the American Art-Union. It was followed by the Western Art-Union, founded in Cincinnati in 1847, the Philadelphia Art-Union organized in 1848 (incorporated in 1850), the New England Art-Union founded in Boston in 1850, the New Jersey Art-Union in Newark in 1850, and the short-lived Brooklyn Art Union in 1851. Until 1852 when it was dissolved as an illegal lottery, the American-Art Union provided an important outlet for the country's artists and stimulated a market for their art. Its *Transactions* and *Bulletin* were among the first art journals published in this country. John Durand, son of the artist Asher B. Durand, described the American Art-Union: "The institution, if not the creator of a taste for art in the community, disseminated a knowledge of it and largerly stimulated its growth. Through it the people awoke to the fact that art was one of the forces of society. How far the Art Union was seviceable to individual artists may be gathered from the fact that, one year, it purchased ten of my father's works."[1]

To some extent the place left empty by the demise of the American Art-Union was filled by the Cosmopolitan Art Association established by C. L. Derby in Sandusky, Ohio, in 1854. Its incorporation in Ohio allowed it to skirt the New York lottery law and open a New York office in 1856. The association offered its members a share in the art lottery and a one year's subscription to any of the publications associated with the enterprise. In July 1856, the first issue of the *Cosmopolitan Art Journal* was published and subsequently, following the example of the art unions, engravings were distributed to subscribers. In June 1857, the Cosmopolitan Art Association bought the Düsseldorf Gallery in New York. This gallery, which had opened in 1849 to promote paintings by German artists, was now used to show the work of others as well. In 1860 a yearly prize was established for the best work by an artist under forty. The money awarded was intended to finance study abroad. Despite its importance for American artists, the association also dealt extensively in European art. In fact, the engravings it most often chose to distribute were after the work of European artists. The financial panic of 1857 had a severe effect on the association, but it managed to survive until the beginning of the Civil War.

At mid-century, the growing market for art in the United States attracted European competition. In addition to the Düsseldorf Gallery, the International Art-Union, an American branch of the Paris firm of Goupil, Vibert and Company, began operation in New York in 1849. It served to promote European, especially French, art and competed vigorously with the American art unions.

Beginning with the opening of the Crystal Palace in London in 1851, major international exhibitions were held every few years in some European capital. The number of Americans represented in these exhibitions grew, and their works received notice in the Paris internationals of 1855 and 1867. At the Crystal Palace in New York, a glass and iron building located at what is now Bryant Park, an "Exhibition of the Industry of All Nations" opened

[1] John Durand, *The Life and Times of A. B. Durand* (New York, 1894), p. 172.

in 1853 and ran for a year. Of the 685 pictures listed in the catalogue of the fine art section, only about 30 were by American artists. One writer observed that the "general absence of American pictures" was "the subject of much surprise and remark."[2] It was not until the Centennial Exhibition in Philadelphia in 1876 that American artists were given full representation in an international exhibition at home.

History, allegorical, and literary painting flourished in the 1840s and 1850s. Daniel Huntington, Henry Peters Gray, and Thomas P. Rossiter were among the best known artists who specialized in these subjects. Following academic procedures, they depended on antique and old master sources. In their common aim—to capture an ideal type—they still adhered to the grand manner advocated by Reynolds. The mass circulation of prints, illustrated books, and periodicals and the institution of one-man exhibitions gave the paintings of these men extensive exposure and established their reputations.

Daniel Huntington was a student of Samuel F. B. Morse and heir to the neoclassical and romantic styles that distinguished the art of Morse and his teacher Washington Allston. Huntington's study of the works of Raphael, Correggio, and Titian and the late paintings of Johann Friedrich Overbeck, one of the Nazarenes, helped to develop his style. Described by Henry T. Tuckerman as an "academic" and "a legitimate admirer of Sir Joshua Reynolds," Huntington favored ideal figure paintings with allegorical, literary, and historical themes. He was, however, "devoted to portraiture by the practical exigencies of his era and country."[3] His interest in moralizing subjects was best realized in such paintings as *Mercy's Dream* (p. 60), drawn from part two of John Bunyan's *Pilgrim's Progress*. The first version of this picture (PAFA) was completed in 1841 and secured Huntington's reputation. In its moral intentions, the work finds a close parallel in Thomas Cole's ambitious allegorical series *The Voyage of Life*, 1839-1840 (Munson-Williams-Proctor Institute, Utica, N.Y.). In addition to painting narrative scenes, Huntington was official portraitist of his generation. Of some 1,200 works he produced, over 1,000 were portraits. He succeeded Morse as president of the National Academy of Design, serving from 1862 to 1870 and again from 1877 to 1890. In the last quarter of the nineteenth century, his commitment to academic traditions made him the representative of the conservative establishment.

Huntington's student Henry Peters Gray succeeded him as president of the National Academy of Design in 1870. Like Huntington, Gray was a prolific portraitist and was chiefly known for his ideal figure compositions and allegorical, mythological, literary, and historical subjects. His painting style, with its pervasive neoclassicizing elements, is exemplified by such works as *The Greek Lovers* (p. 101) and the allegorical painting *The Wages of War*, 1848 (p. 103). *The Wages of War* was bought by the American Art-Union in 1848 for what was then the sensational amount of $1,500. Presented to the Metropolitan Museum in 1872, it has the distinction of being the first painting by an American artist acquired by the museum.

Thomas P. Rossiter specialized in painting large historical and religious works. In 1859, in collaboration with Louis Remy Mignot, he completed *Washington and Lafayette at Mount Vernon, 1784* (p. 88), one of a series of works devoted to the life of George Washington, an

[2] William C. Richards, *A Day in the New York Crystal Palace, and How to Make the Most of It* (New York, 1853), p. 164.

[3] Henry T. Tuckerman, *Book of the Artists: American Artist Life* (New York, 1867), pp. 331, 321.

especially popular subject during the decades preceding the Civil War. In what was perhaps the most transparent expression of nationalism in this country's visual arts, fact and myth flourished in representations illustrating Washington's military, political, and domestic life. Unquestionably the best known image of Washington in the mid-nineteenth century was *Washington Crossing the Delaware* (p. 16) by Emanuel Leutze. By contrast, Rossiter's and Mignot's collaborative effort, with its pronounced genre elements, is an anecdotal variety of history painting, which also enjoyed great popularity.

Painters focused on landscape as well as history and genre painting. The unique character of the American landscape provided an especially formidable challenge to its artists. "The painter of American scenery has, indeed, privileges superior to any other," Thomas Cole observed. "All nature here is new to art."[4]

The great flowering of American landscape painting began in the "Hudson River school," the country's first native school of landscape painting. A pejorative name given by a critic, the Hudson River school was a misnomer because it was not a formal school and the artists included in the group painted far beyond the Hudson. The works of its founders, Thomas Cole and Asher B. Durand, exerted a profound influence on a second generation of Hudson River school painters, many of whom are represented in this catalogue. Several of these artists remained faithful adherents to the style far into the nineteenth century and long after it had been largely superseded by other styles in American painting.

The artists of the first generation of the Hudson River school were indebted for compositional formulas and picturesque devices to the work of the seventeenth-century European masters Claude Lorrain and Salvator Rosa. In this they were true to the theories advanced by Sir Joshua Reynolds, who had urged the study of the old masters and these particular artists to achieve the ideal in nature. Painters strove to reconcile the real and ideal in studio compositions; they made studies based on the direct observation of nature and followed the conventional formulas of the seventeenth-century masters.

Concurrently, "truth to nature" was a major aesthetic creed of that first generation of painters who associated the belief in God's immanence in nature with a view of America as the New Eden. Asher B. Durand, in the first of nine "Letters on Landscape Painting," published in the *Crayon* in 1855, urged students to "go first to Nature to learn to paint landscape," noting that the "external appearance of this our dwelling-place . . . is fraught with lessons of high and holy meaning, only surpassed by the light of Revelation."[5] These ideas were reinforced in the writings of the British critic and author John Ruskin, who strongly influenced America's artists. "The fundamental importance of Ruskin's writing in America," Roger Stein observed, "was his identification of the interest in art with morality and religion as well as with the love of nature, his ability to build a loose but convincing system where art, religion, and nature were inextricably intertwined."[6] Believing in God's immanence in nature, but eschewing pantheism, Ruskin championed J. M. W. Turner as the greatest of all landscape painters and found Claude and Rosa unfaithful to nature,

[4] Louis L. Noble, *The Course of Empire, Voyage of Life, and Other Pictures of Thomas Cole, N. A.* (New York, 1853), p. 202.

[5] A. B. Durand, "Letters on Landscape Painting," *Crayon* 1 (Jan. 3, 1855), p. 2, and (Jan. 17, 1855), p. 34.

[6] Roger B. Stein, *John Ruskin and Aesthetic Thought in America, 1840-1900* (Cambridge, Mass., 1967), p. 41.

thereby challenging the long-established theories of Reynolds. The first volume of Ruskin's *Modern Painters* was published in London in 1843 and the first American edition in 1847. Excerpts from the work appeared regularly in the *Crayon* from its beginnings in 1855. Founded by a pupil of Frederic E. Church and a friend of Ruskin, William James Stillman, who served as co-editor with John Durand, the *Crayon* became one of the leading art periodicals in antebellum America and, until its last issue in 1861, one of the chief advocates of Ruskinian ideas in the country. The Association for the Advancement of the Cause of Truth in Art promoted these ideas. It was founded in New York in 1863 by Thomas C. Farrer, an English artist and a student of Ruskin. The members of this short-lived organization included the critic Clarence Cook (who edited the association's official publication, the *New Path*) and the artists Charles Herbert Moore, John William Hill, his son John Henry Hill, and William Trost Richards. It was in their meticulously detailed and literal representations of nature that the exacting demands of Ruskin's dictum of truth to nature achieved its most complete expression in the United States.

The unresolved conflict between nature and civilization, or the destruction of the wilderness in the interest of technological progress, became a central issue for American landscape painters. The necessity of recording the wilderness before it was irrevocably altered—also the way of life of its native inhabitants, before that too vanished—became the artists' chief concern. Reviewing the landscapes of Jasper F. Cropsey, a leading figure of the second generation of Hudson River school painters, a New York critic observed: "The axe of civilization is busy with our old forests. . . . Yankee enterprise has little sympathy with the picturesque, and it behooves our artists to rescue from its grasp the little that is left, before it is ever too late."[7] In a letter from the Rocky Mountains in 1859 to the *Crayon*, Albert Bierstadt described the region as "the Italy of America in a primitive condition." He reported: "The manners and customs of the Indians are still as they were hundreds of years ago, and now is the time to paint them, for they are rapidly passing away, and soon will be known only in history. I think that the artist ought to tell his portion of their history as well as the writer; a combination of both will assuredly render it more complete."[8]

The railroad, introduced during the 1830s, presented the most serious threat to the American wilderness. Curiously, Cole who considered the railroad a despoiler of the countryside, is credited with what Kenneth Maddox has described as "the *first* painting by a major American artist in which the railroad is found."[9] In Cole's *River in the Catskills* of 1843 (MFA, Boston), a railroad, which had been abandoned the preceding year and was no longer a threat, appears in perfect harmony with the idyllic landscape. Soon the train became a common element in the imagery of the second generation of Hudson River school painters. A symbol of progress, it was included in the paintings of Jasper F. Cropsey, John F. Kensett (see *Hudson River Scene*, p. 33), George Inness (see *Delaware Water Gap*, p. 245), David Johnson, and many others.

Ironically, the clearing and destruction of land to make way for railroads facilitated the

[7] *Literary World* (May 15, 1847), pp. 347-348.

[8] *Crayon* 6 (Sept. 1859), p. 287.

[9] Kenneth W. Maddox, "The Railroad in the Eastern Landscape: 1850–1900," in Wellesley College Museum, exhibition catalogue, *The Railroad in the American Landscape* (Wellesley, Mass., 1981), p. 19.

artists' access to the wilderness, and they were quick to take advantage. Railroad companies, moreover, provided a new, if somewhat erratic, source of patronage, hiring artists to make pictures that publicized their lines. The 1850s were the years of the great railroad excursions. In 1852, for example, William Louis Sonntag was commissioned by the Baltimore and Ohio Railroad Company to paint "that line's wild and impressive scenery as it crossed the Alleghenies"[10] along the route between Baltimore and Cumberland, Maryland; in 1855, George Inness completed *The Lackawanna Valley* (National Gallery of Art, Washington, D.C.), a work originally commissioned by the president of the railroad for use as an advertisement. Throughout the 1850s, railroad companies organized excursions for artists. Thomas Hicks, Louis Lang, and Thomas P. Rossiter were among the artists invited to participate in the celebrations organized by the Ohio and Mississippi Railroad upon the completion of its direct route from Baltimore to Saint Louis. Most famous and best publicized was the excursion from Baltimore to Wheeling run by the Baltimore and Ohio Railroad in 1858. Among the painters included were Thomas Hicks, John F. Kensett, Louis Lang, Louis Remy Mignot, Thomas P. Rossiter, Francis Blackwell Mayer, and Joseph Ames. At the invitation of the railroad, Kensett and others extended their trip to Saint Louis. The Baltimore and Ohio organized another excursion in 1860, which Sanford Robinson Gifford, Jervis McEntee, and Richard William Hubbard made. The completion of the transcontinental railroad in 1869 gave artists easy access to the far reaches of the continent. Thomas Moran was commissioned by the Baltimore and Ohio in 1881 to make a tour of the line in a private car and provide illustrations for a history of the road. *The Picturesque B & O* by J. G. Pangborn with engravings by Moran and others was issued in 1882. In building private collections of paintings, such railroad magnates as Collis P. Huntington and John Taylor Johnston took part in developing the patronage of American art. Albert Bierstadt's *Donner Lake at the Summit* of 1873 (NYHS), for example, was commissioned by Huntington, a director of the Central Pacific Railroad.

The exploration of the continent and western expansion, spurred by the California Gold Rush in 1848, offered the American landscape painters new frontiers. They joined scouting and surveying expeditions to the uncharted territories of the West. Artists like George Catlin, Seth Eastman, Karl Bodmer, Alfred J. Miller, George Caleb Bingham, William T. Ranney, John Mix Stanley, and Charles F. Wimar gave visual representation to the Indians, the trappers, and the pioneers, celebrated in the literature of James Fenimore Cooper and Washington Irving. During the second half of the nineteenth century, Frederic E. Church, Albert Bierstadt, Thomas Hill, William Bradford, and Thomas Moran were among the country's leading artist-explorers. They captured the spectacular and striking effects of nature on large canvases that found enthusiastic and receptive audiences. Chief of these artist-explorers was Frederic E. Church. A pupil of Thomas Cole and heir to the scientific, religious, and nationalist ideas of the nineteenth century, Church won international recognition for such works as *Niagara*, 1857 (Corcoran Gallery of Art, Washington, D.C.), *The Heart of the Andes*, 1859 (p. 269), and *The Icebergs*, 1861 (Dallas Museum of Fine Arts). His paintings of American subjects gave Europeans "an entirely new and higher view both of American nature and art."[11] Church taught William James Stillman, Jervis McEntee, and Louis Remy

[10] Ibid., p. 26; Nancy Dustin Wall Moure, *William Louis Sonntag* (Los Angeles, 1980), p. 19.
[11] "Frederic Edwin Church," *Harper's Weekly* 10 (June 8, 1867), p. 364.

Mignot, among others. He exerted a profound influence on the work of such artist-explorers as William Bradford as well. While Church took his subjects from South America, the far reaches of the North, and the eastern coast of the United States, his near contemporary Albert Bierstadt won acclaim for paintings of the Rocky Mountains, the California redwoods, and Yosemite. He made the first of many trips west in 1859 when he joined Colonel Frederick W. Lander's surveying expedition. Bierstadt eventually became best known as the painter of the far west. Thomas Hill, William Keith, and Thomas Moran also were noted for their representations of the area. Moran, whose work is stylistically indebted to J. M. W. Turner's, made his first trip west in 1871, joining the surveying expedition of Ferdinand V. Hayden. His paintings of the Grand Canyon of the Yellowstone were instrumental in persuading Congress to establish Yellowstone National Park, preserving the wilderness for future generations. Other prominent members of the second generation of the Hudson River school also made trips west, but it was not the central focus of their work. Kensett traveled up the Missouri in 1857; Whittredge joined General John Pope's tour to Colorado and New Mexico in 1866. Whittredge accompanied Kensett and Gifford on a journey to Colorado and Wyoming in 1870, and Gifford left them to join another of Hayden's surveying expeditions. In 1870, Samuel Colman also went west.

While recording American scenery was the concern of artist-explorers, the effects of light and atmosphere were the major preoccupation of a group of painters whom John I. H. Baur characterized in 1954 as "luminists."[12] This group included Fitz Hugh Lane, Martin Johnson Heade, and such members of the second generation of the Hudson River school as Kensett and Gifford. They were most active from the 1850s to the 1870s. Unlike contemporaries such as Church and Bierstadt, with whom they shared a sensibility for meticulous detail, these artists usually worked on a smaller and more intimate scale. An emphasis on linearism, subtle gradations of tone, and spare compositions characterized their work. Although "luminism" has often been singled out as a purely indigenous development, it has stylistic parallels in the art of other ages and countries.

The landscapes of Thomas Cole and Asher B. Durand served as points of departure for the second generation of Hudson River school artists. Cole's adaptations from such seventeenth-century masters as Rosa and Claude and his studies from nature provided models for the artists who followed him. His allegorical cycles, valued for their didactic character, were widely popularized through prints and inspired a rash of allegorical paintings during the 1840s and 1850s. William Louis Sonntag copied Cole's *The Voyage of Life*. Painters like Cropsey, Inness, Duncanson, and Richards experimented with allegorical subjects in their early work. "Factual" representations of the American landscape, however, soon superseded allegorical ones. Following Cole's death in 1848, the realistic work of Durand provided the artistic model for the younger generation. His close studies of nature were very often fragmentary glimpses of woodland scenes. Painted in an expressive and subjective manner, they captured the imagination of such painters as Worthington Whittredge.

New stylistic ideas from Europe exerted an increasing influence on American artists and collectors during the second half of the nineteenth century. Bierstadt, Church, and Cropsey saw their work supplanted by that of a new generation of American artists who had been

[12] John I. H. Baur, "American Luminism," *Perspectives USA* (Autumn 1954), pp. 90-98.

trained abroad. Some artists, like Jervis McEntee, who had remained faithful to the Hudson River school style, voiced their concern or felt they had outlived their time; others, like George Inness, were quick to assimilate new modes of expression.

The resurgence of nationalism that encouraged the growth of American landscape painting also gave impetus to the development of genre painting. American genre painters reaffirmed the national identity at the most popular level in paintings of rural and urban everyday life, in representations of customs and manners, in rare works of political satire and social commentary, and in illustrations of the writings of Irving and Cooper. Genre painting flourished in the works of John Quidor, David Gilmour Blythe, Francis W. Edmonds, and William Sidney Mount. This early generation exerted a great influence on the painters represented in this catalogue. Moreover, both generations were indebted to seventeenth-century Dutch and Flemish art and the traditions of France and England—for example, the work of Jean Baptiste Greuze, George Morland, David Wilkie, William Hogarth, Thomas Rowlandson, and George Cruikshank. The American genre painters were also inspired by contemporary European styles. Artists like Seymour J. Guy studied at the Royal Academy in London; John G. Brown received his early training in England and Scotland; and Charles Caleb Ward was a student of William Henry Hunt in England. Enoch Wood Perry and Eastman Johnson pursued studies in Düsseldorf and at the atelier of Thomas Couture in Paris. Walter Shirlaw studied in Munich and Henry Mosler, in both Düsseldorf and Munich.

The art academy at Düsseldorf was an international art center in the second quarter of the nineteenth century. The curriculum, under the direction of Friedrich Wilhelm von Schadow, offered a rigorous preparatory course that stressed drawing from engravings, casts, and subsequently, from life. Instruction in perspective and anatomy was also provided. The firm, incisive line encouraged by the emphasis on draftsmanship was an unmistakable hallmark of the school. In uninspired hands, however, it often became simply mechanical. "Strict academic rules are most rigidly brought to bear upon the student," one American reported of the elementary class in 1858, "here they acquire the peculiar style of drawing which inevitably remains with them through life."[13] After completing this intensive course of instruction in draftsmanship and submitting a life-size drawing of a male figure from a cast, students progressed to oil painting. History, genre, and landscape painting were specialties of the academy, and careful drawing, exacting detail, and perfect finish characterized the Düsseldorf style.

The highly publicized opening of the Düsseldorf Gallery in New York in 1849, the extensive account of Emanuel Leutze's painting *Washington Crossing the Delaware* in the *Bulletin of the American Art-Union*, and the enthusiastic reception it received in New York in 1851 contributed to the growing popularity of the Düsseldorf school in the United States. A detailed report by the artist John W. Ehninger in the *Bulletin of the American Art-Union* for April 1850 outlined the academy's curriculum, the economic advantages of artistic life in Düsseldorf, and its social pleasantries. Like many others, he pointed out the technical shortcomings of works by American artists in comparison to the skillful and highly finished works of the Düsseldorf painters. Recommending the strong academic training that the Düsseldorf Academy offered, he wrote: "We think that no other school in Europe could furnish a col-

[13] *Crayon* 5 (August 1858), p. 228.

lection of pictures better calculated than the Düsseldorf Gallery [in New York] to exhibit, by contrast, the most common defect in our American works, namely, the want of careful and accurate drawing." Judging from the lists of students in the Düsseldorf Academy, however, few Americans enrolled in classes, none completed the curriculum, and most preferred to follow an independent course of study. "By far the greater number," one writer noted in 1858, "after struggling half through the Antique [class], give up the Academy in despair, seeking either more comfortable quarters and fare in an atelier, or going home in disgust."[14]

One of the leading figures in Düsseldorf was the German-born portraitist and history painter Emanuel Leutze. His studio served as a center for American artists studying in the city. Born in Schwäbisch Gmünd, Württemberg, Leutze spent his early years in Philadelphia, where he studied with the English-born drawing master John Rubens Smith. With the financial backing of some prominent Philadelphians, Leutze went to Europe in 1840. In 1841 he enrolled in the Düsseldorf Academy as a history painter, joining several other aspiring painters from Philadelphia. By the time Leutze arrived, political, religious, ethnic, and social tensions in Germany had polarized Düsseldorf's artistic population. A group of independent liberals vied with conservative idealists in the academy, which was governed by the Prussian authorities under the leadership of the conservative Schadow. Carl Friedrich Lessing was a leading figure in the liberal independent faction, and Leutze, who shared his sentiments, subsequently allied himself with the independents.

Lessing was Leutze's chief mentor, and several of his early works were strongly influenced by Lessing's compositions. Soon Leutze developed a freedom of execution that departed from the precision of the Düsseldorf school. The immediate success of such works as *Columbus before the High Council of Salamanca*, 1841 (unlocated), and *The Return of Columbus in Chains to Cadiz*, 1842 (private coll.), brought him international recognition. This success, his growing frustration with the academy's program, and his desire for independence led him to leave the academy and establish his own studio sometime between 1842 and 1843. Until Leutze returned to the United States in 1859, his studio was a center for American artists in Düsseldorf. One writer reported in 1858,

> Mr. Leutze, although he has been here and is associated with the artists of Dusseldorf, for more than fifteen years, is still known as "the American." It is to him that all the Americans are sent, whether students, amateurs, or tourists: he is always glad to see them, and seems to take real pleasure in doing anything in his power to advance their several schemes. . . . He has had, at divers times, quite a number of American students in his atelier; in fact, nearly all who ever came here with the intention of painting anything except landscape, have studied with him. Some of these young men have since gained a reputation, and are now painting at home; others are still studying on the continent, some at Paris, some at Rome.[15]

Leutze was in Düsseldorf from 1841 to 1843, 1845 to 1851, 1852 to 1858, and briefly in 1863. Other artists who went there in the period from the 1840s to the 1860s and whose works are represented in the Metropolitan's collection (and the dates they were there) are: William Morris Hunt (1845), Eastman Johnson (1849–1851), Worthington Whittredge (1849–1854), Enoch Wood Perry (1852–1854), Albert Bierstadt (1852–1853 and 1855–1856);

14 J. W. E[hninger], "The School of Art at Düsseldorf," *Bulletin of the American Art-Union* (April 1, 1850), p. 6, and *Crayon* 5 (August 1858), p. 230.
15 *Crayon* 5 (March 1858), p. 82.

James M. Hart (1850–1851), Edwin White (ca. 1850-1854), William Stanley Haseltine (1855–1857), Sanford Robinson Gifford (1856), George Caleb Bingham (1856–1858), William Trost Richards (1856), and Henry Mosler (1863). Others, like Edward Gay and Alexander Wyant, were exposed to the Düsseldorf influence as students in Karlsruhe.

Eastman Johnson and George Henry Hall went to Düsseldorf in 1849 at the recommendation of Andrew Warner, corresponding secretary of the American Art-Union. Both artists had obtained financial support from the art union's acquisition of their works. By the fall of 1849 they were joined by Worthington Whittredge. Disillusioned somewhat early, Hall left Düsseldorf for Paris at the end of 1850, noting in a letter to Warner: "I am convinced that I should have painted better pictures had I remained at home." In addition to the school's shortcomings in color of which he had been forewarned, Hall lamented the absence of "a Gallery of the Great Masters, like that of Dresden or the one which was formerly here, now in Munich." Echoing Leutze, he noted, "This school is a good one for beginners who learn *only* the rudiments of art, or for those artists whose style assimilates with it." More critical yet, he deplored the "lack of invention, and an entire want of originality."[16]

Johnson, who remained in Düsseldorf until July 1851, entered Leutze's atelier in January of that year. "I regret now," he wrote, "that I had not been with him during my entire stay in Düsseldorf." When Johnson looked back on his experience after several months in Holland, he wrote that "the present artists" in Düsseldorf "are very deficient in some of the chief requisites, as in color, in which they are certainly scarsely [*sic*] tolerable. Leutze was the only colorist amongst them."[17] Johnson's training probably reinforced his natural and especially strong gift for draftsmanship. The interest in domestic and everyday subjects, the use of a stage-like composition, and the harking back to the Dutch genre tradition were prevailing trends in Düsseldorf to which he was probably also receptive. Before returning home, Johnson spent some time in the studio of Thomas Couture in Paris. Most likely, it was this experience that had the most enduring influence on his style of painting.

The American landscape painters who studied in Düsseldorf faired somewhat differently than those interested in history, portrait, and genre painting. American scenery, in contrast to the European, presented an alternative. Moreover, there already was a firmly established tradition of landscape painting in the Hudson River school. Stylistically indebted to the seventeenth-century European masters for compositional formulas and romantic devices, the first generation of Hudson River school painters, with their emphasis on working from nature, captured the character of the American landscape. Their work had a powerful effect on the landscape painters of the following generation, and in some cases served to counteract the influence of the Düsseldorf school. Düsseldorf training, with its emphasis on exacting detail and fidelity to nature, however, was not incompatible with the Hudson River school style, which had similar tendencies.

Worthington Whittredge arrived in Düsseldorf in 1849 and was promptly commandeered by Leutze to serve as the model for his *Washington Crossing the Delaware*. Whittredge studied the works of Lessing, Andreas Achenbach, and Johann Wilhelm Schrimer but follow-

[16] George H. Hall to Andrew Warner, July 8, 1850, Letters from Artists, American Art-Union Papers, NYHS.

[17] Eastman Johnson to Andrew Warner, Jan. 16, and Nov. 20, 1851, ibid.

ed none of them. Except for a brief period, his exposure to the Düsseldorf style had little effect on his work. Retreating to the Catskills shortly after his return home in 1859, Whittredge rediscovered aspects of the American landscape that distinguished it from the European. He wrote: "The forest was a mass of decaying logs and tangled brush wood, no peasants to pick up every vestige of fallen sticks to burn in their miserable huts, no well-ordered forests, nothing but the primitive woods with their solemn silence reigning everywhere."[18]

Unlike Whittredge, Albert Bierstadt combined American subject matter with a painting style rooted in the German romantic tradition. A cousin of the Düsseldorf genre painter Johann Peter Hasenclever, Bierstadt was born in Solingen, near Düsseldorf. He spent his early years in New Bedford, Massachusetts. In 1853 he went to Düsseldorf, where he shared a studio with Whittredge and met Achenbach and Lessing. The landscapes of the two German artists had a pronounced effect on Bierstadt's painting style. This influence is especially evident in his celebrated painting of 1863, *The Rocky Mountains* (p. 321). "The mountains," he reported in a letter from the Rockies in 1859, "are very fine; as seen from the plains, they resemble very much the Bernese Alps."[19] A monumental panorama celebrating the American West, *The Rocky Mountains* stylistically demonstrates Bierstadt's debt to German landscape painting. The stage-like illusion of progression in depth, the sense of drama and the picturesque, the use of light and color for maximum expression, and the detail of the foreground reflect the influence of Düsseldorf artists like Lessing and Achenbach. So too does the inclusion of two silhouetted figures overlooking the lake in the middle distance, a favorite device in romantic imagery.

William Trost Richards was a painter whose penchant for detail was reinforced by his training in Düsseldorf. He was a student of the German-born artist Paul Weber in Philadelphia and an admirer of the work of Frederic E. Church. Like other Americans, Richards sought to improve his technical skill in Germany. His brief stay in Düsseldorf in 1856 served to strengthen his meticulous draftsmanship. Later Richards's taste for crisp detail and fine finish was further influenced by the Pre-Raphaelites. Another student of Weber in Philadelphia was William Stanley Haseltine. He accompanied Weber to Düsseldorf in 1855. There Haseltine studied with Andreas Achenbach and became close friends with Whittredge, Bierstadt, and Leutze. The strong draftsmanship that characterized his work was also a product of his studies in Germany.

The presence of Schirmer and Lessing in Karlsruhe in the 1860s made it a center for the study of landscape painting in those years. Both Edward Gay and Alexander Wyant studied there. At the urging of William and James M. Hart (who had studied with Schirmer in Düsseldorf), Gay went to Karlsruhe to pursue his studies in 1862. An account of Gay's life suggests that, like so many other American artists, he was frustrated by his studies in Germany. The Ohio-born painter Alexander H. Wyant went to Karlsruhe in 1865 and studied with the Norwegian landscape painter Hans Fredrik Gude, himself a student of Achenbach and Schirmer at Düsseldorf. Wyant subsequently became disillusioned with the school, finding that it inhibited the imagination. Nonetheless it had an effect on his painting style, which

[18] John I. H. Baur, ed., "The Autobiography of Worthington Whittredge, 1820–1910," *Brooklyn Museum Journal* (1942), p. 42.
[19] *Crayon* 6 (Sept. 1859), p. 287.

is evident in his landscape *Tennessee* (p. 412). In composition, color, and exact draftsmanship—especially in the detailed treatment of the foreground rocks and water—this work, painted in Karlsruhe in 1866, reflects Wyant's assimilation of the Düsseldorf style of landscape painting.

From the 1840s to the 1860s, Paris offered American artists studying abroad a distinct alternative to Düsseldorf. Many, including William Morris Hunt, Eastman Johnson, and Enoch Wood Perry went there after their studies in Germany.

When John F. Kensett arrived in Paris in 1840, he joined Thomas P. Rossiter, George P. A. Healy, Asher B. Durand, and Daniel Huntington—a flourishing group of American artists, memorialized by Rossiter in *A Studio Reception, Paris*, 1841 (Albany Institute of History and Art). Kensett often met the elderly John Vanderlyn, who had been the first American artist to study in Paris. According to Kensett, Vanderlyn made "great efforts to assist the young American artists by the establishment of a small society for copying the works of the best masters." With Rossiter, Kensett drew from antique casts and from life at the Ecole Préparatoire des Beaux-Arts. With Benjamin Champney, who joined the group soon after Kensett, he visited the Forest of Fontainebleau, where they made their "first attempt in colors from nature."[20]

The majority of American artists working in France during the 1840s and 1850s studied at the independent Paris ateliers. Those of François Edouard Picot, Charles Gleyre, and Thomas Couture were especially popular. The American painters represented in the museum's collection who studied in these ateliers and their dates there are: at Picot's, Edwin White (1851) and Elihu Vedder (1856); at Gleyre's, James McNeill Whistler (1856), Edward Lamson Henry (1860), Alfred Wordsworth Thompson, and Francis Blackwell Mayer (1862); and at Couture's, which was by far the most popular, William Morris Hunt (1846-1852), Thomas Hicks (1848-1849), Robert Loftin Newman (1850), Enoch Wood Perry (1854–1855), Eastman Johnson (1855), John La Farge (1856), George Henry Yewell (1856), and Samuel Colman (1860). Others, like George Fuller and Albert Pinkham Ryder were indirectly influenced by Couture—Fuller, through the work of William Morris Hunt and his students, and Ryder, through his teacher William E. Marshall and his friend Robert Loftin Newman, both former Couture students.

The history, genre, and portrait painter François Edouard Picot was a student of François Vincent and Jacques Louis David. Picot's atelier, Thomas Hicks reported, was especially noted for its emphasis on drawing. To prepare his students for the Ecole des Beaux-Arts and the *prix de Rome* competition, Picot had established contests, offering a silver medal every three months for the best of fifteen figure studies and the best compositional sketch.[21] Elihu Vedder, according to his autobiography, "was only in Paris eight months, drawing from plaster casts." He provided a brief account that demonstrated both how arbitrary the choice of an atelier often was and how haphazard the teaching could be. "We at once found out," Vedder reported, "that in the Atelier Picot more *grands prix de Rome* had been won than in any

[20] John F. Kensett to John R. Kensett, Nov. 3, 1842, Edwin D. Morgan Collection, New York State Library, quoted in John K. Howat, *John Frederick Kensett, 1816–1872*, exhibition catalogue (New York, 1969), n. p., and Benjamin Champney, *Sixty Years' Memories of Art and Artists* (Woburn, Mass.), 1900, p. 20.

[21] T. H[icks], "Parisian Hints for Artists," *Bulletin of the American Art-Union* (August 1850), p. 75.

other, so we went there and were admitted. The instruction consisted in a little old man with a decoration coming twice a week and saying to each one of us, '*Pas mal! Pas mal!*' and going away again. . . . Had I fallen in with some of the American students of Couture, I might have gone there and gotten over a faithful but fiddling little way of drawing which hangs around me yet, 'unbeknownst,' or I might have said in later years with a most talented friend of mine, 'I wish to God I could get rid of that cut-and-dried Beaux-Arts style."[22]

James McNeill Whistler studied for a short time in the atelier of the Swiss-born painter Charles Gleyre beginning in 1855. Gleyre was neither an academician nor a teacher at the Ecole des Beaux-Arts. A progressive master, he encouraged originality, composing from sketches and painting outdoors. (Among his pupils were Bazille, Monet, Renoir, and Sisley, who became well-known impressionists.) Edward J. Poynter, the English painter, noted that "during the two or three years when I was associated with him" in Paris, Whistler "devoted hardly as many weeks to study." The English novelist and illustrator George du Maurier, who was one of Whistler's fellow students, later cast him as Joe Sibley, "'the Idle Apprentice,' the King of Bohemia, *le roi des truands*" in *Trilby*. Whistler's biographers, the Pennells, reported that "Fantin-Latour and M. Duret both have said that they seldom heard Whistler speak of Gleyre's," and when questioned about it, he spoke only of the relative decorum in the atelier. Nevertheless, Whistler adopted Gleyre's practice of sketching from memory, his method of preparing the palette, and his belief that black was "the base of tone."[23]

The most popular studio for Americans studying in Paris from the 1840s to the 1860s was unquestionably that of Thomas Couture. Couture had been a pupil of Baron Antoine Jean Gros and Paul Delaroche. He opened his atelier in Paris in 1847 and worked there until 1860. He moved to his birthplace in Senlis and ran another school from 1861 to 1863. Then he gave private lessons and conducted summer classes at his home in Villiers-le-Bel until his death in 1879. Couture insisted that the *ébauche*, or rough sketch, should be preserved in the finished work in order to retain spontaneity. He also advocated the initial establishment of light and dark values, the use of pure color, and a restricted palette. He urged his students to study the works of Correggio and the Venetians in the Louvre. In *Methode et entretiens d'atelier*, a two-volume work published in 1867 and 1869, he set down his methods of painting and teaching. These writings had a profound effect on his American students. The first volume was dedicated "A l'Amerique." An English translation of both volumes with an introduction by Robert Swain Gifford appeared in 1879. An article signed T. H., most likely written by Thomas Hicks, described Couture:

> He is an excellent instructor. He has the natural gift of imparting, with facility, through happy and forcible illustrations, drawn always from his observations of nature, everything the student requires to direct him to the most proper and efficient study of natural objects. He has a contempt for *processes*, and teaches always the necessity of painting, *at once, au premier coup*. M. Couture prefers his pupils to have mastered the rudiments of drawing before they enter his atelier, as it leaves him to teach them solely *how to paint*. No Artist insists upon the necessity of fine drawing more strenuously than he, and he constantly refers his pupils to the study of the grandest antique statues, he himself having studied for years severely the Elgin Marbles.[24]

[22] Elihu Vedder, *The Digressions of V.* (Boston, 1910), p. 129.

[23] Elizabeth R. and Joseph Pennell, *The Life of James McNeill Whistler* (6th rev. ed., Philadelphia, 1919), pp. 36, 327, 34-35.

[24] H[icks], "Parisian Hints for Artists," p. 75.

Couture's most prominent French pupils were Edouard Manet and Puvis de Chavannes. His first American student was William Morris Hunt. Hunt had gone to Düsseldorf in 1845 on the recommendation of Leutze whom he met in Rome. After nine months at the academy, however, he became disenchanted with the tedious academic exercise of working "with a pointed lead pencil and a measure."[25] He then went to Paris to study sculpture. One of Couture's paintings, *The Falconer* (Toledo Museum of Art), however, is said to have inspired Hunt to become a painter and to seek out Couture. Hunt remained one of Couture's favorite disciples for almost six years, until about 1852 when the work of Jean François Millet attracted his attention. William Babcock, another Bostonian, came to study with Couture in 1847. It was probably Babcock who introduced Hunt to the Barbizon style. After Hunt returned to the United States in 1855, he taught in Newport. One of his most important students there was John La Farge, who had already worked briefly with Couture. In 1862 Hunt moved to Boston where he became a leading force in the city's cultural circles and a prominent teacher, inspiring a generation of American artists. He championed the works of the Barbizon painters and encouraged their collection in the United States. He also encouraged his pupils to study with Couture, and several attended summer classes at Villiers-le-Bel. Helen K. Knowlton, one of Hunt's students, recorded his theories on painting in *Talks on Art* (1894-1895), a two-volume work, which later greatly influenced Robert Henri and members of the Eight. Couture's effect on American artists was far-reaching. Another painter and teacher who conveyed Couture's ideas and techniques was Thomas Satterwhite Noble. He studied with Couture from 1856 to 1859, and was appointed professor of art in 1868 at the newly founded School of Design associated with McMicken University in Cincinnati, subsequently the Art Academy of Cincinnati. Noble served as director there until 1904. His pupils included Kenyon Cox, John Twachtman, and John Ward Dunsmore, who was director of the Detroit Museum of Art from 1889 to 1890 and then head of its art school until 1894.

Many of Couture's American students went on to paint at Barbizon, where they were influenced by the works of such artists as Millet, Corot, Rousseau, and Daubigny. Corot first visited Barbizon about 1825; Rousseau, who was to make it his home in 1848, first went there in 1827; and Millet settled there in 1849. Together with Daubigny, Narcisse Virgile Diaz de la Peña, Jules Dupré, Charles Emile Jacque, and Constant Troyon, these artists came to be known as the Barbizon school. They sought in nature and rural life an escape from an increasingly industrial society and, especially in the case of Jacque, Troyon, and Millet, celebrated the life of the peasant. In the United States, William Morris Hunt was the chief advocate of this school. Winckworth Allan Gay, who accompanied Hunt to Paris and studied with Troyon in 1847, is credited as the first American to have studied with a Barbizon painter. Hunt's friend William Babcock remained in Barbizon from about 1849 until 1892. Impressed by Millet's painting *The Sower* at the Salon in 1850, Hunt arranged an introduction through Babcock and the sculptor Antoine Barye. In 1851 he left Couture's studio to live in Barbizon, where he became the student, friend, and patron of Millet. Although Hunt's work, especially his portraits and figure paintings, bears the distinctive stamp of Couture, he later reported: "I am grateful to Couture for what he taught me, but it was well that I left him. When I came to know Millet I took broader views of humanity, of the world, of life. His subjects were real

[25] Helen M. Knowlton, comp., *W. M. Hunt's Talks on Art* (2nd series, Boston, 1883), p. 17.

people who had work to do." John La Farge noted that Hunt introduced him to the works of Millet, "of which he had many, including the famous 'Sower,' and very many drawings, and more especially to the teachings, the sayings, and the curious spiritual life which a great artist like Millet opens to his devotees. Every day some remark of Millet's was quoted, some way of his was noticed, some part of his life was told; he was, in this way, in those studios, a patron saint."[26] The influence of Couture and the Barbizon school had its chief effect on La Farge's painting style during his studies with Hunt in Newport in 1859. La Farge's *Portrait of the Artist* (p. 402), painted the same year at the family home in Glen Cove, Long Island, is perhaps the best example of this period in his painting. Although his work soon took a different direction, La Farge was quick to grasp the freedom and spirit of the Barbizon painters.

Robert Loftin Newman studied for five months in Couture's atelier in 1850. He returned to Paris in 1854, was introduced by Hunt to Millet, and spent several months at Barbizon. The work of this romantic visionary, which stands outside the mainstream of American art, was profoundly influenced by both Couture and Millet. The sacrifice of detail to achieve a unified effect, the emphasis on the *ébauche*, the use of contour line for expression, and the enrichment of texture by the use of scumbling all reflect Newman's debt to Couture.

The Barbizon school influenced American landscape painters in various ways. Some members of the second generation of the Hudson River school, such as Whittredge and Gifford, admired the spirit of these painters and their dedication to nature but initially were disturbed by the lack of finish and detail in their works. Others, like George Inness, chose to explore these very aspects. David Johnson wholeheartedly adopted the Barbizon style, which also played a leading role in the stylistic development of Alexander H. Wyant, Edward Gay, and Homer Dodge Martin.

After visiting the Exposition of 1855 in Paris, Gifford wrote: "I am forcibly struck with the French landscape school." He reported: "It seems to me in most respects the best in the world. . . . In the French landscape everything like finish and elaboration of detail is sacrificed to the unity of the effect to be produced. . . . The subjects are mostly of the simplest and most meagre description; but by the remarkable truth of color and tone, joined to a poetic perception of the beauty of common things, they are made beautiful." He visited Fontainebleau and Barbizon and met Millet, whose work he described in the *Crayon*.[27] Yet the influence of contemporary French art did not have a great effect on Gifford's development. What attracted him was the overall unity Barbizon artists achieved in their pictures, but he was not willing to sacrifice detail and description to the same extent. He used light to unify his work. Despite his comparatively descriptive style, however, he was criticized by some for eliminating detail in the interest of the whole.

On a trip abroad in 1854, George Inness had the opportunity to study the works of the Barbizon school. "As landscape-painters, I consider Rousseau, Daubigny and Corot among the very best," he later remarked.[28] This influence led Inness to abandon the descriptive man-

[26] Knowlton, *Art-Life of William Morris Hunt* (London, 1899), p. 12, and Royal Cortissoz, *John La Farge: A Memoir and a Study* (Boston, 1911), p. 111.

[27] Sanford R. Gifford, Journal, 1, Sept. 29, 1855, typescript copy, p. 116, D21, Arch. Am. Art; Ila Weiss, *Sanford Robinson Gifford (1823–1880)* (New York, 1977), p. 91, notes that Gifford wrote "Gleanings and Items," *Crayon* 3 (Nov. 1856), p. 345.

[28] George Inness, Jr., *Life, Art, and Letters of George Inness* (New York, 1917), p. 30.

ner that characterized his earlier work and develop a broader style and a more poetic approach to landscape painting. His desire to express mood, the influence of Swedenborgianism to which he was introduced by William Page, and the influence of Whistler led him to a more subjective and introspective style. This aligned him with a group of painters now known as tonalists.

David Johnson, a member of the second generation of the Hudson River school, probably did not study abroad. He did, however, have ample opportunity to study Barbizon paintings and prints in the United States. Thus in 1877, when he sent his painting *Housatonic River* to the Paris Salon, it won enthusiastic comment from the French press. Johnson became known as "the American Rousseau" and did well with his American landscapes styled after Barbizon contemporaries.

Another second generation Hudson River school painter and an influential member of the National Academy of Design, Jervis McEntee, called French art "feverish and diseased," characterized Corot's work as "incomplete and slovenly," and noted that French "artists are constantly doing *outré* things, which surprise, or bewilder, or stun." His comments about "foreign-looking art" showed his aversion to the increasing European influence on American painters.[29] Even while resenting this influence, however, McEntee progressively adopted the expressive and subjective style associated with Barbizon.

The reception of Barbizon painting and Barbizon-inspired art in the United States reflected the changing taste in art in the country at mid-century. The increasing popularity of European art, however, was a threat to American artists. The growing market for contemporary European art and that of Americans influenced by it meant vigorous competition for the adherents of older traditions. The subjective and interpretative approach to nature of the Barbizon style liberated some American landscape painters. It was diametrically opposed, however, to the style advocated by the Ruskinians and seriously threatened the Hudson River school tradition—as the Düsseldorf style had not. The artist's responsibility to be true to nature and to view it as a direct reflection of God's immanence, the idea of landscape painting as a vehicle for religious and moral edification, and the image of America as the New Eden were undergoing rapid transformation.

Ruskin continued to exert a strong influence well into the late 1850s. A traveling exhibition of British painting, selected by William Rossetti, shown in New York, Philadelphia, and Boston in 1857 and 1858, included a number of works by the Pre-Raphaelites. Publicized by William James Stillman in the *Crayon*, it was received with great interest but little financial success, coming as it did in a period of depression. The formation of "The Society for the Advancement of Truth in Art" in 1863 reaffirmed Ruskinian precepts. Clarence Cook, editor of its journal, the *New Path*, was for a time one of the severest critics of Barbizon school painting, which was then being championed in Boston by William Morris Hunt and his circle. Another member of the society, Charles Herbert Moore, an artist, author, teacher at Harvard University, and first director of the Fogg Museum, was equally critical of Hunt, his teaching, his work, and that of his students. Both critics complained about the lack of finish

[29] G. W. Sheldon, *American Painters: With Eighty-three Examples of Their Work Engraved on Wood* (New York, 1879), p. 51; G[arnett] McC[oy], "Jervis McEntee's Diary," *Journal of the Archives of American Art* 4 (July 1964), p. 11.

and what they interpreted as technical shortcomings in the Barbizon-inspired works, raising the long-argued controversy over the validity of the sketch versus the finished work. Hunt and his followers were subject to such criticism well into the late 1870s, even though Ruskinianism was then on the decline. As critical attention shifted to new and more radical styles imported from abroad, however, the Barbizon style became commonplace.

In a letter to the author and editor Charles Eliot Norton in February 1861, a disenchanted William James Stillman wrote:

> I have studied the French painters hard this winter especially Rousseau who has taken quite an interest in me and treated me like a pupil as does Troyon. . . . I am learning what color is and how to get it and you will I believe find me much improved both in color and aerial qualities. I regret now my last year's experience, my study in England and my summer with Ruskin. The English artists know almost nothing of the art of painting and Ruskin I am sure is principally and fundamentally wrong on all practical questions and his advice and direction the worst things a young artist can have.[30]

Three years later, the collector, author, and critic James Jackson Jarves wrote:

> The English school has ceased to exercise any influence over ours, unless a crude interpretation of its Pre-Raphaelitism by a few young men may be considered as such. Some, like Mr. [William Trost] Richards and his followers, show decided talent in imitative design, and are earnest in their narrow, external treatment of nature. We do not believe, however, that their principles and manner will become firmly rooted here, in face of the broader styles and more comprehensive ideas of another set of our young artists. . . . But it is the French school that mainly determines the character of our growing art. . . . It is particularly fortunate for the American school that it must compete at its own door with the French. The qualities of French art are those most needed here, in a technical point of view, while its motives and character generally are congenial to our tastes and ideas. The Dusseldorf was an accidental importation. That of Paris is drawn naturally to us by the growth of our own. . . . It [French art] is the natural friend and instructor of American art; and, while it remains true to its present renovating principle, we cannot have too much of it.[31]

Few American artists went to Italy for formal instruction. Beginning in the 1830s, however, a growing number had joined flourishing communities of artists in Florence and Rome. The lure of Italy was chiefly its historic and artistic associations—its great art collections and ruins of an ancient past. Daniel Huntington, Henry Peters Gray, Thomas P. Rossiter, Frederic E. Church, John F. Kensett, Jervis McEntee, George Yewell, Sanford Robinson Gifford, William Stanley Haseltine, George Inness, Thomas Moran, and Elihu Vedder all visited Italy. It was there that American artists came into contact with the neoclassical paintings of Anton Mengs and the work of the Nazarene painters. Many American sculptors, attracted to Italy by the availability of craftsmen, materials, and models, became permanent residents. Few American painters, however, followed their example. Many found growing support from a public increasingly conscious of its national identity. Others were drawn home instead to the American wilderness, which offered a challenging alternative to romantic celebrations of a foreign past.

[30] William Stillman to Charles Eliot Norton, Feb. 14, 1861, Houghton Library, Harvard University, quoted in Peter Bermingham, *American Art in the Barbizon Mood,* exhibition catalogue (Washington, D. C., 1975), p. 47.

[31] James Jackson Jarves, *The Art-Idea* (1864), ed. Benjamin Rowland, Jr. (Cambridge, Mass., 1960), pp. 178, 180-182.

Political upheavals that led to the unification of Italy in 1861 hastened the exodus of some Americans as did the outbreak of the American Civil War. Many artists, however, stayed on, and Italy regained some of its prominence as an international art community in the post-war period. During the last quarter of the nineteenth century, Venice began to attract artists like James McNeill Whistler, Frank Duveneck and his students, and John Singer Sargent.

In 1864 the Metropolitan Fair, which was to aid the war effort of the United States Sanitary Commission (a precursor of the American Red Cross) opened in New York. Paintings included in this major exhibition were Leutze's *Washington Crossing the Delaware*, Bierstadt's *Rocky Mountains*, Church's *Heart of the Andes*, Huntington's *Mercy's Dream*, and Gray's *The Pride of the Village*—all now in the Metropolitan Museum. This exhibition represented, to some extent, the country's artistic accomplishments during the first half of the nineteenth century.

In a letter to John Durand, Francis Blackwell Mayer reflected on the upheavals of the Civil War and their effects on America's artists: "What is to become of us all after this war God only knows, except we all turn battle-painters, a vocation in which, especially in this contest, I, for one, could never engage. However, I am grateful to be an artist and pursue my course as directly as circumstances of so counteracting a nature will permit me. . . . Nothing scarcely is doing here in Art and the public progress we were making has been postponed. How many years we are put back I do not know."[32] Despite Mayer's fears, the war years and those immediately following were artistically productive. Some of the different stylistic currents are evident in three paintings produced in 1865. Completed after a prolonged stay in England, Jasper F. Cropsey's *The Valley of the Wyoming* (p. 190) reflects both the artist's roots in the Hudson River school and, in its precise detail, the pervasive influence of the Pre-Raphaelites. George Inness's *Peace and Plenty* (p. 250), which celebrates the end of the war and the men's return to the land, is a broadly painted expressive landscape that attests to his assimilation of the Barbizon school style. Winslow Homer's *The Veteran in a New Field* (p. 433) deals with the same theme and derives from similar French sources.

The post-Civil War years ushered in a new era. The transformation of rural America into one of the great industrial powers, the creation of a new wealthy class of patrons, and a growing cosmopolitanism changed the direction of American art. In 1867 the publication of Henry T. Tuckerman's *Book of the Artists* provided a record of the country's artistic accomplishments. The same year, thirty-eight Americans were represented by seventy-five pictures at the Exposition Universelle, marking the increasing participation of American artists in international exhibitions. In 1870 the Metropolitan Museum of Art was founded in New York. Its founding trustees included the painters John F. Kensett, Frederic E. Church, Daniel Huntington, Eastman Johnson, the sculptor John Q. A. Ward, the architect Richard Morris Hunt, and the engraver and art dealer Samuel P. Avery. The same year the Museum of Fine Arts was established in Boston. The formation of new organizations during the second half of the nineteenth century reflected changing directions and needs: the American Society of Painters in Watercolors was founded in 1867; the Art Students League of New York in 1875;

[32] Francis B. Mayer to John Durand, Baltimore, Oct. 6, 1861, "History of Art" Autograph Collection, Arch. Am. Art., quoted in Helene Barbara Weinberg, "The Archives' Autograph Collections," *Archives of American Art Journal* 13, no. 4 (1973), p. 3.

the Society of American Artists, the Tile Club, the Society of Decorative Art, and the New York Etching Club in 1877; the Architectural League of New York in 1881; the Society of Painters in Pastel in 1882; the American Fine Arts Society in 1889, the National Sculpture Society in 1893, the Society of Beaux-Arts Architects in 1894; the National Society of Mural Painters in 1895; the Ten American Painters in 1897; and the Eight in 1908. Beginning with the Centennial Exposition in Philadelphia in 1876, international expositions proliferated in the United States. These included the World's Columbian Exposition in Chicago in 1893; the Tennessee Centennial in Nashville in 1897; the Pan American Exposition in Buffalo in 1901; the Louisiana Purchase Exposition in Saint Louis in 1904; and the Panama-Pacific International Exposition in San Francisco in 1915. Wealthy new patrons encouraged the building of lavish private houses modeled after great Renaissance palaces and French chateaux. Public building followed the same pattern, reflecting the nation's new economic power. These elaborate buildings required the collaborative efforts of architects, craftsmen, painters, and sculptors. Out of these decorative pursuits, mural painting emerged as a major art form in the 1870s. Large in scale, these works encouraged the revival of allegorical, historical, and religious painting. Examples of the taste for decoration are John La Farge's work on Trinity Church in Boston in 1876-1877, William Morris Hunt's murals for the New York State Capitol in Albany in 1878 (see p. 213), Mary Cassatt's mural for the World's Columbian Exposition in Chicago commissioned in 1893, and Elihu Vedder's for the Walker Art Building at Bowdoin College in Brunswick, Maine, in 1894.

Stylistic diversity characterized American art in the second half of the nineteenth century. The period was marked by the rediscovery of oriental art and an increase in the influence of several rapidly changing styles of European art. The importance of subject matter as a reflection of national character was no longer a great issue. American painters became more assured and interested in painting for its own sake. The emphasis on content was replaced by a concern for style and formal qualities. While realism was a persistent trend in American painting throughout the nineteenth century, a variety of new realistic styles emerged in the second half of the century. They were based on: a strong indigenous tradition exemplified by the paintings of John Singleton Copley and the Peale family; the work of artists trained in Düsseldorf and Munich; the works of those who followed the Pre-Raphaelites and Ruskin; and the paintings of artists trained under such French artists as Thomas Couture and Jean Leon Gérôme. Three major figures whose works exemplify the new objective realism were Eastman Johnson, Winslow Homer, and Thomas Eakins.

An established figure in New York art circles, Eastman Johnson was noted for portraits, especially group portraits in contemporary settings, such as *The Hatch Family* (p. 223); representations of Indian life and the Civil War; and, most important, genre painting. Trained at the Düsseldorf Academy, Johnson also studied Dutch and Flemish art at The Hague and worked for a brief time in the atelier of Thomas Couture in Paris. The technical and stylistic lessons learned in Düsseldorf and Paris, his study of seventeenth-century Dutch painting, and his familiarity with the earlier genre tradition of such Americans as William Sidney Mount served as points of departure for Johnson's own realistic style. A successful synthesis of these disparate sources is evident in his work. "His pictures bear the unmistakable stamp of originality," John F. Weir wrote. "We are never reminded in them of the influence of

schools or foreign methods; they rest upon their own merits, and the only comparisons they suggest are those afforded by the truths of nature." A member of the National Academy and from 1881 an elected member of its rival, the Society of American Artists, Johnson was claimed by both conservatives who espoused earlier native traditions and young American artists trained abroad who had adopted European styles. "The Academicians call him theirs," reported the critic and artist Samuel G. W. Benjamin, "because, although he studied long abroad, he has imported the style of no foreign artist, but has illustrated the principles of art in a manner entirely his own; and because, too, he has been content to look for subjects at home, thus showing himself wholly in sympathy with the attractions of his own land." "These qualities," he added, "have not been characteristic of the work of the new school of American artists, who, while showing ability and enterprise, have purposely imported the styles of Bonnat, Gerome, Daubigny, Corot, or Manet, together with a selection of subjects entirely foreign, and therefore imitative. . . . They in turn lay claim to Eastman Johnson as one of their number, because his style (a quality they estimate above matter), while wholly his own, suggests the consummate technical ability of the modern Continental masters." In *The New Bonnet* (p. 229) and *Husking-Bee, Island of Nantucket* (Art Institute of Chicago) Johnson showed his ability to work in totally different styles. *The New Bonnet* is painted in a tight, finished style that reflected his academic training and strong draftsmanship. *Husking-Bee*, in contrast, is painted in a broad, fluent manner that reflected his familiarity with contemporary European modes. Johnson always made a distinction between the study and the finished work, maintaining in this respect a relatively conservative attitude. His broadly painted studies, like the one (p. 227) for *Husking-Bee*, were never intended for exhibition and remained in his studio during his lifetime. He is best known for his genre paintings, which Weir describes as "illustrative of characteristic traits of American life and customs." In these paintings he recorded a way of life in rural America that would soon be gone.[33]

Johnson's contemporary, the New England artist Winslow Homer, was one of America's indisputable masters. His training was limited to an apprenticeship in the Boston lithographic firm of J. H. Bufford, night classes in New York at the National Academy of Design, and a month of private painting lessons also in New York with Frederick Rondel, a French landscape and genre painter. Homer supported himself as a freelance illustrator until 1875. As an artist-correspondent for *Harper's Weekly* during the Civil War, he found many of the subjects for his earliest oil paintings. In 1866 he completed *Prisoners from the Front* (p. 437), the work that established his reputation. An arresting contemporary statement of a tragic national conflict and an innovative history painting, it was described by one critic as "a genuine example of true historical art—the only kind of historical art which is trustworthy in its fact, free from flimsy rhetoric and barbaric splendor; sensible, vigorous, honest."[34] Shown at the Exposition Universelle in Paris in 1867, it attracted considerable attention. Although Homer lived in New York City for some twenty years, outdoor life and rural subjects dom-

[33] J. F. Weir, "Group XXVII. Plastic and Graphic Art. Painting and Sculpture," *United States Centennial Commission, International Exhibition, 1876. Reports and Awards, Groups XXI-XXVII*, ed. F. A. Walker, 7 (1880), p. 29; S. G. W. Benjamin, "A Representative American," *Magazine of Art* 5 (Nov. 1882), p. 490.

[34] Sordello [pseud.], *New York Evening Post*, April 28, 1866, p. 1.

inated his early genre paintings. These are noteworthy in their immediacy and exhibit an objective realism based on the direct observation of nature and an interest in the effects of light on form. On two trips to Europe, Homer visited France (1866–1867) and England (1881–1882), where he pursued independent studies. Because of his reticence on the subject of influences and his avowed independence, the origins of his style must be deduced chiefly from the visual evidence of his work. To his fellow artist J. Foxcroft Cole, he once observed that "if a man wants to be an artist, he should never look at paintings."[35] John La Farge, however, reported that Homer's early education, like his own, had been based on "the studies of especially the French masters of whom there were only a very few examples in the country as far as painting went. . . . We had to depend on the engravings and especially the very wonderful lithographs, which gave us the synopsis of a great deal of European art."[36] Homer's originality and strong reliance on his own observations tend to obscure the evidence of such training. Some elements of French influence, however, are apparent in such paintings as *The Veteran in a New Field* (p. 433), *The Studio* (p. 445), and *Harvest Scene* (p. 465).

Homer's depictions of recent events—the Civil War, Reconstruction, and the Spanish American War in works like *Prisoners from the Front* (p. 437), *Dressing for the Carnival* (p. 461), and *Searchlight on Harbor Entrance, Santiago de Cuba* (p. 490)—went beyond the scope of an artist-reporter. They represented a novel form of history painting as well. His strong almost oriental sense of decorative design is evident in *Camp Fire* (p. 466) and *Northeaster* (p. 471). His preoccupation with formal qualities is demonstrated by his choice of a square format in *Cannon Rock* (p. 475). Although his paintings were realistic representations, they did not preclude such romantic elements as one finds in *The Gulf Stream* (p. 482). This work, Bryson Burroughs observed, could "assume the proportion of a great allegory if one chooses."[37] Homer was an artist of great diversity and artistic accomplishment. His commitment to his own powers of observation; his development of a direct technique, unencumbered by the constraints of extensive academic training; and his inventive imagery distinguished his work and earned him a place as one of America's most celebrated painters. Retiring to Prouts Neck, Maine, in the 1880s, he lead the solitary life he favored. There he produced a series of distinctive images of the sea, unparalleled in American art, which inspired a later generation.

The Philadelphia-born genre painter and portraitist Thomas Eakins was a master in the realist tradition. Trained at the Pennsylvania Academy of the Fine Arts, Eakins pursued the study of anatomy at Philadelphia's Jefferson Medical College, and in 1866, like other Americans of his generation, he went to Paris. He continued his studies under the leading academician and genre painter, Jean Léon Gérôme, at the Ecole des Beaux-Arts. He was also briefly a pupil of the fashionable portraitist Léon Bonnat and the sculptor Augustin Alexandre Dumont. "What I have learned," he wrote to his father, "I could not have learned at home; for beginning, Paris is the best place." Gérôme continued to serve as his mentor long after Eakins returned to the United States. Later Gérôme wrote him: "I am happy to have a

[35] Lloyd Goodrich, *Winslow Homer* (New York, 1944), p. 6.

[36] Gustav Kobbé, "John La Farge and Winslow Homer," *New York Herald* (Dec. 4, 1910), magazine section, p. 11.

[37] B[ryson] B[urroughs], "Principal Accessions," *Bulletin of the Metropolitan Museum of Art* 2 (Jan. 1907), p. 14.

student such as you to do me honor in the New World."[38] Eakins's draftsmanship, firm modeling, and strong contrasts of dark and light, which distinguish the best of his works, reflected this French training. He shared Gérôme's interest in photography, anatomy, and perspective. In addition he admired the academics Couture and Meissonier. His studies with Dumont reinforced his preoccupation with three-dimensional form.

Before returning home in 1870, Eakins traveled to Spain. He spent several days in Madrid and studied the works of Velázquez and Ribera in the Prado, which exerted a considerable influence on his development. In 1870 he painted his first composition, *A Street Scene in Seville* (New York art market, 1985), which represented a family of street performers. Carmelita Requeña, the seven-year-old daughter of this family, posed for Eakins in December 1869 (p. 586). One of Eakins's first paintings, this portrait is the earliest by him in the museum's collection. A vigorously painted and richly colored work, *Carmelita Requeña* reflects his exposure to the art of Spain.

With few exceptions, Eakins's early work was largely autobiographical. As a true realist he depicted the world around him. He focused on his family and the people and activities of his native Philadelphia. One of his most accomplished paintings, *The Champion Single Sculls*, 1871 (p. 588), long known as *Max Schmitt in a Single Scull*, depicts a boyhood friend. This ambitious, carefully arranged studio composition was one of the first paintings he exhibited, and it received mixed reviews. An example of Eakins's realist style, it reflected his concern for close and accurate observation. He achieved his exact perspective and carefully modeled form by relying on science and mathematics. Eakins's usual custom was to work out the relationship of lights and darks in oil sketches. In addition to this he made careful perspective drawings like the one for *The Chess Players* (p. 600) in the Metropolitan's collection. In 1875 Eakins completed *The Gross Clinic* (Medical College of Thomas Jefferson University, Philadelphia), a provocative work, which, like *The Agnew Clinic* of 1889 (University of Pennsylvania), is indebted to Rembrandt's *Anatomy Lesson*. Intended for the Centennial in 1876, *The Gross Clinic* was rejected for its uncompromising realism and relegated to the United States Army Hospital exhibit. The same year Eakins began *William Rush Carving His Allegorical Figure of the Schuylkill River*. The final version, completed in 1877 (Philadelphia Museum of Art), showed an eighteenth-century Philadelphia sculptor and his model. While his choice of a historical subject was inspired by the centennial celebration, working from a live model also had a particular significance for Eakins. It was one of his basic tenets.

The study of the human figure was central to Eakins's teaching. It played an important role in his own paintings as well. *Arcadia* (p. 608), an unfinished painting of 1883, provided Eakins with a traditional vehicle for a realistic study of nudes in a landscape setting. Based on photographs and broadly painted life studies, it combines his interest in the study of the human figure and in plein-air landscape. Prolonged copying from the antique, he believed, was of little value; for the accomplishments of the classical masters stemmed from their own careful studies from life. A candid image of the nude outdoors, *Arcadia* celebrates an ideal pagan world, free from the kind of strictures imposed by the society in which Eakins lived.

From about 1880, when he is said to have gotten his first camera, Eakins began experiment-

[38] Quoted in Lloyd Goodrich, *Thomas Eakins: His Life and Work* (New York, 1933), p. 25; quoted in Theodor Siegl, *The Thomas Eakins Collection* (Philadelphia, 1978), p. 24.

ing with photography. Like many realist painters, he used it as a tool in his work. In 1884 and 1885 he collaborated with the English photographer Eadweard Muybridge in photographic experiments of bodies in motion. Eakins contributed to an essay in *Animal Locomotion: The Muybridge Work at the University of Pennsylvania—The Method and the Result* (1888). He also devoted much of his time to portraiture. Such works as *Signora Gomez d'Arza* (p. 627) are characterized by perceptive insight and uncompromising realism. This truthfulness invariably alienated patrons, depriving him of commercial success. Members of his family continued to serve as models. *The Artist's Wife and His Setter Dog* (p. 613) is a probing and eloquent portrait. The artist's brother-in-law, Louis N. Kenton, was the model for the introspective man shown in *The Thinker* (p. 622).

Thomas Eakins was an inspired teacher to an entire generation of American artists. He devoted some ten years to the Pennsylvania Academy of the Fine Arts. Until his forced resignation in 1886, he was instrumental in making it one of the most progressive art schools in the country. He continued to teach in such schools as the Art Students' Union, the Art Students Leagues in Philadelphia and New York, the Brooklyn Art Association, Cooper Union, and the National Academy of Design. He emphasized working from life rather than casts and painting directly on the canvas. He also stressed the study of anatomy and encouraged his students to model in clay. Indirectly his influence later affected the important group of artists known as the Eight. Robert Henri, George Luks, William Glackens, John Sloan, Everett Shinn, Maurice Prendergast, Ernest Lawson, and Arthur B. Davies were hardly a homogenous group in their style, but Henri, Glackens, Sloan, Luks, and Shinn, who studied at the Pennsylvania Academy, continued the traditions of objective realism that characterized the work of Eakins. The Eight had their first exhibition in New York in 1908. The aims of the group were best expressed by its leader, Robert Henri, who wrote: "What is necessary for art in America, as in any land, is first an appreciation of the great ideas native to the country and then the achievement of a masterly freedom in expressing them."[39] Henri, who had studied with Thomas Anshutz, Eakins's student and successor at the Pennsylvania Academy, echoed Eakins's advice to his students: "It would be far better for American art students and painters to study their own country and portray its life and types. To do that they must remain free from any foreign superficialities."[40] In one sense the Eight represented a revitalization of the national consciousness urged by American writers during the first half of the nineteenth century and expressed in the works of many genre painters and the Hudson River school. In their paintings, the Eight depicted contemporary urban scenes. Thus industrial America supplanted earlier celebrations of rural America. A change in subject matter, rather than a break in style, constituted the radicality of the group. "We came to realism," Sloan noted, "as a revolt against sentimentality and artificial subject matter and the cult 'art for art's sake.'"[41] In their concentration on contemporary American life, these painters prepared the foundations for a specifically American school. Henri's students George Bellows and Edward Hopper perpetuated this tradition well into the twentieth century.

By the 1870s new styles and aesthetic ideas imported from abroad by young painters trained

[39] Robert Henri, "Progress in Our National Art," *Craftsman* 15 (Jan. 1909), p. 387.
[40] *Philadelphia Press*, Feb. 22, 1914, quoted in Siegl, *The Thomas Eakins Collection*, p. 36.
[41] Quoted in Henry Geldzahler, *American Painting in the Twentieth Century* (New York, 1965), p. 30.

in Germany and France challenged the older forms and traditions perpetuated in American academies. During the 1860s and 1870s, many Americans studied in Munich, which had replaced Düsseldorf as a center for art. Frank Duveneck, William Merritt Chase, and John H. Twachtman are the best known of the American painters who worked in Munich. They studied at the Royal Academy under such painters as Karl von Piloty, Wilhelm von Kaulbach, and Wilhelm von Diez. They were especially influenced, however, by William Leibl, a leader of the realist movement and an enthusiast of Courbet. A dark tonal palette, dramatic chiaroscuro, and broad vigorous brushwork characterized this school of painting. These stylistic elements were derived primarily from the study of seventeenth-century Dutch and Spanish masters such as Hals, Velázquez, and Goya.

Walter Shirlaw and Henry Mosler are the two artists represented in this volume whose styles were most affected by studies in Munich. The training of Henry Mosler was eclectic. The New York born painter began his training under James H. Beard in Cincinnati, served as an artist-correspondent for *Harper's Weekly* during the Civil War, studied with Heinrich Mücke and Albert Kindler in Düsseldorf, and with Ernest Hébert in Paris. Beginning in 1874 he spent three years in Munich where he worked under Alexander Wagner. Although Mosler never totally relinquished his high finish and linearity, many of his later genre scenes are broadly painted.

Shirlaw, one of the founders of the Art Institute of Chicago, studied in Munich for seven years. Among his teachers were Alexander Wagner, Arthur von Ramburg, Wilhelm Lindenschmit, and Wilhelm von Kaulbach. His dark rich palette and quick brushwork reflected this training. Shirlaw was one of the founding members and first president of the Society of American Artists. He also served as instructor of painting and drawing at the Art Students League in New York, where he was succeeded by another Munich-trained artist—William Merritt Chase. Many of the Americans who trained in Munich became teachers themselves. Besides Shirlaw and Chase, these included Duveneck and Twachtman.

Following their return to the United States, European-trained artists were responsible for the founding of new schools and exhibition organizations. To provide training equal to that of Europe was one of their immediate concerns. In 1875 the decision taken by the National Academy of Design to close its life school for lack of funds led to the formation of the Art Students League of New York. Although the league was not founded in protest against the type of teaching offered by the academy, it was viewed by some as an alternative to the academy's methods. A cordial relationship between the two institutions, however, was soon established. Eventually the formation of the league was instrumental in the decision to continue and restructure the teaching program at the academy.

In 1877 a group of artists trained abroad established the American Art Association. This independent exhibition organization was soon renamed the Society of American Artists. It was formed in opposition to the entrenched conservatism of the National Academy of Design—especially at issue were its policies of selecting and hanging the annual exhibitions. The new organization held annual exhibitions starting in 1878 and for two decades was the leading progressive art organization in the United States. Augustus Saint-Gaudens, Walter Shirlaw, Wyatt Eaton, and Helena de Kay were the original founding members. Among the early members included in this catalogue are: Robert Swain Gifford, Homer Dodge Martin,

Samuel Colman, John La Farge, Thomas Moran, Alexander Wyant, George Inness, and Alfred Wordsworth Thompson. (In 1906 the Society of American Artists merged with the National Academy.) In a review of the first exhibition of the Society of American Artists, held at Kurtz Gallery in New York in the spring of 1878, the critic Susan N. Carter reported: "The idea of the society was to encourage all good work from whatever source it came, and, in short, to give as little opportunity as possible for prejudice either in regard to the school of Art or the class of pictures."[42] In addition to the works of members of the society, the first exhibition included Thomas Eakins's *William Rush Carving His Allegorical Figure of the Schuylkill River* and James McNeill Whistler's *The Coast of Brittany* (Wadsworth Athenaeum, Hartford).

James McNeill Whistler was one of America's most illustrious expatriate artists. His innovative work had an effect on both European and American art. In 1855 he went to Europe, where he spent the rest of his life. Although he studied briefly at the Ecole Imperiale et Speciale de Dessin and the Académie Gleyre in Paris, his development was shaped largely by influences outside the academic world. In 1858 Whistler met Gustave Courbet, the leader of the realist movement, whose style dominated his work in the 1850s. With such contemporaries as Edgar Degas and Henri Fantin-Latour, Whistler shared an interest in seventeenth-century Dutch and Spanish art. His first major painting, *At the Piano*, 1858-1859 (Taft Museum, Cincinnati), reflected his debt to Vermeer and Velázquez, as well as Courbet.

Whistler moved to England in 1859. He continued, however, to divide his time between France and England and maintained a close contact with the most progressive art circles in both countries. In 1861 he met Manet in Paris, and in 1862, Dante Gabriel Rossetti in London. The same year he painted *The Coast of Brittany*, the first of his major seascapes. Although this work still reflected Whistler's ties to realism, his emphasis on flat planes, the general simplification of form, and the assymetrical composition anticipated his shift toward the more abstract approach to painting that would characterize his style after 1870. Whistler's sensibility for the decorative qualities of color and form is even stronger in *The White Girl*, subsequently called *Symphony in White No. 1*, 1862 (National Gallery of Art, Washington), which created a sensation in the Salon des Refusés. In this picture, both the decorative use of color and the uneasiness of the enigmatic woman allied him to the Pre-Raphaelites.

It was his fascination with oriental art, however, that was fundamental to the development of his style and placed him in the forefront of the Aesthetic movement. After Commodore Perry's expedition in 1853 and the establishment of trade with Japan, oriental art became fashionable and greatly affected Western European painters, architects, and craftsmen. The oriental collection of the first British minister to Japan was shown in the 1862 International Exhibition in London. The same year La Porte Chinoise, a shop dealing in oriental art opened in Paris. Its customers included Manet, Degas, and Fantin-Latour who frequently bought things for Whistler on commission. Whistler's introduction to Japanese art may well date as early as 1856 when his friend the etcher Félix Bracquemond is said to have discovered some Japanese woodcuts in Paris. Whistler became an avid admirer of Japanese art, a collector of both prints and blue and white porcelain. Initially, he used oriental cos-

[42] S. N. Carter, "First Exhibition of the American Art Association," *Art Journal*, n.s. 4 (April 1878), p. 124.

tumes, china, fans, and screens in his work chiefly for their decorative and exotic qualities. By 1865, however, in works like *Brown and Silver: Old Battersea Bridge* (Addison Gallery of American Art, Andover, Mass.), Whistler applied the aesthetic principles underlying oriental art as well. This marked the major transformation in his painting style. Eloquent simplicity in line and form, asymmetrical compositions, novel use of space in the absence of conventional perspective, and a strong feeling for the surface plane are the basic features of his work. Throughout the 1860s, Whistler experimented widely, exploring both oriental and classical sources. His classically inspired paintings of this period bear a close relationship to those produced by his friend, the English painter Albert Moore.

In 1867 Whistler firmly rejected realism to pursue what he later called his independent exploration of "the science of color and 'picture pattern.'"[43] During the 1870s, a period of great artistic creativity for Whistler, he achieved his mature style. In 1871 he began his celebrated series of Thames "Nocturnes"; in 1872 he exhibited *Arrangement in Grey and Black, No. 1: Portrait of the Artist's Mother* (Louvre, Paris); and the next year he completed the moving portrait of Thomas Carlyle called *Arrangement in Grey and Black, No. 2* (Glasgow Art Gallery and Museum). To underscore their abstract nature, he gave his works musical titles, a practice initially suggested by his patron Frederick R. Leyland.

Whistler's interest extended beyond painting and printmaking to the design of furniture, frames, exhibition installations, and interiors. The best example and one of his major accomplishments in decorative design was *The Peacock Room*, or *Harmony in Blue and Gold* (Freer Gallery, Washington), a dining room he decorated for Leyland's London house between 1876 and 1877. In 1878 he collaborated with the architect E. W. Godwin on the construction of the White House, his own home in Chelsea. He worked with Godwin on other projects as well.

In 1877 Whistler's art became the object of unprecedented publicity. The exhibition of his paintings at the newly opened Grosvenor Gallery that year, particularly his *Nocturne in Black and Gold: The Falling Rocket* (Detroit Institute of Art), provoked John Ruskin to accuse him of "flinging a pot of paint in the public's face." This led to the infamous libel suit, which pitted Ruskin and the realist cause against Whistler and those in favor of "art for art's sake." Although Whistler won his case, the publicity of the trial drove away patrons, and by 1879 he was bankrupt. With a commission from the Fine Art Society in 1879, he went to Venice where he concentrated on etchings, pastels, and watercolors. There he made a deep impression on a group of American artists who were studying with Frank Duveneck.

The last of Whistler's major portraits, painted in the 1880s, include that of Théodore Duret, the collector, orientalist, prominent art critic, and early champion of Courbet, Manet, and the impressionists. Besides showing a man in contemporary dress, *Arrangement in Flesh Colour and Black: Portrait of Théodore Duret* of 1883–1884 (p. 385) demonstrated Whistler's investigation of formal qualities of design and color. The use of a restricted palette, the exploration of subtle tones and color effects, and the elimination of unessential detail are the characteristics of this style and the fundamental principles of Whistler's aesthetic sensibility. The picture also satisfied Whistler's principle that "A picture is finished when all trace of the

[43] James McNeill Whistler to George A. Lucas, postmarked Jan. 18, 1873, quoted in John A. Mahey, "The Letters of James McNeill Whistler to George A. Lucas," *Art Bulletin* 49 (Sept. 1967), pp. 252-253.

means used to bring about the end has disappeared."[44] His portrait of Duret presents an interesting contrast to *The Thinker* (p. 622), Thomas Eakins's portrait of Louis N. Kenton. Both deal with the formal problem of convincingly representing a dark, standing figure on a light ground. Both are based on Velázquez portraits of this type, which also inspired such artists as John Singer Sargent and Edouard Manet. Sharing a common source, Whistler and Eakins represent two divergent stylistic directions—one committed to the tenets of the Aesthetic movement and the other bound to the principles of realism.

In an exposition of his theories in 1885, Whistler refuted the doctrines of Ruskin and drew a firm distinction between art and nature, asserting that "Nature is very rarely right" and "usually wrong."[45] Repeated on several occasions, published, and then translated into French by Stéphane Mallarmé, the "Ten O'Clock" lecture was a manifesto of Whistler's artistic beliefs. It had a decisive effect in the shaping of European modernism. Whistler's experimentation with formal qualities of design and color made him one of the period's most controversial painters and placed him in the forefront of the avant-garde. He influenced artists working in realist, impressionist, and tonalist styles. In addition to his pupils like the Greaves brothers and Walter Sickert, such Americans as Frank Duveneck, William Merritt Chase, John H. Twachtman, and Thomas Dewing were inspired by him at various stages in their careers.

Another American artist of this period who spent most of her life abroad and whose work, like Whistler's, was shaped solely by her European experience was Mary Cassatt. She studied at the Pennsylvania Academy of the Fine Arts from 1861 to 1865, at the Parma Academy in Italy with Carlo Raimondi in 1872, independently in the museums of Spain, Holland, and France in the late 1860s and early 1870s, and briefly with Charles Chaplin in Paris in 1875. Her own studies outside the academic world and her awareness of the most progressive contemporary currents, however, superseded her formal training. Her early work reflected the influence of Correggio, Rubens, and Hals. After 1874 when she settled in Paris, the work of Courbet, Manet, and Degas, whom she later described as her true masters, became central to her development. The first exhibition in Paris in 1874 of a group of independent artists, later known as the impressionists, represented a revolutionary break with tradition. Invited by Degas in 1877 to exhibit with them, Cassatt participated in their next exhibition in 1879, and then three more times, including the last, in 1886. She was the only American officially associated with the French group.

Degas became her chief mentor. He encouraged her work in printmaking and pastels and provided invaluable criticism and technical advice. In both technique and composition, Cassatt's painting style reflected her adoption of features fundamental to the impressionist vision. In paintings like *The Cup of Tea* and *Lydia Crocheting in the Garden at Marly* (pp. 632 and 635) she used a high-keyed palette, juxtaposed complementary colors, applied paint in small strokes to create a rich and vibrant surface, used an oblique vantage point, and cropped picture elements to suggest the fragmentary character of the visual experience. In *Lady at the Tea Table* (p. 638) one can see other features of this style—a dark restricted palette and large

[44] James McNeill Whistler, "Proposition No. 2," in 'Notes'—'Harmonies'—'Nocturnes,' exhibition catalogue, Messrs. Dowdeswell (London, 1884).

[45] Whistler, "*Ten O'Clock*" (Portland, Me., 1916), p. 12.

broad areas of paint with little modeling to emphasize silhouetted shape. In addition, Cassatt departed from traditional methods of simulating depth: the high vantage point and plunging perspective of *Lydia Crocheting in the Garden at Marly*, the placement of the foreground figure against the background with no transition in *Portrait of a Young Girl* (p. 642), and the emphasis on the surface for decorative effect in *Lady at the Tea Table* are examples of her various ways of dealing with space. Like Degas, Cassatt was primarily a figure painter. Her early exploration of themes like spectators at a performance and scenes from domestic life were typical subjects that engaged the impressionists. Eventually, she made a specialty of the maternal theme, representing the close world of mother and child with candid objectivity.

In 1890 Mary Cassatt visited the great exhibition of Japanese art at the Ecole des Beaux-Arts with Degas. Japanese art had exerted a considerable influence on Cassatt before 1890, but this exhibition of more than seven hundred prints had a tremendous effect. During 1890 and 1891, she made a series of ten color prints "done with the intention of attempting an imitation of Japanese methods."[46] These prints, in which she combined drypoint, soft-ground, and aquatint techniques on copperplates, are her important contribution to the graphic arts. Cassatt was an American pioneer in the impressionist movement. In addition, as an adviser to American collectors, she was instrumental in building collections of impressionist works in the United States.

Paris was a thriving center for Americans studying abroad in the late 1870s. With the exception of Cassatt, however, American artists were slow in recognizing impressionism. The majority studied at the Ecole des Beaux-Arts with Gérôme, in the atelier of Emile Auguste Carolus-Duran, or at the Académie Julian with Gustave Boulanger and Jules Joseph Lefebvre. Their heroes were the plein-air realists Jules Bastien-Lepage and Jules Breton. Some, like J. Alden Weir, initially rejected impressionism. Characterizing the third impressionist exhibition of 1877 as a "Chamber of Horrors," Weir noted: "They do not observe drawing or form but give you an impression of what they call nature."[47] Nonetheless, Weir later became one of the leading practitioners of the style in the United States. Lack of draftsmanship and form was the major impediment to the adoption of impressionism by American painters. Some like Childe Hassam and Theodore Robinson accepted the style in all its radical manifestations. Most, however, were more moderate in their borrowings. In the late 1880s and 1890s, impressionism became one of the major styles in American painting. "When to-day we look for 'American art,'" Henry James wrote in 1887, "we find it mainly in Paris. When we find it out of Paris, we at least find a great deal of Paris in it."[48] The American painters who became known as impressionists, like their French predecessors, lacked homogeneity as a group but shared common themes, techniques, compositional devices, and a response to light and color. Their way of representing the visual world was a radical departure from accepted conventions. Other than Mary Cassatt, few Americans truly succumbed to the more extreme forms of impressionism, tending to retain form and local color in their work.

[46] Mary Cassatt to Frank Weitenkampf, May 18, 1906, quoted in Frederick A. Sweet, *Miss Mary Cassatt: Impressionist from Pennsylvania* (Norman, Okla., 1966), pp. 121-122.

[47] J. Alden Weir, April 15, 1877, quoted in Dorothy Weir Young, *The Life and Letters of J. Alden Weir* (New Haven, 1960), p. 123.

[48] John L. Sweeney, ed., *The Painter's Eye: Notes and Essays on the Pictorial Arts by Henry James* (Cambridge, Mass., 1956), p. 216.

Impressionist paintings were exhibited in the United States as early as 1879. The most important show to reach the American public, however, took place in 1886. That year a large exhibition of three hundred paintings by Barbizon-school and impressionist painters was organized in New York by the Paris art dealer Paul Durand-Ruel. The reaction of the public was far less violent than it had at first been in France. Despite the growing acceptance of French art, a group of American artists whose work reflected its influence found it necessary to form a separate exhibition group. Seceding in 1897 from the Society of American Artists, which had grown increasingly conservative, they established an organization called the Ten American Painters, popularly known as the Ten. The members were Childe Hassam, John H. Twachtman, J. Alden Weir, Thomas Dewing, Joseph De Camp, Willard Metcalf, Robert Reid, Edward Simmons, Frank W. Benson, Edmund C. Tarbell and, after Twachtman's death, William Merritt Chase. The Ten included impressionists, adherents of plein-air painting, and tonalists, whose painting style reflected the influence of Whistler's work and the expressive landscapes of the Barbizon school. Their exhibition organization was active until World War I. The impressionist style, reduced to an almost academic formula, continued well into the twentieth century.

Despite the fact that prominent contemporary painters like Kensett, Church, Huntington, and Johnson served as founding trustees of the Metropolitan Museum, the formation of the American paintings collection was at first both gradual and haphazard. From 1870 to 1906, the growth of the collection was almost entirely dependent on gifts and bequests. *The Wages of War* by Henry Peters Gray, the first American painting to be acquired was bought by subscription and presented in 1872. It reflected a conservative taste. The next year *American Beauty Personified as the Nine Muses*, a series of nine portraits of socially prominent American women by Joseph Fagnani, was purchased by the artist's friends from his estate and donated to the museum. In 1874, two years after the death of Kensett, the artist's brother presented the museum with thirty-eight paintings known collectively as *The Last Summer's Work*. By the end of the 1870s, fifty-three American paintings acquired by gift had entered the collection.

The first decade also marked the beginning of an active program of loan exhibitions. The first loan exhibition catalogue to be published, in September 1873, contained only a small number of American works. In succeeding years, however, American paintings by both contemporary and early artists were shown with greater frequency. In 1874 Kensett's *Last Summer's Work* was exhibited together with three paintings by Thomas Cole, and a checklist catalogue was published. In 1876, during the celebration of the centennial, the museum together with the National Academy of Design mounted an exhibition of American and European art from private New York collections.

In 1880, shortly before the museum reopened in its new building in Central Park, eighty-six watercolors by William Trost Richards were presented by the Reverend Elias L. Magoon. These were the cornerstone for a large collection of drawings and watercolors by American artists. The following year, the museum organized a large memorial exhibition of the works of Sanford Robinson Gifford, the first in a series of memorial shows devoted to American artists. In addition to an exhibition catalogue, the museum published a comprehensive catalogue of the artist's work, an ambitious undertaking that was a landmark in the field.

Also in 1881, Thomas Eakins presented the museum with *The Chess Players*, the first painting by this illustrious artist to enter the collection. In 1886 the Society of American Artists held its annual exhibition at the museum. Then in 1889 the museum celebrated the centennial of Washington's inauguration. After 1885 the museum's collection of American art sometimes benefited from the American Art Association exhibitions, whereby prize paintings were awarded to American museums. In 1885 Robert Swain Gifford's *Near the Coast* was acquired from the first Prize Fund Exhibition, and in 1887 Edward Gay's *Broad Acres*. In 1887 George I. Seney presented the museum with paintings by such artists as Inness, Fuller, and Wyant. The same year, through the bequest of Catharine Lorillard Wolfe the museum received some one hundred and forty-three paintings, chiefly by European artists, along with funds for the preservation of the collection and the acquisition of paintings. Works later acquired with monies from the Wolfe fund included Homer's *The Gulf Stream* and Whistler's portrait of Théodore Duret.

The collection grew in the 1890s chiefly through the generosity of private donors. Inness's monumental painting *Peace and Plenty* entered the collection in 1894 as a gift of George A. Hearn. Other works given to the museum by Hearn included important paintings by Homer and Whistler. In addition to gifts, Hearn's provision of funds, the income from which was to be used to acquire pictures by artists of American citizenship alive in or born after 1906, fostered an active acquisitions program. The Amelia B. Lazarus Fund had similar restrictions, but was not limited to the work of contemporary artists. The wife of the artist Jacob H. Lazarus in her bequest of 1907 gave money for the purchase of American art. This bequest was used to buy twelve Winslow Homer watercolors from the artist's brother in 1910. These works form the core of the collection of watercolors by this American master. In 1922 the same fund made possible the acquisition of Homer's painting *Dressing for the Carnival*. The fund established in the 1909 bequest of John Stewart Kennedy, a former trustee, enabled the museum to acquire in 1917 both *The Thinker* and *The Writing Master* by Eakins. Through the bequest of Maria DeWitt Jesup in 1914, the museum received the Jesup collection and the Morris K. Jesup Fund, the income of which was to be used for the encouragement of American art in any way that the trustees thought best. Included in the collection was Kensett's *Lake George*, Gifford's *Kauterskill Clove*, and Church's *The Parthenon*. Many major works by American artists have subsequently been acquired from the fund.

One of the prime movers in the building of the museum's collection of American paintings during the early decades of the twentieth century was the artist and curator Bryson Burroughs. Burroughs held curatorial positions in the museum from 1906 until his retirement in 1934. A champion in the cause of modern art, he was responsible for promoting the acquisition and exhibition of American paintings in those years. In addition to regular contributions to the *Bulletin*, he was the author of many catalogues on American art.

During the twentieth century, the collection of American painting has been greatly enriched by several large gifts and bequests. In 1925, through the bequest of Collis P. Huntington, the museum acquired works by Cropsey, Richards, Kensett, and Johnson. Dr. Ernest G. Stillman's gift in 1922 of a group of paintings and pastels by Mary Cassatt from the collection of her friend James Stillman provided the foundation for the extensive representation of work by this impressionist artist. In 1923 Cassatt presented the museum with *Lady at the*

Tea Table. In 1929 the bequest of Mrs. Henry O. Havemeyer, the artist's close friend, enlarged the collection with superb examples of Cassatt's works. In 1954 the bequest of Edward W. C. Arnold's collection of New York prints, maps, and pictures, consisting of about 2,395 items, added a new dimension to the museum's collection. Gifts from Edgar William and Bernice Chrysler Garbisch of American folk art, beginning in 1962, formed the nucleus of the collection of folk art.

The rapid growth of the collection during the first half of the twentieth century was complemented by an active program of exhibitions and publications. In 1909 the Hudson-Fulton celebration, commemorating the tercentenary of the discovery of the Hudson River in 1609 and the centenary of the first successful use of steam to navigate the river by Robert Fulton in 1807, was the occasion of a major American exhibition held at the museum. It included fifty-three paintings and miniatures by artists born before 1800. In 1917 an exhibition of paintings of the Hudson River school, brought together in commemoration of the completion of the Catskill Aqueduct, was installed. Exhibitions devoted to the work of individual artists included Frederic E. Church in 1900, James McNeill Whistler in 1910, Winslow Homer in 1911, Thomas Eakins in 1917, George Fuller in 1923, and John La Farge in 1936.

The museum's collection of American paintings from the late 1830s to the first decade of the twentieth century catalogued in this volume illustrates the major phases in the history of American art during this period. The second generation of the Hudson River school painters is superbly represented by the landscapes of Frederic E. Church, Albert Bierstadt, Jasper F. Cropsey, John F. Kensett, Sanford Robinson Gifford, George Inness, and Alexander H. Wyant; the realists in the paintings of Eastman Johnson, Winslow Homer, and Thomas Eakins; the Aesthetic movement in the paintings of James McNeill Whistler; and the impressionists in a choice group of paintings by Mary Cassatt.

Natalie Spassky

READER'S GUIDE TO THE CATALOGUE

THE same format, methods, and procedures have been followed in the three American paintings catalogues, and the reader can use the following guideline for all of them. The general intention in the arrangement of the catalogues has been to trace the history of American painting, and thus the basic organizing principle is a chronological one. Rather than place each painting strictly according to date, however, paintings are grouped by artist, and within each artist's work they are arranged in chronological sequence with the earliest painting first. The order of artists is by birth and death dates. Thus when two or more painters have the same year of birth, the one who died first precedes. Works by unidentified artists are placed according to their period, style, and subject matter. There is a brief biography with a selected bibliography on every artist after which the entries on the individual paintings in the collection follow. After each discussion of a painting specific information is arranged in the following order: medium, support, and dimensions; inscription and canvas stamp; related works; references; exhibitions; on deposit; ex collections; credit line; and accession number. All works in the catalogues are illustrated, each one with a caption giving artist and title. Illustrations of related works, details, artist's signatures, canvas stamps, radiographs, autoradiographs, and photographs showing a painting's previous condition are included where appropriate. Every attempt has been made to check the physical condition of each painting during the cataloguing process, but since some were out of the museum on extended loan, such an examination was not always possible. While there is no separate discussion of condition for each work, severe problems and irreversible conditions are noted and discussed in the text of an entry.

Each volume has two indexes: one for artists and titles of paintings and another for provenance. For the convenience of the reader an alphabetical list of all artists represented in the three catalogues appears at the end of each volume, indicating in which volume the main entry on a particular artist is to be found. A cumulative index is being reserved for the time when a catalogue of paintings in the collection by artists born after 1864 has been prepared. No absolute cutoff date has been used regarding new acquisitions, but only a few major works received after January 1979 have been included.

These catalogues were begun following the same style as the department's earlier Volume I (1965) by Gardner and Feld, which was in turn based on the museum's European paintings catalogues. As work progressed, however, some changes and additions seemed desirable. Rather than revise the basic format completely, we decided to continue with the tried system and add some new features. There are four basic additions.

In the early volume the sources for quotations in a painting entry were not always indicated; some were given in the reference section, which basically was (and is) limited to works that discuss the museum's painting. Now the sources for all quotations and specific information on an artist's work in general or on his other works are given in parentheses immediately following such information. Thus, the reader should be aware that there is a dual system at work. Where the source for a quotation also mentions the painting, it is listed in the references, and the year

of the publication or item is indicated in the text. The reader can then find the work readily in the reference section, which is organized chronologically. Otherwise, the full bibliographical information appears in parentheses in the text itself.

Under the old method, a similar shortcoming existed regarding information in the artists' biographies. There was often no indication of where the material had been obtained. For this reason a selected bibliography has been added to the biographies to show where most of the information on an artist was found and where further details are available. Here, too, if a particular quotation comes from a work not listed in the bibliography, its origin is indicated in the text in parentheses.

Another new section is one on related works. Although by no means inclusive, it has been added to aid the scholar in sorting out studies, copies, prints, and other versions of a work. It was thought that compiling this information in one place would be helpful.

Finally, it should be noted that attempts have also been made to give the present location of all works of art mentioned in the catalogues. When the present location of a work is not known or the work is not readily available to the public, we have tried to cite a publication where a reproduction of it can be found. Many American paintings have changed hands rapidly in recent years, and it has not always been easy to keep track of them; sometimes the best we could do was to give the place and year in which a work was offered for sale.

No matter how hard one tries to anticipate every possibility in devising a catalogue format, the cataloguer is bound to discover some unexpected but useful information concerning a painting for which there is no proper niche. In such cases we have preferred to be a little inconsistent rather than exclude an interesting item merely because it did not exactly fit the format. As a whole, we have tried to make the catalogues useful to scholars without excluding readers whose interest in American painting is more general and without sacrificing visual design. The following is an explanation of the various categories and editorial procedures used in the catalogues.

Biography of the Artist

The first facts provided on an artist are birth and death dates; these are based on the most recent respected authorities, or in a few cases the discovery of new evidence. Each essay attempts to give pertinent information regarding background, training, stylistic development, influence, and significance. Sources for quoted matter are given in full in the text unless the material comes from one of the publications in the bibliography, in which case only the author's name or a short title and the page number are given. The basic information is derived from works cited in the bibliography.

Cross References

The following method has been used both in biographies and painting entries to indicate a cross reference. When the name of an American painter who is not the subject of that particular entry but whose biography and paintings can be found in the catalogues is first used, it is given in full in small capital letters. For an American painter whose work is not represented in the

catalogues, birth and death dates follow the first mention of the name. This is true only for American painters, not sculptors or engravers, or European artists. To find the volume in which a painter is discussed the reader can consult the complete alphabetical list of artists at the end of each volume. When paintings that have their own entries in the catalogues are mentioned under other entries they are followed by (q.v.).

Bibliography

The bibliography is selective and limited to five items arranged chronologically (obituaries are grouped as one item). Reference works were chosen on the basis of their usefulness in providing the information given in the biography and their reliability as sources for further information. In some cases, however, they are simply all that is available. There are brief annotations to guide the reader.

Titles of Paintings

When known, the original title the artist gave the picture or the title under which the painting was first exhibited or published has been used. For paintings that are obviously portraits, the subject's proper name is given as the title. In some cases, a painting has become so well known by a certain title that to change it would cause considerable confusion, so the popular one has been retained. When, however, a title has been changed, this is indicated in the text of the entry; varying titles appearing over the years are noted in "references" and "exhibited". Where the original title is in a foreign language, it appears in parentheses following the English translation.

Medium and Support

Works have been classified as paintings on the basis of medium and/or support. All works in oil done on canvas, wood, metal, leather, or paperboard supports are included; so too are works in wax, tempera, or mixed media on canvas or wood. In general, works on paper are not included except for a few oils.

Measurements

The dimensions of the support are given in inches followed by centimeters in parentheses. Height precedes width.

Inscriptions

The artist's signature, inscriptions, and their location on the support are given. Inscriptions not in the artist's hand are recorded and indicated as such. Canvas and manufacturers' stamps are also included. Certain labels or stickers are noted when they provide information (e.g., on ex collections or exhibition history) that is not available elsewhere, but they are usually

mentioned where that information is relevant, for example, in the text, or under "exhibited," or "ex coll."

Related Works

A work is considered "related" to a painting in the collection if it is thought to be a preliminary drawing or study, a replica, a variant by the artist, a copy by another artist, or a high quality print based on the painting. There are many cases where artists have painted the same scene or subject repeatedly; such occurrences are generally stated in the text of an entry, but works that just treat the same theme are not included under related works unless there is good reason to consider the museum's picture to be based on one of them.

We do not suggest that the related works noted in this section provide a complete listing. Represented are examples known to our authors through publications or brought to their attention by scholars or the owners of such works. In many cases, our authors have not had the opportunity to examine the related works and have had to rely on previously published information or on the owners for attributions and physical descriptions. A reference to a published illustration is given wherever possible, and some related works are illustrated in the catalogues.

Information on related works is listed as follows: Artist (if other than the artist of the museum's work), Title or Description, Medium, Size, Date, Collection, and City (except in the case of prints), Accession number (only where needed, for example, in the case of drawings in large collections), Reproduction (cited as "ill." in Author, Title, Date, Page or Plate number).

References

For the most part these are sources that refer directly to the painting under discussion. Sometimes, however, sources for the biography of a subject or information on settings or items shown in the paintings are included, but they are always annotated as such. The references are selective: contemporary sources on the paintings are included, as are newspaper and periodical reviews of their exhibitions; more recent books, articles, manuscripts, and spoken accounts appear when they offer new information, interpretations, or in general add to the knowledge of the works. Where a painting is not included in an exhibition but is *discussed* in an exhibition catalogue, the exhibition catalogue appears in the reference section. Otherwise all information from exhibition catalogues is given under "exhibited." Illustrations are noted in the references, and special attempts have been made to mention at least one reproduction in color. At times too, the authors have indicated that an illustration shows the work in a different condition from the present one.

The standard form for a reference is as follows: the writer's first initials and last name, the main title of the book or periodical (subtitles are usually excluded) or a description of the document, the first date of the writing (with the date of later or revised editions following), the volume in arabic numbers, the page number, and possibly a brief annotation. References are separated from one another by the symbol // unless two works by the same writer happen to come one after the other, in which case a semicolon is used. Newspaper and manuscript refer-

ences follow the method prescribed in the twelfth edition of the Chicago *Manual of Style*. A few abbreviations are used and they are listed at the end of these notes.

Material from the Archives of American Art, Smithsonian Institution, has been cited repeatedly, and the reader should know how we distinguish collections owned by the archives from those owned by others but available on microfilm at the archives. When the Archives of American Art has the collection, the item is described, and the date, collection, and archive number is given, followed by "Arch. Am. Art" (e.g. A. H. Thayer to G. de F. Brush, Jan. 6, 1917, Thayer Papers, D200, Arch. Am. Art). When the material is only on microfilm there, the item is described, and the date, the collection, and the place where the collection is to be found are given, followed by the microfilm number used by the Archives of American Art and its name (e.g. J. S. Sargent to I. S. Gardner, August 18, 1894, Isabella Stewart Gardner Museum, Boston, microfilm 403, Arch. Am. Art).

Documents in the museum's possession are also cited frequently, and they are found either in the files of the Department of American Paintings and Sculpture (Dept. Archives) or in the Archives office of the museum (MMA Archives).

Exhibited

The listing of exhibitions in which the painting has appeared is selective. Efforts have been made, however, to include all known exhibitions of a painting before its acquisition by the museum. Also one-man shows, memorials, retrospectives, and major group shows are given. In cases where a catalogue for an exhibition provides new information or places the museum's painting in a new interpretive context, this exhibition, too, is included.

In the listings, the institution, gallery, or exhibition hall is given first, followed by the city (when not already indicated in the name of the institution), the year, the title of the exhibition and catalogue. We then list the author of the catalogue or entry, the number assigned to the painting there, and the title under which the painting was exhibited if it is the first known exhibition or the title is different from the present one. A brief annotation summarizing the information supplied (lender, price, or discussion of the work where significant) is placed last. In the case of regular annual exhibitions the title is dropped (e.g. *Fifteenth Annual Exhibition...*) and only the institution or its abbreviation is given (e.g. NAD, 1831, no. 181, as Portrait of a Gentleman, lent by M. E. Thompson).

Exhibitions, like references, are separated from one another by the symbol //. When the same institution appears consecutively, a semicolon is used and the name is not repeated. The places to which an exhibition traveled are listed, except in the case of ones that had many stops, then usually the names of the organizing institutions are given, followed by "traveling exhibition" (e.g. MMA and American Federation of the Arts, traveling exhibition, 1975–1977, *The Heritage of American Art*, cat. by M. Davis, no. 77, ill. p. 172; p. 173).

On Deposit

Paintings are considered as on deposit when they have been housed in, or placed on long-term loan to, an institution or agency that does not own them. Depending on the circumstances,

they may or may not have been available to the general public. Deposits made before the Metropolitan Museum's acquisition of works have been included when known and verifiable.

Ex Coll.

The names of previous owners of a painting from the earliest known to the last are given with their city of residence and the years when they are known to have held the painting. (Dates are usually derived from exhibition information, and owners' death dates are sometimes supplied for the terminal date.) The family relationship of one owner to another is given when known. When a work was owned by, or consigned to, a dealer the preposition *with* appears before the name; a person who simply negotiated the sale or gift of a painting is further described "as agent." Auction information is always given in parentheses. A semicolon is used between the listings of various transactions, except where a painting passed directly from its known owner to an auction sale. A semicolon in also used, however, if we do *not* know or cannot verify the owner at the time of the auction. For example in ". . . Bertha Beckwith, New York, 1917–1926 (sale, Silo's, New York, Nov. 19, 1926, no. 389, as Chase's Wife on the Lake in Prospect Park, 13 1–2 × 19 1–2, $250). . . ." we know that the painting was sold by Mrs. Beckwith at Silo's; if we did not know for sure that she was the owner when Silo's sold the painting, a semicolon would appear before the parenthesis and sale.

Great effort has been made to verify the information we have on previous ownership, but this has not always been successful. In some cases, therefore, a listing may be qualified by "probably," "possibly," or with a question mark. Very often information comes to the museum second hand, and sometimes there is only family tradition to rely on. The sources for the information we have received are usually found under "references" or "exhibited"; otherwise a statement on the source follows the name of the former owner, e.g. James Smith (according to a label on the back). The artist's name is sometimes given in this section when the work remained in his possession for a long period after it was known to have been completed and of course if it later reverted to him.

We have given the names of all collections known to us except in the case of anonymous donors to the museum where the person's intent or legal stipulations prevent such disclosure.

Kathleen Luhrs, *Editor*

ABBREVIATIONS AND SHORT TITLES

Am. Acad. of Arts and Letters	American Academy of Arts and Letters, New York
Arch. Am. Art	Archives of American Art, Smithsonian Institution, Washington, D.C.
Arch. Am. Art. Jour.	*Archives of American Art Journal*
DAB	*Dictionary of American Biography* (New York, 1926–1936)
FARL	Frick Art Reference Library, New York
Gardner and Feld	Albert Ten Eyck Gardner and Stuart P. Feld, *American Paintings: A Catalogue of the Collection of the Metropolitan Museum of Art. Volume I: Painters Born by 1815* (New York, 1965)
Groce and Wallace	George C. Groce and David H. Wallace, *The New-York Historical Society Dictionary of Artists in America, 1564-1860* (New Haven, 1957)
MFA, Boston	Museum of Fine Arts, Boston
MMA	Metropolitan Museum of Art, New York
MMA Bull.	*Metropolitan Museum of Art Bulletin*
MMA Jour.	*Metropolitan Museum Journal*
NAD	National Academy of Design, New York
NYHS	New-York Historical Society
NYPL	New York Public Library
PAFA	Pennsylvania Academy of the Fine Arts

THE CATALOGUE

OTTO BOETTICHER

ca. 1816–died after 1864

Born in Germany, possibly Prussia, as he is said to have served in the Prussian army, Boetticher came to America about 1850 and was active in New York from 1851 to 1859. He is listed in the New York City business directory for 1851–1852 as a partner with the Bremen-born lithographer Charles (or Karl) Gildemeister (1820–1869) in the firm of "Botticher & Gildemeister, 289 Broadway," portrait painters. Boetticher soon allied himself with Thomas Benecke (active 1853–1856), and the firm of "Boetticher & Benecke" at 397 Broadway appears in the business directory for 1853–1854 under portrait painters and lithographers. From 1854 to 1859 Boetticher is listed alone in the directories as a lithographer at various Broadway locations. His name disappears from the directories after 1859. In the 1850s and early 1860s Boetticher made several paintings of army subjects, some of which were subsequently published as lithographs. It is for his detailed descriptions of contemporary military life that he is best known today.

During the Civil War, Boetticher served as an officer of the Sixty-eighth New York Volunteer Regiment of Infantry. According to the New York Muster Rolls, Otto Boetticher, age forty-five years, enrolled on July 22, 1861, and was mustered in as captain of Company G on August 14, 1861. Captured on March 29, 1862, he was imprisoned at the Confederate prison at Salisbury, North Carolina, where he made a drawing that served as the basis for the well-known Sarony, Major & Knapp lithograph *Union Prisoners at Salisbury, N.C.*, showing soldiers playing baseball. On September 30, 1862, Boetticher was exchanged for a Confederate officer, and on February 28, 1863, he was mustered in again as captain of Company B. Discharged on June 9, 1864, Boetticher was breveted lieutenant colonel on September 28, 1865, for his services during the war. Otto Boetticher, Jr., probably the artist's son, served in the same regiment, mustering in as corporal of Company G on August 14, 1861, at the age of twenty. To date nothing further is known of Boetticher's life.

BIBLIOGRAPHY: Frederick Phisterer, comp., *New York in the War of the Rebellion, 1861 to 1865* [published as part of the annual report of the Adjutant-General of the State of New York for the year 1908], (3rd ed., Albany, 1912), 1, p. 321; 3, pp. 2675, 2677, 2680, documents Boetticher's military career // Isaac Newton Phelps Stokes, *The Iconography of Manhattan Island, 1498–1909* (New York, 1918), 3, p. 708, pl. 139, describes several of the artist's works // Library of Congress, *An Album of American Battle Art, 1755–1918* (Washington, D.C., 1947), pp. 195–197, pl. 110, provides information on the artist's military career during the Civil War // Groce and Wallace, p. 59 // MFA, Boston, *M. & M. Karolik Collection of American Water Colors & Drawings* (Boston, 1962), 1, p. 84.

Seventh Regiment on Review, Washington Square, New York

This painting, signed and dated 1851, served as the basis for a lithograph prepared by Charles Gildemeister and printed by the firm of Nagel & Weingartner, New York, in 1852. According to the legend at the bottom of the lithograph, which bears the title "National Guard 7ᵗʰ Regᵗ N.Y. S.M. [New York State Militia]," the painting by "Major Bötticher" was originally in the possession of the Eighth Company, National Guard, and the principal heads were based on daguerreotypes made by the firm of Meade Brothers,

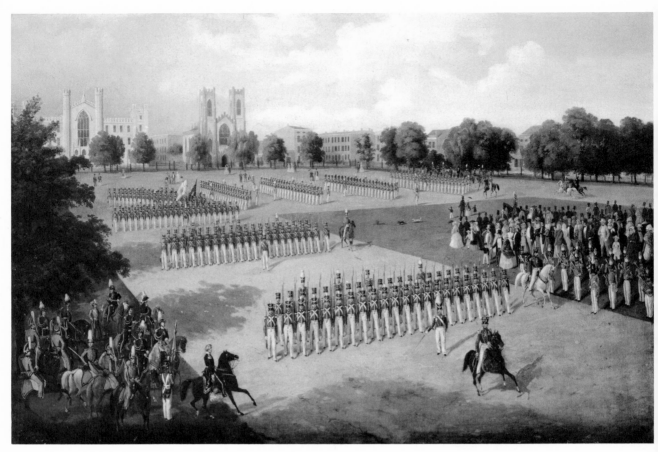

Boetticher, *Seventh Regiment on Review, Washington Square, New York.*

233 Broadway, New York. In 1851 Colonel Abram Duryee was in command of the Seventh Regiment. Henry C. Shumway, a noted miniature painter, was captain of the Eighth Company, and George William Smith and Charles W. Sy were the first and second lieutenants. It is likely that all of these men are shown in this painting.

The view chosen by the artist is the northwest corner of the Washington Square parade ground with New York University in the left foreground. The Gothic Revival structure, designed by Ithiel Town, Alexander Jackson Davis, James Dakin, and David Bates Douglass, was built between 1833 and 1835 and demolished in 1894. Although principally a university building, its upper floor provided studio space for many years for a number of well-known artists including Davis, SAMUEL F. B. MORSE, CEPHAS GIOVANNI THOMPSON, WINSLOW HOMER, and EASTMAN JOHNSON. In the center background is the Dutch Reformed Church, built in the years 1839 to 1840 on the plans of Minard Lafever and demolished in 1895. In the right background are some of the Greek Revival town houses that made the square one

of the most attractive neighborhoods in New York.

In this painting the artist deals inventively with the challenging demands of an intricate composition and a perspective complicated by his choice of a high and oblique vantage point. The style of the painting suggests that Boetticher had little academic training. His use of a high horizon allows a more expansive pictorial field, and he takes full advantage of it to revel in the narrative details so often favored by nonacademic painters. The geometric structuring of the composition and the rows of marching soldiers lend themselves to the penchant for repetitive patterns that is also a characteristic feature of self-taught painters. Although the drawing is often inaccurate, the figures stiff, and the shadows unconvincing, the picture is exceptionally attractive in color and composition and documents a vanished era in the military and social life of New York.

According to I. N. P. Stokes, Boetticher's painting originally belonged to Lieutenant Colonel Marshall Lefferts. Stokes, however, seems to have

confused this work with the artist's painting of the Seventh Regiment at Camp Worth, Kingston, New York, in July 1855, reproduced as a lithograph by Goupil & Company in 1856 with the legend reading in part: "From the original picture by Major Bötticher in the possession of Lieutenant Colonel Marshall Lefferts." There is a possibility that Lefferts never owned the *Seventh Regiment on Review, Washington Square, New York*. Stokes mistakenly called the museum's painting a replica of the original in the possession of the Seventh Regiment. It is actually the original painting, while the other version, which was given to the Seventh Regiment in 1901 by Charles F. Brinck, is a copy after the Gildemeister print.

Oil on canvas, 24 × 36 in. (61 × 91.4 cm.).

Signed and dated at lower left: Otto Boetticher / 1851.

RELATED WORKS: Charles Gildemeister, *National Guard 7th. Regt. N.Y.S.M.*, colored lithograph, 35⅝ × 24⅛ in. (90.3 × 61.3 cm.), printed by Nagel & Weingartner, issued 1852, ill. in I. N. P. Stokes, *The Iconography of Manhattan Island, 1498–1909* (1919), 3, pl. 139 // Unknown artist, *National Guard, Seventh Regiment, Being Reviewed in Washington Square*, copy after Gildemeister lithograph, oil on canvas, 24 × 36 in. (61 × 91.4 cm.), coll. Eighth Company of the Seventh Regiment, Seventh Regiment Armory, New York, ill. in *New-York Historical Society Quarterly* 32 (July 1948), p. 206.

REFERENCES: I. N. P. Stokes, *The Iconography of Manhattan Island 1498–1909* (1918), 3, p. 708, mis-takenly states that this painting is a replica of one formerly owned by Lieut. Col. Marshall Lefferts and currently in the collection of the Seventh Regiment, New York // L. E. Kimball, *New-York Historical Society Quarterly* 32 (July 1948), p. 207, mistakenly describes oil painting in coll. of Seventh Regiment as by Boetticher and notes that the lithograph by Gildemeister was based on it // J. A. Kouwenhoven, *The Columbia Historical Portrait of New York* (1953), color ill. p. 229, discusses this painting, noting copy belonging to the Seventh Regiment // K. C. Miller, letters in Dept. Archives, June 29, 1963, discusses version in coll. Seventh Regiment; May 3, 1966, supplies information on the artist and the subject of the museum's painting and notes that the version in the Seventh Regiment "is smaller than the prints and is probably not the original of them" // J. W. Mitchell, letter in Dept. Archives, Nov. 4, 1976, supplies information on the version in coll. Seventh Regiment.

EXHIBITED: Corcoran Gallery of Art, Washington, D.C., and Detroit Institute of Arts, 1954–1955, *The Sword in America, 1000–1954* (no cat.) // MMA, 1965, *Three Centuries of American Painting*, unnumbered cat.

ON DEPOSIT: Museum of the City of New York, 1940–1963 // Gracie Mansion, New York, 1968–1974 and 1974–1977.

EX COLL.: Eighth Company, Seventh Regiment, National Guard, New York, 1851–? (according to inscription on the print); Edward W. C. Arnold, New York, by 1918–1954.

The Edward W. C. Arnold Collection of New York Prints, Maps, and Pictures. Bequest of Edward W. C. Arnold, 1954.

54.90.295.

JAMES GUY EVANS

active ca. 1835–1860

Active in New Orleans from at least 1844 to 1852, Evans is first listed in the 1844 New Orleans city directory as a painter. An advertisement in that city's *Daily Picayune* for March 11, 1846 (p. 2), announced an auction in the barroom of the St. Charles Hotel of three paintings, "representing the wreck of the ship 'John Minturn,' in its different stages, on the Jersey Coast, . . . executed by Mr. Evans a self-taught artist of this city." By 1850, Evans had formed a partnership with Edward Everard Arnold (1824 or 1826–1866), an immigrant from Heilbronn, Württemberg, who advertised as a "portrait and landscape painter" in the *Daily Orleanian* on September 22, 1850, and as a "sign and marine painter" in the same paper on March 14, 1851. An item in the *Daily Orleanian* for September 22, 1850 (p. 2), reported:

Our next door neighbor, J. G. Evans, is certainly a capital marine painter. He has in his studio some splendid objects of art, well entitled to approbation. The first is an accurate and graphic view of New York City, of very large size houses, churches, and republican places, towers, domes, and steeples—all ground together with great good taste and excellent exactitude San Francisco on fire; the Rock of Gibraltar—that celebrated spot and impenetrable fortress, is correctly delineated: there it stands—and Evans has artistically transferred it to the canvas The Anglo Norman is a beautiful model and a triumphant specimen of "home manufactures"—both in the construction and the painting. It is the intention of Mr. Evans, in connection with his partner, Mr. Arnold, a talented young German artist—who, as a portrait and landscape painter, has few compeers—to sketch, from the window of their studio, in Marigny buildings, our city.

If executed, the sketch Evans and Arnold proposed to make of the city of New Orleans from the studio they shared in the Marigny Buildings has not yet come to light. *The Towboat "Panther" Towing the "Sea King," "Themis" and "Columbia"* (Louisiana State Museum, New Orleans), *The Towboat "Panther" Towing the "Shirley" and "Julius"* (Peabody Museum, Salem, Mass.), and *British Ship in a Storm* (coll. Mr. and Mrs. William E. Grove, New Orleans), all signed EVANS & ARNOLD in Roman block letters (in contrast to the fine script with which Evans usually signed his works), are examples of their joint efforts. The partnership appears to have been short-lived, for by 1851 Arnold was advertising alone at another location. The final mention of Evans, known to date, is an advertisement that appeared in the *Daily Orleanian* on July 21, 1852 (p. 2): "EVANS & JOHNSON House, Ship and Sign Painting, also, Historical, Marine and Ornamental Painting. Corner of Enghein and Poet streets." Evans is listed in the New Orleans city directories for 1851 and 1852 as a painter at 69 Poet Street.

Little is known of Evans's life before or after his activity in New Orleans. James Cheevers, in the course of his extensive research on the marine painter, discovered a James Evans, born in New York City about 1809, who was a "shoemaker by trade when he enlisted as a private in the U.S. Marine Corps at Philadelphia in 1829." He served aboard the *USS Delaware* in the Mediterranean Squadron from 1833 to 1836 and was discharged at Norfolk, March 4, 1836. A highly stylized lithograph by Endicott, after a painting by James Evans called *The United States Ship o[f] the Line Delaware* (shown in the Gulf of Lyons on October 11, 1835), appeared in the *Old Print Shop Portfolio* (12, June–July 1, 1953, p. 232, fig. 19). Cheevers notes that Evans reenlisted and returned to the Mediterranean possibly aboard the *USS United States*, subsequently transferring to the *USS Constitution*. Both vessels are recurring subjects in James Guy Evans's works. The artist has been identified as the J. Evans whose marine views appeared in the *United States Military Magazine* from July to October 1840. Although the sailor James Evans has not yet conclusively been identified with the painter of the same name, all of the documentation collected by Cheevers supports the identification. It seems possible, judging by the evidence provided in his carefully inscribed works, that Evans was a seaman who traveled widely. Over one hundred paintings and watercolors by Evans have been recorded, according to M. V. Brewington. In 1971, it was suggested by Gail and Norbert H. Savage that the marine painter might be identified with the New England folk art portraitist J. Evans whose works have been dated from 1830 to 1834 and 1840 to 1850. Yet, if the advertisement for Evans and Johnson, cited above, can be applied to the marine painter, it is unlikely that he would have omitted mention of his talent for portraiture.

BIBLIOGRAPHY: Isaac Delgado Museum of Art, New Orleans, Delgado Art Museum Project, W.P.A., "New Orleans Artists Directory, 1805–1940," manuscript supplied by Darla H. Rushing, New Orleans Museum of Art // M. V. Brewington, Kendall Whaling Museum, Sharon, Mass., letters in Dept. Archives, July 24, August 19, 1963, Jan. 9, 1967, and May 27, 1970, notes that Evans was a seaman who spent the greater part of his career working in Gulf Coast ports, particularly New Orleans; notes existence of over one hundred works by Evans, the earliest dated 1835 and the latest, 1860 or 1861; suspects that the artist joined the Confederate navy and may have been killed in action // Anglo-American Art Museum, Louisiana State University, Baton Rouge, *Sail and Steam in Louisiana Waters*, Sept. 19–Dec. 8, 1971, exhib. cat., no. 10, provides the most complete information on J. G. Evans to date; nos. 11–12, supplies biography of Edward Everard Arnold as reconstructed from primary source material // Norbert and Gail Savage, "J. Evans, Painter," *Antiques* 100 (Nov. 1971) pp. 782–785, discuss and date the work of the folk art portraitist; pp. 785–786, suggest he might be identified with the marine painter J. G. Evans; p. 786, cite research on the marine painter by James Cheevers // James W. Cheevers, U.S. Naval Academy Museum, Annapolis, letters in Dept. Archives, March 7, April 1, 1977, supplies documentation on the seaman James Evans and a list of known paintings, watercolors, and prints by the artist.

The Tow Boat Conqueror

The towboat *Conqueror* was built in New Albany, Indiana, in 1847 and registered in New Orleans the following year by the Star Steamboat Company, owned by Junius Beebe, George Heaton, John Heaton, Samuel De Pas, and L. M. Bienvenu. In 1861, the year it was lost, the *Conqueror* was owned by the Good Intent Tow Boat Company and was under Confederate registry.

According to the legend under the image, Evans painted the towboat for Captain John Heaton in November 1852 but showed it as it appeared on October 29, 1847, perhaps to commemorate its maiden voyage. Although the vessel is all but obscured by the ships flanking it, an extended trail of billowing smoke effectively captures the viewer's attention, and the pilot can be seen standing on a tall ladder between the smokestacks. From left to right, the ships shown in the

Evans, *The Tow Boat Conqueror*.

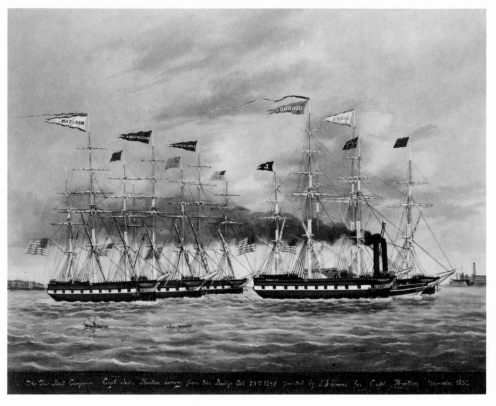

painting are the *Maritana* (misspelled *Maritan* on the pennant), the *Megunticook* (misspelled *Maguntcook*), the *Lord Seaton*, the *Oswego*, and the *Laura*. The *Maritana* was a packet operating between New York and New Orleans; the *Megunticook*, the *Laura*, and the *Oswego* were Boston–New Orleans packets; the *Lord Seaton* was one of several Canadian-built, British-owned ships that transported cotton from New Orleans to Liverpool before the Civil War. Because of the strong current in the Mississippi, such sailing vessels had to be towed upriver to New Orleans by steam tugs like the *Conqueror* from Balize, the pilot station on the northeast pass. The city can be seen on the left, and on the right, a drydock and what has been identified as the Belleville iron foundry.

The reverse lettering on the flags may indicate that Evans intended to make a lithograph of the scene. No print of it, however, has yet be located. The bold use of color, incisive approach in delineating vessels, and affinity for rhythmical patterns distinguish Evans's painting style.

Oil on canvas, 39½ × 50 in. (100.3 × 127 cm.).

Signed, dated, and inscribed at the bottom: The Tow Boat Conqueror Capt. John Heation. coming from the Balize Oct. 29th. 1847. painted by J. [G.] Evans for Capt. Heation November 1852.

REFERENCES: A. Lieutaud, 1933, and Harry Stone Gallery, May 11, 1948, on FARL photograph mount 118-13a, supplies information on the provenance and identifies Belleville // M. V. Brewington, July 24, 1963, and A. M. Barnes, July 25, 1963, letters in Dept. Archives, supply information about the vessels and the location // J. Wilmerding, *A History of American Marine Painting* (1968), ill. p. 44, pl. 30; p. 45 // D. H. Rushing, letter in Dept. Archives, Feb. 28, 1977, supplies correct name for art dealer Louise A. Weems, who once had the painting.

EXHIBITED: MMA, 1961–1962, and American Federation of Arts, traveling exhibition, 1962–1964, *101 Masterpieces of American Primitive Painting from the Collection of Edgar William and Bernice Chrysler Garbisch* (1961), p. 118, color pl. 84; p. 147, no. 84, gives inscription incorrectly transcribed as by James I. Evans; (1962), p. 149, color pl. 85 // MMA, 1965, *Three Centuries of American Painting*, unnumbered cat., as by James I. Evans // Los Angeles County Museum of Art, and M. H. de Young Memorial Museum, San Francisco, 1966, *American Paintings from the Metropolitan Museum of Art*, no. 84 // Phoenix Art Museum, 1967–1968, *The River and the Sea*, no. 7.

EX COLL.: John Heaton, New Orleans, from 1852; with Louise A. Weems, New Orleans; with Albert Lieutaud, New Orleans, 1933; with Harry Stone Gallery, New York, after 1933; with Louis C. Lyons, New York; unidentified owner, Nice; Edgar William and Bernice Chrysler Garbisch, 1960–1962.

Gift of Edgar William and Bernice Chrysler Garbisch, 1962.

62.256.4.

EDMUND C. COATES

active 1837–1872

Although a considerable number of paintings by him are known, Coates remains an elusive figure. He is listed in the New York City directories in 1837 and 1841–1843 as Edmund C., Edmund F., or Edward Coates, and is probably to be identified with the E. C. Coats listed at "Henry n Baltic" streets in the Brooklyn directories from 1845 to 1847. From 1847 to 1872, with the exception of the years 1858–1859, 1863–1864, and 1869–1870, his name appears, variously spelled, in the Brooklyn directories, where he is listed as an artist or painter. With the exception of the years 1849 to 1852, when he was at 13 Union Place, and from 1854 to 1858, when he lived at 92 President Street, Coates moved annually. It is possible that he tried to establish himself in an art related business; for although his name does not appear in the Brooklyn directory for 1858–1859, there is a listing for "Coates & Co. picture-framers, Myrtle Ave. c. Pearl." An entry in an 1854 New York sale catalogue notes a painting by "Coate" called *Marine View, New York*, a subject Coates often painted, and adds, "This most

attractive work was executed some years before its author became a speculator in pictures" (Austin's, New York, Dec. 28, 1854, sale cat., no. 97).

In a list compiled by Theodore Sizer in 1953, Coates appears as a patron of the American Academy of the Fine Arts, although he did not exhibit there. In spite of his long residence in Brooklyn, he never exhibited at the Brooklyn Art Association and showed his paintings only for a brief period in two of New York's major exhibiting institutions. Two sporting subjects, several landscapes, including Italian scenes and a work called *Sunset on the Ohio*, from an original drawing by the artist and author Charles Lanman (1819–1895), were shown at the Apollo Association in May and October of 1839 and September of 1840. Both years the Apollo Association, in which Coates held one share, purchased one of his works for distribution to its subscribers. In 1841, his painting, *Landscape View on the Hudson* (unlocated), was lent to the National Academy of Design by one G. W. Jenkins. Coates was one of many artists employed to provide paintings of New York's major sights for a gothic canopy, surmounting a scale model of the city and its environs designed by E. Porter Belden in 1845–1846. One of the city's leading attractions, the model is known today only from woodcuts (see J. A. Kouwenhoven, *The Columbia Historical Portrait of New York* [1953], ill. p. 194). Coates's painting of the *New York Daily Express Buildings*, dated 1846, and executed on a canvas shaped in the form of a pointed arch, was undoubtedly part of the gothic canopy for Belden's model (see *Old Print Shop Portfolio* 3 [June–July 1944], ill. [p. 240]).

His earliest known extant painting is a *View of New York Harbor from Weehawken*, 1837–1847 (New York State Historical Association, Cooperstown, N.Y.). Views of New York, Brooklyn, and the Hudson River are recurring subjects in his repertoire. Other works include: *Cornwall Landing on the Hudson*, 1851 (Boston art market, 1945), *The Connecticut River from Mt. Holyoke*, ca. 1854–1858 (Mead Art Gallery, Amherst College, Mass.), *Lake Winnepesaukee, Meredith, New Hampshire*, ca. 1854–1858 (private coll.), *Indians Playing Hockey*, 1859 (Yale University Art Gallery, New Haven), *The Narrows, Lake George*, 1864 (coll. Howard S. Merritt, Rochester, N.Y.), and several Canadian scenes. The subjects of his works, however, do not necessarily reflect the artist's travels, since many are based on prints. Engravings after works by William Henry Bartlett (1809–1854) for Nathaniel Parker Willis's *American Scenery* (1840) and *Canadian Scenery* (1842) were a favorite source. In many instances, Coates executed two or more versions of the same composition with only minor variations.

Judging from his currently known signed and dated works, Coates's painting style is curiously uneven, encompassing both academically accomplished works and ones more closely associated with the folk artist's idiom. As far as can be determined in the absence of a comprehensive study of his works, he appears to have practiced both modes concurrently with no consistent development from one to the other.

Coates's name no longer appears in the Brooklyn directories after 1872. A search of local obituaries has proved disappointing, but he probably died shortly after 1872, concluding an unheralded career of some thirty-five years.

BIBLIOGRAPHY: Mary Bartlett Cowdrey, *American Academy of Fine Arts and American Art-Union* (New York, 1953), 1, p. 68, introduction by Theodore Sizer lists Coates among patrons of the American Academy of the Fine Arts; 2, pp. 76–77, provides exhibition record of his works at the Apollo Association. ‖ Groce and Wallace, p. 133.

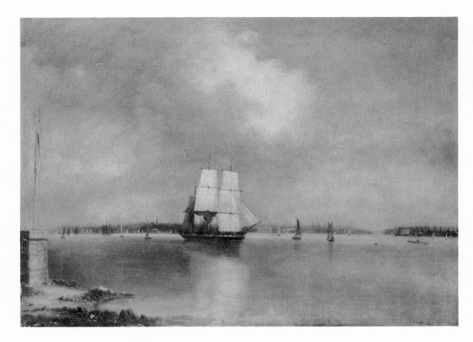

Coates, *Bay and Harbor of New York from Bedlow's Island.*

Bay and Harbor of New York from Bedlow's Island

Dated 1864 or 1866, this painting by Coates is basically modeled on an engraving by James Smillie after a work by JOHN GADSBY CHAPMAN (see G. S. Chamberlain, *Studies on John Gadsby Chapman* [1963], fig. 40). Chapman's sketch and Smillie's print were exhibited at the National Academy of Design in 1836. The engraving, published and distributed by J. Disturnell, was reproduced in the *New-York Mirror* (14 [April 15, 1837], opp. p. 329), where the view was described as follows:

First, on your north lies Gibbet Island.... Next Paulus Hook stands revealed.... Further on, we catch a glimpse of the tall cliffs of Weehawken ... Turn, now, north-east. There is your American London. There is your city of five hundred oyster-shops. This is the emporium of steamboats and liberty poles. There is the heart of politicks, commerce, piety, and all manner of iniquity.

The view, taken from Bedlow's (now Liberty) Island, shown in the left foreground, includes Paulus Hook in the background at the extreme left, Castle William on Governor's Island in the distance at the right, and in the center, Manhattan Island with Castle Garden on the waterfront and the steeple of Trinity Church dominating the skyline.

Judging from his many versions of this composition, the subject was one which either appealed to the artist or was in popular demand. Coates has taken considerable liberties with his source. He has omitted some vessels, added others, and rearranged the composition by eliminating much of the fort in the left foreground and by placing the large vessel in a more central position. Stylistically, Coates's work lacks the careful precision, the distinctive detail, and the linear character that often distinguishes a painting copied from an engraved source. This lack of definition suggests that the model for the painting might already be several times removed from the graphic source. The ship which serves as the focal point in the middle ground is delineated with some precision; in contrast, the highlights on the rocks in the left foreground are broadly handled. Coates's perfunctory technique suggests rather than defines form. His rendering of light is somewhat theatrical, although the muted palette of light blues and grays and the lack of sharp contrasts minimize this effect.

Smillie engraving after Chapman painting, *New York from Bedlow's Island.*

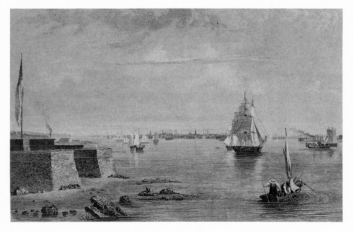

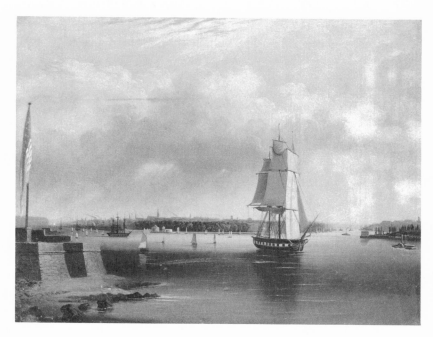

Attributed to Coates,
*Bay and Harbor of New York
from Bedlow's Island.*

Oil on canvas, 23½ × 33¾ in. (59.7 × 85.7 cm.).
Signed and dated at lower right: *E C Coates* 186[4 or 6].
REFERENCE: K. Luhrs, NYHS, letter in Dept. Archives, March 22, 1976, identifies print source of composition.
ON DEPOSIT: Museum of the City of New York, 1935–1963.
EX COLL.: Edward W. C. Arnold, New York, by 1935–1954.
The Edward W. C. Arnold Collection of New York Prints, Maps, and Pictures. Bequest of Edward W. C. Arnold, 1954.
54.90.165.

ATTRIBUTED TO COATES

Bay and Harbor of New York from Bedlow's Island

Neither signed nor dated, this painting is attributed to Edmund C. Coates on the basis of its similarity to a signed painting of the same subject, dated 1853, in the New-York Historical Society. Both works, like the painting by Coates discussed above, are based on James Smillie's engraving after a composition by JOHN GADSBY CHAPMAN. Taken from Bedlow's (now Liberty) Island, which appears in the left foreground, the view shows the bustling marine traffic in the bay and harbor of New York with Castle William on Governor's Island in the distance at the right and Castle Garden on Manhattan Island in the center distance. The graphic source served only as a

Edmund C. Coates

point of departure for the artist, who has introduced minor changes by adding and eliminating vessels and adjusting the composition. The technique, a combination of incisive lines and pigment broadly applied with little distinction between foreground and background elements, contributes to the decorative effect of the whole. Vivid contrasts of light and dark give the painting a theatrical quality. The artist's tendency to represent these contrasting areas as surface patterns and depict water ripples and clouds as rhythmic lines serves to emphasize the decorative aspects of the work.

Oil on canvas, 18 × 24 in. (45.7 × 61 cm.).
REFERENCES: K. Luhrs, NYHS, letters in Dept. Archives, Jan. 29, March 22, 1976, notes similarity of this painting to one in NYHS and identifies print source for Coates's composition.

Coates, *New York Bay*, NYHS.

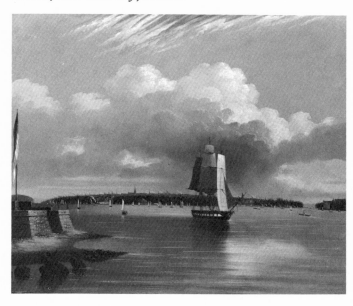

On deposit: Museum of the City of New York, 1935–1963.

Ex coll.: with Robert Fridenberg, New York, 1906 or 1916 (according to a partially legible label on frame); Edward W. C. Arnold, New York, by 1935–1954.

The Edward W. C. Arnold Collection of New York Prints, Maps, and Pictures. Bequest of Edward W. C. Arnold, 1954.
54.90.8.

UNIDENTIFIED ARTIST

Burning of the Sidewheeler Henry Clay

Races between passenger steamboats on the Hudson River were a common occurrence from the 1830s to the 1850s and were part of the intense competition between the different riverboat lines. The races often resulted in disasters of the kind depicted in this painting.

On July 28, 1852, after racing the *Armenia* from Albany, the sidewheeler *Henry Clay* caught fire near Yonkers. Although the captain managed to run the boat aground on the shore about two miles south of the Yonkers dock, in the vicinity of Edwin Forrest's recently built Fonthill Castle in Riverdale, between seventy and one hundred passengers were burned or drowned, among them the architect and landscape gardener Andrew Jackson Downing. On the following day the *New-York Commercial Advertiser* reported the accident:

The Henry Clay started from Albany in company with the steamer Armenia, and it is said the boats engaged in a race, which was kept up with great recklessness, and in defiance of the urgent entreaties of the passengers, until about 3 o'clock in the afternoon, when the Henry Clay, having run ahead of her competitor about four miles, it appears the struggle for priority was abandoned. Near Forrest Point, a short distance below Yonkers, it was discovered that the woodwork of the Henry Clay around her boilers and flues had taken fire. The flames made rapid progress, the timbers having been so heated by the great fires kept up during the race, that they kindled readily.

Captain Tallman was in his state room at the time, suffering it is said from a recent illness; but as soon as the alarm was given, he sprang from his bed, and ordered the pilot to steer the boat ashore. Her head was accordingly turned toward the Westchester county shore, and in a few moments she struck with great violence, her bow being forced up twenty or thirty feet on the land, and lodging near the embankment of the Hudson river rail road. The shock brought down the chimneys, and seemed to increase the fury of the flames.

All the passengers who happened to be on the forward deck now readily escaped, but the stern of the boat was still in deep water, and the fire raging in the middle, the passengers aft were compelled to choose between perishing in the flames or leaping overboard; the latter alternative seeming no less fatal than the former to those unable to swim. The steamer was two hundred and six feet in length, and as she ran head foremost on the shore and not obliquely, it is apparent how perilous was the position of the passengers aft.

Those who first reached the shore tore down a board fence, and threw the boards into the water.— Upon these many managed to float to land. A few boats were also despatched to their aid from sailing craft in the river (July 29, 1852, p. 2).

The owners and officers of the *Henry Clay* were arrested and tried on a charge of manslaughter but were acquitted in 1853. Congress moved, however, to pass expanded legislation concerning the inspection of steamboats and the licensing of officers.

The burning of the *Henry Clay*, widely reported in newspapers across the country, was the subject of at least two prints, a lithograph drawn by Chapin, which appeared in *Gleason's Pictorial Drawing Room Companion* for August 21, 1852, and a colored lithograph by Nathaniel Currier also published in 1852. Chapin's work is a more accurate and literal representation of the scene than Currier's rendition. The museum's painting is not closely related to either. It does reveal a familiarity with the locale, the facts of the disaster, and an acute sense for detail that might suggest that it is the work of an eyewitness, although the artist has incorrectly identified the other boat as the *Amenia*. The canvas stamp, however, shows that the picture was painted at

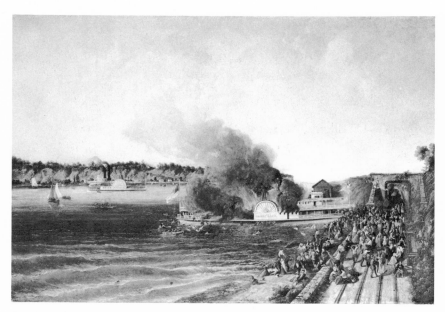

Unidentified artist, *Burning of the Sidewheeler Henry Clay.*

the earliest in 1854, some two years after the event because the firm of Theodore Kelley was located in Philadelphia only from 1854 to 1860.

Oil on canvas, 36¼ × 54 in. (92.1 × 137.2 cm.).

Canvas stamp (appears twice): THEO KELLEY / 16 Arcade / PHILAD.

REFERENCES: J. A. Kouwenhoven, *The Columbia Historical Portrait of New York* (1953), ill. p. 204, discusses the event // W. A. Tieck, *Riverdale, Kingsbridge, Spuyten Duyvil, New York City* (1968), pp. 147–156, describes the catastrophe, supplies contemporary accounts, and discusses pictorial representations; p. 145, illustrates Currier's lithograph of the incident; p. 151, illustrates Chapin's lithograph of the event from *Gleason's Pictorial*; ill. p. 153, discusses the painting, says in text that it is faithful to fact, but in picture

caption suggests that artist's familiarity with the event was secondhand; p. 154, illustrates a painting by James Bard of the *Henry Clay* (coll. Mariners Museum, Newport News, Va.).

EXHIBITED: Los Angeles County Museum of Art, and M. H. de Young Memorial Museum, San Francisco, 1966, *American Paintings from the Metropolitan Museum of Art*, no. 85 // Phoenix Art Museum, Ariz., 1967–1968, *The River and the Sea*, no. 18.

ON DEPOSIT: Museum of the City of New York, 1935–1963; Gracie Mansion, New York, 1974–1977.

EX COLL.: Edward W. C. Arnold, by 1935–1954.

The Edward W. C. Arnold Collection of New York Prints, Maps and Pictures. Bequest of Edward W. C. Arnold, 1954.

54.90.223.

EMANUEL LEUTZE

1816–1868

Born in Schwäbisch Gmünd, Württemberg, Leutze was nine, when his father, a political refugee, brought the family to the United States in 1825. They settled in Philadelphia, and by 1834, Leutze had begun formal studies with the well-known Philadelphia drawing master John Rubens Smith (1775–1849). His rapid progress led two years later to portrait commissions for James Herring's and James Barton Longacre's *The National Portrait Gallery of Distinguished Americans.* When the project was temporarily suspended by the financial panic of 1837, Leutze

worked as an itinerant portraitist in Virginia, Maryland, and Pennsylvania before returning to Philadelphia in 1839. Such works as his *Indian Contemplating the Setting Sun* (unlocated) and his portraits, literary, and religious paintings, exhibited at the Artist's Fund Society in Philadelphia and the Apollo Association in New York, attracted the attention of the leading Philadelphia collector and publisher Edward L. Carey, who, with Joseph Sill, a merchant of that city, encouraged Leutze to go abroad for further study and provided him with financial support.

Leutze arrived in Amsterdam in January 1841 and proceeded to Düsseldorf, where, according to a list of its students ("Die Schülerlisten der königlichen Kunstakademie zu Düsseldorf," Regierung Düsseldorf, CBI, Fach 70/6 II), he enrolled in the Royal Art Academy as a history painter. "For a beginner in the arts," he later wrote:

> Düsseldorf is probably one of the best schools now in existence. The brotherly feeling which exists among the artists is quite cheering, and only disturbed by their speculative dissensions. Two parties divide the school—the one actuated by a severe and almost bigoted Catholic tendency, at the head of which stands the Director of the Academy; and the other by a free and essentially Protestant spirit, of which Lessing is the chief representative. The consistency and severity in the mechanical portion of the art taught at this school, are carried into the theory, and have led, by order and arrangement, to a classification of the subjects, which is of essential service; and soon confirmed me in the conviction that a thorough poetical treatment of a picture required that the anecdote should not be so much the subject, as the means of conveying some one clear idea, which is to be the inspiration of the picture. But the artist, as a poet, should first form the clear thought as the groundwork, and then adopt or create some anecdote from history or life, since painting can be but partially narrative and is essentially a contemplative art (Tuckerman, *Artist-Life*, p. 176).

The immediate success of such early works as Leutze's *Columbus before the High Council of Salamanca*, 1841 (unlocated), which was praised by Wilhelm von Schadow, director of the Düsseldorf academy, and acquired by the Düsseldorf Art Union, and *The Return of Columbus in Chains to Cadiz*, 1842 (coll. William R. Talbot, Jr.), which received a medal at an exhibition in Brussels and was purchased by the Apollo Association in New York, brought him international recognition. He became increasingly dissatisfied, however, with the painting style fostered by the academy, with its insistence on "perfect fidelity to nature, in form, color, and expression; minuteness in detail, delicacy of finish, and perfectness in rendering the language of every subject" (*Descriptive Catalogue of the Paintings now on Exhibition at the Institute of Fine Arts . . .*, New York, 1860, p. 30). This growing frustration with the academic program and a desire for independence soon led to his departure from the academy and the subsequent establishment of his own studio in Düsseldorf.

In 1843 Leutze set off on what was to be a two-year tour of Germany and Italy. In Munich, he studied the religious and historical productions of Peter Cornelius and Wilhelm von Kaulbach and judged its academy "the best school of painting in the world" (Tuckerman, *Artist-Life*, p. 177). From Munich he returned to his birthplace in the Swabian Jura, where he formulated the fundamental ideas that found expression in his history paintings:

> There, the romantic ruins of what were once free cities, with their grey walls and frowning towers, in which a few hardy persevering burghers bade defiance to their noble oppressors, . . . led me to think how glorious had been the course of freedom from those small isolated manifestations of the

love of liberty to where it has unfolded all its splendor in the institutions of our own country. . . . This course represented itself in pictures to my mind, forming a long cycle from the first dawning of free institutions in the middle ages, to the reformation and revolution in England, the causes of emigration, including the discovery and settlement of America, the early protestation against tyranny, to the Revolution and Declaration of Independence (*Bulletin of the American Art-Union* [Sept. 1851], pp. 95–96).

From Swabia, Leutze went to Italy. In Venice, he was captivated by the rich colors of Titian, Veronese, and Bellini, and in Rome, the energetic vigor and originality of Michaelangelo's works inspired him. In 1845, he returned to Düsseldorf by way of Pisa, Genoa, Milan, and Switzerland. The same year he married Juliane Lottner, the daughter of a German officer.

Politically active in the revolutionary period of 1848, Leutze allied himself with the liberal anti-Prussian faction, which espoused ideals of a unified democratic Germany. A leader of the independent artistic community, he became a member and subsequently president of the newly founded Union of Düsseldorf Artists for Mutual Aid and Support (Verein Düsseldorfer Künstler für gegenseitige Unterstützung und Hilfe). In 1848 he was one of the prime movers in the founding of the Malkasten, an artist's association of liberal persuasion, and in 1856 he helped inaugurate the German Art Union (Deutsche Kunstgenossenschaft). His studio was for many years a center for American artists who came to study in Düsseldorf. He served as friend and adviser to EASTMAN JOHNSON, WORTHINGTON WHITTREDGE, ALBERT BIERSTADT, and WILLIAM STANLEY HASELTINE, among others.

In 1849 Leutze began what was to be his best known painting, *Washington Crossing the Delaware* (q.v.). On September 1, 1851, he returned to America, where the painting was exhibited first in New York and then in Washington. Its popularity led him to petition Congress on April 5, 1852, to commission another version and a pendant, *Washington Rallying the Troops at Monmouth,* for the White House or the new Capitol. Although nothing initially came of this project, the artist began the Monmouth picture (now at the University of California at Berkeley) after his return to Düsseldorf in June 1852 and finished it two years later for an American collector. In Düsseldorf, Leutze resumed his position as one of the city's leading artists, and his studio continued to attract Americans who benefited from his friendship and generosity. Although the dissolution of the American Art-Union as an illegal lottery in 1852 deprived him of one of his major promoters and sources of patronage, the popularity of *Washington Crossing the Delaware* continued to generate American commissions. By the late 1850s, however, increasing financial difficulties compounded by the economic panic of 1857 resulted in fewer orders. Disillusioned with the political situation in Germany and hopeful of obtaining a commission for the U.S. Capitol, Leutze returned to America.

He arrived in Boston in January of 1859, and by November he had taken a studio in the Tenth Street Studio Building in New York. Private commissions for such history paintings as *Washington at Princeton,* 1859 (unlocated), and *The Founding of Maryland,* 1860 (Maryland Historical Society, Baltimore), as well as portraits of public figures, kept him occupied. In 1860, the National Academy of Design, where Leutze was an honorary member, elected him an academician. In July 1861, during the early days of the Civil War, he received the long-sought commission to paint a mural for the U.S. Capitol. In preparation for the work depicting westward expansion, the artist traveled to the western territories in August. Using a new

technique called stereochromy, he completed the mural *Westward the Course of Empire Takes Its Way*, popularly known as *Westward Ho*, by December 1862. The following year he returned to Düsseldorf to bring his family to America.

The artist's last years were spent in New York and Washington. Works of this late period include *The Signing of the Alaska Treaty*, 1867 (Foundation Historical Association, Seward House, Auburn, N.Y.), portraits of President Lincoln, General Grant, and various Union officers, and a cartoon for a large mural depicting *The Emancipation of the Slaves* (unlocated). Shortly before his death, Leutze is said to have been under consideration for the position of president of the Düsseldorf Academy. He died in Washington on July 18, 1868.

The German-born painter, who lived abroad for half of his life, was considered by his American contemporaries as one of the chief exponents of the Düsseldorf school, even though he had asserted his independence early in his career by rejecting the strictures of the academy's training. A prolific and competent portraitist, Leutze chose history painting, one of the specialties of the Düsseldorf Academy, as his major mode of expression and often used it as a vehicle for his liberal convictions. Coinciding with the era of assertive nationalism that characterized mid-nineteenth century America, Leutze's epic representations of the country's early history captured the public's imagination. Such works satisfied not only nationalistic interests in America but addressed contemporary issues in revolutionary Germany as well. Leutze's compositions and the gestures and poses of his figures display the theatrical quality that distinguish the historical productions of the Düsseldorf school, but he rejected its painstaking technique for a broader approach. His facile brushwork and the vigor and expressive drama of his ambitious compositions generated both praise and criticism.

BIBLIOGRAPHY: [Henry T. Tuckerman], "Our Artists.—No. III., Leutze," *Godey's Magazine and Lady's Book* 33 (Oct. 1846), pp. 167–171; reprinted with emendations in his *Artist-Life: or, Sketches of American Painters* (New York and Philadelphia, 1847), pp. [171]–186; and *Book of the Artists, American Artist Life* (New York, 1867), pp. [333]–345, which incorporates much of the material from the 1846 and 1847 publications // "Return of Mr. Leutze," *Bulletin of the American Art-Union*, no. 6 (Sept. 1851), pp. 95–96, is similar to material in Tuckerman and includes an autobiographical sketch of the artist // Ann Hawkes Hutton, *Portrait of Patriotism: "Washington Crossing the Delaware"* (Philadelphia, 1959). A popular account of the artist's life that concentrates on Leutze's best known painting and includes family correspondence not previously published // Raymond Louis Stehle, "The Life and Works of Emanuel Leutze," copyright 1972, copy of typed manuscript, NYHS. An extensive account of the artist's life with an annotated list of his work // National Collection of Fine Arts, Smithsonian Institution, Washington, D.C., 1975, *Emanuel Leutze, 1816–1868: Freedom Is the Only King*, exhib. cat. by Barbara S. Groseclose. A comprehensive account of the artist's life, it includes a catalogue of his known works, an appendix of American artists in Düsseldorf, and a selective bibliography.

Washington Crossing the Delaware

On Christmas night 1776, George Washington, accompanied by some 2,500 of his troops, crossed the Delaware River about nine miles above Trenton in a surprise attack on the Hessians. Delayed by ice floes and a heavy snowstorm, the Americans and their allies did not reach Trenton until daylight, but, as Washington had foreseen, the Hessian soldiers had spent the night celebrating and were taken by surprise. Coming directly after a succession of bitter defeats, the Battle of Trenton proved to be a turning point in the American Revolution. It gave new encouragement to the patriots, restored confidence in Washington as commander in chief, and

strengthened the resolution of Congress to continue the war.

Leutze's representation of this critical moment in America's early history has become one of the best known and most extensively published paintings in American art. Like such early representations of the event as THOMAS SULLY's *The Passage of the Delaware*, 1819 (MFA, Boston), Leutze's picture, which he painted in Düsseldorf in 1851, belongs to the tradition of heroic history painting. Satisfying the public demand for expressive patriotic pictures, Leutze's work was a great success in America. Concurrently the revolutionary theme had a special relevance in Germany, which was still emerging from the upheavals of the 1848 revolution. Barbara S. Groseclose suggested in 1975 that Leutze's initial inspiration may have been the poem "Vor der Fahrt," by Ferdinand Freiligrath from his collection *Ça ira!* published in 1846. A metaphoric call to revolt, the poem concerns the ship "Revolution," which is bound for America with a crew in search of freedom, and recalls leaders such as Washington. The political implications of the painting were apparent in Leutze's circle in Germany, but in America these allusions were overshadowed, and the painting was acclaimed primarily as an effective expression of a pivotal event in the nation's history.

From its inception, Leutze's progress on the painting was faithfully reported in the *Bulletin of the American Art-Union*. A report in the issue for October 1849 noted, Leutze "is about to paint '*Washington crossing the Delaware*,' the figures to be of life size. He has already made a number of studies for this work". In August 1850, a letter in the *Bulletin* from an artist in Düsseldorf stated that the canvas was "half underpainted," and in October a description of the work appeared. WORTHINGTON WHITTREDGE, who arrived in Düsseldorf in 1849 and whose portrait Leutze painted in 1856 (q.v.), provided a colorful account of the proceedings in his autobiography.

I suppose there is no artist now living who is as familiar as I am with the assembling of his great picture of "Washington Crossing the Delaware." I had not been in Düsseldorf an hour before he showed me a pencil sketch of this subject, about six by ten inches in size . . . substantially the same in its arrangement as the completed picture. A large canvas for it had been ordered that day. When it came he set to work immediately drawing in the boat and figures with charcoal, and without a model. All the figures were carefully corrected from models when he came to paint them. But he found great difficulty in finding American types for the heads and figures, all the German models being either too small or too closely set in their limbs for his purpose. He caught every American that came along and pressed him into service. Mr. John Groesbeck of Cincinnati, a man over six feet, called to see me at Leutze's studio and was taken for one of the figures almost before he had time to ask me how I was getting along. My own arrival and that of my friend were a god-send to him. This friend, a thin sickly-looking man —in fact all his life a half-invalid—was seized, a bandage put around his head, a poor wounded fellow put in the boat with the rest, while I was seized and made to do service twice, once for the steersman with the oar in my hand and again for Washington himself. I stood two hours without moving, in order that the cloak of Washington could be painted at a single sitting, thus enabling Leutze to catch the folds of the cloak as they were first arranged. Clad in Washington's full uniform, heavy chapeau and all, spy-glass in one hand and the other on my knee, I was nearly dead when the operation was over. They poured champagne down my throat and I lived through it. This was all because no German model could be found anywhere who could fill Washington's clothes, a perfect copy [of] which Leutze, through the influence of Mr. Steward, had procured from the Patent Office in Washington. The head of Washington in this picture was painted from Houdon's bust [actually a cast taken from the face of a full-length statue now in the Virginia State House, Richmond], a profile being represented. It is a very dignified figure, looking intently but calmly through the cold mist to the opposite shore vaguely visible over fields of broken ice. One figure only in the boat was painted from any but an American and he was a tall Norwegian, acquainted with ice and accustomed to a boat and could be admitted. A large portion of the great canvas is occupied by the sky. Leutze mixed the colors for it over night and invited Andreas Achenbach and myself to help him cover the canvas the next day, it being necessary to blend the colors easily, to cover it all over in one day. It was done; Achenbach thought of the star, and painted it, a lone almost invisible star, the last to fade in the morning light (see Baur, ed. 1942).

Judging from this account, Leutze attempted to insure historical accuracy. As historians have been quick to demonstrate, however, the picture is inaccurate as a document: instead of the flat-bottomed "Durham" iron-ore boats that Washington had used, Leutze's craft are too light for their loads; the horses and artillery were brought over after, not with, the men; the uniforms are incorrect and too fastidious; the jagged ice floes stand in marked contrast to the thin ice described by Washington in a report to the Continental Congress; and the flag shown was not adopted until nearly six months after the event.

On November 5, 1850, a fire swept through Leutze's studio, and, although the picture was

quickly cut from the frame and rolled up, it was torn in several places. In a letter to the American Art-Union, dated November 10 and published in their December *Bulletin*, Leutze stated that the canvas was "so much injured" that he had to "give up all hope of being able to finish it without commencing it entirely anew." The damaged canvas, which became the property of an insurance company, was sufficiently restored to be exhibited in the Kaufhaus Guerzenich in Cologne by December 22, 1850. In July 1852 it was shown in Düsseldorf and that September, it was awarded a gold medal at the Berlin Salon. By 1863 the painting had been acquired by the Bremen Kunsthalle, where it remained until destroyed by fire in an Allied bombing raid on September 5, 1942.

Immediately after the fire in his studio, the artist began preparations for a new version, the painting now in the Metropolitan. On January 16, 1851, EASTMAN JOHNSON, who was sharing Leutze's studio at the time, wrote to the American Art-Union: "Leutze is every day expecting his new canvas & in haste to commence again his large picture. In the meantime is engaged on a small one . . . [possibly the painting in coll. Bruce McLanathan] which is progressing delightfully." In a postscript to the same letter, dated January 17, Johnson reported that Adolphe Goupil, a partner of the Parisian firm of Goupil, Vibert and Company, which in 1849, entered the competitive New York art market as the International Art Union, much to the displeasure of the American Art-Union, had visited the studio to purchase the painting. In a second marginal postscript, he reported Goupil's acquisition of the painting that Leutze was about to begin. Somewhat larger than the first version, it was to vary in several respects: the positioning of the figures, elements of the costumes and weapons, and the arrangement of the ice floes. Johnson described Leutze's progress on the picture in a letter to his friend Charlotte Child, in March 1851:

Since the first of January I have been with Leutze. Our studio is a large hall where six of us paint with convenience, three on large pictures. The chief is Leutze's of 'Washington Crossing the Delaware', 20 feet by 16, figures size of life. It is already perhaps two-thirds finished and I am making a copy [see Groseclose, *Leutze*, p. 39, fig. 23] on a reduced scale from which an engraving is to be made. It is sold to the International A[rt] Union of New York and will be exhibited through the States in the fall.

With six in the room, a cask of the best 'Laurish'[?] beer always behind the great canvas and a disposition

to be jolly you may be sure it does not want for animation To give a more decided *tone* to the place three cannons were recently brot and a battery constructed with the stars and stripes waving on one side and the black and white of Prussia on the other. Nothing could exceed the enjoyment produced by the sound of the entire battery, so that almost every one that enters is received with three guns, and accordingly up to the present time there has been a pretty uninterrupted cannonade. The fun has been increased by shooting with bullets also, and the walls are fearfully scarred with the continued bombardment With so much tumult you might suppose there could be very little work, but Leutze has painted the m[ain] of his immense picture in the last three months (see Baur, 1940).

In May 1851, the *Bulletin of the American Art-Union* informed its readers that Leutze had written that he expected to finish the painting before July 10 and would come to America immediately after its completion. In a letter home, recorded by William Walton (1906), Johnson described a reception in Leutze's studio held on May 11, 1851, and attended by the Prince and Princess of Prussia to celebrate the completion of the painting. On July 16, 1851, the *Düsseldorfer Journal und Kreisblatt* announced that the picture had been completed the day before and would be shown briefly in Leutze's studio before being sent to Paris and New York. Either accompanying the painting or following it, Leutze arrived in New York on September 1 aboard the *Atlantic*. Before the picture was shown to the public at the Stuyvesant Institute on October 29, Abraham Cozzens, president of the American Art-Union pronounced it "one of the greatest productions of the age, and eminently worthy to commemorate the grandest event in the military life of the illustrious man whom all nations delight to honor" (*Bulletin of the American Art-Union* [Oct. 1851], p. 116). The *New York Evening Mirror* for November 7 called it "the grandest, most majestic, and most effective painting ever exhibited in America." With few exceptions, unqualified praise was the universal reaction, and it was an immediate popular success. The New York exhibition was one of the major cultural events of the season. Henry James, who saw the painting either then or in 1853, later recalled the experience in *A Small Boy and Others* (1913):

No impression . . . was half so momentous as that of the epoch-making masterpiece of Mr. Leutze, which showed us Washington crossing the Delaware in a wondrous flare of projected gaslight and with the effect of a revelation to my young sight of the capacity

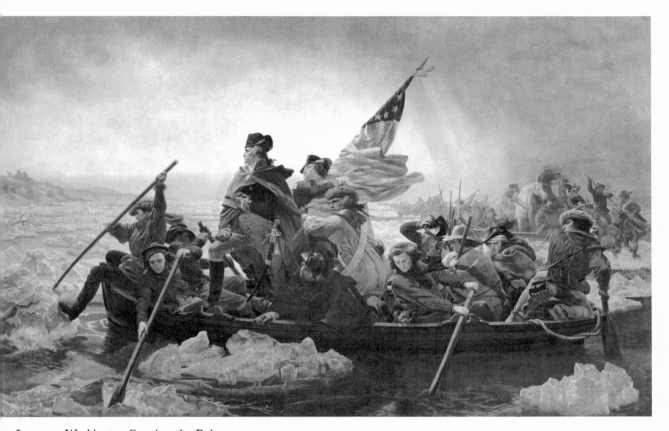

Leutze, *Washington Crossing the Delaware*.

of accessories to 'stand out.' I live again in the thrill of that evening—which was the greater of course for my feeling it, in my parents' company, when I should otherwise have been in bed. We went down, after dinner, in the Fourteenth Street stage, quite as if going to the theatre; the scene of exhibition was near the Stuyvestant Institute, . . . but Mr. Leutze's drama left behind any paler proscenium. We gaped responsive to every item, lost in the marvel of the wintry light, of the sharpness of the ice-blocks, of the sickness of the sick soldier, of the protrusion of the minor objects, that of the strands of the rope and the nails of the boots, that, I say, on the part of everything, of its determined purpose of standing out; but that, above all, of the profiled national hero's purpose, as might be said, of standing *up*, as much as possible, even indeed of doing it almost on one leg, in such difficulties, and successfully balancing. So memorable was that evening to remain for me that nothing could be more strange, in connection with it, than the illustration by the admired work, on its in after years again coming before me, of the cold cruelty with which time may turn and devour its children. The picture, more or less entombed in its relegation, was lividly dead—and that was bad enough. But half the substance of one's youth seemed buried with it (F. W. Dupee, ed., *Henry James: Autobiography* [1956], pp. 151–152).

In the fall of 1851, Goupil, Vibert and Company announced that the Parisian printmaker Paul Girardet had been commissioned to produce an engraving of the painting. The wide distribution of the print, published in 1853 with a copyright to M. Knoedler, Goupil's successor, contributed to the painting's fame. According to Mark Twain in *Life on the Mississippi* (1883; ed. 1951, pp. 318, 322) the engraving was an essential feature of "the residence of the principal citizen, all the way from the suburbs of New Orleans to the edge of St. Louis." Currier and Ives issued their own unauthorized versions, which were only distantly related to Leutze's painting.

When the New York exhibition closed on February 28, 1852, more than fifty thousand people had paid to see the painting. On February 23, it was announced that the picture had been sold for ten thousand dollars, probably directly to the New York collector Marshall O. Roberts, although in 1964 Raymond L. Stehle provided some evidence to suggest that Goupil may have sold the painting back to Leutze, who, in turn, sold it to Roberts. From March 15 through April 4, 1852, it was on exhibition in the Capitol Rotunda in Washington, to the annoyance of JOHN VANDERLYN who complained in a letter on March 26, 1852, that it was blocking his "large picture of Niagara Falls" (quoted in Schoon-

maker, 1950). The enthusiasm Leutze's painting excited led several congressmen to suggest that "the great national painting" be purchased for the president's house. In a petition to Congress dated April 5, 1852, Leutze reported that the picture had already been "purchased for a private gallery," but that he was "desirous to repeat the same (with such emendations as his subsequent experience may suggest) for the government of the United States, and to make a fellow to it, exhibiting 'Washington rallying the troops, at the Battle of Monmouth,' both of which pictures would make appropriate embellishments for the Executive Mansion, or the new Capitol." Nothing ever came of this project, but Leutze was subsequently commissioned by David W. Leavitt to paint the Monmouth scene, 1854 (University of California at Berkeley). In 1853 *Washington Crossing the Delaware* was shown at the "Washington Exhibition" at the American Art-Union for the benefit of the New York Gallery of the Fine Arts, and in 1864, it was one of the central attractions at the Metropolitan Fair, a New York exhibition in aid of the United States Sanitary Commission. A stereoscopic photograph by Bierstadt Brothers of the picture gallery at the fair shows the painting in its elaborate original frame, which is now lost.

The painting's success lay chiefly in Leutze's choice of subject, appealing as it did to the flourishing nationalism of the period, but the monumental scale and the conception of the work also added to its effectiveness. For the composition Leutze adapted a classical format, consisting of an essentially frieze-like arrangement that culminates in a pyramidal grouping with the flagstaff forming the apex above the figure of Washington. The diagonals formed by the oars, poles, flagstaff, figures, and ice floes create a dynamic surface tension. The action is relegated primarily to the foreground and confined to the boat. Leutze skillfully orchestrates the group within these narrow confines. Contorted by their efforts, the figures act as an effective foil for the pensive Washington, one of the few figures to be shown in strict profile. In contrast to the sharp delineation of the foreground elements, the distant boats are shrouded in haze.

There is no key to the painting to identify the other figures with Washington in the lead boat, and it is doubtful that one ever existed. Identities crop up in the literature on the painting, beginning with its exhibition in New York in 1851. A catalogue for the 1853 exhibition says that the young officer supporting the flag is

Leutze, *Washington Crossing the Delaware*, formerly Bremen Kunsthalle.

Colonel James Monroe and that General Nathanael Greene is the man leaning over the side of the craft. Washington's black aide, identified by Sidney Kaplan in 1973, as Prince Whipple, bodyguard to General Whipple of New Hampshire, is also represented. A regiment of fishermen from Marblehead, Massachusetts, under the command of Colonel John Glover manned the boats for the crossing of the Delaware. Leutze represents the Marbleheaders but not in the distinctive blue seaman's jackets, white caps, and tarred trousers identified with the regiment.

The artist's studies for the painting, known to date, include an oil sketch of the head of Washington, which Leutze presented to the National Academy of Design in 1860 when he was made academician; an ink and pencil study of the head of the kneeling figure supporting the flag (coll. John Davis Hatch, Lenox, Mass.), which originally belonged to Eastman Johnson; a pencil drawing of the whole composition ruled for transfer (coll. Kurt Orban, Jersey City, N.J.); and an unfinished oil version of the entire composition (coll. Bruce McLanathan). How these studies relate to the Bremen or Metropolitan paintings deserves further study, but with the possible exception of the National Academy sketch, they appear to be more closely related to the Metropolitan's painting. In addition to the studies and the copy Johnson made for the engraver, several copies of the painting are known: in the collections of the Los Angeles Athletic Club, Ann Hawkes Hutton, Bristol, Pennsylvania, and the American Swedish His-

torical Foundation, Philadelphia. Formerly attributed to Leutze, all these were ascribed to various unknown artists by Barbara Groseclose in 1975 (p. 84). A recent copy of the Metropolitan's painting was made in 1970 for Washington Crossing Park, Bucks County, Pennsylvania.

Initially a work of great patriotic appeal, Leutze's painting has acquired over the years something of the status of a national monument. The extensive reproduction of the image has transformed it into an immediately recognizable representation of patriotic sentiment. Its aesthetic merits and effectiveness as a work of art, however, have often come under fire. The painting's huge popular success undoubtedly gave an added impetus to the flourishing of Washington imagery in the mid-nineteenth century. Some artists like GEORGE CALEB BINGHAM, with his *Washington Crossing the Delaware*, 1856/1871 (coll. Mrs. Thomas E. Keck, Kansas City, Mo.) hoped to rival it; others chose to explore different facets of Washington's life. The measure of its influence extends well into this century. It has served as a point of departure for such works as Grant Wood's (1892–1942) *Daughters of Revolution*, 1932 (Cincinnati Art Museum), and Larry Rivers's (1923—) *Washington Crossing the Delaware*, 1953 (Museum of Modern Art, New York).

Oil on canvas, 149 × 255 in. (378.5 × 647.7 cm.).
Signed, inscribed, and dated at lower right: E. Leutze / Düsseldorf 1851. Dated at lower left: 16.4.51.
RELATED WORKS: *Washington Crossing the Delaware*, oil on canvas, 144 × 244 in. (348 × 616 cm.), 1850, formerly Bremen Kunsthalle, ill. in *MMA Bull.* 26 (March 1968), [p. 290], fig. 1. This painting was damaged by fire on November 5, 1850, restored by December 22, 1850, and destroyed in 1942 // *Studies for Washington Crossing the Delaware* (head of kneeling figure in white supporting the flag), pen, sepia ink, and pencil, $11\frac{9}{16} \times 12\frac{3}{8}$ in. (29.4 × 31.3 cm.), 1849, coll. John Davis Hatch, Lenox, Mass., ill. in Heim Gallery, London, *100 American Drawings, Loan Exhibition from the Collection of John Davis Hatch* (1976), cat. by G. Burger, no. 56, pl. 58 // *Washington Crossing the Delaware*, unfinished study, oil on canvas, $24\frac{1}{2} \times 44$ in. (62.2 × 111.8 cm.), ca. 1850, coll. Bruce McLanahan, color ill., in B. S. Groseclose, *Emanuel Leutze, 1816–1868* (1975), p. 35, fig. 20; p. 84 // *Washington Crossing the Delaware*, pencil, ruled for transfer, coll. Kurt Orban, Jersey City, N.J. Information supplied by C. M. Rosario, letter in Dept. Archives, March 17, 1967 // *Study for the Head of Washington*, oil on canvas, 21 × 17 in. (53.3 × 43.2 cm.), ca. 1850, NAD, ill. in B. S. Groseclose, *Emanuel Leutze, 1816–1868* (1975), p. 84, fig. 59 // *Profile of George Washington*, pencil 12 × $8\frac{1}{2}$ in. (30.4 × 21.6 cm.), October 1851, coll. Mr. and Mrs.

Harry Burgess, Arlington, Va., ill. in B. S. Groseclose, *Emanuel Leutze, 1816–1868* (1975), p. 127, fig. 260 // Eastman Johnson in collaboration with Leutze, *Washington Crossing the Delaware*, oil on canvas, $40\frac{1}{2} \times 67\frac{7}{8}$ in. (102.9 × 172.4 cm), 1851 (sale, Sotheby Parke Bernet, New York, April 20, 1979, no. 28), ill. in B. S. Groseclose, *Emanuel Leutze, 1816–1868* (1975), p. 39, fig. 23. Painted for engraver's use // Paul Girardet, *Washington Crossing the Delaware*, engraving, $22\frac{3}{8} \times 38\frac{1}{2}$ in. (56.8 × 97.8 cm.), copyright issued to M. Knoedler, Sept. 24, 1853, ill. in J. K. Howat, *MMA Bull.* 26 (March 1968), [p. 291], fig. 4 // Attributed to Leutze, *Washington Crossing the Delaware*, oil on canvas, 27 × $40\frac{1}{2}$ in. (68.6 × 102.9 cm.), ca. 1851–1852, Los Angeles Athletic Club, ill. in Los Angeles County Museum of Art, *American Narrative Painting* (1974), exhib. cat. with essay by D. Hoopes and notes by N. W. Moure, p. 99 // Attributed to Leutze, *Washington Crossing the Delaware*, oil on canvas, 60 × 45 in. (152.4 × 114.3 cm.), 1850, coll. Ann Hawkes Hutton, Bristol, Pa. A. Levy [copy of letter in Dept. Archives, February 16, 1935] noted that before lining the painting was inscribed on back: E. Leutze Düsseldorf 1850 // Attributed to Leutze, *Washington Crossing the Delaware*, oil on canvas, American Swedish Historical Foundation, Philadelphia // Attributed to Leutze, *Washington Crossing the Delaware*, oil on canvas, 25 × $31\frac{1}{2}$ in. (63.5 × 80 cm.) ca. 1855, location unknown, ill. in *Old Print Shop Portfolio* 19 (Dec. 1959), p. 78, fig. 6.

REFERENCES: *Bulletin of the American Art-Union* 2 (Oct. 1849), p. 25, announces that Leutze is about to paint the first version and mentions studies (quoted above); (May 1850), p. 31, notes that the artist, "having obtained a large apartment over the railroad depot," is at work on the painting and mentions studies; (August 1850), p. 83, supplies letter from an artist in Düsseldorf who reports that it is "half under-painted" (quoted above); (Oct. 1850), p. 117, quotes letter from *Literary World* in which the correspondent reports a visit to Leutze's studio and describes the nearly completed first version // *Literary World* 7 (Nov. 30, 1850), p. 433, says Leutze is expected in America with the painting in December // *Bulletin of the American Art-Union* (Nov. 1850), p. 139, notes that the painting measures twelve by eighteen feet, like those in the Rotunda of the Capitol, and that it "will probably be completed in the Spring when the artist intends to accompany it" to America; (Dec. 1850), p. 159, supplies extract from Leutze's letter of November 10, which reports the studio fire and damage to the first version (quoted above), its acquisition by an insurance company for distribution by lottery, and announces his intention of painting a second version, for which he has ordered a canvas, and his retention of the damaged one for six months to use as a model (quoted above) // E. Johnson to A. Warner, Jan. 16, 1851, Letters from Artists, vol. 7, American Art-Union Papers, NYHS, notes Leutze is waiting for canvas for second version and working on a small copy (quoted above), notes first version is on exhibition in Cologne; in January 17

postscript, reports Goupil's acquisition of the second version // *Literary World* 8 (March 1, 1851), p. 175, notes Goupil's purchase of the second version // *Bulletin of the American Art-Union* (April 1851), p. 12, notes that the second version, to be completed in July, has been acquired by Goupil and Vibert for 10,000 thalers or about $6,000, adds that they intend to exhibit it in London, Paris, and the United States, and to have it engraved by François, notes favorable notices in German press and cites *Kölnische Zeitung*; (May 1851), p. 32, notes that Leutze has written that he expects to finish the painting before July 10, adds that he had not yet received the canvas for it in January // *Harper's Magazine* 3 (June 1851), p. 136, notes Goupil's acquisition of it for $6,000 and says it is nearly finished // *Düsseldorfer Journal und Kreisblatt*, July 16, 1851, notes that it will be exhibited in Leutze's Düsseldorf studio and sent to Paris before being shipped to New York // E. Johnson to A. Warner, July 19, 1851, Letters from Artists, vol. 7, American Art-Union Papers, NYHS, notes that during the past winter he was chiefly occupied in copying Leutze's Washington and that Leutze intends to go to America as soon as possible // *Bulletin of the American Art-Union* (Sept. 1851), p. 95, notes Leutze's expected arrival in New York; p. 96, discusses the painting; p. 99, notes that they would "forego for a little time" seeing the work if it could be exhibited in Brussels // *Providence Journal* (Sept. 4, 1851), reports its arrival in New York // *New York Evening Post*, Sept. 23, 1851, reports meeting of American Art-Union on September 22 and gives Abraham Cozzens's remarks // *Knickerbocker Magazine* 38 (Oct. 1851), p. 475, announces exhibition at Stuyvesant Institute // *Bulletin of the American Art-Union* (Oct. 1851), pp. 112–113, notes forthcoming exhibition at the Stuyvesant Institute, quotes description of the painting by a German writer translated in the *New York Tribune*, notes that Goupil intends to have it engraved by Girardet and that artist used a cast from Houdon's mask of Washington's face; p. 116, cites A. M. Cozzens's remarks about the painting (quoted above); (Nov. 1851), pp. 130–132, discusses exhibition and describes the painting, giving identities to some of the figures, notes that Goupil intends to exhibit the painting in different cities, and expresses hope that it will remain in America or that a duplicate will be made for the Capitol; (Dec. 1851), p. 149, discusses success of the exhibition; p. 153 // *Daily National Intelligencer*, March 16, 1852, reports arrival of painting in Washington and its installation on the previous day in the Capitol Rotunda // U.S. Congress, Senate, *Congressional Globe*, 32nd Cong., 1st Sess., March 26, 1852, 24, part 2, p. 878, reports Senator John P. Hale of New Hampshire's suggestion that it be purchased for President's Mansion; March 29, 1852, p. 903, reports Senate agreement to purchase it for President's Mansion; April 8, 1852, pp. 1004–1005 // Leutze's petition to Congress, April 5, 1852, U.S. Congress, Senate Records, RG46, Senate 32A-H5, National Archives, Washington, D.C. (quoted above) // *Georgetown Advocate*,

April 6, 1852, reports removal of the picture from the Rotunda on April 4 // *New York Times*, March 17, 1853, p. 2, calls it the "chief ostensible attraction" at the Art-Union exhibition; criticizes installation, noting that the crimson draperies flanking it "make it appear colder than it really is or need be" // R. Wiegmann, *Königliche Kunst-Akademie zu Düsseldorf* (1856), pp. 244–245 // *Crayon* 3 (August 1856), p. 249, mentions it in coll. of Marshall O. Roberts and calls it "the best of Mr. Leutze's large pictures" // H. T. Tuckerman, *The Character and Portraits of Washington* (1859), p. 83; *Book of the Artists* (1867), pp. 335, 343 // E. Strahan [E. Shinn], ed., *The Art Treasures of America* (1880), 2, p. 15, describes it in coll. of Mrs. Marshall O. Roberts, as "designed with the gusty fling and swell of an artist who feels his elbow-room" and as "a theatrical piece of posturing"; says it "looks strange in a private house" // Cicerone [E. Shinn], *Art Amateur* 3 (Oct. 1880), p. 93 // M. Twain [S. L. Clemens], *Life on the Mississippi* (1883; 1951 ed.), pp. 318, 322 (quoted above) // C. Lanman, *Haphazard Personalities* (1886), pp. 254, 258 // *Collector* 8 (Jan. 15, 1897), p. 87, discusses Roberts's sale; (Feb. 1, 1897), p. 100, notes purchase of painting for over $16,000 for presentation to MMA by John S. Kennedy; (March 1, 1897), p. 129 discusses the painting // W. Walton, *Scribner's Magazine* 40 (1906), p. 267, notes that Eastman Johnson arranged to obtain a copy of Washington's uniform for Leutze from his father in Washington; mentions Johnson's letter home describing a reception held in Leutze's studio on May 11, 1851, attended by the Prince and Princess of Prussia to celebrate the completion of the painting, and notes that the prince offered to purchase the small copy of the picture painted by Johnson // H. James, *A Small Boy and Others* in *Henry James: Autobiography*, ed. by F. W. Dupee, (1913; 1956), pp. 151–152, describes exhibition of the painting (quoted above) // C. E. Fairman, *Art and Artists of the Capitol of the United States of America* (1927), pp. 135–138 // J. I. H. Baur, *Eastman Johnson, 1824–1906* (1940), p. 10, notes that Johnson acquired a copy of Washington's uniform for Leutze; pp. 11–13, cites Johnson's letter to Charlotte Child, March 1851 (quoted above) // J. I. H. Baur, ed., *Brooklyn Museum Journal* (1942), pp. 22–23, cites Whittredge's autobiography (quoted above) // Century Association, New York, *Exhibition of Work by Emanuel Leutze*, cat. (1946), part 2 (checklist), no. 72, notes this picture; no. 111, lists study for it, owned by C. H. Wegeman, Baltimore // M. Schoonmaker, *John Vanderlyn* (1950), p. 72, cites letter from Vanderlyn to C. H. Van Gaasbeek, March 26, 1852, mentioning exhibition in the Capitol Rotunda (quoted above) // A. H. Hutton, *Portrait of Patriotism* (1959), discusses this painting and other versions // *Old Print Shop Portfolio* 19 (Dec. 1959), p. 75, describes "an earlier and smaller rendering" of the painting and attributes it to Leutze; ill. p. 78, dates it ca. 1855 // R. L. Stehle, *Pennsylvania History* 31 (July 1964), pp. 269–294, discusses the painting at length and provides excerpts

from contemporary reviews and an extensive bibliography // W. Thomas, Kunsthalle, Bremen, letter in Dept. Archives, Feb. 28, 1967, notes first version destroyed on September 5, 1942 // J. K. Howat, *MMA Bull.* 26 (March 1968), pp. 289–299, discusses the history of the painting and illustrates various versions of it // Museum Schwäbisch Gmünd, *Emanuel Leutze, 1816–1868, Bildnisse und Zeichnungen*, exhib. cat. by E. Kratz (1968), unpaged, mentions this work // R. L. Stehle, *Records of the Columbia Historical Society of Washington, D.C.* (1969–1970), pp. 309–313, discusses both versions; p. 314, reproduces Leutze's petition to the Senate and House of Representatives, April 5, 1852; "The Life and Works of Emanuel Leutze," 1972, copy of typed ms, NYHS, pp. 24–59, discusses it; p. 34, lists it // P. Hills, *Eastman Johnson* (1972), p. 11, discusses the painting and notes that Eastman Johnson copied it for the engraver Girardet; p. 118, note 11 // Munson-Williams-Proctor Institute, Utica, N.Y.; National Collection of Fine Arts, Washington, D.C.; High Museum of Art, Atlanta, traveling exhibition, 1973, *The Düsseldorf Academy and the Americans*, exhib. cat. by W. von Kalnein and D. F. Hoopes (1972), p. 23, mentions a preliminary drawing of Washington's head in MFA, Boston (ill. p. 26); pp. 26–27, discusses; p. 29, compares it with Bingham's painting of the subject; p. 43 // P. Hills, *The Genre Painting of Eastman Johnson* (1973), Ph.D. diss. published in 1977, pp. 34–40, discusses Johnson's work with Leutze in Düsseldorf, compares various versions and notes that Leutze had "sufficiently completed the [MMA] painting by April 16 to incorporate into the painting the date '16.4.51' in among the ice cakes in the foreground," compares engraver's copy, Goupil engraving and MMA version; discusses attribution of engraver's version to Johnson and as supporting evidence cites an article by B. J. Cigrand in 1918 in the *Washington Post*, which also notes that Leutze studied the ice on the Rhine in preparation for his painting; p. 195, fig. 9; ills. pp. 195–197, shows other versions, engraving, and details for comparison // S. Kaplan, *The Black Presence in the Era of the American Revolution, 1770–1800* (1973), pp. 44–46, notes, according to a tradition first printed by William C. Nell in 1851, that the black soldier who accompanied Washington across the Delaware was Prince Whipple, bodyguard to General Whipple of New Hampshire and aide to Washington, and that he is included in both Sully's and Leutze's pictures of Washington crossing the Delaware // Los Angeles County Museum, 1974, *American Narrative Painting*, exhib. cat., with essay by D. F. Hoopes and notes by N. W. Moure (1974), p. 98 // L. Edel, *American Art Journal* 6 (Nov. 1974), p. 6 and note 1, notes Henry James's reaction to the showing of the painting; ill. p. 7 // R. B. Stein, *Seascape and the American Imagination* (1975), p. 55, discusses it; p. 56, fig. 56 // B. S. Groseclose, *American Art Journal* 7 (Nov. 1975), pp. 70–78, discusses the history of the painting and various versions, sees it as an expression of the artist's political sympathies in the context of contemporary Germany and suggests that the theme was inspired by Freiligrath's poem which is cited; p. 71, fig. 1; p. 78, cites poem about the painting by Leutze's contemporaries as an illustration of their recognition of the political implications of his work; *Emanuel Leutze, 1816–1868* (1975), exhib. cat., pp. 10–11, mentions it; pp. 13, 34–41, 43, 44, 45, 46, 47, 55, 57, discusses the history of the work, its political context in contemporary Germany and various versions of it; p. 39, fig. 22; p. 68; p. 83, no. 56, catalogues it, provides history of the various versions and bibliography; notes that "an unspecified number of preliminary drawings are in the collection of a Düsseldorf museum," pp. 83–84, 126, catalogues other versions and studies // Kunstmuseum Düsseldorf, *The Hudson and the Rhine* (1976), exhib. cat., pp. 12, 15, 22–23, 31–32; pp. 69–70, no. 105, catalogues Eastman Johnson version, discusses other versions, and notes that J. Nieuwstraten of the Hague has suggested that Leutze's composition is based on a 1691 engraving by Romeyn de Hooghe for L. Bidloo's *Komste van konig Willem III in Holland.*

EXHIBITED: Leutze's studio, Düsseldorf, 1851 // possibly Goupil, Vibert and Company, Paris, 1851 // Stuyvesant Institute, New York, 1851–1852, *Exhibition of Leutze's Great National Picture of Washington Crossing the Delaware*, pp. 1–2, describes the painting and notes that Goupil and Company commissioned Girardet to engrave it // Rotunda of the United States Capitol, Washington, D.C., 1852 // American Art-Union Gallery, New York, 1853, *The Washington Exhibition in Aid of the New-York Gallery of the Fine Arts . . .* no. 1, pp. 5–7, as lent by Marshall O. Roberts, "R.G.W." describes it at length and identifies three of the figures // Metropolitan Fair, New York, 1864, *Catalogue of the Art Exhibition at the Metropolitan Fair in Aid of the U.S. Sanitary Commission*, no. 1, pp. 3–4, as lent by Marshall O. Roberts, describes it at length, gives identities for three of the figures // MMA, 1897–1898, *Loan Collections and Recent Gifts to the Museum*, no. 232 // MMA, 1970, *19th Century America, Paintings and Sculpture*, exhib. cat. by J. K. Howat and N. Spassky, no. 87.

ON DEPOSIT: Dallas Museum of Fine Arts, 1950–1952; Washington Crossing Park Commission, Washington Crossing, Pa., 1952–1970.

EX COLL.: with Goupil, Vibert and Company, Paris and New York, 1851–1852; Marshall O. Roberts, New York, 1852–1880; his estate (sale, Ortgies and Company, Fifth Avenue Art Galleries, New York, Jan. 20, 1897, no. 172, $16,000); John S. Kennedy, New York, 1897.

Gift of John S. Kennedy, 1897.

97.34.

Worthington Whittredge

Leutze's friendship with the painter WORTH-INGTON WHITTREDGE presumably dates from 1849 when Whittredge came to Düsseldorf and was promptly commandeered by Leutze to serve as the model for both Washington and the steersman in *Washington Crossing the Delaware* (q.v.). Although it was chiefly his historical paintings that won Leutze his reputation, such works as this compelling portrait of Whittredge demonstrate his accomplished skill as a portrait painter. Leutze may have paid a short visit in October 1856 to Rome where Whittredge spent the winter, but it is more likely that he painted the portrait when Whittredge was in Düsseldorf that year. A description of Whittredge by one of his friends, recorded by H. Tuckerman in 1867, mentions the painting:

He is a tall, dark-complexioned man . . . straight, dignified, and more striking than handsome in his general appearance. He resembles in face and figure a middle-aged cavalier of Spain or Portugal, and a portrait of him in that costume, by Leutze, which is hanging in his studio, might pass for a likeness for such an individual by Vandyke, or some old master of a long past century.

Undoubtedly inspired by his study of the old masters, Leutze's conception and choice of a seventeenth-century costume, which was probably drawn from his vast collection of period clothes, gave him a chance to exercise his penchant for historical pieces.

Leutze painted Whittredge's portrait on at least two other occasions when both artists were in New York: the first, a half-length portrait dated 1861 (NAD), is said to have been one of two portraits Leutze submitted to the National Academy of Design when he was elected a member; the second, dated 1865 (private coll., ill. in Groseclose, *Leutze*, p. 138, fig. 45), shows Whittredge at his easel in the Tenth Street Studio Building where both artists worked.

Sometime after Leutze completed the 1856 portrait, Whittredge made a bust-length copy of it (coll. James G. Coatsworth, Houston) for his patron and friend James W. Pinchot, whose summer place in Milford, Pennsylvania, he often visited. Pinchot was one of a committee of six, including the painter DANIEL HUNTINGTON, the sculptor John Q. A. Ward, and the collectors William T. Evans, Samuel P. Avery, and his son, who, in a circular, dated December 27, 1902, proposed the purchase by subscription of the 1856

Leutze, *Worthington Whittredge*.

portrait for the Metropolitan Museum. The presentation of the work, described as a portrait of Whittredge in Spanish costume, time of Velázquez, painted by Leutze at Düsseldorf, was announced in a circular dated January 15, 1903, and the following day Whittredge wrote to Samuel P. Avery, Jr., thanking him and concluded "I will take my place, all in my fine clothes, in the Museum to hang for age[s]."

Oil on canvas, $50\frac{7}{8} \times 40\frac{1}{2}$ in. (129.2 × 102.9 cm.). Signed and dated at lower left: E. Leutze, 1856.

RELATED WORK: Worthington Whittredge, *Portrait of Worthington Whittredge*, bust-length copy after Leutze's 1856 portrait, oil on cardboard, $27 \times 22\frac{1}{4}$ in. (68.6 × 56.5 cm.), coll. James G. Coatsworth, Houston, ill. in Munson-Williams-Proctor Institute, Utica, N.Y. traveling exhibition, *Worthington Whittredge (1820–1910), a Retrospective Exhibition of an American Artist*, cat. by E. H. Dwight (1969), p. 35, no. 12.

REFERENCES: H. T. Tuckerman, *Book of the Artists* (1867), p. 518 (quoted above) // W. Whittredge sketchbook, ca. 1905, Worthington Whittredge Collection, microfilm N59, Arch. Am. Art, contains a note dated Nov. 28, 1902, indicating that he was ordering a new frame for the portrait, "4 ft. 10 × 3 ft. $4\frac{1}{2}$" //

Circular, Dec. 27, 1902, MMA Archives, proposes a subscription to purchase the portrait for the museum and notes that it is on exhibition at Noé Art Galleries, New York // Circular, Jan. 15, 1903, MMA Archives, announces its presentation to the museum and provides a list of subscribers to the fund // Whittredge to S. P. Avery, Jr., Jan. 16, 1903, Wadsworth Atheneum, Hartford, Conn. (quoted above) // Century Association, New York, *Exhibition of Work by Emanuel Leutze* (1946), cat., part 2, p. 123, no. 93 // R. L. Stehle, letters in Dept. Archives, Feb. 28, 1967, and April 21, 1968, supplies evidence concerning Leutze's and Whittredge's whereabouts in 1856 when the portrait was painted; *Records of the Columbia Historical Society of Washington, D.C.* (1969–1970), p. 331; "The Life and Works of Emanuel Leutze," 1972, copy of types ms, NYHS, pp. 71–72 // B. S. Groseclose, *Emanuel Leutze, 1816–1868* (1975), exhib. cat. p. 50, fig. 31, p. 115,

no. 202, discusses painting; p. 117, no. 215, p. 118, no. 215, p. 120, no. 231, and p. 138, fig. 45, lists other Leutze portraits of Whittredge; *Antiques* 108 (Nov. 1975), pp. 987–988, fig. 4.

EXHIBITED: Great Central Sanitary Fair, Philadelphia, 1864, no. 493, as Portrait in Costume, lent by W. Whittridge [*sic*] (probably this picture) // NAD, 1868–1869, Winter Exhibition, no. 315, as W. Whittredge, N.A. in Costume // Brooklyn Art Association, 1872, *Exhibition of American Art*, no. 88A, as The Cavalier, lent by W. Whittredge // Noé Art Galleries, New York, 1902 // Century Association, New York, 1911.

ON DEPOSIT: descendents of Worthington Whittredge, 1915–1957.

EX COLL.: Worthington Whittredge, 1856–1903.

Gift of Several Gentlemen, 1903.

03.16.

UNIDENTIFIED ARTIST

The Claremont

Originally a private house before becoming a popular inn and dining spot about the middle of the nineteenth century, the Claremont stood near the Bloomingdale Road, at what is now Riverside Drive and 124th Street in New York. According to the 1917 sale catalogue of the collection of Percy R. Pyne 2d, "Tradition has it that the painting was made, about 1855, by a tramp artist, in return for hospitality." Although there is no way to confirm this, the style indicates that it is the work of a self-taught painter. Unfamiliar with the academic means of representing form, space, and distance on a two-dimensional surface, the artist has dealt with the problems of representation with the ingenuity characteristic of the untrained painter, and it is this that gives the work its originality. Exaggerating the driveway by extending it high on the canvas, he has tilted the foreground at a sharp angle in order to show the numerous horsedrawn carriages and riders in front of the building, which was located at the top of a rise. His difficulties are most apparent in the foreshortening of some of the vehicles and in delineating the fence at the lower left, which does not visually diminish in size as it recedes. The buildings introduced in the right background are the Church of St. Mary's, Man-

hattanville (erected 1826 and demolished 1907) and the Convent of the Sacred Heart (destroyed by fire in 1888), which were located northeast of the Claremont. The painted plaque showing a bewigged eighteenth-century gentleman, in the tree at the right, has never been satisfactorily explained. It may have served as a trade sign or simply as a type of garden decoration, although no precedents for it have been discovered to date. Brilliant in color and lively with action, the painting shows a refreshing directness of vision that distinguishes the work of the self-taught artist. It also serves as an excellent visual document of the Claremont in its early years as a fashionable resort.

The building had a long and interesting history. The property was acquired in 1796 from Nicholas de Peyster by George Pollock, a wealthy New York merchant. At that time a house stood near the banks of the Hudson River, but some time after 1797, when Pollock's son fell off the cliff and drowned, Pollock disposed of the property. In 1803 it was transferred to John B. Provoost, recorder of the city, and the same year it was acquired by Joseph Alston, husband of Aaron Burr's daughter Theodosia. It passed to John Pintard in 1806 and was purchased by Michael Hogan, who either moved the original house or, more likely, built a new mansion on the

Unidentified artist,
The Claremont.

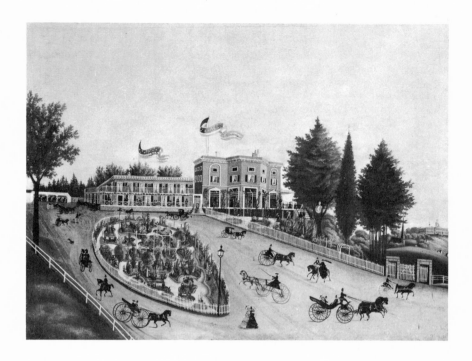

spectacular site with its panoramic view of the river. According to one tradition, Hogan named the house Claremont after the royal residence at Surrey of Prince William, duke of Clarence, afterwards King William IV, with whom he had served as a fellow midshipman in the Royal Navy. The house was at various times occupied by such distinguished tenants as Lord Viscount Courtenay, afterwards earl of Devon; Joseph Bonaparte, former king of Spain and brother of Napoleon; and Francis James Jackson, onetime British minister at Washington. In 1821 it was acquired by Joel Post, who was a wholesale drug importer, and at his death in 1835, by his sons, Edward and Dr. Alfred C. Post. It became a popular public resort in the middle of the nineteenth century. In a memoir, written in 1871 by Abram C. Dayton, *Last Days of Knickerbocker Life in New York* (1882), the author reminisces: "what old or middle-aged resident does not with pleasure recall the good cheer dispensed by Edmund Jones, first at the Second Ward Hotel, in Nassau Street between Fulton and John, and subsequently, until his death, at the celebrated Claremont, on the Bloomingdale Road." Describing the spectacular view from the Claremont, he added: "Thousands have enjoyed the enchanting scene since the house became a public resort, and was made famous as a house of entertainment many years since by the late Edmund Jones." Edmund Jones, who probably leased the house from the Post family, first appears in connection with the Claremont in the city directory of 1853–1854. In the museum's painting, the name E. JONES is inscribed on the flag over the wing of the Claremont, and the inn's name is inscribed on the other flag. A view of the building, identified as the "Residence of the Post Family—Now Claremont Hotel, Bloomingdale Road near Manhattanville, 1860," appears in Valentine's *Manual of the Corporation of the City of New York*, published in 1861 (opp. p. 248).

After the city bought the property in 1873 from Post's descendants, the building was rented to concessionaires as a restaurant, and it continued to be a fashionable rendezvous until well into this century. The building gradually fell into disrepair and, while being demolished in 1951, caught fire and burned to the ground.

Oil on canvas, $25\frac{1}{2} \times 34$ in. (64.8 × 86.4 cm.).
REFERENCES: A. C. Dayton, *Last Days of Knickerbocker Life in New York* (1882), pp. 249, 266–267, mentions Edmund Jones and the Claremont (quoted above) // J. Richards, *New York Mail and Express*, April 3, 1897, pp. 13–14, provides history of the property // C. H. Haswell, *Reminiscences of an Octogenarian of the City of New York* (1897), pp. 25, 541, discusses the subject; ill. p. 377, shows the building // C. True, comp., *Riverside Drive* [1899], unpaged, discusses the subject //

M. C. de T. Post, *The Post Family* (1905), p. 139, notes Joel Post purchased the property known as Claremont, subsequently acquired by the city from his descendants; p. 146, mentions the property // H. S. Mott, *The New York of Yesterday* (1908), pp. 25–27, 39, 40, 47–48, 317, 344–345, 417, provides history of the site and the building; p. 45, mentions Edward Jones as keeper of the Claremont // American Art Galleries, New York, *The Notable Percy R. Pyne 2d, Collection*, sale cat. (1917), no. 231, calls the painting Claremont, describes it, dates it about 1855, and gives tradition concerning the artist (quoted above) // I. N. P. Stokes, *The Iconography of Manhattan Island, 1498–1909* (1918), 3, p. 903, no. 183, lists the painting in Arnold coll.; p. 977, gives information about the subject // H. D. Eberlein, *The Manors and Historic Homes of the Hudson Valley* (1924), pp. 145–146, discusses the subject // I. N. P. Stokes, *The Iconography of Manhattan Island, 1498–1909* (1926), 5, p. 1860, describes the painting under 1855; (1928), 6, p. 345, mentions it under St. Mary's Church, Manhattanville; p. 448, mentions it under Convent of the Sacred Heart // H. C. K[err], *Colonial Days and Old Manor Houses of Riverside* [1929], pp. 2, 8–10, discusses the site and the building // *New York Times*, March 15, 1951, p. 42, reports fire that destroyed the Claremont Inn and provides history of the building; March 22, 1951, p. 37, reports second fire // M. C. Black, letter in Dept. Archives, April 2, 1968, notes similarities of execution in this painting and another painting by an unknown artist, Burnham's Hotel, Bloomingdale, N.Y., reproduced in *Old Print Shop Portfolio* 13 (Feb. 1954), p. 143, fig. 32, and now in coll. Herbert W. Hemphill, New York.

EXHIBITED: MMA, 1965, *Three Centuries of American Painting*, unnumbered cat., as The Claremont Hotel, New York // Museum of American Folk Art, New York, 1967, *The Folk Artist in the City* (no cat.) // Hudson River Museum, Yonkers, N.Y., 1970, *American Paintings from the Metropolitan Museum of Art*, no. 3, as The Claremont Hotel.

ON DEPOSIT: Museum of the City of New York, 1935–1963 // Gracie Mansion, New York, 1972 // Office of the Borough President, Borough Hall, Queens, 1972–1978.

EX COLL.: Percy R. Pyne 2d, New York (sale, American Art Galleries, New York, Feb. 6, 1917, no. 231, as Claremont, $460); with Robert Fridenberg, New York; Edward W. C. Arnold, New York, by 1918–1954.

The Edward W. C. Arnold Collection of New York Prints, Maps, and Pictures. Bequest of Edward W. C. Arnold, 1954.

54.90.169.

WILLIAM H. SCHENCK

active ca. 1854–1864

Judging from the style of the museum's painting, his only known work to date, William H. Schenck was a self-taught artist without academic training. His descriptive manner of painting, based on meticulous observation, reveals a taste for specific narrative detail that is often one of the distinguishing characteristics of the self-trained artist.

According to the inscription on his painting, Schenck was superintendent of the Third Avenue Railroad Company Depot at 65th Street in New York. He is listed in the city directories from 1856 to 1858 as superintendent living at 571 Third Avenue. In the business directories of 1857–1858 and 1860–1861, Schenck's address is given as Third Avenue, the corners of East 61st and East 65th Streets, respectively. In the city directory of 1863–1864, Schenck is listed as superintendent, and his home address is supplied as 65th Street near Third Avenue. He might also be identified as the railway agent of the same name located at 66 West 33rd Street in the city directory for 1854–1855.

BIBLIOGRAPHY: Hugh A. Dunne, letter in Dept. Archives, August 10, 1976, identifies artist and provides information on his activity as superintendent of the Third Avenue Railroad Company Depot at 65th Street.

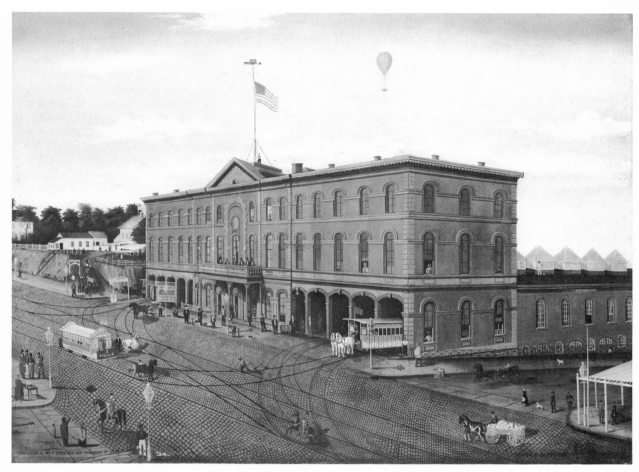

Schenck, *The Third Avenue Railroad Depot.*

The Third Avenue Railroad Depot

On July 4, 1853, the Third Avenue Railroad Company started running its horsecar line from City Hall to its depot at 61st Street, with nineteen cars in service. In 1859 the line was extended to the Harlem River, fifty cars were in service, and a new horsecar barn and depot was completed on the east side of Third Avenue between 65th and 66th streets. Valentine's *Manual of the Corporation of the City of New York* of 1859 described the building as one of the sights of the city (p. 389):

The frontage, 200 feet, is an ornamental style of architecture, known as the 'Modern Italian,' and is composed of brick and brown stone. It is three stories high, and 85 feet from the base. The main front is 50 feet deep, and contains the necessary offices adapted to the use of the company, likewise two large halls for balls, meetings, &c., with the necessary rooms for suppers, &c., on the third floor, and a suit of rooms for the Janitor's use. The top of the building commands a fine view of the suburbs of the city. The stable is arranged on the most approved principle of light, ventilation, and drainage, and is 200 by 300 feet,

containing 720 stalls. Above the stable is a large car house centrewoven with iron rails, capable of housing 100 cars; also the necessary workshops. In the centre of the building is a large feed room or granary, and planned so as to facilitate the working of the road in every department. The whole forming a sight worth seeing by the many strangers visiting the city.

Judging from a lithograph by George Hayward, which accompanies the descriptive note in Valentine's *Manual,* this painting is a very accurate representation of the building. It records the depot as it was built in 1859 and as it existed until sometime before 1869, when a lithograph of it reproduced in the *Manual of the Corporation of the City of New York* shows that it had undergone substantial alterations. The depot was torn down in 1947. On the basis of the dedicatory inscription to William A. Darling, president of the railroad, it can be further ascertained that the painting was done before 1866, when Robert Squires succeeded Darling to the presidency. Most likely the painting was executed between 1859 and 1860, shortly after the completion of

the building. The canvas stamp, visible on the back before lining, lends support to the early dating of the painting. The paint shop of M. Toch and Brothers (consisting of Bernard, Leopold, and Moses Toch) was located at 33 Bowery from 1856 until late 1861, when the firm moved to 35 Bowery. The canvas stamp alone does not provide conclusive evidence for dating the painting because old stock may well have been transferred to the new location of the store, but the signs, shown in the painting and discussed below, supply additional information confirming the date.

For some time the artist has been erroneously identified as J. H. Schenck. Part of the first initial of his name is missing in a small area of paint loss (indicated by brackets in transcribing the inscription). The artist clearly identified himself as the superintendent in inscribing the work, and a search of city and business directories reveals that William H. Schenck was superintendent of the railroad until at least 1864, when his name disappears from the directories. Removal of inpainting in the area of paint loss has revealed traces of original paint used in forming the lower part of the letter *W*.

With a keen eye for detail, Schenck showed the building as the focal point of the bustling activity in the area. A group of men, probably the president and officials of the line, survey the scene from the balcony. The depot is clearly identified on the portico and the flag. A sign on the awning at the lower right identifies "CONRAD'S DINING SALOON." In the city directories of 1858–1860, Ernst or Ernest Conrades' eatinghouse and liquors is located at Third Avenue and the corner of East 65th Street; from 1863 to 1867, it was at Third Avenue and the corner of East 66th Street. In the distance, at the left, are signs for "J LANDMANN.S/ HAMILTON PARK" and "I. SOMMERS./ Jones's Wood. A balloon inscribed "ATLANTIC / J article on Jones's Wood in Valentine's *Manual of the City of New York* (1917–1918), Isaac Sommers acquired the Jones's Wood Hotel at the foot of East 71st Street on February 24, 1860. It is listed as Isaac Sommers' hotel at the foot of East 70th Street in the city directory of 1860–1861. The streetcars carry signs announcing the big event of the day, a balloon ascension at Jones's Wood. A balloon inscribed "ATLANTIC / J WISE" is seen aloft to the right of the elaborate weathervane that surmounts the flagpole. In preparation for the inauguration of a trans-Atlantic balloon company, the balloonist John Wise (1808–1879) set off for New York in a

balloon called the *Atlantic* from St. Louis. Ascending on July 1, 1859, the *Atlantic* was caught in a storm and made a forced landing in Henderson, New York, on July 2. Wise described the journey in his book *Through the Air: A Narrative of Forty Years' Experience as a Aëronaut* (1873), but made no mention of launchings of the *Atlantic* from Jones's Wood. Moreover, according to Wise, the balloon was wrecked in 1859, so its appearance in this painting seems to be an exercise of artistic license.

Alive with incident, Schenck's painting vividly demonstrates the self-taught artist's reluctance to dispense with detail. This affinity for extensive description is one of the distinctive features of the folk art idiom.

Oil on canvas, 36 × 50 in. (91.4 × 127 cm.).

Signed and inscribed at lower right: 3RD AV. R.R. DEPOT' PAINTE[D BY Wm] H. SCHENCK, SUPT. Inscribed at lower left: DEDICATED TO WM A. DARLING ESQ PRESIDENT OF 3RD AV. R.R. Cº.

Canvas stamp before lining: FROM / M. TOCH & BROS. / 33 BOWERY / N.Y. / Importers of / PAINTS OILS GLASS & WHOLESALE DEALERS.

REFERENCES: E. T. Delaney, *New York's Turtle Bay Old & New* (1965), ill. p. 22; p. 23, notes erroneously that it shows the depot in 1873 before remodeling // M. Black and J. Lipman, *American Folk Painting* (1966), p. 104, mention it as by J. H. Schenck; p. 141, fig. 126 // H. A. Dunne, letter in Dept. Archives, August 10, 1976, identifies artist and provides information on his activity as superintendent of the Third Avenue Railroad Company Depot on 65th Street.

EXHIBITED: MMA, 1965, *Three Centuries of American Painting*, unnumbered cat., lists as by J. H. Schenck // Los Angeles County Museum of Art, and M. H. de Young Memorial Museum, San Francisco, 1966, *American Paintings from the Metropolitan Museum of Art*, no. 87, lists as by J. H. Schenck // Museum of American Folk Art, New York, 1967, *The Folk Artist in the City* (no cat.); 1967–1968, *Domestic Manners of the Americans* (no cat.) // M. Knoedler and Company, New York, 1971, *What Is American in American Art* (an exhibition in memory of Joseph B. Martinson for the benefit of the Museum of American Folk Art), cat. by M. Black, no. 67, lists as by H. Schenck and dates ca. 1860.

ON DEPOSIT: Museum of the City of New York, 1940–1963; President of the Council, City Hall, New York, 1975–1976.

Ex COLL.: Edward W. C. Arnold, by 1940–1954.

The Edward W. C. Arnold Collection of New York Prints, Maps, and Pictures. Bequest of Edward W. C. Arnold, 1954.

54.90.178.

JOHN F. KENSETT

1816–1872

Called "the Bryant of our painters" by the art critic James Jackson Jarves in 1864 (*The Art-Idea*, ed. B. Rowland, Jr. [1960], p. 192), Kensett was one of the leading figures of the second generation of Hudson River school painters. The clarity of his tranquil images and his pre-occupation with effects of light and atmosphere ally him to the painters later known as the American "luminists." His best work is characterized by a successful synthesis of descriptive detail, which is translated into a rich surface of paint texture, and a spare composition, stripped of embellishments.

Kensett was born in Cheshire, Connecticut, the second son of the English engraver Thomas Kensett, who immigrated to America from his family home at Hampton Court near London, and Elizabeth Daggett, granddaughter of Yale College president Naphthali Daggett. Shortly after his marriage in 1813, Thomas Kensett joined his brother-in-law Alfred Daggett in his New Haven engraving and publishing firm. John Kensett received his early training in drawing and engraving in the family firm. During the late 1820s, Kensett is believed to have worked in the New York shop of Peter Maverick, and in 1829, when his father died, he returned to New Haven, where he found employment in his uncle's new firm, Daggett & Ely, later Daggett & Hinman. In following years, Kensett worked as an engraver in New Haven and New York, and, from 1837 to 1840, in the Albany firm of Hall, Packard, Cushman & Company. Painting provided an escape from the drudgery of engraving, and in 1838 he exhibited a landscape at the National Academy of Design. In June 1840, he sailed to Europe in the company of the artists ASHER B. DURAND, JOHN CASILEAR, and THOMAS ROSSITER. He kept a detailed journal of his first year abroad (FARL) and remained in Europe until 1847, traveling in England, France, Germany, Switzerland, and Italy. Although he supported himself as an engraver during his travels, he wrote to his English uncle in 1842 of his "strong desire to devote myself exclusively to the art of painting, especially in the department of landscape" (letter to J. R. Kensett, Nov. 3, 1842, Edwin D. Morgan Collection, New York State Library, Albany). He spent the summer of 1840 with relatives at Hampton Court and visited the London collections before joining a group of American artists residing in Paris, where he first shared rooms with Rossiter and subsequently with Benjamin Champney (1817–1907). In Paris, Kensett pursued a rigorous schedule of work and study; he engraved banknote vignettes and other items for various American firms, drew from life and the antique at the Ecole Préparatoire des Beaux-Arts, and copied paintings in the Louvre, including several by Claude Lorrain. In 1843 the death of his grandmother and the settling of her estate sent Kensett to England for two years. He made careful studies of English landscape paintings, especially those of Henry John Boddington, and explored the countryside. "My real life commenced there," he later wrote to the art historian, Henry T. Tuckerman (*Book of the Artists* [1867], p. 510), "in the study of the stately woods of Windsor, and the famous beeches of Burnham, and the lovely and fascinating landscape that surrounds them." His English paintings, characterized by a dark palette of brown and green, are broadly painted with thick impasto and

display a freedom of execution in direct contrast to the control and discipline demanded by engraving. Several of his paintings were exhibited at the British Institution and the Royal Academy of Arts in 1845.

Kensett rejoined Champney in Paris in 1845, and in August they set out for Italy by way of Germany and Switzerland. In October Kensett settled in Rome, where he shared a studio with THOMAS HICKS. His Italian work, distinguished by a lighter, more luminous palette and more firmly controlled compositions, anticipated the development of his distinctive mature painting style, which remained remarkably consistent. During the next two years, Kensett sketched in Rome, Naples, Venice, and other Italian cities, relying increasingly for his income on various commissions and sales of paintings to the American Art-Union in New York. These sales helped establish his reputation in America, and in 1848, the year following his return to New York, he was elected an associate of the National Academy of Design, where he exhibited regularly for the rest of his life. In 1849 he was made an academician and became a member of the Century Association, whose Sketch Club he was invited to join the following year.

A very prolific artist, Kensett traveled widely during the summers making oil and pencil sketches, later used as models for larger works that he painted on commission during the winters in his New York studio. He made numerous trips to the Berkshires, the Catskills, the Adirondacks, the Green and the White mountains, the New England coast, especially Newport; several trips to the western United States (1851, 1854, 1857, 1868, and 1870) and to Europe (1856, 1861, possibly 1865, and 1867).

Although unassuming and retiring by nature, Kensett was an influential and powerful figure in the New York art world. In 1859 President Buchanan appointed him one of three art commissioners to serve as advisers for the decoration program of the Capitol, a project interrupted by the Civil War. In 1864 Kensett was chairman of the art committee of the Metropolitan Fair, which raised funds for the United States Sanitary Commission. He served on various committees of the National Academy of Design and was one of the prime fundraisers for the new academy building, which opened in 1865. A founder and president of the Artist's Fund Society, he was also one of the founders of the Metropolitan Museum, where he served as a trustee from 1870 until his death. After his death the contents of his studio were sold at auction, bringing more than $136,000 for 650 of his paintings and 45 pictures by other artists.

A portrait of Kensett, painted by GEORGE AUGUSTUS BAKER, JR., in 1875, is in the museum's collection.

BIBLIOGRAPHY: John F. Kensett Papers, James R. Kellogg Collection, microfilm N68/84–N68/85 Arch. Am. Art. Contains about 300 items, including correspondence, diary extracts, an account book, photographs, and clippings, 1840–1872 // Edwin D. Morgan Collection, New York State Library, Albany. Includes over 600 items consisting of correspondence and notes // National Academy of Design and Robert Somerville, Auctioneer, Association Hall, Y.M.C.A., New York, *The Collection of Over Five Hundred Paintings and Studies by the Late John F. Kensett* (March 24–29, 1873), exhib. and sale cat. Catalogue of the artist's estate consisting of his works and art collection. A bound volume of photographs shows the installation at the NAD and documents the exhibition (editions of this volume are in MMA Library, NYHS, and FARL) // Ellen·H. Johnson, "Kensett Revisited," *Art*

Quarterly 20 (Spring 1957), pp. 71–92 // American Federation of Arts, *John Frederick Kensett, 1816–1872* (1968), exhib. cat. by John K. Howat.

Hudson River Scene

This view is taken from the heights above the West Point parade ground looking north up the Hudson River. At the extreme right is a corner of Fort Putnam, built in 1778. At the left, Crowsnest Mountain rises above the Washington Valley. Across the river at the left is Breakneck Mountain, and in the center Mount Taurus (Bull Hill) rises above the village of Cold Spring. This picturesque region of the river was a favorite sketching ground of the Hudson River school artists. Kensett visited the area on numerous occasions and made it the subject of several paintings. In a letter to his uncle John R. Kensett, dated March 30, 1854, the artist described his visit to the area during the summer of 1853, noting that he spent "ten or twelve days at West Point in the midst of the beautiful highlands of the Hudson, which I think for their peculiar kind of beauty there is nothing to surpass" (James R. Kellogg Collection, microfilm N68/84, Arch. Am. Art).

Although mentioned by Tuckerman as "Hudson River, from Fort Putnam," this is probably the painting "Hudson River Scene" recorded by Kensett in his account book as sold to Sheperd Gandy in 1857 for five hundred dollars. Since 1968, the painting has been called "View of Storm King from Fort Putnam," although Crowsnest Mountain obscures the view of Storm King. The title of the work has now been changed to what was probably the original title assigned it by the artist.

Composed of strong diagonal elements that serve as a framing device for the open vista of the river, the painting shows Kensett's characteristic affinity for simulating graphic detail, primarily confined in this instance to the foreground. Areas of sunlight give a warm cast to his distinctive palette of cool grays, greens, and browns.

Oil on canvas, 32 × 48 in. (81.3 × 121.9 cm.).
Signed and dated at lower right: J F. (monogram) K 57.

REFERENCES: J. F. Kensett, account book, 1848–1872, James R. Kellogg Collection, microfilm N68/84, · Arch. Am. Art, entry for 1857, as Hudson River Scene, sold to S. Gandy for $500 // H. T. Tuckerman, *Book of the Artists* (1867), p. 511, lists this painting, as "Hudson River, from Fort Putnam," among Kensett's important productions // B. B[urroughs], *MMA Bull.*, suppl. to 12 (1917), p. 7, calls it Landscape and describes it as "a scene on the Hudson River, north of West Point, looking toward Storm King" // C. E. Sears, *Highlights among the Hudson River Artists* (1947), p. 125, mentions it as Hudson River from Fort Putnam // J. K. Howat, *The Hudson River and Its Painters* (1972), notes to the plates by J. K. Howat and S. Feldman, pl. 38; p. 152, as View of Storm King from Fort Putnam, suggest this work may be the result of studies made during a summer's tour of West Point and upstate New York in 1853 // J. K. Howat, *MMA Bull.* 30 (June/July 1972), p. 276.

EXHIBITED: MMA, May 1875, *Loan Exhibition of Paintings and Statuary*, no. 50, as Hudson River, lent by S. D. Babcock; 1917, *Paintings of the Hudson River School Brought Together in Commemoration of the Completion of the Catskill Aqueduct* (no cat.) // Hudson River Museum, Yonkers, N.Y., 1954, *The Hudson River School, 1815–*

Kensett, *Hudson River Scene.*

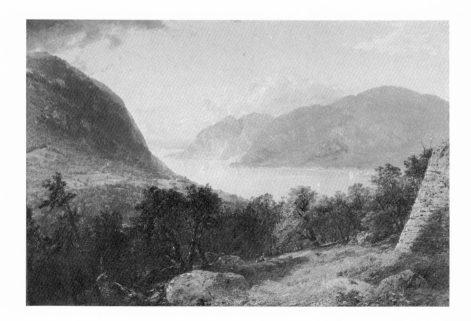

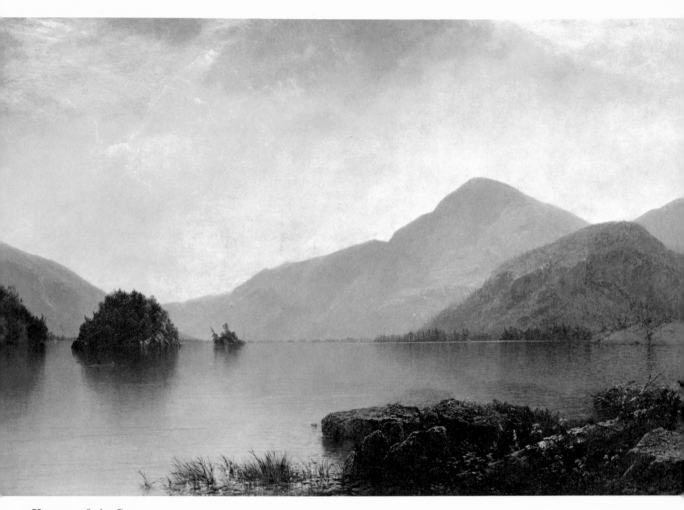

Kensett, *Lake George*.

1865, no. 4, as Hudson River View // American Federation of Arts, traveling exhibition, 1968–1969, *John Frederick Kensett, 1816–1872*, exhib. cat. by J. K. Howat, no. 26, as View of Storm King from Fort Putnam, supplies provenance // Hudson River Museum, Yonkers, N.Y., 1970, *American Paintings from the Metropolitan Museum*, no. 27 // High Museum of Art, Atlanta, 1971, *The Beckoning Land, Nature and the American Artist*, no. 25 // Museum of Fine Arts, Houston, 1972, *Nature and Focus*, exhib. cat. by [E. A. Carmean, Jr.], p. 10; p. 11, fig. 1; p. 19, no. 4 // Hudson River Museum, Yonkers, N.Y., 1977, *Time, Man and the River* (no cat.).

Ex COLL.: Sheperd Gandy, 1857–1875 (sale, Somerville Art Gallery, New York, March 25, 1875, no. 132, as Hudson River, from Fort Putnam, $1600); Samuel D. Babcock, 1875–1902; his son, H. D. Babcock, 1902–1907.

Gift of H. D. Babcock, in Memory of S. D. Babcock, 1907.

07.162.

Lake George

Lake George in the Adirondacks was a favorite site of the Hudson River school artists throughout the nineteenth century as well as a popular summer resort. In a letter to his uncle, dated March 30, 1854, Kensett described his visit there during the summer of 1853:

After ten or twelve days spent at West Point ... I directed my course towards that sheet of water which has a name par exellance among our American inland seas—Lake George. . . . I selected a little unobtrusive spot called Bolton where was a quiet inn upon the lake ... where green hills swept boldly down to the waters edge. Twenty or thirty islands of varying size lay around apparently guarding its entrance. It was among these islands with a light boat fortified with my basket of provisions & my painting materials that I spent the greater part of the day . . . I had some of the most delightful and unobtrusive hours of summer. Nevertheless one grows weary even of such enjoyment, for after a month it became a loneliness & having filled a moderate sized folio of pencil & oil sketches & studies, I packed (J. F. Kensett to J. R. Kensett, March 30, 1854, James R. Kellogg Collection, microfilm N68/84, Arch. Am. Art).

Kensett returned to the area on numerous occasions and made many studies of Lake George. This singularly memorable painting of 1869 is Kensett's most accomplished treatment of the subject, as well as a major example of his mature style. He has taken considerable liberties with the topography in composing the work, but certain distinctive features have been identified by Peter L. Fisher of the Glens Falls Historical Association. Kensett's vantage point was probably from Crown Island off Bolton Landing on the west shore looking across the lake northeast toward the Narrows. The distance has been substantially reduced in the representation, some of the islands have been omitted and others relegated to the shore. The mountains in the background, from right to left, are Sleeping Beauty, Shelving Rock, Erebus, Black, and Elephant. Rising from the shore at the extreme left is the Tongue Mountain range. Montcalm Point is at the left, and, from left to right are Flora or Oahu Island, and Ship Island (14 Mile Island, Hen, and Chicken Islands are omitted). Huckleberry Island can be seen to the right and below Shelving Rock Mountain.

Working on a relatively large scale, Kensett achieves a successful synthesis of descriptive detail and economy of composition. Close inspection reveals his technique of approximating detail in the finishing of foreground rocks, plants, and mosses by a dense concentration of small brushstrokes. In his attention to minute aspects in nature, however, larger forms are not submerged, and his meticulous detailing functions effectively in the context of the spare composition. A monumental work of eloquent lyricism, *Lake George* exemplifies Kensett's preoccupation with the fugitive effects of color, light, and atmosphere. Using a palette restricted in color and low in key, he explores the nuances of subtle tonal modulations. Sharply contrasting values are avoided and darker tones reserved to define the composition.

The introduction of small figures provides a picturesque feature unusual in his late work and recalls the romantic effects sought by other Hudson River school artists, but it is an inconspicuous and minor touch. Avoiding the picturesque devices and grandiose melodramatic effects of color and composition favored by many of his contemporaries, Kensett's mode of romanticism is more subtle, depending for its effect on understatement—a restricted palette, calculated precision in the use of value contrasts, and a composition stripped to its most expressive essentials.

There are various pentimenti in the picture, where the artist made changes. For example, he eliminated part of the rocky shoreline in the foreground and also a small tree on the right side of Ship Island, the small island left of center. During conservation in 1979, some of these pentimenti were made less obtrusive. Examination showed that the area of water on the far right is abraded, and as a result the reddish-brown

ground is visible. This gives a warm cast to an area originally intended to be cooler in tone.

Oil on canvas, $44\frac{1}{8} \times 66\frac{3}{8}$ in. (112.1×168.6 cm.). Signed and dated at lower right: J F (monogram) K. 1869.

RELATED WORK: *Lake George*, oil on canvas, possible study for this painting, unlocated, ill. in bound volume of photographs for 1873 NAD Kensett exhibition, pl. 5, MMA Library.

REFERENCES: J. F. Kensett, account book, 1848–1872, James R. Kellogg Collection, microfilm N68/84, Arch. Am. Art, entry for 1869, as "Lake George—Jesup. 3000.00" // *New York Evening Post*, April 27, 1869, p. 1, in a review of NAD exhibition, describes a painting of Lake George (possibly this work), noting: "Kensett is represented by one of the noblest pictures in the gallery—a view of Lake George, showing the broadest expanse of that fine sheet of water, with its encircling mountains. The view is apparently taken from one of the islands. The atmosphere is pervaded by a delightful summer softness, and the entire painting is one which always draws an admiring crowd about it" // E. Strahan [E. Shinn], ed., *The Art Treasures of America* (1880), 3, p. 102, lists it in coll. Morris K. Jesup // C. E. Clement and L. Hutton, *Artists of the Nineteenth Century and Their Works* (1880), 2, p. 21 // F. A. Walker, ed., *United States Centennial Commission, International Exhibition, 1876, Reports and Awards* (1880), 7, report on group 27, plastic and graphic art, by J. F. Weir, p. 631 // B. B[urroughs], *MMA Bull.* 10 (April 1915), pp. 66–67; ill. p. 69; suppl. to 12 (1917), ill. p. 7, discusses // B. Cowdrey, *Old Print Shop Portfolio* 4 (Feb. 1945), p. 135; fig. 10, illustrates page from Kensett's account book record for 1869, listing this painting as "Lake George—Jesup. 3000.00" // E. H. Johnson, *Art Quarterly* 20 (Spring 1957), pp. 81, 82, 85–86, discusses the picture and cites Kensett's account book recording its sale; p. 90, fig. 6 // J. Howat, *Antiques* 46 (Sept. 1969), p. 400 // B. Novak, *Art in America* 59 (March–April 1971), pp. 71, 73 // *MMA Bull.* 33 (Winter 1975–1976), no. 52 // P. L. Fisher, letters in Dept. Archives, July 5, 19, 1977, identifies the view.

EXHIBITED: Brooklyn Art Association, Spring 1869, no. 289, as Lake George (possibly this picture) // NAD, 1869, no. 130, as Lake George (possibly this picture) // MMA and NAD, 1876, *Centennial Loan Exhibition of Paintings*, no. 189 // MMA, 1917, *Paintings of the Hudson River School Brought Together in Commemoration of the Completion of the Catskill Aqueduct* (no cat.) // Dallas Museum of Fine Arts, 1922, *American Art from the Days of the Colonists until Now*, no. 16 // Centennial Art Gallery, Centennial Exposition, Utah State Fair Grounds, Salt Lake City, 1947, *One Hundred Years of American Painting*, cat. by American Federation of Arts, Washington, D.C., no. 6 // MMA, 1965, *Three Centuries of American Painting*, unnumbered cat. // American Federation of Arts, traveling exhibition, 1968–1969, *John Frederick Kensett, 1816–1872*, cat. by J. K. Howat, no. 40, exhibited only at the Whitney Museum, New York // MMA, 1970, *19th-Century America, Paintings and Sculpture*, exhib. cat. by J. K. Howat and N. Spassky, no. 124 // National Gallery, Washington, D.C.; City Art Museum of St. Louis; Seattle Art Museum, 1970–1971, *Great American Paintings from the Boston and Metropolitan Museums*, exhib. cat. by T. N. Maytham, no. 38 // Pushkin Museum, Moscow, and Hermitage, Leningrad, 1975, *100 kartin iz muzeya Metropoliten, Soedinennie Shtati Ameriki* [*100 Paintings from the Metropolitan Museum, United States of America*], no. 89, pp. 244–245, catalogues this picture // MMA, 1976, *A Bicentennial Treasury* (see *MMA Bull.* 33 above).

EX COLL.: Morris K. Jesup, 1869–1908; his wife, Maria DeWitt Jesup, 1908–1915.

Bequest of Maria DeWitt Jesup, 1915.
15.30.61.

Summer Day on Conesus Lake

The leisurely pleasures of a sunny day on the shore are the subject of this canvas. A towering tree, left of center, provides a strong vertical element in a composition designed in the horizontal format that Kensett favored. Using the austere palette that distinguishes his mature painting style, Kensett effectively suggests the elusive shimmering qualities of air and light on a hazy summer day by minute adjustments of tone and local color.

Painted in 1870, two years before the artist's death, this work was known as *River Scene* when it entered the museum's collection in 1925 as part of the bequest of Collis P. Huntington. Since it does not appear among over five hundred works by Kensett exhibited at the National Academy of Design in 1873 (bound volume of photographs, MMA Library) or among the paintings in Huntington's collection in 1880 (E. Strahan [E. Shinn], ed., *The Art Treasures of America* [1880], 3, p. 42), it was in all likelihood a painting sold by Kensett before 1872 and acquired by Huntington after 1880. Of the paintings sold by the artist in 1870 and 1871, according to his account book, the most likely candidate is *Summer Day on Conesus Lake*, sold in 1870 to the New York collector Benjamin Nathan. Included in the 1880 sale of the late Mrs. Benjamin Nathan's collection as *Lake Conesus, N.Y.*, measuring 36×24, it was, according to the *New York Times*, the object of "very spirited competition between two well-known collectors" before it was acquired by Mrs. Arabella Duval (Yarrington) Worsham. In 1884, Mrs. Worsham was married to Collis P. Huntington, who subse-

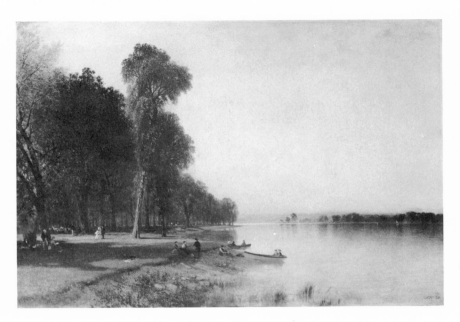

Kensett, *Summer Day on Conesus Lake*.

quently adopted her son Archer. Her husband died in 1900 and in 1913 she was married to his nephew Henry E. Huntington.

Although there are no distinctive topographical features to identify the view, the record of ownership given above tends to support the identification of this painting, long known as *River Scene*, with *Summer Day on Conesus Lake*. Kensett visited Lake Conesus near the Genesee River on many occasions. His close friend and patron Robert M. Olyphant had a home there, and the lake, the river, and the surrounding area were the subject of several of the artist's paintings.

Oil on canvas, 24⅛ × 36⅜ in. (61.3 × 92.4 cm.).

Signed and dated at lower right: JF. (monogram) K. '70. Canvas stamp: GOUPIL'S / 772 / BROADWAY, N.Y.

REFERENCES: J. F. Kensett, account book, 1848–1872, James R. Kellogg Collection, microfilm N68/84, Arch. Am. Art., entry for 1870, notes Summer Day on Conesus Lake, sold to Nathan for $1,500 (probably this painting) // Leavitt Art Galleries, New York, *Executor's Sale of Valuable Paintings, Belonging to the Estate of the Late Mrs. Benjamin Nathan, and Others*, sale cat. (Feb. 10, 1880), no. 62, as Lake Conesus, N.Y., 36 × 24, according to annotated copy in MMA Library sold to Mrs. Worsham (probably this painting) // *New York Times*, Feb. 11, 1880, p. 5, discusses sale of the Nathan collection (quoted above), says that "a fine Kensett, knocked down once at $550, was recalled and sold for $660" // B. Burroughs, *MMA Bull.* 29 (June 1925), p. 143, notes acquisition of painting and describes it as "a racy landscape" // E. P. Richardson, *American Romantic Painting* (1944), p. 89, no. 151, lists it; pl. 151; *Magazine of Art* 39 (Nov. 1946), p. 287; *Painting in America* (1956; 1965), p. 222; ill. p. 238, fig. 99.

EXHIBITED: MMA, 1934, *Landscape Paintings*, no. 70; 1939, *Life in America*, no. 214 // Society of the Four Arts, Palm Beach, Fla., 1950, *From Plymouth Rock to the Armory*, no. 29 // Wildenstein, New York, 1957, *The American Vision, Paintings of Three Centuries* (for the benefit of the American Federation of Arts), no. 14 // MMA, 1965, *Three Centuries of American Painting*, unnumbered cat. // Lowe Art Museum, University of Miami, 1974–1975, *19th Century American Topographic Painters*, as River Scene (in all of the above), no. 87.

ON DEPOSIT: Gracie Mansion, New York, 1971–1974.

EX COLL.: Benjamin Nathan, New York, 1870–1873; his wife, Mrs. Benjamin Nathan, New York (sale, Leavitt Art Galleries, New York, Feb. 10, 1880, no. 62, as Lake Conesus, N.Y., 36 × 24, to Mrs. Worsham, $660); Mrs. Arabella Duval (Yarrington) Worsham, New York, 1880–1884; Collis P. Huntington, 1884–1900; his wife (the former Mrs. Worsham, later Mrs. Henry E. Huntington), subject to a life interest in the donor's widow, 1900–1924; her son, Archer M. Huntington, subject to a life interest in the donor's son, which was relinquished, 1924–1925.

Bequest of Collis P. Huntington, 1900.

25.110.5.

The Last Summer's Work

Kensett owned nine acres on Contentment Island, Darien, Connecticut, three islands called the Fish Islands, five others called the Crabb Islands, and adjacent meadow and marsh land. He spent the summer and fall of 1872 painting on Contentment Island. Early in November, the wife of his close friend, the artist Vincent Colyer (1825–1888), who owned most of the rest of the

Kensett, *Sunset on the Sea*.

island, drowned in Long Island Sound in a tragic accident, when her horse stepped off a roadway covered by an unusually high tide. As a result of his attempts to rescue her, Kensett contracted pneumonia and some five weeks later, on December 14, died in his New York studio of heart failure.

In 1874, Thomas Kensett, the brother of the artist, presented the Metropolitan with thirty-eight paintings (several unfinished) by the artist dating chiefly from the summer of 1872 and known collectively as *The Last Summer's Work*. Found in Kensett's studio after his death, they were exhibited with the artist's private collection at the National Academy of Design in the spring of 1873 during the large auction sale of his work. The following year, the Metropolitan issued a catalogue of these pictures, which were on exhibition for a number of years. Several have since been sold or exchanged for other works, and nineteen remain in the collection today.

At a special meeting of the Century Association held in memory of the artist in December 1872, the Reverend Dr. Samuel Osgood described this group of pictures:

This is certainly a memorable result of a summer's work, and this legacy of the artist is a worthy memorial of the man. These pictures treat very familiar sub-

Kensett, *Twilight in the Cedars at Darien, Connecticut.*

jects, scenes very near to his own door, and he handles them with great simplicity, and without any flights of fancy or straining after dramatic effects. Here are God's common and abounding gifts—the water, the rocks, the trees, the light, the sky—all rendered with severe truthfulness, yet with exquisite beauty, and delicate and profound expression. (*Proceedings at a Meeting of the Century Association, Held in Memory of John F. Kensett, December, 1872* [1872], p. 21).

The majority of paintings in the group represent subjects drawn from the area around Darien, Connecticut, but several studies of Newport and Lake George are included. Various times of day and different weather conditions are represented. Dazzling examples of Kensett's mastery of atmospheric effects include *Twilight on the Sound, Darien, Connecticut*; *Passing Off of the Storm*; and *Salt Meadow in October*. The paintings demonstrate Kensett's technical diversity, ranging from works with a smooth finish to those with a richly textured surface in which free brushwork predominates, and from works thinly painted to reveal the canvas ground to others in which the paint is so thickly applied that it projects from the canvas. A similar diversity is shown in composition, varying from works conceived with a sparse economy and reduced to essentials to more complex and elaborate schemes.

The paintings are in various stages of completion. Some, such as *Sunset on the Sea*, *Newport Rocks*, and *A Foggy Sky*, are quite unfinished. Others, including *Eaton's Neck, Long Island*; *The Old Pine, Darien, Connecticut*; and *Gathering Storm on Long Island Sound*, have been brought almost to completion. Such studies interrupted in process provide an invaluable insight into Kensett's working methods, and in their unfinished state, with their abstract qualities more pronounced, they have a special appeal to the modern viewer.

Sunset on the Sea

"Perhaps his most remarkable picture in this series," the Reverend Dr. Samuel Osgood remarked of *The Last Summer's Work*, "is that which presents the sea under the sunlight, with nothing else to divide the interest—no land or sail, no figure, and not even a noticeable cloud to give peculiar effect, or a rock to provoke the dash of waves. It is pure light and water, a bridal of the sea and sky." Of all of the thirty-eight paintings, this unfinished work best fits Osgood's description.

Oil on canvas, 28 × 41⅛ in. (71.1 × 104.5 cm.).

Kensett, *Newport Rocks.*

REFERENCE: Century Association, New York, *Proceedings at a Meeting of the Century Association Held in Memory of John F. Kensett, December, 1872* [1872], p. 23, includes Osgood's observations (quoted above).

EXHIBITED: NAD, 1873, *On Exhibition Only, Mr. Kensett's Last Summer's Work, and His Private Collection of Pictures by Cotemporaneous Artists,* no. 719, as Sunset on the Sea // MMA, 1874, *Descriptive Catalogue of the Thirty-eight Paintings, "The Last Summer's Work," of the Late John F. Kensett, Presented by Mr. Thomas Kensett of Baltimore, Maryland . . .,* no. 36.

74.3.

Twilight in the Cedars at Darien, Connecticut

A dense, dark thicket of cedars serves as an almost impenetrable screen in this evening landscape. Unexpected glimpses of a vivid sunset are recorded in heavily applied touches of brilliant orange paint at the horizon, and spiky leaves make a lacy silhouette against a deep blue-green sky. Consisting of four horizontal zones of alternating light and dark, accentuated by the irregularly placed verticals of the tree trunks, the painting is simple in construction and romantic in mood, light, and color.

Oil on canvas, $28\frac{1}{2} \times 41$ in. (72.4 × 104.1 cm.).

EXHIBITED: NAD, 1873, *On Exhibition Only, Mr. Kensett's Last Summer's Work . . .,* no. 775, as Twilight in the Cedars at Darien, Conn. // MMA, 1874, *Descriptive Catalogue of . . . "The Last Summer's Work" . . .,* no. 15 // Darien Historical Society, Darien, Conn., 1972, *John Frederick Kensett, 1816–1872, Centennial Exhibition in Commemoration of The Last Summer's Work, Contentment Island, Darien, Connecticut,* ill. no. 19, discusses it.

74.4.

Newport Rocks

Closely related in structure to *A Foggy Sky* (q.v.), *Newport Rocks* exemplifies a compositional formula favored by the artist. Striking in simplicity, it consists of a broad expanse of sky and

water, divided here by a narrow strip of distant shore, with a rising bluff introduced at one side to create an asymmetrical composition.

Judging by this unfinished example, which reveals something of the artist's working methods, Kensett first defined the large basic components of the composition. With fine brushstrokes he applied paint of such thin consistency as to be transparent. At this stage, areas of light and shadow in the land mass are differentiated, and such details as clouds, water ripples, reflections, foliage, and rocks are introduced with a fine, heavily loaded brush, giving texture to the surface.

Oil on canvas, 31 × 48 in. (78.7 × 121.9 cm.).
REFERENCE: U.S. Embassy, Moscow, *Amerikanskaya zhivopis, 1830–1970* [*American Painting, 1830–1970*] (1974), p. 9, no. 6, lists it; color ill. p. 15.
EXHIBITED: NAD, 1873, *On Exhibition Only, Mr. Kensett's Last Summer's Work* . . ., no. 801, as Newport Rocks, unfinished // MMA, 1874, *Descriptive Catalogue of* . . . " *The Last Summer's Work* " . . . , no. 19 // Art Association of Newport, R.I., 1936, *Tercentenary Retrospective Exhibition* (no cat.) // Wingate College, Wingate, N.C., 1968 (no cat.) // Katonah Gallery, Katonah, N.Y., 1972, *Luminism in Mid-Nineteenth Century American Painting*, no. 8.
ON DEPOSIT: U.S. Mission to the U.N., New York, 1965–1968, 1968–1971 // U.S. ambassador's residence, Spaso House, Moscow, 1974–1979.
74.6.

Lake George, New York

In this study of Lake George, Kensett is preoccupied with effects of light, air, and atmosphere. Emerging from a background, deliberately insubstantial and vague in definition, with only a suggestion of the towering mountain range around the lake, the land mass in the right foreground and the islands in the middle ground at the left are given form and definition by means of a heightened intensity of color value and an increased accumulation of brushstrokes. Although, in this work, Kensett leaves the images amorphous, never achieving complete clarity of focus in the foreground elements, there is a gradual development toward definition in the objects nearer to the picture plane. The work is a prime example of Kensett's use of atmospheric perspective—one in which light and atmosphere are given a tangible quality almost equal to that of the islands, mountains, and trees.

Oil on canvas, 22½ × 36½ in. (57.2 × 92.7 cm.).
EXHIBITED: NAD, New York, 1873, *On Exhibition Only, Mr. Kensett's Last Summer's Work* . . ., no. 704, as Lake George, N.Y. // MMA, 1874, *Descriptive Catalogue of* . . . " *The Last Summer's Work* " . . . , no. 14 // Hudson River Museum, Yonkers, N.Y., 1954, *The Hudson River School, 1815–1865*, no. 26 // Hathorn Gallery, Skidmore College, Saratoga Springs, N.Y., 1967, *John Frederick Kensett, a Retrospective Exhibition*, cat. by J. Kettlewell et al., p. 11; p. 25, no. 26d; p. 26.
ON DEPOSIT: Federal Reserve Bank of New York, 1972–present.
74.7.

A Foggy Sky

Similar in composition to *Newport Rocks* (q.v.), *A Foggy Sky* is a painting of great visual power. The economy of composition that distinguishes Kensett's most effective works is apparent in this spare image of ocean, sky, and cliff. Using heavy impasto, the artist delineates the outcroppings

Kensett,
Lake George, New York.

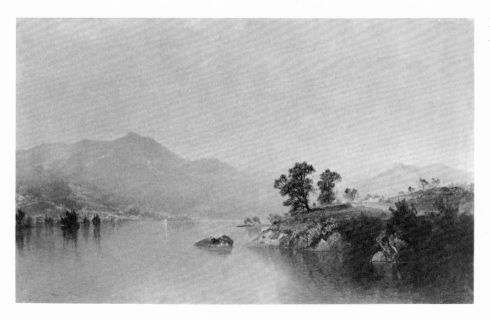

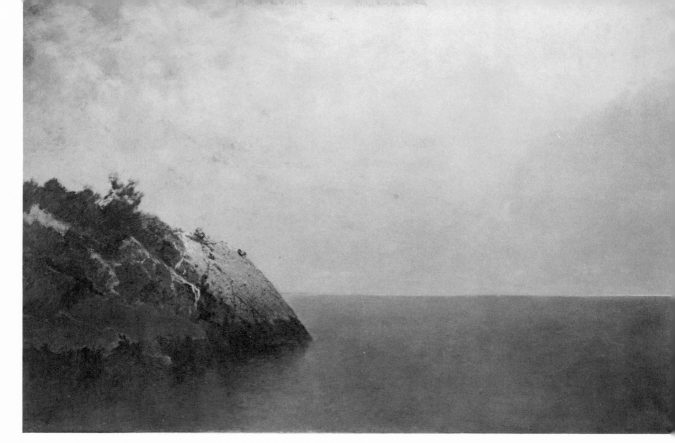

Kensett, *A Foggy Sky.*

of the cliff with a nervous energy that is intensi-
fied by his use of white highlights. On close
examination, the cliff dissolves into vigorously
applied patches and dabs of paint. A similar
technique is used to indicate the clouds above it.
The execution of cliff and water varies not only
in technique but also in the use of color contrast.
Abrupt transitions from light to dark tones in the
painting of the cliff provide the illusion of boldly
modeled form; gradual, almost imperceptible,
tonal transitions in the painting of the water pro-
duce a surface of shimmering vibrancy. Emerg-
ing from the darkness of its reflection, the cliff
appears to hover, suspended on the surface of the
translucent water.

Oil on canvas, $30\frac{1}{2} \times 45\frac{3}{4}$ in. (77.5 × 116.2 cm.).
EXHIBITED: NAD, 1873, *On Exhibition Only, Mr.
Kensett's Last Summer's Work* . . ., no. 730, as A Foggy
Sky // MMA, 1874, *Descriptive Catalogue of* . . . *" The
Last Summer's Work"* . . ., no. 28 // Fine Arts Center,
State University College of New York at Geneseo,
1968, *Hudson River School*, p. 164 // Centennial Art
Gallery, Saint Peter's College, Jersey City, 1972,
*Hudson River School of Painting and Prints of the Hudson
River*, no. 7 // Queens County Art and Cultural Cen-
ter, New York; MMA; Memorial Art Gallery of the
University of Rochester, N.Y.; Sterling and Francine
Clark Art Institute, Williamstown, Mass., 1972–1973,
19th Century American Landscape, exhib. cat. by M. Davis
and J. K. Howat, no. 8.
ON DEPOSIT: U.S. Mission to the U.N., New York,
1965–1968; 1968–1971 // Department of Parks, New
York, 1974–1976// M. H. de Young Memorial Museum,
San Francisco, 1977–1978.
74.8.

Lake George, a Reminiscence

One of several paintings of Lake George in
this group of Kensett's works, this oil sketch has
the characteristic quality of a rapidly executed
study. Using heavy scumbling in the right fore-
ground and quick brushwork throughout, Ken-
sett defines the basic features of the asymmetrical
composition and suggests distance by lightening
the color values as forms appear to recede in
depth.

Oil on canvas, $11 \times 17\frac{1}{2}$ in. (27.9 × 44.5 cm.).
EXHIBITED: NAD, 1873, *On Exhibition Only, Mr.
Kensett's Last Summer's Work* . . ., no. 709, as Lake
George, a reminiscence // MMA, 1874, *Descriptive
Catalogue of* . . . *" The Last Summer's Work"* . . ., no. 1,

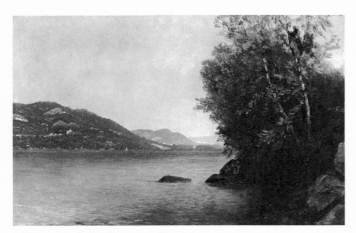

Kensett, *Lake George, a Reminiscence.*

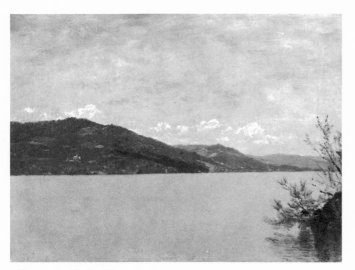

Kensett, *Lake George, 1872.*

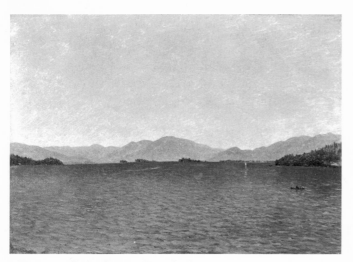

Kensett, *Lake George, Free Study.*

as Reminiscence of Lake George // Hathorn Gallery, Skidmore College, Saratoga Springs, N.Y., 1967, *John Frederick Kensett, a Retrospective Exhibition*, cat. by J. Kettlewell et al., p. 11; p. 25, no. 26b; p. 26 // Lowe Art Museum, University of Miami, Coral Gables, Fla., 1974–1975, *19th Century American Topographic Painters*, intro. by J. Wilmerding, p. 15, no. 91; ill. p. 68.

74.11.

Lake George, 1872

A small, quick study of Lake George, this sketch is characteristic of Kensett's uncluttered compositions. Subtle shifts in color tone define the spatial relationships between the mountains that span and divide the canvas. A small projection of land in the right foreground serves as a corresponding counterweight for the large dark mountain in the left middle ground. Leafy branches, executed with a fine calligraphic touch, are silhouetted against sky and water and add a vivid accent at the right.

Oil on canvas, $10\frac{1}{8} \times 13\frac{1}{2}$ in. (25.7 × 34.3 cm.).

EXHIBITED: NAD, 1873, *On Exhibition Only, Mr. Kensett's Last Summer's Work...*, no. 697, as Lake George, 1872 // MMA, 1874, *Descriptive Catalogue of... "The Last Summer's Work"...*, no. 3 // Hathorn Gallery, Skidmore College, Saratoga Springs, N.Y., 1967, *John Frederick Kensett, a Retrospective Exhibition*, cat. by J. Kettlewell et al., p. 11; p. 25, no. 26c; p. 26 // Myers Fine Art Gallery of the State University College at Plattsburgh, N.Y., 1972, *Adirondack Paintings*, no. 35.

ON DEPOSIT: U.S. Senate, Washington, D.C., 1973–1976.

74.12.

Study of Beeches

This small study of a group of beech trees has the spontaneity of a work executed quickly with great freedom of brushwork. The expressive strokes, spots, patches, and dabs of paint provide a rich, scintillating surface texture and effectively convey the flickering vibrancy of direct and filtered light. This impressionistic technique is confined to the execution of trees and ground. Branches are indicated with expressive calligraphic lines. Local color is used throughout—white, gray, and black for the tree trunks, yellow, green, and gray for the foliage, blue and white for the water.

Oil on canvas, $14\frac{3}{4} \times 10\frac{3}{8}$ in. (37.5 × 26.4 cm.).

EXHIBITED: NAD, 1873, *On Exhibition Only, Mr.*

Kensett's Last Summer's Work ..., no. 705, as *Study of Beeches* // MMA, 1874, *Descriptive Catalogue of* ... "*The Last Summer's Work*" ..., no. 8 // Hathorn Gallery, Skidmore College, Saratoga Springs, N.Y., 1967, *John Frederick Kensett, a Retrospective Exhibition*, cat. by J. Kettlewell et al., p. 11; p. 25, no. 26e; p. 26, fig. 13[26e] // Lowe Art Museum, University of Miami, Coral Gables, Fla., 1974–1975, *19th Century American Topographic Painters*, intro. by J. Wilmerding, p. 15, no. 92.

74.13.

Lake George, Free Study

Restricting himself to a predominately blue palette, Kensett explores a limited range of contrasting tones in this small study of Lake George. A similar restraint is apparent in his characteristic choice of a simplified composition—a mountain range accentuates the demarcation of sky and water and divides the canvas into two unequal parts; distant islands, indicated in dark green, emphasize the division. The paint is thinly applied, and the brushwork creates a uniformly textured surface. At the right, a minute white sail and two rowboats, one with a brilliant patch of red, punctuate the broad expanse of choppy water and provide a sense of scale as well as a narrative note.

Oil on canvas, 10 × 14⅛ in. (25.4 × 35.9 cm.).

EXHIBITED: NAD, 1873, *On Exhibition Only, Mr. Kensett's Last Summer's Work*..., no. 698, as *Lake George, Free Study* // MMA, 1874, *Descriptive Catalogue of*... "*The Last Summer's Work*" ..., no. 7 // Wadsworth Atheneum, Hartford, Conn., 1935, *American Painting and Sculpture of the 18th, 19th and 20th Centuries* (not in cat.) // Hathorn Gallery, Skidmore College, Saratoga Springs, N.Y., 1967, *John Frederick Kensett, a Retrospective Exhibition*, cat. by J. Kettlewell et al., p. 11; p. 25, no. 26a, as *Lake George, a Free Study*; p. 26; p. 27, fig. 12.

ON DEPOSIT: Wesleyan University, Middletown, Conn., 1935.

74.20.

Twilight on the Sound, Darien, Connecticut

In this eloquent study, Kensett uses color and composition effectively to evoke the haunting mood and drama of an early evening on Long Island Sound. Dark islands and a single boat are placed with a discriminating sense of design and make distinctive silhouettes against the crimson

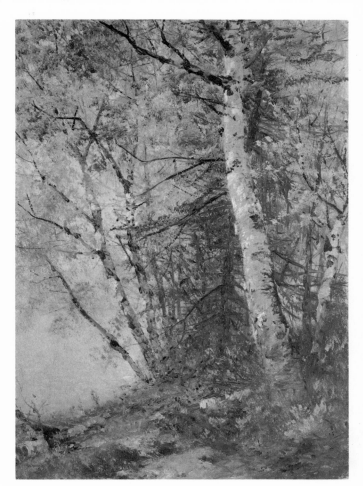

Kensett, *Study of Beeches.*

sky and water. A low horizon, cloud striations, and rippling water reflections reinforce the horizontal format and contribute to the pervasive sense of tranquility.

Oil on canvas, 11½ × 24½ in. (29.2 × 62.2 cm.).

EXHIBITED: NAD, 1873, *On Exhibition Only, Mr. Kensett's Last Summer's Work* ..., no. 729, as *Twilight on the Sound, Darien, Conn.* // MMA, 1874, *Descriptive Catalogue of* ... "*The Last Summer's Work*" ..., no. 6 // Katonah Gallery, Katonah, N.Y., 1972, *Luminism in Mid-Nineteenth Century American Painting*, no. 9 // Queens County Art and Cultural Center, New York; MMA; Memorial Art Gallery of the University of Rochester, N.Y.; Sterling and Francine Clark Art Institute, Williamstown, Mass., 1972–1973, *19th Century American Landscape*, exhib. cat. by M. Davis and J. K. Howat, no. 9 // Whatcom Museum of History and Art, Bellingham, Wash., 1976–1977, *5000 Years of Art*, exhib. cat. by T. Schlotterback, ill. p. 88; p. 89, no. 65.

74.24.

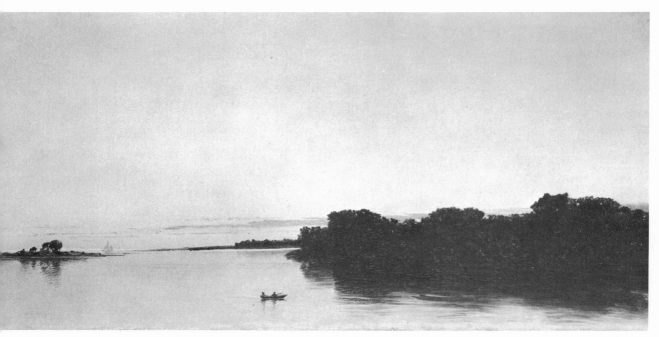

Kensett, *Twilight on the Sound, Darien, Connecticut.*

October in the Marshes

This is one of several studies Kensett made of the salt meadow and marshes near Contentment Island during the fall of 1872. The rich colors of the rust and gold salt marshes make an effective contrast to the blue-gray water, where the reflections offer additional striking color effects.

Oil on canvas, 18½ × 30½ in. (47 × 77.5 cm.).
EXHIBITED: NAD, 1873, *On Exhibition Only, Mr. Kensett's Last Summer's Work* . . ., no. 766, as October in the Marshes // MMA, 1874, *Descriptive Catalogue of* . . . " *The Last Summer's Work*" . . ., no. 13 // Darien Historical Society, Darien, Conn., 1972, *John Frederick Kensett, 1816–1872, Centennial Exhibition in Commemoration of The Last Summer's Work, Contentment Island, Darien, Connecticut,* ill. no. 15, discusses it.
74.25.

Kensett, *October in the Marshes.*

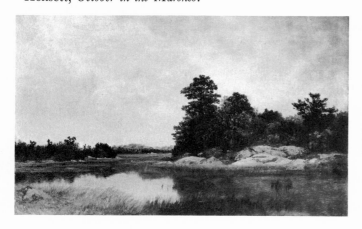

Passing Off of the Storm

Weather and its often dramatic transformation of otherwise prosaic scenes in nature provided a rich body of imagery for Kensett's brush. *Passing Off of the Storm,* a small canvas, is one of Kensett's most striking works in this genre. Using the horizontal format he so often favored, Kensett paints clouds, sky, and water in three bands. Suspended in a uniform field of gray-blue, islands and sailboats, indicated with flecks and dabs of white and dark paint, only disturb the still mirror-like surface of the water with their rippled reflections. With these few components, a sparse composition, and a limited palette, Kensett records the aftereffects of a storm in an arresting image of great clarity.

Oil on canvas, 11⅜ × 24½ in. (28.9 × 62.2 cm.).
EXHIBITED: NAD, 1873, *On Exhibition Only, Mr. Kensett's Last Summer's Work* . . ., no. 710, as Passing off of the Storm // MMA, 1874, *Descriptive Catalogue of* . . . " *The Last Summer's Work*" . . ., no. 5, as Passing away of the Storm // Fogg Art Museum, Harvard University, Cambridge, Mass., 1966, *Luminous Landscape,* no. 27 // M. Knoedler and Company, Hirschl and Adler Galleries, and Paul Rosenberg and Company, New York, 1968, *The American Vision,* (for the benefit of the Public Education Association), no. 103 // Osaka, 1970, *United States Pavilion Japan World Exposition* (no cat.) // Queens County Art and Cultural Center, New York; MMA; Memorial Art Gallery of the University of Rochester, N.Y.; Sterling and Francine

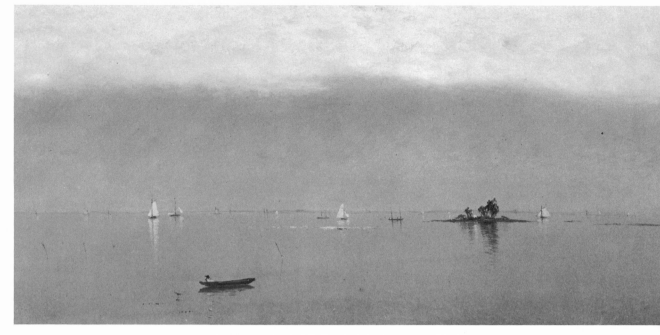

Kensett, *Passing Off of the Storm.*

Clark Art Institute, Williamstown, Mass., 1972–1973, *19th Century American Landscape*, exhib. cat. by M. Davis and J. K. Howat, no. 7 // MMA and American Federation of Arts, traveling exhibition, 1975–1977, *The Heritage of American Art*, exhib. cat. by M. Davis, no. 43, ill. p. 107; rev. ed., 1977, no. 41, ill. p. 103 // William Rockhill Nelson Gallery of Art and Atkins Museum of Fine Arts, Kansas City, Mo., 1977–1978, *Kaleidoscope of American Painting, Eighteenth and Nineteenth Centuries*, p. 41, ill. no. 47, discusses it.

Salt Meadow in October

In this unfinished painting, Kensett explores the rich autumn colors of the marshlands near Contentment Island on an overcast day. The warm ochers, rust browns, and dark earthy umbers of the marshes make an effective contrast to the cool blue and slate-colored layers of sky and water. Islands spotted with dark green vegetation and brown and gray rocks form irregular silhouettes in a composition constructed of horizontal bands. More vivid in coloring and less complex in construction than *October in the Marshes* (q.v.), *Salt Meadow in October* demonstrates Kensett's skill as a colorist and his economy in composition.

Unfortunately, the picture is distorted by large and irregular stains in the foreground and the lower portion of the sky. This type of staining is not infrequent in nineteenth-century paintings on preprimed canvases, but the problem has not yet been studied sufficiently to allow treatment.

Oil on canvas, 18 × 30 in. (45.7 × 76.2 cm.).

EXHIBITED: NAD, 1873, *On Exhibition Only, Mr. Kensett's Last Summer's Work* . . ., no. 755, as Salt Meadow in October // MMA, 1874, *Descriptive Catalogue of* . . . "*The Last Summer's Work*" . . ., no. 4 // Florence Lewison Gallery, 1965, *Americans Remembered, John F. Kensett, 1816–1872*, no. 14 // American Federation of Arts, traveling exhibition, 1968–1969, *John Frederick Kensett 1816–1872*, cat. by J. K. Howat, no. 47 // Darien Historical Society, Darien, Conn., 1972, *John Frederick Kensett, 1816–1872, Centennial Exhibition in Commemoration of The Last Summer's Work, Contentment Island, Darien, Connecticut*, ill. no. 16.

ON DEPOSIT: Department of Parks, New York, 1973–1976.

74.28.

Kensett, *Salt Meadow in October.*

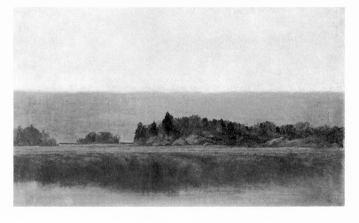

John F. Kensett

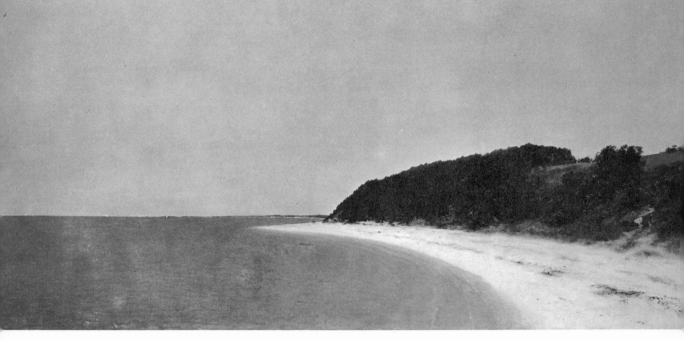

Kensett, *Eaton's Neck, Long Island*.

Eaton's Neck, Long Island

Striking in its simplicity of conception and clarity of design, *Eaton's Neck, Long Island* is one of Kensett's most powerful paintings. It functions effectively on two levels—as a stark representation of sea, sky, and shore, and as a strong abstract surface design. A sweeping curve of dazzling white sand surmounted by a bluff, dark green and brown in color, projects from the right, disrupting the symmetry of sky and sea. Terminating sharply more than half way across the width of the canvas, the resulting crescent shape is not aligned with the horizon. A narrow strip of water beyond it creates the illusion of depth. Colors contrasting widely in value are used to describe this abrupt composite form, which in shape and color draws attention to the right side of the canvas. The dark bluff forms a convex silhouette against the light sky, and, reversing the relationship, the white sand appears concave against the darker water. The intensity of the color of the sand is heightened by its juxtaposition to two of the darkest values used in the painting. This use of contrasting color values creates a sharp, more distinctive, contour, adding to the clarity of forms and contributing to the surreal quality of the whole.

Oil on canvas, 18 × 36 in. (45.7 × 91.4 cm.).
EXHIBITED: NAD, 1873, *On Exhibition Only, Mr. Kensett's Last Summer's Work* . . ., no. 744, as Eaton's Neck, L.I. // MMA, 1874, *Descriptive Catalogue of . . . "The Last Summer's Work"* . . ., no. 33 // Centennial Art Gallery, Centennial Exposition, Utah State Fair Grounds, Salt Lake City, 1947, *One Hundred Years of American Painting*, cat. by American Federation of Arts, Washington, D.C., no. 7 // MMA, 1958–1959, *Fourteen American Masters* (no cat.) // World's Fair, New York, 1964, *Art in New York State*, no. 27 // Carnegie Institute, Pittsburgh, 1965, *The Seashore, Paintings of the 19th and 20th Centuries*, no. 34 // American Federation of Arts, traveling exhibition, 1968–1969, *John Frederick Kensett, 1816–1872*, cat. by J. K. Howat, no. 46 // Bronx County Courthouse, New York, 1971, *Paintings from the Metropolitan*, no. 21 // Katonah Gallery, Katonah, N.Y., 1972, *Luminism in Mid-Nineteenth Century American Painting*, no. 10 // Darien Historical Society, Darien, Conn., 1972, *John Frederick Kensett, 1816–1872, Centennial Exhibition in Commemoration of The Last Summer's Work, Contentment Island, Darien, Connecticut*, ill. no. 18.
ON DEPOSIT: Allentown Art Museum, Allentown, Pa., 1975–1977.
74.29.

Sunset Sky

The subject of this unfinished painting lends itself to the band-like composition favored by Kensett. It also provides him with an opportunity to explore the vivid effects of color and light. The study of different types of cloud formations and light effects has an extensive literary

and pictorial tradition, but, judging by *Sunset on the Sea* and *Sunset* (qq.v.), closely related works, this painting was not originally intended to be solely a study of the sky. The foreground, in all probability reserved for a representation of the sea, is left unpainted. Above the unpainted area, the sunset sky is described in a vivid and melodramatic array of colors unusual for Kensett. A band of bright chrome yellow and deep gold serves as a ground for wispy clouds of pink and purple. Above it a band of purple with orange-tinged pink clouds gives way to a light blue-green sky flecked with white- and purple-tinged pink clouds.

Oil on canvas, 20 × 32 in. (50.8 × 81.3 cm.).
EXHIBITED: NAD, 1873, *On Exhibition Only, Mr. Kensett's Last Summer's Work . . .*, no. 754, as Sunset Sky // MMA, 1874, *Descriptive Catalogue of . . . " The Last Summer's Work" . . .*, no. 38.
74.30.

Kensett, *Sunset Sky.*

The Sea

Kensett's composition is dominated by horizontal elements. Two-thirds of the canvas is reserved for the sky, and the low horizon is interrupted only by a small white sail, one of the artist's favorite devices for drawing attention to a distant horizon and increasing the illusion of depth. The incoming waves break on a rocky shore that extends diagonally across the right foreground, providing the viewer with a sense of immediacy. The slight deviation from the horizontal in the positioning of white caps and shore provides an effective note of tension.

Oil on canvas, 15½ × 30½ in. (39.4 × 77.5 cm.).
EXHIBITED: NAD, 1873, *On Exhibition Only, Mr. Kensett's Last Summer's Work . . .*, no. 765, as The Sea // MMA, 1874, *Descriptive Catalogue of . . . " The Last Summer's Work" . . .*, no. 20, as Long Island Sound, from Fish Island // Hathorn Gallery, Skidmore College, Saratoga Springs, N.Y., 1967, *John Frederick Kensett, a Retrospective Exhibition*, cat. by J. Kettlewell et al., p. 11; p. 25, no. 26f; p. 26; p. 27, fig. 14 [26f].
ON DEPOSIT: Office of the Borough President, Queens Borough Hall, New York, 1972–1978.
74.35.

Kensett, *The Sea.*

Sunset

Brought closer to completion than *Sunset Sky* (q.v.), to which it is quite similar, this painting may indicate Kensett's final plans for finishing that work. In composition, *Sunset* follows Ken-

Kensett, *Sunset.*

Kensett, *The Old Pine, Darien, Connecticut.*

sett's frequent practice in these late works of organizing a painting in horizontal bands. Departing from his usual restricted palette, the artist deploys a full spectrum of colors in this painting, including yellow, blue, pink, orange, and purple. He avoids sharp contrasts in value from light to dark. A submerged wave-washed rock appears in the foreground, and an island emerges from the sea at the right. The ripples on the water establish a subtle surface pattern, faintly echoed by the indication of clouds in the sky.

Oil on canvas, 18 × 30 in. (45.7 × 76.2 cm.).
EXHIBITED: NAD, 1873, *On Exhibition Only, Mr. Kensett's Last Summer's Work . . .*, no. 764, as Sunset //

MMA, 1874, *Descriptive Catalogue of . . . "The Last Summer's Work" . . .*, no. 34 // Darien Historical Society, Darien, Conn., 1972, *John Frederick Kensett, 1816–1872, Centennial Exhibition in Commemoration of The Last Summer's Work, Contentment Island, Darien, Connecticut*, ill. no. 17.

74.37.

The Old Pine, Darien, Connecticut

Designating *Sunset on the Sea* (q.v.) as Kensett's "most remarkable picture" in this group, the Reverend Dr. Samuel Osgood, a summer neighbor of the artist, observed in 1872:

Next to this in power and suggestiveness seems to me

48

to be his picture of a cliff by the shore, with shrubs and a grove and figures above, and the whole surmounted by a noble pine tree, that stretches out its limbs towards the sea. It is a charming scene, and combines great carefulness and severe truth with beauty and sentiment.

An excellent example of one of Kensett's favorite compositional formulas, *The Old Pine, Darien, Connecticut* consists of a massive cliff towering in the left foreground, surmounted by a pine, and, on the right, an open vista of the sea. The asymmetrical composition created by the juxtaposition of form and void, foreground and depth, recurs in several of Kensett's late works. The manner of execution, similar to that used in *A Foggy Sky* and *Newport Rocks*, reflects the dual character of the composition. Quick impressionistic patches, dabs, and touches of paint are used to define the cliff, the figures, the trees, and the foliage of the pine; expressive angular lines, varying in width, delineate the branches. A system of brushstroke clusters, confined to the cliff, the figures, and the trees, approximates the flickering play of light and shadow on form. The resulting richly textured paint surface simulates detail and gives the objects represented a tangible concreteness. In contrast, the water and, to a lesser extent, the sky are executed with broader strokes. The brushstrokes and abrupt changes of color contrast are minimal, creating a smoother, more uniform, paint surface. Small islands along the distant horizon attract the eye and sustain the illusion of depth.

Oil on canvas, 34⅜ × 27¼ in. (87.3 × 69.2 cm.).
Canvas stamp: WILLIAMS STEVENS WILLIAMS / Looking Glass Ware Rooms / & ART REPOSITORY / Engravings Art Materials / 353 BROADWAY NEW YORK / 27 × 34.
REFERENCE: Century Association, New York, *Proceedings at a Meeting of the Century Association, Held in Memory of John F. Kensett, December, 1872* [1872], p. 23, supplies Osgood's remarks (quoted above).
EXHIBITED: NAD, 1873, *On Exhibition Only, Mr. Kensett's Last Summer's Work . . .*, no. 713, as The Old Pine, Darien, Conn. // MMA, 1874, *Descriptive Catalogue of . . . "The Last Summer's Work" . . .*, no. 26 // Florence Lewison Gallery, New York, 1965, *Americans Remembered, John F. Kensett, 1816–1872*, no. 12 // Los Angeles County Museum of Art, and M. H. de Young Memorial Museum, San Francisco, 1966, *American Paintings from the Metropolitan Museum of Art*, no. 41 // Henry Gallery, University of Washington, Seattle, 1968, *The View and the Vision*, exhib. cat. by R. B. Stein, no. 26 // MMA, 1970, *19th-Century America, Paintings and Sculpture*, exhib. cat. by J. K. Howat and N. Spassky (not in cat.).

John F. Kensett

ON DEPOSIT: Department of Parks, New York, 1971–1976.
74.38.

Gathering Storm on Long Island Sound

The uncanny transitory effects of intermittent light that often accompany the interval preceding a storm are given vivid theatrical expression in this painting. Here Kensett demonstrates his command of the romantic vocabulary by using sharp contrasts of light and dark to evoke a scene in nature transformed by inclement weather. The drama of the impending storm is heightened by the stillness of the slate-blue water, shown under a metallic blue-gray sky filled with billowing storm clouds. Brilliant light illuminates the lower right and the middle ground of the canvas; white sails on the horizon and a white-edged cloud emerge in sharp relief from the darkness.

Oil on canvas, 34½ × 27¼ in. (87.6 × 69.2 cm.).
Canvas stamp: WILLIAMS STEVENS WILLIAMS / Looking Glass Ware Rooms / & ART REPOSITORY / Engravings Art Materials / 353 BROADWAY NEW YORK / 27 × 34.
EXHIBITED: NAD, 1873, *On Exhibition Only, Mr. Kensett's Last Summer's Work . . .*, no. 728, as Gathering

Kensett, *Gathering Storm on Long Island Sound.*

Storm on L.I. Sound // MMA, 1874, *Descriptive Catalogue of . . . "The Last Summer's Work" . . .*, no. 21 // Florence Lewison Gallery, New York, 1965, *Americans Remembered, John F. Kensett, 1816–1872*, no. 13 // Charles H. MacNider Museum, Mason City, Iowa, 1966, *Inaugural Exhibition*, unnumbered cat. // Colby College Art Museum, Waterville, Me., 1966, *Art in the Making*, unnumbered cat. // Phoenix Art Museum, Ariz., 1967–1968, *The River and the Sea*, no. 13 //

MMA, 1970, *19th-Century America, Paintings and Sculpture*, exhib. cat. by J. K. Howat and N. Spassky (not in cat.).

ON DEPOSIT: Department of Parks, New York, 1971–1976.

74.39.

EX COLL. (74.3–74.39): the artist's brother, Thomas Kensett, 1872–1874.

Gift of Thomas Kensett, 1874.

M. A. SULLIVAN

active 1868

Dated 1868 and discussed below, *Macomb's Dam Hotel* is the only work currently known that is signed by M. A. Sullivan. Judging from the style of the painting, the artist had some knowledge of perspective and was a capable sign painter but probably only painted pictures as a sideline. Although it is tempting to identify M. A. Sullivan as one of the Sullivan Brothers listed as house and sign painters in the New York business directories for 1867–1868 and 1870–1871, the only members of the firm, according to the city directory for the year ending May 1, 1869, were Thomas and Dennis L. Sullivan. In the directory for the same year there is a listing for Michael Sullivan, a painter, living at 5 Franklin Street, but without additional evidence, he cannot be identified as M. A. Sullivan.

Macomb's Dam Hotel

In 1814 Robert Macomb was granted the right to erect a dam across the Harlem River for the operation of a gristmill. Macomb's Dam, completed in 1815, also served as a causeway and bridge across the river from Manhattan to Morrisania from what is now 155th Street and Seventh Avenue in Manhattan to 162nd Street and Jerome Avenue in the Bronx. The original dam and bridge were partially destroyed in 1838 by neighboring property holders objecting to its obstruction of navigation. The dam was never rebuilt, but the bridge was repaired. In 1858 the demolition of the bridge was ordered, and several years later another was constructed. The present steel structure was opened to traffic in 1895.

Presumably Macomb's Dam Hotel was not far from the site of the dam, although no record of the hotel or its proprietor, L. Overton or Loverton, has been found. It may be, however, the tavern mentioned in the *Hotel Mail* for August 17,

1895: "The famous old Macomb's Dam Tavern is being demolished. It was in its palmy days the favorite roadhouse of New York's wealthy and prominent citizens and with its demolition a noted landmark disappears" (typescript in envelope B, 1895, W. Johnson Quinn Collection of New York Hotels, NYHS).

Dated 1868, this painting may be the only surviving record of the hotel. Its position on the road, the crowd of figures on the porch, and the designation "LADIES ROOM" suggest that it functioned as a coach stop or a posting inn. In the third quarter of the last century this was still a peaceful rural area, where visitors could escape the bustle of the city. The careful attention to the lettering of the signs that dominate the painting, the somewhat uneasy handling of the figures, and the summary treatment of the building, road, and trees suggest that the artist may have been a sign painter not wholly accustomed to painting scenes of this nature.

Sullivan, *Macomb's Dam Hotel.*

Oil on canvas, 23½ × 32½ in. (59.7 × 82.6 cm.).

Signed and dated at lower right: *M. A. Sullivan Px /* 1868.

REFERENCES: I. N. P. Stokes, *The Iconography of Manhattan Island, 1498–1909* (1918), 3, pp. 705–706, 926, supplies history of Macomb's Dam Bridge; (1928), 6, pp. 64f–64g, corrects location of gristmill in relation to Macomb's Dam Bridge and supplies bibliographical information; pp. 329, 474, supplies chronology of the dam and bridge // U.S. Embassy, Moscow, *Amerikanskaya zhivopis, 1830–1970* [*American Painting, 1830–1970*] (1974), p. 9, no. 7, lists the painting; color ill. p. 16, discusses it, suggesting that the artist might be one of the Sullivan Brothers listed in the New York city directories of 1860–1870 as house and sign painters.

EXHIBITED: MMA, 1965, *Three Centuries of American Painting*, unnumbered cat.

ON DEPOSIT: Museum of the City of New York, 1935–1963 // U.S. ambassador's residence, Spaso House, Moscow, 1974–1979.

EX COLL.: Edward W. C. Arnold, by 1935–1954.

The Edward W. C. Arnold Collection of New York Prints, Maps, and Pictures. Bequest of Edward W. C. Arnold, 1954.

54.90.160.

JOSEPH ALEXANDER AMES

1816–1872

A self-taught painter, chiefly noted as a portraitist, Ames was a native of Roxbury, New Hampshire. "When twelve years old," according to Tuckerman, "he attempted a portrait of his little brother on a piece of board in the barn—which crude experiment showed an aptness for likeness in amusing contrast to lack of knowledge in artistic method." By copying the work of other artists, Ames improved his technique markedly, and after moderate success in his native state, he moved to Boston, where from 1841 to 1847 he pursued a successful career as a portraitist. "Joseph Ames was just beginning his work, as were also Thomas Ball, and George Fuller a little later," the artist Benjamin Champney (1817–1907) reminisced: "They were all struggling young men, experimenting as they could in colors, and looking up to Washington Allston as the great master, as indeed he was" (*Sixty Years' Memories of Art and*

Artists [1900], pp. 12–13). In a letter about GEORGE FULLER, published in the *Boston Daily Transcript*, May 7, 1884, the sculptor Thomas Ball also recalled this period in Boston: "Joe Ames was another who was striving after Allston's method, and at that time with more success than either of us; his pictures created quite a sensation for their Titian color, although neither of us had ever seen a Titian" (p. 6).

In 1848, Ames went to Europe and settled in Rome, where, at the request of officials of the Catholic Church in the United States, he painted a portrait of Pope Pius IX (unlocated). Later the same year, Ames returned to America. He spent most of the next two decades in Boston, with the exception of several trips to fulfill portrait commissions and summers in Newport during the late 1850s. He was a member of the Boston Artists' Association and first president of the Boston Art Club, founded in 1855. In 1852, he painted a full-length life portrait of Daniel Webster (unlocated), a work much admired by his contemporaries and described by Charles Henry Hart as "the last of Webster painted from life" (*McClure's Magazine* 9 [May 1897], p. 626). By 1855 he had completed his history painting *The Last Days of Webster at Marshfield* (unlocated), consisting of twenty-two figures from life including Webster's family and friends at his deathbed. The British engraver Charles Mottram was engaged to make a steel engraving of the painting, and subscriptions were taken. Ames's "likenesses of Webster have become, like Gilbert Stuart's Washington, widely recognized as the best counterfeit presentments of that statesman," William Howe Downes noted in 1888 (p. 264). In addition to some nine portraits of Webster, he also painted portraits of President William Conway Felton of Harvard, Rufus Choate, Ralph Waldo Emerson, and Abraham Lincoln. "In Baltimore and Boston he found, for several years," Tuckerman reported in 1867, "more sitters than he could accommodate; as well as frequent orders from New York and Washington." He added: "Ames paints on an average seventy-five portraits in a year; of course they often lack high finish; but his fresh and bright tints and frequent success in likeness—even the rapidity of his execution—contribute to his prosperous activity." His work was exhibited at the Boston Athenaeum, the Maryland Historical Society, the National Academy of Design, the Pennsylvania Academy of the Fine Arts, and the Washington Art Association. His wife, Sarah Fisher Clampitt (1817–1901), was a sculptor, best known for her portrait bust of Lincoln in the Senate Gallery, Washington, and their daughter, the painter Josephine Ames (1854–1925), later Mrs. Asa Henry Morton, was a pupil of THOMAS EAKINS.

In 1870 Ames moved first to Baltimore for reasons of health and then to New York, where, the same year, he was elected an academician at the National Academy of Design. He died two years later in New York. Describing his portraits as "strongly modeled and coarse in handling," Downes noted: "He was the wonder of Boston at one time, but soon afterwards a period of neglect came, which, whether merited or not, caused him great suffering, and had a bad effect upon his work" (p. 265).

BIBLIOGRAPHY: Henry T. Tuckerman, *Book of the Artists* (New York, 1867), pp. 459–460 // Obituaries: *Boston Transcript*, Nov. 1, 1872, [p. 2]; *New York Evening Post*, Nov. 2, 1872, [p. 2]; *New York Times*, Nov. 2, 1872, p. 10 // William Howe Downes, "Boston Painters and Paintings: Allston and His Contemporaries," and "Boston Painters and Paintings: Old Galleries and New Lights," *Atlantic Monthly* 62 (August and Sept. 1888), pp. 261, 264–265, 387, 389 // Theodore Bolton, *DAB* (1928; 1957), s.v. "Ames, Joseph Alexander" // Groce and Wallace, p. 7.

James Topham Brady

The son of Thomas J. Brady, an Irish immigrant, founder of a preparatory school, and a lawyer, James Topham Brady (1815–1869) was born and educated in New York. In 1831 he entered his father's law office, and five years later he was admitted to the New York Bar. His first case, which concerned the status of an indentured servant, brought him public recognition. Shortly thereafter, according to the *American Law Review* (1869), he served as junior counsel to Daniel Webster in the India-rubber patent case of *Goodyear* vs. *Day* and won the admiration of his colleagues. Noted for his knowledge of all departments of the law, Brady was a prominent figure in many of the important civil and criminal lawsuits of the period.

In 1843 Brady was appointed acting district attorney for New York, and two years later he served as corporation counsel. Although he was active in the Democratic party and accepted the nomination as candidate for governor of New York in 1860, he never became a professional politician nor did he accept many of the political offices offered to him.

Brady was active in the cultural life of the city, and as an author, contributed to various periodicals. His best-known and most popular work, "A Christmas Dream," first appeared in the *New World* in 1846. A good friend and patron of the artist William Tylee Ranney (1813–1857), Brady gave a lecture on American art on December 9, 1858, to help defray the expenses of the Ranney Fund exhibition and sale for the benefit of the artist's widow and family. Brady died in New York on February 9, 1869, at the age of fifty-three.

Ames faithfully recorded Brady, a man noted for his brilliant eloquence and urbanity, in this portrait. Dated 1869, the year of the subject's death, it may well have been painted from a daguerreotype rather than life, although it lacks the mechanical quality that often results from this process. Florid in coloring, Brady's face is boldly modeled and broadly painted. As a late example of Ames's work, the portrait differs considerably from the more fluent style of his earlier years.

Oil on canvas, 30 × 25 in. (76.2 × 63.5 cm.).
Signed and dated at lower right: J. Ames / 1869.
RELATED WORK: *James Topham Brady*, oil on canvas, 27 × 22½ in. (69.6 × 57.2 cm.), Association of the Bar of the City of New York.

Ames, *James Topham Brady*.

REFERENCES: *American Law Review* 3 (July 1869), pp. 779–781, supplies biography of the subject // L. B. Proctor, *The Bench and Bar of New-York* (1870), pp. 238–276, supplies biography of the subject // *New York Evening Post*, Nov. 2, 1872, [p. 2], notes that a portrait of the late James T. Brady was in Ames's studio at the time of his death (probably this picture) // F. L. Stetson, letter in MMA Archives, May 23, 1910, notes that this portrait was at the Association of the Bar of the City of New York from 1906 until 1909 when they were presented with another version given by the daughters of Mr. Clarence A. Seward // *MMA Bull.* 5 (July 1910), p. 175; ill. p. 176 // H. W. H. Knott, *DAB* (1928; 1957), s.v. "Brady, James Topham," supplies biography of the subject // G. T. MacDonagh, letters in Dept. Arch., Dec. 18, 1967, and Dec. 1, 1977, supplies information on the portrait and the version at Association of the Bar of the City of New York.

ON DEPOSIT: Association of the Bar of the City of New York, 1906–1909, lent by Mrs. Josephine Ames Morton, Williamstown, Mass.

EX COLL.: the artist's daughter, Mrs. Josephine Ames Morton, Williamstown, Mass., until 1910.

Gift of Francis Lynde Stetson, 1910.
10.106.

Joseph Alexander Ames

RICHARD WILLIAM HUBBARD

1816–1888

Born in Middletown, Connecticut, Hubbard was educated at the Middletown Academy and attended Yale College, subsequently receiving his bachelor's degree as a member of the class of 1837. The following year he went to New York, where he studied with SAMUEL F. B. MORSE at New York University. According to some sources, Hubbard also studied with his contemporary, Morse's student DANIEL HUNTINGTON, either before or after a trip to Europe. Hubbard spent 1840 and 1841 in England and France. "There," according to an article in the *Brooklyn Monthly* (p. 102), "he found fresh inspiration in the works of Claude Lorraine, and to this day he reveres the memory of Claude, and eulogizes his paintings with a degree of warmth that no criticism by Ruskin can chill." After his return from Europe, he settled in Brooklyn. In 1842, he began exhibiting his landscapes at the National Academy of Design, where in 1851 he was elected an associate and in 1858 an academician. Hubbard's works were also shown at the American Art-Union, the Boston Athenaeum, the Maryland Historical Society, the Pennsylvania Academy of the Fine Arts, and the Washington Art Association.

From 1850 to 1858 Hubbard had a studio in the University Building on Washington Square, and his name appears on its rent rolls from 1853 to 1860. From 1859 until his death, he maintained a studio in the Tenth Street Studio Building. A founder and president of the Artist's Fund Society, Hubbard also served as third president of the Brooklyn Art Association from 1873 to 1884 and contributed regularly to its exhibitions from 1861 to 1886. In 1865 he was elected to the Century Association, and in 1874 he was awarded an honorary master's degree from Yale.

A member of the circle of Hudson River school painters, Hubbard was best known for modest, small-scale studies from nature and a preoccupation with effects of light, shadow, and atmosphere that gave his works a luminous quality. Characterizing Hubbard's landscapes as "gems of quiet beauty," Tuckerman observed: "Their tone is usually subdued, their beauty poetic; occasionally the effects are exquisite; they may lack boldness and vigor, but rarely meaning and grace . . . and are related to the gentler, more thoughtful and dreamy impressions we derive from nature" (p. 322).

BIBLIOGRAPHY: Henry T. Tuckerman, *Book of the Artists* (New York, 1867), pp. 522–524 // "Our Artists and Their Works," *Brooklyn Monthly* 2 (April 1878), pp. 101–102 // H[enry] W. French, *Art and Artists in Connecticut* (Boston and New York, 1879), pp. 95–99 // Oliver S. Tonks, *DAB* (1932; 1961), s.v. "Hubbard, Richard William," pp. 331–332 // Theodore Sizer, ed., *The Recollections of John Ferguson Weir, Director of the Yale School of the Fine Arts, 1869–1913* (New York and New Haven, 1957), p. 64. Reprinted with additions from three articles in the *New-York Historical Society Quarterly* 41 (April–Oct. 1957). Weir's manuscript dates after 1913.

Morning on the Mountain

The absence of distinctive topographical landmarks makes it difficult to identify this scene.

Dated 1856, the painting might well have been done in North Conway, New Hampshire. Reporting on the increasing popularity of North Conway with artists during the early 1850s, Ben-

Hubbard, *Morning on the Mountain.*

jamin Champney (1817–1907), noted: "Coleman, Hubbard, Gifford and Shattuck, of New York, settled themselves at the old farmhouse ... near the Moat Mt. house" (*Sixty Years' Memories of Art and Artists* [1900], p. 106). An exchange of artists' letters in the *Crayon* (3, August–Nov. 1856) argued the relative merits of North Conway and West Campton. A letter in the November issue (p. 348) mentions the presence at Conway of Hubbard, "the most profound and conscientious of our landscape students." But, as this is a summer scene, it may have been painted elsewhere, for Hubbard is not listed among the artists to be found at Conway in the August issue of the *Crayon* (p. 250), and a description of his works in the December issue (p. 375) makes note only of his study of the stepping stones on Kearsarge Brook and several sketches of autumn foliage. Like other artists of the Hudson River school, Hubbard traveled widely in New York and New England during the summers and painted works of this kind in various locations. A similar work by Hubbard called *The Mountain Top* (unlocated) was acquired by JOHN FREDERICK KENSETT at the Somerville Art Gallery, New York (sale cat., March 31, 1870, no. 20), and appeared in the 1873 exhibition of Kensett's collection at the National Academy of Design (ill. in bound volume of photographs of Kensett exhibition, pl. 43, MMA Library).

"He was a close student of nature," Champney wrote of Hubbard, "and would work for days upon a small canvas trying to interpret the scene in its most intricate aspects. This he did not do for the picture he obtained, but to gain knowledge. His canvases were not crowded with details, but simple in arrangement, with a charming scheme of color" (p. 144).

In 1857, the winter after he painted this picture, Hubbard wrote to the artist Charles Lanman (1819–1895):

If I were to describe that phase of Nature which touches me most deeply, I should try to recall to your remembrance some view of forested mountain slopes in shadow, their terminations undistinguishable amid the wooded champaign, itself interspersed with lakes & lost in a filmy distance the sky paled to a delicate grey by the overpowering sunlight; & the shadows of mountain & forest so heightened thereby as to lose all abruptness between shadow & light—producing thereby a dreaminess of effect highly poetical. I think this is the best light perhaps in which to exhibit our American nature in the full freshness of Early Summer greenery, as all apparent harshness of verduous tints is by this light toned into a modesty of colour transcendently beautiful (Feb. 26, 1857, Charles Henry Hart Autograph Collection, D5, Arch. Am. Art).

Oil on canvas, 14¼ × 12¼ in. (36.2 × 31.1 cm.).
Signed and dated at lower right: R. W. H. / LVI. Canvas stamp: PREPARED / BY / ED^{WD} DECHAUX / NEW-YORK / 12 × 14.
REFERENCES: S. P. Avery, Jr., letter in MMA Archives, Feb. 13, 1920, notes it is "possibly called 'Sunrise on the mountain'," adding that he purchased it at the Aaron Healy sale and that the correct title is given in the sale catalogue // O. S. Tonks, *DAB* (1932; 1961), s.v. "Hubbard, Richard William," mentions this picture, calling it Sunrise on the Mountains // F. Baekeland, *American Art Review* 3 (Nov.–Dec. 1976), p. 141, fig. 28.

EXHIBITED: Brooklyn and Long Island Fair, 1864, *Catalogue of the Works of Art Exhibited [Under the Auspices of the Brooklyn Art Association] at Brooklyn and Long Island Fair in Aid of the United States Sanitary Commission*, no. 124, as Morning on the Mount, lent by S. P. Avery // MMA, 1946, *The Taste of the Seventies*, no. 119, as Sunrise on the Mountain.

EX COLL.: Samuel P. Avery, Sr., New York, by 1864 (sale, Henry H. Leeds and Miner, New York, Feb. 4, 1867, no. 61, $230, as Morning on the Mountain); Aaron Healy, Brooklyn, 1867 (sale, Ortgies and Company, New York, Feb. 14, 1891, no. 3, $200, as Morning on the Mountain); Samuel P. Avery, Jr., 1891–1920.

Gift of Samuel P. Avery, 1920.
20.189.2.

DANIEL HUNTINGTON

1816–1906

Characterizing Huntington as one of the "representative artists of academic training," the critic James Jackson Jarves noted in 1864 that his "refinement and high-bred tone" were "very winning." "In general," Jarves added, "the academicians proper exhibit considerable skill of manipulation and detail, facility of composition, and those composite qualities which make up an accomplished rather than an original man. No great men are to be looked for in this quarter; for greatness would be at war at once with its system of routine and conventionalism, and consequently would not be tolerated" (*The Art-Idea*, ed. by B. Rowland, Jr. [1960], pp. 188–189). Jarves's appraisal of Huntington as an academic painter, who having mastered the technical skills adheres to established forms and is reluctant to experiment, is subjective but valid. Huntington was a conservative artist, assured in his position, comfortable with the status quo, and wary of innovations.

The artist, born in New York, was one of three sons of Benjamin Huntington, a merchant originally from Norwich, Connecticut, who, despite financial misfortunes, provided his sons with a liberal education. According to Henry T. Tuckerman (p. 21) it was in the studio of JOHN TRUMBULL, a relative of his mother, that Huntington "first realized fully his strong natural inclination to pursue art," despite that disenchanted artist's advice against the profession. "Better to be a tea-water man's horse, in New York," Trumbull is said to have remarked,

"than a portrait painter anywhere" (Townley, p. 44). After attending the collegiate school of Oliver Grosvenor in Rome, New York, Huntington prepared at Smith's Academy in New Haven for Yale College, which he entered in 1832 and attended for one year. From 1833 to 1835 he studied at Hamilton College in Clinton, New York, where he met CHARLES LORING ELLIOTT, who was painting portraits at the college. Encouraging Huntington in his determination to become an artist, Elliott provided him with some instruction. In 1835, Huntington returned to New York. There he studied at New York University with SAMUEL F. B. MORSE and subsequently with HENRY INMAN. "When I knew him," Huntington remarked of Morse, "he had his wires strung around his studio, and his chemical apparatus side by side with his easel" (Sheldon, p. 105).

Huntington's early productions consisted of portraits, genre pieces, and landscapes in the tradition of the Hudson River school. During the summer of 1835, "spent in the close study of Nature," according to the artist, "such a love for Landscape was fostered, as has often since broken out amidst the harrassing fatigues of Portrait Painting, and resulted in occasionally a Landscape—but such Landscapes as will not bear the test of a close comparison with Nature" (*Catalogue of Paintings, by Daniel Huntington*, p. 8). He first exhibited his work at the National Academy of Design in 1836; he was elected an associate there in 1839 and an academician the following year. With his friend and pupil HENRY PETERS GRAY, he spent the year of 1839 studying in Rome, Florence, and Paris. After his return in 1840, he painted his allegorical painting *Mercy's Dream*, 1841 (PAFA; see also below), which brought him acclaim and confirmed his interest in didactic, inspirational subjects. In 1842 he married Harriet Sophia Richards and returned to Europe. Until 1845 he worked and studied mainly in Rome, producing landscapes and historical and religious paintings, the latter reflecting the profound religiosity that was one of his most noticeable personal traits. In December 1849, a group of the artist's friends including New York's leading painters, literary figures, and businessmen approached him with a proposal to organize an exhibition of his work. Installed at the Art Union Buildings in 1850, the exhibition consisted of one hundred and thirty of Huntington's productions, accompanied by a catalogue written by the artist. From 1851 to 1858, Huntington was again in Europe, where he spent much of the time in England painting portraits of such notables as Sir Charles Eastlake, president of the Royal Academy (1851; NYHS). In 1882 he visited Spain and recorded his impressions of Madrid in two articles published in the *Art-Union* in 1884.

The "official" portraitist of New York society in the post Civil War period, the artist was also a leading figure in the city's art circles. He served as president of the National Academy of Design from 1862 to 1870 and again from 1877 to 1890. "His conservative disposition," WORTHINGTON WHITTREDGE observed in his 1905 autobiography, "together with his good judgment and affable manners made him an ideal President" (J. I. H. Baur, ed., *Brooklyn Museum Journal* [1942], p. 43). During his long incumbency, when new concepts of style and aesthetics imported by younger painters trained in Germany and France presented a threat to traditional forms, Huntington was the leader of the old guard. "As for many modern French pictures—for instance, some of those in the Centennial Exhibition in Philadelphia [1876]," Huntington remarked, "they were evidently intended to pamper the tastes of lascivious men" (Sheldon, p. 102). A founder of the Century Association and its president from 1879 to 1895, he was also one of the prime movers in the founding of the Metropolitan Museum,

where he served as a vice-president for thirty-three years, from 1871 to 1874 and 1876 to 1903. "He has an easy, graceful presence, and a manner winning as a woman's," Daniel O'Connell Townley said of Huntington in 1871, adding, "he impresses us as one whose nature shrinks from controversy; a man to mould the manners of his time where the stuff is plastic, but not to hew them into shape with rough words and ways" (p. 48).

Although his work encompasses a wide variety of subjects, Huntington was best known for his portraiture. A prolific artist, he produced some twelve hundred works, of which he is credited with over a thousand portraits. His early works in this genre are firmly painted and reflect the style of his mentors Morse and Inman. "He did not have to struggle through long years of neglect and isolation to perfect himself," Samuel Isham noted, "he only had to produce as rapidly as possible" (*The History of American Painting* [1905], p. 286). His late portraits, often literal, mechanical, and perfunctory in execution, reflect the impact of photography.

"What most impresses one in considering Mr. Huntington's paintings is their evenness of quality," S. G. W. Benjamin noted in 1881:

> We are rarely startled by brilliance either in style or subject, while, on the other hand, we are not often disturbed by the mediocrity or repulsiveness which frequently characterize the works of more daring artists. He is no innovator.... Yet he readily accepts every advance in the expression of artistic truths, while he is essentially and by nature conservative.... What we miss in his handling is force; there is sometimes too much "sweetness," to use a studio term, in both that and his color, which suggests insipidity. He is therefore most at home in subjects that require delicacy of treatment. His drawing of the figure, although he has studied much from the life, is also too often defective in solidity, firmness, and correctness of outline. It cannot be denied, however, that notwithstanding these defects Mr. Huntington's art often gives pleasure to the observer. It has been a source of satisfaction and improvement to multitudes. If he has wrested no discoveries from the truths of nature, if he has not explored deeply into the mysteries of character, or introduced new styles of artistic expression, he has, on the other hand, been no tame imitator, he has not cloyed the taste with inane mannerisms, and the motive of his art life has been pure and elevating (part 2, p. 6).

BIBLIOGRAPHY: [Daniel Huntington] *Catalogue of Paintings, by Daniel Huntington, N.A., Exhibiting at the Art Union Buildings* ... (1850). This catalogue of a special exhibition of one hundred and thirty of his works contains a preface and catalogue entries by the artist // Henry T. Tuckerman, *Book of the Artists* (New York, 1867), pp. 321–332. An account of the artist's life consolidating much of the material on the subject by the author previously published elsewhere // D[aniel] O'C[onnell] Townley, "Daniel Huntington, Ex-President N.A.D.," *Scribner's Monthly* 2 (May 1871), pp. 44–49. An excellent contemporary account of the artist's life // G[eorge] W[illiam] Sheldon, *American Painters: With Eighty-three Examples of Their Work Engraved on Wood* (New York, 1879), pp. 100–109. Chiefly valuable for Huntington's comments on painting and various artists he knew // S[amuel] G[reene] W[heeler] Benjamin, "Daniel Huntington, President of the National Academy of Design," *American Art Review* 2 (1881), part 1, pp. 223–228, part 2, pp. 1–6; reprinted in S. R. Koehler, ed., *American Artists and Their Works* (Boston, 1889), 1, pp. 81–96, and in Walter Montgomery, ed., *American Art and American Art Collections* (Boston, 1889), pp. 19–36.

Mary Inman

When this picture came to the museum it was identified by the donor as a portrait of Mary Inman painted in England about 1844 or 1845 by her father HENRY INMAN. The picture was catalogued this way in the Gardner and Feld volume which appeared soon after the painting was acquired. The portrait, however, is almost certainly not the work of Inman but of Huntington as it corresponds in every detail to an engraving

Huntington, *Mary Inman*.

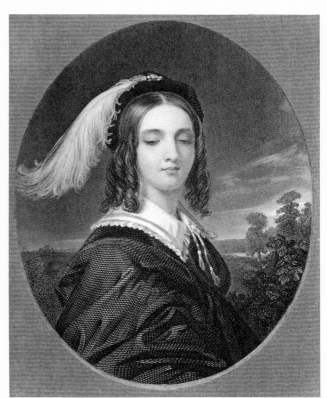

Beatrice, engraving by Cheney after Huntington.

executed by John Cheney in 1843 for *The Gift* (1844), where it is identified as being after a painting by Huntington. Three other versions of the picture are recorded, among them a possible copy by one of Huntington's students and a replica by the artist himself. Of the known pictures, however, the Metropolitan's is the closest in detail to the Cheney engraving. Thus given the absence of another more likely candidate, this painting is most probably Huntington's original. He painted the original portrait of Mary Inman about 1842 or 1843 for her father who was his teacher and friend. It has had various titles, including *The Artist's Daughter*, *The White Plume*, and *Beatrice*.

The museum's painting may be the picture exhibited at the National Academy of Design in 1844 under the title *Beatrice* (the name that appeared on the Cheney engraving in *The Gift*). It may also have been the version exhibited in the 1850 Huntington exhibition and admired by the critic Henry T. Tuckerman as one of the artist's best works. Stylistically it resembles Huntington's early manner in portraying female faces, for example Mercy in the first version of *Mercy's Dream*, 1841 (PAFA; ill. below). The style is also close to the loosely applied brushwork

of Inman's mature period, and, indeed, it is very much the work of an Inman student.

Painted in a sweet sentimental style, *Mary Inman* is an idealized version of feminine beauty and virtue. The lowered eyes, a favorite device of Huntington's, assure the viewer of the subject's modesty and at the same time suggests a submissiveness in tune with Victorian notions of deportment. The sentimental nature of the painting, however, is made palatable by competent execution and beautiful coloring.

Before going to England with her father in 1844, Mary Inman eloped. According to family tradition, when she confessed this on arrival in London, her father sent her home to her husband, Smith Coddington. She became the mother of five children. From a diary she kept in 1857 (typescript copy Dept. Library), we know that she was well-educated, religious, and basically a cheerful woman, although she suffered from severe attacks of asthma.

The shadows, particularly in the area of the subject's head, were abraded at some point during cleaning.

Oil on canvas, 30 × 25 in. (76.2 × 63.5 cm.).
RELATED WORKS: Daniel Huntington, *Portrait of*

Mary Inman, oil on canvas, 17¼ × 14 in. (43.8 × 35.6 cm.), ca. 1846–1854, Munson-Williams Proctor Institute, Utica, N.Y. // *Lady with a White Feather*, oil on canvas, 28 × 23¼ in. (71.1 × 59.1 cm.), n.d., Worcester Art Museum // *Beatrice*, oil on canvas, formerly coll. Players Club, New York (according to memo in Dept. Archives), unlocated // John Cheney, *Beatrice*, engraving 4¼ × 3 1/16 in. (10.8 × 8.8 cm.), probably 1843, published as frontispiece in *The Gift* (1844). This engraving also appears in R. L. Griswold, *The Poets and Poetry of England* (New York, 1845), opp. p. 337, as Fair Inez and again in *The Gift* (1845), opp. p.113, as Beatrice.

REFERENCES: D. Huntington, *Catalogue of Paintings by Daniel Huntington, N.A., Exhibition at the Art Union Building* (1849), with manuscript notes by Huntington, Frederick Fairchild Sherman Papers, Arch. Am. Art, extracts in Dept. Archives, lists "Portrait of a Painter's Daughter. Originally painted for Henry Inman, N.A., Proprietor, D. H., the white plume" (possibly this picture) // H. T. Tuckerman, *Book of the Artists* (1867), p. 330, lists the most outstanding paintings by Huntington exhibited in the 1850 exhibition and states "of the portraits...that of a 'Painter's Daughter' —his friend Inman's, full of rich expression . . . [is] among the heads which gave Huntington so high a reputation for portraiture" (possibly this picture) // S. R. Koehler, *Catalogue of the Engraved and Lithographed Work of John Cheney and Seth Wells Cheney* (1891), p. 70, lists the engraving under its various titles and includes the following: "'The original,' writes Mr. Huntington, was a painting, a portrait of Mary Inman, daughter of Henry Inman, afterwards Mrs. Coddington. The original belongs to Wm. H. Appleton, of New York. I painted a replica for Mr. —— of Phil., the drapery slightly varied. There are two or three copies by pupils. Mrs. Edna D. Cheney has a preparatory outline for this engraving, in pencil on paper, marked off in squares in red ink. From a copy of, or draft for a bill for four plates for 'The Gift,' dated Dec. 30, 1843, still preserved among John Cheney's papers at Manchester, Conn., it appears that he received $225. for this plate" // E. Coddington, donor, letter in Dept. Archives, July 23, 1964, gives information about the sitter and the picture // Gardner and Feld (1965), p. 222, catalogues this painting as by Inman, 1844.

EXHIBITED: NAD, 1844, no. 200, as *Beatrice* (possibly this picture) // Art Union Building, New York, 1849–1850, *Paintings by Daniel Huntington, N.A.* (not listed in 1850 catalogue but mentioned as being in the exhibition in Huntington's 1849 copy of the catalogue and by H. T. Tuckerman in 1867, see references above) (possibly this picture).

EX COLL.: the subject's grandson, Dave Hennen Coddington, until 1956; his wife Eleanor Coddington, New York, until 1964.

Gift of Mrs. Dave Hennen Coddington, in memory of her husband, subject to a life estate in the donor, 1964.

64.95.

Mercy's Dream

The best known of Huntington's allegorical productions and the painting which largely established his reputation, *Mercy's Dream* is drawn from part two of John Bunyan's *Pilgrim's Progress* (1684), a source which inspired the artist on several occasions. The subject centers on the passage in which Mercy tells Christiana:

I was dreaming that I sat all alone in a solitary place, and was bemoaning of the hardness of my heart methought I looked up, and saw one coming with wings towards me. So he came directly to me, and said, "Mercy, what aileth thee?" Now, when he had heard me make my complaint, he said, "Peace be to thee;" he also wiped mine eyes with his handkerchief, and clad me in silver and gold. He put a chain about my neck, and ear-rings in mine ears and a beautiful crown upon my head. Then he took me by the hand, and said, "Mercy, come after me." . . . I followed him up to a throne, upon which One sat; and He said to me "Welcome, daughter!" The place looked bright and twinkling, like the stars, or rather like the sun.

The painting in the Metropolitan is Huntington's third version of *Mercy's Dream*, painted in 1858 during his second visit to England.

The first version of *Mercy's Dream*, painted in 1841, was acquired by the Philadelphia collector Edward L. Carey, whose brother Henry later bequeathed it to the Pennsylvania Academy of the Fine Arts. Exhibited at the National Academy of Design in 1841, it attracted a great deal of attention from public and critics alike. The notices, however, were not wholly uncritical. For example, the *Knickerbocker Magazine* (18 [July 1841], p. 86) reported:

The main effect is very pleasing. The background is grand. The figure of Mercy, too, is exceedingly lovely. . . . The right arm seems to us to be rather feebly drawn and inferior to the rest of the figure. The Angel is less felicitously conceived and executed: the head is not beautiful, and the hair indifferently managed. As a whole, however, this picture reflects great credit upon Mr. HUNTINGTON.

Shown in Philadelphia in 1842, 1843, and 1847, the first version was lent by Carey's sister to the 1850 New York exhibition of Huntington's works. The artist, in the annotated catalogue for that exhibition, wrote: "The landscape of this picture represents a lonely place, at late twilight. Mercy is not sleeping, but in a trance, half conscious" (*Catalogue of Paintings, by Daniel Huntington, N.A., . . .* [1850], p. 22, no. 48).

The original painting was engraved by John Cheney in 1843. Huntington, in a letter to E. L.

Carey on September 30, expressed his delight with "Cheney's Mercy," calling it "a wondrous specimen of engraving" (Gratz Collection, Case 8, Box 1, Historical Society of Pennsylvania, Philadelphia, microfilm P22, Arch. Am. Art). In 1849, Alexander Hay Ritchie was commissioned to engrave the work for the Philadelphia Art Union, and the production of this print became the subject of a lengthy exchange of letters between Huntington and Henry C. Carey. These letters document some of the difficulties of translating a painting into the graphic medium. A copy of the painting by McMurtrie, probably James McMurtrie, Jr. (active 1843–1864), was to be used as a model. Huntington, however, did not approve of it: "I would have as so thought of employing Michael Angelo to copy a miniature by Miss Ann Hall as to have commissioned the erratic and impatient genius of McMurtrie to do *anything* requiring so *minute* and *slavish* an imitation—what can be done?" (Huntington to H. C. Carey, Nov. 24, 1849, Historical Society of Pennsylvania, microfilm P23, Arch. Am. Art). In the end Huntington decided that "to do justice to all concerned," he would make a copy himself for the engraver, and this he did in 1850. The second version, Huntington had assured Carey in a letter dated December 21, 1849, would differ in size and be clearly marked to distinguish it from the original (E. L. Carey Papers, Edward Carey Gardiner Collection, Historical Society of Pennsylvania, Philadelphia, microfilm P24, Arch. Am Art). Inscribed "the 2nd picture of Mercy's Dream / painted 1850," it was acquired by William Corcoran and is now in the Corcoran Gallery of Art, Washington, D.C.

The third, or Metropolitan, version of *Mercy's Dream* was also made for an engraver. Huntington painted it in London for Thomas Oldham Barlow, whose print was published in New York in 1864. The Cooper-Hewitt Museum has several drawings said to be preparatory studies for this version. Showing the protagonists as nude figures, two of the studies reveal Huntington's working methods. Of the figures in Huntington's group compositions, the aspiring artist Sylvester Genin reported, "He drew them naked first, and then clothed them" (*Crayon* 2 [Nov. 1855], p. 290), a practice which he apparently continued. Essentially following the basic composition of the first two versions, the Metropolitan's painting differs chiefly in that the figures are larger, occupying more of the foreground, and the mountain in the right distance has been adjusted to make a more cohesive unit with the foreground

Daniel Huntington

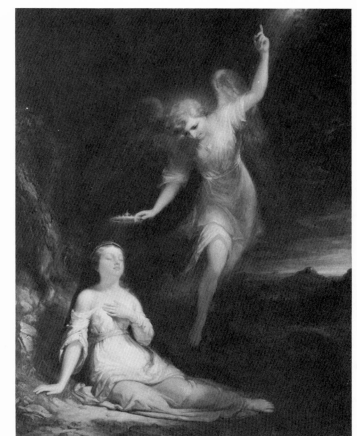

Huntington, *Mercy's Dream*, PAFA.

Huntington, *Mercy's Dream*,
Corcoran Gallery of Art, Washington, D.C.

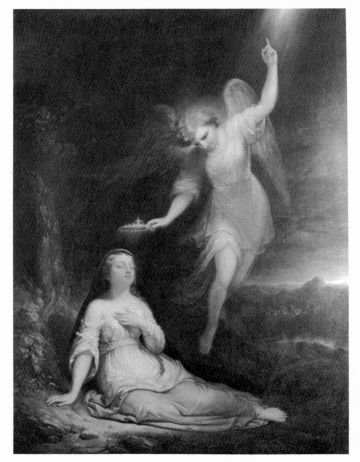

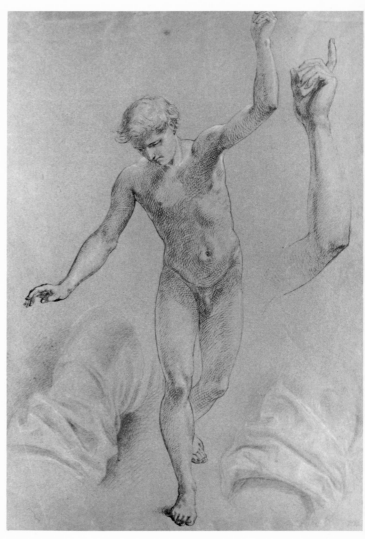

Huntington, *Nude Angel, Angel's Arm, and Drapery Studies*, drawing, Cooper-Hewitt Museum, New York, 1942–50–109.

Huntington, *Mercy's Hand and Arm*, drawing, Cooper-Hewitt Museum, New York, 1942–50–108.

Huntington, *Mercy*, drawing, Cooper-Hewitt Museum, New York, 1942–50–44.

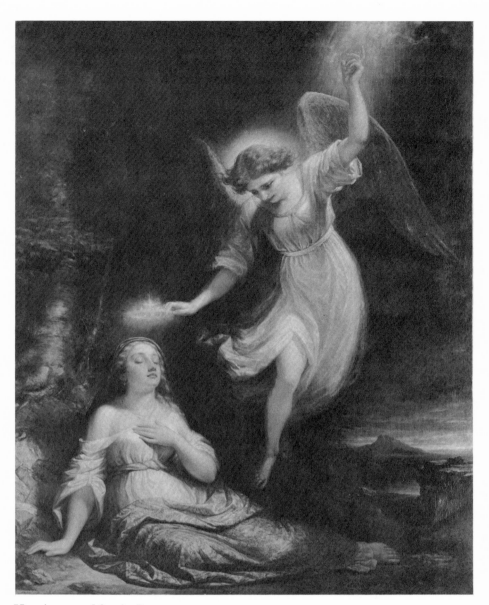

Huntington, *Mercy's Dream.*

elements. Forms function more convincingly as
volumes in space and are better articulated.
Huntington has taken a more linear approach,
depending less on chiaroscuro. In general, there
is a greater interest in descriptive detail in the
third version. Unlike the earlier versions, the
artist adhered more closely to the literary source
in this work, showing Mercy wearing the neck
"chain" and earrings mentioned in the Bunyan
text.

Mercy's Dream reflects Huntington's depen-
dence on models of the Italian Renaissance. In
form and composition Huntington owes a debt

to such Italian masters as Raphael, Correggio,
and Guido Reni, whose works he studied in Italy
during his first trip abroad. As a nineteenth-
century interpretation of these sources, however,
it is dominated by effusive sentiment and rhetoric.
Equally influential were the religious productions
of the Nazarenes, particularly those of Johann
Friedrich Overbeck, whom Huntington extolled
in a lecture on Christian art at the National
Academy of Design on February 24, 1851, pub-
lished in part in the *Literary World* (8 [March 8,
1851], p. 196). The linear and illustrative charac-
ter which distinguishes the Metropolitan's version

from the others owes perhaps as much to the influence of the English Pre-Raphaelites and Huntington's studies at the Kensington Life Academy.

In the preface to his 1850 New York exhibition catalogue, Huntington discussed his interest in such themes (p. 11):

The class of pictures in the collection, which have been painted with the greatest interest, are those which are meant to convey a moral lesson, and are ideally treated . . . Subjects of this kind can be composed without the trammels of a fixed costume; are confined to no age or country, and depend upon no temporary excitement for their interest—but appeal to those feelings which belong to the human race.

This early statement demonstrates Huntington's preference for didactic subjects, a taste that he felt compelled to justify. "A moral design in a work of art is a very proper one, I think—in fact, it is the highest of all designs; but it may be reached by a process little suspected," he later observed.

If you hold that the artist's object is simply to present truth without teaching, you cut off from the realm of art some of the masterpieces of the world. Bunyan's descriptions are certainly pictures, and their sole intention was moral. . . . One gets very much disgusted, certainly, by pictures designed to teach a moral or religious truth, but feebly and poorly painted. Yet, when a picture is a work of art in every other respect, the fact that it conveys and impresses a moral truth does not make it not a work of art. (G. W. Sheldon, *American Painters* [1879], p. 102).

As S. G. W. Benjamin observed in 1881 "Huntington's aspirations have found their truest expression in the ideal compositions based on the principles of the Christian faith" (p. 25). *Mercy's Dream*, the work which largely established his reputation, provided an apt vehicle for these aspirations.

Oil on canvas, 84 × 66¼ in. (213.4 × 168.3 cm.).
Signed, inscribed, and dated at lower left: D. Huntington / London 1858.
RELATED WORKS: *Mercy's Dream*, sketch, 6 × 8 unlocated, listed in the *Crayon* 3 (April 1856), p. 123 and in Leavitt, Strebeigh and Company, Clinton Hall Art Galleries, New York, *Catalogue of the Paintings of the Late Mr. A. M. Cozzens*, sale cat. (May 22, 1868), no. 4, as "The first thought for the large picture" // *Mercy's Dream*, first version, oil on canvas, 84 × 67 in. (213.4 × 170.2 cm.), 1841, PAFA, ill. in National Collection of Fine Arts, *Academy*, exhib. cat. by L. M. Fink and J. C. Taylor (1975), no. 69 // John Cheney, *Mercy's Dream*, engraving, 3⅛ × 4¹⁄₁₆ (7.9 × 10.3 cm.), published as frontispiece to *The Gift* (1843), printed

by Butler and Long // D. Huntington, *Mercy's Dream*, second version, oil on canvas, 90¼ × 67½ in. (229.2 × 171.5 cm.), 1850, Corcoran Gallery of Art, Washington, D.C. ill. in D. Phillips, *A Catalogue of the Collection of American Paintings in the Corcoran Gallery of Art*, 1 (1966; 1974), p. 99 // Alexander Hay Ritchie, *Mercy's Dream*, mezzotint, 1850, made for the Philadelphia Art Union with a copyright to Henry C. Carey // Joseph Kyle and Edward Harrison May, *Mercy's Dream*, copy after Huntington's work for a panorama of *Pilgrim's Progress*, unlocated, noted in *Bulletin of the American Art-Union* (August 1850), p. 82; (Dec. 1850), pp. 155–156 // Jacob A. Dallas and Joseph Kyle, possibly another version of *Mercy's Dream* after Huntington's work for a revised edition of a panorama of *Pilgrim's Progress*, unlocated, but mentioned in *Bulletin of the American Art-Union* (June 1851), p. 48 // D. Huntington, preliminary drawings, 1857–1858, Cooper-Hewitt Museum, New York: *Mercy*, pencil, black and white chalk on gray paper, 15 × 18½ in. (38.1 × 47 cm.), 1942–50–43, ill. in *Winterthur Portfolio* 14 (Summer 1979), p. 189, fig. 14; *Mercy*, pencil and white chalk on blue paper, 14¾ × 21 in. (37.5 × 53.3 cm.), 1942–50–44; *Mercy*, pen, black ink, and white chalk on blue paper, 15 × 22 in. (38.1 × 55.9 cm.), 1942–50–45, ill. in *Winterthur Portfolio* 14 (Summer 1979), p. 189, no. 15; *Angel's Head*, verso, *Nude Angel*, pencil and white chalk on blue paper, 10¾ × 14½ in. (27.3 × 36.8 cm.), 1942–50–104, recto ill. in *Winterthur Portfolio* 14 (Summer 1979), p. 190, fig. 18; *Nude Angel, Angel's Arm, and Drapery Studies*, pencil, pen and ink, and white chalk on blue paper, 21½ × 14¾ in. (54.6 × 37.5 cm.), 1942–50–109, ill. in *Winterthur Portfolio* 14 (Summer 1979), p. 189, no. 16; *Clothed Angel*, pencil and white chalk on blue paper, 15 × 10⅞ in. (38.1 × 27.6 cm.), 1942–50–105, ill. in *Winterthur Portfolio* 14 (Summer 1979), p. 190, fig. 19; *Drapery Study for Angel*, pencil and white chalk on blue paper, 14⁹⁄₁₆ × 10¾ in. (37.0 × 27.3 cm.), 1942–50–106; *Mercy's Arm and Hand*, pencil and white chalk on blue paper, 14¾ × 10½ in. (37.5 × 26.7 cm.), 1942–50–108; *Angel's Hand and Arm*, pencil, pen and ink, and black, red, and white chalk on paper, 10⅞ × 15 in. (27.6 × 38.1 cm.), 1942–50–107; ill. in *Winterthur Portfolio* 14 (Summer 1979), p. 191, fig. 20; *Angel's Head and Arm*, pencil, pen and ink, and white chalk on blue paper, 20⅝ × 15 in. (52.4 × 38.1 cm.), 1942–50–110, ill. in *Winterthur Portfolio* 14 (Summer 1979), p. 190, fig. 17 // *Drapery Study for Mercy's Dream*, charcoal and white chalk on paper, 5½ × 9 in. (14 × 22.9 cm.), University of Kansas Museum of Art, Lawrence, ill. in *Winterthur Portfolio* 14 (Summer 1979), p. 191, fig. 21 // Thomas Oldham Barlow, *Mercy's Dream*, engraving, 1864, published by Thomas Kelly, New York // Unidentified artist, chromolithograph or color print, unlocated, if produced as proposed by Huntington in a letter to H. C. Carey, Dec. 16, 1870, E. L. Carey Papers, Edward Carey Gardiner Collection, Historical Society of Pennsylvania, microfilm, P24, Arch. Am. Art // Unsigned *Mercy's Dream*, oil on canvas, about 36 × 30

(91.4 × 76.2), unlocated, formerly private collection, 1927, noted in National Collection of Fine Arts, *Academy*, exhib. cat. by L. M. Fink and J. C. Taylor, (1975), no. 69 // F. E. Jones, *Mercy's Dream*, engraving after unsigned version listed above, for 1876 edition of *Pilgrim's Progress*, published by Hitchcock and Walden of Cincinnati.

REFERENCES: *Crayon* 5 (Oct. 1858), p. 297, notes "During his stay in London, Mr. Huntington arranged for an engraving, by Barlow, of his picture of Mercy's Dream"; 7 (May 1860), p. 137, cites the recently issued ninth volume of the *New American Cyclopaedia*, which notes that: "He recently painted in England another picture of 'Mercy's Dream,' which Barlow is now engraving" // J. J. Jarves, *The Art-Idea* (1864; 1960 ed. by B. Rowland, Jr.), p. 204, recalls "Huntington's Angel of Mercy," as an illustration of "meretricious weakness" // H. T. Tuckerman, *Book of the Artists* (1867), p. 322, mentions his illustrations of *The Pilgrim's Progress*; p. 328, discusses the original version and gives the passage from Bunyan; p. 331, mentions this version as a replica in the collection of Marshall O. Roberts, New York, and notes that "the original sketch of 'Mercy's Dream'" was owned by A. M. Cozzens; p. 626, lists replica in Roberts's collection // Leavitt, Strebeigh and Company, Clinton Hall Art Galleries, New York, *Catalogue of the Paintings of the Late Mr. A. M. Cozzens*, sale cat. (May 22, 1868), no. 4, lists a Mercy's Dream, 6 × 8, and notes that it is "The first thought for the large picture—one of his most noted and popular works. The large picture has been engraved in line by Thomas Oldham Barlow, London. The original is now in possession of Marshall O. Roberts, Esq" // D. O'C. Townley, *Scribner's Monthly* 2 (May 1871), pp. 46–47, notes this version among the important works Huntington painted in Europe in 1858, adding that it varied "in its details from his first picture of the subject" // E. Strahan [E. Shinn], ed., *The Art Treasures of America* (1880), 2, p. 15, describes this painting in the collection of Mrs. Marshall O. Roberts as "the latest and faultiest of three repetitions of his popular subject by D. Huntington"; p. 16, lists it // S. G. W. Benjamin, *American Art Review*, 2, part 1 (1881), p. 227, reprinted in S. R. Koehler, ed., *American Artists and Their Works* (1889), 1, p. 87, and in W. Montgomery, ed., *American Art and American Art Collections* (1889), p. 25, discusses the painting, its versions and engravings, and notes that: "a third copy, executed from memory for Olden Barlow, the engraver, during Mr. Huntington's second visit to England, is owned by Mr. Marshall O. Roberts, of New York" // S. Isham, *The History of American Painting* (1905), p. 279, fig. 62; pp. 285–286 // O. S. Tonks, *DAB* (1932; 1960), s.v. "Huntington, Daniel," mentions the painting // H. B. Wehle, *MMA Bull.* 4 (April 1946), 203, ill. [p. 213] // A. Gilchrist, *Antiques* 87 (June 1965), p. 710, fig. 3 // D. Phillips, *A Catalogue of the Collection of American Paintings in the Corcoran Gallery of Art* (1966), 1, p. 100, mentions it in cataloging second version // R. Williams, British

Museum, letter in Dept. Archives, Jan. 10, 1967, supplies information on Barlow's engraving // E. L. Kallop, Jr., Cooper Union, letter in Dept. Archives, March 2, 1967, says the drawings for *Mercy's Dream* in Cooper Union (now Cooper-Hewitt) Museum "date 1857 and are, therefore, for the later version" // National Collection of Fine Arts, *Academy*, exhib. cat. by L. M. Fink and J. C. Taylor (1975), no. 69 // L. M. Fink, *American Art Review* 4 (Jan. 1978), color ill. p. 77; p. 78 // W. H. Gerdts, *Winterthur Portfolio* 14 (Summer 1979), pp. 171–194, discusses Huntington's paintings of *Mercy's Dream* in depth.

EXHIBITED: Metropolitan Fair, New York, 1864, *Catalogue of the Art Exhibition at the Metropolitan Fair* (for the benefit of the United States Sanitary Commission), p. 8, no. 66, as lent by M. O. Roberts, notes that the engraving by Barlow was "nearly finished" // Baltimore Museum of Art, 1940, *Romanticism in America*, unnumbered cat. // MMA, 1946, *The Taste of the Seventies*, no. 123; 1965, *Three Centuries of American Painting*, unnumbered cat.

EX COLL.: Thomas Oldham Barlow, 1858; Marshall O. Roberts, by 1864–1880; his estate (sale, Ortgies and Company, Fifth Avenue Art Galleries, New York, Jan. 19, 1897, no. 60, $525); the artist.

Gift of the artist, 1897.

97.35.

Mrs. Birdsall Cornell

The former Sarah H. Lyon of New York was married in 1851 to Birdsall Cornell, the eldest son of Harriet Leslie and George Cornell, who was associated with the New York firm of Cornell, Althause & Company Ironworks. The Birdsall Cornells had two children: Lizzie Leslie, who died unmarried, and George Birdsall, who married Eleanor E. Jackson in 1882 and had eight children. Their only daughter, Elizabeth Leslie, later Lady Doverdale, gave this portrait of her grandmother to the Metropolitan Museum.

Painted in 1860, the three-quarter-length portrait was exhibited at the National Academy of Design in 1862. Mrs. Cornell is shown seated on an iron chair, flanked on the left by a fountain figure of a putto pouring water from an ewer. The open vista into a wooded glade on the right is a conventional compositional device that serves to draw attention into the distance. Mrs. Cornell's pose corresponds to the treatment of the background. The calculated composition, the studied setting, the pose of the sitter, her lavish costume, and the theatrical lighting contribute to the contrived effect of the whole. Fashionable period conventions are closely observed, and the attention given the external trappings, over-

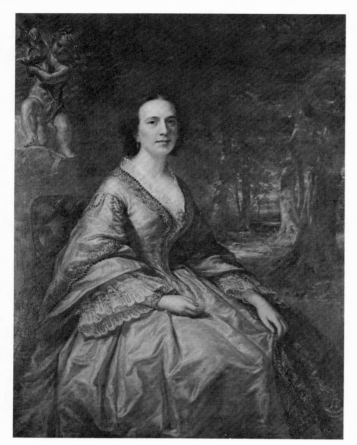

Huntington, *Mrs. Birdsall Cornell.*

1860. Canvas stamp: W. SCHAUS / Artists' Colorman / [torn] BROADWAY / NEW YORK.

REFERENCES: Lady Doverdale, letter in MMA Archives, [1953], offers the painting as a gift, identifying the subject as her grandmother and incorrectly dates it 1863 // J. Cornell, *Genealogy of the Cornell Family Being an Account of the Descendants of Thomas Cornell of Portsmouth, R.I.*, (1902), pp. 259, 265–266, provides biographical information on the sitter.

EXHIBITED: NAD, 1862, no. 424, as A Lady, lent by Birdsal[l] Cornell.

EX COLL.: descendants of the subject, until 1953.

Gift of Lady Doverdale, 1953.

53.76.

Anna Watson Stuart

The subject of this portrait, formerly known only as "Portrait of a Lady," is Anna Watson Stuart (1817–1881). She was the youngest of ten children of Robert and Anne Watson and the grandmother of Mrs. Denny Brereton, who donated the work to the Metropolitan Museum. Anna Watson was married to Joseph Stuart, an Irishman. He and his brothers owned Stuart Brothers, a drygoods business in Philadelphia, but in 1833 Joseph Stuart moved to New York where he later became a senior partner in the banking firm of J. & J. Stuart. The family, which included four children (Margaret, Annie, Joseph, and Robert), lived at 36 Beach Street from 1839 to 1859 when they moved to 11 East 36th Street. Joseph Stuart died in New York on November 18, 1874, and his wife died seven years later in Orange, New Jersey, the victim, according to family accounts, of a carriage accident.

The painting is undated but has stylistic affinities to Huntington's portrait of Mrs. Cornell (see above) executed in 1860. The bracelet worn by Mrs. Stuart also suggests a date not earlier than the 1860s. Consisting of six cameo portraits of Mr. and Mrs. Stuart and their four children, the bracelet was carved by Augustus Saint-Gaudens between 1861 and 1867.

The subject's pensive pose and bemused expression are overpowered by the artist's interest in such details of costume as the jewelry, laces, and ermine stole, which are suggested with quick broad brushstrokes. The effect conveyed by the expansive figure in her lavish apparel and the artist's bravura technique is sustained by the use of a dramatic palette. The black velvet dress serves as a foil for the white lace, the white ermine with its black tails, and the crimson upholstered chair.

shadows the character of the sitter, which lacks strong definition.

In portraits such as this, Huntington deals chiefly with the conventional world of fashion and appearance, accommodating himself to what was apt to find approval. His observations on portraiture, however, present an ambivalent attitude, alternating between a preference for a candid and an edited, or idealized representation of the subject. "Absolute truth is undoubtedly in one sense the most desirable in a portrait, if the artist can know and feel it," Huntington told George W. Sheldon.

The real character, not the obvious character, is what he tries to represent. . . . Still, it seems proper that his [the subject's] finest traits should be emphasized in a portrait, since every side of his character cannot be given in the same picture. For example, in painting a lady's portrait wouldn't it be just to subdue minor infelicities of profile or complexion, to present the best of her appearance . . . ? That painting, it seems to me, is of a higher order which discerns the germs of truth in the sitter's character, and brings them out. (*American Painters* [1879], pp. 100–101).

Oil on canvas, 55⅞ × 44 in. (141.9 × 111.8 cm.).

Signed and dated at left center: D. Huntington /

The dark modeling of the subject's dress, the shadow in her face, and the hand against her cheek have suffered damage from solvents used in cleaning.

Oil on canvas, 50 × 40 in. (127 × 101.6 cm.).

Signed on chair arm at right center: D. Huntington. Canvas stamp: [first line illegible] 111 Fulton St./ NEW YORK/General Depot/ARTISTS' MATERIALS.

REFERENCES: *New York Times*, Nov. 19, 1874, includes obituary notice of the subject's husband // *New York Evening Post*, Sept. 2, 1881, notes subject's death in Orange, New Jersey // Mrs. R. W. Stuart, letters in MMA Archives, Feb. 9, 21, 1908, describes and gives information on the subject's bracelet and includes biographical information on her husband // R. W. Stuart, letter in MMA Archives, Feb. 24, 1908, discusses date of cameos // Mrs. R. W. Stuart, letter in MMA Archives, Feb. 27, 1908, discusses cameo bracelet // E. Brereton, letters in Dept. Archives, March 12, 1973, identifies the subject, and April 10, 1978, provides family history related to the portrait // J. H. Dryfhout, Saint-Gaudens' National Historic Site, Cornish, N.H., orally, May 24, 1978, supplied dates for the bracelet.

Ex COLL.: descendants of the subject, until 1943.

Gift of Mrs. Denny Brereton, 1943.

43.55.2.

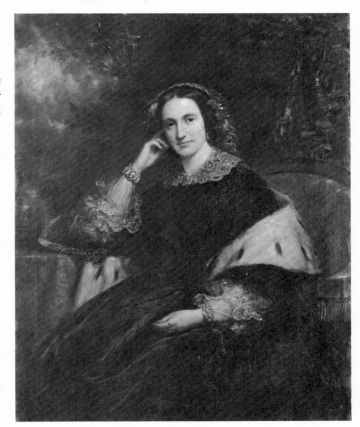

Huntington, *Anna Watson Stuart*.

Study in a Wood

Huntington, *Study in a Wood*.

This cabinet-size portrait of a girl preoccupied with a large book in a grove of trees exemplifies the idealized, often sentimental, "fancy" subjects popular during the mid-nineteenth century.

In the past the painting suffered damage from solvents used in cleaning.

Oil on canvas, 11⅞ × 10 in. (30.2 × 25.4 cm.).

Signed and dated at lower left: D. Huntington/ 1861. Canvas stamp: GOUPIL & C°./Artist's Colourm[en]/[&] PRINT SELLER[S]/366/BROADWAY/NEW YORK.

REFERENCES: Somerville Art Gallery, New York, *Catalogue of Valuable Paintings, Partly Belonging to the Estate of the Late Mr. Charles Harvey, of Baltimore, and sold by order of the executors, Mr. W. T. Walters, and Mr. B. F. Newcomer . . .*, sale cat. (March 31, 1870), no. 53, as Study in a Wood // E. Strahan [E. Shinn], ed., *The Art Treasures of America* (1880), 3, p. 42, lists it in Mr. Colis [*sic*] P. Huntington's collection as Study in the Woods.

EXHIBITED: Brooklyn Art Association, March 1863, no. 32, as A Study in the Woods, lent by Mr. W. [Walters, annotation in MMA copy of catalogue] (possibly this picture).

Ex COLL.: unknown owner (sale, Somerville Art Gallery, New York, March 31, 1870, no. 53, as Study

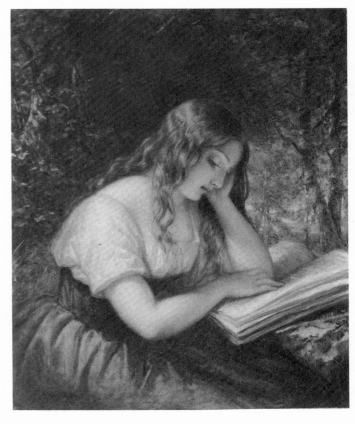

Daniel Huntington

in a Wood, $370); Collis P. Huntington, 1870–1900; his wife, later Mrs. Henry E. Huntington, subject to a life interest in the donor's wife, 1900–1924; Archer M. Huntington, son of Collis P. Huntington, subject to a life interest in the donor's son, which was relinquished, 1924–1925.

Bequest of Collis P. Huntington, 1900.
25.110.42.

John David Wolfe

A native of New York, John David Wolfe (1792–1872) was one of its most prominent citizens. He made a fortune in the hardware business and invested much of his money in New York real estate. His wife was the former Dorothea Ann Lorillard, a member of the tobacco manufacturing family. A founder and director of the Chemical Bank and a director of the Hudson River Railroad, Wolfe retired in 1842 and devoted much of his time to philanthropic enterprises. He served as president of the American Museum of Natural History from 1869 to 1872 and also took an active interest in New York Hospital and the New-York Historical Society. His fortune was inherited by his daughter, Catharine Lorillard Wolfe, who continued his philanthropic interests. Initially advised by her cousin, the collector John Wolfe, she assembled a large art collection, consisting mainly of contemporary nineteenth-century European paintings, which she bequeathed to the Metropolitan Museum, together with a substantial sum to insure their preservation and to provide income for future acquisitions.

This portrait, painted in 1871, shows Wolfe as a benign old gentleman. Wearing a black suit and a cape lined with black satin, he is seated in an armchair upholstered in red. Subtle gradations of brown, gray, and yellow serve to give definition to the background. Executed with quick brushstrokes that describe the texture of the material and flesh in summary fashion, the work, despite this technique, conveys the impression that it was painted from a photograph. Huntington produced replicas of the portrait in 1874 and 1886. He also painted two portraits of Catharine Lorillard Wolfe: one was exhibited at the American Art-Union in 1850, and the second, a copy after her portrait by Alexandre Cabanel, 1876 (MMA), belongs to Grace Church in New York.

Oil on canvas, 43¼ × 37⅜ in. (109.9 × 94.9 cm.).

Signed and dated at lower right: D. Huntington / 1871.

RELATED WORKS: replica, oil on canvas, 37 × 42 in. (94 × 106.7 cm.), 1874, New York Hospital // replica, oil on canvas, 42 × 36 in. (106.7 × 91.4 cm.), 1886, New York Chamber of Commerce, ill. in *Catalogue of Portraits in the Chamber of Commerce of the State of New York* (1924), p. 33, no. 86.

REFERENCES: W. E. Howe, *A History of the Metropolitan Museum of Art* (1913), I, pp. 211–212, describes Catharine L. Wolfe's bequest and mentions this portrait // W. B. Shaw, *DAB* (1936; 1964), s.v. "Wolfe, John David" // H. H. Hoelzer, letter in Dept. Archives, Jan. 5, 1967, supplies dimensions and date of replica in the New York Chamber of Commerce // E. L. Kallop, Jr., Cooper Union, letter in Dept. Archives, Jan. 7, 1967, notes the two additional portraits of the sitter by the artist.

EXHIBITED: NAD, 1871, no. 187.

Bequest of Catharine Lorillard Wolfe, 1887.
87.15.78.

Huntington, *John David Wolfe.*

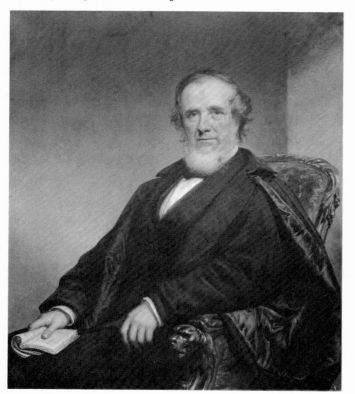

Nicoll Havens Dering

Nicoll Havens Dering (1865–1869) was the son of Sylvester Dering, a prominent lawyer and manufacturer in Utica, New York, who presented this painting to the museum along with four other family portraits, including a representation of his wife also by Huntington (see below) and portraits of Mrs. David Chesebrough and Mary Sylvester, painted by JOSEPH BLACKBURN (qq.v.).

The portrait is not dated, but, according to the donor, it was done in 1871, after the boy's death. Although a photograph may well have served as a model for the artist, its use is unobtrusive here. The child, dressed in blue and holding a toy dog and a tin bucket, stands in front of a dark grove of trees, thinly painted and indicated only in a cursory fashion. The artist has used a predominantly cool palette. The result is a direct and successful portrait of an appealing child without the sentimental overtones that often characterize children's portraits.

The dark areas of this portrait are abraded as a result of damage from solvents used in cleaning.

Oil on canvas, 30 × 25 in. (76.2 × 63.5 cm.).
Signed at lower left: D. Huntington.
REFERENCES: S. Dering, letter and memoranda in MMA Archives, Dec. 13, 1914, dates the painting 1871 // B. Burroughs, *MMA Bull.* 11 (June 1916), p. 132, gives date as 1870 // MMA, *Catalogue of Paintings*, by B. Burroughs (3rd ed., 1917), p. 138, lists it and supplies biographical information on the subject.
ON DEPOSIT: Bartow-Pell Mansion Museum and Garden, Pelham Bay Park, New York, 1973–present.
Gift of Sylvester Dering, 1916.
16.68.5.

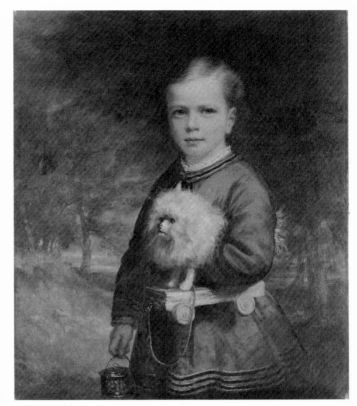

Huntington, *Nicoll Havens Dering*.

Mrs. Sylvester Dering

Ella Virginia Bristol, daughter of Willis Bristol, of New Haven, Connecticut, was married to Sylvester Dering in 1864. They lived in Utica, New York, where her husband was a prominent lawyer and a general in the New York State militia. Her portrait was painted in 1878, seven years after Huntington's representation of the Derings' son (see above). Mrs. Dering, wearing pearls and a white silk dress trimmed with lace, is shown against a rose-colored background. She clasps a bouquet of yellow roses to her bosom in a contrived gesture. Concerned primarily with surfaces, Huntington reveals little of the sitter's character. The intricate costume with its delicate tracery of lace, the appealing light palette, and the unaffected nature of the representation, impaired only by the mannered gesture, make a pleasant picture but not a profound portrait. As Huntington himself once remarked to George W. Sheldon: "The weakness of a portrait consists most often in the absence of the true character of the sitter; you feel the absence, you perceive only a waxy resemblance, an insipidity, even though the work is beautifully handled and

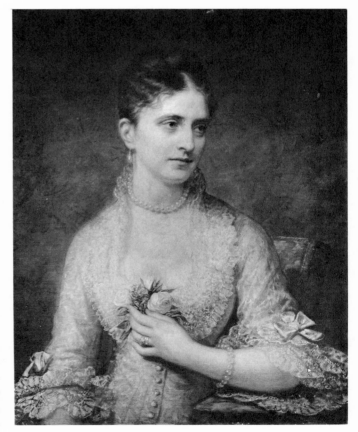

Huntington, *Mrs. Sylvester Dering*.

Daniel Huntington

nicely drawn. It is pretty, but not truthful" (*American Painters* [1879], p. 102).

At some time when the portrait was cleaned, the dark areas became abraded as in the portrait of Nicoll Havens Dering (above).

Oil on canvas, 30¼ × 25 in. (76.8 × 63.5 cm.).

Signed and dated at lower right: D. Huntington. 1878.

RELATED WORK: *Study for Mrs. Dering's left arm*, pencil and white chalk on brown paper, 9 × 12³⁄₁₆ in. (22.9 × 31 cm.), Cooper-Hewitt Museum, New York 1942-50-696.

REFERENCES: S. Dering, letter and memoranda in MMA Archives, Dec. 13, 1914, the donor incorrectly dates the painting 1871 // B. Burroughs, *MMA Bull.* 11 (June 1916), p. 132 // MMA, *Catalogue of Paintings*, by B. Burroughs (3rd ed., 1917), p. 137, lists it and supplies biographical information on the sitter // E. L. Kallop, Jr., Cooper Union Museum, Jan. 7, 1967, notes drawing for it in Cooper Union (now Cooper-Hewitt) Museum.

EXHIBITED: Marlborough-Gerson Gallery, New York, 1967, *The New York Painter* (benefit exhibition for the New York University Art Collection), p. 90.

ON DEPOSIT: Bartow-Pell Mansion Museum and Garden, Pelham Bay Park, New York, 1973-present.

Gift of Sylvester Dering, 1916.

16.68.4.

Cyrus W. Field

Cyrus West Field (1819–1892) was born in Stockbridge, Massachusetts, the son of David Dudley Field, a Congregational minister, and the former Submit Dickinson of Somers, Connecticut. By the age of thirty-three, he had amassed a fortune large enough to retire from his paper manufacturing business to pursue other interests. In 1853 he accompanied FREDERIC E. CHURCH on an expedition to South America. Field is chiefly known for his role in organizing and promoting the first transatlantic cable. After long years of effort, a short-lived success on August 16, 1858, when Queen Victoria sent a message to President James Buchanan, and repeated setbacks, the cable began successful operation in 1866. Field was also instrumental in helping to establish the elevated railway system in New York. One of the contributors to the fund for the Metropolitan Museum's purchase of the Cesnola collection of Cypriot antiquities, he later presented the museum with a collection of paintings, watercolors, and memorabilia connected with the transatlantic cable. The collection was lent to the Smithsonian Institution, Washington, D.C., in 1920.

Huntington, *The Atlantic Cable Projectors*, New York Chamber of Commerce.

Executed in 1879, this portrait is possibly based on preparatory sketches made in 1866 for Huntington's large group portrait *The Atlantic Cable Projectors*, 1895 (New York Chamber of Commerce). Officially commissioned only in 1893, that painting shows Field in a similar pose. "The first thought of a picture representing the Projectors of the Atlantic Telegraph came from Mr. CYRUS W. FIELD," Huntington wrote in 1895:

> He called at my studio soon after the final and complete success of the cable of 1866, and consulted me about painting such a group. I went with him to his house on Gramercy Park. . . . Mr. FIELD stood by the table, with charts and globe at hand, as he usually stood when explaining his plans. I then made sketches for the proposed picture (*The Atlantic Cable Projectors, Painting by Daniel Huntington Presented to the Chamber of Commerce of the State of New-York* [1895], pp. 8–10).

A sense of the theatrical pervades Huntington's romanticized characterization of Field in the Metropolitan's portrait. With his head turned to provide a three-quarter view, his hair carefully disheveled, and an expression of intense preoccupation, he is shown in a lavishly fur-trimmed coat against a dark threatening sky. The paint is applied with quick broad brushstrokes, a bravura technique that in this instance lacks the necessary deftness to be entirely successful.

Huntington, *Cyrus W. Field.*

Oil on canvas, 29½ × 24½ in. (74.9 × 62.2 cm.).

Signed and dated at lower right: D. Huntington / 1879. Canvas stamp: PREPARED BY ED^WD DECHAUX NEW YORK.

RELATED WORKS: Preparatory drawings for *The Atlantic Cable Projectors*, 1866–1895, Cooper-Hewitt Museum, New York // Oliver Ingraham Lay, *Cyrus W. Field*, copy, oil on canvas, 34 × 28 in. (86.4 × 71.1 cm.), 1886, New York Chamber of Commerce, ill. in *Catalogue of Portraits in the Chamber of Commerce of the State of New York* (1924), p. 30, no. 74, misdated 1872 // Huntington, *Cyrus W. Field*, replica, oil on canvas, 30 × 25 in. (76.2 × 63.5 cm.), 1893, New York Chamber of Commerce, ill. in *Catalogue of Portraits in the Chamber of Commerce of the State of New York* (1924), p. 29, no. 73 // *The Atlantic Cable Projectors*, oil on canvas, 87 × 108 in. (221 × 274.3 cm.), 1895, New York Chamber of Commerce, ill. in *The Atlantic Cable Projectors, Painting by Daniel Huntington Presented to the Chamber of Commerce of the State of New-York* (1895), frontis.

REFERENCES: P. B. McDonald, *DAB* (1931; 1959), s.v. "Field, Cyrus West" // H. H. Hoelzer, letter in Dept. Archives, Jan. 5, 1967, supplies dimensions and dates for portraits in the New York Chamber of Commerce // E. L. Kallop, Jr., Cooper Union, letter in Dept. Archives, Jan. 7, 1967, notes portraits in the New York Chamber of Commerce and says the portrait was used for *The Atlantic Cable Projectors* // P. Gray, New York Chamber of Commerce, orally, Jan. 18, 1967, said that the portrait by Lay is dated 1886 // A. A. Gilchrist, orally, Jan. 1967, said that sketches for *The Atlantic Cable Projectors* are in Cooper Union (now Cooper-Hewitt) Museum.

ON DEPOSIT: Smithsonian Institution, Washington, D.C., 1920–1977.

Gift of Cyrus W. Field, 1892.

92.10.41.

William C. Prime

Son of a Presbyterian minister and schoolmaster, the lawyer, journalist, and scholar William Cowper Prime (1825–1905) was born in Cambridge, New York. Following his graduation from the College of New Jersey (now Princeton) in 1843, he studied law and, after being admitted to the bar in 1846, entered practice in New York. Journalism superseded law in 1861 when he acquired an interest in the *New York Journal of Commerce* and became its editor, a position he held until 1869, serving simultaneously as president of the Associated Press. An avid collector from

Huntington, *William C. Prime.*

his early years, he specialized first in numismatics, subsequently prints and illustrated books, and, with his wife, the former Mary Trumbull of Stonington, Connecticut, became an enthusiastic collector of pottery and porcelain. After his wife's death in 1872, he continued collecting ceramics, eventually assembling more than two thousand pieces, ranging from ancient Egyptian and Greek to nineteenth-century European and American productions. In 1882, when he was appointed lecturer in the newly founded art department at Princeton, he promised the Trumbull-Prime collection of pottery to the university as the nucleus of a museum. The gift came to the Art Museum at Princeton between 1890 and 1891. Works from Prime's collection were included in his two books, *Coins, Medals and Seals* (1861) and *Pottery and Porcelain* (1878). A prolific writer, he wrote among other books: *Tent Life in the Holy Land* (1857), *Boat Life in Egypt and Nubia* (1857), *I Go-A-Fishing* (1873), and *Along New England Roads* (1892).

Prime's association with the Metropolitan Museum dates from its founding; he became one of its first vice-presidents in 1874. A firm believer in the strictest observance of the sabbath, he repeatedly opposed suggestions to open the

museum on Sunday. In 1891, when his fellow trustees voted to do so, he resigned.

As a mark of their esteem and in recognition of his work, the trustees requested Prime to sit to Huntington for his portrait. Painted in 1892, it shows Prime in an informal but strained pose, turning away from his reading to glance at the viewer. Wearing a brown velvet jacket and dark gray trousers, he is shown seated in a red-upholstered chair against the reddish-brown background of a book-lined study. A green tabletop introduces a sharp note of color contrast to relieve the primarily red-brown palette.

"A portrait may be liked by the family of the sitter, while not liked by his friends, and *vice-versa*," Huntington observed in his conversations with George W. Sheldon (*American Painters* [1879], pp. 100–101). Drawing a distinction between the official public portrait and the family portrait, he added: "I always wish to know for what purpose it is wanted before I begin to paint it. If it is to be owned by his family, I give the man a more familiar and conversational look; if by society I try to represent his active public character."

An appraisal of the portrait by the subject's nephew, Edward Prime Stevenson, in 1930, confirms Huntington's convictions:

I have never met with any members of the many family-lines interested—not to exclude other personal friends of Dr. Prime—who have thought well of the thing. It is a thousand pities that the portraiture wasn't committed to the brush of any of a score of artists, . . . better able to express the personality—a bit oriental—patriarchal—in any case, dignified and individual—of Dr. Prime at that epoch. I well remember the last time that I happened to see my uncle—. . . dropping in on him, for a bit of chat, one winter afternoon—and finding him, as usual, seated in that rich chiaroscuro of his library, in the old house in East 23rd Street—of which no wall abides today—and poring over a dubious XVI Century wood-cut, with a lens—and much irritated by what he was concluding to be a forgery. The tableau was from Rembrandt. That little squat, smug canvas, as a Museum memorial, is at once a gracious official compliment and a feeble likeness.

The modeling glazes in the painting have suffered damage from solvents used in cleaning.

Oil on canvas, 54¼ × 44 in. (137.8 × 111.8 cm.).
Signed and dated at left center: D. Huntington / 1892.
REFERENCES: D. Huntington to L. Cesnola, MMA Archives, Dec. 10, 1891, notes "I think that the compliment of a portrait of Mr. Prime for the Museum

is well deserved. His services to the museum have been invaluable," gives his price for painting the portrait, and says that the subject might prefer another artist but, he will nevertheless subscribe money for the purpose; Dec. 21, 1891, accepts commission, requests sight "measurement of the canvass," and notes "I shall be very ambitious to paint the portrait as well as possible, & to do full justice to the subject. It will interest me greatly" // W. C. Prime to H. G. Marquand, J. T. Johnston, and trustees, MMA Archives, Dec. 23, 1891, agrees to sit for portrait, expresses his appreciation, and describes his sentiments concerning the museum // D. Huntington to H. G. Marquand, MMA Archives, Feb. 22, 1892, notes "I had this morning a good two hours sitting from Mr. Prime (and it is the 5th or 6th). I have enjoyed it highly, but he may have been bored, though he has not complained. If you can find the time please come & see what has been done—I want your advice" // D. Huntington to L. Cesnola, MMA Archives, Feb. 22, 1892, reports that he has made some changes and Prime has again sat for him, invites Cesnola, Marquand, and Avery to see the portrait and advise him, notes "If you three and Mr. Dudley Warner cannot tell me what the portrait lacks; *who* can? I have post-poned any further sittings till you have pronounced judgment"; March 1, 1892, notes "I have enjoyed painting Dr. Primes portrait so much that I felt as though I ought to present it to the Museum I have a frame in progress, but it will be a week or two before it is finished"; April 23, 1892, notes: "I promised Mr. Avery to join him at the Museum at about eleven Monday . . . and hope to see you there and look at the portrait of Dr. Prime & determine on any retouching that may improve it" // W. E Howe, *A History of the Metropolitan Museum of Art* (1913), I, p. 245, n. 1, notes Prime's resignation and the portrait commission // E. P. Stevenson, nephew of the subject, to R. W. de Forest, Oct. 5, 1930, MMA Archives, discusses portrait (quoted above) // V. Rosewater, *DAB* (1935; 1963), s.v. "Prime, William Cowper," gives biographical information on the subject // F. F. Jones, Art Museum, Princeton University, letter in Dept. Archives, Feb. 27, 1964, provides information on the subject's association with the Princeton Art Museum // W. D. Garrett, *MMA Journal* 3 (1970), p. 334, fig. 27.

Gift of the Trustees, 1892.

92.17.

EDWIN WHITE

1817–1877

White was born in South Hadley, Massachusetts, and began painting at an early age without formal instruction. In 1835 or 1837 he became a pupil of Philip Hewins (1806–1850), a portrait painter in Hartford, Connecticut. He first exhibited at the National Academy of Design in 1840, when he was living in Bridgeport, Connecticut. In 1841 he moved to New York, where he studied drawing with John Rubens Smith (1775–1849) and attended antique and life classes at the National Academy of Design. He was elected an associate of the academy in 1848, and in 1849, an academician. The following year he went to Europe. In Paris he continued his studies with the history, genre, and portrait painter François Edouard Picot, a pupil of François André Vincent and Jacques Louis David, and at the Académie des Beaux-Arts. The *Bulletin of the American Art-Union* reported in November 1850 (p. 139): "EDWIN WHITE is diligently pursuing his studies in Paris. With his fine eye for color and general effect, and a proper use of the opportunities now afforded him for exercise in the other elements of his profession, we anticipate the best results from his foreign residence." "Paris," White observed in a letter to the American Art-Union, dated February 26, 1851, "appears to me as one of the most desirable places for an artist in the world, for whatever branch of the art he may chose to follow or study, he finds here the material, fine models, both male and female, costumes, and . . .

at the old Hotel de Cluny he finds the most complete collection of furniture and other objects such as tapestry, armour, old pictures" (Letters from Artists, vol. 7, American Art-Union Papers, NYHS). In the same letter, White announced his intention of going to Düsseldorf, and that city is given as his address in the catalogue of the National Academy of Design's annual exhibition for 1852. Instead of enrolling in the academy there, however, he spent two years as a student of the Düsseldorf genre painter Carl Wilhelm Hübner. After visiting Florence, Rome, and Paris, he returned to America in 1855. White revisited Europe between 1857 and 1859 and again in 1869, when after a brief trip to Antwerp, he settled in Florence, until 1875. He died two years later at Saratoga Springs, New York.

A prolific artist as well as a devoted teacher, White served on the National Academy of Design's committee of instruction for several years and was a visiting lecturer from 1867 to 1869. He painted portraits, but his principal interest was in historical and genre subjects. Perhaps his best known work was *Washington Resigning His Commission*, which he painted in 1859 for the Maryland State Senate Chamber in Annapolis for the sum of six thousand dollars. Tuckerman called him "one of our most assiduous painters" (p. 439). Admiring his industry, contemporary critics, however, questioned his originality. Designating White as one of the better academic realists and associating him with the Düsseldorf school, with which he had little sympathy, James Jackson Jarves complained that: "There is, however, nothing great or original in his art, though, as a whole, it is truer and more effective than much of that of his German teachers, owing perhaps to his studies in Italy. As a colorist he decidedly excels them." Jarves conceded, however, that "White has good taste, pure sentiment, industry, and a correct intellectual appreciation of his historical subjects" (*The Art-Idea* [1864; 1960 ed. by B. Rowland, Jr.], p. 177). The artist's "aim was the illustration of historical events," the *Art Journal* noted in 1877, "and, if he was not always successful, none can dispute the earnestness of his efforts" (p. 255).

BIBLIOGRAPHY: Henry T. Tuckerman, *Book of the Artists* (New York, 1867), pp. 438–440. Chiefly of interest for its listing of the artist's works // Obituaries: *New York Herald*, June 9, 1877, p. 10; *New York Tribune*, June 9, 1877, p. 2; *Art Journal* 3 (August 1877), p. 255, the latter provides the most comprehensive biography of the artist, although some dates are unreliable // H[enry] W. French, *Art and Artists in Connecticut* (Boston and New York, 1879), pp. 94–95 // Clara Erskine Clement and Laurence Hutton, *Artists of the Nineteenth Century and Their Works* (Boston, 1880) 2, pp. 348–389. Supplies a list of the artist's works // Groce and Wallace, p. 680.

The Antiquary

This painting of a sixteenth-century Florentine collector examining a coin in an ornately furnished Renaissance interior exemplifies the mid-Victorian preoccupation with the past. Painted in Paris in 1855, it demonstrates White's adaptation of a fashionable type of romantic genre, dealing with themes and settings of the past, which was then in vogue in Düsseldorf and Paris. The work, which owes more perhaps to the nineteenth-century theater than to historical accuracy, is a characteristic example of White's period pieces.

Without resorting to a trompe l'œil technique, the artist effectively uses color to differentiate surface and texture in the tapestry, the carved wooden chest, the stone mantel, the metal box, and the vase, and demonstrates his skill in a successful orchestration of a wide-ranging palette of richly glowing colors.

Oil on canvas, 22¼ × 27¼ in. (56.5 × 69.2 cm.).
Signed, inscribed, and dated at lower left: *Edwin White* / Paris 1855.

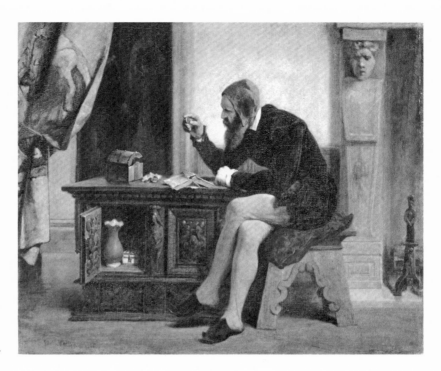

White, *The Antiquary.*

REFERENCES: *Crayon* 2 (Nov. 21, 1855), p. 330, says "Mr. White has a picture just finished, representing 'Columbus receiving the Sacrament before embarking upon his voyage of discovery;' also a small picture called 'The Antiquary,' both of which will add to his reputation" // H. T. Tuckerman, *Book of the Artists* (1867), p. 439, incorrectly states that the painting is in the possession of Robert L. Stuart, New York // *Art Journal* (New York) 3 (August 1877), p. 255, says that the painting was left to the MMA by the artist // Mrs. E. White to J. T. Johnston, June 19, 1877, copy in MMA Archives, says it was her husband's wish that the painting should be presented to the MMA // C. E. Clement and L. Hutton, *Artists of the Nineteenth Century and Their Works* (1880), 2, pp. 348–

349 // J. D. Champlin and C. C. Perkins, *Cyclopedia of Painters and Paintings* (1888), 4, p. 427.

EXHIBITED: Athenaeum Gallery, Boston, 1865, no. 264 // NAD, winter 1867–1868, no. 71, as lent by the artist // Philadelphia, 1876, *Centennial Exposition*, official catalogue, no. 471e; rev. ed., no. 57, as lent by the artist, for sale // MMA, 1880, *Loan Collection of Paintings*, no. 157; 1880–1881, *Loan Collection of Paintings and Sculpture*, no. 167, misdates painting 1857; 1882, *Loan Collection of Paintings and Sculpture*, no. 217; 1895–1896, *Retrospective Exhibition of American Painting*, no. 239.

Gift of Mrs. Edwin White, 1877.

77.5.

JACOB D. BLONDEL

1817–1877

A native of New York, Blondel (or Blondell) spent most of his life there, except for 1847 and 1848, when he lived in Washington, D.C. According to Clement and Hutton he first began studying art at the age of thirty, or in 1847, and was a pupil of WILLIAM PAGE. Since Blondel began exhibiting his works in New York in 1839 and had a studio in the New York University Building from 1839 to 1844, it is more likely that he studied with Page at the age of twenty, or in 1837. His works were exhibited on occasion at the Apollo Association, its successor, the

American Art-Union, the Washington Art Association, the Boston Athenaeum, and with more regularity at the National Academy of Design, where he was elected an associate member in 1854. Although he painted landscapes, genre and religious subjects, his specialty was portraiture, a field in which he attracted some recognition before the Civil War. His paintings were "particularly remarkable for the free effect of his coloring," according to Clement and Hutton (p. 67). With the exception of one portrait shown at the National Academy of Design in 1872, Blondel did not exhibit in any of New York's major institutions during the last thirteen years of his life. These last years are said to have been spent in obscurity and poverty, and it is reported that the artist starved to death in his studio.

BIBLIOGRAPHY: Clara Erskine Clement and Laurence Hutton, *Artists of the Nineteenth Century and Their Works* (Boston, 1880), 1, p. 67 ∥ Groce and Wallace, p. 56.

Luigi Palma di Cesnola

Luigi Palma di Cesnola (1832–1904), soldier, archaeologist, and first director of the Metropolitan Museum, was born in Rivarolo, Canavese, near Turin, the second son of an Italian count. He attended the royal military academies in Turin and Cherasco and served in the Sardinian army of the Savoys and, during the Crimean War, with the Anglo-Turkish army in the eastern Mediterranean. He immigrated to the United States about 1858 and settled in New York, where he supported himself by giving language

Blondel, *Luigi Palma di Cesnola.*

lessons. In 1861 he married Mary Jennings Reid. At the outbreak of the Civil War, he opened a training school for army officers in New York. From February to June 1862, he served in the Eleventh New York Cavalry Regiment and thereafter as a colonel of the Fourth Regiment of the New York State Voluntary Cavalry. Wounded and taken prisoner at the battle of Aldie in 1863, Cesnola was confined in Libby Prison until March 1864. After his release, he served under General Sheridan in the Shenandoah Campaign, and was mustered out of service in September 1864. The following year, he secured a minor diplomatic appointment as American consul at Cyprus, which post he took up in December 1865.

During his eleven years on Cyprus, Cesnola took an avid interest in archaeology and made extensive excavations, exploring a reported sixty-five necropoleis and some twenty-three other sites, digging up over thirty-five thousand objects, including statues, pottery, glass, metalwork, jewelry, and engraved gems. The bulk of the collection was sold to the Metropolitan Museum in 1872, and the following year Cesnola was hired to classify it and supervise its installation at the museum, then located in the Douglas Mansion on 14th Street. Late in 1873 he returned to Cyprus, where in 1875 he reported his find of the "Treasure of Curium." After several months in London in 1876, he returned to America. The new collection was purchased by the Metropolitan in 1876, and the following year, Cesnola's *Cyprus, Its Ancient Cities, Tombs, and Temples,* was published. A revised edition was issued in 1878, followed by his three-volume work, *A Descriptive Atlas of the Cesnola Collection* (1885–1903).

In 1877 the Metropolitan's board of trustees appointed Cesnola secretary, and two years later

he became the museum's first director, a position he retained until his death. One of his first tasks was to supervise the transfer of the collections from the Douglas Mansion to the new building in Central Park in 1879–1880. Under his directorship, a plan of departmental organization was adopted based on that of the British Museum and a membership program was launched which helped to finance the operation of art and technical schools and the growth of a professional staff. Among Cesnola's first suggestions as director was that the museum form a collection of early American art.

His administration, however, was marred by controversy over the authenticity of objects in the Cypriot collection. In 1880, Gaston L. Feuardent, a French antiques dealer, charged that certain statues had been restored with modern additions and were reconstructed from unrelated parts, also that some bronzes had been artificially patined. An ensuing three-year dispute resulted in a libel suit against Cesnola. Although he was vindicated, attacks on the collection continued until John L. Myres, a leading authority on Cypriot artifacts, published his findings in the handbook of the collection: "Thorough cleaning and close examination have established the authenticity of almost every object in the Collection, and have thrown full light on the repairs and restorations which they have undergone in the past" (*Handbook of the Cesnola Collection of Antiquities from Cyprus* [1914], p. vii). Noting Cesnola's haphazard methods as well as the state of archaeology, Myres observed:

The moment certainly was near when Cyprus must be won for archaeology, and 'digging' be transformed from a mischievous pastime into a weapon of historical science. With Cesnola's opportunities, an archaeological genius had the chance to anticipate modern work by a generation; it was a pity—but no fault of Cesnola—that the United States Consul in Cyprus was not an archaeological genius (p. xv).

Evaluating the collection, he concluded:

For scientific purposes, therefore, the Cesnola Collection must be regarded as a magnificent series of isolated objects, almost all of demonstrably Cypriote style. They are invaluable to fill out the scheme of Cypriote archaeology, which has been established by other men's work in the generation which followed; but they do not themselves supply the evidence on which such a scheme could be designed (p. xvi).

After Cesnola's death, the trustees wrote:

His military training, when joined to his public experience, gave him distinguished powers of administration; and, while critics are never wanting, his capacity to adminster the Museum and adequately to exhibit its contents has not been questioned. (W. E. Howe, *A History of the Metropolitan Museum of Art* [1913], 1, pp. 281–282).

Blondel's portrait of Cesnola, painted in 1865 and given to the Metropolitan by the subject's granddaughter, shows him as a colonel of the Fourth New York Cavalry, wearing the officer's badge of Sheridan's Cavalry Corps. The silver bars on the badge probably bore the names of battles in which he fought. The portrait, painted in a straightforward manner, gives a direct impression of the subject's character. "Art and nature had combined to make him a picturesque and pleasing personality," Henry Murray Calvert, one of his recruits, noted, adding: "I see him now through the vista of years as I saw him then, comely and animated, the embodiment of chivalry, a born soldier, scenting the approaching fight afar off, and imparting to others a share of his enthusiasm" (*Reminiscences of a Boy in Blue, 1862–1865* [1920], p. 17).

Oil on canvas, oval, 27¼ × 22⅛ in. (69.2 × 56.2 cm.).

Signed and dated at left center: J D Blondel / 1865.

REFERENCES: M. J. McAfee, U.S. Military Academy, West Point, N.Y., letter in Dept. Archives, June 15, 1971, provides information about the uniform and the badge // E. McFadden, *The Glitter and the Gold* (1971), gives biographical information on the subject.

Ex COLL.: descendants of the subject.

Gift of Mrs. James Bradley Cook, 1967.

67.29.

NELSON COOK

1817–1892

A portraitist, furniture decorator, and occasional poet, Nelson Cook was the son of Mary Ann (Tolman) and Joseph Cook. His father, who was a cabinetmaker, moved from Wallingford, Connecticut, to Saratoga County, New York, in the winter of 1800–1801 and subsequently settled in Saratoga Springs. Nelson Cook initially worked as a painter and decorator of chairs for his older brother Ransom, who was also a cabinetmaker. He soon gained local prominence as a portrait painter, and his paintings were shown at a number of the annual exhibitions of the National Academy of Design between 1841 and 1859. Although Cook worked chiefly in Saratoga Springs, where the French silhouettist Auguste Edouart (1789–1861) cut silhouettes of the portraitist and his wife on September 9, 1840 ([Emily N.] Jackson, *Ancestors in Silhouette Cut by August Edouart* [1921], p. 199), he was also active in Buffalo in 1853 and in Rochester in 1852, part of 1853, 1854, and 1856. *The Rochester Daily Democrat* for March 4, 1852 (p. 2), reported:

> For some months past, NELSON COOK, Esq., an artist who has won some distinction as a portrait painter, has been engaged in transferring to canvass the features not only, but the living animated likeness, the speaking expression of the countenance, the index of the mind; so that posterity may look upon the lineaments of their ancestors, and perceive what sort of men they were, not only in exterior appearances but in their mental characterics [*sic*] and temperament. At his studio, No. 22 Blossom Hotel, may be seen various of his pictures, that will serve to commend the painter to all who wish their faces to live forever.

Cook was also something of a poet, and his poems "Summer" and "The Hills of Corning" appeared in the *Rochester Daily Union* for June 24 and September 14, 1854. By 1857 he had returned to Saratoga Springs, where he later taught art at the Temple Grove Seminary, on the present site of Skidmore College. He visited Florence and Rome in 1878. On July 29, 1892, the *Boston Transcript* reported his death: "Mr. Nelson Cook, a well-known artist, poet and portrait painter, died at his home, Saratoga, N.Y., this morning, aged seventy-five."

Few of Cook's signed works are known today, and many of his portraits may be classified as anonymous or erroneously ascribed to other contemporary artists. Although he lacked academic training, he became familiar with the conventional devices of high-style portraiture and translated them into his own stylized folk art idiom.

BIBLIOGRAPHY: Nathaniel Bartlett Sylvester, *History of Saratoga County, New York* (Philadelphia, 1878), pp. 153, 204–206, 216. Supplies biographical information on the Cook family // Groce and Wallace, p. 145 // Blake McKelvey, city historian, Rochester, N.Y., letter in Dept. Archives, Oct. 16, 1962, provides transcriptions of references to Nelson Cook in the Rochester newspapers // Evelyn Britten, city historian, Saratoga Springs, N.Y., letter in Dept. Archives, Dec. 27, [1962], supplies biographical information on the artist.

James Merrill Cook

James Merrill Cook (1807–1868), no relation to the artist, was a prominent citizen of Ballston Spa, New York. The son of Judge Samuel Cook, he became active in politics and held numerous offices in the state government. Originally a Democrat, he allied himself with the Whig party

Cook, *James Merrill Cook.*

shortly after Martin Van Buren's election to the presidency in 1836. Cook was elected supervisor of Milton, New York, in 1838 and held this position again from 1844 to 1845. He was a delegate to the state constitutional convention of 1846 and served three terms as state senator, 1848–1849, 1850–1851, and 1864–1865. Between his last two terms in the senate, he was state treasurer, 1853, state comptroller, 1854–1855, and superintendent of the banking department, 1856–1861. His major contributions were his skillful analysis of the state banking laws and effective management of the banking department during the financial panics of 1857 and 1859. A founder and president of the Ballston Spa Bank,

Cook was also a director of the Rensselaer & Saratoga Railroad Company and a major general in the state militia.

This ambitious portrait of James Merrill Cook and the pendant of his wife (see below), painted in Ballston Spa in 1840 and presented to the Metropolitan by the subjects' granddaughter, demonstrate the self-taught artist's adaptation of sophisticated academic formulas. Hat in hand and sporting a walking stick, Cook is shown in a theatrical setting, which, complete with a column and billowing clouds, follows a fashionable stock formula for high-style portraiture. The artist demonstrated his skill in foreshortening by choosing to show the inside of Cook's hat, but it is a

Cook, *Mrs. James Merrill Cook.*

demonstration wholly at odds with his un-
convincing treatment of the base of the adjacent
column. He makes little attempt at differentiat-
ing the texture of flesh, cloth, and stone. His
method of modeling, with uniform shading ap-
plied almost mechanically, gives his forms a
tubular quality and the surface a smooth homo-
geneity.

Oil on canvas, 48⅛ × 24½ in. (122.2 × 62.2 cm.).
Inscribed on the back by a later hand: Painted by
Nelson Cook / Ballston Spa / 1840.

REFERENCES: *Memoir of James M. Cook* (1869), sup-
plies biographical information on the subject // K.
Batcheller, letters in MMA Archives, Nov. 20, 1930,
and March 10, 1931, supplies biographical information
on the subject and the artist and notes that the in-
scription was added by a conservator after lining, when
the artist's signature and date were obscured // H. P.
Willis, *DAB* (1930, 1958), s. v. "Cook, James Merrill,"
discusses subject's career // M. Davenport, *The Book of
Costume* (1948), 2, ill. p. 858; p. 859, discusses subject's
apparel.

ON DEPOSIT: Museum of the City of New York,
1931-1938 // Gracie Mansion, New York, 1966-1974.

Gift of Katherine Batcheller, 1931.

31.29.1.

Mrs. James Merrill Cook

The only child of Catharine Phillips Cady and
Shuler Cady of Florida, New York, Anna was
married in 1833 to James Merrill Cook in New

York, with her uncle William Phillips, pastor of the Twelfth Street Presbyterian Church, officiating. Mrs. Cook, later the mother of three children, spent her life in the family home in Ballston Spa, New York.

The portrait, a companion piece to her husband's (see above), shares a number of compositional features with it. The elegantly dressed subject is shown, bonnet in hand, in a setting with a column that corresponds to the one in her husbands' portrait. A red curtain, introduced on the left, sustains the theatrical mood of the painting. The artist portrays Mrs. Cook's fringed net shawl and lace with painstaking care, demonstrating his interest in detail, pattern, and decorative effects, often a hallmark of the self-taught painter. The systematic shading, which serves to model form and is a characteristic trait

of Nelson Cook's painting style, satisfies a similar end by creating its own rhythmical patterns.

Oil on canvas, $48\frac{1}{8} \times 24\frac{1}{2}$ in. (122.2 × 62.2 cm.).

Inscribed on the back by a later hand: Painted by Nelson Cook / Ballston Spa / 1840.

REFERENCES: K. Batcheller, letters in MMA Archives, Nov. 20, 1930, and March 10, 1931, supplies biographical information on the subject and the artist, noting that the inscription was added by a conservator after lining // "Record of the 'Old First' Presbyterian Church, New York City," p. 98, in New York Genealogical and Biographical Society, lists subject's marriage date // M. Davenport, *The Book of Costume* (1948), 2, ill. 858; p. 859, notes that Mrs. Cook's dress and hairstyle show a "slight provincial time-lag" regarding fashion.

ON DEPOSIT: (same as preceding entry).

Gift of Katherine Batcheller, 1931.

31.29.2.

ROBERT S. DUNCANSON

1817 or 1821/1822–1872

The son of a black mother and a Scotch-Canadian father, Robert S. Duncanson was born in New York State in 1817, 1821, or 1822. His obituary in the *Detroit Tribune* (Dec. 26, 1872, p. 4) gave his age as fifty-five at the time of his death. In 1860, however, the census for Cincinnati gave his age as thirty-eight. In this case, he would have been only fifty when he died.

Duncanson spent his early years in Canada. By 1842 he had joined his mother in Mount Healthy, Ohio, fifteen miles north of Cincinnati, where he began exhibiting his paintings. Four years later, he was working successfully in Detroit. The *Detroit Daily Advertiser* of February 2, 1846, reported: "Mr. Duncanson, a young artist who has been some weeks here. . . . has already taken the portraits of a number of our citizens and has designed and finished several historical and fancy pieces of great merit." His work attracted the notice of one of Detroit's prominent families, the Berthelets, who commissioned several family portraits, which Duncanson completed in 1846 (now in the Detroit Institute of Arts). The same year he painted a portrait of the abolitionist senator Lewis Cass (Chamber of House of Representatives, Lansing, Mich.), modeled after the "Lansdowne portrait" of George Washington by GILBERT STUART. A portrait of James G. Birney (unlocated) dates from the same year. Birney was editor of the *Philanthropist*, an abolitionist newspaper.

In 1848 Nicholas Longworth (1782-1863), a Cincinnati lawyer, philanthropist, and art patron, commissioned Duncanson to provide murals for his home, Belmont (now the Taft

Museum). Painted between 1848 and 1850 in oil on plaster, there are eight large landscapes and five vignettes (two of flowers and three of eagles). All the paintings include trompe l'oeil frames that simulate elaborate, gilded, rococo frames. The romantic and idealized landscapes reflect Duncanson's familiarity with the work of Nicholas Poussin and Claude Lorrain and his assimilation of the conventions of the Hudson River school; the floral still lifes reveal the self-taught artist's affinity for decorative work and sense of design.

In 1849 and 1850 the Western Art-Union purchased and raffled off several works by Duncanson. Although he appears to have been a well-established painter, Duncanson found it necessary until 1856 to supplement his income by working as a daguerreotypist. His most accomplished paintings of this period are *Blue Hole, Flood Waters, Little Miami River*, 1851 (Cincinnati Art Museum), and *View of Cincinnati, Ohio, from Covington, Kentucky*, about 1851 (Cincinnati Historical Society). The latter, a topographical view, is thought to be based on a daguerreotype. In 1853 at the request of James Francis Conover, editor of the *Detroit Tribune*, Duncanson painted *Uncle Tom and Little Eva* (Detroit Institute of Arts), based on Harriet Beecher Stowe's *Uncle Tom's Cabin*. The painting received a scathing review that attacked Duncanson's skill as a figure painter.

In 1853 Duncanson went to Europe with WILLIAM LOUIS SONNTAG and John Robinson Tait (1834–1909). In a letter of introduction to the American sculptor Hiram Powers in Rome, Nicholas Longworth described Duncanson as a self-taught artist and added: "He is a man of integrity and gentlemanly deportment, and when you shall see the first landscape he shall paint in Italy, advise me of the name of the artist in Italy, that with the same experience can paint so fine a picture" (G. McElroy [1972], p. 12). English landscapes, especially the works of J. M. W. Turner, made a strong impression on Duncanson during this visit to Europe. By 1854 he was back in Cincinnati, painting from sketches made in Italy. He continued to spend time in Detroit, where he purchased some land in 1858. The same year he painted a portrait of his leading patron, Nicholas Longworth (Cincinnati Art Museum, on permanent loan from the Ohio College of Applied Science). Three years later he completed *Land of the Lotos Eaters*, 1861 (coll. HRH, the King of Sweden), a major work based on Tennyson's poem "The Lotos-Eaters." The following year he visited Minnesota, Vermont, and Canada. In 1863, during the Civil War, Duncanson returned to Europe and spent most of his time in England and Scotland. An enthusiastic review of his painting *Land of the Lotos Eaters*, which the artist had brought with him, appeared in the *London Art Journal* (Jan. 1, 1866, pp. 174–177). After the war ended, Duncanson returned to Cincinnati, where his name reappears in the city directory for 1867. Between 1870 and 1871 he made his last trip to Scotland, the subject of several justly celebrated landscapes. In the late summer of 1872 he became mentally ill, and after three months in the Michigan State Retreat, he died on December 21, 1872.

Primarily known for his landscapes, Duncanson also painted portraits, and on occasion genre, still-life, and literary subjects. Some of his portraits show the ingenuous inventiveness of the self-taught artist. They are imbued with a vitality often absent in the works of academically trained painters. His figure paintings. on the other hand, are often marred by a disconcerting lack of skill in representing anatomy. Some of Duncanson's landscapes are literal and meticulously detailed representations of specific scenes. Many of them, however,

are idealized, drawn from the imagination, in a romantic style derived from European traditions.

BIBLIOGRAPHY: James A. Porter, "Robert S. Duncanson, Midwestern Romantic-Realist," *Art in America* 39 (Oct. 1951), pp. 98–154. A comprehensive study of the artist with checklist of located and unlocated paintings and bibliography // Edward H. Dwight, "Robert S. Duncanson," Ohio Historical Society, *Museum Echoes* 27 (June 1954), pp. 43–45 // Edward H. Dwight, "Robert S. Duncanson," *Bulletin of the Historical and Philosophical Society of Ohio* 13 (July 1955), pp. 203–211 // Cincinnati Art Museum, *Robert S. Duncanson: A Centennial Exhibition* (1972), cat. by Guy McElroy, entries by Richard J. Boyle. Updated account of the artist, checklist of works not included in the exhibition, and bibliography // Los Angeles County Museum of Art, traveling exhibition, *Two Hundred Years of Black American Art* (1976), cat. by David C. Driskell with notes by Leonard Simon, pp. 38–44, 124–125.

Landscape with Shepherd

Landscape with Shepherd was painted in 1852, the year before Duncanson made his first trip to Europe. The choice of twilight or dawn, with its expressive shadows, reveals the influence of romantic painting. The use of conventional devices—such as a gnarled tree trunk to contrast with the tranquility of the pastoral scene, a solitary shepherd and his flock dwarfed by the vast expanses of nature, and a winding brook and small cascade—is also part of the romantic vocabulary. Intricate details are painted with a fine, nervous brush on a composition that has been only loosely defined with broad brushwork. This contrast is characteristic of Duncanson's style and originates from his study of work by artists of the Hudson River school. The indistinct passages in the middle ground undermine the illusion of recession and transition from foreground to background. This treatment of space and distance reflects either Duncanson's

as yet incomplete understanding of perspective or the deliberate vagueness often characteristic of the romantic's style.

It has been suggested that this work is based on sketches that Duncanson made during a trip to western Pennsylvania in 1852. There are, however, no identifiable topographical features, and such idyllic, pastoral scenes were recurring subjects in his early work.

A photograph provided by the former owner and close examination of the painting show that the canvas at one time sustained much damage, including four sizeable tears in the group of trees on the left and three tears in the sky on the right. These areas are still out of plane, and there has been considerable overpainting around them.

Oil on canvas, $32\frac{1}{2} \times 48\frac{1}{4}$ in. (82.6 × 122.6 cm.).
Signed and dated at lower left: R. S. Duncanson/ 1852.
REFERENCE: Cincinnati Art Museum, *Robert S. Duncanson*, cat. by G. McElroy and cat. entries by R. J. Boyle (1972), p. 41, lists it among works not on

Duncanson, *Landscape with Shepherd*.

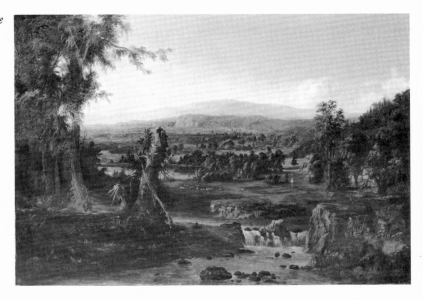

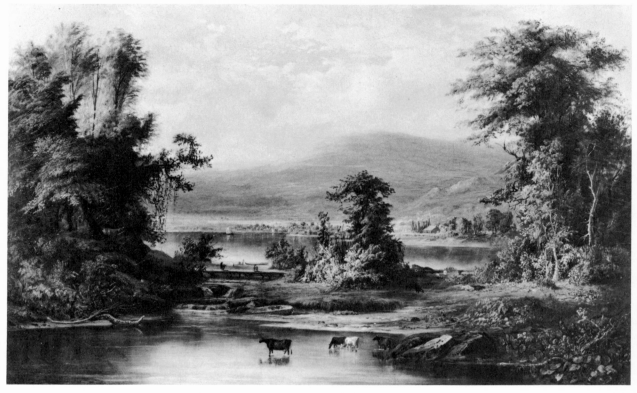

Duncanson, *Landscape with Cows Watering in a Stream.*

exhibition as Landscape with Shepherd, 1852, private coll., Kentucky.

EXHIBITED: MMA and American Federation of Arts, traveling exhibition, 1975–1977, *The Heritage of American Art*, exhib. cat. by M. Davis [not in cat.]; rev. ed. 1977, no. 45, suggests it may be based on sketches Duncanson made while working in western Pennsylvania, ill. p. 111.

EX COLL.: private coll., Kentucky, 1972–1975; with Carl Solway Gallery, Cincinnati, 1975.

Purchase, Gift of Hanson K. Corning, by exchange, 1975.

1975.88.

Landscape with Cows Watering in a Stream

Duncanson's lifelong commitment to a style derived from the Hudson River school is apparent in this pastoral scene, painted in 1871, one year before his death. Like others working in the same tradition, Duncanson combined an almost obsessive concern for detail with an equal interest in suggestive effects. The first he

achieved by using a fine brush to approximate detail; the second, by painting broadly executed passages. Small figures engaged in various activities are introduced into the vast landscape and, together with the house and a sailboat, provide the kind of narrative detail that is characteristic of Duncanson's landscapes. The painting bears a superficial resemblance to his *View of St. Anne's River*, 1870 (Saint Louis Art Museum). The two views, however, are not necessarily of the same locality. More likely, they demonstrate Duncanson's repetition of favorite compositional formulas.

Oil on canvas, $21\frac{1}{8} \times 34\frac{1}{2}$ in. (53.7 × 87.6 cm.).

Signed and dated at lower right: Duncanson/1871.

REFERENCES: J. A. Porter, *Art in America* 39 (Oct. 1951), p. 151, no. 16, as Landscape with Cattle, gives slightly different dimensions, coll. Mrs. Margaret Williams, Cincinnati // Cincinnati Art Museum, *Robert S. Duncanson* (1972), cat. by G. McElroy and cat. entries by R. J. Boyle, p. 42, lists it among works not in exhibition as Landscape, coll. Paul North, Columbus, Ohio // L. Fleischman, orally, June 25, 1976, gave information on provenance // E. H.

Dwight, Munson-Williams-Proctor Institute, Utica, N. Y., letter in Dept. Archives, July 9, 1976, provides references and information on provenance.

EXHIBITED: MMA, 1976, *Selections of Nineteenth-Century Afro-American Art*, exhib. cat. by R. A. Perry, pl. 11, dates it 1860s.

EX COLL.: Mrs. Margaret Williams, Cincinnati, by 1951–1955; with Lou Spiegel, Cincinnati, 1955; Paul North, Jr., Columbus, Ohio, March 1955; Lawrence A. Fleischman, Detroit and New York, 1955–present.

Jointly owned by the Metropolitan Museum of Art and Lawrence A. Fleischman, 1974.

1974.359.

THOMAS P. ROSSITER

1818–1871

Thomas Pritchard (or Prichard) Rossiter was born in New Haven, Connecticut. He studied with the engraver and portrait painter Nathaniel Jocelyn (1796–1881) and then worked as a portraitist in New Haven, Troy, and New York. In 1837, he exhibited for the first time at the National Academy of Design, which elected him an associate two years later and an academician in 1849. He began to exhibit at the Apollo Association in 1839, when he moved to New York.

On June 1, 1840, he accompanied ASHER B. DURAND, JOHN F. KENSETT and JOHN W. CASILEAR to Europe. After several months in London, Rossiter and Kensett set out on August 14 for Paris. They enrolled at the Ecole Préparatoire des Beaux-Arts and drew both from antique casts and from life. Rossiter also copied one of Rubens's paintings from the Marie de' Medici series at the Louvre. *A Studio Reception, Paris*, 1841 (Albany Institute of History and Art), by Rossiter records many members of the flourishing American community of artists in Paris during the early 1840s. The painting includes portraits of Rossiter, Kensett, Durand, DANIEL HUNTINGTON, GEORGE P. A. HEALY, and THOMAS COLE. Late in the fall of 1841, Rossiter, probably accompanied by Cole, traveled to Rome via Switzerland. Rossiter worked in Rome for the next five winters, spending the warmer months in Florence, Venice, Naples, Sorrento, the Apennines, Germany, and Switzerland.

After six years abroad, Rossiter returned to America in 1846. With Kensett and LOUIS LANG, in 1851, he moved into a specially designed studio at Broadway and Fourth Street. Large historical and religious works, which outranked portraiture in the eyes of academic painters, became his specialty, although he continued to paint portraits as well. His *Opening of the Wilderness* (MFA, Boston), a railroad scene in a forest clearing, usually dated about 1846 to 1850 but possibly painted about 1858, represents a departure from his usual subject matter and demonstrates his diversity. He also provided illustrations for Anne C. Lynch's *Poems* (1849), Parke Godwin's *Vala, a Mythological Tale* (1851), and *Prismatics* (1853) by Frederick S. Cozzens.

Accompanied by his wife of two years, Anna Ehrick Parmly (1830–1856), Rossiter went abroad again on May 18, 1853. After touring England, the Low Countries, Germany, Switzerland, and Italy, the Rossiters settled in Paris, where on September 14, the twins

Ehrick Kensett and Charlotte Evangeline were born. In 1855 Rossiter received a gold medal for three paintings at the Exposition Universelle at the Palais des Beaux-Arts. His review of the exposition, published as a letter, dated November 20, 1855, in the *Crayon* (2 [Dec. 1855], pp. 390–391) reveals his preference for large epic works that convey a moral lesson. He communicated such lessons best, however, in smaller works like *Such Is Life: Scene in London during the Crimean War*, 1855 (Newark Museum), a satire on upper-class indifference to the sufferings of the poor and wounded.

In 1856, after their third child, Anna Rosalie, was born, Rossiter's wife died. He returned to New York, took a studio at 3 Bond Street, and devoted himself to portraiture and a study for a large religious painting. In 1857 he was selected to paint a group portrait of leading American merchants (NYHS). The work was one of a series commissioned by William P. Wright, which would have included notable literary figures by THOMAS HICKS, major artists by GEORGE A. BAKER, and leading men of science by DANIEL HUNTINGTON. The series was in various stages of completion when Wright died in 1866.

By the autumn of 1857, Rossiter was established in a residence, studio, and art gallery at 17 West 38th Street, a building commissioned by his father-in-law, Dr. Eleazer Parmly, and designed by Richard Morris Hunt. The *Crayon* (4 [Nov. 1857], p. 349) reported his change of address and noted the "fine accommodations for pupils who desire to study painting under the eye of a professional." In June 1858, he participated in the artists' excursion from Baltimore to Wheeling, Virginia, on the Baltimore and Ohio Railroad. In 1859, Rossiter collaborated with LOUIS REMY MIGNOT in painting *Washington and Lafayette at Mount Vernon, 1784* (q.v.), one of a group of works devoted to Washington's life. In December of the same year, a sale of his works was held by Thomas J. Miller at the National Academy of Design; it realized over five thousand dollars.

In 1860 with Mary (Mollie) Sterling, his second wife, Rossiter moved to a house of his own design in Cold Spring, New York, where he spent the last decade of his life. Works of this period included *A Pic-nic on the Hudson*, 1863 (Julia L. Butterfield Memorial Library, Cold Spring, N.Y.), a group portrait on Constitution Island; five paintings illustrating Milton's *Paradise Lost*; and a series of scriptural subjects. He was engaged on a series of twenty-five paintings of the life of Christ and had finished six when he died at the age of fifty-three. In February 1873, two years after his death, his collection of paintings, prints, and sculpture was sold, together with his library, costumes, armor, studio furniture, and artists' materials.

Rossiter's development was characterized by an increasing penchant for historical, literary, and scriptural subjects. As a result of his studies in Rome and Paris, he followed academic traditions and was not inventive. His vast canvases were showpieces, skillfully promoted, sent on tour, and engraved for a large audience. Panoramic works, theatrical in nature, found an enthusiastic audience in mid-nineteenth century America. "As an artist," H. W. French observed:

Mr. Rossiter was not a complete success, nor yet by any means a failure. He had much ability in color, and ready skill in catching a likeness. But in drawing he was more deficient. Many of his larger pictures he sent about the country on exhibition: in fact, his success was partially due to the energy with which he kept himself before the public His smaller pictures are,

many of them, exquisite gems; but the larger ones are invariably confused (*Art and Artists in Connecticut* [1879], p. 103).

BIBLIOGRAPHY: NAD, *Catalogue of Rossiter's Collection of Pictures and Sketches to be Sold at Auction by Thomas J. Miller, on . . . December 19th, 1859, . . . at the National Academy of Design* [19th deleted and 20th substituted], sale cat. (Dec. 20, 1859). Lists 107 lots // Leavitt, Strebeigh and Company, New York, *Thomas Pritchard Rossiter: Paintings, Studies, Sketches*, sale cat. (April 24, 1868). Lists 101 lots. // George A. Leavitt and Company, New York, *Administratrix' Sale: The Valuable Collection . . . Belonging to the Late Thomas Prichard Rossiter, Esq . . .*, sale cat. (Feb 5–8, 1873). Lists 693 lots // Edith Rossiter Bevan, "Thomas Pritchard Rossiter, 1818–1871," D33, Arch. Am. Art. A biography and checklist of Rossiter's works by his granddaughter // Margaret Broaddus, "Thomas P. Rossiter: In Pursuit of Diversity," *American Art & Antiques* 2 (May/June 1979), pp. 106–113.

LOUIS REMY MIGNOT

1831–1870

Louis Remy Mignot was born in Charleston, the son of an avid Bonapartist who had left France at the time of the Bourbon restoration. He studied drawing in Charleston and, around 1850, worked for a short time in the studio of the landscape painter Andreas Schelfhout in The Hague. According to the London *Art Journal* of 1871, Mignot "resolved very quickly to follow no school, to read no books on Art, but to go to nature, which he did faithfully."

It is not known when Mignot returned to the United States. His exhibition record suggests that he returned to New York in 1853 and spent the next three years in Europe. According to some biographers, however, Mignot did not return from his first trip until 1855. He spent part of the following year working from nature in Cooperstown, New York. In 1857, the *Crayon* reported that his "studies have been confined to various localities in Otsego County" (4 [Feb. 1857], p. 55). Mignot was represented by four works at the annual exhibition at the National Academy of Design in 1857: *Sources of the Susquehanna*, 1857 (NAD), which Henry T. Tuckerman characterized as "a powerful, deeply *American* landscape"; *Autumn* (unlocated), favorably reviewed in the *Crayon* (4 [July 1857], p. 222); and two collaborative works, *The Foray* (unlocated) painted with John W. Ehninger (1827–1889), and *Winter Scene in Holland* (New York art market, 1972) painted with EASTMAN JOHNSON. In both instances Mignot did the landscape and the collaborator, the figures. In the summer of 1857 Mignot visited Mount Vernon, which was to be the subject of the 1859 painting *Washington and Lafayette at Mount Vernon, 1784* (q. v.), a joint effort with THOMAS P. ROSSITER. In 1857 Mignot accompanied FREDERIC E. CHURCH to South America, which provided subjects for the tropical landscapes for which he became best known. Mignot, as Tuckerman noted, "has a remarkable facility of catching the expression, often the vague, but, therefore, most interesting, expression of a scene; he seizes upon the latent as well as the prominent effects. He is a master of color, and some of his atmospheric experiments are wonderful."

By 1858 Mignot was established at the Tenth Street Studio Building. He was elected an associate of the National Academy in 1859 and an academician in 1860. In January of that year, he married a Miss Harris, daughter of a Baltimore doctor, in a ceremony attended by his friend JOHN F. KENSETT. At the outbreak of the Civil War, Mignot decided to go abroad. A sale of his works, held in New York on June 2, 1862, realized over five thousand dollars, and he sailed for England on the 26th. Mignot settled in London. His works, exhibited at the Royal Academy in 1863, 1865–1867, 1870, and 1871, were very well received. He visited France in 1870, and two of his paintings were exhibited that year at the Paris Salon. When the Franco-Prussian War began, he returned to England. A victim of smallpox, he died September 22, 1870, at Brighton at the age of thirty-nine. About Mignot, S. G. W. Benjamin (1837–1914), observed:

> He can be justly ranked with the pioneers who first awoke the attention of the nation to a consciousness of the beauty, glory, and inexhaustible variety of the scenery of this continent, which had fallen to them as a heritage such as no other people have yet acquired. Mignot was at once a fine colorist and one of the most skilled of our painters in the handling of materials; his was also a mind fired by a wide range of sympathies; and whether it was the superb splendor of the tropical scenery of the Rio Bamba, in South America, the sublime maddening rush of iris-circled water at Niagara, or the fairy-like grace, the exquisite and ethereal loveliness of new-fallen snow, he was equally happy in rendering the varied aspects of nature" (*Art in America* [1880], p. 83).

BIBLIOGRAPHY: Henry T. Tuckerman, *Book of the Artists* (New York, 1867), pp. 563–564 // Obituaries: *Art-Journal* [London] (Nov. 1, 1870), p. 343, and (Jan. 1, 1871), p. 6 // William Howe Downes, *DAB* (1933; 1961), s. v. "Mignot, Louis Remy," pp. 609–610 // Groce and Wallace, p. 442 // NAD, *Next to Nature: Landscape Paintings from the National Academy of Design*, exhib. cat. (New York, 1980), pp. 64–66. Entry on Mignot by Kathie Manthorne is the most comprehensive treatment of the artist to date.

Washington and Lafayette at Mount Vernon, 1784 (The Home of Washington after the War)

This collaborative effort of Rossiter and Mignot is typical of the prosaic history paintings that enjoyed great popularity in mid-century America. Rich in anecdote and genre elements, they captured the public's imagination by idealizing the past. Although many portraits of Washington and occasional history paintings were done before his death in 1799, representations of his everyday life were rare in the eighteenth century. The nineteenth century, especially the decades preceding the Civil War, produced the greatest diversity of Washington imagery. A growing body of literature, notably Mason Locke Weems's popular though largely fictitious *The Life of Washington* (1800), Richard Rush's *Washington in Domestic Life* (1857), Ben-

son J. Lossing's *Mount Vernon and Its Associations* (1859), inspired new images. Works in the tradition of heroic history painting like the immensely popular *Washington Crossing the Delaware* by EMANUEL LEUTZE (q. v.) had their counterpart in paintings of the domestic life of the nation's first president, such as *The Marriage of Washington to Martha Custis*, 1849, and *Washington as Farmer at Mount Vernon*, 1851 (both Virginia Museum of Fine Arts, Richmond) by Junius Brutus Stearns (1810–1885). In the same spirit, Thomas P. Rossiter produced in 1859 *Washington and Lafayette at Mount Vernon, 1784*. A succession of other works included *Washington's First Cabinet* (unlocated), *Washington in His Library at Mount Vernon* (unlocated), and *Palmy Days at Mount Vernon* (coll. Malcolm Matheson, Mount Vernon, Va.).

The fundraising efforts that began in 1853 for the purchase and restoration of Mount Ver-

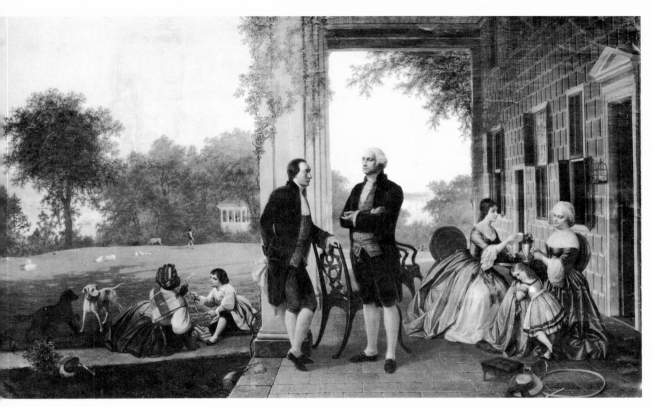

Rossiter and Mignot, *Washington and Lafayette at Mount Vernon, 1784.*

non stimulated interest in Washington's home. Louis Remy Mignot visited it during a painting trip in the summer of 1857 with EASTMAN JOHNSON. Thomas P. Rossiter visited the house with Mignot and a group of other artists in June 1858. In an article entitled "Mount Vernon, Past and Present, What Shall Be Its Destiny?" in the September *Crayon*, Rossiter complained of its dilapidation and urged public support for the Ladies' Mount Vernon Association. The November *Crayon* reported that Mignot's studies of Mount Vernon (now unlocated), "including a view from the piazza of the Washington mansion," were on exhibit in his New York studio.

Capitalizing on the growing interest in Mount Vernon, Rossiter and Mignot decided in 1859 to paint the Washington family at home. Rossiter was to paint the figures, and Mignot, the landscape. In March, a study (now unlocated) for the large painting was near completion. Sent to London, the study served as a model for Thomas Oldham Barlow's engraving *The Home of Washington*, which was published the same year. The final painting, completed during the sum-

mer of 1859, was exhibited at Rossiter's gallery in November and at the National Academy of Design from November through December.

In the brochure that accompanied the exhibition, Rossiter described the work:

> The busy portion of the day is over; and, as the long shadows creep slowly over the lawn, the family portion of the household have congregated under the ample portico. The General and his noble guest have arisen from the chairs, which indicate that they had formed a portion of the group with the ladies, and are standing in colloquy: Washington in the act of speaking, and Lafayette leaning against a pillar, in deferential attitude, holds a newspaper in his hand—suggestive that the discourse is a topic of the times.

Martha Washington is sewing, and her daughter-in-law Mrs. Stuart, the former Mrs. John Parke Custis, reads a note. Mrs. Stuart's daughter, Eleanor Parke Custis, leans against Mrs. Washington, and her brother George Washington Parke Custis prepares to fire a toy cannon. Rossiter noted that Mignot made extensive studies of the location and had many interviews with an old retainer on the estate to insure

"that the topographical features are delineated as far as possible to accord with the date of the picture, and the house restored to the condition which it must have possessed."

The portrait of Washington is based on Houdon's bust, a work that Rossiter characterized in his brochure as "invaluable for later generations of artists." He also used it as a model for his portrait of George Washington, 1858 (Yale University, New Haven). Portraits now in the collection of Washington and Lee University, Lexington, Virginia, have been suggested as Rossiter's source for the likenesses of Lafayette and the Custis children. There is, however, very little resemblance. According to a member of the Rossiter family, the artist's twins posed for the figures of the children.

Rossiter presented his subjects in his best approximation of eighteenth-century dress, showed Lafayette with a copy of the *Pennsylvania Gazette*, and put a powderhorn bearing the date 1776 in the center foreground. The painting, nevertheless, has a decidedly nineteenth-century flavor, which is evident in anachronisms of costume and furnishings. For example, Eleanor Parke Custis's hairstyle, dress, and hat (in right foreground) date to the middle of the nineteenth century, as does the upholstery of the footstool. The painting is very much a period piece, but of the Victorian era. As such, it is an ambitious example of the then popular taste for combining history and genre.

The painting has wrinkled drying cracks throughout the sky of the type normally associated with excess medium.

Oil on canvas, 87 × 146½ in. (221 × 372.1 cm.).
Signed and dated at lower right, inside child's hoop: ROSSITER 1859. Signed at lower left: MIGNOT.
RELATED WORKS: Louis Remy Mignot made studies at Mount Vernon in 1857 or 1858 which, according to the *Crayon* 5 (Nov. 1858), p. 328, included a view from the piazza of the Washington mansion (unlocated) // Thomas P. Rossiter, *George Washington*, after Jean Antoine Houdon's bust, oil on canvas, 31¾ × 25⅞ in. (80.6 × 65.7 cm.), 1858, Yale University, New Haven, Conn. // Thomas P. Rossiter and Louis Mignot made a study for the picture in 1859 (unlocated), according to the *Crayon* 6 (March 1859), p. 91, and (Oct. 1859), p. 319; it was later used for the Barlow engraving // Thomas Oldham Barlow, *The Home of Washington*, engraving, 23 × 33 in. (58.4 × 83.8 cm.), 1859, ill. in *Antiques* 47 (March 1945), p. 167 // G. Spohni, after a drawing by Charles P. Tholey, *Genl. Lafayette's Departure from Mount Ver-*

non, *1784*, lithograph published by John Smith, Philadelphia, 1868, ill. in *Antiques* 47 (March 1945), p. 167 // Bencke and Scott, *Reception of Lafayette at Mount Vernon, Home of Washington*, chromolithograph, 1875.

REFERENCES: *Crayon* 5 (Sept. 1858), pp. 243–253, Rossiter's article on Mount Vernon; p. 273, a full-page appeal for funds by the Ladies' Mount Vernon Association; 5 (Nov. 1858), p. 328, says that Mignot has "several studies made at Mount Vernon, including a view from the piazza of the Washington mansion" on view in the Studio Building, Tenth Street; 6 (Jan. 1859), p. 25, reports that "Rossiter and Mignot are to paint a Mount Vernon subject, of which the principal figures will be the Washington family, grouped on the piazza of the mansion; the figures by the former, and the landscape accessories by the latter"; 6 (March 1859), p. 91, notes that "Rossiter and Mignot's Mount Vernon picture—or rather a finished study for it—is drawing near to completion" and "will prove an attractive work," describes the picture, and says that the "likenesses of Lafayette and the two children are from original pictures procured at Arlington"; 6 (Oct. 1859), p. 319, describes the picture at length and notes that the small completed study is being engraved in England // *New-York Daily Tribune*, Nov. 16, 1859, p. 7, reports that a "numerous company of gentlemen assembled last Monday evening at the residence of Mr. Rossiter, in thirty-eighth street, to witness the first exhibition of the large painting of Washington at Mount Vernon, upon which he, in connection with Mr. Mignot, has long been engaged. In the division of labors of the two artists, Mr. Mignot worked up the landscape, and Mr. Rossiter put in the figures and painted the mansion" // *Home Journal* (Nov. 19, 1859), p. 2, calls it "one of the most valuable additions to the historical pictures of which the country can boast" and notes it will be exhibited at the NAD // T. P. Rossiter, *A Description of the Picture of the Home of Washington after the War painted by T. P. Rossiter and L. R. Mignot . . .*, exhib. cat. (1859), pp. 4–5, describes the painting (quoted above); pp. 6, 29, notes that the head of Washington is based on the Houdon in Richmond (quoted above) // *Crayon* 6 (Dec. 1859), p. 382, says that the picture is on exhibition at the NAD // *New-York Daily Tribune*, Dec. 6, 1859, p. 2, advertisement for it at NAD exhibition // *New York Times*, Jan. 17, 1860, p. 4, says that the painting will be on exhibit at the NAD until next Saturday "after which it is to be removed to Washington" // *New-York Daily Tribune*, Jan. 17, 1860, p. 7, mentions exhibition // *Home Journal* (Jan. 21, 1860), p. 2, mentions exhibition // T. S. Cummings, *Historic Annals of the National Academy of Design* (1865), p. 276, notes its exhibition // H. T. Tuckerman, *Book of the Artists* (1867), p. 435 // *Aldine* 7 (Feb. 1874), p. 48, in a review of the painting at the Brooklyn Art Association, comments that the "father of his country was as

stately, and Lafayette as idiotic-looking, as usual" // *MMA Bull.* 1 (Nov. 1905), p. 10, announces acquisition of this work, calling it Reception of Lafayette by Washington at Mount Vernon // P. Wilstach, *Garden & Home Builder* (July 1927), ill. opp. p. 457, mistitled as Palmy Days // G. A. Eisen, *Portraits of Washington* (1932), 2, p. 558, lists and describes the picture, misdates it 1858 // W. H. Downes, *DAB* (1933; 1961), s. v. "Mignot, Louis Remy," p. 609; (1935; 1963), s. v. "Rossiter, Thomas Prichard," p. 182, says that it was begun in October 1857 and finished in 1859 but gives incorrect title // *Old Print Shop Portfolio* 2 (Feb. 1943), p. 126, discusses it in connection with Barlow engraving // R. L. Harley, *Antiques* 47 (March 1945), pp. 166-167, describes Barlow's 1859 engraving after the painting, discusses 1868 lithograph after Tholey's drawing as freely modeled after the painting, and notes facsimiles by Ed. Farrell, John Lynch, and others // E. R. Bevan, "Thomas Pritchard Rossiter, 1818-1871," 1957, typescript, D33, Arch. Am. Art, p. 9, mentions it as Lafayette at the Home of Washington; p. 13, notes that Rossiter's portrait of Washington at Yale is similiar to the portrayal of Washington in this painting and is modeled after Houdon's bust; p. 13, records Rossiter's meeting with Madame Le Vert (Octavia Walton), later vice-regent for Alabama for the Mount Vernon Ladies' Association, says it is not known if her influence or publicity prompted his paintings, says his painting was begun in 1858; pp. 15–16, describes first exhibition of it in Rossiter's gallery; states that his children posed for the figures of the children; p. 16, mentions that after the Civil War Rossiter exhibited the picture in Philadelphia and Baltimore and in the Capitol Rotunda for three months in 1867 and that it was included in the sale of his estate and acquired by the MMA in 1905 in the bequest of William Nelson; checklist p. 12, lists and catalogues this picture // S. Hamilton, *Early American Book Illustrators and Wood Engravers, 1670-1870* (1958), p. 203 // C. C. Wall, Mount Vernon Ladies' Association of the Union, letter in Dept. Archives, Nov. 29, 1966, says that he thinks that Rossiter, while working on the painting, had a studio in the home of G. W. Riggs, first treasurer of the Mount Vernon Ladies' Association; gives location of Palmy Days and the portraits of the Custis children by Robert Edge Pine, as well as the portrait of Lafayette presented to Washington // J. K. Howat, *MMA Bull.* 26 (March 1968), p. 298, fig. 10, calls it an example of the nonheroic trend in history painting // T. B. Brumbaugh, *American Art Journal* 5 (May 1973), pp. 76–77 // L. Fink, *American Art Journal* 5 (Nov. 1973), pp. 46–47, mentions this picture in a discussion of Rossiter's subject matter and French art, fig. 11 // P. Hills, *The Genre Painting of Eastman Johnson* (Ph.D. diss., Institute of Fine Arts, New York University, 1973; published 1977), pp. 47-48, discusses Johnson's visit to Mount Vernon with Mignot and the revival of Mount Vernon and Washington in literature and art; pp. 54–55, and note 34, quotes Rossiter's article on Mount Vernon and mentions the painting // American Federation of Arts, New York, 1974, *Revealed Masters*, exhib. cat., essay by W. Gerdts, pp. 100 and 111 // I. A. Rossiter, letter in Dept. Archives, July 18, 1976, says that her father-in-law, the artist's son, "posed as a child for the little Custis boy on the lawn"; Sept. 4, 1976, notes that she believes Rossiter used his portrait of Washington now at Yale as a model and that "it is very likely" that the artist's late wife, Anne, was the inspiration for Mrs. Custis // M. Heckscher, American Decorative Arts Department, MMA, note in Dept. Archives, March 10, 1982, dates the furniture // J. Long, orally March 12, 1982, dated child's dress.

EXHIBITED: Rossiter's gallery in his residence, 17 West 38th Street, New York, Nov. 1859 // NAD, Nov. – Dec. 1859, as The Home of Washington after the War // Washington, D. C., 1860 // Fine Art Institute, New York, 1863, *Catalogue of the Third Annual Exhibition of American & Foreign Paintings*, no. 11, as Mount Vernon or The Home of Washington after the War // Rotunda of the U. S. Capitol, Washington, D. C., 1867 // Brooklyn Art Association, Dec. 1873, *Winter Exhibition*, no. 368, as Lafayette and Washington at M't Vernon, lent by Wm. Nelson // Maison Française, New York, 1934, *Lafayette Centenary Exhibition* (not in cat.).

EX COLL.: the artist, 1859–1871; his wife, Mary S. Rossiter, as administratrix of Rossiter's estate, 1871–1873 (sale, George A. Leavitt and Company, Clinton Hall Book Sale Rooms, New York, Feb. 5–8, 1873, no. 224); William Nelson, New York and Poughkeepsie, N. Y., 1873–1905.

Bequest of William Nelson, 1905.

05.35.

CHARLES G. ROSENBERG

1818–1879

Identified as an artist, journalist, and author in Watson's *American Art Journal* for October 1879, Charles G. Rosenberg appears to have pursued a dual career in which painting played a subordinate role to writing. "The brush and the pen," he wrote in 1854, "were the two gods of my idolatry" (p. 140). Rosenberg collaborated with JAMES H. CAFFERTY on at least three occasions. Together they painted a large picture titled *Wall Street, Half Past 2 O'Clock, Oct. 13, 1857* (Museum of the City of New York), a smaller grisaille painting with a similar title (q. v.), and *Wall Street in 1789, Sketch for a Large Picture* (unlocated).

According to his own account, Rosenberg was a native of Bath, England, and the son of an artist. His father was probably Thomas Elliott Rosenberg (1790–1835), a drawing master and a painter of miniatures, landscapes, and silhouettes. His grandfather was most likely Charles Rosenberg (1745–1844), a miniature and silhouette painter, probably from Austria, who became known in England as Rosenberg of Bath (S. McKechnie, *British Silhouette Artists and Their Work, 1760–1860* [1978], pp. 558–566, 719–720). Charles G. Rosenberg is identified also as the brother of George Frederick Rosenberg (1825–1869), another artist (H. L. Mallalieu's *Dictionary of British Watercolour Artists up to 1920* [1976], p. 224). He is probably the painter Charles Rosenberg who exhibited still-life, genre, and landscape paintings at the Royal Academy, the British Institution, and the Suffolk Street Galleries between 1844 and 1848, and whose two watercolors *Still Life* and *Norwegian Landscape* are in the collection of the Victoria and Albert Museum. He is also the author of *A Critical Guide to the Exhibition of the Royal Academy* (1847) and *A Guide to the Exhibition of the Royal Academy and Institution for the Free Exhibition of Modern Art* (1848). He traveled widely for his own pleasure and for his work as a music, drama, and literary critic. He visited Vienna in 1846, Dresden in 1847, Leipzig in 1848, and came to America in 1849 or 1850. He was an enthusiastic witness to the arrival of the singer Jenny Lind, "the Swedish Nightingale," in the fall of 1850 and accompanied her on her tour of the United States and her visit to Havana. His book *Jenny Lind in America* was published in New York in 1851. Havana is the subject of two paintings, now unlocated, that he showed at the National Academy of Design in 1859. He exhibited at the National Academy from 1858 to 1860, in 1862, 1867, and 1872, and at the Pennsylvania Academy of the Fine Arts in 1863 and 1866. Portraits, landscapes, city views, street scenes, historical and literary subjects, as well as those drawn from imagination, were all part of his repertory. He was also on occasion an illustrator for works such as *Young Sam*, a short-lived humorous weekly begun in New York in 1852, and George W. Perrie's *Buckskin Mose; or Life from the Lakes to the Pacific, as Actor, Circus-rider, Detective, Ranger, Gold-digger, Indian Scout and Guide* (1873), for which Rosenberg also served as editor.

His paintings attracted the attention of the art critic for Watson's *American Art Journal*, who in October 1866 described *Caravan Overtaken by a Sand Storm* (now unlocated) from the collection of the Crosby Opera House Association, as "the gentleman's most important work. . . . Taken altogether, not alone for its brilliancy of execution, but for its uniqueness of the subject, this is, without a doubt, the gem of the collection." The same critic in

February 1868 dwelt on the artist's effective use of light, masterly grouping of figures, and skillful character studies in an as yet unfinished work called *Cape May by Moonlight*. This is probably the painting recently called *Enjoying the Breezes*, 1869 (unlocated, ill. in *Kennedy Quarterly* 8 [Jan. 1969], p. 239). In the May 25, 1878, issue of the *American Art Journal* a long, favorable review was given of Rosenberg's elaborate *Freemasonry and Civilization* painted in London the same year (unlocated). The artist's sudden death on a visit to England was reported in the October 18, 1879, issue: "Rosenberg was a gentleman of varied talents in art and literature, a genial, open nature, full of kindly impulses, prompt in the service of his friends."

BIBLIOGRAPHY: Q[Charles Rosenberg], *You Have Heard of Them* (New York, 1854). A collection of sketches on statesmen, artists, musicians, and literary figures, interspersed with autobiographical notes // Paletta [pseud.], "Art Matters," Watson's *American Art Journal* 5 (Oct. 11, 1866), pp. 389–390; 6 (Nov. 1, 1866), p. 25; 6 (March 16, 1867), p. 326; 7 (April 27, 1867), p. 5; 7 (August 10, 1867), p. 246; 8 (Feb. 1, 1868), pp. 206, 208. Contains reviews of Rosenberg's paintings // *American Art Journal* 27 (April 28, 1877), p. 43; 29 (May 25, 1878), pp. 58–59; 31 (Oct. 18, 1879), p. 393. Contains a review of Rosenberg's *Freemasonry and Civilization*, a notice of his death, and the announcement of the Rosenberg Art Fund organized by the New York Press Club // Maria Naylor, comp. and ed., *The National Academy of Design Exhibition Record, 1861–1900* (New York, 1973), 2, p. 810.

JAMES H. CAFFERTY

1819–1869

Cafferty was born in Albany, New York, and had settled in New York City by 1839, when he first appeared in the city business directory as a sign painter. In 1847 he became the first vice-president of the newly founded New-York Sketch Club, an association established by "the *younger* artists," according to Thomas Seir Cummings (*Historic Annals of the National Academy of Design* [1865], p. 202), and not to be confused with the two older sketch clubs. From 1843 to 1849 Cafferty's landscapes and genre paintings were acquired, exhibited, and raffled off by the Apollo Art Association and its successor, the American Art-Union. His work was also represented in the final sale of the holdings of the Art-Union, when it was dissolved as an illegal lottery, depriving American artists of an important source of patronage. He exhibited annually at the National Academy of Design from 1843 to 1869, with the exception of the year 1867. He was elected an associate of the academy in 1850 and an academician in 1853. His work appeared occasionally at the Boston Athenaeum, the Washington Art Association, and the Pennsylvania Academy of the Fine Arts. Cafferty apparently found it necessary, at least from 1848 to 1854, to supplement his income by dealing in artists' materials at 609 Broadway.

In addition to painting landscapes and genre scenes, Cafferty was a prolific portraitist, and during the last two decades of his life, he also painted still lifes. On several occasions, he collaborated with other painters. Two views of Wall Street executed with CHARLES G. ROSENBERG were shown at the National Academy, one in 1850 and the other in 1860. A painting of the *Grave Digger* from Hamlet (unlocated), exhibited in 1869, was a joint effort with Lemuel Maynard Wiles (1826–1905). Cafferty also worked as an illustrator. His illustrations appeared in *Fairy Tales and Legends of Many Nations*, selected and translated by C. B. Burkhardt (New York, 1849), and *Appleton's Illustrated Hand-Book of American Travel* (New York, 1857).

Cafferty's death in 1869 was attributed to "dropsy, superinduced by want of care on his own part," according to an obituary notice in the *New York Herald* (Sept. 8, 1869, p. 4). "Perhaps no more versatile and accomplished painter . . . has existed, at all events, in America," it noted. "His pencil had a facility and truth which enabled him not only at times to dazzle, but to defy criticism."

BIBLIOGRAPHY: Grace H. Mayer, "A Painting of The 'Revulsion' of 1857," *Museum of the City of New York Bulletin* 3 (May 1940), pp. 68–72. Includes biographical material // Groce and Wallace p. 103 // Sinclair Hamilton, *Early American Book Illustrators and Wood Engravers, 1670–1870* (Princeton, 1958), pp. 87–88, 201–202 // Jerome Nathans, "Colourmen's Stencils," *Remembrances of Passaic County: Passaic County Historical Society* 2 (1972), p. 4. Gives Cafferty's occupation and addresses from 1840 to 1862 // Hermann Warner Williams, Jr., *Mirror to the American Past: A Survey of American Genre Painting, 1750–1900* (Greenwich, Conn., 1973), pp. 175–176, figs. 170–171. Short biographical note and illustrations of two of Cafferty's genre paintings.

Wall Street, Half Past Two, October 13, 1857

Shortly after two o'clock on October 13, 1857, the banks in New York, with the exception of the Chemical Bank, suspended specie payments and did not resume business until December 12. This was one of a series of crises that rocked the country. Banks and brokerage firms failed, railroads declared bankruptcy, real estate values plummeted, construction came to a halt, and unemployment became widespread as a result of overspeculation, inflation, and rapid expansion. It was not until the summer of 1858 that the country showed signs of recovery. Wall Street at the time of the panic is the subject

Detail of version in the Museum of the City of New York.

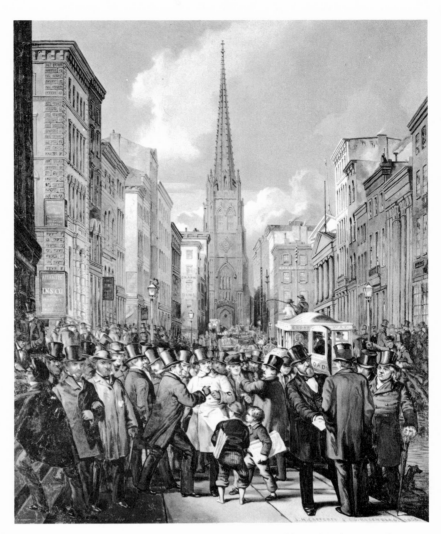

Cafferty and Rosenberg, *Wall Street, Half Past Two, October 13, 1857.*

of this grisaille study painted in oil on paper by James H. Cafferty and Charles G. Rosenberg in 1858.

Looking west from William Street to Trinity Church on Broadway, the view along Wall Street includes: on the right, the Bank of America at the northwest corner of Wall and William streets; two doors west, the Merchant's Bank; at the intersection of Wall and Nassau streets, the Doric-style Custom House (now the Federal Hall National Memorial); and on the far left, the large Insurance Building. Only three figures have been identified. The short man with sideburns at the extreme right is the financier Cornelius Vanderbilt. The promoter Jacob Little appears in the center in a light gray drover's topcoat; and the managing editor of the *New York Herald*, Frederick Hudson, is the short stocky figure near the bearded man at the left.

The lawyer and diarist George Templeton Strong provided a vivid account of the scene on Wall Street:

Went into the street and found it pretty densely crowded. Over a dozen banks (on the west side of the city mostly), including the North River, Merchants' Exchange, and Ocean had stopped. A steady stream was setting in toward the counter not merely of the American Exchange Bank, but of every other bank in the street, and not billholders alone but depositors were calling for gold. Old David Leavitt (of the American Exchange) in his diaconal white cravat, addressed an allocution to the crowd, in substance that they might come on as fast as they pleased, that all the sound banks were acting in concert and would not suspend. The crowd cheered him with hysterical vehemence, but the influx and

drain of specie continued. From Hanover Street to Nassau, both sidewalks were densely packed with business men, capitalists, and operators. It was a most "respectable" mob, good-natured and cheerful in its outward aspects but quivering and tingling with excitement. They laughed nervously, and I saw more than one *crying*.

At a little after two the Bank of New York, . . . our oldest bank, had stopped Several second-class banks had succumbed. All closed at eight P. M." (A. Nevins and M. H. Thomas, eds., *The Diary of George Templeton Strong* [1952], 2, p. 361).

This painting varies in only a few details from a large painting of the same subject and date by Cafferty and Rosenberg in the collection of the Museum of the City of New York. The large version was lent by E. W. Hudson, brother of Frederick Hudson (one of the figures represented), to the National Academy of Design in 1858. The Metropolitan's painting has been called a study for the larger work. The monochromatic scheme and the presence of an inscription, however, suggest that it may have been made for a print that was never executed. Close examination shows that the image appears on the primary support and the inscription on a secondary support that was added. The painting therefore may have served as both a preliminary presentation for approval and a model for a proposed print. It is representative of the collaborative work of Cafferty and Rosenberg, in which Cafferty is usually credited with the figures and Rosenberg with the buildings. The painting is also of historical interest because it documents a contemporary event and depicts some of the leading personalities of the day.

Painted with bitumen (an extremely unstable substance) and once framed under glass that rested directly against it, the painting has suffered some surface damage.

Oil on paper, $17\frac{7}{8} \times 14$ in. (43.5 × 35.9 cm.).

Inscribed along bottom: WALL STREET. HALF PAST TWO. OCT. XIII. 1857.

Signed and dated at lower right: J. H. CAFFERTY & C. G. ROSENBERG, 1858.

RELATED WORK: *Wall Street, Half Past 2 O'Clock, Oct. 13, 1857*, oil on canvas, $50 \times 39\frac{1}{2}$ in. (127 × 100.3 cm.), 1858, Museum of the City of New York, ill. in G. M. Mayer, *Museum of the City of New York Bulletin* 3 (May 1940), p. 69.

REFERENCES: Parke-Bernet Galleries, New York, *Fine American Furniture . . . Historical Paintings and Miniatures including Portraits, The Cafferty-Rosenberg "Wall Street Panic, 1857," . . . from the Collection of Herbert Lawton, Boston, Mass . . .*, sale cat. (Jan. 4, 1940), p. 30, no. 114, discusses the large painting, coll. of E. W. Hudson, Concord, Mass., identifies three of the figures, says that it "is believed to be the only existing contemporary pictorial record of this event other than the small sketch from which Cafferty apparently worked in preparing the large painting," notes that the sketch is at the Museum of the City of New York on loan from Edward W. C. Arnold // G. M. Mayer, *Museum of the City of New York Bulletin* 3 (May 1940), p. 68, mentions that this sketch is on loan.

ON DEPOSIT: Museum of the City of New York, 1935–1963.

EX COLL.: Edward W. C. Arnold, New York, by 1935–1954.

The Edward W. C. Arnold Collection of New York Prints, Maps, and Pictures. Bequest of Edward W. C. Arnold, 1954.

54.90.136.

THOMAS LE CLEAR

1818–1882

The portraitist and genre painter Thomas Le Clear (sometimes spelled Le Clere or Le Clair) was largely self-taught. His natural talents enabled him to compete successfully with academically trained painters. Born in the village of Candor, near Owego, in upstate New York, he was attracted to painting at an early age. "His first productions were painted from paint made by squeezing the juice of poke-berries and green grass together," according to L. W. Kingman, who added that one "Eldridge Forsyth [later a house painter] assisted

young Le Clere in mixing his first colors." Both Tuckerman and Kingman recorded that Le Clear's initial attempt at portraiture with oils, using lampblack, Venetian red, and white lead on a pine board, was made at the age of nine. When he was twelve, Le Clear painted a head of St. Matthew "which made a sensation" in the village, according to Tuckerman, and the young artist sold replicas at $2.50 a copy to satisfy local demand.

In 1832 he and his family moved to London, Ontario, where the patronage of John Wilson, a former member of Parliament, brought him a number of portrait commissions. In 1834, at Goderich, Ontario, on Lake Huron, he was hired to decorate the paneling of a lake steamer. Hoping to paint historic scenes, he was disappointed by the owner's demand for more mundane work. From 1834 to 1836 Le Clear painted portraits in Norfolk, New York. He then worked as an itinerant painter and traveled as far west as Green Bay, Wisconsin, reputedly painting Indians en route and speculating unsuccessfully in real estate. He returned to London, Ontario, only to depart for New York City, but was then stranded in Elmira, New York, for lack of funds. Commissions there and in Rochester subsequently financed the journey.

In 1839 he arrived in New York City "an almost penniless stranger," according to Tuckerman, "opened a studio in Broadway, and, by honest industry, soon maintained himself with comfort and respectability." Reportedly, he was a student of HENRY INMAN for a brief period. He married Caroline Wells, daughter of Russell R. Wells of Boston, in 1844. In February of the same year, he opened a studio in Owego, where he gave lessons in painting and drawing for a short time and then returned to New York.

Although he was chiefly known as a portraitist, Le Clear also won acclaim for genre paintings. He began exhibiting at the National Academy of Design in 1845. The following year two of his genre paintings were acquired by the American Art-Union for distribution by lottery to its subscribers. The organization, which contributed greatly to the support of American artists, purchased more genre paintings by Le Clear in 1848 and 1849. Although many of his genre scenes are known from descriptions, relatively few have been located. The one best-known today is probably *Buffalo Newsboy*, 1853 (Albright-Knox Art Gallery, Buffalo).

By 1847 Le Clear was living in Buffalo, where he became a leader of that city's art circle. He was instrumental in organizing the Buffalo Fine Arts Academy (the parent body of the Albright-Knox Art Gallery) in 1862 and served as one of its directors for a short time before returning to New York. From December 1861, he exhibited regularly at the Brooklyn Art Association and from 1861 to 1862 served on its board of managers. He was elected an associate of the National Academy of Design in 1862 and an academician a year later. He also became a member of the Century Association. His daughter, Caroline, was married to the portraitist and animal painter William Holbrook Beard (1824–1900) in 1863.

From 1863 to 1866 and 1868 to 1879, Le Clear worked in the celebrated Tenth Street Studio Building. He served on a five-man committee of the National Academy of Design to implement an 1869 resolution to improve the academy's educational program. He was a visiting instructor at the academy from 1869 to 1870, and painting instructor from 1872 to 1873. In 1873, two of his portraits were shown at the Royal Academy in London. Le Clear's last years were devoted almost exclusively to portraiture. In addition to actors,

artists, and literary men, Le Clear painted Presidents Fillmore, Grant, Garfield, and Arthur. From about 1873 he made his home in Rutherford Park, New Jersey, although he maintained a New York studio until his death.

BIBLIOGRAPHY: Henry T. Tuckerman, *Book of the Artists* (New York, 1867), pp. 440–442 // Obituaries: *Boston Evening Transcript*, Nov. 28, 1882, p. 8; *Buffalo Express*, Nov. 28, 1882, p. 4; *New York Daily Tribune*, Nov. 28, 1882, p. 2; *New York Times*, Nov. 28, 1882, p. 2 // LeRoy Wilson Kingman, *Early Owego* (Owego, N. Y., 1907), pp. 77–78 // William Howe Downes, *DAB* (1933, 1961), s. v. "Le Clear, Thomas" // Chase Viele, "Four Artists of Mid-Nineteenth Century Buffalo," *New York History* 43 (Jan. 1962), pp. 49–78. The most comprehensive treatment of the artist to date, includes additional bibliography.

Amory Sibley Carhart

Amory Sibley Carhart (1851–1912) was born in Brooklyn. He was the son of Mary E. Rose and George Beavers Carhart, a founder of the New York Cotton Exchange and president of the New York, New Haven and Hartford Railroad. Educated in this country and in Europe, Amory Carhart developed an early interest in art, indicated in this portrait by the sketchbook and pencil he holds. He later formed an extensive art collection. In 1893, Carhart married Marion Prentice Brookman of Brooklyn. He served as a director of the Union Trust

Le Clear, *Amory Sibley Carhart*.

Company of New York and the Peoples Trust Company of Brooklyn and was a member of many New York social clubs.

This portrait, which shows Carhart as a serious and self-possessed boy about twelve years old, was painted no later than the fall of 1864, for it was exhibited then at the Brooklyn Art Association. Although the canvas stamp indicates a date between 1854 and 1859, when Goupil and Company were located at 366 Broadway, the subject's age as well as the exhibition in 1864 confirm that the work dates in the early 1860s.

The picture, a typical example of Le Clear's mature portrait style, was given to the Metropolitan Museum by Carhart's daughter.

Oil on canvas, 63¾ × 43⅞ in. (161.9 × 11.4 cm.). Signed at lower left: T. Le Clear.

Canvas stamp: GOUPIL & C°. / Artists Colourman / & PRINT SELLERS / 366 Broadway / NEW YORK.

REFERENCE: G. S. Amory, letter in MMA Archives, August 21, 1964, provides biographical information on the subject.

EXHIBITED: Brooklyn Art Association, 1864, Fall Exhibition, no. 44, as Portrait of a Boy, lent by G. B. Carhart // MMA, 1965, Three Centuries of American Painting, exhib. cat., unpaged, incorrectly dates this painting about 1865; gives wrong accession number.

ON DEPOSIT: MMA, 1962–1964, lent by Mrs. George S. Amory.

EX COLL.: descended to the subject's daughter, Marion Renée (Mrs. George S.) Amory, by 1962.

Gift of Mrs. George S. Amory, 1964.

64.220.3.

William Cullen Bryant

The well-known poet and newspaper editor William Cullen Bryant (1794–1878) was closely associated with the artistic and cultural life of New York for many years. Elected professor of mythology and antiquities at the National Academy of Design in 1828, he gave lectures to its students until 1832. He became an honorary member of the academy in 1833 and delivered one of the inaugural addresses at the opening of its new building in 1865. Bryant was president of the American Art-Union from 1844 to 1846, a trustee of the New York Gallery of Fine Arts, and a member of the Sketch Club, the predecessor of the Century Association. He presided over the Union League Club meeting in 1869 that founded the Metropolitan Museum and

Le Clear, *William Cullen Bryant.*

served as a vice-president on the museum's first board of trustees from 1870 to 1874. "Among the artists of our country are some of my oldest and best friends," Bryant noted at his seventieth birthday celebration in 1864 (P. Godwin, *A Biography of William Cullen Bryant* [1883], 2, p. 220). On his eightieth birthday, his friends presented him with a large silver vase, especially designed for the occasion by Tiffany and Company. In 1877 Bryant presented the vase to the Metropolitan Museum as an example of American craftsmanship of that period.

The portrait, which shows the subject at an advanced age, is not dated. Le Clear's daughter, Caroline, wrote: "Mr. Bryant was so much in my father's studio that the picture was considered unusual, for aside from the sittings his face was studied more than it perhaps otherwise would have been. I am quite sure it was the last picture painted of Mr. Bryant." Le Clear exhibited a portrait of Bryant at the Bryant Memorial Meeting held at the Century Association on November 12, 1878, where it was dated 1876, and at the annual exhibition of the National Academy of Design in 1880. Because no other portrait by Le Clear of Bryant is known, both these showings were probably of the work now

in the museum's collection. The arresting face and memorable head, so often dramatized by painters and sculptors, are diminished here. Le Clear records the alertness of his friend in the dignity of old age. This portrait is briskly painted with broad brushstrokes in contrast to the artist's early, tightly contained, linear technique. Darks and lights are boldly used with dramatic effect to suggest the three-dimensional form of the head. Close examination shows that the picture was originally painted as an oval on a rectangular canvas; the corners were filled in later. Unfortunately, the face is somewhat disfigured by stains on the right cheek, the right ear, and the lower portion of the beard. The area around the mouth also shows some damage.

The Metropolitan Museum has on deposit from the New York City Department of Parks a monumental bust of Bryant by the American sculptor Launt Thompson.

Oil on canvas, 27⅜ × 22¼ in. (69.5 × 56.5 cm.).
Signed at lower center: T. Le Clear N. A.

REFERENCES: *New York Evening Post*, Nov. 13, 1878, p. 1, notes that the "well-known portrait by Le Clear" of Bryant was one of the four portraits of the subject shown at the Bryant Memorial Meeting at the Century // *Bryant Memorial Meeting of the Century, Tuesday Evening, November 12th, 1878*, Century Rooms, New York [1878], p. [7], notes Le Clear's portrait of Bryant is dated 1876 // *Boston Evening Transcript*, Nov. 28, 1882, p. 8, in Le Clear's obituary mentions his portrait of Bryant // J. G. Wilson, *Bryant and His Friends* (1886), p. 114 n, in chronological list of portraits of Bryant mentions one by Thomas Le Clear and dates it 1874 // Mrs. W. H. Beard (Le Clear's daughter) to A. J. Conant, Feb. 1, 1906, MMA Archives (quoted above) // W. C. Bryant II, letter in Dept. Archives, Dec. 2, 1977, supplies references to Le Clear's portrait of Bryant at the Bryant Memorial Meeting at the Century.

EXHIBITED: Century Association, New York, 1878 (probably this picture) // NAD, 1880, no. 419 (probably this picture).

EX COLL.: the artist's daughter, Caroline (Mrs. William H.) Beard.

Rogers Fund, 1906.
06.1323.

HENRY PETERS GRAY

1819–1877

Henry Peters Gray was born in New York City and attended school in Clinton, New York. His father, George W. Gray, encouraged his artistic interests; and, according to Charles P. Daly (p. 4), "his young life and early artistic career was one of unclouded sunshine and juvenile success." In 1838, at the age of nineteen, Gray decided to become a professional artist. He chose as his teacher DANIEL HUNTINGTON, a portrait and landscape painter who was only twenty-two and whose training was limited. Gray made his first trip to Europe in 1839 with Huntington and Cornelius Ver Bryck (1813–1844). He spent most of the time in Rome and Florence. According to Henry T. Tuckerman, Gray "grew intimate with the masterpieces of art, especially devoting himself to the Roman and Venetian school, and to acquiring facility and accuracy in drawing" (p. 442). He returned to the United States in 1841 and established himself as a portrait painter in New York. In 1843 he married Susan Clark, an artist who subsequently became president of the New York Association of Women Painters. For several months Gray had a studio in Boston, where his work was very popular. He then returned to New York. In 1845, "feeling the necessity of a still better acquaintance with the old masters," Gray made a second trip to Italy (Tuckerman, p. 442). After his return to the United States in 1846, he became well known for historical and mythological

pictures based on his studies of Italian Renaissance paintings. "Few of our artists exhibit so clearly the results of academical study as Henry Peters Gray," Tuckerman observed, "his careful and sympathetic knowledge of the masters of pictorial art is evident in all his pictures, the best of which have the mellow and finished tone which distinguishes the Italian school" (p. 442).

Elected an associate of the National Academy of Design in 1841 and an academician in 1842, Gray for many years played an influential role in its affairs. He was vice-president from 1861 to 1870, when he succeeded Huntington as president for one year. Gray's effective leadership of the campaign to provide building and endowment funds helped the National Academy to raise $100,000 in three months during 1863. Known as the Fellowship Fund, it gave the academy financial stability and prestige matched by no other American art institution, provided it with a Ruskinian Venetian Gothic palace on East 23rd Street, and brought to a close a forty-year period of rented halls and dependence on the generosity of a half dozen faithful patrons.

In 1871 Gray went to Italy, where he became a prominent member of the American colony in Florence. He returned to New York in 1875 and died there two years later. A miniature portrait of Gray, painted about 1842 by Henry C. Shumway (1807–1884), is in the museum's collections.

Although he painted some five hundred portraits, Gray was chiefly known for his idealized figures in mythological and historical scenes. He was an avid admirer of Titian and the Venetian school, and his work reflects this influence. His choice of themes alien to American life, in combination with the academic character of his work, often left him open to criticism from contemporaries, who found him "too conservative in taste and practice, renewing obsolete mythological subjects, and giving his artistic sympathies wholly to the past" (Tuckerman, p. 442).

BIBLIOGRAPHY: Henry T. Tuckerman, *Book of the Artists* (New York, 1867), pp. 442–446 // Daniel O'C. Townley, "Living American Artists. No. II, Henry Peters Gray, President of the National Academy of Design," *Scribner's Monthly* 2 (August 1871), pp. 401–402 // Obituaries: *New York Tribune*, Nov. 13, 1877, p. 2; *New York Evening Post*, Nov. 13, 1877, p. [3]; *Boston Daily Advertiser*, Nov. 14, 1877, p. 1; *Art Journal* 4 (Jan. 1878), pp. 29–30; Charles P. Daly, *In Memory of Henry Peters Gray* (New York, 1878), pp. 1–22 // Century Association, New York, *Pictures and Portraits by Henry Peters Gray (1819–1877)* (Nov. 2–10, 1943), exhib. cat. // Bruce Weber, "Henry Peters Gray: The Ideal Painter," 1975, unpublished paper for the City University Graduate Center, copy in Dept. Archives. Contains biographical account of the artist, discussion of his ideal paintings, a selected bibliography, exhibition reviews, and a list of his ideal paintings.

The Greek Lovers

According to the catalogue of the collection of Abraham M. Cozzens, *The Greek Lovers* was the first work Gray painted after returning from Europe in 1846. "Mr. Cozzens," we are told, "was so well pleased with it while in progress that he became the purchaser.... It was the means of introducing Mr. Gray immediately to the public, and the foundation of his reputation." The painting was shown at the 1847 annual exhibition of the National Academy of Design.

Henry T. Tuckerman, in 1867, described it as one of Gray's pictures "which early attracted favorable notice" and observed that the "classically draped and beautiful figure touching a lute is finely executed." C. P. Daly, in 1878,

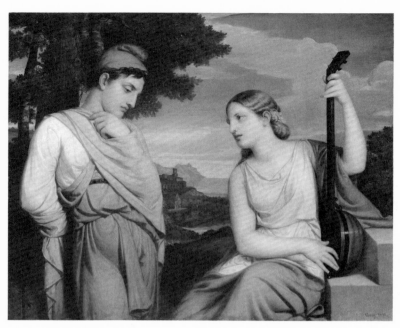

Gray, *The Greek Lovers*.

singled out the "sparkling pearly effect," and observed, "It is the picture that has always been the most admired by Gray's artistic friends."

Two monumental figures dominate the foreground of the painting—an introspective youth wearing a Phrygian cap and a woman playing a long-necked lute, the artist's conception of the Greek folk instrument. Many American artists during the second and third quarters of the nineteenth century were fascinated by ancient Greece and very sympathetic to the modern Greeks' struggle for independence. Gray's choice of subject may well reflect these concerns. The style of the painting, however, owes more to the Renaissance masters than to Gray's study of Greco-Roman antiquities. Margaretta M. Salinger has noted, for example, that the woman's face is modeled after that of the nude in Titian's painting *Sacred and Profane Love* (Galleria Borghese, Rome).

Oil on canvas, 40¼ × 51½ in. (102.2 × 130.8 cm.).
Signed and dated at lower right: Gray 1846.

Canvas stamp: PREPARED / BY / EDWARD DECHAUX/ NEW YORK.

REFERENCES: W. S. Mount to C. Lanman, William Sidney Mount Papers, March 7, 1847, NYHS, cited in A. Frankenstein, *William Sidney Mount* (1975), p. 116, comments on painting // *Literary World* (May 22, 1847), p. 371, reviews this painting in the NAD exhibition and says, "It is 'Rosa Matilda-ish' in sentiment, and the *banjo* we suspect to be an anachronism. The flesh is delicately painted, and the arrangement of color is pleasing, with the exception of the background, which is more like old pictures than nature" // *Crayon* 3 (April 1856), p. 123, mentions this picture in the Cozzens collection // H. T. Tuckerman, *Book of the Artists* (1867), p. 443 (quoted above); p. 623, lists it as part of the A. M. Cozzens collection // Leavitt, Strebeigh and Co., New York, *Catalogue of Paintings of the Late Mr. A. M. Cozzens*, sale cat., May 22, 1868, no. 33 (quoted above) // C. P. Daly, *In Memory of Henry Peters Gray* (1878), p. 21 (quoted above) // S. Isham, *History of American Painting* (1905), p. 288 // W. H. Downes, *DAB* (1931; 1959), s. v. "Gray, Henry Peters," p. 518 // E. P. Richardson, *Magazine of Art* 39 (Nov. 1946), p. 289 // B. Weber, "Henry Peters Gray: The Ideal Painter," 1975, unpublished paper, copy in Dept. Archives, p. 7, notes that it was probably inspired by a poem by Letitia Landon; pp. 14-15, discusses painting; pp. 16, 22-23, 47, 49; ill. pl. 4 // F. Baekeland, *American Art Review* 3 (Nov.-Dec. 1976), pp. 137-138, discusses Abraham M. Cozzens and Henry Peters Gray; ill. p. 138, fig. 21 // M. M. Salinger, European Paintings, MMA, note in Dept. Archives, 1979, suggests European source for one of the figures // L. Libin, Musical Instruments, MMA, note in Dept. Archives, Feb. 9, 1982, states that the lute is not modeled from a real one but is a cross between a mandolin and a guitar.

EXHIBITED: NAD, 1847, no. 83, as Greek Lovers, lent by A. M. Cozzens // Century Association, New York, 1943, *Pictures and Portraits by Henry Peters Gray*, no. 9, as Greek Lovers, misdated 1848 // MMA, 1946, *The Taste of the Seventies*, no. 114; 1965, *Three Centuries of American Painting* (unnumbered cat.).

Ex COLL.: Abraham M. Cozzens, New York, 1846–1868 (sale, Leavitt, Strebeigh and Company, New York, May 22, 1868, no. 33); Mrs. Jonathan Sturges,

New York, by 1878; her grandson, William Church Osborn, New York, until 1902.

Gift of William Church Osborn, 1902.
02.7.2.

The Wages of War

Completed in 1848 and sold to the American Art-Union for the then sensational amount of $1,500, *The Wages of War* was considered a masterpiece of American painting. A reviewer in the Art-Union's *Bulletin* for April 1849 characterized Gray as a follower of the Venetian school and praised the work for its "purity and splendor of color, . . . its classic dignity, its chastened expression of character and feeling, and with some exceptions, its simple gracefulness in point of form and composition." He conceded, however, that because it was allegorical and thus less than direct in its appeal, it would probably never be as popular as Gray's other works.

An etching by Charles Burt after the painting appeared in the October issue of the *Bulletin*. On December 21, 1849, the painting was awarded as a prize in the Art-Union's lottery to a John Doig of Lowville, New York. Gray later regained possession of the picture and in the fall of 1851 took it to London for exhibition. After Gray went to Italy in 1871, his son managed a subscription for its sale and collected $5,000 from a group of patrons who presented the painting to the Metropolitan Museum in 1872. It was the first painting by an American artist to be acquired by the museum and appears in FRANK WALLER's *Interior View of the Metropolitan Museum of Art when in Fourteenth Street*, 1881 (q. v.).

In *The Wages of War* Gray drew on his European studies of classical antiquities and works of the Renaissance. His indiscriminate borrowings and the transformation of his sources give the work its eclectic and peculiarly nineteenth-century character. The arrangement of figures as a frieze across the foreground and the use of a continuous narrative (three scenes appearing within one frame) are classical devices. Gray also borrowed compositional elements from Giorgione and Titian; and for the fallen warrior, he may have used a model closer

Gray, *The Wages of War*.

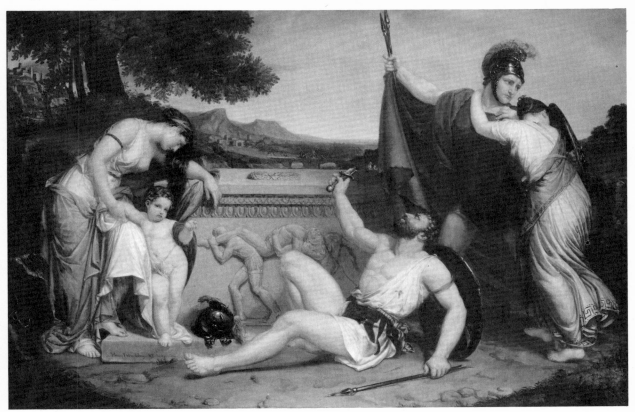

at hand—SAMUEL F. B. MORSE's *The Dying Hercules*, 1813 (Yale University, New Haven).

Gray's choice of subject may have been inspired by the Mexican War and the revolutionary upheavals in Europe in 1848. If the painting was meant to allude to these events, however, the allusion seems to have escaped contemporary notice. *The Wages of War* is, nonetheless, an allegorical statement on war. It is also one of Gray's most ambitious works and reflects his strong reliance on classical and Renaissance models.

Oil on canvas, 48¼ × 76¼ in. (122.6 × 193.7 cm.).

Signed, inscribed, and dated at lower left: *Henry Peters Gray, N. Y. 1848.*

RELATED WORK: Charles Burt, *The Wages of War*, etching, 4½ × 6 13/16 (11.4 × 17.3 cm.), 1849, ill. in *Bulletin of the American Art-Union* 2 (Oct. 1849), opp. p. 5.

REFERENCES: *Bulletin of the American Art-Union* 2 (April 1849), p. 13 (quoted above); p. 25, no. 24, lists this painting and gives description; (May 1849), p. 23, no. 24; (June 1849), p. 34, no. 24; (Sept. 1849), p. 35, no. 24; (Oct. 1849), ill. opp. p. 5, shows etching by Burt; p. 5, discusses etching; p. 29, no. 24; (Nov. 1849), p. 5; p. 31, no. 24; (Dec. 1849), p. 5; p. 19, discusses landscape; p. 28, no. 24 // *Transactions of the American Art-Union for the Year 1849* (May 1850), p. 42, no. 24, notes that this painting was won by John Doig, Lowville, N. Y. // *Bulletin of the American Art-Union* (August 1851), p. 80, notes that Gray and Huntington went to England, and Gray took this painting with him; (Oct. 1851), p. 115, says "Mr. Gray has returned. He left his picture of the *Wages of War* in London, where we understand it will be exhibited"; suppl. to 1851 (Dec. 1852), p. 8, no. 424, lists sale of the plate for the engraving of this painting, 7 × 4¼, on December 17, 1852 // H. T. Tuckerman, *Book of the Artists* (1867), pp. 442, 443 // D.O'C. Townley, *Scribner's Monthly* 2 (August 1871), p. 402, calls it Wages and War and misdates it 1849 // *Art Journal* (New York), n. s. 4 (Jan. 1878), p. 29, notes of Gray, "One of his largest works was an allegorical composition, entitled 'Peace and War.' It is a richly-coloured work, but has never been greatly esteemed, as it is too severe for popular applause" // C. P. Daly, *In Memory of Henry Peters Gray* (1878), pp. 12–13, mistakenly states that the American Art-Union bought the painting in 1844 for $1,200 and notes that after its exhibition in the Art-Union, Huntington wrote a "discriminating and complimentary criticism upon it" in the *Evening Post* // C. H. Caffin, *American Illustrated Magazine* (1905), p. 653 // W. H. Downes, *DAB* (1931; 1959), s. v. "Gray, Henry Peters," p. 518 // M. B. Cowdrey, *American Academy of the Fine Arts and American Art-Union* (1953), 1, p. 160, essay by C. E. Baker; p. 257, Cowdrey mentions engraving // J. T.

Flexner, *That Wilder Image* (1962), pp. 178–179 // A. T. Gardner, *MMA Bull.* 23 (April 1965), p. 265, fig. 1; p. 269 // W. D. Garrett, *MMA Jour.* 3 (1970), p. 312, fig. 4; pp. 313–314; p. 315, fig. 7 // B. Weber, "Henry Peters Gray: The Ideal Painter," 1975, unpublished paper, copy in Dept. Archives, pp. 7–8; pp. 19, 28, 47, 50, discusses related works.

EXHIBITED: American Art-Union, New York, 1849, no. 24 // British Institution, London, 1852, no. 145 // Great Central Sanitary Fair, Philadelphia, 1864, no. 612, lent by the artist // Philadelphia, 1876, *Centennial Exposition*, no. 492 // Century Association, New York, Nov. 1943, *Pictures and Portraits by Henry Peters Gray*, no. 10 // MMA, 1946, *The Taste of the Seventies*, no. 112; 1965, *Three Centuries of American Painting* (unnumbered cat.) // Los Angeles County Museum of Art and M. H. de Young Memorial Museum, San Francisco, 1966, *American Paintings from the Metropolitan Museum of Art*, no. 33.

EX COLL.: American Art-Union, New York, 1849; John Doig, Lowville, New York, 1849 to about 1851; Henry Peters Gray, by 1851–1872; subscribers to a fund for its presentation to the museum: William Cullen Bryant, Jonathan Sturges, John Taylor Johnston, Benjamin G. Arnold, William R. Travers, Samuel J. Tilden, S. B. Chittenden, "E. L.," William T. Blodgett, William E. Dodge, Jr., Sanford R. Gifford, Robert Schell, Lucius Tuckerman, Adrian Iselin, Robert M. Olyphant, Robert Gordon, Benjamin H. Field, Miss Catharine L. Wolfe, Henry T. Morgan, Morris K. Jesup, George Cabot Ward, Henry G. Stebbins, John B. Trevor, and J. B. Colgate, 1873.

Gift of Several Ladies and Gentlemen, 1873.

73.5.

The Pride of the Village

This painting was inspired by the concluding section of Washington Irving's story "The Pride of the Village" from the *Sketch Book of Geoffrey Crayon, Gent.* The tale concerns an innocent country lass whose beauty and gentleness made her the pride of the village. She fell in love with an army officer, who, when transferred to another post, suggested that she accompany him. The shock of this proposal sent her into a decline:

By degrees her strength declined, and she could no longer leave the cottage. She could only totter to the window, where, propped up in her chair, it was her enjoyment to sit all day and look out upon the landscape. . . . In this way she was seated between them [her parents] one Sunday afternoon; her hands were clasped in theirs, the lattice was thrown open, and the soft air that stole in, brought with it the fragrance of the clustering honeysuckle, that her own hands

Gray, *The Pride of the Village.*

had trained round the window. Her father had just been reading a chapter in the Bible; it spoke of the vanity of worldly things, and the joys of heaven; it seemed to have diffused comfort and serenity through her bosom Was she thinking of her faithless lover? — or were her thoughts wandering to that distant churchyard, into whose bosom she might soon be gathered? (New York, 1819–1820, vol. 6, pp. 45–47.)

Gray's representation of this scene was painted during 1858 and 1859 for the New York collector William H. Osborn. The *Crayon* for January 1859 reported finding Gray "engaged upon a picture illustrating a passage in Irving's story of 'The Pride of the Village.'" At the Dodsworth Building on Broadway in New York, in February, Gray showed a sketch of the work, which was probably the painting that later came into the collection of JOHN F. KENSETT and was exhibited at the National Academy of Design in 1873 with the title *Convalescent* (unlocated). In March 1859 Gray exhibited *The Pride of the Village* at the Dodsworth Building, and a month later it was described in the *Crayon* as "a picture of genuine sentiment and pathos." A wood engraving after the painting appeared in an artists' edition of Irving's *Sketch Book*, published in New York by George P. Putnam in 1864.

Irving's popular story inspired many artists. An engraving of John Callcott Horsley's painting *The Pride of the Village*, 1839 (Tate Gallery, London), appeared in the London *Art Journal* for December 1, 1851. Although Gray, who visited London in the fall of 1851, had returned to America by October, he probably saw either the engraving or Horsley's painting, which, albeit different in composition, deals with the same episode in Irving's story.

Gray's painting is a departure from his allegorical works. Closely following Irving's text, it is an example of literary genre painting. Tuckerman said that this picture proved that Gray was as successful dealing with "more domestic and modern subjects" as with the themes of the past that usually occupied him.

Oil on canvas, 30¼ × 25¼ in. (76.8 × 64.1 cm.).
Signed, dated, and inscribed at lower right: H. P. [monogram] Gray '58 N. Y.
RELATED WORKS: Henry Peters Gray, *Convalescent*,

oil on canvas (?), 9 × 12 in. (22.9 × 30.5 cm.), formerly coll. John F. Kensett, now unlocated, listed in NAD, 1873, *On Exhibition Only, Mr. Kensett's Last Summer's Work, and His Private Collection of Pictures by Cotemporaneous Artists*, no. 790, ill. pl. 43 in book of photographs (copies in MMA Library, NYHS, and FARL) showing installation of 1873 NAD exhibition // Richardson and Cox, *Pride of the Village*, wood engraving, ill. in artists' edition of Washington Irving, *Sketch Book of Geoffrey Crayon, Gent.* (New York, 1864).

REFERENCES: *Crayon* 6 (Jan. 1859), p. 25 (quoted above); (March 1859), p. 93, notes that "Gray sent the sketch of his last production—'The Pride of the Village'" to the second exhibition of the season at Dodsworth's; 7 (April 1859), p. 132, reports on the March 6th reception and quotes from a *Home Journal* review: "a picture of genuine sentiment and pathos, treated with great delicacy of handling, and with strength of tone and effect: all the details most carefully rendered, and the character of the three heads expressed with dramatic feeling" // H. T. Tuckerman, *Book of the Artists* (1867), pp. 442–443 // *Watson's Art Journal*, n. s. 8 (Jan. 11, 1868), p. 169, lists this picture among those exhibited at the NAD following the Paris Exposition of 1867 // D. O'C. Townley, *Scribner's Monthly* 2 (August 1871), p. 402 // *Art Journal* (New York), n. s. 4 (Jan. 1878), p. 29 // W. H. Downes, *DAB* (1931; 1959), s. v. "Gray, Henry Peters," p. 517 // D. W. Lawall, *Princeton University Library Chronicle* 20 (Autumn 1958), pp. 22–23, discusses engraving based on the painting // B. Weber, "Henry Peters Gray: The Ideal Painter," 1975, unpublished paper, copy in Dept. Archives, pp. 11, 12, 19–20, discusses it and notes influences; pp. 24, 25, 47, 49; ill. pl. 9.

EXHIBITED: Dodsworth Building, New York, March 1859 // NAD, 1863, no. 128, lent by W. H. Osborn // Metropolitan Fair, New York, 1864, *Catalogue of the Art Exhibition at the Metropolitan Fair in Aid of the U. S. Sanitary Commission*, no. 93, lent by Wm H. Osborne [*sic*], N. Y. // Great Central Sanitary Fair, Philadelphia, 1864, no. 93, lent by W. H. Osborne [*sic*], New York // Paris, 1867, *Exposition Universelle*, no. 22, lent by W. H. Osborn // NAD, winter 1867–1868, no. 666, lent by W. H. Osborn // Philadelphia, 1876, *Centennial Exposition*, no. 492, lists MMA as owner // MMA and NAD, 1876, *Centennial Loan Exhibition of Paintings*, no. 252, lent by Mr. William H. Osborn.

ON DEPOSIT: Bartow-Pell Mansion Museum and Garden, Pelham Bay Park, New York, 1961–1973.

EX COLL.: William Henry Osborn, New York, 1859–1894; his son, William Church Osborn, New York, 1894–1949.

Gift of William Church Osborn, 1949.
49.166.

SEVERIN ROESEN

active in America 1848–1872

Roesen was born in Germany, probably in or near Cologne. He is usually considered to be the porcelain painter who exhibited a flower piece in Cologne in 1847. Possibly as a result of the 1848 political upheavals in Germany, Severin Roesen immigrated to the United States. The date of his earliest known American work, *Still Life, Flowers and Fruit* (Corcoran Gallery of Art, Washington, D. C.) is 1848. He settled in New York, where he was listed in the city directories from 1848 to 1857. Eleven of his still lifes (six flower, three fruit, and two composite pieces) were acquired by the American Art-Union between 1848 and 1850. Shortly after his arrival in New York, Roesen married Wilhelmina Ludwig (1832–1903). Also an immigrant, she was born in Altsei, a village in the Rhine valley near Cologne. The first of their three children, Louisa, was born February 1, 1851, followed by Wilhelmina. A third child, Oscar, was born on August 13, 1857. In 1857 or early 1858 Roesen left New York and went to Pennsylvania. The reasons for his departure are obscure. It has been suggested that his inability to support a growing family during the financial panic of 1857 and its ensuing depression was one factor; he was probably affected as well by the waning demand for German, specifically Düsseldorf-inspired paintings as newly imported French and British works grew in popularity. Oral tradition and the provenance of various paintings suggest that Roesen worked in Philadephia, Harrisburg, and Huntingdon during the late 1850s and early 1860s before he settled in Williamsport about 1862 or 1863. An article in the *Williamsport [Pa.] Sun and Banner* for June 27, 1895, however, gives the date of Roesen's arrival in Williamsport as 1858. His name appears in the city directories for 1866–1867, 1869–1870, and 1871–1872. His studio, according to residents who knew him, became a rendezvous for members of the German population in and around Williamsport. Described in the *Sun and Banner* as "a typical Bohemian den," it had "about a hundred pictures, mostly half finished and covered with dust, standing about the room, and about a half dozen easels holding canvases." Roesen was also a teacher, and the difference in quality of his works, even those that are signed, suggests that his pupils' efforts occasionally may have been passed off as his own. His students in Huntingdon included Henry W. Miller, a clerk to the Huntingdon County Commission, with whom he shared a studio, and a young man named Lyle Bartol. In Williamsport, John Talman (1810–1885) and Christopher Ludwig Lawrence (1792–1879) took lessons from him as well (William R. Gerdts and Russell Burke, *American Still-Life Painting* [New York 1971], p. 241, n 7). Moreover, the popularity that his works enjoyed is attested to by the copies made of them.

The sources of Roesen's still lifes can be found in seventeenth-century Dutch painting. Whether he was influenced directly by Dutch paintings or indirectly through the works of such nineteenth-century German artists as the Düsseldorf still-life painter Johann Wilhelm Preyer is not known. In his flower, fruit, and combination pieces Roesen used motifs like birds, butterflies, and fallen buds, which signify the temporal nature of life, and eggs in a bird's nest, which often connote abundance and fertility. It is uncertain whether Roesen

intended such allusions or merely adopted them as conventional still-life motifs of long standing. His fruit and flowers are characterized by botanical accuracy, and his arrangements include a variety of species regardless of season—including such exotics as the pineapple. An examination of his work shows that Roesen developed a stock repertory of images that he used repeatedly in various combinations. Highly finished, brilliantly colored, and at times extravagantly elaborate, Roesen's work demonstrates his meticulous draftsmanship and technical virtuosity.

After 1872 there is no listing for Roesen in the Williamsport directories. He is reported to have died either in New York, Philadelphia, or Williamsport, but there are no records, to substantiate any of these as the place where he died. It has recently been suggested that he left Williamsport in 1872, returned to Huntingdon, and died enroute to New York City. His last known dated painting is 1872.

BIBLIOGRAPHY: Richard B. Stone, "'Not Quite Forgotten,' a Study of the Williamsport Painter, S. Roesen," *Lycoming Historical Society Proceedings and Papers*, No. 9 (Nov. 1951). The first published monograph on the artist, it contains a list of 132 paintings, 111 of which are signed // Maurice A. Mook, "Severin Roesen: The Williamsport Painter," *Lycoming College Magazine* 25 (June 1972), pp. 33–42. A revised biographical account of the artist, his family, and career gives information from Williamsport directories and incorporates material supplied by the artist's great-grand-daughter, Mrs. Edna L. Hazelton // Maurice A. Mook, "Severin Roesen and His Family," *Journal of the Lycoming County Historical Society* 8 (Fall 1972), pp. 8–12. An account of the artist, his family, and descendants // Maurice A. Mook, "Severin Roesen: Also the Huntingdon Painter," *Lycoming College Magazine* 26 (June 1973), pp. 13–16, 23–30. A study offering evidence of the artist's activity in Huntingdon, Pennsylvania, and a discussion of his students // Lois Goldreich Marcus, *Severin Roesen: A Chronology* (Williamsport, Pa., 1976). A study published by the Lycoming County Historical Society and Museum, it lists twenty-one known dated works by the artist and includes illustrations and a bibliography.

Still Life: Flowers and Fruit

With very few exceptions, Roesen's pictures are still lifes of flowers, fruit, or a combination of the two. This exceptionally large composite piece represents him at his best. It is undated but was probably painted between 1850 and 1855 when he was living in New York.

The still-life arrangement consists of a glass bowl overflowing with flowers of all seasons, a bird's nest with eggs, which is a recurring motif in Roesen's work, and a variety of fruit, including a pomegranate and a pineapple. The flowers and fruit are arranged on two parallel marble ledges. The foliage and fruit overlap the lower ledge and reinforce the illusion of depth. By introducing a reflected image of a window on the foot of the glass bowl, Roesen provides a glimpse of the world outside the painting. This device, which he also included in other works, has a long tradition in European painting.

The elaborate and crowded composition is characteristic of Roesen's still lifes, as is the brilliant color, technical virtuosity, and meticulous attention to detail expected of someone trained as a porcelain painter. The picture is a fine example of the excess that underlies much of Victorian design.

Oil on canvas, 40 × 50⅜ in. (101.6 × 127.9 cm.).
Signed at lower right: *S. Roesen* (initials in monogram).
REFERENCES: A. T. Gardner and S. Feld, *MMA Bull.* 26 (1967), ill. p. 45, as Still Life: Flowers; p. 47, dates it about 1850 // *Book of the Month Club News* (Nov. 1971), color ill. on cover // M. A. Mook, *Lycoming College Magazine* 25 (June 1972), p. 41, fig. 8.
EXHIBITED: M. Knoedler and Co., Hirschl and Adler Galleries, and Paul Rosenberg and Co., New York, 1968, *The American Vision, Paintings 1825–1875* (for the benefit of the Public Education Association), no. 30, as Still Life – Flowers, dates it 1850–1855, shown at M. Knoedler and Co. // Seventh Regiment

Roesen, *Still Life: Flowers and Fruit.*

Armory, New York, 1970, *16th Winter Antiques Show* (for the benefit of East Side House Settlement) // MMA, 1970, *19th-Century America, Paintings and Sculpture*, no. 104 // National Gallery, Washington, D.C.; City Art Museum of St. Louis; Seattle Art Museum, 1970–1971, *Great American Paintings from the Boston and Metropolitan Museums*, no. 48 // Wildenstein, New York, 1973, *Masterpieces in Bloom* (for the benefit of the New York Botanical Garden), no. 58 // MMA and American Federation of Arts, traveling exhibition, 1975–1977, *The Heritage of American Art*, exhib. cat. by M. Davis, no. 37, as Still Life: Flowers, ill. p. 95 // Philbrook Art Center, Tulsa, Okla., traveling exhibition, 1981–1982, *Painters of the Humble Truth*, cat. by W. H. Gerdts, color ill. p. 5, pl. 5.

Ex COLL.: with Eugene Sussel, Philadelphia, 1967.

Purchase, Bequest of Charles Allen Munn, by exchange, Fosburgh Fund, Inc., and Mr. and Mrs. J. William Middendorf II Gifts, and Henry G. Keasbey Bequest, 1967.

67.111.

Still Life: Fruit

Dated 1855 and painted when Roesen was in New York, this large still life is a representative example of his more elaborate fruit pieces. The objects are arranged on a double tier consisting of a gray stone lower ledge and a marble upper ledge. The still life includes a group of objects the artist used repeatedly in different combinations—a Parian compote with applied roses, a *Pilsner* or tapered champagne glass, a large round plate, a covered *Pokal* or trophy cup, a bird's nest with three eggs, a wicker basket, and an open work metal épergne.

Uneven dark and light patches in the background may have been caused by harsh cleaning solvents.

Oil on canvas, arched top, 36 × 50 in. (91.4 × 127 cm.).

Roesen, *Still Life: Fruit.*

Signed and dated at lower left: S. Roesen. / 1855.

REFERENCES: M. A. Mook, *Lycoming College Maga-zine* 25 (June 1972), p. 36, discusses composition; p. 41, fig. 8 // L. G. Marcus, *Severin Roesen* (1976), p. 32, as Fruit Still-Life with Champagne Bottle and Bird's Nest, discusses it and notes general similarity in format, selection of objects, and arched frame to Fruit Still-Life with Bird's Nest (Brooklyn Museum); p. 34, fig. 23; p. 52, lists it among Roesen's dated works.

EXHIBITED: MMA, 1965, *Three Centuries of American Painting* (unnumbered cat.) // Los Angeles County Museum of Art and M. H. de Young Memorial Museum, San Francisco, 1966, *American Paintings from the Metropolitan Museum of Art*, no. 51 // MMA, 1970, *19th-Century America, Paintings and Sculpture* (not in cat.) // Hudson River Museum, Yonkers, N. Y., 1970, *American Paintings from the Metropolitan Museum of Art*, no. 38.

ON DEPOSIT: Gracie Mansion, New York, 1974–1977.

EX COLL.: with H. and R. Sandor, Lambertville, N. J., 1963.

Rogers Fund, 1963.

63.99.

JOSEPH FAGNANI

1819–1873

Joseph Fagnani was born in Naples on December 24, 1819. His early talent for drawing attracted the attention of Prince de Militelle, who allowed Fagnani to study and copy the works in his gallery and arranged several portrait commissions for him. When he was thirteen, Fagnani met Maria Isabella, widow of Francis I and dowager queen of the Two Sicilies. She sat for her portrait and sponsored Fagnani's studies at the Royal Academy in Naples under

Francesco Oliva. The continued patronage of the queen mother assured Fagnani's success. In 1840 she sent him to Vienna by way of Milan, Florence, and Venice to paint a portrait of the Archduke Charles. In 1842, Fagnani visited Paris. Later, he spent nearly three years in Spain, where he met Sir Henry Bulwer, British minister to Spain and later to the United States. In 1849, after two years in Paris, Fagnani went to Washington at Bulwer's invitation.

Fagnani's arrival in the United States on December 23, 1849, as part of Bulwer's entourage aboard H. M. S. *Hecate*, was marked with great fanfare. His American career was singularly successful. In Washington he painted portraits of Henry Clay and Daniel Webster and in 1850, a posthumous portrait of President Zachary Taylor. The same year, Fagnani settled in New York, where he worked as a portraitist in both crayon and oil. His subjects included prominent society figures, clergymen, educators, politicians, and military figures. In 1858, he returned to Paris and contributed frequently to the Paris salons. In 1860 he visited Naples, where Garibaldi sat for him. In 1862, in Turin, he began the first official portrait of Victor Emmanuel as a commission from the city of Naples (copy in the Boston Athenaeum). After five years abroad, Fagnani returned to the United States in 1863. The following year, he visited Sir Henry Bulwer in Constantinople. Fagnani brought his family to the United States in December of 1865. He became an American citizen and made his home in New York, where, with the exception of a trip to Europe in 1871, he remained for the rest of his life.

A fashionable painter of the glittering international scene, Fagnani never lacked patrons. He painted over fourteen hundred portraits. Rapid execution, marked facility in catching a flattering likeness, and personal charm made him one of the most popular portrait painters of the day. His paintings exemplify the facile international portrait style of the mid-nineteenth century.

BIBLIOGRAPHY: Emma Fagnani, *The Art Life of a XIXth Century Portrait Painter, Joseph Fagnani, 1819–1873* (Paris, 1930). A privately printed account of the artist's life written in 1873 by his wife. Contains diary entries, letters, reviews, a partial list of 1432 portraits arranged chronologically, and a list of his decorations and honors // Groce and Wallace, p. 218 // Albert Ten Eyck Gardner, "An American Primitive and Sophisticate," *MMA Bull.* 15 (April 1957), pp. 183–188 // MFA, Boston, *M. & M. Karolik Collection of American Water Colors & Drawings, 1800–1875* (Boston, 1962), 1, p. 153.

The Nine Muses (American Beauty Personified as The Nine Muses)

In tribute to the varied beauty of American women, Fagnani painted a series of portraits of American society belles in the guise of the nine muses of classical antiquity. According to contemporary accounts, the project was intended to prove that American women were as beautiful as European ones. Fagnani's celebration of American womanhood appealed to national pride, the use of classical references provided an uplifting spirit, and the anonymity of the sitters introduced a tantalizing note of mystery—until an enterprising reporter revealed their identities. When the series was completed in 1869, it was exhibited with great success in Boston, New York, and Philadelphia. A critic for the *Round Table* commended Fagnani for "the felicity with which he invariably hits off the happiest and most flattering resemblance of his model" and urged all "to go and refresh their classic reminiscences and their patriotic aspirations by judging for themselves of the charms and merits of the Nine Muses." At the time of the Boston exhibition, the critic for the *Chicago Art Journal* showed less restraint:

Fagnani, *Melpomene*.

Fagnani, *Clio*.

Ladies of the very highest social position have granted him repeated sittings. From Massachusetts to Louisiana, from the lakes to the gulf, each section has lent its loveliest to aid the artist in his self-imposed labor The success with which this has been accomplished shows a rare discretion and refinement of feeling on the part of the artist.

In contrast, a critic writing for the *Tribune* observed, "The poor muses have surely fallen on evil days if they are satisfied with these counterfeit presentiments." Characterizing the series as "very poor art," he concluded:

These are no goddesses of heavenly art and song. They are simply pretty women, tricked out in garments no human creature could wear, and affecting characters they do not comprehend and cannot imitate. Pretty women they are, very pretty; at least they would be if they were becomingly dressed, and placed quietly at home, instead of being transported into the uncongenial regions of classical mythology.

Shortly before he died in 1873, Fagnani made copies of the paintings in charcoal for engravings that were never executed. After his death, a group of friends bought *The Nine Muses* and presented them to the newly opened Metropolitan Museum, where they were exhibited for many years. Each muse has her Greek name painted at the upper left.

Melpomene

Wearing a tiara, the Muse of Tragedy is shown with a dagger and scepter in place of the traditional tragic mask and club of Hercules. The model was Mrs. Ferdinand de Luca, wife of the Italian consul in New York, formerly Miss Kennedy of New Orleans. Her costume is said to have been worn by the Italian actress Madame Adelaide Ristori in her celebrated role of Phaedra.

Signed at lower left: J. F. Inscribed at upper left: ΜΕΛΠΟΜΕΝΗ.

74.41.

Clio

The Muse of History wears a laurel wreath and sits, pen in hand, at a writing table on which rest a parchment scroll and a trumpet. The model was Mrs. William M. Johnson, formerly Miss Sallie Day, of Stonington, Connecticut. She was later married to Edward Townsend. The painting is disfigured by drying cracks.

Signed at lower right: J. F. Inscribed at upper left: ΚΛΕΙΩ.

74.42.

Calliope

The Muse of Epic Poetry holds a partially unrolled manuscript of the *Iliad* in one hand and a trumpet in the other. The model was Miss Lizzie Wadsworth, the youngest daughter of General James S. Wadsworth, of Geneseo, New York.

Signed at lower left: J. F. Inscribed at upper left: ΚΑΛΛΙΟΠΗ.

74.43.

Terpsichore

Mrs. George Lorillard Ronalds of New York posed for the Muse of Lyric Poetry and Dance. The face is disfigured by drying cracks.

Signed at lower right: J. F. Inscribed at upper left: ΤΕΡΨΊΧΟΡΗ.

74.44.

Polyhymnia

The Muse of Heroic Hymn is seated in a meditative pose with a scroll in one hand. She is flanked by a lyre and a lighted lamp, representing knowledge. The model was Mrs. Francis Channing Barlow, formerly Miss Ellen Shaw, of Boston. In 1911, she wrote that the series of paintings looked "like ladies on prune boxes."

Signed at lower right: J. F. Inscribed at upper left: ΠΟΛΥΜΝΙΑ.

74.45.

Euterpe

The Muse of Flute-Playing holds a lyre and two auloi or aulos-like instruments. The latter are nineteenth-century interpretations of the ancient Greek instruments. The Greek models, however, were reed instruments; these are whistles. The subject is Miss Minnie Parker, granddaughter of Mrs. Henry Hill of New York.

Signed at lower left: J. F. Inscribed at upper left: ΕΥΤΕΡΠΗ.

74.46.

Fagnani, *Calliope*.

Fagnani, *Terpsichore*.

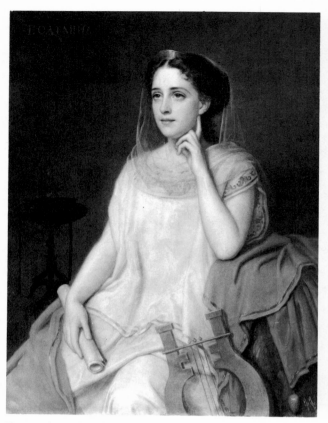

Fagnani, *Polyhymnia*.

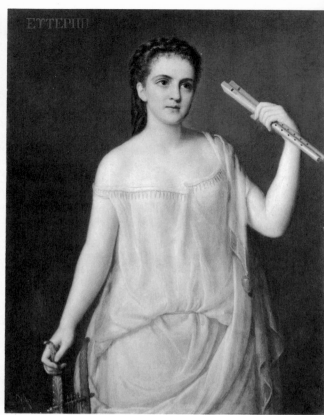

Fagnani, *Euterpe*.

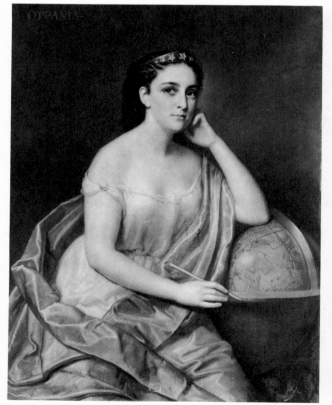

Fagnani, *Urania*,

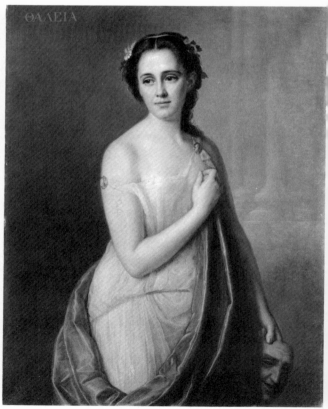

Fagnani, *Thalia*.

Urania

Wearing a circlet of stars and an azure robe fastened with a crescent, the Muse of Astronomy is shown with a globe and, in place of the customary compass, a rod. The model was Miss Josephine Blodgett, daughter of Daniel Blodgett of Boston. She was later married to Joseph Allston Gillet. The painting has a fine network of drying cracks particularly in the head of the figure and on the bodice of her dress.

Signed at lower right: J. F. Inscribed at upper left: OΥΡΑΝΙΑ.

74.47.

Thalia

The model was Miss Nellie Smythe of New York, who afterwards was married to William P. Jaffray. As the Muse of Comedy, she holds a comic mask.

Signed at lower left: J. F. Inscribed at upper left: ΘΑΛΕΙΑ.

74.48.

Erato

Wearing a wreath of roses and myrtle, the Muse of Sapphic Poetry is shown fingering a stringed instrument identified as a *phorminx* in the catalogue *American Beauty Personified as the Nine Muses*. The instrument represents a lyre but has six strings instead of the usual seven. Like several of the other instruments in the series, this one is an adaption rather than an accurate representation of an actual instrument. Miss Kate Sullivant, the daughter of William S. Sullivant of Columbus, Ohio, posed for this muse. Miss Sullivant is accompanied by Master George Watts as Cupid, bearing a flaming torch. The head of the muse is somewhat disfigured by drying cracks.

Signed at lower left: J. F. Inscribed at upper left: ΕΡΑΤΩ.

74.49.

Oil on canvas, each 43½ × 33½ in. (110.5 × 83.8 cm.).

Canvas stamp (on 74.42–46): PREPARED / BY / E. Dechaux, Jr. & Co. / MANUFACTURERS AND / IMPORTERS OF / ARTISTS / MATERIALS / 894 BROADWAY, N. Y.

RELATED WORKS: Eight of *The Nine Muses* (excluding Erato), charcoal, 11½ × 8½ in. (29.2 × 21.6

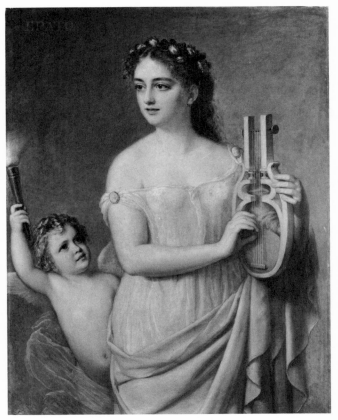

Fagnani, *Erato*.

cm.), ca. 1869. These drawings were auctioned in New York in 1978 (property of the artist's descendants). *Clio* is illustrated in Phillips, New York, *American and European Paintings, Watercolors and Drawings*, sale cat. (Dec. 5, 1978), no. 198. Of the eight known drawings *Thalia* and *Polyhymnia* are in the collection of Peter A. Feld, New York, 1980; others are also either in private collections or on the art market.

REFERENCES: *Round Table* 9 (April 24, 1869), p. 267 (quoted above) // *New York Times* (April 30, 1869), pp. 4–5, discusses the series and reports that it will be exhibited in Boston and then New York // *Galaxy* 7 (June 1869), p. 913, says that the series is being sent to Boston for exhibition // *Putnam's Magazine* 3 (June 1869), p. 748, describes the series // J. H., "They Live Once More, Suggested by Fagnani's 'Nine Muses,'" New York, July 1, 1869, a poem reprinted in booklet form, copy in NYPL, pp. 11–21 // [A. A. Childs], *American Beauty Personified as the Nine Muses* (Boston, 1869), includes reprint of "The Nine Muses" by C.A.B. from the *Chicago Art Journal* (July 1869) (quoted above), MMA has Samuel P. Avery copy with a bound-in list from A. A. Childs and Company, Boston, identifying the subjects // *Putnam's Magazine* 4 (Nov. 1869), p. 630, notes that the series is on exhibit at the Somerville Art Gallery // *Eclectic Magazine of Foreign Literature, Science, and Art* 10 (Dec. 1869), p. 765, review of the exhibition of the series, reprinted from the *Tribune* (quoted above) // F.D.L., "The Nine

Muses," Philadelphia, Feb. 1, 1870, a poem translated from Italian and printed in booklet form, copy in NYPL, pp. 3–9 // MMA, *Fourth Annual Report of the Trustees of The Association* (1874), pp. 51, 55 // D. C. Preyer, *The Art of the Metropolitan Museum of New York* (1909), pp. 291–292 // E. S. Barlow to R. de-Forest, April 20, 1911, in MMA Archives (quoted above) // E. Fagnani, *The Art Life of a XIXth Century Portrait Painter, Joseph Fagnani, 1819–1873* (1930), pp. 92–98, discusses the series, citing Henry T. Tuckerman in the *Boston Transcript* and article by C.A.B., notes poem by H. E. Pietro Brailas, says that the series was exhibited in Boston, New York and Philadelphia for a period of four months in each city, mentions "copies in black and white crayon" that were made for engraving; p. 120, mentions the series and identifies the subjects in a partial list of the artist's work in New York for 1868 // A. T. Gardner, *MMA Bull.* 15 (April 1957), pp. 183–188, discusses the artist and the series; ill. pp. 185–187 // A. T. Gardner, *MMA Bull.* 23 (April 1965), p. 266, fig. 2, ill. *Polyhymnia*; p. 296, discusses the acquisition of the series // W. D. Garrett, *MMA Jour.* 3 (1970), p. 316, discusses acquisition of the series; p. 317,

fig. 9, ill. *Calliope* // C. Tomkins, *Merchants and Masterpieces* (1970), p. 43 // S. P. Feld, letter in Dept. Archives, Jan. 3, 1980, provides a set of photographs of Fagnani's eight drawings // L. Libin, Musical Instruments, MMA, orally, Feb. 9, 1982, provided information on the instruments.

EXHIBITED: Fagnani's studio at 43 East 12th Street, New York, 1869 // A. A. Childs and Company, Boston, 1869 // Somerville Art Gallery, New York, 1869 // Philadelphia, 1870 // MMA, 1946, *The Taste of the Seventies*, nos. 98–106.

ON DEPOSIT: Museum of the City of New York: *Erato*, 1936–1938, and *Melpomene*, 1955–1956.

EX COLL.: the artist's estate with Somerville Gallery, New York, 1873; subscribers to an association for its presentation to the museum (Emma Fagnani, Charles Fagnani, Courtlandt Palmer, Jr., Charles P. Palmer, Mrs. Henry Draper, Edward S. Jaffray, Edward Clark, Thomas Lord, J. Warren Goddard, William B. Isham, and William T. Blodgett), 1874.

Gift of an Association of Ladies and Gentlemen, 1874.

74.41–49.

JAMES HAMILTON

1819–1878

Much of the work of the marine and landscape painter James Hamilton remains unlocated, making a detailed evaluation of his artistic career somewhat difficult. His parents were Scottish, but he was born in Entrien, near Belfast, in the north of Ireland. In 1834 his family immigrated to Philadelphia, which became the center of his activities, if not always his actual home, for the next forty years. Through the kindness of a man named William Irwin, young Hamilton received an education, and when he showed an ability for drafting, he was placed in a drawing school. On completion of his studies, he worked in a countinghouse but soon decided to pursue a career in art. He was encouraged by the engraver, painter, and publisher John Sartain (1807–1897). Although the particulars of Hamilton's artistic training are not known, according to Sartain (1852), he "procured instruction in drawing, and studied alternately with the best teachers in Philadelphia."

Hamilton supported himself by giving drawing lessons, and THOMAS MORAN and EDWARD MORAN were among his better known pupils. His first paintings, done in watercolor, were admired by a number of distinguished Philadelphia artists, including JOHN NEAGLE and Thomas Birch (1779–1851). His earliest oils, exhibited at the Artists' Fund Society of Philadelphia in 1840, resemble Birch's topographical landscapes and marine views, but they are more tightly and awkwardly executed. In 1843, Hamilton began to show his work at the Pennsyl-

vania Academy of the Fine Arts, where he remained a regular exhibitor. In 1861 this prestigious institution elected him an academician. He exhibited at the National Academy of Design in New York in 1846, 1847, and 1867, and his work was included in exhibitions in Baltimore, Washington, and Boston.

During the 1840s, Hamilton worked as an illustrator, achieving some recognition for his contributions to John Frost's *The Pictorial History of the American Navy* (ca. 1845). Later he collaborated with the Arctic explorer Elisha Kent Kane and, working from Kane's drawings, produced some illustrations for the explorer's *The U. S. Grinnell Expedition in Search Of Sir John Franklin* (1853). He also did the illustrations for Kane's two volume *Arctic Explorations* (1856), a report on the second Grinnell expedition made from 1853 to 1855. In the following years he continued to illustrate books, among them Nathaniel Parker Willis's *Sacred Poems* (1860), Susan Fenimore Cooper's *Pages and Pictures, from the Writings of James Fenimore Cooper* (1861), and Edward Strahan's *A Century After: Picturesque Glimpses of Philadelphia and Pennsylvania* . . . (1875). The subjects of many of Hamilton's oils, for example, *Capture of the "Serapis" by John Paul Jones*, 1854 (Yale University, New Haven, Conn.) and *The Vision of Columbus*, 1850 (New York art market, 1966), were inspired by literary works, sometimes those he had illustrated.

Titles recorded in contemporary exhibition catalogues suggest that Hamilton painted in Maryland, Delaware, New Jersey, and New York, and traveled as far north as Massachusetts. By 1850, he had developed the painterly style and dramatic subjects that characterized his work for the remainder of his career. His pictures are "not apt to be overdone with non-essential detail and minute forms," Sartain noted. Hamilton was undoubtedly familiar with the work of the English painters Samuel Prout, John Constable, and J. M. W. Turner, if not in the original, at least through engravings and publications. In 1854 he made an extended trip to England where he was able to see many of their works for himself. Ambitious and imaginative works like *Foundering*, 1863, and *The Last Days of Pompeii*, 1864 (both Brooklyn Museum) show the artist's continued reliance on British romantic painters.

In 1875 Hamilton sold the contents of his studio at Earle and Sons in Philadelphia in order to make a trip around the world. He planned to visit California and then set out for Japan, India, China, Africa, and Europe. The following year he arrived in San Francisco, where he worked for the next two years. He died there on March 10, 1878, and his funeral was arranged by local artists at the San Francisco Art Association. Writing in 1880, Samuel G. W. Benjamin (1837–1914) ranked him as the "ablest marine-painter of this period," noting that he "rendered the wildest and grandest effects of old ocean with breadth, massiveness, and power" (*Art in America* [1880], p. 84).

BIBLIOGRAPHY: [John Sartain], "James Hamilton," *Sartain's Union Magazine of Literature and Art* 10 (1852), pp. 331–333 // Henry T. Tuckerman, *Book of the Artists* (New York, 1867), pp. 565–566 // John I. H. Baur, "A Romantic Impressionist: James Hamilton," *Brooklyn Museum Bulletin* 12 (Spring 1951), pp. 1–9 // John Gordon, "James Hamilton, a Forgotten Painter," *Art in America* 44 (Fall 1956), pp. 15–17, 56 // Brooklyn Museum, *James Hamilton, 1819–1878: American Marine Painter*, exhib. cat. by Arlene Jacobowitz (1966). Includes biography, annotated catalogue of works in the exhibition, list of located works not in the exhibition, bibliography, and many illustrations.

On Hampstead Heath

This view of Hampstead Heath looking toward London, with the dome of Saint Paul's Cathedral in the right background, was painted in 1856, soon after Hamilton returned from a long visit to England. It is most likely the painting that he exhibited at the Pennsylvania Academy of the Fine Arts the same year. The work was once owned by his friend, the engraver John Sartain (1808–1897), who "when a boy . . . was familiar with all parts of Hampstead Heath" (J. Sartain, *The Reminiscences of a Very Old Man, 1808–1897* [1899], p. 244).

The free brushwork, rich colors, and heavy impasto are unusual in American painting of the period. As Henry T. Tuckerman later noted: "His style is bold and free; he does not aim at high finish; he is the reverse of literal, and aims to give emphatically his own feeling and sense of a subject" (*Book of the Artists* [1867], p. 565). Hamilton's style was undoubtedly the result of his interest in British romantic painting, and, in this particular case, the works of John Constable.

Hamilton has painted a simple landscape scene of a field with two figures, their diminutive size emphasizing the panoramic scope of the picture. Like Constable, he concentrated on the more transient effects of nature, suggesting the falling rain with powerful slanted brushstrokes and building up the clouds with thick layers of paint. The turbulent clouds cast dark shadows on the field below and are the most expressive feature of the landscape. Hamilton is known to have made cloud studies (coll. Katherine A. Reed, Philadelphia), which, although not as extensive as Constable's, were probably influenced by them.

Oil on canvas, 14 × 20 in. (35.6 × 50.8 cm.).

Signed at lower left: J. Ham[illegible]. Inscribed and dated on the back: On Hampstead Heath / Jas. Hamilton / 1856.

REFERENCES: C. S. Keyser, in *Hamilton Etchings*, Art Union of Philadelphia (1883), n. p., mentions 1856 exhibition // W. Sartain, letter in MMA Archives, March 28, 1912, says this painting originally belonged to his father // J. I. H. Baur, *Brooklyn Museum Bulletin* 12 (Spring 1951), p. 6, conjectures that it was painted abroad; ill. p. 7 // J. Gordon, *Art in America* 44 (Fall 1956), p. 17.

EXHIBITED: PAFA, 1856, no. 29, lent by J. Buckstone (probably this picture) // MMA, 1946, *The Taste of the Seventies*, no. 116 // Brooklyn Museum, 1966, *James Hamilton, 1819–1878*, exhib. cat. by A. Jacobowitz, no. 13; pp. 13–14; ill. p. 37.

EX COLL.: probably J. Buckstone, 1856; John Sartain, Philadelphia, d. 1897; William Sartain, Philadelphia and New York, by 1897–1912.

Gift of William Sartain, 1912.

12.64.

Hamilton, *On Hampstead Heath*.

MARTIN JOHNSON HEADE

1819–1904

Heade was born in Lumberville, Pennsylvania, on August 11, 1819; he was the eldest of eight children of Sarah Johnson and Joseph Cowell Heed. In 1846 the artist adopted an early spelling of the family name. His father, who is variously described as a prosperous farmer, gunmaker, and owner of a lumbermill, encouraged him in his interest in art and sent him to Newtown, Pennsylvania, to study with EDWARD HICKS. There, Heade met young THOMAS HICKS, a cousin and student of Edward's, who painted Heade's portrait, ca. 1841 (Bucks County Historical Society, Lumberville, Pa.) and probably also instructed him. Heade began exhibiting in 1841 when he showed a portrait at the Artists' Fund Society of Philadelphia. His early portraits exhibit the characteristic hallmarks of provincial training in their rudimentary modeling, linear quality, and surface patterns.

According to one source, Heade's father sent him abroad to study in 1838. His most recent biographer, Theodore E. Stebbins, Jr., however, suggests that the trip took place sometime between 1840 and 1843. Heade spent two years in Rome and visited France and England before returning home. In 1843, when he exhibited at the National Academy of Design, he was listed in the catalogue as living in New York. An incessant traveler, he moved frequently during the next two decades: in 1845 he was in Brooklyn, in 1847 in Philadelphia, in 1848 in Rome, and probably in England and France as well, and from 1850 to 1858, he visited Saint Louis; Chicago; Madison, Wisconsin; Trenton, New Jersey; and Providence, Rhode Island. Painting in an academic manner, he became a proficient portraitist, and judging by exhibition records of the 1840s, he also branched out into genre, allegorical, and landscape painting as well. In 1844 he showed *The Dead-fall* (unlocated) at the Pennsylvania Academy, and in 1847 his *Sleepy Fisherman* (unlocated) was exhibited at the American Art-Union in New York. Of all of Heade's recorded genre paintings only *The Roman Newsboys*, ca. 1848–1849 (Toledo Museum of Art, Ohio) is presently located. His only known allegorical painting, *Gertrude of Wyoming*, ca. 1850 (coll. Mr. and Mrs. J. R. Dodge, Washington, D. C.), is an idealized work, conceived in a neoclassical manner and inspired by the heroine of Thomas Campbell's poem of the same title. In his landscapes of the 1840s, Heade initially followed the traditional conventions of the Hudson River school, but such works as *Rocks in New England*, 1855 (MFA, Boston), his earliest known dated landscape, anticipate the originality that would distinguish his work in succeeding decades.

In 1859 Heade moved back to New York, where he took a studio in the Tenth Street Studio Building. There he met, among others, FREDERIC E. CHURCH, who became a lifelong friend. From his base in New York, Heade continued his travels. His summers were often spent on the Rhode Island coast, around Narragansett and Newport. This area inspired the series of arresting seascapes and marsh scenes that became his specialty.

By 1861 Heade had moved to Boston, where he probably remained until 1863. In search of subjects, he continued to explore Rhode Island, Maine, the White Mountains of New Hampshire, and the salt marshes near Newburyport, Massachusetts. The similarities of his

work with that of FITZ HUGH LANE, who was also painting along the New England coast, suggest that they knew each other. While direct contact has not been documented, the two painters had the opportunity to see each other's work in the exhibitions of the Boston Athenaeum during the late 1850s.

The early 1860s proved to be extraordinarily productive and creative years for Heade. In addition to increasingly evocative landscapes and coastal views, representing both tranquil and dramatic moments in nature and executed with the relentless clarity that characterized his linear style, he painted flower pieces, marshlands, and hummingbirds—his major subjects in the years that followed. The Rev. James C. Fletcher was probably the first to suggest that Heade visit South America. Fletcher, an amateur naturalist, lived in Newburyport from 1856 to 1862 and had been acting secretary of the United States legation at Rio de Janeiro in 1852 and 1853. He knew the Brazilian emperor Dom Pedro II and was coauthor of *Brazil and the Brazilians* (1857). Reports from Frederic E. Church, who had won international acclaim with his *Heart of the Andes* in 1859 (q. v.), were probably equally instrumental in Heade's trip to Rio de Janeiro in 1863. Once there, Heade's interest in nature, wildlife, and conservation found special expression in his study of the hummingbird. Although the English naturalist John Gould had written a five-volume work on the subject, published in London between 1849 and 1861, Heade decided to produce an illustrated book on the hummingbirds of South America. In 1864 at the Institute of Fine Arts in Rio de Janeiro, he exhibited "Gems of Brazil," twelve small paintings of hummingbirds. They were part of a projected series of twenty pictures intended as models for chromolithographs. The artist took his paintings to London for printing in 1864, but the project was eventually abandoned. Examples of four prints, of which only two to four impressions are known, are in the collection of the Museum of Fine Arts, Boston.

From 1866 to 1881, with a few exceptions, the Tenth Street Studio was again the address given for Heade in various exhibition catalogues, but he continued to travel extensively. He visited Nicaragua in 1866, and at Church's urging in 1870, he went to Colombia, Panama, and then to the Caribbean island of Jamaica. These trips inspired a series of tropical landscapes, among them *Mountains of Jamaica* (unlocated), which was exhibited in London in 1873 and very favorably reviewed. The London *Art Journal* in July 1873 acclaimed Heade as one of the "great masters" of American landscape painting (p. 223). Following his return from South America, he began his series of orchid and hummingbird paintings, which date from 1871. In 1872 he went to British Columbia and in 1875 to California. He moved to Washington, D. C., in 1881, and two years later married Elizabeth Smith and went to Saint Augustine, Florida. There he had a studio behind the Ponce de Leon Hotel, built by Henry Morrison Flagler, who became his patron.

During the 1880s, Heade introduced yet another theme into his repertory. He began to paint a series of still lifes, occasionally featuring fruit, but more often flowers native to Florida, especially magnolias and cherokee roses. These paintings are among the most sensual of American still lifes. John I. H. Baur once described Heade's white magnolia blossoms "arrayed on sumptuous red velvet like odalisques on a couch" (M. Knoedler, exhib. cat. 1954). Heade died in Saint Augustine on September 4, 1904, at the age of eighty-five.

Although Heade exhibited regularly at the annual exhibitions of the National Academy

of Design, he never became a member. He was also never an active participant in New York's sociable artistic community. Probably by choice, he remained something of an outsider. Protective of his privacy, he revealed himself in his art and in his occasional publications. By virtue of his preoccupation with effects of light and atmosphere, Heade's painting style is allied to the works of such artists as Fitz Hugh Lane, JOHN F. KENSETT, and SANFORD R. GIFFORD. Of this group of second generation Hudson River school artists, Heade emerges as one of the most versatile and original. He took a distinctly individual approach to the subjects he chose to represent. Doubtlessly his unconventionality contributed to the degree of success he achieved during his lifetime. For nearly forty years after his death, however, his name was almost forgotten. Not until 1943, when his *Thunderstorm, Narragansett Bay*, 1868 (Amon Carter Museum of Western Art, Forth Worth), was shown at the Museum of Modern Art, New York, did he emerge as one of the masters of American painting.

BIBLIOGRAPHY: Robert G. McIntyre, *Martin Johnson Heade, 1819–1904* (New York, 1948). Contains a biography with extracts from the artist's letters, a selection of reviews of his work, a list of exhibitions, pictures sold at auction, and owners of works // MFA, Boston, *M. and M. Karolik Collection of American Paintings, 1815 to 1865* (Cambridge, Mass., 1949), intro. essay by J. I. H. Baur, pp. xliii–xliv; catalogue entries and biography, pp. 301–350 // M. Knoedler and Company, New York, *Commemorative Exhibition, Paintings by Martin J. Heade (1819–1904), Fitz Hugh Lane (1804–1865) from the Private Collection of Maxim Karolik and the M. and M. Karolik Collection of American Paintings from the Museum of Fine Arts, Boston* (New York, 1954), exhib. cat. with intro. by John I. H. Baur // University of Maryland Art Gallery, *Martin Johnson Heade* (College Park, Md., 1969), exhib. cat. by Theodore E. Stebbins, Jr., for an exhibition that traveled to MFA, Boston; University of Maryland Art Gallery; and Whitney Museum of American Art, New York. Contains essay and annotated catalogue entries // Theodore E. Stebbins, Jr., *The Life and Works of Martin Johnson Heade*, Yale Publications in the History of Art 26 (New Haven, 1975). A profusely illustrated catalogue of Heade's paintings, drawings, watercolors, prints, and sketches, it contains a selective bibliography, a list of Heade's writings, a chronological outline of his life and exhibited works, and an index of owners. It is the most comprehensive account of the artist to date.

The Coming Storm

The appearance in 1975 of this previously unknown, major painting by Heade provides insight into the genesis of his extraordinary cycle of marine pieces that culminated in *Thunderstorm, Narragansett Bay*, 1868 (Amon Carter Museum of Western Art, Fort Worth). Although in concept, content, and form, *The Coming Storm*, dated 1859, anticipates Heade's final, more polished statement, it presents a more elementary image, closer to the untutored yet immensely powerful sensibility of a self-taught artist.

In *The Coming Storm*, as in other seascapes, Heade deals with nature in one of its unpredictable moods. The drama of the impending storm is heightened by the contrasting tranquility of the dark, still water and by the inclusion of a man and a dog watching nature's ominous spectacle unfold. It is a calculated composition in which the tension is chiefly sustained by the dramatic and discriminating use of dark and light for maximum expressive effect. The foreground, the projecting spits of land converging asymmetrically in the middle ground, the lone figure rowing to shore on the left, and the sailboat marking the center of the composition are brilliantly illuminated in contrast to the rest of the painting. Form and depth are suggested largely by the abrupt juxtaposition of sharply contrasting colors rather than subtle tonal modulations. The intricate pattern of light and dark shapes on contrasting grounds, reflecting the interplay of dark clouds and intermittent sunlight, and a highly effective use of silhouetting contribute to the decorative quality of the work and its strong structural coherence.

Attempts to identify this painting of 1859 with

Heade's work called *Approaching Thunder Storm* lent by the Reverend Noah Hunt Schenck to the 1860 exhibition of the National Academy of Design have not been successful. The provenance and contemporary reviews of that painting make it highly unlikely that *A Coming Storm* could be the same work. The critic for the *Cosmopolitan Art Journal* (4 [June 1860], p. 81) reported that the exhibition "elicited comparatively little notice from the press" and observed that the young marine painters, Heade among them, "all have wrought with water and sea-sky in a very pleasing if not a very striking manner." The rather arresting and original character of this painting would have elicited greater notice. Nineteenth-century critics often took exception to Heade's unconventional representations, of which *The Coming Storm* is a prime example. One critic's review of *Thunderstorm, Narragansett Bay*, another of Heade's more unconventional works, noted: "It is to be regretted that so hard and chilling a painting as this should have been allowed to leave his studio" (G. T. C., *National Academy of Design, Exhibition of 1868* [New York, 1868], p. 87).

The paint surface of this work has been somewhat flattened in the lining process. Pentimenti around the rock and sail at the left and the principal figure on the right indicate the artist's alterations.

Oil on canvas, 28 × 44 in. (71.1 × 111.8 cm.).
Signed and dated at lower left: M. J. Heade / 1859.
REFERENCES: T. E. Stebbins, Jr., *The Life and Works of Martin Johnson Heade* (1975), ill. p. 233, no. 110, coll. David N. Fleischer, Bethlehem, Pa. // D. N. Fleischer, letter in Dept. Archives [1975], notes, "My great great grandfather, William H. Chapman, was an importer in New York City and he was the original owner of the picture. It is assumed that he purchased the painting while Heade was painting in New York in the years 1859 to 1860"; suggests that it might be the painting shown at the NAD in 1860 and that it might have served as "a precursor for Heade's more famous work 'Thunderstorm over Narragansett Bay,' which was done in 1868" // Condition report, Dec. 18, 1974, copy in Dept. Archives, discusses conservation and treatment // *MMA Annual Report, 1974–75*, p. 36; ill. p. 37 // *MMA Bull.* 33 (Winter 1975/1976), ill. p. [240] // D. N. Fleischer, letter in Dept. Archives, Sept. 27, 1978, provides provenance.
EXHIBITED: MMA, 1976, *A Bicentennial Treasury, American Masterpieces from the Metropolitan* (see *MMA Bull.* 33 above) // MMA and American Federation of Arts, traveling exhibition, 1975–1977, *The Heritage of American Art*, cat. by M. Davis (rev. ed. 1977), no. 42, color ill. p. 105 (shown in Australia only).

EX COLL.: William H. Chapman, New York and East Orange, N. J., d. 1891; his widow, Helen Chapman, Oakland, Fla., and Bethlehem, Pa., 1891–1905; her son, Niles Chapman, Indianapolis, 1905–1944; descended in the family to Helen W. Fleischer, 1944–1969; Thomas Fleischer, Bethlehem, Pa., 1969–1973; his son, David N. Fleischer, Bethlehem, Pa., 1973–1975; the Erving Wolf Foundation and Mr. and Mrs. Erving Wolf, New York, 1975 (Mr. and Mrs. Wolf retained one-third interest until 1977).

Gift of Erving Wolf Foundation and Mr. and Mrs. Erving Wolf, 1975.
1975.160.

Hummingbird and Passionflowers

For more than twenty years, from 1880 to 1904, Heade contributed over one hundred letters and articles on hummingbirds, wildlife, game preserves, and related topics to *Forest and Stream* under the pseudonym Didymus. "From early boyhood," he wrote, "I have been almost a monomaniac on hummingbirds, and there is probably very little regarding their habits that I do not know" (*Forest and Stream* 38 [April 14, 1892], p. 348). Although his intention of publishing a book on the subject was never realized, his preoccupation with what he later characterized as "the all-absorbing hummingbird craze" continued until his death (quoted in McIntyre [1948], p. 10).

According to Theodore E. Stebbins, Jr., Heade's earliest known representation of the hummingbird dates from 1863; the earliest dated compositions combining hummingbirds and orchids date from 1871; and the series of paintings of hummingbirds and passionflowers probably date between 1875 and 1885, after his final trip to South America. The species of hummingbird shown with a passionflower plant (*Passiflora incarnata*) in this painting is the black-eared *Heliothryx* (*Heliothryx aurita*) found in Central and South America. Here, as in Heade's entire series of small-scale canvases, the hummingbird provides the frame of reference. Placed prominently in the foreground, close to the picture plane, the minute bird and its habitat, described with exacting precision, often appear magnified in contrast to a distant expansive landscape. This intriguing interplay of disparities in scale and the abrupt transition from foreground to back-

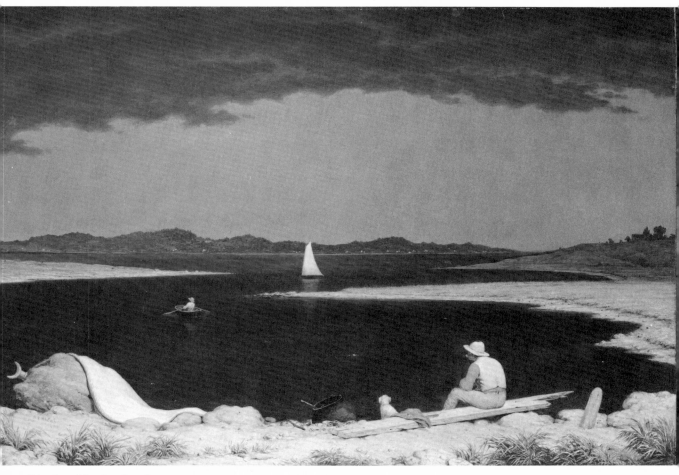

Heade, *The Coming Storm*.

ground, are characteristic of his hummingbird pictures. Heade's skillful use of atmospheric perspective in rendering the moisture-laden tropics serves to mitigate the transition from the foreground to the background. Poised on the sinuous stem of the plant, the bird appears in close proximity to an unopened bud of similar shape. Besides including the bud, Heade shows the plant's vividly colored blossoms in all other stages of flowering. Dense tropical vegetation carpets the foreground, and a dead tree, wreathed with moss, a recurring motif in these works, provides a dramatic framing device. In the best romantic tradition, the painting offers an arresting image of opulent growth and decay. The artist spells out the drama of nature's life cycle in explicit terms that go beyond mere ornithological and botanical description.

At some time in the past, the painting was severely damaged, suffered paint loss, and was extensively restored.

Heade, *Hummingbird with Passionflowers.*

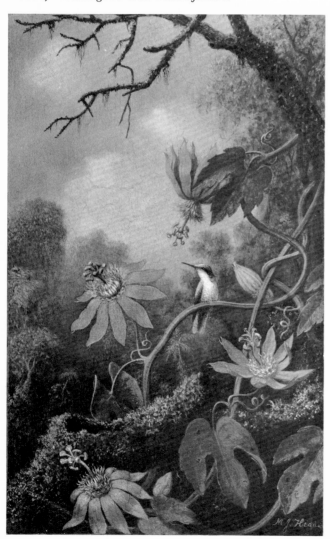

Oil on canvas, 20 × 12 in. (50.8 × 30.5 cm.). Signed at lower right: M. J. Heade.

REFERENCES: R. G. McIntyre, *Martin Johnson Heade, 1819–1904* (1948), p. 60 // E. T. Gilliard, curator, American Museum of Natural History, letter in Dept. Archives, Jan. 3, 1964, identifies the species of hummingbird // A. Cronquist, curator, New York Botanical Garden, letter in Dept. Archives, March 19, 1964, identifies the species of flower // T. E. Stebbins, Jr., *The Life and Works of Martin Johnson Heade* (1975), p. 149, refers to it in a discussion on the series of paintings of passionflowers and hummingbirds which he dates between 1875 and 1885, noting that Heade used the passionflower, a recognized symbol of Christ's passion, "in only a few pictures which are uniformly well painted," and that their mood is "more exotic" and "evocative" than in "all but the best of the orchid paintings"; p. 150, fig. 81; ill. p. 257, no. 227, catalogues it.

EXHIBITED: MMA, 1953–1954, *American Painting, 1754–1954* (no cat.) // De Cordova Museum, Lincoln, Mass., 1957, *Birds of Nature and the Nature of Birds* (no cat.) // Montclair Art Museum, N. J., 1961, *The World of Flowers in Painting* (second of six exhibitions), no. 20 // Guild Hall, East Hampton, N. Y., 1961, *Of Art and Nature*, no. 12 // Los Angeles County Museum of Art and M. H. de Young Memorial Museum, San Francisco, 1966, *American Paintings from the Metropolitan Museum of Art*, no. 49 // University of Maryland Art Gallery, College Park, traveling exhibition, 1969, *Martin Johnson Heade*, cat. by T. E. Stebbins, Jr., no. 46, dates ca. 1875–1885 and notes, "The hummingbird is a 'Brazilian Fairy' (*Heliothrix Auriculatus*), seen here with a Passionflower (*Passiflora Incarnata*)" // Hudson River Museum, Yonkers, N. Y., 1970, *American Paintings from the Metropolitan Museum of Art*, no. 20.

ON DEPOSIT: Gracie Mansion, New York, 1974–1977.

EX COLL.: with Newhouse Galleries, New York, 1946.

Purchase, Gift of Albert Weatherby, 1946.
46.17.

Jersey Meadows

Judging from works known to date, Heade apparently began painting marsh scenes of salt haystacks about 1860. The subject became one of his recognized specialities and a recurring theme in his painting. In 1864 the art critic James Jackson Jarves, who was not favorably disposed to the artist's work, called it "realistic to a disagreeable degree," and wrote: "His speciality is meadows and coast-views, in wearisome horizontal lines and perspective, with a

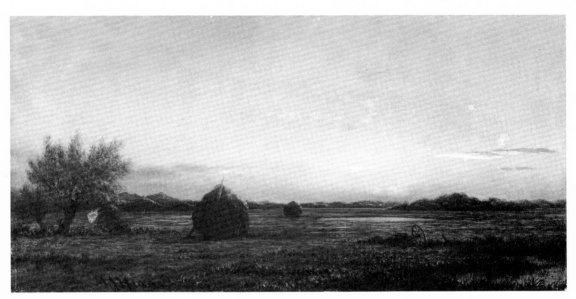

Heade, *Jersey Meadows.*

profuse supply of hay-ricks to vary the monotony of flatness, but flooded with rich sun-glow and sense of summer warmth" (*The Art-Idea* [1864], p. 236). Three years later Henry T. Tuckerman noted that Heade "especially succeeds in representing marsh-lands, with hay-ricks, and the peculiar atmospheric effects thereof," adding that no American artist "has a more refined sense of beauty, or a more delicate feeling for color" (*Book of the Artists* [1867], pp. 542–543). By 1879 it was reported that Heade "has been very successful in his views of the Hoboken and Newburyport meadows, for which the demand has been so great that he has probably painted more of them than of any other class of subjects" (C. E. Clement and L. Hutton, *Artists of the Nineteenth Century* [1879], 1, p. 340). Heade painted marshes in Rhode Island, New Jersey, Massachusetts, and Florida, and it is often difficult to identify specific localities. In his development of this theme as in others, he created a standard vocabulary of elements that he used repeatedly in different combinations. These features invariably included: a low horizon, bulbous stacks of salt hay with their distinctive shapes, still ponds or winding rivers, and on occasion, haywagons, figures, livestock, and birds. All were arranged with an eloquent sense of design in a long, narrow, horizontal format.

A desolate sunset scene, *Jersey Meadows* was painted about 1881. The remains of a broken haywagon suggest perhaps the approaching end of this arduous method of harvesting salt hay for fodder. The painting was exhibited at

the Massachusetts Charitable Mechanics Association and at the Pennsylvania Academy of the Fine Arts in 1881. It may also be the painting exhibited in 1881 at the National Academy of Design, where a picture of the same title was offered for sale by the artist for two hundred dollars, the same price listed in the Philadelphia catalogue.

Oil on canvas, 12¼ × 24 in. (31.1 × 61 cm.).

Signed at lower left: M. J. Heade. Inscribed on a sticker on the back: No. 2 / Jersey Meadows / M. J. Heade / Owner: Dr. H. C. Haven.

REFERENCES: E. McCausland, *Panorama* 1 (Oct. 1945), ill. p. 5, states that it was probably painted in 1881; p. 6, notes that according to a torn label on the stretcher the painting was shown at the Massachusetts Charitable Mechanics Association exhibition in 1881 and the same year Heade exhibited a painting of the same title at the NAD // *Antiques* 50 (Sept. 1946), p. 186 // H. Comstock, *Panorama* 2 (April 1947), opp. p. 87; p. 90 // R. G. McIntyre, *Martin Johnson Heade, 1819–1904* (1948), pp. 56, 58, 60 // University of Maryland Art Gallery, College Park, traveling exhibition, *Martin Johnson Heade* (1969), cat. by T. E. Stebbins, Jr., no. 39 (not exhibited), notes it probably dates from 1881 and is related to such late New Jersey marsh scenes as Sunset (Detroit Institute of Arts) and Hayfield at Sunset (Montclair Art Museum, N. J.) // T. E. Stebbins, Jr., *The Life and Works of Martin Johnson Heade* (1975), ill. p. 257, no. 228, catalogues it as Jersey Meadows with Ruins of a Haycart, ca. 1881, and notes that it is possibly the painting *Jersey Meadows* exhibited at the NAD in 1881.

EXHIBITED: Massachusetts Charitable Mechanics Association, Boston, 1881, no. 227, for sale // PAFA, 1881, *Special Exhibition of Paintings by American Artists*

at *Home and in Europe*, no. 137, for sale $200 // NAD, 1881, no. 261, for sale $200 (possibly this picture) // State Museum, Trenton, N. J., 1965, *New Jersey and the Artist* // MMA, 1970, *19th-Century America, Paintings and Sculpture*, exhib. cat. by J. K. Howat and N. Spassky (not in cat.) // Katonah Gallery, N. Y., 1972, *Luminism in Mid-Nineteenth Century American Painting*, no. 4 // Queens County Art and Cultural Center, New York; MMA; Memorial Art Gallery of the University of Rochester, N. Y.; Sterling and Francine Clark Art Institute, Williamstown, Mass., 1972–1973, *19th Century American Landscape*, exhib. cat. by M. Davis and J. K. Howat, no. 10.

Ex coll.: Victor Spark, New York, 1945; with M. Knoedler and Company, New York, 1945; Dr. H. C. Haven, 1945; with M. Knoedler and Company, New York, 1945.

Purchase, Thomas J. Watson Gift, 1945.

45.53.

ARTHUR FITZWILLIAM TAIT

1819–1905

The youngest of a large family, Arthur Fitzwilliam Tait was born at Livesey Hall, near Liverpool, England. His father's shipping business failed after the Napoleonic Wars, and Tait was sent to live with relatives on a farm. At the age of fifteen, he went to work as a clerk for the art dealers Thomas Agnew and Vittore Zanetti in Manchester. Essentially self-taught, he pursued his art studies with such aids as a 1794 English edition of *Principles of Design* by the seventeenth-century French engraver Sébastien Le Clerc, which contained outline drawings from classical models and a catalogue of facial expressions. (Tait's copy, inscribed "Arthur Tait his book/Manchester 1832," is in the collection of the Adirondack Museum, Blue Mountain Lake, N. Y.) According to family tradition, he also sketched at night in the Manchester Royal Institution. His first exhibited work was *Pencil Landscape*, shown at the Manchester Royal Institution Exhibition of Modern Artists in 1839. His increasing proficiency in art permitted him to give up his clerical job and become a teacher of drawing and a lithographer. His lithographs of the 1840s were chiefly of architectural subjects and topographical views; but, as noted by Patricia C. F. Mandel (1974), at least two, both executed in 1842, were animal subjects after paintings by Richard Ansdell and Sir Edwin Landseer. The works of such prominent English animal painters as Ansdell and Landseer, in turn much indebted to seventeenth-century Dutch traditions, were instrumental in Tait's development. Stylistically, he was also influenced by John Ruskin's concept of "truth to nature" and, by the work of the Pre-Raphaelite painters. As Mandel observes, this inclination toward extreme realism was probably reinforced later by the influence of photography. Tait numbered among his friends the photographers Napoleon Sarony (1821–1896) and Mathew B. Brady (1823–1896).

In August and September of 1841 Tait visited Scotland. The trip is documented in his journal (Adirondack Museum, Blue Mountain Lake, N. Y.) and in a series of drawings and skillful watercolors (Yale University, New Haven).

A growing awareness of the lack of opportunities available to him in England led Tait to immigrate to the United States. In 1850 he settled in New York and soon established him-

self as a leading painter of animals and of hunting, fishing, and camping scenes. Tait, who never visited the West, was inspired to paint frontier life chiefly by his study of the works of George Catlin (1796–1872), Karl Bodmer (1809–1893), and William Ranney (1813–1857). In 1852 Tait began to exhibit at the National Academy of Design and the Pennsylvania Academy of the Fine Arts. The same year he went for the first time to the village of Malone in the Adirondack Mountains, near the Chateaugay Lakes. The unmapped wilderness, abundant in game, proved very attractive, and Tait returned regularly. He was elected an associate of the National Academy of Design in 1855 and an academician in 1858. Reviews and exhibition records show that he sometimes collaborated with JAMES M. HART: Tait painted the animals and figures, and Hart painted the backgrounds. In addition to pictures of hunting, fishing, and camping scenes, Tait occasionally painted still lifes of game birds, a genre which originated in Europe and became popular in America with such painters as WILLIAM MICHAEL HARNETT and ALEXANDER POPE.

Tait's paintings were extremely popular, sold readily, and won wide acclaim. He became best known, however, through prints after his works. In 1852 Currier and Ives issued the first of a series of western subjects on which Tait collaborated with Louis Maurer (1832–1932). Subsequent lithographs by Currier and Ives after Tait's works included outdoor scenes and pictures of both domestic and wild animals. Goupil and Company's publication of an engraving after Tait's painting *Halt in the Woods* in 1856 was widely distributed and did much to advance his reputation. In 1866 Tait met Louis Prang of Boston, whose chromolithographs of his paintings proved enormously popular. Financially secure and well established in his profession, Tait moved during the early 1860s to Morrisania, a suburb northeast of New York in what is now the Bronx. He continued to spend vacations in the Adirondacks, on Loon Lake, Racquette Lake, and Long Lake. After the death of his first wife in 1872, Tait went to England to visit relatives. From 1874 to 1877 he lived year-round on Long Lake with his second wife and spent his time sketching and painting. In 1880 his wife died after giving birth to their second son. Tait married her half-sister and, to please his new wife, sold his house at Long Lake in 1882. His last recorded visit there was in September of 1888. Moving first to New York and later to Yonkers, Tait spent the summers in neighboring Orange and Putnam counties. Pastoral scenes took the place of works inspired by the Adirondack wilderness, and he continued to paint until his death at his Yonkers home at the age of eighty-five.

BIBLIOGRAPHY: Arthur Fitzwilliam Tait, "A. F. Tait's Register of Paintings," 1 (Sept. 1850 - Oct. 1871), 2 (Jan. 1872 - March 1899), 3 (March 1899 - Dec. 1904), Tait-Marsh Papers, Adirondack Museum, Blue Mountain Lake, N. Y. Records 1,527 paintings, including title, description, support, dimensions, price, and buyer // "Arthur F. Tait," *Cosmopolitan Art Journal 2* (March-June 1858), pp. 103–104. A contemporary biography // Obituaries in: *New York Times*, April 29, 1905, p. 5; *American Art News* 3 (May 6, 1905), p. [7]; *American Art Annual* 5 (1905), p. 124 // Adirondack Museum, Blue Mountain Lake, N. Y., *A. F. Tait: Artist in the Adirondacks* (June 15 - Oct. 15, 1974). Contains biographical sketch by Warder H. Cadbury, essay on the English influences on the work of A. F. Tait by Patricia C. F. Mandel, and an annotated and illustrated catalogue of selected works // Patricia C. F. Mandel, "The Animal Kingdom of Arthur Fitzwilliam Tait," *Antiques* 108 (Oct. 1975), pp. [744]–755. Discusses the influence of the Pre-Raphaelite painters on Tait as well as the influence of photography.

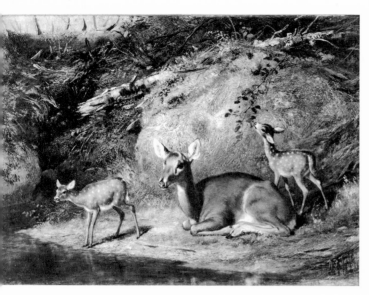

Tait, *Doe and Two Fawns.*

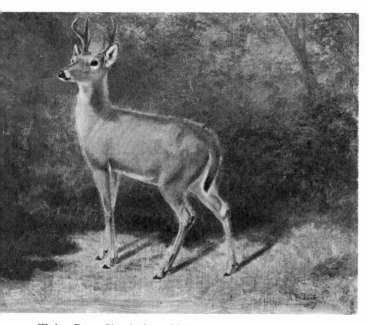

Tait, *Deer—Sketch from Nature.*

Doe and Two Fawns

This small sketch is the ninety-fifth painting recorded in 1882 in Tait's register. The painting was sold the same year for one hundred dollars to a buyer identified as Reichard (possibly the art dealer Gustav Reichard of Reichard and Company in New York). Executed with quick brushstrokes, it retains a spontaneous quality often lost in the artist's more highly finished and belabored works.

Oil on academy board, 10 × 14 in. (25.4 × 35.6 cm.).

Signed, inscribed, and dated at lower right: A. F. Tait N. A. / N. Y. 82.

REFERENCES: Tait's register, vol. 2, p. 97, Tait-Marsh Papers, Adirondack Museum, Blue Mountain Lake, N. Y. // H. F. Marsh, letter in Dept. Archives, May 25, 1964, supplies information from Tait's register.

EX COLL.: Reichard, New York, 1882; with Kennedy Galleries, New York; Mrs. Emily Winthrop Miles, New York, and Sharon, Conn., by 1962; the estate of Mrs. Emily Winthrop Miles, 1963; Mrs. Miles's sister, Mrs. Darwin Morse, Richmond, Mass., 1963.

Gift of Mrs. Darwin S. Morse, 1963.

63.200.7.

Deer—Sketch from Nature

In small, spontaneous studies like this rapidly and thinly painted sketch of a deer, Tait's ability as a painter is most effectively revealed. Although he kept records of most of his work in his register, he did not record preliminary sketches such as this.

Oil on canvas, 11½ × 14 in. (29.2 × 35.6 cm.).

Signed at lower right: A. F. Tait.

REFERENCE: H. F. Marsh, letter in Dept. Archives, May 25, 1964, says that Tait never recorded such rapid sketches in his register (Tait-Marsh Papers, Adirondack Museum, Blue Mountain Lake, N. Y.).

EX COLL.: Mrs. Emily Winthrop Miles, New York, and Sharon, Conn., by 1962; the estate of Mrs. Emily Winthrop Miles, 1963; Mrs. Miles's sister, Mrs. Darwin Morse, Richmond, Mass., 1963.

Gift of Mrs. Darwin S. Morse, 1963.

63.200.6.

CHARLES C. HOFMANN

1820–1882

Hofmann was born in Germany and immigrated to the United States in 1860. He entered the port of New York at the age of thirty-nine. One of two pen and watercolor studies representing the Berks County Almshouse in Reading, Pennsylvania, dated 1865 (Historical Society of Berks County, Reading, Pa.), is inscribed in German, stating that it is by C. C. Hofmann, lithographer, but it is not certain that he worked as a lithographer in this country. Little is known of his life before October 26, 1872, when he first committed himself at the age of fifty-two to the Berks County Almshouse. The pauper's register provides the following information about him: "*Sex*, male; *Color*, white; *If committed, by whom*, self; *Place of Settlement*, none; *Nativity*, Europe; *Time in the United States*, 12 years; *At What Port Landed*, New York; *Occupation*, painter; *Civil Condition*, was never married; *Habits*, intemperate; *Education*, could write name; *Physical Condition*, able-bodied; *Classification*, sane; *Cause of Pauperism*, intemperance." Judging by the subjects of his works, Hofmann stayed at other Pennsylvania almshouses as well. He seems, however, to have returned most frequently to the one in Berks County.

Hofmann's known works, chiefly views of the almshouses in Berks, Montgomery, and Schuylkill counties, Pennsylvania, date from 1865 to 1881 and appear to have served as models for two other Pennsylvania almshouse painters, JOHN RASMUSSEN and Louis Mader (1842–after 1899). With the exception of a few brief absences, Hofmann made the Berks County Almshouse his home until his death in 1882. He was buried in the paupers' field near the almshouse in an unmarked grave.

BIBLIOGRAPHY: Abby Aldrich Rockefeller Folk Art Collection, Williamsburg, Va., *Pennsylvania Almshouse Painters* (Oct. 1 - Dec. 8, 1968), exhib. cat. by Thomas N. Armstrong III // Whitney Museum of American Art, New York, *American Folk Painters of Three Centuries* (1980), ed. by Jean Lipman and Tom Armstrong, exhib. cat., pp. 103–109. The most complete account of the artist and his works by Tom Armstrong.

View of the Schuylkill County Almshouse Property

In this 1876 view of the buildings and grounds of the Schuylkill County Almshouse, Hofmann exhibits some of the characteristic features of the folk artist—a strong sense of abstract design and surface pattern; a preoccupation with narrative detail; a use of vivid, chiefly unmodulated colors; and an ingenuity in dealing with a complex composition without the academic skills of mathematical and atmospheric perspective. His use of a high vantage point, providing a more extensive pictorial field, is one of the favorite compositional devices of the folk painter. This mode of representation, which is one method of dealing with depth on a two-dimensional surface, is somewhat analogous to the "bird's-eye view" favored by topographical lithographers.

In this composite view, with all of its unresolved spatial inconsistencies, Hofmann records the orderly world of the almshouse with geometric precision. The painted border framing the view reaffirms the two-dimensional character of the representation. A signboard on the fence in the center foreground reads: "Notice/Positively no Admittance on Sunday / Visitors to the Alms House will / be admitted only on Thursday of / each week from 9 A.M. to [remainder illegible]." The elaborate lettering of the inscription, identifying the property and its of-

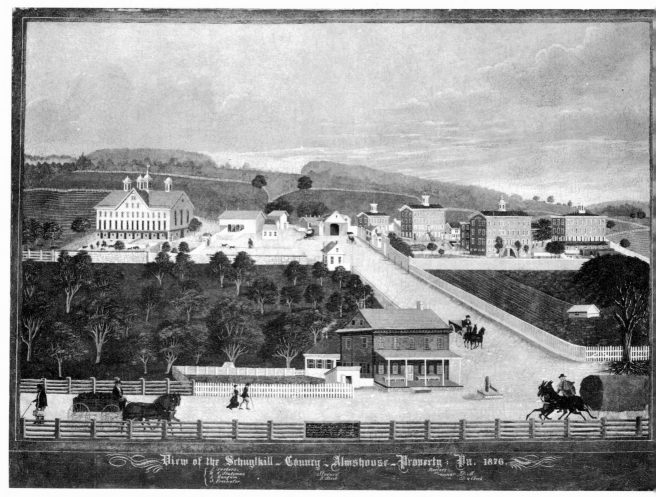

Hofmann, *View of the Schuylkill County Almshouse Property.*

ficers, shows that the painter was a skillful calligrapher.

Because of Hofmann's inexpert combination of materials, the surface has developed a netlike pattern of cracking over the years that reveals the black-colored priming he used to prepare the canvas. The painting has suffered some paint loss which especially affects the inscription. The picture, which was restored extensively before it entered the museum's collection, retains its original gilded frame.

Oil on canvas, 28¾ × 38⅞ in. (73 × 98.7 cm.).

Inscribed and dated at bottom: View of the Schuylkill - County - Almshouse - Property: Pa. 1876. Directors: / U. A. Stutzman. / L. Mangam. / J. Freehafer. / Steward / F. Beck / Doctors: / [C]hannor, D. M. / [part missing] D. & Clerk.

REFERENCES: M. Allis, Fairfield, Conn., letter in Dept. Archives, May 7, 1967, notes that she bought the painting at the White Plains antiques show // D. T. Boyer, letter in Dept. Archives, May 11, 1977, provides photographs of version in Rest Haven, Schuylkill Haven, Pa.

EXHIBITED: National Gallery, Washington, D. C., 1957, *American Primitive Paintings from the Collection of Edgar William and Bernice Chrysler Garbisch*, part II, p. 107 // Springfield Art Museum, Mo., 1958, *American Primitive Paintings* (no cat.) // Pan American Union, Washington, D. C., 1963, *Primitive Artists of the Americas*, no. 19 // Abby Aldrich Rockefeller Folk Art Collection, Williamsburg, Va., 1968, *Pennsylvania Almshouse Painters*, exhib. cat. by T. N. Armstrong III (unnumbered), mistakenly notes that this painting is signed and lists another work by the artist with the same title and date // Hudson River Museum, Yonkers, N. Y., 1970, *American Paintings from the Metropolitan Museum*, no. 22 // Queens County Art and Cultural Center, New York; MMA; Memorial Art Gallery of the University of Rochester, N. Y.; Sterling and Francine Clark Art Institute, Williamstown, Mass., 1972–1973, *19th Century American Landscape*, exhib. cat. by M. Davis and J. K. Howat, no. 3 // MMA and American Federation of Arts, traveling exhibition, 1975–1977, *The Heritage of American Art*, exhib. cat. by M. Davis, ill. [p. 108]; p. 109, no. 44; (rev. ed., 1977), ill. [p. 106]; p. 107, no. 43.

ON DEPOSIT: National Gallery, Washington, D.C., 1958–1966; U. S. Mission to the U. N., New York, 1974–1975.

EX COLL.: with unknown dealer, 37th Eastern States Antique Fair, Westchester County Center, White Plains, N. Y., Nov. 16–21, 1953; with Mary Allis, Fairfield, Conn., 1953; Edgar William and Bernice Chrysler Garbisch, Cambridge, Md., 1953–1966.

Gift of Edgar William and Bernice Chrysler Garbisch, 1966.

66.242.26.

JOHAN MENGELS CULVERHOUSE

1820 – about 1891

Born in Rotterdam on August 29, 1820, Johan Mengels Culverhouse was one of six children of R. Culverhouse and C. Mengels. Culverhouse made a name for himself as a "candlelight painter," specializing in nocturnal scenes illuminated by moonlight or candlelight in the tradition of seventeenth-century Dutch painting. In the same tradition he also painted genre subjects, including rowdy taverns, busy markets, and bustling streets. It is sometimes said that Culverhouse studied at the Düsseldorf Academy, but this is unlikely as his name does not appear on its rolls. According to Pieter A. Scheen, Culverhouse lived and worked in Rotterdam until 1845 and The Hague in 1846. He exhibited at Groningen in 1845 and Rotterdam in 1846 before coming to the United States. The year of his arrival is not known.

Culverhouse's life in America is documented mainly by exhibition records and his work. He exhibited at the American Academy of the Fine Arts in 1849, the Boston Athenaeum and the New Jersey Art-Union in 1851, and the National Academy of Design and the Pennsylvania

Academy of the Fine Arts in 1852. The American Art-Union in New York acquired and exhibited seven of his paintings in 1849 and distributed them to its subscribers. It sold six more at public auction in 1852 when it was disbanded as an illegal lottery.

Culverhouse apparently returned to Europe in the late 1850s. He exhibited at the Paris Salons of 1857, 1859, 1861, 1863, and 1864, giving a Paris address. According to Scheen, he exhibited in Antwerp in 1861 and in Amsterdam the following year. By the mid–1860s Culverhouse was back in America. He exhibited at the National Academy of Design in 1865 and 1866, giving a New York address, and at the Pennsylvania Academy of the Fine Arts in 1867. By December 1871 he had settled in Syracuse, New York. Notes from a variety of sources in the collection of the Onondaga Historical Association provide a brief record of his stay there. The *Syracuse Journal* for December 12, 1871, reported that he opened a studio in Judson N. Knapp's art gallery and frame store at 47 Genesee Street. The building is shown in Culverhouse's painting of Syracuse by moonlight, now titled *Clinton Square – 1871* (Onondaga Historical Association, Syracuse). According to the city directory for 1872, Culverhouse was boarding at the St. Charles Hotel. On May 17th of the same year he offered "a rare lot of paintings" for public auction as he was "about to leave the city." A lawsuit, however, brought against him by a prominent Syracuse citizen two years later provides evidence that Culverhouse either remained in, or returned to, the city.

Several of Culverhouse's paintings were shown in the fall exhibition of the Brooklyn Art Association in 1877 and one in the spring of the following year. Although he is said to have died about 1891, the date and place of his death are not known. Judging by his sporadic exhibition record, Culverhouse led a peripatetic life. Perhaps, as has been suggested, he returned to Europe several times. Although he tried to accommodate the American market by painting local scenes, he remained a firm adherent to Dutch traditions. His choice of subjects and the style of his known paintings reflect this European background.

BIBLIOGRAPHY: Groce and Wallace, p. 158. Provides biography and bibliography for the artist, whose name is given as Johann Mongles Culverhouse // Pieter A. Scheen, *Lexicon Nederlandse beeldende kunstenaars, 1750–1850*, (The Hague, 1969), 1, p. 234. Under Culverhouse, Johan Mengels, provides information on the artist's family, early life, and activity in Europe (courtesy of David Heiser, NYHS, letter in Dept. Archives, Sept. 23, 1976) // Onondaga Historical Association, Syracuse, "Johann Mongles Culverhouse in Syracuse," July 1971. Three-page mimeograph compilation from newspaper articles mainly concerning the artist's activity in Syracuse (copy in Dept. Archives, courtesy of Richard N. Wright, Onondaga Historical Association, Syracuse, May 24, 1978) // Los Angeles County Museum of Art, *American Narrative Painting* (1974), cat. notes by Nancy Wall Moure and essay by Donelson F. Hoopes, pp. 17, 107 (no. 49), 185. Provides biographical information and bibliography.

Skating on the Wissahickon

Popular with Dutch and Flemish genre painters beginning in the late sixteenth century, skating scenes became popular in America chiefly in the nineteenth century, although the sport had been introduced to the new world with the Dutch settlement of New Amsterdam (D. Button, *Antiques* 103 [Feb. 1973], pp. 351, 354). Judging by the number of skating scenes shown by Culverhouse in America, they were among his favorite themes. His most elaborate and accomplished treatment of the subject with an American setting is *Skating in Central Park*, 1865 (Museum of the City of New York). Ten years later, in 1875, he painted

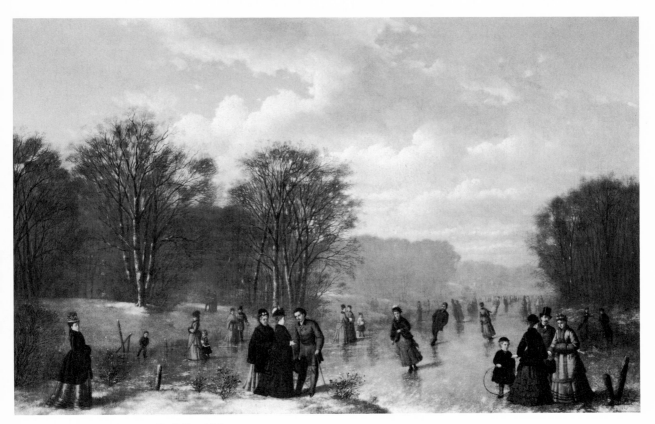

Culverhouse, *Skating on the Wissahickon.*

this more modest Philadelphia skating scene. It was in Philadelphia, Dick Button noted, that the third oldest skating club in the world was organized in 1849 for "instruction and improvement in the art of skating, the cultivation of a friendly feeling in all who participate in the amusement, and the efficient use of proper apparatus for the rescue of persons breaking through the ice" (p. 361). Called *Skating on the Schuylkill* when it was offered for sale in New York in 1942, the painting was renamed *Skating on the Wissahickon* when it was exhibited at the Museum of Fine Arts in Boston two years later. Wissahickon Creek flows through Philadelphia to the Schuylkill River. In Philadelphia, the Wissahickon Valley is a popular recreational area.

The scene is a sunny, late afternoon in winter with a bright blue sky. Bare brown trees line the banks, and the skaters cast long shadows. Precisely delineated, the figures provide an accurate record of American dress in the third quarter of the nineteenth century. Although

the repetitive arrangement of the figures is stilted and the composition somewhat contrived, the painting is a competent work by an artist of European training. The surface, unfortunately, looks slightly stained. The scumbling that defined the trees and the ice has become increasingly transparent, allowing the dark underpainting to show through, especially on the left where the ice meets the bank. There is paint loss at the upper left and upper right in the sky.

Oil on canvas, 24 × 37½ in. (61 × 95.3 cm.).

Signed and dated at lower right: *J. M. Culverhouse* / 1875.

REFERENCES: *Old Print Shop Portfolio* 1 (April 1942), p. 4, calls it Skating on the Schuylkill and says that although it is by "a Dutch painter of the school of Düsseldorf," it is "a clear record of a phase of American life, and, incidentally of a period of American dress"; p. 19, fig. 15, for sale $250; p. 20, no. 15, lists it, discusses the artist and mentions his painting Skating in Central Park // V. D. Spark, letter in Dept.

Johan Mengels Culverhouse

Archives, May 27, 1976, notes that the title Skating on the Schuylkill was incorrect and changed to Skating on the Wissahickon and that about 1974 it was with Mr. and Mrs. Harold Samuels, Locust Valley, N. Y. // H. Samuels, letter in Dept. Archives, June 19, 1978, states that he and his wife bought it August 4, 1972, from the estate of Muriel Vanderbilt Adams of San Francisco, that it was shown on the estate inventory as Skating on the Wissahickon, that it was exhibited at the MFA, Boston, and that it was traded through an agent in 1974 for other paintings.

EXHIBITED: MFA, Boston, 1944, *Sport in American Art*, no. 20, as Skating on the Wissahickon, Pennsylvania, lent by Victor D. Spark.

Ex COLL.: with the Old Print Shop, New York, 1942; with Victor D. Spark, New York, 1944; estate of Muriel Vanderbilt Adams, San Francisco, until August 4, 1972; with Mr. and Mrs. Harold Samuels, Locust Valley, N. Y., 1972–1974; with John R. Carroll, New York, 1974.

Purchase, Rogers, Morris K. Jesup and Maria DeWitt Jesup Funds, and Charles and Anita Blatt Gift, 1974.

1974.263.

WORTHINGTON WHITTREDGE

1820–1910

The youngest child of a former New England sea captain, Thomas Worthington Whittredge was born in a log cabin on his father's farm near Springfield, Ohio. With his parents' permission, he left the farm at seventeen to learn house and sign painting from his brother-in-law in Cincinnati. He was soon diligently employed in that trade. Realizing the lucrative possibilities of the recently invented daguerreotype, Whittredge learned the process and opened a business in Indianapolis about 1840, but it soon failed. Impoverished and ill, Whittredge was taken in by an old family friend, Henry Ward Beecher, who at that time was pastor of the Second Presbyterian Church in Indianapolis. After a year with the Beecher family, whose portraits he painted, Whittredge returned to Cincinnati. He then went to Charleston, West Virginia, in search of portrait commissions. Disillusioned with his work, which did not meet his expectations, Whittredge abandoned portraiture and in 1843 returned to Cincinnati determined to be a landscape painter. In 1846 he sent a landscape to the National Academy of Design, where it won warm praise from ASHER B. DURAND, then president of the academy. Whittredge's work and growing reputation soon attracted the attention of important Cincinnati art patrons, and their support and commissions enabled him to go to Europe in 1849.

He spent the first summer in Belgium and Germany and the winter in Paris, where he made a half-hearted and unsuccessful attempt to find an instructor in landscape painting. Learning of a group of landscape painters at Barbizon, who had been described as "genuine 'Kickers' against all pre-existing art," Whittredge visited Barbizon. Although he liked the spirit of the young painters, he "did not think much of their pictures," an opinion he later reconsidered (Baur, p. 21). Conscious of his dwindling resources, he left Paris for Düsseldorf in 1849.

Düsseldorf, which was then the center of an international community of artists, proved especially attractive to Whittredge. An hour after arriving he met the celebrated painter

EMANUEL LEUTZE who soon pressed him into service as a model for the figures of Washington and the steersman in his monumental painting *Washington Crossing the Delaware* (q. v.). Leutze later also painted Whittredge's portrait (q. v.). Whittredge roomed in the house of the German landscapist Andreas Achenbach, and together they helped Leutze paint the sky of his immense work. Contrary to published reports, however, Whittredge was never Achenbach's pupil. He frequented the artists' club, the Malkasten, bought works by Düsseldorf painters for Cincinnati collectors, took sketching trips with other artists, and visited The Hague, Dresden, Berlin, Antwerp, and Paris. More important, he came under the influence of the dry, incisive painting style which characterized the Düsseldorf school.

In 1853 Whittredge was joined in Düsseldorf by ALBERT BIERSTADT, who worked in his studio. Whittredge set out on a leisurely trip to Rome with WILLIAM STANLEY HASELTINE in 1854. Although his first view of the Swiss Alps made a deep impression on him, he found the scenery unsuitable, preferring "simple scenes and simple subjects," or as he put it, "I never got into the way of measuring all grandeur in a perpendicular line" (Baur, p. 32). He spent several weeks in Florence, visited the American sculptor Hiram Powers, and discovered to his disillusionment that "landscape painting seemed ... to cut but an insignificant figure among the great works of art which had been produced in this world" (Baur, pp. 33–34). In Rome in 1855 he encountered a flourishing community of American painters, sculptors, and writers. He approached the Old Masters "with a kind of indifference" but studied them diligently, concluding that "a landscape painter may derive about as much benefit from studying the works of a figure painter as the works of the mere painter of landscape" (Baur, p. 36). He made frequent trips to the Campagna and to the Sabine and Alban hills, gathering material that he eventually worked into paintings for his American patrons. "It was then, is now, and probably always will be a question whether our students going abroad to study art, are likely to make better artists than if they stayed at home," he observed about 1905.

> Frankly, I doubt the desirability of long foreign study. A flying visit across the water is not objectionable but rather to be commended. But to go abroad and to become so fascinated with the art life in Paris and other great centers as to take up permanent abode there is not everywhere believed to be the best thing for an American artist. We are looking and hoping for something distinctive in the art of our country, something which shall receive a new tinge from our peculiar form of Government, from our position on the globe, or something peculiar to our people, to distinguish it from the art of the other nations and to enable us to pronounce without shame the oft repeated phrase, "American Art" (Baur, pp. 39–40).

In 1859, after ten years abroad, Whittredge returned to the United States. Following brief trips to Newport and Cincinnati, he established himself in New York at the Tenth Street Studio Building. Characterizing this time as "the most crucial period of my life," Whittredge struggled to find the distinctive character of the American landscape in hopes of formulating a new statement inspired by his native land. He made trips to sketch scenery in New England and the Catskills, studied the works of Durand, whom he particularly admired, and sought to free himself from the tight manner of the Düsseldorf school.

Whittredge soon became a major figure in New York art circles. He was elected an academician of the National Academy of Design in 1861, and from 1874 until 1877 he served as its president. He was also a member of the Century, Lotos, and Union League clubs.

In 1866 Whittredge accompanied General John Pope on a tour of inspection from Kansas, through Nebraska, Colorado, and New Mexico. He found himself particularly drawn to the western plains, a subject which assumed an important place among his landscapes of this period. He made a second trip west in 1870 with SANFORD R. GIFFORD and JOHN F. KENSETT and a third trip in 1877. In 1880 he moved to Summit, New Jersey, where he spent the remaining thirty years of his life. In 1893 he traveled to Mexico and three years later returned there with FREDERIC E. CHURCH. About 1905 he wrote his autobiography, a work as striking in its sincerity as it is entertaining and informative. It still remains the primary source for the man and the artist and serves as an invaluable document of the major currents of nineteenth-century American art.

Whittredge emerged from a lengthy European experience with a firm commitment to his native artistic tradition and a profound sensibility to the American landscape. A preoccupation with light, first as an agent in defining form and later as a vehicle for expressing mood and atmospheric effects in nature, characterized all of his productions and allied him with such contemporary artists of the second generation of the Hudson River school as Gifford and Kensett. Whittredge's admiration for the works of Durand, his exposure to the Düsseldorf school, and his own direct studies from nature shaped his development. In his later years, under the influence of Barbizon painters like Corot, Rousseau, and Daubigny, he achieved a more personal vision of nature and a style distinguished by an increasingly free use of paint and a sensibility to paint texture.

BIBLIOGRAPHY: John I. H. Baur, ed., "The Autobiography of Worthington Whittredge, 1820–1910," *Brooklyn Museum Journal* (1942), pp. 5–68. Reprint ed., Arno Press, New York, 1969. This informative autobiography is drawn from a manuscript in the Worthington Whittredge Papers. The papers were donated by L. Emory Katzenbach and W. W. Katzenbach, descendants of the artist, to the Archives of American Art in 1959 // Munson-Williams-Proctor Institute, Utica, N. Y., *Worthington Whittredge (1820–1910): A Retrospective Exhibition of an American Artist* (1969), exhib. cat. by Edward H. Dwight // Nancy Dustin Wall Moure, "Five Eastern Artists out West," *American Art Journal* 5 (Nov. 1973), pp. 15–31 // Anthony F. Janson, "The Western Landscapes of Worthington Whittredge," *American Art Review* 3 (Nov.-Dec. 1976), pp. 58–69 // Anthony F. Janson, "Worthington Whittredge: The Development of a Hudson River Painter, 1860–1868," *American Art Journal* 11 (April 1979), pp. 71–84.

The Trout Pool

When he returned to the United States in 1859 after ten years abroad, Whittredge felt that, if he was to succeed, he "must produce something new . . . inspired by my home surroundings" (Baur, p. 42). Painted in 1870, eleven years after his return from Europe, *The Trout Pool* exemplifies his mature style and is among his most successful efforts at capturing the American wilderness. Judging from the exhibition records of the National Academy of Design, a trout pool was a subject to which the artist returned on many occasions. In content and style the painting reflects Whittredge's study of the works of ASHER B. DURAND, whose paintings he described as "truly American landscape" (Baur, pp. 41-42). It is equally a product of Whittredge's direct study of nature, a practice he advocated and shared with Durand.

It is to such paintings as Durand's *The Beeches* and *In the Woods* (qq.v.) that *The Trout Pool* is primarily indebted. The composition shows a carefully chosen segment of forest scenery. The use of light is equally calculated. The trees dominating the foreground serve as a framing element and are placed in shadow with

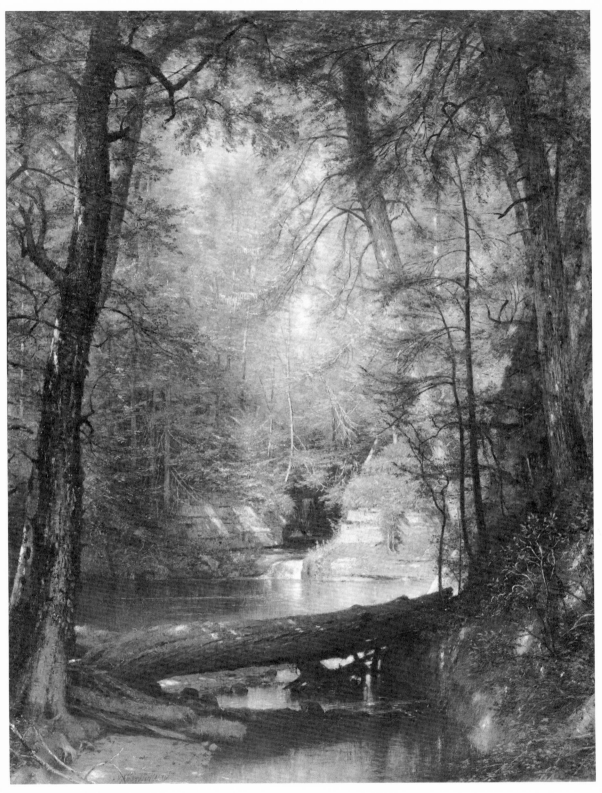

Whittredge, *The Trout Pool*.

a few flickers of sunlight to indicate the patterns created by the foliage. In contrast, the middle ground is brilliantly illuminated, attracting attention to the distance and reinforcing the illusion of depth. In both the composition and handling of light Whittredge deals with conventions explored earlier by Durand, but unlike him he shows a more candid and direct approach based on close observation.

The use of color and handling of paint also differentiate the works of these two artists of separate generations. Durand chose a wide-ranging palette; Whittredge severely restricted his to local color but allowed a broad scope of values and tonalities. Durand's carefully recorded details are an intrinsic aspect of his work; Whittredge, like other members of the second generation of Hudson River school painters, approximated detail, maintaining a tenuous balance between the quality of objects represented and the texture of paint. In such works as *The Trout Pool* he followed the expressive and subjective approach of the Barbizon style of landscape painting.

Oil on canvas, 36 × 27⅛ in. (91.4 × 68.9 cm.). Signed at lower right: W. Whittredge. Inscribed on the back: The Trout Pool. / Painted by W. Whittredge. / 1870.

REFERENCES: J. I. H. Baur, *Brooklyn Museum Journal* (1942), ill. opp. p. 14 // E. P. Richardson, *Painting in America* (1956), p. 223; p. 239, fig. 100 // J. T. Flexner, *Nineteenth Century American Paintings* (1970), color ill. p. 70.

EXHIBITED: Detroit Institute of Arts, 1933, *Art before the Machine Age* (no cat.) // Whitney Museum of American Art, New York, 1938, *A Century of American Landscape Painting*, no. 26 // Detroit Institute of Arts, 1957, *Painting in America*, no. 105 // MMA, *Three Centuries of American Painting*, unnumbered cat. // Los Angeles County Museum of Art and M. H. de Young Memorial Museum, San Francisco, 1966, *American Paintings from the Metropolitan Museum of Art*, no. 44 // Fine Arts Center, State University College of New York, Geneseo, 1968, *Hudson River School*, cat. by A. H. Jones, p. 190 // Hudson River Museum, Yonkers, N.Y., 1970, *American Paintings from the Metropolitan Museum of Art*, no. 51 // Queens County Art and Cultural Center, New York; MMA; Memorial Art Gallery of the University of Rochester, N. Y.; Sterling and Francine Clark Art Institute, Williamstown, Mass., 1972–1973, *19th Century American Landscape*, exhib. cat. by M. Davis and J. K. Howat, ill. no. 18 // MMA and American Federation of Arts, traveling exhibition, 1975–1977, *The Heritage of American Art*, exhib. cat. by M. Davis, no. 45; rev. ed. 1977, no. 44, ill. p. 109.

Ex COLL.: Charles A. Fowler, New York, by 1921. Gift of Colonel Charles A. Fowler, 1921. 21.115.4.

The Camp Meeting

Originating in Kentucky in 1799, the camp meeting became an important part of American life in the nineteenth century. Crowds of worshippers gathered in the open air or in tents to attend a series of religious services often marked by an atmosphere of excitement. Especially popular among evangelical sects in the rural areas of the South and West, camp meetings satisfied religious needs and were social occasions as well. As America became more urbanized, these outdoor meetings were held less frequently.

In 1874, when Whittredge painted *The Camp Meeting*, the scene was already an occasion for nostalgia. One reviewer described it as "the old-time 'Camp-Meeting.'" A genre painter probably would have seized the opportunity to record the various expressions of emotion that religious experience generated among the fervent participants. Whittredge, however, relegated the camp meeting to the background of what is primarily a landscape composition. Only the stand erected for the preacher and the title of the work identify the subject. At one time it was even misidentified as a scene in New York's Central Park. The location is probably somewhere in the Catskill Mountains.

One of Whittredge's favorite devices, characteristic of his work of the 1870s, is evident in this picture. He illuminates the background so that the trees and some of the figures in the middle ground appear in silhouette. The inclusion of many tree trunks creates an effective pattern of short vertical elements in the long horizontal composition.

On June 1, 1874, JERVIS MC ENTEE wrote in his diary: "Today I called on Sam. Coykendall [a collector], and asked him to go and see Whittredge's picture of the camp meeting, which he promised to do. I said all I could in favor of Whittredge's picture and I only hope he will buy it." Coykendall apparently declined, for the painting was for sale when it was exhibited at the Brooklyn Art Association that fall. It was also shown at the National Academy of Design the following year, where it and another of the artist's works were cited by the critic for the

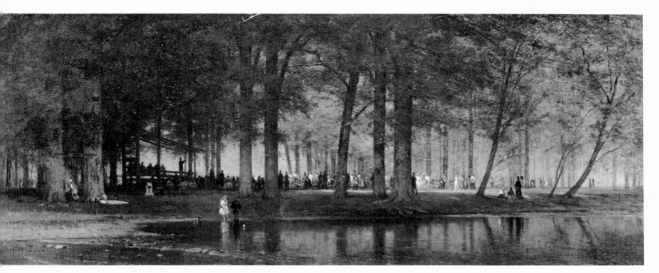

Whittredge, *The Camp Meeting*.

Art Journal as showing "Mr. Whittredge at his best, and . . . justly entitled to praise."

According to McEntee, the painting was bought by Matthew Chaloner Durfee Borden on "buyers' day" at the academy.

Oil on canvas, 16 × 40 11/16 in. (40.6 × 103.4 cm.).
Signed and dated at lower right: W. Whittredge 1874.

REFERENCES: J. McEntee, diary, June 1, 1874 (quoted above), and April 7, 1875, notes sale of one of his paintings, Saturday Afternoon (q. v.), and "Whittredge's 'pic-nic'" to Mr. Borden, Howard McEntee Collection, microfilm D 180/70 and D 180/94, Arch. Am. Art // *Art Journal* (New York), 1 (May 1875), p. 158, reviews it in NAD exhibition (quoted above) // J.I.H. Baur, ed., *Brooklyn Museum Journal* (1942), p. 63, in 1905 Whittredge lists it as Camp Meeting // *Illustrated Catalogue of the Notable Paintings by Great Masters belonging to the Estate of the Late M. C. D. Borden*, sale cat. (1913), unpaged introductory notes, discusses it; no. 74, as Scene in Central Park // *MMA Bull.* 8 (1913), p. 87 // B. B[urroughs], *MMA Bull.*, suppl. to 12 (1917), p. 8, discusses it // E. P. Richardson, *American Romantic Painting* (1944), p. 49, no. 166, pl. 166 // J. T. Flexner, *That Wilder Image* (1962), p. 274, no. 78.

EXHIBITED: Brooklyn Art Association, 1874, Fall Exhibition, no. 357, as A Camp-Meeting, for sale, $350 // NAD, 1875, no. 206, for sale // Century Association, New York, 1909, *Exhibition of Paintings and Sketches by Worthington Whittredge*, no. 11, as The Camp Meeting—Catskills // MMA, 1917, *Paintings of the Hudson River School Brought Together in Commemoration of the Completion of the Catskill Aqueduct* (no cat.) //

Detroit Institute of Arts, 1933, *Art before the Machine Age* (no cat.) // Albany Institute of History and Art, 1943 // Corcoran Gallery of Art, Washington, D. C., 1950, *American Processional*, no. 273 // Art Institute of Chicago and Whitney Museum of American Art, New York, 1945, *The Hudson River School*, no. 159 // Munson-Williams-Proctor Institute, Utica, N. Y., Albany Institute of History and Art, and the Cincinnati Art Museum, 1969–1970, *Worthington Whittredge (1820–1910)*, p. 19, ill. p. 42.

EX COLL.: Matthew Chaloner Durfee Borden, New York, 1875–1913 (sale, American Art Association, New York, Feb. 14, 1913, no. 74, as Scene in Central Park, 1874).

Amelia B. Lazarus Fund, 1913.

13.39.1.

Evening in the Woods

Like *The Trout Pool* (q. v.), this picture shows the continuing influence on Whittredge of Durand's woodland interiors. Whittredge's details, however, are less precise and the atmospheric effects more pronounced than in Durand's works. These differences reflect Whittredge's interest in the Barbizon school and its subjective approach to landscape painting. JOHN FERGUSON WEIR characterized Whittredge's style succinctly when he wrote:

Mr. Whittredge's pictures of forest solitudes, with their delicate intricacies of foliage and the sifting down of feeble rays of light into depths of shade, are

always executed with rare skill and feeling. His style is well suited to this class of subjects: it is loose, free, sketchy, void of all that is rigid and formal. It evinces a subtle sympathy with the suggestive and evanescent qualities of the landscape (United States Centennial Commission, *International Exhibition, 1876*; *Reports and Awards* 7 [1880], p. 633 [p. 27 of General Report of the Judges of Group XXVII]).

Evening in the Woods was painted in 1876 and was shown at the National Academy in 1877 along with a work called *Morning in the Woods* (unlocated), which although larger may have been a companion piece. They attracted the notice of the critic for the *Art Journal* who wrote:

Two subjects by Whittredge have great charm. One is called 'Morning in the Woods' (186), the other 'Evening in the Woods' (391). They are wood in-teriors of the character this artist so much delights to paint, and in which he appears at his best. 'Morning in the Woods' shows a forest principally of young trees, amid which flows a woodland stream 'Evening in the Woods' is not so large a painting, and scarcely so satisfactory. A group of trees in the fore-ground, a light in the distant evening sky shining through the trees, and casting, in the brook that flows amid the trees, reflections of those dark-red tints that always seem to give to a twilight landscape strange depths of solemn mystery—these features make up the well-painted scene.

Oil on canvas, 42 $\frac{5}{16}$ × 36$\frac{1}{8}$ in. (107.5 × 91.7 cm.). Signed at lower right: W. Whittredge.

REFERENCES: *Art Journal* (New York), 3 (May 1877), pp. 158–159, reviews it in NAD exhibition (quoted above) // C. E. Clement and L. Hutton, *Artists of the Nineteenth Century* (1879), 2, p. 350, say it was done in 1876 // B. B[urroughs], *MMA Bull.*, suppl. to 12 (1917), p. 8.

Whittredge, *Evening in the Woods*.

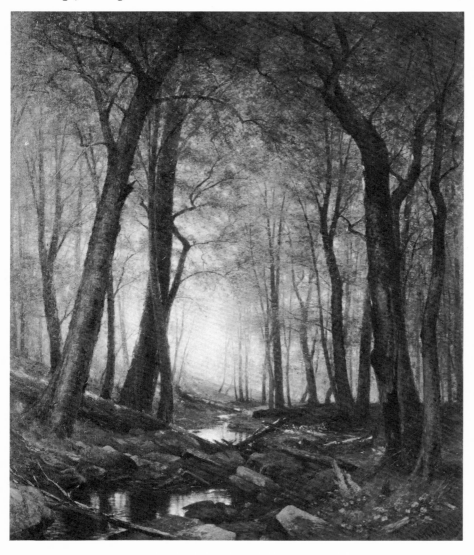

EXHIBITED: NAD, 1877, no. 391, for sale, $1000 // MMA, 1917, *Paintings of the Hudson River School Brought Together in Commemoration of the Completion of the Catskill Aqueduct* (no cat.) // Centennial Art Gallery, Centennial Exposition, Utah State Fair Grounds, Salt Lake City, 1947, *One Hundred Years of American Painting* (American Federation of Arts, Washington, D. C.), no. 8 // MMA, 1965, *Three Centuries of American Painting* (unnumbered cat.) // Henry Gallery, University of Washington, Seattle, 1968, *The View and the Vision,* no. 36 // Saint Peter's College Centennial Art Gallery, Jersey City, N. J., 1972, *Hudson River School of Painting and Prints of the Hudson River,* no. 8 // Lowe Art Museum, University of Miami, 1974–1975, *19th Century American Topographic Painters,* no. 142 // Kunstmuseum Düsseldorf, 1976, *The Hudson and the Rhine,* p. 90, no. 177, fig. 177, dates it 1868.

EX COLL.: Henry H. Cook, New York, d. 1905. Bequest of Henry H. Cook, 1905. 05.13.10.

GEORGE A. BAKER, JR.

1821–1880

George Augustus Baker, Jr., was born in New York, the son and namesake of an immigrant miniature painter from Strasbourg. His father was his first art teacher. According to H. W. French, an early biographer, Baker began his career at sixteen and painted about one hundred and forty miniatures during the first year. He continued his studies at the National Academy of Design, where he drew from antique casts and from life until 1844, when he left for Europe. Baker was abroad for two years and spent some time in Italy, but little else is known of his travels. In 1846 when he returned to America, he established himself as a portrait painter. Judging from New York exhibition records, he also painted idealized figures and genre and literary scenes. He specialized in portraiture, however, and was so popular that, it is reported, he often had orders two years in advance. "Baker is highly esteemed for his portraiture of women and children," Tuckerman noted in 1867: "There is often a clear and vivid flesh-tint, a grace of expression, and a beautiful refinement in his portraits which render them at once attractive and authentic." Reporting on Baker's portrait painting technique, WILLIAM S. MOUNT wrote in his diary for July 6, 1851: "George Baker— says that he commences his portraits quite gray—which gives value to his warm colors. He uses no Naples in the flesh, but yellow ochre and raw sienna. He prefers to paint up at once, if possible—the first sitting governs the rest" (A. Frankenstein, *William Sidney Mount* [1975], p. 247).

In 1851 Baker was elected an academician at the National Academy of Design, and from 1863 to 1864 he served with DANIEL HUNTINGTON, JOHN F. KENSETT, and the sculptor Launt Thompson on the academy's Fellowship Fund Committee under the chairmanship of HENRY PETERS GRAY. From 1867 to 1869 Baker was a visiting instructor at the academy. He was also on the art committee of the Union League Club, whose members were instrumental in the founding of the Metropolitan Museum.

French noted that Baker moved to Darien, Connecticut, about 1866. He continued, nevertheless, to maintain a house and studio in New York. In 1867, an art critic reported that Baker, Kensett, and LOUIS LANG "have just formed a most delightful art colony at the new

building 1,195 [1193] Broadway, where they have pitched their easels, and surrounded themselves with all the elegances of modern beauty and improvement" (*Watson's American Art Journal* 6 [March 16, 1867], p. 325).

Characterizing Baker as "an unassuming gentleman, of the highest refinement and intelligence," French reported that another artist had observed of Baker: "One secret of his great success is the concentration of all his powers upon the one specialty of *portrait-painting* he never touches politics, philanthropy, or literature. Art, and portrait-painting the only art, occupies all of his working hours."

Baker died of Bright's disease on April 2, 1880, in New York, leaving a widow, three sons, and a daughter. A contemporary writer reporting the artist's death in the New York *Art Journal* remarked on the conservative nature of Baker's work in a period when such artists as JAMES MC NEILL WHISTLER were challenging the establishment: "His methods, as an artist, were straightforward and old-fashioned. He used bright colours, and he tried to make his portraits resemble his sitters. He disliked eccentricities, and did not 'fling paint-pots.'" A sale of Baker's paintings, studies, and sketches was held at George A. Leavitt and Company, New York, on March 16, 1881.

BIBLIOGRAPHY: Henry T. Tuckerman, *Book of the Artists* (New York, 1867), pp. 489–490 // H[enry] W. French, *Art and Artists in Connecticut* (Boston, 1879), pp. 109–110 // Obituaries: *New York Times*, April 3, 1880, p. 3; *Art Journal* (New York) 6 (May 1880), p. 159; *American Art Review* 1 (1881), pp. 320–321 // Theodore Bolton, *DAB* (1928; 1957), s. v. "Baker, George Augustus," p. 519 // Groce and Wallace, pp. 21–22.

Mrs. William Loring Andrews

Jane Elizabeth Crane (1840–1930), daughter of Theodore and Margaret B. Crane of New York, was married to William Loring Andrews (1837-1920) on October 17, 1860. Mrs. Andrews was active as a member of the board of directors of the Woman's Hospital and the National Society of Colonial Dames. She died in New York at the age of ninety. Her husband retired from the New York business world in 1877, at the age of forty, and devoted himself to research in American history, bibliography, and printmaking. He wrote the first of his many books in 1865. Andrews was a notable collector of rare books and a founder of the Grolier Club (1884) and the Society of Iconophiles (1895). A trustee of the Metropolitan Museum from 1878 until his death in 1920, he was instrumental in organizing the museum's library in 1880 and was appointed honorary librarian. In his memory, Mrs. Andrews bequeathed a substantial sum to the museum to be used as an endowment fund for the purchase of books.

According to a label on the back of the portrait, it was probably painted between 1861 and 1863, or shortly after Mrs. Andrews's marriage. She wears a red, blue, and yellow gown with a white bodice, a red shawl, and red flowers in her hair. Baker's rendering of the pensive young woman has the romantic and idealized characteristics that made his work so popular. In 1867 Henry Tuckerman ascribed "the delicacy and fidelity" of Baker's draftsmanship to the "high finish and exactitude" he learned as a miniature painter (*Book of the Artists*, p. 489). An adept performance in the accepted academic manner, this broadly painted portrait demonstrates the artist's successful transition from the painstaking stippling technique demanded of the miniaturist. The painting is in its original frame.

Oil on canvas, 30 × 25 in. (76.2 × 63.5 cm.).

Inscribed on an old label on the back, by a later hand: Mrs. William Loring Andrews-/ (Jane Elizabeth Crane Andrews) / By- / George Baker- / [execu]ted / [torn] - 1861-1863.

REFERENCE: *New York Times*, Nov. 20, 1930, p. 27, subject's obituary provides biographical information.

EXHIBITED: NAD, 1865, no. 567, as A Lady, lent

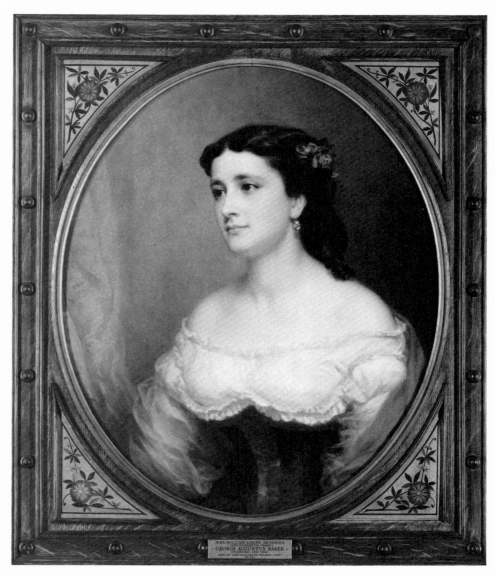

Baker, *Mrs. William Loring Andrews.*

by W. L. Andrews; 1894, *Portraits of Women, Loan Exhibition for the Benefit of St. John's Guild and The Orthopaedic Hospital*, no. 11, as Portrait, lent by William L. Andrews, Esq. // MMA, 1895–1896, *Retrospective Exhibition of American Paintings*, no. 200v, lent by Mr. W. L. Andrews; 1946, *The Taste of the Seventies*, no. 62; 1965, *Three Centuries of American Painting*, unnumbered cat.

Ex COLL.: William Loring Andrews, New York, by 1865–d. 1920; probably Mrs. William Loring Andrews, New York, by 1920–1930; descended in the Andrews and Crane families to the subject's niece, Jane Elizabeth Decker, by 1940.

Gift of Jane Elizabeth Decker, 1940.

40.144.

John F. Kensett

In addition to being one of America's most gifted landscape painters, JOHN F. KENSETT (1816–1872) was, in his later years, one of the most influential members of the New York art world. Following his death in 1872, his friends paid him tribute in a collection of reminiscences published in the 1873 sale catalogue of his works. In an extract from Rome, the portraitist George A. Baker wrote:

It was here, in old Rome, that I first made the acquaintance of our dear friend, twenty years ago; and it

George A. Baker, Jr.

143

Baker, *John F. Kensett.*

was here that his native power and talent began to develop itself (*The Collection of Over Five Hundred Paintings and Studies, by the Late John F. Kensett* [March 24–29, 1873], p. 4).

Kensett and Baker met in Rome in about 1845 or 1846 during their first trips abroad. In his *Sixty Years' Memories of Art and Artists* (1900, pp. 71–72), Benjamin Champney mentions them as members of the American art colony there.

When Kensett was elected an associate of the National Academy of Design in 1848, Baker painted his portrait for the academy's collection

(NAD). In New York, the two artists frequented the same circles, belonged to the same clubs, and during the late 1860s had studios in the same building and country homes in Darien, Connecticut. About 1864 Baker painted another portrait of Kensett (NAD) for the collector Robert M. Olyphant, Kensett's friend and patron. That portrait served as the model for an engraving by Frederick W. Halpin.

The Metropolitan's portrait is dated 1875, three years after Kensett's death. A candid and unaffected characterization, it shows him as a plump and benign gentleman, with his whiskers dressed in the Dundreary style fashionable in the 1860s. The work resembles another Kensett portrait (New York art market, 1982), possibly by Kensett himself or his friend Vincent Colyer (1825–1888).

Oil on canvas, 27 × 22 in. (68.6 × 55.9 cm.).
Signed and dated at left center: G. A. Baker / 1875.
REFERENCES: *New York Evening Post*, March 18, 1881, p. 4, notes: "The sale of Mr. George A. Baker's collection last night brought $2,523. The portrait of Mr. Kensett went for $500, and is expected to find a home in the Metropolitan Museum" // *American Art Review* 2 (1881), part 2, p. 254, notes portrait in sale of Baker's works // M. Fielding, *Dictionary of American Painters, Sculptors and Engravers* (1926), p. 15 // Theodore Bolton, *DAB* (1928; 1957), s. v. "Baker, George Augustus," p. 519
EXHIBITED: MMA, Nov. 1881–April 1882, Nov. 1882–April 1883, May-Oct. 1883, *Loan Collection of Paintings and Sculpture in the West Galleries and the Grand Hall*, nos. 113, 122, and 104-a, respectively.
EX COLL.: the artist, 1875–1880 (sale, George A. Leavitt and Company, New York, March 16, 1881, no. 61, for $500).
Gift of an Association of Gentlemen, 1881.
81.13.

PLATT POWELL RYDER

1821–1896

A genre painter and portraitist, Platt Powell Ryder remained for most of his life in Brooklyn, where he was born. He attended the Graham Art School, which opened on November 16, 1852, in a rented room at the Brooklyn Institute building. He served on the board of management of the Brooklyn Art Association from 1861 to 1862 and was one of the founders of

the Brooklyn Academy of Design in 1866. Although Ryder first exhibited at the National Academy of Design in 1850 and was a fairly regular contributor to its annual exhibitions, he was not elected an associate member until 1868. The following year he went to Paris, where he studied with Léon Bonnat. Ryder also studied in Belgium and Holland and spent some time in London before returning to America. According to the catalogues for the annual exhibitions of the National Academy of Design, he maintained a studio in New York at various times after 1872—for example, from 1890 to 1895 he was in the Tenth Street Studio Building. In the spring of 1879 he was again in Paris. Ryder's realistic portraits, characterized by academic drawing and a skillful use of light and dark in modeling, reflect both his debt to Bonnat and the increasing influence of photography. In his genre paintings, such as *Patience* 1884 (Yale University, New Haven, Conn.), Ryder reveals a familiarity with Dutch traditions shared by other contemporaries like EASTMAN JOHNSON.

Ryder died at Saratoga Springs, New York, at the age of seventy-five.

BIBLIOGRAPHY: Groce and Wallace, p. 553 ‖ Clark S. Marlor, *A History of the Brooklyn Art Association with an Index of Exhibitions* (New York, 1970), pp. 5, 12, 14, 23 ‖ Patricia Hills, *The Painters' America: Rural and Urban Life, 1810–1910* (New York, 1974), pp. 80, 82, 151. Catalogue for a traveling exhibition at the Whitney Museum of American Art, New York, the Museum of Fine Arts, Houston, and the Oakland Museum.

George P. Putnam

George Palmer Putnam (1814–1872) founded one of New York's leading publishing houses. He was born in Brunswick, Maine, and was apprenticed at eleven to a Boston carpet merchant. In 1829 he went to New York, where he worked as an errand boy in a bookstore and read at night to complete his education. Putnam's first book, *Chronology, or an Introduction and Index to Universal History*, was published in 1833, when he was nineteen. The same year he joined the firm of Wiley and Long, which became Wiley and Putnam in 1840. After his marriage in 1841 to Victorine Haven, he settled in London, where he opened an agency for the sale of American books. In New York in 1853 he began *Putnam's Monthly Magazine*. Publication was suspended, however, in 1857 when the firm almost failed. The magazine, reestablished in 1868, merged with *Scribner's Monthly* in 1870.

During the Civil War Putnam's books were published on commission by the firm of Hurd and Houghton. He returned to publishing in 1866, when he established the firm of G. P. Putnam and Son, renamed G. P. Putnam and Sons in 1871. He was a member of the art committee of the Union League Club, which was instrumental in the founding of the Metro-

Platt Powell Ryder

politan Museum. He was chairman of the subcommittee that drew up the plan to organize the museum, and in 1870 he was elected a member of the executive committee of the first board of trustees. In 1872, when the museum opened

Ryder, *George P. Putnam.*

to the public and a superintendent was needed, Putnam generously volunteered to serve for one year without salary. On December 20 of the same year he died in office.

This portrait is dated 1872, the year of Putnam's death. The boldly modeled head makes a marked contrast to the simple treatment of the subject's clothes. The pronounced sculptural effect, characteristic of Ryder's late style, shows the influence of his studies with Léon Bonnat.

Oil on canvas, 27½ × 22 1/16 in. (69.9 × 56 cm.).
Signed and dated at lower left: *P. P. Ryder 72*.
REFERENCE: J. Bakeless, *DAB* (1935; 1963), s. v. "Putnam, George Palmer," p. 279, supplies biographical information.
Gift of Samuel P. Avery, 1893.
93.18.1.

Stephen Whitney Phoenix

Stephen Whitney Phoenix (1839–1881), the son of Mary Whitney and Jonas Phillips Phoenix, was born in New York. He was graduated from Columbia College in 1859 and received a law degree in 1863 but never practiced. Having inherited a large fortune, he devoted his life to

Ryder, *Stephen Whitney Phoenix*.

travel and to the study of genealogy, Egyptology, botany, and ethnology. His extensive travels included trips to Europe, China, Japan, Syria, Egypt, the West Indies, and Labrador. In his article "Ice and Esquimaux" (*Atlantic Monthly* 14 [Dec. 1864], p. 731), the Reverend D. A. Wasson characterized Phoenix:

fine Greek and Latin scholar, rich as Croesus and simple in his habits as Ochiltree,—passionately fond of travel,—as well read, I will undertake to say, in the literature of travel in Egypt, Arabia, Syria, and Turkey, as any other man twenty-five years old in Europe or America,—full of facts, strong in mind, deep in heart, religious, candid, sincere, courageous, at once frank and reticent,—a thoroughly large and profound nature, whom it was worth going to Labrador to meet.

At his death at the age of forty-two, Phoenix left his collection of curios and works of art to the Metropolitan Museum (where he had served as trustee since 1874), his botanical collection to the American Museum of Natural History, his books on heraldry and genealogy to the New-York Historical Society, and his general library and a large sum of money to Columbia College. His art collection, numbering over six hundred objects, consisted mainly of oriental ivories, lacquer and metal work, with some European crystal, a small group of European paintings, and a collection of tobacco pipes.

Dated 1892, nine years after Phoenix's death, this portrait is almost identical to an engraving by Charles Burt which served as the frontispiece in *Memorial Sketches of Stephen Whitney Phoenix*, published in 1883. The engraving shows Phoenix as a young man during the 1860s and is modeled after either an earlier, unlocated portrait or a photograph.

Oil on canvas, 27 × 22 in. (68.6 × 55.9 cm.).
Signed and dated at lower left: *P. P. Ryder / '92*.
RELATED WORK: Charles Burt, engraving, 4⅞ × 3¾ in. (12.4 × 9.5 cm.), in Jacob Bailey Moore and Henry Thayer Drowne, *Memorial Sketches of Stephen Whitney Phoenix* (1883), frontis.
Gift of Samuel P. Avery, 1893.
93.18.2.

GEORGE FULLER

1822–1884

Acclaimed in the third quarter of the nineteenth century for his enigmatic works, George Fuller emerged as a major figure in the romantic tradition.

Fuller was born on his family's farm in Deerfield, Massachusetts. At thirteen he spent a short time in Boston where he worked in a grocery and then a shoe store. At fifteen he joined a railroad survey headed for Illinois. During the trip, he met the sculptor Henry Kirke Brown, who later became his teacher. After two years in the West, Fuller returned to Deerfield, where he completed his schooling at the local academy. He was always interested in novelty. In 1840 he convinced his father to help him buy a camera and equipment for taking daguerreotypes. It is said, however, that he seldom used it (Millet, pp. 14-15).

Fuller's first professional portraits date from 1841, when he accompanied his half-brother, Augustus Fuller (1812-1873), an itinerant miniaturist and portrait painter, through western New York. George Fuller subsequently spent nine months studying with Henry Kirke Brown in Albany. He settled in Boston in the winter of 1842 and was elected to the Boston Artists' Association the following year. By 1846, he had acquired a studio next to one occupied by the artist Thomas Ball (1819–1911) at 17½ Tremont Row. In Boston, Fuller succumbed to what Ball called the "Allston epidemic." Fuller's study of the works of WASHINGTON ALLSTON, the leading proponent of romanticism in America, was instrumental in the development of his painting style. "We were then struggling after Allston's color," Ball wrote. "I think the effect of his then admiration for that great artist can be traced in all Mr. Fuller's works" (*Boston Evening Daily Transcript*, May 7, 1884, p. 6).

In 1847 Fuller left Boston for New York, where he made friends of many of the leading artists of the city. His works were shown at the American Art-Union from 1847 to 1849. In 1849 he began exhibiting at the National Academy of Design and attended the life class there. In 1853 he was elected an associate. Active chiefly in New York during the next few years, he also spent time in Philadelphia and visited the South on portrait painting excursions.

The death of his father in 1859 left Fuller with the responsibility for the family and the farm. Before returning to Deerfield, however, he went to Europe in 1860 with the artist and critic William J. Stillman (1828–1901), who founded and co-edited the *Crayon*. They traveled together as far as England, where Fuller met the Pre-Raphaelites Dante Gabriel Rossetti and William Holman Hunt. Fuller then visited France, Italy, Switzerland, Germany, Holland, and Belgium. In Geneva he rejoined Stillman, who introduced him to John Ruskin, the spokesman for the Pre-Raphaelites. During his tour of Europe Fuller also had the opportunity to study the works of other European contemporaries and the old masters. According to letters and journal entries from his trip abroad, he was especially impressed with Titian, Rembrandt, and Velázquez. Turner's early landscapes were characterized as "the greatest landscapes ever painted" but those of his later years as "being so exceeding vague art as to be 'the stuff that dreams are made of,' and then not the most delightful." Of the Barbizon painter Jean François Millet, Fuller wrote: "In most of his melancholy pictures your sympathies are

moved, and you are so sorry for the poor people that you are glad to pay tribute to his genius" (Millet, pp. 29, 30).

After returning home, Fuller turned increasingly to figure and landscape painting. In 1861 he married Agnes Higginson of Cambridge, Massachusetts, and settled on the farm in Deerfield, where he spent the next fifteen years. He divided his time between farming and painting. Material gathered during his European trip, the country around Deerfield, and his family served as subjects. The failure of the farm's tobacco crop in 1875 and impending backruptcy prompted Fuller to exhibit his work at Doll and Richards gallery in Boston in 1876. The relative success of this exhibition won him recognition and financial security. The increased attention to Fuller's work coincided with a growing taste for subjective, interpretative painting. This trend contrasted strongly with an equally vital contemporary interest in realism and may have been a reaction against a world that seemed too complex, materialistic, and industrialized. In Boston Fuller's champions were the advocates of the French school and, in particular, the students of WILLIAM MORRIS HUNT, who promoted the work of the Barbizon painters in America.

In New York, Fuller's work was acclaimed by the Society of American Artists, a progressive art organization established in 1877 by a group of young European-trained artists opposed to the conservatism of the National Academy. Fuller's long years as a farmer doubtlessly contributed to his romantic image. His paintings of obscure, indistinct figures, shrouded in mystery, found an enthusiastic audience. "I like every picture I paint to have an atmosphere of its own, to be a little world by itself, back, and within the frame," Fuller is reported to have said (Millet, p. 80). In his "devotion to understatement and half-tones," Frank Jewett Mather, Jr., observed, "[Fuller] is in an authentic New England tradition." He favored a green, gold, and brown palette, a "brown sauce . . . with a saving difference, for it is not a studio recipe but a true inference from those late October twilights in Massachusetts, when the air shimmers with a luminous dust that has been crushed up from dried leaves" (*Estimates in Art*, 2 [1931], pp. 106–107). The original, much admired effect of Fuller's colors is lost today. His penchant for reworking his canvases and his use of bitumen, which is unstable, have considerably and thus far irreversibly altered his works. This deterioration probably accounts in part for the drop in the public's interest in his paintings.

After Fuller's death in Boston, a memorial exhibition was held there at the Museum of Fine Arts in 1884. In 1923 the Metropolitan Museum held an exhibition of Fuller's work in commemoration of the hundredth anniversary of his birth.

BIBLIOGRAPHY: MFA, Boston, *Memorial Exhibition of the Works of George Fuller* (1884). Contains essay by Mariana Griswold Van Rensselaer and 179 catalogue entries // Josiah B. Millet, ed., *George Fuller: His Life and Works* (Boston, 1886). Contains essays by William Dean Howells, Francis Davis Millet, William James Stillman, Thomas W. Ball, John Greenleaf Whittier, John J. Enneking, and William B. Closson, as well as a list of the artist's works arranged chronologically // MMA, *Centennial Exhibition of the Works of George Fuller* (1923). Contains essay by Augustus Vincent Tack, 34 catalogue entries, and illustrations // William I. Homer and David M. Robb, Jr., "Paintings by George Fuller in American Museums and Public Collections," *Art Quarterly* 24 (Autumn 1961), pp. 286–294 // Sarah Burns, "A Study of the Life and Poetic Vision of George Fuller (1822–1884)," *American Art Journal* 13 (Autumn 1981), pp. 11–37.

Ideal Head of a Boy
(George Spencer Fuller)

Fuller's children "in all stages of growth and development" served as his models, according to his wife (J. B. Millet, ed., *George Fuller* [1886], p. 41). The eldest son, George Spencer Fuller (1863–1911), often posed for his father. Judging from the child's probable age in this portrait, it was painted during the late 1860s or early 1870s. George Spencer Fuller also became a painter and was best known for his winter landscapes. He married Mary W. Field in 1889 and spent most of his life in Deerfield, Massachusetts.

The boy's head emerges from the dark ground that Fuller favored. Although called *Ideal Head of a Boy*, the painting is very much a distinctive portrait because the artist has captured the elfin features and solemn innocence of his subject. Describing the nature of Fuller's portraits, FRANK MILLET wrote:

Fuller doubtless often failed with his portraits to satisfy the requirements of ordinary portraiture, because he could not be content with the superficial imitation of flesh, feature, or textures. What he attempted, and usually succeeded in doing was to represent his sitters under the best aspect which his observation and imagination suggested. Of absolute realism in his portraits there is little; of accurate imitation of the details of form and color there is also little; but there is, what is very much better, a masterly generalization of the characteristic traits of the sitter (*Harper's Monthly* 69 [Sept. 1884], pp. 521-522).

Although this painting was probably one of the many ideal heads and portraits of children by Fuller shown at his memorial exhibition in Boston in 1884, the absence of a label prevents its identification with a specific work in that exhibition.

Oil on canvas, 27¼ × 22 in. (69.2 × 55.9 cm.).
REFERENCES: *Studio* 2 (May 1887), p. 197, calls it Ideal Head of a Boy; notes that it is on exhibition at Reichard's gallery and was recently presented to the Metropolitan // *American Artists and Their Works* (1889), 2, p. 312 // W. Montgomery, ed., *American Art and American Art Collections* (1889), 2, p. 952 // *American Art Annual* 9 (1911), p. 311, supplies obituary of the subject // W. H. Fuller, *Genealogy of Some Descendants of Thomas Fuller of Woburn* (1919), 4, pp. 38, 49 // W. H. Downes, *International Studio* 75 (July 1922), ill. p. 270 // L. Mumford, *The Brown Decades* (1931), ill. opp. p. 212 // W. I. Homer and D. M. Robb, Jr., *Art Quarterly* 24 (Autumn 1961), p. 290, lists it // D. M. Robb, Jr.,

Fuller, *Ideal Head of a Boy*.

letters in Dept. Archives, August 10, 1964, identifies subject and dates painting about 1870 to 1875; Nov. 2, 1964, encloses note from the subject's daughter E. B. Fuller, dated Oct. 20, 1964, identifying subject and giving his dates.

EXHIBITED: Reichard and Company's Gallery, New York, 1887, *Works by George Fuller*, either no. 6, 7, 8, or 9, as Ideal Head // NAD, 1942, *Our Heritage*, no. 250, as Ideal Head of a Boy // Hilson Gallery, Deerfield Academy, Deerfield, Mass., 1955 (no cat.) // MMA, 1965, *Three Centuries of American Painting*, unnumbered cat.

EX COLL.: George I. Seney, Brooklyn, by 1887.
Gift of George I. Seney, 1887.
87.8.4.

And She Was a Witch

In the 1886 memorial volume dedicated to the artist, William Dean Howells discussed the title for this picture: "[Fuller] had usually completed one of those divine figures or touching histories before his thought had crystallized a name for it. Then he turned to his friends for help, and in one such extremity I had the honor

Fuller, *And She Was a Witch.*

of suggesting the Romany Girl to him, and in another She was a Witch, going to Emerson for the first and to Shakespeare for the last." The quote, however, is not from Shakespeare.

Fuller sent both *The Romany Girl*, 1877–1879 (coll. Helen C. Frick, Pittsburgh), and this painting to the annual exhibition at the National Academy of Design in 1879. The meaning of this picture, never clarified by the artist, became the subject of speculation for many critics. In 1879, *Scribner's* called it "quite a little drama in itself." W. C. Brownell, writing in *Scribner's* the following year, attempted to explain the subject:

An accused woman is being taken from her house among the pines by the officers of colonial fanaticism, and another, entering the door, is looking around at the disappearing figures. The observer can make his own tragedy out of it, imagine the short trial and swift condemnation of the unhappy victim of Puritan superstition.

In 1902 Sadakichi Hartmann offered a similar interpretation: "through tall tree-trunks a woman is led away to the dread tribunal, while in the foreground a young girl seeks refuge at the door of her humble dwelling." The ambiguity of the scene is sustained by the style of the painting. "The general hue of this picture is a yellow, misty green, and at first seems very peculiar," wrote a critic in the *Art Journal* of

1879, "but as the eye becomes accustomed to it, and penetrates into its recesses, this misty hue is recognized as a vital part of the painting."

Although the picture was first exhibited in 1879, Fuller worked on it at various times from 1877 to the spring of 1884. In a review of its exhibition at the Williams and Everett gallery in Boston in the spring of 1884, the *Art Interchange* reported that it had "been repainted since it was exhibited before." The canvas is heavily painted. With the passage of time the painting has darkened considerably, and the result is a loss of contrast. There is extensive crackle, which is caused by Fuller's use of bitumen.

Oil on canvas, 30 × 40 in. (76.2 × 101.6 cm.).
Signed at lower left: G. Fuller.
REFERENCES: *New York Times*, March 30, 1879, p. 6, in a discussion of varnishing day before the opening of the NAD exhibition, describes the scene in the picture and says: "The public will enjoy the way in which the story is told; painters ought to admire the singular key of color which is found throughout the mystery of a twilight that is both of the day and of the woods; they will also enjoy the painting of the figure of the girl, the way in which she is modeled without minute brushwork, and the expressiveness of her face and movement" // *Nation* 28 (May 22, 1879), p. 359, in review of NAD exhibition calls it the "best imaginative picture," describes the scene, and notes that the "posture of the

hunted maiden forms a complete, original, and striking statuette, while the melting landscape is pathetic in its drain of evening light" // *Art Journal* (New York), n. s. 5 (May 1879), p. 158 (quoted above) // [W. H. Bishop], *Atlantic Monthly* 43 (June 1879), p. 786 // E. Strahan, *Art Amateur* 1 (June 1879), p. [4] in a review of it at NAD, says "the artist proves himself stronger than if he had been more definite" // *Scribner's Monthly* 18 (Sept. 1879), p. 313 (quoted above) // W. C. Brownell, *Scribner's Monthly* 20 (July 1880), pp. 325, 326, describes it, compares with Corot, and discusses subject (quoted above) // M. G. Van Rensselaer, *Century* 27 (Dec. 1883), pp. 227, 230, 232, 234; reprinted as *Six Portraits* (1889), pp. 195–196, mentions it in NAD exhibition; pp. 212, 213, describes picture; p. 214, notes that Fuller "recast [it] just before he died"; p. 226, says it "recalls Hawthorne's mood even to dull perceptions—not more by its choice of subject than by its subtilely artistic, dreamy, individual methods of expression"; p. 233 // *Art Interchange* 12 (March 27, 1884), p. 77, discusses exhibition at Boston gallery of Williams and Everett and notes picture was repainted (quoted above) // *Art Amateur* 10 (May 1884), p. 133; 11 (June 1884), p. 4, comments on the "elegance and refinement of the figures and of the whole scheme of color and composition" // S. Dickinson, *Granite Monthly* 9 (Jan. and Feb. 1886), pp. 38–39, says that Fuller considered this painting still unfinished at his death // J. B. Millet, ed., *George Fuller* (1886), p. 49; p. 90, in checklist dates it 1877–1883, estate of George Fuller // *Studio* 2 (May 1887), p. 197, notes that it is on exhibition at Reichard's and was recently presented to MMA by George I. Seney // C. Cook, *Art and Artists of Our Time* (1888), 3, p. 253 // *American Artists and Their Works* (1889), 2, pp. 311–312, discusses it and says that it was withdrawn from the 1884 sale; p. 318 // W. Montgomery, ed., *American Art and American Art Collections* (1889), 2, pp. 951–952, 958 // C. de Kay, *Magazine of Art* 12 (1889), p. 354 // S. Hartmann, *A History of American Art* (1902), 1, p. 211 (quoted above) // C. H. Caffin, *American Masters of Painting* (1903), p. 108 // S. Isham, *The History of American Painting* (1905), p. 393 // E. L. Carey, *International Studio* 35 (Sept. 1908), p. xcii // F. F. Sherman, *American Painters of Yesterday and Today* (1919), p. 25; *Art in America* 7 (Feb. 1919), p. 86 // W. H. Downes, *International Studio* 75 (July 1922), ill. p. 267; pp. 267–268, notes its withdrawal from the 1884 sale // W. H. Downes, *DAB* (1931; 1960), s. v. "Fuller, George," p. 55 // W. I. Homer and D. M. Robb, Jr., *Art Quarterly* 24 (Autumn 1961), p. 290, lists it // Mrs. N. H. Krivatsy, Folger Shakespeare Library, Washington, D. C., letter in Dept. Archives, June 2, 1978, states that "And She was a Witch" does not appear in Shakespeare concordances or quotation dictionaries // S. Burns, *American Art Journal* 13 (Autumn 1981), p. 23, cites Howells's letter to William H. Bishop requesting review of Fuller's work at 1879 NAD

George Fuller

exhibition (subsequently published in the *Atlantic Monthly*); pp. 25–26, quotes Howells on the naming of the work; p. 30, describes it; p. 31, fig. 21; p. 35.

EXHIBITED: NAD, 1879, no. 421, as "And she was a Witch"—*Cymbeline*, for sale, $2,000 // Williams and Everett, Boston, spring 1884 // MFA, Boston, 1884, *Memorial Exhibition of the Works of George Fuller*, p. 28, no. 40, dates it 1877–1883 // Reichard and Company's Gallery, New York, 1887, *Works by George Fuller*, no. 3 // Corcoran Gallery of Art, Washington, D. C., and Grand Central Art Galleries, New York, 1925–1926, *Commemorative Exhibition by Members of the National Academy of Design, 1825–1925*, no. 333 // Museum of Modern Art, New York, 1943–1944, *Romantic Painting in America*, no. 92.

EX COLL.: the artist's estate (sale, Williams and Everett, Boston, May 9, 1884, no. 40, withdrawn); the artist's estate, 1884–1886; George I. Seney, Brooklyn, by 1887.

Gift of George I. Seney, 1887.

87.8.7.

The Quadroon

This young woman is typical of Fuller's brooding figures, shrouded in twilight gloom and mystery. She has the anonymous quality common to all of his idealized women. The painting was completed in 1880 and exhibited the same

Fuller, *The Quadroon*.

year at the National Academy of Design, where it received mixed reviews. In *Scribner's Monthly* for 1880, W. C. Brownell called it "more or less of a failure," but the *Art Amateur* of the same year reported that it was "full of expression, deep feeling, and real sentiment." Samuel G. W. Benjamin (1837–1914) in the *American Art Review* of 1881 wrote: "American art has produced few, if any pictorial compositions which suggest more, or seem so truly to proceed from deep reflection and sympathy with the mystery of humanity. . . . sympathy with the burden which countless multitudes bear without remedy." Some thirty years later Frederic Fairchild Sherman, in *American Painters of Yesterday and Today*, wrote:

Again it is a girl he chooses to interpret his idea, and, young as she is, he manages to invest her with the definite appearance of a comprehension of the sorrows of her inheritance, overwhelming if unconvincing to her troubled heart. In her he has contrived a graphic presentation of the bitter wrong mankind has worked upon man since time began, and has driven its meaning home by the look of weary despair that clouds her childish face.

The Quadroon is characteristic of Fuller's late paintings. The girl dominates the foreground, and in the field behind her several indistinct figures are at work. The composition is simple, drawing is restricted to general outlines, and details are avoided in the interest of the whole. No attempt is made to define flesh, fabric, or grass. Fuller's interest is primarily in the texture of the paint surface, which he has worked over with the end of his brush. His interest in paint for its own sake, as a vehicle for expressive effects, aligned Fuller with the progressive artists of his time. It also brought him recognition from a younger generation of artists.

The painting has darkened with time. The surface is disfigured in many areas by drying cracks, particularly in the hair of the girl, where the artist used bitumen.

Oil on canvas, 50½ × 40½ in. (128.3 × 102.9 cm.). Signed at lower left: G. Fuller.

RELATED WORKS: *Portrait of a Girl: Study for the 'Quadroon,'* 1879, oil on canvas, 30 × 25 in. (76.2 × 63.5 cm.), ill. in American Art Association, Anderson Galleries, New York, *European and American Paintings . . . Including the Property of . . . Mrs. William H. Schofield*, sale cat., April 30, 1936, p. 17, no. 36 // *A Sketch of the Quadroon*, made for magazine reproduction by the artist, unlocated, ill. in S. G. W. Benjamin, *American Art Review* 1, part 2 (1881), p. 308.

REFERENCES: *Scribner's Monthly* 20 (June 1880), p. 315, notes in review of NAD exhibition: "A quadroon girl in a field was a fine composition, whether for expressiveness of look, or for the mystery which the painter has had the art to throw around the figure" // *Art Amateur* 3 (June 1880), p. 2 (quoted above) // W. C. Brownell, *Scribner's Monthly* 20 (July 1880), p. 326 (quoted above) // S. G. W. Benjamin, *American Art Review* 1, part 2 (1881), p. 308 (quoted above), illustrates sketch of it by the artist // M. G. Van Rensselaer, *Century* 27 (Dec. 1883), pp. 227, 229, reprinted as *Six Portraits* (1889), p. 196, mentions it in NAD exhibition; p. 208, describes it; p. 233 // *Art Union* 1 (April 1884), p. 96, reports sale of the painting for $3,500 // S. Dickinson, *Granite Monthly* 9 (Jan. and Feb. 1886), p. 38 // J. B. Millet, ed., *George Fuller* (1886), p. 91, lists study for it, dated 1879, in the collection of Mr. J. J. Enneking, Boston; p. 92, lists this picture as dated 1880, in the collection of Mr. S. D. Warren, Boston // *American Artists and Their Works* (1889), 2, pp. 305, 309, 311; p. 312, lists it in the collection of Mrs. S. D. Warren; p. 317, illustrates drawing Fuller did from the painting; pp. 318–319, quotes unidentified New York critic who called it "beautiful, impressive, and widely effective"; p. 320 // W. Montgomery, ed., *American Art and American Art Collections* (1889), 2, pp. 945, 951, 952, 958–959, 960, discusses it // C. de Kay, *Magazine of Art* 12 (1889), p. 354, mentions study for it in 1884 sale and the exhibition of this picture from the collection of Mr. Samuel D. Warren, Boston // S. Hartmann, *A History of American Art* (1902), 1, p. 211 // C. H. Caffin, *American Masters of Painting* (1903), p. 108 // *American Art Annual* 4 (1903), p. 41, no. 118, lists it as sold from the estate of Mrs. S. D. Warren to George A. Hearn for $5,500 // *Catalogue of the Collection of Foreign and American Paintings owned by Mr. George A. Hearn* (1908), ill. no. 201, p. 161 // *MMA Bull.* 5 (May 1910), ill. p. 108, and lists it // MMA, *George A. Hearn Gift to the Metropolitan Museum of Art . . .* (1913), ill. p. 54 // F. F. Sherman, *American Painters of Yesterday and Today* (1919), ill. after p. 22; pp. 24–25 (quoted above); *Art in America* 7 (Feb. 1919), p. 86 // W. H. Downes, *International Studio* 75 (July 1922), p. 267, ill. p. 270 // F. J. Mather, Jr., *The Pageant of America* (1927), 12, p. 59; *Estimates in Art* (1931), 2, p. 114 // W. H. Downes, *DAB* (1931; 1960), s. v. "Fuller, George," p. 55 // W. I. Homer and D. M. Robb, Jr., *Art Quarterly* 24 (Autumn 1961), p. 290, lists it; p. 292, fig. 6 // S. Burns, *American Art Journal* 13 (Autumn 1981), p. 25; p. 28, fig. 19; pp. 29, 30, discusses style and compares with art of Millet and Jules Breton.

EXHIBITED: NAD, New York, 1880, no. 483, lent by Z [*sic*] J. B. Lincoln // MFA, Boston, 1880, *Living American Artists*, no. 33, lent by L. J. B. Lincoln // MFA, Boston, 1884, *Memorial Exhibition of the Works of George Fuller*, p. 40, no. 138, lent by Samuel D. Warren, dates it 1880; p. 30, no. 56, lists 1879 study for it // Paris, 1889, *Exposition Universelle*, no. 112 // World's Co-

lumbian Exposition, Chicago, 1893, no. 2818, lent by Mrs. S. D. Warren, Boston // American Fine Arts Society, New York, 1904, *Comparative Exhibition of Native and Foreign Art, under the auspices of the Society of Art Collectors,* no. 64, lent by Mr. George A. Hearn.

Ex coll.: L. J. B. Lincoln, 1880; Mr. and Mrs. Samuel D. Warren, Boston, by 1884–1903 (sale, American Art Association, New York, Jan. 9, 1903, no. 118, $5,500); George A. Hearn, New York, 1903–1910.

Gift of George A. Hearn, 1910.
10.64.3.

Nydia

Nydia, the blind heroine of Edward Bulwer-Lytton's novel *The Last Days of Pompeii* (1834), was a popular subject with American painters and sculptors in the 1840s and 1850s. Among the best known was Randolph Rogers's sculpture *Nydia,* 1855–1856 (MMA).

According to one writer: "It was not in Fuller's mind to paint Bulwer's heroine—the name came after, the idea of blindness was what preoccupied him" (quoted in S. Burns [1981], p. 26). Fuller painted *Nydia* in 1882 and showed it at the Society of American Artists in 1883. In a review of the exhibition, the critic for the *New York Times* reported:

Mr. Fuller has painted a lovely damsel. . . . Through the golden mist which he affects and paints so beautifully other figures are descried. . . . But, seriously, did not Mr. Fuller paint the figure first, and then search for a title! There is loveliness and obscurity in the picture, but no evidence that the girl in the yellow twilight is blind.

Ghostly figures are seen in the right background and an unidentified sculpture on a pedestal appears on the left.

Fuller generally used strong contrasts of light and dark to highlight his foreground figures. The background of this painting probably had more contrast originally. The picture, however, has darkened considerably, and the range of values has diminished. Fuller's interest in the texture of paint is evident in his handling of the drapery and flesh of the figure. His relentless repainting contributed to the rich and intricate surface effects that he achieved. In the 1886 memorial volume to the artist, William Dean Howells quoted one of Fuller's sons: "He would sometimes nearly complete a picture at the first painting, and in some instances, as in the Nydia,

Fuller, *Nydia.*

the picture would not be materially changed by subsequent paintings."

Oil on canvas, 50 × 32¼ in. (127 × 81.9 cm.).
Signed at lower left: G. Fuller.
RELATED WORK: Stephen James Ferris, *Nydia,* etching.
REFERENCES: *New York Times,* March 25, 1883, p. 14, reviews it in the 1883 exhibition of the Society of American Artists (quoted above) // M. G. Van Rensselaer, *Century* 27 (Dec. 1883), pp. 227, 232, 234, reprinted as *Six Portraits* (1889), p. 196, mentions its 1883 exhibition; pp. 209-210, discusses subject and says that if Fuller's "'Nydia' is not Nydia at all, it does not matter in the least. The name is the mistake and not the picture. What we are looking for is the illustration of some ideal, not of . . . Bulwer's but of Fuller's own"; pp. 220-221, discusses color in the picture; pp. 223–224, describes and says, "it is so clear that the title seems indeed ill-chosen. No one could divine Bulwer's blind Thessalian in this dainty

rosy little maid, not even by the help of the shadowy volcanic suggestions which the background shows. It was a mistake, perhaps, for an artist of this temper to essay illustration even in the vaguest and most general way" // *Art Union* 1 (April 1884), pp. 90–91, in artist's obituary, notes that this picture was shown at the 1883 exhibition, and "while attracting much attention and being criticized on the one hand for phenomenal excellence, and on the other for what were termed inexcusable mannerisms and faults, was not equal to the artist's best work"; p. 91, adds, "It was very charming in conception, but the pecularities of the painter's technique were shown in an extreme degree" // S. Dickinson, *Granite Monthly* 9 (Jan. and Feb. 1886), pp. 38, 39 // J. B. Millet, ed., *George Fuller* (1886), p. 46, reports artist's son's mention of it (quoted above); p. 92, in checklist dates it 1882, estate of George Fuller // *Studio* 2 (May 1887), p. 197, notes that it is on exhibition at Reichard's gallery and was recently presented to the MMA by George I. Seney; p. 199, describes it // *American Artists and Their Works* (1889), 2, pp. 311–312, discusses it, notes that it was withdrawn from the 1884 sale, and mentions an etching of it by S. J. Ferris which was published; pp. 316–319 // W. Montgomery, ed., *American Art and American Art Collections* (1889), 2, pp. 951–952, 959, discusses it // C. H. Caffin, *American Masters of Painting* (1903), p. 108 // E. L. Carey, *International Studio* 35 (Sept. 1908), p. xcii, discusses it // F. F. Sherman, *American Painters of Yesterday and Today* (1919), pp. 22–23, 24, 25; *Art in America* 7 (Feb. 1919), pp. 85, 86 // W. H. Downes, *International Studio* 75 (July 1922), ill. p. 266; pp. 267–268, notes its withdrawal from 1884 sale // R. Cortissoz, *American Artists* (1923), p. 64 //

H. McBride, *New York Herald*, April 15, 1923, sec. 7, p. 7 // *New York Times Magazine*, April 15, 1923, p. 12 // F. J. Mather, Jr., *The Pageant of America* (1927), 12, p. 59; *Estimates in Art* (1929), p. 112 // W. H. Downes, *DAB* (1931; 1960), s. v. "Fuller, George," pp. 55, 56, notes its exhibition in Williams and Everett galleries in Boston in the spring of 1884 and the death of the artist while the exhibition was in progress // W. I. Homer and D. M. Robb, Jr., *Art Quarterly* 24 (Autumn 1961), p. 290, lists it // S. Burns, *American Art Journal* 13 (Autumn 1981), pp. 25, 26, 27.

EXHIBITED: Society of American Artists, New York, 1883, no. 56 // Williams and Everett, Boston, Spring 1884 // MFA, Boston, 1884, *Memorial Exhibition of the Works of George Fuller*, pp. 18, 21, discussed by M. G. Van Rensselaer; p. 30, no. 57, dates it 1882 // Reichard and Company's Gallery, New York, 1887, *Works by George Fuller*, no. 5 // Royal Academy, Berlin, and Royal Art Society, Munich, 1910, *Ausstellung Amerikanischer Kunst*, no. 78 // MMA, 1923, *Centennial Exhibition of the Works of George Fuller*, no. 18 // Centennial Art Gallery, Centennial Exposition, Utah State Fair Grounds, Salt Lake City, 1947, *One Hundred Years of American Painting*, cat. by American Federation of Arts, Washington, D. C., no. 9 // NAD, 1951, *The American Tradition*, no. 56 // MMA, 1953, *American Painting, 1754–1954* (no cat.) and 1965, *Three Centuries of American Painting*, unnumbered cat.

EX COLL.: the artist's estate (sale, Williams and Everett, Boston, May 9, 1884, no. 57, withdrawn); the artist's estate, Boston, 1884–1886; George I. Seney, Brooklyn, by 1887.

Gift of George I. Seney, 1887.

87.8.10.

JACOB HART LAZARUS

1822–1891

Although he was chiefly known for his portraits, Jacob Hart Lazarus also painted miniatures, figures, and scenes from the writings of Shakespeare and Washington Irving. He studied for a time with HENRY INMAN, who was one of the foremost portraitists in New York. From 1841 until 1865 Lazarus contributed to the annual exhibitions of the National Academy of Design, where in 1850 he was elected an associate member. His paintings were also shown at the Boston Athenaeum and the Pennsylvania Academy of the Fine Arts. Lazarus's early portraits, which are softly modeled, broadly painted, and idealized, reflect the influence of his studies with Inman. His later work is more concrete, probably as a result of the growing influence of photography.

After the artist's death in New York in 1891, his widow, Mrs. Amelia B. Lazarus, and his daughter, Emilie Lazarus, established a memorial fund, the income from which is currently awarded by the Metropolitan Museum through the American Academy in Rome to young artists for study in Europe.

BIBLIOGRAPHY: Winifred E. Howe, *A History of the Metropolitan Museum of Art, with a Chapter on the Early Institutions of Art in New York* (New York, 1913), pp. 249–250. Discusses the Jacob H. Lazarus Traveling Scholarship // [Mary Bartlett Cowdrey], *National Academy of Design Exhibition Record, 1826–1860* (New York, 1943), 1, pp. 288–289 // Groce and Wallace, p. 389 // Maria Naylor, comp. and ed., *The National Academy of Design Exhibition Record, 1861–1900* (New York, 1973), 1, pp. 549–550.

Henry Inman

Lazarus studied with HENRY INMAN (1801–1846) in the 1840s, and this cabinet-size portrait was probably painted in memory of that association. Although it may have been painted from life, it was not exhibited until 1848, two years after Inman's death. A daguerreotype showing a bust-length image of Inman in the same attire but facing left may have been used as a model for this portrait (ill. in T. Bolton, *Art Quarterly* 3 [Autumn 1940], p. 355, fig. 2). If that is the case, Lazarus has idealized the face and shown Inman as a younger man.

Broadly painted with a predominantly brown palette, the portrait is a conventional academic work. Conceived in the romantic spirit that characterizes Lazarus's early portraiture, it reflects his training with Inman.

Oil on canvas, 10⅝ × 8⅝ in. (27 × 21.9 cm.).
Signed at lower right: J. H. Lazarus Pinx.
Canvas stamp: PREPARED / BY / ED WD DECHAUX / NEW YORK.
RELATED WORK: Victor Prevost, *Henry Inman*, lithograph, undated, printed by Louis Nagel, ill. in H. T. Peters, *America on Stone* (1931), p. 25.
EXHIBITED: NAD, 1848, no. 233.
EX COLL.: the artist, New York, 1848–1891; his wife, Amelia B. Lazarus, New York, 1891–1893.

Gift of Mrs. Jacob H. Lazarus, 1893.
93.19.1.

Lazarus, *Henry Inman*.

Lazarus, *Self-portrait*.

Self-portrait

Probably painted in the 1870s, this self-portrait presents Lazarus as a mild-mannered, sensitive-looking man with fashionable Dundreary whiskers. Conventional and conservative in style, it is equally restrained in color. Gray, brown, and black dominate, relieved by a faint warmth in the flesh tones and a note of blue in the cravat.

The artist's wife, Amelia B. Lazarus, who died in 1906, bequeathed the portrait to her nephew Frank Lazarus. He gave it to Samuel Riker, executor of the estate and a friend of the artist, who presented it to the museum.

Oil on canvas, 27⅛ × 22 in. (68.9 × 55.9 cm.).
Ex COLL.: the artist's wife, Amelia B. Lazarus, New York, by 1891–1906; her nephew, Frank Lazarus, New York, 1906 or 1907; Samuel Riker, Jr., New York, 1907–1908.
Gift of Samuel Riker, Jr., 1908.
08.18.

Joseph W. Drexel

Born in Philadelphia, Joseph William Drexel (1833–1888) was the youngest of three sons of the banker Francis Martin Drexel (1792–1863).

Lazarus, *Joseph W. Drexel.*

Joseph attended a local high school; but his education in languages, music, art, and banking was directed by his father, a former portrait painter, who had traveled widely in Europe, South America, and Mexico. When Joseph's schooling was finished, he joined the family firm and was active in banking here and abroad. He returned to Philadelphia when his father died in 1863. Two years later he married Lucy Wharton. In 1867 he became a partner in the Parisian firm of Drexel, Harjes and Company and in 1871 an associate of J. P. Morgan in Drexel, Morgan and Company in New York. In 1876 Drexel retired to devote his time to philanthropic and cultural interests. He served as treasurer of the New York Cancer Hospital, president of the Philharmonic Society, and from 1881 to 1888 trustee of the Metropolitan Museum. His interest in music and art led to the formation of an extensive music library and a collection of instruments, prints, and antiquities. A valuable group of forty-four musical instruments was donated to the museum by Drexel between 1885 and 1887. He bequeathed his library to the Lenox Library, now part of the New York Public Library. After his death in 1888 at the age of fifty-five, his widow presented his art collection to the Metropolitan.

This bust-length portrait was painted in 1877, when he was forty-four. An example of Lazarus's mature style, it is a direct, unembellished representation. The precision and realism of its execution reflect the influence of photography.

Oil on canvas, 30⅛ × 25½ in. (76.5 × 64.8 cm.).
Signed and dated at lower left: JHLazarus (initials in monogram) / 1877.
REFERENCES: W. E. Howe, *A History of the Metropolitan Museum of Art* (1913), pp. 221, 254, describes Drexel's gifts to the Metropolitan // W. H. Bowden *DAB* (1930; 1959), s. v. "Drexel, Joseph William," provides biographical information on the subject.
Ex COLL.: Mr. and Mrs. Joseph W. Drexel, New York, 1877–1888; Mrs. Joseph W. Drexel, New York, 1888–1896.
Gift of Mrs. Joseph W. Drexel, 1896.
96.23.

NICHOLAS BIDDLE KITTELL

1822–1894

The son of Maria Clauw and Nicholas Kittle, the artist was born in Kinderhook, New York, and spent his childhood in Tioga. Sometime between 1845 and 1847 he changed the spelling of his name from Kittle to Kittell. His father was a bandmaster and clarinetist in nearby Owego. Self-trained as a miniature and portrait painter, Kittell first advertised as a professional artist on September 3, 1840, at the age of eighteen. The same year, he entered the Athens Academy in Pennsylvania, where the future composer Stephen Foster was a classmate and friend. Kittell left the academy and established himself as a painter in nearby Towanda in May 1841. The following year he returned to Athens, where he opened a portrait studio.

On November 13, 1845, Kittell married Jane Olivia Rudderow in New York City. At that time he gave his address as Norwich, New York. He first exhibited at the National Academy of Design in 1847, while living in Norwich. Kittell appears to have moved to New York in 1848. He lived in Brooklyn from 1856 to 1864 and from 1856 until his death in 1894 maintained studios at various addresses in Manhattan. He was a frequent contributor to exhibitions at the National Academy and the Brooklyn Art Association, where he served on the board of management from 1861 to 1862. Painting commissions took him to Northampton, Massachusetts, in 1861–1862, and to Portland, Maine, in 1879. The Kittells spent summers in North Conway, New Hampshire, from about 1871 to 1888. His earliest known portrait from North Conway is dated 1877. Although he is said to have done landscapes there and is also known to have painted still lifes, none of either genre has yet been located. After the death of his wife in 1888, Kittell continued to visit North Conway until 1891. He died three years later in New York.

Kittell's early portraits show the self-taught artist's original and often powerful solutions to such problems as the accurate depiction of anatomy and the convincing representation of three-dimensional form on a two-dimensional surface. With time and the influence of academic painting and photography, his work became increasingly conventional.

BIBLIOGRAPHY: Helen Burr Smith, "Nicholas Biddle Kittell (1822–1894): A Forgotten New York State Artist," *New-York Historical Society Quarterly* 44 (Oct. 1960), pp. 394–412. The most comprehensive account of the artist to date, it contains a chronological checklist of works by or attributed to him.

Charles Henry Augustus Carter

C. H. A. Carter (1819–1878), the son of Mr. and Mrs. Henry Carter, was born in France on March 25, 1819, according to the records of the Green-Wood Cemetery, Brooklyn, New York. About 1845 he married Elizabeth Perces Brooks, daughter of Dr. John Brooks of Bernardston, Massachusetts. They joined the First Congregational Church in Norwich, New York, on May 7, 1848, and transferred to the Presbyterian congregation of the Reverend Mr. Spear in Brooklyn, New York, on November 21 of the same year. C. H. A. Carter was first listed in the New York city directory for 1852–1853, as a salesman working at 56 Cedar Street and living

Kittell, *Charles Henry Augustus Carter*.

double portrait, which is undated, shows the subjects seated in the parlor of their home. The rococo revival furniture with Gothic arches suggests a date in the late 1840s. Both paintings could date soon after the Carters's marriage in 1845.

Stylistically, the Metropolitan's portrait betrays the hand of the self-taught artist in the somewhat awkward handling of the anatomy, the unconvincing representation of the subject's right arm, the stylized treatment of form, and the uniform modeling. Yet Kittell's attempt to depict different textures and his choice of an ambitious pose show his increasing awareness of academic conventions, which would become more evident in his 1857 portrait of William Learned Marcy (NYHS).

The canvas has an unusual stamp consisting of the arms of Russia and the shield of Moscow, dating from about 1840 to 1850, and a stenciled inscription in English.

The Metropolitan also owns a portrait of Charles Henry Augustus Carter (q. v.) as a boy, painted by an unidentified American artist twelve to fifteen years before the Kittell portrait. A portrait of Carter's sister, Amy Jane Carter, and a pair of portraits of his parents, Mr. and Mrs. Henry Carter, probably by the same unidentified American artist, are also in the collection (qq. v.).

at Carroll Place (later part of Bleecker Street). From 1853 or 1854 to 1858 the Carters's address was 123 Bleecker Street. His wife died in 1859, and the last mention of Carter in the city directory was in 1859–1860, when his home address was given as 48 West 36th Street. Carter, a salesman and merchant, traveled extensively in connection with his business. He served as the Paris representative of Lord and Taylor, the New York department store. In 1861 his services were rewarded with a gold watch, which is now in the collection of the Museum of the City of New York. Carter spent his last years abroad and died in Paris on July 5, 1878. He is buried in the Green-Wood Cemetery.

Carter probably met Kittell in Norwich. In 1847 Carter lent a portrait of a lady by Kittell to the annual exhibition of the National Academy of Design. Perhaps this was a portrait of his wife, commissioned shortly after their marriage. The museum's portrait of Carter may have been intended as a companion piece. The Museum of the City of New York has a portrait by Kittell of Mr. and Mrs. Carter that depicts Carter at the same age and in the same attire as the Metropolitan's portrait. Only the pose is different. The

Canvas stamp on painting by Kittell.

Oil on canvas, 36⅛ × 30 in. (91.8 × 76.2 cm.).

Signed at lower right: N. B. Kittel Pin. Canvas stamp: a double-headed eagle displayed crowned, holding in the dexter claw a scepter and in the sinister claw an orb; on its breast an escutcheon charged with a rampant horse and rider; the whole within a shaped shield ensigned by a regal crown; (stenciled below) ALL / FINE / FLAX. Inscribed on stretcher by a later hand: C. H. A. Carter Property of Ethel Cram / March 189[7 or 1].

RELATED WORK: *Mr. and Mrs. Charles Henry Augustus Carter in the Living Room of Their Home*, oil on canvas, 21½ × 23½ in. (54.6 × 59.7 cm.), Museum of the City of New York, color ill. in J. E. Patterson, *The City of New York* (1978), p. 129.

REFERENCES: C. R. Johnson, *History and Manual of the First Congregational Church, Norwich, N. Y.* (1879), p. 85, lists the Carters as members of the church in 1848 // M. A. Mathewson, comp., "Unpublished Records, Births - Marriages - Deaths, First Congregational Church of Norwich, Chenango County, N. Y.," vol. 235 (1961–1962), typescript in Local History and Genealogy NYPL, p. 30, gives biographical data, including incorrect death date, July 9, 1875, and says that his drowning in the Seine was a suicide // J. M. Dennis, Western European Arts, MMA, note in Dept. Archives [1966], describes heraldic canvas stamp // M. Stearns, Museum of the City of New York, orally Oct. 1966, supplied biographical information on Carter // Y. M. Cumerford in letter, Dept. Archives, Nov. 12, 1966, supplies information on the subject, who was her great-grandfather, and the provenance of the picture // A. R. Koenig, superintendent, Green-Wood Cemetery, Brooklyn, letter in Dept. Archives, Feb. 27, 1978, supplies burial transcript for Carter, which includes death date as July 5, 1878.

ON DEPOSIT: MMA, 1964–1965, lent by Mrs. Yvonne Moën Cumerford.

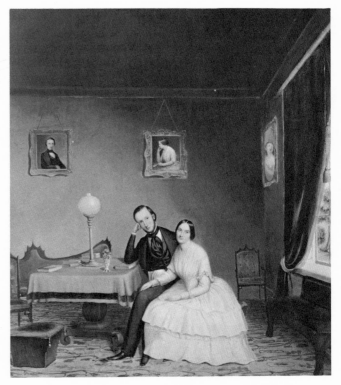

Kittell, *Portrait of Mr. and Mrs. Charles Augustus Carter.* Museum of the City of New York.

EX COLL.: the subject's sister, Amy Jane Carter (Mrs. Stuart Perry), Newport, N. Y.; her daughter Gertrude Perry Chapman, Newport, N. Y.; Ethel Cram (Mrs. Edward C. Moën), New York, by about 1910–d. 1963; her daughter Yvonne Moën (Mrs. Frederick T. Cumerford), New York, 1964–1965.

Gift of Yvonne Moën Cumerford, 1965.
65.232.1.

UNIDENTIFIED ARTIST

Henry Carter

Little is known of Henry Carter, whose portrait is one of a group of four Carter family portraits (see below). All, judging by the stylistic similarities, were painted by the same unidentified self-trained artist during the early 1830s in upstate New York. Together with the portrait of Henry Carter's son, Charles Henry Augustus

Carter, by NICHOLAS BIDDLE KITTELL (q. v.), they were found in a barn in Newport, New York, about 1910. Henry Carter's granddaughter, Gertrude Perry Chapman, bequeathed them to Ethel Cram, a family descendant and the donor's mother.

All the paintings have suffered extensive damage and show inept and badly discolored inpainting.

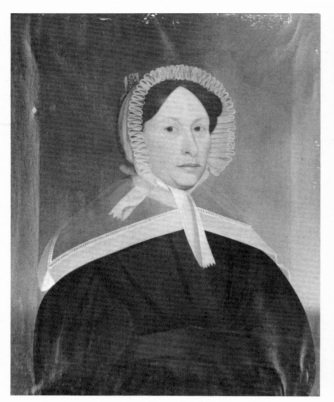

Unidentified artist, *Mrs. Henry Carter*.

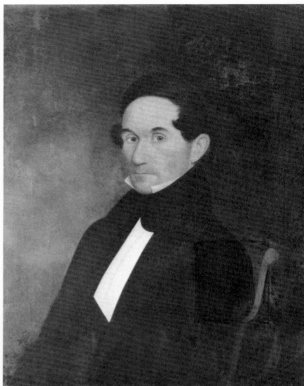

Unidentified artist, *Henry Carter*.

Wearing a high-standing white collar, a black stock, and a dark jacket, Henry Carter is shown seated in a three-quarter view, turned to the left — a pose echoed in the portrait of his son.

Oil on canvas, 30 × 25⅛ in. (76.2 × 63.8 cm.).
Inscribed on stretcher by a later hand: Henry Carter Property of Ethel Cram.
REFERENCE: Y. M. Cumerford, New York, letter in Dept. Archives, Nov. 12, 1966, supplies information on the family and the provenance of the picture.
ON DEPOSIT: MMA, 1964–1965, lent by Mrs. Yvonne Moën Cumerford.
EX COLL.: Henry Carter's daughter, Amy Jane Carter (Mrs. Stuart Perry), Newport, N. Y.; her daughter, Gertrude Perry Chapman, Newport, N. Y.; Ethel Cram (Mrs. Edward C. Moën), New York, by 1910 – d. 1963; her daughter, Yvonne Moën (Mrs. Frederick T. Cumerford), New York, 1964–1965.
Gift of Yvonne Moën Cumerford, 1965.
65.232.4.

Mrs. Henry Carter

Probably intended as a companion to the portrait of her husband (q. v.), this portrait of the former Sarah Brown shows the preoccupation with pattern and surface design that are characteristic of the self-taught artist. Special care is given to the intricate pleating of the elaborate bonnet that frames her face and contrasts with her simple and somber dress. The collar that rests lightly on her shoulders is made into a bold element of design — directing attention to the face. Careful modeling alternates with areas defined only as flat surfaces. The three-quarter view, with the body turned slightly to the right, suggests volume and relieves the symmetry of the representation. It is reinforced by the asymmetrical placing of the pinked ribbons of the bonnet.

Oil on canvas, 29⅞ × 25 in. (75.9 × 63.5 cm.).
Inscribed on stretcher by a later hand: Sarah Brown Carter — Property of / Ethel Cram.
REFERENCE: same as *Henry Carter*.
ON DEPOSIT: same as *Henry Carter*.
EX COLL.: same as *Henry Carter*.
Gift of Yvonne Moën Cumerford, 1965.
65.232.5.

Amy Jane Carter

The daughter of Mr. and Mrs. Henry Carter and older sister of Charles Henry Augustus Carter, Amy Jane Carter was married to Stuart Perry of Newport, New York, in 1838. The costume and hairstyle help date this portrait to the early 1830s, or a few years before Amy Jane Carter's marriage. It was possibly intended to serve as a companion to the portrait of her brother (see below), which is approximately the same size.

Oil on canvas, 24½ × 19⅜ in. (62.2 × 49.2 cm.).
REFERENCE: same as *Henry Carter*.
ON DEPOSIT: same as *Henry Carter*.
EX COLL.: same as *Henry Carter*.
Gift of Yvonne Moën Cumerford, 1965.
65.232.3.

Charles Henry Augustus Carter

The young man in this portrait is the same Charles Henry Augustus Carter (1819–1878) who was later depicted by NICHOLAS BIDDLE KITTELL (q. v.). Painted in the early 1830s, the portrait is probably the work of the unidentified, self-trained artist responsible for the other three Carter portraits (see preceding entries). The four paintings, however, vary considerably in quality. The portrait of Charles serves as a companion to that of his sister and has the same composition and pose as the portrait of their father. Seated in a chair, the sensitive-looking boy appears fastidiously groomed. The artist uses little modeling for the body, relying instead on simple, clearly defined shapes of contrasting colors in the characteristic manner of the self-taught painter. He takes great pains, however, to model the face subtly and to represent the turned-back shirt collar accurately.

Oil on canvas, 24½ × 19⅜ in. (62.2 × 49.2 cm.).
REFERENCE: same as *Henry Carter*.
ON DEPOSIT: same as *Henry Carter*.
EX COLL.: same as *Henry Carter*.
Gift of Yvonne Moën Cumerford, 1965.
65.232.2.

Unidentified artist,
Amy Jane Carter.

Unidentified artist,
Charles Henry Augustus Carter.

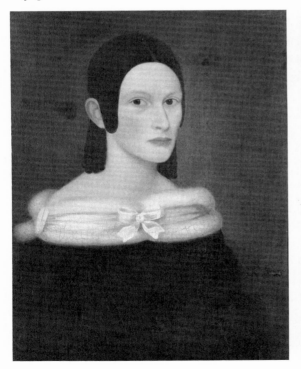

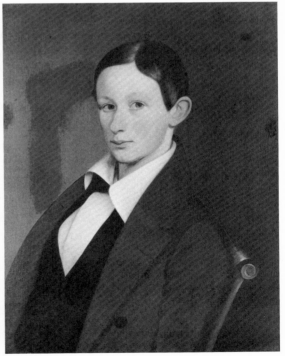

WILLIAM L. SONNTAG

1822–1900

A grandson of Wilhelm Louis von Sonntag, who served with the French during the American Revolution, William Louis Sonntag was born in East Liberty (now part of Pittsburgh), Pennsylvania. About 1823 the family moved to Cincinnati. Sonntag's father, Charles, who initially tried to discourage his son's interest in art in favor of a more practical profession, apprenticed him at age eighteen to a carpenter. That apprenticeship, however, ended after only three days. Following a tour of the Wisconsin Territory, Sonntag was apprenticed to an architect but left after three months. His father then abandoned attempts to divert him from artistic pursuits.

Nothing is known of Sonntag's training in art, but he was very likely self-taught. The title of his first exhibited work, *Jupiter and Calisto* (unlocated), shown in Cincinnati in 1841, suggests that he may have copied from prints or paintings. From 1842 to 1844 the Cincinnati city directories listed him as a clerk. About 1846, Sonntag was hired by the proprietor of the Western Museum in Cincinnati to "paint the needed dioramas, to *make thunder* on the drums, to *blow* for the organist, light the lamps and to make himself *generally useful*" (*Cosmopolitan Art Journal* 3 [Dec. 1858], p. 27). This work apparently enabled him to open his own studio. The American Art-Union in New York acquired and exhibited landscapes by Sonntag in 1846, 1848, 1849, and 1850.

In late 1846 or early 1847, the Reverend Elias Lyman Magoon, a Baptist minister, collector, and art patron, encouraged Sonntag to paint a series of four paintings, *The Progress of Civilization*, 1847 (unlocated). Based on William Cullen Bryant's poem "The Ages," it was probably inspired as well by THOMAS COLE'S *The Course of Empire*, 1836 (NYHS). The series brought Sonntag recognition and commissions. In 1847 he sold eight paintings to the newly founded Western Art Union in Cincinnati. By 1850 he had begun his only known panorama, *Paradise Lost and Paradise Regained* (unlocated), which was completed by John C. Wolfe (active 1843–1859) when Sonntag became ill. The panorama was shown at Barnum's American Museum in New York in May 1851. The same year Sonntag painted scenery for Wood's Theatre in Cincinnati. When FRANK BLACKWELL MAYER visited Cincinnati in 1851, he characterized Sonntag as the painter "most eminent in landscape" and described his work as "remarkably fine, distinct, characteristic & truthful" (*With Pen and Pencil on the Frontier in 1851*, ed. by B. Heilbron [1932], p. 44).

In 1851 Sonntag married Mary Ann Cowdell. The following year he was commissioned by the director of the Baltimore and Ohio Railroad Company to paint landscapes along its route between Baltimore and Cumberland. The Sonntags, it seems, used the excursion as a delayed honeymoon. The artist's grandson, William Sonntag Miles (1970), reported that "trains would drop them off at a site chosen to paint and another train would have orders to pick them up in the evening when the light was no longer suitable for painting." Sonntag exhibited at the Pennsylvania Academy of the Fine Arts for the first time in 1853. He then set off for Europe with his pupil John R. Tait (1834–1909) and ROBERT S. DUNCANSON. Sonntag spent eight months in Europe. Little is known of his itinerary, but there is some evidence

that he visited London, Paris, and Italy. By January 1854 he had returned to New York, and six months later he was in Cincinnati. In 1855 he began exhibiting at the National Academy of Design in New York, where he was elected an associate member in 1860 and an academician in 1861. He went to Florence in 1855 with the intention of settling there, but within a year he returned to America and in 1857 was living in New York. He visited the Carolinas and West Virginia in 1860, made trips to Italy possibly in 1860 and again in 1861 and 1862, spent the summers in the White Mountains in New England in the 1860s and in Vermont during the 1870s. From the 1860s Sonntag became increasingly interested in water-color painting and beginning in 1881 exhibited on a regular basis at the American Water-color Society. In 1882 and 1883 he collaborated on several paintings with ARTHUR FITZ-WILLIAM TAIT. Sonntag's son William L. Sonntag, Jr. (1869–1898), who was also an artist, died two years before his father.

Sonntag's early work reflects his debt to the Hudson River school painters. Later, like many other American artists of his generation, he came under the influence of the Barbizon school, and his painting style changed considerably. An extraordinarily prolific painter, he was sometimes criticized for the uniformity and size of his output. He specialized almost exclusively in landscape painting and was a gifted watercolorist.

BIBLIOGRAPHY: *Cosmopolitan Art Journal* 3 (Dec. 1858), pp. 26–28 // Groce and Wallace, p. 593 // Vose Galleries, Boston, *William L. Sonntag, 1822–1899, William L. Sonntag, Jr.,* (Sept. 14 - Oct. 10, 1970), exhib. cat. with essay by William Sonntag Miles, the artist's grandson // Nancy Dustin Wall Moure, *William Louis Sonntag: Artist of the Ideal, 1822–1900* (Los Angeles, 1980). A study of the artist's career with checklists of paintings and a chronology.

Landscape with Waterfall and Figures

The original title of this undated landscape is not known nor can the geographical site be identified with certainty. Sonntag's most recent biographer, Nancy Moure, has suggested that the painting dates from the mid-1860s and that it might have been inspired by scenery in New Hampshire, where he spent the summers after the beginning of the Civil War. Working from out-line drawings and oil sketches, Sonntag com-posed the large paintings in his studio and de-veloped a certain number of favorite motifs that he used repeatedly with variations in different

Sonntag, *Landscape with Waterfall and Figures.*

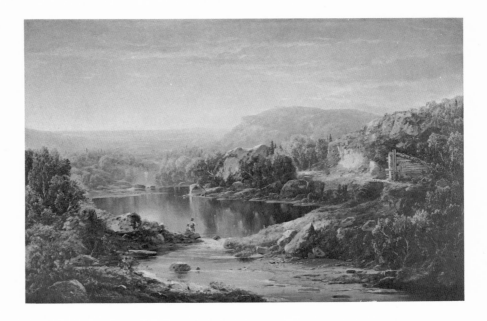

compositions. The fishermen and the dilapidated wood cabin in this work are recurrent features in his painting. Each of the cabins, Moure notes, is different in construction, and the one shown here is unusual because of its single-sloped roof. During the 1860s Sonntag also repeated favorite formulas in composition. This painting with its central body of water and the distant waterfall surrounded by rolling hills and mountains is a prime example. Equally characteristic are the careful suggestions of detail in the foreground and the contrasting use of atmospheric perspective in the background.

Oil on canvas, 36 × 51 in. (91.4 × 129.5 cm.).
Signed at lower left: W. L. Sonntag. N. A.
REFERENCES: W. R. Hoesel, headmaster, St. George's School, Spokane, letter in Dept. Archives, Feb. 6, 1976, states that nothing is known of the history of the painting // N. Moure, Los Angeles County Museum of Art, letter in Dept. Archives, Feb. 6, 1979, dates the work in the mid-1860s, suggests setting might be New Hampshire, notes that an unlocated painting by Sonntag called Scene in the Adirondacks of similar dimensions was sold at the Fifth Avenue Art Galleries, New York, March 26, 1914, no. 56, for $80.
EXHIBITED: Staten Island Institute of Arts and Sciences, New York, 1977, Sully to Sargent, cat. by B. L. Delaney, no. 16.
ON DEPOSIT: Staten Island Institute of Arts and Sciences, New York, 1977–1978.
EX COLL.: St. George's School, Spokane, by 1976.
Gift of Erving Wolf Foundation, 1976.
1976.154.

WILLIAM BRADFORD

1823–1892

William Bradford was born and brought up as a Quaker in Fairhaven, Massachusetts. His father, a ship outfitter, had a drygoods store in the nearby whaling port of New Bedford, where Bradford worked as a youth. In his free time he copied from a book of English drawings and made sketches and paintings of ships in the harbor. In 1846 Bradford married Mary Breed of Lynn, Massachusetts. For a short time in 1852, he operated a wholesale clothing store, but, as he later noted, "I spent too much time in painting to succeed" (Ellis, p. 99).

By about 1853, Bradford was able to devote all his time to art. He took a studio about 1855 in Fairhaven, where he initially specialized in ship portraiture. Painstaking detail, exacting draftsmanship, and a restricted palette dominated by cool colors characterize his painting style of the 1840s and 1850s. In its precision, clarity, and preoccupation with effects of light and atmosphere, his work is similar to that of the Gloucester painter FITZ HUGH LANE, who visited New Bedford on at least two occasions, in 1845 and 1856. Both artists share a dependence on English and Dutch traditions of marine painting.

By the fall of 1855, the Dutch marine painter Albert Van Beest (1820–1860) had joined Bradford in Fairhaven. He spent two years there instructing Bradford and also ROBERT SWAIN GIFFORD. Van Beest provided Bradford with his only formal training and collaborated with him on several paintings. Under his influence, Bradford turned to more dramatic themes and compositions. Instead of wholly adopting the broader and more fluid brushwork that characterized Van Beest's work, however, he retained much of his own linear style.

Bradford maintained a studio in Boston for several winters and exhibited at the Boston Athenaeum in 1857, 1859, 1862, 1864, 1865, and 1871. In 1860, however, he went to New York. By the following year he was working in the Tenth Street Studio Building, where he

subsequently made the acquaintance of fellow New Bedford artist ALBERT BIERSTADT. Taken with the challenge of new artistic frontiers that drew, among others, such contemporaries as FREDERIC E. CHURCH on expeditions to the Arctic and South America, Bradford joined the ranks of the artist-explorers. It is primarily for his Arctic subjects that he became best known. The attractions of the Arctic were given added impetus by such publications as Elisha Kent Kane's *Arctic Explorations: The Second Grinnell Expedition in Search of Sir John Franklin*, 1853, '54, '55 (2 vols., 1856). A work well known to Bradford, it had illustrations by the marine painter JAMES HAMILTON. Bradford had made several trips to Labrador between 1854 and 1857, but he did not venture farther north until his Arctic voyages of the 1860s. He visited the Arctic in 1861, and with one exception, for the next seven years as well. His most celebrated expedition was in 1869, when he chartered the 325-ton steamer *Panther*. In the company of Dr. Isaac I. Hayes, the noted Arctic explorer, J. L. Dunmore and George Critcherson, two photographers from J. W. Black's Boston firm, and others, Bradford embarked for Greenland. Out of this successful expedition came his *The Arctic Regions* (1873), a book containing 125 photographs. He also completed a commission for Queen Victoria, *The Panther off the Coast of Greenland under the Midnight Sun*, 1873 (coll. H. R. H. Queen Elizabeth II, London). Bradford settled in London in 1872 and began a successful career as a lecturer on the Arctic. His talks were illustrated with his own photographs.

An established artist in the states and abroad, Bradford returned to America, where he was elected an associate of the National Academy of Design in 1874. Freer brushwork and a predilection for melodramatic color effects characterize his work of the 1870s and 1880s. He came to rely increasingly on his photographs and sketchbooks as models for compositions. "Why, my photographs have saved me eight or ten voyages to the Arctic regions," he told a reporter in 1883, "and now I gather my inspirations from my photographic subjects, just as an author gains food from his library, and I could not paint without them" (*Philadelphia Photographer* 21 [Jan. 1884], p. 8). Earlier, in his *The Arctic Regions* (pp. 11-12), he had commented on the roles of the photographer and the artist: "The wild rugged shapes, indescribable and ever changing, baffle all description, and nothing can do them justice but the sun given powers of the camera. And even that must fail in part, for until retouched by the hand the glorious phases of color remain unexpressed." During the 1870s and 1880s, Bradford continued his lecture tours, experimented with printmaking, and turned his attention west. He kept a studio in San Francisco for several years and traveled widely in the western United States, painting the Yosemite region and the Sierra Nevada. He died in New York at the age of sixty-eight.

BIBLIOGRAPHY: William Bradford, *The Arctic Regions* (London, 1873). The artist's account of his 1869 expedition to the Arctic // Leonard Bolles Ellis, *History of New Bedford and Its Vicinity, 1602–1892* (Syracuse, N. Y., 1892), part 2, pp. 98–103. Includes a contemporary biography written by the Rev. F. H. Kasson with information provided by the artist // John Wilmerding, *A History of American Marine Painting* (Boston, 1968), pp. 73, 83, 132, 149, 175, 187, 191–194, 196–198, 205. Discusses Bradford, his contemporaries, and the sources of his painting style // De Cordova Museum, Lincoln, and Whaling Museum of New Bedford, Mass., *William Bradford, 1823–1892* (1969–1970), exhib. cat. by John Wilmerding. Most comprehensive account of the artist to date. Contains essay and bibliography // Frank Horch, "Photographs and Paintings by William Bradford," *American Art Journal* 5 (Nov. 1973), pp. 61–70.

Shipwreck off Nantucket
(Wreck off Nantucket, after a Storm)

Contemporary descriptions identify this painting as *Wreck off Nantucket, after a Storm* exhibited at the National Academy of Design in 1861 and later called *Shipwreck off Nantucket* by Tuckerman and others. A critic for the *New-York Daily Tribune* in 1861, probably after a visit to Bradford's studio, described the recently completed painting:

In a large picture of his, which he has lately finished, representing the wreck of a whale ship, apart from the beauty of the sky and the waves, which are painted with great vigor, great value is given to the composition by the accuracy with which the smaller craft surrounding the principal object are represented. Though no land is visible, yet the scene of the wreck is perfectly indicated by the character of the vessels. The Chebacco boat, or pink stern, is a vessel peculiar to the eastern coast of New-England, and the presence of one of these odd-looking craft localizes the scene of the wreck.

Despite the critic's assertion of the technical accuracy of Bradford's work, the painting, according to one authority, "is full of anomalies." The scale of the deck layout and fittings is out of proportion to the figures; the vessel, identified as a whaleship, "is not rigged or fitted as one, except for the barely discernable iron knees of the tryworks"; the small, carefully done, boats "are not wholly believable, being under full sail directly over a ledge or shoal." In effect, Bradford has exercised artistic license and in exaggerating the deck and portraying the flanking sea craft under full sail sacrifices veracity in the interest of drama. The whaleboat in the foreground, however, does help to identify the scene; for the presence of such boats north of Cape Cod would have been unusual.

In another vivid description of the work some technical "incongruities" were noted, but the painting was found none the worse for them:

There is a large picture of a wrecked whaleman by Mr. Bradford, which has a great variety of sea-going craft represented in a brisk gale, with remarkable accuracy and spirit. The water is drawn and colored with rare felicity, and the wrecked ship lies like a leviathan on huge waves. There are two or three incongruities about the wreck which might strike the eye of a professional observer, but do not in the least diminish the general effect of the picture (see Kugler, 1978).

It was under the influence of Albert Van Beest, noted for his dramatic paintings of ships in stormy seas, that Bradford turned to such spirited scenes as this. In content and composition, this painting of a whaling ship listing to port and foundering in heavy seas reflects his indebtedness to the Dutch painter. Curves and diagonals take precedence over the horizontal and vertical lines that Bradford usually favored. A wide-ranging, richly varied palette replaces the low-key, restricted palette that characterizes much of his work. Contrasts of light and dark are skillfully used for maximum dramatic value. Unlike Van Beest, however, Bradford demonstrates a reluctance to relinquish detail for expressive effects. Even the turbulent storm represented here fails to obscure the exacting delineation of figures and rigging which is an intrinsic feature of his painting style.

According to some reports the inscription "Nantucket" once appeared on the transom of the vessel.

Oil on canvas, 40 × 64 in. (101.6 × 162.6 cm.).

Canvas stamp, before lining: GOUPIL & CO / ARTISTS COLOURMEN / & PRINT SELLERS / 366 / BROADWAY / NEW YORK.

REFERENCES: *New-York Daily Tribune*, March 9, 1861, p. 8, discusses this painting (quoted above) // *New Bedford Daily Mercury*, undated clipping in Old Dartmouth Historical Society Whaling Museum, copy in Dept. Archives, discusses Bradford's success in New York and cites *New-York Daily Tribune* article // *Crayon* 7 (April 1861), p. 95, notes "a *Shipwreck* by Bradford" in NAD exhibition // F. H. Norton, *A Few Notes on the Thirty-Sixth Annual Exhibition of the National Academy of Design* (1861), p. 16, mentions Bradford's "Wreck off Nantucket in a Storm" as a "very good water painting; perhaps with one exception, the best sea picture in the Exhibition" // H. T. Tuckerman, *Book of the Artists* (1867), p. 556, lists it as Shipwreck off Nantucket // C. E. Clement and L. Hutton, *Artists of the Nineteenth Century and Their Works* (1889), 1, p. 87, list it // *New Bedford Evening Standard*, April 25, 1892, notes it in Bradford's obituary // L. Mechlin, *DAB*, s. v. "Bradford, William" (1929; 1957), p. 567 // Parke-Bernet Galleries, New York, *18th, 19th and 20th Century American Paintings*, sale cat. (May 21, 1970), p. 36, no. 42; color ill. p. 37, no. 42 // J. K. Howat, *MMA Bull.* 30 (June-July 1972), unpaged // R. Bahssin, Post Road Antiques, Larchmont, N. Y., letter in Dept. Archives, Dec. 7, 1971, supplies copy of canvas stamp before lining // R. C. Kugler, Director, Old Dartmouth Historical Society Whaling Museum, New Bedford, Mass., letters in Dept. Archives, Jan. 9 and Feb. 21, 1978, supplies information on the work (quoted above), provides two undated

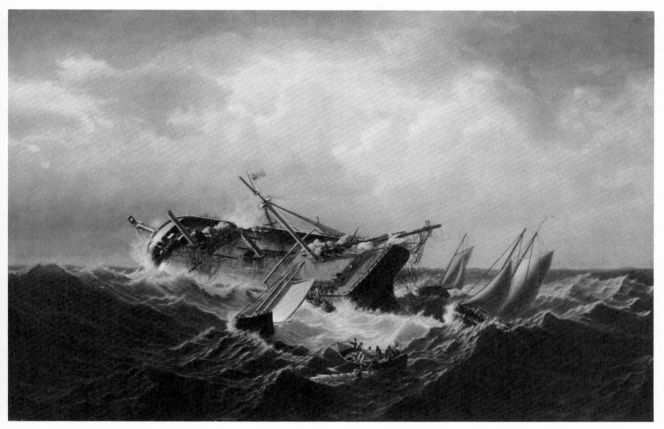

Bradford, *Shipwreck off Nantucket*.

clippings from the *New Bedford Daily Mercury* and an unidentified source (quoted above) reviewing it.

EXHIBITED: NAD, 1861, no. 516, as Wreck off Nantucket, after a Storm, for sale (probably this picture) // De Cordova Museum, Lincoln, and Whaling Museum of New Bedford, Mass., 1969–1970, *William Bradford, 1823–1892*, cat. by J. Wilmerding (not in cat.), shown only at New Bedford // MMA, 1972, *Recent Acquisitions*, 1967–1972 (no cat.) // Whitney Museum of American Art, New York, 1975, *Seascape and the American Imagination*, cat. by R. B.

Stein, no. 12; p. 89; p. 92, fig. 96; p. 112.

ON DEPOSIT: Algonquin Club, Boston, before 1970.

EX COLL.: Boston art market; with Post Road Antiques, Larchmont, N. Y., by 1970; (sale, Parke-Bernet Galleries, New York, May 21, 1970, no. 42, withdrawn from sale); with Post Road Antiques, Larchmont, N. Y., until 1971.

Purchase, John Osgood and Elizabeth Amis Cameron Blanchard Memorial Fund, Fosburgh Fund, Inc., Gift, and Maria DeWitt Jesup Fund, 1971.

1971.192.

SANFORD ROBINSON GIFFORD

1823–1880

The fourth of eleven children, Gifford was born in Greenfield, Saratoga County, New York, and spent his early life in Hudson, where his father was joint owner of a profitable iron foundry. After two years at Brown University (1842–1844) Gifford decided to become an artist. He went to New York in 1845 to study with the drawing master John Rubens Smith (1775–1849). He also attended drawing classes at the National Academy of Design and anatomy lectures at Crosby Street Medical College. His training centered on the human figure, but within a short time Gifford devoted himself chiefly to landscape painting. During the summer of 1846 he toured the Catskill and Berkshire mountains, where he made many sketches. "These studies," he wrote to O. B. Frothingham on November 6, 1874, "together with the great admiration I felt for the works of [Thomas] Cole developed a strong interest in Landscape art, and opened my eyes to a keener perception and more intelligent enjoyment of Nature. Having once enjoyed the absolute freedom of the Landscape painter's life, I was unable to return to Portrait painting. From this time my direction in art was determined" (S. R. Gifford to O. B. Frothingham, Nov. 6, 1874, D10, Arch. Am. Art).

While the works of THOMAS COLE exerted an influence on Gifford's development, his direct observations from nature ultimately played a greater part. Gifford made small, rapid pencil sketches that served both as a record of his immediate impressions and, together with small studies in oil, as a point of departure for studio compositions. The American Art-Union acquired one of his works in 1847. The same year he began to exhibit at the National Academy of Design where he was elected an associate in 1851 and an academician in 1854.

In May 1855 Gifford traveled to Europe. His accounts of this and a second trip, 1868–1869, are preserved in a journal written as a series of letters to his family. The initial five months of his first trip were spent in England and Scotland, seeing collections and sketching. He called on John Ruskin, champion of the works of J. M. W. Turner, and on Charles Robert Leslie (1794–1859), John Constable's biographer, who arranged for him to see the works of that artist. Disturbed at first by the liberties Turner took with nature, Gifford later came to admire his expressive color and light effects. Gifford thought that Constable's work resembled Turner's in "suggestiveness and mystery" (S. R. Gifford, Journal, 1, July 4, 1855, typescript copy, p. 41, D21, Arch. Am. Art).

From late September 1855 to May 1856 Gifford was in Paris, where he visited the Louvre, Thomas Couture's studio, and the 1855 Exposition Universelle at the Palais des Beaux-Arts. He also went to Fontainebleau and Barbizon, where he met Jean François Millet. The works of the Barbizon painters had already made a strong impression on him. This French landscape school, he wrote, "seems to me in most respects the best in the world . . . everything like finish and elaboration of detail is sacrificed to the unity of the effect to be produced" (S. R. Gifford, Journal, 1, Sept. 29, 1855, typescript copy, p. 116, D21, Arch. Am. Art). Gifford's exposure to contemporary art changed his view of the works of the seventeenth-century masters who had exercised a profound influence on the first generation of the Hudson River school. Acknowledging the excellence of Claude Lorrain "in 'tone' and in composition

of lines—a certain dignity about Poussin—and the energy and vigor" of Salvator Rosa, he concluded, "I much prefer the more truthful and more varied rendering of nature in the modern works" (S. R. Gifford, Journal, 1, Sept. 30, 1855, typescript copy, p. 117, D21, Arch. Am. Art).

After touring the Low Countries, Germany, Switzerland, and Italy, Gifford spent the winter of 1856–1857 in Rome, where his close friends included WORTHINGTON WHITTREDGE and ALBERT BIERSTADT. With Bierstadt he explored southern Italy in May 1857. A tireless traveler and perceptive observer, Gifford made the most of his first trip to Europe. He was acutely alert, however, to the dangers of the European experience. "The harm," he wrote, "which sometimes happens to American painters from too long a sojourn in Europe can not come from travel which brings one in constant intercourse with Nature. It arises I think from subjecting oneself too long to the influence of a particular school of painting." He thought that American painters should be careful not to let the methods and manner of any one school "usurp the place of Nature." He noted, "perhaps I do not surrender myself sufficiently to the influence of the art I find about me" (S. R. Gifford, Journal, 1, Feb. 4, 1856, typescript copy, p. 162, D21, Arch. Am. Art).

On his return to New York in September 1857, Gifford painted in the Studio Building on West Tenth Street. He worked there for the rest of his life. In a day when artists' studios were filled to overflowing, Gifford's was distinguished by its simplicity. Each summer, with few exceptions, he took sketching and painting trips with other landscape painters, including Whittredge, JERVIS MC ENTEE, RICHARD WILLIAM HUBBARD, and JOHN F. KENSETT. The Catskills and Adirondacks were favorite haunts, but he also visited the Green Mountains in Vermont, the White Mountains in New Hampshire, as well as Maine and Nova Scotia. *In the Wilderness*, 1860 (Toledo Museum of Art), and *Kauterskill Clove*, 1862 (q. v.), are among his most accomplished paintings inspired by these expeditions.

During the Civil War, Gifford served in the Seventh Regiment of the New York State National Guard. His absorbing interest in light and color found expression in *Bivouac of the Seventh Regiment at Arlington Heights, Va.*, 1861 (Seventh Regiment Armory, New York), and several other paintings based on his Civil War experiences. This interest was also evident in such landscapes as *Twilight in the Adirondacks*, 1864 (Adirondack Museum, Blue Mountain Lake), and *A Home in the Wilderness*, 1866 (Cleveland Museum of Art).

On his second trip abroad, from June 1868 to September 1869, Gifford toured Europe and the Near East, including Italy, Greece, Turkey, Egypt, Syria, Jerusalem, and Lebanon. *Tivoli*, 1870, and *Isola Bella in Lago Maggiore*, 1871 (qq. v.), are based on studies dating from this trip. In 1870 Gifford went with Whittredge and Kensett to the Rocky Mountains, where he joined Ferdinand V. Hayden's survey expedition to Wyoming. Four years later, Gifford visited California, Oregon, British Columbia, and Alaska. His last major work was *The Ruins of the Parthenon, Looking South-west from the Acropolis*, 1880 (Corcoran Gallery of Art, Washington, D. C.), which was based on studies he made in 1869. During a trip to Lake Superior in July 1880, with his wife of three years, he was suddenly taken ill. Gifford died at the age of fifty-seven shortly after his return to New York. He was honored with a large memorial exhibition at the Metropolitan, which included 160 of his paintings. The museum issued a catalogue listing 739 paintings by Gifford—a pioneering effort in art publication.

A leading figure of the second generation of the Hudson River school, Gifford was revered by his contemporaries as a true gentleman, a fine human being, and a gifted artist. His preoccupation with effects of light and atmosphere was expressed in works of poetic eloquence. He achieved these effects by the skillful use of scumbling, subtle modulations of color, and, as George W. Sheldon observed in his discussion of the artist's techniques, by the use of oil and glaze in varnishing to simulate the density of air (*Art Journal* [New York] 3 (Sept. 1877), p. 285). In an address to the Century Association in 1880, JOHN FERGUSON WEIR provided a perceptive analysis of Gifford's work:

> He was a close student of nature, of her forms and facts, as well as of her moods. He recognized in the landscape, that its expression, for him, rested mainly in its atmosphere. He rendered this atmosphere, palpably, with very subtle sympathy, with great delicacy; but the forms he flooded with it he drew firmly, for he well knew that the finest delicacies of nature are those that are associated with vigorous truths (*Gifford Memorial Meeting of the Century*, November 19, 1880, Century Association, New York, 1880, pp. 20-21).

The museum owns a bronze bust of Gifford by Launt Thompson, dated 1871, and an oil portrait by EASTMAN JOHNSON (q.v.), painted in 1880.

BIBLIOGRAPHY: Sanford R. Gifford, Journal or "European Letters," 3 vols. 1: May 1855 – Feb. 1856; 2: March 1856—August 1857; 3: June 1868—August 1869. Typescript copy, D21, Arch. Am. Art // MMA, *A Memorial Catalogue of the Paintings of Sanford Robinson Gifford, N.A., with a Biographical and Critical Essay by Prof. John F. Weir* (New York, 1881). Contains a biography by John Ferguson Weir extracted from his address at the Gifford Memorial Meeting at the Century Association on November 19, 1880, and a catalogue of 739 of Gifford's paintings arranged in chronological order // Thomas E. Kirby and Company, New York, *The Sanford R. Gifford Collection: Catalogue of Valuable Oil Paintings, Works of Famous Artists, Sanford R. Gifford, N. A., Deceased*, part 1, April 11–12, 1881, and part 2, April 28–29, 1881. These sale catalogues contain respectively 151 and 143 works by the artist // University of Texas at Austin; Albany Institute of History and Art; and Hirschl and Adler Galleries, New York, traveling exhibition, 1970–1971, *Sanford Robinson Gifford (1823–1880)*, cat. by Nicolai Cikovsky, Jr. (Austin, 1970) // Ila Weiss, *Sanford Robinson Gifford (1823–1880)* (Ph.D. diss., Columbia University, 1968; published New York, 1977). Most comprehensive account to date, contains illustrations and a bibliography.

Kauterskill Clove

"As an artist, [Gifford] was born in the Catskill Mountains," according to his friend WORTHINGTON WHITTREDGE.

No autumn came that he did not visit them, and for a long period of his artist life he went in summer . . . to the Catskills as a boy goes to school. Many years ago he hunted up a little house in Kaaterskill Clove, in which lived a family of plain country folk, and, as the place was secluded and there were no boarders, he liked it and managed to obtain quarters there. This house, scarcely large enough to hold the family, was, nevertheless, for many summers the abiding place of a congregation of artists (J. I. H. Baur, ed., "The Autobiography of Worthington Whittredge, 1820–1910," *Brooklyn Museum Journal* [1942], p. 59).

From 1845 until his death in 1880, Kauterskill Clove was one of Gifford's favorite subjects. This painting, dated 1862, was called *Kauterskill Falls* in the catalogue of the 1876 New York *Centennial Loan Exhibition of Paintings* and in the 1881 catalogue of Gifford's work. The title has since been changed to *Kauterskill Clove*, for as Roland Van Zandt pointed out, the view is taken from the south, looking west to Haines Falls at the head of the clove.

The museum's painting is one of Gifford's most accomplished representations of the clove. The afternoon sun illuminates the autumn

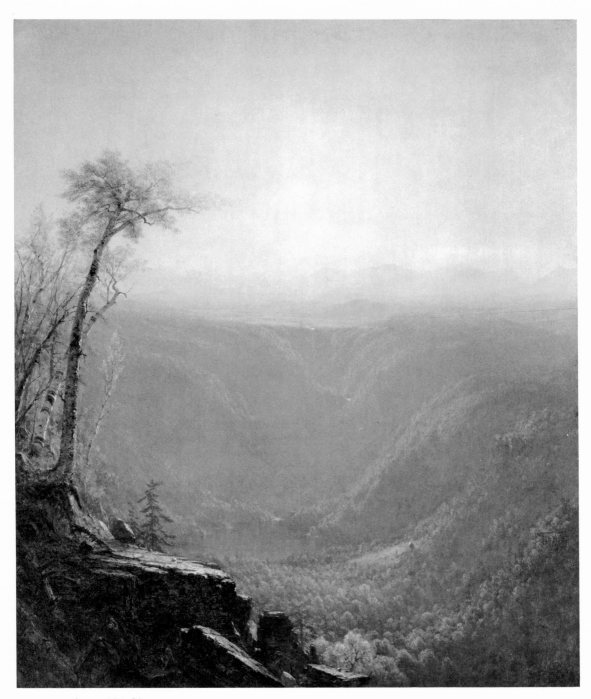

Gifford, *Kauterskill Clove.*

foliage, a house in the middle distance, and the rocky ledge and trees in the left foreground. A man and a dog make their way to the ledge at the lower left. The ledge and the birch tree, which are represented in sharp relief, serve as an effective framing device and a dramatic transition from the foreground to the background. They also reinforce the illusion of distance and depth. By adding a lake and many more cliffs than exist in reality, Gifford gives added definition to the middle ground.

Gifford's interest in light and atmosphere finds full expression in this evocative painting. The shadowed parts of the clove are thinly painted in subtle tones of blue and gray, and the effects of sunlight are suggested by dabs of yellow and green.

Cleaning and the increased transparency of the paint over time have made the man and dog indistinct and reduced the opacity of the paint that defines the rocks in the foreground. As a result of these changes, the colors in the left foreground are somewhat hotter in tone than the artist intended and out of key with the cooler background.

A composite studio work, *Kauterskill Clove* was undoubtedly based on many studies. Several representations of the clove of the same date or slightly earlier than this painting show that Gifford sketched and painted it from various vantage points at different times of day under various light conditions. These include: two quickly executed pencil drawings dated August 1861 in a sketchbook in the Albany Institute of History and Art (ill. in Weiss, *Sanford Robinson Gifford [1823–1880]*, figs. VII C 6 and VII C 7) and three oil studies, *Kauterskill Clove, a Study*, 1862 (private coll., ill. in Sotheby Parke Bernet, New York, *American 18th Century, 19th Century & Western Paintings, Drawings, Watercolors & Sculpture* [Oct. 17, 1980], no. 122), *A Sketch in Kauterskill Clove*, ca. 1862 (private coll., ill. in Weiss, fig. VII C 8), and *Kauterskill Clove, in the Catskills*, 1862 (coll. Jo Ann and Julian Ganz, Jr., Los Angeles). Of these representations of the clove, only the oil sketch in the Ganz collection bears a direct relationship to this painting. Despite the absence of the lake and house in the middle ground and minor differences in the foreground trees, it closely resembles the museum's painting in general composition and treatment of light and unquestionably served as one of the final studies for the picture. Gifford's apparent

satisfaction with the composition and light effects is attested to by the fact that eighteen years later he used a similar format for *October in the Catskills*, 1880 (Los Angeles County Museum of Art).

Two major representations of the clove by Gifford documented in the 1881 memorial catalogue of his work are unlocated today. Their relationship to this picture therefore cannot be determined. The two works are *Twilight in the Catskills—Kauterskill Clove* (formerly estate of J. B. Brown, Portland, Me.), which was exhibited at the National Academy of Design in 1861, and *Kauterskill Clove*, which was lent by D. Willis James to the academy in 1863. The painting Henry T. Tuckerman called "Catskill Clove" and eloquently described in 1867 has sometimes been identified as the one in the museum's collection. It is equally likely, however, that Tuckerman's description referred to the painting owned by D. Willis James. Another small study of the clove, titled *A Small Sketch of Kauterskill Clove*, which was sold in 1862 to a Mr. Halliday according to the 1881 catalogue, is also unaccounted for at present.

Oil on canvas, 48 × 39⅞ in. (121.9 × 101.3 cm.). Signed and dated at lower left: S. R. Gifford / 1862.

RELATED WORK: *Kauterskill Clove, in the Catskills*, oil on canvas, 12⅞ × 11 1/16 in. (32.7 × 28.1 cm.), 1862, coll. Jo Ann and Julian Ganz, Jr., Los Angeles, ill. in National Gallery of Art, Washington, *An American Perspective* (1981), p. 29, fig. 16, and p. 131.

REFERENCES: H. T. Tuckerman, *Book of the Artists* (1867), p. 527, discusses a Catskill Clove (either this painting or one lent to the NAD in 1863 by D. Willis James) // MMA, *The Memorial Collection of the Works of the Late Sanford R. Gifford (1880–1881)* (1881) p. 4, notes that this picture was omitted from the memorial exhibition // MMA, *A Memorial Catalogue of the Paintings of Sanford Robinson Gifford, N. A.* (1881), p. 25, no. 276, lists it as Kauterskill Falls, 1862, owned by Morris K. Jesup // B. B[urroughs], *MMA Bull.* 10 (April 1915), p. 67, discusses this painting as Kaaterskill Clove and identifies it as the Catskill Clove discussed by Tuckerman; ill. p. [68]; suppl. to 12 (Oct. 1917), p. 8, notes that Gifford's "most lively influence being apparently received from the type of Turner's pictures, where the effect of looking toward the early morning or late afternoon sun is the motive"; ill. p. [9]; *Catalogue of Paintings in the Metropolitan Museum* (1931), p. 135 // A. T. Gardner, *MMA Bull.* 6 (April 1948), ill. p. 233; p. 236, mentions it and calls it Kaaterskill Clove // J. T. Flexner, *That Wilder Image* (1962), p. 283, describes it; ill. p. 285 // R. Van Zandt, *The Catskill Mountain House* (1966), p. 139,

states that Gifford "painted or drew at least five pictures of the falls within one ten-year period"; p. 362, n 41, lists five pictures of the falls by Gifford from the 1881 memorial catalogue and states that this work shows Haines Falls // I. Weiss, *Sanford Robinson Gifford (1823–1880)* (Ph.D. diss., Columbia University, 1968; 1977), pp. xvi, xxvii; p. 218, mentions sketches related to paintings of the clove; p. 225, says that the area was the artist's favorite subject after 1845; pp. 226–228, states that this painting was a reinterpretation of Twilight in the Catskills – Kauterskill Clove of 1861; notes three small oil versions of 1862 as probably related to the Metropolitan painting; describes it as "a view from the mountain south of the clove, looking west towards the head of the clove and into the late-afternoon, haze-diffused sunlight"; notes that the house might be the one where the artist boarded; pp. 229–230, discusses two drawings of 1861 as probable studies and an oil sketch as an intermediate stage and suggests that Tuckerman's description is of this version; pp. 233, 235, 237, 309, 361; fig. VII C 1; figs. VII c2–c5, details // University of Texas at Austin, traveling exhibition, *Sanford Robinson Gifford (1823–1880)* (1970) cat. by N. Cikovsky, Jr., p. 8 // M. S. Young, *Apollo* 91 (April 1970), p. 291; p. 292, color pl. I // J. T. Flexner, *Nineteenth Century American Painting* (1970), color ill. p. 81; p. 83 // B. Novak, *Art in America* 60 (Jan.-Feb. 1972), ill. p. 53, as Kaaterskill Falls // J. K. Howat, *Honolulu Academy of Arts Journal* 1 (1974), pp. 28–29, mentions Gifford's works on the subject // National Gallery of Art, Washington, D. C., *American Light* (1980), p. 36, essay by L. F. Andrus compares it with October in the Catskills, 1880, in the Los Angeles County Museum of Art // National Gallery of Art, Washington, D. C., traveling exhibition, *An American Perspective* (1981), pp. 28–29, essay by E. A. Powell compares it with oil study in the Ganz collection; pp. 131–132, entry by S. Edidin notes that the Ganz painting is probably related to this work.

EXHIBITED: MMA and NAD, 1876, *Centennial Loan Exhibition of Paintings*, no. 188, as Kauterskill Falls, lent by Morris K. Jessup [*sic*] // MMA, 1917, *Paintings of the Hudson River School Brought Together in Commemoration of the Completion of the Catskill Aqueduct* (no cat.); 1946, *The Taste of the Seventies*, no. 111, as Kaaterskill Clove // Hudson River Museum, Yonkers, N. Y., 1954, *The Hudson River School, 1815–1865*, no. 28, as Kaaterskill Clove // MMA, 1965, *Three Centuries of American Painting*, unnumbered cat., as Kauterskill Falls; 1970, *19th-Century America, Paintings and Sculpture*, exhib. cat. by J. Howat and N. Spassky, no. 101 // National Gallery, Washington, D. C., City Art Museum of St. Louis, Seattle Art Museum, 1970–1971, *Great American Paintings from the Boston and Metropolitan Museums*, exhib. cat. by T. N. Maytham, no. 39 // MMA, 1971–1972, *The Painter's Light*, exhib. cat. by J. Walsh, Jr., no. 26 // Museum of Modern Art,

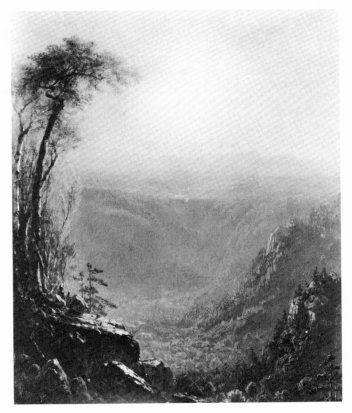

Gifford, *Kauterskill Clove, in the Catskills.* Coll. Jo Ann and Julian Ganz, Jr., Los Angeles.

New York, 1976, *The Natural Paradise*, exhib. cat., ill. p. 21; p. 22, R. Rosenblum discusses it among landscapes "where material forms, whether animal, vegetable, or mineral, are virtually pulverized or banished by the incorporeal deity of light" and notes that this painting "also takes us to such a site, where distant rock, water, and mountain become as apparitional in their luminous but intangible presence as the uncongealed cloud shapes that hover in Rothko's paintings"; in checklist, no. 58 // New York State Museum, Albany, 1977, *New York: The State of Art*, ill. p. 34; in checklist, no. 9, incorrectly dated as 1863.

EX COLL.: Morris K. Jesup, New York, by 1876–d. 1908; his wife, Maria DeWitt Jesup, New York, 1908–1914.

Bequest of Maria DeWitt Jesup, 1914.

15.30.62.

Tivoli

In his journal entry for October 11, 1856, Gifford described this view as "the finest thing to be seen at Tivoli" (S. R. Gifford, Journal, 2, Oct. 11, 1856, p. 123, typescript copy, D21,

Drawing for *Tivoli*, Sanford R. Gifford sketchbook, p. 75. Brooklyn Museum.

Arch. Am. Art). When he returned to Tivoli in 1868, he called it "one of the finest views in the world." He described a late afternoon walk around the head of the gorge of the Anio (or Aniene River) on October 13, 1868:

Below is the deep gorge with the Anio winding thro' it. On the left the high ridge crested with the houses and towers of Tivoli—its rich flanks streaming with the "cascatelle" which pour from the arches of Maecenas' villa. On the right of the valley, are olive covered ridges—beyond—the vast expanse and wide horizon of the campagna—above—the sun, shedding floods of light and color over the whole. Under the light of an hour before sunset, when the sun is over the scene, directly in front, words can not describe the richness and fullness of the light and color on the varied vegetation of the valley and mountain flank, and on the vast aerial plain. The horizon, 18 miles off, is broken only by the dome of St. Peters, which rises above it like the point of a mountain. This is one of the two or three things which have remained in my memory and occupied my mind these ten years, and which I came over here to see again, and if possible, to paint. I find, however, on reviewing it that my mind had cherished only the broad and simple splendor of the scene, and had quite eliminated all that interfered with that breadth and simplicity. I have made many sketches, but they seem only to show me the difficulties instead of the beauties of the scene. They make me see how the broad flank of the mt. is broken up in petty lights and shadows, and

how the flashing "cascatelle" and the windings of the Anio, make awkward lights which refuse to be subjugated. It has not unfrequently happened that subjects that I have long entertained, and to which I have given much time and labor, come to nothing—while some of the most successful of my pictures have been some of the most spontaneous—those that come freely, I scarcely know how—without pain or conscious effort, and which are executed without weariness. I have many times found that art is a mistress who bestows her favors graciously, and who never yields them either to force or importunity. Whether she will give me the gorge of the Anio or not is yet to be seen.

Following his customary practice, Gifford first made several quick pencil sketches of the view from nature. Preserved in his 1868 sketchbook in the Brooklyn Museum are: a study of the whole composition; studies of several figures in costume with color notations; two studies on one sheet of the skyline and the whole composition without the trees that appear in the right foreground of the painting; and an elaborate pencil and chalk drawing of the view without the foreground trees, dated October 14, 1868, or the day following the walk described in his journal. In 1869, Gifford did a small oil study (private coll.) for the painting. The present whereabouts of yet another study recorded in the 1881 catalogue of his works

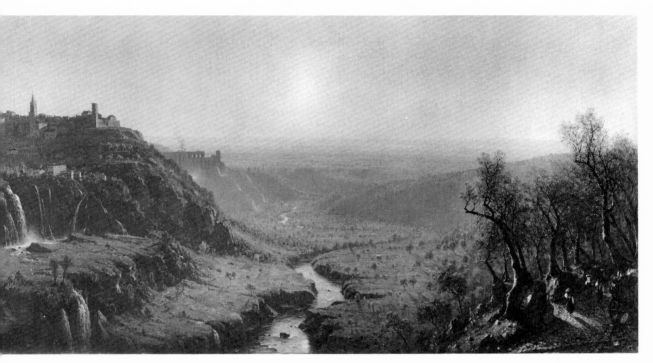

Gifford, *Tivoli*.

is not known. It was not until after Gifford returned to America, however, that he began this painting which is dated 1870. *Tivoli* was based largely on his studies of the late 1860s. Examination of the painting under infrared light reveals that he first made a careful pencil drawing on the canvas. With the exception of the olive trees and picturesque peasants in the right foreground, the drawing remains remarkably faithful to the detailed pencil study in the Brooklyn Museum. The small, elaborate oil study, complete with foreground trees and pea-

sants, also served as a model. Examination under ultraviolet light shows that the only subsequent changes were in the positioning of the outer branches of the olive trees overlooking the gorge at the right. There are pentimenti in that area.

Tivoli was painted for the important New York collector Robert Gordon, who wrote in March 1870:

Gifford is now painting for me a splendid picture . . . the result of his recent visit to Italy. It is a view near Tivoli, looking toward Rome. . . . It is, I believe,

Gifford, oil study for *Tivoli*. Coll. Alexander Gallery, New York.

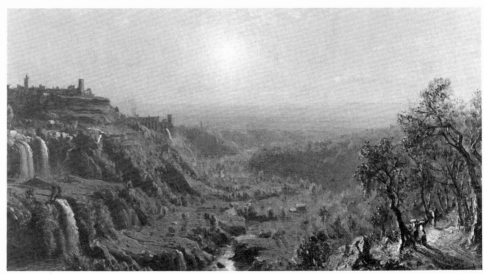

literally true to nature, except in the foreground, where a little license has been taken for artistic effect.

Lent by Gordon to the annual exhibition at the National Academy of Design in 1870, the painting received considerable attention from the press. Eugene Benson in *Putnam's Magazine* called it "a wonderfully glowing landscape" and noted that the "sunshine seems literally to flood in one vast stream of light the whole valley." Another reviewer writing in the *Nation* had reservations. Objecting to the liberties Gifford took with nature in the interest of pictorial effects, he observed, "the atmosphere of this picture may be critically spoken of as a conception, an artistic idea rather than a representation of a natural fact." In a conciliatory vein, however, he added that Gifford's pictures were:

fascinating on account of their unity, their simplicity of design, their very uniformity of tone. . . . The master has studied many phases of nature, and, selecting from what he knows, gives what he thinks his pictures will be better for. Perhaps to our mind he gives too little, and the picture is not full enough of the varied impressions, the mystery and the change of nature, but it is perfectly possible that in the attempt to give more matter, some grace would be lost.

Rather than providing a strictly literal, faithful, and factual representation from nature, in the opinion of this advocate of "truth to nature," Gifford used nature as a point of departure. As his journal reveals, Gifford was acutely conscious of the difficulties in reconciling the "breadth and simplicity" of the scene as he remembered it and the actual view with its many "petty lights and shadows." His primary interest was in rendering the effects of light. In *Tivoli* he used light to unify and consolidate the many component parts of the scene. Inevitably, detail assumed a secondary position.

In this complex and carefully constructed composition, Gifford chose a high-keyed palette restricted to white, yellow, pink, orange, and brown. Thin, transparent layers of paint, with subtle, barely perceptible transitions in tone, suggest the atmosphere. Quick touches of white and yellow impasto give the rich glittering effects of light glancing off the trees, the buildings, the winding river, and the cascades.

JOHN FERGUSON WEIR described this picture in a memorial address in 1880:

"Tivoli" is a miracle of tremulous atmosphere through which the eye pierces to illimitable distances. Wonderfully harmonious, its unity is perfect; and its luminous quality may almost lead one to fancy that he steeped his brush in sunlight. To my mind, Gifford's principal aim in his art attained its consummation in this picture. It is a golden mean between extremes, in hue, in tone, in repose, or a sense of it under the endless activities of nature—and as a manifestation of power exercised seemingly without effort.

Included by Gifford in a list of his chief pictures, *Tivoli* exemplifies his expressive use of light to powerful effect.

Oil on canvas, 26⅜ × 50⅜ in. (67.0 × 128.0 cm.). Signed and dated at lower right: S. R. Gifford. 1870. Signed, dated, and inscribed on the back: Tivoli / S. R. Gifford pinxit / 1870.

RELATED WORKS: preliminary drawings in S. R. Gifford Sketchbook, 1868: p. 11, study of whole composition without figures, pencil on paper, sheet size 4¾ × 4⅛ in. (12.1 × 10.5 cm.), image size 2 × 4 in. (5.1 × 10.2 cm.); p. 70, studies of figures with color notations for costume, pencil on paper, sheet size 4¾ × 9 in. (12.1 × 22.9 cm.), ill. in I. Weiss, *American Art Journal* 9 (Nov. 1977), p. 101, fig. 15; p. 74, small study of whole composition without foreground trees and figures and contour drawing of Tivoli's skyline, pencil on paper, sheet size 4¾ × 8⅞ in. (12.1 × 22.5 cm.), image size of small study 1 × 1⅞ in. (2.5 × 4.7 cm.); p. 75, *Tivoli Oct 14th 68*, pencil and white chalk on paper, sheet size 4⅞ × 8⅞ in. (12.4 × 22.5 cm.), ill. in ibid., p. 103, fig. 17; Brooklyn Museum // *Tivoli, a Study*, oil on canvas(?), 10 × 19 in. (25.4 × 48.3 cm.), formerly coll. John Bett, Roballion, Scotland, in 1881 (now unlocated) // *The Falls of Tivoli, a Study*, oil on canvas, 7 × 13 in. (17.8 × 33 cm.), 1869, coll. Alexander Gallery, New York, ill. in PAFA, *In This Academy* (1976), exhib. cat., p. 136, no. 169.

REFERENCES: S. R. Gifford, Journal, 3, Oct. 13, 1868 (letter dated Oct. 19, 1868), pp. 48–49, typescript copy, D21, Arch. Am. Art (quoted above) // R. Gordon to D. M. Armstrong, March 1870, in D. M. Armstrong, *Day before Yesterday* (1920), p. 325, Gordon describes this painting (quoted above) // *New York World*, April 24, 1870, p. 3, in a review of 1870 NAD annual exhibition calls it "a very seductive picture" and describes it as follows: "It is a perspective view of the celebrated vale, bathed in golden sunlight. The battlements and towers on the heights have a dreamy indistinctness. Cascades innumerable shoot from the rocks. Festive peasants are dancing for joy in the golden mist. The whole picture is a swoon of nature. It is luxuriously painted" // *New York Evening Post*, April 27, 1870, p. [1], in a review of 1870 NAD annual exhibition compares Gifford and Turner and says. "The charm of this landscape, representing the famous gorge of Tivoli with the cascade, the ruins of Maecenas villa and the Campagna beyond, lies in its subtle expression of atmosphere,

sunniness and distance. Landscape-painting of this kind is poetry, whatever may be its aim from technical points of view" // E. Benson, *Putnam's Magazine*, n. s. 5 (June 1870), p. 705, reviews it in NAD annual exhibition (quoted above) // *Nation* 10 (June 2, 1870), p. 357, reviews it in NAD annual exhibition (quoted above) // S. R. Gifford to O. B. Frothingham, Nov. 6, 1874, Arch. Am. Art, D10, includes it in list of "Chief Pictures" in autobiographical letter // G. W. Sheldon, *American Painters* (1879), p. 19, lists it among Gifford's best-known pictures, says it is dated 1870 and owned by Robert Gordon // Century Association, *Gifford Memorial Meeting of the Century* (1880), p. 25, J. F. Weir discusses it (quoted above) // MMA, *A Memorial Catalogue of the Paintings of Sanford Robinson Gifford, N. A., with a Biographical and Critical Essay by Prof. John F. Weir* (1881), p. 10, Weir discusses this picture; p. 37, no. 546, lists it as owned by Mr. Robert Gordon // R. Gordon to D. M. Armstrong, April 9, 1886, in D. M. Armstrong, *Day before Yesterday* (1920), pp. 325–326, in a letter from London, Gordon writes, "I am beginning to find that I made no mistake in investing as I did in American pictures. They attract a great deal of attention in my house, few good pictures having found their way to this side. In my dining-room, which is large, I have Wyant's 'Old Clearing' over the fireplace, with Gifford's 'Tivoli' and 'Mansfield Mountain' flanking it, all three being cleverly lighted by lamps with reflectors.... We had the American Minister, Mr. Phelps, dining with us on Tuesday and he greatly enjoyed the Gifford and Wyant" // W. Montgomery, ed., *American Art and American Art Collections* (1889), p. 710 // B. Burroughs, *Catalogue of Paintings in the Metropolitan Museum* (1914), p. 96, misdates as 1879 // B. B[urroughs], *MMA Bull.*, suppl. to 12 (Oct. 1917), p. 8, records date as 1879; *Catalogue of Paintings in the Metropolitan Museum* (1931), p. 135, records date as 1879 // A. T. Gardner, *MMA Bull.* 6 (April 1948), ill. p. 235; p. 236, records date as 1879 // A. T. Gardner, comp., *A Concise Catalogue of the American Paintings in the Metropolitan Museum of Art* (1957), p. 17, records date as 1879 // G. McCoy, Arch. Am. Art, letter in Dept. Archives, Nov. 6, 1963, quotes from the Gifford journal // I. Weiss, *Sanford Robinson Gifford (1823–1880)*, (Ph.D. diss., Columbia University, 1968; 1977), p. xx, mentions drawing and rediscovered oil sketch of 1869; p. xxxvi, n 64, pp. 308–310, discusses this painting, misdates it 1869, notes studies for it, and quotes from Gifford's journal; p. 361, calls it a "panoramic" image; p. 368, n 10; p. 455, n 1, notes that this picture had been incorrectly dated 1879; fig. IX A 1; *American Art Journal* 9 (Nov. 1977), p. 101, discusses the picture and studies; pp. 102–103, fig. 16, discusses it, cites Gifford's journal and the 1870 review from the *Nation*, and mentions unlocated studies.

EXHIBITED: NAD, 1870, no. 362, lent by Robert Gordon; 1870, Summer, no. 362, lent by Robert Gordon (withdrawn) // Brooklyn Art Association,

1872, *Chronological Exhibition of American Art*, no. 55, lent by Robert Gordon, N. Y. // Philadelphia, 1876, *Centennial Exhibition*, no. 489, lent by Robert Gordon (according to the label on the back; the catalogue incorrectly gives the owner as C. H. Luddington) // MMA, Oct. 1880 – May 1881, *The Memorial Collection of the Works of the Late Sanford R. Gifford*, in *Loan Collection of Paintings in the West and East Galleries*, no. 32, lent by Robt. Gordon; 1917, *Paintings of the Hudson River School Brought Together in Commemoration of the Completion of the Catskill Aqueduct* (no cat.) // Detroit Institute of Arts and Toledo Museum of Art, 1951, *Travelers in Arcadia*, exhib. cat. by E. P. Richardson and O. Wittmann, Jr., pp. 37–38, no. 48, dates it 1879 // MMA, 1953–1954, *American Painting, 1754–1954* (no cat.) // American Federation of Arts, 1965–1966, *Romantic Art, 1750–1900*, no. 13 // MMA, 1970, *19th-Century America, Paintings and Sculpture* (not in cat.) // University of Texas at Austin; Albany Institute of History and Art; and Hirschl and Adler Galleries, New York, 1970–1971, *Sanford Robinson Gifford [1823–1880]*, exhib. cat. by N. Cikovsky, Jr., p. 17; pp. 28–29, no. 47, dates it 1870; ill. p. 68, no. 47 (shown only at Austin and Albany) // MMA and American Federation of Arts, traveling exhibition, 1975–1977, *The Heritage of American Art*, exhib. cat. by M. Davis, no. 47, ill. p. 115, dates it 1879.

EX COLL.: Robert Gordon, New York, 1870–1912.

Gift of Robert Gordon, 1912.

12.205.1.

Isola Bella in Lago Maggiore

Gifford's visits to Lago Maggiore in 1856 and again in 1868 are recorded in his journal. On August 18, 1856, he wrote:

On the famous Isola Bella is the large and splendid palace of the Count Borromeo, with gardens, terraces, statues, grottos, etc. From one point of view (side of Isola Madre) the island, with its architecture and foliage, is beautiful; but from other points when a terraced and pinnacled pyramid is seen it is too fantastic for good taste (S. R. Gifford, Journal, 2, August 18, 1856, typescript copy, p. 91, D21, Arch. Am. Art).

A dozen years later, Gifford revisited Isola Bella and noted: "I have come to the conclusion that this part of Maggiore is the finest of all the Italian lakes" (Ibid., 3, July 31, 1868, p. 25).

Some eleven pictures of Lago Maggiore listed in the Gifford memorial catalogue, including this one, attest to his interest. Dated 1871, this view of the lake includes the "terraced and pinnacled" aspect that Gifford had found "too fantastic for good taste" in 1856. The neigh-

boring island is Isola dei Pescatori. A small oil sketch, *Lago Maggiore, a Study*, 1859 (Vassar College Art Gallery, Poughkeepsie, N. Y.), shows essentially the same scene at closer range without Isola Bella and its elaborate architecture. In contrast, the Metropolitan's picture reflects Gifford's primary concern with the effects of light and atmosphere rather than a detailed representation of the terrain. This painting is the largest of three oils that depict Isola Bella in the 1881 catalogue of Gifford's works. The second, *A Study of Sunset over Lago Maggiore*, measuring thirteen by twenty-four inches, sold in 1870, has not been located. The third is a small oil titled *Isola Bella, in Lago Maggiore, a Sketch* (coll. Paul Katz, Shaftsbury, Vt.). Except for details, it is the same view as the Metropolitan's painting. In both, topographical detail is sacrificed in the interest of the whole image and the effects of light. There is also an undated full-size preparatory study for the work, but without boats, in the collection of the Santa Barbara Museum.

Oil on canvas, 20¼ × 36 in. (51.4 × 66 cm.).

Signed and dated at lower right: S. R. Gifford 187[1]. Signed, dated, and inscribed on the back: Lago Maggiore / S. R. Gifford pinxit 1871. Canvas stamp: GOUPIL & CO. (badly faded).

RELATED WORKS: *Isola Bella, in Lago Maggiore, a Sketch*, oil on canvas, 8 × 13½ in. (20.3 × 34.3 cm.), coll. Paul Katz, Shaftsbury, Vt., color ill. in Sotheby Parke Bernet, New York, *American 18th Century, 19th Century & Western Paintings, Drawings & Sculpture* (Oct. 22, 1981), no. 50 // *Isola Bella in Lago Maggiore*, oil on canvas, 20 × 35⅞ in. (50.8 × 91.1 cm.), Santa Barbara Museum of Art, ill. in Sotheby Parke Bernet, New York, *American 19th & 20th Century Paintings, Drawings, Watercolors & Sculpture* (April 25, 1980), no 10.

REFERENCES: MMA, *A Memorial Catalogue of the Paintings of Sanford Robinson Gifford, N. A.* (1881), p. 39, no. 571, lists this picture as 20 × 34, owned by William B. Northrup // A. T. Gardner, *MMA Bull.* 6 (April 1948), ill. p. 234; p. 236 // G. McCoy, Arch. Am. Art, letter in Dept. Archives, Nov. 6, 1963, supplies quotes from the Gifford journal // I. Weiss, *Sanford Robinson Gifford (1823–1880)* (Ph.D. diss., Columbia University, 1968; published, 1977), pp. xxiii, compares this painting to study now in Santa Barbara; pp. 311–312, discusses this work and compares with 1859 version, quotes from Gifford's journal; p. 456, n 14 // I. Weiss, *American Art Journal* 9 (Nov. 1977), p. 91, fig. 7; p. 92, quotes from Gifford's journal; notes that the 1881 catalogue lists three oils of the subject, of which the Metropolitan's painting is the largest; says it is completely different from the 1859 version and no sketches are known; p. 92, n 38.

EXHIBITED: Brooklyn Art Association, 1871, Spring, no. 168, as Lake Maggiore, lent by the artist // MMA, 1953–1954, *American Painting, 1754–1954* (no cat.); 1958–1959, *Fourteen American Masters* (no cat.) // Fogg Art Museum, Harvard University, Cambridge, Mass., 1966, *Luminous Landscape*, pp. 25–26, no. 16 // Phoenix Art Museum, Arizona, 1967–1968, *The Metropolitan Museum of Art Loan Collection "The River and the Sea,"* no. 8 // University of Texas at Austin, Albany Institute of History and Art, and Hirschl and Adler Galleries, New York, 1970–1971, *Sanford Robinson Gifford [1823–1880]*, exhib. cat. by N. Cikovsky, Jr., p. 29, no. 48, discusses it and quotes from Gifford's journal; ill. p. 69, no. 48 (shown only at Austin and Albany) // Centennial Art Gallery, Saint Peter's College, Jersey City, N. J., 1972, *Hudson River School of Painting and Prints of the Hudson River*, no. 6 // Queens County Art and Cultural Center, New York; MMA; Memorial Art Gallery of the University of Rochester, N. Y.; Sterling and Francine Clark Art Institute, Williamstown, Mass., 1972–1973, *19th Century American Landscape*, exhib. cat. by M. Davis and J. K. Howat, no. 12 // Galerie des Beaux-Arts, Bordeaux, 1981, *Profil du Metropolitan Museum of Art de New York*, ill. p. 149, no. 189; pp. 149-150, no. 189, catalogues and discusses it.

ON DEPOSIT: United Nations, New York, 1947–1950.

EX COLL.: William B. Northrup, New York, by 1881; Charles A. Fowler, New York, by 1921.

Gift of Colonel Charles A. Fowler, 1921.

21.115.1.

Gifford, *Isola Bella in Lago Maggiore*.

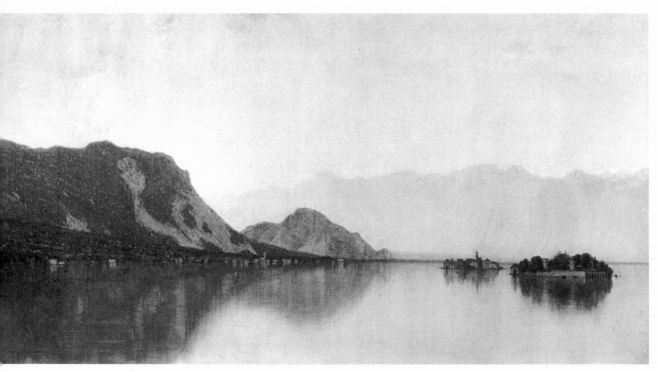

Version of Gifford, *Isola Bella in Lago Maggiore* in Santa Barbara Museum of Art.

THOMAS HICKS

1823–1890

The portrait, genre, landscape, and occasional still-life painter Thomas Hicks was born in Newtown, Pennsylvania. He showed an early interest in drawing and is said to have started to paint at the age of fifteen. He was trained initially as a sign and coach painter by his cousin EDWARD HICKS. One of his earliest works was a portrait of Hicks, 1838 (Abby Aldrich Rockefeller Folk Art Collection, Williamsburg, Va.). He continued his studies at the Pennsylvania Academy of the Fine Arts in Philadelphia and later at the National Academy of Design in New York. In January 1839 Hicks exhibited a portrait and a still life at the Apollo Association. The same year he also exhibited for the first time at the National Academy of Design, which elected him an associate two years later and an academician in 1851.

Hicks went to Europe in 1845. He traveled to London, Paris, Florence, and Rome, where he shared a studio with JOHN F. KENSETT. He and Kensett visited Venice in August 1847. After returning to Paris in 1848, Hicks studied with Thomas Couture, whose atelier was becoming increasingly popular with American artists. According to G. W. Sheldon, Hicks "ascertained that the demerits rather than the merits of that painter usually descended upon his pupils, became satisfied that his own case was not likely to be an exception, and, after an eighteen months' sojourn, came home" (p. 37). Hicks's studies with Couture, however, had considerable influence on his painting style.

In 1849 Hicks established himself as a portrait painter in New York. For a number of years he served as president of the Artists' Fund Society in New York. A member also of the Century Association, he was remembered by a foreign visitor as "a pleasant boon-companion," who besides "painting people, chiefly celebrities . . . used to mimic them amusingly" and was especially noted for his "whimsical" imitations of Daniel Webster (Eyre Crowe, *With Thackeray in America* [1893], pp. 73-74).

One of Hicks's most celebrated works is his portrait of Abraham Lincoln, 1860 (Chicago Historical Society). Painted in Springfield, Illinois, shortly after Lincoln's nomination to the presidency and reputed to be the first portrait of the future president, it was commissioned by W. H. Schaus and Company, which subsequently issued a lithograph after the painting. Hicks's account was published in A. T. Rice, ed., *Reminiscences of Abraham Lincoln by Distinguished Men of His Time* (1880). Other prominent figures who sat for Hicks were Henry Ward Beecher, William Cullen Bryant, Oliver Wendell Holmes, Henry Wadsworth Longfellow, and Harriet Beecher Stowe. Of his portraiture, the critic Henry T. Tuckerman observed: "He usually catches a likeness with facility, and often indulges in warmth of coloring and elaborate accessories which have contributed to the popularity of his portraits."

Hicks died at his country home, Thornwood, near Trenton Falls (West Canada Creek), New York, on October 8, 1890.

BIBLIOGRAPHY: Henry T. Tuckerman, *Book of the Artists* (New York, 1867), pp. 465–466 // George William Sheldon, *American Painters* (New York, 1879), pp. 35–39 // George A. Hicks, "Thomas Hicks, Artist, a Native of Newtown," *Bucks County Historical Society Papers* 4 (Jan. 18, 1910), pp. 89–92 // Jesse Merritt, "Thomas Hicks, N.A.," *Nassau County Historical Journal* 6 (Spring 1943), pp. 17–18 // Walter Pach, *DAB* (1932; 1961), s. v. "Hicks, Thomas," p. 8.

Mrs. Thomas Hicks

Angelina D. King (1834–1917), daughter of Sarah Ann Arnold and Dr. Theodore F. King, was born in Brooklyn and became the wife of Thomas Hicks in 1855. For a number of years, they lived at 43 Lafayette Place in New York and were active in the city's artistic and literary circles. Mrs. Hicks was evidently both fascinating and popular. It is said that "Angie" inspired the poet and diplomat George H. Boker of Philadelphia to compose many sonnets to her, which he wrote over a period of thirty years. Her admirers also included the author and editor Parke Godwin.

Hicks probably painted this portrait of his wife about 1884 because it was exhibited at the National Academy of Design that year. Wearing a black satin and lace dress and tan gloves and holding her hat on her lap, Mrs. Hicks is shown in profile against a crimson curtain. The use of dark contour lines in delineating her figure and the treatment of dark and light in the modeling reflect Hicks's study with Couture. The informality of the pose and the broad handling of paint represent Hicks's cautious adaptation of contemporary trends in French painting.

Hicks, *Mrs. Thomas Hicks.*

Oil on canvas, 46 × 29 in. (116.8 × 73.7 cm.).

Signed at lower right: T. HICKS N.A.

REFERENCES: C. M. Kurtz, ed., *National Academy Notes* (1884), ill. p. 111, no. 460, as A Portrait, describes dress; p. 173, no. 460 // *New York Times,* March 14, 1917, p. 9, subject's obituary provides biographical information // *MMA Bull.* 12 (June 1917), ill. p. 139, discusses acquisition of the portrait // Walter Pach, *DAB* (1932; 1961), s. v. "Hicks. Thomas," p. 8 // S. Bradley, *American Literature* 8 (Nov. 1936), p. 264, mentions this portrait in an article discussing Boker's poems to Mrs. Hicks, also includes a letter to her from Parke Godwin written in verse // J. Merritt, *Nassau County Historical Journal* 6 (Spring 1943), p. 18.

EXHIBITED: NAD, 1884, no. 460, as A Portrait.

ON DEPOSIT: Gracie Mansion, New York, 1954–1966.

EX COLL.: the subject, New York, until 1917.

Bequest of Angie King Hicks, 1917.

17.67.

WILLIAM HART

1823–1894

William Hart, the elder brother of the painter JAMES M. HART, was born in Paisley, Scotland. The Hart family immigrated to America in 1831 and settled in Albany, New York. Like his brother, William Hart gained his first experience as a painter by decorating coach panels and windowshades. He soon expanded his painting activities to include sketching

from nature. At the age of eighteen he became a portrait painter, using his father's woodshed in Troy as a studio and charging five dollars a head. "In regard to his pictures," the *Art Journal* reported in 1875, "he says that a good likeness was required, and that art and technical execution were of secondary consideration." In the early 1840s Hart traveled in search of portrait commissions. He spent three years in Michigan painting portraits at twenty-five dollars a head and, as he put it, "boarding 'round" among his patrons. Ill health forced him to return to Albany about 1845, when he is said to have devoted himself wholly to landscape painting. The financial assistance of Dr. J. H. Armsby enabled Hart to go abroad in 1849 to recover his health. An item in the *Albany Argus* reprinted in the November 1850 issue of the *Bulletin of the American Art-Union* reported:

> Many of our citizens will doubtless be glad to hear that our young townsman, WILLIAM HART, the landscape painter, is still living, and now prosecuting his art with great energy and success in Scotland. He left this city in very feeble health last November, with orders from our own citizens that will occupy two or three years. He received no advances on any of these orders, and does not expect pay until the pictures are sent home, nor then, even, unless they are satisfactory to the persons ordering them. Several pictures have already arrived and afford gratifying evidence of his improvement and high cultivation in the art. ... The pictures are all careful studies from nature, and truthful representations of the scenes intended to be portrayed. His studies are all taken in oil, of cabinet size, and copied on the larger canvas.

After recuperating, Hart went to Edinburgh, where he studied works at the academy. Some of his American paintings were exhibited, and he painted from nature in and around the city. He also visited Melrose Abbey, Roslin Castle, and Abbotsford. In the summer of 1850 he painted in the Highlands.

Hart spent three years in his native Scotland and other parts of Great Britain and returned to Albany in 1852. By 1854 he had taken a studio in New York City. He moved to the Tenth Street Studio Building shortly after it was erected in the spring of 1857. Hart was elected an associate of the National Academy of Design in 1854 and an academician in 1858. One of the founders of the Brooklyn Academy of Design, he became its first president in 1865. While in office, he delivered a notable lecture on American landscape painting titled "The Field and the Easel," which was summarized by Henry T. Tuckerman in his *Book of the Artists*. He was one of the founders of the American Watercolor Society and served as its president for three years from 1870 to 1872. Largely self-taught, Hart believed in individuality and feared that one's own artistic vision might suffer by studying the style of others too closely. Nevertheless, he was influenced early in his career by the work of the Hudson River school painters and remained remarkably faithful to their principles. As his grandson, the author and humorist E. B. White, reported: "he was drawn to landscape painting and ended up as one of the pillars of the Hudson River school. He was particularly excited by a landscape that contained cows. Many of his best and most ambitious oils featured cattle. I have seen some of his sketch books: they are loaded with the details of udders, rear ends, heads, horns, and hooves" (*Letters of E. B. White*, collected and edited by D. L. Guth [1978], p. 4).

Hart spent his last years in Mount Vernon, New York, where he died on June 17, 1894, shortly after the death of his wife, the former Janet Wallace. Both are buried in the Green-Wood Cemetery, Brooklyn.

BIBLIOGRAPHY: Henry T. Tuckerman, *Book of the Artists* (New York, 1867), pp. 546–547 // "American Painters.—William Hart," *Art Journal* (New York) 1 (August 1875), pp. 246–247 // George W. Sheldon, *American Painters* (New York, 1879), pp. 84–88 // "Individuality in Art" and "Influence and Individuality," *Art Union* 1 (Jan. 1884), pp. 18-20, and (May 1884), pp. 105, 107–108. Articles based on conversations with Hart. // Obituaries: *New York Tribune*, June 18, 1894, p. 7; *New York Times*, June 18, 1894, p. 5, and June 26, 1894, p. 9; *New York Evening Post*, June 18, 1894 p. 3.

Seashore, Morning

Called "An Adirondack Lake (Morning)," by one of the donors in 1909, this painting was subsequently retitled *Seashore, Morning*, because the large sailing vessel and the towering cliffs belie its identification as a lake scene in the Adirondacks. In all likelihood, the setting for this painting, dated 1866, is Mt. Desert Island, Maine, which Hart visited in August of that year (Watson's *American Art Journal* 5 [August 22, 1866], p. 277). It could, however, be Nahant, Massachusetts, or Grand Manan Island, New Brunswick, because he exhibited paintings of both areas at the National Academy of Design in New York during the 1860s. A short biographical account of Hart in the New York *Art Journal* states:

His paintings in illustration of sunset effects on the coast, particularly those drawn on the Island of Grand Menan [*sic*], several of which he has sent from his easel during the past ten years, for exquisite treatment of detail, unity of sentiment, and fidelity, give a good idea of his poetic fancy, and have been recognized as among his strongest works (1 [August 1875], p. 247).

Hart is more interested in the romance of the shore at sunrise than in the specific topography, and his emphasis on light and atmosphere obscures details of the landscape. The wrecked hulk offshore and the picturesque but indistinct figures in the water give the work a sense of mystery that engages the imagination.

Oil on canvas, 23 × 41 in. (58.4 × 104.1 cm.).
Signed and dated at lower left: WᴹHART/66.
REFERENCES: W. A. Paton, letter in MMA Archives, Dec. 23, 1909, calls it An Adirondack Lake (Morning) // *MMA Bull.* 5 (Feb. 1910), p. 46, describes it and gives title as Adirondack Lake—Morning; ill. p. 47 // B. B[urroughs], *MMA Bull.* suppl. to 12 (1917), p. 8, calls it Seashore—Morning; *Catalogue of Paintings in the Metropolitan Museum* (1931), p. 155.
EXHIBITED: MMA, 1917, *Paintings of the Hudson River School Brought Together in Commemoration of the Completion of the Catskill Aqueduct* (no cat.) // Norfolk Museum of Arts and Sciences, Va., 1947, *Fifteen Nineteenth Century Landscape Paintings*, no. 12 // Heckscher Art Museum, Huntington, N. Y., 1958, *Marine Paintings by American Artists* (unnumbered cat.).
ON DEPOSIT: Federal Reserve Bank of New York, 1972—present.
EX COLL.: William Paton, New York, d. 1890; his sons William Agnew Paton, David Paton, and Stewart Paton, until 1909.
Gift of the sons of William Paton, 1909.
09.214.2.

Hart, *Seashore, Morning*.

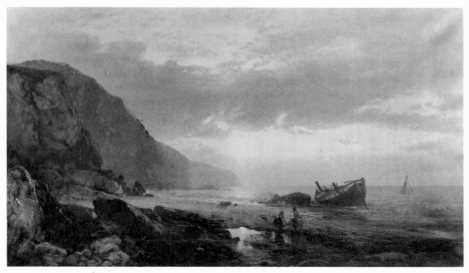

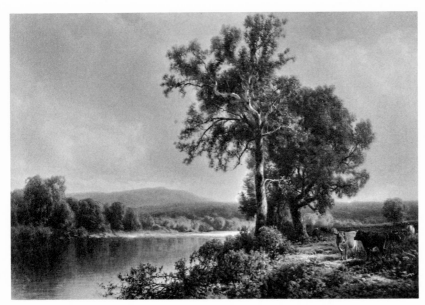

Hart, *Scene at Napanoch.*

Scene at Napanoch

This view near Napanoch, New York, a small village in the Shawangunk Mountains some twenty-five miles west of Poughkeepsie, is characteristic of the idyllic landscapes Hart produced during the last decade of his life. Painted in 1883, *Scene at Napanoch* is less a record of a specific site than an idealized rural scene. Such idealizations gained great popularity with the American public as the country became increasingly urbanized. Hart produced these landscapes in great numbers. His well-developed adaptation of the Hudson River school style always found a ready market. Complimenting Hart for the originality of his early work and his Scottish studies, George W. Sheldon offered perhaps an unduly harsh appraisal of Hart's later work of this sort:

Mr. Hart never was a copyist—of anybody but himself. His recent works, for the most part, closely resemble one another. If you go into his studio you will see ten or a dozen of them in various states of incompleteness, but very similar in subject, in composition, and in treatment. His latest and extremely popular cabinet landscapes, which may be found in almost all the auction-rooms where pictures are sold, and in almost all the principal private collections in the Atlantic cities, consist of a central piece of forest divided by a running stream, where are some cows, whose backs gleam with sunshine from a background sun. These productions always meet with a ready sale. Their author multiplies them fast. He is very industrious and persevering. (*American Painters* [1879], p. 86).

Hart exhibited several paintings of Napanoch at the National Academy of Design in New York during the 1880s, but none have yet been identified with this painting. It was presented to the museum by the artist's descendants in 1897.

Oil on canvas, 23½ × 33⅜ in. (59.7 × 84.8 cm.).
Signed and dated at lower right: wᴹ HART / 1883.
REFERENCES: *MMA Bull.* 1 (1906), p. 113, lists it // C. H. Caffin, *The Story of American Painting* (1907), ill. p. 79, calls it "a good example of the 'Hudson River School'" and says, "It exhibits on the painter's part a genuine love of nature and a determination to imitate nature as closely as possible. But the imitation is of details, put together bit by bit. This lack of synthesis, itself resulting from the lack of a large embracing comprehension of the whole, produces an effect of pettiness, notwithstanding the handsomeness of the composition" // B. B[urroughs], *MMA Bull.* suppl. to 12 (1917), p. 8.
EXHIBITED: MMA, 1897–1898, *Loan Collections and Recent Gifts to the Museum*, no. 166; 1917, *Paintings of the Hudson River School Brought Together in Commemoration of the Completion of the Catskill Aqueduct* (no cat.) // Corcoran Gallery of Art, Washington, D. C., and Grand Central Art Galleries, New York, 1925–1926, *Commemorative Exhibition by Members of the National Academy of Design, 1825–1925*, no. 122.
ON DEPOSIT: Federal Reserve Bank of New York, 1972—present.
EX COLL.: the artist's descendants, Jessie White, William W. Hart, James M. Hart, and Clara F. McCarten, until 1897.
Gift of descendants of the artist, 1897.
97.6.

JASPER F. CROPSEY

1823–1900

The eldest of eight children, Cropsey was born at Rossville, Staten Island. His family was of Dutch and Huguenot ancestry. He spent his youth working on his father's farm and attended the local country school. In his unpublished "Reminiscences of My Own Time," prepared for Charles E. Lester's *Artists of America* in 1846, he wrote: "I was so disposed to adorn my writing book, on the margin, wherever there was a blank space, with fancy letters, boats, houses, trees, etc., and paint, or color the pictures in my books that I would undergo the reprimand of the teacher, rather than desist from it." Cropsey's early interest in architecture led him to construct an elaborate model of a country house, which won him a diploma at the 1837 fair of the Mechanics' Institute of the City of New York. The model attracted the attention of the New York architect Joseph Trench, and Cropsey entered a five-year apprenticeship in his architectural office. After eighteen months, almost all of the firm's finished drawings passed through Cropsey's hands. In his fourth year he was painting the backgrounds of the architectural designs. At this time, with Trench's encouragment, Cropsey studied watercolor painting with Edward Maury, an Englishman. To advance his education, he obtained various treatises on painting and visited the annual exhibitions at the National Academy of Design. In December 1841 Cropsey began oil paintings based on his watercolors. His efforts were encouraged by the artists William T. Ranney (1813–1857), WILLIAM SIDNEY MOUNT, and HENRY INMAN. Cropsey left Trench's office in 1842 with hopes of supporting himself as an architect while continuing his landscape painting. His view of Greenwood Lake, New Jersey, exhibited at the National Academy of Design in 1844, won favorable comment from Inman and resulted in Cropsey's election as an associate of the academy. The following year in an essay for the American Art-Union titled "Natural Art," Cropsey summarized his views (typescript copies, MFA, Boston, and the Newington-Cropsey Foundation, Hastings-on-Hudson, N. Y.). As a staunch advocate of being true to nature, he professed his great admiration for the works of THOMAS COLE, which he found the most faithful transcripts from nature, questioned Joshua Reynolds's belief that the imitation of nature had an adverse effect on quality, and urged young painters to study nature. Like Cole and other contemporaries, however, Cropsey also produced works drawn from the imagination or inspired by literary sources.

In 1847 Cropsey married and embarked on his first trip to Europe. He set up a studio in London and toured England, Scotland, and Wales. Then he went to Paris, made the usual tour through Switzerland and the lake country of northern Italy, and finally arrived in Rome. He occupied the same studio Cole had used several years earlier and soon joined a circle that included the painters THOMAS HICKS and Christopher P. Cranch (1813–1892) and the sculptors William Wetmore Story and Thomas Crawford. He became familiar with the works of the Nazarenes and other German artists in Rome. Their influence may have reinforced his own penchant for detail. Like Cole, Cropsey made frequent sketching trips into the Roman Campagna and other regions of Italy, such as Sorrento, Capri, Amalfi, and Paestum. On the way back to the United States, he traveled through northern Italy, France, and

England, including visits to Fontainebleau and Barbizon with Thomas Hicks and Winckworth Allen Gay.

Cropsey returned to the United States in 1849 and made an excursion to the White Mountains in New Hamsphire. He then settled in New York and shared the studio of EDWIN WHITE, where he painted from his European sketches and supplemented his income by teaching. One of his most prominent students was DAVID JOHNSON. In 1851 the National Academy of Design elected Cropsey an academician. The same year he took a studio with Thomas Hicks. Although Cropsey's interest in allegorical, historical, and literary subjects is well documented, his main concern was American scenery. Following the practice of the artists of the Hudson River school, he made frequent sketching trips to upstate New York, Vermont, New Hampshire, and Rhode Island, and in 1855, visited Michigan and Canada. Studying nature was fundamental to Cropsey's artistic philosophy and a major theme of his essay "Up among the Clouds," which was published in the *Crayon* in 1855.

In anticipation of a second trip abroad Cropsey sold all his remaining pictures at an auction in 1856. The critic Henry T. Tuckerman noted that the sale was "so remunerative as to afford the best evidence of the extent of his popularity" (*Book of the Artists* [1867], p. 532). In London, Cropsey took a house and studio in Kensington and soon became active in the city's artistic and social circles. Among his acquaintances were the author John Ruskin, the director of the National Gallery Sir Charles Eastlake, JOHN SINGLETON COPLEY'S son Lord Lyndhurst, and DANIEL HUNTINGTON. Cropsey studied the work of John Constable, J. M. W. Turner, and the Pre-Raphaelites and became familiar with contemporary English and French art. In addition to sketching and painting in the English countryside and on the Isle of Wight, Cropsey provided illustrations for books of poetry by Edgar Allan Poe and Thomas Moore and did a series of views of American scenery published by Gambert and Company, London. He remained in England for seven years and frequently exhibited in London. He was acclaimed not only for such autumnal landscapes as *Autumn — On the Hudson River*, 1860 (National Gallery of Art, Washington, D. C.), but also for "rapidly making the untravelled portion of the English public familiar with the scenery of the great Western continent." Queen Victoria appointed him to the American Commission of the 1862 International Exposition in London, and he subsequently received a medal for his services.

Although the *New-York Daily Tribune* (Nov. 15, 1859) reported that "His success in England is so great that he is tempted to remain there permanently," Cropsey returned to New York in 1863. To alleviate growing debts and expenses, he gave art lessons and undertook architectural commissions. He continued to record nature with great fidelity in large panoramic landscapes and was best known for his autumn scenes. The sale of *The Valley of Wyoming* (q. v.) and *Starrucca Viaduct*, 1865 (destroyed in the Chicago fire of 1871), brought financial security and enabled him to buy forty-five acres in Warwick, New York, in 1866. By 1869 Cropsey had completed Aladdin, an elaborate Gothic revival mansion and studio there. His other architectural work included designs for town houses in the Gothic revival style, a multi-family residence in the French Renaissance style, the passenger stations of the Gilbert Elevated Railway along Sixth Avenue in New York, and the decoration of the drill shed of the Seventh Regiment Armory in New York. By 1884 Cropsey was beset with new financial problems and was forced to give up Aladdin. The following year he moved to

Hastings-on-Hudson, New York, where he designed a studio for himself (now maintained by the Newington-Cropsey Foundation).

Cropsey was an honorary member of the Pennsylvania Academy of the Fine Arts, a founder of the American Watercolor Society, and a member of the Century, Union League, and Lotos clubs. He died at his home in Hastings-on-Hudson in 1900.

BIBLIOGRAPHY: Jasper F. Cropsey, "Reminiscences of My Own Time," 1846, MS, coll. Brown Reinhardt, Newark, Del., typescript copies, MFA, Boston, and the Newington-Cropsey Foundation, Hastings-on-Hudson, N. Y. The artist wrote this account for Charles Edward Lester's *Artists of America* (New York, 1846), but it was not included // University of Maryland Art Gallery, J. Millard Tawes Fine Arts Center, College Park, Md., *Jasper F. Cropsey, 1823–1900: A Retrospective View of America's Painter of Autumn* (1968), exhib. cat. by Peter Bermingham. Contains five chapters, a chronology, selected bibliography, and illustrations // Cleveland Museum of Art, Munson-Williams-Proctor Institute, Utica, N. Y., and National Collection of Fine Arts, Washington, D. C., traveling exhib., 1970–1971, *Jasper F. Cropsey, 1823–1900* (1970), cat. by William S. Talbot. Contains essay, annotated catalogue entries, illustrations, chronology, and bibliography // William S. Talbot, *Jasper F. Cropsey, 1823–1900* (Ph. D. diss., Institute of Fine Arts, New York University, 1972; published New York, 1977). Most comprehensive account to date, contains over two hundred illustrations, a chronology, an exhibition record, a record of sales, a catalogue raisonné of 245 works, and a bibliography.

View near Sherburne, Chenango County, New York

Long called simply *Landscape*, this painting has been identified as *View near Sherburne, Chenango County, New York*. According to Cropsey's account book, it was sold on April 5, 1853, to Nicholas Ludlum for $250. Ludlum subsequently lent it to the 1853 annual exhibition of the National Academy of Design. Painted after Cropsey's return from his first trip to Europe, the picture may be based on studies he made when he visited Sherburne in August of 1852. Two drawings by Cropsey of Sherburne, dated September 1852, are in the collection of the Corcoran Gallery of Art, Washington, D. C., and in the Karolik Collection, Museum of Fine Arts, Boston.

In this serene, bucolic scene, Cropsey uses light effectively to capture the rising mists and hazy heat of a summer day. The raised vantage point, warm palette, and crisp treatment of the tree at the far left anticipate the mature style for which he is best known.

Oil on canvas, 33⅛ × 48⅜ in. (84.1 × 122.9 cm.).
Signed and dated at lower right: J. F. Cropsey / 1853.

REFERENCES: B. B[urroughs], *MMA Bull.*, suppl. to 12 (Oct. 1917), p. 8, as Landscape; *Catalogue of Paintings in the Metropolitan Museum* (1931), p. 79, as

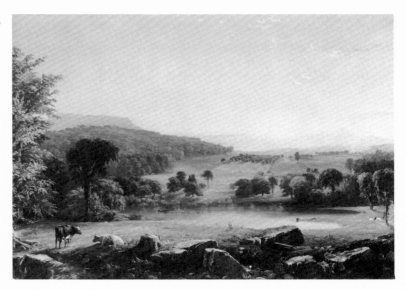

Cropsey, *View near Sherburne, Chenango County, New York.*

Landscape // A. Burroughs, *Limners and Likenesses* (1936), p. 148 // W. S. Talbot, *Jasper F. Cropsey, 1823–1900* (Ph.D. diss., Institute of Fine Arts, New York University, 1972; published 1977), p. 95, discusses use of light in this painting, described as an early morning scene; p. 287, lists exhibition at NAD, 1853; p. 313, reproduces Cropsey's account book listing it as View in Chenango County sold on April 5, 1853, to Mr. Nickolas Ludlum for $250.00; p. 371, no. 69, catalogues it; fig. 59.

EXHIBITED: NAD, New York, 1853, no. 86, as View near Sherburne, Chenango Co., N. Y., lent by N. Ludlum // MMA, 1917, *Paintings of the Hudson River School Brought Together in Commemoration of the Completion of the Catskill Aqueduct* (no cat.) // New York State Museum, Albany, 1977, *New York: The State of Art*, in checklist, no. 4, in cat. ill. p. 32; p. 33, lists it // Roberson Center for the Arts and Sciences, Binghamton, N. Y., 1981, *Susquehanna*, cat. by R. B. Stein, p. 57, fig. 17; p. 59, describes it as a twilight scene and notes tree stump in the foreground as "a signature of human activity in clearing the land, evident as well in the fields across the Chenango River"; p. 142, lists it.

ON DEPOSIT: Bartow-Pell Mansion, Pelham Bay Park, New York, 1946, 1964–1972 // Department of Parks, New York, 1974–1976 // Gracie Mansion, New York, 1981—present.

EX COLL.: Nicholas Ludlum, New York, from 1853–d. 1868; his wife, Sarah Ann Ludlum, New York, 1868–d. 1876.

Bequest of Sarah Ann Ludlum, 1877.

77.3.2.

Wyoming Valley, Pennsylvania

This is a meticulous oil study for Cropsey's *Valley of Wyoming* of 1865 (see below). In contrast to the large, elaborately detailed painting it is more broadly and quickly painted. Despite the fact that Cropsey did not return from his second trip to Europe until 1863, the date on this sketch was, for a long time, read as 1862. Close examination, however, has revealed that the work is dated 1864.

Two preliminary drawings in the Museum of Fine Arts, Boston, dated August 8, 1864, indicate Cropsey's experiments with various vantage points. One of these drawings, a detailed and carefully annotated work made from "Inmans Hill" looking north across the valley, which is intersected by the Susquehanna River, records the view ultimately selected for the painting. The foreground and the tree on the right in the oil study do not appear in the drawing. At the upper right of the drawing, however,

is a small sketch possibly for the general composition.

According to Cropsey's account book, in March 1868 he received $354.56 from Henry H. Leeds of New York for "Pompton Plains" and "Wyoming Valley." The museum acquired *Wyoming Valley* and a painting titled *Pompton Plains* (q. v.) through the bequest of Collis P. Huntington in 1925. Although not certain, it is likely that both works were those purchased from Cropsey by Henry H. Leeds in 1868.

Oil on canvas, 15 × 24 in. (38.1 × 61 cm.).
Signed and dated at lower right: J. F. Cropsey / 1864.

RELATED WORKS: *Wyoming Valley from Inmans Hill*, August 8, 1864, pencil on paper, 12 × 18¼ in. (30.5 × 46.4 cm.), Karolik Collection, MFA, Boston, 1972.761 // *The Valley of Wyoming* (see below).

REFERENCES: B. Burroughs, *Catalogue of Paintings in the Metropolitan Museum* (1931), p. 79, misdates it 1862 // B. Cowdrey, *Panorama* 1 (May 1946), pp. 93–94 // S. P. Feld, *MMA Bull.* 23 (April 1965), p. [293], notes that this sketch is dated 1864 // W. S. Talbot, *Jasper F. Cropsey, 1823–1900* (Ph.D. diss., Institute of Fine Arts, New York University, 1972; published 1977), pp. 174–175, discusses date of this study and related drawings; p. 228, notes sale of a Wyoming Valley at Leeds Art Galleries, New York, on Feb. 7, 1868; p. 327, in Cropsey's account book for March 1868 notes receipt of $354.56 from H. H. Leeds for "Pompton Plains" and "Wyoming Valley"; pp. 426–427, no. 141, catalogues it as *Valley of the Wyoming*, 1864, a study for the larger painting; fig. 125 // W. H. Siener, Wyoming Historical and Geological Society, Wilkes-Barre, Pa., letter in Dept. Archives, August 3, 1978, identifies places in Cropsey's drawing.

EXHIBITED: Detroit Institute of Arts, 1933, *Art before the Machine Age* (no cat.) // Harry Shaw Newman Gallery, New York, 1946 (see above *Panorama*) // Centennial Art Gallery, Centennial Exposition, Utah State Fair Grounds, Salt Lake City, 1947, *One Hundred Years of American Painting* (American Federation of Arts, Washington, D. C.), no. 10 // Guild Hall, Easthampton, N. Y., 1951, *A Historical Survey of American Art* (unnumbered cat.) // MMA, 1953–1954, *American Painting, 1754–1954* (no cat.) // Bruce Museum, Greenwich, Conn., 1964, *Jasper F. Cropsey Retrospective Exhibition* (not in cat.) // MMA, 1965, *Three Centuries of American Painting* (unnumbered cat.) // J. Millard Tawes Fine Arts Center, University of Maryland Art Gallery, College Park, 1968, *Jasper F. Cropsey, 1823–1900*, exhib. cat. by P. Bermingham, p. 30, n 20, says the study "seems somewhat stronger in its variety of values" than the painting; p. 31, pl. 17; p. 61, no. 20 // Staten Island Institute of Arts and Sciences, Staten Island Museum, 1968, *Jasper F. Cropsey, 1823–1900*, no. 20 // Cleveland Museum of

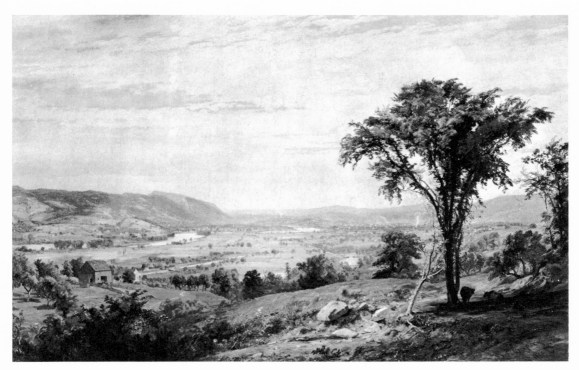

Cropsey, *Wyoming Valley, Pennsylvania.*

Cropsey drawing, *Wyoming Valley from Inmans Hill.* MFA, Boston.

Art, Munson-Williams-Proctor Institute, Utica, N. Y., and National Collection of Fine Arts, Washington, D. C., traveling exhib., 1970–1971, *Jasper F. Cropsey, 1823–1900*, cat. by W. S. Talbot, p. 36, discusses the study; p. 90, no. 40, gives date as 1864; ill. p. 91, no. 40 // De Cordova Museum, Lincoln, Mass., 1972, *Man and His Kine*, no. 19 // Queens County Art and Cultural Center, New York; MMA; Memorial Art Gallery of the University of Rochester, N. Y.; Sterling and Francine Clark Art Institute, Williamstown, Mass., 1972–1973, *19th Century American Landscape*, exhib. cat. by M. Davis and J. K. Howat, no. 11 // MMA and American Federation of Arts, traveling exhibition, 1975–1977, *The Heritage of American Art*, exhib. cat. by M. Davis, no. 46, ill. p. 112 (not shown in Australia) // Roberson Center for the Arts and Sciences, Binghamton, N. Y., 1981, *Susquehanna*, cat. by R. B. Stein, p. 10, fig. 9; p. 60; p. 134, n 2, points out that the 1864 sketch excludes the foreground group of children.

Ex coll.: with Henry H. Leeds, New York, 1868 (probably this work); Collis P. Huntington, New York d. 1900; his wife, later Mrs. Henry E. Huntington, subject to a life estate in the donor's widow, 1900–d. 1924; her son, Archer M. Huntington, subject to a life estate in the donor's son, which was relinquished, 1924–1925.

Bequest of Collis P. Huntington, 1900.

25.110.63.

The Valley of Wyoming

This large studio picture was commissioned in 1864 by Milton Courtright (1810–1883). Courtright was born and raised on his family's farm in Plains, between Scranton and Wilkes-Barre, Pennsylvania, in the heart of the Wyoming Valley. A civil engineer by profession, he served as first president of the New York Elevated Railroad Company. Cropsey records a payment from Milton Courtright of $125 on August 4, 1864, and three additional payments in January, March, and May 1865, totaling $3,500. On August 8, Cropsey made at least two preliminary drawings (Karolik Collection, MFA, Boston). One of these, a view from "Inmans Hill" looking north across the valley and the Susquehanna River, eventually provided the vantage point for the painting, which is also closely based on the oil study of 1864 discussed above. In addition, on August 9, Cropsey made a drawing titled *The Birthplace of Milton Courtright, Esq.* (now unlocated).

Cropsey's representation of the valley was probably determined to some extent by his patron. Courtright undoubtedly had a say in the size of the work, a decision that may have been influenced by the popularity of such large-scale paintings as FREDERIC E. CHURCH'S *Heart of the Andes* of 1859 and ALBERT BIERSTADT'S *The Rocky Mountains* of 1863 (qq. v.). Cropsey represented the panoramic view in minute detail providing a meticulous record. While such painstaking precision is characteristic of his mature style, his recent contact with John Ruskin and the work of the Pre-Raphaelites may have reinforced it. The warm reception that he had witnessed in London for Church's highly detailed *Heart of the Andes* may also have encouraged this tendency.

The Valley of Wyoming was shown at the National Academy of Design in 1865. A review in the *New York World* described the "very large and elaborate canvas" as "remarkable for a Constable-like tone which pervades it, and for the courage with which a vast sweep of country is laid bare to the clearest, purest light. The picture is signally full of sunshine." A critic writing in the *New York Times* aptly described it as "a monument of patient and accurate labor. . . . a topographical survey of a highly picturesque and romantic region" but found the details "perplexing." The same exhibition at the academy included a now unlocated painting by Cropsey titled *The Old Homestead, Wyoming Valley*, which the *Times* reviewer singled out for its "charming variety of verdure" and its "exceedingly gorgeous sun," which "occupies a prominent and rather startling position on the canvas."

The Valley of Wyoming retains its original frame, which bears a plaque inscribed with an excerpt from the poem *Gertrude of Wyoming* (1809) by the Scottish poet Thomas Campbell. The poem recalls the beauties of the Wyoming before the Wyoming Massacre in 1778 and tells the tale of Gertrude who was killed in the attack. The Valley of Wyoming was celebrated in art and literature for its scenic beauty and historical associations. Roger B. Stein observed (1981), however, that Cropsey avoided any reference to the valley's violent past. That the painting was completed as the Civil War ended, Stein noted, was a significant factor in the nature of Cropsey's representation. The pastoral image of tranquility and promise expresses hope and parallels such postbellum works as GEORGE INNESS's *Peace and Plenty* (q. v.) of the same year. The juxtaposition of the cultivated farmland and the distant smoking chimneys of the city of Wilkes-Barre celebrates agricultural prosperity and industrial

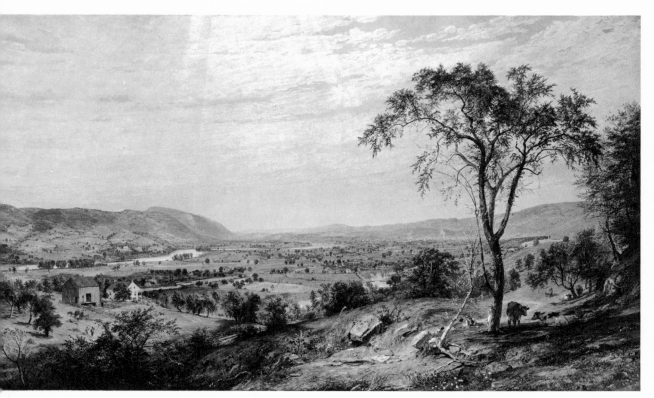

Cropsey, *The Valley of Wyoming.*

progress. The introduction of a group of children at the right and farmers haying at the left—figures not in the 1864 oil study—reinforces the idyllic character of the work.

Oil on canvas, 48½ × 84 in. (123.2 × 213.4 cm.).
Signed and dated at lower right: J. F. Cropsey/1865 –. Inscribed on plaque mounted on frame:

The Valley of Wyoming. J. F. Cropsey.

On Susequehana's side, fair Wyoming!
Although the wild-flower on thy ruin'd wall
And roofless homes, a sad remembrance bring
Of what thy gentle people did befall;
Yet thou wert once the loveliest land of all
That see the Atlantic wave their morn restore.
. . . . beneath thy skies,
The happy shepherd swains had nought to do
But feed their flocks on green declivities.
Or skim perchance thy lake with light canoe,
. . . . So sweet a spot of earth, you might, (I ween)
Have guess'd some congregation of the elves
To sport by summer moons, had shaped it for themselves. Campbell.

RELATED WORKS: *Wyoming Valley from Inmans Hill*, Aug. 8th 1864, pencil on paper, 12 × 18¼ in. (30.5 × 46.4 cm.), Karolik Collection, MFA, Boston, 1972.761 // *Wyoming Valley, Pennsylvania* (see above).

REFERENCES: *New York Times*, May 12, 1865, p. 4 // *New York World*, May 16, 1865, p. 4 (quoted above) // *New York Times*, June 13, 1865, p. 5 (quoted above) // *Richmond County* [*N. Y.*] *Gazette*, March. 21, 1866, notes that it was exhibited at the Dusseldorf Gallery in New York // H. T. Tuckerman, *Book of the Artists* (1867), p. 536, lists it among Cropsey's "late elaborate works" // J. H. Abbott, *The Courtright (Kortright) Family, Descendants of Bastrian Van Kordryk* (1922), p. 63, provides biographical information on Courtright // H. J. Peters, Erie, Pa., letters in Dept. Archives, Jan. 6 and 19, and March 3, 1963, supplies information about Courtright, the commission, and the painting // S. P. Feld, *MMA Bull.* 23 (April 1965), ill. p. 293, discusses it // *MMA Bull.* 25 (Oct. 1966), ill. p. 65 // W. S. Talbot, *Antiques* 92 (Nov. 1967), p. 716, fig. 7 // J. Millard Tawes Fine Arts Center, University of Maryland Art Gallery, College Park, *Jasper F. Cropsey, 1823–1900* (1968), exhib. cat. by P. Bermingham, pp. 27–30, discusses it; p. 33, suggests possible influence of Bartlett's engravings in *American Scenery*; pp. 43, 46 // W. S. Talbot, *Jasper F. Cropsey, 1823–1900* (Ph.D. diss., Institute of Fine Arts, New York University, 1972; published 1977), pp. 174–181, discusses the painting as a work of the post-Civil War period and reviews of it; p. 179, n 18, says that Cropsey had *Campbell's Poetical Works* (London, 1830) in his library; pp. 182, 183, 184, 186, 188, 193, 201, 249, 258; p. 275, lists it in chronology; p. 293, lists it in 1865 NAD exhibition; p. 325, states that Cropsey's account book records $3,500 received from Milton Courtright for "Wyoming Valley" on May 22, 1865; pp. 427–428, no. 142, catalogues it, notes related works and payments from Courtright; ill. fig. 126 // Brooklyn Museum and the Pennsylvania Academy of the Fine Arts, *William Trost Richards* (1973), exhib. cat. by L. S. Ferber, p. 64, no. 40, mentions it in relation to a painting by Richards dated 1866 // W. H. Siener, Wyoming Historical and Geological Society, Wilkes-Barre, Pa., letter in Dept. Archives, August 3, 1978, identifies places in Cropsey's preliminary drawing // G. Dahlberg, *American Art and Antiques* 2 (Nov. / Dec. 1979), p. 106 // Hudson River Museum, Yonkers, N. Y., *An Unprejudiced Eye* (1979), exhib. cat. with essay by K. W. Maddox, p. 9; p. 59, no. 86 // L. S. Ferber, *William Trost Richards (1833–1905)* (Ph.D. diss., Columbia University, 1980; published 1980), pp. 121, 181–182; p. 481, fig. 89 // Roberson Center for the Arts and Sciences, Binghamton, N. Y., *Susquehanna* (1981), exhib. cat. by R. B. Stein, p. 10, fig. 9; pp. 60–61, 63, 64.

EXHIBITED: NAD, New York, 1865, no. 232 // Düsseldorf Gallery, New York, 1866 // Bruce Museum, Greenwich, Conn., 1964, *Jasper F. Cropsey Retrospective Exhibition*, no. 1, lent by Mrs. John C. Newington // MMA, 1965, *Three Centuries of American Painting* (unnumbered cat.), lent by Mrs. John C. Newington; 1970, *19th-Century America, Paintings and Sculpture*, exhib. cat. by J. K. Howat and N. Spassky, no. 94 // Cleveland Museum of Art, Munson-Williams-Proctor Institute, Utica, N. Y., and National Collection of Fine Arts, Washington, D. C., 1970–1971, *Jasper F. Cropsey, 1823–1900*, exhib. cat. by W. S. Talbot, pp. 36, 43, discusses it; ill. p. 92, no. 47; p. 93, no. 47, catalogues it (exhibited in Utica and Washington only).

ON DEPOSIT: MMA, 1964–1966, lent by Mrs. John C. Newington.

EX COLL.: Milton Courtright, Erie, Pa. and New York, 1865–d. 1882; probably with Mrs. Milton Courtright, Erie, Pa. and New York, 1882–d. 1885, or estate of Milton Courtright; unidentified owner who acquired it from Courtright's estate; his son, and later, his granddaughter; Howard J. Peters, Erie, Pa., by 1963–1964; Mrs. John C. Newington, Greenwich, Conn., by 1964–1966.

Gift of Mrs. John C. Newington, 1966.
66.113.

Pompton Plains, New Jersey

Cropsey made frequent sketching trips to New Jersey to record the countryside and villages in an area that was still unaffected by encroaching urbanism. In this painting of 1867, he gave a bird's-eye view of Pompton Plains, a town some seven miles northwest of Paterson. He chose a vantage point looking west across the

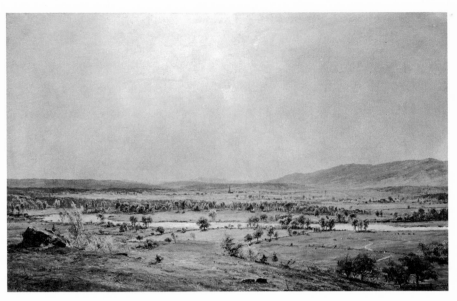

Cropsey, *Pompton Plains, New Jersey.*

Pequannock (now Pompton) River. By elim-
inating foreground trees, he accentuated the
expansive vista of low-lying plains. The Appa-
lachian range can be seen in the distance. The
steeple of the First Reformed Dutch Church,
established in 1771, provides a note of punctua-
tion in the center of the canvas. The rapidity
with which the paint was applied suggests that
Cropsey was working from nature, perhaps pre-
paring for a large studio picture, although none
has come to light.

The canvas was once torn at the left of the
sun. As a result, the surface in this area is not
completely smooth.

Oil on canvas, 20⅛ × 32¼ in. (51.1 × 81.9 cm.).
Signed and dated at lower left: J. F. Cropsey /
1867 –.

REFERENCES: *New York Times Magazine*, August 2,
1925, p. 21, describes it // B. Burroughs, *Catalogue of
Paintings in the Metropolitan Museum* (1931), p. 79, lists
it as Pompton Plains // W. S. Talbot, *Jasper F. Cropsey,
1823–1900* (Ph.D. diss., Institute of Fine Arts, New
York University, 1972; published 1977), pp. 184–185,
discusses technique used in this painting; p. 195,
compares with Sidney Plains, N. Y., 1874 (Los An-
geles County Museum of Art); p. 327, notes that
Cropsey's account book records receipt of $354.56
from H. H. Leeds in March 1868 for "Pompton
Plains" and "Wyoming Valley"; pp. 437–438, no.
155, catalogues it and notes that the town of Pompton
Plains is in the area where the Wanaque and Ramapo
rivers converge to form the Pompton River, says that
a painting of Pompton Plains was acquired by H. H.
Leeds in March 1868; fig. 129.

EXHIBITED: Brooklyn Art Association, 1867, Fall,
no. 249, as Pompton Plains, N. J., for sale // MMA,
1946, *The Taste of the Seventies*, no. 81 // Norfolk Mu-
seum of Arts and Sciences, Va., 1947, *Fifteen 19th
Century Landscape Paintings*, no. 6 // MMA, 1953–1954,
American Painting, 1754–1954 (no cat.) // Charles H.
MacNider Museum, Mason City, Iowa, 1966, *Inau-
gural Exhibition* (unnumbered cat.) // Meredith Long
and Company, Houston, 1974, *Tradition and Inno-
vation, American Paintings, 1860–1870* [for the benefit
of the Houston Museum of Fine Arts], no. 7 // Lowe
Art Museum, University of Miami, 1974–1975, *19th
Century American Topographic Painters*, no. 34; ill. p. 23,
no. 34 // MMA and American Federation of Arts,
traveling exhib., 1975–1977 (Australian tour only),
rev. ed. 1977, *The Heritage of American Art*, cat. by
M. Davis, no. 46, ill. p. 112.

EX COLL.: with Henry H. Leeds, New York, 1868
(possibly this painting); Collis P. Huntington, New
York, until 1900; his wife, later Mrs. Henry E.
Huntington, subject to a life estate in the donor's wid-
ow, 1900–d. 1924; her son, Archer M. Huntington,
subject to a life estate in the donor's son, which was
relinquished, 1924–1925.

Bequest of Collis P. Huntington, 1900.
25.110.22.

Autumn Landscape, Mount Chocorua, New Hampshire

"No mountain of New Hampshire has inter-
ested our best artists more. It is everything that
a New Hampshire mountain should be," noted
Thomas Starr King, the poet and preacher.

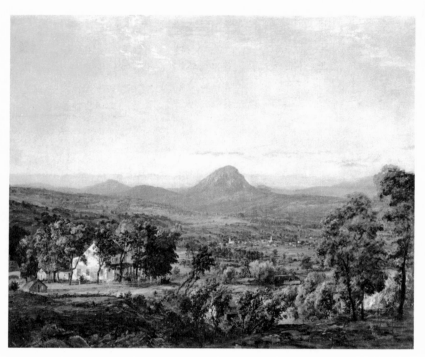

Cropsey, *Autumn Landscape, Mount Chocorua, New Hampshire.*

It bears the name of an Indian chief. It is invested with traditional and poetic interest. In form, it is massive and symmetrical. The forests of its lower slopes are crowned with rock that is sculptured into a peak with lines full of haughty energy, in whose gorges huge shadows are entrapped, and whose cliffs blaze with morning gold. And it has the fortune to be set in connection with lovely water scenery — with Squam and Winnispiseogee and the little lake directly at its base (*The White Hills* [Boston, 1859], p. 141).

Mount Chocorua in the Sandwich range of the White Mountains, eight miles southwest of Conway, was painted by Cropsey several times. The brilliant light, crisp brushstrokes, and predominantly gold and violet palette suggest that this autumn scene, a view across Conway Valley, was painted during the early 1870s.

Oil on canvas, $28\frac{1}{2} \times 35\frac{1}{2}$ in. (72.4 × 90.2 cm.).
Signed at lower left: J. F. Cropsey.
REFERENCES: *Antiques* 68 (Sept. 1955), ill. p. 193, as Autumn Landscape, Mt. Chocorua, New Hampshire, in an advertisement for James Graham and Sons, New York // R. Davidson, *Antiques* 80 (Nov. 1961), ill. p. 410, as with James Graham and Sons // B. L. Delaney, *Staten Island Sunday Advance*, Oct. 1, 1967, ill. p. E 4 // R. Davidson, *Antiques* 92 (Dec. 1967), p. 872 // W. S. Talbot, *Jasper F. Cropsey, 1823–1900* (Ph.D. diss., Institute of Fine Arts, New York University, 1972; published 1977), pp. 203–204, as

Mt. Chocorua, N. H., dates it about 1872 and discusses technique; pp. 445–446, no. 172, catalogues and dates it about 1872 on stylistic evidence; ill. fig. 162.

EXHIBITED: Currier Gallery of Art, Manchester, N. H., 1955, *Artists in the White Mountains*, no. 8, lent by Victor Spark // Los Angeles County Museum of Art and M. H. de Young Memorial Museum, San Francisco, 1966, *American Paintings from the Metropolitan Museum of Art*, no. 43 // Staten Island Institute of Arts and Sciences, Staten Island Museum, N. Y. 1967, *Staten Island and Its Artistic Heritage* (no cat.) // Slater Memorial Museum, Norwich, Conn., 1968, *A Survey of American Art*, no. 9 // Cleveland Museum of Art, Munson-Williams-Proctor Institute, Utica, N. Y., and National Collection of Fine Arts, Washington, D. C., 1970–1971, *Jasper F. Cropsey, 1823–1900*, exhib. cat. by W. S. Talbot, pp. 98–99, no. 60, dates it about 1872; ill. p. 99, no. 60 (exhibited in Cleveland and Utica only) // National Gallery of Art, Washington, D. C., City Art Museum of St. Louis, and Seattle Art Museum, 1970–1971, *Great American Paintings from the Boston and Metropolitan Museums*, exhib. cat. by T. Maytham, no. 37 // Centennial Art Gallery, Saint Peter's College, Jersey City, N. J., 1972, *Hudson River School of Painting and Prints of the Hudson River*, no. 4.

Ex COLL.: John Lenz; with Victor Spark, New York, by 1955; with James Graham and Sons, New York, by 1961.

Purchase, Bertram F. and Susie Brummer Foundation, Inc., Gift, 1961.

61.262.

THOMAS WATERMAN WOOD

1823–1903

Thomas Waterman Wood was the son of John and Mary Waterman Wood, both originally from Lebanon, New Hampshire. He was born on November 12, 1823, in Montpelier, Vermont. After completing his education in local schools, he worked in his father's cabinet shop. An itinerant portrait painter visiting Montpelier stimulated Wood's interest in art; and a boyhood friend, John C. Badger, reputedly shared art materials and books acquired on a trip to Boston. Wood learned to draw by copying from instruction books by the Scottish-born artist John Burnet and the English artist James D. Harding. Some sources claim that Wood studied with CHESTER HARDING in Boston from 1846 to 1847, but this has not been substantiated. Wood was essentially self-taught. His earliest known dated works—a series of pencil sketches of the Vermont landscape made in 1844 and 1845—reflect the influence of the Hudson River school and English landscape painting.

During the late 1840s and early 1850s Wood made a living in a variety of ways that included sketching a farmer's livestock, numbering seats in the statehouse, playing the guitar at local gatherings, designing furniture, making drawings for an inventor, sketching portraits, and painting signs for the Vermont Central Railroad. In 1850 he married Minerva Robinson of Waterbury and built Athenwood, a summer home and studio in Montpelier. By 1852 when he took a studio in New York, Wood was specializing in portraiture. He continued his self-education with visits to the exhibitions of the National Academy of Design, the Düsseldorf Gallery, and, in 1853, the Crystal Palace. In addition, he read Goethe's *Theory of Color with Notes by Eastlake*. Wood's portraits attracted the attention of Mr. Derbystone, a printer from Quebec, who urged him to go to Canada, which he did in 1855. Wood visited Quebec City, Kingston, and Toronto and then traveled to Washington, D. C. In 1856 he went to Baltimore, where he is said to have begun painting genre subjects. *The Baltimore News-Vendor*, 1858 (California Palace of the Legion of Honor, San Francisco), was shown at the National Academy of Design in 1858, the first time that Wood participated in the academy's annual exhibitions. A reviewer for the *Crayon* (5 [June 1858], p. 178) characterized the painting as "an admirable figure-study," and a heated dispute between two collectors over its ownership brought the artist additional attention.

In 1858 Wood went to Europe for a year to study the works of European contemporaries and the old masters and to fulfill commissions for his American patrons. According to some sources, he studied with the Norwegian-born landscape painter Hans Gude in Düsseldorf from 1858 to 1859; but there is no evidence to confirm this. Wood visited the National Gallery in London and spent the winter of 1858–1859 in Paris, where he went to the Louvre, the Luxembourg, and the studio of Thomas Couture. He especially admired the work of Léon Cogniet, Paul Delaroche, and Charles Gleyre. Wood made copies after Titian, Rubens, Rembrandt, Murillo, Greuze and Gerard Dou. To the 1859 spring exhibition of the National Academy of Design, he sent a genre piece titled *La Chiffonière* (unlocated), which was well received. In April Wood left Paris to tour Italy. He visited Genoa, Rome, Florence, and Milan and then went to Switzerland before sailing home in August 1859.

Upon his return to the United States, Wood settled in Nashville, Tennessee, and lived there until 1862. Before this he made a trip to Minnesota, where he sketched Sioux Indians, and in 1862 he visited Montpelier. From 1862 until the autumn of 1866, Wood lived in Louisville, Kentucky. Figure studies made in the South provided material for his genre paintings. Similarly, in later years friends and neighbors in Montpelier, where he was a frequent visitor, served as models in his scenes of village life. In 1866 he moved to New York. Although he continued to paint portraits, he specialized in genre painting and thereby won recognition. One critic observed: "As a colourist he is forcible, and as a delineator of character he never accepts the ideal, but goes directly to Nature for his models. In the composition of a picture every object is clearly drawn and he secures attention by the directness of his story" (*Art Journal* [New York] 2 [April 1876], p. 114).

Elected an associate member of the National Academy of Design in 1869 and an academician in 1871, Wood served as visiting instructor in its schools between 1875 and 1877, as vice-president of the academy from 1879 to 1891, and as president from 1891 to 1899. He helped organize the New York Etching Club in 1878 and was president of the American Watercolor Society from 1878 to 1887. With DANIEL HUNTINGTON, ENOCH WOOD PERRY, and other academicians, he was one of the founders in 1883 of the short-lived American Art Union and served as its vice-president until 1885.

In 1890 Charles S. Smith, twenty-sixth president of the New York Chamber of Commerce, Wood's friend and owner of *A Bit of War History* (q. v.), helped him secure a commission for a series of portraits of members of the Chamber of Commerce. In 1895 Wood established the Wood Gallery of Art in Montpelier, Vermont, for which Professor John W. Burgess of Columbia University helped secure financial backing. Wood donated many of his works, including copies after Rembrandt, Titian, Rubens, Turner, Ribera, Murillo, and others made during trips abroad in 1894 and later. He also acquired works by his contemporaries for the gallery.

A prominent figure in New York art circles during the last quarter of the nineteenth century, Wood died in New York on April 14, 1903.

BIBLIOGRAPHY: G[eorge] W. Sheldon, *American Painters* (New York, 1879), pp. 109–110 // Obituaries: *New York Times*, April 15, 1903, p. 9; *American Art Annual, 1903–1904* 4 (1903), p. 147 // *Catalogue of the Pictures in the Art Gallery in Montpelier: The Thomas W. Wood Collection* (2nd ed., Montpelier, Vt., 1913). Contains a brief history of the art gallery, a biography of the artist, and an illustrated catalogue of the collection, including works by Wood and his contemporaries // William C. Lipke, *Thomas Waterman Wood, PNA, 1823–1903* (Montpelier, Vt., 1972). Catalogue for loan exhibition of paintings, watercolors, and sketches from the Wood Art Gallery that traveled to the Robert Hull Fleming Museum, Burlington, Vt., the Currier Gallery of Art, Manchester, N. H., and the Wiggin Gallery, Boston Public Library, it includes an account of Wood's life based on diaries and other records in the Wood Art Gallery // Leslie A. Hasker and J. Kevin Graffagnino, "Thomas Waterman Wood and the Image of Nineteenth-century America," *Antiques* 118 (Nov. 1980), pp. 1032–1042.

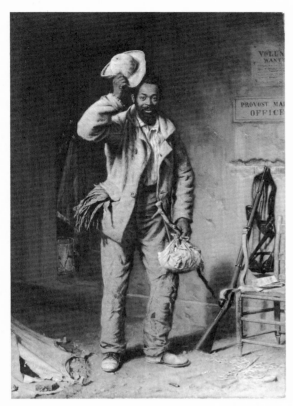

Wood, *The Contraband.*

A Bit of War History:
The Contraband, The Recruit,
and The Veteran

Painted in 1866 in Louisville, Kentucky, *A Bit of War History* is said to have been inspired by a black soldier injured in the Civil War. *The Contraband, The Recruit,* and *The Veteran* were lent by one of Wood's major patrons, Charles Stewart Smith, to the annual exhibition of the National Academy of Design in 1867. They established Wood's reputation in New York and secured his election as an associate of the academy in 1869. Called *A Bit of War History* by the artist, the three pictures were framed together and titled *War Episodes* when Smith donated them to the Metropolitan in 1884.

A reviewer of the 1867 exhibition, quoted by Henry T. Tuckerman, described the works as follows:

The three pictures referred to illustrate three eras in the life of an American negro, and tell his story so well that no one can fail to understand it. In the first the newly-emancipated slave approaches a provost-marshal's office with timid step, seeking to be enrolled

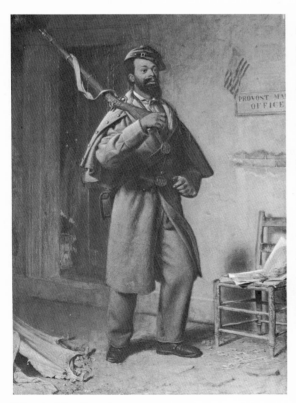

Wood, *The Recruit.*

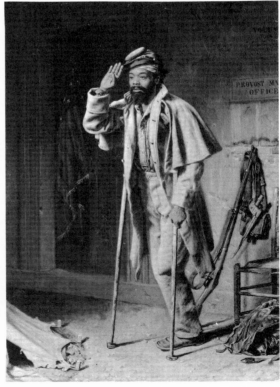

Wood, *The Veteran.*

among the defenders of his country. This is the genuine "contraband." He has evidently come a long journey on foot. His only baggage is contained in an old silk pocket-handkerchief. He is not past middle age, yet privation and suffering have made him look prematurely old. In the next we see him accepted, accoutred, uniformed, and drilled, standing on guard at the very door where he entered to enlist. This is the "volunteer." His cares have now vanished, and he looks younger, and, it is needless to say, happy and proud. In the third picture he is a one-legged veteran, though two years since we first saw him can scarcely be said to have passed. He approaches the same office to draw his "additional bounty" and pension, or perhaps his back pay.

These pictures have little value as far as their technical qualities are concerned. Whatever merits they have are of drawing rather than color. But their best qualities consist in the clearness with which they tell their story, and the evident sympathy of the artist with his subject. These are the charms by which all who see them are attracted. . . . But Mr. Wood's backgrounds are all very conventional in treatment, being disagreeably and unnecessarily black, and injure rather than improve the general effect of the pictures.

The critic for the *American Art Journal* described *The Contraband* and *The Recruit* as "two excellent specimens of character drawing, good alike in color and expression, though somewhat marred by an unpleasant feeling of hardness." Well aware of this characteristic, Wood had written in a diary entry for September 26, 1853, "To paint a picture which is not hard is something I have never been able to do" (quoted in Lipke, p. 20). William C. Lipke attributes this hardness to Wood's efforts to represent the real world faithfully in keeping with the contemporary preoccupation with "truth to nature." It may, however, also be attributed to the self-trained artist's penchant for both line and detail. Yet another factor is the possible influence of the Düsseldorf style, which became popular in America during the late 1840s and early 1850s. Adherents of that school were also criticized for dark backgrounds and a hard, linear style. Although Wood probably never studied in Düsseldorf, he visited the Düsseldorf Gallery in New York during the 1850s. *The Baltimore News-Vendor*, 1858 (California Palace of the Legion of Honor, San Francisco), painted before his trip to Europe, reflects this influence and anticipates the style of the Metropolitan's paintings.

Close examination of the three paintings in *A Bit of War History* reveals that Wood used a slightly different palette for each work. This suggests that they were not painted in quick succession. The flag above the sign for the provost marshal's office in *The Recruit* looks unfinished. Otherwise, the series is painted with Wood's usual attention to detail. Each boldly modeled figure is illuminated by a strong light from the left, which creates an almost sculptural effect and adds to the realistic quality that made Wood's genre paintings immediately comprehensible and popular. *A Bit of War History* dealt with a topical subject in an emotional manner that satisfied the contemporary taste for sentiment.

Oil on canvas, each $28\frac{1}{4} \times 20\frac{1}{4}$ in. (71.8 × 51.4 cm.).

Each signed and dated at lower left: T. W. WOOD/ 1866.

REFERENCES: Paletta [pseud.], *American Art Journal* 7 (May 18, 1867), p. 53 (quoted above) // R. Sturgis, Jr., *Galaxy* 4 (June 1867), p. 236, in review of NAD exhibition mentions "figure pictures of as much cleverness as Mr. Wood's three Contrabands" // H. T. Tuckerman, *Book of the Artists* (1867), pp. 488–489 (quoted above) // T. W. Wood to A. Stebbins, undated, Alfred Stebbins Autograph Collection, Henry F. du Pont Winterthur Museum, PAA–1, Arch. Am. Art, writes, "In answer to your letter of March 10th I enclose three photographs from my 'Contraband,' 'Recruit,' and 'Veteran,' which I think are mentioned in Tuckerman's book of the Artists" // *Art Journal* [New York] 2 (April 1876), pp. 114–115, states that the paintings, acquired by Mr. Charles S. Smith, were called "A Bit of War History" by the artist and that their exhibition in 1867 was instrumental in securing Wood's election as an associate of the NAD // G. W. Sheldon, *American Painters* (1879), pp. 109–110 // E. Strahan [E. Shinn], ed., *The Art Treasures of America* (1880), 3, p. 86, lists the paintings in the collection of Charles Stewart Smith // *Artistic Houses* (1883), 1, ill. between 127–129 is Smith's picture gallery showing The Contraband and The Recruit hung separately // C. E. Clement and L. Hutton, *Artists of the Nineteenth Century and Their Works* (1889), 2, p. 360, mistakenly say that Wood sent only The Recruit and The Veteran to the 1867 exhibition and sent the Contraband the following year // American Art Galleries, American Art Association, New York, *Private Art Collection of Thomas B. Clarke*, sale cat. (1899), p. 118, mentions the paintings in a biography of the artist // *Appletons' Cyclopaedia of American Biography* (1900), 6, p. 597, notes that Wood painted the pictures in Louisville // Wood Gallery of Art, Montpelier, Vt., *Catalogue of the Pictures in the Art Gallery in Montpelier* (rev. ed., 1913), p. 14 // R. W. Frenier, Washington, D. C., letter in Dept. Archives, August 21, 1968, supplies references for the paintings // B. S.

Groseclose, *Emanuel Leutze, 1816–1868* (1975), exhib. cat., p. 149, calls them "War Episodes" // K. M. Adams, *American Art Journal* 7 (Nov. 1975), p. 58, figs. 19–21, ill. as War Episodes // W. C. Lipke, *Thomas Waterman Wood, PNA, 1823–1903* (1972), pp. 38–40, discusses as War Episodes: pp. 40–41, mentions; p. 44, dates Flag, Drum and Cannon (an oil study for The Return of the Flag) on the basis of its relationship to the flag and drum motif in the Metropolitan's paintings // L. A. Hasker and J. K. Graffagnino, *Antiques* 118 (Nov. 1980), pp. 1034, 1035; p. 1037, figs. 6, 6a, and 6b.

EXHIBITED: NAD, 1867, nos. 273, 496, 501, as The Veteran, The Contraband, and The Recruit, lent by C. S. Smith // Philadelphia, 1876, Centennial Exposition (official catalogue), no. 552a, lists Contraband only; (official revised catalogue), nos. 43, 44, and 51, as The Veteran, The Recruit, and The Contraband, lent by C. S. Smith // Exposition Universelle, Paris, 1878, nos. 121, 122, 123, as Le contrabandier, Le recrue, and Le veteran, lent by C. S. Smith // College Art Association, traveling exhib., 1931, *Survey of American Painting*, no. 2, as War Episodes: the Contraband, the Volunteer, and the Veteran // Los Angeles County Museum and M. H. de Young Memorial Museum, San Francisco, 1966, *American Paintings from the Metropolitan Museum of Art*, no. 62 // University of Kentucky Art Museum, Lexington, 1981, *The Kentucky Painter from the Frontier Era to the Great War*, cat. by A. F. Jones and B. Weber, p. 31, discuss it as War Episodes; pp. 72–73, nos. 112–114; ills. pp. 146–148, nos. 112–114.

EX COLL.: Charles Stewart Smith, New York, 1867–1884.

Gift of Charles Stewart Smith, 1884.

84.12a-c.

WILLIAM MORRIS HUNT

1824–1879

The most prominent artist in Boston during the 1860s and 1870s was William Morris Hunt. As a teacher and an adviser to private collectors, he did much to popularize French art, especially Barbizon painting. Like WASHINGTON ALLSTON before him, he set the tone for his Boston contemporaries.

Hunt was born in Brattleboro, Vermont, and spent his early years in Washington, D. C. After his father's death in 1832, the family moved to New Haven, Connecticut. There Mrs. Hunt hired an Italian portraitist, Spiridione Gambardella (or Gambadella), to instruct the children in drawing. The Hunts moved to Boston in 1838, and two years later William entered Harvard College. He studied art with Crookshanks King (1806–1882), who may have taught him to model portraits in plaster. After being suspended twice from Harvard, Hunt continued his academic studies with the Reverend Dr. Samuel P. Parker, in Stockbridge, Massachusetts.

In 1843, to recuperate from a respiratory ailment, Hunt went to Europe with his mother. After visiting Paris and Geneva, they settled in Rome, where he worked with the American sculptor Henry Kirke Brown. At the recommendation of EMANUEL LEUTZE, Hunt studied for nine months at the art academy in Düsseldorf. In 1846 he rejoined his mother in Paris. He had planned to study with the sculptor Jean Jacques Pradier, but he saw a painting by Thomas Couture that inspired him to become a painter rather than a sculptor. Hunt studied with Couture for five years. The French master exerted a deep and enduring influence on his artistic development. Couture placed great importance on the rough sketch, or ébauche, which always remained evident in his pictures in spite of the impasto and glazes applied

over it. Hunt followed Couture's method, applying unmixed colors directly on the canvas to create a fresh, lively effect. During the 1850s he also borrowed one of Couture's favorite formats. This can be seen in *The Fortune Teller*, 1852 (MFA, Boston), in which Hunt placed large figures on a shallow stage close to the picture plane.

A turning point in Hunt's career came when he visited Jean François Millet at Barbizon, a village outside Paris. As he worked closely with Millet between the winter of 1852/53 and 1855, he became interested in humbler subjects and abandoned allegorical and religious themes for scenes of rural life. He often depicted large-scale figures like *The Belated Kid*, ca. 1854–1857, and *Girl with Cat*, 1856 (both MFA, Boston), showing dignified people in contemplative poses.

Hunt returned to America in 1855 and married Louisa Dumaresq Perkins, the granddaughter of Thomas Handasyd Perkins, a prominent Boston philanthropist. After spending the winter painting at Brattleboro, Hunt settled in Newport, where he began to attract students, among them JOHN LA FARGE and William and Henry James. In 1862 Hunt moved to Boston, which remained the focal point of his activities for the rest of his career. During the 1860s he concentrated on portraiture and received commissions from many of Boston's leading citizens. He painted them in elegant poses and sophisticated settings reminiscent of such European artists as Jean Auguste Dominique Ingres and Franz Xavier Winterhalter. At the same time he executed a number of figure paintings, some of which were small genre scenes and others, ideal themes like *The Drummer Boy*, ca. 1862, and *Hamlet*, ca. 1864–1870 (both MFA, Boston). He made a second trip to Europe in 1866 with his family. He stayed in Paris, where he visited Millet and Jean Baptiste Camille Corot and spent the summer at Dinan in Brittany with the Americans ELIHU VEDDER and Charles C. Coleman (1840–1923). He also traveled to Belgium and Holland and, during the winter of 1867–1868, lived in Rome.

On his return to the United States, Hunt resumed work in Boston. This was his most active period as a teacher. Between 1868 and 1875, he regularly conducted a class for about forty women. One of his students, Helen Mary Knowlton (1832–1918), recorded and published his comments in *Talks on Art*, which first appeared in 1875. Hunt painted many ideal heads, perhaps in connection with his teaching, and continued to paint portraits; but he did few genre subjects during the 1870s. Landscapes in oil and in charcoal became more common in his work. They were intimate in scale and composition and spontaneous in treatment, like the Barbizon paintings that inspired them.

The final decade of Hunt's life was difficult. When much of Boston was destroyed by fire in 1872, he lost the contents of his studio. He separated from his wife in 1873. The following year his brother Jonathan committed suicide. In June 1878 he received an important commission for two murals for the New York State Capitol in Albany. By the end of the year he had completed two ambitious compositions — *The Flight of Night* (see *Anahita* below) and *The Discoverer* (see *Fortune* below). These murals did not receive the acclaim that Hunt had anticipated and, as a result, he became despondent. He drowned in November 1879 while visiting friends at Appledore, Isles of Shoals.

BIBLIOGRAPHY: Henry C. Angell, *Records of William M. Hunt* (Boston, 1881). An account written by an admiring acquaintance // Helen M. Knowlton, *Art-Life of William Morris Hunt* (London,

1899). Biography written by a devoted student // Martha A. S. Shannon, *Boston Days of William Morris Hunt* (Boston, 1923) // University of Maryland Art Gallery, College Park, *The Late Landscapes of William Morris Hunt*, exhib. cat. (1976), essay by Marchal E. Landgren, annotated chronology by Sharman Wallace McGurn, bibliography, detailed catalogue of works in the exhibition // MFA, Boston, *William Morris Hunt: A Memorial Exhibition* (1979), introduction by Theodore E. Stebbins, Jr., essays by Martha J. Hoppin and Henry Adams, catalogue by Martha J. Hoppin.

Girl at the Fountain

Girl at the Fountain was painted during the early 1850s when Hunt was studying in France. The choice of subject, a peasant woman engaged in an everyday task, shows the influence of Jean François Millet, whom Hunt knew well and greatly admired. It is more idealized than Millet's work, however, and strongly reflects the principles of Hunt's mentor Thomas Couture. In some areas the paint surface has the characteristics of an ébauche, or rough sketch. This fresh treatment is particularly reminiscent of Couture's working method. Hunt also uses a favorite compositional device of Couture's—a stone wall that not only serves as a backdrop to limit spatial recession but also provides a variegated surface to reflect light. The figure leaning against the wall is carefully drawn and firmly modeled; her body, clothes, and cast shadow create a balanced and well-designed composition. The pose was reportedly inspired by Hunt's view of a coachman leaning against a wall to draw water for his horses. According to

Hunt, *Girl at the Fountain.*

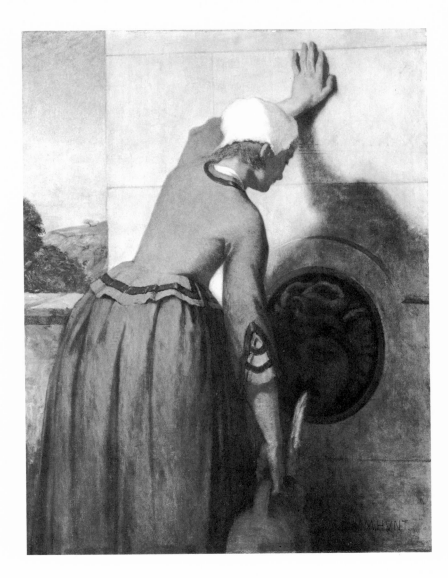

Helen M. Knowlton (1899), Hunt exclaimed, "'If that were a young woman with a good figure, it would make a picture'"; his sister Jane posed for him, and "the result was a firm, serious work,—gracious and well considered." The subject's position, with her back to the viewer, becomes common in Hunt's later paintings, for example, *Marguerite*, 1870 (MFA, Boston).

Girl at the Fountain is not dated. According to the catalogue of the memorial exhibition held at the Museum of Fine Arts, Boston, in 1879, the painting was begun in 1852, when the artist was working at Barbizon with Millet, and "finished at Brattleboro." This information is probably correct as it was most likely obtained from the artist's sister Jane, who owned the painting. It was completed by the spring of 1855, when it was featured in the Exposition Universelle in Paris. The only time that Hunt could have been in Brattleboro, Vermont, between the time the painting was begun and exhibited seems to have been in 1854, when he returned to the United States to visit his family. *Girl at a Fountain* can thus be dated between the winter of 1852/53 and 1854.

Oil on canvas, 46 × 35½ in. (116.8 × 90.2 cm.).
Signed at lower right; W. M. HUNT.
RELATED WORKS: Two unlocated charcoal drawings for the painting are listed in Warren Chambers, Boston, *Exhibition and Public Sale of the Celebrated Paintings and Charcoal Drawings of the Late William Morris Hunt*, Feb. 23–24, 1898, as nos. 14 and 91 // *Girl at the Fountain*, lithograph with tint stone, image 9⅝ × 7⅜ in. (24.5 × 18.7 cm.), in *Pictures Painted & Lithographed by Wm. M. Hunt 1859*, MMA, 23.69.7, ill. in H. M. Knowlton, *Art-Life of William Morris Hunt* [1899], opp. p. 36. Reverses the composition of the painting and adds subtle refinements, notably in the contour of the back and raised arm.
REFERENCES: A. J. Du Pays, *L'Illustration* 26 (Dec. 29, 1855), p. 428, in a review of the Exposition Universelle, says "On trouve dans . . . sa *Petit fille à la fontaine* le sentiment de l'harmonie. Il procède largement, avec une simplicité de rendu un peu vide, et il semble chercher l'aspect sourd de la peinture de M. Millet" // *Crayon* 4 (July 1857), p. 223, discusses it in a review of NAD; 6 (March 1859), p. 92, discusses Hunt's making a lithograph of it // H. T. Tuckerman, *Book of the Artists* (1867), p. 449, cites it as an example of the artist's treatment of French "types of city life"; mentions Hunt's lithograph // [Henry James], *Atlantic Monthly* 29 (Feb. 1872), p. 246, in a review of an exhibition, laments its absence and says it shows "the artist's best powers" // *New York Times*, April 29, 1875, p. 2, in a review of exhibition at Cottier, calls it a "strong and winning picture"; says that "the hand

carelessly braced against the wall, as the girl stoops with her jug, seems to suggest a history and a character all its own" // [R. W. Gilder], *Scribner's Monthly* 10 (June 1875), p. 253, in a review of a group exhibition at Cottier, calls it "a painting which has his best qualities of drawing, breadth and sentiment. The single thought of the figure is very delicately carried out in every part" // J. H. W., *New York Times*, Nov. 24, 1879, p. 3, mentions it in a review of the exhibition at the MFA, Boston // *American Architect and Building News* 6 (Nov. 29, 1879), p. 172, gives it as an example of his painting "in the Millet style" // W. H. Downes, *Atlantic Monthly* 62 (Sept. 1888), p. 388, mentions it among Hunt's paintings on view at the MFA, Boston; p. 389, describes it // H. M. Knowlton, *Art-Life of William Morris Hunt* (1899), pp. 26–27 (quoted above); p. 37, notes lithograph after it // B. B[urroughs], *MMA Bull* 3 (June 1908), p. 119, ill. p. 121 // E. L. Cary, *International Studio* 35 (Sept. 1908), p. xciv, says bequeathed to the MMA by the artist's sister who served as the model; ill. p. xcvi // M. H. Elliot, *Bulletin of the Newport Historical Society*, no. 35 (Jan. 1921), p. 23 // M. A. S. Shannon, *Boston Days of William Morris Hunt* (1923), p. 46 // J. J. Sweeney, ed., *The Painter's Eye* (1956), p. 50, quotes Henry James's comments (1872) // P. O. Marlow, "William Morris Hunt, His Relationship to the Barbizon School," M. A. thesis, New York University, 1965, p. 9, notes similarity to Corot's Italian subjects; fig. 3 // University of Maryland, Art Gallery, College Park, *The Late Landscapes of William Morris Hunt* (1976), essay by M. Landgren, p. 22: chronology by S. W. McGurn, p. 62, includes it as Petite Fille à la Fontaine in a list of works exhibited at the Exposition Universelle; p. 65, says that it is one of six paintings of which lithographs were printed by Frizzel and published by Phillips and Samson; pp. 70 and 72, says that in April 1875 Jane Hunt lent it to an independent exhibition at Cottier and Company // C. Troyen, MFA, Boston, orally, May 1, 1979, said records seem to indicate that it remained at the MFA between 1883 and 1908.
EXHIBITED: Exposition Universelle, Paris, 1855, no. 721, as Petite fille à la fontaine // NAD, 1857, no. 39, as The Fountain, for sale // Cottier and Company, New York, 1875 [*Works by Some of the Most Noted, as Well as Some of the Younger Artists of New-York and Boston*], as Girl at the Fountain (no cat. available) // MFA, Boston 1879–1880, *Exhibition of the Works of William Morris Hunt*, no. 57, as The Girl at the Fountain, lent by Miss Hunt, Newport, p. 24 (quoted above) // MMA, 1880, *Loan Collection of . . . Paintings by the Late William Morris Hunt*, no. 27, as Girl at Fountain, lent by Miss Jane Hunt; 1882 and 1883, *Loan Collection of Paintings and Sculpture*, no. 219 and no. 79, as Girl at a Fountain, lent by Miss J. Hunt, Boston // MFA, Boston, *William Morris Hunt: A Memorial Exhibition*, cat. (1979), essay by M. J. Hoppin, p. 12, dates it ca. 1852–1856; in a discussion of Hunt's tendency to combine aspects of Couture's and Millet's

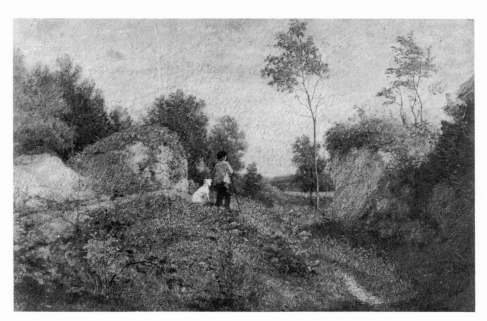

Hunt, *Landscape.*

styles, notes that the figure is "a strong, flat shape, in the manner of Couture"; that Hunt juxtaposed "grainy highlights" in the fountain with "thin, soft brushwork in clothing, as in Millet's work"; n 12, mentions the lithograph after Girl at the Fountain issued in 1858; p. 13, says that it was one of the "less ambitious, decorative subjects," more appealing than religious or allegorical works.

ON DEPOSIT: MFA, Boston, 1883–1907, lent by Jane Hunt.

EX COLL.: the artist's sister, Jane Hunt, Newport and Boston, by 1879–1907.

Bequest of Jane Hunt, 1907.

08.88.

Landscape

This painting is not dated, but it is believed to have been done while Hunt was studying art in France, probably after 1852/53 when he first visited Jean François Millet at Barbizon. The Barbizon painters had a great influence on Hunt, who admitted that "when I look at nature I think of Millet, Corot, and sometimes of Daubigny" (*W. M. Hunt's Talks on Art* [1877], p. 45). This influence can be seen here in the humble subject—a peasant and his dog in a rocky landscape—and in the rich texture of the paint. Hunt has roughened the surface of the clouds and sky, perhaps by striking the damp pigment with the stiff bristles of his brush. In many areas, notably the foliage, he has left the paper support blank or scraped pigment away to reveal it. Unfortunately, the paper has been penetrated by oil and varnish and has discolored, irreversibly altering the appearance of the picture. Some areas that are now dark brown would originally have been much lighter.

Oil on pressboard mounted on wood, 12 ½ × 19 ½ in. (31.8 × 49.5 cm.).

REFERENCES: E. H. Slater, the artist's daughter and executor of his estate, to W. Macbeth, Jan. 16, [1906], Macbeth Gallery Papers, MNc11, Arch. Am. Art, includes it in a list of eight paintings sold for $4,500 // *MMA Bull.* 1 (Sept. 1906), ill. p. 131 // H. Cahill and A. H. Barr, Jr., ed., *Art in America in Modern Times* (1934), ill. p. 19 // P. O. Marlow, "William Morris Hunt, His Relationship to the Barbizon School," M.A. thesis, New York University, 1965, p. 14, says its composition and paint texture show influence of Rousseau; p. 21, relates its strong color accents to influence of Narcisse Virgile Diaz de la Peña; ill. p. 27 // M. Hoppin, "William Morris Hunt," Ph. D. diss., Harvard University, 1974, p. 312, includes it as no. 239 in a checklist of the artist's works and dates it 1852–1855 // M. Shelley, Paper Conservation, MMA, memo, Dept. Archives, April 8, 1982, identifies the support and discusses condition.

EX COLL.: estate of the artist, until 1906; with Macbeth Gallery, New York, 1906.

Rogers Fund, 1906.

06.170.

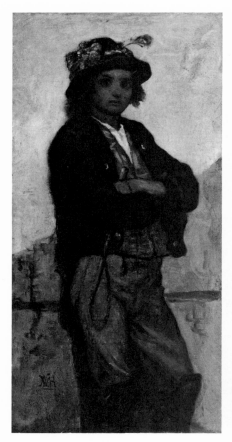

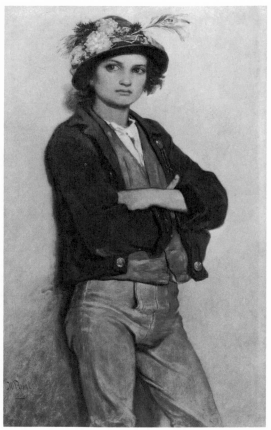

Hunt, *Italian Boy*.

Hunt's finished version, *Italian Peasant Boy*.
MFA, Boston.

Italian Boy

Italian Boy was almost certainly painted in 1866, when Hunt was working in France. The subject and composition, as well as the spontaneous execution and free brushwork, show the influence of his renewed contact with French artists, particularly Thomas Couture and Jean Baptiste Camille Corot, whom he saw in Paris that year.

The Metropolitan painting is a study for *Italian Peasant Boy*, 1866 (MFA, Boston). A comparison of the two works shows that a number of changes were made as Hunt developed the finished picture. In the Boston painting he altered the composition by cropping the figure at the knees and reducing the empty space above the hat. These refinements draw the figure closer to the picture plane and establish a delicate balance between the irregular outline of the body and the flat backdrop. Compared to the harsh illumination and strong contrasts of the Metropolitan study, the Boston picture is softened by subtle modeling and a generalized light source.

Some details in the study, such as the whip held by the boy, are eliminated in the finished work; others are elaborated. For example, the creases and wrinkles in the trousers and the flowers and feathers in the hat, which are only suggested in the study, are carefully depicted in the finished painting.

Hunt did a drawing of a similar subject, *Italian Boy* (MFA, Boston), which appears to date from the same European trip. The painting *Italian Peasant Boy II* (MFA, Boston) is no longer believed to be by Hunt.

Oil on canvas, $16\frac{1}{4} \times 8\frac{5}{8}$ in. (36.2 × 21.9 cm.).
Signed at lower left: WMH (monogram).
RELATED WORK: *Italian Peasant Boy*, 1866, oil on canvas, $38\frac{1}{2} \times 25$ in. (97.8 × 63.5 cm.), MFA, Boston, ill. in *American Paintings in the Museum of Fine Arts*, Boston (1969), 2, p. 224.
REFERENCES: B. B[urroughs], *MMA Bull.* 3 (Nov. 1908), pp. 199–200, provides information about donor and says the study was done while the artist was in Rome // M. Hoppin, "William Morris Hunt: Some Aspects of His Work," Ph.D. diss., Harvard University, 1974, pp. 186–187, compares it to the large-

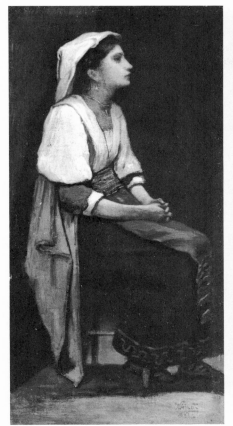

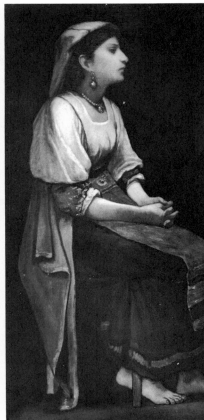

Finished version of
Hunt's *Italian Girl*.
Bennington Museum.

Hunt, *Italian Girl*.

scale work in the Boston Museum and notes it as an example of his refining process; p. 263, discusses; p. 301, no. 178, calls it a study for the Boston picture in a checklist of the artist's work and notes inclusion in memorial exhibition; fig. 181 // MFA, Boston, *William Morris Hunt: A Memorial Exhibition*, cat. [1979], entry by M. J. Hoppin, p. 66, says that it is "a small version" of a larger painting, Italian Peasant Boy, 1866 (MFA, Boston); discusses another treatment of the theme, formerly attributed to Hunt, but which may be by Hamilton Wilde, another Boston artist; notes that MMA paintings Italian Boy and Italian Girl belonged to the same owner and were exhibited together in the 1879 memorial.

EXHIBITED: MFA, Boston, 1879, *Exhibition of the Works of William Morris Hunt*, no. 96 (deleted in fifth ed. of cat.), as Italian Boy, lent by J. M. Fiske, says it was painted in Paris in 1867 // MMA, 1946, *The Taste of the Seventies*, no. 121.

Ex COLL.: Josiah M. Fiske, Boston, by 1879 – d. 1892; his wife, Martha T. Fiske (later Mrs. George Whitfield Collord), New York and Newport, by 1892–1908.

Bequest of Martha T. Fiske Collord, in memory of Josiah M. Fiske, 1908.

08.136.1.

Italian Girl

In this oil study for *The Roman Girl* (Bennington Museum, Vt.), the position of the seated figure and the dark neutral setting focus attention on the graceful line of the woman's profile. In the finished painting Hunt made subtle changes in the pose, moving the figure closer to the picture plane and altering the placement of the feet. Then, too, the illumination is softer and the modeling more developed than in the study. Hunt also changed some of the details of the jewelry and costume. The sandals and the Greek key design on the border of the skirt have been eliminated in the final painting. Most important are the girl's features and expression, which in the finished work are idealized.

Dated 1867, the Metropolitan's picture was probably painted in Italy during Hunt's second trip to Europe. In subject and treatment it recalls paintings of the same decade by Jean Baptiste Camille Corot, the French Barbizon artist whom Hunt had seen during his student years and again in Paris in 1866. In *Italian Girl* Hunt captures

the contemplative attitude of Corot's women and adopts his simple, powerful forms. Hunt's palette, however, is both darker and wider in range than the delicate colors used by the French artist.

Hunt's *Italian Peasant Girl*, 1867 (MFA, Boston), shows a half-length view of a similarly dressed woman. Her face is also in profile but her back is turned to the viewer.

Oil on canvas, 16¼ × 8⅜ in. (41.3 × 21.3 cm.).

Signed and dated at lower right: WMHunt (initials in monogram) / 1867.

RELATED WORK: *The Roman Girl*, oil on canvas, 48 × 24 in. (121.9 × 61 cm.), Bennington Museum, Vt.

REFERENCES: B. B[urroughs], *MMA Bull.* 3 (Nov. 1908), pp. 199–200, provides information about the donor and says the painting was done when the artist was in Rome // M. Young, *Apollo* 83 (Jan. 1966), p. 25; ill. p. 26 // M. Hoppin, "William Morris Hunt: Aspects of His Work," Ph.D. diss., Harvard University, 1974, pp. 186–187, compares it to large-scale work in MFA; p. 263, says it may have been done after the larger work but that this is unlikely; p. 291, includes it as no. 135 in a checklist of the artist's works; fig. 182 // MFA, Boston, *William Morris Hunt: A Memorial Exhibition*, cat. (1979), entry by M. J. Hoppin, p. 66, says it probably served as a study for his large Italian Girl (now called Roman Girl, in the Bennington Museum); suggests that, although the Bennington painting is larger than Italian Peasant Boy (MFA, Boston), Hunt viewed these works as companion pieces; notes that the MMA paintings Italian Girl and Italian Boy belonged to the same owner and were exhibited together in the 1879 memorial.

EXHIBITED: MFA, Boston, 1879, *Exhibition of the Works of William Morris Hunt*, no. 94 (deleted from fifth ed. of cat.), as Italian Girl, lent by J. M. Fiske // MMA, 1946, *The Taste of the Seventies*, no. 120.

EX COLL.: Josiah M. Fiske, New York, by 1879–d. 1892; his wife, Martha T. Fiske (later Mrs. George Whitfield Collord), New York and Newport, 1892–1908.

Bequest of Martha T. Fiske Collord, in memory of Josiah M. Fiske, 1908.

08.136.2.

Charles Sumner

Charles Sumner (1811–1874) was born in Boston and educated at Harvard, where he was graduated from the college in 1830 and the law school three years later. He served in the United States Senate for twenty-three years, from 1851 until he died. As a senator, Sumner opposed the fugitive slave law and the Kansas-Nebraska Act, played an important role in the formation of the Republican party, and argued for the emancipation of slaves and for their civil rights. His later years were marred by illness, domestic troubles, and the political problems of Reconstruction.

There is no record of Sumner's having posed for Hunt. Sumner died on March 11, 1874, and the portrait is usually dated around 1875. This date is supported by a newspaper account of March 7, 1875, which reported that "William M. Hunt is engaged in painting a portrait of the late Charles Sumner." The source for the portrait is believed to have been a photograph taken by Allen and Rowell of Boston in 1873. The painting is awkwardly executed and lacks the freshness of Hunt's life portraits, for which he often made preliminary drawings in charcoal. Commissioned by a committee, the portrait was to be presented to Carl Schurz, a fellow senator

Photograph of Charles Sumner by Allen and Rowell. Massachusetts Historical Society.

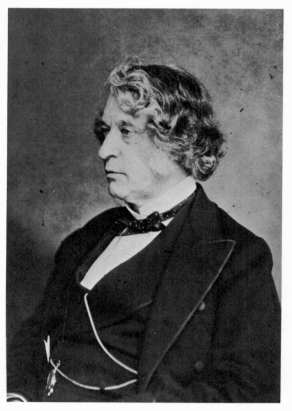

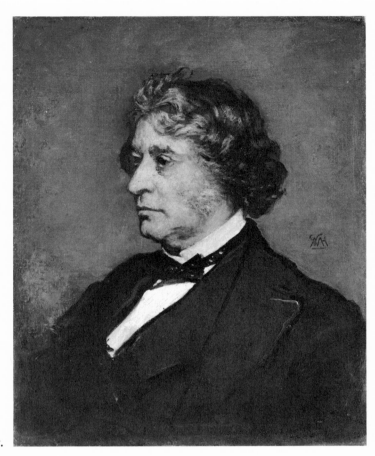

Hunt, *Charles Sumner.*

described as Sumner's "loyal friend, sympathetic in private intercourse, . . . chivalrous and valiant in public defense" (E. L. Pierce, *Visit of the Hon. Carl Schurz to Boston, March 1881* [1881], pp. 61–62). Helen M. Knowlton (1899) recorded the reaction of one committee member to the portrait:

Feeling some doubt of the absolute correctness of the likeness, he took up a pair of calipers, and began to measure the photograph from which the portrait had to have been painted, comparing its measurements with the painting. Hunt was so surprised and amazed at the impertinence that he exclaimed:—"Is your knowledge of art limited to what a pair of calipers can measure? Is Summer's character confined to his nose? You need not do any measuring in my studio!"

Knowlton continued: "the committee who engaged Hunt to paint it were not satisfied, and the artist's bill was never presented."

Another portrait by Hunt (New York art market, 1979) and a sketch for it (lent by Enid Hunt Slater to MFA, Boston) were long thought to depict Charles Sumner. The subject of those works, however, is now identified as William H. Gardiner, whose portrait Hunt painted in 1879 (ill. in MFA, Boston, *William Morris Hunt* [1979], p. 52).

Oil on canvas, 22 × 27 (68.6 × 55.9 cm.).
Signed at upper right: WMH (monogram).

RELATED WORKS: Allen and Rowell, Boston, photograph of Sumner, 1873, bust length and in profile, ill. in E. L. Pierce, *Memoirs and Letters of Charles Sumner* (1893; reprinted 1969), 4, frontis. // Charles Sumner, oil painting, 25 × 30 in. (63.5 × 76.2 cm.), is listed in Warren Chambers, Boston, Feb. 23, 1898, *Exhibition and Subsequent Sale of the Celebrated Paintings and Charcoal Drawings of the Late William Morris Hunt*, no. 23. (This may be another portrait of Sumner or the Metropolitan's painting with frame included in dimensions.)

REFERENCES: *Boston Sunday Herald*, March 7, 1875, p. 2 (quoted above) // J. H. W., *New York Times*, Nov. 24, 1879, p. 3, in a review of the exhibition at the MFA, Boston, mentions painting favorably // H. C. Angell, *Records of William M. Hunt* (1881), p. vii, lists it among his best known portraits // E. L. Pierce,

Memoirs and Letters of Charles Sumner (1893; 1969), 4, p. 610, includes it as no. 17 in a list of Sumner portraits and says it was painted from the Allen and Rowell photograph // L. D. Hunt, list of paintings offered for sale and their values, Nov. 25, 1896, MFA, Boston, microfilm 559, Arch. Am. Art, includes portrait of Sumner, $4,000 // L. D. Hunt to C. G. Loring, Jan. 25, 1897, MFA, Boston, microfilm 560, Arch. Am. Art, says that she would like portrait to remain at the museum pending the arrival of an interested gentleman from New York // C. G. Loring to [E. H.] Slater, Jan. 24, 1898, MFA, Boston, microfilm 548, Arch. Am. Art, says he is sending it to her // H. M. Knowlton, *Art-Life of William Morris Hunt* (1899), pp. 131–132 (quoted above); p. 195 // *Dial* 28 (Jan. 1, 1900), pp. 20–21, mentions it // E. H. Slater to W. Macbeth, Macbeth Gallery Papers, NMc 11, Arch. Am. Art, Nov. 29, 1905, says it is still in the possession of the estate; March 4, [1906], writes, "As you know we have not very many pictures of father's and we would much rather sell the portraits of Lincoln & Sumner or the splendid Hamlet"; n.d. [1905 or 1906?], comments, "We ought to get 10,000 for the two [Lincoln and Sumner portraits], & how I should love to have them in the Metropolitan Museum — or in some appropriate place" // M. A. S. Shannon, *Boston Days of William Morris Hunt* (1923), pp. 78–79, says it was commissioned for presentation to Schurz // MMA, *Eminent Americans* (1939), no. 17 // F. J. Mather, Jr., *Magazine of Art* 39 (Nov. 1946), ill. p. 295 // M. Young, *Apollo* 83 (Jan. 1966), ill. p. 25 // R. A. Welchans, "The Art Theories of Washington Allston and William Morris Hunt," Ph.D. diss., Case Western Reserve University, 1970, pp. 182–183, mentions sitter's "craggy, particularized features"; pl. xxix, misdates it about 1859 // M. Hoppin, "William Morris Hunt: Aspects of His Work," Ph.D. diss., Harvard University, 1974, p. 117; pp. 123–124, says it is one of Hunt's "boldest, most exuberant works," and although it may have been done when the sitter was still alive, it is more likely posthumous, about 1875; notes its similarity to a photograph and engraving and provides stylistic analysis; p. 125, compares it to other Hunt portraits of about the same time; p. 283, includes it as no. 85 in a checklist of the artist's works and lists exhibitions and references; fig. 143 // Art Gallery, University of Maryland, College Park, *The Late Landscapes of William Morris Hunt* (1976), chronology by S. W. McGurn, p. 80 // S. Wagner, MFA, Boston, letter in Dept. Archives, March 21, 1978, reports that there were two portraits of Sumner on loan at MFA with the same measurements as the MMA painting, one between 1914 and 1916 // M. J. Hoppin, *American Art Journal* 11 (April 1979), p. 44, notes Hunt's use of a photograph for this portrait; p. 47, identifies Allen and Rowell photograph as source for portrait and says the same photograph may have been used by William Page in his unfinished portrait of Sumner; dates painting to 1875

on the basis of a contemporary newspaper account; ill. p. 48; pp. 50, 52, discusses the effect of using a photograph as the source.

EXHIBITED: MFA, Boston, 1879–1880, *Exhibition of the Works of William Morris Hunt*, no. 14, lent by the estate of Wm. M. Hunt // MFA, 1880, *Loan Collection of . . . Paintings by the Late William Morris Hunt*, no. 53, lent by the estate of the artist // 14 Grafton Street, Old Bond Street, London, 1881, (no cat. available) // Warren Chambers, Boston, *Exhibition and Subsequent Sale of the Celebrated Paintings and Charcoal Drawings of the Late William Morris Hunt* (1898), sale cat., no. 23, as Portrait of Chas. Sumner, gives measurements as 25 × 30 (possibly this painting) // Town Hall, Milton, Mass. (under the auspices of the Milton Educational Society), 1905, *Catalogue of Loan Exhibition of the Works of William Morris Hunt*, no. 50, Portrait, Charles Sumner, lent by Mrs. Hunt Slater // MMA, 1939, *Life in America*, no. 173, as Charles Sumner, p. 128, discusses; ill. p. 129 // MFA, Boston, 1943, *Boston, Its Life and Its People* (no cat.) // National Gallery of Art, Washington, D. C., 1950, *Makers of Historical Washington*, no. 63 // National Portrait Gallery, Washington, D. C., 1968, *This New Man*, ill. p. 69, dates it 1874–1879.

ON DEPOSIT: MFA, Boston, possibly 1897; 1914–1916, lent by Enid Hunt Slater.

EX COLL.: the artist's estate, Boston, 1879; the artist's wife, Louisa D. Hunt, Boston, d. 1897 (possibly sale, Warren Chambers, Boston, Feb. 23, 1898, no. 23, gives measurements as 25 × 30); the Hunt estate, Enid Hunt Slater as executrix, until 1925.

Amelia B. Lazarus Fund, 1925.

25.182.

Sand Bank with Willows, Magnolia

This picture was painted in 1877, when Hunt spent the summer at Kettle Cove, in Magnolia, a small fishing village near Gloucester, Massachusetts. In this newly established summer colony he converted a barn and carpenter's shop into a studio. From there he took short sketching trips in a wagon that served as a traveling studio. According to Helen M. Knowlton:

The summer of 1877 was productive of much good work. The van was almost daily in requisition, and Hunt painted some excellent landscapes, marines, and wood-interiors. He would start off for the day's work, taking with him Tom, the wagon-boy, and [John G.] Carter, the assistant. Arrived at the spot selected, Hunt would leap from the van, take a camp-stool and a block of charcoal paper, and, with a stick of soft charcoal seize the salient points of the subject to be rendered. While thus engaged the assistant would arrange an easel and select necessary paints

Hunt, *Sand Bank with Willows, Magnolia.*

and brushes. Sometimes he was told to 'lay in' the first painting,—reproducing the effect of the charcoal-sketch, while Hunt would watch intently for the right moment to come, when he would seize palette and brushes, and perhaps complete the picture in one sitting (*Art-Life of William Morris Hunt* [1899], pp. 118–119).

As Martha Hoppin (1979) has observed, the painting retains some features of Hunt's charcoal drawings, notably "broad, soft masses, indistinct edges, . . . and flat forms." This simplification of detail greatly strengthens the composition. Children and tree trunks are reduced to silhouettes that create dark patterns against the glittering sand and water.

Oil on canvas, 24 × 42 in. (61 × 106.7 cm.).

REFERENCES: American Art Association, New York, *Illustrated Catalogue of the Very Notable Collection of American Paintings Formed . . . By Dr. Alexander C. Humphreys . . .*, sale cat. (1917), ill. no. 156, gives provenance, part of which may be incorrect, and describes the picture // *American Art Annual* 14 (1917), p. 365, says that A. M. White purchased it for $3,200 at the Humphreys sale // P. O. Marlow, "William Morris Hunt, His Relationship to the Barbizon School," M. A. thesis, New York University

(1965), p. 17, notes its sentimentality, discusses relationship to works by Rousseau, and analyzes composition; p. 22, relates technique to Daubigny's; fig. 16 // R. C. Vose, Jr., Vose Galleries, Boston, letter in Dept. Archives, Feb. 13, 1978, discusses provenance // A. Boime, *Thomas Couture and the Eclectic Vision* (1980), p. 563, says the painting recalls the Barbizon mood in its "silhouetted forms and melancholy desolation" // Essex Institute, Salem, Mass., *William Morris Hunt and the Summer Art Colony at Magnolia, Massachusetts, 1876–1879*, exhib. cat. by F. A. Scharf and J. H. Wright (1981), p. 11.

EXHIBITED: Horticultural Hall, Boston, 1880, *Exhibition Catalogue of the Paintings and Charcoal Drawings of the Late William Morris Hunt*, no. 43 (of the oil paintings sold Feb. 3) as Sand Bank with Willows, Magnolia, says painted in the summer of 1877 // Lotos Club, New York, 1907, *Exhibition of American Paintings from the Collection of Dr. Alexander C. Humphreys*, no. 31, as Sand Bank with Willows, Magnolia // Carnegie Institute, Pittsburgh, 1914, *Catalogue of an Exhibition of Paintings Lent by Dr. A. C. Humphreys of New York City*, no. 70, as Sand Bank with Willows, Magnolia // Wingate College, Wingate, N. C., 1968, M. Knoedler and Co., Hirschl and Adler Galleries, and Paul Rosenberg and Co., New York, 1968, *The American Vision* (for the benefit of the Public Education Association), no. 106 // University of Maryland Art Gallery, College Park, 1970, *American Pupils of Thomas Couture*, exhib.

cat. by M. E. Landgren, no. 18 // American Feder-
ation of Arts, traveling exhibition, 1975–1976, *The
Heritage of American Art*, no. 49, cat. by M. Davis, ill.
p. 119, and discusses; rev. ed. 1977, no. 49, ill. p. 117 //
MFA, Boston, 1979, *William Morris Hunt: A Memorial
Exhibition*, cat. by M. Hoppin, p. 17 (quoted above),
dates it ca. 1877; p. 76, ill. no. 40, discusses.

Ex COLL.: estate of the artist, Boston (sale of his
estate, Horticultural Hall, Boston, Feb. 4, 1880, no.
43 under oil paintings, $850); Dr. Alexander C.
Humphreys, New York, by 1907 (sale, American Art
Association, New York, Feb. 15, 1917, no. 156, $3,200);
with Otto Bernet, New York, as agent; A. M. White;
with Macbeth Gallery, New York, until 1938; Francis
M. Weld, New York, 1938.

Gift of Francis M. Weld, 1938.

38.153.

The Bathers

William Morris Hunt, THOMAS EAKINS, and
GEORGE FULLER were among the many nine-
teenth-century American artists who depicted
swimming hole themes. This subject reflected
their growing interest in painting the nude in an
outdoor setting. "All of these artists brought a
personal approach and personal experience to
the same subject," commented William H.
Gerdts (1974):

At the same time, their paintings achieved a perfect
mating of an informal and natural presentation of the
nude with the unclassicized, informal natural setting
that was a heritage of the Barbizon tradition. Nature,
like the nude contained within it, was studied and
presented naturally and shown to be in harmony with
her human occupants.

The artist's biographer Helen M. Knowlton
(1899) described the scene that inspired Hunt:

Hunt was driving at the time, and was powerfully
impressed by what he had seen. Against a background
of trees, full of the mystery of the woods, stood a
beautiful nude figure on the shoulders of another
youth whose feet seemed to rest upon the bed of the
shallow stream. The top figure was poising itself be-
fore giving a leap into the water, and its action was
one of sinuous grace. The flesh, with its tints of pearl
and rose, gleamed softly in the shadow of overhanging
trees On seeing this vision of beauty, Hunt drove
back into town, drew at once a small charcoal sketch
of the subject, and from this made his painting.

He completed the first version of the painting
(Worcester Art Museum, Mass.) in 1877. Ac-
cording to Knowlton (1899), it was sold to

Charles Fairchild with the understanding that
Hunt could "repeat the subject on a somewhat
larger canvas." That same year he did a second,
and larger, version, which is the Metropolitan's
painting. Writing on December 14, 1905, the
artist's daughter Enid Hunt Slater noted that
this was the one "father . . . much preferred."

There are subtle variations between the two
paintings, notably in the drawing of the standing
figure. Of the first, Hunt admitted,

I don't pretend that the anatomy of this figure is
precisely correct. In fact, I know it is not. It's a little
feminine; but I did it from memory, without a model,
and was chiefly occupied with the pose. I *do* think the
balancing idea is well expressed, and it is the fear of
disturbing that which prevents my making any
changes in the contour of the figure. I know I could
correct the anatomy, but if the pose were once lost I
might never be able to get it again (Angell, 1881).

In the Metropolitan painting, however, Hunt
does seem to try to "correct" the earlier version.
The draftsmanship is more decisive, and the
figure thus appears more muscular. The waist
is thinner, and the shoulders have a broader,
more powerful appearance. The pose has also
been altered: the left forearm is extended at a
less severe angle and the torso is held more
rigid, without the gentle curve along the right-
hand side.

According to Helen M. Knowlton's notes
(1884), Hunt showed his students a photograph
of one of the two paintings and commented on
its meaning. He described the figure as "Youth,
or Summer, going forth, seeming to walk mi-
raculously on the surface of the water." The
bather would be balanced for a long time, "never
getting anywhere until he has made his dive into
the Unknown." The artist's explanation of the
meaning of the painting is a poignant one in
light of subsequent events. Less than three years
later, Hunt was found dead, floating in a shal-
low pool of water on Appledore Island, where
he had been visiting his friend, Celia Thaxter,
the poet.

Oil on canvas, 38 × 25 in. (96.5 × 63.5 cm.).

RELATED WORKS: Two charcoal drawings for *The
Bathers* are listed in Warren Chambers, Boston, *Ex-
hibition and Public Sale of the Celebrated Paintings and
Charcoal Drawings of the Late W. M. Hunt*, sale cat.
(1898), nos. 88 and 94. One of these may be *Sketch
for "The Bathers,"* charcoal on paper, 18 15/16 × 15 9/16
in. (48.1 × 39.5 cm.) Worcester Art Museum, Mass.,
1942.44, ill. in University of Maryland, *The Late*

Hunt, *The Bathers.*

Landscapes of William Morris Hunt (1976), p. 75 // *The Bathers*, 1877, oil on canvas, 24 5/16 × 16 1/8 in. (62.6 × 41 cm.), Worcester Art Museum, Mass., 1910.21, color ill. in W. H. Gerdts, *The Great American Nude* (1974), p. 116 // Stephen A. Schoff, engraving after *The Bathers*, published by John A. Lowell and Company, ca. 1880.

REFERENCES: *New York Times*, Jan. 1, 1878, p. 4, in a review of the loan exhibition at the NAD, says lent by Miss Jane Hunt, compares it to a landscape by Narcisse Virgile Diaz de la Peña and calls it "an example of the unconscious in painting. It is not merely a wonderful little piece of woodland landscape, with a nude figure gracefully and boldly painted in the foreground, but the bearing of the whole speaks of an artist quite unconscious of any spectators" // S. N. Carter, *Art Journal* [New York] 4 (Dec. 1878), p. 378, describes it at NAD loan exhibition as "one of the most charming pictures in the whole gallery" // *Art Interchange* 1, suppl. [following Dec. 25, 1878], unpaged, in a review of the loan exhibition at the NAD, says it is "merely a sketch from memory," but "there is a truth of action which could hardly be improved by more careful study" // *New York Times*, Feb. 5, 1880, p. 4, in a discussion of Hunt's estate sale, notes that it was offered but did not meet its reserve of $12,000 // *New-York Daily Tribune*, Feb. 8, 1880, p. 7, in a review of the estate sale, says it was not sold and that it is being sent to Europe for exhibition // *Art Interchange* 4 (Feb. 18, 1880), p. 31, says that it was bought in when it did not meet reserve // S. W. Whitman, *International Review* 8 (April 1880), p. 399, notes that after his work in Albany, Hunt "added the finishing touches to the picture of the 'Bathers,' now well known" (probably this painting) // H. C. Angell, *Records of William M. Hunt* (1881), pp. vii-viii; pp. 110–111 (quoted above) // H. M. Knowlton, comp., *W. M. Hunt's Talks on Art* (1884), second series, p. 94 (quoted above) // L. D. Hunt (artist's widow), list of paintings offered for sale and their values, Nov. 25, 1896, MFA, Boston, microfilm 559, Arch. Am. Art, offers it to the Boston Museum for $8,000; letter to C. G. Loring, Jan. 25, 1897, MFA, Boston, microfilm 560, Arch. Am. Art, says that she would like to keep it at the Boston Museum pending the arrival of a New York gentleman interested in the picture // *Collector* 8 (March 15, 1897), p. 150, mentions that Mrs. W. M. Hunt has lent it to an exhibition of Boston's masterpieces at Copley Hall // C. G. Loring to "Mrs. Slater" (one of artist's daughters), Jan. 24, 1898, copy, MFA, Boston, microfilm 548, Arch. Am. Art, says he is holding it pending future orders // H. M. Knowlton, *Art-Life of William Morris Hunt* (1899), pp. 120–121 (quoted above) // E. H. Slater (artist's daughter) to C. G. Loring, Oct. 18, 1900, MFA, Boston, microfilm 562, Arch. Am. Art, says it "is to be mended by Harold . . . Fletcher on Tremont Street, near West" // *New York Times*, Nov. 11, 1904, p. 5; Nov. 16, 1904, p. 8, in review of the comparative

exhibition, describes it as "the spirited scene of boys in a pool" // A. N. Meyer, *Harper's Weekly* 48 (Dec. 3, 1904), p. 1841, in a review of the comparative exhibition, calls it a "splendid animated nude" // S. Isham, *History of American Painting* (1905), p. 314, says that Hunt "neither corrected the faults nor retained the freshness of the original sketch" // C. H. Caffin, *The Story of American Painting* (1905), pp. 130–134, notes its inclusion in the exhibition at American Fine Arts Society and says "it is vastly superior" to mid-nineteenth-century American paintings because of "the poise of the figure, the elastic force of the body and limbs" and "the charm of colour as the sunlight plays over the nude form"; *American Illustrated Magazine* 61 (Nov. 1905), ill. p. 25 and discusses; pp. 26, 29, notes that there is "an idea involved in its subject that appeals to the imagination" // E. H. Slater to W. Macbeth, Macbeth Papers, NMc 11, Arch. Am. Art, Nov. 29, 1905, mentions it in answer to Macbeth's inquiry about the availability of works from the estate; Dec. 8, 1905, lists it among works in the estate and values it at $12,000; Dec. 14, 1905, notes it as the version of the painting that Hunt preferred (quoted above) and says, "The Bathers is the one you have seen at all the great exhibitions—it was at the Comparative Art-Ex in N. Y. & they tell me perhaps as much admired as any thing there. It hung on the line & I am sure you saw it in the room with father's portrait of Mrs. Richard Morris Hunt"; [1905 or 1906], mentions that it will be sent to the Corcoran for the summer // *Masters in Art* 9 (August 1908), pp. 32, 35 // P. J. G[entner], *Bulletin of the Worcester Art Museum* 1 (Nov. 1, 1910), pp. 2-3, compares the two versions // E. H. Slater to Macbeth, Feb. 20, 1913, Macbeth Papers, NMc 11, Arch. Am. Art, includes it in a list of those works still in the estate, suggests a value of $12,000 for it, and asks his advice about dispersal of the estate // M. A. S. Shannon, *Boston Days of William Morris Hunt* (1923), ill. p. 114, gives collection as MFA, Boston, where it was then on loan from the Hunt estate; pp. 126–129, calls it "one of the most original and striking of all Hunt's works" and "almost the only example of the nude which Hunt executed"; *American Magazine of Art* 15 (May 1924), ill. p. 224; p. 229, discusses it // H. Cahill and A. H. Barr, Jr., eds., *Art in America in Modern Times* (1934), p. 19 // J. L. Allen, *MMA Bull.* 31 (Oct. 1936), pp. 211–212, discusses it and related version in the Worcester Art Museum, misdates it 1878, gives provenance, and lists exhibitions and loans // D. L. Smith, *American Artist* 26 (March 1962), ill. p. 32; p. 64, mistakenly calls it The Swimmers // M. Young, *Apollo* 83 (Jan. 1966), ill. p. 28; p. 29 // University of Maryland, Art Gallery, College Park, *American Pupils of Thomas Couture* (1970), exhib. cat. by M. E. Landgren, pp. 40–41, discusses it // W. H. Gerdts, *The Great American Nude* (1974), p. 128 (quoted above); p. 130, dates it to 1877, after the Worcester version // University of Maryland, Art Gallery,

College Park, *The Late Landscapes of William Morris Hunt* (1976), essay by M. E. Landgren, pp. 34, 42; p. 44, quotes a review of the 1878 NAD exhibition that compares it to a painting by Bouguereau; p. 74, in chronology by S. W. McGurn, discusses its exhibition in Boston in 1877 and says it is the version engraved by Schoff, quotes a contemporary review, describing it as "masterly in its action, and transparent in the flesh-color, the foliage being subordinated in the fine manner for which Mr. Hunt is noted"; p. 76, quotes a review of the 1878 exhibition; p. 78, says it remained unsold after estate sale in 1880 and was exhibited in London in May and June 1881; p. 80, notes that it was among the works offered to the MFA, Boston, it was included in the Warren Chambers sale, and Enid Hunt Slater lent it to the Corcoran Gallery of Art in 1905–1907 // S. Wagner, MFA, Boston, letter in Dept. Archives, March 21, 1978, verifies its loan to the museum between 1914 and 1926, says there is no record of loan in 1897, 1898, 1900 // A. Boime, *Thomas Couture and the Eclectic Vision* (1980), pp. 564, 566, relates its style to his training with Couture.

EXHIBITED: NAD, New York, 1877, *Loan Exhibition in Aid of the Society of Decorative Art*, no. 211, as Children, lent by Miss Jane Hunt (probably this painting); 1878, *Catalogue of the Loan Exhibition—1878 — in Aid of The Society of Decorative Art*, no. 79 // Massachusetts Charitable Mechanics Association, Boston, 1878, no. 394, The Bathers (probably this painting) // Horticultural Hall, Boston, 1880, *Exhibition Catalogue of the Paintings and Charcoal Sketches of the Late William Morris Hunt*, sale cat., no. 46 under oil paintings, as The Bathers; misdates it 1878 and gives measurements as 25 × 28 // 14 Grafton Street, London, 1881 (no cat. available) // St. Botolph Club, Boston, 1887, *Catalogue of Loan Exhibition*, no. 22 // Art Institute of Chicago, 1887, *Catalogue of the Loan Collection of Paintings Exhibited . . . at the Opening of the New Art Museum*, no. 6, lent by Mrs. W. M. Hunt, Boston // St. Botolph Club, Boston, 1894, *Catalogue of a Loan Collection of Oil Paintings by William Morris Hunt*, no. 20, as The Bathers, lent by Mrs. W. M. Hunt // Warren Chambers, Boston, 1898, *Exhibition and Public Sale of the Celebrated Paintings and Charcoal Drawings of the late W. M. Hunt*, no. 15, as The Bathers, large picture, misdates it 1878, and gives measurements as 24 × 36 // American Fine Arts Society, New York, 1904, *Comparative Exhibition of Native and Foreign Art under the Auspices of the Society of Art Collectors*, no. 77, lent by Mrs. Hunt Slater // Royal Academy, Berlin, and Royal Art Society, Munich, 1910, *Austellung Amerikanischer Kunst*, no. 112, lent by Mrs. Enid Hunt Slater // MFA, Boston, 1924, *Catalogue of a Memorial Exhibition of the Works of William Morris Hunt, 1824–1879*, no. 77, as The Bathers, lent by estate of Louisa D. Hunt // Albright Art Gallery, Buffalo Fine Arts Academy, 1924, *Centennial Exhibition of Paintings by William Morris Hunt*, cat. by C. B. S. Quinton, no. 15, as The Bathers, lent by Mrs. Enid Hunt Slater, Boston // Fogg Art Museum, Cambridge, Mass., 1939, *New England Genre*, no. 15 // New York Cultural Center (in association with Fairleigh Dickinson University); Minneapolis Institute of Arts; University of Houston Fine Art Center, 1975, *Three Centuries of the American Nude*, introduction by W. H. Gerdts, no. 26, dates it 1877 // J. N. M. Howells, William Dean Howells Memorial, Kittery, Me., letter in Dept. Archives, Nov. 18, 1979, discusses a photograph of The Bathers signed by Hunt // MFA, Boston, 1979, *William Morris Hunt*, essay by M. Hoppin, p. 17, cites it as an example of Hunt's difficulty in completing a painting; catalogue, p. 70, discusses its meaning, notes that contemporary sources agree that the Worcester painting was done first and that this picture was begun "in order to make corrections on the first as he was unwilling to disturb the freshness and pose of his original work," calls it "larger and more finished in effect"; p. 71, ill. no. 35, dates it ca. 1877–1878 and lists exhibitions.

ON DEPOSIT: Corcoran Gallery of Art, Washington, D. C., 1905, 1906–1907, 1907, lent by Enid Hunt Slater // MMA, 1908–1914, lent by Enid Hunt Slater // MFA, Boston, 1914–1926 // MMA, 1926, lent by Enid Hunt Slater // Virginia Museum of Fine Arts, Richmond, 1947–1950.

EX COLL.: the artist's sister, Jane Hunt, Newport, 1878; artist's estate (Horticultural Hall, Boston, Feb. 4, 1880, no. 46 under oil paintings, as The Bathers, reserved at $12,000 and not sold); the artist's widow, Louisa Dumaresq Hunt, Boston, d. 1897; her estate (Warren Chambers, Boston, Feb. 23, 1898, no. 15 of the oil paintings, as The Bathers, apparently bought in); the Hunt estate, with the artist's daughter Enid Hunt Slater as executor, until at least 1926; estate of Enid Hunt Slater; with Charles D. Wheelock, as agent.

Morris K. Jesup Fund, 1936.
36.99.

Anahita: A Study for *The Flight of Night*

Anahita, the Persian goddess of the moon and the night, is the central figure in *The Flight of Night*, one of two murals that Hunt painted for the New York State Capitol in Albany in 1878. The murals, which were done directly on sandstone, quickly deteriorated from dampness. The decision to conceal them by constructing a wooden ceiling twenty feet below was made in the winter of 1887–1888, and the ruined murals remain hidden today. Nevertheless, this ambitious project did much to revive interest in mural painting in America late in the last century.

This particular study shows Anahita much as she appears in the finished work. The partially draped figure is silhouetted by the glow of the crescent moon in a background of clouds. The idea for *The Flight of Night* came to Hunt in 1846 when his brother Leavitt gave him a translation of a Persian poem that described Anahita:

... So swift her course,
So bright her smile, she seems on silver wings, ...
Behind, far-flowing, spreads her deep blue veil
Yet all, with even-measured footsteps, mark
Her onward course, and floating in her train
Repose lies nestled on the breast of Sleep,
While soft Desires enchain the waists of Dreams,
And light-winged Fancies flit around in troops
(quoted in H. M. Knowlton [1899], p. 79).

Hunt began work on *The Flight of Night* in 1847, while he was still a student of Thomas Couture, and continued to rework and refine it until 1878, the year before his death.

Anahita must be interpreted as part of the entire mural *The Flight of Night* and in relation to its companion, *The Discoverer* (see *Fortune* below). Writing a decade after the execution of the two murals, the artist's wife explained that they represented "the great opposing Forces which control all nature" and

must absolutely be taken *in conjunction* to be rightly understood, as each is the complement of the other. They represent Negative and Positive—Night and Day—Feminine and Masculine—Darkness and Light—Superstition and Science—Pagan and Divine Thought—Self and Altruism, and youth here may find a lesson as grand as Homer and the ancients ever taught (*The Paintings on Stone at the Albany Capitol, New York, U.S.A., by William Morris Hunt completed [1878]* [1888], annotated copy, NYPL).

Anahita, representing the negative or feminine force, is being driven from "her realms of Fantasy and Unreality, impelled by the dawn of civilization," which is portrayed in *The Discoverer*. Anahita looks for the last time on the kingdom she is about to relinquish, while a slave

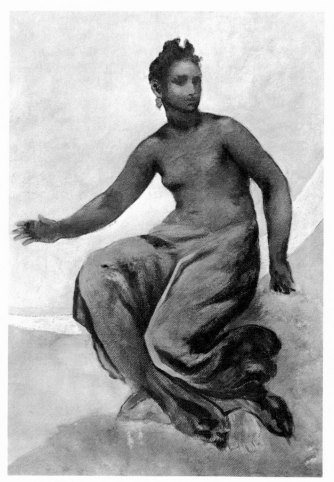

Hunt, *Anahita: A Study for The Flight of Night.*

Hunt, *The Horses of Anahita*, plaster relief.

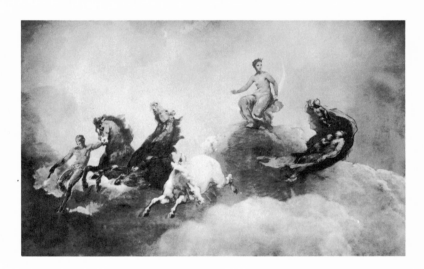

Hunt, *The Flight of Night*, 1878, oil and chalk on canvas. PAFA.

restrains the horses. A sleeping mother and child are enclosed in Anahita's trailing veil where a cherub shields their eyes from the coming dawn.

There are a number of possible visual sources for the composition of Hunt's *The Flight of Night*. He must have known baroque decorations depicting Aurora, the Roman goddess of the dawn. In his treatment of Anahita, however, Hunt was most strongly influenced by contemporary French paintings that he saw as a student in Paris. He was certainly inspired by the paintings of Thomas Couture, his instructor during the years when he first considered the Anahita subject. Albert Boime has pointed to the similarities between Hunt's Anahita and Liberty in Couture's sketches for *The Enrollment of the*

Volunteers, 1848 (Musée Départemental de l'Oise, Beauvais), especially in the first version now in the Museum of Fine Arts, Springfield, Massachusetts (ill. Boime [1980], p. 196). Liberty, the focal point of Couture's composition, is enhanced by strong illumination. Using the same approach in his treatment of Anahita, Hunt presents her as an idealized, partially draped figure illuminated from behind. In a discussion of Couture's painting, Boime notes several possible sources (pp. 203–207). Some of these, such as Michel Martin Drölling's ceiling *The Law Descends to Earth*, 1825 (Louvre, Paris), may well have been known to Hunt. Couture's influence is not limited to the mural's composition, for the strong outlines and roughly scumbled paint de-

monstrate Hunt's continued reliance on Couture's technique.

Henry Adams (1980) isolated four periods of activity during which Hunt developed the composition for *The Flight of Night*. The initial work dates from 1847 to 1850, when he determined the overall format. Hunt resumed work on the composition during the 1860s in his Newport studio. By this time he seems to have arrived at the composition that would appear in the finished mural fifteen years later but not to have defined the figures within the groupings. The third phase of work occurred in 1872, when Hunt did a large-scale version of *The Flight of Night* (destroyed), in which some figures were much altered but Anahita remained unchanged. The picture was then close to its final appearance, except for small details. Hunt concluded the composition in 1878, when he was working feverishly on the Albany murals. The Metropolitan study was probably done during this last period and thus dates from 1878.

Oil on canvas, 37 × 25½ in. (94 × 64.8 cm.).
RELATED WORKS: *Study for Anahita*, pencil on paper in sketchbook, image 4 11/16 × 7 5/16 in. (12 × 18.5 cm.), American Institute of Architects, Washington, D. C., is the artist's first conception of the composition // *The Horses of Anahita (The Flight of Night)*, probably circa 1849 but certainly by 1866, plaster relief painted brown, 18½ × 28½ in. (47 × 72.4 cm.), MMA, 80.12, ill. in A. T. Gardner, *American Sculpture* (1965), p. 22. Other public collections that have casts include the MFA, Boston, and the Isabella Stewart Gardner Museum, Boston. P. P. Caproni and Brother, Boston, marketed a plaster cast as late as 1929 // *Study for Anahita*, 1863, oil on panel (on a Japanese tea tray), 9 × 14½ in. (22.9 × 36.8 cm.), MFA, Boston, 97.203 // *Anahita*, painting, ca. 1872, unlocated but recorded in a photograph at the American Institute of Architects, Washington, D. C., ill. in Adams (1980), fig. 12B // *Anahita: The Flight of Night*, charcoal, 11 5/8 × 16 15/16 in. (29.5 × 43 cm.), Art Museum, Princeton University, 43–26, ill. in B. T. Ross, *American Drawings in the Art Museum, Princeton University* (1976), p. 48 // *Anahita, Flight of Night*, pastel on paper, sight 9¼ × 22¼ in. (23.5 × 56.5 cm.), Colby College Art Museum, Waterville, Me., 64–P–2 // *Study for Anahita*, before 1872, oil on panel, 9 × 14½ in. (22.9 × 36.8 cm.), MFA, Boston, 97.203 // *Anahita*, 1878, oil on canvas, 25 × 21½ in. (63.5 × 54.6 cm.), MFA, Boston, 21.2173, ill. in M. A. S. Shannon (1923), opp. p. 128 // *Anahita: The Flight of Night*, 1878, oil on canvas, 62 × 99 in. (157.5 × 251.4 cm.), MFA, Boston, 44.48, ill. in *American Paintings in the Museum of Fine Arts, Boston* (1969), 2, p. 231 // *Sketch for the State Capitol at Albany (The Flight of Night)*, 1878, oil

on panel (in a scalloped lunette frame), 16 × 36¾ in. (40.6 × 93.3 cm.), Mrs. Enid Hunt Slater, on loan to MFA, Boston, 104.14 // *Study for Anahita, or The Flight of Night*, gouache, 16 × 36 in. (40.6 × 91.4 cm.), coll. William Morris Hunt II, Milton, Mass., ill. in University of Maryland, *American Pupils of Thomas Couture* (1970), p. 42 // *The Flight of Night*, 1878, oil and chalk on canvas, 62 × 99 in. (157.5 × 251.4 cm.), PAFA, ill. in W. H. Gerdts, *The Great American Nude* (1974), p. 131 // *The Flight of Night*, 1878, oil on sandstone, 15 × 45 ft. (4.57 × 13.71 m.), finished mural in the assembly chamber, New York State Capitol, Albany, ill. in University of Maryland, *The Late Landscapes of William Morris Hunt* (1976), p. 39. Ruined by dampness, the mural is concealed by a false ceiling.

REFERENCES: W. M. Hunt to R. Lamb, William Morris Hunt Misc. MSS, Arch. Am. Art, n.d., Oct. 17, Oct. 23, Oct. 30, Nov. 8, Nov. 18, Dec. 23, 1878, provides detailed information about his procedure in painting the murals. // *Art Journal* (New York) 6 (August 1880), p. 255, reports an interview with Hunt's assistant, Carter, who asserts that the designs for the murals were begun in 1846 or 1847 and 1856 // H. C. Angell, *Records of William M. Hunt* (1881), pp. viii-x, pp. 59–66, 69–71, 120–125, provides lengthy discussion of commission and preparatory studies // H. M. Knowlton, *The Art-Life of William Morris Hunt* (1899), p. 79, includes translation of Persian poem (quoted above); pp. 157–180, discusses commission // M. Wetherbee, letter in Dept. Archives, March 11, 1911, says that her father purchased the study from Hunt's studio before the 1880 sale // B. B[urroughs], *MMA Bull.* 6 (April 1911), p. 100 // M. A. S. Shannon, *Boston Days of William Morris Hunt* (1923), pp. 122, 124–125, 135, 139–153, discusses commission; ill. opp. 104, photo of Hunt's studio showing various studies for the commission // A. T. Gardner, *MMA Bull.* 3 (May 1945), pp. 222–227, discusses Albany murals; p. 225, says that Hunt's wife posed for Anahita; ill. p. 226 // University of Maryland, Art Gallery, College Park, *The Late Landscapes of William Morris Hunt* (1976), essay by M. E. Landgren and chronology by S. W. McGurn, p. 14, notes his early work on the sculpture of Anahita; pp. 36–40, 60, 76, 78, discusses project // MFA, Boston *William Morris Hunt* (1979), essay by M. Hoppin, pp. 18–19, discusses commission, theme, and Hunt's development of the mural; essay by H. Adams, p. 25, 27, discusses Hunt's work on the mural; catalogue by M. Hoppin, p. 73, discusses the mural and preliminary studies // A. Boime, *Thomas Couture and the Eclectic Vision* (1980), p. 508, 567–568, notes Couture's influence on the murals // H. Adams, letters in Dept. Archives, August 24, 1980, dates Hunt's first period of work on the mural between 1847 and 1850; discusses the ongoing development of the composition and its artistic sources; Oct. 25, 1980, dates the study to the summer of 1878 and speculates that Hunt made the Metropolitan's two studies "almost simul-

Hunt, *Fortune: A Study for The Discoverer*.

taneously, in the same phase of his preparations for the murals"; discusses versions of Anahita done by Hunt before 1878; "The Development of Hunt's Murals at Albany," typescript of essay [1980], copy in Dept. Archives, gives four periods for work on the mural: 1847–1853, 1861–1863, 1872, and 1878; discusses the various artistic sources; discusses Hunt's work on Anahita in 1878, when the study was probably executed, and describes changes made in the figure at that time.

EXHIBITED: Art Institute of Chicago, 1905, no. 180, as Study for the Figure in "Flight of Night" // Art Institute of Chicago, 1939, *Half a Century of American Art*, no. 81 // World's Fair, New York, 1940, *Masterpieces of Art*, no. 303.

EX COLL.: Winthrop Wetherbee, Boston, from 1880; his daughter, Martha Wetherbee, until 1911.

Rogers Fund, 1911.

11.34.2.

Fortune:
A Study for *The Discoverer*

The Discoverer is one of two murals (see *Anahita*, above) that Hunt executed for the New York State Capitol at Albany. In it Columbus is shown approaching the New World accompanied by several allegorical figures: Faith, her eyes hidden, leads the expedition; Hope stands at the prow with her arm extended; Science, with her back to the viewer, holds a chart for Columbus to consult; and Fortune takes the helm. The artist's wife described this last figure "with wings half out-spread," and:

placed *behind* Columbus (which is very significant). Her left hand grasps the tiller which guides this whale-shaped craft; around her right arm is wreathed the rude sail. Storm winds fill it full, and drive them

outward to the West (*The Paintings on Stone at the Albany Capitol . . .* [1888]).

Henry Adams (1980) identified a number of sources for the figure of Fortune and discusses its evolution. Hunt's first conception shows her reclining like an antique river god. Later she assumes the commanding pose seen in this study and in the finished mural. Here, with her arm raised in a gesture of encouragement and her body only partially draped, Fortune recalls Liberty, the symbolic figure in Couture's *Enrollment of the Volunteers,* 1848 (Musée Départemental de l'Oise, Beauvais). Hunt was also indebted to a classical source, the Venus de Milo.

Hunt made many studies for *The Discoverer.* The Metropolitan's painting relates most closely to several large studies of the figure Fortune, two in oil (Swarthmore College, Pa., and Cleveland Museum of Art) and two in charcoal (MFA, Boston, and Fogg Art Museum, Cambridge, Mass.). All show a three-quarter view with slight variations, mainly in her face. Inasmuch as two of these are signed and dated 1878, it seems likely that the Metropolitan's painting was done the same year.

Oil on paper, 37 × 25½ in. (94 × 64.1 cm.).

RELATED WORKS: *The Discoverer,* pastel on paper, sight 9⅝ × 25¾ in. (24.5 × 65.4 cm.), Colby College Art Museum, Maine, 64-P-1 // *The Discoverer: Composition Study and Figure Sketches,* charcoal and pencil, 14 × 20 in. (35.5 × 50.6 cm.), Art Museum, Princeton University, 45-83, ill. in B. T. Ross, *American Drawings in the Art Museum, Princeton University* (1976), p. 49 // *The Discoverer: Two Composition Studies,* charcoal, 11¾ × 17 in. (30 × 43.5 cm.), Art Museum, Princeton University, 44-547, ill. in ibid., p. 50 // *Sketch for the State Capitol at Albany (The Discoverer),* oil on wood (in a scalloped lunette frame), 16 × 36¾ in. (40.6 × 93.3 cm.), MFA, Boston, 105.14, ill. in *American Paintings in the Museum of Fine Arts, Boston* (1969), 2, p. 231 // *Study for "The Discoverer,"* charcoal on cream laid paper, 11⅓ × 17½ in. (28.8 × 44.2 cm.), Fogg Art Museum, Harvard University, Cambridge, Mass., 1936.10.66, shows Fortune reclining // *Study for "The Discoverer,"* pastel on heavy brown paper, irregular 12½ × 18¼ in. (31.7 × 46.4 cm.), Fogg Art Museum, 1956.237 // *Study for "The Discov-*

erer," charcoal on off-white watercolor paper, 14 15/16 × 21 3/16 in. (37.9 × 53.9 cm.), Fogg Art Museum, 1956.238 // *Study for "The Discoverer,"* charcoal on cream laid paper, 8⅞ × 11 9/16 in. (22.5 × 29.4 cm.), Fogg Art Museum, 1956.239 // *Study for "The Discoverer",* charcoal on off-white laid paper, 11⅛ × 17 1/16 in. (28.2 × 43.3 cm.), Fogg Art Museum, 1956.240 // William Rimmer, *The Discoverer,* black chalk and graphite on cream laid paper, 11½ × 17½ in. (29 × 44.5 cm.), Fogg Art Museum, 1936.10.64, "corrected" version of one of Hunt's drawings // *Fortune at the Helm,* 1878, charcoal on tan paper, sight 83 × 54 in. (210.8 × 137.2 cm.), MFA, Boston, 99.121 // *Study for the Figure of "Fortune" in the State House Assembly Room Fresco at Albany,* 1878, charcoal with touches of graphite on cardboard, sight 37⅝ × 25 9/16 in. (95.6 × 64.9 cm.), Fogg Art Museum, 1949.21 // *Winged Fortune No. 1,* oil on canvas, 84 × 60 in. (213.4 × 152.4 cm.), Swarthmore College, Pa. // *Winged Fortune,* oil on canvas, 99 × 63 in. (251.5 × 160 cm.), Cleveland Museum of Art, ill. in *Bulletin of the Cleveland Museum of Art* 58 (Feb. 1971), p. 38 // *Large sketch for The Discoverer,* oil on canvas, ex coll. Steven Juvelis, Lynn, Mass., now divided into five sections and dispersed // *The Discoverer,* 1878, oil on sandstone, 15 × 45 ft. (4.57 × 13.71 m.), finished mural in the assembly chamber, New York State Capitol, Albany, ill. in University of Maryland, *The Late Landscapes of William Morris Hunt* (1976), p. 39. Ruined by dampness, the mural is concealed by a false ceiling.

REFERENCES (see preceding entry): H. Adams, "The Development of Hunt's Murals at Albany," typescript of essay [1980] copy in Dept. Archives, p. 32, in a discussion of the great number of studies for the Fortune figure, suggests that it was "preparatory to the large compositional study"; pp. 37–46, says that the development of *The Discoverer* mural cannot be followed in as much depth as that of *The Flight of Night;* notes that the figure of Fortune was revised heavily in 1878, the second period of Hunt's work on the mural; identifies its source as the classical Venus de Milo.

EXHIBITED: Art Institute of Chicago, 1905, no. 179, as Study for figure in "The Discoverer."

EX COLL.: the artist, Boston, d. 1879; Winthrop Wetherbee, 1879; his daughter, Martha Wetherbee, Boston, until 1911.

Rogers Fund, 1911.

11.34.1.

Hunt, *Fortune at the Helm*,
charcoal on tan paper.
MFA, Boston (99.121).

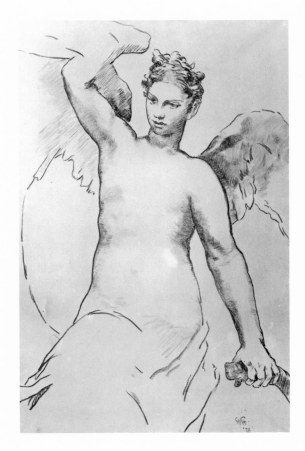

Hunt, *Large Sketch for The Discoverer*, oil on canvas.
Photograph courtesy of Steven Juvelis.

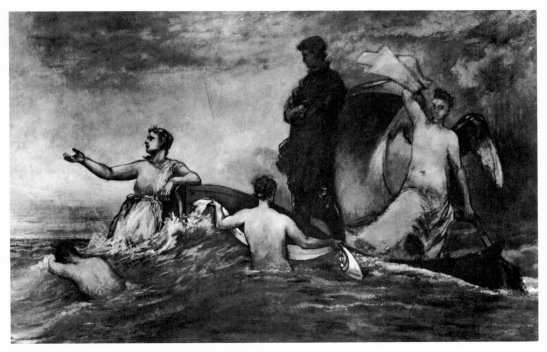

EASTMAN JOHNSON

1824–1906

Jonathan Eastman Johnson was born in Lovell, Maine, on July 29, 1824. He spent his child-hood in Fryeburg and Augusta, the state capital, where his father, Philip Carrigan Johnson, was secretary of state for some thirty years. After finishing school, Johnson worked for about a year as a clerk in a drygoods store. He showed a natural inclination for drawing, however, and about 1840 his father placed him as an apprentice in a Boston lithographer's shop. John I. H. Baur suggests it was Bufford's, where WINSLOW HOMER later served an apprentice-ship. Johnson designed title pages for books and music, but like Homer, he found the work tedious. In 1842 Johnson returned to Maine and established himself as a portraitist. He drew sketches in pencil, charcoal, chalk, and crayon of his relatives and his father's friends from the state legislature. According to his early biographer, William Walton, Johnson visited Newport and spent several months in Portland, where he executed portraits, now unlocated, of Henry Wadsworth Longfellow's parents.

Realizing that Washington had more to offer an aspiring portraitist, Johnson moved to the capital in 1844 or 1845. Shortly thereafter, his father was appointed chief clerk in the Navy's Bureau of Construction and Repair, and the rest of the family came to Washington. Johnson obtained permission, probably through his father's influence, to use one of the Senate committee rooms as a studio. His sitters included Mrs. Alexander Hamilton, Dolley Madison, John Quincy Adams, and members of Congress and the Supreme Court. In 1846 Johnson went to Boston at the invitation of Longfellow, who commissioned him to draw portraits of himself, his family, and his friends Ralph Waldo Emerson, Nathaniel Hawthorne, Charles Sumner, and Cornelius Conway Felton. In Boston, where he had a studio in Amory Hall and later in Tremont Temple, Johnson began working in pastel and reportedly first experimented with oil painting. On August 14, 1849, with fellow artist George Henry Hall (1825-1913), he sailed to Europe to study painting at the Düsseldorf Academy. On October 10, 1850, he sent two oils to the American Art-Union with an apology that they were rather early attempts in his practice of the medium. By that time he had concluded that, although the Düsseldorf school excelled in landscape, "their works of history & genre" lacked "truth & richness of color, qualities so congenial and indispensable in the eyes of American artists" (E. Johnson to A. Warner, Oct. 10, 1850, Letters from Artists, American Art-Union Papers, NYHS). In January 1851, Johnson joined the studio of EMANUEL LEUTZE, who was about to begin his second version of *Washington Crossing the Delaware* (q. v.). Johnson regretted that he had not spent all of his time in Düsseldorf with Leutze, under whose direction he painted a small copy of *Washington Crossing the Delaware*, 1851 (Alex and Marie Manoogian Foundation, Detroit), for the engraver.

Johnson left Düsseldorf in the summer of 1851. After a brief visit to Amsterdam and then London to see the International Exposition, he settled in The Hague, where he spent the next three and a half years studying the paintings of seventeenth-century Dutch and Flemish masters. Their styles were the antithesis of the tight style associated with Düsseldorf. Johnson made copies after Rembrandt and Van Dyck, painted heads, figures, and genre pieces in the

Dutch tradition, and worked on portrait commissions secured largely with the help of August Belmont, then United States ambassador at The Hague. In 1855 Johnson left for Paris, which had become an increasingly popular center for American artists. There he pursued his studies under the direction of Thomas Couture. The death of his mother prompted Johnson's return to the United States in October of 1855.

Back in Washington, Johnson painted some portraits but soon turned to genre subjects. In the summer of 1856 he visited his sister in Superior, Wisconsin, where he saw the American frontier at first hand before returning to Washington probably in the late spring of 1857. Accompanied by LOUIS REMY MIGNOT, Johnson visited George Washington's home, Mount Vernon, during the summer and painted the first of several works that it inspired. Later the same summer he paid a second visit to Superior. He spent several months at Grand Portage, one of the camps of the Chippewa Indians. There he did a series of paintings and drawings of Indian life, including a remarkable set of portraits, which, aside from their documentary value, are among his most powerful works in portraiture. After leaving Wisconsin, Johnson went to Cincinnati, where he set up a portrait studio in the Bacon Building at Sixth and Walnut streets.

In April 1858, Johnson moved to New York and took a studio in the University Building on Washington Square. He stayed there until 1872 when he moved to 65 West 55th Street. In 1859 he finished his painting *Old Kentucky Home — Life in the South* (NYPL, on permanent loan to NYHS). It showed the slave quarters in the backyard of his father's home in Washington. Exhibited as *Negro Life at the South* at the National Academy of Design in 1859, the painting secured Johnson's reputation. He was elected an associate member that year and an academician the next, and he continued to exhibit in the academy's annual exhibitions until the end of his life. He also served as visiting instructor at the academy from 1867 to 1869.

The 1860s and 1870s were Johnson's most productive and creative years, devoted to the American subjects for which he is best known. During the Civil War he followed the Union troops on three campaigns. Both *A Ride for Liberty — The Fugitive Slaves* of about 1862 (Brooklyn Museum) and *The Wounded Drummer Boy* of 1871 (Union League Club, New York) were based on his experiences during the war. In the 1860s he painted the first of his informal group portraits and began a series of maple sugaring scenes based on visits to his childhood home in Fryeburg, Maine. In 1869 he married Elizabeth Buckley of Troy, New York. The following year, he visited Nantucket, which became his summer retreat. His studio on Cliff Road just above the Sea Cliff Inn was illustrated in *Scribner's Monthly* for August 1873. The accompanying article stated that "Johnson has shown his usual fine taste in taking up his residence here and has transformed two of the old houses that stood on the site into a home and studio" (p. 390). On Nantucket, Johnson found the subjects for some of his best genre pictures, including the cranberry picking scenes that culminated in 1880 with *The Cranberry Harvest* (Timken Art Gallery, San Diego).

Johnson was prominent in New York art circles. A member of the Century Association and the Union League Club, he was also one of the founders of the Metropolitan Museum in 1870 and served as a trustee until 1871. A number of his pictures were shown in 1876 at the Centennial Exposition in Philadelphia. In 1881 he became a member of the Society of American Artists, initially a rival organization of the National Academy of Design. The

appeal of his work to both factions was described by S. G. W. Benjamin (1837-1914) in 1882:

His work is to be seen at the exhibitions of both societies, and he is claimed by the followers of both schools. The Academicians call him theirs, because, although he studied long abroad, he has imported the style of no foreign artist, but has illustrated the principles of art in a manner entirely his own; and because, too, he has been content to look for subjects at home, thus showing himself wholly in sympathy with the attractions of his own land. These qualities have not been characteristic of the work of the new school of American artists, who, while showing ability and enterprise, have purposely imported the styles of Bonnat, Gérôme, Daubigny, Corot, or Manet, together with a selection of subjects entirely foreign, and therefore imitative. Evidences are accumulating, however, which show that some of them are endeavouring to give expression to their own individuality, and rescue their identity from the subservience in which it has been merged. They in turn lay claim to Eastman Johnson as one of their number, because his style (a quality they estimate above matter), while wholly his own, suggests the consummate technical ability of the modern Continental masters. Thus justified and applauded, he may fairly be described as a representative American (*Magazine of Art*, 5 [1882], p. 490).

In the 1880s Johnson gradually abandoned genre painting and became a leading portrait painter. His last known dated genre scene, *The Nantucket School of Philosophy* (Walters Art Gallery, Baltimore), was done in 1887. "The country has reason to regret that he ever stopped painting them and went back to portraiture," WORTHINGTON WHITTREDGE wrote, "not that portrait painting is any less noble work than the painting of genre pictures, but because the subjects themselves are disappearing and because no one has come upon the stage who could quite fill Eastman Johnson's place" (J. I. H. Baur, ed., "The Autobiography of Worthington Whittredge," *Brooklyn Museum Journal* [1942], p. 54). Well-painted and generally regarded as good likenesses, his portraits occasionally were powerful characterizations. The subjects included such prominent men as William Evarts, Edwin Booth, Jay Gould, Cornelius Vanderbilt, John D. Rockefeller, and Presidents Cleveland and Harrison. Johnson made trips to Europe in 1885, 1891, and 1897. He died in New York on April 5, 1906, at the age of eighty-two.

BIBLIOGRAPHY: William Walton, "Eastman Johnson, Painter," *Scribner's Magazine* 40 (August 1906), pp. 263-274. An informative early biography of the artist, published a few months after his death // American Art Galleries, New York, *Catalogue of Finished Pictures, Studies and Drawings by the Late Eastman Johnson, N. A.*, sale cat. (Feb. 26 and 27, 1907). Contains descriptions of 151 of the artist's works // John I. H. Baur, *Eastman Johnson, 1824–1906: An American Genre Painter* (New York, 1940). Reprint ed. New York: Arno Press, 1969. Published in conjunction with an exhibition at the Brooklyn Museum, it includes an essay, annotated catalogue entries for exhibited works, and a general catalogue of 472 works by the artist // Patricia Hills, *Eastman Johnson* (New York, 1972). Published by the Whitney Museum of American Art in conjunction with a traveling exhibition, it contains an essay, a chronology, and a selected bibliography // Patricia Hills, *The Genre Painting of Eastman Johnson: The Sources and Development of His Style and Themes* (Ph.D. diss., Institute of Fine Arts, New York University, 1973; published New York, 1977). Most comprehensive account of the artist's genre paintings to date, it includes illustrations and an extensive bibliography.

Johnson, *The Hatch Family*.

The Hatch Family

Alfrederick Smith Hatch (1829–1904) was a prominent Wall Street broker in the firm of Fisk and Hatch and president of the New York Stock Exchange from 1883 to 1884. Like many of his business associates, he was an enthusiastic collector of paintings. He bought Italian and French works and an impressive group of American paintings. One of the finest paintings in Hatch's collection was this imposing group portrait he commissioned, which shows three generations of his family. A marvelous record of a domestic interior representing the somewhat overpowering splendor of the Brown Decades, it shows the family in the library of their New York home, 49 Park Avenue, on the northeast corner of 37th Street. Hatch is seated to the right at his desk, and his wife, the former Theodosia Ruggles (1829–1908), leans on the mantle-

piece. Her mother, Mrs. John Gould Ruggles (1809–1891), is knitting at the left of the central table. Behind her, reading his paper, is Hatch's father, Dr. Horace Hatch (1788–1873). The remaining figures are Alfrederick Hatch's children (left to right): William Dennison (1858–1926); John Ruggles (1855–1900); Louisa Fisk (b. 1864), later Mrs. George R. Preston; Frederic Horace (1862–1952), the donor of the picture; Emily Theodosia (b. 1860), later Mrs. Elwood O. Roessle; the baby, Emily Nichols (1871–1959), later a painter, a Chase student; Edward Payson II (1868–1909); Jessamine (1870–1947), later Mrs. Robert A. Patteson; Mary Yates (seated) (1856–1926), later Mrs. Willard; Horace (1867–1950); and Jane Storrs (1865–1940), later Mrs. John C. F. Gardner.

When Frederic Hatch offered the painting to the museum, he wrote that Johnson in his later years had said that "he considered it the best of

Johnson, *Study for Mrs. Ruggles*. Private collection.

In addition to preserving the likenesses of the members of a prominent New York family, the picture provides an accurate record of a Victorian interior. The room is decorated in a Renaissance or Italianate style made popular through Sir Charles Lock Eastlake's *Hints on Household Taste* (1868). The Eastlake style quickly became fashionable in the United States. The hangings, furniture, rug, chandelier, and other decorations are typical of the work of the Paris-born New York cabinetmaker and interior furnisher Leon Marcotte, whose fashionable establishment was patronized by New York society in the 1860s and 1870s.

The most elaborate of Johnson's informal group portraits in a domestic interior, the painting stems from the tradition of eighteenth-century English conversation pieces and seventeenth-century Dutch interiors. This type of picture, although popular in eighteenth- and nineteenth-century America, enjoyed its greatest vogue in the affluent period following the Civil War.

Stylistically the painting marks Johnson's return to the highly finished, realistic draftsmanship that characterized his work of the late 1850s and early 1860s. From a distance it appears tightly painted in the manner of the Düsseldorf school. Close examination, however, reveals Johnson's use of thin paint layers, through which the drawing is visible in many places, reflecting his training with Thomas Couture. Johnson usually made preparatory sketches in various media, and a number of those relating to this picture have been passed down in different branches of the Hatch family.

Oil on canvas, 48 × 73⅜ in. (121.9 × 186.4 cm.).
Signed and dated at lower left: E. Johnson 1871. Canvas stamp (before lining): 48 80 / PREPARED / BY / EDWD DECHAUX / NEW YORK.

RELATED WORKS: *Study for Mrs. Alfrederick S. Hatch*, oil on academy board, 17 × 11½ in. (43.2 × 29.2 cm.), coll. Miss Emily Nichols Hatch, 1940, ref. in J. I. H. Baur, *Eastman Johnson*, exhib. cat. (1940), p. 69, no. 199a // *Study for Alfrederick S. Hatch*, charcoal heightened with white on brown paper, sight 17½ × 13½ in. (44.5 × 34.3 cm.), coll. Miss Emily Nichols Hatch, 1940, ref. ibid., p. 74, no. 318a // *Study for Mary Hatch*, charcoal heightened with white on brown paper, sight 17½ × 13½ in. (44.5 × 34.3 cm.), coll. Mrs. John C. F. Gardner, 1940, ref. ibid., p. 75, no. 318b // *Study for Mrs. Hatch*, charcoal heightened with white on paper, 8¾ × 9 in. (22.2 × 22.9 cm.), private coll., 1972, ill. in P. Hills, *Eastman Johnson*, exhib. cat. (1972), p. 105 // *Study for Mrs. Ruggles*, charcoal and pencil heightened with white on paper,

his works." Hatch added that he believed it took about a year and a half to complete the work, which is dated 1871. "When you see it you will note a very small baby in the central foreground," he continued. "There was another baby there at the beginning but shortly before the painting was completed there was a new arrival that called for a slight change, which the artist cleverly accomplished by putting the original baby in short dresses, and while clinging to her mother's gown looking with interest, and possibly with a little jealousy, at the attention the new baby is receiving." Another member of the Hatch family reported that when Emily Nichols Hatch was born, in August 1871, Alfrederick Hatch wired Johnson that he would receive another $1,000 for including the new baby in the picture. According to Johnson's nephew, the highest price Johnson ever received was $10,000 for the picture of a family group. He could not recall the name of the picture, but it was probably *The Hatch Family*, which remains one of Johnson's undisputed masterpieces.

$9\frac{7}{8} \times 7\frac{7}{8}$ in. (25.1 × 20 cm.), private coll., 1972, ill. ibid., p. 105.

REFERENCES: F. H. Hatch, letters in MMA Archives, Feb. 15, 1926, supplies information on the painting and notes that it was never placed on public exhibition (quoted above); May 13, 1926, identifies the subjects on a photograph of the painting // B. Burroughs, *Catalogue of Paintings in the Metropolitan Museum* (1931), p. 192, as Family Group // A. Burroughs, *Limners and Likenesses* (1936), pp. 169, 171; fig. 137 // H. B. Wehle, *MMA Bull.* 4 (April 1946), p. 203; ill. p. 211 // F. J. Mather, Jr., *Magazine of Art* 39 (Nov. 1946), p. 295, discusses it // John Ruggles Hatch's granddaughter, orally 1947, verified new baby anecdote // R. B. Davidson, *Antiques* 58 (Nov. 1950), p. 371, describes apparel worn by the family // J. T. Flexner, *That Wilder Image* (1962), p 220, describes it // *Antiques* 89 (Jan. 1966), ill. p. 109 // H. L. Peterson, *Americans at Home* (1971), pl. 143, describes carpet, window cornice with monogram, curtains and gas chandelier; notes that the wreath in the window suggests that it is the Christmas season // Heckscher Museum, Huntington, N. Y., and Parrish Art Museum, Southampton, N. Y., 1973, *The Students of William Merritt Chase*, exhib. cat. by R. G. Pisano, p. 17, no. 22, mentions portrait of the painter Emily Nichols Hatch in the work // Mrs. Daniel Conger (Mary Hatch Davis), granddaughter of John Ruggles Hatch, letter in Dept. Archives, March 14, 1973, mentions baby anecdote // P. Hills, *The Genre Painting of Eastman Johnson* (Ph.D. diss., Institute of Fine Arts, New York University, 1973; published 1977), pp. 112, 121-125, discusses the painting at length; p. 226, fig. 75 //

MMA Bull. 33 (Winter 1975/1976), color ill. no. 58, p. [215].

EXHIBITED: Whitney Museum of American Art, New York, 1935, *American Genre*, no. 62, as Family Group // MMA, 1939, *Life in America*, no. 225, as Family Group // Brooklyn Museum, 1940, *Eastman Johnson*, exhib. cat. by J. I. H. Baur, p. 20, as Family Group; p. 25, cites letter from Johnson's nephew which may refer to this painting (quoted above); p. 53, lists it as Family Group [The Hatch Family]; pl. xxxv; p. 69, no. 199, lists it // MMA, 1946, *The Taste of the Seventies*, no. 130; 1953–1954, *American Painting, 1754–1954* (no cat.); 1958–1959, *Fourteen American Masters* (no cat.); 1965, *Three Centuries of American Painting*, unnumbered cat. // Wildenstein Gallery, New York, 1966, *Three Hundred Years of New York City Families* (for the benefit of the Museum of the City of New York), no. 28, as The Alfrederick Smith Hatch Family // MMA, 1970, *19th-Century America, Paintings and Sculpture*, cat. by J. K. Howat and N. Spassky, no. 144 // MFA, Boston 1970, *Masterpieces of Painting in the Metropolitan Museum of Art* (not in cat.) // Whitney Museum of American Art, New York, traveling exhib., 1972, *Eastman Johnson*, cat. by P. Hills, p. xxi, no. 67 (shown only in New York); color ill. p. 100; p. 104; p. 106, discusses it // MMA, 1976, *A Bicentennial Treasury, American Masterpieces from the Metropolitan* (see *MMA Bull.* above).

EX COLL.: Alfrederick Smith Hatch, New York, 1871–d.1904; his son, Frederic H. Hatch, New York, by 1926.

Gift of Frederic H. Hatch, 1926.

26.97.

Johnson, *Study for Mrs. Hatch.*
Private collection.

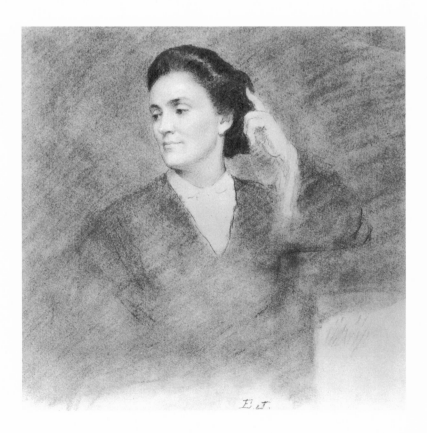

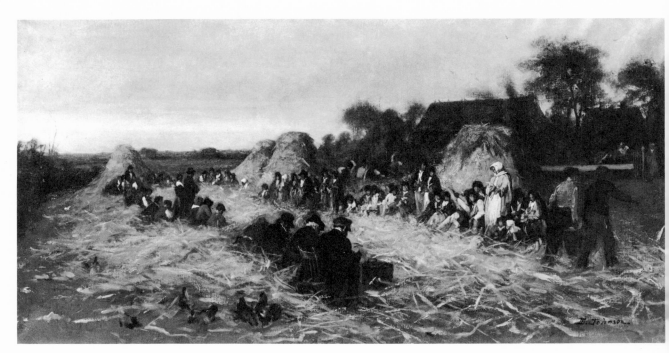

Johnson, *Corn Husking at Nantucket*.

Johnson, *Husking-Bee, Island of Nantucket*. Art Institute of Chicago.

Johnson, *Studies for Corn Husking.*
Free Library of Philadelphia.

Corn Husking at Nantucket

This picture was probably Johnson's final oil study for *Husking-Bee, Island of Nantucket,* 1876 (Art Institute of Chicago), which was exhibited at the National Academy of Design that year. The Chicago painting was praised in the New York *Art Journal* for its "breadth of handling, depth of perspective and general effect as an outdoor composition of figures in a landscape" (2 [May 1876], p. 159). It was sold to the photographer and artist Napoleon Sarony (1821-1896), who lent it to the Exposition Universelle in Paris in 1878. In contrast to the Metropolitan's study, details and forms in the Chicago picture are given more definition and paint is more tightly handled. Nevertheless, the final version is remarkably similar to the study and retains its spontaneity.

Eastman Johnson

Corn Husking at Nantucket was probably painted in 1875. In a letter to the museum in 1913, the artist's wife wrote that it was painted in late November, on a "day of dark skies and wind he came upon the scene . . . the yellow corn and husks the bright chickens running about, the old sea captains with their silk hats of better days — figure in the center — too old to enjoy the crouching by the hour on the ground their quaint chairs form a part of the picture." Another oil sketch for the painting, dated October 28, 1875 (now unlocated), showed that Johnson had established the composition by that time. While the same elements appear in all three works, the artist experimented by increasing the size of the picture from the long, narrow, and unconventional format of the early sketch to a more vertical one.

A seasonal activity that involved the rural community in social events as well as work, corn husking was a popular subject for nineteenth-century American genre painters. Johnson's "earliest dated work of rural life," according to Patricia Hills's study of the artist, was *Corn Husking* of 1860 (Everson Museum of

Detail from Johnson, *Studies for Corn Husking.*
Karolik Collection, MFA, Boston.

Art, Syracuse). In the tight handling and the strong anecdotal character, Johnson's treatment of the subject is closely allied to early nineteenth-century American genre scenes. As Hills noted, the work, which was the subject of a color lithograph published by Currier and Ives in 1861, is strongly reminiscent of barn interiors by WILLIAM SIDNEY MOUNT. Johnson's treatment of the same subject in the 1870s presents a marked contrast. Rich and vigorous brushwork replaces the linear handling of the earlier work. Anecdotal elements, while still present, are subordinate to the whole composition. Figures, for example, are integrated into the landscape. What the New York *Art Journal*, in a review of the Chicago painting, characterized as the "painstaking but cramped technique" of Johnson's earlier work has been replaced by the "brilliancy and freedom of handling of this year's picture of the 'Husking Bee.'" These qualities noted in the final picture are even more apparent in the superbly painted sketch.

By 1907, when this painting was included in the Johnson estate sale, his genre pictures were considered "of great historic value" as documents of a rapidly vanishing era in American life. The scene is described in the catalogue:

The Indian corn has been gathered and stacked in an open field adjacent to a large farmyard, and the fine autumn weather has made it possible to have the usual husking bee in the open instead of in the spacious barn, where the festival commonly takes place. Two lines of busy workers, of both sexes and all ages, are ranged along, facing each other, most of them seated, and all surrounded by the yellow corn husks. ... The whole scene glows with the warm color of early autumn, and the sky is covered with a thin stratum of luminous gray clouds.

In Johnson's unconventional composition, two rows of figures diminish rapidly in perspective and form a strong diagonal thrust. Forms are suggested with quick brushstrokes, and bright punctuations of color relieve a relatively austere palette. The dazzling brushwork, the arresting effects of light, and the notes of rich color distinguish this work as one of Johnson's best oil studies.

Oil on canvas, 27⅝ × 54½ in. (70.2 × 138.4 cm.). Signed at lower right: E. Johnson.
RELATED WORKS: *Study for Corn Husking*, oil, 8 × 27 in. (20.3 × 68.6 cm.), Oct. 28, 1875, unlocated, ill. in *World's Work* 13 (Dec. 1906), p. 8317, see American Art Galleries, New York, *The Works of the Late Eastman Johnson, N. A.*, sale cat. (1907), no. 29, for size and description (purchased by William T. Evans) // *Studies for Corn Husking*, pencil and watercolor on paper, 18¾ × 12¼ in. (47.6 × 31.1 cm.), Free Library of Philadelphia, ill. in P. Hills, *Eastman Johnson*, exhib. cat. (1972), p. 88 // *Studies for Corn Husking*, pencil on buff paper, 10 × 12¼ in. (25.4 × 31.1 cm.), Karolik Collection, MFA, Boston // *Husking-Bee, Island of Nantucket* oil on canvas, 31½ × 50 in. (80 × 127 cm.), 1876, Art Institute of Chicago, ill. in J. I. H. Baur, *Eastman Johnson* (1940), pl. 32, no. 55.

REFERENCES: *New York Sun*, Jan. 12, 1900, p. 6, says the "large study for Mr. Johnson's well-known picture The Cornhuskers" is on exhibition at Union League Club // E. King, *Monthly Illustrator* 4 (June 1895), ill. p. 267; p. 268 // E. French, *World's Work* 13 (Dec. 1906), ill. p. 8317, shows this painting and the now unlocated study in Johnson's studio // W. Walton, *Scribner's Magazine* 40 (August 1906), ill. p. 274 // American Art Galleries, New York, *The Works of the Late Eastman Johnson, N. A.*, sale cat. (1907), no. 146, as The Corn Husking (quoted above) // *American Art News* 5 (March 2, 1907), unpaged, in report of Johnson sale, lists this painting as acquired by the MMA, misquotes price as $120 // M. Selby, *Putnam's Monthly* 2 (August 1907), p. 533, mentions this version at sale; ill. p. 541 // Mrs. E. Johnson, letter in MMA Archives, Jan. 28, 1913 (quoted above), notes that some of the same sea captains figure in The Nantucket School of Philosophy, 1887 (Walters Art Gallery, Baltimore), A Glass with the Squire, 1880 (Brown University), and The Reprimand, 1880 (New York art market, 1978) // J. I. H. Baur, *Eastman Johnson*, exhib. cat. (1940), p. 62, no. 54 // E. U. Crosby, *Eastman Johnson at Nantucket* (1944), p. 12, no. C. 2; ill. p. 22 // P. Hills, *The Genre Painting of Eastman Johnson* (Ph.D. diss., Institute of Fine Arts, New York University, 1973; published 1977), pp. 146–149, discusses the subject, various versions and studies; p. 239, fig. 98, dates it 1876.

EXHIBITED: Union League Club, New York, 1900, *American Paintings*, no. 13, as The Corn Huskers // Musée du Jeu de Paume, Paris, 1938, *Trois siècles d'art aux Etats-Unis*, no. 100 // MMA, 1939, *Life in America*, no. 233 // Norfolk Museum of Arts and Sciences, Va., 1947, *Fifteen 19th Century Landscape Paintings*, no. 14 // MMA, 1953–1954, *American Painting, 1754–1954* (no cat.) // Vancouver Art Gallery, British Columbia, 1955, *Two Hundred Years of American Painting*, no. 19 // MMA, 1965, *Three Centuries of American Painting*, unnumbered cat. // Los Angeles County Museum of Art and M. H. de Young Memorial Museum, San Francisco, 1966, *American Paintings from the Metropolitan Museum of Art*, no. 53 // National Gallery of Art, Washington, D. C.; City Art Museum of Saint Louis; Seattle Art Museum, 1970–1971, *Great American Paintings from the Boston and Metropolitan Museums*, exhib. cat. by T. N. Maytham, no. 49 // Whitney Museum of American

Art, New York; Detroit Institute of Arts; Cincinnati Art Museum; and Milwaukee Art Center, 1972, *Eastman Johnson*, exhib. cat. by P. Hills, p. xxii, no. 79, dates it 1876; ill. p. 90, this picture misidentified as Chicago version // Finch College Museum of Art, New York, 1973–1974, *Twice as Natural, 19th Century American Genre Painting*, exhib. cat. by R. H. Luck, no. 46.

Ex COLL.: the artist, 1875–1906; estate of the artist (sale, American Art Galleries, New York, Feb. 27, 1907, no. 146, as The Corn Husking).

Rogers Fund, 1907.
07.68.

The New Bonnet

Dated 1876, *The New Bonnet* is among Johnson's best-known Nantucket interiors. It shows a woman at home displaying a new hat. The subject was popular with genre painters. Johnson was undoubtedly familiar with the painting by FRANCIS W. EDMONDS also called *The New Bonnet*, 1858 (q. v. Vol. 1), which was exhibited at the National Academy of Design in 1859 at the same time as Johnson's *Old Kentucky Home — Life in the South* (NYPL, on permanent loan to NYHS). Although they show the same subject in similar settings, the two paintings are different in character. They represent different generations and stem from separate stylistic traditions. Edmonds uses exaggerated gestures and expressions verging on caricature for maximum expressive effects; Johnson is more subtle. His work, as William Walton observed, is characterized by "the careful avoidance of carrying the obvious thing too far he never descends to the mere story-telling, or the merely comic" (p. 270).

Johnson demonstrates his skill in this complex and unconventional three-figure composition. The woman who admires the bonnet and prepares a drink for the man serves to link the two other figures in the composition. The position of her body and turn of her head draw the viewer's gaze from one figure to the other. This link is subtly reinforced by the curve of the chimney and the angle of the mantle. The cutting off of the stool and the hatbox at the canvas edge contributes to the informality and suggests Johnson's knowledge of the more radical compositional devices of the French avant-garde.

The Windsor chair, the oil lanterns and axes hanging from the beam, the pipe, the fireplace with its brick hearth, brass candlesticks, and pewter utensils are recurring objects in Johnson's Nantucket interiors. His painting *Nantucket Sea Captain* of 1873 (private coll.) contains many of the same elements.

The New Bonnet was exhibited at the National Academy of Design in 1876 with *Husking-Bee, Island of Nantucket*, 1876 (Art Institute of Chicago). The vigorous outdoor scene with its bravura brushwork offered a striking contrast to the fastidiously detailed painting of the domestic interior. In a review a critic for the *Nation* remarked on Johnson's "two styles" and described this work as being in his "wooly manner elaborated in the colored cobwebs Mr. Johnson paints in his less inspired moments." The *Art Journal* described it as "a praiseworthy contribution" but criticized the austere palette: "The work is drawn and composed with great precision, and although very brilliant in effect, has scarcely a suggestion of positive color in the whole design." The critic for the *New York Times* called *The New Bonnet* "one of the best of Mr. Johnson's smaller compositions."

In addition to Johnson's skill in composition, this painting demonstrates his strong draftsmanship and use of different techniques. A pencil and charcoal drawing, *Girl with Glass* (private coll., New York), served as a preparatory study for the central figure. Johnson remained remarkably faithful to the study and drew this pivotal figure on the canvas with heavy contour lines in the manner advocated by Thomas Couture. In contrast, examination under infrared light shows that at least the face and hands of the man were transferred to the canvas in a mechanical manner, while the figure of the woman with the bonnet was summarily drawn.

Oil on academy board, 20¾ × 27 in. (52.7 × 68.6 cm.).

Signed and dated at lower left: E. Johnson 1876.

RELATED WORK: *Girl with Glass*, pencil and charcoal heightened with white on brown paper, 17¼ × 11¾ in. (45.1 × 29.8 cm.), Sept. 22, 1875, private coll., New York.

REFERENCES: *New York Times*, April 3, 1876, p. 5, describes painting in NAD exhibition (quoted above)// *Nation* 22 (April 6, 1876), p. 234, reviews picture in NAD exhibition (quoted above) // *Art Journal* (New York) 2 (May 1876), p. 159, reviews this painting at NAD exhibition (quoted above) // E. Strahan [E. Shinn], ed., *The Art Treasures of America* (1880), 3, p. 42, lists it in Collis P. Huntington's collection // *New York Times Magazine*, August 25, 1925, p. 21 // B. Burroughs, *MMA Bull.* 20 (June 1925), ill. p. 143,

Johnson, *Girl with Glass*, drawing.
Private collection, New York.

Infrared photographs of the figures
show the underdrawing.

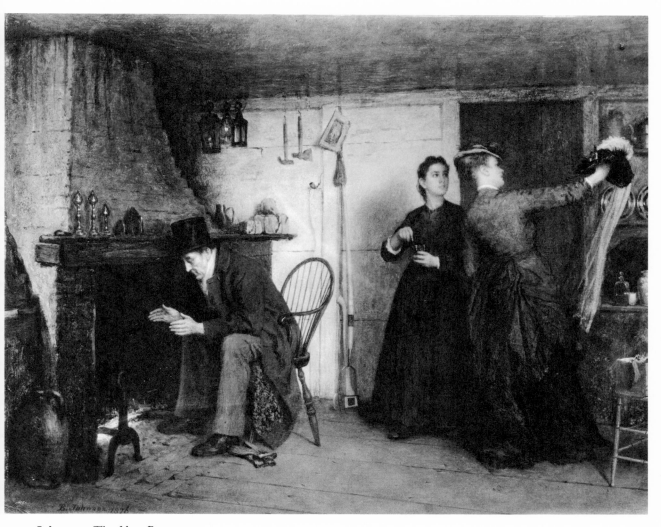

Johnson, *The New Bonnet*.

Johnson, *Sanford Robinson Gifford*.

reports acquisition and calls it "one of the best of Eastman Johnson's genre pictures" // A. Kistler, *American Magazine of Art* 28 (Oct. 1935), ill. p. 615; p. 618 // A. Burroughs, *Limners and Likenesses* (1936), p. 170 // S. Keck, *Technical Studies in the Field of the Fine Arts* 9 (Jan. 1941), p. 148, fig. 4; p. 149, discusses Johnson's technique; p. 151, fig. 6, shows infrared detail of the woman with the glass // E. U. Crosby, *Eastman Johnson at Nantucket* (1944), p. 9, discusses technique in connection with this picture; p. 15, c. 30, lists painting; ill. p. 46 // P. Hills, *The Genre Painting of Eastman Johnson* (Ph.D. diss., Institute of Fine Arts, New York University, 1973; published 1977), pp. 156-157, discusses the painting, noting that the fireplace recurs in Johnson's work; p. 246, fig. 113.

EXHIBITED: NAD, 1876, no. 289 // M. H. de Young Memorial Museum, San Francisco, 1935, *Exhibition of American Painting*, no. 155 // MMA, 1939, *Life in America*, no. 222 // Brooklyn Museum, 1940, *Eastman Johnson*, exhib. cat. by J. I. H. Baur, p. 23; p. 50, lists painting; pl. xxvii; p. 63, no. 70 // Centennial Art Gallery, Centennial Exposition, Utah State Fair Grounds, Salt Lake City, 1947, *One Hundred Years of American Painting* (American Federation of Arts, Washington, D. C.), no. 12 // NAD, 1951, *The American Tradition*, no. 84 // Montclair Art Museum, N. J., 1954, *The Changing Pattern* (no cat.) // MMA, 1958-1959, *Fourteen American Masters* (no cat.); 1965, *Three Centuries of American Painting*, unnumbered cat. // Marlborough-Gerson Gallery, New York, 1967, *The*

New York Painter (benefit exhibition for New York University), p. 29 // Osaka, 1970, *United States Pavilion Japan World Exposition* (no cat.) // Whitney Museum of American Art, New York; Detroit Institute of Arts; Cincinnati Art Museum; and Milwaukee Art Center, 1972, *Eastman Johnson*, exhib. cat. by P. Hills, p. xxii, no. 77, lists this picture; p. 101; ill. p. 107 // Los Angeles County Museum of Art, 1974, *American Narrative Painting*, cat. notes by N. W. Moure, essay by D. F. Hoopes, p. 20, calls this work a "decidedly old-fashioned genre subject well within the established boundaries of an American linear style"; ill. p. 122; p. 123, no. 57, notes that the fireplace, candlesticks, and lanterns also appear in Johnson's Nantucket Sea Captain, 1873; discusses composition and states that such scenes recording intimate domestic moments anticipate the work of the impressionists // MMA and American Federation of Arts, traveling exhibition, 1975-1976, *The Heritage of American Art*, cat. by M. Davis, color ill. p. 116, no. 48, notes women's fashions and bonnet as "symbol of the elegance of French fashion" in post Civil War years and suggests that Johnson was familiar with Francis W. Edmonds's The New Bonnet.

ON DEPOSIT: Virginia Museum of Fine Arts, Richmond, 1954-1958.

EX COLL.: Collis P. Huntington, by 1880-d.1900; his wife, later Mrs. Henry E. Huntington, subject to a life estate, 1900-d.1924; her son, Archer M. Huntington, subject to a life estate, which was relinquished, 1924-1925.

Bequest of Collis P. Huntington, 1900.
25.110.11.

Sanford Robinson Gifford

From the late 1880s, Johnson devoted himself almost exclusively to portraiture. A highly skilled portraitist, he was much in demand; yet, with few exceptions, he did not venture beyond the conventional. Among the exceptions are his group portraits, his powerful early studies of the Chippewa Indians, his portraits of Nantucket sea captains and those of a few friends. Penetrating psychological insight, like that shown in contemporary portraits by THOMAS EAKINS, is rare in Johnson's works. This portrait of his friend SANFORD ROBINSON GIFFORD (1823-1880), however, transcends the limitations of the well-painted, satisfactory likeness.

Painted in 1880, the year of Gifford's death, and possibly posthumous, this work has an immediacy that is often lacking in Johnson's commissioned portraits. It is closely related to his portrait of Gifford, which Mrs. Johnson pre-

sented to the National Academy of Design in 1907. The academy's painting, however, is more freely painted than the Metropolitan's. Another portrait by Johnson, showing Gifford in three-quarter view, is in the Pennsylvania Academy of the Fine Arts.

The Metropolitan's portrait was bequeathed by Gifford's widow to Richard Butler. Gifford's friend and patron, Butler served with him as a member of the committee to establish the Metropolitan Museum. Butler was a trustee of the museum from 1871 to 1893, a pallbearer at Gifford's funeral, and one of the organizers of the museum's memorial exhibition of Gifford's work. In 1902 Mrs. Butler presented the Metropolitan with a bronze portrait bust of Gifford made in 1871 by Launt Thompson.

Oil on academy board, 26¾ × 22⅛ in. (67.9 × 56.2 cm.).

Signed and dated at lower left: E. Johnson / 1880.

RELATED WORK: *Sanford Robinson Gifford*, oil on canvas, 26½ × 22¼ in. (67.3 × 56.5 cm.), NAD.

REFERENCES: R. Butler, letter in MMA Archives, Nov. 10, 1888, says that this portrait was bequeathed to him by Mrs. Gifford // Kennedy and Company, New York, *Exhibition of Charcoal Drawings by Eastman Johnson*, exhib. cat. (June 1920), p. 12, lists it // J. I. H. Baur, *Eastman Johnson*, exhib. cat. (1940), p. 68, no. 190, lists it // A. T. Gardner, *MMA Bull.* 6 (April 1948), ill. p. 248 // F. H. Goodyear, Jr., PAFA, letter in Dept. Archives, June 12, 1978, supplies information on PAFA portrait // S. C. Gifford, letters in Dept. Archives, July 4, 18, 1978, notes that Mrs. Gifford (Mary Cecelia Canfield), the wife of the subject and former owner of the painting, died in 1887 // A. Boime, *Thomas Couture and the Eclectic Vision* (1980), p. 597, mentions it among works by Johnson that show influence of Couture and discusses technique // A. B. Gerdts, NAD, orally, June 2, 1982, supplied information on NAD portrait.

EXHIBITED: Century Association, New York, Nov. 19, 1880, *Gifford Memorial Meeting of the Century*, frontispiece ill., p. 9, no. 25, lent by Mrs. Gifford // MMA, 1958–1959, *Fourteen American Masters* (no cat.) // Whitney Museum of American Art, New York, Detroit Institute of Arts, Cincinnati Art Museum, and Milwaukee Art Center, 1972, *Eastman Johnson*, exhib. cat. by P. Hills, p. xxiii, no. 102; p. 106, suggests that portrait may be posthumous; ill. p. 112.

EX COLL.: Mrs. Sanford Robinson Gifford, New York, 1880–1887; Richard Butler, New York, 1887–1888.

Gift of Richard Butler, 1888.

88.16.

The Funding Bill

In the early months of 1881, after much debate, Congress passed "An Act to Facilitate the Refunding of the National Debt," which caused dismay in business and banking circles. When the bill was sent to President Rutherford B. Hayes for signature, he vetoed it.

This picture, painted in 1881, shows Robert W. Rutherfurd, Mrs. Eastman Johnson's brother-in-law (on the left), and Samuel W. Rowse (1822-1901), an artist best known for his crayon portraits. Neither had anything to do with the bill, but like many men of the period, they discussed it. In a letter to the Pennsylvania Academy of the Fine Arts in 1881, Johnson wrote:

I saw these two gentlemen sitting in my own house with accessories & c. as in the picture. Their conversation suggested to me the title. They are from life and in fact fair portraits. The scene struck me at the moment as the picture of a discussion and was so painted.

In a letter to the Metropolitan in 1913, Mrs. Johnson recalled:

"Two Men" was his Academy picture for 1881. Samuel W. Rowse an artist of distinction and Robert W. Rutherfurd, two friends of his were discussing "The Funding Bill," a political or financial question of 1881. It happened he had no Academy exhibition picture for that year. He said in looking at them — "I see my Academy picture." In three weeks it was finished and in the place of honor and in 1898 presented to the Museum by Robert Gordon Trustee.

One of Johnson's most effective works, this large double portrait combines genre and portraiture. A raking light illuminates the life-size figures. The setting is rich and dim with faintly gleaming furnishings. Johnson's use of dark and light reflects his careful study of seventeenth-century Dutch art and his assimilation of Thomas Couture's methods. The painting is an exceedingly accomplished work and was widely acclaimed when first exhibited. A reviewer of the 1881 National Academy of Design exhibition for the *Art Amateur* observed that Johnson "produced one of the best pictures of his life, filled with swift energy and decision in the painting, and treated with altogether masterly brio in a scale unusual for him."

Overzealous cleaning has removed many of the subtle transitions from light to dark. A comparison to the study for this picture, however, shows that the finished painting retains the

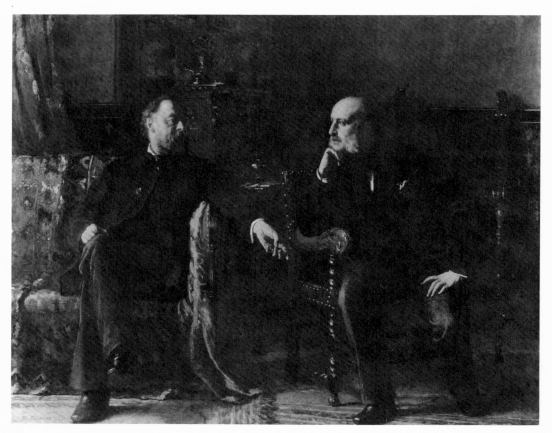

Johnson, *The Funding Bill.*

spontaneity and deft brushwork that distinguish the study.

 Oil on canvas, 60½ × 78¼ in. (153.7 × 198.8 cm.).
 Signed and dated at lower left: E. Johnson / 1881.
 RELATED WORK: *Two Men* (Study for *The Funding Bill*), oil on canvas, 22¼ × 27 in. (56.5 × 68.6 cm.), 1880, private coll., ill. in P. Hills, *Eastman Johnson*, exhib. cat. (1972), p. 114.
 REFERENCES: *New York Times*, March 20, 1881, p. 2, reviews this picture at 1881 NAD exhibition as "the large double portrait by Mr. Eastman Johnson, which holds, by the best of right, that of worth, the place of honor It is many years since Mr. Johnson showed work equal to this If no one else has hit high-water mark this year, Mr. Johnson has" // *Nation* 32 (March 31, 1881), p. 229, in review of the NAD exhibition, notes that "the picture is a masterpiece; it is the perfection of that kind of painting so often urged upon unpatriotic American artists who repair to Venice and Brittany for inspiration, and neglect the possibilities with which our own life and land teem, and which are never touched without awakening a sympathetic popular echo. Artistically, too, it combines portraiture with *genre*; and whenever this is done with any success one wonders afresh why the expe-

dient, old as it is, is not oftener resorted to"; p. 230, discusses; 32 (April 21, 1881), p. 286 // C. M. Kurtz, ed., *American Academy Notes* (2nd ed., 1881), ill. p. 22, no. 216; p. 23, no. 216, calls it "a painting of freshness and strength in its lights, of depth in its shadows, and a realistic quality throughout that makes it seem very near perfection" // *Art Journal* [New York] 7 (April 1881), p. 127, describes it in 1881 NAD exhibition // S. G. W. Benjamin, *American Art Review* 2, part 2 (1881), p. 26, reviews it at 1881 NAD exhibition, noting that the subject is not as interesting as "Johnson's inimitable genres" // *Art Amateur* 4 (May 1881), p. 116 (quoted above); ill. p. 117 // E. Johnson to G. Corliss, Nov. 17, 1881, PAFA, copy in Dept. Archives, discusses delay in transporting the painting from Chicago to Philadelphia, adds that his asking price for the painting is $3,500, and provides a history of the work (quoted above) // E. Johnson to J. F. Weir, July 17, 1884, John Ferguson Weir Papers, D129, Arch. Am. Art, reports: "I have this morning returned from Nantucket where I have been a week, and hoped to find my picture 'The Funding Bill' here, as it is wanted for one or two exhibitions it is already rather late for the Louisville show but could probably be sent if here tomorrow" // C. M. K., *Art Union* 1 (August and Sept. 1884), p. 146, notes that at

the 1884 Southern Exposition in Louisville: "One of the most admired pictures in the collection is Eastman Johnson's picture, 'The Funding Bill,' which hangs in the principal place of honor"; 2 (Oct. 1885), ill. p. 81 // *New York Times*, June 1, 1895, p. 3, mentions this picture at the MMA loan exhibition: "Perhaps nothing here is stronger in its way than a portrait group of two men by Eastman Johnson" // R. Gordon and S. P. Avery, letters in MMA Archives, 1897, discuss acquisition // *Arts for America* 7 (Oct. 1897), ill. p. 72; pp. 91-92, in a review of the annual exposition at Saint Louis, says that it "certainly is one of the ablest productions of American art—solid and firm in the lights, transparent and tender in the shadows—reminding one of the pictures of the old Dutch masters" // *International Studio*, suppl. to 5 (1898), pp. i-iii, reviews it as new acquisition at MMA, describing subject, technique, and artist at length // W. Walton, *Scribner's Magazine* 40 (August 1906), p. 274, discusses it // E. French, *World's Work* 13 (Dec. 1906), ill. p. 8322; p. 8323, notes that it is "often considered his best work" // Mrs. E. Johnson, letter in MMA Archives, Jan. 28, 1913 (quoted above) // Keeler Art Galleries, New York, *Catalogue of the Collection of Paintings Formed by the Late Daniel Huntington*, sale cat. (Jan. 27-28, 1916), no. 140, lists original sketch for this picture // P. Arbiter [pseud.], *Art World and Arts & Decoration* 9 (Sept. 1918), ill. p. 268; pp. 270-271, 294, calls it one of "the great portraits of modern times" and discusses at length // *The Pageant of America* (1927), 12, ill. p. 67, F. J. Mather, Jr., calls Johnson "a sterling portraitist in the objective tradition" and describes this painting as "admirably solid and characterful, and handsomely painted," but observes, "Perhaps the fine sobriety of the method told against it at a moment when technical ostentation was in fashion" // A. Burroughs, *Limners and Likenesses* (1936), p. 170 // *Pictures on Exhibit* 6 (Nov.

1944), p. 40, mentions it on exhibit at the Philadelphia Art Alliance // F. J. Mather, Jr., *Magazine of Art* 39 1946), ill. p. 295, describes it and notes, "Technically everything is of the best—the modeling of head and hands, the easy postures, revealing both of immediate mood and of permanent character. The picture is as decorative as this kind of a picture has any business to be" // A. T. Gardner, *MMA Bull.* 23 (April 1965), p. 273; p. 274, fig. 15 // *Kennedy Quarterly* 7 (March 1967), p. 6, discusses this painting and sketch for it // P. Hills, *The Genre Painting of Eastman Johnson* (Ph.D. diss., 1973; published 1977), pp. 125-126, discusses study and this painting, quotes Johnson correspondence; p. 228, fig. 78.

EXHIBITED: NAD, 1881, no. 216, as The Funding Bill — Portrait of Two Men // Inter-state Industrial Exposition, Chicago, 1881, no. 337, as The "Funding Bill," for sale // PAFA, 1881, *Special Exhibition of Paintings by American Artists at Home and in Europe*, no. 427 // Boston Art Club, 1882, no. 112 // MMA, 1882, *Loan Collection of Paintings and Sculpture*, no. 168, as The Funding Bill, Portraits of Two Men, lent by the artist // Art Gallery of the Southern Exposition, Louisville, 1884, no. 130 // Exposition Universelle, Paris, 1889, no. 178, as Deux hommes // MMA, 1894, 1895, *Loan Collections and Recent Gifts to the Museum*, nos. 124, 117, as Two Men, lent by the artist // Saint Louis Exposition and Music Hall Association, 1897, ill. p. [5], as installed; ill. p. 58, as A Discussion — Portraits of Two Men; p. 97, no. 289, lists it as The Discussion — Portraits of Two Men // MMA, 1939, *Life in America*, no. 225, as Two Men: Samuel W. Rowse (1822-1901) and Robert W. Rutherford [*sic*] // Brooklyn Museum, 1940, *Eastman Johnson*, exhib. cat. by J. I. H. Baur, p. 54, lists it as Two Men and mentions oil sketch; pl. XXXVI; p. 71, no. 254, lists it // Carnegie Institute, Pittsburgh, 1940, *Survey of American*

Johnson, *Two Men (Study for the Funding Bill)*. Private collection.

Painting, no. 123, as Two Men // Philadelphia Art Alliance, 1944, *Eastman Johnson Exhibition*, no. 17, as Portrait of Two Men // Detroit Institute of Arts, 1957, *Painting in America*, no. 115, as Two Men // MMA, 1958–1959, *Fourteen American Masters* (no cat.); 1965, *Three Centuries of American Painting*, unnumbered cat., as The Funding Bill // Los Angeles County Museum of Art and M. H. de Young Memorial Museum, San Francisco, 1966, *American Paintings from the Metropolitan Museum of Art*, no. 54 // MMA, 1970, *19th-Century America, Paintings and Sculpture*, exhib. cat. by J. K. Howat and N. Spassky, no. 146 // Whitney Museum of American Art, New York; Detroit Institute of Arts; Cincinnati Art Museum; and Milwaukee Art Center, 1972, *Eastman Johnson*, exhib. cat. by P. Hills, p. xxiii, no. 104, lists it; pp. 106, 114, discusses it; ill. p. 115 // Worcester Art Museum, Mass., 1973, *The American Portrait*, exhib. cat. by W. J. Hennessey, no. 34.

Ex coll.: the artist, New York, until 1898.

Purchase, Robert Gordon Gift, 1898.

98.14.

Lewis Einstein

Lewis Einstein (1877-1967), son of David and Caroline Einstein, was born in New York on March 15, 1877. He was graduated from Columbia College in 1898 and was awarded a master's degree the following year. In 1903, at the start of what became a distinguished career in the diplomatic service, Einstein met Oliver Wendell Holmes, then sixty-one. Their correspondence, which spanned the next thirty-two years, was published in 1963. Einstein served in the American embassies in Paris, London, Constantinople, and Peking. He was also posted to Costa Rica and Bulgaria and was appointed the first United States minister to Czechoslovakia. As a result of his service, he received international recognition. He was a prolific writer. His books include *The Italian Renaissance in England* (1903), *Napoleon III and American Diplomacy at the Outbreak of the Civil War* (1905), *Roosevelt: His Mind in Action* (1930), and *Divided Loyalties: Americans in England during the War of Independence* (1933). In addition he contributed many articles on art and history to European and American journals. He died in Paris at the age of ninety.

In answer to a letter from the museum requesting information on this portrait, he wrote from Florence in 1948:

The Eastman Johnson portrait about which you write me has never been out of the possession of my family. The subject is myself, at the age of five and it was painted in the "Japanese" room of my father's house at 39 West 57th St. It was taken to England by my mother in 1910 and since then has hung either in my sister's house near Cambridge, or at my son-in-law's the Marquess of Tweeddale in Scotland [William George Montagu Hay, 11th marquess, who married Marguerite Christine Ralli, step-daughter of Lewis Einstein, in 1912]. It has never been exhibited.

He added, "Eastman Johnson also painted about the same time a portrait of my sister Lady Walston, then a girl of eight or nine & who is seated on the stairs. I believe that this portrait was exhibited, by the artist's request, at the Chicago World Fair. It is now in my sister's place 'Newton Hall' near Cambridge." In addition to the World's Columbian Exposition in Chicago in 1893, the portrait of Einstein's sister was exhibited at the Society of American Artists in 1882 and at the National Academy of Design in 1883. Johnson's sketch of it appears in *Illustrated Art Notes upon the Fifty-Eighth Annual Exhibition of the National Academy of Design* (1883), p. 55, no. 348. The portrait, which is in a private collection, is the same size as the one of Einstein and was probably intended as a companion to it. The paintings complement each other in the angular pose of the figures and the use of oblique planes and diagonals.

Johnson's portrait of Lewis Einstein, dated May 20, 1882, shows a self-possessed child in a lace-trimmed suit of deep burgundy. The setting is the richly decorated "Japanese" room of his father's house, which reflects the contemporary fascination for designs inspired by the Orient. The boy stands on a beige and dark red rug in front of a gold-tasseled portiere. His hand rests against an ebonized architrave with glazed shelves and fretwork.

Johnson's training with Couture is apparent in the strong contours of the child's legs and the handling of light and dark. His bold use of contrasts, his rich, dark palette and his broad handling of paint reflect his study of seventeenth-century Dutch painting.

Some of the areas of shadow, most noticeably the left side of the boy's jaw and his left hand, are very thin and transparent with the crown of the canvas weave exposed. These areas appear to have been scraped by the artist.

Oil on canvas, 54 × 40 in. (137.2 × 101.6 cm.).

Signed and dated at lower right: E. Johnson / May 20–1882.

Canvas stamp: PREPARED BY / F. W. DEVOE & CO. / NEW YORK / MANUFACTURERS AND IMPORTERS / ARTISTS' MATERIALS.

REFERENCES: *Artistic Houses* (1883) 1, pp. 29-30, says the portrait hung in the library of the David L. Einstein house and notes, "since the advent of the younger school of the 'Society of American Artists,' Mr. Johnson has displayed new possibilities in dealing with the potencies of color and nowhere, perhaps, better displayed them than in this charming portrait The key-note of the chromatic scheme is the boy's red jacket, which lends, but does not sell, itself to the prevailing tone of the room" // L. Einstein, letter in Dept. Archives, Feb. 3, 1948 (quoted above)// *MMA Bull.* 7 (Summer 1948), p. 21, mentions acquisition // *Who Was Who in America* (1950), 2, p. 171, supplies biographical account of the subject, mistakenly gives death date as 1949 // *New York Times*, Dec. 5, 1967, p. 50, obituary notice of subject.

EXHIBITED: MMA, 1965, *Three Centuries of American Painting*, unnumbered cat. // Hudson River Museum, Yonkers, N. Y., 1970, *American Paintings from the Metropolitan Museum*, no. 26.

EX COLL.: the subject's parents, David Lewis and Caroline E. Einstein, New York, 1882–1909; Caroline E. Einstein, New York and Cambridge, 1909; the subject, Lewis Einstein, by 1947.

Gift of the Honorable Lewis Einstein, 1947.

47.128.

Grover Cleveland

The son of a Presbyterian clergyman, Grover Cleveland (1837-1908) was born in Caldwell, New Jersey, and spent his early years in western New York State. Cleveland was admitted to the bar in 1859, became active in local Democratic organizations, and was elected mayor of Buffalo

Johnson, *Lewis Einstein*.

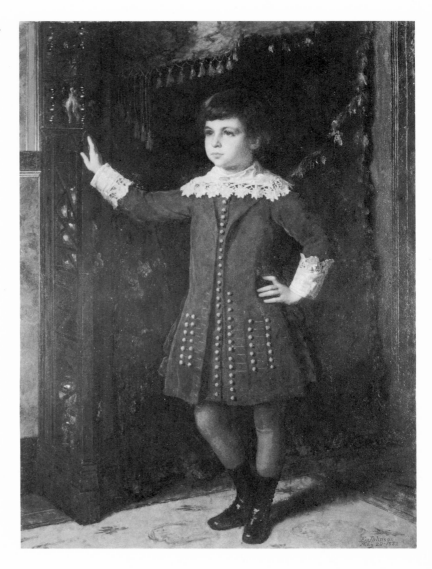

in 1881. His success in reforming the city administration attracted considerable attention, and in 1883 he was elected governor. The following year, the Democratic national convention nominated him for president. His election put a Democrat in the White House for the first time since 1861. When he ran for re-election in 1888, he was narrowly defeated by Benjamin Harrison. Cleveland returned to the practice of law and established an office in New York City. In 1892 he defeated Harrison, thereby becoming the only president to serve two nonconsecutive terms in the White House. At the end of his second term in 1897, Cleveland settled in Princeton, New Jersey, where he lived until his death a decade later.

Johnson discussed his portraits of Cleveland in a letter to Montague Marks of the *Art Amateur* in 1894.

You are not quite correct with regard to there not being a single bust or portrait of Mr. Cleveland extant, and as you mention my name in your remarks on that subject in the last number of The Art Amateur, I feel at liberty to say that I have painted him twice

The first portrait was as Governor of New York for the series that are in the Court House in Albany,

Johnson, *Grover Cleveland.*

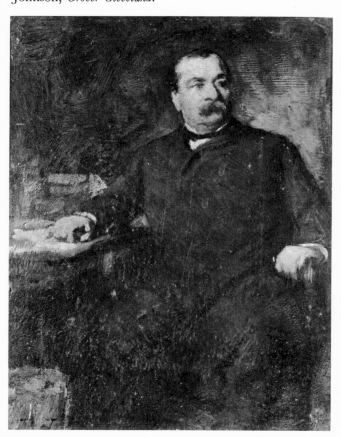

and painted at Albany the week before his inauguration the first time as President, and in the midst of such excitement and intrusion as you can imagine incident to that moment. But it turned out as well, I think, as anything I do — a three-quarter figure, standing. The next was as President, after his term had expired, and for the White House two or three years ago. He sat to me in my studio while living in New York, giving me plenty of time, and mounting my four stairs without a murmur. Both occasions are full of pleasant and interesting memories to me. It was not possible for me to show either of these portraits publicly. The last one I did have for a night at The Century Club. They went immediately to their ultimate and final seclusion. (*Art Amateur* 32 [Dec. 1894], p. 2).

The three-quarter-length standing portrait of Cleveland, now in the Albany Institute of History and Art, is dated 1885. The White House portrait, which shows Cleveland seated, is dated April 1891. In addition to several smaller portraits, Johnson also painted two large portraits of Cleveland that are virtually identical to the White House portrait. One of these is now at the State Capitol, Albany, and the other is at City Hall, New York.

The museum's undated sketch was acquired by Albert Rosenthal from Johnson's widow, according to a label once on the back of the painting. The label identifies the work as a study for Johnson's "well known large portrait of President Cleveland," in all probability the White House portrait, which would date the study before April 1891.

As a preliminary study, the museum's painting was intended essentially to establish the composition, the position of lights and darks, and the placement of color. It is therefore only a very summary representation of the subject. Working on a thinly painted, warm brown ground, worked over with red and yellow, Johnson indicates the flesh tones and the subject's white collar and cuffs in impasto applied in patch-like fashion. Drawing is restricted to a few dark contour lines around the head and shoulders. The building up of the paint in successive layers, the deliberate boldness of the brushwork, and the use of a palette knife contribute to a richly textured surface. Johnson's practice of making such studies probably reflects the enduring influence of his brief training with Thomas Couture. This influence is even more readily apparent, however, in Johnson's portrait of SANFORD ROBINSON GIFFORD (q. v.). William Wal-

ton noted that Johnson "very seldom contented himself with the one canvas delivered to the sitter; in his endless search for the better way, he would render, in black and white, or in color, one, or two, or even three variations, even of life-size figures" (*Scribner's Magazine* 40 [August 1906], pp. 273-274). For the Cleveland portrait in the State Capitol in Albany, Johnson made an oil study similar in all but a few features to the museum's sketch (Frank S. Schwarz and Son, Philadelphia, *In Celebration of 50 Years, 1930-1980*, sale cat. [Dec. 1980], no. 4). Such studies were never intended for public exhibition and generally remained in his studio.

Oil on cardboard, 10½ × 8¾ in. (26.7 × 22.2 cm.).

Signed at lower left: E. J. Inscribed on a label formerly on the back, now in Dept. Archives: "This original Study by Eastman Johnson of Pres. Cleveland, / was purchased, with a collection of oil sketches and portraits / & charcoal studies, by me, in 1915, from Mrs. Eastman Johnson. / This study was made as a basis of his well known large portrait / of President Cleveland. / Albert Rosenthal / N. Y. 12/29 — 1936."

RELATED WORK: *Grover Cleveland*, oil on canvas, 56½ × 41¾ in. (143.5 × 106 cm.), April 1891, White House, Washington, D. C., ill. in H. C. Hambidge, *Munsey's Magazine* 39 (August 1908), p. 589.

REFERENCES: A. L. Cutler, letter in Dept. Archives, May 18, 1982, supplies information on study at Frank S. Schwarz and Son, Philadelphia // N. S. Rice, Albany Institute of History and Art, letter in Dept. Archives, June 23, 1982, supplies information on portraits in Albany.

EXHIBITED: Heckscher Art Museum, Huntington, N. Y., 1947, *European Influence on American Painting of the 19th Century*, no. 4.

EX COLL.: Mrs. Eastman Johnson, New York, until 1915; with Albert Rosenthal, Philadelphia and New York, 1915-at least 1936; with Harry Stone, New York, by 1941.

Fletcher Fund, 1941.

41.125.

SEYMOUR JOSEPH GUY

1824–1910

Relatively little is known about the life and artistic development of Seymour Joseph Guy, one of the most successful American genre painters of the late nineteenth century. Born in Greenwich, England, he was the son of Jane Delver and Frederick Bennett Guy. He attended school in Surrey, and, after being orphaned at the age of nine, was raised by guardians. Accounts of his early art career vary. He was reportedly instructed by a Mr. Buttersworth (or Butterworth), sometimes described as a marine painter, who may have been the artist Thomas Buttersworth (1768-1842). It has also been said that he studied at the British Museum (Sheldon, p. 66). His guardian apparently opposed his decision to become an artist and, instead, Guy seems to have worked in "the oil and color trade for seven years" (*National Cyclopaedia* 11, p. 301). In 1847 he was apprenticed to Ambrosini Jerôme (active 1840-1871), a woman who was portrait painter to the duchess of Kent. Four years later, perhaps under Jerôme's influence, he exhibited a mythological painting at the British Institution in London. *Cupid in Search of Psyche* (George Walter Vincent Smith Art Museum, Springfield, Mass.), an imaginative picture showing Cupid sailing a shell propelled by a leaf sail, is a rare example of Guy's known work in this genre.

In 1854, at the age of thirty, Guy immigrated to the United States, where shortly after his arrival, he married the daughter of William Barber, an engraver. Guy settled in New York and devoted himself at first to portraiture. His 1857 portraits *Deborah Taylor* and *John Taylor*

(New York art market, 1978) are realistic but saccharine. Their ambitious poses and elaborate settings demonstrate his familiarity with the grand tradition of English portraiture. Guy, who began to exhibit at the National Academy of Design in 1859, was elected an associate member in 1861 and an academician four years later. He exhibited at the Pennsylvania Academy of the Fine Arts in 1862, 1866, and 1868 and, beginning in 1862, contributed regularly to exhibitions at the Brooklyn Art Association. When the American Watercolor Society held its first exhibition in 1867, he was listed among the charter members. In New York he also joined the Artists' Fund Society and the Century Association.

Although Guy began his American career as a portraitist, he soon demonstrated his ability as a genre painter and thereby established his reputation. His genre paintings usually depict children and are laden with sentiment and moralizing. Some of these scenes, such as *Making a Train*, 1867 (Philadelphia Museum of Art), are set indoors with strong artificial light. Critics compared these genre paintings to works by such Europeans as Meyer von Bremen. Guy's work seems closest to that of the nineteenth-century Dutch genre painter Petrus van Schendel, whose realistic candlelight scenes were exhibited in New York. Many of Guy's other paintings are sunfilled landscapes, in which children are shown at play or work, for example, *Unconscious of Danger*, 1865 (coll. Jo Ann and Julian Ganz, Jr., Los Angeles). Whatever the subject, Guy's genre scenes were quite popular. He reportedly worked slowly, and his paintings were enthusiastically sought after by such prominent collectors as John M. Falconer (1820-1903), George I. Seney, Samuel P. Avery, and Jay Gould.

The final two decades of Guy's career are somewhat obscure. He continued to exhibit at the National Academy as late as 1906 and maintained a studio in the famous Tenth Street Studio Building, where he had been working since at least 1867. In 1893, a small number of his paintings were exhibited and auctioned with those of Arthur Parton (1842-1914). Guy's wife, Anna, died after a brief illness in 1907. Three years later, at the age of eighty-six, Guy died in New York.

BIBLIOGRAPHY: "American Painters. Seymour Joseph Guy, N. A. – Lemuel E. Wilmarth, N. A.," *Art Journal* (New York) 1 (Sept. 1875), pp. 276–278 // G. W. Sheldon, *American Painters* (New York, 1881), pp. 65–70; reprinted in part in "Seymour Joseph Guy," Walter Montgomery, ed., *American Art and American Art Collections* (Boston, [1889]), 2, pp. 589-591 // Ortgies and Co., at the Fifth Avenue Art Galleries, New York, *Catalogue of Paintings by Seymour J. Guy, N. A., and Arthur Parton, N. A., to be Sold by Auction . . . February 7th & 8th, . . . [1893]*, lists and gives dimensions of a number of his works // *National Cyclopaedia of American Biography* 11 (New York, 1909), p. 301. Provides some details about his childhood and work in England // National Gallery of Art, Washington, D. C., *An American Perspective: Nineteenth-Century Art from the Collection of Jo Ann & Julian Ganz, Jr.*, exhib. cat. (1981), pp. 56-61, essay by Linda Ayres; pp. 135-136, biographies by John Lamb, Stephen Edidin, and Deborah Chotner, entries by Stephen Edidin.

Charles Loring Elliott

This portrait of Guy's fellow artist CHARLES LORING ELLIOTT (1812–1868) was painted in 1868. It is not known whether the painting was done from life or as a memorial to Elliott, who died on August 25 of that year. A number of portraits of him were executed around this time, including sculptures by Charles Calverly and Launt Thompson (both MMA) and an oil painting by GEORGE A. BAKER, JR. (NAD). Elliott was honored by a memorial display of his work at the winter exhibition of the National Academy of Design in 1868–1869. "His death," eulogized

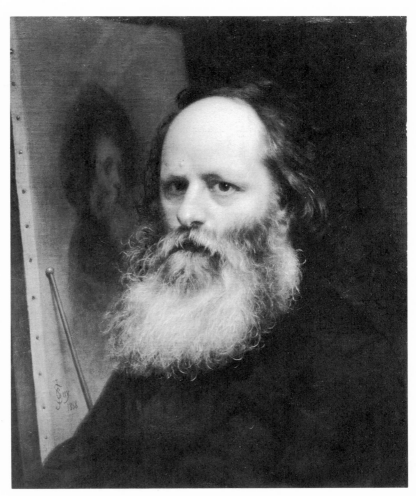

Guy, *Charles Loring Elliott.*

the journalist Samuel Stillman Conant, "leaves a vacancy in American art which no portrait painter living can fill" (*Galaxy* 6 [Oct. 1868], p. 574).

This bust-length portrait shows the aging Elliott bareheaded and dressed in a dark suit. His balding head, unkempt beard, and blemished skin are faithfully recorded. Guy, however, has softened his sitter's profile and eliminated the wrinkles seen around his eyes in contemporary photographs.

Elliott is shown in front of what is undoubtedly an unfinished self-portrait. The incomplete state of the portrait and the artist's maulstick, which has been placed aside, can be seen as reminders that death has taken the artist from his work. Guy has placed his own signature and the date 1868 on the self-portrait. The placement of the maulstick draws attention to this detail. Elliott is known to have painted a number of

self-portraits, including one in the Metropolitan (q. v. Vol. 1). The self-portrait in Guy's painting, however, cannot be tied directly to any particular one by Elliott.

Oil on canvas, 12⅛ × 10 in. (30.8 × 25.4 cm.).

Signed and dated at lower left: SJGuy (initials in monogram) / 1868.

REFERENCES: *New York Times*, April 30, 1869, p. 4, discusses it in a review of NAD exhibition // *Putnam's Monthly* 3 (June 1869), p. 747, in a review of the NAD exhibition, says, "There is a portrait of Elliott, by Guy, in the East Room, of which we cannot speak very favorably" // C. E. Clement and L. Hutton, *Artists of the Nineteenth Century* (1879), 1, p. 321, supply early exhibition record of the picture // *Appleton's Cyclopedia of American Biography* (1898), 3, p. 17, misdates it 1869 // U. Thieme and F. Becker, *Allgemeines Lexikon der Bildenden Künstler* 15 (1922), p. 365, mistakenly says that it is in the collection of the New York Public Library // T. Bolton, *Art Quarterly* 5 (Winter 1942), p. 80, mentions its early exhibition record // W. H.

Downes, *DAB* (1932; 1960) s. v. "Guy, Seymour Joseph," p. 63.

EXHIBITED: Brooklyn Art Association, spring 1869, no. 212, lent by Sam'l P. Avery // NAD, 1869, no. 260, lent by S. P. Avery // Paris, 1878, *Exposition Universelle*, no. 51, lent by John H. Sherwood.

EX COLL.: with Samuel P. Avery, New York, by 1869; John Taylor Johnston, New York (sale, Somerville Art Gallery, New York, Dec. 19, 1876, no. 19, $110); John H. Sherwood, New York, 1876 (sale, Chickering Hall, New York, Dec. 18, 1879, no. 92, $80); John Taylor Johnston, 1879–d. 1893; his daughter Emily (Mrs. Robert W.) de Forest, until 1903.

Gift of Mrs. Robert W. de Forest, 1903.

03.31.

The Crossing Sweeper

This small-scale picture is one of the many genre works that established Guy's reputation as a painter of sentimental scenes of childhood. Like JOHN GEORGE BROWN, who often depicted

Guy, *The Crossing Sweeper*.

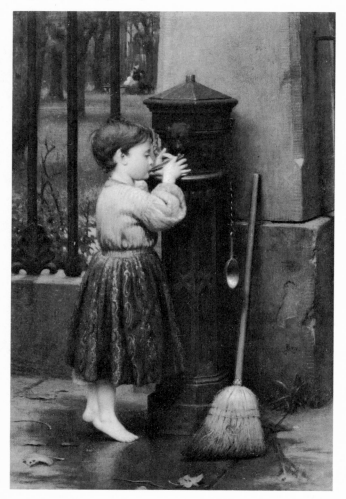

newsboys and shoeshine boys, Guy idealized his models. As he noted in an interview:

The true picture is both Nature and art. We must follow Nature as closely as we can, but we must select from Nature; we must take the most beautiful things and discard deformities. Of course, nothing in art has yet surpassed Nature, and we all go wrong when we go away from her. Still, we want something more than her alone. I 'paint up' a simple story, trying to get into it as much beauty as possible from color, light, and shade—as much beauty of every sort as it will admit (G. W. Sheldon, *American Painters* [1881], pp. 67-68).

In *The Crossing Sweeper* the subject of Guy's "simple story" is a barefoot girl who pauses in her task of sweeping a street crossing to drink from a fountain. He contrasts this laboring child, who stands on a bleak, littered sidewalk, with a group of figures at rest in a park or garden visible through the bars of the fence. The sweeper is clearly separated from the pleasant world beyond the fence. Here Guy's story carries a message that would have been obvious to his viewers in an age of strong moral sentiment.

The Crossing Sweeper was probably painted during the 1860s. The canvas stamp for Goupil and Company gives the firm's address as 772 Broadway, which was their place of business between 1860 and 1868. The painting was included in an auction of the collection of Silas C. Evans in 1877.

Oil on canvas, 12⅛ × 8½ in. (30.8 × 21.6 cm.).

Signed on back wall at right: SJGuy (initials in mongram). Canvas stamp: GOUPIL's / 772 BROADWAY, N.Y.

REFERENCES: E. Strahan [E. Shinn], ed., *The Art Treasures of America* (1880), 3, p. 42, lists it as being in the collection of Collis Huntington.

EX COLL.: Silas C. Evans, New York (sale, Association Hall, Y.M.C.A., March 15, 1877, no. 129, as The Crossing Sweeper, $335); Collis P. Huntington, 1877–d. 1900; his wife, later Mrs. Henry E. Huntington, subject to a life estate, 1900–d. 1924; her son, Archer M. Huntington, subject to a life estate, which was relinquished, 1924–1925.

Bequest of Collis P. Huntington, 1900.

25.110.50.

GEORGE INNESS

1824–1894

Like his contemporaries JOHN LA FARGE and WILLIAM MORRIS HUNT, the landscape painter George Inness stimulated American interest in French art, especially the Barbizon painters. He was born in Newburgh, New York, the son of a successful grocer, and spent most of his youth in Newark, New Jersey. He began his art studies with Jesse Barker (active 1815-1856), an itinerant painter, and worked as an apprentice engraver at the New York firm of Sherman and Smith. His first significant training, however, was in New York with the French painter Régis Gignoux (1816-1882), sometime between 1843 and 1845. Even in works done during these early years, Inness departed from the approach to landscape painting of his contemporaries, members of the Hudson River school. Rather than being topographical views of American scenery, his landscapes reflected his admiration for the seventeenth-century old masters; they are self-consciously composed and somewhat idealized in treatment. He exhibited at the National Academy of Design in 1844, and the following year he offered some of his paintings for sale at the American Art-Union. His first trip to Europe was financed by the New York auctioneer Ogden Haggerty and probably took place in 1850, shortly after Inness's marriage to Elizabeth Hart. He spent about fifteen months in Italy, first in Florence and then in Rome, and returned to New York in 1852.

Inness made a second visit to Europe in 1853. There he was influenced by the work of such Barbizon painters as Théodore Rousseau, who inspired the free brushwork, bright colors, and informal compositions of Inness's paintings in the late 1850s and 1860s. His change in style, however, was hardly complete or immediate. In paintings like *The Lackawanna Valley*, 1855 (National Gallery of Art, Washington, D. C.), he retained the meticulous detail and pervasive old master tone of his earlier work. In 1860, neglected by patrons and critics and in poor health, Inness left New York. He settled first in Medfield, Massachusetts, and then late in 1863, at Eaglewood, an estate near Perth Amboy, New Jersey. Eaglewood had been the site of a cooperative community during the 1850s, and, before Inness arrived, several of its members, led by Marcus Spring, had founded a school there, the Eaglewood Military Academy. This was a crucial period for Inness. He became friendly with WILLIAM PAGE, who introduced him to the beliefs of the Swedish philosopher Emanuel Swedenborg, whose spiritualism exerted a strong influence on him. An ardent abolitionist, Inness was also deeply affected by the Civil War. Throughout the 1860s, his style of painting remained unchanged, but he showed a new interest in the potential for meaning and expression in landscape painting. While reducing the narrative detail and staffage typical of his earlier work, he heightened the expressiveness of his paintings with threatening storms and radiant sunsets. His works conveyed specific moods; many, like *Peace and Plenty* (q. v.), were calm and quiet.

The 1870s and early 1880s were years of great change for Inness. He made an agreement with his dealers, Williams and Everett of Boston, to provide paintings in exchange for regular monthly payments and left for Europe in 1870. After a brief stop in Paris, he spent much of the next four years in Rome, traveling in the summers to Tivoli, Albano, and Venice. In Italy he created some of his most original pictures, among them *The Monk*, 1873 (Addison

Gallery of American Art, Phillips Academy, Andover, Mass.). In the spring of 1874 Inness settled in Paris, where his son George Inness, Jr. (1854–1926), studied with Léon Bonnat. Early in 1875 he returned to Boston to negotiate with a new representative, Doll and Richards. Attempting to escape his agreement with them a year later, he went to New York.

In 1878, after achieving some financial stability, Inness took a studio in the University Building and acquired a home and studio in nearby Montclair, New Jersey. That same year the art dealer Thomas B. Clarke became his agent. As early as 1875 Inness had begun to record his ideas on art. They were published in an article "A Painter on Painting" in *Harper's New Monthly Magazine* for February 1878. Inness, who had not been elected a member of the National Academy of Design until 1868, emerged as one of the less conservative members of the older generation of artists. He was a founding member of the Society of American Artists, an exhibition organization founded in 1878 by artists disillusioned with the National Academy of Design. During this period the public became interested in Inness's theories as well as his painting. Charles de Kay, under the pseudonym Henry Eckford, published an important critical article on him in 1882. Two years later a comprehensive exhibition helped establish the enormous reputation that Inness enjoyed for the remainder of his career. Although no single style or subject characterized his work between 1870 and 1884, in general he emphasized color to express the moods and drama of nature. Works like *Autumn Oaks* (q. v.) show the richly colored, painterly style that he developed during the 1870s after his renewed contact with French art. For five years beginning around 1879, he also included more and larger figures in his landscapes.

By the final decade of his career, Inness had arrived at a new and highly original style. In paintings like *Sunrise* (q. v.) he sacrificed detail and form to explore the effects of color and light. His compositions became decorative with two-dimensional shapes silhouetted against richly colored, glowing light. These aspects of his work suggest that Inness was influenced by the paintings of J. M. W. Turner. In his tonal palette and use of simplified forms, Inness may also have been inspired by JAMES MC NEILL WHISTLER. His late paintings are also often compared to those of the impressionists, whose works he could have seen in Paris in 1874. In spite of certain superficial resemblances his work bears to that of the impressionists, however, he was more concerned with mood and meaning than with the objective recording of light and atmosphere. During these years he painted in a variety of places in Connecticut, New York, Massachusetts, and Virginia. In the early 1890s he went to California and Florida. He sailed for Europe in 1894 and visited Paris, Baden, and Munich before his death in Bridge of Allan, a small Scottish resort village. In New York Inness was honored with a funeral service at the National Academy of Design and a memorial exhibition at the Fine Arts Building. He remained a major influence on younger painters, particularly the landscapists who adopted his tonal palette, simplification of form, and evocative mood.

BIBLIOGRAPHY: Elliott Daingerfield, *George Inness: The Man and His Art* (New York, 1911). An appreciative account by a friend and admirer // George Inness, Jr., *Life, Art, and Letters of George Inness* (New York, 1917). The recollections of Inness's son. // Elizabeth McCausland, *George Inness: An American Landscape Painter, 1825–1894* (New York, 1946) // Leroy Ireland, *The Works of George Inness: An Illustrated Catalogue Raisonné* (Austin, 1965). Includes an entry for each of the artist's paintings, with references, exhibitions, and provenance // Nicolai Cikovsky, Jr., *George Inness* (New York, 1971).

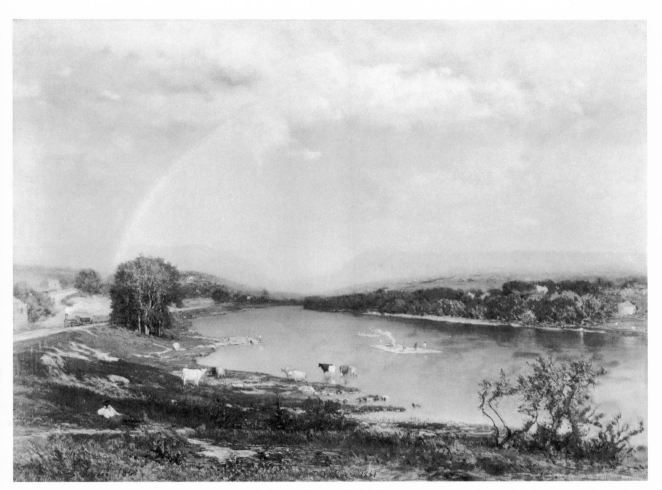

Inness, *Delaware Water Gap*.

Delaware Water Gap

Inness painted a number of views of the Delaware Water Gap, many of which feature similar motifs—a moving train, heavily laden barges, grazing cows, a rainbow, a retreating storm, and figures contemplating the landscape. He first painted the view around 1857 and then repeated it several times over the next decade. He appears to have returned to the subject again in 1873, 1878, and 1891.

The Metropolitan's painting, dated 1861, is a view from the Pennsylvania side of the Delaware River with the Kittatinny Mountains in the distance. Mount Minsi, Pennsylvania, at the left, and Mount Tammany, New Jersey, on the right, are shrouded in the mist of a retreating storm. Three known Inness landscapes closely resemble this painting in composition: *Delaware Water Gap*, ca. 1857 (National Gallery, London, ill. Ireland [1965], no. 145), *Delaware Water Gap*, ca. 1861–1866 (private coll., Grosse Pointe,

ill. Ireland, no. 230), and *On the Delaware*, 1873 (Brooklyn Museum, ill. Ireland, no. 231). The small oil *Delaware Water Gap* (Grosse Pointe) has been described as a preliminary study for the Metropolitan's painting. This seems unlikely. It was done from a different vantage point, closer to the mountains, and shows a stormier sky and a double rather than a single rainbow. Then, too, there are figures, not cows, on the riverbank. In composition and style, the Metropolitan's painting most closely resembles the version at the National Gallery, London. There are, however, subtle differences. The Metropolitan's picture has a figure and some plants and bushes in the foreground and an extra barge on the river; furthermore, the mountains are shrouded in a luminous haze rather than silhouetted against the sky.

One of Inness's depictions of the Delaware Water Gap was exhibited at the Williams and Everett gallery in 1861, the year in which the Metropolitan's picture was painted. An article

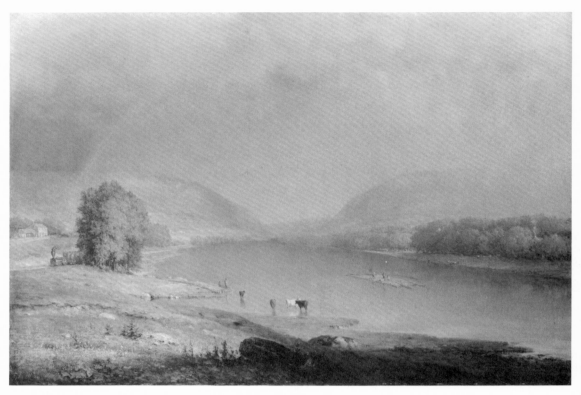

Inness's earliest *Delaware Water Gap*, 1857. National Gallery, London.

in the *Boston Daily Advertiser* described the painting on exhibition as "a new picture of a river, with barges and lumber rafts coming out of the highlands, the water-gap of the Delaware." It continued:

Over the background is a retreating thunder storm, half-veiling the distant landscape and filling the gorges of the hills. At left a rainbow rides in the flank of storm-clouds. At the right the sun has burst out, and flooded river and hill with its glorious light.

In the middle distance we see the sunlight stealing up the river, and invading the path of the retreating storm, while in the foreground, the grazing cattle, the lazy gliding lumber rafts, the grass and flowers, almost twinkling with rain-drops, fill one with the most impatient yearnings to hasten from the noisy city to the glowing and radiant river side.

The writer contrasted *Delaware Water Gap* with *Heart of the Andes* by FREDERIC E. CHURCH (q. v.):

the more highly your glass magnified, the more beautiful were the details. Not so in this picture . . . it affects one like an inspiration. It is painted hastily, but so strong, and with much knowledge of the effects of color, that a mere daub of white paint, when looked at from the proper distance, is a man, and a patch of brown, a cow or a farm house.

The painting described here is most likely the Metropolitan's *Delaware Water Gap*. The National Gallery's version, the earliest in the group, fits the description rather closely but has only one barge or lumber raft. Inasmuch as it was exhibited in London in 1859 and bequeathed to the Tate Gallery there by a descendant of the person who commissioned it, it was probably not the painting being sold in Boston in 1861. The Grosse Pointe picture lacks the strong area of sunlight mentioned in the description. Also, its small size makes it an unlikely choice for such lengthy critical comment. *On the Delaware River* (Brooklyn Museum) is quite similar in composition to the Metropolitan's painting, but it lacks a rainbow. Previously thought to have been painted between 1861 and 1863, it is now known to be dated 1873. *Delaware Water Gap* (unlocated; ill. Ireland [1965], no. 229) contains many of the elements described in the review, but it is very different in composition from the rest of the group and has a rainbow on the right rather than the left.

The painting shown in Boston in 1861, which we assume was the Metropolitan's picture (and not an as yet unknown version of the subject), was

reportedly sold from the exhibition. A *Delaware Water Gap* was exhibited in Brooklyn in 1865, but nothing certain is known about the museum's picture until 1888, when it was lent to an exhibition in Chicago. At that time, the painting was listed for sale so presumably it was lent by the artist. Thomas B. Clarke, the well-known collector and dealer, is reported to have handled the sale of the painting to Benjamin Altman, the New York merchant, in 1892.

In certain respects, the style of the picture resembles that of the Hudson River school painters. Like them, Inness chooses a panoramic view of the countryside and a dramatic climatic effect. Even in this early work, however, he shows an individual style of painting, applying pigment freely and summarily with little concern for detail or finish.

Oil on canvas, 36 × 50¼ in. (91.4 × 127.6 cm.).
Signed and dated at lower left: G. Inness 1861.
Signed and dated at lower center: G. Inness 1861.

REFERENCES: *Boston Daily Advertiser*, April 3, 1861, p. 2, in a review of paintings on view at Williams and Everett gallery, Boston, "C" describes what is probably this version of Delaware Water Gap (quoted above) // Inventory of the collection of Michael Friedsam, B. Altman & Co., New York [before 1922], includes it as no. B-79, describes it and notes it is "from the Altman Collection" and that "Inness himself regarded this as one of the best pictures of his career, and was particularly fond of it" // Will of Michael Friedsam, June 13, 1930, copy in MMA Archives, p. 3, eighth article lists it as a bequest to his friend Clarence W. Wood // B. Burroughs, letter in MMA Archives, Nov. 3, 1932, says that according to T. Y. Hobby, keeper of the Altman collection, Altman purchased it "at private sale" in 1892 and gave it to Friedsam in 1907 // H. B. Wehle, *MMA Bull.* 28 (April 1933), pp. 70-71, suggests that sketches for this painting may have been made as early as 1855; ill. p. 71 // M. de Sherbinin, New York, letter in Dept. Archives, May 23, 1936, states that according to Nathanial O. Jarvis, an elderly invalid, his father Nathanial Jarvis owned it and sold it to "Sypher the dealer, who in turn sold it to B. Altman" // T. Y. Hobby, memo in Dept. Archives, May 26, 1936, reasserts 1932 statement that Altman purchased it in June 1892 along with another Inness called The Shower, for the two "Mr. Altman paid the sum of $8,500," and states that there is no record of its having been owned by Jarvis or Sypher // E. P. Richardson, *American Romantic Painting* (1944), p. 38; fig. 183 // W. Born, *American Landscape Painting* (1948), p. 159, discusses; ill. p. 160 // E. P. Richardson, *Painting in America* (1956), p. 225, calls it "the first mature statement" of Inness's new style // A. T. Gardner to M. Davies, in Dept. Archives, Jan. 31, 1958,

after some research, concludes that the National Gallery version was painted from the Pennsylvania side of the river below the gap and shows Tammany and Minsi mountains in the Kittatinny range and that the railroad shown is the Delaware, Lackawanna and Western, completed in 1855 // National Gallery, London, *The British School* (rev. ed., 1959), cat. by M. Davies, p. 70, notes the Metropolitan's painting in relation to London version // J. T. Flexner, *That Wilder Image* (1962), p. 318; ill. p. 319 // L. Ireland, *The Works of George Inness* (1965), ill. p. 57, includes it as no. 232 in a catalogue of the artist's paintings // N. Cikovsky, *American Art Journal* 2 (Fall 1970), p. 57 n 44, says the rainbow above the train calls attention to it and alludes to its meaning; *George Inness* (1971), p. 38; fig. 21 // A. Werner, *Inness Landscapes* (1973), p. 28, mentions painting as the most famous of Inness's treatments of this subject // J. S. Burke, Jr., B. Altman and Co., New York, July 17, 1980, letter in Dept. Archives, says that he is unable to locate any lists of the Altman collection prior to its acquisition by the museum but provides an inventory of the Friedsam collection [before 1922] // Wellesley College Museum, Mass., *The Railroad in the American Landscape* (1981), cat. by S. D. Walther, K. W. Maddox, and J. H. Fox, p. 83.

EXHIBITED: Williams and Everett, Boston, 1861 (probably this painting) // Brooklyn Art Association, 1865, no. 79, as Delaware Water Gap (possibly this painting) // Chicago, Inter-state Industrial Exposition, 1888, no. 212, for sale // Gallery of the Late Benjamin Altman, New York, 1915, *Loan Exhibition of Fifty-nine Masterpieces of Ancient and Modern Schools*, no. 30, lent by Mr. M. Friedsam // MMA, 1934, *Landscape Paintings*, no. 71; 1939, *Life in America*, no. 215 // Detroit Institute of Arts, 1944, *The World of the Romantic Artist*, no. 58 // Art Institute of Chicago and Whitney Museum of American Art, New York, 1945, *19th Century French and American Paintings from the Collection of the Metropolitan Museum of Art*, no. 20 // MMA, 1958-1959, *Fourteen American Masters* (no cat.).

EX COLL.: probably with Williams and Everett, Boston, 1861; probably the artist, by 1888; with Thomas B. Clarke, New York, 1892; Benjamin Altman, New York, 1892-1907; Michael Friedsam, New York, 1907-d. 1931; Clarence W. Wood, 1931-1932.

Morris K. Jesup Fund, 1932.

32.151.

The Delaware Valley

Like a number of Inness's paintings of the 1860s, this panoramic view depicts the scenic Delaware Valley in Pennsylvania, where the Delaware River cuts through the Kittatinny Mountains to New Jersey. The fertile valley is

overshadowed by mountains and a turbulent sky. Inness heightened the drama with strong contrasts of light and dark. The middle ground is brightly illuminated, drawing attention to the hay-filled wagon and the figure struggling to complete the harvest before the storm. Inness worked in a direct, free style. His paintings were characterized by fluid paint and a lack of topographical accuracy. ELLIOTT DAINGERFIELD commented in 1911 that this picture showed Inness's real power, particularly in the foreground where "there are beautiful textures of rock and weed and earth, touched in with vigor and a sure brush, the color laid on heavily and much manipulated for the very sake of its texture."

The Delaware Valley is signed and dated, but the final digit of the date is not clear. The year was often given as 1863, particularly during the 1890s when the painting was widely exhibited. Later 1865 became the accepted date. A recent examination of the numbers under a microscope, however, established that the final digit is not five, but either two or three. The physical evidence and the frequency with which 1863 was used during Inness's lifetime suggest that it is the correct date.

This harvest scene is similar to other paintings of the 1860s by Inness. In fact, although it lacks a rainbow, it closely corresponds to descriptions of a sketch for his lost painting *The Sign of Promise*, 1862. The completed version of *The Sign of Promise* was often said to have been repainted into *Peace and Plenty*, 1865 (see below). *The Delaware Valley*, like *Peace and Plenty*, may be viewed in allegorical terms. America, represented by a harvest scene, is threatened by a violent storm — the Civil War. *The Delaware Valley* represents the threat of the conflict, whereas *Peace and Plenty* symbolizes its resolution in favor of the Union, which Inness ardently supported. Such an interpretation is consistent with Inness's work during the 1860s, when, under the influence of religious writers like Emanuel Swedenborg and the Reverend Henry Ward Beecher, he became more concerned with meaning in his paintings.

The painting was one of more than sixty Innesses owned by Thomas B. Clarke, an art collector and dealer who began to handle the artist's work in the late 1870s. In 1899 the picture was included in an auction of Clarke's American paintings. This landmark sale set record prices for works by many artists and greatly stimulated interest in collecting American art. A writer for the *New-York Daily Tribune* noted that when the Metropolitan's purchase of *The Delaware Valley* was announced at the auction, the news was greeted by "prolonged applause." Coming only five years after Inness's death, the acquisition of this picture—by purchase rather than gift or bequest—affirmed Inness's importance in the history of American art.

Oil on canvas, 22¼ × 30⅜ in. (56.5 × 77.2 cm.). Signed and dated at lower left: G. Inness 186[3].

REFERENCES: *New-York Daily Tribune*, Feb. 4, 1889, p. 6, in a review of the New York Athletic Club exhibition, comments: "The superb 'Delaware Valley,' painted by George Inness in 1863, is the centre of the group. In breadth of design, truthful rendering of form and fine tonality, this noble landscape leaves little to be desired" // *New York Evening Post*, Feb. 4, 1889, p. 6, mentions it in a review of the New York Athletic Club exhibition, notes that many of the works exhibited belong to Clarke // *New York Herald*, Jan. 10, 1890, p. 10, in a review of an exhibition at the Union League Club, calls it "delightful" and says that it is a "powerful expression of nature in a pouting mood" // *New-York Daily Tribune*, Jan. 10, 1890, p. 6, in a review of exhibition at the Union League Club, says the painting "proves that a 'view' may be made pictorial," and calls it "noble" // *New York Sun*, Jan., 12, 1890, p. 6, in a review of Union League Club exhibition, observes that the painting demonstrates Inness's "power of synthesis" // *New York Times*, Jan. 12, 1890, p. 12, in a review of Union League Club exhibition, dates painting to 1863 // *Philadelphia Public Ledger*, Oct. 15, 1891, p. 2, in a review of Clarke collection at PAFA, says that it "is, perhaps, the most pleasing" of the twelve Inness paintings on view // *New York Sun*, Jan. 15, 1897, p. 7, in a review of an exhibition at the Century Association of paintings done before 1868, says it is "among the most notable landscapes" // *New York Commercial Advertiser*, March 11, 1898, p. 4, in a review of Union League Club exhibition, dates painting 1863 and describes it // Thomas B. Clarke Scrapbook, [1889–1918], Arch. Am. Art, 1358, unpaged, lists extensive discussions of it while on view at the Union League Club in 1898 // *Critic* n. s. 29 (March 19, 1898), p. 201, mentions it in a review of Union League Club exhibition // "Statement," [1899], MMA Archives, lists subscribers to the fund with which it was purchased // *New-York Daily Tribune Illustrated Supplement*, Feb. 7, 1899, pp. 8-9, calls it "fresh and charming" in a discussion of Clarke's paintings // *New York Sun*, Feb. 7, 1899, p. 6; Feb. 12, 1899, p. 5, says it is an "early work" and "full of power" // American Art Association, *Catalogue of the Private Art Collection of Thomas B. Clarke*, sale cat. (1899), p. 71, no. 365, describes and dates it 1865 // *New York Sun*, Feb. 18, 1899, p. 2, says that it fetched

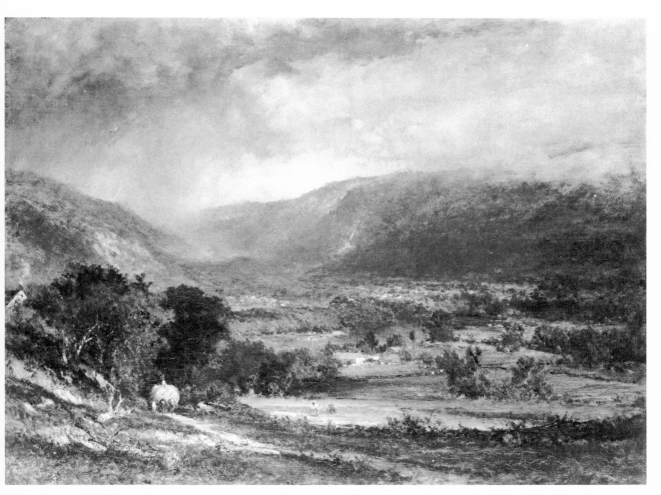

Inness, *The Delaware Valley*.

the highest price achieved by an Inness painting that evening, $8,100, gives the museum as the purchaser, and describes reaction to the purchase // *New York Commercial Advertiser*, Feb. 18, 1899, p. 3, in a discussion of the Clarke sale, says painting was purchased "after great competition," and that reportedly Clarke had paid only $400 for it // *New-York Daily Tribune*, Feb. 18, 1899, p. 9, gives price and provides a detailed account of its sale at the Clarke auction (quoted above) // L. Cesnola, to [S. P.] Avery, draft, Feb. 1899, in MMA Archives, says that because Avery is ill, Story has been authorized to attend the sale and "spend a certain limited sum for American pictures. He did spend a little more than the amount that was placed at his disposal, but the purchase is a good one and I approved of his action in the matter" // Board of Trustees, MMA, Minutes, Feb. 20, 1899, records authorization for curator of paintings to purchase two paintings at Clarke sale and approves the acquisition // J. W. Pemberton, *Illustrated American Magazine* 25 (April 1899), p. 72, notes that painting fetched $8,100 at the Clarke sale // H. B. Walton, *Metropolitan Magazine* 9 (May 1899), ill. p. 487 // H. P. du

Bois, *New York Journal*, May 2, 1899, p. 8, explains that ten men joined together to purchase Homer's *Eight Bells*, 1886 (Addison Gallery of American Art) for the MMA at the Clarke sale but, deciding that it was too expensive, their agent purchased the Inness instead; one of the subscribers reportedly expressed his regret over the loss of the Homer // *American Art Annual* (1899), p. 64, includes it in a list of paintings sold at the Clarke sale // J. Inness, letter in Dept. Archives, June 18, [1900–1925], says that George Inness, Jr., who has been ill, "does not at all remember when it was painted" // S. Isham, *The History of American Painting* (1905; new ed. 1915), ill. p. 258 // G. B. Zug, *Chautauquan* 50 (May 1908), p. 371 // *Masters in Art* 9 (June 1908), pl. 2, pp. 36-37, discusses it and misdates it 1867; p. 252 // E. Daingerfield, *George Inness* (1911), color ill. frontis.; pp. 18-20, says that when Inness saw the painting again "after some years," he "found fault with it, called it 'labored,' 'over-elaborated' — he felt the forms were 'petty' . . . and wished for some more color" // A. Hoeber, *International Studio* 45 (Nov. 1911), suppl., p. 37, mentions price at Clarke sale // *International Studio* 45 (Nov. 1911), suppl., ill. p. 21, in a

review of Daingerfield's book // B. B[urroughs], *MMA Bull.* 12 (Oct. 1917), suppl., p. 10, discusses and dates 1865; p. 11 // G. Inness, Jr., *Life, Art, and Letters of George Inness* (1917), ill. p. 72 // L. M. Bryant, *American Pictures and Their Painters* (1921), ill. opp. p. 50; p. 51 // M. Vaughan, *New York American*, Feb. 7, 1929, p. 2 // F. J. Mather, Jr., *Estimates in Art* (1931), 2, pp. 50-52, in a reprint of a 1922 essay, discusses it; pp. 54, 56; *American Magazine of Art* 27 (June 1934), ill. p. 305 // *Index of Twentieth Century Artists* 4 (Dec. 1936), p. 650, dates it 1865; p. 651; p. 657, lists illustrations of it // J. Cournos, *Art News* 43 (July 1944), p. 22, says painting is "an especially successful example of the artist's transitional period" // E. P. Richardson, *Painting in America* (1956), pp. 225-226, dates it 1865 and calls it "the grandest and most eloquent" example of his new style // L. Ireland, *The Works of George Inness* (1965), ill. p. 79, no. 313 in a catalogue of the artist's work; lists provenance, references, and exhibitions, including an undocumented exhibition at the Union League Club in 1895 // W. D. Garrett, *MMA Jour.* 3 (1970), p. 334; ill. p. 335 // H. B. Weinberg, *American Art Journal* 8 (May 1976), p. 77, includes it in a list of paintings owned by Thomas B. Clarke and says he had it from February 1889 until his 1899 sale // L. Hardenburgh, Art Institute of Chicago, letters in Dept. Archives, April 6, June 16, June 26, August 7, 1978, provides information on provenance and exhibition history // Oakland Museum, *George Inness Landscapes* (1978), exhib. cat. by M. D. Arkelian, p. 11, quotes from the *New York Journal* (May 2, 1899) // H. B. Weinberg, letter in Dept. Archives, April 10, 1980, provides extensive information on bibliography, exhibition history, and provenance.

EXHIBITIONS: New York Athletic Club, 1889, *Third Annual Art Loan Exhibition*, as The Delaware Valley, lent by Thomas B. Clarke (no cat. available) // Union League Club, New York, 1890, *Catalogue of a Loan Collection of American Landscapes Together with Terra-Cotta Figures and Vases*, no. 1, as The Delaware Valley, lent by Thomas B. Clarke, dated 1863 // PAFA, 1891, *Catalogue of the Thomas B. Clarke Collection of American Pictures*, no. 102 // NAD, 1892, *Columbian Celebration of the Four Hundredth Anniversary of the Discovery of America*, no. 58, as The Delaware Valley, lent by Thomas B. Clarke // Union League Club, New York, 1893, *A Group of Paintings by American Artists Accepted for the Columbian Exposition of 1893*, no. 8, as Delaware Valley, 1863, lent by Thomas B. Clarke (no cat. available) // World's Columbian Exposition, Chicago, 1893, no. 607, as Delaware Valley, lent by Thomas B. Clarke // Century Association, New York, 1897, *American Paintings Done before 1868* (no cat. available) // Union League Club, New York, 1898, *The Paintings of Two Americans*, no. 18, as Delaware Valley, dates it 1863, lent by "a member of the club" // Royal Academy of Art, Berlin, and Royal Art Society, Munich, 1910, *Ausstellung Amerikanischer Kunst*, no. 77, as Delaware-Tal; pl. 30 // MMA, 1917,

Paintings of the Hudson River School Brought Together in Commemoration of the Completion of the Catskill Aqueduct, no. 6-5 (see *MMA Bull.*, 1917, above) // Wilmington Society of the Fine Arts, Delaware Art Center, 1962, *American Painting, 1857-1869*, no. 52 // University of Iowa Gallery, Iowa City, 1964, *Impressionism and Its Roots*, no. 41; ill. p. 31 // University Art Museum of the University of Texas, Austin, 1965-1966, *The Paintings of George Inness (1844-94)*, exhib. cat. by L. Ireland, N. Cikovsky, and D. B. Goodall, no. 25; ill. p. 15; p. 19, lists references, exhibitions, and provenance // American Federation of Art, traveling exhibition, 1967-1968, *American Masters*, no. 25; entry by S. Feld, p. 74; ill. p. 75.

EX COLL.: Thomas B. Clarke, New York, by 1889 (sale, American Art Association, New York, Feb. 17, 1899, no. 365, as Delaware Valley); subscribers to a fund for its presentation to the museum (William E. Dodge, John S. Kennedy, H. O. Havemeyer, Collis P. Huntington, Darius O. Mills, Thomas B. Clarke, Cornelius Vanderbilt, Heber R. Bishop, Frederick W. Rhinelander, Edward D. Adams, George F. Baker, Morris K. Jesup, Mrs. Alfred Corning Clark, Charles Stewart Smith, and William L. Andrews).

Gift of Several Gentlemen, 1899.
99.27.

Peace and Plenty

George Inness's idyllic landscape of 1865 shows several farmers harvesting grain. The foreground is bounded by dark trees, a road, a low bridge, and a small stream. At the left on a distant hillside, a shepherd gathers his flock, and on the right a haywagon crosses a field bordering the bank of a placid, winding river. Bathed in glowing light, the valley stretches back between low-lying hills, where a number of buildings can be seen. When the painting was offered at auction in 1866, the site was designated as the Charles River near Medfield, Massachusetts — an identification presumably provided by the artist. The river with its gentle bend, however, closely resembles the Raritan River at Eagleswood, near Perth Amboy, New Jersey, where Inness lived while working on *Peace and Plenty*.

On this site in 1853 was founded the Raritan Bay Union, a cooperative community that emphasized religion. Like Brook Farm and other progressive communities established in America at mid-century, it was inspired by the writings of the French socialist Charles Fourier. A large dwelling was the focal point of activities, but members were permitted to build or rent separate houses on the property. Residents con-

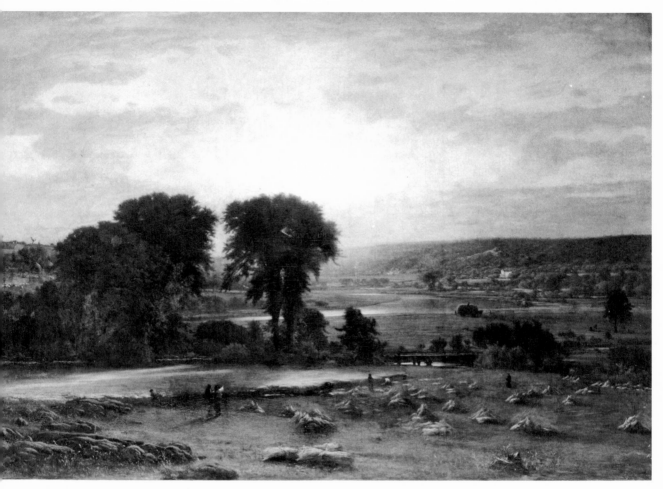

Inness, *Peace and Plenty*.

tributed the labor to sustain the community. One of their principal projects was a school run by the abolitionist Theodore Weld, his wife the former Angelina Grimké, and her sister Sarah. Although the Raritan Bay Union was not officially dissolved until 1866, it had really ceased to function by the late 1850s. Nevertheless, some of the members of the community remained, and their ideals were perpetuated during the 1860s when Inness was a resident. Like many of Inness's paintings of the 1860s, *Peace and Plenty* transcends topography and represents ideas, in this case ideas closely linked to Eagleswood.

When Inness arrived at Eagleswood in 1863, the community was dominated by Marcus Spring, a New York merchant who had been a founding member of the Raritan Bay Union. Like Inness, Spring was an ardent abolitionist, deeply devoted to the Union cause in the Civil War. When the Weld school closed in 1861, Spring opened the Eagleswood Military Academy. Among its cadets were the aspiring painter LOUIS COMFORT TIFFANY, who was enrolled there between 1861 and 1865, and the sons of a number of prominent artists like HENRY PETERS GRAY, THOMAS LE CLEAR, GEORGE CALEB BINGHAM, and Christopher Pearse Cranch (1813–1892), as well as the son of the photographer Mathew B. Brady (1823–1896). Eagleswood offered instruction in art, described in one of its brochures as "Figure, Landscape, and Mechanical Drawing and Painting" (*Triennial Catalogue of Eagleswood Military Academy and Prospectus for 1864–65* [1864]). Art instructors included Steele MacKaye (1842–1894), G. W. King, and Frederick T. Vance (active at least 1866–1883); Spring's son Edward (1837–1907), a sculptor, offered lectures on design. In addition, the landscape architect Frederick Law Olmsted served on the school's advisory board. The artists John Sartain (1808–1897), Elisha W. Hall (1833–1903), and William McEwan (active 1859-1869) are known to have visited Eagleswood. In an attempt to revive the intellectual spirit of the Raritan Bay Union, Spring invited artists to live and work in the houses that surrounded the school. The two best known residents were Inness and WILLIAM PAGE, who worked there from about 1863 to 1867. This period, which included the final two years of the Civil War and the first two of Reconstruction, had a profound influence on Inness. Page introduced him to the spiritualism of Emanuel Swedenborg;

MacKaye, who had previously studied with WILLIAM MORRIS HUNT and JOHN LA FARGE at Newport, reinforced Inness's interest in the Barbizon style; and Spring and his friends encouraged the artist's abolitionist sentiments. All of these factors affected the style and subject matter of *Peace and Plenty*, which was painted in 1865, midway through Inness's stay at Eagleswood.

Nicolai Cikovsky has established that during the 1860s Inness was strongly influenced by the writings and sermons of the Reverend Henry Ward Beecher, pastor of Plymouth Church in Brooklyn. As Cikovsky wrote: "Beecher demonstrates a remarkable gift for vivid description, which he used not infrequently for its own sake, and to demonstrate the virtues of rural life (a favorite theme of his), but also to indicate that in nature one may find symbols or expressions of transcendent meaning and power" ([1965], p. 195). The correlation between the images in Beecher's sermons and those in Inness's paintings may be even more direct. For example, the preacher used sowing and reaping as metaphors in which slavery was condemned as "poisonous seed sown in colonial days," which "the North chose to weed" but "the South determined to cultivate" (H. W. Beecher, *Freedom and War* [1863], reprinted by Books for Libraries, Freeport, New York, 1971, p. 39).

The idealized, light-filled landscape shown in *Peace and Plenty* might also relate to Inness's interest in Swedenborg, the eighteenth-century Swedish theologian. Swedenborg described a world of the spirit existing simultaneously with the material world but invisible to almost all living men. This spiritual world closely resembled earth but defied normal expectations about spatial relationships and the continuity of time. The harvest—a central motif in the museum's painting—was discussed in detail in Swedenborg's *Arcana Coelestia* (1749–1756). In an interpretation of a passage from Exodus, Swedenborg presented his understanding of the biblical meaning of the harvest: "in the broadest sense it signifies that state of the whole human race in respect to the reception of good by means of truth" (no. 9295, quoted from the standard ed. [1949] of the Swedenborg Foundation). A thorough examination of Swedenborg's writings might well suggest possible meanings for other activities represented, such as the shepherd and his sheep. At any rate, because Inness's involve-

ment with this philosophy began in the late 1860s, it seems logical that it would have been reflected in his work at this time.

Peace and Plenty was owned for a time by Marcus Spring and his wife Rebecca for whom it may have had a more personal meaning. Unfortunately, their response to the painting has not been discovered. An unpublished, somewhat fictionalized biography (1973) written by their granddaughter Beatrice E. Borchardt suggested that to Mrs. Spring "the whole scene was symbolic of her dream of the Kingdom of God, with final peace on earth" (chapter 27, p. 8, Raritan Bay Union Papers, New Jersey Historical Society, Newark). This was the Springs's ideal in founding the Raritan Bay Union and later the Eagleswood Military Academy and the settlement that surrounded it. As Rebecca Spring once wrote to a friend: "The truth is it was a noble thought of Mr. Spring's to gather about us a truly Christian neighborhood. I use the name Christian to express in one word all virtues of Peace, Kindness, Temperance, and holy lives" (letter to J. L. Kearney, August 9, 1885, ibid.) The sanctification of daily life evident in *Peace and Plenty* certainly reflects the spirit of this community.

The provenance of *Peace and Plenty* is somewhat complicated by conflicting evidence. George Inness, Jr., asserted (1917) that *Peace and Plenty* was actually the reworking of an earlier painting *The Sign of Promise*, 1862 (now unlocated), which had been damaged by accident. The younger Inness reported that while working in the garden in Medfield, Massachusetts, he "heard the most terrible, muffled noise coming from the studio that sounded like 'George'; but the voice was so strange and weird that I was frightened, and ran into the house, and hid my face in the folds of my grandmother's apron." His father then appeared at the kitchen door, "his face streaked with color." Inness continues:

We went hand in hand to the studio; there on the floor, face down, lay "The Sign of Promise." Pop explained to me that if I had not been such a little coward I could have removed the chair that, as he tried to kick it out of the way, had caused him to fall with his canvas, his face down, and into the palette, which he had no time to remove from his thumb. As he crawled from under the canvas a great deal of "The Sign of Promise" had come off on Pop's clothes. Not being able to dispose of this canvas, which has

since become famous, in any other way, it was given in part payment for a house in New Jersey. I fancy that "Peace and Plenty" would now bring a good many houses like that one in New Jersey.

The elder Inness is known to have suffered from epilepsy, and it is possible that this incident occurred during an attack. That would explain the intensity of his son's reaction and the vividness of his recollections after more than half a century. His recollections therefore may not be totally reliable. Furthermore, the focus of this anecdote is not on the painting but on the relationship between father and son.

It is even possible that George Inness, Jr., became confused about the paintings involved in this incident. He provides only a vague description of *The Sign of Promise* as a "wheatfield, . . . with a rainbow in the sky" and these elements appear in any number of early Inness paintings. Assuming that there is some truth to the anecdote and that *The Sign of Promise* was heavily repainted, it does not necessarily follow that it was repainted into *Peace and Plenty*. In fact, two years before *Peace and Plenty* was painted, *The Sign of Promise* was exhibited at Snedecor's gallery in New York with a pamphlet explaining that "since it was exhibited in Boston many alterations and improvements have been made" ("*The Sign of Promise.*" *by George Inness . . .* [1863], p. 3).

Whatever the case, it seems clear that *Peace and Plenty* and *The Sign of Promise* were related in subject matter, in thematic intent, and in their reference to the Civil War and the issues that prompted it. To support this contention it is necessary to describe the appearance of the lost painting, which was given in 1863 as follows:

a heavy thunderstorm is passing off, down a broad and fertile valley, over a bold, steep hill or mountain on the right, while the darkling vapor clings to the summit and rolls upon the ridge in angry collision, a clear light rifts the clouds, and a deep, pure azure is seen through a parting silvery film, the last hazy veil to the coming sunlight, harbingered by the rainbow, which, starting from the base of the valley, on the very edge of the retreating rain, rises a short way till it is lost in tangled shreds of cloud, which on the left, fiercely rush in ragged ranks from the brightening scene. Down the valley, in the distance, seeps the heavy descending shower, blue and purple, with faintly penetrating light.

From a road upon the rising hill, in the immediate foreground, the eye passes over a broad harvest-field

with reapers, down across an ample lawn with cattle, to a farm-house and barn among trees, and beyond to a winding river. We do not cross the river, but pass directly around the bend, by green fields, to the foot of a mountain on the right, or we cross directly, and are lost among the clustered trees till they, too, are lost in the far-off storm-mist (*New York Evening Post*, March 3, 1863, p. 1).

Judging from this description, *The Sign of Promise* and *Peace and Plenty* had many details in common. Both depicted a harvest, a group of domestic animals, and a farm in a valley with a winding river. There were, nevertheless, several obvious differences. Instead of the drama of the receding storm, *Peace and Plenty* has a tranquil mood created by warm, glowing light that permeates the scene. It is in theme, however, that the two pictures were closest. Both related to the Civil War. *The Sign of Promise* presented the artist's hope for an end to the violent war then in progress, while *Peace and Plenty* showed his anticipation of a return to prosperity following the resolution of the conflict.

George Inness, Jr.'s recollections about some aspects of the early provenance of *Peace and Plenty* appear to be accurate. Cikovsky observed that it would have been impossible for Inness to purchase a house with *Peace and Plenty* as part payment and then offer the painting for sale for his own benefit at the Snedecor auction on April 25, 1866. In actual fact, however, when Inness first came to Eaglewood in 1863, he rented a house from the writer William Kirkland. Inness did not buy land until May 12, 1866, immediately after the painting failed to reach its reserve at the Snedecor auction. (See Deed Book 102, pp. 294–296, Middlesex County, N. J.) Thus, when he bought two acres of land from Marcus Spring in 1866, Inness could have given him the painting as partial payment.

Marcus Spring's ownership of *Peace and Plenty* is documented, but it is not known if the painting left his possession before his death in 1874. It is not mentioned in his will (entered Sept. 2, 1874, Middlesex County, N. J.). One article published at the time the painting was presented to the museum in 1894 asserted that it had been inherited by Spring's son, who in turn sold it to the donor, George A. Hearn. This would appear logical as the Springs were in need of money, and Hearn may well have known them personally because he, like Marcus Spring, was active in the drygoods business in New York. Despite the evidence, however, the issue is by

no means resolved. As early as 1872 Marcus Spring wrote to William Page saying that he planned to send one of Page's paintings to his daughter Jeanie in San Francisco "with one of my Inness pictures for her to sell or have sold there" (Dec. 31, 1872, William Page Papers, Arch. Am. Art). *Peace and Plenty* was on view at the Young Men's Christian Association in New York in the 1880s and early 1890s, but whether it was lent by the Spring family or some other owner is not known.

Oil on canvas, $77\frac{5}{8} \times 112\frac{3}{8}$ in. (197.2 × 285.4 cm.).

Signed and dated at lower left: Geo. Inness 1865.

REFERENCES: *New York Evening Post*, April 17, 1866, p. 2 (April 20, 1866, semi-weekly issue, p. 1), in a review of the painting then on view at Snedecor's gallery, says that "in the catalogue it would be entitled 'Harvesting in the Afternoon of a Day in Early Autumn,' but the lover of nature who studies it is tempted to change its name to 'The Sunlight, the Glorious Life giving Sunlight'"; notes that "the picture has been the work of many months, and is perhaps the greatest effort of the artist"; urges that it be sent to "the Paris Exhibition"; April 25, 1866, p. 2, says that it "makes an epoch in the history of American landscape painting, and may not be hereafter accessible to the public" // *American Art Journal* 5 (May 2, 1866), p. 21, says that it will remain on view at Snedecor's for a week or two; it depicts "a land overflowing with milk and honey"; notes that "here, in this land, man may dwell in peace, bless God, and be content. The picture is a harvest song, flowing from a pure heart"; p. 28, says it was withdrawn from the sale at Snedecor's // *New York Times*, May 3, 1866, p. 4, in a review of the exhibition at Snedecor's, says that as you pass the painting "a glance . . . deludes you with the idea that you catch a glimpse of a meadow on the Connecticut"; calls it "so real, so fresh, palpable and alive to the eye that it requires a second thought to bring the fact home that you are looking on a picture" // H. T. Tuckerman, *Book of the Artists* (1867), pp. 528-530, discusses The Sign of Promise; quotes from *New York Times*, May 3, 1866, review of Peace and Plenty; discusses Inness's "allegorical" landscapes, compares his work to Cole's and then asserts that Inness's subjects "are still more vague and ideal"; suggests that Peace and Plenty is "a simple and appropriate designation" // E. Fawcett, *The Californian* 4 (Dec. 1881), p. 460, says that it is dated 1865–1866 and that it is "now in possession of the Young Men's Christian Association of New York"; describes it in detail // *New York Art Guide and Artists' Directory* [1893], p. 20, says that it is owned by and on exhibit at the Young Men's Christian Association, New York // *Art Amateur* 31 (Oct. 1894), p. 89, says

it is "very characteristic" and that Hearn has just presented it to the museum; describes it; relates another version of the anecdote later elaborated by George Inness, Jr. (1917): "it was damaged by falling off the easel on the back of a chair, and was cleverly mended by the village tailor" // *Art Interchange* 33 (Nov. 1894), ill. p. 115, says it was painted in 1865–1866 for Mr. Spring who owned it "until his death, when it passed to his son by inheritance, from whom it was purchased by the generous donor"; calls it "typically American" // A. Trumble, *George Inness, N. A.* (1895), p. 24 // *American Art Annual* 1 (1898), p. 221, mentions in a report on recent activities at the museum // S. Isham, *The History of American Painting* (1905), p. 257, mentions // *The George A. Hearn Gift to the Metropolitan Museum . . .* (1906), p. xi; p. 5; p. 6, discusses; ill. p. 7 // C. H. Caffin, *The Story of American Painting* (1907), p. 140; ill. p. 141 and discusses // G. B. Zug, *Chautauquan* 50 (May 1908), p. 371 // *International Studio* 34 (April 1908), suppl., p. 68, discusses; ill. suppl. p. 71 // *Masters in Art* 9 (June 1908), p. 215, pl. 1; p. 245, quotes C. H. Caffin's 1907 comments; pp. 247–248, discusses it // *George A. Hearn Gift to the Metropolitan Museum of Art . . .* (1913), ill. pl. 56 // E. Daingerfield, *Fifty Paintings by George Inness* (1913), pl. 5, dates it 1865 // *MMA Bull.* 9 (Jan. 1914), ill. p. 4, in a memorial to George A. Hearn // G. Inness, Jr., letter in Dept. Archives, June 22, 1916, says it "was painted from studies made of harvest scenes in Medfield, Mass." // *Art World* 1 (Jan. 1917), ill. p. 235 // B. B[urroughs], *MMA Bull.* 12 (Oct. 1917), suppl. p. 10, mentions // G. Inness, Jr., *Life, Art, and Letters of George Inness* (1917), pp. 46–47, discusses the painting, says that the artist painted "a large canvas called 'The Sign of Promise'" in the barn at Medfield, Massachusetts, that "it," presumably The Sign of Promise, showed "a wheat-field, as I remember it, with a rainbow in the sky" (quoted above); says that although part of the painting was destroyed, it was repainted and entitled 'Peace and Plenty'"; says it was "given in part payment for a house in New Jersey"; ill. p. 65 // L. M. Bryant, *American Pictures and Their Painters* (1920), ill. opp. p. 50; pp. 51-52, says that Inness painted it "just as peace was declared from the Civil War and the country had had an unprecedented year of plenty" and that when Snedecor saw it he offered to frame and exhibit it for half the proceeds of the sale, but no buyer was found // F. W. Ruckstull, *Great Works of Art and What Makes Them Great* (1925), p. 483, calls it "his masterpiece" but notes that artists hold various opinions about it; ill. opp. p. 485 // P. MacKaye, *Epoch: The Life of Steele MacKaye* [ca. 1927], 1, pp. 98-99, quotes a letter (1924) from George Inness, Jr., who reports that Marcus Spring traveled to Medfield to persuade the artist to move to Eaglewood; says that before they moved there, his father visited Eaglewood to select a site for their home and that he

later gave Peace and Plenty in part payment for it (quoted above) // F. J. Mather, Jr., *Estimates in Art* (1931), 2, pp. 50-51, in a reprint of a 1922 essay, compares it to Thomas Cole's The Oxbow (q. v. vol. 1) // E. Neuhaus, *The History & Ideals of American Art* (1931), ill. p. 92 // (London) *The Studio* 5 (April 1933), ill. p. 274; p. 276, cites it as an example of "his earlier, panoramic manner" // F. J. Mather, Jr., *American Magazine of Art* 27 (June 1934), color ill. p. 294; p. 306 // *Index of Twentieth Century Artists* 4 (Dec. 1936), p. 354, discusses it as "solid, tangible, beautiful in detail, with still a suggestion of effort in some of its features"; p. 363, lists reproductions // *Art Digest* 11 (August 1, 1936), p. 6, mentions it in a review of an exhibition held in Cleveland // E. Mc-Causland, *George Inness and Thomas Eakins* [1940], ill. p. 4; p. 11, dates it 1865 // [K. McCormick], "Raritan Bay Union: The Story of the Springs at Eaglewood," transcript of a lecture, Nov. 18, 1943, Raritan Bay Union Papers, New Jersey Historical Society, Newark, based on George Inness Jr.'s 1917 comments, says it was given "in part payment for the house Marcus Spring built for Inness" // E. P. Richardson, *American Romantic Painting* (1944), p. 38; pl. 184 // F. J. Mather, Jr., *Magazine of Art* 39 (Oct. 1946), ill. p. 293 // George Walter Vincent Smith Art Museum, Springfield, Mass., *George Inness* (1946), essay by E. McCausland, p. 3; p. 29, discusses its relationship to the theme of the Civil War; p. 30, relates it to a poem by Walt Whitman; p. 31, says it was given to Marcus Spring in part payment for a house he built Inness at Eaglewood; p. 32, says it was done at the beginning of Inness's productive Medfield period; p. 83, in a chronology of Inness's life, says it was painted in 1865 // W. Born, *American Landscape Painting* (1948), p. 159, says that it emphasizes "poetic content rather than . . . artistic form" // [B. E. Borchardt], the granddaughter of Marcus Spring, to K. McCormick, March 1, 1949, reminisces about visiting the museum and watching her father [Edward A. Spring] make a copy of Peace and Plenty; comments about the history of the painting: "I do not know how this picture left the Spring family. It must have been when the estate was being disposed of. I have never heard whether it was given away, or sold, but I presume it was the latter" // M. H. Greene, *Proceedings of the New Jersey Historical Society* 68 (Jan. 1950), p. 30, in a discussion of Raritan Bay Union at Eaglewood, N.J., says that Inness lived in the home of Caroline and William Kirkland while "Mr. Spring built a house for him, for which, as part payment, Inness gave Mr. Spring his famous painting 'Peace and Plenty,' now owned by the Metropolitan Museum of Art" // E. P. Richardson, *Painting in America* (1956), p. 226, calls it "heroic-sized"; says its mood expresses "the emotions of a sensitive mind at the close of the Civil War" // A. T. Gardner, *MMA Bull.* 16 (Summer 1957), ill. p. 9 // L. Ireland, *The Works of George Inness* (1965), p. xx, says it was done in Medfield, damaged in an

accident, "Inness had to repaint it, and he changed the composition throughout"; notes that it was given to Marcus Spring; p. 78, includes it in a catalogue of the artist's works as no. 310, Sign of Promise, which he says "no longer exists as Inness made some changes and called it Peace and Plenty"; also includes it in a catalogue of the artist's work as no. 311, Peace and Plenty, describes; gives provenance, exhibitions, and references; ill. // N. Cikovsky, *The Life and Work of George Inness*, Ph.D. diss., Harvard University, 1965; published 1977, pp. 37, 39, discusses The Sign of Promise (1862); pp. 42–43, questions the assertion that Peace and Plenty was given to Marcus Spring as part payment for a house, notes that it was painted a year after Inness arrived at Eagleswood and that at the time of the 1866 sale it was offered "for the exclusive benefit of the artist"; because it did not sell in 1866 and Inness left Eagleswood in 1867, speculates that it was only given to Spring as security for the cost of building a house; p. 44, discusses its being offered at Snedecor's on April 25, 1866; notes that it did not meet its reserve of $3,500 and was withdrawn; pp. 112–113, says that The Sign of Promise is an example of Inness's tendency to work on paintings over an extended period of time; p. 130, fn. 109, discredits George Inness, Jr.'s 1917 account which describes how the artist repainted The Sign of Promise to create Peace and Plenty; notes this explanation "does not seem correct, since the painting had clearly been finished at one time"; pp. 191–199, interprets Inness's allegorical landscapes, including The Sign of Promise and Peace and Plenty; p. 195, says that Peace and Plenty was not as widely discussed as The Sign of Promise; that it may have been intended as "the return to 'peace and plenty' after the war—a meaning enhanced, unconsciously perhaps, by this new theme having been painted over, and therefore a fulfillment of the promise and hope that were the theme of the earlier painting"; p. 197, notes that in it "all the figures were merely accessories"; pp. 206–207, says that The Sign of Promise and Peace and Plenty are specific and literal in meaning and as in all of Inness's paintings of the 1860s nature is made significant "not in any literary way, but as it is the reflection of some higher power, as its material forms may express spiritual qualities"; p. 337, notes his use of a prominent rainbow in The Sign of Promise before his awareness of Swedenborg's philosophy; ill. fig. 42, as Peace and Plenty // D. Huntington, *The Landscapes of Frederic Edwin Church* (1966), p. 62, mentions it as an example of the "optimistic landscape" following the Civil War // D. Warren, *New-England Galaxy* 9 (Summer 1967), p. 23, in an article on Marcus Spring, discusses Inness's giving Spring the painting in part payment for a house at Eagleswood // N. Cikovsky, *George Inness* (1971), p. 34, says that Inness demonstrated his patriotism in The Sign of Promise, 1862, which was repainted as Peace and Plenty, 1865; p. 37, discusses the meaning, exhibition

of, and reaction to The Sign of Promise; says Peace and Plenty is a harvest scene like The Light Triumphant; calls it "an allegorical landscape, celebrating the 'peace and plenty' that replaced the strife of war"; maintains that its meaning is "enhanced" by its being painted over the earlier painting; p. 38, sees it as "the fulfillment of the hope and promise that were the theme of the earlier painting"; cites it as an instance of the "general symbolic tendency in Inness's art of this period"; p. 150, fn. 67, discusses it and The Sign of Promise; ill. 30 // A. Werner, *Inness Landscapes* (1973), p. 12, relates it to Thomas Cole's *The Oxbow* (q. v. vol. 1); p. 34, discusses and compares to The Lackwanna Valley, 1855 (National Gallery of Art, Washington, D. C.); color ill. p. 35 // B. E. Borchardt, "Lady of Utopia: The Story of Marcus and Rebecca Buffum Spring of Eagleswood," MS (1973), Raritan Bay Union Papers, New Jersey Historical Society, Newark, Chapter 27, p. 8 (quoted above); p. 10, describes Rebecca during the Civil War, "as she faced the picture of Peace and Plenty she prayed that peace might come soon" // J. A. Sokolow, *New Jersey History* 94 (Summer-Autumn 1976), p. 94, mentions that Inness gave the painting in part payment for a house at Eagleswood // Oakland Museum, *George Inness Landscapes* (1978), essay by M. D. Arkelian, ill. p. 16; p. 32, mentions in a chronology of the artist's life // National Gallery of Art, Washington, D. C., *American Light* (1980), essay by T. E. Stebbins, Jr., p. 216, includes it in a discussion of Inness's paintings from the 1860s; calls it "a warm yet heroic celebration of the war's end" // D. Dwyer, Paintings Conservation, MMA, orally, April 16, 1981, observed that the physical condition of the paint layer indicates that the artist made numerous changes, which are most evident in the haystacks; said that this work lacks the thin areas of paint typical of Inness's work; and noted that the toned glazes are broken, particularly in the sky.

ON DEPOSIT: Young Men's Christian Association, New York, at least 1881–1893.

EX COLL.: the artist, Eagleswood, N. J., 1865–1866 (sale, Snedecor's Gallery, New York, Henry H. Leeds and Miner, Auctioneers, April 25, 1866, no. 41, as Landscape, Peace and Plenty. Charles River, near Medfield, Mass.); bought in by the artist, Eagleswood, N. J., 1866; Marcus Spring, Eagleswood, N. J., probably 1866–d. 1874; probably his son, Edward Spring, Eagleswood, N. J.; George A. Hearn, New York.

Gift of George A. Hearn, 1894.

94.27.

Autumn Meadows

Dated 1869, the painting repeats a compositional format that Inness had used earlier in *Scene on the Hudson*, 1861, and *Sunset*, 1865 (see

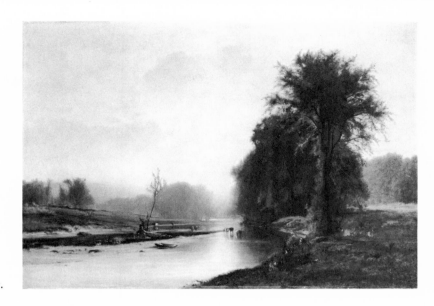

Inness, *Autumn Meadows.*

Ireland [1965], nos. 228 and 322). In all of these pictures, there is a dark copse of trees beside a tranquil stream that winds through a meadow. The scene is illuminated by the glow of the late afternoon light, an effect particularly noticeable in *Autumn Meadows*, where the sun and its rays are painted in heavy impasto. The setting of this landscape has never been identified with certainty. Little is known about Inness's activities and movements in 1869. Late that year he displayed *View at Hastings on the Hudson* (present location unknown) in his studio, and *Autumn Meadows* may also represent this locale.

Oil on canvas, 30 × 45½ in. (76.2 × 115.6 cm.). Signed at lower right: G. Inness 1869.

REFERENCES: W. J. Dobbin, Fine Arts Conservation Laboratories, New York, letters in Dept. Archives, May 16 and June 19, 1961, discusses condition and reports on treatment // L. Ireland, *The Works of George Inness* (1965), ill. p. 116, and includes it as no. 475 in a catalogue raisonné of the artist's work // J. T. Tynion, attorney for the estate of Morgan O'Brien, orally, June 30, 1981, said that it hung in the home of Judge Morgan O'Brien, may have been a gift to his wife, and was never in possession of their son.

EXHIBITED: University Art Museum of the University of Texas, Austin, 1965–1966, *The Paintings of George Inness (1884–1894)*, no. 31, p. 20, lists, gives provenance and incorrect measurements // Whitney Museum of American Art, New York, 1972, *18th and 19th Century American Art from Private Collections*, no. 38.

EX COLL.: Judge Morgan O'Brien, New York, d. 1937; estate of Morgan O'Brien; with Kennedy Galleries, New York, 1959, Walter Knight Sturges, Ardsley-on-Hudson, New York, 1959–1974.

Gift of Walter Knight Sturges, 1974.

74.75.

Evening at Medfield, Massachusetts

The influence of the Barbizon style is evident in this picture, painted in 1875 when Inness had just returned from Italy and France. The composition and color are especially reminiscent of the work of Charles François Daubigny, which may have inspired the poetic treatment of twilight. *Evening at Medfield, Massachusetts* also demonstrates the new interest in formality that Inness developed in the 1870s, when he manipulated composition and form for maximum decorative effects. Here he arranged the major elements in horizontal bands: trees in the foreground, animals and stone wall in the middle ground, and dark copse of trees in the distance. The elements are united by the sweeping curve of the cowpath that leads the viewer into the picture. Trees and figures are silhouetted against a golden sunset, producing a calculated pattern of dark shapes.

Describing aspects of Inness's technique in this landscape, his son wrote:

You will find by looking closely at this picture that it has been painted on a clean white canvas, contrary to his usual method of painting and repainting. The colors of the landscape have been frotted or scrubbed in, very thinly, the texture of the canvas being visible through the film of paint. The local color of the shadow is imitated by mixing greens with umber or some such color, and then with a delicate use of gray he traces out the forms of the stone wall, the trunks of trees, and the road that leads you over the bridge. The opaque gray, dragged over the under color, gives one the sense of different textures, and though the whole is nothing more than a wash, gives the feeling of solidity. Now, he paints in the sky, a

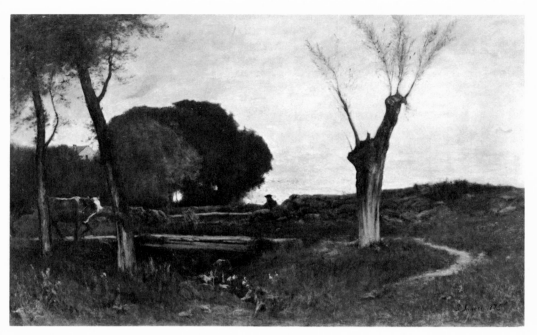

Inness, *Evening at Medfield, Massachusetts.*

golden yellow, in an entirely different way. He lays the paint on thick and solid, and unless we know his process, we feel that it has no connection with the landscape. In other words, it is crude and disappointing. But when this is dry, he glazes it all over with raw sienna, which brings the sky into harmony with the rest of the picture and gives it a vibrant glow, and you have before you a twilight sky that is brilliancy itself.

Oil on canvas, 38 × 63⅛ in. (96.5 × 160 cm.).
Signed and dated at lower right: G. Inness 1875.
REFERENCES: Doll and Richards Gallery, Boston, Account Book A [1875], p. 256, copy in Leroy Ireland Papers, Chapellier Galleries, microfilm 995, Arch. Am. Art, lists it at Doll and Richards as sale no. 127, under paintings by George Inness, no. 8, Evening in Medfield, 38 × 63, price annotated as $1,000 // *Boston Evening Transcript,* Dec. 17, 1876, p. 6, says it sold for $525 // American Art Association, New York, *A Descriptive Catalogue of Paintings, Pastels and Watercolors Collected by the Late Mrs. S. D. Warren of Boston* (1903), intro. by C. H. Caffin, p. xv, says that "the beast is none too good, but the landscape is sonorous in color, mellow and luminous in its shadowed tones, and full of strong, deep, poetic feeling"; no. 119, describes it in detail // *Art Interchange* 50 (Feb. 1903), p. 381, in a discussion of Warren sale, says it is "poetic in feeling" // *American Art Annual* 4 (1903–1904), p. 42, notes its inclusion in the Warren sale and gives purchaser as M. Knoedler, which may be incorrect // *New-York Daily Tribune,* Feb. 14, 1904, p. 4, says that it was one of the "extraneous Innesses" in the estate sale and was bought by C. S. Philip for $1,300 // Thomas B. Clarke Scrapbook H [1889–1918], 1358,

Arch. Am. Art, "Summary of Executor's Sale of Paintings by the Late George Inness, Sold at the Fifth Avenue Art Galleries," under "A Lot," notes that it was added to Inness's estate sale and that it had previously been in the Warren collection; records its sale to C. S. Philip for $1,300 // *Catalogue of the Collection of Foreign and American Paintings Owned by Mr. George A. Hearn* (1908), ill. p. 163 // *MMA Bull.* 5 (May 1910), ill. p. 107, in a discussion of the Hearn bequest // *George A. Hearn Gift to the Metropolitan Museum of Art . . .* (1913), pl. 57 // E. Daingerfield, *Fifty Paintings by George Inness* (1913), pp. 9-10, discusses it; p. 12 // G. Inness, Jr., *Life, Art and Letters of George Inness* (1917), ill. p. 50; pp. 237–238 (quoted above) // J. C. Van Dyke, *American Painting and Its Traditions* (1919), pp. 31-32, says that it shows French influence because "it is broader, freer, thinner in handling; simpler in masses and has more unity"; ill. opp. p. 32 // F. H. Mather, Jr., *Estimates in Art* (1931), 2, ill. opp. p. 39; in a reprint of a 1922 essay, p. 56, misdates it 1873; pp. 56–57, discusses it; *American Magazine of Art* 27 (June 1934), ill. p. 304 // George Walter Vincent Smith Art Museum, Springfield, Mass., *George Inness* (1946), essay by E. McCausland, p. 32, notes that it was done at Medfield in 1875; p. 37, says that it represents "an esthetic middle ground, between the Italian manner and the emerging broader, less plastic mode" that came to control Inness's style // J. T. Flexner, *That Wilder Image* (1962), p. 319, says that in it "a shallow and quaint composition reminiscent of Corot has been mysteriously imbued with an American wildness" // L. Ireland, *The Works of George Inness* (1965), p. 174, ill. and lists it as no. 709, in a catalogue raisonné of the artist's

work; describes, gives provenance, exhibitions, and references // N. Cikovsky, Jr., *The Life and Work of George Inness*, Ph.D. diss., Harvard University, 1965; published 1977, p. 231, cites it as an example of "a tendency to compositions of a simpler, more abstractly two dimensional character" during the 1870s; pl. 76; *George Inness* (1971), p. 46, gives it as an example of the abstract, decorative quality evident in Inness's work of the 1870s; ill. p. 56 // N. C. Little, M. Knoedler and Co., New York, letters in Dept. Archives, March 7 and April 15, 1981, says that the picture is not recorded in their registrarial files; the 1903 exhibition mentioned by Ireland cannot be substantiated // C. Troyen, MFA, Boston, orally, April 9, 1981, provided information on Mrs. Warren, her ownership of the painting, and its exhibition at the MFA, Boston.

EXHIBITED: Chicago, Inter-state Industrial Exposition, 1875, no. 303, as Evening, at Medfield, Mass., $2,000 // MFA, Boston, 1902, *Special Exhibition of Paintings from the Collection of the Late Mrs. S. D. Warren*, no. 67, as Evening, Medfield, annotated copy, MFA, Boston, indicates that frame was being sent to New York // MMA, 1965, *Three Centuries of American Painting*, unnumbered cat.

ON DEPOSIT: MFA, Boston, 1884–1885, lent by Samuel Dennis Warren.

EX COLL.: with Doll and Richards, Boston, ca. 1875 (sale, Leonard and Co., Auctioneers, Boston, Dec. 13, 1876, no. 18, as Evening, Medfield, Mass., 38 × 63 in., $525); Samuel Dennis Warren, Waltham and Boston, 1884–1885; his wife, Mrs. Samuel D. Warren (née Susan Cornelia Clark), Waltham and Boston, d. 1902 (sale, American Art Association, New York, Jan. 9, 1903); (sale, Fifth Avenue Art Galleries, New York, Feb. 13, 1904, $1,300 [not listed in cat.]) C. S. Philip, 1904; George A. Hearn, New York, by 1908–1910.

Gift of George A. Hearn, 1910.

10.64.6.

Pine Grove of the Barberini Villa

The Villa Barberini is situated on the outskirts of the town of Castel Gandolfo, southeast of Rome. A favorite subject of landscape painters during the nineteenth century, the town overlooks Lake Albano, which is visible here through the pine trees. Inness reportedly painted this scene from studies made during visits there. No known study corresponds exactly to the Metropolitan's painting, but there are two other paintings of the site illustrated in Ireland's catalogue raisonné (see nos. 657 and 671).

Inness intended to exhibit the painting at the important Centennial Exhibition in Philadelphia in 1876 but was unable to finish it in time. He evidently reworked the painting extensively. According to an 1894 interview with his studio assistant John Austin Sands Monks (1850–1917), Inness wanted to redo the sky, and Inness's son George and Monks carefully reworked it while Inness revised the foreground. At the end of the day, all three artists were pleased with the effect. The next morning, however, Inness rose early, and, before either of his two assistants arrived, he changed the sky to gray and adjusted the color scheme of the entire picture. A physical examination of the painting under raking light in March 1981 revealed that it was reworked in other areas as well. The pine trees have all been slightly reduced in height, particularly the three tallest ones, the crowns of which are surrounded by very thick pentimenti. Some features of Inness's technique also became evident during this examination. In several areas, like the sky around the limbs of the tallest tree, he seems to have applied the paint with a palette knife in broad, sweeping strokes. The limbs and trunk of this tall pine are built up with heavy impasto and then stippled with a stiff-bristled brush. This effect is so pronounced that the tree projects noticeably from the surface.

In the dark areas the painting has traction cracks caused by the uneven drying of the paint. A series of parallel vertical cracks suggests that the painting was removed from its stretcher at some time and rolled for storage or shipping. In fact, the stretcher, which consists of four vertical and four horizontal parts, is collapsible, and the parts are numbered for easy assembly. This arrangement must have facilitated the transportation of the canvas, which was sent to Boston and San Francisco as well as New York.

George Inness, Jr. (1917), cited *Pine Grove of the Barberini Villa* as an example of his father's belief "that painting a picture was purely mechanical, needing only the master brain to direct" (p. 76). Nicolai Cikovsky (1971) suggested that the unusual composition of the painting with its emphatic division into two nearly equal parts—dark, solid earth and empty, light sky—had some special significance for Inness. Cikovsky pointed to Inness's interest in the writings of Emanuel Swedenborg, which may have inspired the artist to seek an underlying order and balance in nature. It is possible that Inness's interest in carefully measured proportions was heightened by WILLIAM PAGE, his

neighbor at Eagleswood during the early 1860s. An ardent Swedenborgian, Page believed that natural forms had corresponding spiritual forms. The human figure, for example, reflected man's spiritual state. For Page, art was not the imitation of nature but an interpretation in which contrast and harmony, as well as color and form, expressed a spiritual impulse. These ideas could account for the carefully thought-out structure of Inness's picture.

Pine Grove of the Barberini Villa was apparently one of several paintings that Inness signed over to Doll and Richards, his dealers, in exchange for a cash advance. When his relationship with them soured in 1877, he took the picture to New York, where it was exhibited at Snedecor's gallery. On April 17, 1877, following legal proceedings, Inness and his brother agreed to return the painting to Doll and Richards. Little else is known about the painting's early history until its acquisition by the New York collector Lyman G. Bloomingdale.

Oil on canvas, 78¾ × 118½ in. (200 × 301 cm.). Signed and dated at lower right: G. Inness 1876.

REFERENCES: Extracts from Doll and Richards, Account Book A [ca. 1877], p. 256, Leroy Ireland Papers, Chapellier Galleries, New York, microfilm 995, Arch. Am. Art, lists it as sale no. 127, the only one of eleven paintings with no listed sale price // J. Inness and G. Inness, statement to W. C. Conner and B. Reilly and the Stuyvesant Safe Deposit Company, April 19, 1877, Doll and Richards Papers, Arch. Am. Art, say that "we have executed and delivered to Messrs. Doll & Richards a bill of sale of a certain oil painting in your possession, or that of one of you, entitled 'The Pine Grove of the Barberini Villa,' and that we hereby relinquish and disclaim any interest therein and consent to the immediate delivery to the said Doll & Richards of the said painting and its appurtenances and the storage receipt therefor and policy of insurance thereon" // *San Francisco Evening Post,* July 26, 1879, p. 1, says that it is still on view in the rooms of the San Francisco Art Association // *Art Interchange* 3 (August 6, 1879), p. 23, mentions it in a review of an exhibition at the San Francisco Art Association // *Critic* n.s. 22 (August 11, 1894), p. 97, mentions it in artist's obituary as one of his best pictures // E. H. C., *Boston Evening Transcript,* August 27, 1894, p. 6, in an article based on an interview with J. A. S. Monks, discusses the reworking of the painting and says it was intended for exhibition in Philadelphia but never sent // *Boston Daily Advertiser,* August 27, 1894, p. 4 // Thomas B. Clarke Scrapbook H [1889-1918], Arch. Am. Art, 1358, includes clippings that relate Monks's remarks about the painting // *New-York Daily Tribune,* April 14, 1895, p. 22, says that it is

on view at Bloomingdale Brothers art galleries, where it "occupies a conspicuous place in the collection"; notes that "$10,000 has been paid" for it // L. G. Bloomingdale, letter in MMA Archives, Oct. 13, 1898, offers it to the museum and notes that it "has been put in good condition under Mr. [George H.] Story's supervision" // S. Isham, *The History of American Painting* (1905), p. 257 // *Masters in Art* 9 (June 1908), pp. 28, 252 // E. Daingerfield, *Fifty Paintings by George Inness* (1913), pl. 6 // G. Inness, Jr., *Life, Art, and Letters of George Inness* (1917), pp. 86–88, 91, gives an account of Inness's difficulties with this picture; ill. p. 90 // F. J. Mather, Jr., *Estimates in Art* (1931), 2, p. 56, misdates it in an essay written in 1922 // George Walter Vincent Smith Art Museum, Springfield, Mass., *George Inness* (1946), essay by E. McCausland; p. 37, calls it "splendidly formal" // S. Cobb, *Art Quarterly* 26 (Summer 1963), pp. 237-238, in a reminiscence written by the artist Darius Cobb around 1894 describes Inness at work on what might be this painting, pp. 240-241 // L. Ireland, *The Works of George Inness* (1965), foreword by R. McIntyre, p. xi, mentions it as an example of Inness's romanticism; pp. 195-196, ill. and discusses; catalogues it as no. 786, Pine Grove, Barberini Villa, Albano, Italy, or Barberini Pines // N. Cikovsky, Jr., *The Life and Work of George Inness,* Ph.D. diss., Harvard University, 1965; published 1979, p. 57, quotes Inness, Jr.'s 1917 account of the artist's dealings with Doll and Richards over the picture; p. 60, says that Inness, Jr., reported that it was sent to Snedecor's for safekeeping until Doll and Richards learned of its whereabouts; pp. 243-245, discusses the composition as being the most important aspect of the painting and that it may "have held for him some undisclosed religious meaning," pl. 77; *George Inness* (1971), p. 40, says that when Inness fled Boston to escape his agreement with Doll and Richards, he took the painting with him; p. 47, discusses it as an example of Inness's communicating through artistic form; discusses composition, noting that it is somewhat artificial and exaggerated, which may be due to Inness's philosophy (quoted above); fig. 60 // Oakland Museum, *George Inness Landscapes* (1978), essay by M. D. Arkelian, p. 19, mentions its exhibition at the San Francisco Art Association and a review of it; p. 29 n 38, says it is discussed in a clipping from the *San Francisco Post* (July 26, 1879) in the Edward Deakin Scrapbook, Archives of California Art, Oakland Museum; p. 33, notes the 1879 exhibition // S. Frankenbach, MFA, Boston, letter in Dept. Archives, May 2, 1980, says that it was on loan there from 1881 to 1883 from Doll and Richards // D. Dwyer, Paintings Conservation, MMA, orally, April 1981, discussed the changes made by the artist and noted the traction cracks.

EXHIBITED: Snedecor's Gallery, New York, 1877 (no cat. available) // Massachusetts Charitable Mechanics Association, Boston, 1878, no. 178, as Pine Grove of the Barberini Villa, Albano, for sale // San

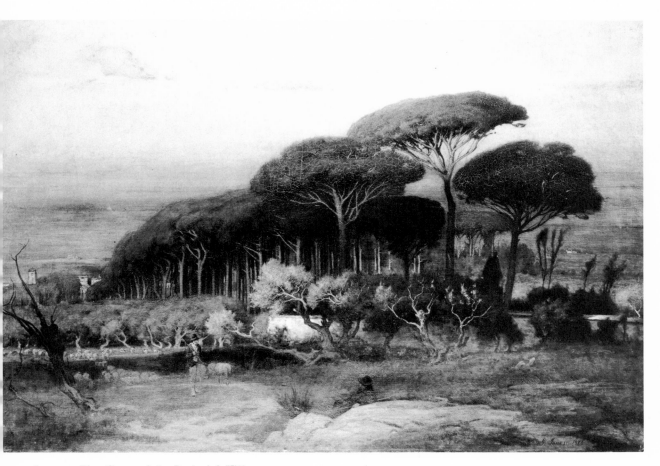

Inness, *Pine Grove of the Barberini Villa.*

Francisco Art Association, spring 1879 (no cat. available) // Art Galleries of Bloomingdale Brothers, New York, 1895 (no cat. available).

ON DEPOSIT: MFA, Boston, 1881–1883, lent by Doll and Richards.

EX COLL.: with Doll and Richards, Boston, by 1877–at least 1883; Lyman G. Bloomingdale, New York, by 1894–1898.

Gift of Lyman G. Bloomingdale, 1898.
98.16.

Autumn Oaks

Autumn Oaks was painted around 1878, when George Inness's progressive style and aesthetic philosophy made him one of the older artists popular with the young painters who had studied in Paris and Munich. The picture reveals Inness's interest in the Barbizon painting he had seen in France earlier in the decade. His rich palette is enlivened by dramatic light and dark contrasts, and his paint is applied directly with little concern for descriptive detail. The freshness of his style, the seemingly unlabored composition, and the effects of light and atmosphere he achieved make this one of his most beautiful landscapes. The artist's son, George Inness, Jr., pointed out that this picture was not done from nature but "from art," suggesting that it was composed in the studio. He ascribed its success to a technique of painting directly, then applying glazes in the shadows "with some such tone as sienna, to give richness and depth to the colors," and finally, adding highlights of opaque color.

The early provenance and exhibition history of the painting remain obscure. Although probably executed in the late 1870s, it does not appear to have been exhibited under its current title until 1886.

Oil on canvas, 20⅜ × 30⅛ in. (54.3 × 76.5 cm.).
Signed at lower right: G. Inness.

RELATED WORKS: A number of copies of this painting are discussed in the Leroy Ireland Papers, microfilm 992, Arch. Am. Art. Max Weber copied the painting in 1901 (private coll., San Anselino, Calif.).

REFERENCES: *Art Interchange* 17 (Nov. 20, 1886), p. 164, in a review of a loan collection on view at the MMA, says it is "possibly open to the charge of being a trifle too much cooked up and doctored" // G. I. Seney to S. P. Avery, March 28, 1887, MMA Archives, presents it to the museum // S. Isham, *The History of American Painting* (1905; 1915), ill. opp. p. 254 // G. B. Zug, *Chautauquan* 50 (May 1908), p. 371; ill. p. 377 // E. Daingerfield, *Fifty Paintings by George Inness*

(1913), pl. 4 // G. Inness, Jr., *Life, Art, and Letters of George Inness* (1917), ill. p. 229; pp. 232–233, discusses it (quoted above) // *Art World* 1 (Jan. 1917), frontis. engraving after it by Timothy Cole; p. 231, discusses // F. J. Mather, Jr., *American Magazine of Art* 27 (June 1934), ill. p. 306 // Elizabeth McCausland Papers, ca. 1945, microfilm D384, Arch. Am. Art, dates it about 1875; discusses // M. Weber to A. Westmore, April 15, 1946, in Dept. Archives, notes copy of the work // [H. Comstock] *Connoisseur* 117 (June 1946), p. 112 // H. V. N. Gearn, *Historical Society of Newburgh Bay and the Highlands*, no. 41 (1956), ill. p. 12 // L. Ireland, *The Works of George Inness* (1965), ill. p. 179, and includes as no. 729 in catalogue raisonné // N. Cikovsky, Jr., *The Life and Work of George Inness*, Ph.D. diss., Harvard University, 1965; published 1977, pl. 79 // A. Werner, *Inness's Landscapes* (1973), p. 84, compares it to The Red Oaks (Morning, Catskill Valley), 1894 (Santa Barbara Museum of Art).

EXHIBITED: MMA, 1886–87, *Loan Collection of Paintings and Sculpture*, no. 127, as Autumn Oaks // Royal Academy, Berlin, and Royal Art Society, Munich, 1910, *Ausstellung Amerikanischer Kunst*, no. 79 // NAD, 1939, *Special Exhibition*, no. 244 // Santa Barbara Museum of Art, 1941, *Painting Today and Yesterday*, no. 64 // Art Students' League, New York, 1943, *Fifty Years on Fifty-seventh Street*, no. 113 // George Walter Vincent Smith Art Museum, Springfield, Mass.; Brooklyn Museum; and Montclair Art Museum, N. J., 1946, *George Inness*, cat. by E. McCausland, color frontis.; p. 36, dates it about 1875 and says typical of his middle period; p. 37; p. 78, catalogues as no. 25 // Heckscher Museum, Huntington, N. Y., 1947, *European Influence on American Painting of the 19th Century*, no. 5 // NAD, 1951, *The American Tradition*, no. 77 // University Art Museum of the University of Texas, Austin, 1965–1966, *The Paintings of George Inness (1844–94)*, essay by N. Cikovsky, ill. p. 21; p. 25, includes it as no. 59 // Los Angeles County Museum of Art and M. H. de Young Memorial Museum, San Francisco, 1966, *American Paintings from the Metropolitan Museum of Art*, no. 96 // National Gallery of Art, Washington, D. C.; City Art Museum of Saint Louis; and Seattle Art Museum, 1970–1971, *Great American Paintings from the Boston and Metropolitan Museums*, no. 53 // Queens County Art and Cultural Center, New York; MMA; Memorial Art Gallery of the University of Rochester, New York; and Sterling and Francine Clark Art Institute, Williamstown, Mass., 1972–1973, *19th Century American Landscape*, exhib. cat. by M. Davis and J. K. Howat, no. 19, dates it 1875.

EX COLL.: George I. Seney, New York, by 1887; with Samuel P. Avery, New York, as agent, 1887.

Gift of George I. Seney, 1887.
87.8.8.

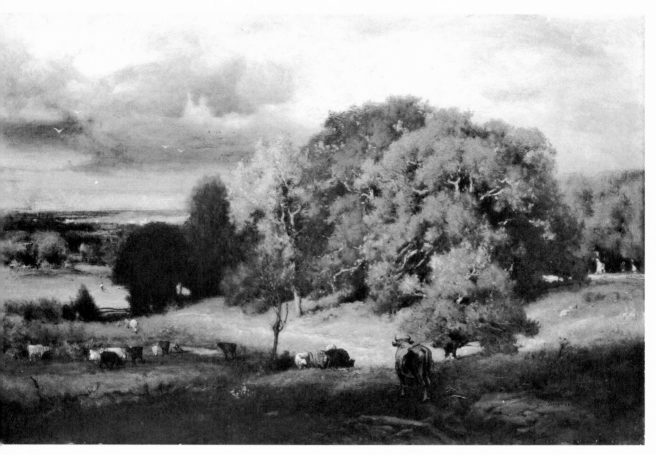

Inness, *Autumn Oaks*.

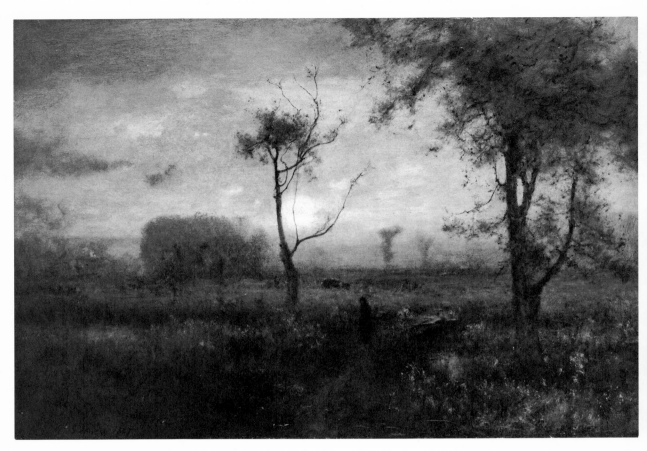

Inness, *Sunrise*.

Sunrise

Dated 1887, this painting is typical of Inness's work during the final decade of his career. Contours are softened, details avoided, and forms flattened to create a subjective view of nature. As Inness explained to the art critic Ripley Hitchcock in a letter dated March 23, 1884:

Long before I ever heard of impressionism, I had settled to my mind the underlying law of what may properly be called an impression of nature, and I felt satisfied that whatever is painted truly according to any idea of unity, will as it is perfectly done possess both the subjective sentiment — the poetry of nature — and the objective fact sufficiently to give the commonest mind a feeling of satisfaction (Montclair Art Museum, N. J.).

It has not been possible to trace completely the provenance and exhibition history of this painting, for there are other Inness paintings of similar subject, title, size, and date.

Oil on canvas, 30 × 45¼ (76.2 × 114.9 cm.).
Signed and dated at lower left: G. Inness 1887.

RELATED WORK: *Sunset Glow*, oil, 16 × 24 in. (40.6 × 61 cm.), coll. Miss Elizabeth Ball, Muncie, Ind., ill. in L. Ireland, *The Works of George Inness* (1965), no. 1250, appears to be the same composition.

REFERENCES: donor, letter in MMA Archives, August 16, 1954, says that it has been in family's possession since "about 1893" and that it is "a view of the Hackensack Meadows" // L. Ireland, *The Works of George Inness* (1965), ill. p. 313, includes it as no. 1257 in a catalogue raisonné of the artist's works // N. Cikovsky, Jr., *The Life and Work of George Inness* (Ph.D. diss., Harvard University, 1965; published 1977), fig. 101 // D. Dwyer, Paintings Conservation, MMA, orally, April 16, 1981, noted that a number of the artist's changes are visible.

EXHIBITED: Corcoran Gallery of Art, Washington, D. C., 1959, *The American Muse*, no. 25 // Marlborough-Gerson Gallery, New York, 1967, *The New York Painter* (benefit exhibition for the New York University Art Collection), ill. p. 31; p. 90, lists it.

EX COLL.: private coll., New York and Los Angeles, about 1893–1954.

Anonymous gift in memory of Emil Thiele, 1954. 54.156.

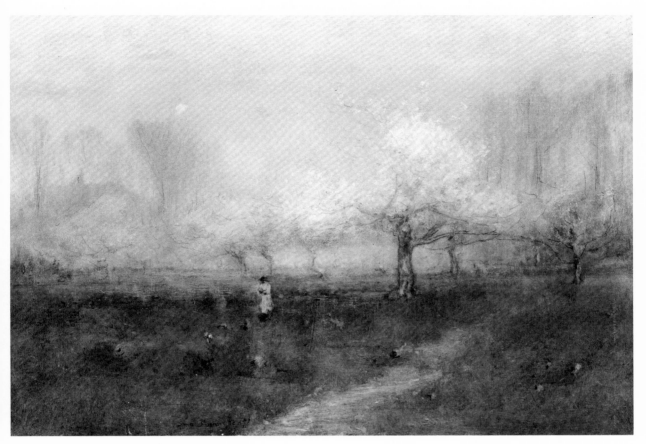

Inness, *Spring Blossoms, Montclair, New Jersey.*

Spring Blossoms, Montclair, New Jersey

In this, one of his most poetic paintings, Inness succeeded in capturing the essence of spring at a transitional time of day—probably twilight. To depict the ephemeral light, he covered the canvas with large areas of subtly modulated colors. Against this background, the blossoming trees are rendered in impasto, their delicacy enhanced by calligraphic lines along the trunks and limbs. These lines, in crayon or charcoal, have been drawn directly on the paint surface. The result is fresh, direct, and unlabored.

Paintings like this from Inness's late period have often led to his classification as an impressionist. Nonetheless, Inness was hostile to the aims of the movement as he understood them, and he did not accept its scientifically inspired color theories. His work does, however, share certain features of impressionism: the seemingly arbitrary cropping of a view and the free brush-work unrestricted by the contours of the subject. Still, his primary concern was aesthetic—he used color and structure to express feeling and mood. It is this poetic subjectivity that dominates *Spring Blossoms.*

The date of the painting has been variously given as 1887, 1889, and 1891. The confusion occurred because Inness placed five numbers, 18891, on the canvas, and the nine has often been misread as a seven. When the painting was first exhibited in 1894, its date was given as 1891, and presumably this is correct. It may be that Inness first worked on the painting in 1889 and then returned to it two years later.

Oil and crayon or charcoal on canvas, 29 × 45¼ in. (73.7 × 114.9 cm.).

Signed and dated at lower left: Geo. Inness 18891.

REFERENCES: *New York Times*, Feb. 14, 1895, p. 5, lists it among paintings sold in artist's estate sale, gives Frederick Bonner as purchaser and price as $1,200 // *Collector* 6 (Feb. 15, 1895), p. 130, dates it 1891; mentions sale and price // *Art Amateur* 32 (Feb. 1895), p. 78, says it is "a very poetic picture of

'Spring Blossoms' by twilight, all dim and white and pink in a thin, grayish mist" // A. Trumble, *George Inness, N. A.* (1895), p. 47, mentions sale // *Catalogue of the Private Collection of Valuable Modern Paintings . . . Belonging to Mr. Frederick Bonner* (1900), no. 74, dates it 1889; describes; annotated copy in MMA Library gives Hearn as purchaser // *Catalogue of Foreign and American Paintings Owned by Mr. George A. Hearn* (1908), ill. p. 166 // *George A. Hearn Gift to the Metropolitan Museum . . .* (1913), ill. p. 112 // E. Daingerfield, *Fifty Paintings by George Inness* (1913), p. 13, discusses, fig. 30 // G. Inness, Jr., *Life, Art, and Letters of George Inness* (1917), ill. p. 121; p. 234, notes "delicacy of touch" in it and says that the artist was "afraid to touch even the pencil marks for fear of one harsh note that might disturb the blush and make the petals fall" // *Art Notes* (Macbeth Gallery), no. 72 (Feb.–March 1921), pp. 1229–1230, discusses a "too successful" copy of it // F. J. Mather, Jr., *Estimates in Art* (1931), 2, p. 67 [in essay written in 1922], mentions it // *Index of Twentieth Century Artists* 4 (Dec. 1936), p. 651; p. 660, lists reproductions of it // Leroy Ireland Papers, Chapellier Galleries, microfilm 992, Arch. Am. Art, n.d. records a copy of this painting, discussed in 1921 *Art Notes* // L. Ireland, *The Works of George Inness* (1965), ill. p. 330, includes as no. 1305 in a catalogue raisonné of the artist's work, describes, provides extensive information on the provenance, bibliography, and exhibition history of the painting, and dates it 1889 // D. Dwyer, Paintings Conservation, MMA, orally, April 16, 1981, said that the lines still visible on the surface were made in charcoal or crayon, not pencil, and are not part of a preliminary drawing showing through but lines applied on top of a rather thick paint surface.

EXHIBITED: American Fine Arts Society, New York, 1894, *Exhibition of the Paintings Left by the Late George Inness*, no. 184, as Spring Blossoms, Montclair, N. J., dated 1891 // Lotos Club, New York, 1901, *American Paintings from the Collection of George A. Hearn*, no. 22, as Spring Blossoms // George Walter Vincent Smith Art Museum, Springfield, Mass., Brooklyn Museum, and Montclair Art Museum, N. J., 1946, *George Inness*, essay by E. McCausland, pp. 80–81; no. 39; ill. p. 57 // University Art Museum of the University of Texas, Austin, 1965–1966, *The Paintings of George Inness (1844–94)*, cat. by L. Ireland, N. Cikovsky, and D. B. Goodall, no. 111 // Los Angeles County Museum of Art and M. H. de Young Memorial Museum, San Francisco, 1966, *American Paintings from the Metropolitan Museum of Art*, no. 97.

EX COLL.: the artist's estate (sale, Ortgies and Co., New York, Feb. 13, 1895, no. 121, as Spring Blossoms, Montclair, New Jersey, $1,200); Frederick Bonner, New York, 1895 (sale, American Art Galleries, New York, April 10, 1900, no. 74, $1,600); George A. Hearn, New York, 1900–1911.

Gift of George A. Hearn, in memory of Arthur Hoppock Hearn, 1911.

11.116.4.

FREDERIC E. CHURCH

1826–1900

Frederic Edwin Church was the son of a wealthy Hartford, Connecticut, businessman. His early training in art came from studying with Benjamin Hutchins Coe (1799–1883) and Alexander Hamilton Emmons (1816–1884), both local painters. In 1844, through the influence of the art patron Daniel Wadsworth, Church became the first pupil of the renowned Hudson River school painter THOMAS COLE. At Cole's studio in Catskill, New York, Church rapidly mastered his teacher's methods of sketching outdoors and adopted his heroic style of landscape painting. After two years of study, Church returned to Hartford, intending to set up a studio of his own there. Instead, however, he moved to New York and opened a studio in the Art-Union building.

Church became active in the city's artistic community. At the age of twenty-two, he was one of the youngest academicians ever elected at the National Academy of Design. He took pupils of his own, notably JERVIS MC ENTEE and William James Stillman (1828–1901), later

founder of the art magazine the *Crayon*. For the next few years Church continued to emulate Cole by painting large romantic landscapes of Hudson River and New England scenery. Contemporary aesthetic theory, notably that of John Ruskin, however, gradually altered his approach to the representation of nature. Stillman reported seeing a copy of Ruskin's *Modern Painters* (1843) in Church's studio in the winter of 1848–1849. It is likely that the impetus to paint the precise details of nature, concentrating on various effects of weather and atmosphere came from Ruskin's eloquent defense of J. M. W. Turner. Church derived additional inspiration from the scientific writings of the German naturalist-explorer Alexander von Humboldt. Abandoning the romantic, moralistic manner of Cole, Church began to seek a more scientific approach to nature, incorporating specific vignettes, sketched out-of-doors, into large paintings composed in the studio. In April of 1853, accompanied by Cyrus Field, who later earned international recognition for his part in the transatlantic cable project, Church became the first American artist to explore South America. He retraced Humboldt's route of 1802 from Colombia to Ecuador. Humboldt had urged the examination of natural phenomena through travel and botanical study, insisting that "coloured sketches, taken directly from nature, are the only means by which the artist, on his return, may reproduce the character of distant regions in more elaborately finished pictures; and this object will be the more fully attained, where the painter has, at the same time, drawn or painted directly from nature a large number of separate studies of the foliage of trees; of leafy, flowering, or fruit-bearing stems; of prostrate trunks, overgrown with pothos and orchideae" (*Cosmos* [London, 1849], 2, p. 452).

Following Humboldt's suggestions, Church returned to his studio in New York and commenced two years of intense work. The results of his initial encounter with exotic subject matter appeared in the paintings he submitted to the National Academy of Design in 1855. These included *The Cordilleras: Sunrise*, 1855 (coll. Mrs. Dudley Parker) and several works that record the sublimity of the tropical landscape and place a powerful emphasis on light and shadow. His canvases were met with universal praise, and the ensuing demand for similar subjects sent Church on a second expedition in 1857. Accompanied this time by the landscape painter LOUIS REMY MIGNOT, he headed for Ecuador, where he could concentrate on Andean scenery. He recorded his journey in diaries and sketchbooks that he filled with exact renderings of the vegetation and terrain. On July 9 he wrote:

> Riobamba lies in a bowl formed by the great slopes of Chimborazo and El Altar and from any part of the town noble views can be seen. Immediately surrounding the city are abrupt slopes and ravines giving an aspect of aridity and barrenness very striking, but when one ascends the summit, he will perceive that they are merely walls supporting gently inclined plains. . . . We followed the course of the Rio Grande which wound its way among the mountain slopes dashing on this side and that, foaming with rage at being hemmed in so narrow a channel.

Church's sketches from the second trip signal the development of his mature style, and are characterized by wide scope and increased attention to color and atmospheric detail. Nowhere is this new approach more evident than in his *Niagara* of 1857 (Corcoran Gallery of Art, Washington, D.C.), which was exhibited that same year in New York. Perhaps his greatest work, it established Church as the country's foremost landscape painter. Sent abroad for exhibition, *Niagara* was compared to masterpieces by Turner. The London *Art Journal*

proclaimed: "On this American more than any other . . . does the mantle of our greatest painter appear to us to have fallen" (Oct. 1859, p. 298). In 1859 Church scored another triumph with *Heart of the Andes* (q.v.), his great summary of the tropics. The painting was exhibited in the Tenth Street Studio, where Church was then working. It was viewed amid exotic palms and each area of the canvas could be closely scrutinized through a magnifying glass. It was a grand event, and the pattern of Church's success was firmly established. In 1864 the painting was included in the great Metropolitan Fair, where it hung with ALBERT BIERSTADT'S *Rocky Mountains* (q.v.) and EMANUEL LEUTZE's *Washington Crossing the Delaware* (q.v.) in a position of honor.

Church continued to travel and make sketches for future paintings. In 1865, after the tragic death of his two young children from diphtheria, he went to Jamaica. Although none of the large paintings that emerged from this trip compare to *Heart of the Andes*, Church's broadly brushed oil studies of nature close-up are among his most delightful works. By 1867 Church had tired of producing tropical visions, and he turned to more traditional subject matter. He set off on a one and a half year tour of Europe and the Middle East. His first six months were spent mainly in London and Paris, after which he went on to Alexandria, Beirut, Constantinople, Baalbeck, Petra, and Jerusalem. Fascinated by the ruins of ancient civilizations, he added Naples, Paestum, and Greece to his itinerary. By June 1869, enroute home, Church stopped briefly in London, where he was treated to an opportunity to study the works of Turner. Writing later of this experience, he recalled: "Many years ago Tom Taylor took me to a basement room of the National Gallery in London, where were stored a great many of Turner's smaller pictures and sketches. It was an excellent opportunity to study his methods. A favorite effect of his was a brilliant central light contrasted with a bold mass of shadow in close proximity on one side" (*Brooklyn Eagle*, April 15, 1900, p. 28).

As always the initial products of Church's trip were scores of oil sketches and drawings, which he would transpose and interpret in a series of paintings. These included *The Parthenon* (q.v.) and *The Aegean Sea* (q.v.). In 1878 H. W. French outlined Church's working methods:

> He has accomplished some feats of rapid execution, but generally paints slowly—rarely over one large picture in a year, beside several smaller ones. Five hours of hard work before an easel, any artist will admit, is sufficient for a full day's work; but his indefatigable energy often holds him for ten hours upon a canvas. He paints standing, and with every minute's progress inspects his picture from a distance. His gait, manner and use of brush, all alike are indicative of the characteristic energy that has marked his life (*Art and Artists in Connecticut*, p. 131).

Church continued his participation in New York cultural activities. He was, for example, one of the founders of the Metropolitan Museum of Art. His style and the scale of his works were emulated by countless American landscape painters, and his success with tropical subjects inspired some of his colleagues, notably MARTIN JOHNSON HEADE, to follow him to South America. Church continued to exhibit in numerous competitions, and his works were reproduced frequently. In 1878 his *Morning in the Tropics*, 1877 (National Gallery of Art, Washington, D.C.) and *The Parthenon* were shown at the Exposition Universelle in Paris. By 1880, however, his activity was somewhat curtailed by failing health. Three years later, rheumatism crippled his right arm and hand. He all but ceased painting in the last decade of his life, retreating to Olana, the magnificent villa near Hudson, New York, designed for him by

Calvert Vaux in 1870. Inspired by his travels in the Near East, where he and his wife had collected exotic furnishings and decorative objects, Olana was and remains, a fusion of Persian and Moorish styles. Its walls are lined with mementoes of various journeys and with a revealing collection of copies of the painter's favorite works by old masters, notably landscapes by Claude Lorrain and Salvator Rosa. There are works by his mentor Thomas Cole as well. Church spent most of his final years at Olana, although he generally went to Mexico in the winter. He died in New York on April 7, 1900.

BIBLIOGRAPHY: Frederic Edwin Church Archives, Olana, Hudson, N. Y. This is the major repository of Church manuscript material, it includes the artist's diaries and letters as well as sketchbooks and photographic material // David C. Huntington, *The Landscapes of Frederic Edwin Church: Vision of an American Era* (New York, 1966). The first major work on Church // National Collection of Fine Arts, Washington, D.C.; Albany Institute of History and Art; M. Knoedler and Company, New York, *Frederic Edwin Church* (1966), exhib. cat. by Richard P. Wunder and David C. Huntington // Theodore E. Stebbins, Jr., *Close Observation: Selected Oil Sketches by Frederic E. Church* (Washington, D.C., 1978), exhib. cat. for a traveling exhibition organized by the Cooper-Hewitt Museum // Gerald L. Carr, *Frederic Edwin Church, The Icebergs* (Dallas, 1980). An important study of Church's career.

Heart of the Andes

Heart of the Andes, completed in 1859, is the result of Church's second trip to South America, which he made in the spring of 1857. Inspired by the German naturalist Alexander von Humboldt who suggested that painters find subjects "in the humid mountain valleys of the tropical world" (*Cosmos* [1849], 2, p. 452), Church had first visited South America in 1853 and followed Humboldt's route from Colombia to Ecuador. The success of the paintings he did from this trip probably encouraged him to return. In 1857 he spent nine weeks exploring Ecuador, concentrating on the vicinity of Chimborazo and the nearby volcanoes of Sangay and Cotopaxi. Despite primitive conditions and inclement weather, he completed scores of drawings, filling several sketchbooks with minute details of tropical vegetation.

In his diary of the 1857 expedition, Church described a panoramic scene much like that in the painting:

During the first part of the journey, behind us at the West, towered the distant Chimborazo which, like all these mountains, seem to increase in magnitude as we recede from them. Surrounding us were lower snow peaks, some of which are not clad in perpetual snow. Among the most conspicuous was the Tuna range exactly in front of a very irregular sierra but comparatively not very high. The lack of trees gives a singularly lonely effect which was increased by the absence of birds; the river contains no fish.

Examination of the numerous oil sketches and pencil drawings Church made during his trip confirms that he had already begun to formulate his ideas for *Heart of the Andes*. Most of his sketches concentrate on the snow-capped Chimborazo, which forms the central motif of the final work. In sketches like *Chimborazo from the House of Señor Pablo Bustamente, Riobamba, Ecuador,* July 14, 1857 (Cooper-Hewitt Museum, New York), one can observe Church's fascination with the atmospheric conditions and changing light. The other main feature, the waterfall that dominates the middle ground, he also culled from his on-the-spot drawings, most notably from *Waterfall near the Hacienda Chillo,* June 26, 1857 (Cooper-Hewitt Museum, New York). The first plan of the entire composition, a small oil sketch, dated 1858 (Olana, Hudson, N.Y.), reveals that he concentrated on the main features first, embellishing them much later. He also altered details of his initial arrangement. The trees at the right, for example, were originally palms, but in the end he chose sturdier looking Hudson River type trees to strengthen the right side of the composition.

The most unprecedented aspect of *Heart of the Andes*, however, was the pervasiveness of minute detail in a composition where so many perspec-

tive points might otherwise confuse and overwhelm the viewer. Evidently Church carefully chose these details from his sketchbooks, in which he had also made notations concerning color and the effects of sunlight. What was unusual and gave his composition a new look was his precise representation of material not only in the foreground but in the middle ground and background as well, thus ensuring a convincing and cohesive final impression.

On April 27, 1859, the picture was publicly unveiled in New York at Lyrique Hall, 756 Broadway. Subsequently moved to the gallery in the Tenth Street Studio Building, the painting was lit by gas jets concealed behind silver reflectors in a darkened chamber. The painting's dark walnut frame dramatized the presentation as did the surrounding dried palm leaves the artist had collected on his travels. The public became obsessed with the work; twelve to thirteen thousand people paid twenty-five cents a piece to file by the canvas each month, a reaction that JOHN FERGUSON WEIR referred to as "phenomenal in the history of single-picture exhibitions" (see Sizer, ed. [1957], p. 44).

Equally awed, the press expressed universal admiration. The critic for the *New York Times*, for example, praised Church's ambitious conception of a landscape:

In Baptizing the work the *Heart of the Andes* the artist happily indicated the high poetic tenor of the composition. It is not like Niagara a simply magnificent mirror of one moment in Nature but like the noblest works of CLAUDE and TURNER, a grand pictorial poem, presenting the idealized truth of all the various features which go into the making up of the Alpine landscape of the tropics.

The analogy to European landscape paintings was well founded; for although the subject matter was tropical as suggested by Humboldt, its treatment reflected Church's own fusion of several stylistic sources. The idealized appearance of *Heart of the Andes*, which was a skillful pastiche of diverse tropical motifs, recalled the sublime manner of Claude Lorrain and Salvator Rosa, painters greatly admired by Church's teacher THOMAS COLE. The remarkable attention to detail and the convincing atmospheric effects, however, were motivated by Church's study of the theories of John Ruskin. The first volume of Ruskin's *Modern Painters* (1843), an extended defense of J. M. W. Turner's landscapes, had impressed Church with its emphasis on the moral

value of "truth to nature," which included rendering details accurately. The visual unity of *Heart of the Andes* was the result of Church's ability to reconcile traditional romantic landscape painting with the new aesthetic.

Aware of the implications of this novel conception of landscape painting, Louis Legrand Noble and Theodore Winthrop, two close associates of Church, published pamphlets about the painting. Their interpretations of Church's reflection of spirituality in nature and complex composition are extensive. According to Winthrop, Church had "condensed the condensation of nature." "It is not an actual scene," he wrote, "but the subtle essence of many scenes." The landscape could be divided into the following regions:

The Sky. The Snow Dome. The Llano, or central plain. The Cordillera. The Clouds, their shadows and the atmosphere. The Hamlet. The Montana, or central forest. The Cataract and its Basin. The Glade on the right foreground. The Road and left foreground.

"The Scene," he added, "is an elevated valley in the Andes, six thousand feet above the sea;—the Time, an hour or two before sunset."

The wealth of detail in the painting drew public appreciation as well. Mark Twain, who saw the painting in Saint Louis, wrote to his brother on March 18, 1860:

We took the opera glass, and examined its beauties minutely, for the naked eye cannot discern the little wayside flowers, and soft shadows and patches of sunshine, and half-hidden bunches of grass and jets of water There is no slurring of perspective about it—the most distant—the minutest object in it has a marked and distinct personality—so that you may count the very leaves on the trees.

Following its exhibition in New York, *Heart of the Andes* was shown in London and Edinburgh where it brought international attention to American landscape painting.

The painting has had some condition problems, mainly in the upper central portion of the canvas. At some point, probably during a cleaning, scumble was removed, revealing some of the deep purple underpaint. Several pentimenti appear: one in the center left and one directly in front of the small village at the center.

Oil on canvas, 66⅛ × 119¼ in. (168 × 302.9 cm.). Signed and dated on tree at lower left: 1859 / F. E. CHURCH.

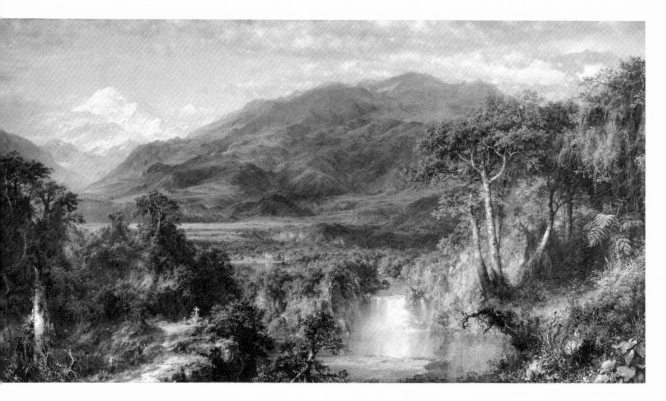

Church, *Heart of the Andes* (details below).

RELATED WORKS: Preliminary drawings of vegetation and minor motifs, in two sketchbooks of June–July 1857, pencil on paper, Olana, Hudson, N.Y. // *Ecuador, Waterfall near the Hacienda Chillo*, pencil and gouache on paper, 14 × 21½ in. (35.6 × 54.6 cm.), June 26, 1857, Cooper-Hewitt Museum, New York, 1917.4.247 // *Chimborazo from the House of Señor Pablo Bustamente, Riobamba, Ecuador*, pencil and gouache on paper, 13⅞ × 21¾ in. (35.2 × 55.2 cm.), July 14, 1857, Cooper-Hewitt Museum, New York, 1917.4.256, ill. in Stebbins, *American Master Drawings and Watercolors* (1976), p. 129, fig. 98 // *Study for Two Palm Trees*, pencil on paper, 12½ × 9 in. (31.8 × 22.9 cm.), July 23, 1857, Olana, Hudson, N.Y., pd. 414 // *Chimborazo from the Town of Guaranda*, oil with pencil on paperboard, 13⅝ × 21¼ in. (34.5 × 53.9 cm.), 1857, Cooper-Hewitt Museum, N.Y., 1917.4.859, ill. in T. E. Stebbins, Jr., *Close Observation*, exhib. cat. (1978), p. 66, no. 28 // *Chimborazo Seen through Rising Mists and Clouds*, oil with pencil on paperboard, 13⅝ × 21¼ in. (34.6 × 54 cm.), 1857, Cooper-Hewitt Museum, 1917.4.824, ill. ibid., p. 66, no. 29 // *A Sheet of Studies of Chimborazo*, oil with pencil on paperboard, 11¾ × 17⅝ in. (29.8 × 44.7 cm.), 1857, Cooper-Hewitt Museum, 1917.4.825, ill. ibid., p. 67, no. 30 // *Mount Chimborazo*, oil with pencil on paperboard, 13⅝ × 21 in. (34.5 × 53.2 cm.), 1857, Cooper-Hewitt Museum, 1917.4.1296B, ill. ibid., p. 67, no. 31 // Study for *Heart of the Andes*, oil on canvas, 10 × 18 in. (25.4 × 45.7 cm.), 1858, Olana, Hudson, N.Y. // Attributed to Charles Horwell Woodman or Richard Horwell Woodman, watercolor, 19¾ × 36⅛ in. (50.2 × 91.7 cm.), 1859–1861 National Gallery of Art, Washington, D. C., ill. in G. L. Carr, [*National Gallery of Art*] *Studies in the History of Art* 12 (1982), p. 82 // William Forrest, *Heart of the Andes*, steel engraving, 13½ × 24⅞ in. (image), 1863. The original plate and proofs of three early stages are at Olana.

REFERENCES: F. E. Church, Diary for July 1857, Olana, Hudson, N.Y. (quoted above) // L. L. Noble, *The Heart of the Andes* (1859), pp. 3–24, describes and analyzes the painting in depth // T. Winthrop, *A Companion to the Heart of the Andes* (1859), describes and explains the painting in detail; p. 12 (quoted above) // *Crayon* 6 (May 1859), pp. 193–194, reviews it, noting that the "composition is defective" but "rendering of light is admirable," criticizes "lack of repose and unity" // *Century* 1 (May 21, 1859), p. 4, reviews it, noting, "This picture is greater in the parts than in the whole [Church] paints objects so well that he is tempted to make a picture by combination of objects. . . . He introduces a multitude of particulars, interesting enough, and well presented, but they break the unity of his work, and seem to stand there for their own sake, and not to be subordinated to the spirit of the scene" // W. Irving, May 23, 1859, *Life and Letters of Washington Irving* (1864) 4, pp. 288–289, describes his reaction to the painting // B. d'Artois, *New York Leader*, May 28, 1859, p. 6, says the in-

clusion of the cross places the picture in the highest range of art // *Littell's Living Age* 62 (June 1859), p. 64, describes the work // *London Illustrated News of the World* (July 30, 1859), criticizes the work // *Crayon* 6 (Sept. 1859), pp. 281–282, contains laudatory comments from London reviews of the painting // *Littell's Living Age* 62 (Sept. 1859), p. 817, discusses it // London *Art Journal* (Oct. 1859) pp. 297–298, discusses the painting then on exhibition at the German Gallery, London // *New York Daily Tribune*, Nov. 21, 1859, p. 7, discusses exhibition of the work then at the Tenth Street Studio // *New York Times*, Nov. 24, 1859, p. 4 // *New York Herald*, Dec. 5, 1859, p. 1 // Kurtz Gallery, New York, *Heart of the Andes* [1859], reprints American and English reviews of the painting through December 1859 // *A Critical Guide to the Exhibition at the National Academy of Design* (1859), p. 12, discusses it and quotes reviews // S. Clemens [Mark Twain] to O. Clemens, March 16, 1860, in A. B. Paine, ed., *Mark Twain's Letters* (1917), 1, p. 46 // *New York Morning Express*, April 29, 1861, p. 3, announces exhibition of the painting in Brooklyn to close on May 1 // *New York Times*, March 17, 1863, p. 4 // *Harper's Weekly* 7 (April 4, 1863), p. 210, notes an engraving of the painting, executed by William Forrest in Edinburgh, published in London in 1863, "after three years' labor of ten hours a day" // T. Winthrop, *Life in the Open Air and Other Papers* (1863), pp. 329–374, discusses his contact with Church and the painting // London *Art Journal* 27 (Sept. 1865), pp. 265, 689, describes and discusses the painting // H. T. Tuckerman, *Book of the Artists* (1867), p. 372, suggests that the work is the "pictorial counterpart" of Humboldt's descriptions of the tropics; p. 373, mentions engraving after the work; p. 375, calls the painting a "Faithful rendering of the facts of nature"; p. 378, prints his poem about the painting; p. 385, notes Blodgett owner of the work // *Harper's Weekly* (June 8, 1867), p. 364, describes the work // *Art Journal* 4 (June 1875), p. 179 // *New York Evening Post*, April 17, 1876, p. 3 // *New York Evening Mail*, April 24, 1876, p. 2 // *Aldine* 8 (1876), p. 17 // Chickering Hall, New York, *Executor's Sale of the Collection of Paintings Belonging to the Estate of the Late Wm. T. Blodgett*, sale cat. (April 27, 1876), no. 92 (the painting was sold privately before the auction) // *Art Journal* 4 (March 1878), p. 67 // H. W. French, *Art and Artists in Connecticut* (1879), pp. 129, 132–133; p. 134, notes that David Dows bought the painting before the Blodgett sale // London *Art Journal* 18 (Nov. 1879), pp. 238–240, discusses the painting // G. W. Sheldon, *American Painters* (1879), p. 82 // T. Buchanan Read, *Poetical Works of T. Buchanan Read* (1881) 2, pp. 414–415, includes a poem entitled "Church's Heart of the Andes" // *Art Age* 2 (April 1885), p. 135, says the painting was sold for $10,000 // F. E. Church to J. D. Champlin, Sept. 6, 1885, letter in MMA Archives // E. Shinn [E. Strahan], *American Art and American Art Collections* (1889) 2, p. 772, mentions the painting

Church, oil study for *Heart of the Andes*, 1858.
Olana State Historic Site.

Church, *Chimborazo from the Town of Guaranda*, oil with
pencil on paperboard, 1857. Cooper-Hewitt Museum.

Church, *Ecuador, Waterfall near the Hacienda Chillo*,
pencil and gouache on paper, Cooper-Hewitt Museum.

in the collection of David Dows, New York // B.
Champney, *Sixty Years' Memories of Art and Artists*
(1900), p. 141, discusses the artist's rendering of
flora in the work // F. E. Church, *Brooklyn Eagle*,
April 18, 1900, p. 28, reminisces on career and the
painting of the work // H. F. Schwartz, *Natural History* 24 (1924), ill. p. 442, in discussion of the Andes //
E. Clark, *Art in America* 15 (June 1927), p. 182,
discusses and illustrates sketches for the painting //
Magazine of Art 25 (Oct. 1932), ill. p. 192 // W.
Whittredge, *Brooklyn Museum Journal* 1 (1942), p. 28,
describes the impact of the painting on the American
artists living in Rome in 1859 // A. T. Gardner, *MMA
Bull.* 4 (Oct. 1945), pp. 59–65, discusses the work in
the context of an emerging tradition of scientific landscape painting // C. E. Slatkin and R. Schoolman,
Treasury of American Drawings (1947), p. xii, pl. 41,
misidentifies a pencil sketch in the City Art Museum,
Saint Louis, as pertaining to this painting // J. T.
Flexner, *A Short History of American Painting* (1950), p.
43, describes the work // T. Sizer, ed., *Recollections of
John Ferguson Weir* (1957), pp. 44–45, describes seeing
the painting at the Tenth Street Studio in 1859
(quoted above) // J. T. Flexner, *That Wilder Image*
(1962), p. 136, notes 1864 exhibition; p. 156, recounts
effect of the *New York Herald*, Dec. 5, 1859, review on
the American artists in Rome; pp. 161, 162, discusses
the painting; ill. p. 163, shows detail; p. 164, mentions foreign exhibitions of the painting, some of
which did not actually take place // D. C. Huntington,
Brooklyn Museum Annual 5 (1963–1964), pp. 65–98,
discusses on the basis of Church's diaries his trips to
South America; *Landscapes of Frederic Edwin Church*
(1966), pp. 1, 5–9, discusses the work, noting that
there was a report that Church was to take the painting on a tour of nine European cities but in fact it
only crossed the ocean once to shows in London and
Edinburgh; the American tour included Boston, Philadelphia, Cincinnati, Chicago, and Saint Louis; discusses Church's agreement with Blodgett // National

Collection of Fine Arts, Washington, D. C., Albany
Institute of History and Art, M. Knoedler and Company, New York, *Frederic Edwin Church* (1966), exhib.
cat. with intro. by D. C. Huntington, p. 32, says
picture completed April 27, notes that the price paid
by Blodgett was the highest price to date for a painting by a living American artist; p. 33 // B. Stevens,
Arts 40 (1966), p. 44, refers to "the small figure and
cross" in the work // W. H. Truettner, *Art Quarterly*
31 (Autumn 1968), p. 267 // J. D. Prown, *American
Painting* (1969), p. 69 // C. Ratcliff, *Art International*

Stereophotograph showing *Heart of the Andes* in
the 1864 Metropolitan Fair, New York. NYHS.

14 (Summer 1970), ill. p. 93, discusses it in a review of 19th Century America // B. Novak, *Art in America* 59 (March–April 1971), cover ill; pp. 67, 71, discusses it // G. Hendricks, *Antiques* 52 (Nov. 1972), p. 893; color ill. p. 894; p. 897 // *MMA Bull.* 33 (Winter 1975–1976), color ill. no. 51 // A. F. Meservey, *American Art Journal* 10 (May 1978), pp. 87–88 // G. L. Carr, *Frederic Edwin Church, The Icebergs* (1980), p. 9, 22; ill. p. 24, fig. 4; p. 27, compares to John Martin's The Plains of Heaven; pp. 28, 30, discusses its success; pp. 35, 36; p. 59, discusses its exhibition in 1859; pp. 60, 61; ill. p. 78, an advertisement for a showing in Brooklyn, 1861; p. 80, mentions Brooklyn 1861 exhibition; pp. 82, 83, 85, 93; [*National Gallery of Art*] *Studies in the History of Art* 12 (1982), pp. 81–99, attributes the National Gallery's watercolor of the picture to Richard Woodman or one of his two sons // G. L. Carr, Olana, Hudson, N.Y., April 29, May 12, 1983, letters in Dept. Archives, supplies some early reviews of the painting, including some negative comments.

EXHIBITED: Lyrique Hall, New York, 1859 // Tenth Street Studio Building, New York, 1859 // German Gallery, London, 1859 // Edinburgh, 1859 // Kurtz Gallery, New York, 1859 // Boston Athenaeum, 1859–1860 // PAFA, 1860 // Midwest tour which included Cincinnati, Chicago, and Saint Louis, 1860–1861 // Low's Building, Brooklyn, 1861 // Metropolitan Fair, New York, 1864, *Exhibition at the Metropolitan Fair in Aid of the U. S. Sanitary Commission*, ill. p. 10, no. 111, lent by William T. Blodgett // Chickering Hall, New York, 1876 // MMA, 1900, *Paintings by Frederic E. Church, N. A.*, unnumbered cat.; 1946, *Taste of the Seventies*, no. 74; 1953–1954, *American Painting, 1754–1954* (no cat.); 1965, *Three Centuries of American Painting*, checklist alphabetical; 1970, *19th Century America, Paintings and Sculpture*, exhib. cat. by J. K. Howat and N. Spassky, no. 106.

Ex COLL.: William T. Blodgett, New York, 1859–1876 (sale, Chickering Hall, New York, April 27, 1876, no. 92), but bought before the auction by David Dows, New York, 1876–d.1890; Mrs. David Dows, New York, until 1909.

Bequest of Mrs. David Dows, 1909.

09.95.

The Parthenon

Church visited Greece in April of 1869 and spent several weeks in Athens. There he focused his attention on the ruins of the Parthenon. Built on the Acropolis between 447 B.C. and 432 B.C., under Pericles, the entire center portion of the Parthenon was destroyed by an explosion in 1687, when the Turks used it as a powder magazine during the Venetian attack on Athens. Modern appreciation of the temple began in the eighteenth century. The large number of oil sketches and pencil drawings of the Parthenon that Church made indicate his fascination with the site. From Athens on April 14 he wrote to his friend William H. Osborn of his intention to paint a major picture of the scene:

The Parthenon is certainly the culmination of the genius of man in architecture. Every column, every ornament, every moulding asserts the superiority which is claimed for even the shattered remains of the once proud temple over all other buildings by man.

I have made architectural drawings of the Parthenon and fancied before I came to Athens that I had a good idea of its merits. But in reality I knew it not. Daily I study its stones and feel its inexpressible charm of beauty growing upon my senses. I am glad I came here—and shall try and secure as much material as possible. I think a great picture could be made of the ruins. They are very picturesque as well as imposing and the color is superb.

It was not until 1871, however, with a commission from the financier and philanthropist Morris K. Jesup, that Church finally began the intended canvas. By February of that year he was in the midst of the work and wrote to MARTIN JOHNSON HEADE from Olana that he was "painting a big Parthenon." Several months later, in May, he had apparently finished the painting and wrote to Heade of his concern for the proper lighting of it in Jesup's home.

The final work reveals Church's reliance on the many sketches he executed on the site. One such oil sketch, *Athens, the Parthenon in Night Light* (Cooper-Hewitt Museum, New York), presents the scene from an identical angle and is suffused with a reddish glow of light that seems to suggest the rosy tonality of the finished painting. The vast foreground, covered with fragments of fallen capitals and columns also draws its inspiration from the sketches.

As in many of his previous works, notably *Heart of the Andes* (q.v.), Church used the compositional device of a small figure situated in the middle ground to emphasize the tremendous size of even the smallest of fragments. He also made the main building stand out by bathing it in afternoon shadows. Unlike earlier works, however, the artist concentrated on one central motif, eliminating extraneous details and emphasizing the barren aspect of the surrounding land-

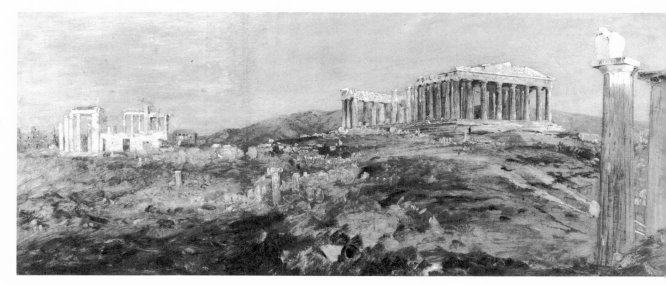

Study for *The Parthenon* includes the Erechtheum at the left,
oil on paper (two pieces joined). Private collection.

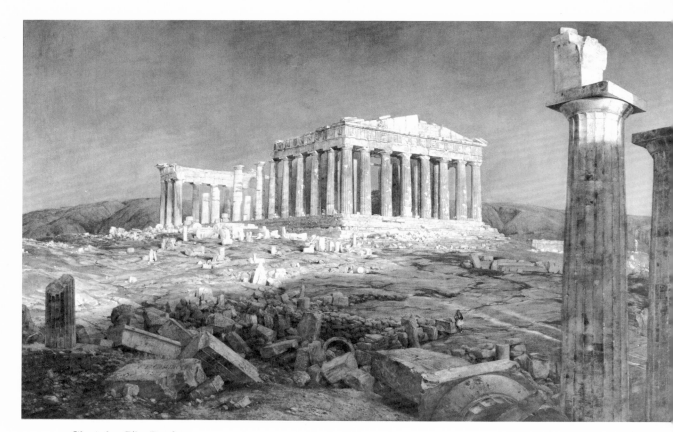

Church, *The Parthenon.*

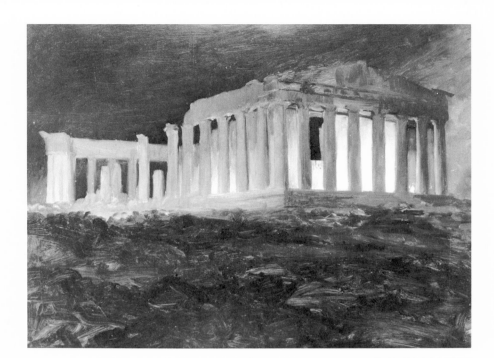

Church, *Athens, the Parthenon in Night Light*, April 1869, oil on paper (1917.4.573A).

Church, pencil drawing, *Parthenon, Athens*, April 1869 (1917.4.378C). Cooper-Hewitt Museum.

Church, *Athens Fallen Capital of the Parthenon*, oil on paper. Cooper-Hewitt Museum.

scape. Unsurprisingly his approach is not far removed from that of his former teacher THOMAS COLE. Cole's *The Temple of Segesta with the Artist Sketching*, ca. 1842 (MFA, Boston), and *Mount Aetna from Taormina, Sicily*, 1844 (Lyman Allyn Museum, New London, Conn.), contain similar devices and extol the passing of ancient civilization in much the same vein.

When first exhibited in 1872 at Goupil's Gallery, New York, the painting was heralded as "the best picture by this artist that we have seen for many years," and the subject was found to be "much better for the delineation of minute detail than of scenes in nature where *degrees* of solidity, light, shade, etc. are necessarily marked with great delicacy, and where many different planes, so to speak, are required to render a scene artistic and effective." The work was subsequently shown in many major exhibitions, including the Exposition Universelle in Paris in 1878.

There is considerable evidence that Church reworked the lower part of the sky after the picture was completed. This effort at brightening the picture is visible in the areas around the building.

Oil on canvas, $44\frac{1}{2} \times 72\frac{5}{8}$ in. (113×184.5 cm.). Signed and dated at lower left: F. E. CHURCH / 1871.

RELATED WORKS: *Athens, Fallen Capital of the Parthenon*, oil on paper, $19\frac{13}{16} \times 17\frac{7}{16}$ in. (50.3×44.2 cm.), 1869, Cooper-Hewitt Museum, New York, 1917.4.574B // *Athens, Fragments of the Parthenon*, oil on paper, $11\frac{7}{8} \times 17$ in. (30.2×43.2 cm.), April 1869, Cooper-Hewitt Museum, 1917.4.574A // *Athens, with a View of the Acropolis*, oil on cardboard, $13 \times 20\frac{1}{8}$ in. (33×51.1 cm.), April 1869, Cooper-Hewitt Museum, 1917.360A // *Athens, the Parthenon in Night Light*, oil on paper, $12\frac{15}{16} \times 16\frac{3}{8}$ in. (32.8×41.6 cm.), Cooper-Hewitt Museum, April 1869, 1917.4.671 // *Athens, Detail of the Parthenon*, oil on cardboard, $20\frac{1}{16} \times 12\frac{1}{16}$ in. (50.9×30.6 cm.), April 21, 1869, Cooper-Hewitt Museum, 1917.4.573A // *Parthenon, Athens*, pencil on paper, $4\frac{3}{16} \times 8\frac{1}{4}$ in. (10.6×20.9 cm.), April 1869, Cooper-Hewitt Museum, 1917.4.378A // *Parthenon, Athens*, pencil on paper, $4\frac{3}{16} \times 7\frac{15}{16}$ in. (10.6×20.2 cm.), April 1869, Cooper-Hewitt Museum, 1917.4.378B // *Parthenon, Athens*, pencil on paper, $11\frac{7}{8} \times 21\frac{1}{2}$ in. (30.2×54.6 cm.), April 1869, Cooper-Hewitt Museum, 1917.4.378C // *Parts of a Fluted Column*, pencil on paper, $4\frac{3}{16} \times 8\frac{3}{16}$ in. (10.8×20.8 cm.), 1868 or 1869, Cooper-Hewitt Museum, 1917.4.577 // Study for *The Parthenon*, oil on paper, $12\frac{1}{4} \times 20\frac{1}{4}$ in. (31.1×51.4 cm.), private coll., New York.

REFERENCES: F. E. Church to W. Osborn, April 14, 1869, Church Archives, Olana, Hudson, N.Y., discusses plans to paint the work (quoted above) // Church to M. J. Heade, Feb. 8, 1871, Heade Papers, D5, Arch. Am. Art, says he is working on picture (quoted above) // E. K. Goodman to Church, April 20, 1871, ibid., says Jesup has directed him to pay Church or anyone Church designates the sum of $5,000 in gold (for this painting) // Church, bankbook for Park Bank in New York for 1861–1872, contains a note of deposit from Jesup of $5,543.75, on April 28, 1871 // E. K. Goodman to Church, April 28, 1871, says $5,543.75 has been deposited to his credit, bringing "proceeds of $5000 gold = 111% = $5550. — Less $\frac{1}{8}$% brokge. 6.25 or $5543.75" // Church to E. D. Palmer, April 28, 1871, Albany Institute of History and Art, says, "The Parthenon is finished" // M. K. Jesup to Church, May 1, 1871, Church Archives, Olana, Hudson, N.Y., writes: "The 'Parthenon' is up, improves all the time, in fact is a glorious picture"; James Lenox is coming to see it; and, "I think your picture would be improved by a shadow box — at any rate I want you to come in & look at it // Church to M. J. Heade, May 13, 1871, Heade Papers, D5, Arch. Am. Art, writes, "I can't give any advice about reflectors," but will consider what Jesup needs "to put the shine on the Parthenon" // *New York Commercial Advertiser*, March 29, 1872, p. 1, says it "is full of subtle art" // *New York Evening Mail*, April 3, 1872, p. 1, says it "is the Parthenon without a soul" // *New York Evening Post*, May 7, 1872, p. 1, reviews it at Goupil's, calling it one of Church great pictures // *Appleton's Journal* 6 (June 1, 1872), p. 611, describes the work on exhibition at Goupil's Gallery, New York // *Scribner's Monthly* 4 (June 1872), p. 251, describes the painting // *Art Journal* 4 (1878), ill. p. 67, describes and misdates it // H. W. French, *Art and Artists in Connecticut* (1879), p. 130, mentions that the picture is in the coll. of Morris K. Jesup, New York // G. W. Sheldon, *American Painters* (1879), p. 11, describes the work // S. G. W. Benjamin, *Art in America* (1880), p. 83, describes it // C. E. Clement and L. Hutton, *Artists of the Nineteenth Century and Their Works* (1889), 1, p. 137, notes its exhibition in Paris in 1878 // E. Shinn [E. Strahan], *American Art and American Art Collections* (1889), 2, p. 774 // *International Studio*, suppl. (Sept. 1900), p. xv // S. Isham, *History of American Painting* (1905), p. 251 // B. Burroughs, *MMA Bull.* 10 (April 1915), p. 66, announces accession and discusses the picture; ill. p. 67 // *MMA Bull.* 12 (Oct. 1917), suppl. pp. 6–7, discusses it // E. Clark, *Art in America* 15 (June 1927), p. 182 // R. B. Hale, *MMA Bull.* 12 (March 1954), ill. p. 179 and mentions that there are numerous studies for the work // J. T. Flexner, *That Wilder Image* (1962), p. 166, discusses the work // D. C. Huntington, *Frederic Edwin Church*, exhib. cat. (1966), pp. 76–77, notes three sketches for the work; *Landscapes of Frederic Edwin Church* (1966), pp. 96, 104, 107, 119 // W. D. Garrett, P. F. Norton, A. Gowans, and J. T. Butler, *The Arts in America* (1969), p. 250, pl. 187 // J. Ryan, Olana,

Hudson, N.Y., Feb. 16, 1983, letter in Dept. Archives, supplies letters from Jesup and Goodman // G. L. Carr, Olana, Hudson, N.Y., letter in Dept. Archives, April 29, 1983, supplies references and information from Church Archives.

EXHIBITED: Goupil's Gallery, New York, 1872 // MMA and NAD, 1876, *Centennial Loan Exhibition of Paintings*, no. 190 // Paris, Exposition Universelle, 1878, no. 21 // MMA, 1900, *Paintings by Frederic E. Church, N.A.*, unnumbered cat.; 1917, *Paintings of the Hudson River School* (see *MMA Bull.* [Oct. 1917]); 1946, *The Taste of the Seventies*, no. 73; 1953–1954, *American Painting* (no cat.); 1965, *Three Centuries of American Painting*, checklist alphabetical // Los Angeles County Museum of Art and M. H. de Young Museum, San Francisco, 1966, *American Paintings from the Metropolitan Museum of Art*, ill. p. 82, no. 48 // National Gallery of Art, Washington, D. C.; City Art Museum, Saint Louis; Seattle Art Museum, 1970–1971, *Great American Paintings from the Boston and Metropolitan Museums*, no. 36 // MMA and the American Federation of Arts, traveling exhibition, 1975–1976, *The Heritage of American Art*, cat. by M. Davis, ill. p. 125, no. 52, mistakenly says it was exhibited at the Centennial in Philadelphia in 1876.

EX COLL.: Morris K. Jesup, 1871–d. 1908; his wife, Maria DeWitt Jesup, 1908–d. 1914.

Bequest of Maria DeWitt Jesup, from the collection of her husband, Morris K. Jesup, 1914.

15.30.67.

The Aegean Sea

Church made his first and only visit to Europe in 1867. From there he traveled to the Near East, seeking inspiration for his landscapes among the ancient sites. In January 1868 he arrived in Alexandria to begin a lengthy tour that included Beirut, Jerusalem, Cyprus, Rhodes (and other Greek islands of the Aegean), Troy, and Constantinople. In addition, he made side trips to the exotic ruins of Baalbeck and Petra in Syria, where he sketched in oil and, with the aid of professional photographers, also recorded precise details of various monuments. From the drawings and photographs he made and collected during his trip, Church began a new group of paintings. The first of these works inspired by the antique was *Damascus*, 1869 (later destroyed).

There is ample indication that these landscapes drew heavily on the pictorial conventions of J. M. W. Turner, familiar to Church through his study of Ruskin's *Modern Painters* (1843–

1860). Moreover, enroute home from Europe in 1869, Church stopped in London for an extensive viewing of Turner's paintings in the basement of the National Gallery. This firsthand look at the English painter's work may explain the radical change in Church's orientation in the 1870s and early 1880s.

The Aegean Sea was painted about 1877 for Church's friend and patron William Henry Osborn. It was first exhibited in 1878 at Goupil's Gallery in New York. One of the last large works executed by the artist, the painting combines motifs from all over the Middle East in one panoramic view. As the critic for the *Art Journal* commented in 1878, *The Aegean Sea* was "not a portrait of any definite part of that classic sea, but a dream rather of its many aspects, an expression and an epitome of its rare beauties, derived from a long study of their characteristics." In this respect the work could be compared to *Heart of the Andes* (q.v.), which also involved a pastiche of scenes. *The Aegean Sea*, however, has none of the obsessive detail that characterizes its tropical predecessor. Instead it reveals Church's strong debt to Turner; for in *The Aegean Sea* Church has abandoned his detailed, naturalistic style in favor of increased idealization. His primary concern lies in the effects of atmosphere and light. He also shows more interest in the paint surface. The pervasive use of impasto, especially in the cloudy sky, however, may have been the result of his continuing battle with rheumatism, which crippled his right arm only a few years later.

The central motifs of the painting are characteristically drawn from Church's collection of travel photographs and on-the-spot sketches. Fallen capitals from the temple of Bacchus at Baalbeck, in the left foreground, so reminiscent of Turner's *Forum Romanum*, ca. 1826 (Tate Gallery, London), are based directly on a photograph of the site (Olana, Hudson, N.Y.), on which Church also based an oil sketch (Cooper-Hewitt Museum, New York). Above the ruins he has depicted a rock temple from the red city of Petra, where he made many oil sketches and took numerous photographs. There are also studies for the group of Arab figures in the central foreground. He enlarged the figures from a composite oil sketch, *Three Bedouins* (Cooper-Hewitt Museum) and redrew them together on tracing paper (Olana) before transferring them to the canvas.

Church, *The Aegean Sea*.

The sources for the right side of the composition are more difficult to identify, perhaps because Church took greater liberties with them. The rainbow, singled out by the critic for the *Art Journal* as "too merely pictorial and theatric," was undoubtedly inspired by the almost identical one in Turner's *Buttermere Lake*, ca. 1798 (Tate Gallery, London). The rainbow also appears in Church's other work of 1877, *Morning in the Tropics* (National Gallery of Art, Washington, D.C.).

Despite its contrived composition and the infirmity of the artist's hand, *The Aegean Sea* was well received by critics. The reviewer in the *Art Journal* probably presented the consensus of opinion on Church's ambitious summation of the ancient world when he called it "most likely

to attain lasting reputation, and to confer glory upon the national name." This success prompted Church to undertake a second panorama of the antique world, *The Mediterranean Sea*, 1882 (coll. Mrs. Iola Haverstick).

Oil on canvas, 54 × 63¼ in. (137.8 × 160.7 cm.). Signed at lower left: F. E. CHURCH.
RELATED WORKS: *Fallen Fragments from the Interior of the Temple of Bacchus, Baalbeck, Syria*, pencil and oil on cardboard, 10 × 11¼ in. (25.4 × 28.6 cm.), ca. May 1868, Cooper-Hewitt Museum, New York, 1917. 4.581, ill. in Cooper-Hewitt Museum, New York, *Close Observation* (1966), exhib. cat. by T. Stebbins, Jr., p. 93, no. 81 // *Three Bedouins*, oil on cardboard, 10³⁄₁₆ × 9¹⁄₁₆ in. (25.8 × 23 cm.), 1868–1869, Cooper-Hewitt Museum, 1917.4.425B // *Three Bedouins*, ink on tracing paper, 9⅛ × 9⅜ in. (23.2 × 23.8 cm.), n.d.,

Olana, Hudson, N.Y., pd. 484 // Collection of photographs taken during Church's tour of the Near East, 1868–1869, uncatalogued, Olana.

REFERENCES: *New York Herald*, April 24, 1878, p. 6, says the picture will go on exhibition at Goupil's today; that it was exhibited "in its unfinished state at the last monthly meeting of the Century Club"; and describes in detail, noting that "The true motive of the painting is the atmospheric effect, and this is very successful // *Boston Evening Transcript*, April 24, 1878, p. 6, quotes from the *New York Herald* // *New York World*, April 25, 1878, pp. 4–5, reviews it, noting, "A dozen things are to be said against this picture of Mr. Church's. A hostile critic may express dissatisfaction at its conventionality; may say that the very leaves on the olive-trees may be counted; that the effect of the whole thing is theatric: that the swirls of vapor, the rent mists of fog and cloud are dramatic; that the rainbows, of which there are two, are a factitious auxiliary to the main purpose of the painting — all the same it remains that this 'Aegean Sea' will continue the chief attraction of the . . . gallery so long as it is hung there" // New York *Art Journal* 4 (June 1878), p. 192, reviews the painting on exhibition at Goupil's Gallery (quoted above) // H. W. French, *Art and Artists in Connecticut* (1879), p. 130, says it was painted for William H. Osborn, New York; p. 134 // G. W. Sheldon, *American Painters* (1879), p. 14 // S. G. W. Benjamin, *Art in America* (1880), p. 83, describes it // E. Shinn [E. Strahan], *American Art and American Art Collections* (1889), 2, pp. 774–776, describes the painting in the coll. of William H. Osborn // *International Studio* (Sept. 1900), suppl., p. xv // R. W. DeForest, *MMA Bull.* 4 (April 1909), p. 70 // B. Burroughs, *MMA Bull.* 10 (April 1915), p. 66, announces its acquisition // *MMA Bull.* (Oct. 1917), suppl., p. 6 // *Arts* 8 (Nov. 1925), ill. p. 251 // J. T. Flexner, *That Wilder Image* (1962), p. 167, says the work shows "Greece's modern degradation" // D. C. Huntington, *Landscapes of Frederic Edwin Church* (1966), p. 96, discusses the painting's critical acclaim in 1878; p. 107, discusses its structure; p. 110, compares it to Church's Mediterranean Sea; pl. 89, shows a detail of the work // G. L. Carr, Olana, Hudson, N.Y., letter in Dept. Archives, May 12, 1983, supplies references and sketch related to the picture.

EXHIBITED: Century Association, New York, probably March 1878 // Goupil's Gallery, New York, 1878 // American Fine Arts Society, London, 1893, no. 6 // MMA, 1900, *Paintings by Frederic E. Church, N.A.*, unnumbered ill., lent by Mrs. W. H. Osborn // National Collection of Fine Arts, Washington, D.C.; Albany Institute of History and Art; M. Knoedler and Company, New York, 1966, *Frederic Edwin Church*, exhib. cat., intro. by D. Huntington, p. 19, no. 139; p. 80, discusses it, noting that "Vignettes of all the Near East have been brought together into a single composition; Fallen Monoliths of Baalbeck, temple of Petra, Cape Sounion in Greece, Constantinople, the Bosphorous, and the ruins of Delphi" // Hudson River Museum, Yonkers, N.Y., 1970, *American Paintings from the Metropolitan Museum of Art*, checklist no. 9 // Dallas Museum of Fine Arts, 1971, *Romantic Vision in America*, p. 27, no. 27.

EX COLL.: William H. Osborn, New York, 1878–d. 1894; his wife, New York, 1894–d. 1902.

Bequest of Mrs. William H. Osborn, 1902.
02.23.

Church, oil study *Three Bedouins*.
Cooper-Hewitt Museum.

FRANCIS BLACKWELL MAYER

1827–1899

Francis Blackwell Mayer was born in Baltimore, the son of a distinguished lawyer and grandson of a successful businessman involved in the city's shipping industry. His interest in art was encouraged by Alfred Jacob Miller (1810–1874), a friend of his uncle, the historical writer Brantz Mayer. The young artist traveled to Philadelphia and New York, where he is said to have elicited approval for his early drawings from THOMAS SULLY, John Sartain (1808–1897), and Peter Rothermel (1817–1895). In Baltimore Mayer studied with a drawing instructor named J. Prentiss. In 1847, after he had sold a lithographic portrait of General Zachary Taylor to a Philadelphia printer, he went to work there on lithographs of Mexican War scenes. In the evenings he attended life and antique classes at the Pennsylvania Academy of the Fine Arts. He soon returned to Baltimore, where he became the assistant librarian of the Gallery of Fine Arts of the Maryland Historical Society. At this time he received further training from Ernst Fischer (1815–1874), a German artist working in Baltimore. The income Mayer earned in 1850 by preparing illustrations for a book by Brantz Mayer on Mexico enabled him to go west in 1851. He traveled to the Minnesota Territory and spent three months sketching in Traverse des Sioux, where a treaty relinquishing title to Indian lands was signed by the Sioux. Many of his watercolors depict the Indian ceremonies and customs he witnessed there. Mayer made several attempts to have his diary and sketches from the trip published. It was not until long after his death, however, that this was accomplished. *With Pen and Pencil on the Frontier* was published by the Minnesota Historical Society in 1932.

Mayer was very involved in artistic activities in Baltimore. One of the founders of the Maryland Art Association in 1847, he also helped establish in 1855 the Charcoal Club and the Artists' Association of Maryland and three years later, the Allston Association. Between 1859 and 1861 several of his works were shown at the Pennsylvania Academy and the National Academy of Design. His early genre scenes *Leisure and Labor*, 1858 (Corcoran Gallery of Art, Washington, D.C.), and *Independence, Squire Jack Porter*, 1858 (National Museum of American Art, Washington, D.C.), are fluidly painted, dramatically lighted, and unusually composed, with figures arranged on a narrow foreground stage. He also did historical genre subjects like *My Lady's Visit*, 1856 (Maryland Historical Society, Baltimore), an eighteenth-century scene which shows the Calvert family visiting Charles Carroll in Annapolis.

When Mayer left for Paris in 1863, he was already an accomplished painter. During the seven years he spent abroad, he studied with the Swiss painter Charles Gleyre, in 1869 and 1870, and with the French painter Gustave Brion. Mayer exhibited at the Paris Salon from 1865 to 1870, except for 1867, when an international exposition preempted the annual exhibition. His work was strongly influenced by such French academic painters as Ernest Meissonier, whose historical genre paintings seem to have inspired works like *The Violin* and *The Lost Letter* (both unlocated; see *Drawings and Paintings by Francis B. Mayer*, photographed by E. Balch [1872], nos. 9 and 20).

Mayer left Paris during the Franco-Prussian War in 1870 and returned home. Disillusioned by the changes he found in Baltimore, he moved to Annapolis. In 1876, when his painting *The Continentals in 1776*, 1875 (National Museum of American Art, Washington, D.C.), won an award at the Centennial Exhibition in Philadelphia, Mayer bought Mare's Nest, his home in Annapolis. Although he continued to teach at the Charcoal Club in Baltimore, he became increasingly absorbed in local affairs in Annapolis. He wrote and illustrated a number of articles on Maryland history for *Harper's New Monthly Magazine* and *Scribner's Monthly*. *Old Annapolis, Francis Street*, 1876 (see below) reflects his appreciation of this historic city. During the 1890s he undertook paintings showing local historical events for the Maryland State House, for example, *The Planting of the Colony of Maryland*, 1893. In 1897 he was commissioned to do sixty-three watercolors after his Indian drawings of 1851, but he finished only about thirty before his death two years later. He died at the age of seventy-two after a long illness. He was survived by his wife whom he had married in 1883. It was estimated that by 1892 he had painted one hundred portraits and ninety-five "pictures" (*Baltimore Sun*, July 29, 1899, p. 9).

BIBLIOGRAPHY: *Drawings and Paintings by Francis B. Mayer*, photographed by E. Balch (Baltimore, 1872). Contains many illustrations of his early work with owners listed // Obituaries: *Baltimore Sun*, July 29, 1899, p. 9; *Baltimore American*, July 29, 1899, p. 3 // Frank B. Mayer, *With Pen and Pencil on the Frontier in 1851*, edited with an introduction and notes by Bertha L. Heilbron (Saint Paul, 1932). Mayer's diary of his trip to the Minnesota Territory includes a biographical essay and illustrates a selection of his Indian sketches. The manuscript is in the Ayer Collection, Newberry Library, Chicago // Jean Jepson Page, "Francis Blackwell Mayer," *Antiques* 109 (Feb. 1976), pp. 316–323. The most complete recent article on the artist. A correction by Dorothy E. Ellesin is in *Antiques* 109 (April 1976), p. 710 // Jean Jepson Page, "Notes on the Contributions of Francis Blackwell Mayer and His Family to the Cultural History of Maryland," *Maryland Historical Magazine* 76 (Sept. 1981), pp. 217–238.

Old Annapolis, Francis Street

Old Annapolis, Francis Street was painted in 1876, the year that Mayer settled in Annapolis, Maryland. He had first spent some time there in 1873, when he recorded the city's buildings and residents in two of his sketchbooks (Baltimore Museum of Art).

Mayer had a strong interest in local history. Early in his career he painted historical genre paintings, and in Paris he chose as his teacher Charles Gleyre, who specialized in similar subjects drawn from his Swiss heritage. After settling in Annapolis, Mayer became fascinated by its past. In 1884 he established the Local Improvement Association of Annapolis. The depiction of a quaint section of Annapolis is further evidence of his interest. That it was painted in the year of the Centennial suggests that Mayer shared the national enthusiasm for American history.

Old Annapolis, Francis Street is painted in the rich, fluid style that Mayer developed during his early years in Maryland and enhanced while abroad. His account book records the gift of this painting to "my friend John Hopkins." This is almost certainly John G. Hopkins (ca. 1837–1891), a Maryland artist, photographer, and restorer of paintings. Correspondence between the two, dating from the late 1870s and the 1880s, can be found in the Maryland Historical Society.

Oil on canvas, 15¾ × 20½ in. (40.1 × 52.1 cm.).
Signed and dated at lower right: F. M. 1876. Canvas stamp: WM. MINIFIE'S / ARTIST'S / DRAUGHTSMAN'S & / STATIONERY STORE / [illegible address] / BALTIMORE MD.
REFERENCES: F. B. Mayer, account book, undated entry between April 27 and June 1880, Baltimore Museum of Art, notes gift of painting to Hopkins (quoted above) // B. Randall, Baltimore, letter in

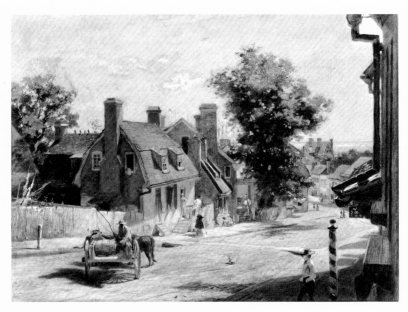

Mayer, *Old Annapolis, Francis Street*.

Dept. Archives, Feb. 14, 1940, says that he purchased
it from a onetime resident of Annapolis // A. D.
Breeskin, Baltimore Museum of Art, letter in Dept.
Archives, March 4, 1940, notes its inclusion in the
account book // B. Randall, Baltimore, letters in Dept.
Archives, March 9, 12, 1940, says that he purchased
it about twenty years earlier from George Forbes, a
former resident of Annapolis, says that he knew
Mayer // J. J. Page, *Antiques* 109 (Feb. 1976), ill.
p. 321; *Maryland Historical Magazine* 76 (Sept. 1981),
ill. p. 216.

EXHIBITED: MMA, 1939, *Life in America*, no. 167,
as Francis Street, Annapolis, lent by Blanchard
Randall; p. 124, discusses its subject matter.

EX COLL.: John G. Hopkins, Annapolis and Bal-
timore, 1880–d. 1891; George Forbes, Annapolis and
Baltimore, by about 1920; Blanchard Randall, Bal-
timore, about 1920–1939.

Rogers Fund, 1939.

39.175.

THEODORE PINE

1827–1905

Born in Whippany, New Jersey, on November 13, 1827, Theodore Pine was the son of James
Pine (ca. 1805–after 1876), a portrait painter. By 1834 the family had moved to New York.
At first, James seems to have discouraged his son's interest in painting, for he apprenticed
him at fourteen to a stockbroker. After a year, Theodore gave up the apprenticeship and
obtained permission to work in his father's studio. There, he demonstrated such ability that
his father placed him under the tutelage of the well-respected drawing teacher John Rubens
Smith (1775–1849). For two years, Smith taught him drawing, perspective, and the principles
of painting. Then poor health forced Pine to rest for six months.

In 1847 he moved with his family to Newark, New Jersey. Within a year, however, he went
to Sing Sing (now Ossining), New York, to execute a portrait commission. In 1849, encour-
aged by an influential patron, he reestablished himself in New York City, where, according to

the 1850 federal census, he lived with the family of John E. Muchmore, a coachmaker. Pine maintained a studio in lower Manhattan from 1850 to 1860, except for two years (probably 1851 and 1857) when he suffered from ill health. From 1852 to 1857 his father shared the studio, and J. Pine and Son jointly exhibited several works at the National Academy of Design. Theodore Pine's home address during this time ranged from New York to Newark to Sing Sing. Many of his sitters in New York were members of the Methodist Episcopal church where he himself was active.

On June 15, 1860, Pine and several friends began a two year tour of Europe, including Dublin, Edinburgh, Paris, Florence, and Rome. He also spent one winter in Munich, copying paintings in museums and reading treatises on art. Later he returned to Paris to study in the galleries of the Louvre, the Luxembourg Palace, and Versailles.

By September 1862, Pine was back in New York where he set up a new studio. Poor health again plagued him. In 1864 he sought a cure at the mineral springs in Massena, New York. To provide employment as his health improved, Pine and a friend purchased and renovated the hotel near the springs. "Through the artistic skill of Mr. Pine in adorning the place, and his gentlemanly deportment towards his guests . . . [it] became quite popular as a fashionable watering place, as well as a resort for invalids" (Upton and Colbert, p. 82).

In May 1865 Pine married Phebe A. McLane of Sing Sing. The following year, he sold the hotel in Massena and moved with his wife and aging father to Chicago where his work was well received. In his studio on Rush Street he painted portraits of the prominent citizens of the city. The great fire of 1871, however, consumed most of the contents of his studio, and the resulting economic depression in the city destroyed the market for his paintings. He moved to Saint Louis and prospered for two years until he developed a disease of the throat. On the advice of his doctors, he moved to Colorado, where he lived and painted in Manitoa until the late 1870s. Many of his Chicago friends and patrons visited him there, and he occasionally returned to Chicago.

Much of the information on Pine's later years comes from material supplied by his second wife, Cornelia Stillwell Pine, who was still living in 1936. The artist returned to Sing Sing in 1879 and established a studio in New York. He moved his household to New York in 1882. The last mention of him in New York appears in the 1887 city directory and states that he had a studio in the city and a home in Mount Vernon, New York. Between 1894 and 1897 he was in Chicago, where he again painted many portraits of leading citizens. Subsequently, Pine went to Asheville, North Carolina, for his health. While there, he painted a posthumous portrait of Robert E. Lee, 1904 (Washington and Lee University, Lexington, Va.). Pine died a year later in his wife's hometown of Ogdensburg, New York.

BIBLIOGRAPHY: [George P. Upton and Elias Colbert], "Theodore Pine," *Biographical Sketches of the Leading Men of Chicago* (Chicago, 1876), pp. 81–83. Detailed biography from 1827 to 1876 includes information about Pine's father // *American Art Annual* 5 (1905), p. 122. Notes that Theodore E. Pine died at Ogdensburg, New York, June 10, 1905, and that he was the last of an English family of artists // John E. Stillwell, "Some 19th Century Painters," *New-York Historical Society Quarterly Bulletin* 14 (Oct. 1930), pp. 84–93. Contains extracts from New York city directories and NAD catalogues, 1834–1859, and lists sitters and owners of portraits by both James and Theodore Pine // Helen E. Webster, secretary to the treasurer of Washington and Lee University, to Richard Crane, Westover, Va., Nov. 27, 1937, Chicago Historical Society, copy in Dept. Archives. Contains

quotations from biography of Pine published in Ogdensburg, New York, newspaper in 1937, based on information supplied by Cornelia Stillwell Pine.

Kate Lyon Cornell

Kate Lyon (1841–1923) was the ninth child of Moses and Catharine Wright Lyon. She was legally adopted sometime after 1850 by William W. Cornell, husband of her elder sister Sarah. William and his brother John B. Cornell owned one of the largest ironworks in the country. Together they built many of New York's great iron buildings.

On June 4, 1862, Kate Lyon Cornell married Dabney William Diggs, who was serving in the 132nd Regiment of the New York Volunteers. Dabney Diggs and various members of his family are listed in the New York city directories as active in the drygoods and fancy goods business from 1866 to 1874.

According to the subject's husband, Pine painted the portrait in 1856 when she was fifteen years old. In this painting, as in the portraits of the Macfarlans (below), Pine had difficulty with anatomy. The figure is rather boneless. Pentimenti show that the position of the right arm was adjusted; the left, however, remains awkwardly foreshortened so that the elbow seems

Pine, *Kate Lyon Cornell.*

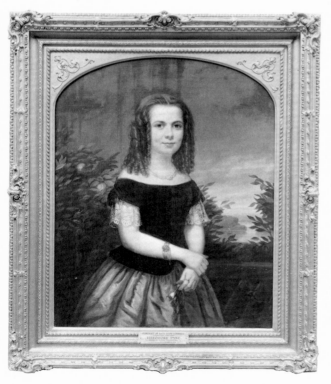

only inches from the shoulder. The head appears two-dimensional. The common practice of painting the head from the model and adding the body later from memory probably accounts for the disproportion between head and torso. There is little sense of true space within the portrait. The distant scene is only a backdrop, separated from the sitter by the garden fence and silhouetted leaves. Like many nineteenth-century portraitists, Pine carefully depicted details of costume, such as Kate's jewelry and the tight ringlets of her wig-like hair, but left the larger areas somewhat undefined.

Oil on canvas, 36 × 29 in. (91.4 × 73.7 cm.).

Canvas stamp: WILLIAMS & STEVENS / 353 / BROADWAY / NEW YORK.

REFERENCES: D. W. Diggs, letter in MMA Archives, March 28, 1924, dates it 1856 and supplies information about the sitter // J. E. Stillwell, *New-York Historical Society Quarterly* 14 (1930), p. 91, mentions it as Portrait of a Child owned by J. B. Cornell and exhibited at the 1855 Annual Exhibition of the NAD. (This is unlikely as the subject is not really a child, and J. B. Cornell, Kate's uncle, had several small children of his own.)

ON DEPOSIT: Gracie Mansion, New York, 1950–1954; Bartow-Pell Mansion, New York, from 1961.

Ex COLL.: the subject, New York; her husband, Dabney William Diggs, 1923–1924.

Gift of Dabney William Diggs, 1924.

24.89.

The Daughters of Daniel T. Macfarlan

Theodore Pine began this portrait of Marietta and Helen Macfarlan, partly as a memorial to Marietta, who had died the previous year. Her death on December 29, 1855, and burial in Balmville, New York, are recorded in both her father's and grandfather's diaries. Marietta's exact date of birth is unknown, but the portrait suggests that she was approximately two years old when she died. Her older sister, Helen Rutherfurd Stuyvesant Macfarlan (1851–1940), was only five years old at the time of the portrait. Helen later attended Professor van Norman's Institute in New York City and eventually taught music in Yonkers, New York. Unmarried, she lived in the family home until she died.

Daniel Macfarlan recorded in his diary that Helen sat for her portrait on June 14 and 16, 1856. On June 14, he also wrote, "I have just had a fine portrait of Marietta finished today by Pine the Artist." Probably Macfarlan was referring not to this double portrait but to a bust-length portrait (private coll., Yonkers, N.Y.) that was made from a death mask. Pine used it as a model for the Metropolitan's double portrait. On July 5, Macfarlan wrote, "Went to Newburgh after breakfast for Mr. Pine the Artist, where I met him and brought him up home to sketch the house (probably the home of his in-laws, the Merritts, in Middle Hope, New York) for the purpose of placing it upon the Children's portrait." An August 16 entry states, "At 3½ o'clock started for Newburgh, stopped at Sing Sing and called upon Mr. Pine the Portrait Painter and looked at the Children's portrait, which is nearly finished. Was very much pleased with it." The painting is dated 1857, which suggests that Pine continued to work on it as time permitted.

Pine used several devices that were fashionable in portraiture at the time: the dog enlivens the composition and gives a feeling of spontaneity; the diagonal placement of the dog and the bench, as well as the diagonals in the children's poses, suggest progression into space and attempt to unite the foreground with the background of the picture. The results, however, are not totally successful, for the figures appear to be in an interior, against a flat backdrop; the effect is very much like a mid nineteenth century photograph. Pine's immaturity as an artist is further apparent in the stiff and awkward positions of both children (for example, Helen's right leg), the inaccurate proportions, and the inept foreshortening. There is little concern for finish. The details of costume, however, are carefully rendered: the blue bows and the lace bloomers of Helen's orange-gold dress and the more delicate lacework of Marietta's pinkish-white outfit are well defined.

Oil on canvas, 56 × 44 in. (142.2 × 111.8 cm.).
Signed and dated at lower left: PINE 1857.

REFERENCES: D. T. Macfarlan, Journal, private coll., Yonkers, N.Y.: June 14, 1856 (quoted above); June 16, 1856, "Wife went out with me today and took Helen down to Portrait Painters"; July 5, 1856 (quoted above); August 16, 1856 (quoted above); August 26, 1858, refers to this portrait as hanging on wall "at our house" // E. M. Gregg, letters in MMA Archives, July 14, Oct. 26, and Nov. 4, 1949, offers

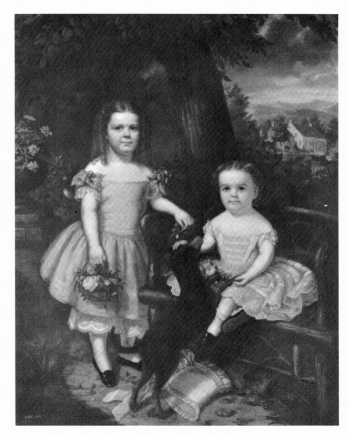

Pine, *The Daughters of Daniel T. Macfarlan.*

the portrait to the museum, provides information on the subjects and provenance, and states that the house in the landscape was the Merritt family home at Middle Hope, built before the Revolution // Owners of Macfarlan Journal, Yonkers, N.Y., orally, 1964, gave biographical information // L. L. Gregg, letter in Dept. Archives, Oct 31, 1980, gives information on the subjects and provenance.

EXHIBITED: American Federation of Arts, traveling exhibition, 1958–1959, *The Charm of Youth* (no cat.).

EX COLL.: Mr. and Mrs. Daniel T. Macfarlan, Yonkers, N.Y., from 1857; their daughter, Helen Rutherfurd Stuyvesant Macfarlan, Yonkers, N.Y., to 1940; her cousin, Eleanor Merritt (Mrs. Louis D.) Gregg, Newfoundland, N.J., and Orlando, Fla., 1940–1950.

Gift of Mr. and Mrs. Louis D. Gregg, 1950.
50.155.2.

Mr. and Mrs. Daniel T. Macfarlan

On Christmas day 1858, Daniel T. Macfarlan recorded in his diary, "At 9½ o'clock A.M. I went to Mr. Pine and sat for my portrait, in order to finish it up. I remained until 2 o'clock P.M." Probably he was referring to this

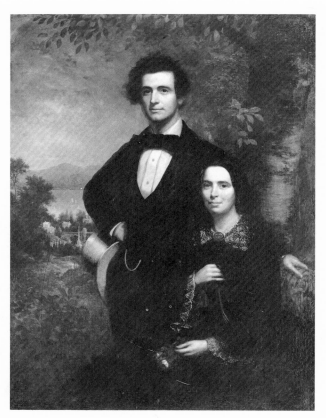

Pine, *Mr. and Mrs. Daniel T. Macfarlan.*

cluded real estate, refining maple syrup, and running a coal business. He was also a lay minister in the Methodist Episcopal church.

Like his father, Daniel Macfarlan was an ardent diarist, filling nearly fifty volumes with lively accounts of personal, local, national, and international events from 1856 until his death in 1897. The Macfarlans lived in New York until 1860 when they moved with their surviving daughter, Helen, to Yonkers. Macfarlan commuted daily by train to New York.

In this portrait, as in the one of the Macfarlan daughters, Pine had difficulty representing the proportions of the fashionably dressed figures and integrating them into the background. He rendered the faces with consideration for individual character but treated detail summarily, creating heavy, formless areas. The landscape is said to represent the church and several houses at Middle Hope, New York, with the Hudson River in the distance.

portrait of him and his wife, which seems to have been painted as a companion piece to that of their two young daughters (see above).

Daniel Macfarlan (1828–1897) of New York City and Mary Jane Merritt (b. 1829) of Middle Hope, New York, were married on November 20, 1850. The following year the New York city directory listed Daniel as a clerk for his father, Thomas, a successful agent who managed the financial affairs of Peter Gerard Stuyvesant and Hamilton Fish. Daniel had left his father's firm by 1853 to follow various pursuits that in-

Oil on canvas, 56 × 44 in. (142.2 × 111.8 cm.).
REFERENCES: D. T. Macfarlan, Journal, Dec. 25, 1858, private coll., Yonkers, N.Y. (quoted above) // E. M. Gregg, letters in MMA Archives, July 14, Oct. 26, and Nov. 4, 1949, offers portrait to the museum, gives previous owner, and says it was painted for Mrs. Macfarlan's father and shows the church at Middle Hope, N.Y. // Owners of journal, orally, 1964, provided biographical information // L. L. Gregg, letter in Dept. Archives, Oct. 31, 1980, gives information on the subjects and provenance.
EXHIBITED: Newark Museum, 1957, *Early New Jersey Artists*, no. 76.
EX COLL.: Mr. and Mrs. Daniel T. Macfarlan, Yonkers, N.Y.; their daughter, Helen Rutherfurd Stuyvesant Macfarlan, Yonkers, N.Y., until 1940; her cousin, Eleanor Merritt (Mrs. Louis D.) Gregg, Newfoundland, N.J., and Orlando, Fla., 1940–1950.
Gift of Mr. and Mrs. Louis D. Gregg, 1950.
50.155.1.

DAVID JOHNSON

1827–1908

Johnson was a second-generation Hudson River school painter. He was born in New York City and worked there most of his life. As his many landscapes indicate, he often traveled through New England, New Jersey, and upstate New York. Around 1860 he was in the South, where he painted *Natural Bridge, Virginia*, 1860 (Reynolda House, Winston-Salem). In addition to the landscapes for which he became well known, Johnson painted several portraits, copied either from photographs or other paintings—the most notable is the powerful likeness of his friend the dramatic actor Edwin Forrest, 1871 (National Gallery of Art, Washington, D.C.). In addition he did a handful of still lifes and a flower piece, *Phlox*, 1886 (Reynolda House), which, in the Pre-Raphaelite manner, shows the plant growing in its natural setting.

In 1849, Johnson began exhibiting at the American Art-Union and the National Academy of Design, where in 1861 he was elected an academician. He continued to exhibit at the academy throughout the rest of the century with only a brief hiatus in the 1880s. Johnson was apparently a prominent member, for his name appears alongside those of SAMUEL F. B. MORSE, ASHER B. DURAND, and DANIEL HUNTINGTON on an appeal for funds for a new building in 1862 ("Fellowship Fund of the National Academy of Design," broadside, NYHS). In 1876 Johnson exhibited four landscapes in oil at the Centennial Exhibition in Philadelphia. One of two versions of *Scenery on the Housatonic* was commended for excellence in landscape painting. At the Paris Salon the following year, he exhibited what was perhaps the same painting with a slightly different title, *Housatonic River*. The whereabouts of these Housatonic paintings is unknown. That several engravings were executed after his paintings attests to the popularity of his work. For example, *Mouth of the Moodna, on the Hudson*, 1869 (unlocated), was engraved by G. W. Wellstood for *Picturesque America* (1874). While Johnson is said to have made a comfortable living during part of his career, he rarely received critical acclaim from his contemporaries. The artist Benjamin Champney (1817–1907) noted that Johnson "quietly and modestly attained to a very high rank as one of the leading landscapists of New York" (*Sixty Years' Memories of Art and Artists* [1900], p. 139).

It is generally assumed that Johnson was self-taught, but it seems likely that a few informal teachers influenced the development of his style and working method. His elder brother, Joseph Hoffman Johnson (1821–1890), was a portrait painter in New York beginning in the 1840s. Surely he encouraged his younger brother's interest in painting and perhaps taught him the basic techniques. Moreover, the inscription on the back of an 1849 canvas entitled *Haines Falls, Kauterskill Clove*—a favorite spot with Hudson River school painters—indicates that this picture was Johnson's first study from nature and was executed in the company of JOHN F. KENSETT and JOHN W. CASILEAR, both of whom had just returned from abroad (Hirschl and Adler Galleries, New York, *American Scene*, exhib. cat., 1969, no. 50, p. 43). No doubt these artists passed on what they had learned from the Barbizon painters in France about faithfully transcribing nature. In 1851, Johnson and Casilear visited North Conway in the White Mountains of New Hampshire, an area long popular with tourists. Within three

or four years, as other painters of the Hudson River school joined them, it became a haven for landscape painters, much like Barbizon. The titles of his pictures suggest that Johnson returned to the White Mountains many times.

Johnson has been viewed as one of the most acclaimed students of JASPER F. CROPSEY. Actually, he seems to have received only a few lessons from Cropsey in the early 1850s, when, judging by such works as *Old Mill, West Milford, New Jersey*, 1850 (Brooklyn Museum), he was already an accomplished painter. Some of Johnson's works from that period may reflect Cropsey's influence in their panoramic scope, thickly painted trees, high-key autumn colors, and detailed treatment. These characteristics, however, are indicative of the Hudson River school in general. Indeed, Johnson's later paintings reflect other aspects of the style; his works of the 1860s and 1870s are closer to Kensett's in their expansive and simplified blending of water and sky, cool tonalities, and quiet mood.

Although it has generally been believed that Johnson never went abroad, evidence to the contrary has been uncovered. First, the exhibition catalogue for the Pennsylvania Academy of the Fine Arts lists a London address for him in 1862, a year in which so far no paintings by him have been discovered. Second, a letter written in 1924 to the Metropolitan Museum states that Johnson's widow wished to sell some pictures, several of which the artist had "purchased abroad"; the attached list includes works by Théodore Rousseau, Jules Dupré, and Félix Ziem.

After the 1880s, Johnson's work became cliché-ridden as he imitated Barbizon painters like Rousseau and Dupré, whose pictures were then being avidly collected by Americans. In 1904 Johnson moved to Walden, New York, where he spent the rest of his life.

BIBLIOGRAPHY: Clara Erskine Clement and Laurence Hutton, *Artists of the Nineteenth Century and Their Works* (Boston, 1880), 2, p. 11. First biographical notice of Johnson // Obituaries: *American Art News* 6 (Feb. 1, 1908), p. 1; *American Art Annual* 7 (1909–1910), p. 78 // Wolfgang Born, *American Landscape Paintings: An Interpretation* (New Haven, 1948), pp. 59, 65, 100, 218. Places Johnson's work in the context of nineteenth-century landscape painting // William H. Gerdts and Russell Burke, *American Still-life Painting* (New York, 1971), p. 105, ill. 1–7 // John I. H. Baur, "'. . . the exact brushwork of Mr. David Johnson,': An American Landscape Painter, 1827–1908," *American Art Journal* 12 (Autumn 1980), pp. 32–65. The first major article on the artist and his work with many illustrations.

Near Squam Lake, New Hampshire

Squam Lake, northwest of Lake Winnipesaukee, is in central New Hampshire, an area frequented by David Johnson. Painted in 1856, the picture was exhibited that year at the National Academy of Design, where one critic singled it out as "a bright lovely landscape, full of incident and showing great promise." An early work by Johnson, the picture has a composition and confident quality often associated with the Hudson River school. It is similar to the work of one of that school's major exponents, JASPER F. CROPSEY, one of Johnson's mentors. Like many of Cropsey's works, Johnson's landscape is characterized by a wide vista, an expansive sky, distant mountains that fade into the atmosphere, and a relatively empty foreground. Additional similarities are the tiny figures in the middle ground, thick paint, vivid colors, and precisely delineated foliage.

Oil on canvas, $18\frac{15}{16} \times 28$ in. (48.1 × 71.1 cm.).
Signed and dated at lower center: D. Johnson 1856. Inscribed on back before lining: Scene near Squam Lake, N.H. / D. Johnson 1856.
REFERENCES: *Frank Leslie's Illustrated Newspaper* 1 (April 12, 1856), p. 282 (quoted above) // B. B[urroughs], *MMA Bull.*, suppl. to 12 (1917), p. 8, de-

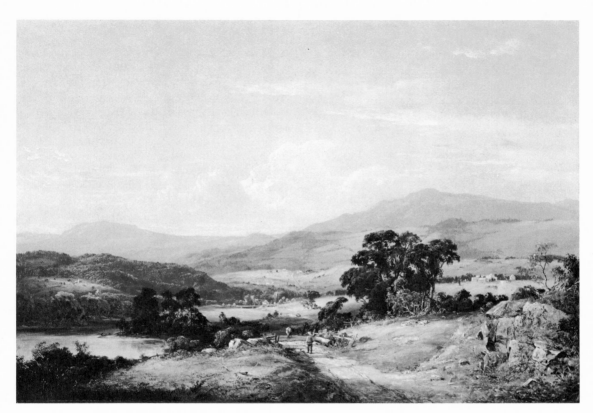

Johnson, *Near Squam Lake, New Hampsire*.

scribes it as carrying "to a far degree the luminosity and delicacy in the imitation of hazy distances."

EXHIBITED: NAD, 1856, no. 150, lent by S. H. Carpenter // *American Art Annual* 14 (1917), p. 368, gives information regarding sale of picture, measurements are inaccurate // MMA, 1917, *Paintings of the Hudson River School Brought Together in Commemoration of the Completion of the Catskill Aqueduct* (no cat.) // Queens County Art and Cultural Center, New York; MMA; Memorial Art Gallery of the University of Rochester, N.Y.; Sterling and Francine Clark Art Institute, Williamstown, Mass., 1972–1973, *19th Century American Landscape*, exhib. cat. by M. Davis and J. K. Howat, no. 13, discusses it.

ON DEPOSIT: Halloran General Hospital of the U.S. Army, Willow Brook Reservation, Staten Island, New York, 1943–1954.

EX COLL.: S. H. Carpenter, 1856; (sale, Fifth Avenue Auction Rooms, New York, May 18, 1917, no. 47, to A. Oberwalder, $55).

Rogers Fund, 1917.

17.110.

On the Unadilla, New York

According to the inscription on the back, this 1884 painting is a view near the Unadilla River in central New York State. Unlike Johnson's *Near Squam Lake, New Hampshire* of 1856 (see above), which is in the style of the Hudson River school, this work reflects the influence of the Barbizon painters, whose landscapes were popular in the United States by the 1880s. The picture's small and intimate scale, restricted palette, and lively sky are characteristic of the Barbizon style. So too is the composition with copses of trees at one side, an open area at the other, and a path diagonally crossing a field and disappearing into the distance.

Johnson, who was said to have been a quiet and reclusive man, created a mood of contemplation and melancholy, reinforced by the tiny, summarily treated figure at the right who seems insignificant and dwarfed by his surroundings. Grazing cows, a favorite subject of Barbizon

David Johnson

painters, convey the notion of an idyllic rustic life. According to Peter Bermingham, farm animals shown in their natural habitat "served as an antidote for the sense of nostalgia and loss experienced by the thousands who had left agrarian backgrounds to seek their fortunes in the growing cities" (National Collection of Fine Arts, Washington, D.C., 1975, *American Art in the Barbizon Mood*, exhib. cat., p. 74).

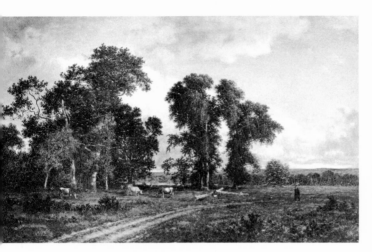

Johnson, *On the Unadilla, New York.*

Oil on canvas, 23 × 37 (58.4 × 94 cm.).

Signed at lower right: DJ (monogram). Signed, dated, and inscribed on the back: On the Unadilla / N–Y / David Johnson / 1884. Label on stretcher: WRIGHT & GARDNER'S / Improved Canvas Stretchers / (Patented January 19, 1875). . . . Factory 107 & 109 Orchard St., Brooklyn, E.D.

ON DEPOSIT: Halloran General Hospital of the U.S. Army, Willow Brook Reservation, Staten Island, New York, 1943–1954.

EX COLL.: Collis P. Huntington, until 1900; his wife, later Mrs. Henry E. Huntington, subject to a life estate, 1900–1925; Archer M. Huntington, son of Collis P. Huntington, subject to a life estate which was relinquished, 1924–1925.

Bequest of Collis P. Huntington, 1900.

25.110.135.

Bayside, New Rochelle, New York

In 1886, Johnson painted this inlet off Long Island Sound in New Rochelle. A large tower in the background indicates that the area is probably Fort Slocum. The composition has much in common with such Barbizon paintings as Jules Dupré's *La Barque* of about 1835, a work that was lithographed as *Les Chasseurs (Paysage)* by Auguste Anastasi and published in Paris in 1849 (M. M. Aubrun, *Jules Dupré, 1811–1889: catalogue raisonné de l'oeuvre peint, dessiné et gravé* [1974], no. 115). The composition is also in the tradition of seventeenth-century Dutch landscape painting, and the foliage silhouetted against the sky recalls the work of Claude Lorrain, whose style Dupré and others self-consciously imitated and popularized in the mid-nineteenth century.

Two years before he did this painting, Johnson made a pencil sketch of another New Rochelle view (MMA). Although the painting and the drawing differ compositionally, the two works share a striking similarity. Both are dominated by the same large bushy tree.

Oil on canvas, 19½ × 24 in. (49.5 × 61 cm.).

Signed at lower left: DJ (monogram). Signed, dated, and inscribed on back within a cartouche: Bayside—/New Rochelle. / N–Y. / David Johnson. / 1886.

REFERENCES: B. B[urroughs], *MMA Bull.*, suppl. to 12 (1917), p. 8, calls it "little more than an imitation of Rousseau."

EXHIBITED: MMA, 1891, *Loan Collections and Recent Gifts to the Museum*, no. 51, lent by Mr. Henry M. Johnston // Brooklyn Art Association [spring exhibition], 1892, no. 72, lent by W. [*sic*] M. Johnston // MMA, 1917, *Paintings of the Hudson River School Brought Together in Commemoration of the Catskill Aqueduct* (no. cat.) // National Collection of Fine Arts, Washington, D. C., 1975, *American Art in the Barbizon Mood*, exhib. cat. by P. Bermingham, ill. no. 58, p. 152, discusses it // Scarsdale Historical Society, N.Y., 1982, *A Celebration of Westchester*, p. 44, identifies the location by the water tower of Fort Slocum in the background.

EX COLL.: Henry Mortimer Johnston, Brooklyn, by 1891–1893 (sale, Fifth Avenue Art Galleries, New York, Feb. 28, 1893, no. 12, $550 to Julius Oehme); with Julius Oehme, New York, from 1893; Morris K. Jesup, d. 1908; his wife, Maria DeWitt Jesup, 1908–1914.

Bequest of Maria DeWitt Jesup, from the collection of her husband, Morris K. Jesup, 1914.

15.30.65.

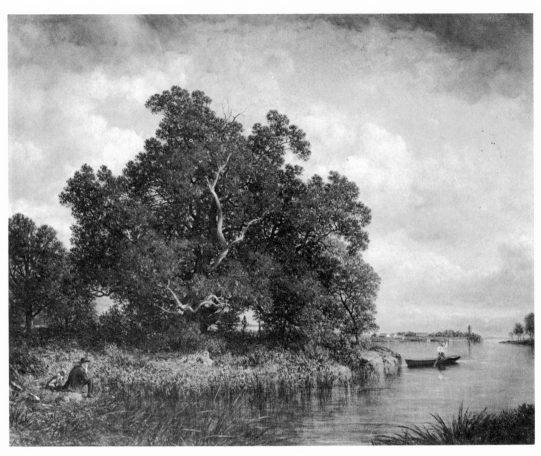

Johnson, *Bayside, New Rochelle, New York*.

Johnson, pencil and crayon, *Landscape and Lake*, shows very similar tree. MMA.

ROBERT LOFTIN NEWMAN

1827–1912

Newman was born in Richmond, Virginia. He lived there and then at Louisa Court House, also in Virginia, until 1838 when his mother and stepfather took him to Clarksville, Tennessee. Essentially self-taught, Newman was said to have read widely about art during his youth, made pictures after engravings, and dabbled in portraiture. No works of this early period, however, have been identified.

In 1850, he went to Europe intending to study painting in Düsseldorf, but a visit to Paris changed his mind. He spent several months in the studio of Thomas Couture, whose students included Edouard Manet and Pierre Puvis de Chavannes. Although much has been made of Couture's influence on Newman, the poorly painted surfaces of many of Newman's later works suggest that he never really mastered Couture's innovative techniques. He does seem to have learned Couture's method of achieving remarkable color effects by brushing thick paint into a still-tacky foundation layer of paint and thus blending the colors. The spontaneity of oil sketches, with their vaguely defined forms and loose technique, appealed as much to Newman as to Couture. For Couture, however, the sketch was the basis for a finished picture, a component in the painting procedure and not an end in itself, as it clearly was for Newman.

Newman returned to France in 1854 and was introduced by WILLIAM MORRIS HUNT to Jean François Millet. Newman spent several months painting with Millet at Barbizon. He later bought Millet's painting of 1847–1848 *Le Vanneur* (private coll.) and also copied several compositions by him and Eugène Delacroix. Newman's friend the banker Nestor Sanborn noted that Newman "was a lover of the Venetian school of color and considered that after Rubens, Delacroix represented the great tradition" (p. 4). His respect and admiration for Millet and Delacroix suggest that these artists influenced him more than Couture.

During the Civil War, Newman was a topographical draftsman with the Confederate army at Richmond. After peace was declared in April of 1865, he headed north and, according to Sanborn, stayed about a year in Baltimore, making political banners in a sign painter's loft (p. 158). The Montgomery County records indicate, however, that Newman was back in Clarksville by August of 1865. Landgren points this out (p. 35) and says that Newman then went to New York for a short time.

In the winter of 1872–1873, Newman and the portrait painter George Dury (1817–1894) tried to establish an Academy of Fine Arts at Nashville, where Newman was teaching a small group of students and painting portraits. After the death of his mother in the early 1870s, Newman moved to New York where he briefly designed stained glass with Francis Lathrop (1849–1909). By 1882 he had raised enough money through sales of his pictures in Boston and New York to visit London, Paris, and Barbizon. Thanks to several influential admirers, including WILLIAM MERRITT CHASE, Stanford White, Francis Lathrop, and the collector John Gellatly, Newman had his first exhibition (and the only one during his lifetime) in 1894 at Knoedler and Company in New York; it was titled *Loan Collection of Paintings by Mr. R. L. Newman*. Part of the exhibition went on to Boston where it was shown at the

Museum of Fine Arts. Impractical about financial affairs, Newman was supported for the rest of his life by the generosity of friends, particularly the sculptor Daniel Chester French, who gave him a monthly stipend. Nestor Sanborn and his wife Caroline (ca. 1843–1934), an artist, helped Newman sell many of his pictures. The proceeds of these sales enabled him to return to Europe in 1908 and again 1909.

Like his friend ALBERT PINKHAM RYDER, Newman led a solitary existence. His distinctive work remains outside the mainstream of American art. Few of his early works have survived. Most of his later works are undated, but those that are dated fall between 1875 and 1910. Newman's paintings are small in scale and primarily explore religious subjects. Vibrant color, fluent brushwork, and simplification and expressive distortion of forms are the main characteristics of his style. During his lifetime, his work was appreciated by only a small group of connoisseurs and, even today, remains unknown to the general public.

BIBLIOGRAPHY: Frederic Fairchild Sherman, "Robert Loftin Newman: An American Colorist," *Art in America* 4 (April 1916), pp. 177–184 // "Reminiscences about the life of the artist," Nestor Sanborn to Frederic Fairchild Sherman, April 25, 1919, FARL // N[estor] S[anborn], "Robert Loftin Newman, Colorist," *Brooklyn Museum Quarterly* 8 (Oct. 1921), pp. 157–161 // Albert Boime, "Newman, Ryder, Couture and Hero-Worship in Art History," *American Art Journal* 3 (Fall 1971), pp. 5–22 // National Collection of Fine Arts, Washington, D. C., *Robert Loftin Newman, 1827–1912* (1974), exhib. cat. by Marchal E. Landgren. Most complete treatment of the artist's life, it includes a chronology and catalogue of known works.

The Fortune Teller

Newman's tiny picture is one of several variants he painted on the theme of fortune telling or prophecy—a popular subject throughout western European art. As a student in Couture's studio in Paris in 1852, Newman's friend WILLIAM MORRIS HUNT painted a *Fortune Teller* (MFA, Boston). Its triangular composition may well have lingered in Newman's mind and years later inspired his own interpretations. The painting includes another of Newman's favorite themes, that of mother and child. It expresses his compassion for children, so ignorant of what lies ahead. Indeed, as the child seems to shrink back into the gentle protection of its young mother, the haggard seer confronts him and points to his future. The subject also preoccupied several European symbolists, notably Edvard Munch and Gustav Klimt. Newman's approach of taking religious subject matter out of context is similar to the practices of the symbolists.

Newman is known to have worked rapidly, and as a result he often did not completely articulate the forms of his broadly painted figures, as in this picture. Examination of the paint surface in raking light shows that he made numerous changes and struggled to synthesize the images. His colors seem to have been carefully chosen and his forms selectively distorted to produce the evocative mood of the painting. The pink colors and rounded shapes of the mother and child, for example, create a gentle, passive unit that contrasts with the aggressive, angular figure of the fortune teller. Her threatening character is suggested by a dark, tattered cloak and garish red-orange hair. The mysterious quality of the bleak and uninhabited landscape is increased by an unnatural, flame-like glow in the background.

Another *Fortune Teller*, also undated and very similar in composition, but more loosely painted, is in the Brooklyn Museum. In 1974, Landgren catalogued a third version of this subject as unlocated (no. 71). By 1894 Newman had executed at least two paintings entitled "Fortune Teller" and exhibited them in a show at Knoedler's (nos. 54 and 107). It has not been possible to determine whether either the Metropolitan or Brooklyn paintings is one of those.

Oil on canvas, 10 × 14 (25.4 × 35.6 cm.).
Signed at lower right: R. L. Newman.

Newman, *The Fortune Teller*.

REFERENCES: M. E. Landgren, *American Magazine of Art* 28 (March 1935), ill. p. 137; p. 138 // University of Maryland Art Gallery, College Park, *American Pupils of Thomas Couture*, exhib. cat. by M. E. Landgren (1970), p. 56, under no. 35, mentioned // M. E. Landgren, *Antiques* 108 (Dec. 1975), p. 1178, pl. I.

EXHIBITED: Whitney Museum of American Art, New York, 1935, *Textiles and Sculpture by Arthur B. Davies (1862–1928); Paintings by Robert Loftin Newman (1827–1912)*, p. 20, no. 50 // Virginia Museum of Fine Arts, Richmond, 1942, *A Memorial Exhibition of the Work of Robert Loftin Newman*, exhib. cat. by M. E. Landgren, p. 10, pl. 5; p. 17; p. 38, no. 15, lists it // Museum of Modern Art, New York, 1943, *Romantic Painting in America*, exhib. cat. by J. T. Soby and D. C. Miller, p. 80, no. 156; p. 139, lists it // Children's Museum, Denver, 1951, *Myths and Magic* (no cat.) // American Federation of Arts, traveling exhibition, 1959–1960, *Major Work in Minor Scale* (no cat.) // National Collection of Fine Arts, Washington, D. C., *Robert Loftin Newman, 1827–1912*, exhib. cat. by M. E. Landgren (1974), fig. 74, p. 105; no. 69, p. 145, provides provenance, references, and related works // Museum of Fine Arts, Saint Petersburg, Fla.; Henry Flagler Museum, Palm Beach, 1976, *The New Vision*, exhib. cat. by M. D. Schwartz, unpaged ill.

EX COLL.: Mrs. Wallace Sawyer, Asbury Park, N. J., by 1921.

Gift of Mrs. Wallace Sawyer, 1921.

21.159.1.

Madonna and Child and Little Saint John

This painting depicts the Virgin and Child with Saint John the Baptist. Although formerly called *Saint John the Baptist*, the picture is now titled *Madonna and Child with Little Saint John*. At least two canvases by Newman with that title were exhibited in 1894 at Knoedler's, numbers 64 and 80 in the catalogue. John holds a staff and is dressed in a raiment of camel's hair as described in the Gospel according to Saint Matthew (3:4). With arm extended, he offers the Christ Child an apple, which, in traditional Christian iconography is generally regarded as an allusion to salvation. In spite of the clear religious subject of this painting, the message seems more secular than religious, as Newman has invested the images with such tender, human emotions. Frederic Fairchild Sherman noted in 1939 that "It is as a painter of religious pictures that Newman will be remembered probably, for his interpretations of biblical scenes and characters, besides being illumined with a veritable glory of color, are peculiarly personal, human and persuasive creations of artistic genius" (p. 74).

The picture has suffered from harsh cleaning sometime in its past. The top layer surrounding the head of Mary has been rubbed away, leaving an irregularly shaped bright area around her head. The figure of the infant clearly shows the underdrawing and is probably an initial version. Similarly, there are various areas of underpainting visible in the sky.

Oil on canvas, $10\frac{1}{8} \times 12\frac{1}{8}$ in. (25.7 × 30.8 cm.). Signed, at lower left: R. L. Newman.

REFERENCES: MMA, *Catalogue of Paintings*, by B. Burroughs (1931), p. 263, as St. John the Baptist // M. E. Landgren, *American Magazine of Art* 28 (March 1935), ill. p. 136, as St. John the Baptist // F. F. Sherman, *Art in America* 27 (April 1939), p. 75, lists it as Saint John the Baptist.

EXHIBITED: Knoedler Gallery, New York, and MFA, Boston, 1894, *Loan Collection of Paintings by Mr. R. L. Newman*, no. 64, (New York only) or no. 80, Madonna and Child and Little Saint John, lent by Mrs. E. A. Seecomb (possibly this painting) // Whitney Museum of American Art, New York, 1935, *Textiles and Sculpture by Arthur B. Davies (1862–1928): Paintings by Robert Loftin Newman (1827–1912)*, p. 23, no. 42 // Virginia Museum of Fine Arts, Richmond, 1942, *A Memorial Exhibition of the Work of Robert Loftin Newman*, exhib. cat. by M. E. Landgren, p. 12, pl. 6; p. 38, no. 15 // National Collection of Fine Arts, Washington, D. C., *Robert Loftin Newman, 1827–1912*, (1973) checklist, no. 20; exhib. cat. by M. E. Landgren (1974), p. 104, fig. 73; ill. p. 105; p. 135, no. 40, as Saint John the Baptist, provides references.

Ex COLL.: Mrs. Wallace Sawyer, Asbury Park, N. J., by 1921.

Gift of Mrs. Wallace Sawyer, 1921.

21.159.2.

Hagar and Ishmael

According to the Bible, Hagar was the Egyptian consort of Abraham, the ancestor of the Hebrews, and bore him his first son, Ishmael. She had been the personal maid of Abraham's wife Sarah. When Abraham's second son, Isaac, was born to Sarah, she jealously forced her husband to banish Hagar and Ishmael. The two outcasts wandered in the desert for some time until their water supply was depleted. Young Ishmael soon collapsed in exhaustion. Helpless and despondent, Hagar turned away to avoid seeing the death of her only child. It is this dramatic moment that Newman re-created here in a free, abstract transformation of Jean François Millet's celebrated *Hagar and Ishmael* of 1849 (Rijksmuseum H. W. Mesdag, The Hague), which Newman may well have seen in France in 1854. Newman's figures are barely decipherable, and they appear in an indistinct, barren, gray-green landscape. The anguished Hagar is prostrate in the dunes in the foreground. Ishmael lies on his back protected by the shade of a tree in the background. Hanging over the tree is a delicate pale-yellow crescent moon, the one sharply delineated form in this otherwise amorphous picture. The scene is meant to be evocative and poetic, rather than realistically descriptive.

While the picture is undated, it was probably painted by 1894 when Newman showed three versions of this subject in the exhibition organized by Knoedler's. Listed in the checklist of works shown at the Museum of Fine Arts in Boston were a Hagar and Ishmael owned by a Miss A. D. Kittell (no. 43) and two others owned by the Canadian collector William C. Van Horne (numbers 66 and 83). One of the versions owned by Van Horne was smaller and was still in the possession of his family in 1939.

Often Hagar and Ishmael are shown with an angel which was said to have appeared to comfort Hagar and to lead her to a spring. In the lower corner of the painting there is a hint of a painted-out image, which could have been an angel. Examination of the surface indicates that the artist made numerous changes, but the X-

Robert Loftin Newman

Newman, *Madonna and Child and Little Saint John.*

radiograph reveals no coherent underlying images. The surface is disfigured by wrinkling of the paint film, which is generally caused by the use of excess medium or by applying thick paint layers over an insufficiently dry undercoat.

Oil on canvas, 14⅛ × 18 in. (35.9 × 45.7 cm.).

Signed at lower left: R. L. Newman.

REFERENCE: MMA, *Catalogue of Paintings*, by B. Burroughs (1931), p. 263.

EXHIBITED: Knoedler Gallery, New York, and MFA, Boston, 1894, *Loan Collection of Paintings by Mr. R. L. Newman*, no. 66, Hagar and Ishmael, lent by Mr. Wm. C. Van Horne, or no. 53, lent by Miss A. D. Kittell (possibly this painting) // Frank

Newman, *Hagar and Ishmael.*

K. M. Rehn Galleries, New York, 1924, *Loan Collection of Paintings by Robert Loftin Newman*, no. 26, as Hagar in the Wilderness // National Collection of Fine Arts, Washington, D. C., 1973–1974, checklist, no. 12; exhib. cat. by M. E. Landgren (1974), p. 55, fig. 30; p. 129, no. 23, gives references and history.

Ex coll.: Mrs. Wallace Sawyer, Asbury Park, N. J., by 1924.

Gift of Mrs. Wallace Sawyer, 1925.

25.198.

ALONZO CHAPPEL

1828–1887

Perhaps one of the best historical illustrators in the United States, Alonzo Chappel was born of French ancestry in New York in 1828. By the age of twelve, he was selling his portraits for ten dollars a head, and at fourteen he was listed as an artist in the New York city directory. He left school at fourteen and learned japanning, the art of applying a hard, brilliant lacquer to wood or metal. His interest and training in this craft may have come from his father who was a tinsmith. Soon turning his attention to the popular art of window-shade painting, Chappel depicted romantic landscapes that were greatly admired. He seems to have received his only formal training in art from a single term at the antique class of the National Academy of Design when he was about seventeen.

In 1845, Chappel moved with his family to Brooklyn and within a few years married Almira Stewart. His reputation as an artist grew quickly. Most of his early paintings for the American Art-Union of New York were landscapes with figures; but the subject of one of his paintings, purchased by EMANUEL LEUTZE, suggested that Chappel also did genre paintings. In 1849, he made his only known trip outside the United States. He traveled to Cuba to prepare sketches for a panorama commissioned by some New York patrons. His success can be measured by his refusal a few years later to accept a generous commission to paint under the patronage of an American dealer and importer in London. More significant was his introduction to the publishing firm of Martin, Johnson Company (later Johnson, Fry and Company) by the Reverend Dr. Elias Magoon of Brooklyn, an important collector who had seen Chappel's paintings at Goupil's Gallery in New York. For the rest of his life, Chappel maintained his association with the Johnson, Fry firm, which specialized in finely illustrated books published in limited editions and sold by subscription. His portraits of historical figures and illustrations of past events depended heavily on photographs and likenesses by earlier artists such as GILBERT STUART, CHARLES WILLSON PEALE, and JOHN TRUMBULL. Among the books Chappel illustrated were Jesse F. Schroeder's *Life and Times of Washington* (1857), Jesse A. Spencer's *History of the United States* (1858), Evert A. Duyckinck's *Lives and Portraits of the Presidents of the United States* (1865) and *National Portrait Gallery of Eminent Americans* (1861–1862), and *The Complete Works of William Shakespeare*, edited by William Cullen Bryant. In several of these assignments, Chappel was joined by others, including Leutze, Felix O. C. Darley (1822–1888), and William Henry Powell (1824–1879).

Chappel was not a member of the National Academy of Design and rarely exhibited

there. Instead his work was shown at the Brooklyn Art Association, and he played an active role in various other Brooklyn art organizations. In 1859, with GEORGE INNESS, JOHN G. BROWN, William Mason Brown (1828–1898), and several others, Chappel founded an art school. He was also instrumental in establishing the Brooklyn Academy of Design, which was formed in 1863 in protest over the Brooklyn Art Association's failure to consider art education. Chappel donated a large collection of casts to the academy and served as its vice president. He was a founding member in 1878 of the Brooklyn Sketch Club, whose members met monthly to present and criticize sketches based on a pre-assigned subject.

Chappel's first wife died a few years after their marriage, and he later married Mrs. Abbie J. Briggam; they had three children. In the 1860s he moved to Middle Island on Long Island, where he had several young artists working with him. He died at Artist's Lake, Middle Island, in 1887.

BIBLIOGRAPHY: Henry R. Stiles, *History of Kings County, including Brooklyn* (Brooklyn, 1884), p. 1147. Provides basic information regarding Chappel's life and professional career // W. B. Howard, *The Eagle and Brooklyn: A History of Brooklyn* (Brooklyn, 1893). Discusses his participation in professional associations in Brooklyn and events of his last years // Herman H. Diers, "The Strange Case of Alonzo Chappel," *Hobbies* 49 (Oct. 1944), pp. 18–20, 28. Gives information on the artist and an extensive list of his works // Oliver Ramsay, "Alonzo Chappel, 1828–1887: Prolific American Illustrator and Painter of Historical Scenes," *Essay Proof Journal* 18 (Spring and Summer 1961), pp. 49–53; pp. 109–114. Gives the most complete account of Chappel's life.

George Washington: Design for an Engraving

Chappel painted several portraits of George Washington. The Metropolitan's grisaille showing him seated at a table was painted about 1860 as the model for a steel engraving in Evert A. Duyckinck's *National Portrait Gallery of Eminent Americans* (1861–1862). The engraving was later also included in Duyckinck's *Lives and Portraits of the Presidents of the United States* (1868).

By the beginning of the nineteenth century, GILBERT STUART'S depiction had become the most popular likeness of Washington. Chappel based his portrait on Stuart's famous Athenaeum portrait. He adapted the setting, however, from the full-length Lansdowne portrait, which Stuart had based on an engraving by P. I. Drevet after Hyacinth Rigaud's late seventeenth-century portrait of Bishop Bossuet. Chappel included the same basic elements but produced a totally different image of Washington. In Chappel's painting, the column that had reinforced the steadfastness of Stuart's standing Washington is moved to the side and almost concealed by drapery. Washington's body and expression are relaxed. He is no longer an activist but a contemplative senior statesman. Surrounded by books,

Alonzo Chappel

Chapel, *George Washington: Design for an Engraving.*

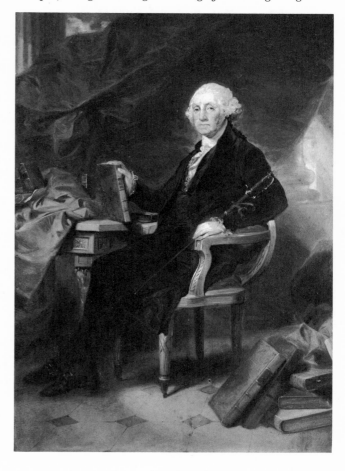

he has become the scholar in his study. Chappel has captured Duyckinck's characterization of Washington as a man pure "in his morals and manners."

Oil on paper, mounted on paper and unstretched canvas, 16⅜ × 12⅝ in. (42.2 × 32.1 cm.).

RELATED WORKS: Unidentified engraver, stipple engraving after Chappel, frontispiece preceding Washington's biography in E. A. Duyckinck's *National Portrait Gallery of Eminent Americans* (1861–1862) and *Lives and Portraits of the Presidents of the United States*

(1868), caption reads: "'Gᵒ WASHINGTON' / FROM THE ORIGINAL PAINTING BY CHAPPEL IN THE POSSESSION OF THE PUBLISHERS. / JOHNSON, FRY & CO. PUBLISHERS, NEW YORK."

REFERENCES: C. H. Hart, *Catalogue of the Engraved Portraits of Washington* (1904), p. 286, no. 680, lists stipple engraving of this work by an unidentified engraver.

EX COLL.: Johnson, Fry and Co., New York; William H. Huntington, Paris, by 1883.

Gift of William H. Huntington, 1883.
83.2.473.

JERVIS McENTEE

1828–1891

Jervis McEntee was born in Rondout, New York. According to his own recollections, his interest in art was stimulated by Henry Pickering, a highly cultured man who boarded with McEntee's family for some time. He "wrote poetry, chiefly descriptive of natural scenery and the charms of the out-of-door world" (T. B. Aldrich, *Our Young Folks* 2 [Oct. 1866], p. 624). Among his friends were several prominent artists, who encouraged McEntee to take up painting.

During the winter of 1850–1851, McEntee studied with FREDERIC E. CHURCH in New York. After his marriage in 1854, McEntee briefly abandoned painting to try his hand at the flour and feed business in Rondout. It apparently did not suit his temperament, however, and in 1858 he returned to New York and rented space in the Tenth Street Studio, joining such painters as Church, JOHN W. CASILEAR, SANFORD ROBINSON GIFFORD, JOHN F. KENSETT, and WILLIAM HART. McEntee spent summers sketching in the Catskill and Adirondack mountains. In 1868 the McEntees went to Europe. After a visit to England and a stop in Paris, they met up with the Giffords in Italy in the autumn. By November McEntee had settled in a studio in Rome in the same building as Church and WILLIAM S. HASELTINE. Along with GEORGE P. A. HEALY, who was also in Rome at the time, McEntee collaborated with Church in painting *The Arch of Titus*, 1871 (Newark Museum). In the collection of the Metropolitan Museum there is a small McEntee sketchbook, inscribed Rome 1869, with views of several Italian lakes.

Back in the United States in the summer of 1872, McEntee went on a sketching trip with WORTHINGTON WHITTREDGE and Gifford to the Massachusetts coast and then with Gifford to the Catskills. In 1881 he made a trip west to visit his sister, whose husband was the commander of Fort Halleck in Nevada. At some point, McEntee probably also traveled to Mexico, because a few of the works listed in the 1892 sale of his estate bear such titles as *Street Scene in Mexico* and *A Mexican Village* (Ortgies and Co., New York, *Catalogue of Paintings by the Late Jervis McEntee . . . March 29th and 30th* [1892], nos. 77, 95).

McEntee exhibited at the National Academy of Design in New York as early as 1850, but was not elected an academician until 1861. His paintings were shown at the Paris exposition of 1867 and the Royal Academy in London in 1872. Ten of his works were exhibited at the Centennial Exposition in Philadelphia in 1876. During his later years, he spent increasing time at his home in Rondout, where he lived until his death.

McEntee is usually associated with the artists of the Hudson River school. His work, however, represents a later development in which careful naturalistic detail is replaced by a freer, more painterly and expressive style. In the early 1860s McEntee's work was characterized by a measured calm. In his mature work he tended to paint intimate, genre-like landscapes that evoked a quiet, melancholy mood. While one might find in his work some elements in common with the Barbizon painters, McEntee often expressed his hostility to "foreign-looking" art. Whether it was the Barbizon school, Munich-trained American artists, or the impressionists, he deplored the increasing European influence on American painting. McEntee also claimed he disliked painting "what is known as 'a fine view'":

> From my home in the Catskills I can look down a vista of forty miles, a magnificent and commanding sight. But I have never painted it. . . . What I do like to paint is my impression of a simple scene in Nature. That which has been suggested is more interesting than that which has been copied. The copying that an artist does should appear in a study rather than in a picture proper. . . . All art is based upon a knowledge of Nature and a sympathy for her; but in order to represent her it is not necessary to make a thing exactly like a thing. Imitation is not what we want, but suggestion (Sheldon, *American Painters*, p. 52).

BIBLIOGRAPHY: George W. Sheldon, *American Painters: With Eighty-three Examples of Their Work Engraved on Wood* (New York, 1879), pp. 51–56 // Jervis McEntee Papers, coll. Mrs. Helen T. McEntee, D180, Arch. Am. Art. Contain a five-volume diary kept by McEntee from 1872 to 1890 // John F. Weir, *Jervis McEntee: American Landscape Painter* . . . (New York, 1891). Memorial address done for the National Academy of Design // "The Jervis McEntee Diary," *Journal of the Archives of American Art* 8 (July–Oct. 1968), pp. 1–29 // Hirschl and Adler Galleries, New York, 1976, *A Selection of Drawings by Jervis McEntee from the Lockwood de Forest Collection*, exhib. cat. by Sandra K. Feldman. Includes a biographical sketch and discusses McEntee's drawings.

Saturday Afternoon

From sketches done in Vermont, presumably the previous fall, McEntee began *Saturday Afternoon* in February 1875 for the spring exhibition at the National Academy of Design. The painting was completed by April 7, when he recorded in his diary: "All day at the Academy, it being 'buyers day' . . . happily for me, my 'Saturday Afternoon' [sold] for $1250 to Mr. Borden."

In his mature work, beginning in the 1870s, McEntee specialized in winter and autumn landscapes like *Saturday Afternoon*. He strove for the evocation of a mood, although he acknowledged that the effect on the viewer could often be "gloomy and disagreeable."

The popularity of McEntee's work at this time coincided with the vogue in America for Barbizon painting, a poetic landscape tradition in which unity of effect was more important than slick finish or the literal transcription of naturalistic details. In spite of his antipathy to French art, McEntee had much in common with such Barbizon painters as Jean François Millet, Théodore Rousseau, Charles François Daubigny, and Jules Dupré. Inspired by the subjective poetry of William Cullen Bryant, McEntee's landscape is a celebration of rustic simplicity. The major action in *Saturday Afternoon* is in the turbulent sky and the transient glimmer of sunlight that peaks through the clouds and enlivens a corner of the still pond. The grazing cattle and the country folk are without shadows

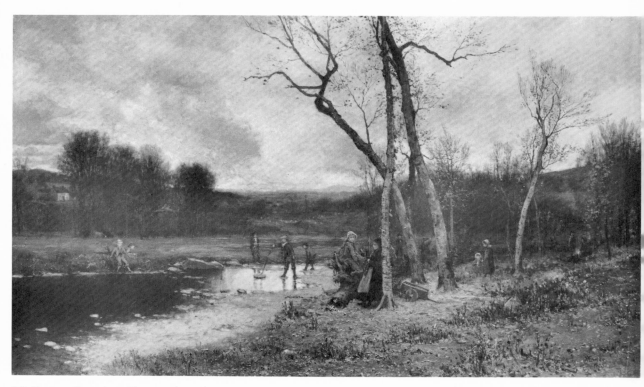

McEntee, *Saturday Afternoon*.

and summarily drawn in frozen poses that emphasize a melancholy mood.

This cool, barren ambience is sustained by McEntee's dominant use of low-keyed colors—olive, russet, gray, and brown—which are applied in impasto. He creates a richly textured, painterly surface by varying his brushstrokes depending on what he is describing. He applies dollops of paint with the tip of the brush to describe foliage and rocks and thin wisps of paint to create the last vestiges of the delicate autumn leaves.

For the most part, this painting was well-received when it was shown at the National Academy. The critic for the *Art Journal* called it a "strong and manly illustration of a late autumn landscape.... The work is solidly painted, and its harmony of feeling well accords with the sentiment of the season, the solemn features of which it so ably sets forth."

Henry James, a great admirer of Barbizon paintings, wrote in *Galaxy* that *Saturday Afternoon* "is excellent in tone; it is a genuine piece of melancholy autumn; we felt as if we were one of the children grubbing unaesthetically in the ugly wood, breaking the lean switches, and kicking the brown leaves."

Sometime between 1876, when *Saturday Afternoon* was exhibited at the Centennial Exposition, and 1913, when it was sold in the Borden estate sale, the picture acquired the title *Autumn Landscape with Figures* and was accessioned as such by the museum. Later, an old label was discovered, providing the original title.

Oil on canvas, 24 × 45 in. (61 × 106.7 cm.).
Signed and dated at lower right: J. McEntee (monogram) / 1875.
REFERENCES: J. McEntee, diary, Feb. 18, March 23, April 6 and 7, 1875, coll. Mrs. Helen T. McEntee, D180, Arch. Am. Art // *New York Times*, April 17, 1875, p. 3, describes the painting in a review of the NAD exhibition as "one of the most striking landscapes in the collection ... a picture full of genuine feeling" // *Art Journal* 1 (May 1875), p. 158, notes it

in a review of the NAD exhibition (quoted above) // *Nation* 20 (May 20, 1875), p. 352, in a review calls it "a fine subject, with sky in bold impasto and admirably-fitting groups of children" // *Scribner's Monthly* 10 (June 1875), p. 252, refers to it as "a large scene of autumnal decline" with "rich browns and chilly grays" // Henry James, *Galaxy* 20 (July 1875), pp. 95–96 (quoted above) // American Art Galleries, New York, *Illustrated Catalogue of the Notable Paintings by Great Masters Belonging to the Estate of the Late M. C. D. Borden,* sale cat. (1913), unpaged introduction, discusses it; no. 75, as Autumn Landscape with Figures // *MMA Bull.* 8 (1913), p. 87, calls it Autumn Landscape with Figures; ill. p. 89 // B. Burroughs, *MMA Bull.,* suppl. to 12 (1917), p. 8, as Autumn Landscape with Figures.

EXHIBITED: NAD, 1875, no. 220, as *Saturday Afternoon* // Philadelphia, 1876, Centennial Exposition, no. 182, as Saturday Afternoon, lent by M. C. D. Borden // MMA, 1917, *Paintings of the Hudson River School Brought Together in Commemoration of the Completion of the Catskill Aqueduct* (no cat.) // Federal Reserve Bank of New York, *American Paintings and Sculptures from the Metropolitan Museum of Art at the Federal Reserve Bank of New York,* 1983, exhib. cat. by D. T. Johnson, ill. p. 20.

EX COLL.: Matthew C. D. Borden, New York, 1875–1913; his estate (sale, American Art Galleries, New York, Feb. 14, 1913, no. 75, as Autumn Landscape with Figures).

Amelia B. Lazarus Fund, 1913.
13.39.2.

JOHN RASMUSSEN

1828–1895

An inmate of the Berks County Almshouse in Reading, Pennsylvania, for some sixteen years, Rasmussen is one of a small group of immigrant artists who lived in Pennsylvania almshouses during the second half of the nineteenth century. Born in Germany, he immigrated to New York in 1865. Two years later he was living in Pennsylvania, where he is listed as a painter in the Reading directories from 1867 to 1879. He was committed to the Berks County Almshouse on June 5, 1879. The almshouse register supplies the following information about the artist: "Age, *51*; Nativity, *Germany*; Time in United States, *14*; Occupation, *painter*; Civil Condition, *widowed*; Habits, *intemperate*; Moral Condition, *had frequented houses of prostitution*; Disease, *rheumatism*; Cause of Pauperism, *vagrant.*" Rasmussen died in the almshouse on June 16, 1895, and, according to its records, his daughter-in-law arranged for his burial in Paterson, New Jersey.

Rasmussen painted portraits, still lifes, landscapes, and at least six known paintings of the grounds and buildings of the Berks County Almshouse. The works of CHARLES C. HOFMANN, a contemporary almshouse painter, often served as models for Rasmussen's compositions. Rasmussen's frequent adoption of a geometrical framework in organizing his compositions, his use of brilliant, usually unmodulated colors and his almost mechanical approach to modeling contribute to the decorative effect that characterizes much of his work.

BIBLIOGRAPHY: Abby Aldrich Rockfeller Folk Art Collection, Williamsburg, Va., *Pennsylvania Almshouse Painters,* exhib. cat. [by Thomas N. Armstrong III], (Oct. 1 – Dec. 8, 1968), unpaged. Provides the most complete account of the artist and his works to date // Whitney Museum of American Art, New York, *American Folk Painters of Three Centuries* (1980), ed. by Jean Lipman and Tom Armstrong, exhib. cat., p. 107. Armstrong's essay on Charles C. Hofmann provides information on Rasmussen.

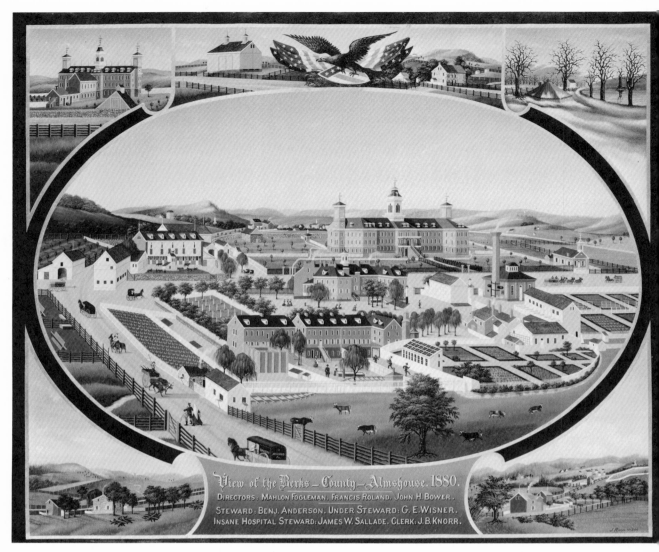

Rasmussen, *Berks County Almshouse, 1880.*

Berks County Almshouse, 1880

When John Rasmussen entered the Berks County Almshouse in 1879, he joined CHARLES C. HOFMANN, whose compositions often served as models for his work. This painting of 1880 is one of six known views of the almshouse by Rasmussen, all of which, according to Thomas Armstrong, are based on Hofmann's 1878 views of the Berks County Almshouse (National Gallery, Washington, D.C., Historic Society of Berks County, Reading, Pa.; and private coll.). Working with brilliant primary colors on a prepared zinc ground, Rasmussen follows Hofmann's compositional format, presenting a view of the

almshouse property within an oval cartouche surmounted by a heraldic device and flanked by peripheral views of various buildings at different seasons. This geometrical division of the painting ground into compartments provides the painter with an opportunity for incorporating several different images and periods of time. The cartouche and the introduction of the heraldic motif reinforce the two-dimensional quality of the work. In contrast, the individual views of the almshouse property are conceived to suggest depth. A wagon, inscribed, "BAKERY / READING / Pa.," emerges from the painted frame in the center foreground onto a thoroughfare which functions as a device for directing atten-

tion into the distance. The abrupt transitions from surface plane to painted distance enhance the painting's decorative character. People, livestock, carts, and wagons enliven the central scene, providing the narrative element that is so often an intrinsic part of the folk artist's vocabulary. The painting retains its original frame with a silver-gilt inner liner.

Another painting of the almshouse by Rasmussen, virtually identical to the museum's picture and dating from the same year, was on the New York art market in 1978. In 1881 Rasmussen repeated this composition with minor variations (see J. Lipman, *American Primitive Painting* [1942], pl. 56).

Oil and gold paint on zinc, 32⅝ × 40 in. (82.9 × 101.6 cm.).

Signed, dated, and inscribed at lower right: J.

Rasmussen.; at bottom: View of the *Berks—County Almshouse.* 1880. / DIRECTORS: MAHLON FOGLEMAN. FRANCIS ROLAND. JOHN H. BOWER / STEWARD: BENJ. ANDERSON. UNDER STEWARD: G. E. WISNER. / INSANE HOSPITAL STEWARD: JAMES W. SALLADE. CLERK: J. B. KNORR.; on wagon: BAKERY / READING / Pa.

EXHIBITED: Abby Aldrich Rockefeller Folk Art Collection, Williamsburg, Va., 1968, *Pennsylvania Almshouse Painters,* exhib. cat. [by T. N. Armstrong III], unnumbered cat. // Staten Island Institute of Arts and Sciences, 1977–1978, *Sully to Sargent, 19th-Century American Paintings and Bronzes from the Metropolitan Museum of Art* (no cat.).

ON DEPOSIT: New York City Department of Parks, 1973–1974; Governor's Office, New York, 1975–1976.

EX COLL.: with Robert Burkhardt, Pa., 1954; Edgar William and Bernice Chrysler Garbisch, 1954–1966.

Gift of Edgar William and Bernice Chrysler Garbisch, 1966.

66.242.22.

JAMES M. HART

1828–1901

James Hart, the younger brother of the painter WILLIAM HART, was born in Kilmarnock, Scotland, and came to the United States with his parents in 1831. He spent his youth in Albany, where he and his brother were apprenticed to a coach and sign painter. Hart dabbled in portraiture for a time, but his interest soon turned to landscape painting. In 1850 he went abroad to further his training: he spent three years in Europe, studying in Munich and in Düsseldorf under Johann Wilhelm Schirmer and others. He sketched in the Tyrol and along the Rhine before returning to Albany in 1853. That year he submitted his first painting to the National Academy of Design; it was perhaps the success his pictures enjoyed in New York that encouraged him to open a studio in the city in 1857. In 1858 he was elected an associate of the National Academy, and in 1859 he became an academician. He occasionally collaborated with ARTHUR FITZWILLIAM TAIT, and two of their joint efforts were exhibited at the National Academy in 1859. Later Hart served for three years as vice-president of the academy. In 1866 he married Marie Theresa Gorsuch, an amateur painter who occasionally exhibited at the National Academy. Their daughter Letitia and son William Gorsuch Hart also became artists. James Hart contributed two works to the Exposition Universelle in Paris in 1878. He spent his later years in New York and died at his home in Brooklyn.

Although Hart's earliest landscapes showed the tight literalism of the Hudson River school, the character of his pictures gradually changed, probably under the influence of his Düssel-

dorf training, and he became less interested in recording a scene in all of its minute details than in evoking the feeling and sentiment that it conveyed. "I strive", he said, "to reproduce in my landscapes the feeling produced by the original scenes themselves . . . If the painting were perfect, you would feel precisely as you feel when contemplating such a scene in Nature" (Sheldon, p. 47).

BIBLIOGRAPHY: Henry T. Tuckerman, *Book of the Artists* (New York), 1867, pp. 547–551 // "American Painters—James M. Hart," *Art Journal*, n.s. 1 (June 1875), pp. 180–183 // George William Sheldon, *American Painters: With Eighty-three Examples of Their Work Engraved on Wood* (New York, 1879), pp. 46–51 // Clara Erskine Clement and Laurence Hutton, *Artists of the Nineteenth Century and Their Works* (Boston, 1880), 1, pp. 334–335 // Obituary: *American Art Annual* 4 (1903–1904), p. 141.

Godesberg

Although this 1852 oil sketch is inscribed "Goadesberg," that is probably a misspelling of Godesberg. The town of Bad Godesberg on the Rhine was noted for its mineral springs. The Godesberg, or Godesburg, are the ruins of a medieval castle that command an excellent view of the area. It is not too far south of Düsseldorf, where Hart was studying at the time. He made this sketch of an overgrown, rocky landscape in a very free and generalized manner. This practice of rendering a vignette from nature in summary fashion is particularly associated with the Düsseldorf painters.

Oil on wove paper, 12¼ × 9½ in. (31.1 × 24.1 cm.).

Inscribed and dated, at lower left: Goadesberg [*sic*] / May 9/1852.

Ex COLL.: Evette and Stanley Nash, Douglaston, N.Y., 1972–1973.

Rogers Fund, 1973.

1973.14.4.

Mountain Range

This colorful oil sketch probably represents a view in the Tyrolean Alps, where Hart sketched when he was in Europe in the early 1850s. It is a straight-forward, unpretentious landscape that captures the drama of a sunset. Hart's main concerns seem to be form and color. The blackish-green trees, already in shadow, are silhouetted against the mountain which is aglow with a brilliant coral color. In the bright sky float greenish-blue clouds.

There is a pencil drawing of a tree on the back of this sketch.

Oil on wove paper, 9½ × 13 in. (24.1 × 33 cm.).

Ex COLL.: Evette and Stanley Nash, Douglaston, N.Y., 1972–1973.

Rogers Fund, 1973.

1973.14.3.

Hart, *Godesberg*.

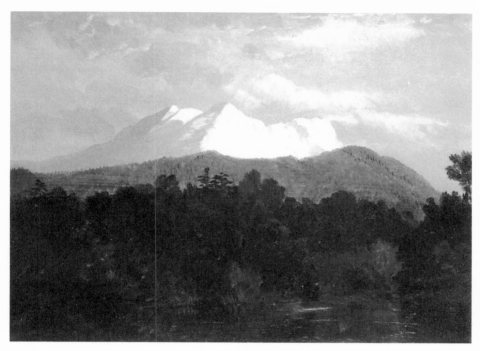

Hart, *Mountain Range*, and, below, the pencil drawing on the back.

Pasture Scene

Hart specialized in painting landscapes with cows, oxen, and other farm animals. It is said that so remarkable was his ability to capture the attitudes and faithfully to describe cows that his patrons claimed "they could distinguish the Alderneys from the Guernseys" (K. H. Amend, *DAB* [1931; 1960], s.v. "Hart, James Mac-Dougal"). George W. Sheldon wrote, "perhaps no artist in this country better appreciates the nature and the merits of oxen."

This picture was painted in 1876, when Hart's reputation was already well established. The year before, he had been praised in the *Art Journal* for his "thorough knowledge of the properties of light and shade, of atmosphere and perspective" (n.s. 1 [June 1875], p. 181). Like his brother William, however, James developed a convenient landscape formula, which he often repeated with only minor variations. In this picture, which follows his usual composition, a haying scene is brightly illuminated in the background. One of Hart's chief contributions was to stimulate among his admirers a general ap-

James M. Hart

Hart, *Pasture Scene*.

preciation of the placid beauty of the New York countryside which constituted the primary subject of his paintings.

Oil on canvas, 20 × 34 in. (50.8 × 86.4 cm.).
Signed and dated at lower right: James M. Hart. 1876.
EXHIBITED: College Art Association, New York, 1934, *American Painters Memorial Exhibition*, p. 13, no. 14, as Pasture Scene // Florence Lewison Gallery, New York, 1964–1965, *The Brothers Hart*, no. 1.
Ex COLL.: Charles A. Fowler, Hopewell Junction, N.Y., by 1921.
Gift of Colonel Charles A. Fowler, 1921.
21.115.2.

EDWARD MORAN

1829–1901

Edward Moran, the elder brother of the artists Peter (1841–1914) and THOMAS MORAN, was born at Bolton-le-Moor, Lancashire, England. His father was a handloom weaver, and, as a youth, Edward also worked at the looms. In 1844 the Morans came to the United States and settled first in Maryland and then in Philadelphia. There, Edward worked at a variety of jobs, including cabinetmaking, assisting in a bronzing shop, house painting, and supervising power-loom workers in a factory. Eventually he studied art with the marine painter JAMES HAMILTON and then later with the German landscape painter Paul Weber (1823-1916).

According to Theodore Sutro, if Moran "was influenced by any other artists to any extent it was by Clarkson Stanfield and J. M. W. Turner, whom he greatly admired and many of whose pictures, for the sake of practice, he copied." Indeed many of Moran's early seascapes have much in common with the romantic works of Turner. Like them, they show heroic events which are played out in storm-tossed seas. Characteristically, these loosely painted scenes have swirling compositions in which turbulent waters merge with bleak and stormy skies. Nature is represented as terrifying, overwhelming the tiny, floundering figures on rolling ships. A bright ethereal light often emerges from the center of the sky, creating an aura of mystery.

Moran began exhibiting at the Pennsylvania Academy of the Fine Arts in 1853 or 1854. By 1855 he was supporting himself as a lithographer. He opened a studio in 1857 and was soon joined by his younger brother Thomas, who later wrote: "He taught the rest of us Morans all we know about art and grounded us in the principles we have worked on all our lives. It is scarcely probable that any of us would have been painters had it not been for Edward's encouragement and assistance" (Coleman, p. 191). In 1860 Edward Moran was made an academician at the Pennsylvania Academy; he resigned in 1869, however, in a disagreement with the board over the hanging of his pictures in the previous year's exhibition.

In the summer of 1861, Edward and Thomas went to England. Edward studied for a short time at the Royal Academy, enjoyed seeing Turner's work firsthand, and made a sketching tour. He returned to Philadelphia in 1862. At the end of the 1860s he began to turn away from picturesque compositions and dramatic subjects to paint genre scenes and idyllic landscapes. In 1871 he showed seventy-five paintings at the galleries of James S. Earle and Sons in Philadelphia in an exhibition called "Land and Sea," for the benefit of the sufferers of the Franco-Prussian War. The introduction to the catalogue, with over seventy lithographs after the paintings, noted that: "Mr. Moran has extended his sketching tours along our Eastern coast to New Brunswick, and as far South as the sands of Virginia." By 1872 Moran had moved to New York, where he exhibited regularly at the National Academy of Design and became an associate member in 1874. Here, perhaps under the influence of artists like JOHN F. KENSETT and SANFORD ROBINSON GIFFORD, Moran depicted tranquil harbor scenes, in which action was minimal, brushwork was less vigorous, and water and air merged to create a moist, atmospheric haze.

In 1877 Moran sold the paintings in his studio and went to Paris, where it is believed he studied figure painting. Whether he attended classes or worked under another artist is not known. His paintings of French peasants, however, are characterized by a broad handling of paint and may have been influenced by the work of such artists as Jules Bastien-Lepage and Jules Bréton. Moran also painted scenes along the French coast.

While he painted some landscapes, genre scenes, and figure compositions, Moran's fame rests primarily on his marine paintings. He spent most of the last years of his life working on a series of thirteen paintings representing the "Marine History of the United States" from the landing of Leif Ericson to the Spanish-American War (United States Naval Academy, Annapolis). He worked on these pictures for almost twenty years, finishing them shortly before his death.

Moran's second wife, Annette Parmentier Moran (d. 1904) was an artist, as were his sons Edward Percy Moran (1862–1935) and John Leon Moran (1864–1941).

BIBLIOGRAPHY: James S. Earle and Sons, Philadelphia, *Land and Sea: A Collection of the Works of Edward Moran, Philadelphia*, sale cat., March 25, 1871. A good example of Moran's paintings // Hugh W. Coleman, "Passing of a Famous Artist, Edward Moran," *Brush and Pencil* 8 (July 1901), pp. 188, 191–192 // William Howe Downes, *DAB* (1936), s.v. Moran, Edward. A good biographical sketch with bibliography // Theodore Sutro, *Thirteen Chapters of American History: Represented by the Edward Moran Series of Thirteen Historical Marine Paintings* (New York, 1905). Contains early listing of better known works and a biographical sketch // Paul D. Schweizer, *Edward Moran (1829–1901): American Marine and Landscape Painter* (Wilmington, Del., 1979). A catalogue for an exhibition held at the Delaware Art Museum, it contains the most complete biographical material and analysis of Moran's work.

Marine

Although this modest painting is undated, it may have been executed about 1871; for it is similar in subject matter to Moran's *Lifting Lobster Cribs*, 1871 (unlocated, ill. in James Earle and Sons Gallery, Philadelphia, *Land and Sea: A Collection of the Works of Edward Moran*, sale cat., no. 37). Both scenes show fishermen in small dinghies pulling in their day's catch, a late afternoon sun setting in the background, and a typically Turneresque light emanating from the sky.

Marine has a vertical format, which is unusual in Moran's work. It is neither one of his particularly ambitious nor successful pictures. The broadly painted figures are awkwardly described, general in features, and repetitious in pose. The treatment of the water lacks the verve of Moran's best works, in which the waves are chiseled to a sharp edge and the foam imparts energy.

The painting shows some surface cracking, and there are some areas of paint loss.

Oil on canvas, 30 × 25 in. (50.8 × 63.5 cm.).
Signed at lower left: Edward Moran.
EX COLL.: Emily Buch, New York.
Bequest of Emily Buch, 1963.
64.198.6.

Moran, *Marine.*

THOMAS HILL

1829–1908

Along with ALBERT BIERSTADT and WILLIAM KEITH, Thomas Hill is considered one of the major landscape painters of the American West. He was born in Birmingham, England, and came to the United States in 1844. His family settled in Taunton, Massachusetts, where Hill was apprenticed to a coach painter. He later moved to Boston and worked for various interior decorators there. In 1853 he went to Philadelphia, where he attended life classes at the Pennsylvania Academy of the Fine Arts and studied under Peter Frederick Rothermel (1817–1895), a noted historical and portrait painter who was then head of the academy. At that time, Hill specialized in painting still lifes and portraits and won a medal in portraiture from the Maryland Institute in Baltimore. Two years later he returned to Massachusetts.

Around 1861 Hill moved to California and opened a studio in San Francisco, where he continued to pursue a career in portraiture. A year later he is said to have made a sketching trip to Yosemite with WILLIAM KEITH and Virgil Williams (1830–1886). Nevertheless, he continued to concentrate on the figure in his paintings. In 1865 he exhibited *The Trial Scene from the Merchant of Venice* (unlocated) at the California Art Union, inspired by a current theater production. In 1866, his *View of the Yosemite Valley*, 1865 (NYHS), was shown at the National Academy of Design.

That same year he went to Paris for a short time where he studied with the genre, animal, and landscape painter Paul Meyerheim. After seeing the sketches Hill made at Fontainebleau, Meyerheim encouraged him to specialize in landscape painting. Several of Hill's paintings were exhibited at the Exposition Universelle in 1867. When he returned to the United States, he settled in Boston, and there, working from the sketches he had made earlier in California, he painted his first important landscape, *Yosemite Valley*. Exhibited at Childs Gallery, Boston, in 1868, it was critically acclaimed. The *Boston Commonwealth* on November 12, 1868, called Hill "the recognized authority in Yosemite and Sierra painting." Louis Prang and Company made a chromolithograph of the picture, and it was engraved for the frontispiece to James Mason Hutchings's *Scenes of Wonder and Curiosity in California* (1870).

Hill returned to California in 1870. He became a prominent figure in San Francisco art circles, serving as one of the early vice-presidents of the San Francisco Art Association and helping to organize the California School of Design in 1874. During this time he made sketching excursions to the Monterey Peninsula and in 1880 to the White Mountains in New Hampshire. Two of his paintings, *The Home of the Eagle, Donner Lake* and *Yosemite Valley* were shown at the Centennial Exhibition in Philadelphia, where Hill was commended for excellence in landscape painting. One of his best known works is his monumental *The Last Spike*, now called *The Driving of the Last Spike* (State of California, Sacramento). Commissioned by Leland Stanford, the railroad builder and politician, it was meant to commemorate the completion of the Central-Pacific Railroad to the junction with the Union Pacific on May 10, 1869. Following photographs and descriptions, Hill worked on the picture for three years. He included four hundred figures, among them recognizable portraits of sixty-seven dignitaries.

Stanford, however, was dissatisfied with the results and refused to accept the picture. After the artist's death, it was bought by the San Francisco art collector David Hewes.

Because of chronic poor health, Hill began to spend his summers at Yosemite in 1888. He established a studio at Wawona near the entrance to Yosemite Valley, and from there he supplied many wealthy tourists with views of the valley. He generally spent the winters in Raymond, California, near Yosemite. Hill suffered a paralyzing stroke in 1898 and continued in poor health until his death ten years later. Several other members of Hill's family were painters, his sons Edward R. (1852–1908) and Thomas V. T., and his brother Edward (b. 1843).

BIBLIOGRAPHY: Frederick W. Coburn, *DAB* (1932), s.v. Hill, Thomas // "Thomas Hill, 1829–1908: Biography and Works," *California Art Research* 2 (San Francisco, 1937), pp. 67–97A // Larry Curry, *The American West* (New York and Los Angeles, 1972), pp. 28, 41. Includes a chronology of Hill's life // Marjorie D. Arkelian, *The Kahn Collection of Nineteenth-Century Paintings by Artists in California* (Oakland, 1975), pp. 28–29 // Marjorie Dakin Arkelian, *Thomas Hill: The Grand View* (Oakland, 1980). A catalogue for a traveling exhibition curated by George W. Neubert, it includes new information on Hill's life.

View of Yosemite Valley

Yosemite Valley is located in eastern central California, about 150 miles east of San Francisco. The area was not extensively explored until 1851. One of the first artists to record the topography, in 1855 and 1856, was Thomas A. Ayers (d. 1858). The photographer Carleton E. Watkins also recorded the area. During this period a rich interchange developed between artists and photographers. ALBERT BIERSTADT, for example, used Watkins's large-scale views as

Hill, *View of Yosemite Valley.*

models for his compositions, and they were also said to have influenced Watkins's friends WILLIAM KEITH and Thomas Hill. Indeed, in this popular view of Yosemite Valley, one Hill repeated often with minor variations, the painter and Watkins share a common aesthetic in their use of the broad empty foreground and treatment of the hazy background.

The painting shows the Merced River flowing through the valley, while Bridal Veil Falls is visible at the right, and El Capitan looms majestically at the left. Unlike Watkins who self-consciously omitted the human figure, however, Hill did not. At the lower center, a tiny fisherman casts off the rocks, providing an effective indication of the monumental scale of the peaks and suggesting the minor role man plays in nature. While the view is clearly recognizable in terms of location, Hill has not attempted to transcribe faithfully the details of the landscape. Instead he suggests the texture of water, rocks, and leaves in a loosely brushed style consistent with the late nineteenth century taste for rich painterly surfaces.

Oil on canvas, 36¼ × 54¼ in. (92.1 × 137.8 cm.). Signed and dated, lower left: T. Hill. / 1885.

REFERENCES: H. W. Lovell, letter in Dept. Archives, July 25, 1973, discusses provenance.

EXHIBITED: Queens County Art and Cultural Center; MMA; Memorial Art Gallery of the University of Rochester; Sterling and Francine Clark Art Institute, Williamstown, Mass., 1972–1973, *19th Century American Landscape*, exhib. cat. by M. Davis and J. K. Howat, no. 16 // Lowe Art Museum, University of Miami, Coral Gables, 1974–1975, *19th Century American Topographic Painters*, p. 13, no. 65 // MMA and American Federation of Art, traveling exhibition, 1975–1977, *The Heritage of American Art*, exhib. cat. by M. Davis, no. 53, ill. p. 126; rev. ed., 1977, no. 52, ill. p. 125.

EX COLL.: private coll., New York, ca. 1948; Dr. Harold W. Lovell, New York, ca. 1948–1971.

Gift of Dr. and Mrs. Harold W. Lovell, 1971. 1971.245.

JOSEPH H. HIDLEY

1830–1872

Born in Greenbush, New York, on March 22, 1830, Joseph Henry Hidley spent most of his life in nearby Poestenkill, a town about ten miles east of Troy. He worked as a housepainter, handyman, artist, and taxidermist. On March 30, 1864, he joined the Poestenkill Evangelical Lutheran Church, where he was employed as sexton at a salary of twenty-five dollars a year. Hidley and his family lived next to the church. Only three of his six children survived infancy. Hidley's wife, the former Caroline Danforth, died at the age of thirty-three, and he died soon after, at the age of forty-two.

Hidley's reputation depends on fewer than a dozen townscapes of Poestenkill and nearby villages. These pictures are, according to Jean Lipman, "among the most remarkable achievements of nineteenth-century American folk art" (*Primitive Painters in America*, p. 132). Hidley's townscapes appear to be accurate historical records. In his views of Poestenkill, the buildings are recognizable, and changes in the town can be traced through successive stages as new buildings appear, old buildings are enlarged, and trees disappear. The way of life is suggested by lively figures of people and animals. Hidley also painted some religious scenes, a few portraits, and many decorative panels and fire screens.

BIBLIOGRAPHY: Janet R. MacFarlane, "Hedley, Headley, or Hidley, Painter," *New York History* 28 (Jan. 1947), pp. 74–75. Provides biographical information supplied by the artist's daughter

and taken from his gravestone // Jean Lipman, "Joseph Hidley (1830–1872): His New York Townscapes," *American Collector* 16 (June 1947), pp. 10–11. Suggests a chronology for three early scenes of Poestenkill in winter and in summer. Reprinted in Jean Lipman and Alice Winchester, *Primitive Painters in America, 1750–1950* (New York, 1950), pp. 132–138 // Florence M. Hill, town historian, Poestenkill, N.Y., letter in Dept. Archives, Nov. 13, 1978. Provides additional information on the artist, particularly his association with the Lutheran church // Warren F. Broderick, ed., *Brunswick . . . A Pictorial History* (Brunswick, N.Y., 1978), pp. 84–103 // Whitney Museum of American Art, New York, *American Folk Painters of Three Centuries* (1979), exhib. cat., entry on Hidley by Tom Armstrong, pp. 98–102. Contains the most up-to-date information on the artist.

View of Poestenkill, New York

This painting is typical of the town views that were popular household decorations during the eighteenth and nineteenth centuries. Produced for local patrons, these paintings and lithographs were accurate portraits of the community. They shared certain characteristics—an aerial view, strong perspective, and clearly defined, unmodeled forms—that created a decorative effect typical of American primitive painting.

Poestenkill is a small village about eight miles to the east of Troy, New York. Hidley's view looks east, down the main street. The Poestenkill Evangelical Lutheran Church, next to which Hidley lived, is the most prominent element of the composition and may have been purposely emphasized. The smaller, towered building nearby is the Poestenkill Union Academy, formerly a girls' school. The large columned building at the crossroads to the east is the Union Hall; the one farther west, the Poestenkill Hotel. At the eastern end of town, opposite the road to Snake Hill, which turns south, is the Eagle Hotel. Behind it, the Poesten Kill (or creek) flows over a dam. In the 1800s Poestenkill was an important lumbering center, and many mills were located along this creek. The small, towered building on the north side of town is the two-room school that served the town until about 1927. The small building directly across from the school is the Church of Christ, built in 1850. There James A. Garfield, who later became the twentieth president of the United States, delivered sermons when he was a student at Williams College. The wagonmaker's shop just south of the bridge over the Poesten Kill and the renovated blacksmith's shop on the southwest corner of the main crossroads would have been clearly recognizable to Hidley's neighbors.

This is one of at least five views that Hidley made of his hometown. According to a contem-

porary, Hidley painted some of them without a commission, on speculation. The present version is closest in composition and detail to *Poestenkill, New York: Summer* (Abby Aldrich Rockefeller Folk Art Collection, Williamsburg, Va.). Both are undated and used to be considered early works, painted between 1850 and 1855. They must, however, be dated after 1865, as Stuart Feld pointed out (note in departmental files), because both show the new Lutheran Church, which was built in 1865 to replace a small chapel. A lithograph of a similar view of Poestenkill in winter by Hidley, published by G. W. Lewis, Albany, was most likely executed sometime between 1865 and 1867, the last year of Lewis's activity in Albany. An oval view *Poestenkill, New York: Winter* (Abby Aldrich Rockefeller Folk Art Collection) with a partially legible date, Fe 18 18 [?] 8, is similar to the upper half of the lithograph, includes the Lutheran Church, and therefore was probably painted in 1868. Changes in topographical details suggest that the Metropolitan's painting is the last of the series and should be dated about 1870. It and the slightly earlier painting *View of Poestenkill: Summer* show more houses along the main street and an enlarged blacksmith shop. Also, the large grove of trees that stood alongside the road to Snake Hill is absent. The tree that grew at the crossroads has been replaced in the Metropolitan's painting by a halted wagon.

Oil on wood, 19¾ × 18 in. (50.2 × 71.1 cm.).

RELATED WORKS: *Poestenkill, Rens. Co. N.Y.*, lithograph by G. W. Lewis after a design by J. H. Hidley // *Poestenkill, New York: Summer*, oil on wood, 20 × 29¾ in. (Abby Aldrich Rockefeller Folk Art Collection, Williamsburg, Va. 59–DW–423).

REFERENCES: *Antiques* 59 (Jan. 1951), ill. p. 22, describes this work as Poestenkill, N.Y. in Summer in an advertisement for W. A. Morrill, Jr., Poestenkill, N.Y. // Troy, N.Y., *Time Record*, August 22, 1962, ill. p. 11 // T. Armstrong, New York, orally, Jan. 4, 1967,

Hidley, *View of Poestenkill, New York.*

supplied information about Hidley and this painting // W. A. Morrill, Jr., letter in Dept. Archives, June 15, 1967, supplies provenance; notes that Ed Predigar, a friend of the artist's, said Hidley told him that he painted five paintings of Poestenkill, one of which did not have a buyer and the artist raffled it off at a dollar a chance // F. M. Hill, town historian, Poestenkill, N.Y., letter in Dept. Archives, Nov. 13, 1978, calls this A Crow's Eye View of Poestenkill, identifies various landmarks, and confirms date of construction of the Evangelical Lutheran Church.

EXHIBITED: MMA and American Federation of Arts, traveling exhibition, 1961–1964, *101 Masterpieces of American Primitive Painting from the Collection of Edgar William and Bernice Chrysler Garbisch*, no. 92, as Poestenkill, New York, about 1855 // MMA, 1965, *Three Centuries of American Painting*, unnumbered cat., as View of Poestenkill, New York, about 1850 to 1855 // American Federation of Arts, traveling exhibition, 1968–1970, *American Naive Painting of the 18th and 19th Centuries, 111 Masterpieces from the Collection of Edgar William and Bernice Chrysler Garbisch*, no. 92, as Poestenkill, New York, about 1855 // Osaka, 1970, *United States Pavilon Japan World Exposition: American Paintings* (no cat.) // Queens County Art and Cultural Center, Queens, N.Y.; MMA; Memorial Art Gallery of the University of Rochester, 1972–1973, *19th Century American Landscape*, no. 2.

EX COLL.: Charles Read (at auction for fifty cents); his daughter, Mrs. Ada Read Lowrie; her daughter, Mrs. Marjorie Lowrie DeFrate, until 1949; with William A. Morrill, Jr., Troy, N.Y., 1949–1954; with George McKearin, Hoosick Falls, N.Y., 1954–1959; Mr. and Mrs. Edgar William Garbisch, 1959–1963.

Gift of Edgar William and Bernice Chrysler Garbisch, 1963.

63.201.5.

Joseph H. Hidley

WILLIAM OLIVER STONE

1830–1875

Called "one of the most popular of our New York portrait-painters" by Henry T. Tuckerman in 1867 (*Book of the Artists*, p. 399), Stone was born in Derby, Connecticut, where his family was prominent. At the age of eighteen he became a pupil of Nathaniel Jocelyn (1796–1881), the New Haven portrait and miniature painter. He remained under Jocelyn's guidance until 1849, when a fire completely destroyed the teacher's studio. In 1851 Stone moved to New York, where he opened his own studio. He quickly became one of the leading portraitists, especially popular with society families. By 1856 he had become an associate of the National Academy of Design, and in 1859 was elected an academician. From that time on, "he was acknowledged to be one of the most able portrait painters in the country, and particularly in New York; no collection was considered complete without having one or more of his heads in it" (*Art Journal* 1 [Nov. 1875], p. 349). His most memorable works appear to have been his portraits of women and children, executed in a romantic, slightly idealized style. In addition, he seems to have preferred a cabinet-size canvas, frequently oval.

Prolific throughout his career, Stone exhibited yearly at the National Academy of Design from 1861 to 1875, sending nine portraits to the exhibition of 1866. He was also a member of the Union Club and the Century Association. Among his better known subjects were Cyrus West Field, 1867 (coll. Mrs. R. K. Jones, New York), and the founder of the Corcoran Gallery of Art in Washington, D.C., William Wilson Corcoran (Walters Art Gallery, Baltimore). Stone died at the height of his career in Newport, Rhode Island, on September 15, 1875.

BIBLIOGRAPHY: Henry W. French, *Art and Artists of Connecticut* (Boston, 1879), pp. 141–142 // "William Oliver Stone," *Art in America* 143 (April 1925), pp. 156–158. Discusses the artist's work // William Howe Downes, *DAB* (1935), s.v. "Stone, William Oliver" // "William Oliver Stone," *Art in America* 27 (Jan. 1939), pp. 45–46. Recounts the artist's life and gives a listing of some of his works.

Mary Cadwalader Rawle

Mary Cadwalader Rawle (1850–1936) was born in Philadelphia, the eldest daughter of a prominent Quaker family. Her immediate relatives included clergymen, jurists, as well as a member of the United States Congress. She moved to New York after her marriage in 1869 to Frederick Rhinelander Jones, whom she had met aboard a ship bound for Europe. Her husband's sister, the novelist Edith Wharton, became a lifelong friend and introduced Mary Cadwalader Jones to the fashionable literary society of New York. She rapidly became one of New York's most popular hostesses. Her Sunday luncheons were attended by such notables as JOHN LA FARGE, Henry James, Henry Adams, and Theodore Roosevelt. Well educated and fluent in several languages, she often translated works like Raymond Recouly's *Foch: The Winner of the War* (1920). In addition she was the author of many articles for the *Bookman* and wrote *European Travel for Women* (1900) and an autobiography, *Lantern Slides* (1937).

Her particular interest in art is documented by her chapter on fan collecting in *A Book About Fans: The History of Fans and Fan-Painting* (1895) by M. A. Flory and her preface to John La Farge's *The Gospel Story in Art* (1913), which she also edited and prepared for publication after his death.

According to Mrs. Jones, she sat for this por-

trait in Lenox, Massachusetts, in September of 1868, when she was barely eighteen years old. Stone's prominence as a society painter made him an obvious choice for her family. As in many of his mature works of the 1860s and 1870s, he chose an oval format and rendered the sitter in loosely brushed tones of brown and buff. Her penetrating gaze and preciously posed hands further reveal the painter's flattering style of portraiture.

Stone apparently considered this portrait among his most successful; for, according to the sitter, "he thought it his best work, and kept it always in his studio, and I bought it after his death" in 1875.

Oil on canvas, oval 12 × 10½ in. (30.6 × 26.7 cm.).

REFERENCES: M. C. Jones to B. Burroughs, November 10, 1910, letter in MMA Archives (quoted above), says she sat for Stone "at Lenox in September 1868" // Mrs. M. Farrand, August 17, 1953, letter in MMA Archives, discusses the portrait of her mother and misdates it 1864 // *DAB* 9 (1935), p. 91, mentions the work in the collection of the museum // M. C. Jones, *Lantern Slides* (1937), frontis., dates it about 1865 // *Who Was Who in America* (1963), p. 510, lists it as Miss Rawle, one of Stone's major works.

EX COLL.: the subject, New York, after 1875–1953.

Gift of Mrs. Max Farrand and Mrs. Cadwalader Jones, 1953.

53.144.

Stone, *Mary Cadwalader Rawle.*

GEORGE COCHRAN LAMBDIN

1830–1896

Lambdin was born in Pittsburgh. In 1837 he moved to Philadelphia, where his father, James Reid Lambdin (1807–1889), became a well-known portrait and miniature painter. After receiving his earliest art lessons at home, Lambdin went to Europe in 1855 and spent two years studying painting in Munich and Paris. He had begun sending pictures to the annual exhibitions of the Pennsylvania Academy of the Fine Arts in 1848. From 1856 on, he exhibited at the National Academy of Design in New York, where he was elected an academician in 1868. He lived in New York from 1868 to 1870. Until this time Lambdin's reputation was chiefly based on his portraits of children and sentimental genre scenes, particularly of Civil War soldiers in camp or at home. Although the critic Henry T. Tuckerman greatly admired

his "skill in pathetic expression, both as to human features and the still-life accessories," he regretted Lamdin's "evident lack of discipline in the technical details."

After a brief visit to Europe in 1870, Lambdin returned to Philadelphia and settled in the Germantown section. There he cultivated a garden of fine roses and other flowers and devoted himself exclusively to floral pictures. Along with MARTIN JOHNSON HEADE, Lambdin is considered one of the major American specialists in floral painting in the late nineteenth century. "Lambdin mastered a sureness of form and draftsmanship that permitted him to display a considerable bravura, and his flowers gain vitality from the very dash and verve of the painting" (Gerdts and Burke, p. 92). Some of his flower paintings were reproduced as chromolithographs by Louis Prang and Company of Boston.

BIBLIOGRAPHY: Henry T. Tuckerman, *Book of the Artists* (New York, 1867), pp. 450–451. Provides early critical appraisal // Clara Erskine Clement and Laurence Hutton, *Artists of the Nineteenth Century and Their Works* (Boston, 1890), 2, p. 32. Provides early biography // William H. Gerdts and Russell Burke, *American Still-life Painting* (New York, 1971), pp. 90–95. Most extensive discussion of the artist's relation to the still-life tradition.

Lambdin, *Roses*.

Roses

Like so many of Lambdin's pictures, this painting is executed on a surface prepared with black lacquer. The original gilt and black frame of the picture has simplified floral motifs that harmonize with the background and the imagery of the painting. Lambdin clearly intended to create a highly decorative object and one cannot help but compare it to oriental lacquer work. He may well have been influenced by the art exhibited at the Japanese pavilion at the Centennial Exposition in Philadelphia in 1876, which created a sensation.

Flower paintings were very popular during the Victorian period. In Pre-Raphaelite fashion Lambdin has chosen to depict the roses growing. Initially he used a white or neutral ground in his works but then changed to the unmodulated black that is so dramatic a foil for the delicate colors of flowers. The roses in this picture are pale yellow, white, and orange.

Roses were Lambdin's favorite flower. He was not, however, interested in their symbolic meaning. His appreciation was scientific, aesthetic, and perhaps somewhat sentimental. He wrote:

There is probably no inanimate object in the world more beautiful than a delicately tinted Rose. There is certainly nothing else which combines such beauty

of form and color with such exquisite delicacy of texture and such delicious perfume. . . . The charm seems to me to lie, in great part, in the fine silky texture of the petals and in their translucency. . . . It is the charm which it shares with every beautiful thing which is "hidden yet half revealed" (*Art Union* I [June–July 1884], p. 137).

Oil on wood, 24 × 11⅞ in. (61 × 30.2 cm.).

Signed and dated at lower right: Geo. C. Lambdin. 78.

REFERENCES: F. Welcher, letter in MMA Archives, July 13, 1918, provides information on ownership.

EX COLL.: Samuel P. Avery, New York, d. 1904; his daughter, Fanny (Mrs. Manfred P.) Welcher, 1918.

Gift of Mrs. Manfred P. Welcher, 1918.
18.116.

ALBERT BIERSTADT

1830–1902

Beginning with the first government survey expedition of 1819, the American frontier west of the Mississippi was explored, scientifically documented, and carefully illustrated. Images of the vast wilderness became metaphorical expressions for the exploration of the continent. Albert Bierstadt, in his enormous mountain landscapes, captured the heroic grandeur and sweeping panoramas of the American West. Bierstadt was born in Solingen, near Düsseldorf, Germany, and came to the United States at the age of one. His family settled in New Bedford, Massachusetts. Little is known about his early life, but by 1850 he was offering instruction in "monochromatic painting" to the citizens of New Bedford. According to the critic Henry T. Tuckerman: "The future artist had frequently executed clever sketches in crayon; but it was not until 1851, when he was in his twenty-third year, that he began to paint in oils, and determined to earn the means of visiting his native city, Düsseldorf, and his eminent cousin [Johann Peter] Hasenclever, whose unique genre pictures have been so popular in this country" (p. 387).

By 1853 Bierstadt was in Düsseldorf, but Hasenclever's recent death left him to seek direction from his American colleagues there, EMANUEL LEUTZE and WORTHINGTON WHITTREDGE. He was soon sharing a studio with Whittredge, who had developed a close association with the eminent German landscape painter Carl Friedrich Lessing. Bierstadt gradually absorbed the manner of Lessing's circle and of other contemporary German artists like Andreas Achenbach, emulating the dry, highly finished style of their heroic landscape paintings. Under this influence, he developed the working procedure that he used throughout his career: collecting numerous studies on his sketching trips, he later developed them into large finished compositions in the studio. In 1856 he spent time painting in Rome with Whittredge and then traveled through the mountains of Germany, Switzerland, and Italy before returning to the United States in the autumn of 1857. In April of the following year he sent his first entry to the National Academy of Design—*Lake Lucerne*, 1856 (coll. Jo Ann and Julian Ganz, Jr., Los Angeles). With the spectacular Alpine scenery fresh in his mind, Bierstadt resolved to see what comparable views the American frontier might offer. By 1859 he had joined an expedition led by Colonel Frederick W. Lander to survey and improve

the existing overland route from Fort Laramie, Wyoming, to the Pacific Coast. On July 10, 1859, in a letter to the *Crayon*, posted from the Rocky Mountains, Bierstadt expressed his enthusiastic reaction to the Wind River Range in Wyoming: "The mountains are very fine; as seen from the plains, they resemble very much the Bernese Alps, one of the finest ranges of mountains in Europe, if not in the world. They are of a granite formation, the same as the Swiss mountains and their jagged summits, covered with snow and mingling with the clouds, present a scene which every lover of landscape would gaze upon with unqualified delight" (6 [Sept. 1859], p. 287).

Bierstadt made his customary sketches of the surroundings and, in addition, inspired perhaps by the photographic experiments of his two brothers Charles and Edward, made many stereoscopic views of the wilderness and the Indian inhabitants. Upon his return East, he went to live in New York, where he opened a studio in the popular Tenth Street Studio Building. He began the first series of sweeping western landscapes, among them *The Rocky Mountains, Lander's Peak* (q.v.). These works were often compared to those of FREDERIC E. CHURCH; for both artists presented the landscape as a theatrical panorama, unified by dramatic lighting. But Bierstadt's style had little to do with Church's detailed naturalism. Instead he combined the stylistic conventions of contemporary German landscape painting with the spatial relationships he observed in photography. His compositions were loosely based on both plein-air sketches and stereoscopic views. The drama of his mountain scenes was produced by skillful manipulation of perspective in which he frequently eliminated the middle ground and treated in detail only the genre elements in the foreground. At the National Academy of Design in 1860, Bierstadt exhibited one of his enormous pieces, *The Base of the Rocky Mountains, Laramie Peak* (now unlocated). Although the painting established the artist as the foremost painter of the American frontier, its impact on the public was reduced by the initial turmoil of the Civil War. He continued to produce western panoramas and sought new subject matter in the White Mountains of New England and at the battle sites of the war. His first significant public success was scored with *Sunshine and Shadow*, 1862 (coll. Mrs. John D. Rockefeller), based on an early European study, revamped for the National Academy of Design show in 1862. His interest in the West continued, and in 1863 he made a second trip, accompanied by the author Fitz Hugh Ludlow, to the Pacific Northwest. Bierstadt was intent on reaching the Yosemite Valley, the magnificent peaks of which had recently appeared in the photographs of Carleton E. Watkins. The valley was the highlight of the journey and inspired a new series of landscapes that included *The Valley of the Yosemite*, 1864 (MFA, Boston), and *Merced River, Yosemite Valley*, 1866 (q.v.).

By 1864, Bierstadt's vision of the American wilderness had captured the imagination of the public, and he was hailed as the preeminent American landscape painter. This was due in part to the reception of *The Rocky Mountains, Lander's Peak*, which caused a sensation when it was exhibited in New York in 1864 at the Seitz and Noelle Gallery and at the United States Sanitary Fair where it was one of the focal points of the exhibition. The public demand for similar subjects was soon satisfied by the painter's rapid, almost mechanical productions. He gained financial success, which enabled him to build a thirty-five-room mansion on the Hudson in Irvington, New York, named Malkasten after the artists' club in Düsseldorf. In 1867 he went to Europe, commissioned by the United States government to

paint *The Discovery of the Hudson*, 1875 (U.S. Capitol, Washington, D.C.). He stayed abroad for two years, and during this period was awarded the French Legion of Honor and the Russian Order of St. Stanislas. Back at home, however, the popularity of his work declined. The size of his now even larger canvases was criticized as taste shifted to the new impressionist style popularized by the French. Bierstadt's travel was increasingly limited by the ill-health of his wife, the former Rosalie Osborne whom he married in 1886. By 1889 his work had fallen so out of favor that his canvas *The Last of the Buffalo*, 1888 (Corcoran Gallery of Art, Washington, D.C.), was rejected by the selection committee of the Exposition Universelle on the grounds that it was out of keeping with the developing French influence on American painting. The subject of the work, however, did prompt the first official census of America's remaining buffalo and their subsequent protection.

The decline in Bierstadt's popularity was accompanied by several misfortunes: the burning of Malkasten in 1882, the death of his wife in 1893, and bankruptcy in 1895. In the 1890s his support for a National Academy of Art in Washington may have first brought him together with the widow of David Stewart, the millionaire banker. Bierstadt's marriage to Mary Hicks Stewart in 1894 gave him a more comfortable life and the time to devote to the promotion of inventions, including his own designs for improved railway cars and those of the philosopher and logician Charles Sanders Peirce. During this period, Bierstadt made yearly trips abroad and continued to paint. By 1897, however, he had closed his Broadway studio and was working at home on Fifth Avenue. He died in New York in 1902.

BIBLIOGRAPHY: Henry T. Tuckerman, *Book of the Artists* (New York, 1867), pp. 387–397. A contemporary discussion of the artist and his approach to nature // John I. H. Baur, ed., "The Autobiography of Worthington Whittredge," *Brooklyn Museum Journal* (1942), pp. 26–28, 32. Gives details of Bierstadt's period of study in Düsseldorf // Gordon Hendricks, "The First Three Western Journeys of Albert Bierstadt," *Art Bulletin* 46 (Sept. 1964), pp. 333–365. The most complete discussion of Bierstadt's western subjects // Elizabeth Lindquist-Cock, "Stereoscopic Photography and the Western Paintings of Albert Bierstadt," *Art Quarterly* 33 (1970), pp. 361–378. The best discussion of the relationship of photography to the artist's paintings // Gordon Hendricks, *Albert Bierstadt* (New York, 1974). The most complete treatment of his life and works.

The Rocky Mountains, Lander's Peak

This painting is the major work that resulted from Bierstadt's first trip west. His intention to create panoramic views of the American frontier was apparent by December 1858 when it was noted in a letter to the *Crayon* that he was about to start "for the Rocky Mountains" to make "sketches of the scenery," and study "the manners and customs of the Indians preparatory to painting a series of large pictures" (6 [Jan. 1858], p. 26). Several months later, he accompanied the government survey expedition, headed by Frederick W. Lander, to the Nebraska Territory. By summer, the party had reached the Wind River Range of the Rocky Mountains in what

is now Wyoming. Lander's Peak is actually Frémont's Peak.

By the end of 1859, Bierstadt had returned to New York with his sketches, stereographs, and a collected assortment of tribal artifacts. He began to create his initial views of the massive wilderness. The first of these, *The Base of the Rocky Mountains, Laramie Peak* (unlocated), *Wind River Country*, 1860 (coll. Britt Brown, Wichita), and *Wasatch Mountains, Wind River Country, Wyoming*, 1861 (New Britain Museum of American Art), were landscapes done in the crisply meticulous Düsseldorf style. They were characterized by romantic and breathtaking mountain vistas. At the same time, Bierstadt painted a series of substantially smaller canvases, including *The*

Wolf River, Kansas, 1859 (Detroit Institute of the Arts), and *Indian Encampment, Shoshone Village*, 1860 (NYPL, on permanent loan NYHS), in which he focused on Indian genre scenes. He then produced a very large landscape with Indians — *Sunset Light, Wind River Range of the Rocky Mountains*, 1861 (Free Public Library, New Bedford, Mass.), which can be viewed as a precursor of *The Rocky Mountains, Lander's Peak*. Like the Metropolitan picture, *Sunset Light* depicts a Shoshone Indian encampment on the Green River, at the base of the snowcapped peaks of the Wind River Mountains. Besides the subject and location, the overall composition and other details are very similar. *The Rocky Mountains, Lander's Peak*, however, is about six feet by ten feet, twice the size of *Sunset Light*. The enormous size of the work probably reflects Bierstadt's attempt to compete with FREDERIC E. CHURCH'S *Heart of the Andes* (q.v.), which had been such an immense success only a few years before.

To create the dramatic background of the painting, Bierstadt embellished the mountains. He developed the middle ground, enlarging the central waterfall and river to create a transition from background to foreground. His effective spatial arrangement was largely due to his skillful use of strong accents of light, which the Düsseldorf artists used to insure convincing perspective. Despite such techniques, however, the highly finished foreground did not seem compatible with the more crudely painted background. James J. Jarves observed in 1864 that the painting was "liable to artistic objection of two pictures in one, from different points of view." That same quality, however, appealed to others.

One small preliminary study for the overall composition (coll. A. Dean Larsen, Provo, Utah) indicates that Bierstadt began with a simpler conception of the work, one without the Indian scenes in the foreground. To produce the foreground vignettes of Indian life, he relied on sketches such as *Indian Amulet*, 1859 (private coll.), stereographs like those of the Shoshone children in the New-York Historical Society, and the Indian artifacts he kept in his studio. This plethora of detail was deplored by the critic for the *Round Table* (1864), who declared:

Mr. Bierstadt's subject, in treatment, is marred in its impression of solitary grandeur by the introduction of an Indian encampment in the foreground. For an incident which is merely one of the accidents of the place, the artist has sacrificed the greatest element of his subject; he has sacrificed sublimity of impression to variety of interest.

Such criticism was not without some validity.

The picture was completed early in 1863. It was exhibited in Bierstadt's New York studio on February 2 and shown in Boston in April. By March of the following year, it was back on exhibition in New York at the Seitz and Noelle Gallery. In April it was included in the Metropolitan Fair, where it hung opposite Church's *Heart of the Andes* (q.v.). In another part of the fair, a display of Indian life was arranged by Bierstadt.

Detail of James Smillie, engraving of Bierstadt's *The Rocky Mountains, Lander's Peak*, MMA.

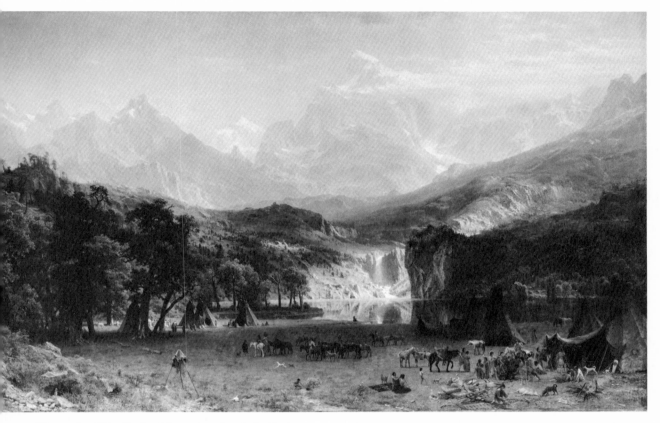

Bierstadt, *The Rocky Mountains, Lander's Peak*.

Bierstadt's *The Rocky Mountains, Lander's Peak* on view at the Metropolitan Fair in 1864. Photograph courtesy of NYHS.

Authentic wigwams were set up before a painted backdrop, and Indians demonstrated their native activities and dances. *Harper's Weekly* reported the overwhelming public response: "In the Fourteenth Street Building Bierstadt's Indian Wigwam has been constantly crowded with visitors desiring to study the habits and peculiarities of the aborigines. Several entertainments have been given daily."

Such celebrity established Bierstadt as the foremost painter of the American frontier, and *The Rocky Mountains, Lander's Peak* remained a paradigm of American subject matter for many years. The critic Henry T. Tuckerman wrote of it (1866): "No more genuine and grand American work has been produced in landscape art than Bierstadt's 'Rocky Mountains.' Representing the sublime range which guards the remote West, its subject is eminently national."

The painting was bought in 1865 by James McHenry, an American living in London. The price reportedly paid for the picture, $25,000, was probably the highest ever paid at that time for an American painting. In 1898 Bierstadt bought the picture back and either gave or sold it to his brother Edward.

Oil on canvas, 73½ × 120¾ in. (186.7 × 306.7 cm.).

Signed and dated at lower right: ABierstadt/ 1863.

RELATED WORKS: Study for *The Rocky Mountains*, oil on canvas, 7¼ × 10 in. (18.4 × 25.4 cm.), ca. 1863, coll. A. Dean Larsen, Provo, Utah, ill. in *The Hudson and the Rhine*, exhib. cat. (1976), fig. 12 // *Sunset Light, Wind River Range of the Rocky Mountains*, 1861, oil on canvas, 39 × 60 in. (99.1 × 152.4 cm.), Free Public Library, New Bedford, Mass., ill. in G. Hendricks, *Albert Bierstadt* (1972), p. 149, no. 106 // *Indian Amulet*, oil on paper, 5 × 4⅜ in. (12.7 × 11.1 cm.), 1859, private coll., ill. ibid., p. 149, no. 106 // Attributed to Bierstadt, *Shoshone Warrior, Nebraska*, stereograph, 1859, Kansas State Historical Society, Topeka, ill. ibid., p. 67, no. 44 // Attributed to Bierstadt, *Shoshone Children*, stereograph, 1859, NYHS, ill. ibid., p. 67, no. 43 // Attributed to Bierstadt, *Ogalillah Sioux, Horse Creek, Nebraska*, stereograph, 1859, NYHS, ill. ibid., p. 67, no. 42 // Attributed to Bierstadt, *Sioux Village Near Ft. Laramie, Nebraska*, stereograph, 1859, NYPL, ill. in W. Naef and J. Wood, *Era of Exploration*, exhib. cat. (1975), p. 31 // James Smillie, *Rocky Mountains, Lander's Peak*, engraving, (sheet) 29½ × 39⁹⁄₁₆ in. (74.9 × 100.5 cm.), ca. 1864–1867 (MMA has copy colored by Bierstadt, 1974.211) // G. B. Collins, copy after Bierstadt's *Rocky Mountains, Lander's Peak*, oil on canvas, 26 × 45 in. (66 × 114.3 cm.), coll. Betty Hoag McGlynn, San Mateo, Calif. // J. Hagny, copy after Bierstadt's *Rocky Mountains, Lander's Peak*, oil on canvas, 25 × 36 in. (63.5 × 91.4 cm.), 1869, unlocated, ill. in Edward Eberstadt and Sons, New York, *American Paintings* (1858), sale cat., no. 146, fig. 75 // Chromolithograph attributed to Prang, trial proof before letters, MMA, 49.40.260.

REFERENCES: *New York Daily Tribune*, April 4, 1863, p. 2, reports that Bierstadt "is said to have refused $10,000. for his Rocky Mountain landscape" (probably this picture) // *Round Table* 1 (Feb. 27, 1864), p. 169, refers to the work on exhibition at the Seitz and Noelle Gallery, New York, as "Lander's Pass," says that it "has been exhibited in most of the important cities and towns of the Eastern and Middle States," and that it was "well received in New England," describes the painting and criticizes its Indian scene (quoted above); (March 5, 1864), p. 184, men-

tions a reception at Dodsworth's Studio Building Association on March 2, 1864, at which "Mr. Smillie was represented by a very fine and complete drawing in India ink, after Bierstadt's 'Rocky Mountains' (probably the preparatory drawing for Smillie's engraving of the picture) // *New York Herald*, April 5, 1864, p. 3, reported that the work on exhibition at the fair was accompanied by "a few hundred curiosities, including a large wigwam, in which the red men of the forest live" // *New York Times*, April 6, 1864, p. 3, reviewing the Sanitary Fair, commented that the work and Church's Heart of the Andes would "retain their reputation better if they had not intruded into the presence of so much splendid art as everywhere surrounds them" // *New Path* 12 (April 1864), pp. 160–161, describes the furor generated by the work during its earlier exhibition in Boston, and criticizes its scale as "too pretentious" // *Harper's Weekly* 8 (April 23, 1864), p. 260, describes the Indian performances that accompanied the Metropolitan Fair exhibition of the painting (quoted above) // *Our Daily Fare* [Philadelphia] 9 (June 1864), p. 69, describes the work on exhibition // J. J. Jarves, *The Art Idea* (1864), p. 92; (1877 ed.), p. 234, criticizes the work (quoted above) // *New York Evening Post*, March 30, 1866, [p. 4], notes "Mr. Bierstadt has recently sold his 'Rocky Mountains' to an English collector (Mr. McHenry) for $25,000" // H. T. Tuckerman, *Galaxy* 1 (August 15, 1866), p. 682, praises the subject (quoted above) // *American Art Journal* (1866), p. 190, describes the painting at length, calling it "a production of transcendent merit" // H. T. Tuckerman, *Book of the Artists* (1867), p. 393, says the work belongs to James McHenry of London and cost $25,000; pp. 395–396, indicates the national character of the work and describes it // F. Leslie, *Reports of the United States Commissioners to the Paris Universal Exposition, 1867* (1870), p. 12, describes the painting // F. A. Walker, ed. *United States Centennial Commission, International Exhibition, 1876 Reports and Awards* (1880), p. 633, Report of the judges, submitted to John F. Weir, says the work gave Bierstadt his reputation and is of "exceptional power" // G. W. Sheldon, *American Painters* (1879), p. 146, erroneously reports that the work was first exhibited at the Sanitary Fair in 1863 // S. G. W. Benjamin, *Art in America* (1880), pp. 7–8, says it is "difficult to understand" why the public is ecstatic over the work // M. Bierstadt to Sir C. P. Clarke, Sept. 14, 1906, MMA Archives, says the work remained in the possession of James McHenry until his death // *MMA Bull.* 2 (1907), p. 109, indicates the work was sold to McHenry for $25,000 // *Bookman* 31 (April 1910), ill. p. 157; p. 158, discusses it and describes Bierstadt as "the pictorial historian of the Rocky Mountains" // *Mentor* 1 (August 11, 1913), ill. p. 4 // *Arts and Decoration* 6 (Nov. 1915), ill. p. 11, discusses the work // L. Goodrich, *Arts* 8 (Nov. 1925), ill. p. 248 // B. P. Draper, *Art in America* 28 (April 1940), p. 62, discusses the work // J. I. H. Baur, ed., *Brooklyn Museum Journal* 1 (1942), p. 26, Worthington Whittredge in his "Autobiography" refers to the artist as having "afterward sold his 'Recollections of the Rocky Mountains' for $30,000" (probably this picture) // E. P. Richardson, *American Romantic Painting* (1944), p. 25, no. 204 // C. E. Sears, *Highlights among Hudson River Artists* (1947), pp. 147–148, mentions sale of the work to McHenry // R. B. Hale, *MMA Bull.* 12 (1954), p. 172 // E. P. Richardson, *Painting in America* (1956), p. 230, calls the work "melodramatic" // J. T. Flexner, *Antiques* 82 (Oct. 1962), ill. p. 403; p. 404, discusses and says that it set the artist up "in competition with Church as America's most successful painter of showpieces"; *That Wilder Image* (1962), ill. p. 295; p. 296, says that the Indians "needed only a change of costume to be quaint Westphalian peasants" // *Kennedy Quarterly* 5 (1964), p. 15 // G. Hendricks, *Art Bulletin* 46 (Sept. 1964), p. 338, discusses the painting and says the artist did sketches for it on his 1859 trip west; p. 354, no. 13, lists the work in a catalogue of "Pictures Assumed to Have Resulted from Bierstadt's Western Journeys"; fig. 2 // D. C. Huntington, *Landscapes of Frederic Edwin Church* (1966), p. 89, discusses competition between Bierstadt and Church; fig. 70 // B. Novak, *Art in America* 59 (March–April 1971), p. 67, discusses the relationship of the painting to popular panoramas and Church's Heart of the Andes; ill. p. 73 // G. Hendricks, *Antiques* 102 (Nov. 1972), pp. 893–898, discusses the exhibition of the painting at the Metropolitan Fair in 1864; p. 896, color pl. II // E. Parry, *Image of the Indian and the Black Man in American Art* (1974), pp. 115–117, quotes reviews of the work from 1864 exhibitions and discusses the Indian show that accompanied the exhibition // G. Hendricks, *Albert Bierstadt* (1974), p. 9, discusses various attitudes toward the work and indicates that the artist "was able to transmit to them [the public] his own love of nature"; p. 90, calls the work Bierstadt's "most celebrated depiction of the Wind River Range"; p. 94, cites the confusion of titles between this work and Bierstadt's *The Base of the Rocky Mountains, Laramie Peak* (now lost); p. 113, quotes from an unidentified clipping calling the artist "the acknowledged Prince of mountain regions" and notes a reception at Dodsworth's on March 18, 1863; p. 116, indicates the work was sent to Boston after being shown briefly at the artist's studio and at Dodsworth's in the spring of 1863; p. 134; pp. 140–160, in an in-depth discussion of the painting, says Smillie may have begun work on the engraving in March of 1864 but did not produce the final engraving until early 1867, mentions that McHenry bought the work and that Bierstadt went to visit him in London in 1867; ill. p. 149, shows studies for the work; pp. 150–153, fig. 108, 109, 110, shows details; p. 179; p. 233; p. 258, reports that Bierstadt saw the work at McHenry's in London in June of 1878; p. 261, quotes reviews of the work from the late 1870s; p. 277, says the Rev. Henry Whitney Cleveland called it in 1883 one of the "truly great

Bierstadt, *Study of a Tree.*

Study of a Tree

Throughout his career Bierstadt created his dramatic canvases of the American wilderness in his studio, drawing from the scores of studies he collected on his trips. Following his western journey of 1863, his traveling companion, the journalist and author Fitz Hugh Ludlow, recorded Bierstadt's particular fascination with what he referred to as the "Big Tree." He recalled how their party had stopped frequently in its wanderings to "get a capital transcript of the Big Tree's color,—a beautiful cinnamon-brown" and "of their typical figure, which is a very lofty, straight, and branchless trunk, covered almost at the summit by a mass of colossal gnarled boughs, slender plumy fronds" (*Atlantic Monthly* 13 [June 1864], p. 745).

This study of the trunk of a tree is undoubtedly one of the artist's many wilderness sketches and reveals an unusual degree of freedom when compared with his precise, carefully manipulated, finished compositions. Bierstadt apparently produced many such studies of flora and fauna, allowing himself fifteen minutes for each one, and frequently improvising the color.

Oil on paper, backed by board, 9¼ × 7⅞ in. (23.5 × 20 cm.).

EXHIBITED: Florence Lewison Gallery, New York, 1964, *Man, Beast and Nature,* no. 6.

EX COLL.: the artist's wife, Mary Bierstadt, New York, d. 1916; with H. D. G. Rohlfs, Jr., Brooklyn; with Florence Lewison Gallery, New York; Mr. and Mrs. Maurice Glickman, New York, 1976.

Gift of Mr. and Mrs. Maurice Glickman, 1976.

1976.337.

landscapes of our country," fig. CL-170, catalogues work // B. Novak, *Artforum* 14 (Oct. 1975), p. 41 // *MMA Bull.* 4 (Winter 1975–1976), pp. 212–213, ill. no. 55 // N. Anderson, Washington, D. C., letter in Dept. Archives, Sept. 1984, supplies information on the history of the painting.

EXHIBITED: the artist's studio, New York, Feb. 1863 // Studio Building, Boston, April 1863 // Brooklyn, Feb. 1864 // Seitz and Noelle Gallery, New York, 1864 // Philadelphia, June 1864, *Great Central Fair,* no. 84, lent by Emil Seitz // New York, 1864, *Metropolitan Fair for the Benefit of the United States Sanitary Commission,* no. 50, lent by Emil Seitz // Buffalo, Academy of Fine Arts, July 1864 // McLeans Gallery, London, 1866 // Paris, 1867, *Exposition Universelle,* no. 4 // MMA, 1965, *Three Centuries of American Painting* (checklist alphabetical); 1970, *19th Century America, Painting and Sculpture,* exhib. cat. by J. K. Howat and N. Spassky, ill. no. 121, describe the Indians as Shoshones, camped "near the headwaters of the Green River."

EX COLL.: with Emil Seitz, Seitz and Noelle Gallery, New York, by 1864; James McHenry, London, 1866–1898; Edward Bierstadt (the artist's brother), 1898–d. 1907; his daughter, Mary Adeline Bierstadt 1907.

Rogers Fund, 1907.

07.123.

Merced River, Yosemite Valley

On May 12, 1863, the *New York Evening Post* announced that Bierstadt had departed on a trip west: "He is accompanied by Fitz Hugh Ludlow, who, it is understood, will make copious notes of the tour, which, on his return, will be published in book form." The journey was Bierstadt's second venture west. His party headed for San Francisco, from where they would approach the Yosemite Valley. Ludlow later recorded their anticipation of the sublime scenery that awaited them in the valley:

If report was true, we were going to the original site of the Garden of Eden,—into a region which ... surpassed the Alps in its waterfalls, and the Him-

mal'yeh in its precipices . . . the superiority of the Yo-Semite to the Alpine cataracts was a matter put beyond doubt by repeated judgements (*Atlantic Monthly* 13 [June 1864], p. 740).

There is considerable indication that the initial impetus to visit the wilderness of Yosemite had come from Bierstadt's familiarity with the enormous-size stereoscopic photographs of Carleton E. Watkins, who had recorded the valley's magnificent peaks under various atmospheric conditions in 1861. Apparently Watkins's photographs had reached the New York galleries before the Bierstadt expedition left; for Ludlow recounted how the pioneering photographer's "giant domes and battlements" of Yosemite had caused "exclamations of awe at Goupil's window," and that both he and Bierstadt "had gazed upon them by the hour" (ibid., p. 476).

In August of 1863, the party reached Yosemite and made their first camp in a "green meadow, ringed by woods, on the banks of the Merced" (ibid., p. 479). This spot on the Merced River, the largest of the streams that flow through the Yosemite Valley, undoubtedly provided the inspiration for Bierstadt's *Merced River, Yosemite Valley*. Dated 1866, the painting is one of many similar subjects executed in the artist's New York studio from studies made dur-ing his 1863 trip. Ludlow described Bierstadt's procedure for collecting material for his series of Yosemite landscapes:

Sitting in their divine workshop, by a little after sunrise our artists began labor in that method which can ever make a true painter or a living landscape, *color*-studies on the spot; and though I am not here to speak of the results, I will assert that during their seven weeks' camp in the Valley they learned more and gained greater material for future triumphs than they had gotten in all their lives before at the feet of the greatest masters (ibid., p. 479).

Merced River, Yosemite Valley is not among the artist's most successful Yosemite compositions. It lacks the panoramic sweep of works like *The Domes of the Yosemite*, 1867 (Saint Johnsbury Athenaeum, Saint Johnsbury, Vt.), or the romantic drama of *Sunset in Yosemite Valley*, 1868 (Pioneer Museum and Haggin Galleries, Stockton, Calif.). There is, however, the juxtaposition of monumental jagged background peaks with a low, carefully detailed foreground that is common in Bierstadt's pictures. The pervasive attention to detail—especially evident in the tiny figures dotting the river bank and the gnarled pines—and the overall muted tonality of the landscape reveal his Düsseldorf training.

Bierstadt, *Merced River, Yosemite Valley*.

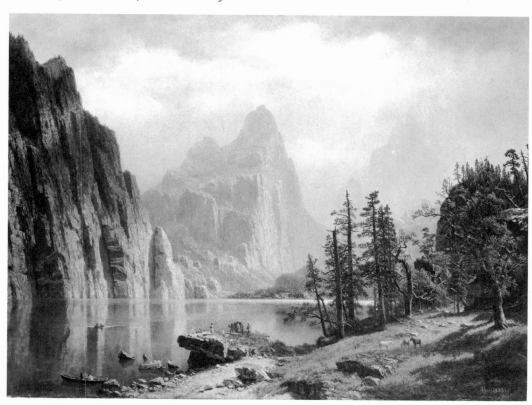

Oil on canvas, 36 × 50 in. (91.4 × 127 cm.).

Signed and dated at lower right: ABierstadt/ 1866.

Canvas stamp: PREPARED/BY ED^{WD} DECHAUX/NEW YORK.

REFERENCES: W. A. Paton, letter in MMA Archives, Dec. 23, 1909, says his father acquired the painting from the artist // *MMA Bull.* 5 (Feb. 1910), ill. p. 45: p. 46, announces its acquisition // MMA, *Catalogue of American Paintings* (1914), pp. 15–16, discusses the work // *Art and Archaeology* 20 (Nov. 1925), ill. on cover // B. P. Draper, *Art in America* 18 (April 1940), ill. p. 63; p. 65, mistakenly states that sketches for the work were done during the artist's first trip west // G. Hendricks, *Art Bulletin* 46 (Sept. 1846), p. 346, indicates that Bierstadt made studies for the painting during his visit to the Yosemite Valley in 1863; p. 356, no. 57, lists the work among pictures "Assumed to Have Resulted from Bierstadt's Western Journeys" // G. Hendricks, *Albert Bierstadt* (1974), no. CL-171, ill., indicates "Merced River, Yosemite Valley" is not the correct title for the work // M. Brown, *American Art to 1900* (1976), color ill. p. 341, no. 41.

EXHIBITED: Dallas Museum of Fine Arts, 1922, *American Art from the Days of the Colonists to Now*, no. 21 // Corcoran Gallery of Art, Washington, D.C., and Grand Central Art Galleries, New York, 1925–1926, *Commemorative Exhibition by the Members of the National Academy of Design*, ill. p. 91, no. 58 // Newark Museum, 1930–1931, *Development of American Painting, 1700–1900* (no. cat.) // College Art Association, New York, 1934, *American Painters Memorial Exhibition since 1900*, no. 5 // Union League Club, New York, 1935, *Paintings by American Artists*, no. 3 // Virginia Museum of Fine Arts, Richmond, 1936, *Main Currents in the Development of American Painting*, ill. no. 49 // MMA, 1965, *Three Centuries of American Painting*, checklist alphabetical // Los Angeles County Museum of Art and M. H. de Young Memorial Museum, San Francisco, 1966, *American Paintings from the Metropolitan Museum of Art*, exhib. cat. by L. Curry, no. 45, p. 13, discusses the painting in relation to the artist's Düsseldorf training // High Museum of Art, Atlanta, 1971, *The Beckoning Land*, pp. 16–17; no. 54, ill. p. 75.

ON DEPOSIT: White House, Washington, D.C., 1971–1974.

EX COLL.: William Paton, New York, 1866–d. 1890; his sons, William Agnew, David, and Stewart, 1909.

Gift of the sons of William Paton, 1909.

09.241.1.

Rocky Mountain Goats

Bierstadt's interest in the undisturbed wilderness of the American frontier included the careful recording of its native animals. On each of his expeditions west he made numerous detailed studies of buffalo, moose, antelope, deer, coyote, and sheep. Since few of the sketches are dated, it is difficult to assign them to specific trips or locations. Beginning in the late 1870s, however, the artist produced entire compositions structured around animals. In 1876 he was commissioned by Wyndham Thomas Wyndham-Quin, the fourth earl of Dunraven, a noted sportsman and politician, to paint Longs Peak in Estes Park, Colorado, a favorite hunting ground for big game. Late that same year, Bierstadt accompanied Dunraven on a trip to hunt moose in Colorado and there sketched the rapidly vanishing prey. Some of those sketches, notably *The Mountain Sheep*, were later used by A. Pendarves Vivian, Dunraven's brother-in-law, as illustrations for his travelogue *Wanderings in the Western Land* (1879). Bierstadt apparently transposed several of the illustrations into fully realized canvases; for the *Art Union* of April 1884 reproduced a slightly altered version of *The Mountain Sheep*, entitled *Rocky Mountain Sheep*, done in oil, with the caption:

Mr. Bierstadt's painting . . . gives a graphic idea of the peculiar species of wild or mountain sheep found throughout the Rocky Mountains and Sierra Nevadas No peak is too high, no pinnacle of rock too steep to be surmounted by these surefooted beasts With his well known love of the sublime in nature, Mr. Bierstadt has done well to go up among

Bierstadt, *Rocky Mountain Goats.*

the clouds and eternal snows of the American Alps to depict for us these hardy climbers in their chosen haunts (p. 1).

Rocky Mountain Goats appears to be closely related to the painting reproduced in the *Art Union*. In the Metropolitan picture, however, the variety of animal is slightly different and is more likely the *Oreamnos montanus*, a goat which inhabits the higher slopes of the Canadian and northern Rockies, remaining above the timberline. Both paintings present the animal perched dramatically atop a rocky crag, surrounded by towering peaks. But *Rocky Mountain Goats* is a much less spontaneous composition and was probably executed in the artist's New York studio in the mid–1880s, based on earlier studies. The central animal is stiff and lifeless, posed like the stuffed goat Bierstadt kept in his studio. The surrounding herd seems equally staged. A melodramatic play of clouds dominates the background.

Oil on canvas, 49¾ × 43 in. (126.4 × 109.2 cm.). Signed at lower left: ABierstadt.
REFERENCES: G. Hendricks, *Art Bulletin* 46 (Sept. 1964), p. 363, lists no. 247, *The Mountain Sheep*, location unknown (possibly this picture).
Ex COLL.: John Divine Jones, New York, before 1889; his wife, Mrs. John Divine Jones, New York; Louise Floyd Jones (Mrs. Condé Raguet Thorn), d. 1961; her daughter Mrs. Delancey Thorn Grant, about 1950 until 1964.
Anonymous Gift, subject to life a estate in the donor, 1964.
64.191.

Sunrise on the Matterhorn

Bierstadt's first exposure to the sublime mountain vistas of Switzerland occurred at the close of his studies in Düsseldorf. In the summer of 1856, he joined several American colleagues, including WORTHINGTON WHITTREDGE, WILLIAM STANLEY HASELTINE, and ENOCH WOOD PERRY for several weeks' sketching in Germany, Switzerland, and Italy. His fascination with the Swiss terrain is witnessed by the scores of studies he executed during that trip and the resultant painting, *Lake Lucerne*, 1856 (coll. Jo Ann and Julian Ganz, Los Angeles), which was the first picture he exhibited at the National Academy of Design (1858).

Throughout his career, Bierstadt periodically returned to Switzerland in search of inspiration

Bierstadt, *Sunrise on the Matterhorn.*

and new subject matter. In June of 1867, he began a two-year European visit, during which he spent considerable time in Switzerland, making "almost fifty splendid studies" of the Jungfrau (R. O. Mayer to Mrs. R. O. Taggart, June 21, 1947, Archives of the MFA, Boston). Again, in 1878, he returned to Europe, although there is no firm evidence that he included the Alps in his itinerary. Six years later, in 1884, he again spent an extended period in the Swiss mountains. The summers of 1895, 1896, and 1897 saw him repeat the pilgrimage.

Bierstadt rarely exhibited his Alpine subjects at the National Academy of Design, although in 1885 he did enter a work entitled *Valley of Zermatt, Switzerland* (unlocated). His practice of reusing old outdoor studies to create new compositions in his studio makes it difficult to assign *Sunrise on the Matterhorn* to a specific date or European trip. The stamp on the stretcher has a patent date of January 9, 1875, indicating that the work was executed after that time. Gordon Hendricks dated the subject sometime after 1880.

In composition and style, the painting is not unlike one Bierstadt gave his wife for Christmas in 1895, *The Morteratsch Glacier, Upper Engadine, Pontresina* (Brooklyn Museum).

With the exception of *The Morteratsch Glacier*, none of Bierstadt's major Alpine paintings, *Mont Blanc* (Amon Carter Museum of Western Art, Fort Worth), *View of the Wetterhorn, from Grindelwald* (Fine Arts Gallery of San Diego), or *The Matterhorn* (Dallas Museum of Fine Arts) are dated. Of these, the last, although quite small and painted on paper, bears a striking resemblance to *Sunrise on the Matterhorn*. Both works present the cloud-enveloped peak in the distance, strikingly juxtaposed with a low rocky foreground. In the Metropolitan picture, however, the composition is focused on the vertical thrust of the mountain, reinforced by the towering pines that dominate the left foreground. The middle ground is radically accordionized, heightening the dramatic effect of the towering sunlit mountain and repeating a compositional device used in many of Bierstadt's western landscapes.

Oil on canvas, 58½ × 42⅝ in. (148.6 × 108.3 cm.). Signed at lower left: ABierstadt.

Stamp on stretcher: Wright & Gardner's / Improved Canvas Stretchers'/PAT JAN 9th 1875.

RELATED WORKS: *The Matterhorn*, oil on paper mounted on canvas, 21½ × 29½ in. (54.7 × 74.9 cm.), Dallas Museum of Fine Arts, ill. in G. Hendricks, *Albert Bierstadt* (1974), CL-234.

REFERENCES: G. Hendricks, note in Dept. Archives, 1971, suggested that the painting was done after one of Bierstadt's European trips of 1878 or 1887–1888; *Albert Bierstadt* (1974), ill. CL-234.

EXHIBITED: Bronx County Courthouse, New York, 1971, *Paintings from the Metropolitan*, exhib. cat. by J. Pilgrim, no. 17, dates the work ca. 1880 // Dallas Museum of Fine Arts, 1971, *The Romantic Vision in America*, no. 46.

EX COLL.: Mrs. Karl W. Koeniger, 1966.

Gift of Mrs. Karl W. Koeniger, 1966.

66.114.

GEORGE HENRY YEWELL

1830–1923

A member of the close-knit colony of American artists in Rome after the American Civil War, Yewell painted genre scenes, landscapes, and the interiors of buildings. In his later years in New York, he concentrated on portraits. He also made etchings of old doorways, shadowy entrances, and porticos. A contemporary critic noted in 1877: "We think Mr. Yewell is more successful in his interiors than in his figure-pieces; he has the necessary delight in details which include color, the patience to represent them faithfully, and the intelligence which is able to combine all forms in a rich, quiet unity" (*New York Tribune*, April 28, 1877, p. 7).

Yewell was born in Harve de Grace, Maryland, in 1830. At the age of eleven he and his widowed mother moved to Iowa City, where as a youth he earned a local reputation as a clever caricaturist. Inspired by prints of THOMAS COLE's series of paintings *The Voyage of Life* (Munson-Williams-Procter Institute, Utica, N. Y.), Yewell turned to traditional subjects and methods. On the advice of Judge Charles Mason, an early patron who had been attracted by his caricatures in 1848, Yewell went to New York in 1851. There he studied with THOMAS HICKS and at the National Academy of Design. Yewell spent five years with Hicks who gave him a firm foundation in drawing and prepared him for study in Paris in 1856 at the famous atelier of Thomas Couture, where Hicks himself had been a student. Yewell spent much of his time in Paris in the galleries of the Louvre and the Luxembourg Palace, copying paintings by

the old masters. The great success of Yewell's copy of a painting by the contemporary artist Rosa Bonheur earned him the respect of his fellow artists. He returned to New York in 1861, and at the end of that year was elected an associate of the National Academy of Design. He became an academician in 1880. In the 1870s Yewell was also exhibiting now and then at the Paris Salon.

Yewell went back to Europe in 1867 with his wife, the former Mary Elizabeth (Mollie) Coast, and her young brother Oscar Regan Coast (1851-1931), who was studying with him. They stayed in Venice for several months and then settled in Rome, where they soon formed close friendships with a number of other young American artists, including ELIHU VEDDER and Charles C. Coleman (1840-1928), who had also recently arrived from New York. Yewell spent his summers and autumns near Vedder in the countryside outside Perugia. Also among Yewell's friends was the famed writer, traveler, and lecturer Bayard Taylor, whom he had met in Venice in 1867. When Taylor visited Rome in 1868, he became Yewell's eager student, and in subsequent years the two corresponded. Yewell went to Cairo in 1875 enticed by Taylor's letters praising the "wonderful interiors to paint" (Hansen-Taylor and Scudder, eds., p. 647).

In 1878 Yewell returned to New York, where he worked in the popular Tenth Street Studio Building and spent his summers at Lake George. His departure from Italy may have been precipitated by his wife's behavior, which had shocked the American community in Rome. The couple were divorced the following year, and Mollie Coast Yewell married the British artist Edwin Ellis, with whom she had been romantically involved for many years.

Yewell died at Lake George in 1923 at the age of ninety-three. Throughout his career he had maintained his connections with Iowa City, sent paintings there for exhibition, and returned in his later years to paint portraits of local celebrities. Nine of these portraits belong to the Iowa Historical Society in Des Moines. The University of Iowa holds the largest and most representative collection of paintings from all periods of Yewell's long career.

BIBLIOGRAPHY: Marie Hansen-Taylor and Horace E. Scudder, eds., *Life and Letters of Bayard Taylor* (Boston, 1885), 2. Includes letters from Taylor to Yewell // Obituaries: *American Art Annual* 20 (1923), p. 266, lists his most important works; *New York Times*, Sept. 27, 1923, p. 7 // Mildred Pelzer, "George H. Yewell," *Palimpsest* 11 (Nov. 1930), pp. 483–498. Early article published by the State Historical Society of Iowa based on its collection of Yewell's letters and papers // Oneita Fisher, "The Journals of George Henry Yewell," *Books at Iowa* 5 (Nov. 1966), pp. 3–10. An excellent article based on Yewell's journals in the State Historical Society of Iowa // "George Henry Yewell," 1978. A three-page biographical typescript supplied by the Iowa State Historical Society, Iowa City. Contains new information on his family and early life.

Convent near Rome

This view of the Roman campagna with Monte Soratte in the distance was a Christmas present in 1871 from George Henry Yewell to his friend the writer Bayard Taylor. According to the inscription, it was painted in Rome in 1870.

The artist has reduced the scene to geometric forms. He has emphasized this reduction by limiting his color range to muted tones, which he applied in almost square patches. The summary treatment and interest in the abstract qualities of light and shadow suggest both Yewell's plein-air execution of the painting and his acquaintance with Nino (Giovanni) Costa and the other Macchiaiolli. Opposed to the traditions of academic art, this group of contemporary Italian realists painted outdoors and sought to capture the fleeting impressions of nature.

Yewell, *Convent near Rome.*

Oil on canvas, 5½ × 9 in. (14 × 22.9 cm.).

Signed and dated at lower left: G. H. Y. Rome. 1870. Inscribed on torn label on back of frame: Convent near Rome: Mt. S . . . t in the distance. / Geo. H. Yewe[ll] / to his very dear friend Bayard Taylor / with "Merry Christmas." / Dec. 25th 1871.

Ex coll.: Bayard Taylor, 1871—died 1878; Susan Dwight Bliss, New York, by 1966.

Bequest of Susan Dwight Bliss, 1966. 67.55.1620.

Pulpit in Saint Mark's, Venice

The sensuous splendor of Saint Mark's Cathedral was a magnet for romantic artists. John Ruskin's popular *Stones of Venice*, written in 1853, augmented this attraction by praising the Byzantine architecture of Saint Mark's, the richly colored marbles and porphyry, and the sparkling mosaics.

George Yewell painted the cathedral several times around 1870. He described this picture in 1890 as one of his "best and most carefully painted studies made of St. Mark's Church, Venice." Yewell captured the warm glow of the cathedral interior in a muted haze of color. The view is from the crossing toward the eastern end of the north transept. The unusual and dramatic angle focuses on the double polygonal pulpit, which was composed in the fourteenth century from various earlier elements. The steps at the lower right lead up through the rood, or choir, screen into the sanctuary, where the service is performed. The screen is surmounted by a great cross and fourteen marble statues, four of which are visible in the painting. The entire group of statues, consisting of the Virgin, Saint John the

Evangelist, Saint Mark, and eleven Apostles, carved by Jacobello and Pier Paolo dalle Masegne in 1394, is considered a masterpiece of Venetian Gothic sculpture.

Yewell, *Pulpit in Saint Mark's Venice.*

This painting may be the *Intérieur de l'église de Saint-Marc à Venise* shown at the Paris Salon in 1872 or the *Interior of St. Mark's, Venice* shown at the annual exhibition of the National Academy of Design in 1877. More likely, however, it is the *Pulpit in St. Mark's Church, Venice* exhibited at the academy in 1879 and then in 1880 at the Metropolitan Museum. A painting entitled *Interior St. Mark's*, 1874, was in the collection of the Wadsworth Atheneum, Hartford, until 1950.

Oil on canvas, 21½ × 12⅞ in. (54.6 × 32 cm.).
Signed at lower left: Geo. H. Yewell.
REFERENCES: S. R. Gifford Journal, 3 (letter July 17, 1869), p. 121, D21, Arch. Am. Art, says that Yewell "is making a very fine study in the interior of St. Mark's" (possibly this painting) // D. M. Armstrong, 1874 letter in *Day before Yesterday* (1920), p. 256, says that Yewell's "things in the church here have in them such a look of marble and truth of color" // C. E. Clement and L. Hutton, *Artists of the Nineteenth Century* (1889) 2, p. 367, mentions that the artist sent Interior of St. Mark's, Venice for exhibition in New York in 1877 (possibly this painting) // G. H. Yewell, letter in MMA Archives, Nov. 12, 1890, offers it as a gift (quoted above) // *American Art Annual* 20 (1923), p. 266, mentions it in artist's obituary // M. W. Pelzer, *Palimpsest* 11 (Nov. 1930), p. 494, calls this "one of the finest of his many carefully executed and highly finished interiors" // Z. B. Ness and L. Orwig, *Iowa Artists of the First Hundred Years* (1939), p. 227 // M. Lovell, Fine Arts Museums of San Francisco, letter in Dept. Archives, July 9, 1984, supplies early references.

EXHIBITED: Paris Salon, 1872, no. 1532, as Intérieur de l'église de Saint-Marc à Venise (Italie) (possibly this painting); NAD, 1877, as Interior of St. Mark's, Venice, no. 542 (possibly this painting); 1879, no. 356, as Pulpit in St. Mark's Church, Venice, $650 (probably this painting) // MMA, 1880, *Loan Collection of Paintings*, no. 89, as Pulpit St. Mark's, Venice, lent by the artist (probably this painting).

EX COLL.: the artist, until 1890.
Gift of the artist, 1890.
90.23.

CHARLES SIDNEY RALEIGH

1830–1925

C. S. Raleigh began his artistic career late in life, after thirty years at sea. He was born in Gloucester, England, and ran away from home at ten to become a cabin boy on a merchant vessel. Little is known of his early years as a merchant seaman, but his travels apparently included many South American ports, as well as a period of service aboard a United States supply vessel in the Gulf of Mexico during the Mexican War. In 1870 Raleigh was put ashore in New Bedford, Massachusetts, suffering from a fever he had contracted during a voyage to Rio de Janeiro. In nearby Sandwich, Massachusetts, he was nursed by the family of his ship's cook, Isaac Stevens, and shortly thereafter married Stevens's daughter Amelia.

Raleigh briefly earned his living sailing local cargo up and down the East coast but finally settled his family in New Bedford, where he found employment with William H. Caswell, a painting contractor. His experience in Caswell's shop, which included the painting of miscellaneous signs and pictures of whaling ships, gave Raleigh the basis for his linear, slightly primitive style and increased his interest in marine subjects. In 1877, the former sailor opened his own studio in New Bedford and began producing scores of highly competent, yet naive, paintings of local whaling vessels. In addition, he painted house interiors, shop signs, and carriages. Although the majority of his estimated eleven hundred paintings meticulously depict whaling scenes, he also painted a huge stationary panorama entitled

A Whaling Voyage in the Ship "Niger," 1878–1880 (Whaling Museum, New Bedford, Mass.), and many Arctic scenes of polar bears, like *Chilly Observation*, 1889 (Philadelphia Museum of Art), in which a flat, linear, figurative style is combined with more naturalistic water and cloud effects. These subjects, although comparatively old-fashioned, established Raleigh as a popular marine painter, and he soon moved his studio and home to nearby Bourne. He continued to document the life of New England whalers but tried other genre as well. There are several still-life paintings bearing his signature, as well as his illustrations for *The Fishes and Fisheries of the United States* (1887). Toward the end of his career he suffered from increasing loss of vision, which forced him to view his subjects from the corner of his eye. He died in Bourne in 1925 at the age of ninety-four.

BIBLIOGRAPHY: Philip F. Purrington, *4 Years A-Whaling: Charles S. Raleigh, Illustrator* (New Bedford, Mass., 1972). Provides the most extensive material available about the artist's career and work.

Fruit with Blue-footed Bowl

Although Raleigh is best known for his whaling scenes and marines, his production appears to have included a variety of subject matter. He is known to have painted commercial shop signs and decorated the interiors of homes in his native New Bedford. *Fruit with Blue-footed Bowl* reveals that he explored formal still-life subjects as well. The picture's predominant linearity suggests some relationship to the contemporary use of stencil designs in interior decoration. It is known that Raleigh covered the walls of his own home with such designs.

The composition is characteristic of theorem painting, the most common form of still-life representation and household decoration in New England in the 1820s and 1830s. Paintings were created by using stencil kits; the individual shapes included could be arranged in a variety of patterns to suit one's taste. The naivete of Raleigh's picture is reminiscent of many of these still lifes, and the pervasive use of linear elements echoes his marines. The symmetrical organization of the picture is striking, as is the illusionistic modeling of the central apple and pear. In contrast, other areas are left quite flat. Raleigh's lack of formal artistic instruction is most evident in the confused perspective that characterizes the juxtaposition of bowl stem, tabletop, and supporting pedestal, and in the precarious positioning of the mass of fruits above.

Raleigh, *Fruit with Blue-footed Bowl.*

Oil on canvas, 23¾ × 16⅟₁₆ in. (60.3 × 40.8 cm.).
Signed and dated at lower left: C. S. Raleigh./ 1893.
ON DEPOSIT: Gracie Mansion, New York, 1974–1975.
Ex COLL.: Edgar William and Bernice Chrysler Garbisch, 1973.
Gift of Edgar William and Bernice Chrysler Garbisch, 1973.
1973.323.3.

CHARLES CALEB WARD

1831–1896

Charles Caleb Ward was born in Saint John, New Brunswick, Canada. His loyalist grand-father, Major John Ward, had settled there after leaving Poughkeepsie, New York, at the close of the Revolution in 1783 and set himself up in business as a merchant. His firm eventually was known as John Ward and Sons. While supposedly learning the family shipping business in Liverpool, Charles Caleb Ward spent most of his time studying figure painting with the English artist William Henry Hunt, who is best known for watercolors, still lifes, and genre paintings. Ward also traveled in Europe and stayed for a time in Paris. In 1850 and 1851, he moved to New York, where he studied landscape painting with ASHER B. DURAND and exhibited at the National Academy of Design. He spent a few years in other eastern American cities before returning to New Brunswick in 1856. There he married and resided for several years at Saint George. From 1868 to 1872 Ward maintained a studio in New York. He exhibited at the American Watercolor Society, the Brooklyn Art Association, and the National Academy of Design. Later he organized a business in Saint George, quarrying red granite. It prospered for a time but then failed; thereafter Ward devoted himself exclusively to art. The death of two young sons caused him great sorrow. In 1882 he settled in Rothesay, New Brunswick, where he spent the rest of his life.

Ward established his reputation primarily as a genre painter, in oils and in watercolors, and specialized in depictions of children, Indians, and sports. His interest in outdoor life, particularly hunting and fishing, was reflected in his art and in the articles he wrote for various periodicals, including the *Illustrated London News*, 1863, *Scribner's Magazine*, 1868–1877, 1880, *Century Magazine*, and *St. Nicholas Magazine*, 1884–1885. These were often accompanied by his own illustrations. While Ward was said to have been prolific, less than forty works have been located. Most of these are in private collections in Canada, where he was greatly admired in his day. At his death, the *Saint John Globe* (February 25, 1896, typescript in Dept. Archives) called him not only "an accomplished artist, but also a most kindly, courteous gentleman, a sincere friend and a delightful companion" and described "his exquisite little landscapes, with the marvellous charm of their beautiful, natural and harmonious colors."

BIBLIOGRAPHY: Charles Caleb Ward Papers, New Brunswick Museum Archives, Saint John // Charles C. Ward, clipping file, Art Reference Room, NYPL. Contains good early biography of artist from unidentified periodical dated May 1891 // Samuel M. Green, "Charles Caleb Ward, the Painter of 'The Circus is Coming,'" *Art Quarterly* 14 (Autumn 1951), pp. 231–251. Most complete published account of the artist's life and work // J. R. Harper, *Early Painters and Engravers in Canada* (Birkenhead, England, 1970), pp. 321–322. Good biographical sketch with bibliography.

Coming Events Cast Their Shadows Before

The circus theme appears rarely in nineteenth-century American genre painting. Ward's best-known work, *Coming Events Cast Their Shadows Before*, is one of the few examples. The posters shown here announce that P. T. Barnum's circus will be coming on April 28 to Jerryville, a small town in West Virginia, near the Virginia border

Ward, *Coming Events Cast
Their Shadows Before.*

north of Roanoke. The title of the painting is a line of "Lochiel's Warning" (1802), a poem by the Scotsman Thomas Campbell, which became a popular war song in the nineteenth century.

P. T. Barnum opened his first circus in Brooklyn, New York, in the spring of 1871, the year this picture was painted. Although there were entertainments, including variety acts, theater pieces, and acrobatics, the circus was mainly an expansion of his American Museum and therefore featured the kinds of rare, exotic, curious, and mysterious exhibits that are depicted on the posters: Egyptian mummies, a horned horse, and the *Greek Slave*, Hiram Powers's sensational sculpture of 1851. Called "American art's first antislavery document in marble," the *Greek Slave* was replicated six times and exhib-

ited more widely than any other nineteenth-century American statue. Another poster shows a dying Zouave, a member of a French infantry unit originally composed of Algerians who wore colorful Middle-Eastern uniforms. The name Zouave also had Civil War associations, because it was adopted by a unit of Union army volunteers who patterned themselves after the French.

Fragments of several YMCA posters also appear on the storehouse wall. It is tempting to speculate that they may refer to an alleged incident in Barnum's life. It was rumored that, although the famous circus promoter was a teetotaler and a leading citizen of Bridgeport, Connecticut, the local YMCA refused him membership because he was a staunch Universalist (see Neil Harris, *Humbug* [Boston, 1973], p. 204).

The backdrop of the cluttered billboard and the unsentimental depiction of children are typical of several other mid nineteenth century artists, such as JAMES H. CAFFERTY, THOMAS LE CLEAR, and GEORGE HENRY YEWELL. In general, however, Ward's technique is less academic than that of popular Victorians like JOHN GEORGE BROWN. Indeed, the flat color and the emphasis on geometry in the architecture and posters have particular appeal to the modern eye that has experienced cubism and geometric abstraction.

The painting has long been known as *The Circus is Coming*. A description, however, by a critic in the *Brooklyn Daily Eagle*, November 3, 1871, of a painting by Ward titled *Coming Events Cast Their Shadows Before*, exhibited at the Brooklyn Art Association that year, corresponds to this picture, and so the title has been changed.

Oil on wood, 10⅛ × 8 in. (25.7 × 20.3).
Signed and dated at lower right: C. C. Ward / 1871.
Stamped on back: GOUPIL'S / 170 / FIFTH / AVENUE N. Y.
REFERENCES: *Brooklyn Daily Eagle*, Nov. 3, 1871, gives detailed description of this painting, calls Ward "one of the most truthful as well as brilliant among the resident genre painters of New York ... [He] has the happy faculty of painting children as they are, just as we meet them in every day life" // L. E., *Art News* 32 (Dec. 30, 1933), ill. p. 5 // H. E. K[eyes], *Antiques* 27 (June 1935), p. 228, fig. 1 // E. P. Richard-son, *American Romantic Painting* (1944), p. 49, no. 198 // J. I. H. Baur, *College Art Journal* 6 (Summer 1947), p. 279, discusses it; fig. 2, as coll. Mrs. Bates Block // S. M. Green, *Art Quarterly* 14 (Autumn 1951), pp. 231–232, discusses it; p. 233, fig. 1, as coll. Stephen C. Clark, pp. 235, 238, 245, 246; p. 248, no. 5, lists it // A. T. Gardner and J. Feld, *MMA Bull.* 26 (Oct. 1967), p. 46, lists it as Street Scene // H. W. Williams, Jr., *Mirror to the American Past* (1973), pp. 163–164, discusses it, fig. 155.

EXHIBITED: Brooklyn Art Association, 1871, Fall exhibition, no. 111, as Coming Events Cast Their Shadows Before // Brooklyn Art Association, 1874, Spring exhibition, no. 125, as Coming Events Cast Their Shadows Before, $800 // Newhouse Galleries, New York, 1933–1934, *The Second Annual Exhibition of American Genre Paintings Depicting the Pioneer Period*, no. 63, as The Circus is Coming // M. H. de Young Memorial Museum, San Francisco, 1935, *Exhibition of American Paintings*, no. 232, as lent by Ehrich-Newhouse Galleries // MMA, 1939, *Life in America*, p. 179, no. 236, lent by Mrs. Bates Block // M. Knoedler and Company, New York, Hirschl and Adler Galleries, New York, and Paul Rosenberg and Company, New York, 1968, *The American Vision, Paintings, 1825–1875* (for the benefit of the Public Education Association), no. 73.

EX COLL.: Daniel W. Patterson, New York; with Newhouse Galleries, New York, by 1933; Mrs. Bates Block, Atlanta, by 1939—at least 1947; Stephen C. Clark, New York, by 1951—d. 1960; Susan Vanderpoel Clark, d. 1967.

Bequest of Susan Vanderpoel Clark, 1967.
67.155.2.

JOHN GEORGE BROWN

1831–1913

John George Brown was born in Durham, England, on November 11, 1831. He spent his childhood in Newcastle-on-Tyne, where at the age of fourteen, he became apprenticed in the glass-cutting trade. The last four years of his apprenticeship he spent studying evenings at the government school of design at Newcastle under William Bell Scott, a poet, painter, and friend of the Pre-Raphaelites. Scott is best remembered for his sympathetic depiction of the working class in *Newcastle Quayside in 1861*, 1861 (National Trust, Wallington Hall, Newcastle), and his contributions to the Pre-Raphaelite magazine the *Germ*. In 1852 Brown found employment in Edinburgh at the Holyrood Glass Works. He continued, however, to attend evening painting classes and studied under Robert Scott Lauder at the drawing

academy in Edinburgh. Brown apparently worked in the antique class, where he won a prize for the best drawing in 1853. The same year, he left Edinburgh for London, where according to him, he remained "only long enough to paint a few portraits" (autobiographical note, April 15, 1909, Dept. Archives). On September 24, he sailed for the United States. He found employment at the Brooklyn Flint Glass Company. His sketches for stained glass apparently so impressed his employer William Owen that he was encouraged to study further. His instructor was Thomas Seir Cummings (1804–1894), the miniature painter.

By 1855 Brown had married Owen's daughter and rented a studio in Brooklyn. Five years later he secured a studio in the illustrious Tenth Street Studio Building, where he remained throughout his career. In an interview with Charles de Kay in 1904, Brown reminisced about the famous building: "To think that I should have been here now more than forty years! Many are the good fellows who have made these walls echo with their laughter. There was Homer D. Martin, bubbling over with quaint, funny speeches; there was George Inness, with his Swedenborgian theories—the Beards, Sanford Gifford, Kensett, McEntee, Wood, Le Clear, Wyant, Albert Bierstadt, William Page—sooner or later almost every one of the Academicians have been here for longer or shorter periods" (*New York Times*, Nov. 13, 1904, p. 29).

In 1858 Brown exhibited for the first time at the National Academy of Design in New York. He continued to exhibit there yearly, becoming an academician in 1863. Among several of the genre paintings he showed in 1861 was one owned by his friend and colleague JOHN F. KENSETT. Brown served as vice-president of the academy from 1899 until 1903 and was also active in the American Watercolor Society. His first wife died in 1867, and four years later he married her sister.

By the 1880s Brown had established a solid reputation as a painter of children and genre scenes of the working class, such as *The Longshoreman's Noon*, 1879 (Corcoran Gallery of Art, Washington, D.C.). George W. Sheldon recorded Brown's comments on subject matter: "Art . . . should express contemporaneous truth, which will be of interest to posterity. I want people a hundred years from now to know how the children that I paint looked, just as we know how the people of Wilkie's and Hogarth's times looked" (p. 151). The reference to the popular Scottish genre painter Sir David Wilkie was of some significance; for Brown was very familiar with Wilkie's scenes and probably copied some of them during his student years. In a painting *The Young Artist*, 1867 (unlocated; ill. *Antiques* 67 [May 1955], p. 367), Brown paid tribute to Wilkie by placing a version of his *The Blind Fiddler*, 1806 (Tate Gallery, London), on the table of a young aspiring artist. In the 1880s, however, Brown took up a new variety of genre scene, one which was directly related to the rapid rise of the immigrant population in the United States. He began to produce anecdotal scenes depicting the life of street children. The urchins he painted were most often bootblacks and newsboys who posed in his studio. Samuel G. W. Benjamin (1837–1914) described Brown's method of composing: he "collects all the figures that are to appear in a given design in his studio. Posing them in various arrangements, he finally succeeds in arriving at what he is after. There is little evidence of fancy in his works, or of sympathy with nature aside from the human nature he has made his specialty" (p. 267). The public was apparently willing to accept the well-scrubbed children as true to nature. The popularity of scenes

like *A Tough Story*, 1886 (North Carolina Museum of Art, Raleigh), and their frequent illustration brought Brown financial success. His works remained popular into the first decade of the twentieth century.

Throughout his career, Brown spent his summers in the rural areas of New York and Vermont, where in his inimitable anecdotal style he painted local farmers and their families. He also portrayed fishermen at Grand Manan Island, New Brunswick, Canada, on several sketching trips and experimented with an occasional landscape. His preference, however, remained the genre scenes that he had made so popular. In 1906 the *American Art News* noted: "No painter has ever been as happy in the delineation of the street boys of American cities. He is a master of composition and grouping, and the rendering of expression and character."

BIBLIOGRAPHY: Samuel G. W. Benjamin, "A Painter of the Streets," *Magazine of Art* 5 (April 1882), pp. 265–270. Details Brown's life, technique, and works // George W. Sheldon, *Hours with Art and Artists* (New York, 1882), pp. 148–152. An interview with Brown about his subject matter, training, and philosophy // Patricia Hills, "The Painter's America, Rural and Urban Life, 1810–1910," *Antiques* 106 (Oct. 1974), pp. 646–647. Discusses Brown's work in some depth and illustrates several of the street urchin pictures // Robert Hull Fleming Museum, Burlington, Vt., *John George Brown, 1831–1913: A Reappraisal*, exhib. cat. (1975). The most in-depth biographical and stylistic material available.

The Music Lesson

This painting documents Brown's familiarity with contemporary English art. When he left England, the influence of the Pre-Raphaelites was at its height, and it is not surprising that like them he chose narrative subjects that depict intimate moments of middle-class life.

His interest in domestic genre is revealed in this detailed picture of a typical Victorian interior. The room, which includes a Renaissance revival sofa and Greek revival harp, could easily conform to the dictates of *Hints on Household Taste* by Charles Lock Eastlake.

On the surface *The Music Lesson* is a traditional courtship scene. An undated but probably contemporary engraving of the work bears the title *A Game Two Can Play At*, indicating that here the leisurely pursuit of music has moralistic overtones. In 1879 Brown told George Sheldon:

Morality in Art? Of course, there is. A picture can and should teach, can and should exert a moral influence... Millais' "Huguenot Lovers"—you can't look at the picture without being better for it, can you?... there is a moral in everything (*American Painters* [1879], p. 142).

Comparison of *The Music Lesson* with a work like William Holman Hunt's *The Awakening Conscience*, 1853 (Tate Gallery, London), confirms Brown's debt to the Pre-Raphaelites both in style and content. He appears to have borrowed Hunt's musical milieu along with a Victorian interior that reflects the painting's narrative theme in its every detail. Brown, however, characteristically keeps his imagery sentimental. Whereas Hunt made veiled references to adultery, Brown has included the pure image of a haloed saint framed above the sofa.

Oil on canvas, 24 × 20 in. (61 × 50.8 cm.).
Signed at lower left: J. G. Brown / N.Y. 1870.

RELATED WORKS: *A Game Two Can Play At*, engraved by Illman Brothers, n. d., ill. in NYPL, Scrapbook of American Genre and Historical Painters.

REFERENCES: A. Burroughs, *Limners and Likenesses* (1936), p. 168, fig. 140, notes that the picture "brings into focus casual details ordinarily missed, even by a camera" // *Art News* 37 (April 29, 1939), ill. p. 7, shows the painting on exhibition at the Metropolitan Museum // H. W. Williams, Jr., *Mirror to the American Past* (1973), p. 180, notes that the painting's sentimentality is characteristic of Brown's work // M. Brown, *American Art to 1900* (1976), p. 533, fig. 661, suggests relationship to Hunt's painting Awakening Conscience.

EXHIBITED: MMA, 1939, *Life in America*, no. 220; 1965, *Three Centuries of American Painting*, checklist

alphabetical; 1970, *19th Century America, Painting and Sculpture*, exhib. cat. by J. K. Howat and N. Spassky, fig. 147, discusses it // Whitney Museum of American Art, New York, 1974–1975, *Painters' America*, exhib. cat. by P. Hills, no. 108; p. 84, says the painting "focuses on middle-class involvement with cultural self-improvement. Here, though, music is the occasion for flirtation, and Brown dwells upon the sociability of two people rather than their self-involvement in making art"; p. 88, fig. 108 // MMA and American Federation of Arts, traveling exhibition, 1975–1977, *The Heritage of American Art*, exhib. cat. by M. Davis, no. 54, ill. p. 128.

Ex coll.: Charles A. Fowler, 1921.

Gift of Colonel Charles A. Fowler, 1921.

21.115.3.

To Decide the Question

Painted in 1897, this work is characteristic of Brown's late style and career-long production of rural genre scenes. The 1914 sale catalogue of the artist's estate lists the painting as "Country Critics," describing the subject as: "Three important-looking men advanced in years, of the independent American farmer type and the kind that don't scorn a 'hoss race,' are seated on boxes and a chair against the harness-hung wall of a barn, looking with intensely critical expression . . . presumably 'measuring up' a horse or a 'critter.' "

The figures were probably done from sketches Brown made during one of his summer trips in Vermont or upstate New York. He depicted the same men in other compositions, notably *Cornered* (ill. in *National Academy of Design Illustrated Catalogue* [1900], no. 61, opp. p. 30), in which the men sit in a similar interior. Brown's interest in rural life was typical of many of his American contemporaries, whose genre paintings reflected their concern with national subject matter. Similar anecdotal scenes were represented by

Brown,
The Music Lesson.

Brown, *To Decide the Question.*

WILLIAM SIDNEY MOUNT, EASTMAN JOHNSON, and George Henry Durrie (1820–1863). In 1882, Samuel G. W. Benjamin (1837–1914) remarked: "There are two features which especially distinguish Mr. Brown's art. It is, in the first place, distinctly and emphatically native to the soil. . . . whatever the motif he selects, it is at once recognizable as being wholly American in subject and treatment" (*Magazine of Art* 5 [Month Year], p. 267.

To Decide the Question is a picture that shows Brown's skill at characterization. The critic for the *New York Times*, in a review of the National Academy of Design exhibition of 1897, wrote: "in composition and drawing, and particularly as a study of character and expression, [it] is one of the best works Mr. Brown has ever produced."

Oil on canvas, 30 × 40 in. (76.2 × 101.6 cm.).
Signed at lower left: copyright/J. G. Brown, N.A.
REFERENCES: *New York Times*, April 10, 1897, p. 4 (quoted above) // American Art Galleries, New York, *Catalogue of the Finished Pictures and Studies Left by the Well-known American Artist, the Late J. G. Brown*, sale cat., Feb. 9–10, 1914, no. 140, as Country Critics, describes it (quoted above).
EXHIBITED: NAD, 1897, no. 284, To Decide the Question, ill. between pp. 54–55 // Saint Louis Ex-

position, 1897, no. 71; ill. p. 44 // Carnegie Institute, Pittsburgh, 1899, no. 25.
Ex COLL.: the artist, d. 1913; estate of the artist (sale, American Art Galleries, New York, 1914, as Country Critics, $390); E. Everett Dickinson, 1914; his son, E. Everett Dickinson, Jr., Essex, Conn., until 1963.
Gift of E. Everett Dickinson, Jr., 1963.
63.130.2.

Meditation

Throughout his career, Brown spent his summers in rural communities, painting the farmers and their families. According to him, the subject of *Meditation* was a farmer's daughter he painted "at her home in the Catskills, where they all do their share of the family duties."

A young woman seated in quiet contemplation was a popular theme at the turn of the century, the period to which this work undoubtedly dates. Brown, however, has chosen the rural counterpart to the familiar elegant lady of leisure, seen in such works as FRANK BENSON'S *Girl Playing Solitaire*, 1909 (Worcester Art Museum, Mass.). *Meditation* may in fact date to the same year. In it the young woman sits before a background of objects representing her austere yet

Brown, *Meditation.*

comfortable environment. The work is similar to many of the paintings Brown did of single figures in the first decade of the twentieth century. *Cosy Corner of the Barn* (unlocated, ill. in *National Academy of Design Illustrated Catalogue* [1903], between

pp. 52–53), for example, shows an elderly man in a similar setting.

The pensive pose of the farmer's daughter, caught daydreaming in the pantry, is typical of Brown's humble and sentimental scenes, which so appealed to the national mood. He once wrote: "when I paint the picture of a young girl, I want to make her look as if you would like to call her your sister or wife, show the *pure* in woman & the 'far-away' look" (J. G. Brown to I. Wheeler, June 19, 1891, Brown Papers, D8, Arch. Am. Art). In *Meditation* Brown has captured the desired innocence. At the same time he has made a rare concession to the contemporary taste for impressionism in his free handling of the brushwork in the girl's apron and dress.

Oil on canvas, 30 × 25 in. (76.2 × 63.5 cm.).
Signed at lower left: J. G. Brown/N.A.
REFERENCES: J. G. Brown, April 15, 1909, letter and autobiographical note, MMA Archives (quoted above) // *Catalogue of the George A. Hearn and Arthur Hoppock Hearn Memorial Fund* (1913), p. 2, lists the painting.
EXHIBITED: Los Angeles County Museum of Art and M. H. de Young Memorial Museum, San Francisco, 1966, *American Paintings from the Metropolitan Museum of Art*, p. 70, ill. no. 56.
EX COLL.: Clarkson Cowl, New York, 1909.
George A. Hearn Fund, 1909.
09.26.5.

ENOCH WOOD PERRY

1831–1915

Enoch Wood Perry, one of four children of Hannah Knapp Dole Perry and Enoch Wood Perry, was born in Boston. His father had a grate and fender shop there, which he lost during the panic of 1837. Sometime between 1843 and 1845 the family moved to New Orleans, where Perry's father opened a hardware and house furnishing store. After graduating from the local high school, young Perry became a clerk at Pickett, Perkins and Company, a commission house in the city. A contemporary report in a local newspaper suggests that during his four years as a clerk Perry supplemented his income by painting.

On May 13, 1851, Perry wrote to Andrew Warner, corresponding secretary of the American Art-Union in New York, requesting advice on studying art and information on the Düssel-

dorf Academy (Letters from Artists, American Art-Union Papers, NYHS). The following year he again consulted Warner and requested "the address of a person (an American would be the best) at Düsseldorf, who could give me some information regarding *the time and terms* of admission to the academy at that place." He added, "I'm going there in a few months and wish to learn how 'the land lays' before starting" (Feb. 20, 1852, ibid.). In his reply of March 2, Warner recommended consulting EMANUEL LEUTZE and WORTHINGTON WHITTREDGE.

Perry sailed in the late spring or early summer of 1852 and went to Düsseldorf by way of London and Paris. His activities in Düsseldorf are poorly documented. He did enroll in the academy, and it is reported that he also studied with Leutze for two to two and a half years. In the fall of 1854, Perry went to Paris, where he entered the popular studio of Thomas Couture. Perry's studies in Düsseldorf had encouraged careful draftsmanship, firm modeling, and a proclivity for stage-like compositions. From Couture he learned to preserve the sketch, to use dark contour lines, and to apply impasto in light areas.

To advance Perry's plans to study in Italy, his father petitioned the United States government in June 1855 to appoint his son to the post of United States consul in Venice. The elder Perry was at this time a prominent merchant with political connections. He had been chairman of the Louisiana State Central Democratic Committee. The appointment was made in March 1856. Perry, then in Rome, was informed, but did not take up his post until August. He returned to Düsseldorf in May and in June joined WILLIAM STANLEY HASELTINE, Whittredge, William Henry Furness, Jr. (1827-1867), John Beaufain Irving (1825-1877), and Henry Lewis (1819-1904) on a sketching excursion on the Nahe River, a tributary of the Rhine. His consular duties in Venice allowed him to continue painting, and he remained there until he resigned his position in October 1857. Before returning to the United States, Perry paid another visit to Rome, where among his colleagues at this time were Whittredge, ALBERT BIERSTADT, WILLIAM PAGE, and the sculptor Thomas Crawford.

In 1858 Perry settled in Philadelphia. The same year he exhibited his works (largely Venetian subjects) for the first time at the National Academy of Design, the Boston Athenaeum, and the Pennsylvania Academy of the Fine Arts. In 1860 he left Philadelphia for New Orleans, where he opened a studio and specialized in portraiture. Among his sitters in 1860 was John Slidell, United States senator from Louisiana (portrait now in Louisiana State Museum), whom he painted in Washington, D. C. Perry's portrait of Jefferson Davis, 1861 (Alabama State Department of Archives and History, Montgomery), was raffled at a benefit for the Confederacy. He also began work on *The Signing of the Secession Ordinance*, intended to be an ambitious historical painting that was to include all the members of the Convention at Baton Rouge on January 26, 1861. The picture was never painted, but there is a preliminary oil study for it in the Louisiana State Museum. In 1862 Perry completed *How the Battle Was Won* (Newark Museum), which represents a Confederate soldier describing a battle to a group of men. During the war, Perry's younger brother, who was a doctor, served as a surgeon in the Confederate army. Perry, however, left New Orleans in 1862 and went west. By the end of the year he was in San Francisco, where he supported himself chiefly as a portrait painter. In August 1863 he joined the artists Bierstadt and Virgil Williams (1830-1886), the author Fitz Hugh Ludlow, and Dr. John Hewston, a metallurgist, on a trip to Yosemite Valley. From that excursion of several weeks came such works as Perry's *Cathedral*

Rock, 1863 (private coll.) and *Cathedral Rock, Yosemite Valley*, 1866 (Oakland Museum of Art). His landscapes from this trip strongly reflect the influence of Bierstadt's work (Gibbs, p. 39).

Another major trip was one Perry made in the fall of 1864 to the Sandwich Islands. There he painted several landscapes and portraits of dignitaries including Kings Kamehameha IV and V (unlocated) and Prince Albert Edward Kauikeaouli Leiopapa (Bernice P. Bishop Museum, Honolulu). Perry was back in California by July 1865. Later that year he moved to Salt Lake City, where he filled a commission from the Mormon Church to paint portraits of Brigham Young and twelve governing members of the church (coll. Church of Jesus Christ of Latter-day Saints, Salt Lake City). Another portrait of Young, done in 1866, was commissioned for the City Hall (Salt Lake City and County Building). Together with the artist George Martin Ottinger (1833-1917) and his photographer-partner Charles R. Savage, Perry founded the short-lived Deseret Art Union, which was modeled after the American Art-Union. He left Salt Lake City in 1866.

By January of 1867 Perry was working in Bierstadt's former studio in the Tenth Street Studio Building in New York. He was elected an associate of the National Academy of Design in 1868 and an academician the following year. Active in the academy's affairs, he was a leader of the liberal faction committed to improving the academy's schools and served as recording secretary from 1871 to 1873. He was also a member of the Century Association, the Artists' Aid Society, and the American Watercolor Society.

Late in 1877 or early 1878 Perry went on his second trip to San Francisco, joining his younger brother who had established a medical practice there. Perry remained in San Francisco until 1881. Among his patrons were the railroad magnates Collis P. Huntington and Leland Stanford. It was probably at this time that Perry learned of Eadweard Muybridge's photographic studies of animal motion. He was among the original subscribers to Muybridge's publication *Animal Locomotion*; and plates from it were included in a collection of Perry's work, letters, and memorabilia sold in New York during the 1940s.

By 1882 Perry had returned to New York. He was one of the founders and an officer of a revived American Art-Union, which was organized to promote the sale of American art but lasted only from 1883 to 1885. By 1891 Perry was once again in the Studio Building. In 1899, at the age of sixty-eight, he married the writer Mrs. Fanny Field Hering, whom he had met on a painting excursion to Sandwich, New Hampshire. They spent their summers there, where Perry built his own studio. Winters were spent visiting Europe or in New York, where Perry worked in the University Building on Washington Square.

Perry was a competent portraitist, but his reputation rests chiefly on his genre paintings. In July 1875, the New York *Art Journal* reported: "Mr. Perry at the present time occupies a position very nearly at the head of our *genre* painters." His work reflects his debt to such painters of an earlier generation as WILLIAM SIDNEY MOUNT and FRANCIS W. EDMONDS. Like them, he was influenced by the work of early Dutch and British genre artists. His studies in Düsseldorf and Paris, as well as contemporary European trends, effected his style. He died in New York in 1915 at the age of eighty-four.

BIBLIOGRAPHY: George W. Sheldon, *American Painters* (New York, 1879), pp. 70-72 // Edward Larocque Tinker, *DAB* (1934; 1962), s.v. "Perry, Enoch Wood" // Bartlett Cowdrey, "The Discovery of Enoch Wood Perry," *Old Print Shop Portfolio* 4 (April 1945), pp. 170-181 // Linda Mary Jones Gibbs,

"Enoch Wood Perry, Jr.: A Biography and Analysis of His Thematic and Stylistic Development" (M. A. thesis, University of Utah, 1981). The most comprehensive study of the artist to date.

Talking It Over

Completed in 1872 and exhibited at both the National Academy of Design and the Brooklyn Art Association, *Talking It Over* is a typical example of Perry's rural genre subjects. Two farmers, one seated on an upended sawbuck and the other on a chair, are the focus of attention in this studied composition. The setting is the inside of a barn with a pile of pumpkins and a barrel holding pitchforks and rakes. Straw, cornstalks, and husks are strewn on the floor, and a horse looks on from a stall behind the men. Perry introduces the shadow of a horse's head on the barrel. Continuing the pictorial tradition that celebrates American rural life, the work recalls barn scenes featuring farmers by WILLIAM SIDNEY MOUNT. Such imagery was also explored in the 1860s by several of Perry's contemporaries, including EASTMAN JOHNSON.

A strong source of light from the left provides sharp contrasts. This dramatic manner of lighting contributes to the three-dimensional illusion or sculptural quality of the boldly modeled figures. While the shallow stage-like composition and the descriptive delineation of the figures reflect the influence of Perry's studies in Düsseldorf, the brushwork, paint texture, and strong contrasts of light and dark reflect his studies with Thomas Couture.

Oil on canvas, 22¼ × 29¼ in. (56.5 × 74.3 cm.).
Signed and dated at lower left: E. W. Perry / [N A]/ '72.
REFERENCES: J. K. Howat, [*Metropolitan Museum of Art*] *Notable Acquisitions, 1980-1981* (1981), ill. p. 55; pp. 55-56, discusses and says that the picture impresses the viewer with its quiet strength // E. W. Baumgartner, Daniel B. Grossman, Inc., New York, letter in Dept. Archives, May 18, 1983, supplies information about provenance.

Perry, *Talking It Over*.

EXHIBITED: NAD, 1872, no. 147, for sale // Brooklyn Art Association, Dec. 1872, *Catalogue of Pictures Exhibited at Their Fall Exhibition*, no. 306.

Ex COLL.: Nesmith family, Brooklyn, 1870s; Mrs. Tarbell (née Nesmith); private coll., Camden, Me.; auctioned in Maine; with Milliard Spencer, Bridgton, Me., 1978; with Daniel B. Grossman, Inc., New York, 1978; Erving and Joyce Wolf, New York, 1978-1980.

Gift of Erving and Joyce Wolf, 1980.

1980.361.

ATTRIBUTED TO PERRY

The True American

This painting was included in a collection of Enoch Wood Perry's works, letters, and memorabilia in 1944. In technique the painting resembles other works by him. Stylistically, it is similar to such paintings as his *How the Battle Was Won*, 1862 (Newark Museum). Nevertheless, the attribution presents several problems. The satirical subject is atypical in Perry's work, and the painting is signed with a monogram that does not appear on any known work by him.

All the heads in the picture are deliberately hidden, including those of the dog on the porch of the National Hotel and the horse on a stud card inscribed "Young." The painting, called *The True American* after the title of the newspaper in the scene, is not dated, and the implications intended by the artist are not clear. A chromolithograph after the painting was published by the New York firm of Bencke and Scott in 1875. Of the few known prints, two were submitted to the Library of Congress for copyright. From those copies it appears that the title *The True American* was scratched out on the stone and replaced by *The Bummers*. A label on the back identifies the print as "BUMMERS" and notes that it was to be sold only by subscription for $2.50. No reference to an artist appears on the label or the chromolithograph. If Perry, then a well-known painter, was indeed the artist, the omission of his name is unusual. Furthermore, the date of the print cannot necessarily be assumed to be the date of the painting. The possible political situations to which the artist might be referring in this enigmatic scene are much earlier than the 1870s.

There were several newspapers with the title

Attributed to Perry, *The True American*.

The monogram on *The True American*.

True American, including the New York organ for the Know-Nothing movement in the 1850s. The theme of the picture would be in keeping with Know-Nothingism. The basic tenets of the movement were anti-immigrant and anti-Catholic. As a political force, the Know-Nothings lasted until about 1856. The actual masthead in the painting, however, is the same as that on the abolitionist newspaper published by Cassius M. Clay from June 3, 1845, until October 21, 1846. The paper was issued in Lexington, Kentucky, until Clay's opponents drove him out. It was then published in Cincinnati and later Louisville, from June 19, 1847, until December 8, 1849, under the name *Examiner*.

The strongest clue to the identity of the artist should be the monogram on the painting. Close examination has determined that it is contemporary to the work. Attempts to decipher it, however, have led to the conclusion that it can be read many ways. Perhaps this was the artist's intention. If so, it is in keeping with the puzzling nature of the picture.

In 1874 F. D. Moulton lent a painting by Perry called *The Weekly Paper* to the National Academy of Design. Unfortunately none of the reviews for this exhibition provide descriptions of this now unlocated painting.

Oil on canvas, 11⅞ × 16⅛ in., (30.2 × 41 cm.).
Signed at lower left: EWP [?] (monogram).
RELATED WORK: *The Bummers*, chromolithograph printed by Bencke and Scott, New York, 1875, 16¾ × 22¾ in. (42.6 × 57.8 cm.), ill. in P. C. Marzio, *The Democratic Art* (1979), p. 296, pl. 42.
REFERENCES: B. Cowdrey, *Old Print Shop Portfolio* 4 (April 1945), ill. p. 173, calls it the Vanishing American and dates it about 1850 // *Pictures on Exhibit* 12 (Feb. 1950), ill. p. 41, calls it The True American; notes that it is on exhibition at the Edwin Hewitt Gallery // *Old Print Shop Portfolio* 22 (Dec. 1962), ill. p. 84, shows chromolithograph after the painting and dates it

Chromolithograph printed by Bencke and Scott, New York, 1875.
National Museum of History and Technology, Smithsonian Institution.

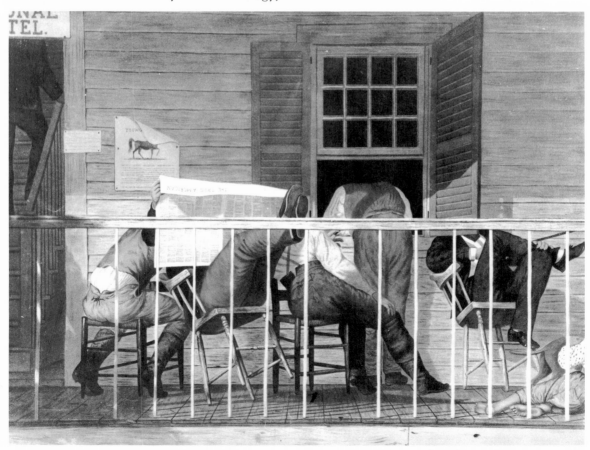

1860 // K. M. Newman, Old Print Shop, New York, letter in Dept. Archives, Dec. 23, 1966, notes that they purchased the painting from Charles Grand in 1944 and suggests that he probably found it in New York // H. W. Williams, Jr., *Mirror to the American Past* (1973), ill. p. 200, fig. 192; p. 201, discusses and notes that it recalls the work of David Claypoole Johnston // J. F. Escover, "*The True American*: A True Enigma," unpublished paper for the State University of New York at Binghamton, Dec. 13, 1974, copy in Dept. Archives, pp. 1-6, describes it; pp. 6-7, discusses nineteenth-century newspapers called *The True American*, notes the masthead is identical to the one published in Lexington, Kentucky, suggests that the painting is possibly a comment on the Know-Nothing movement // *Old Print Gallery Showcase* (Washington, D. C.) 2 (March 1975), ill. p. 48, shows chromolithograph after the painting and dates it about 1860 // J. C. Taylor, *America as Art*, with a contribution by J. G. Cawelti (1976), ill. p. 42, dates the painting about 1875 // A. Johnson, *Christian Science Monitor*, Jan. 30, 1978, ill. p. 20, discusses the painting and dates it 1875 // P. C. Marzio, Division of Graphic Arts, National Museum of History and Technology, Smithsonian Institution, letter in Dept. Archives, March 23, 1978, provides copy of Bencke and Scott label from the chromolithograph, a copy of the relettered title from the print, and an excerpt from his manuscript discussing the work; notes that neither the label nor the chromolithograph contain Perry's name or monogram which suggests that Perry may not be the artist of the original // P. C. Marzio, *The Democratic Art* (Boston, 1979), p. 45, notes that the chromolithograph after the painting appeared in 1875, sold for $2.50 a copy, and originally bore "the biting title 'The True American,' which was later scratched out and replaced"; says the print was produced from twelve or thirteen stones and the shop experimented with different printings; p. 46, notes that the print in the Smithsonian is closest to this painting and discusses the suitability of the Düsseldorf style as adopted by Perry for chromolithography; p. 216, pl. 42, describes print; p. 236, n 30, describes two prints submitted for copyright // J. S. Owaroff, Houghton Library, Harvard University, letter in Dept. Archives, July 9, 1979, provided copy of the masthead from the Lexington, Kentucky, newspaper // A. Boime, *Thomas Couture and the Eclectic Vision* (1980), pp. 590-591, discusses Couture's influence on Perry's painting style; says this atypical painting by Perry reflects Couture's "taste for social satire" and notes that the "True American," "obviously implies that such an animal is totally unidentifiable or is otherwise seen as a mindless creature"; p. [593], pl. xv 33; p. 657, n 115, mentions lithograph, says that the masthead resembles that of a newspaper published in Lexington, Kentucky, and suggests that "Perry's theme may very well be an attack on the kind of American who read the paper" // L. M. J. Gibbs, letter in Dept. Archives, May 6, 1980, says she has not seen a monogram on any other works by Perry and dates this work in the late 1850s on the basis of its resemblance to Perry's early style; notes stylistic similarities to his How the Battle Was Won; suggests Perry was experimenting with various signatures possibly under Bierstadt's influence; "Enoch Wood Perry, Jr.: A Biography and Analysis of His Thematic and Stylistic Development" (M. A. thesis, University of Utah, June 1981), p. 95, reaffirms statements in letter above and notes that it is the only known painting by Perry that attempts "to make some kind of social statement"; says that the date and attribution to Perry have been disputed; suggests a date in late 1860s or 1870s; pp. 96-97, discusses possible meanings; p. 207, fig. 47.

EXHIBITED: Old Print Shop, New York, 1945, as The Vanishing American, ca. 1850, for sale $1,200 // Edwin Hewitt Gallery, New York, 1950, *The Tradition of Trompe L'Oeil*, as The True American // Newark Museum, 1957, *Of Other Days*, unnumbered cat., as The True American // National Collection of Fine Arts, Washington, D. C., 1976, *America as Art*, no. 82, as The True American by Perry, ca. 1875 // Amon Carter Museum of Western Art, Fort Worth, Joslyn Museum, Omaha, Chicago Historical Society, and Museum of Our National Heritage, Lexington, Mass., 1979-1980, *The Democratic Art*, cat. by P. C. Marzio, pp. 36, 38, discusses chromolithograph and painting; p. 108, no. 36 (a) // MMA, 1981, *German Influence on Nineteenth-Century American Art* (no cat.).

EX COLL.: with Charles Grand, New York, 1944; with Old Print Shop, New York, 1944-1945; with Edwin Hewitt Gallery, New York, by 1950-1955.

Arthur Hoppock Hearn Fund, 1955.

55.177.

SAMUEL COLMAN

1832–1920

Samuel Colman was born in Portland, Maine, in 1832. His father, Samuel Sr., was a prosperous bookseller and publisher, who later moved his family to New York and opened a publishing house. He published illustrated works by some of the most eminent American authors of the day, including Nathaniel Parker Willis and Henry Wadsworth Longfellow, and his establishment was a favorite gathering place for artists and literati. According to Henry T. Tuckerman, Colman's father "was one of the first tasteful dealers in fine engravings in New York, and his store on Broadway was a unique depository of pictures" (*Book of the Artists* [1870], p. 559). Young Colman must have become familiar with many examples of engravings and illustrated works, and it is not surprising that he decided to become an artist. He submitted an oil painting entitled *Twilight* (unlocated) to the National Academy of Design in 1851. Little is known of Colman's formal training, although it has frequently been suggested that he was briefly a pupil of ASHER B. DURAND in the early 1850s. The landscape pictures he chose to exhibit at the National Academy of Design during those years, like *Franconia Mountains, New Hampshire* (unlocated), confirm his concentration on the favorite haunts of the Hudson River school painters, and works like *Meadows and Wildflowers at Conway*, 1856 (Vassar College Art Gallery, Poughkeepsie, N.Y.), suggest he owes a certain debt to their style, and more specifically to Durand's compositional organization.

In 1860 Colman went abroad. According to his own account (letter in Dept. Archives, May 30, 1908), he spent the following two years in Paris and Madrid "engaged in an analysis of the early masters." He does not seem to have worked under a teacher, "preferring the above method of study." He also seems to have devoted himself to observing the romantic architectural sights of southern Spain, notably those of Seville and Granada. He also ventured across the Strait of Gibraltar to Tangier. From these travels, he produced a series of Spanish landscapes, including *Gibraltar*, ca. 1863 (New York art market, ill. in Craven, p. 20), and *The Hill of the Alhambra, Granada*, 1865 (q.v.). Henry T. Tuckerman described the former as a "splendid success" and the delicate rendering of detail as "remarkable for accuracy in form and tint" (p. 560). The delicacy and refinement that characterized most of Colman's early works were further reinforced by his growing involvement with the medium of watercolor. In 1866 he became a founder and the first president of the American Society of Painters in Water-Colors, later the American Watercolor Society. His productions of the late 1860s, like *Storm King on the Hudson*, 1866 (National Museum of American Art, Washington, D.C.), indicate the progressive fluidity of his style and a looseness of facture which must be credited as much to familiarity with the work of J. M. W. Turner as to his experience with watercolor. By 1870 Colman again sought new subject matter for his landscapes, and he journeyed west, to the Rocky Mountains, following the example of ALBERT BIERSTADT and other American painters before him. In 1871 he exhibited his first frontier scene at the National Academy of Design, *Twilight on the Western Plains* (unlocated), inaugurating a series of works depicting the westward voyage of the American pioneer. His wilderness landscapes ceased temporarily at the end of 1871, as he embarked upon an extended tour of Europe. Over the next four

years Colman apparently visited several European cities and spent time in Holland and Algeria. Returning to this country at the end of 1875, he concentrated on developing Dutch-like landscape subjects and painting an occasional Arab genre scene. He also turned his attention to the developing vogue for etching, joined the New York Etching Club in 1878, and exhibited his prints in many New England shows. Around the same time he began to take a serious interest in oriental art. He gradually amassed an enormous collection of Japanese objects, including brocades, swords, porcelains, prints, and other exotic items with which he decorated his studio. His interest in the decorative was also witnessed by his collaboration, beginning in the late 1870s, with the firm of Tiffany and Company. He participated in the decoration of numerous interiors, notably the "Rembrandt Room," the library of the Henry O. Havemeyer house in New York (1890–1891).

In the late 1880s, Colman apparently resumed his western excursions, visiting Colorado, the Yosemite Valley in California, the Canadian Rockies, and Mexico. He continued to paint an assortment of landscapes with international subjects, although he devoted more and more attention to watercolors. His style grew progressively looser, perhaps under the influence of Barbizon painting, which he had begun to collect years earlier. By 1896 he had ceased exhibiting at the National Academy of Design. His time was taken up writing theoretical treatises on the relationship of mathematics to art. In 1912 he published *Nature's Harmonic Unity* and in 1920 *Proportional Form*, which was published only days before his death.

BIBLIOGRAPHY: Samuel G. W. Benjamin, *Our American Artists* (Boston, 1879), chapter nine. Discusses Colman's travels // George W. Sheldon, *American Painters* (New York, 1879), pp. 72–76. Gives an analysis of his style and involvement with watercolors // Nancy Dustin Wall Moure, "Five Eastern Artists out West," *American Art Journal* 5 (Nov. 1973), pp. 15–28. Includes details of his western journeys // Wayne Craven, "Samuel Colman (1832–1920): Rediscovered Painter of Far-away Places," *American Art Journal* 8 (May 1976), pp. 16–37. The most detailed discussion available on the artist's life and works.

The Hill of the Alhambra, Granada

Following his first trip abroad, Colman began a series of Spanish landscapes. With such works as *Bay of Malaga*, 1861 (New York art market, ill. Craven [1976], p. 19), he began to document the terrain of southern Spain, revealing his fascination with Moorish architecture. His interest in Spain was unusual for an American painter of the period and reflected his involvement with contemporary American literature. It was undoubtedly Washington Irving's *The Alhambra* (New York 1832), a collection of reminiscences of Spain and Spanish-Moorish folktales that provided Colman with the impetus to visit Spain. It is also likely that Irving's text was the direct inspiration for *The Hill of the Alhambra, Granada*, which Colman painted in 1865. Regarding another Spanish work, *Antequera*, Colman wrote Samuel A. Coale, Jr., "I intended to send you a

description . . . but you may find it on page 30. . . . of Irving's Alhambra, 'The Journey'. The subject is therefore in a measure historical" (Sept. 14, 1870, Coale Papers, NYHS).

Irving's vivid description of the historic fortress of Moorish kings fits Colman's rendition easily:

The royal palace forms but part of a fortress, the walls of which, studded with towers, stretch irregularly round the whole crest of a hill, a spur of the Sierra Nevada or Snowy Mountains, and overlooking the city; externally it is a rude congregation of towers and battlements, with no regularity of plan nor grace of architecture, and giving little promise of the grace and beauty which prevail within (1851 ed., p. 47).

Colman's dependence on Irving's text is confirmed by the introduction in the painting's foreground of a procession of soldiers dressed in Renaissance costume and carrying banners and

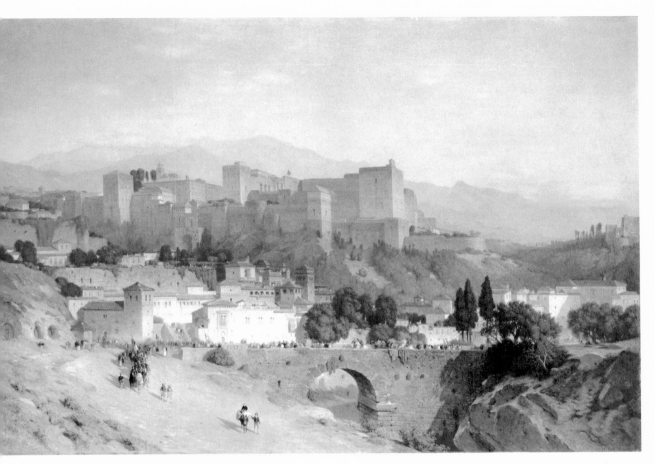

Colman, *The Hill of the Alhambra, Granada.*

lances. Irving had written at length of the city's traditional fêtes, jousts, and parades. He devoted an entire chapter to the street processions that took place during the reign of Ferdinand and Isabella.

It is likely that Colman derived the inspiration for his version of the Alhambra from the frontispiece to the 1851 G. P. Putnam edition of Irving's *Legends.* The illustration, designed by Felix O. C. Darley (1822–1888) showed a portion of the exterior walls of the palace and was similar in style to Colman's more extensive *The Hill of the Alhambra, Granada.* There is no doubt that the artist would have been familiar with the Putnam edition, for he had recently collaborated with the publisher on illustrations for a volume of Irving's *The Sketch Book of Geoffrey Crayon, Gent.*

Colman's painting, however, goes beyond illustration and reveals the fluidity of his maturing brush, as well as his characteristic command of brilliant color, atmospheric clarity, and convincing perspective. Structured like his earlier Spanish landscape *Bay of Malaga,* the work has a bridge that leads the eye back through the carefully balanced composition. Colman's decision to combine a contemporary landscape view with the historical detail of a bygone era is perfectly in keeping with Irving's equally romantic literary style. The author's preface to the revised edition of *The Alhambra,* published in 1851, might easily describe the painter's attempt to capture the *The Hill of the Alhambra, Granada* on canvas (p. 13):

It was my endeavor scrupulously to depict its half Spanish half Oriental character; its mixture of the

heroic, the poetic, and the grotesque; to revive the traces of grace and beauty fast fading from its walls; to record the regal and chivalrous traditions concerning those who once had trod its courts; and the whimsical and superstitious legends of the motley race now burrowing among its ruins.

Colman's painting was called "an important Spanish subject" by one reviewer of the National Academy exhibition in 1865:

It is in every respect a well-conceived and carefully-executed work. Mr. Coleman [sic] is rarely strong, but his delicate variety of detail is eminently interesting. The architectural features of Granada are presented with less hardness than might be anticipated from the mass of angles that strike the eye. Life and animation are furthermore imparted to the scene by the introduction of a many-colored procession—an expedient to which Mr. Coleman has before resorted.

Oil on canvas, $47\frac{1}{2} \times 72\frac{1}{2}$ in. (120.7 × 181.6 cm.). Signed and dated at lower right: S. COLMAN 65.
REFERENCES: *New York Evening Post*, Feb. 16, 1865, p. 1, notes, "Colman is engaged on a large and characteristic painting of the Alhambra as it was in Charles the Fifth's time, with its lofty towers and settlements Below it lies the city of Granada, and in the foreground a body of troops are coming forth on horseback. A fine tone pervades the picture and when finished it will prove an effective and pleasing work // *New York Times*, May 29, 1865, p. 5, reviews it (quoted above) // S. Colman to J. Q. A. Ward, Oct. 4, 1865, John Quincy Adams Ward Papers, 2909, NYHS, mentions: "To make a long story short. My much abus[e]d Alham[bra] is in my room the key with James and if Sned[ecor] wants he can have it if he will give it a good place, otherwise not, as I have had enough of that" // *Nation* 1 (Nov. 16, 1865), pp. 631–632, describes the scene in detail and says, "It is useless to describe, one by one, the numerous separate absurdities of this pretentious work. It is to be hoped that, in spite of our fears, it may be soon as completely forgotten as it deserves to be // *Art Journal* 76 (1880), p. 264, says the work was painted during the first four or five years after Colman's return from Europe in 1862 and calls it "Hill of the Alhambra" // J. H. Snow, Oct. 12, 1966, letter in MMA Archives, quotes the original bill of sale for the painting: "This Bill of Sale, dated April 3, 1872, is that of the Somerville Art Gallery, 82 Fifth Avenue, New York City, being a receipt for $1300.00 for this canvas, purchased at the time by a member of Mrs. Hering's family, Mr. S. J. Harriot" // W. Craven, *American Art Journal* 8 (May 1976), pp. 19–20, says, "The picture represents Colman's art as it reaches maturity and reveals his Romantic spirit in the choice of subject," and also remarks that the elements of Col-

man's composition "are characteristic of the Romantic escapist's fascination with exotic lands and long-past eras."
EXHIBITED: NAD, 1865, no. 258, as The Hill of the Alhambra, Granada, Spain // PAFA, 1866, as The Hill of the Alhambra, Spain, no. 597, for sale // Exposition Universelle, Paris, 1867, no. 11, as Vue de l'Alhambra // NAD, 1867–1868, *Winter Exhibition*, no. 679, as View of the Alhambra // MMA, 1972, *Recent Acquisitions, 1967–1972* (no cat.).
EX COLL.: with Somerville Art Gallery, New York, 1872; Samuel J. Harriot, New York, 1872; descended to his grandniece Adelaide Heriot Arms (Mrs. Oswald C.) Hering, New York and Shelburne Falls, Mass., until 1968.
Gift of Mrs. Oswald C. Hering, in memory of her husband, 1968.
68.19.

Finish — First International Race for America's Cup, August 8, 1870

In 1851 the British royal yacht *Squadron* offered a silver ewer valued at one hundred guineas as a trophy in an open race around the Isle of Wight. The winner was the United States vessel the *America*, whose six skippers brought their prize back to New York, later deeding it to the New York Yacht Club. Beginning in 1857, the America's Cup, as the trophy was subsequently named, was held in trust by the club, which invited challenge by yachts of all nations.

No challenge to American ownership of the silver cup was taken up until 1870, when the first international contest took place. A fleet of seventeen defending American vessels was pitted against a sole British challenger, James Ashbury's *Cambria*. The ships sailed over the New York Yacht Club's regular racing course, "starting from at anchor above the Narrows, proceeding down the channel, around Southwest Spit Buoy, to Sandy Hook Lightship and return" (*New York Yacht Club Centennial*, 1944, p. 45). At the finish, the British vessel, its mast severely damaged, was ninth over the line. The trophy was officially won by the American yacht *Magic*, owned by Franklin Osgood.

The initial recording of these yachting competitions on canvas is credited to English marine painters, notably James E. Buttersworth (1817–1894), who came to this country in the first half of the nineteenth century. As the business of painting clipper ships declined, interest shifted

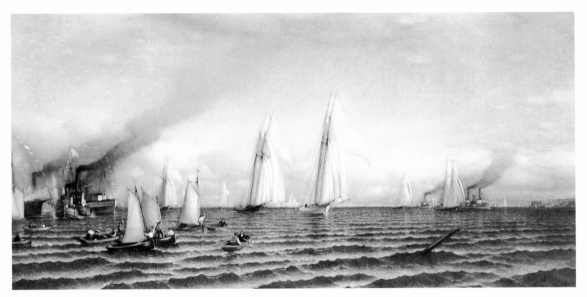

Colman, *Finish—First International Race for America's Cup, August 8, 1870.*

to yacht racing, and many artists made a living painting portraits of private yachts and recording their competitions. Such works were undoubtedly familiar to Colman. A contemporary biographer, George W. Sheldon, noted that at an early age Colman "was often seen sketching the ships and the shipping, the waters and the sky, the wharves and the wharfmen" (*American Painters*, 1879, p. 73). Colman's own production of marine subjects began in the mid–1850s with landscapes of the Hudson River like *Becalmed in the Highlands*, 1856 (coll. Jo Ann and Julian Ganz, Jr., Los Angeles). By the 1860s he had made his first trip abroad, where he observed the atmospheric seascapes of J. M. W. Turner. Similar effects were also being rendered in this country by FITZ HUGH LANE, and Colman soon began to incorporate steam and clouds in many of his marine compositions, like *Storm King on the Hudson*, 1866 (National Museum of American Art, Washington, D.C.).

Finish—First International Race for America's Cup, August 8, 1870 was painted the year of the race. In it Colman combined several styles that he culled from contemporary American marine painting. Consistent with works by James Buttersworth and prints by Currier and Ives, the picture depicts the moment when the *Magic*, the central vessel, approached the finishing marker. The sweeping breadth of the composition recalls earlier harbor paintings by THOMAS

THOMPSON and THOMAS BIRCH, as well as contemporary oils by FITZ HUGH LANE, whose *Boston Harbor*, 1853 (coll. E. P. Richardson, Philadelphia), depicts the bustling activity of that ocean port with unprecedented clarity. Colman's style, his detail in the rigging of each competing vessel, and his careful drawing of the avid spectators appears old-fashioned in comparison with more fluid contemporary works by WINSLOW HOMER and others. The schematic treatment of the foreground waves, however, suggests more than a minor dependence on contemporary prints for inspiration. Only the delicate atmospheric steam from the harbor craft on either side of the picture indicates Colman's true level of stylistic sophistication at this point in his career.

Oil on canvas, 30 3/16 × 60 1/8 in. (76.7 × 152.7 cm.).
Signed and dated at lower right: *S. Colman.* 1870.
REFERENCES: S. Feld, *Antiques* 87 (Apr. 1965), ill. p. 443, describes the work // W. Craven, *American Art Journal* 8 (May 1976), p. 22, says: "The delineation of the sailing ships is one of the beauties of the picture and the smoke-belching steamboats at the left and right seem to be curious misfits of technological progress, and carry Colman's art further beyond the limitations of the Hudson River School."
EXHIBITED: MMA, 1965, *Three Centuries of American Painting* (checklist alphabetical) // Los Angeles County Museum of Art and M. H. de Young Memorial Museum, San Francisco, 1966, *American Paintings from the Metropolitan Museum of Art*, no. 93, ill. p. 107 //

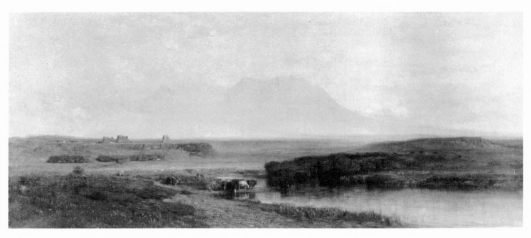

Colman, *Spanish Peaks, Southern Colorado, Late Afternoon.*

Phoenix Art Museum, Arizona, 1967–1968, *The River and the Sea*, ill. no. 3.

ON DEPOSIT: Xerox Corporation, Rochester, N.Y., 1969–1970 // Gracie Mansion, New York, 1975–1977 // New York City Department of Parks, 1978–present.

EX COLL.: with Paul Hamel, Springfield, Mass.; with Childs Gallery, Boston, and Old Print Shop, New York, jointly 1962.

Arthur Hoppock Hearn Fund, 1962.

62.202.

Spanish Peaks, Southern Colorado, Late Afternoon

Knowledge about Colman's journeys to the American West is not complete. Based on several dated works, however, it can be surmised that he made his first visit to the frontier in 1870, additional trips in 1871, 1886, 1888, and a later venture sometime between 1898 and 1905. His early western subjects dealt almost uniformly with pioneering and most frequently depicted wagon trains, like *Ships of the Plains*, 1872 (Union League Club, New York). More than a decade seems to have elapsed between his 1871 trip west and the resumption of his interest in western subjects. *Spanish Peaks, Southern Colorado, Late Afternoon*, painted in 1887, was apparently the result of an 1886 visit Colman made to Colorado. It was first exhibited in February of 1890 at Avery's Art Gallery in New York, where it was accompanied by a pastel entitled *Sketch of the Spanish Peaks, Colorado* (unlocated). In a letter to the Metropolitan in 1908 Colman described the work:

There is a stream of water running through the centre of the picture, to the right of a shadowy foreground with arid plains on either side. In the middle distance masses of limestone rocks arise, which appear like the towers of a castle or fortress; while beyond the Spanish peaks are seen against a late afternoon sky. Some cattle and horses are on the bank of the river.

Unlike his earlier wilderness canvases, the painting does not depend on the imagery of the American pioneer. Instead, it reflects the stylistic influence on Colman of the French Barbizon painters. The spirit of Colman's *Spanish Peaks* is close to that of many Barbizon landscapes, although the rugged terrain is far different from that of the forest of Fontainebleau, near Paris. Nevertheless, Colman's atmospheric treatment reveals an understanding of the concern these French artists had with the subtle manipulation of color and the changing effects of light. He has adopted a different technique of applying paint, brushing the canvas loosely with a minimum of surface variation. This and the elimination of all extraneous detail in favor of a simplified composition is in keeping with the Barbizon quest for the evocation of mood in landscape through little more than tonality.

Oil on canvas, $31\frac{1}{8} \times 72\frac{1}{4}$ in. (79.1 × 183.5 cm.). Signed and dated at lower right: Samuel Colman 1887.

RELATED WORKS: *Sketch of the Spanish Peaks, Colorado* (unlocated), listed in Avery's Galleries, New York, 1890, *Collection of Pictures by Samuel Colman, N.A.*, no. 23.

REFERENCES: Avery's Art Gallery, New York, 1890, *Collection of Pictures by Samuel Colman, N.A.*, no. 4, as Spanish Peaks, Southern Colorado, Late Afternoon // *Collector* 4 (April 1, 1893), notes that this picture was purchased at the Fifth Avenue Art Galleries by "President Henry G. Marquand for the Metropolitan Mu-

seum of Art for $700"; (April 15, 1893), p. 182, corrects earlier statement and indicates that someone else had actually purchased the work for donation to the museum [H. O. Havemeyer] // *Art Amateur* 28 (May 1893), says Havemeyer bought it at auction for $700 // *Art Interchange* 30 (May 1893), p. 129, notes that picture will go to the MMA // S. Colman, May 30, 1908, letter and autobiographical note in MMA Archives, describes the work (quoted above) // N. Moure, *American Art Journal* 5 (Nov. 1973), p. 27; p. 28, fig. 10 // W. Craven, *American Art Journal* 8 (May 1976), pp. 16, 27, mentions it as "Spanish Peaks, Southern California"; p. 28, fig. 16.

EXHIBITED: Avery's Art Gallery, New York, 1890, *Collection of Pictures by Samuel Colman, N.A.*, no. 4, as Spanish Peaks, Southern Colorado, Late Afternoon // Utah Centennial Exposition, Salt Lake City, 1947, *100 Years of American Painting*, no. 15 // Henry Art Gallery, University of Washington, Seattle, 1968, *The View and the Vision*, no. 10 // Los Angeles County Museum of Art, traveling exhibition, 1972–1975, *The American West*, exhib. cat. by Larry Curry, pl. 106, p. 156. // MMA and American Federation of Arts, traveling exhibition, 1975–1977, *The Heritage of American Art*, exhib. cat. by M. Davis, no. 55, ill. p. 131.

EX COLL.: the artist, until 1893 (sale, Fifth Avenue Art Galleries, New York, March 29, 1893, no. 51, $700); Henry O. Havemeyer, New York, 1893.

Gift of H. O. Havemeyer, 1893.

93.21.

WILLIAM TROST RICHARDS

1833–1905

William Trost Richards was famous during the last decades of the nineteenth century for his paintings and watercolors of the sea. He analyzed the motion of the waves with the same careful study that he devoted to nature throughout his life. About the sea, he once wrote to his patron, the prominent Philadelphia collector George Whitney, "I watch and watch it, try to disentangle its push and leap and recoil, make myself ready to catch the tricks of the big breakers" (quoted in Brooklyn Museum, exhib. cat., 1973, p. 33). Standing in the water, he painted quick sketches that later served as the source material for his studio paintings. He was particularly interested in capturing the effects of light on wet sand, quiet or stormy water, and through the diffusing haze of mist.

Richards was born in Philadelphia in 1833 and was educated in the city's public schools until shortly after his father's death in 1846. Having taught himself to draw at an early age, he became a designer of gas lighting fixtures in about 1850. In the evenings he studied with Paul Weber (1823–1916), a German landscape and portrait painter whose insistence on precision and detail reinforced the meticulous style that Richards was developing through his work as a designer. During this period, Richards was as much an essayist as an artist and contributed to the publications of the Forensic and Literary Circle of Philadelphia, which he had helped to found in 1848. His earliest paintings reflect the romanticism of his essays and the influence of the Hudson River school of painters. In 1854, Richards met JOHN F. KENSETT and FREDERIC E. CHURCH in New York. Later that year he sketched with JASPER F. CROPSEY in Philadelphia.

In August 1855, Richards went to Europe. He visited Paris and Zurich, spent several months in Italy, and, in the spring of 1856, went to Düsseldorf and Stolzenfels in Germany. "You cannot imagine," he wrote, "what a new world has been opened to me" (quoted in

Brooklyn Museum, exhib. cat., 1973, p. 20). His respect for the work of Church nevertheless remained undiminished: "I have found nothing as yet in the way of Landscape Art to equal the pictures painted by Church of New York" (ibid.). Richards returned to the United States and, on June 30, 1856, married Anna Matlack in Germantown, Pennsylvania.

He maintained a studio in Philadelphia and exhibited frequently at the Art Union of Philadelphia, the Pennsylvania Academy of the Fine Arts, the American Watercolor Society, and the National Academy of Design. During the early 1860s, when his paintings were characterized by precise draftsmanship and minute realistic detail, Richards was identified with the Pre-Raphaelite landscape painters and with the ideas of John Ruskin. Richards was elected a member of the Association for the Advancement of Truth in Art when it was founded in 1863; its members were known as the American Pre-Raphaelites.

In the winter of 1866–1867, Richards returned to Europe with his family in hopes of establishing his reputation there. After seeing the Exposition in Paris where two of his paintings were shown, he visited his former teacher Paul Weber in Darmstadt and sketched in Switzerland and Italy. It was after his return to the United States that Richards concentrated on depicting the sea. During the early years of his career, he had spent summers painting coastal scenes at Atlantic City and in New England, as well as landscapes of the Adirondack and the White mountains. From 1871, however, he committed himself almost exclusively to studying and sketching the ocean, always aware of the geological peculiarities of each location. Newport, Rhode Island, became his favorite site. In 1875, he bought the first of several summer homes that he owned in Newport.

In 1878 the Society of American Artists refused to invite Richards to participate in its first exhibition. The members, young artists who preferred spontaneity and plein-air painting, considered his work to be old-fashioned and inartistic.

In 1878 Richards went to live in England, where he remained with his family until 1880. He was especially captivated by the drama and excitement of the rugged coast of Cornwall. He traveled widely in Great Britain and visited the continent. The trip satisfied his two-fold ambition to expand his subject matter and the market for his paintings. His paintings were exhibited at the Royal Academy and the Paris Exposition, as well as at a number of galleries. Richards continued to paint until his death in 1905. He made several trips abroad during the last years of his life, often to sketch on the coast of Ireland and Scotland. His late paintings increasingly show looser brushstrokes, broader treatment of form, and a reduced range of color. Richards received a number of significant awards, including a bronze medal at the Centennial Exhibition in 1876, a silver medal from the Pennsylvania Academy in 1885, a bronze medal at the Paris Exposition in 1889, and a gold medal from the Pennsylvania Academy in 1905. In 1881, shortly after its founding, the Metropolitan Museum received a collection of over fifty Richards's watercolors from the noted collector the Rev. Elias L. Magoon. The painter Anna Richards Brewster (1870–1952) was Richards's daughter.

BIBLIOGRAPHY: Harrison S. Morris, *William T. Richards: A Brief Outline of His Life and Art* (Philadelphia, 1912). A standard reference, cites anecdotes of the artist and quotes family recollections // New Britain Museum of American Art, Conn., *He Knew the Sea: William Trost Richards, N.A. (1833–1905)*, *Anna Richards Brewster (1870–1952)*, exhib. cat. by Charles B. Ferguson (1973). Introduces a number of sketchbooks // Brooklyn Museum, PAFA, *William Trost Richards: American*

Landscape and Marine Painter, 1833–1905, exhib. cat. by Linda Ferber (1973). A major retrospective of his work // Linda S. Ferber, *William Trost Richards (1833–1905): American Landscape and Marine Painter* (Ph.D. diss., Columbia University, 1980; published 1980). Includes many references to letters and documents.

Indian Summer

During the early and mid–1870s, Richards painted the kind of small, vertical woodland scenes that had been popularized by ASHER B. DURAND. *Indian Summer*, signed and dated by Richards in 1875, has the standard features of these paintings. Tall, graceful trees frame the pool of still water in the middle distance. Light fills the center of the painting and diffuses the distant autumn foliage. A horse-drawn cart and two figures resting by the pool unobtrusively animate the scene.

Indian Summer reflects Richards's response to criticisms of his earlier, detailed compositions. In 1867, Henry T. Tuckerman had described Richards as the "most remarkable" of those "landscape-painters who, in the minuteness of their limning, carry out in practice the extreme theory of the Pre-Raphaelites." He added his misgivings about "a literalness so purely imitative" (p. 524). Here Richards has eliminated many details, such as underbrush in the forest, and lightened others. By simplifying the composition he has created a decorative image.

Oil on canvas, 24⅛ × 20 in. (61.3 × 50.8 cm.).

Signed and dated at lower left: Wᵐ T. Richards / 1875.

Label on the back: GOUPIL'S / 170 / Fifth / Ave.

REFERENCES: E. Strahan [E. Shinn], ed., *The Art Treasures of America* 3 (1880), p. 42, lists it in Collis P. Huntington's collection // L. S. Ferber, *William Trost Richards*, (Ph.D. diss., Columbia University, 1980), p. 216, fig. 152.

EXHIBITED: Art Association of Newport, 1954, *A Memorial Exhibition of Marine Paintings by William T. Richards, 1833–1905*, no. 5 // Brooklyn Museum and PAFA, 1973, *William Trost Richards*, exhib. cat. by L. S. Ferber, p. 78, no. 61, p. 33, compares it to Old Orchards [at Newport] and calls it "highly composed."

ON DEPOSIT: Albany, Executive Mansion, 1975 to 1979.

EX COLL.: Collis P. Huntington, from at least 1879 to 1900; his wife (later Mrs. Henry E. Huntington), subject to a life estate, 1900–d. 1924; her son, Archer M. Huntington, subject to a life estate, which was relinquished, 1924–1925.

Bequest of Collis P. Huntington, 1900.

25.110.6.

William Trost Richards

Near Land's End, Cornwall

In 1879 when this picture was painted, George W. Sheldon wrote that Richards made "the best drawings of waves that this country can produce" (*American Painters* [1879], p. 62). From August 1878 until October 1880, Richards lived in England, and the rugged coast of Cornwall was one of his favorite subjects. Like many of his other marine paintings, *Near Land's End, Cornwall* conveys the panorama of the sea in a long horizontal format emphasized by waves and clouds. Sunlit gulls circle faceted rocks on the distant horizon. The smooth surface of the painting is disturbed only by the impasto of the breaking waves and cirrus clouds. The absence of beach and the low horizon increase the immediacy of the cool, blue-green ocean. The silhouettes of two distant ships give evidence of human presence. The broken, nail-studded boards of a past shipwreck seem to allude to the destructive power of the sea.

Until recently the picture was known only

Richards, *Indian Summer*.

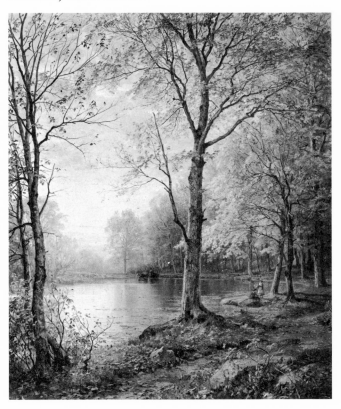

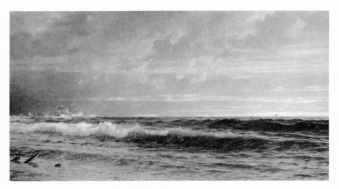

Richards, *Near Land's End, Cornwall.*

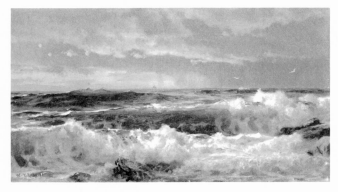

Richards, *Surf on Rocks.*

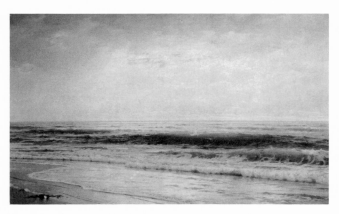

Richards, *New Jersey Beach.*

as *Seascape.* There is a label from the MFA, Boston, on the back of the frame, however, that indicates its loan there. From this it was ascertained that the title in 1924 and probably before was *Near Land's End, Cornwall.*

Oil on canvas board, 23¼ × 44¼ in. (59.1 × 112.4 cm.).

Signed and dated at lower left: Wᵐ. T. Richards 1879.

REFERENCES: S. Frankenbach, MFA, Boston, May 9, 1980, letter in Dept. Archives, supplies information

on loan dates and title // T. S. Matthews, letter in Dept. Archives, June 9, 1982, supplies information on the provenance.

EXHIBITED: Art Association of Newport, 1954, *A Memorial Exhibition of Marine Paintings by William T. Richards, 1833-1905,* no. 6 // Heckscher Art Museum, Huntington, N. Y., 1958, *Marine Paintings by American Artists* (no cat.).

ON DEPOSIT: MFA, Boston, 1924, 1929, 1930, as Near Land's End, Cornwall, lent by Mrs. Horace Gray, Boston.

EX COLL.: Horace Gray, Boston, 1911; his wife, d. 1930; her nephew, Thomas S. Matthews, New York, until 1950.

Gift of T. S. Matthews, 1950.

50. 9.

Surf on Rocks

During the 1890s, when this picture was painted, Richards was especially fascinated by the effects of storms on the sea. He also concentrated more on the rough breakers than on the coast itself. He never ceased to study the sea, although his method of recording his observations changed. In his later seascapes he depended more on studies in oil than on the quick pencil sketches that he had made for his earlier, more detailed paintings. *Surf on the Rocks* is one of hundreds of these later oil sketches. Painted relatively broadly, with a greater sense of texture and brushwork than is found in his finished compositions, it captures the vibrancy of the light and the motion of the sea and sky after a storm. Richards's wife often despaired at the difference between his free, more richly colored sketches and his tighter, finished paintings. She once remarked: "I throw tables and chairs at William to make him paint broadly." (H. T. Morris, *William T. Richards* [1912], p. 43). *Surf on Rocks,* like his other oil sketches, is painted on hard board and corresponds to one of the five standard sizes that fit into his portable easel box.

Oil on board, 8¾ × 15⅞ in. (22.2 × 40.3 cm.).

Signed at lower left: Wᵐ T. Richards. Inscribed on back: Anna.

EXHIBITED: Art Association of Newport, 1954, *A Memorial Exhibition of Marine Paintings by William T. Richards, 1833-1905,* no. 7 // Queens County Art and Cultural Center, New York; MMA; Memorial Art Gallery of the University of Rochester, N.Y.; Sterling and Francine Clark Art Institute, Williamstown, Mass., 1972-1973, *19th Century American Landscape,* exhib. cat. by M. Davis and J. K. Howat, no. 17 //

Brooklyn Museum and PAFA, 1973, *William Trost Richards*, exhib. cat. by L. Ferber, no. 92.

Ex COLL.: the artist's daughter, Anna Richards (Mrs. William T.) Brewster, Scarsdale, N.Y., until 1932.

Gift of Mrs. William T. Brewster, 1932.

32.73.2.

New Jersey Beach

Painted in 1901, *New Jersey Beach* is representative of the last stage of Richards's productive career. It reveals his definite, though reluctant, concession to the broader rendering of form and looser brushstroke that had become popular. He has not, however, sacrificed realistic effects. His preference for detail is still evident in the crisp definition of the cresting waves. The description of the light gray foam, which skims the surface of the green water, however, is rendered in terms of broad, almost abstract areas, and the foam of the curling waves as they wash the beach is blurred rather than sharply defined.

Light from an unseen source in the center of the sky reflects on the pearly colored wet sand and on the surface of the water. This and the translucent green of the cresting waves point to the artist's continued interest in the effects of reflected light. There is a strong panoramic quality to the composition, which is reinforced by an uninterrupted band of blue-gray at the horizon.

Oil on canvas, 28¼ × 48¼ in. (71.8 × 122.6 cm.).

Signed and dated lower left: W^m T. Richards. 1901.

EXHIBITED: Phoenix Art Museum, 1967–1968, *The River and the Sea*, ill. no. 15.

ON DEPOSIT: Barnard College, New York, 1950–1951 // Borough Hall, Queens, New York, 1972–1978.

Ex COLL.: the artist's daughter, Anna Richards (Mrs. William T.) Brewster, Scarsdale, N.Y., until 1932.

Gift of Mrs. William T. Brewster, 1932.

32.73.1.

CHARLOTTE BUELL COMAN

1833–1924

At the turn of the century Charlotte Coman was among the leading women artists in the United States. She was born in Waterville, New York, and began her career as a painter after the death of her husband, with whom she had led a pioneer's life in Iowa. She was in her thirties when she returned East, settled in New York, and sought her first formal instruction from James R. Brevoort (1832–1918), a landscape painter.

Her studies soon led her to Paris. She remained there for six years, first as a student of the English expatriate artist Harry Thompson and then of Emile Vernier. Under Vernier's guidance she mastered the methods of plein-air painting as well as the techniques of watercolor. She made frequent sketching trips to the French and Dutch countrysides. In her later works she would draw periodically on landscape subjects from these experiences abroad. She insisted, however, that "Although I learned something in Paris, I learned far more here in America after I came back" (*New York Herald*, p. 6).

When Charlotte Coman returned to the United States she settled in a New York studio. In 1875 she showed two paintings at the National Academy of Design, *A Path through the Woods near Waterville, New York* and *A Lane near St. Valerie, France* (both unlocated). She was an active member of the city's artistic community. Her works were exhibited regularly

in New York and at the Paris Salons. In 1905 she was awarded the Shaw Memorial Prize by the Society of American Artists and in 1910 was elected an associate of the National Academy of Design. She was a member of the New York Water Color Club, the Art Workers' Club, and the Association of Women Painters and Sculptors.

Except for a brief period early in her career when she apparently painted a series of flower compositions, Charlotte Coman concentrated on landscape. French scenery predominates in her earliest work. By the 1880s, however, she was also doing many Dutch views, frequently in watercolor. Beginning in 1887, her focus shifted to the American landscape, and her compositions were based on sketches done during summers in the Adirondacks and winters in New Jersey and Saint Augustine, Florida, where she had a studio for several years in the same building as MARTIN JOHNSON HEADE. The format of her paintings remained consistent throughout most of her career: simple, undetailed views of the countryside, constructed with a high horizon line. Her preferences for scumbled, suggestive brushwork and muted tonalities has often been interpreted as a continuing response to French plein-air painting.

Mrs. Coman continued a rigorous daily routine of sketching outdoors and painting at her easel in the studio until she was well over eighty years old. She died in Yonkers, New York, at the age of ninety-one.

BIBLIOGRAPHY: *New York Herald*, magazine section, Jan. 12, 1913, pp. 6–7. In an interview the artist reveals details of her career and philosophy of painting ‖ Obituary: *Art News* 23 (Nov. 15, 1924), p. 6. Includes career information ‖ Zenobia Ness and Louise Orwig, *Iowa Artists of the First Hundred Years* (Des Moines, 1939), p. 48. An account of Mrs. Coman's beginnings as an artist.

Clearing Off

First exhibited in 1908, this landscape is undoubtedly a scene in the Adirondacks, where Charlotte Coman had a studio in her later years. Focused on a bit of countryside under changing atmospheric conditions, it is typical of the scenes she painted after 1887.

Following her formative years of study in Paris, Charlotte Coman's style remained closest to that of the Barbizon painters. Like Jean François Millet and Théodore Rousseau, she depicted specific times of the day and weather conditions that tempered the play of light on the landscape. Her debt to French painting is apparent in her use of the palette knife to create a rich impasto

Coman, *Clearing Off.*

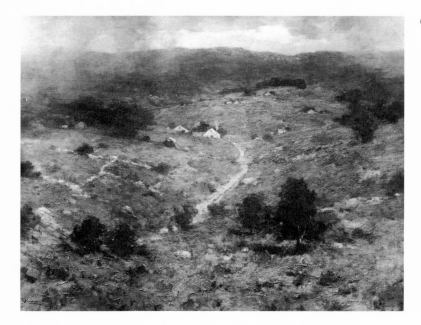

and her preference for low-key colors. The absence of linear elements assures the overall harmony of the composition in which no one detail distracts from the general impression.

Oil on canvas, 27⅛ × 36¼ in. (68.9 × 92.1 cm.). Signed at lower left: *C. B. Coman.*

REFERENCES: C. B. Coman to W. Macbeth, August 2, 1910, Sept. 13, 1911, Macbeth Gallery Papers, NMc6, Arch. Am. Art, says the painting is being picked up by someone from the gallery and indicates that someone (illegible) is interested in finding out the price of the painting // E. Butterworth, New York, Feb. 27, 1912, offers it to the museum on "behalf of some friends of Mrs. Charlotte B. Coman and myself" // *MMA Bull.* 7 (April 1912), p. 81, records acquisition of the work // *New York Herald,* magazine section, Jan. 12, 1913, p. 7 // *Art News* 23 (Nov. 15, 1924), p. 6, mentions the work in the painter's obituary // Z. Ness and L. Orwig, *Iowa Artists of the First Hundred Years* (1939), p. 48.

EXHIBITED: Macbeth Gallery, New York, 1908, *Exhibition of Forty Selected Paintings by Living American Artists,* no. 4 // Art Club of Philadelphia, 1909 (no cat. available) // Engineers Club, New York, 1909, *Loan Exhibition of Paintings by American Artists,* no. 6, lent by William Macbeth // Carnegie Institute, Pittsburgh, 1911, no. 53 // Macbeth Gallery, New York, 1914, *Paintings by American Artists,* ill. p. 22 // NAD; Corcoran Gallery of Art, Washington, D.C.; and Grand Central Art Galleries, New York, 1925–1926, *Commemorative Exhibition by Members of the National Academy of Design,* no. 189.

EX COLL.: with William Macbeth Gallery, New York, by 1908—at least 1911, Mrs. Emily Butterworth, 1912.

Gift of friends of the artist, 1912.

12.47.

WILLIAM P. W. DANA

1833–1927

Described in 1867 by the prominent critic and historian Henry T. Tuckerman as "an accomplished disciple of the modern French school," William Parsons Winchester Dana spent the greater part of his life abroad. A native of Boston, he left a promising career in a mercantile house at the age of nineteen to pursue the study of painting in Paris. He entered the atelier of François Edouard Picot, a distinguished history, genre, and portrait painter. Picot's guidance contributed to Dana's admission in 1853 to the prestigious Ecole des Beaux-Arts. There the young artist concentrated on drawing and painting from life. He had a special affinity for landscape painting and spent his summers in Normandy and Brittany, making countless sketches of coastal life. Dana's passion for the sea led him to seek instruction from Eugène Lepoittevin, a painter noted for his seascapes and scenes of daily life along the rivers of France.

After ten years of study abroad Dana returned to the United States in 1862. That same year he began to exhibit his work at the National Academy of Design, where he was elected an associate member. The following year, because of his painting *Heart's Ease* (q.v.), he was made an academician. Dana maintained studios in New York and Newport, where he produced a variety of seascapes, genre paintings, and portraits. His work was popular, and his pictures of children and animals were universally praised. The critic James Jackson Jarves noted: "The motives of his compositions are among the most charming of *genre* painting. Children become real on his canvas, in their merry games or pensive moods. He

has a tender sympathy for them, for animals, and for whatever is refined and beautiful" (*The Art-Idea* [1864; 1960 ed. by B. Rowland, Jr.], p. 184).

Despite his success in this country, Dana returned to Europe in 1870. He settled in Paris, where he exhibited regularly at the Salon. His painting *Solitude* (unlocated) won a medal of honor at the Exposition Universelle in 1878. Dana was active in the large community of American artists in Paris in the late nineteenth century. Romantic seascapes set under the moonlit skies of Normandy, Brittany, and the Basque region were his specialty. In the 1880s he established a home and studio in London. By the 1890s, however, Dana's health began to fail, and he gradually dropped out of artistic circles and exhibited infrequently. He died in England in 1927. A memorial exhibition was held in London that year.

BIBLIOGRAPHY: Henry T. Tuckerman, *Book of the Artists* (Boston, 1867), pp. 483–484. Gives an outline of Dana's career and mentions some of his better known works // Robert W. Dana, *William Parsons Winchester Dana, Biographical Note by His Son* (London, 1927). Pamphlet with a foreword by Lord Northbourne includes some of the artist's best-known works. // George C. Groce and David H. Wallace, *The New-York Historical Society's Dictionary of Artists in America, 1564–1860* (New Haven, 1966), p. 163. Includes available source material.

Heart's Ease

Among Dana's earliest exhibited works, this picture of a convalescent child captures the essence of Victorian sentiment. Painted in 1863, it was shown the same year at the National Academy of Design. There, the exhibition catalogue contained the following verse:

> By books and toys no more beguiled
> What now has power to please?
> Flowers! God's gift, the wearied child
> Has found in them Heart's Ease.

The poetic accompaniment was undoubtedly intended to complement the subject of the canvas. "Heart's ease" is most frequently defined as "peace of mind" or "tranquility" and is also the name for a wild pansy, the predominant flower among those scattered across the child's bed and at the bedside table.

This picture was the first of many genre scenes of children Dana painted in the 1860s. Inspired by his experience of contemporary English genre painting, in which themes of illness and death were common, it is no coincidence that he chose the subject immediately after his return from ten years of study abroad.

The popularity of *Heart's Ease* earned Dana the rank of academician at the National Academy of Design. Critical reaction to it, however,

Dana, *Heart's Ease.*

was mixed. James Jackson Jarves found that "neither in taste nor in treatment" was the canvas "equal to some of [Dana's] less pretending works." Several years later, Henry T. Tuckerman called the scene "pathetic in the extreme."

Oil on canvas, 37½ × 47¾ in. (95.3 × 121.3 cm.).
Signed at lower center: W. P. W. DANA. / 1863.
REFERENCES: J. J. Jarves, *The Art-Idea* (1864; 1960 ed. by B. Rowland, Jr.), p. 222 (quoted above) //

H. T. Tuckerman, *Book of the Artists* (1867), p. 484 (quoted above).

EXHIBITED: NAD, 1863, no. 27, as Heart's Ease, for sale // PAFA, 1864, no. 47, lent by the artist // College Art Association, New York, traveling exhibition, 1934–1935, *American Painters Memorial Exhibition, since 1900*, no. 7 // MMA, 1965, *Three Centuries of American Painting* (checklist alphabetical).

EX COLL.: S. Howland Russell, 1890.

Gift of S. Howland Russell, 1890.

90.24.

JAMES McNEILL WHISTLER

1834–1903

James McNeill Whistler was one of the most innovative and influential artists of his time. His radical art and carefully cultivated eccentricities made him one of the most controversial and misunderstood figures, as well. His compatriot WILLIAM MERRITT CHASE observed:

> There were two distinct sides to Whistler, each of which he made famous. He succeeded as few ever have in creating two distinct and striking personalities, almost as unlike as the storied Dr. Jekyll and Mr. Hyde. One was Whistler in public—the fop, the cynic, the brilliant, flippant, vain and careless idler; the other was Whistler of the studio—the earnest, tireless, sombre worker, a very slave to his art, a bitter foe to all pretense and sham, an embodiment of simplicity almost to the point of diffidence, an incarnation of earnestness and sincerity of purpose. . . . there is not a mediocre touch in all his work; neither is there any semblance of the academic. It is all absolutely original and thoroughly distinctive (K. M. Roof, *The Life and Art of William Merritt Chase* [1917], pp. 124, 127.

A relentless perfectionist, possessed of a brilliant but devastating wit, Whistler "managed at a very early period in his career, to alienate,—Dealers, Painters, and Public, the three factors upon which commercial success depends" (Arthur Jerome Eddy, *Recollections and Impressions of James A. Whistler* [1903], p. 276).

James Abbott Whistler was born in Lowell, Massachusetts, in 1834, the third son of Major George Washington Whistler, a West Point graduate and civil engineer, and his second wife Anna Matilda McNeill, a southerner of Scottish descent. The family moved to Stonington, Connecticut, in 1837 and to Springfield, Massachusetts, in 1840. At the age of nine, Whistler was taken to Saint Petersburg, Russia, where his father served as a consulting engineer for the construction of the railroad to Moscow. Whistler attended drawing classes at the Imperial Academy of Science in Saint Petersburg and took private lessons from an officer named Karitzky. In 1847 Whistler's half-sister Deborah married the English doctor Seymour Haden who later became known as an etcher. The following year Whistler was sent to school in England, where he lived with the Hadens. After the death of Major Whistler in 1849, the family returned to the United States and settled in Pomfret, Connecticut. Following family

tradition, Whistler entered the United States Military Academy at West Point in 1851. About this time he began to use his mother's maiden name, McNeill, as his middle name. Although he ranked first in the drawing class taught by ROBERT W. WEIR, Whistler's frequent violation of regulations and his poor grades in chemistry led to dismissal from the academy in 1854. As he put it in a short-lived journal (MMA Archives): "After a brief but brilliant career as a military man, when I served my sweet fatherland through three years of fun, folly, and cadetship at West Point, it was discovered that the sphere, whose limits are determined in the Academic Regulations, was entirely too small and confined for one of my elastic capacities, so, upon, the recommendation of the 'Board,' my trunk was packed." Whistler worked for a brief time at the Winans Locomotive Works in Baltimore, where his half-brother was a partner, and then in the drawings division of the United States Coast and Geodetic Survey, where he received his first training in etching. An indifferent and unreliable employee, he resigned in 1855. Determined to become an artist, he went to Europe.

After visiting with his sister in London, Whistler settled in Paris and took up a bohemian life. George du Maurier, one of Whistler's new-found English friends, described this period in his novel *Trilby*, which included a thinly disguised portrait of Whistler as Joe Sibley, the idle apprentice. Whistler studied briefly at the Ecole Imperiale et Speciale de Dessin in 1855 and the following year entered the Académie Gleyre. The influences that shaped his development came, however, from outside the academic world.

The revival of printmaking in the 1840s by such Barbizon painters as Charles Emile Jacque provided a favorable climate for Whistler's interest in graphics. In 1858 he published a set of etchings, *Douze eaux-fortes d'après nature*, the so-called *French Set*, printed by Auguste Delâtre. He also met Gustave Courbet, whose style had dominated his work of the 1850s. Whistler's admiration for Courbet and for Dutch and Spanish art of the seventeenth century was shared by the French artists Henri Fantin-Latour and Alphonse Legros. To mark their mutual artistic interests, the three artists formed a group called Société des Trois through which they shared patrons and maintained close ties with avant-garde art circles in England and France.

Whistler's first major painting, *At the Piano*, 1858-1859 (Taft Museum, Cincinnati), reflected his study of Vermeer, Velázquez, and Courbet. After it was rejected for the Salon of 1859, Whistler moved to England. *At the Piano* was exhibited at the Royal Academy and immediately sold, prompting him to observe that England "welcomes young artists with outstretched hands." He settled in Wapping and began the etchings published in 1871 as *A Series of Sixteen Etchings of Scenes on the Thames and Other Subjects*, or the *Thames Set*. Whistler was a frequent visitor to France. He met Manet in Paris in 1861 and painted *The Coast of Brittany* (Wadsworth Athenaeum, Hartford), the first of his major seascapes. He posed for Fantin-Latour's *Hommage à Delacroix* (Louvre, Paris) in 1864 and painted at Trouville on the Normandy coast with Courbet, Daubigny, and Monet in the autumn of 1865.

In England he came in contact with the Pre-Raphaelites, including Dante Gabriel Rossetti. This influence had an immediate effect in *The White Girl*, subsequently called *Symphony in White, No. 1*, 1862 (National Gallery of Art, Washington, D.C.), a portrait of Joanna Hiffernan, his mistress and principal model. It was painted in Paris between 1861 and 1862. Rejected by the Royal Academy in 1862 and the Paris Salon in 1863, it created a sensation in the Salon des Refusés. In 1863 Whistler leased the house at 7 Lindsay Row (now 101 Cheyne

Walk), not far from Rossetti, with whom he shared a taste for Japanese prints and blue-and-white porcelain. Initially Whistler used oriental costumes and accessories in works like *La Princesse du Pays de la Porcelaine*, 1864 (Freer Gallery, Washington, D. C.) and *The Lange Lijzen of the Six Marks*, 1864 (Philadelphia Museum of Art), but gradually he adopted the formal elements of oriental composition and organization of space evident, for example, in *Brown and Silver: Old Battersea Bridge*, ca. 1865 (Addison Gallery of Art, Andover, Mass.).

In 1866 Whistler visited South America. He spent most of his time in Valparaiso, where he painted a series of seascapes that demonstrate the increasing influence of oriental aesthetics and the waning effect of Courbet, who is reported to have said of Whistler, "he always makes the sky too low or the horizon too high." In a lengthy letter to Fantin-Latour in 1867, Whistler rejected Courbet's realism and expressed regret that he had not been a pupil of Ingres (see L. Bénédite, *Gazette des Beaux-Arts* 34 [1905], pp. 232-233). Oriental and classical sources continued to preoccupy Whistler throughout the 1860s, a period of frustrated experimentation. He began a series of monumental figure compositions, which were never realized except as a group of uncompleted oil sketches, the so-called *Six Projects* (Freer Gallery, Washington, D. C.). Conceived in the classical spirit, they are closely related to the work of the English painter Albert Moore whom Whistler had met by 1865 and who replaced Alphonse Legros in the Société des Trois.

By 1869 Whistler was signing his works with a butterfly monogram derived from his initials. His artistic crisis was resolved by 1870. In 1871 Whistler began his celebrated series of Thames "Nocturnes," first called "Moonlights." By 1872 he was using musical terms as titles for his paintings, a practice probably suggested earlier by his patron Frederick R. Leyland. In 1872 he exhibited *Arrangement in Grey and Black, No. 1: Portrait of the Artist's Mother*, 1871 (Louvre, Paris). Following a course independent of his contemporaries, he developed his own theory of art, which he described to his friend the Baltimore collector George Lucas in 1873 as "the science of color and 'picture pattern' as I have worked it out for myself during these years" (J. A. Mahey, *Art Bulletin* 49 [Sept. 1967], p. 253).

As a central figure in the Aesthetic movement, Whistler influenced interior decoration, furniture, and the design of frames and exhibitions. The dining room he decorated for Leyland in 1876-1877—The Peacock Room, or *Harmony in Blue and Gold* (now in the Freer Gallery)—demonstrates his major achievement in decorative design. A bitter disagreement over his fees, however, alienated Leyland. Then the exhibition of his paintings at the newly opened Grosvenor Gallery in 1877 gave Whistler additional trouble. Incensed particularly by *Nocturne in Black and Gold: The Falling Rocket*, ca. 1875 (Detroit Institute of Arts), the influential English critic John Ruskin wrote, "I have seen, and heard, much of Cockney impudence before now; but never expected to hear a coxcomb ask two hundred guineas for flinging a pot of paint in the public's face." Whistler sued Ruskin for libel. Before the trial opened in November 1878, Whistler contributed to the summer exhibition of the Grosvenor Gallery, designed a room with the architect E. W. Godwin, and made his first experiments in lithography. Although he won his case, Whistler was awarded only a farthing in damages. The publicity of the trial drove away patrons, and by 1879 he was bankrupt. Bailiffs took possession of his home, the White House, which he had designed in collaboration with Godwin. In September Whistler went to Italy with a commission from the Fine Art Society for twelve etchings of Venice. There he

concentrated on etchings and pastels and greatly impressed a group of American artists working with FRANK DUVENECK, among them Joseph DeCamp (1858-1923) and JOHN WHITE ALEXANDER.

When Whistler returned to England in the fall of 1880, he began to paint small panels—marines, landscapes, portraits, and later such urban subjects as shop fronts and house facades inspired by travels in England, France, and Holland. In these exquisite works of the 1880s and 1890s he captured ephemeral effects and displayed them with great eloquence. By 1885 he had abandoned Nocturnes but continued to paint Arrangements or portraits. He also continued his work in printmaking. In 1886 his *Set of Twenty-six Etchings of Venice* was issued by Dowdeswells', and in 1887 Whistler's *Notes*, a set of six lithographs, was published in London by Boussod, Valadon and Cie.

During the 1880s Whistler continued to affirm his artistic beliefs in various ways. The catalogue for '*Notes*'—'*Harmonies*'—'*Nocturnes*,' an exhibition devoted to his work, held in London in 1884, included "Proposition—No. 2," written by Whistler, which began: "A Picture is finished when all trace of the means used to bring about the end have disappeared." In 1885 he delivered his famous "Ten O'Clock" lecture in London. In this elaboration of his theories, he attacked Ruskin's aesthetics and asserted that "Nature is rarely right" and "usually wrong." The poet Stéphane Mallarmé, whom Whistler had met through Monet in 1888, agreed to translate the "Ten O'Clock" lecture into French. In 1890 a collection of Whistler's writings, *The Gentle Art of Making Enemies*, was published in London by William Heinemann.

Whistler's innovative ideas continued to invite controversy. In 1886 he was elected president of the Society of British Artists, which he immediately set out to reform. Largely as a result of his contributions to commemorate Queen Victoria's Jubilee in 1887, the society was given a royal charter and became the Royal Society of British Artists. Whistler's revolutionary efforts in such areas as exhibition installation, however, were not appreciated. In 1888 he was voted out of office. Several of his supporters resigned as a result, provoking Whistler to remark, "The 'Artists' have come out and the 'British' remain."

The late 1880s and 1890s brought Whistler growing international recognition. A large exhibition of his works was held at Wunderlich's in New York in 1889. The same year he was awarded medals in Munich, Paris, and Amsterdam. He was elected an honorary member of the Royal Academy of Fine Arts in Munich, made a chevalier of the Légion d'Honneur, and in 1892 made an officier. In 1890 Whistler met Charles L. Freer of Detroit, who became one of his major American patrons. The following year the city of Glasgow bought his portrait of Thomas Carlyle (City Art Gallery, Glasgow), the first of Whistler's pictures to be purchased for a public collection, and the Musée du Luxembourg purchased the portrait of his mother. In 1894 *Arrangement in Black: La Dame au brodequin jaune—Portrait of Lady Archibald Campbell* was acquired for the Wilstach Collection at the Philadelphia Museum of Art, the first Whistler painting to be bought for a public American collection. Whistler had married Beatrice Godwin, the widow of E. W. Godwin, in 1888. After several years of illness, she died of cancer in 1896. These were difficult years for Whistler, and he withdrew from his active social life. He adopted his sister-in-law, Rosalind Birnie Philip, as his ward and made her his executrix. He founded the Company of the Butterfly to sell his work, but it operated only from 1898 to

1901. In 1898 he was elected president of the International Society of Sculptors, Painters and Gravers. The same year the Académie Carmen, named for his former model Carmen Rossi, opened in Paris, but Whistler spent very little time there. During his last years his work continued to win recognition. In 1904, the year after he died, a memorial exhibition was held in Boston, and in 1905 memorial exhibitions were held by the International Society in London and the Ecole des Beaux-Arts in Paris.

BIBLIOGRAPHY: E[lizabeth] R[obins] and J[oseph] Pennell, *The Life of James McNeill Whistler* (2 vols., London and Philadelphia, 1908; rev. 5th ed., Philadelphia, 1911; rev. 6th ed., Philadelphia, 1920). A basic reference supplemented by material in the authors' *The Whistler Journal* (Philadelphia, 1921) and incorporating some manuscript material from over 1500 items given by them to the Library of Congress, Washington, D.C. (microfilm, Arch. Am. Art, LCW1-LCW4) // Don C. Seitz, *Writings by & about James Abbott McNeill Whistler: A Bibliography* (Edinburgh, 1910) // "James Abbott McNeill Whistler—Painter and Graver," *The Index of Twentieth Century Artists* 1 (June 1934), pp. 129-144; (July 1934), pp. 145-156; two suppls., i-iv. Reprint ed. with cumulative index, New York: Arno Press, 1970, pp. 175, 182-209, 214-220. Contains a short biography; a list of awards, honors, affiliations, and works in public collections; an exhibition record; an extensive bibliography; and a list of reproductions // Andrew McLaren Young, *James McNeill Whistler: An Exhibition of Paintings and Other Works Organized by the Arts Council of Great Britain and the English-Speaking Union of the United States* (London and New York, 1960). Catalogue for an exhibition held at the Arts Council Gallery, London, and Knoedler Galleries, New York, with an introduction and annotated catalogue entries by Andrew McLaren Young, a chronology by Grizel Beese, a record of exhibitions, and an extensive, annotated bibliography compiled by Elizabeth Johnston // Andrew McLaren Young, Margaret MacDonald, and Robin Spencer, with the assistance of Hamish Miles, *The Paintings of James McNeill Whistler* (2 vols., New Haven and London, 1980). The most comprehensive study of Whistler's paintings to date.

Cremorne Gardens, No. 2

Cremorne Gardens in Chelsea by the Thames was originally a private twelve-acre estate, briefly an unsuccessful club, and, from 1845 until it was closed to the public in 1877, a popular amusement park. Not far from Whistler's house on Lindsay Row (now Cheyne Walk), the park was one of his favorite haunts during the 1870s, when he was preoccupied with nocturnal subjects. He was drawn to its spectacular fireworks, milling crowds, and colored lights. Sometimes he viewed them from a boat on the river in the company of his neighbors and pupils Walter and Harry Greaves. According to them, Whistler "never tried to use colour at night or at Cremorne Gardens, but made notes on brown paper in black and white chalk" (E. R. and J. Pennell, [1921], p. 117).

The festive crowds, glowing kiosks, and colored lights are the subject of *Cremorne Gardens, No. 2*. Painted in the 1870s, it is the second in a series of six known nocturnes featuring activities within the gardens: *Cremorne, No. 1* (Fogg Art Museum, Harvard University, Cambridge, Mass.); *Nocturne: Cremorne Gardens, No. 3* (Freer Gallery of Art, Washington D. C.); *Nocturne in Green and Gold* (see below); *Nocturne: Black and Gold—The Fire Wheel* (Tate Gallery, London); and *Nocturne in Black and Gold: The Falling Rocket* (Detroit Institute of Arts). Although none are dated, all were painted between 1872 and 1877. In what Denys Sutton described as "a sort of *fête galante*, in contemporary terms," Whistler dispensed with the mythological or classical allusions that characterized the works of the rococo painters and evoked the leisurely, pleasure-seeking mood of outdoor public entertainment that became a major theme of the impressionists.

Working on a prepared dark ground, Whistler diluted his paint to the consistency of a wash (his celebrated "sauce"). The thinner was either linseed oil and turpentine (according to Walter Greaves) or copal, mastic, and turpentine (as Whistler told the Pennells). This ground provided

a smooth surface for the expressive and brilliantly colored figures he constructed of patch-like dabs of paint. The composition, with its seemingly random placement of figures and calligraphic rendering of chairs and tree, reflects Whistler's assimilation of oriental art. Shown here in Victorian dress, the elegant, attenuated, promenading figures recall his figure studies of the 1860s. His summary manner in defining the figures and the increasing transparency of the light paint on the dark ground contribute to the ephemeral mood of the work.

The seated figure at the extreme right was identified as a self-portrait in the 1905 catalogue of the artist's work, but the likeness, according to the Pennells, was subsequently lost during a cleaning of the painting. In their 1918 book, the Pennells noted that when they had the painting photographed for the early edition of the biography it contained portraits of Whistler and his patron Frederick Leyland. The reproduction in the 1908 book, however, does not bear this out. Moreover, the anonymity and suggestive rather than descriptive character of the other figures indicate that individual portraits were probably never intended.

Rejected as unsalable by the auctioneers at Whistler's bankruptcy sale in 1879, the painting was bought before the sale by the printer Thomas Way, Whistler's friend. It was his son, Thomas R. Way, who first cleaned the painting, according to the Pennells. The younger Way subsequently wrote that Whistler attempted to regain possession of the work, claiming that he "never had any consideration for the picture" and therefore wanted it returned. Way speculated that Whistler wanted the painting to resell it. Some years after Whistler's death, Way sold the painting. When it was acquired by the museum in 1912, Bryson Burroughs described it as "an unfinished work of great promise," and ascribed its ambiguities to its "unfinished state." It was undoubtedly Whistler's style that led Burroughs to the mistaken conclusion that the painting was unfinished. Comparing it to Whistler's pastels, however, Burroughs perceptively noted: "It has their peculiar charm of suggestiveness and their limpidity of deftly-touched color—a virtue according to some, a shortcoming for others. But the picture gives every onlooker a quickened sense of the mysterious beauty that the night lends to all places."

Oil on canvas, 27 × 53⅛ in. (68.6 × 134.9 cm.).

REFERENCES: C. L. Freer, n. d., diaries, Book 13, Freer Gallery of Art, Smithsonian Institution, Washington, D.C., notes that "Agnew has 'Cremorne Garden' with the small dancing figures [.] Later in Met. Museum Art" // O. Sickert, *Studio* 21 (Nov. 1903), ill. p. 13, as Cremorne by permission of T. R. Way // T. R. Way and G. R. Dennis, *The Art of James McNeill Whistler* (1903; 1905), p. xv, list it with illustrations as Cremorne Gardens, coll. T. R. Way; ill. between pp. 60 and 61, call it a large nocturne study "that might almost be classed among the figure-subjects," note river in the background, and mention portrait sketch of the artist at the right // A. Dreyfus, *Die Kunst für Alle* 22 (Feb. 1907), ill. p. 208 // E. L. Cary, *The Works of James McNeill Whistler* (1907), p. 213, no. 383 // B. Sickert, *Whistler* (1908), p. 157, no. 52, lists it as Nocturne, Cremorne Gardens No. 2, ca. 1877, says it may have been exhibited as no. 158 at the Royal Society of British Artists, summer 1887 // E. R. and J. Pennell, *The Life of James McNeill Whistler* (1908), 1, p. 258; 2, ill. opp. p. 40 // S. Hartmann, *The Whistler Book* (1910), p. 266, lists it incorrectly with Nocturnes as Cremorne Gardens, MMA [probably means Nocturne in Green and Gold, because this painting was not in the MMA at the time] // T. R. Way, *Memories of James McNeill Whistler* (1912), pp. 134-138, describes Whistler's attempts to regain possession of Cremorne Gardens; p. 136 (quoted above); p. 138, speculates that Whistler wanted the painting to resell it; opp. p. 136, color lithograph by Way after Cremorne Gardens // B. B[urroughs], *MMA Bull.* 7 (April 1912), pp. 74-75, discusses at length (quoted above) // A. E. Gallatin, *The Portraits and Caricatures of James McNeill Whistler* (1913), pp. 7-8, dismisses notion that the figure on the right is Whistler; pp. 7-8, n 1, states that the painting is unfinished // P. Arbiter [pseud.], *Art World and Arts & Decoration* 9 (May 1918), pp. 20, 46 // A. E. Gallatin, *Portraits of Whistler* (1918), p. 10 // E. R. and J. Pennell, *The Life of James McNeill Whistler* (rev. 6th ed., 1920), pp. 76-77, discuss Whistler's sketching at Cremorne and on the river; p. 187, say that Way sold it for twelve hundred pounds to A. H. Hannay, that London dealers tried to sell it for almost four times the price to the National Gallery in Melbourne, and that later it was sold to the Metropolitan; note that it was first cleaned by T. R. Way, and when photographed for the 1908 edition of this book, it contained portraits of both Leyland and Whistler: "It has since been cleaned again and the portraits have completely disappeared"; ill. opp. p. 428, as installed in London memorial exhibition; p. 432, mentions it as Cremorne Gardens; *The Whistler Journal* (1921), p. 117 (quoted above); p. 134, mentions as one of the pictures Thomas Way refused to return to Whistler // D. Sutton, *Nocturne* (1963), p. 63, notes that "the elegant figures" in Variations in Pink and Gray: Chelsea (Freer Gallery) of about 1870-1871 anticipate those in the Cremorne Gardens series; pp. 67-68 (quoted above); compares

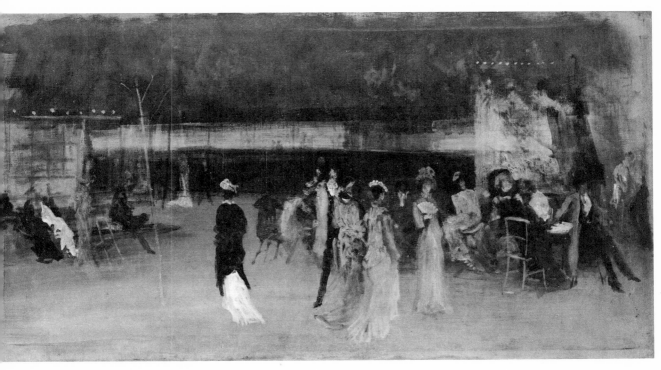

Whistler, *Cremorne Gardens, No. 2.*

rendering of the figures to those in a Kakemono, "the wistful figures are somehow breathed on to the canvas"; notes, "This happens to be one of Whistler's few pictures in which the arrangement of the figures in space and the arabesques they form are analogous to similar features in certain pictures by Toulouse-Lautrec, Bonnard and Vuillard; but the application of colour and its range are quite different"; opp. p. 76, fig. 27; *James McNeill Whistler* (1966), p. [17], fig. 8, as installed in the Whistler Memorial Exhibition, London, 1905; pp. 24-25, discusses paintings of Cremorne Gardens; pl. 68; pl. 69, detail of seated figure at extreme right; p. 191, no. 68, dates it about 1875 // B. Laughton, *Apollo* 86 (Nov. 1967), p. 378, suggests that it might have been the painting exhibited as "Nocturne en noir et or. No. 2 Souvenir de Cremorne" at the Société des XX in 1888 // J. T. Flexner, *Nineteenth Century American Painting* (1970), ill. p. 158 // A. M. Young, note in Dept. Archives [1972], says that one of the best early color reproductions of this picture was by Franz Hanfstaengl of Munich // R. McMullen, *Victorian Outsider* (1973), p. 274, lists it // R. J. Boyle, *American Impressionism* (1974), p. 67, compares the "tonal harmonies and horizontal construction" of John Singer Sargent's The Luxembourg

Gardens at Twilight (Minneapolis Institute of Art) with this work; ill. p. 68 // S. Weintraub, *Whistler* (1974), pp. 432-433, gives Way's account of Whistler's attempts to regain possession of the painting // H. Taylor, *James McNeill Whistler* (1978), pp. 69-72, notes that this painting "full of fashionable and active figures, parallels, to some extent, the 'modern life' paintings of [Whistler's] French associates Manet and Tissot, with whom he was in close contact during the early 1870s"; p. 72, pl. 52 // A. M. Young, M. MacDonald, R. Spencer, and H. Miles, *The Paintings of James McNeill Whistler* (1980), 1, p. 94, no. 164, catalogue it; date it about 1872-1877; note that it "shows signs of alterations . . . that there were originally more figures in the two groups to left and right of centre"; state that Sickert was probably wrong in thinking it was exhibited at the Royal Society of British Artists in 1887 and Laughton in suggesting that it was shown in Brussels in 1888; give information from 1909 letter from C. L. Freer to R. B. Philip that F. C. Yardley of East Sheen was offering it for sale; note that, according to the records of the Felton Bequest, National Gallery of Victoria, Melbourne, the painting was offered to that museum in August and September 1910 for 4,000 pounds, but Joseph Pennell, who

described it as "a good and beautiful example of Whistler's art," advised that the price was too high; 2, pl. 90.

EXHIBITED: International Society of Sculptors, Painters and Gravers, New Gallery, London, 1905, *Paintings, Drawings, Etchings and Lithographs: Memorial Exhibition of the Works of the Late James McNeill Whistler*, ill. opp. p. 66; p. 84, no. 25, lent by T. R. Way, says that the artist is shown seated at a table on the right // Art Institute of Chicago, 1934, *A Century of Progress*, no. 422, says it was painted before 1879, is unfinished, and a lithograph was made by T. R. Way // Cleveland Museum of Art, 1937, *American Painting from 1860 until Today*, no. 207, pl. viii // Museum of Modern Art, New York, 1944, *Art in Progress*, p. 18 // Lyman Allyn Museum, New London, Conn., 1949, *J. McNeill Whistler*, no. 19 // Pomona, Calif., Los Angeles County Fair, 1950, *Masters of Art from 1790 to 1950*, unnumbered cat. // Columbus Gallery of Fine Arts and Dayton Art Institute, Ohio, 1951, *America and Impressionism* (no cat.) // Munson-Williams-Proctor Institute, Utica, N.Y., 1953, *Expatriates: Whistler, Cassatt, Sargent*, no. 6 // Art Institute of Chicago and MMA, 1954, *Sargent, Whistler and Mary Cassatt*, exhib. cat. by F. A. Sweet, ill. no. 107, describes it // MMA, 1958-1959, *Fourteen American Masters* (no cat.) // American Academy of Arts and Letters, New York, 1959, *The Impressionist Mood in American Painting*, no. 25 // Arts Council Gallery, London, and Knoedler Galleries, New York, 1960, *James McNeill Whistler*, exhib. cat. by A. M. Young, no. 36, catalogues it and dates it about 1875; pl. 12 [shown only in New York] // MMA, 1965, *Three Centuries of American Painting*, unnumbered cat. // Los Angeles County Museum of Art and M. H. de Young Memorial Museum, San Francisco, 1966, *American Paintings from the Metropolitan Museum of Art*, no. 98 // Art Institute of Chicago and Munson-Williams-Proctor Institute, Utica, N.Y., 1968, *James McNeill Whistler*, exhib. cat. by F. A. Sweet, ill. p. 51, no. 23; p. 70, no. 23, catalogues it, dates it about 1875 // Nationalgalerie, Staatliche Museen, Berlin, 1969, *James McNeill Whistler (1834-1903)*, ill. p. 27, describes Cremorne Gardens and says that, although this is not an impressionist painting, it recalls contemporary French developments // Hudson River Museum, Yonkers, N. Y., 1970, *American Paintings from the Metropolitan Museum of Art*, no. 52 // Columbus Gallery of Fine Arts, Ohio, 1971, *British Art, 1890-1928*, exhib. cat. by M. S. Young and D. Sutton, no. 102, fig. 2 // MMA, 1972, *Drawings, Watercolors, Prints and Paintings by James McNeill Whistler* (no cat.) // Birmingham Museum of Art, Ala., 1973, *Arts of France—Birmingham Festival of Arts* (see E. Frohock, *Birmingham Museum of Art Bulletin*, no. 16 [March, April, May 1973], ill. in an unpaged essay) // Albany Institute of History and Art, 1974, *Drawings, Watercolors, Prints and Paintings by James Abbott McNeill Whistler* (no cat.) // New York Cultural Center in association with Fairleigh Dickinson University, New York, 1974, *Grand Reserves*, ill. no. 92, discusses it under no. 91 // MMA and American Federation of Arts, traveling exhibition, 1975-1976, *The Heritage of American Art*, exhib. cat. by M. Davis, no. 56, discusses it; (1977 rev. ed.), no. 55 // National Portrait Gallery, Washington, D. C., 1979, *Return to Albion*, cat. by R. Kenin, ill. p. 173; checklist, no. 135.

EX COLL.: Thomas Way, London, by 1879 (purchased from auctioneers before sale of Whistler's White House, 1879); his son, Thomas R. Way, London, until at least 1905; Alexander Arnold Hannay, London, after 1905—at least 1910; with Percy M. Turner, London, 1912.

John Stewart Kennedy Fund, 1912.

12.32.

Nocturne in Green and Gold

Whistler's preoccupation with night scenes—in Valparaiso, Chile, in 1866, in London during the 1870s, and in Venice in 1880—followed the romantic tradition. Nevertheless, his wide-ranging exploration of their aesthetic possibilities was a radical departure for the time.

Whistler at first called his night scenes "moonlights," although the moon rarely appeared. Sometime in the 1870s, one of his patrons, Frederick R. Leyland, suggested the title "Nocturne." Whistler wrote him:

I can't thank you too much for the name "Nocturne" as the title for my moonlights. You have no idea what an irritation it proves to the critics and consequent pleasure to me; besides, it is really charming, and does so poetically say all I want to say and *no more* than I wish! (quoted in V. C. Prinsep, London *Art Journal* [August 1892], p. 252).

Nocturne is descriptive of his subject matter; whereas his other titles, Symphony, Harmony, and Arrangement demonstrate his primary concern with formal problems of design. Such titles, with an analogy to music, were deliberately chosen. "Art should be independent of claptrap—should stand alone, and appeal to the artistic sense of eye or ear without confounding this with emotions entirely foreign to it, as devotion, pity, love, patriotism, and the like," Whistler wrote in 1878. "All these have no kind of concern with it; and that is why I insist on calling my works 'arrangements' and 'harmonies'" (reprinted in *The Gentle Art of Making Enemies* [1890], pp. 127-128).

At twilight and night, Whistler observed in

his 1885 Ten O'Clock lecture, details become obscure and shapes ambiguous. "Nature contains the elements, in colour and form, of all pictures," but it is for the artist "to pick, and choose, and group with science, these elements," as "seldom does Nature succeed in producing a picture." In one of his revolutionary or, as he termed them, 'blasphemous' statements, he asserted:

Nature is very rarely right, to such an extent even, that it might also be said that Nature is usually wrong: that is to say, the condition of things that shall bring about perfection of harmony worthy a picture is rare, and not common at all.

Certain moments, thought Whistler, pass unappreciated except by the artist:

when the evening mist clothes the riverside with poetry, as with a veil, and the poor buildings lose themselves in the dim sky, and the tall chimneys become campanili, and the warehouses are palaces in the night, and the whole city hangs in the heavens, and fairy-land is before us—then the wayfarer hastens home; the working man and the cultured one, the wise man and the one of pleasure, cease to understand, as they have ceased to see, and Nature, who, for once, has sung in tune, sings her exquisite song to the artist alone, her son and her master—her son in that he loves her, her master in that he knows her (ibid., pp. 142–144).

In his biography of Whistler, Théodore Duret wrote: "The nocturnes, on their appearance, were found to shock the conventions then observed in painting even more than the harmonies and symphonies. They represented the extreme point of originality to which Whistler went, but they also excited a corresponding hostility and became the cause of the worst attacks and insults he had to endure" (*Whistler*, trans. F. Rutter, [1917], p. 44).

Nocturne in Green and Gold was probably painted before 1877, when the gardens closed to the public. Shown in London at the 1905 memorial exhibition of Whistler's work, it was confused with *Nocturne in Black and Gold: The Falling Rocket*, ca. 1875 (Detroit Institute of Arts) in the exhibition catalogue and described as the picture exhibited at the Whistler-Ruskin trial. This caused more confusion when the Metropolitan Museum acquired the picture and published the same information again in 1906. No fireworks are evident in the painting, which before lining

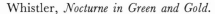

Whistler, *Nocturne in Green and Gold*.

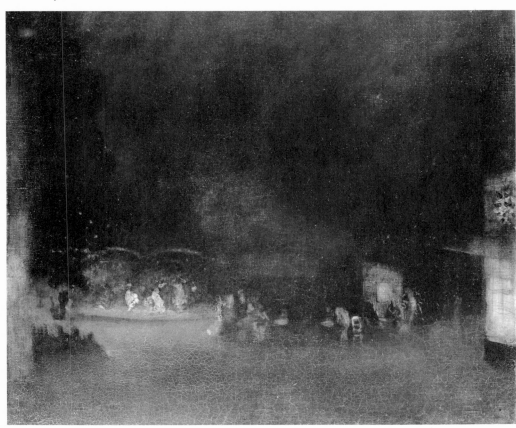

was inscribed "Nocturne in Green and Gold" without the "Falling Rocket" subtitle.

The painting is one of at least six featuring Cremorne Gardens. (For a list see *Cremorne Gardens, No. 2* above.) Formerly in the collection of Théodore Duret, the work was acquired by Mrs. William Heinemann, the wife of Whistler's publisher, and subsequently brought to the attention of the painter WALTER GAY. Gay, who expressed the opinion that he found "the picture a little black ... the fault of a good many Whistlers," was instrumental in the negotiations that brought it to the Metropolitan. The paint has continued to darken over the years in a chemical reaction that conservation can neither arrest nor reverse. When the painting was exhibited in London in 1905, it was described as "a group of figures dancing on a platform to left, and spectators seated looking on in centre and to left. Illuminated kiosk on right." When the museum acquired the painting a year later, it was already darkened and severely cracked. At that time Elisabeth Luther Cary provided the following description: "The scene is Cremorne Gardens at night, with coloured lights and gaily dressed people dancing or gathered in groups at little tables. An illuminated kiosk is at the right of the picture, and waiters in red coats are here and there in the foreground." Today only touches of color are discernible.

Oil on canvas, 25⅛ × 30⅜ in. (63.8 × 77.2 cm.).
Inscribed and signed on the back before lining: Nocturne in Green & Gold. / the artist's butterfly symbol.

REFERENCES: *New York Herald*, April 10, 1876, p. 5, describes works in Whistler's studio, including "a dim nocturne, Cremorne Gardens, seen by starlight and the *fitful* gleam of fireworks" (possibly this picture) // W. Gay, letters in MMA Archives, Feb. 28, 1906, says, "One of the well known series of Nocturnes by Whistler has just been offered me to purchase. It is Cremorne gardens at night, with figures dancing in the distance. It was bought from Agnew last summer only, and the present owner, a fickle sort of person, wants to sell it again.... It is in a private house in Paris. ... The picture has been reproduced, I dont remember in what process but I recollect seeing it somewhere. Personally, I find the picture a little black, but that is the fault of a good many Whistlers, but they are so hard to find, and so few of them of any importance, that I thought you might like to hear of it"; March 22, 1906, says, "The Whistler (Cremorne Gardens) I wrote about, has a first rate pedigree. It came from the Duret collection in 1902, when it was sold to Mrs. Heineman[n]. Mr. Heineman[n] sold it to Agnew.

The picture was catalogued under the no. 62 at the Whistler Exhibition in London & then owned by Heineman[n.] I quote from Agnew 'I had the picture from Monsieur Duret with the advice of Whistler himself, who always looked on this Nocturne as one of his finest works'"; April 27, 1906, says, "On arriving from Italy last night I found the Whistler awaiting us and this morning cabled you that it was yours. It is needless to say how I want it myself [;] still having promised it to you, I cant change my mind, but you dont know how it hurts to let it go, but next to having it myself, I would prefer its going to the Metropolitan. The signature and writing on the back of the picture is as described by Mr Fry, 'Nocturne in green and gold' in Whistler's hand writing, with the butterfly signature, so it is unquestionably the picture of the trial. The picture awaits your orders. The cheque has not as yet turned up, but as I have bought it, there is no hurry" // *MMA Bull.* 1 (June 1906), p. 105, describes the painting; notes its acquisition as a gift of Harris C. Fahnestock, a trustee, and mentions Walter Gay's role in bringing it to the attention of the museum; misidentifies it as "The Falling Rocket," exhibited at the Whistler vs. Ruskin trial; adds that it was formerly in the collection of William Heinemann of London and exhibited at the 1905 Whistler memorial exhibition in London // E. L. Cary, *MMA Bull.* 1 (July 1906), p. 109, describes the painting (quoted above) and a spot of retouching // W. Gay, letter in MMA Archives, Nov. 13, 1906, in a discussion of condition, notes that the cracks "must have become accentuated on the voyage," adds, "At all events, the picture when it left my hands was in the same condition that it was in the Whistler Exhibition two years ago, when the cracks existed, but very fine, and *no white* showing underneath. The latter development has taken place since I saw it, I feel sure. I showed the picture to a number of people while it was at my place, and no one spoke about the cracks," encloses an undated letter about the condition from P. Mathey who sold him the painting // E. L. Cary, *The Works of James McNeill Whistler* (1907), pp. 62-64; p. 218, no. 413, lists it as Nocturne in Green and Gold, The Falling Rocket, lent by William Heinemann to the London exhibition, notes that the subtitle in the London catalogue is probably a mistake as no rocket appears in the work and the inscription reads "Nocturne in Green and Gold" // B. Sickert, *Whistler* (1908), pp. 146-147, discusses incorrect subtitle; p. 157, no. 54, lists it as Nocturne, Cremorne Gardens No. 4, ca. 1877, owner W. Heinemann, exhibited in London, 1905, as no. 62 // E. R. and J. Pennell, *The Life of James McNeill Whistler* (1908), I, p. xx, list it with illustrations as Cremorne (Nocturne in Green and Gold), formerly in the possession of W. Heinemann; ill. opp. p. 164, as Cremorne (Nocturne in Green and Gold) // R. Fry to B. Burroughs, letters in MMA Archives, Jan. 5, 1909, describes another Whistler seen in London as "too dark & in danger of

going like the Nocturne"; Jan. 15, 1909, says of Whistler's the *Fur Jacket* (now Worcester Art Museum, Mass.), "Whistler used bitumen largely in it and . . . there is every reason to fear that in New York it would behave like our present ill-fated *Nocturne*"; Feb. 16, 1909, says of Whistler's Duret, "there is no cracking and dragging at all. This, as we know to our cost with Whistler, is of the utmost importance" // S. Hartmann, *The Whistler Book* (1910), p. 266, lists it with nocturnes as Cremorne Gardens, MMA // B. B[urroughs], *MMA Bull.* 7 (April 1912), p. 74, mentions it among works painted in the 1870s // D. Sutton, *Nocturne* (1963), p. 67, discusses "series" of four pictures of Cremorne Gardens, noting that "The *Nocturne in Green and Gold: Cremorne Gardens, London, at Night No. 4*, in the Metropolitan, . . . which is now in a poor state, is no less revolutionary by reason of its almost complete denial of colouristic possibilities and the reduction of light to a bare minimum; in fact, only a few areas are lighted at all and the figures themselves are indicated by means of summary dashes of pigment"; *James McNeill Whistler* (1966), p. 24 // Nationalgalerie, Staatliche Museen, Berlin, *James McNeill Whistler (1834-1903)*, exhib. cat. by R. Spencer (1969), p. 76, no. 27, mentions it // R. Fry, *Letters of Roger Fry*, ed. with an intro. by D. Sutton (1972), 1, p. 28, mentions this painting among Fry's recommended acquisitions; pp. 310-311, 312-313, includes letters from Fry to B. Burroughs, Feb. 16 and 28, 1909, in MMA Archives (noted above) // A. M. Young, M. MacDonald, R. Spencer, and H. Miles, *The Paintings of James McNeill Whistler* (1980), 1, p. 93; p. 95, no. 166, catalogue it as Nocturne in Black and Gold: The Gardens, say it was possibly the nocturne described in the *New York Herald* on April 10, 1876, and that, according to information in the Birnie Philip Collection, Glasgow University Library, it was probably the work called Nocturne — [Cremorne] Dancing listed by Whistler in 1886 as owned by Sir Charles McLaren; 2, pl. 92 // D. Dwyer, Paintings Conservation, MMA, orally, March 21, 1983, stated that besides natural darkening, examination showed drying cracks, burns that probably occurred during lining of the picture, and further darkening effects from chemicals used in previous restorations.

EXHIBITED: International Society of Sculptors, Painters and Gravers, New Gallery, London, 1905, *Paintings, Drawings, Etchings and Lithographs: Memorial Exhibition of the Works of the Late James McNeill Whistler*, p. 100, no. 62, as Nocturne in Green and Gold, The Falling Rocket, lent by William Heinemann // Heckscher Museum, Huntington, N. Y., 1947, *European Influence on American Painting of the 19th Century*, no. 7 // New York Cultural Center in association with Fairleigh Dickinson University, New York, 1974, *Grand Reserves*, no. 91, as Nocturne in Green and Gold, Cremorne Gardens, London at Night, describes condition // Museum of Fine Arts, Saint Petersburg, and Henry Morrison Flagler Museum, Palm Beach, Fla., 1976,

"The New Vision," American Styles of 1876-1910, exhib. cat. by M. D. Schwartz, unnumbered, as Nocturne in Green and Gold (Cremorne Gardens, London at Night).

EX COLL.: possibly Sir Charles McLaren (later Lord Aberconway), London, 1886; Théodore Duret, Paris, May 1902; with Thomas Agnew and Sons, London, May 1902; Mrs. William Heinemann, London, May 1902–Nov. 1903; Edmund Davis, London, Nov. 1903–Feb. 1904; Mrs. William Heinemann, London, Feb. 1904; William Heinemann, London, until Feb. 1905; with Thomas Agnew and Sons, London, Feb. 1905; Princesse Edmond de Polignac, Feb. 1905; with P. Mathey, Paris, 1906; Walter Gay, Paris, 1906; Harris C. Fahnestock, 1906.

Gift of Harris C. Fahnestock, 1906.

06.286.

Harmony in Yellow and Gold: The Gold Girl—Connie Gilchrist

As a child, Constance Macdonald Gilchrist (1865-1946) posed for the painter William Powell Frith and other members of the Royal Academy. She also performed in juvenile pantomimes and music halls, where she attracted the attention of John Hollingshead, manager of the Gaiety Theatre in London. He hired her when "she was a mere child of twelve" (J. Hollingshead, *Good Old Gaiety* [1903], p. 38). Popularly known as "the Child" and "the original Gaiety Girl," Miss Gilchrist had a successful career on the London stage in light comedy and vaudeville. Among her admirers were Lord Lonsdale and the duke of Beaufort. In 1892 she was married to Edmond Walter Fitz-Maurice, the seventh earl of Orkney. She died in 1946 at their estate, Tythe House, Stewkley, in Buckinghamshire, and was survived by her husband and their only child, Lady Mary Constance Hamilton Gosling.

Whistler posed Connie Gilchrist in his studio as she appeared on the stage of the Gaiety Theatre in the skipping-rope dance, which took "the fashionable frequenters of the place by storm, her ingenuousness capturing all hearts, especially in contrast to the precocious cynicism of her stage dialogue" (*New York Times*, May 10, 1946, p. 19). The painting, said to date from about 1876, was exhibited at the Grosvenor Gallery in the summer of 1879. The critic Charles E. Pascoe, reporting from London for the New York *Art Journal*, reviewed the work with uncharacteristic charity:

Whistler, *Harmony in Yellow and Gold: The Gold Girl—Connie Gilchrist*.

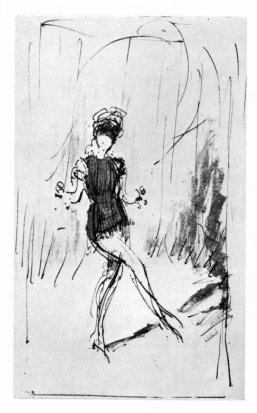

Whistler, *Sketch of Harmony in Yellow and Gold*, pen and ink (left),
British Museum, and pencil (right), Baltimore Museum of Art.

His full-length portrait of Miss Connie Gilchrist—a
young lady at present one of the attractions at Mr.
Hollingshead's theatre, The Gaiety—dubbed by Mr.
Whistler "A Harmony in Yellow and Gold," is capital.
It is neither more nor less, however, than a very good
full-length of a rather pretty, flaxen-haired girl of
sixteen, in light-brown dress, and black-silk stock-
ings, skipping. Mr. Whistler's "Harmony" forms
in this instance a common-sense and lifelike portrait
with neither hazy light nor incomprehensible misty
effects.

Mrs. Henry Adams, who visited the exhibi-
tion with Isabella Stewart Gardner, was less im-
pressed: "Connie has a red flannel vest reaching
to her hips, a handkerchief, bag and satin boots
with high Louis XV heels; is jumping rope with
red handles. Any patient at Worcester [Insane
Asylum] who perpetrated such a joke would be
kept in a cage for life" (see Tharp [1965]). The
critic for the London *Art Journal* reported that
the painting was "not carried far enough." The
most disparaging remarks, however, came from
WILLIAM TROST RICHARDS. His realistic work, also

on exhibition, was the antithesis of Whistler's.
Describing this painting as "too bad," Richards
observed in a letter on May 5, 1879, to his patron
George Whitney:

I have no way of characterizing the coarseness of
work and thought in this portrait. It has no grace, or
excellence of drawing and is excessively ugly in colour,
and altogether a piece of barefaced impudence. On
varnishing day I saw him [Whistler] take a friend
through an open door far away into the corner of
another gallery, from whence he said his picture
could be best seen! It would answer as well to turn
one's back on it.

Whistler was an avid theatergoer, and this
undoubtedly influenced his choice of subject.
Theatrical themes were also important to his
French colleagues, and Whistler kept in touch
with artistic developments on the Continent. In
this work, however, as in his *Arrangement in Black,
No. 3* (q.v.), he chose to focus on the performer
in isolation rather than explore the interplay of
spectator and spectacle that engaged his French

contemporaries. *Harmony in Yellow and Gold* is, as the Pennells and others observed, one of Whistler's rare attempts to show a life-size figure in motion. In addition to being a portrait of the popular child dancer, it is, like his other portraits, an experiment in design and color. Working with a restricted palette of yellows and browns, he introduced notes of red in the rope handles and the girl's lips. Sweeping curves serve as the basic unit of composition. While the figure and the background curtain are modeled to suggest three-dimensional form, the carefully placed butterfly signature and the rather prominent inscription of the performer's name reinforce the sense of surface and decorative pattern—major concerns of the artist.

The painting was acquired by a Mr. Wilkinson at a bankruptcy sale of Whistler's effects at Sotheby's on February 12, 1880. Soon afterwards it came into the possession of the journalist and politician Henry Labouchere. Although Thomas R. Way reported that Whistler was enthusiastic about the painting, the Pennells (1921) maintained that he considered it unfinished or unsuccessful and wanted to regain possession in order to alter or destroy it. According to the Pennells (1921) and Ward (1923), Labouchere returned the painting to Whistler but got it back after the artist's death in 1903. The Pennells asserted: "The picture was a failure, and Whistler knew it. For long, down the back of the figure there ran a great black line of paint that showed the whole thing was to have been drawn again. Eventually it came into the possession of Mr. Hearn who carefully had the black line removed." There is no evidence to support these contentions. Moreover, the painting bears Whistler's butterfly signature, suggesting that he considered it completed. His relentless perfectionism and incessant reworkings are, however, well-documented, and anecdotes about them are myriad. Another story concerning his alterations to this painting, which bears telling if only for its entertainment value, was related in a letter sent to the Metropolitan in 1932:

The bailiff, it appears, as was too often his custom, served notice on Whistler that he would be obliged to take some of his belongings in payment for a debt. This happened when the Gilchrist portrait was in the studio, & Whistler said to a friend that he would put the joke on another foot. He daubed the canvas over with black in a pyramidal shape & at the bottom made four daubs in red. This he called *The four oysters at the foot of the mountain.* The game didn't work, &

afterwards the daubs were removed, fortunately, or not, as one chooses to think.

According to the Pennells (1908 and 1921), two sketches of this painting (one now in the British Museum and the other in the Baltimore Museum) were made by Whistler while the work was in progress. Thomas Way (1912) illustrates two pen sketches of Connie Gilchrist in the same costume but different poses. Another, unfinished portrait by Whistler of the subject, called *The Blue Girl: Portrait of Connie Gilchrist,* dating from about 1879, is in the Hunterian Museum and Art Gallery, University of Glasgow.

Oil on canvas, $85\frac{3}{4} \times 43\frac{1}{8}$ in. (217.8 × 109.5 cm.).

Signed at right center with artist's butterfly symbol. Inscribed at upper left: CONNIE GILCHRIST.

RELATED WORKS: *Sketch of Harmony in Yellow and Gold: The Gold Girl—Connie Gilchrist,* pen and ink, $6 \times 3\frac{11}{16}$ in. (15.3 × 9.4 cm.), British Museum, London, ill. in E. R. and J. Pennell, *The Whistler Journal* (1921), between pp. 182–183 // *Sketch of Harmony in Yellow and Gold: The Gold Girl—Connie Gilchrist,* pencil on blue graph paper, $8\frac{5}{16} \times 5\frac{7}{16}$ in. (21.1 × 13.8 cm.), Baltimore Museum of Art, 33.53.8310, ill. in J. Pennell, *International Studio* 72 (Feb. 1921), p. cxi // Possibly by Whistler, *Sketch after the Painting Harmony in Yellow and Gold: The Gold Girl—Connie Gilchrist* for *Grosvenor Notes,* ed. by Henry Blackburn (May 1879), no. 55, p. 24, pen and ink, unlocated, ill. in E. R. and J. Pennell, *The Whistler Journal* (1921), between pp. 182–183, then coll. Henry Blackburn // Thomas R. Way, possibly after Whistler, *Pen Sketches of Connie Gilchrist,* frontal and in profile, unlocated, ill. in T. R. Way, *Memories of James McNeill Whistler* (1912), between pp. 20–21.

REFERENCES: H. Blackburn, ed., *Grosvenor Notes* (May 1879), ill. p. 24, no. 55 // W. T. Richards to G. Whitney, May 5, 1879, in L. S. Ferber, *William Trost Richards (1833–1905)* (Ph.D. diss., Columbia University, New York, 1980), pp. 308–309 (quoted above) // *Mask* 2 (May 17, 1879), ill. p. 4, shows the picture and other works at the Grosvenor Gallery, identified as "A Gaiety in Gilt, and three Noctoffs in a Twinkle. Connie soit qui mal y pense" // [London] *Art Journal* 18 (July 1879), p. 136, reviews it (quoted above) // C. E. Pascoe, [New York] *Art Journal* 5 (July 1879), p. 224, reviews it (quoted above) // *Collector* 3 (April 15, 1892), p. 182 // G. Vuillier, *A History of Dancing from the Earliest Ages to Our Own Times from the French of G...V..., with a Sketch of Dancing in England by Joseph Grego* (1898), p. vii; ill. opp. p. 412 // A. J. Eddy, *Recollections and Impressions of James A. McNeill Whistler* (1903), p. 119 // T. R. Way and G. R. Dennis, *The Art of James McNeill Whistler* (1903; 1905), p. 9 // B. Sickert, *Burlington*

Magazine 6 (March 1905), p. 434, says figure is rigid and immobile; ill. p. 435 // H. Macfall, *Whistler* (1905), p. 44 // H. W. Singer, *James McNeill Whistler* (1905), p. 82, no. 19 // J. E. Blanche, *Renaissance Latine* (June 1905), p. 358 // A. Symons, *Outlook* (Nov. 4, 1905), p. 626 // E. L. Cary, *The Works of James McNeill Whistler* (1907), p. 228, no. 490 // B. Sickert, *Whistler* (1908), p. 160, no. 69, gives its owners as H. Labouchere and Messrs. Carfax & Co. // E. R. and J. Pennell, *The Life of James McNeill Whistler* (1908), 1, p. 201, mention it with works painted or begun in 1876; p. 202, note that "Whistler posed her in the studio as he had seen her on the stage, in the act of skipping. But the movement does not seem part of the decorative arrangement on his canvas. It told on the stage by its simplicity, its spontaneity, but it becomes in the picture theatrical, artificial. . . . A long line swept down the outline of the figure shows that he meant to change it. The pose and the movement haunted him. Often in friends' houses, he would make little sketches of pictures he was working on, and one evening he left with Mr. Cole" a sketch of "the *Connie Gilchrist* [coll. British Museum] . . . done in this way"; p. 218, cite this painting as one of three portraits in which Whistler "attempted to give movement to the figure"; p. 248; ills. between pp. 258 and 259, this painting and a sketch of it [now British Museum]; p. 259, in catalogue of bankruptcy sale; pp. 259–260, note sale to Mr. Wilkinson for fifty guineas; 2, p. 23, quote Harper Pennington's reminiscences which mention that Labouchere bought it // H. Mansfield, *A Descriptive Catalogue of the Etchings and Dry-Points of James Abbott McNeill Whistler* (1909), p. xxv // *American Art News* 8 (May, 14, 1910), ill. p. 1 and reports Hearn's acquisition of the painting from Knoedler and Company; says it "is in Whistler's best and happiest manner" and "has a delicious color scheme of warm browns, mellowed into the richest of dull golden tones, and the feeling is one of life and joyousness" // *MMA Bull.* 5 (June 1910), p. 152, notes that it was lent to the MMA exhibit; 6 (March 1911), p. 66, reports its acquisition; ill. p. 68 // F. Rutter, *James McNeill Whistler* (1911), p. 61; ill. opp. p. 80; p. 81; p. 83, notes that Labouchere acquired it at the bankruptcy sale for twelve pounds // T. R. Way, *Memories of James McNeill Whistler* (1912), p. 21; p. 25, describes it among three paintings at a well-attended "show day" Whistler held before the second Grosvenor exhibition and says Whistler was "very enthusiastic" about this work // J. E. Blanche, *Essais et Portraits* (1912), p. 88, describes seeing Whistler's portraits of Connie Gilchrist and Henry Irving in the artist's Tite Street studio // MMA, *George A. Hearn Gift to The Metropolitan Museum of Art . . .* (1913), ill. p. 65 // E. R. and J. Pennell, *The Life of James McNeill Whistler* (rev. 6th ed., 1920), pp. 146–147, note that Whistler tried to gain possession of the picture to destroy it and his dissatisfaction "is shown by that long black line from the girl's head to her heels"; add

that Hearn presented it to the MMA where it hung for some time before the line was removed and "what is left of the picture Whistler wanted to destroy can now be seen on the walls"; pp. 159, 185, 188 and 432 // L. M. Bryant, *American Pictures and Their Painters* (1921), opp. p. 97, fig. 57; p. 97, calls it "a colour poem" // J. Pennell, *International Studio* 72 (Feb. 1921), p. cxii, describes the sketch of Connie Gilchrist in the George A. Lucas coll., Baltimore Museum of Art, Maryland, as a sketch "such as Whistler often made from memory to show what he was working at, and probably . . . made in this way for Lucas" // E. R. and J. Pennell, *The Whistler Journal* (1921), p. 183, discuss ownership, noting that Robert Ross of Carfax Gallery had the painting in 1904; give differing opinions as to whether Whistler took the painting back to alter or destroy it; assert that the painting was a failure and had a black line drawn down the back of the figure and that Hearn had the line removed (quoted above); p. 260, note that Heinemann held the copyright to the painting; p. 271, state that Whistler wanted to destroy it // E. A. Ward, *Recollections of a Savage* (1923), p. 263, says Labouchere told him that "having purchased Whistler's picture of Connie Gilchrist, 'The Gold Girl,' at an auction, he was induced to lend the picture to the artist, who desired to effect some slight alteration. Labouchere laughingly added: 'That is ten years ago. He is still not sufficiently satisfied with it to return my picture, and I don't expect ever to see it again.' On this point Whistler entertained rather select views, holding that mere payment for one of his masterpieces did not necessarily mean that the purchaser was worthy to remain in undisputed possession of the picture" // L. Langtry, *The Days I Knew* (1925), p. 64, quotes comments on the painting by art critic George W. Smalley and says she told Whistler "'Oh! Mr. Whistler, what a lovely portrait. I have seen Connie Gilchrist but once, but I am sure it is hers. Nobody but you could have done it so beautifully.' As guests we could have no other opinion. As critics we might think it a flimsy piece of work, as Whistler in his heart probably did" // A. Symons, *Studies on Modern Painters* (1925), pp. 47-50, discusses the painting and its exhibition at Carfax Gallery and says, "For our sophisticated age that he may give its essence, he gives us the last sophistication; a girl travestied as a boy, and scarcely a girl, but a child and a dance which mimics the games of childhood. . . . it is the child playing for other people's pleasure" // H. W. Kent to H. Wehle, August 21, 1932, letter in Dept. Archives, relates anecdote about Whistler repainting it (quoted above) // *New York Times*, May 10, 1946, p. 19, subject's obituary // *London Times*, May 10, 1946, p. 4, subject's obituary // D. Sutton, *Nocturne* (1963), p. 77, notes that Connie Gilchrist posed for Whistler about 1878; describes the painting and mentions possible alteration; notes pen and ink drawing in the British Museum and the portrait in Glasgow, which he suggests probably dates

from the same period // L. H. Tharp, *Mrs. Jack* (1965), p. 62, describes Mrs. Adams's reaction to the painting (quoted above) // D. Sutton, *James McNeill Whistler* (1966), pl. 73; p. 191, no. 73 // R. McMullen, *Victorian Outsider* (1973), pp. 167–168, discusses the painting and says that Connie Gilchrist was eleven when it was painted and she was something of a professional model, posing also for Leighton and Frank Holl; p. 197; p. 275, lists it // S. Weintraub, *Whistler* (1974), pp. 164–165, gives the dancer's age as eleven and calls the painting artificial looking; p. 188, describes Mrs. Adams's reaction to the painting; p. 232, notes 1879 exhibition; p. 237, says that Whistler valued the painting "immodestly" at 500 pounds; p. 239, reports that it sold for 63 pounds to Henry Labouchere // A. M. Young, M. MacDonald, R. Spencer, and H. Miles, *The Paintings of James McNeill Whistler* (1980), 1, pp. 111–112, no. 190, catalogue it, note that it was seen and described in Whistler's studio in March 1879, say the drawing reproduced in Blackburn in 1879 was not by Whistler, discuss related drawings, note that (according to information in the Birnie Philip Collection, Glasgow University Library), on August 25, 1879, C. A. Howell offered to retrieve the painting for Whistler from the artist's bankrupt estate in exchange for another painting; p. 120, no. 207, compare this painting to The Blue Girl: Portrait of Connie Gilchrist, probably painted in 1879; 2, pl. 129.

EXHIBITED: Whistler's studio, London, 1879 // Grosvenor Gallery, London, 1879, *Summer Exhibition*, no. 55, Harmony in Yellow and Gold—The Gold Girl—Portrait of Miss Connie Gilchrist // Carfax Gallery, London, 1905 // International Society of Sculptors, Painters and Gravers, New Gallery, London, 1909, *Fair Women*, no. 130 // MMA, 1910, *Paintings in Oil and Pastel by James A. McNeill Whistler*, a late addition, not in cat., lent by George A. Hearn // Utah Centennial Exposition, Salt Lake City, 1947, *100 Years of American Painting*, no. 17 // MMA, 1958–1959, *Fourteen American Masters* (no cat.) // Arts Council Gallery, London, and the Knoedler Galleries, New York, 1960, *James McNeill Whistler*, exhib. cat. by A. M. Young, pp. 59-60, no. 40, catalogues it and discusses related works; pl. 10 // Los Angeles County Museum of Art and M. H. de Young Memorial Museum, San Francisco, 1966, *American Paintings from the Metropolitan Museum of Art*, ill. no. 99 // Art Institute of Chicago and Munson-Williams-Proctor Institute, Utica, N. Y., 1968, *James McNeill Whistler*, exhib. cat. by F. A. Sweet, pp. 72–73, no. 26, catalogues it // Nationalgalerie, Staatlichen Museen, Berlin, 1969, *James McNeill Whistler (1834–1903)*, p. 76, no. 28, catalogue entry by R. Spencer lists related works; p. 87, nos. 76 and 76a, cites two studies // MMA, 1972, *Drawings, Watercolors, Prints and Paintings by James Abbott McNeill Whistler* (no cat.) // Albany Institute of History and Art, 1974, *Drawings, Watercolors, Prints and Paintings by James Abbott McNeill Whistler* (no cat.).

ON DEPOSIT: Virginia Museum of Fine Arts, Richmond, 1947-1950 // U. S. Ambassador to the U. N., Waldorf Towers, New York, 1964-1965.

EX COLL.: the artist, London, 1876-1880 (bankruptcy sale, Sotheby's, London, Feb. 12, 1880, no. 87, as Oil Painting [life size] of Connie Gilchrist, dancing with a skipping rope, styled "A Girl in Gold," £ 52. 10); Mr. Wilkinson, 1880; Henry Labouchere, London, 1880s-1904 (from about 1884 until Whistler's death in 1903 it was in his studio); with Robert Ross, Carfax and Company, London, 1904-1905(?); with Knoedler and Company, Paris and New York, by 1910; George A. Hearn, New York, 1910-1911.

Gift of George A. Hearn, 1911.

11.32.

Arrangement in Black, No. 3: Sir Henry Irving as Philip II of Spain

Henry Irving (1838-1905) was born John Henry Brodribb in Somerset, England, and brought up by relatives in Cornwall. After short terms as a clerk in a law office and then an import house, he entered the provincial theater at the age of eighteen, took the name Henry Irving, and subsequently became the leading Shakespearean actor of his day. For many years Irving managed the Lyceum Theatre in London, where he and Ellen Terry were the principal players. His effectiveness as an actor-director-manager earned him knighthood in 1895, the first English actor to be so honored.

On April 18, 1876, Tennyson's *Queen Mary* (1875), adapted for the stage by Irving, opened at the Lyceum Theatre, where it ran for only twenty-three nights. Irving's grandson, Laurence Henry Forster Irving, observed:

Queen Mary was a sombre poem rather than a play and was received with respect rather than enthusiasm ... Irving created a convincing portrait after Titian of the bloodless Philip II and, in the expression of the King's diseased solitude and of the cold concentration of his selfish purpose, his characterization was perfect ... as far as it went his performance won high praise from Tennyson's intellectual friends, Browning declaring that he "was very good indeed" (Irving, *Henry Irving* [1951], p. 273).

Impressed by Irving's performance, Whistler induced the reluctant actor to pose for him in costume. Alan S. Cole told Whistler's biographers the Pennells (1908) that when he saw the picture at the artist's studio on May 5, 1876, he found Whistler "quite madly enthusiastic about his

power of painting such full-lengths in two sittings or so."

As *Arrangement in Black, No. 3, Irving as Philip II. of Spain*, the portrait was exhibited with seven of Whistler's other paintings, including four radical Nocturnes, at the newly opened Grosvenor Gallery in 1877. According to the Pennells (1908), Sir Coutts Lindsay, the founder of the gallery, "expressed his disappointment in the Irving and the Nocturnes" before the private view on April 30, 1877. The painting, Oscar Wilde wrote,

is called *Arrangement in Black No. 3*, apparently some pseudonym for our greatest living actor, for out of black smudge clouds comes looming the gaunt figure of Mr. Henry Irving, with the yellow hair and pointed beard, the ruff, short cloak and tight hose in which he appeared as Philip II . . . One hand is thrust into his breast, and his legs are stuck wide apart in a queer stiff position that Mr. Irving often adopts preparatory to one of his long, wolflike strides across the stage. The figure is life-size, and, though apparently one-armed, is so ridiculously like the original that one cannot help almost laughing when one sees it.

Henry James was disparaging, yet astute, in his review of Whistler's contribution to the exhibition:

I will not speak of Mr. Whistler's "Nocturnes in Black and Gold" and in "Blue and Silver," of his "Arrangements," "Harmonies," and "Impressions," because I frankly confess they do not amuse me. The mildest judgment I have heard pronounced upon them is that they are like "ghosts of Velasquezes"; with the harshest I will not darken my pages. It may be a narrow point of view, but to be interesting it seems to me that a picture should have some relation to life as well as to painting.

The *Times* speculated on May 1, 1877, how Irving enjoyed "being reduced to a mere arrangement," lamented the "entire absence of details, even details generally considered so important to a full-length portrait as arms and legs," and concluded: "Mr. Whistler's full-length arrangements suggest to us a choice between materialized spirits and figures in a London fog." The *Art Journal* noted: "as to J. Whistler's 'Nocturnes,' they are simply too subtle for us, and his portrait of Irving, as Philip II. of Spain, is like seeing the man through a glass darkly." The critic Frederick Wedmore in 1879 dismissed the work as a "murky caricature of Velasquez."

The portrait was introduced as evidence during Whistler's famous libel suit against Ruskin in November of 1878. Asked whether it was "a finished picture," Whistler replied: "It is a large impression—a sketch; but it was not intended as a finished picture. It was not exhibited as for sale." The question of finish was often raised in connection with Whistler's paintings and with works of many of his French contemporaries. Their deliberately sketch-like paintings were deplored by the establishment as inept and unfinished. Whistler's choice of title was ridiculed at the trial. The attorney-general aroused much laughter when he inquired why Whistler called "Mr. Irving an *Arrangement in Black*," and the judge intervened to explain that "the picture, not Mr. Irving, was the *Arrangement*."

Before the trial, Whistler, who was hard-pressed for money, sold the portrait of Irving to his friend Charles A. Howell for ten pounds and a sealskin coat. At about the same time, according to the Pennells (1908), Whistler made an etching after the portrait. They claim that it was the only portrait he reproduced on copper and as such it was unsuccessful. Actually, two etchings of Irving by Whistler are known; the plates for both were canceled or destroyed. Howell is credited with introducing Whistler to Henry Graves and Company, printsellers in Pall Mall, who agreed to issue engravings of Whistler's paintings. According to James Laver (1951), Howell also induced Graves to acquire the rights to the Irving portrait, but no reproduction was made. From Howell, the painting passed to Graves, who sold it to Sir Henry Irving for a hundred pounds.

In 1885 Whistler asked Irving to look at his portrait of the violinist Pablo de Sarasate, *Arrangement in Black*, 1884 (now in the Carnegie Institute, Pittsburgh), on view at the Society of British Artists, "and let that show you what I meant your portrait to be and then arrange with me for a day or two at my new studio" (Irving, p. 274). The 1904 edition of Théodore Duret's biography of Whistler has a reproduction of the Irving portrait before its revision in 1885. Made from a photograph lent to Duret by George A. Lucas, the reproduction was thought for some time to represent a study or an unlocated version of the portrait. The issue was raised again in 1930, when Gordon Craig, grandson of Ellen Terry, turned up another copy of the same photograph. X-rays of the museum's painting revealed that the photographs show an

early state of the much altered painting. Before Whistler repainted the portrait, the plume in the hat was considerably smaller; the cape was worn about the shoulders leaving the right arm exposed; the legs and feet lacked definition; the two decorations, the Order of the Garter and the chain representing the Order of the Golden Fleece, were not shown. Whistler's two etchings are closer to this early state of the painting. The major change, the positioning of the cloak with its edge indicated in sweeping strokes, greatly strengthed the design and reinforced the asymmetry of the figure.

In 1897, twenty years after its exhibition at Grosvenor Gallery, the painting was included in an exhibition of dramatic and musical art at Grafton Galleries in London. The critics' response had changed considerably, either as a result of the alterations or Whistler's growing reputation, or both. The *Art Journal* reported: "The most conspicuous canvas by a living painter is Mr. Whistler's superbly painted portrait of 'Sir Henry Irving as Philip,' a masterly piece of colour arrangement and fluent brushwork." Henry James, writing in *Harper's Weekly*, gave an entirely different appraisal of the work than he had in 1877. In discussing "Mr. Whistler's exquisite image of Henry Irving as the Philip of Tennyson's *Queen Mary*," he wrote:

To pause before such a work is in fact to be held to the spot by just the highest operation of the charm one has sought there—the charm of a certain degree of melancholy meditation. Meditation indeed forgets Garrick and Hogarth and all the handsome heads of the Kembles in wonder reintensified at the attitude of a stupid generation toward an art and a taste so rare. Wonder is perhaps, after all, not the word to use, for how *should* a stupid generation, liking so much that it does like, and with a faculty trained to coarser motions, recognize in Mr. Whistler's work one of the finest of all distillations of the artistic intelligence? To turn from his picture to the rest of the show—which, of course, I admit, is not a collection of masterpieces—is to drop from the world of distinction, of perception, of beauty and mystery and perpetuity, into—well, a very ordinary place.

When the painting was sold at auction after Irving's death, it brought 4,800 guineas. Characterizing it as the chief attraction of the late actor's picture collection, the *Art Journal* (1906) noted, "Whistler was amazingly interested in the portrait, inasmuch as it represents

Left: Early photograph of Whistler, *Arrangement in Black, No. 3* shows it before 1885 revision. Prints Division, NYPL. Right: Whistler, drypoint, *Irving as Philip of Spain, No. 2*, second impression. Freer Gallery of Art.

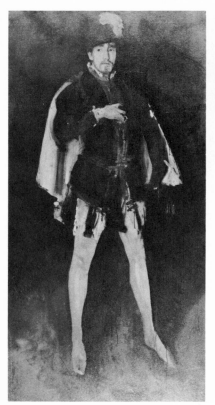

Irving in the character of the king whose grandson was immortalized by the great Velazquez." The portrait was acquired by B. F. Stevens and Brown for A. Howard Ritter of Philadelphia and later entered the collection of George C. Thomas, also of Philadelphia. It was exhibited at Blakeslee Galleries in New York in 1909; and the following year, it was purchased by the collector Charles Lang Freer with the express purpose of getting the Metropolitan Museum to buy it.

The third *Arrangement in Black*, this portrait, like many of Whistler's other life-size, full-length single figures, owes a strong debt to Velázquez. The paintings of the seventeenth-century Spanish master inspired not only the format but also the restricted palette of black, white, and silver grays, tempered with golden ochers. Contemporary critics, aware that Velázquez was the source for many nineteenth-century works, invariably drew unfavorable comparisons. In Whistler's case, the strong decorative design often overshadowed realistic representation. Whistler's *Arrangement in Black, No. 3* is broadly painted with facile strokes that belie the extensive reworking. Unfortunately, it suffers from a problem shared by several of his other works in which light colors are painted on dark grounds. The lights have become increasingly transparent with time, while the subtle modeling of the dark tones gradually has been lost, as they deepened to a uniform darkness. The painting retains the original frame Whistler designed for it.

At least two known copies, probable forgeries, of this painting exist.

Oil on canvas, 84¾ × 42¾ in. (215.3 × 108.6 cm.).

RELATED WORKS: *Irving as Philip of Spain, No. 1*, drypoint, 9 × 6 in. (22.9 × 15.2 cm.), three states, ill. in E. G. Kennedy, *The Etched Work of Whistler* (1910), 2, pls. no. 170, I–III // *Irving as Philip of Spain, No. 2*, drypoint, 9 × 6 in. (22.9 × 15.2 cm.), four states, ill. ibid., 2, pls. no. 171, I-IV.

REFERENCES: *London Times*, May 1, 1877, p. 10, reviews it in the exhibition at Grosvenor Gallery (quoted above) // O. Wilde, *Dublin University Magazine* 90 (July 1877), p. 124, reprinted in O. Wilde, *Miscellanies*, ed. R. Ross (1908), p. 18 // H. James, *Galaxy* 24 (August 1877), p. 156, reviews Whistler's contribution to the exhibition at Grosvenor Gallery (quoted above) // [London] *Art Journal* 16 (August 1877), p. 244 (quoted above) // *London Daily News*, Nov. 26, 1878, unpaged clipping, Pickford Waller scrapbook, coll. Paul F. Walter, vol. 1, p. 2, reports

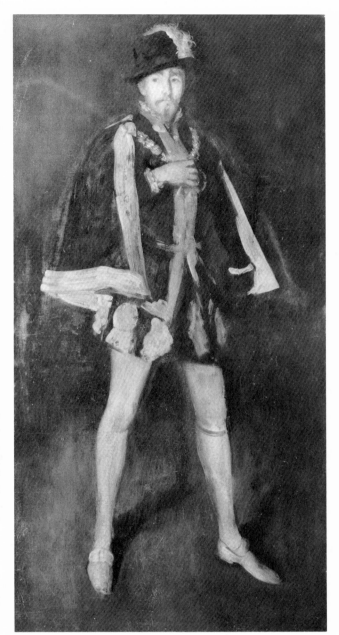

Whistler, *Arrangement in Black, No. 3: Sir Henry Irving as Philip II of Spain.*

remarks about this painting at the trial (quoted above) // F. Wedmore, *Nineteenth Century* 6 (August 1879), p. 338, notes that "the originality of [Whistler's] painted work is somewhat apt to be dependent on the innocent error that . . . exalts an adroit sketch into the rank of a permanent picture. 'Mr. Irving, as Philip of Spain,' was a murky caricature of Velasquez—an effort in which the sketchiness of the master remained, but the decisiveness of the master was wanting. I am told that at a yet earlier stage than the

stage at which it was exhibited, the portrait promised well; but it is not to *portraits manqués* that we can look to sustain a theory or establish a reputation"; *Whistler's Etchings* (1886), p. 63, no. 139, lists etching incorrectly as Irving in the role of Charles the First and says, "Mr. Whistler tells me it did not greatly interest him, as he had already done with the subject in the painted picture. But it is full of character" // J. M. Whistler, *The Gentle Art of Making Enemies* (1890), p. 6, cites exchange at trial concerning this portrait (quoted above) // H. Irving, *The Drama* (1892), frontis. shows this painting at an intermediate stage // H. James, *Harper's Weekly* 41 (June 26, 1897), p. 640 (quoted above) // [London] *Art Journal* (July 1897), ill. p. 223 (quoted above) // S. H. Purser, [London] *Art Journal* (May 1899), p. 156, mentions the portrait as "mysterious-looking" in a review of the 1899 exhibition in Dublin // W. G. Bowdoin, *James McNeill Whistler* (1902), p. 16 // A. J. Eddy, *Recollections and Impressions of James A. McNeill Whistler* (1903), p. 119, mentions it as one of the paintings exhibited at the Grosvenor Gallery in 1877 and notes that Irving was said to have learned Whistler's laugh while posing and used it "with effect" in the part of Mephistopheles // A. Graves, *Printseller and Print Collector* 1 (August 1903), p. 341 // T. R. Way and G. R. Dennis, *The Art of James McNeill Whistler* (1903; 3rd ed. 1905), p. 10, lists with works shown at the "Working Women's College in Queen's Square" in 1888 [1889]; pp. 47–48, discusses it in relation to portraits by Velázquez and notes the frame was designed by Whistler; ill. opp. p. 48, in frame // T. Duret, *Histoire de J. M^c N. Whistler et de son oeuvre* (1904), p. 37, discusses Whistler's use of black grounds and lists with his arrangements in black as "l'acteur Irving, dans le rôle de Philippe II, campé sur ses jambes, de la façon comme saccadée qui lui était propre à la scène"; p. 56, lists it; ill. p. 63, reproduces photograph of the painting at an early stage; *Whistler*, trans. F. Rutter (1917), pp. 32, 44 // M. Menpes, *Whistler as I Knew Him* (1904), pp. 75–76, says, "Sir Henry Irving has told me that he posed for Whistler many times. At last, after having given him twenty sittings, and still finding the canvas swept and bare, except for a small piece of linen, he said, 'How is it that in all these sittings I have given you, you have only painted a piece of linen?'—'Ah,' said Whistler; 'but who save the Master could have painted that linen? Surely that is excuse enough'"; p. 99, discusses proofs of the etchings after the picture // D. C. Thomson, [London] *Art Journal* (April 1905), p. 110, discusses 1905 London exhibition and says, "Another full-length that has not yet reached the height of its glory is the portrait of Sir Henry Irving; more really like the tragedian than any other that has been painted. Most of these portraits are low in tone, notably the 'Fur Jacket' and the 'Sarasate,' as well as the 'Irving'" // J. E. Blanche, *Renaissance Latine* (June 1905), p. 358, describes seeing the portrait in the art-

ist's Tite Street studio; reprinted in his *Essais et Portraits* (1912), p. 88 // L. Bénédite, *Gazette des Beaux-Arts* 34 (Sept. 1, 1905), p. 244 // *London Observer*, Dec. 17, 1905, reports the sale of Irving's pictures and says, "The great event was, of course, Whistler's portrait of Irving as Philip II. of Spain, which was greeted with a round of applause from a crowd which suggested nothing more than an old time hearty Lyceum pit audience"; notes that at 4,800 guineas "it became the property of Messrs. Stevens and Brown, American agents" and "There is no doubt that this noble work is lost for ever to this country" // *London Daily Express*, Dec. 18, 1905, describes this painting and calls it "the jewel of [Irving's] whole collection" and "one of the artist's most famous works" // *London Daily Graphic*, Dec. 18, 1905, calls this painting "the picture of the day" // *London Daily Mail*, Dec. 18, 1905, mentions this painting in report of Irving sale and says it is an "irretrievable loss" to the country "of one of the greatest master's greatest masterpieces" // *London Daily Telegraph*, Dec. 18, 1905, says in reporting sale that "some who hissed at the master's work . . . rejoiced openly that an English auction room would not see the 'Irving' any more. They hardened their hearts and let it go, and on a foggy view-day one sardonic wag was heard to say that there was nearly as much mist in the room as the frame contained. . . . In the flashing bidding . . . the Irving Philip showed the greatness of Whistler" // *London Standard*, Dec. 18, 1905, observes that "Public opinion with regard to Whistler has greatly changed since the days when his works were hissed on their appearance at Christie's" // *Sketch* 52 (Dec. 20, 1905), p. 308, reports on Irving sale; suppl., ill. p. 5, describes it // *London Sphere*, Dec. 23, 1905, calls this work the "sensation of the sale" of Irving's collection // H. Macfall, *Whistler* (1905), p. 39 // H. W. Singer, *James McNeill Whistler* (1905), pp. 34, 82, lists it // [London] *Art Journal* (Feb. 1906), p. 39, in reporting sale of Irving's pictures, discusses the painting, its frame, price, and public reaction; p. 60 (quoted above) // *American Art News* 4 (June 16, 1906), p. 1, notes that this painting was bought at the Irving sale for $25,000 by Mr. George C. Thomas of Philadelphia // B. Stoker, *Personal Reminiscences of Henry Irving* (1906), 1, pp. 151–152 // E. L. Cary, *The Works of James McNeill Whistler* (1907), ill. opp. p. 82; p. 83, says that it "has precisely the touch of dramatic gesture, not emphasized or to the slightest degree insisted upon, but hinted at in the clutch of the hand at the chain and the lifting of the eyebrow that brings the actor before us in his least exaggerated, most uncaricatured aspect"; p. 214, no. 384 // E. Terry, *McClure's Magazine* 30 (Dec. 1907), ill. opp. p. 131; pp. 135–136, discusses this painting and says Irving, "in his dress without much colour (from the common point of view), his long grey legs, and his Velasquez-like attitudes, looked like the kind of thing which Whistler loved to paint. Velasquez had painted a real Philip of the same race; Whistler would paint

the actor who had created the Philip of the stage. I have a note from Whistler written to Henry at a later date (I think) which refers to the picture. It is common knowledge that the sitter never cared much about the portrait. . . . Whistler's Philip probably seemed to him not nearly showy enough" // J. Meier-Graefe, *Modern Art Being a Contribution to a New System of Aesthetics*, trans. by F. Simmonds and G. W. Chrystal (1908), 2, pp. 222–223, compares with Velázquez and Manet and suggests that Whistler's Irving was influenced by Manet's Faure as Hamlet // B. Sickert, *Whistler* (1908), pp. 20–23, says that it "is not even to be counted among Whistler's best portraits," that he fails to suggest the character of Irving's face, that Irving's legs while "not exactly his strong point . . . had not that fin-like absence of construction" of Whistler's representation, and the hand, "suggestive of his particular trick of fidgeting with a trinket," is "a mere suggestion" and "has none of the fine and nervous expression of that wonderful hand"; remarks that he has "not seen any mention of the fact, that the portrait in the final stage, as it was seen at the New Gallery, has been considerably altered since it was first exhibited, and as it appears reproduced in M. Duret's book"; describes both states, comments that the cloak covering the arm is not an improvement, as it is painted in a "very careless and slovenly way," but that the legs have been altered "for the better" and "the left foot better drawn, but not quite successfully"; p. 104; p. 157, no. 50 // E. R. and J. Pennell, *The Life of James McNeill Whistler* (1908), 1, p. 103; pp. 199–200, report Alan S. Cole's remarks on the painting (quoted above); discuss reproduction in Duret's book, which he told them was made from a photograph borrowed from George Lucas, and conclude that this is the same painting much altered; give two accounts of Irving's acquisition of the painting; note that Whistler actually sold it to Howell, then it passed to Mr. Graves, who sold it to Irving and after the Irving sale it became the property of Mr. Thomas of Philadelphia; p. 211; p. 212, record Sir Coutts Lindsay's disappointment with the painting; p. 215, discuss print; p. 228, mention Howell's acquisition of the painting; pp. 234–235, 239, record remarks at the trial concerning the painting; pp. 249–250; ill. opp. p. 288, an etching and this painting; p. 297, report sale to Irving; p. 308, cite as example of Whistler's "rapid method of sketching" full-length figures; 2, p. 93 // H. Mansfield, *A Descriptive Catalogue of the Etchings and Dry-Points of James Abbott McNeill Whistler* (1909), p. xxiv; p. xxx, thinks this picture was exhibited in the Salon du XX at Brussels in 1888; p. xxxiii; pp. 105–106, no. 167, describes five states of the print and mentions the painting; p. 106, no. 168, describes three states of the print // C. L. Freer to W. K. Bixby, Aug. 4, 1909, Freer Gallery of Art, Washington, D. C., thanks him for information about the sale of the portrait and says he once could have bought it from Irving // Freer to F. J. Hecker, Nov. 10, 1909, ibid., says Whistler ob-

jected to his buying the portrait so he didn't // B. P. S., *New York Evening Post*, Dec. 11, 1909, p. 9, discusses the portrait on exhibit at Blakeslee Galleries and describes circumstances of sitting // *American Art News* 8 (Dec. 18, 1909), ill. p. 1, says, "the picture is really not a portrait of Irving, disguised as he was with false whiskers and the unbecoming court costume, and its chief interest and value lie in its characteristic treatment and expression" // Freer to Bixby, April 25, 1910, Freer Gallery of Art, says years ago Whistler objected to his buying the picture from Irving; says he recently urged the MMA to buy it but without avail; he then bought it himself and sent it to the MMA saying they ought to have it and he would take what he paid for it // S. Hartmann, *The Whistler Book* (1910), ill. opp. p. 90; p. 124, lists it with portraits influenced by Velázquez and notes that Whistler "repeats the same inspirations but in an etherealized, modernized and individualized manner"; pp. 136, 263 // E. G. Kennedy, *The Etched Work of Whistler* (1910), p. xxxiv, p. 64, no. 170, I-III, no. 171, I–IV, addenda following p. 143, discusses print // C. L. Freer, letters in MMA Archives, April 11, 1910, says that he acquired the painting from Blakeslee Galleries and offers to sell it to MMA; April 23, 1910, calls it "one of Whistler's most individual works"; May 21, 1910, forwards volume (given to him by Blakeslee) of newspaper clippings and correspondence relating to the painting // *MMA Bull.* 5 (June 1910), ill. p. 152, states that the picture was added to the MMA Whistler exhibition, calls it Arrangement in Black // F. Rutter, *James McNeill Whistler* (1911), p. 61, comments that it was "hardly one of his most successful works, even remembering, as Mr. Pennell reminds us, that 'Whistler was painting Irving made up as Philip II and not as Henry Irving'"; p. 70, mentions it in the 1877 exhibition; pp. 80–81, reports sale to Howell, p. 109, notes its exhibition in 1889 // J. W. Alexander, *Arts & Progress* 3 (May 1912), ill. p. 576 // L. Baury, *Bookman* 35 (June 1912), p. 389, notes that Irving told him that Whistler insisted on treating him as "simply an arrangement," that Irving did not buy the painting from Whistler because of his high asking price but later bought it at a shop for a lower price // A. Hoeber, *Arts & Decoration* 5 (Nov. 1914), p. 16, says that Whistler traded it for a fur overcoat; states incorrectly that the painting was acquired for $30,000 by the museum's donor; ill. p. 17 // K. M. Roof, *The Life and Art of William Merritt Chase* (1917), p. 142, quotes a letter to Chase, dating from 1885, in which Whistler says that he would like to get back some of his pictures which were in the hands of Henry Graves and Company; pp. 143–144, notes that, according to Algernon Graves, these paintings included the portrait of Henry Irving, given by Charles Howell as security for a loan and later sold by Graves // E. R. and J. Pennell, *The Life of James McNeill Whistler* (rev. 6th ed., 1920), p. 74, mention it in 1905 London Memorial Exhibition; p. 84, relate story concerning Whistler and Irving

but doubt its authenticity; pp. 144–145, cite Sickert and Cole, discuss reproduction in Duret's book, note that "Mrs. Stillman remembers that three different outlines of the figure were visible," when the painting was shown at the Grosvenor Gallery; p. 154, mention it in 1877 exhibition, record Lindsay's disappointment with it, and quote *Times* review; p. 156, discuss etching; p. 166, note Howell's acquisition of the painting; pp. 171, 175, record remarks at trial; p. 185, cite Wedmore's criticism; ill. opp. p. 200; p. 208, note its acquisition by Irving and then Thomas; p. 283, mention it as one of the works shown at the College for Working Men and Women, Queen's Square, London; opp. p. 428, top, included in photograph of installation at London Memorial Exhibition; p. 432, list it in the MMA; *The Whistler Journal* (1921), opp. p. 150, show it in photograph of installation at Whistler Exhibition at Bradford as arranged by J. Pennell; p. 184, call it "the one distinguished Whistler" in the Metropolitan Museum's collection; pp. 271–272, characterize the etching of Irving as a "hopeless failure"; ill. opp. p. 272, right, print of Henry Irving from destroyed plate // A. Ludovici, *An Artist's Life in London and Paris, 1870–1925* (1926), pp. 90–91 // *New York Herald Tribune*, Sept. 25, 1930, p. 1, reports that Gordon Craig, son of Ellen Terry, has a photograph showing the painting in a different state; ill. p. 10, shows the painting and Craig's photograph; quotes Craig's contention that if both "are the same, then Whistler practically ruined the picture"; reports that Leon Dabo, the painter, while admitting that Whistler may have made the changes, nonetheless calls the painting "pretty rough in spots, not altogether Whistlerian in its lack of evenness of tone values"; provides provenance and exhibition history of the painting and states incorrectly that it was exhibited at the Paris Memorial Exhibition // *New York Times* (Sept. 26, 1930), p. 23, quotes Bryson Burroughs, curator of paintings, who defends the authenticity of the painting and suggests that the museum's portrait might be painted over an earlier version // *Art News* 29 (Oct. 4, 1930), p. 25, reprints *New York Times* article (see above) // J. W. Lane, *Whistler* (1942), p. 21 // B. A. Stubbs, *Freer Gallery of Art Occasional Papers*, publication 3994, no. 4 (1950), pp. 14, 17 // L. H. F. Irving, *Henry Irving* (1951), ill. opp. p. 224; p. 273 (quoted above); p. 274 (quoted above); describes early sittings and notes that Irving bought the painting for thirty pounds; p. 337, says that it hung in the Beefsteak Club or Room at the Lyceum Theatre; p. 511, comments that Irving "was an unwilling and impatient sitter" // J. Laver, *Whistler* (1930; rev. 2nd ed. 1951), p. 160, notes that Howell induced Graves to buy the rights to the Henry Irving portrait; p. 235 // J. L. Sweeney, ed., *The Painter's Eye* (1956), pp. 25–26, discusses James's change in attitude toward Whistler's work and this painting; pp. 258–259, reprints James's 1897 review of this work // H. Gregory, *The World of James McNeill Whistler* (1959), pp. 117–120, 124–125, discusses the

painting of this portrait; pp. 129, 142 // D. Sutton, *Nocturne* (1963), p. 78, discusses the portrait, the sittings, the etchings, and the reproduction in Duret's publication; says, "It is not a picture which yields to the first inspection and only after some study does its vivacity become apparent. It demonstrates that when in form he could prove a master of a sort of modern 'state portrait,' and of a type which had almost died out in his time, at any rate, in the hands of a true artist"; opp. p. 112, fig. 45; *James McNeill Whistler* (1966), p. [17], fig. 8, photograph of it as installed in 1905 London exhibition; p. 36, lists this painting among some of his most famous male portraits and discusses; pl. 76; p. 192, no. 76, discusses it // R. McMullen, *Victorian Outsider* (1973), p. 168, discusses it; pp. 183, 186, 195, 273, mentions it // S. Weintraub, *Whistler* (1974), pp. 162–163, discusses the painting; p. 186 // Allen Memorial Art Museum, Oberlin College, *The Stamp of Whistler* (1977), exhib. cat. by R. H. Getscher with intro. by A. Staley, p. 38, no. 14, says that Whistler rarely copied his own paintings in etching, the exceptions being his portraits of Leyland and Irving; notes that he worked on the Irving portrait from 1876 to 1885 and suggests that the prints, in reverse, provided another way of studying the painting // S. Hobbs, *American Art Review* 4 (August 1977), p. 96, states that Whistler asked Charles Lang Freer not to purchase the portrait from Irving; p. 101, n 49, cites subsequent letters from Freer to Frank J. Hecker and Edward Robinson and says that Freer offered the MMA his option to buy the painting of Irving // H. Taylor, *James McNeill Whistler* (1978), p. 95; p. 97, pl. 73, says begun 1876 and reworked about 1885; p. 127; p. 183, n 8, mentions reworking in the late 1880s // A. M. Young, M. MacDonald, R. Spencer, and H. Miles, *The Paintings of James McNeill Whistler* (1980), 1, p. 57, say that a photograph of Whistler's Irving was mistakenly inscribed by the artist Arrangement in Black, No. 2, but was exhibited several times as Arrangement in Black, No. 3; p. 106; p. 109, no. 187, catalogue the painting; cite entry from Alan Cole's diary from letterbooks, Glasgow University Library, in which Cole says he saw an early state of the portrait on May 1, 1876; say that according to those letterbooks J. Waddell, trustee during Whistler's bankruptcy sale, gave Howell permission to remove the painting; cite Freer letters concerning the painting; p. 110, no. 187, note and describe photographs showing the portrait in an earlier state; say photograph of the painting reproduced in *The Drama: Addresses by Henry Irving* (1893) appears to show an intermediate state; note that, although Meier-Graefe compares it to Manet's Portrait de Faure dans le rôle de Hamlet (Museum Folkwang, Essen), which was exhibited at the 1877 Salon, Whistler's Irving is closer to Manet's 1865 *The Tragic Actor*, a portrait of Philibert Rouvière as Hamlet (National Gallery of Art, Washington, D. C.), which Whistler could have seen in Paris in 1867; p. 129; 2,

pl. 128; pl. 407 and pl. 408, show earlier states of the portrait // E. A. Nollman, Freer Gallery of Art, July 12, 1983, provided copies of Freer letters.

EXHIBITED: Grosvenor Gallery, London, 1877, *Summer Exhibition*, west gallery, no. 7, as Arrangement in Black No. 3, Irving as Philip II. of Spain, lent by the artist // College for Working Men and Women, Queen's Square, London, 1889 (no cat.) // Grafton Galleries, London, 1897, *Exhibition of Dramatic and Musical Art*, no. 137, as Sir Henry Irving as Philip // Leinster Hall, Dublin, 1899, *A Loan Collection of Modern Paintings* (according to a label on the stretcher), no. 78, lent by Irving // Royal Scottish Academy, Edinburgh, 1904, no. 252 // International Society of Sculptors, Painters, and Gravers, New Gallery, London, 1905, *Paintings, Drawings, Etchings and Lithographs: Memorial Exhibition of the Works of the Late James McNeill Whistler*, ill. between pp. 72–75; p. 85, no. 27 // PAFA, 1907, no. 328, as Portrait: Sir Henry Irving, lent by George C. Thomas // Blakeslee Galleries, New York, 1909 // MMA, 1910, *Paintings in Oil and Pastel by James Abbott McNeill Whistler*, not in cat. // Carnegie Institute, Pittsburgh, 1940, *Survey of American Painting*, no. 140 // Wildenstein and Company, New York, 1944, *Stars of Yesterday and Today*, no. 48 // Utah Centennial Exposition, Salt Lake City, 1947, *100 Years of American Painting*, no. 16 // Virginia Museum of Fine Arts, Richmond, 1947, *Portrait Panorama*, no. 13 // Lyman Allyn Museum, New London, Conn., 1949, *J. McNeill Whistler*, no. 21 // MMA, 1958–1959, *Fourteen American Masters* (no cat.) // Arts Council Gallery, London, and Knoedler Galleries, New York, 1960, *James McNeill Whistler*, exhib. cat. by A. M. Young, no. 38, as Arrangement in Black, No. 3: Sir Henry Irving in the character of Philip II of Spain in Tennyson's "Queen Mary"; catalogues it, notes the sitting in about 1885, says that the reproduction in Duret must represent this picture as it was after the early sittings in 1876; discusses differences, says that the absence of a signature suggests that Irving did not pose as long as Whistler wished, notes that the etchings, "one of the very few instances of Whistler repeating himself in another medium," are related to the early version; pl. 14 // MMA, 1965, *Three Centuries of American Painting*, unnumbered cat.; 1972, *Drawings, Watercolors, Prints and Paintings by James Abbott McNeill Whistler* (no cat.) // Albany Institute of History and Art, 1974, *Drawings, Watercolors, Prints and Paintings by James Abbott McNeill Whistler* (no cat.).

EX COLL.: Charles Augustus Howell, London, 1878 – about 1881; with Henry Graves and Company, London, about 1881; probably with the artist, 1884–1885; with Henry Graves and Company, London, 1885; Henry Irving, London, by 1897 – d. 1905 (sale, Christie's, London, Dec. 16, 1905, no. 148); with B. F. Stevens and Brown, London, 1905, as agents; A. Howard Ritter, Philadelphia, 1905 – 1906; George C. Thomas, Philadelphia, 1906-1909; with Blakeslee Galleries, New York, 1909-1910; with Charles Lang Freer, Detroit, as agent, 1910.

Rogers Fund, 1910.

10.86.

Arrangement in Flesh Colour and Black: Portrait of Théodore Duret

Théodore Duret (1838-1927), heir to the firm of Duret et Cie, brandy dealers in Cognac, was a collector, orientalist, and art critic. An early champion of Courbet, Manet, and the impressionists, he was introduced to Whistler by Manet and became a chief exponent of Whistler's art as well.

Duret posed for this portrait in 1883 in Whistler's studio at 13 Tite Street, London. It is both an example of Whistler's use of portraiture to investigate problems of design and color and a polished representation of a worldly and urbane man. In 1904 Duret wrote about the painting:

One evening in 1883 we [Whistler and Duret] were dining together at the house which he then inhabited in Fulham Road, London. During the day we had attended the opening of an exhibition of painting and we passed in review the pictures we had remarked there. He began to criticise particularly the portrait of a president of some society or corporation. This personage was represented bareheaded, his hair separated by a parting on the forehead, and frizzed, and at the same time he was garbed in a red robe of an antique character, the emblem of his office. This combination of hair done in the latest fashion and an ancient robe appeared to him to be in detestable taste. Conversation flowed thence to the costume and pose to choose in a portrait. We agreed that the originals ought to be posed variously according to their physique, and that they should be clothed in one of the suits they habitually wore.

The incongruities of portraying a contemporary man in antique dress and the desirability of using contemporary clothes had been pointed out by Baudelaire in *Le Peintre de la vie moderne* (1863). As "evening dress (*l'habit noir*) was the suit in which gentlemen in England passed a portion of their life," Duret continued:

The conclusion reached was that one ought to paint "evening dress," and after a moment's reflection he asked me to pose for him. It was understood then that he should paint my portrait in evening dress. It

was successively decided that it should be full length, life size, with a light background. He evidently did not trouble himself about difficulties to come, for the full length against a light background was of all poses the most arduous. After that it was necessary to find an arrangement, an accessory, something which should render less gruff the man in black from head to foot. I confess that I had nothing to suggest. Whistler thought it over for some time. Finally, when he had decided, he said to me: "Come on such and such a day; bring your evening dress and a pink domino." I was surprised enough at the domino, but without making any comment I went to seek the object at a costumier's in Covent Garden, and on the appointed day I was in his studio at Tite Street.

He posed me standing in front of a rose-grey hanging, the domino thrown over my left arm, bareheaded, the hat held in the hand of the right arm, which hung down, and he began to attack the portrait without any preliminary drawing. He merely put on the white canvas a few chalk marks to indicate the top of the head and the end of the feet, on right and left, the sides of the body. He placed immediately on the canvas the colours and tones, just as they ought to be in the finished picture. At the end of the sitting one could already judge the general appearance that the work would have. It had, as first motive, a man standing, seen full face, in evening dress, and then the domino permitted him to realise that combination of colour of a decorative order that he introduced into every work he painted. The black of the suit, the pink of the domino and the grey of the background formed an *Arrangement in Flesh-colour and Black*. Finally, the domino, falling over the left leg and covering part of it, had allowed him to destroy the ugly parallelism of the two sides of the body and to diversify the contours. This idea of the domino, then, had come to him as a true painter's invention: from a very simple object he had gathered the unexpected arrangement of a picture.

In satisfying his maxim that a "Picture is finished when all trace of the means used to bring about the end has disappeared," Whistler succeeded so well that, ironically, his works were criticized as effortless sketches. His practice of eliminating all but essential features contributed to the sketch-like character that the contemporary establishment found unacceptable. Another of Whistler's major aesthetic concerns, according to Duret, was "to maintain the relation of tones between all the parts." About this portrait, Duret wrote:

where the arrangement in flesh-colour and black was formed by the black suit on one hand and by the pink domino and grey background on the other, as soon as the slightest deviation of tone appeared, whether in

the black of the suit or the grey of the background, he put a new layer of colour over the whole picture, so as to bring the least parts of it into the exact relationship which constituted the desired arrangement. Thus he had to repaint perhaps ten times the figure and the background. Reworked upon, after three attacks, this portrait was not finished till several months after it had been commenced. To-day the practised eye easily recognises by its construction that it can only have been brought about by prolonged application, but when it was first shown in the Paris Salon of 1885 it was found, according to the preconception then existing, to have the character of a sketch, and most people thought that its execution had only required a very short time.

While Duret posed, Whistler's student and assistant Walter R. Sickert also painted him (a small panel, now unlocated). Whistler's portrait, according to the Pennells (1920), was completed in 1885 and sent to the Paris Salon that year. It was skied in hanging, as the art critic Octave Maus noted: "It is almost impossible to appreciate it, the jury having decided to relegate it to heights inaccessible to mortal eyes." Comparing it unfavorably to Whistler's portrait of Lady Campbell (Philadelphia Museum of Art), also on exhibition, A. Michel (1885) considered the Duret to be less three-dimensional than the other portrait. Joris Karl Huysmans (1889) found the Duret painting odd, the colors sad, almost like a smooth and dull Manet, and the work strong but less adventurous than Whistler's portrait of Lady Campbell. To George Moore it confirmed that Whistler's art was "guided by his mind, and not by his eyes." Moore asked:

Did he ever see Duret in dress clothes? . . . Did he ever see Duret with a lady's opera cloak? . . . Is Duret in the habit of going to the theatre with ladies? No, he is a *littérateur* who is always in men's society, rarely in ladies'. But these facts mattered nothing to Whistler as they matter to Degas or to Manet. Whistler took Duret out of his environment, dressed him up, thought out a scheme—in a word, painted his idea without concerning himself in the least with the model (1886; 1959 ed.).

Manet had painted Duret's portrait (Petit Palais, Paris) in 1868. It was exhibited in Paris in 1884 and was in Duret's collection until 1908 when he presented it to the Petit Palais. Undoubtedly Whistler had seen it before he painted his portrait. An astute, if biased, comparison of the two paintings was provided by Julius Meier-Graefe (1908):

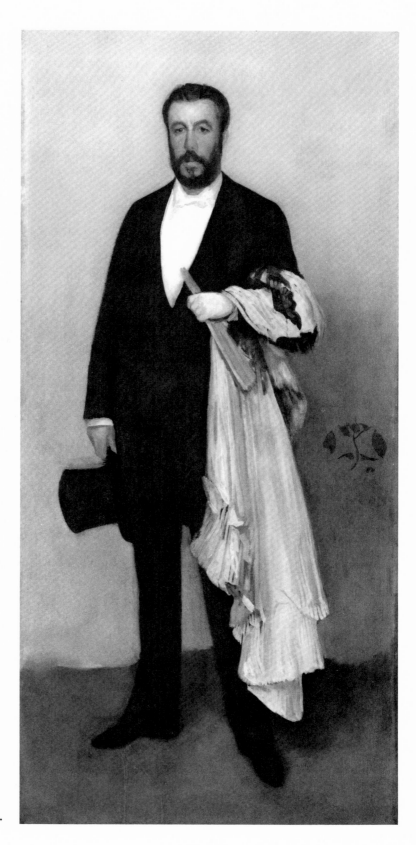

Whistler, *Arrangement in Flesh Colour and Black: Portrait of Théodore Duret.*

[Whistler's] picture is painted with a masterly regard to its permanent beauty. Whistler worked at it for three months, painting and repainting till he got absolute smoothness of surface, and then veiled it with a colourless porous glaze. It offers a perfect exemplification of his theory concerning "finish."

He went on to contrast Manet's portrait as

hardly comparable to the other, for, as Duret has told us, it was not intended for public inspection, and has none of the careful elaboration of the work of Whistler, who was not unmindful that the portrait was to represent him in what was then a brilliant collection. Manet painted his in two or three sittings. It is inelegant, in the well-known brown tone of the early period, the only relief a few dashes of colour in the neck-tie and the accessory still-life, and it has not stood so well as the other; yet it is far above it. With all its finish, Whistler's elaborate portrait is less complete than Manet's little picture. This is a swift, spontaneous creation, a work of the mind rather than of the hand, an invention so convincing that faulty details, did they exist in it, would seem unimportant. The other is handicraft, the outcome of industry rather than inspiration, the harmony of which is made up of so many trifles that the slightest defect, such, for instance, as the want of definition on the top of the head, irritates the spectator. The one creates life, the other an artistic illusion. Manet is "more artless," as Constable would have said. We can imagine how minutely Whistler arranged every detail of his composition. . . . It is difficult to believe that the two pictures represent the same person; nay, they seem hardly to belong to the same species. We note the bones and flesh in the Manet. Whistler's *Duret* stands on trousers.

Shown at the ninth exhibition of the Berlin Secession in 1904, Whistler's Duret was singled out by Emil Heilbut as the most brilliant painting of the exhibition. He described it as "identical with nature," noting that the subject stands before us in his entirety. Whistler's portrait of Duret is one of a series of single figure paintings of men in evening clothes. Preceded by his portraits of Frederick R. Leyland, 1873 (Freer Gallery of Art, Washington, D. C.), and Sir Henry Cole, 1881-1882 (probably destroyed), and followed by his portraits of the violinist Pablo de Sarasate, 1884 (Carnegie Institute, Pittsburgh), and the Comte Robert de Montesquiou-Fezensac, 1891 (Frick Collection, New York), it is distinguished from them by the choice of a light ground for the dark-clothed figure, which, as John Rewald pointed out, has precedents in the work of Courbet, Manet, and Velázquez (who was the common source).

Whistler eschews conventional devices to establish the weight of a figure in space, such as pronounced modeling and a prominent cast shadow. The figure is so slightly modeled that it is nearly a silhouette, and there is only the suggestion of a cast shadow, created by subtle transitions in tones. The source of light is obscure. The ground line, another device for establishing the illusion of depth, remains indefinite. It is suggested only in the juxtaposition of the backdrop and the slightly contrasting color of the floor. Whistler's representation anticipates modern developments. Working with an essentially black, gray, and white palette, he introduces one color in a range of values in the fan, the pink domino, the flesh tones, and the stylized butterfly positioned with exacting care. The reduction of content to the most essential and expressive forms, the subtle asymmetrical placement of the figure (reinforced by the domino), the strong silhouette, and the monogram reflect his assimilation of oriental art. The portrait is a successful artistic statement of Whistler's aesthetic sensibilities.

In 1913 when the painting was acquired from Duret for the museum, he wrote:

When a singular and inventive painter is developing, it is certain that his most particularly original works will be beyond the traditional and accepted and for this reason will be especially misunderstood. That was the case of my portrait among Whistler's. One might say it was a work of provocation. In this portrait Whistler seems to have built in obstacles to overcome. A man in black is set without compromise against a light background, and, in addition, there is the combination of three colors, the gray of the background, the black of the figure, and the pink of the domino. The pink of the domino is meant to unite with the gray, by itself basically neutral, to warm it and give it a pink reflection.

Only I know how much effort was involved in making this portrait a success and bringing it *in keeping with Whistler's own aesthetics*, to that point of perfection where all appearance of effort has disappeared. For a long time this portrait was mocked by many, appreciated only, *but then to the highest degree*, by a few artists and connoisseurs. Now, however, that Whistler's work is for the most part generally understood, this painting will be increasingly regarded for what it really is, one of the master's most daring, most characteristic and most successful works.

The portrait is shown, reflected in a mirror, in Edouard Vuillard's 1912 painting of Duret with his cat Lulu, amid his books and his art

collection (National Gallery of Art, Washington, D. C.).

Oil on canvas, 76⅛ × 35¾ in. (193.4 × 90.8 cm.). Signed at right center with artist's butterfly symbol.

REFERENCES: J. M. Whistler to T. Duret [1884], letter 18 in "Letters from James Abbott McNeill Whistler to Théodore Duret," MMA Library, arranges appointment for next sitting and reminds Duret to bring the same costume "que nous puissions toujours avoir le même effet" // O. Maus, *L'Art Moderne* 5 (May 24, 1885), p. 164, describes this portrait at the Paris Salon of 1885 and notes, "Il est à peu près impossible de l'apprécier, le jury ayant jugé à propos de le reléguer dans des hauteurs inaccessibles aux yeux des mortels" (translation quoted above) // A. Michel, *Gazette des Beaux-Arts* 32 (July 1, 1885), p. 17 // G. Moore, *Confessions of a Young Man* (1886; 1959 ed.), pp. 126-127, reviews Whistler's portrait of Duret (quoted above) // J. K. Huysmans, *Certains* (1889), pp. 70-71, says, "L'oeuvre est curieuse, ferme mais moins jaillie dans les au-delà et les couleurs sont tristes;—l'on dirait presque d'un Manet lisse et atone" // G. Geffroy, *L'Art dans les Deux Mondes* 2 (June 27, 1891), ill. p. 63, detail; p. 64, describes it; *La Vie Artistique* (1892), 1, p. 75, mentions its exhibition at the Paris Salon; pp. 275-276, describes it // T. R. Way and G. R. Dennis, *The Art of James McNeill Whistler* (1903; 1905), pp. 37-38, note "how admirably the difficulties" of the two parallel lines of the legs are overcome; ill. opp. p. 38; pp. 47-48, discuss portraits of Irving, Duret, and Sarasate; p. 48, describe it, discuss its success as a portrait of a black figure on a light background, mention that this "most original and interesting portrait" was exhibited at the 1885 Salon, and claim it is reproduced "for the first time" in this book // T. Duret, *Histoire de J. Mᶜ N. Whistler et de son oeuvre* (1904), pp. 99-105; p. 153, says that it was exhibited at the Paris Salon in 1885; color ill. opp. p. 162, as Arrangement en couleur chair et noir; English trans. by F. Rutter (1917), pp. 10-11, notes that in 1914 he was recognized by Mr. Pauli, then director of the Bremen Museum, from having seen Whistler's portrait of him at the Secession in Berlin and cites this as evidence of the excellent likeness; pp. 68–72 (quoted above); ill. opp. p. 102; p. 103, notes 1885 exhibition // [E.] H[eilbut], *Kunst und Künstler* 2 (July 1904), p. 404, characterizes this painting as the most brilliant in the ninth exhibition of the Berlin Secession and notes that, although not equal to Whistler's portraits of his mother or Carlyle, it is exquisite and stands with the best of Whistler's works; pp. 404–405, discusses; p. 405, says that it is "*identisch* mit der Natur" (quoted above) // H. W. Singer, *James McNeill Whistler* (1905), p. 34, lists it with his "celebrated portraits"; p. 82, no. 14, lists it with principal works // E. L. Cary, *The Works of James McNeill Whistler* (1907), ill. opp. p. 86; pp. 86-88, discusses this painting; pp. 89-91, discusses Manet's

portrait of Duret and contrasts Whistler's approach with Manet's; p. 212, no. 373, lists it as Portrait of Monsieur Duret, Writer on Art // B. Sickert, *Whistler* (1908), p. 39, criticizes it; p. 163, no. 86, lists it and notes 1885 and 1905 exhibitions // J. Meier-Graefe, *Modern Art Being a Contribution to a New System of Aesthetics*, trans. by F. Simmonds and G. W. Chrystal (1908), 2, pp. 223-224 (quoted above), notes that this portrait interrupted Whistler's series of male portraits against black backgrounds, and that "The choice of colour would be perfect but for the vermilion of the fan"; ill. opp. p. 223 // E. R. and J. Pennell, *The Life of James McNeill Whistler* (1908), 1, p. 125, describe the butterfly "made simply in silhouette, on the background, by a few touches of the rose of the opera cloak and the fan" and note that "it was introduced as a note of colour, as important in the picture as anything else"; pp. 306-308, describe the painting of this portrait and the technique, stating, "There are finer portraits, but not many that show so well Whistler's meaning when he said that colour is 'the arrangement of colour.' The rose of the domino, the fan, and the flesh, is so skillfully managed that it flushes the cold grey of the background with rose"; add that "M. Duret, when he shows you the picture, in his apartment at Paris, will take a sheet of paper, cut a hole in it, and place it against the background, to prove that the grey, when surrounded by white is pure and cold, without a touch of rose, and that Whistler got his effect by his knowledge of the relation of colours, and his mastery of the tones he wished to obtain"; 2, p. 3; ill. opp. p. 20; p. 24; p. 116, note its exhibition at the Salon // R. Fry to B. Burroughs, letters in MMA Archives, Dec. 29, 1908, says that Duret would sell this painting "privately and preferably to a museum"; calls it "one of the most striking and effective of Whistler's portraits"; adds that it "has rarely been shown"; Jan. 5, 1909, notes, "This Duret portrait seems to me to be the very thing we want" // B. Burroughs to Sir C. P. Clarke, letter in MMA Archives, Jan. 12, 1909, recommends the painting for consideration by the Committee on Purchases but suggests that the price is too high // R. Fry to B. Burroughs, letters in MMA Archives, Jan. 15, 1909, writes, "it seems to me the kind of Whistler we want" and "strikes me as having the decorative side of Whistler well-expressed. It is a wonderfully thought out silhouette and it has vigorous though delicate contrasts. I should imagine that the pink of the opera cloak is a most exquisite note of colour against the vapoury black of the dress suit"; recommends purchase; Jan. 26, 1909, urges submission of painting and states, "I think it far more important to get a good Whistler than even a good late Corot"; Jan. 29, 1909, notes, "It is my impression that we shall make a great mistake if we miss this opportunity" // Minutes of the MMA Committee on Purchases, 2 (1908–1911), MMA Archives, Feb. 11, 1909, p. 45, says, "It was determined not to enter into negotiations for the purchase of Portrait of Duret, by

Whistler" // R. Fry to B. Burroughs, letters in MMA Archives, Feb. 16, 1909, after seeing the portrait in Paris, writes: "it is in perfect condition. It is indeed one of the solidest and soundest works he did and for the simple reason that it was painted while Whistler was living with Duret in London and that he took three months to paint it, allowing each *couche* to dry thoroughly. Consequently there is no cracking and dragging at all. This, as we know to our cost with Whistler, is of the utmost importance. Another thing very much in its favour is that it is a light picture. As you know Whistler did very few such"; describes the painting, noting, "The background is a grey warm neutral of a wonderful quality. It has a faint echo of the dull rose of the domino, or rather appears to have, but that is only because being very atmospheric and elusive in quality it takes on that tint sympathetically, as it were . . . it is all a question of atmospheric quality, as opposed to crude pigment. The face is warm and rather deep in tone, slightly reddish or deep rose tints predominating. The black is a wonderful *sfumato* with scarcely any modelling and yet it is without any flatness owing to the extraordinary quality of the edges. The white of the shirt front is a marvel of tactful adjustment of tone, suggesting an almost brilliant-white and yet as a matter of fact of a rather fully-toned grey. The domino is dull rose with exquisite notes in the half tones and the face introduces a single note of positive red. It is to my mind one of the most extraordinarily scientific works he ever did, *soigné* to the last degree and yet amazingly fresh. It has, of course, no charm of subject; it relies upon its art pure and simple, but it is classic in its completeness and reserve—almost academic in the best sense of the word . . . I am convinced that we ought to get it. It is one of his most serious and complete works, much better than the *Irving* and, I think, than the *Sarasate*"; March 8, 1909, writes that he regrets the committee's decision on the portrait // H. Mansfield, *A Descriptive Catalogue of the Etchings and Dry-Points of James Abbott McNeill Whistler* (1909), p. xxx // W. R. Sickert, *Art News*, no. 14 (Feb. 10, 1910), p. 113, mentions Whistler's portrait and his own portrait of Duret // S. Hartmann, *The Whistler Book* (1910), p. 124, lists it; p. 136; p. 137, dates it 1883; p. 138, notes its "superior characterization" and "the strange combination of an awkward shape . . . and the gay insignia of an opera ball"; p. 139, includes it among the most important portraits; p. 143, reiterates the admirable character delineation; ill. opp. p. 214; p. 263, lists it with principal paintings and says incorrectly that it was first exhibited in 1883 // F. Rutter, *James McNeill Whistler* (1911), p. 92, states that Whistler took a studio at 13 Tite Street, where he painted this work // W. R. Sickert, *New Age* (June 15, 1911), p. 160, notes, "I painted a small panel of Duret while Whistler painted his large portrait" // T. R. Way, *Memories of James McNeill Whistler* (1912), p. 64 // E. G. Kennedy to B. Burroughs, letter in MMA

Archives, Oct. 30, 1912, says that Duret will send portrait for inspection if there is any serious consideration of buying it and states, "I need not say how strongly I advocate its purchase by the Museum, and for several reasons. In the first place it is in perfect preservation; secondly, it is complete in every detail; thirdly, it is the only one left of the really great portraits that is likely to come into the market. . . . I offered to buy the portrait myself, and to guarantee that it would be disposed of only to a Museum, but Duret said that he had determined that it would be sold only on condition that it went directly from his house to a museum—Metropolitan preferred" // B. Burroughs and E. G. Kennedy, letters in MMA Archives, Oct. 31, Nov. 2, Nov. 6, 1912, discuss it; E. G. Kennedy on Dec. 23, 1912, calls it "the most complete of all, or any, of [Whistler's] full length figures and a remarkably good portrait; B. Burroughs on Jan. 20, 1913, informs Kennedy of acquisition // B. B[urroughs], *MMA Bull.* 8 (March 1913), pp. 44-46, notes exhibition of newly acquired portrait of Duret and quotes Duret's account of the painting of the portrait; says that when he first saw it in 1909, Duret expressed "his desire that the portrait might find its final resting-place in some great permanent collection in the painter's native country," calls it "incontestably in the first rank of Whistler's production," compares with portrait of Whistler's mother, notes perfect condition // T. Duret, letters in MMA Archives, March 2, 1913 (quoted above in translation); June 20, 1913, requests photograph and says, "I see, with great satisfaction, that the art of Whistler is at last generally understood and praised, as it should be, and that even those who continued not to understand have ceased to disparage him and begun to praise him" // E. R. and J. Pennell, *The Life of James McNeill Whistler* (rev. 6th ed., 1920), pp. 89, 216-217 (same information as in 1908 ed.); p. 233, mention that in 1885 Whistler moved from Tite Street to 454 Fulham Road, where Duret's portrait was finished; ill. opp. p. 277; p. 299; p. 432, note acquisition by museum and Duret's sentiments // J. Rewald, *The History of Impressionism* (1946; 4th rev. ed., 1973), pp. 240-241, discusses the device of a dark figure against a gray background as used by Courbet, Manet, and Whistler; ill. p. 241 // B. A. Stubbs, *Freer Gallery of Art Occasional Papers*, publication 3994, no. 4 (1950), p. 20 // H. Gregory, *The World of James McNeill Whistler* (1959), p. 246, mentions it and compares Whistler's work with Sargent's // A. M. Young, *James McNeill Whistler*, exhib. cat. (1960), pp. 64, 115 // L. W. Havemeyer, *Sixteen to Sixty* (1961), p. 189, discusses it // F. Fels, *Jardin des Arts* 107 (Oct. 1963), ill. p. 29 // D. Sutton, *Nocturne* (1963), fig. 44; pp. 101-102, relates Duret's account of the painting of this portrait and discusses; *James McNeill Whistler* (1966), p. 36, gives Duret's account; pl. 92; p. 193, no. 92, discusses it and notes it was painted in 1882-1884 // Philadelphia Museum

of Art and Art Institute of Chicago, *Edouard Manet, 1832–1883*, exhib. cat. by A. C. Hanson (1966), p. 107, suggests that Manet's portrait of Duret "lacks the flair which Whistler had added to his portrait," cites George Moore who preferred Manet's approach to Whistler's // B. Laughton, *Apollo* 86 (Nov. 1967), p. 373, notes that Whistler was pleased with two articles about him by Octave Maus, art critic, musical impressario, and secretary of the Société des XX in Brussels, in the journal *L'Art Moderne* in 1885; p. 379, n 8, cites appreciative letter from Whistler to Maus, saying, "never has any work of mine been so sympathetically and daintily dwelt upon" // R. Fry, *Letters of Roger Fry*, ed. with an intro. by D. Sutton (1972), 1, p. 26, notes this painting among those Fry recommended for acquisition when he was an adviser to the MMA; p. 28, says that he was instrumental in the acquisition of this painting; p. 98, lists Fry's visit to Paris in Feb. 1909 to see the painting; pp. 307–308, 310–311, 312–313, reprints letters in MMA Archives from Fry to B. Burroughs, Dec. 29, 1908, Jan. 15, and Feb. 16, 1909, concerning this painting // J. L. Barrio-Garay, *Goya* 112 (Jan.-Feb. 1973), ill. p. 237; p. 238, notes, "es un alarde de elegancia y austeridad, de forma y color: recuerda a Velázquez, supera el retrato de Duret por Manet, establece un modelo a seguir—entre otros por nuestro Casas—y como el titulo, *Composición en color de carnaciones y negros* sugiere, es una síntesis de caracterización psicológica y abstracción formal" // W. Baron, *Sickert* (1973), pp. 8, 13 n 13, mentions Whistler's portrait and Sickert's portrait of Duret // R. McMullen, *Victorian Outsider* (1973), pl. 28; pp. 211–212, calls it a commissioned work dating from around 1883, provides biography of the subject, describes the portrait as "one of Whistler's strongest characterizations and most successful arrangements of figure and ground," notes that it was painted at the same time as Arrangement in Black: Lady in the Yellow Buskin, Lady Archibald Campbell; p. 215, says that the portrait was rubbed out and repainted ten times; p. 273 // S. Weintraub, *Whistler* (1974), pp. 270–271, discusses the painting // Y. Bizardel (trans. by F. Yorke), *Apollo* 100 (August 1974), ill. p. 150, fig. 9, and dates it 1882–1884; p. 153, discusses; p. 155 // *MMA Bull.* 33 (Winter 1975–1976), color ill. [p. 221], no. 67, discusses it // J. Newton and M. F. MacDonald, *Zeitschrift für Kunstgeschichte* 41 (1978), ill. p. 151, pl. 3; p. 152, report that Manet introduced Duret to Whistler and cite letter dated Nov. 22 [1880]; state that Duret was one of the few French people to pose for Whistler; p. 156, note that the portrait was skied at the Salon of 1885 and that the press, aware of Duret's support of the artist, felt Whistler had not done him justice // H. Taylor, *James McNeill Whistler* (1978), pp. 125–126, discusses, notes that it was probably begun in 1882 although Duret mentions 1883, quotes from Whistler's letter to Duret in MMA Library, says that of all Whistler's portraits of men in

contemporary dress "it is the first portrait in which Whistler was quite obviously and consciously concentrating upon and developing this colour scheme," describes it and notes that the "left side of the picture is quite heavily worked, as also is the head; and yet again there appears to have been some uncertainty over the placing of the butterfly," notes that ten years later, in 1895, Whistler hoped to rework it; color pl. 15, p. 129; p. 178, cites Fry's remark on the portrait // F. Spalding, *Whistler* (1979), p. 66, describes; p. 69, color pl. 58; p. 71, compares with Whistler's portrait of Comte Robert de Montesquiou-Fezensac // A. M. Young, M. MacDonald, R. Spencer and H. Miles, *The Paintings of James McNeill Whistler* (1980), 1, pp. 138–139, no. 252, catalogue it; note that "Duret posed repeatedly in 1883-4, the canvas being completely repainted at least ten times"; cite Whistler's letter to Duret now in MMA Library; from correspondence in the Birnie Philip Collection, Glasgow University Library, note that Whistler sent this portrait for exhibition at the Grosvenor Gallery, London, in April 1884, that it was rejected by Sir Coutts Lindsay who wrote, "I trust that you will withdraw [your portrait] of Monsieur Duret, the work is so incomplete & slightly made out that I cannot accept it at the Grosvenor," and that the artist replied that his pictures were "sunken in & degraded & begrimed from their journey" and that "the work—when properly hung cleaned & varnished—would be the fine picture it was when I painted it in my studio"; state according to letters from the artist to Duret in the Pennell Collection, that Whistler worked on the portrait after June 1884; suggest that Duret bought it from the artist about 1885; from Whistler correspondence in the Birnie Philip Collection, Glasgow University Library, note that in 1895 the artist wrote that he still wanted to touch it up so that it could be "made really to live"; say the title was given by Duret in 1904; mention Fry's letters to Burroughs; describe alterations and technique; say Moore and Mrs. Havemeyer questioned the realism of the portrait; and note Sickert's portrait of Duret; 2, color pl. 159.

EXHIBITED: Paris, Salon of 1885, no. 2460, as Portrait de M. Théodore Duret // Berlin, 1904, *Neunten Kunstausstellung der Berliner Secession*, no. 239, as Portrait des Schriftstellers Duret // International Society of Sculptors, Painters and Gravers, New Gallery, London, 1905, *Memorial Exhibition of the Works of the Late James McNeill Whistler*, ill. between pp. 34 and 35; West Room, p. 78, no. 10, as Portrait of Monsieur Théodore Duret, Writer on Art, describes it and notes 1885 exhibition // Museum of Modern Art, New York, 1942, *Twentieth Century Portraits*, unnumbered cat. // MMA, 1950, *20th Century Painters*, p. 12 // Minneapolis Institute of Art, 1952, *Great Portraits by Famous Painters*, no. 41 // Art Institute of Chicago and MMA, 1954, *Sargent, Whistler and Mary Cassatt*, exhib. cat. by F. A. Sweet, ill. no. 115,

discusses it // MMA, 1958–1959, *Fourteen American Masters* (no cat.); 1965, *Three Centuries of American Painting*, unnumbered cat. // Brooklyn Museum; Virginia Museum of Fine Arts, Richmond; California Palace of the Legion of Honor, San Francisco, 1967–1968, *Triumph of Realism*, intro. by A. von Saldern, pp. 51–52, discusses it; p. 82, no. 89; ill. p. 170 // Nationalgalerie, Staatliche Museen, Berlin, 1969, *James McNeill Whistler (1834–1903)*, ill. p. 44, no. 35; p. 78, no. 35, catalogue entry by R. Spencer, says it was probably begun in 1883/84 and completed only shortly before the Paris Salon of 1885 // MMA, 1970, *19th-Century America, Paintings and Sculpture*, exhib. cat. by J. K. Howat and N. Spassky (not in cat.); 1970, *Masterpieces of Fifty Centuries*, ill. no. 377, discuss it // Wildenstein, New York, and Philadelphia Museum of Art, 1971, *From Realism to Symbolism, Whistler and His World*, color frontis., no. 37, entry by S. F[lescher] catalogues it // MMA, 1972, *Drawings, Watercolors, Prints and Paintings by James Abbott McNeill Whistler* (no cat.) // Albany Institute of History and Art, 1974, *Drawings, Watercolors, Prints and Paintings by James Abbott McNeill Whistler* (no cat.) // Pushkin Museum, Moscow, and Hermitage, Leningrad, 1975, *100 kartin iz muzeya Metropoliten, Soedinennie Shtati Ameriki* [*100 Paintings from the Metropolitan Museum, United States of America*], ill. p. 254; no. 94, p. 222, catalogues it // MMA, 1976, *A Bicentennial Treasury* (see *MMA Bull.* 33 above).

Ex coll.: Théodore Duret, Paris, until 1913; with Edward G. Kennedy, New York, as agent, 1913.

Wolfe Fund, Catharine Lorillard Wolfe Collection, 1913.

13.20.

Edward G. Kennedy

Edward Guthrie Kennedy (1849-1932) was born in Carvagh, Ireland, and came to the United States at the age of eighteen. After ten years in the art business in Boston, he joined the New York gallery of H. Wunderlich and Company. After Hermann Wunderlich's death in 1891, Kennedy became the head of the gallery that bears his name today. For many years the firm represented Whistler in the United States, and a close friendship developed between Kennedy and the artist. In the 1890s the two men were constant companions during Kennedy's annual trips to Europe; but toward the end of his life Whistler quarreled with Kennedy, and the friendship came to an end. Kennedy, who was among the first to buy Whistler's etchings, wrote *Catalogue of Etchings by J. McN. Whistler* (1902) and *The Etched Work of Whistler* (1910), the standard book on the subject.

After nearly fifty years in business, Kennedy retired in 1916 and devoted himself to collecting. He donated many prints and his collection of Whistler's letters and related material to the New York Public Library. He was also a benefactor of the Metropolitan Museum, to which he gave his collection of Chinese cloisonné and oriental textiles. Kennedy died in New York at the age of eighty-three.

Kennedy first posed for Whistler in July of 1892 for a drypoint titled *Man in an Arbour*. The plate for the print was later destroyed by the artist (Young et al., p. 180, no. 403). In June 1893 Kennedy posed again, this time for a painting. Joseph Pennell, who was present, said that after working all afternoon and into the evening, Whistler, "with one fierce dash," rubbed the whole work away. Correspondence between Kennedy and Whistler establishes that the portrait now in the Metropolitan was also begun in the summer of 1893. Whistler worked on it in 1894 and again in 1895, when it was sent to Kennedy. The artist called it "the little OK," OK being the nickname given Kennedy by Whistler's wife. The portrait, according to Kennedy, was "a replica" of the destroyed painting and followed the same composition. When Kennedy presented it to the museum in 1909, he characterized it as "a 'poor' portrait, but interesting as a piece of colour," and added:

It was painted by Whistler as a slight token of his thanks for a great service I did him. I forget the year, though I ought to remember it, as I suffered enough I can tell you. Thermometer in the 90s & we near the roof 89 rue Notre Dame des Champs [Whistler's studio on the top floor of 86 Rue Notre-Dame-des-Champs]. Oh it was hot! And I suffered so much that I wanted to kick painter's paintpots into the street. He painted another one, but foolishly erased it.

This small full-length portrait is one of several painted by Whistler to demonstrate, according to the Pennells, "the fallacy of the life-size theory and the belief that the importance of a portrait depended on the size of the canvas." Despite its size, it succeeds in suggesting the character and presence of the subject with powerful effect. Kennedy, wearing a black frock coat, black waistcoat, gray trousers, and brown gloves, is shown in an informal pose against a green ground. In his report on the acquisition of the painting Bryson Burroughs wrote in 1910:

Although the sitter's general character is admirably suggested, the likeness is not insisted on to a great

extent. The peculiar excellence and fascination of the picture is in its tone and color—a luminous half-shadow pervades the panel and envelops the figure on all sides. Notwithstanding their great delicacy the brush strokes are frank and evident and show a masterly virtuosity. The glossy white of the linen is suggested by a faint gray, the rich blacks are made by a scrumble of dark color over a brownish underpainting, and the dull brown of the gloves seems a climax of brilliancy in this perfectly poised arrangement of dark tones and shadows. All is limpid and illusive and intangible as colors seen in the depth of water, though the forms never lose their decision. It is done with the "poetic nearsightedness" which this most exquisite of modern artists made his own and by means of which he escaped from the tyranny of fact.

The Metropolitan Museum has in its collection two other portraits of Kennedy: a pencil drawing by the Italian artist Giovanni Boldini and an oil painting by WILLIAM MERRITT CHASE (see vol. 3, p. 90).

Oil on wood, 11⅝ × 7 in. (29.4 × 17.8 cm.).

Signed at right center with the artist's butterfly symbol.

REFERENCES: J. M. Whistler to E. G. Kennedy, June 9, 1895, Kennedy Papers, vol. 1, no. 63, Manuscript Division, NYPL, writes, "Bring the small OK with you & [I dare say] we shall manage some morning soon"; June 18, 1895, vol. 1, no. 64, writes that after Thursday "we will manage to complete the little OK"; July 5, 1895, vol. 1, no. 65, notes that "The small OK had better go on drying where he is—for the present"; July 12, 1895, vol. 1, no. 67, writes, "The little O.K. must be packed separately— but shall go at once"; Kennedy annotates, July 20, 1895, "'The Little OK' alludes to my portrait by Whistler which is a replica of a former one not so good, but which was put aside. Same composition" // E. H. Bell to E. G. Kennedy, Oct. 16, 1895, ibid., vol. 1, no. 71, requests loan of his portraits by Chase and Whistler for forthcoming exhibition at NAD // Whistler to Kennedy, April 3, 1896, ibid., vol. 2, no. 80, tells him to bring portrait back and he will look at it again // E. L. Cary, *The Works of James McNeill Whistler* (1907), p. 169, no. 77, lists it as Portrait of Man in catalogue of works // B. Sickert, *Whistler* (1908), p. 174, no. 182, lists it as Portrait of E. G. Kennedy // E. R. and J. Pennell, *The Life of James McNeill Whistler* (1908), 2, p. 146, describe painting of earlier portrait and its destruction (quoted above); pp. 171–172, mention Whistler's opinion on the size of the portraits (quoted above) and note that Kennedy posed for another portrait // E. G. Kennedy to H. W. Kent, letter in MMA Archives [1909] (quoted above) // B. B[urroughs], *MMA Bull.* 5 (Feb. 1910), ill. p. 46, pp. 46–49 (quoted above) // S. Hartmann, *The Whistler Book* (1910), ill. opp. p. 192 // E. G. Kennedy to H.

Whistler, *Edward G. Kennedy*.

W. Kent, letter in MMA Archives, Nov. 7, 1910, concerning S. Hartmann's book, says, "Just look at the portrait of E. G. Kennedy by Whistler in that book! It is disgraceful, as indeed are nearly all the other illustrations"; notes that he did not want the painting to be shown during his lifetime // B. Burroughs to E. G. Kennedy, Nov. 16, 1910, and E. G. Kennedy to B. Burroughs, Nov. 19, 1910, MMA Archives, discuss the exhibition of the portrait // E. R. and J. Pennell, *The Life of James McNeill Whistler* (rev. 6th ed., 1920), p. 319, give account of the painting of the first portrait of Kennedy (quoted above); pp. 334–335, discuss the small full-length portraits and mention the Kennedy; ill. opp. p. 417; p. 432, note that Kennedy gave the portrait to the MMA // R. Cortissoz, *Bulletin of the New York Public Library* 32

(Feb. 1928), p. 72, quotes Whistler's letter in which he suggests engraving a portrait of Kennedy and notes this painting // H. S. Morris, *Confessions in Art* (1930), p. 76, says, "E. G. Kennedy . . . was a friend of Whistler and had been painted by him as a small standing figure, very characteristic in its tonal qualities, and very dark. We knew it as the black cat in a dark cellar, and often joked with Kennedy over it. But it was, after all, something to be painted by Whistler and to remain his friend, and Kennedy's handsome figure deserved the compliment" // *New York Times*, Oct. 9, 1932, p. 33, Kennedy's obituary provides biographical information // *New York Herald Tribune*, Oct. 10, 1932, p. 15, gives biographical information on Kennedy and confuses this portrait with the earlier portrait which was destroyed // R. Cortissoz, *New York Herald Tribune*, Oct. 11, 1932, p. 16, mentions Whistler's proposed print of Kennedy and this portrait; reprinted in *Bulletin of the New York Public Library* 36 (Dec. 1932), p. 801 // *New Bedford [Mass.] Mercury*, Oct. 13, 1932, clipping in Watson Library, MMA, Kennedy's obituary, mentions this portrait // E. R. Pennell, *Baltimore Sun*, July 8, 1934, p. 8, notes that portrait "is now in the Metropolitan Museum, where the curious can go and study it and try to puzzle out Whistler's meaning" // J. W. Lane, *Whistler* (1942), ill. p. 100 // A. M. Young, M. Mac-Donald, R. Spencer, and H. Miles, *The Paintings of James McNeill Whistler* (1980), 1, p. 180, no. 403, catalogue destroyed portrait of Kennedy and discuss print; p. 180, no. 404, catalogue MMA portrait and provide information from letters between Kennedy and Whistler in the Birnie Philip Collection, University of Glasgow; 2, pl. 274.

EXHIBITED: NAD, 1895, *Loan Exhibition of Portraits for the Benefit of St. John's Guild and the Orthopaedic Hospital*, no. 329, as Portrait Study, lent by E. G. Kennedy // Copley Society of Boston, Copley Hall, Boston, 1904, *Oil Paintings, Water Colors, Pastels & Drawings, Memorial Exhibition of the Works of Mr. J. McNeill Whistler*, p. 11, no. 80, as Portrait of Man, lent by E. G. Kennedy // International Society of Sculptors, Painters and Gravers, New Gallery, London, 1905, *Memorial Exhibition of the Works of the Late James McNeill Whistler*, p. 107, no. 83, as Portrait of E. G. Kennedy, Esq., lent by E. G. Kennedy // Lyman Allyn Museum, New London, Conn., 1949, *J. McNeill Whistler*, no. 20 // MMA, 1958–1959, *Fourteen American Masters* (no cat.) // MMA, 1972, *Drawings, Watercolors, Prints and Paintings by James Abbott McNeill Whistler* (no cat.) // Albany Institute of History and Art, 1974, *Drawings, Watercolors, Prints and Paintings by James Abbott McNeill Whistler* (no cat.).

ON DEPOSIT: Virginia Museum of Fine Arts, Richmond, 1954–1956.

EX COLL.: the subject, until 1909.

Gift of Edward G. Kennedy, 1909.

09.222.

Whistler, lithograph, *Reading*, impression is from the large stone before the two figures on the left were cleaned off. Freer Gallery of Art.

Arrangement in Black: Girl Reading

This painting is one of a number of small powerful figure pieces that Whistler painted during the 1880s and 1890s. Spare and spontaneous, they are among his most effective creations. A seated figure in profile, such as we see here, appears often in Whistler's paintings, prints, and watercolors. The best-known examples are the portrait of his mother, done in 1871 (Louvre, Paris), and of Thomas Carlyle, 1872-1873 (City Art Gallery, Glasgow); but the pose was used as early as 1858-1859 in his celebrated painting *At the Piano* (Taft Museum, Cincinnati). As in those paintings, the figure here is parallel to the picture plane, reinforcing the sense of the two-dimensional surface. Constructed of quickly applied dabs of paint, the woman can be discerned only from changes in color tones and variations of brushstroke. In many areas the distinction between figure and background is obscure.

The painting is an example of Whistler's tonal experiments. The palette is restricted to black, gray, and brown. The woman emerges from a black ground, her face, hands, hat, and tippet defined with great subtlety. Once Whistler

Whistler, *Arrangement in Black: Girl Reading.*

Whistler, lithograph, *Reading*, the state published in *Art Notes*. Freer Gallery of Art.

Whistler, lithograph, *Maude, Reading.* Freer Gallery of Art.

reportedly responded to a sitter who questioned posing in a darkening room:

As the light fades and the shadows deepen all petty and exacting details vanish, everything trivial disappears, and I see things as they are in great strong masses: the buttons are lost, but the garment remains; the garment is lost, but the sitter remains; the sitter is lost, but the shadow remains; the shadow is lost, but the picture remains. And *that* night cannot efface from the painter's imagination (A. J. Eddy, *Recollections and Impressions of James A. McNeill Whistler* [1903], p. 214).

Whistler's mistress Maude Franklin probably served as the model for both this painting and for the lithograph *Reading* (Way 13, Kennedy 13 and 13A), which dates from about 1878 or 1879. The painting is not dated, but its similarity to the lithograph suggests that it may have been done at about the same time, or more likely later, before the second state was published in 1887. That year Whistler exhibited two paintings, *Note in Black* and *Note in Black: Reading*, at the summer exhibition of the Royal Society of British Artists. They were described in the *London Times* as "Two clever studies of girls in reading attitudes, in black dresses against black backgrounds" (Young et al., 1980, p. 126, no. 223). The museum's painting was probably one of these works; the other was *Arrangement in Black: Reading*, early 1880s (coll. Charles Kohlmeyer, New Orleans). An inscription in black paint on the back of the frame reads F. H. GRAU/LONDON, indicating the framemaker Grau, who worked for Whistler in the years 1890 to 1892 (M. F. MacDonald, *Gazette des Beaux-Arts* 85 [Feb. 1975], p. 75). The reeded frame is closely identified with Whistlerian design. Bought directly from the artist in 1891 by John C. Bancroft of Boston, the painting was framed and sent to Boston the same year. If it is the same work that was exhibited in 1887, it presumably had a different frame at that time.

The painting bears a label from the 1904 memorial exhibition of Whistler's works held in Boston. Described on the label as *Girl Reading*, owned by Mrs. John C. Bancroft, it is probably the work identified in the catalogue as *Girl in Black*.

Oil on wood, 12 × 9 in. (22.9 × 30.5 cm.).
RELATED WORKS: *Reading*, lithograph, 6 × 5 in. (15.2 × 12.7 cm.), 100 proofs, drawing erased, 1879; 9½ × 14¼ in. (24.1 × 36.2 cm.), 15 proofs; included in the set of six lithographs entitled *Art Notes*, published by Messrs. Boussod, Valadon and Company, London, in 1887 (30 sets of six lithographs and later 70 sets on

smaller paper), ill. in E. G. Kennedy, ed., *The Lithographs of Whistler: Arranged According to the Catalogue by Thomas R. Way* (1914), no. 13.
REFERENCES: M. MacDonald, orally, June 23, 1978, told of correspondence at the University of Glasgow saying that the Bancrofts bought this painting directly from the artist; she also observed that the painting is related to a lithograph and might date sometime between 1878 and 1887 // A. M. Young, M. MacDonald, R. Spencer and H. Miles, *The Paintings of James McNeill Whistler* (1980), 1, p. 126, no. 223, catalogue it as Arrangement in Black: Girl Reading, date it between 1879 and 1881, describe relationship to lithographs and drawing Maude, Reading in the Freer Gallery, Washington, D. C., suggest the model for the prints was probably Maude Franklin, cite London Sunday *Times* review of Whistler's Notes in Black at the exhibition of the Royal Society of British Artists in 1887, provide information from letters between J. C. Bancroft, the first owner, and Whistler in the Birnie Philip Collection, University of Glasgow; p. 126, no. 224, catalogue Arrangement in Black: Reading, coll. Charles Kohlmeyer, New Orleans; 2, pl. 140 // M. St. Clair, Babcock Galleries, New York, orally, April 15, 1983, supplied information on provenance.
EXHIBITED: Royal Society of British Artists, London, 1887, p. 3, no. 25, Note in Black, or p. 14, no. 155, Note in Black: Reading (probably one of these paintings); p. 28, no. 155, £105 // St. Botolph Club, Boston, Feb. 1892 (no cat. available) // Society of American Artists, New York, 1897, no. 107, Girl Reading (possibly this painting) // Copley Society of Boston, Copley Hall, Boston, Feb. 1904, *Oil Paintings, Water Colors, Pastels & Drawings: Memorial Exhibition of the Works of Mr. J. McNeill Whistler*, p. 4, no. 17, lists Girl in Black, lent by Mrs. John C. Bancroft (probably this painting which on the back bears a label from this exhibition but with the title Girl Reading) // MMA, 1972, *Drawings, Watercolors, Prints and Paintings by James Abbott McNeill Whistler* (no cat.) // Albany Institute of History and Art, 1974, *Drawings, Watercolors, Prints and Paintings by James Abbott McNeill Whistler* (no cat.).
ON DEPOSIT: Yale University Art Gallery, New Haven, Conn., 1946–1952, lent by Adelaide Milton de Groot // MMA, 1952–1967, lent by Adelaide Milton de Groot.
EX COLL.: John C. Bancroft, Boston, 1891–d. 1901; his widow, Mrs. John C. Bancroft, Boston, by 1904; Francis P. Garvan, New York, d. 1937; estate of Francis P. Garvan, 1937; with Macbeth Galleries, New York, consigned to Babcock Galleries, New York, 1943–1944; Adelaide Milton de Groot, New York, 1944 (painting was held at Babcock until 1946) – 1967.
Bequest of Miss Adelaide Milton de Groot (1876–1967), 1967.
67.187.209.

WILLIAM STANLEY HASELTINE

1835–1900

At Haseltine's death in 1900 his colleague and close friend WORTHINGTON WHITTREDGE wrote: "I should sum up Haseltine's excellencies as an artist, with three phrases: he was, from the beginning, a superior draughtsman; he is a good colourist; and he has sentiment coupled, in an unusual degree, with strength and frank expression. His pictures can always be understood; they have a largeness and grandeur in form with agreeable masses of light and shade not often met with" (quoted in H. H. Plowden, p. 81).

One of fourteen children of a prosperous merchant, Haseltine was born in Philadelphia. At fifteen he began to study art under the landscape painter Paul Weber (1823-1916), who had brought the romantic spirit and disciplined drawing techniques of the German school to the United States in 1848. While working under Weber, Haseltine attended the University of Pennsylvania and spent his free time sketching in the countryside along the Delaware and Susquehanna rivers. In 1852 the young student left his native Philadelphia to finish his education at Harvard College from which he graduated in 1854. At that juncture and still intent on pursuing a career as an artist, Haseltine returned home and sought out his former mentor, who was about to leave for Europe. Intrigued by the prospect of following his teacher abroad, Haseltine managed to convince his parents that it was imperative that he be allowed to accompany Weber to Düsseldorf.

After a brief stopover in Paris, Haseltine arrived in Germany. Like many other American painters who had traveled abroad, he settled in Düsseldorf. Apparently he spent some time in the studio of Andreas Achenbach, one of the leading landscape painters of the period. During the next three years, Haseltine became an active member of the large colony of resident American artists and formed lasting friendships with WHITTREDGE, EMANUEL LEUTZE, and ALBERT BIERSTADT. Beginning in the spring of 1856, Leutze took Haseltine, Bierstadt, and Whittredge on a sketching tour of the Rhine, Ahr, and Nahe rivers. The following year, the four headed south to Italy, ending up in Rome, where they spent many days sketching in the Campagna.

In the fall of 1858, Haseltine returned to the United States with the dual objectives of setting up his own studio in New York and courting Helen Lane, a wealthy young woman noted for her musical accomplishments, whom he had met in Rome some months before. During the next two years, he exhibited his landscapes at the National Academy of Design, where he was elected an associate in 1860. The same year he married Helen Lane.

In the interim he had moved into the Studio Building on East Tenth Street, a haven for many of his returning Düsseldorf colleagues and scores of other prominent painters. The *Crayon* (4 [Dec. 1859], p. 379) described Haseltine's workspace there as "filled with souvenirs of European scenery. The walls are hung with sketches of the magnificent rocks and headlands on the bays of Naples and Salerno, added to which are Campagna and mountain views near Rome, and scenes in Venice; the whole forming a pictorial journey through the rare picturesque regions of Italy."

His production in those early years was impressive. The majority of his landscapes were

Italian coastal subjects, but included among them were occasional views of northeastern American shores. Haseltine's skill in precise rendering won him critical acclaim from the first, although his Düsseldorfian palette was not universally appreciated. A reviewer of the National Academy of Design's 1860 annual exhibition, to which Haseltine had submitted six Italian scenes, remarked: "His pictures are well drawn, show good taste in composition and a delicate feeling, all of which rare merits would be more impressive if the Düsseldorf system of color did not interfere with them" (*Crayon* 7 [May 1860], p. 140).

Although his work was popular and he was involved in many artistic events (like the 1864 William Cullen Bryant Jubilee Celebration), Haseltine longed to return to Europe. Two years after the untimely death of his wife in 1864, he married her closest friend, Helen Marshall, and the couple set off for Europe. They settled in Paris, where Haseltine was soon part of a circle of important French artists, including Benjamin Constant, Alphonse Legros, William Adolphe Bouguereau, and Jean Léon Gérôme. Haseltine was fascinated with contemporary French plein-air painting. He spent days sketching the environs of Barbizon, and the experience permanently affected his approach to landscape painting. Because of his emphasis on reflected light and atmosphere, he was later known as a "pre-impressionist" (NAD, *Memorial Exhibition: William Stanley Haseltine* [1958], p. 2). Meanwhile, he continued to make frequent sketching excursions to Switzerland and northern Italy, developing the drawings from these trips into finished paintings in his studio.

In 1869 he moved his household to Rome and joined the American community there. He continued to send works to the United States for exhibition, and his Italian landscapes were well received in New York, where he payed a short visit every summer or two. Between 1873 and 1874 he even rented a studio in New York in order to prepare for major exhibitions at the National Academy of Design and the Century Association. By late 1874, however, he had moved his family into an apartment in the sumptuous Palazzo Altieri in Rome, which remained his permanent residence.

His personal life was again touched by tragedy in the late 1870s with the death of his two older sons. He did not resume painting actively until the early 1880s, when he again began to travel throughout Europe. During that period he developed exceptional facility in watercolor and executed many of his finest works in that medium.

By 1886 Haseltine had earned an international reputation. He was elected to the Kunst Verein in Munich and to the Accademia Nazionale delle Belle Arti in Rome. His standing in the United States led to his appointment as a judge for the 1893 World's Columbian Exposition in Chicago. During the early 1890s he was one of a group of distinguished Americans who established the American School of Architecture, later the American Academy, in Rome. Haseltine made his last trip to the North American continent in 1899, when despite infirmities, he traveled with his son, Herbert, to the West and Alaska. He died in Rome in 1900. His son later became a sculptor.

BIBLIOGRAPHY: Henry T. Tuckerman, *Book of the Artists* (New York, 1867), pp. 556-557. A contemporary evaluation of the artist's early achievements // Helen Haseltine Plowden, *William Stanley Haseltine: Sea and Landscape Painter (1835–1900)* (London, 1947). This biography contains the most complete information available on the artist and is written from notes and recollections by his daughter // NAD, *Memorial Exhibition: William Stanley Haseltine* (1958). A brief and general in-

troduction to the artist's work // Dayton Art Institute, Ohio, *American Expatriate Painters of the Late Nineteenth Century*, exhib. cat. by Michael Quick (1976), pp. 104-105. Indicates the artist's position in the community of American painters abroad // Davis and Langdale Company, New York, *William Stanley Haseltine (1835–1900): Drawings of a Painter* (New York, 1983). This catalogue includes an essay by John Wilmerding, a chronology of Haseltine's life, and a group of his drawings from the 1860s and 1880s.

Santa Maria della Salute, Sunset

The imposing church of Santa Maria della Salute on the Grand Canal appears as a background in many of Haseltine's sketches and watercolors of Venice. Here it is seen against the striking light of a late afternoon sky. Although the canvas is undated, the choice of lighting and the handling of certain portions of the foreground suggest that it was completed during a transitional period in the painter's work: sometime after 1870 and before 1885.

When he returned to Europe in 1866, Haseltine spent the first few years in Paris, where he followed the development of plein-air painting with special interest. His admiration for Claude Monet undoubtedly influenced his subsequent treatment of landscape and is evident in *Santa Maria della Salute, Sunset*. The work is a stylistic hybrid. The meticulous delineation of architectural elements in the distance and the fishing boats in the middle ground, together with the brilliant coloration of the sky surrounding the

dome of the church, indicates the influence of Haseltine's early training in the German manner. The broken brushwork of the foreground, representing the fluid play of light, however, reveals his interest in nascent impressionism.

Oil on canvas, 23 × 36 in. (58.4 × 92.2 cm.).

REFERENCE: R. B. Hale to J. Taylor, May 19, 1954, memorandum in Dept. Archives, says Mrs. Plowden would like to give the museum a painting by her father, "one of the leaders of the American colony in Rome in the 1860s and 70s. The picture was painted about 1880."

EXHIBITED: Doll and Richards, Boston, 1954, *Paintings and Watercolors by William S. Haseltine, N.A.*, no. 26 // Phoenix Art Museum, 1967–1968, *The River and the Sea*, ill. no. 9.

ON DEPOSIT: Department of Parks, New York City, 1974–1976.

EX COLL.: the artist, d. 1900; his daughter, Helen Haseltine Plowden, until 1954.

Gift of Helen Haseltine Plowden, in memory of the artist, 1954.

54.100.

Haseltine, *Santa Maria della Salute, Sunset.*

JOHN LA FARGE

1835–1910

John La Farge was among the most innovative American artists of the nineteenth century. A pioneer in plein-air landscape painting, mural decoration, and stained glass, he was acknowledged as preeminent in these pursuits both at home and abroad. Born in New York, he was the son of wealthy French emigrés from Santo Domingo. His maternal grandfather, a painter of miniatures, gave La Farge his earliest instruction in drawing, and more formal art training began when he entered Columbia Grammar School in 1845. Although he pursued a classical education and studied law, his interest in art did not diminish, and in the 1850s he avidly began to collect prints by the Barbizon painters. He later recalled "the delight of buying a Diaz and a Troyon and a Barye for a few dollars that I had intended for books instead" (R. Cortissoz, p. 70). He also made the acquaintance of several American disciples of French art, including HOMER DODGE MARTIN and GEORGE INNESS.

By 1856 La Farge had tired of his studies in a New York law office, and his family sent him to France. He arrived in Paris in the spring and was immediately thrust into the center of the artistic and literary scene by his cousin the journalist and critic Paul de Saint-Victor. Through him, La Farge met the most influential people of the day, including Théophile Gautier, Victor Hugo, Charles Baudelaire, the Goncourt brothers, and many important painters like Jean Léon Gérôme, Pierre Puvis de Chavannes, and Théodore Chassériau. Most of his time, however, was spent in the Louvre, where he copied and studied the works of the old masters. Contemporary paintings also interested him greatly, especially the work of Millet. La Farge developed his knowledge of color and optics by reading the popular theories of Eugène Chevreul. Meanwhile, through his connections with the large community of American painters in Paris, he was encouraged to seek formal training. Years later he wrote his secretary, Grace Edith Barnes, that in 1856:

> My American acquaintances were then very much inclined to the painter Couture, who had quite a number of Americans in his studio and had been the master of several of them, well known in Paris and having quite a position of their own. One of these, Edward May, took me to the master one day and I explained to him what I wished, which was to get a practical knowledge of painting, as practiced by him. I also made him understand that I was doing this as a study of art in general and had no intention of becoming a painter (quoted in R. Cortissoz, p. 91).

As it turned out, he did not remain in Couture's studio more than a few weeks. La Farge made several trips from Paris to various places, among them Brittany, Germany, and Denmark. It is apparent from his sketches during this time that the works of Rubens and Rembrandt interested him greatly. In the fall of 1857, he was called home because his father was ill. En route he made a brief stop in England, where he visited the Manchester Art Treasures Exhibition and saw the work of the Pre-Raphaelite painters. Years later he remembered that: "They made an important impression on me, which later influenced my first work when I began to paint" (ibid., p. 98). Once back in New York, he began to practice law but still remained closely involved with art. In 1858 he had a studio in the Tenth Street Studio Build-

ing, where he met the architect Richard Morris Hunt. At his suggestion La Farge gave up legal work and studied painting under the guidance of Hunt's brother WILLIAM MORRIS HUNT, a former student of Couture and Millet. William Morris Hunt had settled in Newport, Rhode Island, where he ran an informal class in his studio. By 1859 La Farge was in Newport producing his first flower compositions and landscapes. He drew inspiration from Hunt's enormous collection of Barbizon works and intimate knowledge of Millet's technique. La Farge exhibited his first still lifes and figure compositions at the National Academy of Design in New York in 1862. His interest in color theory gradually became apparent, and he developed great facility in plein-air painting. By the late 1860s, he was producing a series of highly innovative landscapes, including *Paradise Valley*, 1866–1868 (private coll., Boston, ill. in Cortissoz, opp. p. 24), that parallels the work of Claude Monet and the other impressionists in the use of light and color. La Farge's *The Last Valley*, 1867 (private coll., ill. in B. Novak, *American Painting of the Nineteenth Century* [1969], p. 256), was exhibited at the 1874 Salon in Paris, where it was universally admired.

La Farge had studied mural decoration and stained glass while in Paris, and, through his association with several architects, he followed the development of those media in the United States. In 1876, the noted architect Henry Hobson Richardson invited him to decorate the interior of Trinity Church in Boston. There La Farge combined his knowledge of encaustic painting and the precedents of Christian art to produce a series of murals and architectural motifs unprecedented in American art. Stressing the traditional unity of a building's decorative scheme, he supervised nearly every phase of the execution of the church's interior. At its completion in 1877, it was enthusiastically hailed as a landmark in artistic collaboration. George P. Lathrop, a writer in *Scribner's Magazine*, commented: "For the first time in the United States, the painting of a church came into the hands of artists instead of artisans The result, accordingly, was—so far as the general harmony and a subdued splendor of coloring are concerned—a great advance upon any decoration heretofore achieved in this country" (21 [Feb. 1881], p. 514).

Trinity Church was the first of many religious commissions that came La Farge's way, and he subsequently executed murals for the Church of the Incarnation, New York (1885), and the Church of the Ascension, New York (1886–1888). In addition, he was invited to decorate several secular buildings, beginning with the Union League Club, New York (1881–1882), and then the New York homes of William H. Vanderbilt and Cornelius Vanderbilt (1879–1883). Meanwhile, in 1874, inspired by the work of the Pre-Raphaelite painters, he began to experiment with stained glass. His first attempts were not memorable, but he did develop several significant modifications of the medium, particularly the introduction of "opalescent glass," which gave tonality to colored glass, eliminating traditional painted detail. He produced thousands of windows in the course of his career, and his stylized designs, which had much in common with those of William Morris and Company in England, revolutionized American stained-glass manufacture. Toward the end of his career, in the 1880s and 1890s, La Farge traveled to Japan and the South Seas and created scores of delightful watercolors. He began to publish illustrated accounts of these journeys. He also wrote several theoretical discourses. In 1893 he gave a series of talks at the Metropolitan Museum of Art in New York, later issued as *Considerations on Painting* (1895), and in 1903 he delivered the Scammon

Lectures at the Art Institute of Chicago, in which he elaborated on the Barbizon school. At his death in 1910, he was an acknowledged pioneer in the field of stained glass, an advocate of avant-garde principles of painting, and a leading artist.

BIBLIOGRAPHY: Cecilia Waern, *John La Farge: Artist and Writer* (London, 1896). Good biographical study and discussion of La Farge's student years // Royal Cortissoz, *John La Farge: A Memoir and a Study* (Boston, 1911). An authorized biography, including the most complete biographical material available and many statements by the artist // Knoedler Galleries, New York, *John La Farge*, exhib. cat. by Henry A. La Farge (1968). An incisive analysis of La Farge's landscape style and late works // H. Barbara Weinberg, *The Decorative Work of John La Farge* (Ph.D. diss., Columbia University, 1972; published, New York, 1977). A well-documented study of the artist's decorative style based on important manuscript holdings in the Sterling and Beinecke libraries, Yale University, New Haven, and NYHS // James Leo Yarnall, *The Role of Landscape in the Art of John La Farge* (Ph.D. diss., University of Chicago; published, Chicago, 1981). A major discussion of La Farge and his style.

Portrait of the Artist

This self-portrait, painted in October of 1859, reveals the strong influence of contemporary French painting on La Farge's early stylistic development. The loosely painted, generalized background is reminiscent of many Barbizon landscapes and recalls contemporary works by La Farge's teacher WILLIAM MORRIS HUNT. It is

La Farge, *Portrait of the Artist.*

likely that the romantic pose of the dark, solitary figure, strikingly set against a light background, depended on Hunt's portrait style, which in turn reflected the precedents of the Barbizon school.

Hunt had brought the conventions of French romantic portraiture to this country following his residence abroad. The same year that La Farge painted this self-portrait, Hunt completed a large portrait of Chief Justice Lemuel Shaw, 1859 (Essex Institute, Salem, Mass.). The low-keyed tonality and strong contours of the image of the renowned jurist must have provided La Farge with an immediate model for his own first attempts at portraiture.

The landscape setting of *Portrait of the Artist* has been identified by Henry La Farge, the artist's grandson, as the La Farge family estate at Glen Cove, Long Island. In 1935 he wrote: "A small daguerreotype which my father owns, shows John La Farge, with two or three other members of the family, standing in front of the house at Glen Cove, and in the background, the identical curving path, and trees beyond, as in the painting." The elegant figure of the young artist, stylishly dressed and casually leaning on a painter's umbrella, has also been compared to daguerreotypes of him, specifically to one from 1860 that appeared as the frontispiece to the 1911 La Farge biography by Royal Cortissoz.

The wood support is extended on all four sides with strips about an inch wide.

The Metropolitan Museum also has a bronze bust of La Farge done in 1908 by Edith Woodman Burroughs.

Oil on wood, 16 1/16 × 11 1/2 in. (40.8 × 29.2 cm.).
Dated at lower right: October.26.27/1859.

REFERENCES: S. G. W. Benjamin, *Our American Artists for Young People* (1881), ill. p. 7 // *New York Herald*, Jan. 1, 1911, ill. p. 11, as "Portrait of John La Farge by Himself," says it is among three early works by La Farge that have recently come to light, the property of Mrs. Albert Stickney of New York; notes they will be auctioned on the 16th; and says La Farge painted the self-portrait in 1859 and presented it to friends: "As a likeness the painting is interesting and still more so as an example of his style, which was then forming Tall and slender, yet not without grace, he stands with hands resting on a long staff. The configuration of his body seems to be followed somewhat in the path in the landscape. He appears as if on a tramping trip in search of material for sketches // Anderson Galleries, New York, Jan. 16-18, 1911, *Illustrated Catalogue of Paintings from Private Collections by Foreign and American Artists*, no. 76, as "Portrait of the Artist as a Young Man" // *American Art Annual* 9 (1911), p. 25, indicates picture sold for $140 // F. F. Sherman, *Art in America* 8 (1920), ill. p. 90 // Mrs. J. Durup, June 25, 1934, letter in MMA Archives, says painting came into her possession when Major Higginson died // J. M. Lansing, *MMA Bull.* 30 (Feb. 1935), p. 38, notes the similarity between the painting and the daguerreotype used for Cortissoz's 1911 biography of La Farge and gives incorrect provenance // G. S. Hellman, letter in MMA Archives, Feb. 20, 1935, says that the work was originally given by La Farge to his sister // H. A. La Farge, letter in MMA Archives, July 8, 1935, indicates that Albert Stickney of New York was the original owner and acquired the work directly from the artist, discusses the setting and possible daguerreotype source for the portrait (quoted above) // J. M. Lansing, letter in MMA Archives, July 10, 1935, confirms Albert Stickney as the original owner // G. Danes, *Magazine of Art* 43 (April 1950), ill. p. 147, says it was executed during La Farge's first year with Hunt in Newport and reveals how much La Farge "had absorbed of his teacher's way of drawing and development of a simplified arrangement of value and low-keyed color" // H. B. Weinberg, *The Decorative Work of John La Farge* (1977), pp. 50-51, says the work exhibits "decorative flatness" like Japanese prints; p. 552, fig. 20 // M. Brown, *American Art to 1900* (1977), p. 547, says that the work is "Huntian in the simplified silhouette, luminous haze enveloping form, and general Romantic feeling, although there is a greater concern with naturalistic detail" than one finds with Hunt; ill. p. 548 // J. L. Yarnall, *The Role of Landscape in the Art of John La Farge* (Ph.D. diss., University of Chicago; published, 1981), pp. 70-77, discusses various levels of meaning in the portrait, says that La Farge may have painted it for his fiancee whom he was instructing in the Catholic faith and that he therefore gave himself a clerical appearance; ill. p. 469, no. 25.

EXHIBITED: Ortgies and Company, New York, 1884, no. 32, as "Portrait of the Painter. Figure in black standing on a hillside and leaning on a long Staff of a Painter's Umbrella" // M. H. de Young Memorial Museum, San Francisco, 1935, *Exhibition of American Painting*, no. 159 // MMA, 1936, *An Exhibition of the Work of John La Farge*, no. 1; 1939, *Life in America*, no. 254, ill. p. 194, as Self-portrait // Museum of Modern Art, New York, 1943, *Romantic Painting in America*, no. 127, ill. p. 73 // Macbeth Gallery, New York, 1948, *John La Farge*, no. 4, as Portrait of the Artist // American Academy of Arts and Letters, New York, 1954, *The Great Decade in American Writing, 1850-1860*, no. 114 // Brooklyn Museum, 1957-1958, *Face of America*, no. 60 // MMA, 1965, *Three Centuries of American Painting*, checklist alphabetical // Graham Gallery, New York, 1966, *John La Farge, 1835-1910*, no. 1 // Knoedler and Company, New York, 1968, *The American Vision, 1825-1875*, no. 19 // MFA, Boston, 1969-1970, *Back Bay Centennial Exhibition* (not in cat.) // MMA, 1970, *19th Century America: Paintings and Sculpture*, no. 112 // Hudson River Museum, Yonkers, N.Y., 1970, *American Paintings from the Metropolitan Museum of Art*, no. 28 // Wildenstein Galleries, New York, and Philadelphia Museum of Art, 1970, *From Realism to Symbolism: Whistler and His World*, no. 86, ill. pl. 21.

ON DEPOSIT: Dallas Museum of Fine Arts, 1960.

EX COLL.: Albert Stickney, New York, d. 1908; his wife, New York, until 1911 (sale, Anderson Galleries, New York, Jan. 16-18, 1911, $140); Henry Lee Higginson, Boston, 1911 – d. 1919; Helene (Mrs. Johan) Durup, Hingham Center, Mass., 1919-1934.

Samuel D. Lee Fund, 1934.

34.134.

Bishop Berkeley's Rock, Newport

La Farge began to experiment with landscape painting in the late 1850s and 1860s under the tutelage of WILLIAM MORRIS HUNT. *Bishop Berkeley's Rock, Newport*, completed in 1868, is among the most stylistically avant-garde of his many Newport works. The scene is a promontory on Sachuest Beach named after George Berkeley, bishop of Cloyne, Ireland, who resided in the area from 1729 to 1731.

By 1859, when La Farge began his plein-air compositions of the Newport terrain, he had been to Paris, where he had carefully observed the loose, naturalistic style of the Barbizon painters. His own first attempts at landscape, like *Evening Sky, Newport*, 1859, are reminiscent of the Barbizon canvases of Théodore Rousseau in their dark expressive masses silhouetted against light backgrounds. La Farge's instructor, Hunt,

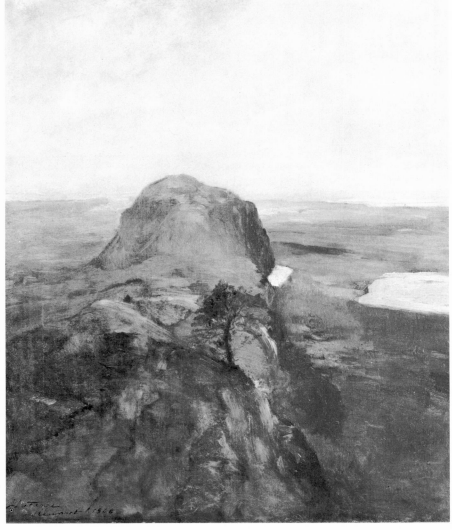

La Farge, *Bishop Berkeley's Rock, Newport.*

who had gone to Barbizon in the 1840s, encouraged the direct study of nature and advocated the simple compositional structure used by such painters as Millet and Corot. His own collection of Barbizon works included Millet's *The Sower*, 1850 (MFA, Boston), and its freely brushed landscape background must have been familiar to his students. Years later La Farge recalled the effect of the free plein-air technique on his first canvases at Newport:

the closed light of the studio is more the same for every one, and for all day, and its problems, however important, are extremely narrow, compared with those of out of doors. There I wished to apply principles of light and color of which I had learned a little. I wished my studies from nature to indicate something

of this, to be free of *recipes*, as far as possible, and to indicate very carefully, in every part, the exact time of day and circumstances of light (quoted in R. Cortissoz, *John La Farge* [1911], pp. 112–113).

La Farge's preoccupation with the scientific analysis of light in a natural setting at a particular time of day was in keeping with that of the Barbizon painters, notably Rousseau. Like Rousseau's *Sunset* (National Gallery, London), *Bishop Berkeley's Rock, Newport* is the result of the rapid recording of a landscape subject in natural light.

Next to the detailed panoramic landscapes of such second generation Hudson River school contemporaries as FREDERIC E. CHURCH, La Farge's simplified contours, fluid brushwork, and subtle tonality give this canvas an emphatically

modern look. This style was harshly criticized as unfinished when he began to exhibit similar Newport scenes at the National Academy of Design in 1864. In the following decade, he gradually abandoned all experimentation with plein-air painting and turned his attention to more decorative projects. In the 1870s, however, once the stylistic principles of Claude Monet and the impressionists were accepted, the modernism of La Farge's approach to nature was acknowledged as part of the mainstream of American landscape painting.

Oil on canvas, 30¼ × 25¼ in. (76.9 × 64.2 cm.).

Signed, inscribed, and dated at lower left: J. La Farge / Newport 1868.

RELATED WORKS: *Bishop Berkeley's Rock from the North*, carbon pencil on white paper, MFA, Boston, ill. in *American Art Journal* 16 (Spring 1984), p. 28 // *Bishop Berkeley's Rock, Newport*, black crayon, 6¾ × 4⁵⁄₁₆ (17.1 × 10.9 cm.), 46–66dd, Princeton Art Museum, Princeton, N. J.

REFERENCES: C. E. Clement and L. Hutton, *Artists of the Nineteenth Century* (1889), 2, p. 30, notes that the work was exhibited at the Centennial Exposition in 1876 // *New York Times*, Nov. 15, 1910, p. 11, describes the painting and says it reflects the "distinction" of the artist's vision // *Art World* 2 (June 1917), p. 208, describes the locale of the work, says that the picture "already showed a wonderful ease of brush and glorious color," and reports that it was the centerpiece of the La Farge section of the Panama-Pacific Exposition in San Francisco in 1915; ill. p. 209, as Bishop Berkeley's Rock, Paradise, Near Newport, Rhode Island // F. J. Mather, Jr., to T. Rousseau, Feb. 5, 1949, letter in MMA Archives, mentions the painting then in his collection as exemplary of La Farge's early work // J. L. Yarnall, *The Role of Landscape in the Art of John La Farge* (Ph.D. diss., University of Chicago; published, 1981), p. 186; p. 218, fig. 106; pp. 227–228, says the picture demonstrates La Farge's continuing devotion to the French manner (it embodies the stylistic features of an ébauche); notes scene is at sunset looking out over the summit of the ridge that appears in La Farge's Last Valley; and says that La Farge drew and sketched the site many times; p. 229, n 1, notes that the possiblity that the picture is unfinished cannot be completely discounted; p. 230, mentions provenance; ill. p. 523.

EXHIBITED: Philadelphia, 1876, *Centennial Exposition*, no. 275g, Bishop Berkeley's Rock, Newport, lent by the artist // Society of American Artists, New York, 1878, no. 6, Autumn Sunset, Study of Bishop Berkeley's Rock from the Valley behind Newport, R. I., for sale, $1500 (possibly this painting) // Onondaga County Savings Bank, Syracuse, N. Y., *Inaugural Exhibition of the Syracuse Museum of the Fine Arts*, no. 66,

Bishop Berkeley's Rock, Newport, R. I. // Montross Gallery, New York, 1901, *Works by John La Farge*, no. 419, Bishop Berkeley's Rock, Paradise, Newport, lent by Charles de Kay // San Francisco, 1915, *Panama-Pacific International Exposition, Department of Fine Arts*, no. 2673, Bishop Berkeley's Rock, lent by Charles de Kay // Art Association of Newport, Rhode Island, 1936, *Retrospective Exhibition of the Works of Artists Identified with Newport*, no. 74, Bishop Berkeley's Rock, Paradise, Newport, lent by Mrs. Charles de Kay // MMA, 1965, *Three Centuries of American Painting* (checklist alphabetical) // Los Angeles County Museum of Art and M. H. de Young Memorial Museum, San Francisco, 1966, *American Paintings from the Metropolitan Museum of Art*, no. 92, ill. p. 106 // Delaware Art Center, Wilmington; M. H. de Young Memorial Museum, San Francisco; Wichita Art Museum; Cincinnati Art Museum, 1969–1970, *American Paintings from Newport*, exhib. cat. by R. J. Boyle, p. 45; no. 41, ill. p. 75.

EX COLL.: the artist, until 1884 (sale, Ortgies and Co., New York, April 17, 1884, no. 23, as Autumn Study, View over Hanging Rock, Newport, R. I., $150); Charles de Kay, New York, 1884–1935; his wife, Mrs. Charles de Kay, New York, until 1949; Frank Jewett Mather, Jr., Princeton, N. J., 1949.

Gift of Dr. Frank Jewett Mather, Jr., 1949.

49.76.

La Farge, *Bishop Berkeley's Rock, Newport*, black crayon. Art Museum, Princeton University.

The Muse of Painting

In 1870, when this work was completed, La Farge was making the transition from a loosely painted, Barbizon-inspired style to a tight, highly decorative one, most evident in his mural paintings. A shift in subject matter also came about, largely through his increasing involvement in book illustration in the late 1860s and early 1870s. These changes, however, were rooted in his experiences in Paris and his friendship with the French mural painter Pierre Puvis de Chavannes.

La Farge's association with Puvis began in 1856 and lasted until that artist's death in 1898. His admiration for Puvis's architectural decoration prompted La Farge's own continuing experimentation, which began as early as 1865, when he began the works exhibited two years later at the National Academy of Design, each called simply *Decorative Panel*. These have been identified by Henry B. Adams (*Art Bulletin* 62 [March 1980], pp. 269–70) as probably *Morning Glories* and *Eggplant* (Chrysler Museum, Norfolk, Va.) and *Fish* (Fogg Art Museum, Cambridge, Mass.). La Farge's familiarity with Puvis's flat, tonal compositions of classically draped, allegorical figures and studio technique of *peinture à la cire*, in which wax was mixed with oil paint to create mat color, facilitated his realization of decorative works like *The Muse of Painting*; *The Golden Age*, 1870 (National Museum of American Art, Washington, D. C.), and his murals for Trinity Church in Boston, 1876.

Also influential in La Farge's decorative composition were several groups of illustrations of allegorical subjects that he completed between 1865 and 1873. The first project consisted of nine drawings for an edition of Tennyson's *Enoch Arden* (Boston, 1865). Then followed a number of designs for the *Riverside Magazine for Young People*, between 1867 and 1870, including his well-known *Wolf Charmer*, which appeared in December 1867. Shortly thereafter he did four plates illustrating Mrs. Abby Richardson's edited *Songs from the Old Dramatists* (New York, 1873). In these last two series, La Farge depicted the idealized figure and tried to find a way to incorporate it effectively into a decorative ground. In several of the illustrations to the Richardson text, notably in *The Song of the Siren*, he resorted to a device he had undoubtedly observed in Puvis's work and in Japanese art, enlarged floral motifs arranged around the edges of the composition to bind the figure to it. He used this device in *The Muse of Painting*, where a solitary muse, draped in yellow, sits in a landscape framed at the right and upper edges of the painting by vines and oversized flowers.

It is likely that La Farge intended *The Muse of Painting* as a study for an architectural decoration because, when it was sold at Ortgies and Company in New York in 1884, it was listed as "Decorative Panel—Study for the Muse of Painting." Later, in 1887, he used a similar figure in his lunette decorations *Music* and *Drama* in the Whitelaw Reid house in New York (now part of the Helmsley Palace Hotel). In those works classical subjects languish in arcadian landscapes reminiscent of those of Puvis, but in *The Muse of Painting* the figure inhabits a landscape of sketchy, expressive masses similar in style to La Farge's Newport scenes of the late 1860s.

La Farge, *The Muse of Painting*.

Oil on canvas, 49½ × 38¼ in. (125.1 × 97.2 cm.).

Signed and dated on tree trunk at upper right: LA FARGE / 1870. Signed, dated, and inscribed on the back before lining: *J. La Farge* / 1870 / no. 18 / Sale / April 17, 1884.

Canvas stamp before lining: GOUPIL'S / 170 / FIFTH / NY.

REFERENCES: D. French to F. Dielman, August 20, 1909, NAD, says, "I was on the point of writing to Mr. Morgan recommending the purchase of the picture [Adoration] when my mind reverted to that beautiful picture over the mantel-piece in Mr. [Otto] Heinigke's house, and I was inspired to write to him to see whether he might not have changed his mind, and would be willing to part with the picture now; August 21, 1909, "I suppose our recommendations of this picture would secure us the undying animosity of La Farge, but I feel that our first duty is to the museum. Perhaps you are not so keen about the Heinigke picture as I am? Moreover, if you think that the Adoration fills the requirements, it will be all right to recommend it anyway; Sept. 13, 1909, says he has discussed acquisition with Morgan and Walters; Oct. 20, 1909, says Morgan and Walters are enthusiastic about it // O. Heinigke, bill of sale, Oct. 23, 1909, MMA Archives, reads, "Received from Daniel Chester French, Ten Thousand (10,000) Dollars, in payment for painting 'The Muse of Painting,' by John La Farge, delivered to Metropolitan Museum, October 22nd" // G. E. Allen to E. Robinson, Oct. 28, 1909, MMA Archives, encloses bill of sale at the request of J. P. Morgan // E. L. Cary, MMA Bull. 4 (1909), cover ill.; p. 220, describes the work, announces its acquisition, and indicates that it was executed when the artist "had done much landscape, comparatively little decorative work, and not very much figure painting" // C. de Kay, Harper's Weekly 54 (March 12, 1910), ill. p. 7, discusses its acquisition; calls it a rare combination of a romantic school landscape and a symbolic figure; says, "Lovely in color, charming in its atmospheric qualities, pleasing if not forceful in its seated figure of the Muse," it belongs to La Farge's Newport period // J. C. Van Dyke, American Painting and Its Tradition (1919), ill. opp. p. 134 // F. J. Mather, The Pageant of America 12 (1927), color frontis.; ill. p. 72, comments, "In this gracious canvas of 1870, the later monumentality of La Farge's style is clearly forecast, and it has his full splendor of color. In a general way the tradition is that of the Venetian painters of the Renaissance, but it had an urbanity proper to La Farge himself. It was painted at a moment when La Farge was occupied with narrative illustration, and represents an advance toward symbolism" // G. P. du Bois, Arts 17 (Jan. 1931), p. 253, says La Farge originally gave the picture to a dealer in stained glass to pay a debt and the museum chose this work over La Farge's Wolf Charmer // R. Cortissoz, New York Herald Tribune, March 29, 1936, p. 10, says of La Farge's work: "It all tends to bring us back to the lofty key of 'The Muse of Painting,' the key to beauty, endured with thought" // A. Burroughs, Limners and Likenesses (1936), pp. 75–76, suggests that "La Farge borrowed from all sources with restraint, and he kept his individual taste, well illustrated by the firm drawing, soft mood, and insistent color of 'The Muse of Painting' ... without being swamped by the pomp of Italian decoration" // H. B. Weinberg, Decorative Work of John La Farge (1977), p. 67, calls it one of the artists "most ambitious oil paintings" of the early 1870s and discusses; p. 564, fig. 48 // J. L. Yarnall, The Role of Landscape Painting in the Art of John La Farge (Ph.D. diss., University of Chicago; published, 1981), pp. 253–256, discusses, noting that the muse is represented as a painter inspired by the true muse, Nature; pp. 258–260, says La Farge never revealed the projected decorative context in which the work was done; pp. 262–263, says it combines abstract elements with realistic ones for a decorative purpose; p. 266; p. 269.

EXHIBITED: Ortgies and Co., New York, April 17, 1884, no. 18, as Decorative Panel. Seated Figure in Yellow. Study for the Muse of Painting, $220 // Toledo Museum of Art, 1912, Inaugural Exhibition, no. 54, ill. opp. p. 20 // NAD, Corcoran Gallery of Art, Washington, D.C., and Grand Central Art Galleries, New York, 1925–1926, Commemorative Exhibition by Members of the National Academy of Design, 1825–1925, no. 310 // MMA, 1936, An Exhibition of Works by John La Farge, ill. no. 19 // Centennial Art Gallery, Salt Lake City, Utah, 1947, One Hundred Years of American Painting, no. 18 // MMA, 1950, 20th Century Painters (checklist alphabetical) // American Federation of Arts, traveling exhibition, 1950–1953, American Paintings of the 20th Century, no cat. // MMA, 1965, Three Centuries of American Painting (checklist alphabetical) // National Collection of Fine Arts, Washington, D.C., 1975, Academy, exhib. cat. by L. M. Fink and J. C. Taylor, no. 99, p. 203.

EX COLL.: the artist, until 1884 (sale, Ortgies and Co., New York, April 17, 1884, no. 18, as Decorative Panel. Seated Figure in Yellow. Study for the Muse of Painting, $220); Otto Heinigke, Bay Ridge, N. Y., 1909; Daniel Chester French, as agent, 1909; J. Pierpont Morgan and Henry Walters, 1909.

Gift of J. Pierpont Morgan and Henry Walters, 1909.

09.176.

FORMERLY ATTRIBUTED TO LA FARGE

Orange Branch

Although this painting has been attributed to La Farge since the 1930s, there is no conclusive proof that he painted it. The painting is signed, and examination shows that the signature is probably original to it. The form of the signature, however, was questioned in 1966 by Henry La Farge, the artist's grandson, who found it atypical. He also noted that, since he first saw this work in the 1930s, he has never been completely convinced it is by John La Farge. More likely, he suggests, it was painted by one of the studio

assistants La Farge employed to carry out his interior designs.

The painting seems to be a decorative panel for a room. La Farge did many decorative projects, especially in the 1880s. Without further information, however, this work cannot be dated. Its unusual shape may serve as a clue to its origins. The fruit appears in various stages of growth against a blue sky; there are blossoms and unripe and ripe oranges growing in abundance. From a palette limited primarily to greens and oranges, the colors are applied in the patch-like fashion associated with impressionism. The style is unlike La Farge's; the handling of the paint is different and less competent. Overall the picture lacks the subtle atmospheric and evocative effects for which La Farge's still lifes are noted.

No recent La Farge scholar has been convinced that the work is by La Farge. Until more evidence is available, the question of the painting's attribution remains unresolved.

Oil on canvas, 54⅝ × 11⅝ in. (138.4 × 29.5 cm.). Signed at lower left: Lafarge.
REFERENCES: H. La Farge, June 6, 1966, letter in Dept. Archives, says, "I have seen the picture off and on for years . . . but have never been able to convince myself that it is unequivocally in his hand. It is a nice painting, but seems somehow a little too facile, too flashy for John La Farge. Then there is the question of the signature. . . . My theory about the painting is that it is a panel in a decorative scheme for a private dwelling . . . of which La Farge was in charge, but that the painting was actually executed by an assistant, perhaps from his [La Farge's] designs. This would offer an explanation why another hand had dutifully placed La Farge's name there" // E. Clare, Knoedler and Co., New York, June 15, 1966, gives information on provenance // M. Walker, Maynard Walker Gallery, New York, June 21, 1966, recalls having had it in the 1930s // H. La Farge, Dec. 5, 1983, letter in Dept. Archives, says he first saw it in a New York gallery in the 1930s, reaffirms earlier idea that it is the work of someone in La Farge's studio but not in his opinion any other member of the La Farge family // D. Dwyer, Paintings Conservation, orally, Dec. 7, 1983, after examining the picture, stated that the signature is probably original to the work. It is signed in a damaged and abraded area that shows signs of restoration, but the restoration is carefully worked around the signature // H. Adams, Carnegie Museum, Pittsburgh, orally, Dec. 14, 1983, said he did not think it was by La Farge but it may have been by one

Formerly attributed to La Farge, *Orange Branch*.

of his assistants // N. Little, Knoedler and Co., New York, orally, Dec. 28, 1983, gave information on provenance, noted that the painting was simply called Fruit when it was received in 1936 and later Oranges of Seville, and said records indicated that it was probably framed at Knoedler's.

EXHIBITED: Museum of Modern Art Gallery, Washington, D. C., 1939, *A Century of American Painting*, no cat. // Washington County Museum of Fine Arts, Hagerstown, Md., 1939, *Masters of American Painting*, no. 30 // New York, Coordinating Council of French Relief Societies, 1944, *Jardin d'Eté*, no cat. // New York, American British Art Center, 1945, *Americans, 1810–1890*, no. 23, as Oranges of Seville, ca. 1890 // Montclair Art Museum, N. J., 1948, *History of Still Life and Flower Painting*, no. 20, lent by M. Knoedler and Co. // Milwaukee Art Institute, 1949, *American Painting, 1850–1900*, no. 36 // Montclair Art Museum, N. J., 1957, *Master Painters*, cover ill., no. 30, lent by M. Knoedler and Co.

EX COLL.: Alexander Singer, New York, 1936; with M. Knoedler and Co., New York, Nov. 1936–Oct. 1937; with Maynard Walker Gallery, New York, Oct. 1937–Dec. 1937; with M. Knoedler and Co., New York, Dec. 1937–Dec. 1960; J. William Middendorf II, New York, 1960–1966.

Gift of J. William Middendorf II, 1966.
66.73.

GEORGE HENRY STORY

1835–1922

George Henry Story was born in New Haven, Connecticut. He began his career as an apprentice to a wood carver. After several years, he turned to painting and studied under Charles Hine (1827-1871) and then later in Paris. When he came back to the United States in 1858, Story set up a studio in Portland, Maine. Soon, however, he moved to Washington, D. C., where he worked for two years. At this time, he was given the task of posing Abraham Lincoln for his first official presidential photograph. He took the opportunity to make sketches that he later used to paint several portraits of the president; one done in 1916 is in the National Museum of American Art, Washington, D. C.

In 1862 Story traveled in the Caribbean, spending most of his time in Cuba and Trinidad. When he returned, he settled in New York. Besides portraits, he painted genre scenes that he exhibited at the National Academy of Design, where he was elected an associate in 1875. A year later he was awarded a medal at the Centennial Exhibition in Philadelphia.

In 1889 Story was appointed curator of paintings at the Metropolitan Museum of Art. On several occasions he served as the museum's acting director. When he resigned in 1906, he was made curator emeritus. During his tenure as curator, he organized a major exhibition of American paintings, held in 1895, and a memorial exhibition of the works of FREDERIC E. CHURCH in 1900. The catalogue he compiled of the museum's painting collection was published in 1905. For this work he consulted not only the various eminent authorities in the field but relatives of deceased artists and a large number of living artists—among them Meissonnier, Bonheur, Jacque, Gérôme, Henner, and Breton.

Story was an honorary curator at the Wadsworth Athenaeum in Hartford. For nine years he was president of the New York Artists' Fund Society. He continued to paint in his later years and exhibited his work at the National Academy of Design.

BIBLIOGRAPHY: Memo in MMA Archives, July 31, 1906 // Obituaries: *New York Herald*, Nov. 25, 1922, p. 9; *New York Tribune*, Nov. 25, 1922, p. 11; *MMA Bull.* 18 (Jan. 1923), p. 18.

Story, *Alexander Stuart Murray.*

Story, *Portrait of the Artist.*

Alexander Stuart Murray

Alexander Stuart Murray (1841–1904) was keeper of Greek and Roman antiquities at the British Museum when Story painted his portrait in 1890. He began to work there in 1867 as an assistant in the department and was appointed keeper in 1886. He was educated at Edinburgh, where he received his M. A. in 1864. He later was a student at Berlin. During his tenure at the British Museum he reorganized the Greek and Roman galleries. He was noted for being warmhearted and helpful to visitors and correspondents.

Story, in a letter to Luigi di Cesnola, the director of the Metropolitan Museum, wrote:

Between dinners and sightseeing, your friend Mr. Murray of the British Museum found time to give me sittings for a portrait, which I commenced as a study but being well pleased with the commencement carried it along until it developed into a full fledged portrait. As the picture was painted out of museum hours, I feel at liberty to make such disposition of it as pleases me; I therefore take pleasure in placing it in your hands to do with it what you like, either to retain it for the museum, or hang it in your own library if you will do me that honor.

Although the drawing of the hand is slightly awkward, the head is painted with skill. In the distance is a view of the Acropolis in Athens.

Oil on canvas, 30 × 24 in. (76.2 × 61 cm.).

REFERENCES: G. H. Story to L. di Cesnola, Oct. 1, 1890, MMA Archives (quoted above) // *Dictionary of National Biography*, 2nd suppl., 2, pp. 664–665, gives biographical information on the subject.

Gift of George H. Story, 1890.

90.26.

Portrait of the Artist

Story portrays himself in an imposing manner. Both the hat with its wide sweeping brim and the pose are reminiscent of self-portraits of several famous artists, notably Rubens and Van Dyck.

The composition is cramped, yet the handling of the face is adept, and the color of the flesh is clear and lively. An earlier self-portrait, from about 1876, is at the National Academy of Design.

Oil on canvas, 24 × 21 in. (61 × 53.3 cm.). Signed and dated at lower center: *G. H. Story / Dec. 1902*.
Gift of Mrs. George H. Story, 1906.
06.308.

ALEXANDER H. WYANT

1836–1892

The career of Alexander Helwig Wyant demonstrates the dramatic change that took place in American landscape painting during the thirty years following the Civil War. Wyant's early landscapes were influenced by the late Hudson River and Düsseldorf schools, which stressed sharp focus and topographically accurate panoramas. His mature works, on the other hand, were smaller in size, intimate, and less detailed, showing the influence of the Barbizon school of French painters.

Wyant was born in 1836 in Evans Creek, Ohio. The son of an itinerant farmer and carpenter, he spent most of his youth in Defiance, Ohio, where he was apprenticed to a harness-maker. By 1857 he had become a sign painter in nearby Port Washington. That year he made a trip to Cincinnati, which was the nearest major art center. The paintings he saw there inspired him to become an artist. Landscape paintings in the tradition of the Hudson River school were extremely popular, and he would have been able to see many on view in Cincinnati. Wyant was particularly impressed by the works of GEORGE INNESS.

Two years later Wyant traveled to New York to meet Inness and seek his advice. Through him, Wyant received an introduction to the important Cincinnati collector Nicholas Longworth. In 1860 Longworth's assistance enabled Wyant to live in New York for about a year. He returned to Cincinnati in 1861, stayed there until Longworth died in 1863, and then settled in New York.

Wyant's early training in painting, if any, remains a mystery. He submitted his first entries to the annual exhibition of the National Academy of Design in 1864. They were much like the works of the Hudson River school and early Innesses. An exhibition in New York of Düsseldorf painters in 1863 had probably strengthened Wyant's inclinations toward the precise linear style that both schools emphasized. Two years later, he went to Germany to study with the Norwegian painter Hans Fredrik Gude, who was teaching at the academy in Karlsruhe. Gude had studied at Düsseldorf, and he followed the strict technical training of that school. Wyant's enthusiasm for Gude's teaching quickly waned, and he was soon eager to leave. After a brief but inspiring trip to Paris, he went to London and traveled in the British Isles. The works of Turner and Constable especially impressed him with their free brushwork and concern for atmosphere. These influences deepened when Wyant returned to New York and found that tight, finely detailed paintings— like those of the Hudson River and

Düsseldorf schools—were falling out of favor. During the following years, his paintings gradually became freer and more atmospheric.

Wyant was one of the founders in 1862 of the American Watercolor Society. The National Academy of Design elected him an associate in 1868 and an academician the following year. He was an active member of the Society of American Artists and the Century Association. Watercolors constituted an important part of his work, and, like his oil paintings, were regularly exhibited in New York, Brooklyn, and Philadelphia.

After a government expedition to Arizona and New Mexico in 1873, Wyant suffered a stroke that partially paralyzed his right side. He trained himself to paint with his left hand, a fact often cited as contributing to the increasing looseness of his brushstroke. *An Old Clearing* (q.v.), signed and dated 1881, however, shows that eight years after his stroke, Wyant was still capable of extreme control in his painting. From the mid-1870s he spent summers in Keene Valley in the Adirondack Mountains and winters in his New York studio. During the two decades after his return from Europe, he taught a number of students, including BRUCE CRANE and the watercolorist Arabella Locke (d. 1919), who became his wife in 1880. After the birth of a son in 1882, the Wyants spent increasing periods of time at their home in Keene Valley. Then in 1889, they moved to Arkville, New York, in the Catskill Mountains. Wyant died in New York City in 1892.

For thirty years after his death, Wyant was regarded as second only to Inness as a landscape painter. His late works share many qualities with the popular Barbizon painters as well as with Inness. Characteristically, they suggest a tangible atmosphere through the combination of indistinct forms and subtle gradations of tone. They do not, however, share Inness's rich palette; Wyant preferred quiet, somber greens and grays.

BIBLIOGRAPHY: Eliot Clark, *Alexander Wyant* (New York, 1916). Author who knew Wyant provides basic information on his career // Eliot Clark, *Sixty Paintings by Alexander H. Wyant* (New York, 1920). Convenient source of illustrations, finely reproduced, the book includes discussions of each painting shown // *Index of Twentieth Century Artists* 4 (Oct. 1936), pp. 327-333. Reprint ed. New York: Arno Press, 1970, pp. 627-633. Helpful lists of exhibitions, references, and illustrations of Wyant's paintings // Utah Museum of Fine Arts, University of Utah, Salt Lake City, *Alexander Helwig Wyant, 1836-1892* (1968), exhib. cat. by Robert S. Olpin. Contains a good chronology of Wyant's life and summary of his development with a basic list of paintings and their locations // Robert S. Olpin, *Alexander Helwig Wyant (1836-1892), American Landscape Painter: An Investigation of His Life and Fame and a Critical Analysis of His Work with a Catalogue Raisonné of Wyant Paintings*, Ph.D. diss., Boston University, 1971; published Ann Arbor, Mich., 1978. The most complete study of Wyant to date.

Tennessee

Scholars hailed this painting, previously titled *Mohawk Valley*, as the most important and representative work of Wyant's early career. It marked the end of his interest in romantic realism. Signed and dated 1866, the painting was assumed to have been executed immediately after he returned to New York from Europe. The following description by Wyant in a customs declaration, dated February 26, 1866, for six paintings shipped to New York from Karlsruhe, however, enables us to identify the work as *Tennessee* and to establish that it was painted while he was still a student of Hans Fredrik Gude:

The largest—"Tennessee" scene 34¾ × 53½ inches. Water running into scene from foreground—spray seen rising from waterfall below: distance long & not clearly defined—river reappearing in middle-

Wyant, *Tennessee.*

ground—cedar tree against cloudy sky rises from foreground on left.

Wyant had planned to withhold *Tennessee* from the 1866 annual exhibition of the National Academy of Design in order to present it at either the Royal Academy in London or at the Exposition Universelle in Paris. To his disappointment, however, the latter two places rejected the painting. Writing Thomas M. Turlay, his friend and patron in New York, on February 21, 1866, Wyant called it "the condemned landscape" and insisted that "It must go into the [National] Academy, without fail." He instructed Turlay to set the price at $1,000.

Despite Wyant's expectations, the response to *Tennessee* and his three other entries in the exhibition at the National Academy was disappointing. A reviewer in the *American Art Journal* compared them unfavorably to his entry of the previous year, *View on the Ohio River*:

His pictures in the present exhibition are certainly not as pure in color as his "View on the Ohio River". . . . His "Tennessee" is full of truthful paint-

ing—full of natural characteristic—but it greatly lacks vitality of color, and displays t[h]roughout something of that harshness which is associated with the German school. The general impressiveness of the picture, as a unit, is hurt by the obtrusion of a solitary unsupported tree in the left foreground.

Yet, in his closing comments, the critic noted: "Taken altogether, notwithstanding all deficiences that may be pointed out, Mr. Wyant's works are marked features of the exhibition, and give promise of a great future." The present whereabouts of the 1865 *View of the Ohio River* is unknown. It may be the painting entitled *Mohawk Valley*, signed and dated 1865, in the Los Angeles County Museum of Art. The Los Angeles painting, which is considerably smaller than *Tennessee*, is very similar in composition. Both paintings reflect the influence of the Hudson River school, especially FREDERIC E. CHURCH'S *Twilight in the Wilderness*, 1860 (Cleveland Museum of Art), and the early landscapes of GEORGE INNESS. The two Wyant paintings differed, however, in their treatment of the subject matter. *View of the Ohio Valley* was praised in the same

Alexander H. Wyant

413

American Art Journal review as a "powerful cloud painting, full of impending storm, its distant river reaches full of detail delicately overwrought beneath a veil of mist." *Tennessee*, on the other hand, shows Wyant's experiments with the atmospheric effects of diffused light, tonal color, and the shifting patterns of light created by passing clouds.

In 1867, the year after Wyant completed *Tennessee* and returned to New York, he produced a less dramatic version of the same composition: *On the Ohio River* (unlocated).

Oil on canvas, 34¾ × 53¾ in. (88.3 × 136.5 cm.).
Signed and dated on rock at lower left: A. H. Wyant 1866.

REFERENCES: A. H. Wyant to T. M. Turlay, Jan. 26, 1866, Misc. MSS Wyant, microfilm N/70-48, Arch. Am. Art, says, "I am having a nice time painting a large landscape which as I wrote you, I was instructed to scrape off when I had only the design on the canvas. Yesterday Gude said to me, 'You may be very glad to have painted that picture.' He said this while the picture was yet quite unfinished so I take some comfort from the remark"; Feb. 17, 1866, says, he is detaining the picture "for another purpose, which I will tell you about some time"; Feb. 21, 1866, says "I will send you the condemned landscape. I painted it for a London exhibition, but if there is anything in it, I would rather have it and any credit in New York, than any where else. It must go into the Academy, without fail, so I send size now. Give it to a frame maker who is friendly to me and who can take his pay when the picture is sold"; addendum notes that number one is called "Tennessee" and "is my condemned picture, the large one"; Feb. 26, 1866, verso of letter gives customs declaration for six paintings being shipped to Mr. Place and T. M. Turlay, 42 Dey Street, New York, signed by A. H. Wyant and bearing the seal of the American consul in Karlsruhe, describes *Tennessee* (quoted above); Feb. 27, 1866, boasts about *Tennessee*: "My friends here . . . regret that I didn't kill all these students by showing my larger picture amongst them even without a frame. I had permission to take it into a couple of studios and it killed them very dead. Made them look like chalk or lead, and those painters have been here from three to ten years // *American Art Journal* 5 (May 2, 1866), p. 20, notes it in review of NAD exhibition; (May 16, 1866), p. 52, discusses it in review of NAD exhibition (quoted above) // C. H. Caffin, *American Masters of Painting* (1902), ill. opp. p. 146, calls it The Mohawk Valley // *Catalogue of the Collection of Foreign and American Paintings Owned by Mr. George A. Hearn* (1908), ill. p. 189, no. 243, as The Mohawk Valley // *Bulletin of the Brooklyn Institute of Arts and Sciences* 6 (May 13, 1911), ill. [p. 387] // *George A. Hearn Gift to the Metropolitan Museum*

of Art . . . (1913), ill. no. 114 // E. Clark, *Art in America* 2 (June 1914), p. 302; ill. p. 303, fig. 1; p. 305; E. Clark, *Alexander Wyant* (1916), pp. 19, 26–28; ill. opp. p. 30 // J. C. Van Dyke, *American Painting and Its Tradition* (1919), pp. 51–52, says it is dated 1866 but suggests that "it was probably completed just before Wyant went to Europe" // F. J. Mather, Jr., et al., *The Pageant of America* (1927), 12, ill. p. 79, no. 118 // *Index of Twentieth Century Artists* 4 (Oct. 1936), p. 332 // A. Burroughs, *Limners and Likenesses* (1936), p. 152, says that it "is in the detailed, realistic spirit" of Inness's Peace and Plenty (MMA) // J. W. Lane, *Apollo* 27, (March 1938), ill. p. 145; pp. 145-146, discusses Whitney exhibition // E. P. Richardson, *American Magazine of Art* 39 (Nov. 1946), ill. p. 289 // E. Clark, *History of the National Academy of Design, 1825-1953* (1954), p. 125 // W. H. Pierson, Jr., and M. Davidson, eds., *Arts of the United States* (1960), ill. p. 329 // J. T. Flexner, *That Wilder Image* (1962), ill. p. 325, says it was painted after Wyant's return from Europe and calls it an "amalgam of Gude's style with the Hudson River manner" // Utah Museum of Fine Arts, University of Utah, Salt Lake City, 1968, *Alexander Helwig Wyant, 1836–1892*, exhib. cat. by R. S. Olpin, unpaged ill., as Mohawk Valley (not exhibited), calls it the "most representative statement" of the artist's first mature style // P. Bermingham, *American Art in the Barbizon Mood* (1975), ill. p. 56, fig. 39; p. 56, calls painting "the most representative work of Wyant's early mature style . . . Hudson River picturesque at its best," and notes that it is generally dated late 1865, possibly before his trip to Germany // R. S. Olpin, *Alexander Helwig Wyant (1836-1892), American Landscape Painter* (Ph.D. diss., Boston University, 1971; published, 1978), ill. no. 22; pp. 115, 140–142, 144, discusses influence of Gude, calls landscape "hard and insistent," implies it was painted after his return from Europe; pp. 264–265, catalogues it.

EXHIBITED: NAD, 1866, no. 361, as Tennessee, for sale // Lotos Club, New York, 1901, *American Paintings from the Collection of Mr. George A. Hearn*, no. 45, as Valley of the Mohawk, 1860 (probably this painting) // MMA, 1917, *Paintings of the Hudson River School Brought Together in Commemoration of the Completion of the Catskill Aqueduct*, no cat. // Whitney Museum of American Art, New York, 1938, *A Century of American Landscape Painting, 1800–1900*, no. 42 // Utah Centennial Exposition, Salt Lake City, 1947, *100 Years of American Painting*, no. 19 // MMA, 1965, *Three Centuries of American Painting* (checklist alphabetical) // Geneseo Fine Arts Center, Geneseo, N. Y., 1968, *Hudson River School*, no. 196, incorrectly identifies scene as Trenton High Falls, New York // MMA, 1970, *19th Century America, Paintings, and Sculpure*, exhib. cat. by J. K. Howat and N. Spassky, no. 136 // State Museum, Albany, New York, 1978, *New York, the State of Art*, exhib. cat., ill. p. 33, caption incorrectly gives date as 1862.

EX COLL.: George A. Hearn, New York, by 1901; his daughter, Mrs. George E. Schanck.

Gift of Mrs. George E. Schanck, in memory of her brother, Arthur Hoppock Hearn, 1913.
13.53.

View in County Kerry

Traditionally this painting has been dated 1866 on the assumption that Wyant painted it during his trip to Ireland or shortly after he returned home. In a letter to John Van Dyke, published in 1919, however, the artist BRUCE CRANE, who studied with Wyant in the 1880s, suggested that a date about ten years later was more likely. This later date seems reasonable when one compares *View in County Kerry* with *Pat O'Donohue's Farm, Kerry*, 1870 (New Britain Museum of American Art, Conn.). The similarities suggest that Wyant may have composed both paintings from a sketch made when he was in Ireland. *Afternoon*, a small painting by Wyant in the Worcester Art Museum, has the qualities of an oil sketch and could be the source for both these paintings. *Pat O'Donohue's Farm, Kerry* is very close to *Afternoon*.

Compared with the New Britain painting,

Wyant, *View in County Kerry*.

Wyant, *Afternoon*. Worcester Art Museum.

View in County Kerry has less detail and wider brushstrokes, done in drier paint—harbingers of the looser style of Wyant's late work. The composition and the flat brushstrokes reflect his interest in landscapes by John Constable, such as *Weymouth Bay*, ca. 1817 (National Gallery, London), and *Keswick Lake*, 1806–1807 (National Gallery of Victoria, Melbourne). The gray-green landscape, gray sky, and the overlapping vertical strokes of dry paint that bring together the grass and water suggest the style of the Barbizon painters. This is further support for the late 1870s date of the painting because it was at this time that Wyant became interested in these painters.

Twice in 1878 Wyant exhibited paintings with titles similar to that of the Metropolitan's painting: at the Society of American Artists (*A County Kerry Scene*) and the Brooklyn Art Association (*Scene in County Kerry*). George I. Seney, who presented this work to the Metropolitan in 1887, was actively involved in the Brooklyn Art Association and collected many paintings by Wyant. It is therefore tempting to assume that he bought the painting at the 1878 exhibition. Such an identification, however, is uncertain because there is another painting by Wyant entitled *Scene in County Kerry* (Smith College Art Museum, Northampton, Mass.) that was first illustrated in 1880 (*Art in America*, p. 105). For the same reason, *In County Kerry*, a painting owned by the artist and exhibited at the Metropolitan Museum in 1882, cannot be securely identified as the painting now in the collection.

Oil on canvas, 26¼ × 40 in. (66.7 × 101.6 cm.).
Signed at lower left: A. H. Wyant.
REFERENCES: *National Cyclopedia of American Biography* (1900), 10, p. 370 // Berlin Photographic Company, *A Selection of Photogravures after Paintings Exhibited at the Royal Academy of Arts* [1910], pl. 55 // MMA, *Bulletin* 12 (Oct. 1917), suppl., p. 8 // J. C. Van Dyke, *American Painting and Its Tradition* (1910), pp. 50–52, discusses differences in style between this painting and Mohawk Valley (q. v. Tennessee); quotes Dec. 13, 1917, letter from Bruce Crane, expressing his reservations about the traditional 1866 date of the painting // E. Clark, *Sixty Paintings by Alexander H. Wyant* (1920), ill. p. 24, no. 9; p. 25 // E. Clark, *Ohio Art and Artists* (1932), pp. 184–185 // *Index of Twentieth Century Artists* 4 (Oct. 1936), p. 333, lists it // R. S. Olpin, *Alexander Helwig Wyant (1836–1892), American Landscape Painter* (Ph.D. diss., Boston University, 1971; published, 1978), ill. no. 16; p. 90, notes painting shows influence of Constable; pp. 137–139, dates it early 1866 and considers the style an expression of Wyant's youthful experimentation; pp. 259–260, catalogues it.

EXHIBITED: Society of American Artists, New York, 1878, no. 107, as A County Kerry Scene, $500 (possibly this painting) // Brooklyn Art Association, 1878, no. 195, as Scene in County Kerry, $800 (possibly this painting) // MMA, 1882, *Loan Collection of Paintings and Sculpture*, no. 74, as In County Kerry, Ireland, lent by the artist (possibly this painting) // MMA, 1887, *The Catharine Lorillard Wolfe Collection and Other Modern Paintings...*, no. 219, p. 55, as View in County Kerry, presented by George I. Seney, 1887 (on exhibition at time of gift) // Royal Academy of Art, Berlin, and Royal Art Society, Munich, 1910, *Ausstellung Amerikanischer Kunst*, no. 109, pl. 5, as Landschaft aus Irland // MMA, 1917, *Paintings of the Hudson River School Brought Together in Commemoration of the Completion of the Catskill Aqueduct* // MMA, 1934, *Landscape Paintings*, no. 74 // Saginaw Museum of Art, Mich., 1948, *Nineteenth Century American Landscape Painters*, no cat. // Utah Museum of Fine Arts, University of Utah, Salt Lake City, 1968, *Alexander Helwig Wyant, 1836–1892*, exhib. cat. by R. S. Olpin, ill. no. 38; (unpaged under heading 1866), discusses dating of painting in comparison with Mohawk Valley (i.e., Tennessee); note 20, cites three similar paintings // Hathorn Gallery, Skidmore College, Saratoga Springs, N.Y., 1970, *Some Quietist Painters*, no. 7 // Heckscher Museum, Huntington, N.Y., 1973, *Mistaken Identity*, no. 7B, compares painting as authentic work by Wyant to one called Lights and Shadows, formerly attributed to Wyant but reattributed to Asher B. Durand.

Ex COLL.: George I. Seney, Brooklyn, 1887.
Gift of George I. Seney, 1887.
87.8.11.

An Old Clearing

A sunny landscape glimpsed through trees was one of Wyant's favorite subjects. This large painting on that theme is dated 1881 and was exhibited the same year at the National Academy of Design. A reviewer of the exhibition noted:

The place of honor on the largest wall of the largest gallery is given to Wyant's "Old Clearing," apparently because of the insinuating charm of the work of the painter. Better paintings by him have often been exposed at the Academy, but the scene has a good portion of that pensive grace which endears him to his fellow workmen.

From a distance, the painting gives the impression of careful, detailed rendering reminiscent of Wyant's early style; yet close examination reveals a looser, more textured surface, which reflects light and brightens the dark foreground. Wyant gives the impression of distant space by simplifying the composition and flood-

ing the middle distance with light. Light also draws attention to the distant trees, which dissolve in a soft, golden haze.

Oil on canvas, 49¼ × 37 in. (125 × 119.4 cm.).

Signed and dated at lower left: A. H. WYANT 1881.

REFERENCES: *New York Times*, April 3, 1881, p. 10 (quoted above) // *Nation* 32 (April 21, 1881), p. 286, says the picture is not noteworthy: it "has the main centre of the large gallery, given it probably because it leaves a pleasant impression of landscape unaccompanied by anything tremendous or sensational . . . it is weak and mannered in execution here and there // J. D. Champlain, Jr., ed., *Cyclopedia of Painters and Paintings* (1887), 4, p. 453 // *National Cyclopedia of American Biography* (1900) 10, p. 370 // R. Gordon to J. P. Morgan, Oct. 21, 1912, MMA Archives, notes that the painting had been with him in England since 1884 // S. Isham, *Mentor* 1 (August 11, 1913), ill. no. 3 // *MMA Bull.* 12 (1917), suppl., p. 10 // *Art and Archaeology* 20 (Nov. 1925), ill. p. 250 // F. J. Mather, Jr., C. R. Morey, and W. J. Henderson, *Pageant of America* 12 (1927), p. 80, ill. no. 119 // A. Burroughs, *Limners and Likenesses* (1936), p. 152 // *Index of Twentieth Century Artists* 4 (Oct. 1936), p. 332, lists it // W. H. Pierson, Jr., and M. Davidson, eds., *Arts of the United States, a Pictorial Survey* (1960), ill. p. 329 // R. S. Olpin, *Alexander Helwig Wyant (1836–1892), American Landscape Painter* (Ph.D. diss., Boston University, 1971; published, 1978), no. 128; ill. pp. 184–185, pp. 321–322.

EXHIBITED: NAD, 1881, no. 415, lent by Robert Gordon // MMA, 1917, *Paintings of the Hudson River School Brought Together in Commemoration of the Completion of the Catskill Aqueduct*, no cat. // NAD, Corcoran Gallery of Art, Washington, D. C.; and Grand Central Galleries, New York, 1925–1926, *Commemorative Exhibition by Members of the National Academy of Design, 1825–1925*, no. 292, p. 10, as The Old Clearing; ill. p. 27, as The Clearing // NAD, 1942, *Our Heritage*, no. 209 // MMA, 1965, *Three Centuries of American Painting* (checklist alphabetical) // Los Angeles County Museum of Art, and the M. H. de Young Memorial Museum, San Francisco, 1966, *American Paintings from the Metropolitan Museum of Art*, ill. no. 94, p. 108 // Utah Museum of Fine Arts, University of Utah, Salt Lake City, 1968, *Alexander H. Wyant, 1836–1892*, exhib. cat. by R. S. Olpin, unpaged ill., no. 37; discusses it in text.

ON DEPOSIT: NAD, 1941–1950.

EX COLL.: Robert Gordon, New York and London, 1881–1912.

Gift of Robert Gordon, 1912.

12.205.2.

Broad, Silent Valley

Probably painted in the early or mid-1880s, this picture represents a major reorientation for

Wyant, *An Old Clearing.*

Wyant. Whereas earlier works depicted specific locations or the romantic picturesque qualities of nature, *Broad, Silent Valley* comes close to the spirit of the Barbizon painters in whose work Wyant was becoming increasingly interested. A tranquil mood is created by indistinct brushstrokes and a simplified composition. Forms and space merge in the foreground as well as in the distance, giving a sense of atmosphere. The canvas is thinly painted, except for areas of impasto that define the billowing cumulus clouds and the distant rocks. The sunlight reflected on the clouds draws land and sky together. Wyant connects the light background with the dark foreground by his favorite device of light reflected in pools of water partially concealed by grasses.

Oil on canvas, 60⅝ × 50½ in. (154 × 128.3 cm.).

Signed at lower left: A. H. WYANT.

REFERENCES: *George A. Hearn Gift to the Metropolitan Museum of Art . . .* (1906), p. xii, lists painting in amended offer of gift, Jan. 11, 1906, to J. P. Morgan, president of MMA; opp. p. 186, brief catalogue reference; ill. p. 187 // *George A. Hearn Gift to the Metropolitan*

Wyant, *Broad, Silent Valley*.

Museum of Art . . . (1913), p. x, lists painting in amended offer of gift, Jan. 11, 1906; p. xiii, quotes April 19, 1909, letter to Sir Caspar Purdon Clarke, director of MMA, in which Hearn requests that Gallery 14 be set aside for the Hearn collection of American pictures, including the three Wyants given in 1906; ill. p. 51 // *MMA Bull.* 9 (Jan. 1914), ill. p. 6 // J. C. Van Dyke, *American Painting and Its Tradition* (1919), pp. 57-58; ill. opp. p. 58 // E. Clark, *Sixty Paintings by Alexander H. Wyant* (1920), ill. p. 118; p. 119 // Macbeth Gallery, *Art Notes*, no. 85 (June 1927), ill. p. [1517] // S.C.K. Smith, *An Outline of Modern Paintings in Europe and America* (1932), p. 136, mentions it as in George Hearn collection // E. Clark, *Ohio Art and Artists* (1932), p. 185, calls it one of the best examples of Wyant's work // S. Isham, *The History of American Painting* (1936), ill. p. 259, fig. 56, as owned by George A. Hearn; p. 262 // *Index of Twentieth Century Artists* 4 (Oct. 1936), p. 331, lists it // R. S. Olpin, *Alexander Helwig Wyant (1836–1892), American Landscape Painter* (Ph.D. diss., Boston University, 1971; published, 1978), pp. 190-191, calls it an example of Wyant's "combined view" but "an even stronger assemblage of contrast and unity" than before; pp. 331-332, no. 140, catalogues painting, dates it about 1882.

EXHIBITED: Macbeth Gallery, New York, 1901, *A Group of Landscapes by Alexander H. Wyant and George Inness*, no. 1, as the Broad, Silent Valley.

EX COLL.: with Macbeth Gallery, New York, by 1901; George A. Hearn, New York, 1906.

Gift of George A. Hearn, 1906.

06.1306.

Glimpse of the Sea

This painting, which has also been called *Looking toward the Sea*, shows Wyant's continuing interest in the effects of light. It is characteristic of his work in the mid-1880s, when he was strongly influenced by the Barbizon painters. The quiet marsh water, reflecting the light of the active sky, forms a strong central focus. The water recedes into the distance according to a one-point perspective, emphasized by the firm lines of the river banks and the arrangement of dark trees. Although still applied in wide brushstrokes, the paint is more viscous than in the slightly earlier *Broad, Silent Valley* (q. v.). Wyant uses a soft, wet brush everywhere except in the water, where a drier brush creates reflections. He imparts an atmosphere heavy with moisture and affected by rapidly changing weather. The location of the scene is unknown.

Oil on canvas, 18⅛ × 30⅛ in. (46 × 76.5 cm.).

Signed at lower right: A. H. Wyant.

REFERENCES: E. Clark, *Art in America* 2 (June 1914), ill. [p. 303], fig. 3; p. 311, notes its "beautiful suggestions and poetic inspiration" // *George A. Hearn Gift to the Metropolitan Museum of Art . . .* (1906), p. xii, lists painting in amended offer of gift, Jan. 11, 1906, to J. P. Morgan, president of MMA, as Looking towards the Sea; p. 178, brief catalogue entry; ill. [p. 179], as Glimpse of the Sea // *Arts and Decoration* 2 (May 1912), ill. p. 254, as Glimpse of the Sea // *George A. Hearn Gift to the Metropolitan Museum . . .* (1913), p. x, lists painting in amended offer of gift, Jan. 11, 1906, to J. P. Morgan, president of MMA, as Looking towards the Sea; p. xiii, cites letter to Sir Caspar Purdon Clarke, director of MMA, April 19, 1909, noting that the picture is to be moved from Gallery 15 to Gallery 14 as part of Hearn collection of American pictures; ill. p. 53, as A Glimpse of the Sea // S. Isham, *Mentor* 1 (August 1913), ill. p. 7 // E. Clark, *Alexander Wyant* (1916), p. 56 // R. E. Jackman, *American Arts* (1928), ill. opp. p. 73, pl. xxi // S. LaFollette, *Art in America* (1929), p. 192, calls it "a reminiscence of Rousseau" // *Index of Twentieth Century Artists* 4 (Oct. 1936), p. 331 // H. Cahill and A. H. Barr, Jr., eds., *Art in America in Modern Times* (1934), ill. p. 14 // H. Cahill and A. H. Barr, Jr., *Art in America* (1935), p. 72 // R. S. Olpin, *Alexander Helwig Wyant (1836–1892), American Landscape Painter*, (Ph.D. diss., Boston University, 1971;

Wyant, *Glimpse of the Sea.*

published, 1978), no. 156, pp. 341–342, catalogues and dates ca. 1884–1885.

EXHIBITED: Museum of Modern Art, New York, 1932–1933, *American Painting and Sculpture, 1862–1932,* exhib. cat., ill. no. 117; p. 41, lists it // NAD, 1951, *The American Tradition,* no. 153.

EX COLL.: George A. Hearn, New York, by 1906.

Gift of George A. Hearn, 1906.

06.1308.

Landscape in the Adirondacks

Beginning in the mid-1870s, Alexander Wyant was a summer resident of Keene Valley in the Adirondack Mountains of northern New York State. Within ten years this small, rural community became an artists' colony. John Fitch (1836–1895), Roswell Morse Shurtleff (1838–1915), Robert Minor (1840–1904), and many others spent summers there. GEORGE INNESS joined them in about 1888 and frequently visited Wyant, who was by then seriously ill. In 1889 Wyant left Keene Valley and moved to Arkville in the Catskills.

Landscape in the Adirondacks probably dates from 1885 to 1886. It is typical of Wyant's style during these years. The short, horizontal brushstrokes of the underpainting break up the surface so that the landscape seems to dissolve into the surrounding atmosphere. A still pool that reflects the light of the sky and connects the dark foreground to the bright distance was one of Wyant's favorite devices—one he learned from studying the works of the Barbizon painters. Here, however, the effect is less dramatic than usual. The silhouette of the dark foreground is muted, and the forms are softly defined. The overall atmosphere is tranquil.

Oil on canvas, 20¼ × 30¼ in. (51.4 × 76.8 cm.).
Signed at lower left: A. H. WYANT.
REFERENCES: S. W. Howard, *Harper's Monthly Magazine* 10 (April 1905), p. 802 // *George A. Hearn Gift*

Wyant, *Landscape in the Adirondacks.*

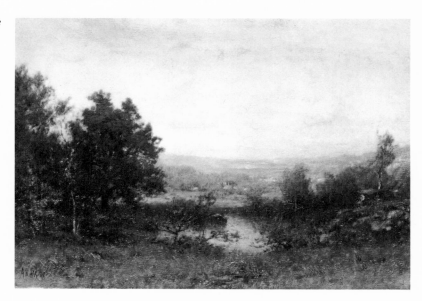

to the *Metropolitan Museum of Art*... (1906), p. xii, lists it in amended offer of gift, Jan. 11, 1906, to J. P. Morgan, president of MMA, p. 182, brief catalogue entry; ill. p. [183] // *Fine Arts Journal* 27 (Oct. 1912), p. 675 // *George A. Hearn Gift to the Metropolitan Museum of Art*... (1913), p. x, listed; p. xiii, letter to Sir Caspar Purdon Clarke, director of MMA, April 19, 1909, notes it is to be moved from Gallery 15 to Gallery 14 as part of Hearn collection of American pictures, ill. p. 52 // E. Clark, *Sixty Paintings by Alexander Wyant*

(1920), ill. p. [48]; p. 49, no. 17, says it is typical of Wyant's mature work // *Index of Twentieth Century Artists* 4 (Oct. 1936), p. 332 // R. S. Olpin, *Alexander Helwig Wyant (1836–1892), American Landscape Painter* (Ph.D. diss., Boston University, 1971; published, 1978), p. 197, discusses it; pp. 350–351, no. 170, catalogues and dates it ca. 1884–1886.

Ex coll.: George A. Hearn, New York, by 1905. Gift of George A. Hearn, 1906. 06.1307.

HOMER DODGE MARTIN

1836-1897

A transitional figure in American landscape painting during the second half of the nineteenth century, Homer Martin links the painters of the Hudson River school to the American followers of impressionism. The fourth son of a carpenter and his wife, Martin was born in Albany. He began to draw as a child. When he left school at the age of thirteen, however, he entered his father's carpentry shop. This did not work out nor did his next job as a clerk in a shop. He then went to work for a cousin who was a builder. His ensuing lack of success as a mechanical draftsman has been attributed alternately to a congenital sight defect that prevented him from either perceiving or drawing straight lines accurately or to his deep interest in art and habit of inscribing trees on the work in which he was engaged.

About 1852 his artistic talent came to the attention of the Albany sculptor Erastus Dow Palmer, who convinced Martin's parents to allow their son to paint. Palmer invited Martin to regular gatherings of local artists, among whom were George Boughton (1833–1905), the sculptor Launt Thompson, EDWARD GAY, WILLIAM HART, and JAMES M. HART. It was from the latter that Martin received his only formal instruction in painting, which lasted two weeks. Martin's early works of the 1850s were detailed panoramas of the wilderness and reflected the Albany circle of painters and their emulation of the style of THOMAS COLE and other members of the Hudson River school.

In 1857 Martin sent two paintings to the National Academy of Design and spent the winter in New York. By the beginning of 1863 he had moved to New York and was painting in the Tenth Street studio of James D. Smillie (1833–1909). Martin was elected an associate at the National Academy in 1867 and an academician in 1874. He was also a member of the Tile Club and the Society of American Artists, founded in 1877. His style and subject matter remained much the same throughout the 1860s. He sketched from nature in the Catskill, Adirondack, or White mountains in the summers and, often after prolonged periods of contemplation, composed expansive lake and mountain views in his studio each winter. Gradually, he reduced the considerable amount of detail he included in his paintings and began to select and isolate motifs to create striking compositions like *Lake Sanford in the Adirondacks*,

1870 (Century Association, New York), and *The White Mountains, from Randolph Hill* (q.v.). The poetic effect of silhouetted shapes, placement of masses, and luminous paint surfaces in his works of the early 1870s must be tied to the work of JOHN F. KENSETT. In 1912 Frank Jewett Mather, Jr., observed that Kensett "was the only one of the older artists who was worth imitating, and Homer Martin was about the only painter intelligent enough to grasp that fact. The fine Martins of the early seventies are like glorified Kensetts, Kensetts with the addition of nerve, substance, and higher seriousness" (pp. 37-38). The course of Martin's stylistic development, however, was profoundly altered by a trip to Europe in 1876. He toured Holland, Belgium, and France, observing the works of the old masters. In France he sketched in the region around Barbizon, particularly at Saint-Cloud, a place Jean Baptiste Camille Corot had also favored. Martin's fascination with the Barbizon style of painting and especially with the work of Corot dated back to the 1850s, when George Boughton had brought to Albany a small painting by the French artist. Martin's wife later described her husband as "one of the Corot worshippers from the first" (p. 10).

While abroad, Martin also stopped in London, where he made the acquaintance of JAMES MC NEILL WHISTLER. It was apparently at Whistler's suggestion that he began to use charcoal to sketch his subjects on the canvas. Martin's works of the late 1870s reveal the influence of both Whistler and Corot in the choice of small forest scenes, increased freedom of handling, and concentration on tone without the complete sacrifice of color. In 1881 Martin returned to Europe with a commission for a series of landscape illustrations for *Century Magazine*. He and his wife decided to remain in France, and by the winter of 1882–1883 they were settled in Normandy, at Villerville, not far from Honfleur. They spent the next four years in this vicinity during which time Martin's style and technique underwent a radical change. His increased familiarity with the works of the Barbizon school and acquaintance with impressionism prompted him to constant experimentation. Although he produced few canvases, he made many sketches. In the paintings he did at this time, he often used a palette knife and large brushes loaded with saturated color. The contours in his works grew considerably looser, prefiguring his late expressionistic works like *View of the Seine: Harp of the Winds* (q.v.). He also began to apply new methods to older themes, such as his Adirondack and Lake Ontario subjects. The results were landscapes of increased elegance and clarity, painted in somber, muted tones.

When he returned to the United States in 1886, Martin brought with him a few completed works, such as *The Mussel Gatherers*, 1886 (Corcoran Gallery of Art, Washington, D. C.), several canvases in progress, such as *Behind Dunes, Lake Ontario* (q.v.), and sketches for many future subjects, including *The Sun Worshippers*, 1886 (Norfolk Museum of Arts and Sciences, Va.), and *Normandy Farm*, 1895 (unlocated, ill. in D. H. Carroll, *Fifty-eight Paintings by Homer D. Martin* [1913]), no. 52, p. 135). He took a studio in New York on Fifty-fifth Street and continued to paint, although his production became more and more sporadic, and the works that he exhibited at the National Academy of Design were never particularly well received. Most of his income came from commissions secured through friends, but it was barely enough to survive. His eyesight deteriorated; the optic nerve in one eye was dead, and the other eye was clouded by a cataract. In 1893 Martin's poor health and lack of money forced him to join his wife and relatives in Saint Paul, Minnesota. There, as he slowly succumbed to cancer,

he finished his last works. At his death in 1897, his paintings were appreciated by only a few. During the next decades, however, they became the sensation of the art market.

BIBLIOGRAPHY: Elizabeth Gilbert Martin, *Homer Martin: A Reminiscence* (New York, 1904). A firsthand biographical account by the artist's wife, including many anecdotes // Samuel Isham, *History of American Painting* (New York, 1905), pp. 262–263. An outline of Martin's stylistic development and discussion of his technique // Frank Jewett Mather, Jr., *Homer Martin: Poet in Landscape* (New York, 1912). The most accurate, detailed biography of the artist, it has a good evaluation of his style // Dana H. Carroll. *Fifty-eight Paintings by Homer D. Martin* (New York, 1913). Valuable reproductions of many of the artist's works with short discussions // Patricia C. F. Mandel, "Homer Dodge Martin: American Landscape Painter, 1836–1897" (Ph.D. diss., New York University Institute of Fine Arts, 1973). A study of Martin's works and the origins of his style.

The White Mountains, from Randolph Hill

During the early 1860s, Homer Martin spent his summers sketching in the Catskill, Adirondack, or White mountains. The summer of 1862 found him in the Gorham region of the White Mountains, the subject of this picture.

He frequently took several years to develop his summer sketches into finished oils and often continued to rework them after they had been exhibited. Although this painting came into the museum's collection bearing the date 1868 (which is no longer visible), it is probably the work Martin exhibited in the spring of 1864 at the National Academy of Design. The later date was most likely added after he made several major changes, which would explain the peculiar contrast between the detailed foreground and the atmospheric rendering of the mountains in the distance. Martin reportedly returned to the White Mountains in 1868 with WINSLOW HOMER, who had recently been in France. Homer was familiar with Barbizon painting and undoubtedly communicated its stylistic principles to Martin,

who was already attracted to the work of Corot. The painting may have been revised still a second time, after Martin had been abroad; for Frank Jewett, Jr., reported in 1912 that "this fine canvas was considerably repainted long after the date it bears, 1868" (p. 34).

Further confusion about the picture arose when the two peaks in the background were misidentified in a sale catalogue from Ortgies and Company in December 1890. There the work was listed as "Madison and Jefferson, from Randolph Hill, White Mountains," and it was with this title that William T. Evans bought the landscape and a year later gave it to the Metropolitan Museum. As in many of Martin's early landscapes, the vista depicted was familiar to devotees of the region, and the error was soon pointed out. The view is toward the south from Randolph Hill near Gorham, New Hampshire, and the mountains pictured are Mount Madison at the left and Mount Adams at the right. Martin's failure to correct the title of the painting, despite correspondence with Evans, has subsequently (1932) been explained:

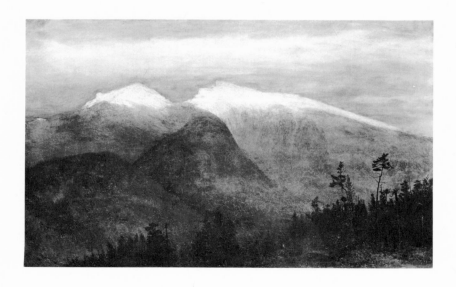

Martin, *The White Mountains, from Randolph Hill.*

At the time when the picture was painted, the names given to Mt. Adams and its next neighbor to the southwest, Mt. Jefferson, were subject to much confusion. On Boardman's map, published about 1858, the names were reversed. . . . Probably Martin's original title designated the two peaks as Madison and Jefferson. In the effort to make the correction, Mt. Madison was changed to Mt. Adams, whereas the correction should have been to substitute Mt. Adams for Mt. Jefferson.

In its present state, the painting reveals Martin's style in transition. The foreground represents his early manner, which depended on accumulated detail and meticulous rendering in the tradition of the Hudson River school. The atmospheric treatment of the background, however, in which muted tones and layers of paint were applied with a palette knife, seems to indicate a reworking in the loose, Barbizon-influenced style of his 1880 and 1890 landscapes.

Oil on canvas, $30\frac{1}{16} \times 50\frac{1}{4}$ in. (76.4 × 127.6 cm.).
Signed at lower right: H. D. Martin.
REFERENCES: *Art Journal* [New York] 6 (Nov. 1880), ill. p. 322, as The White Mountains, from Randolph Hill // Ortgies and Co., New York, *Catalogue of the Private Collection of Modern Paintings and Bronzes Belonging to Dr. F. N. Otis, of this City,* Dec. 4 and 5, 1890, no. 104, as Madison and Jefferson from Randolph Hill, White Mountains, 64 × 30 (MMA copy annotated $250) // H. Martin to W. T. Evans, Oct. 16, 1891, coll. Robert E. Price, Dover, N. J., Arch. Am. Art, discusses the painting, and Martin to Evans, March 24, 1894, thanks Evans for buying the painting // F. J. Mather, Jr., *Homer Martin* (1912), ill. opp. p. 16, as Mt. Jefferson and Mt. Adams; p. 34, says that it was repainted after 1868 (quoted above) // P. R. Jenks, March 22, 1913, letter in Dept. Archives, indicates that the title is wrong and the peaks are Madison and Adams // F. Kilbourne, *Chronicles of the White Mountains* (1916), ill. p. 201, correctly states the picture shows Madison and Adams from Randolph Hill // B. Burroughs, *Catalogue of Paintings in the Metropolitan Museum of Art* (1931), p. 232, calls the work The White Mountains; Adams and Jefferson, dated 1868, and indicates that it was "repainted by Martin in his late manner" // W. H. Downes, *American Magazine of Art* 25 (Oct. 1932), ill. p. 197, as White Mountains—Adams and Jefferson // H. I. Orme, Appalachian Mountain Club, Nov. 12, 1932, and B. Burroughs to H. Orme, Nov. 15, 1932, letters in Dept. Archives, discuss title and site // R. C. Larrabee, Boston, to B. Burroughs, Nov. 23, 1932, Dept. Archives, points out the mistake in title and explains how the misidentification may have come about (quoted above); *Appalachia* (June 1933), pp. 482–483, discusses title mixup // W. H. Truettner, *American Art Journal* 3 (Fall 1971), p. 76, in a checklist of works

owned by William T. Evans, gives it as The White Mountains from Randolph Hill, 1864, 30 × 50¼, and says it was bought for $250 at Otis sale // P. C. F. Mandel, "Homer Dodge Martin" (Ph.D. diss., New York University Institute of Fine Arts, 1973), pp. 35–37, discusses composition and style.

EXHIBITED: NAD, 1864, no. 286, as The White Mountains, Randolph Hill (probably this painting) // MMA, 1883, *Loan Collection of Paintings and Sculpture in the West Galleries and the Grand Hall,* May to Oct. 1883, no. 53, as The White Mountains, lent by Dr. F. N. Otis, New York.

EX COLL.: Dr. Fessenden N. Otis, New York, by 1883 to 1890 (sale, Ortgies and Co., New York, Dec. 4, 5, 1890, no. 104, as Madison and Jefferson, from Randolph Hill, White Mountains, $250); William T. Evans, New York, 1890 to 1891.

Gift of William T. Evans, 1891.

91.29.

Old Manor of Criqueboeuf

Martin's years in Normany from 1882 to 1886 generated a series of landscapes that were based on the countryside surrounding his home in Villerville, not far from Honfleur. The nearby hamlet of Criqueboeuf inspired several paintings, including *Criqueboeuf Church,* 1893 (Hilson Gallery of Art, Deerfield Academy, Deerfield, Mass.), and *Normandy Farm,* 1895 (unlocated, ill. in D. H. Carroll, *Fifty-eight Paintings by Homer D. Martin* [1913], no. 52, p. 135).

The noted critic Frank Jewett Mather, Jr., considered *Old Manor of Criqueboeuf* "a consummate example" of Martin's mature style and described its contemplative, poetic imagery (1912):

Beneath a troubled gray sky, in which a single flash of red gives the last signal of dying day, the old manor house stands amid a copse of leafless, untrimmed poplars. Vacant doors and windows are so many dark gashes in the warm-brown, crumbling wall. The sordid trees are swarthy and their branches give forth a peculiar murkiness that invests the deserted mansion. It seems as if some memory of Poe's "House of Usher" must have been in the artist's mind as he painted, so exactly does he make visual the familiar words: "About the whole mansion and domain there hung an atmosphere peculiar to themselves and their immediate vicinity—an atmosphere which had no affinity with the air of Heaven, but which had reeked up from the decayed trees, and the gray wall, and the silent tarn,—a pestilent and mystic vapor, dull, sluggish, faintly discernible, and leaden-hued."

Elizabeth Gilbert Martin, the artist's wife, also acknowledged the ghostly quality of the de-

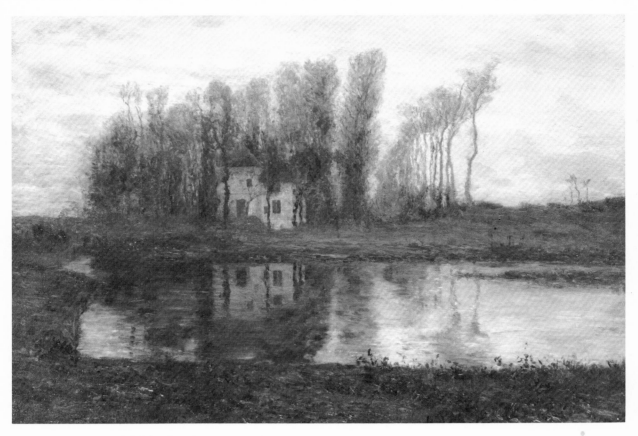

Martin, *Old Manor of Criqueboeuf.*

piction. She noted (1904) that one family friend called the picture "The Haunted House," a title under which it has at times been exhibited.

Martin began the painting while still in France. It was exhibited on his return to New York in 1886 at the autumn exhibition of the National Academy of Design. He continued to revise the composition, however, into the early 1890s, finishing it in 1892 for Dr. D. M. Stimson, an old friend.

The picture is a combination of several of the painter's favorite landscape motifs, among them the juxtaposition of a real and a reflected image. In this respect, *Old Manor of Criqueboeuf* bears a striking resemblance to Eugène Boudin's contemporary *Criqueboeuf L'Eglise,* 1880–1885 (private coll., ill. in R. Schmit, *Eugène Boudin* [1973], 2, p. 71, no. 1447), which Martin may have known. The loose brushwork also reveals a familiarity with the impressionist style. The slightly muddy color of the pond and the trees engulfing the manor house indicates the extent to which Martin's eyesight had failed during his last years. Despite this, Mather considered it one of Martin's best works.

Oil on canvas, 25¼ × 37½ in. (64.1 × 95.3 cm.). Signed at lower right: H. D. Martin.

REFERENCES: *Art Review* 1 (Dec. 1886), p. 12, reviews the work at the NAD, says it has "a certain Hawthornesque quality—weird uncanny imagination is uppermost . . . in . . . a deserted, hobgoblin sort of house hardly concealed in a cluster of tall, gaunt trees with witchlike arms" // E. G. Martin, *Homer Martin* (1904), pp. 27–28, describes scene as next to the Criqueboeuf Church near Villerville and notes that the picture, which a friend declared ought to be called 'The Haunted House,' was finished in New York for an old friend, Dr. Stimson; ill. opp. p. 28, as The Haunted House; p. 46, says it was completed in his last studio in New York on Fifty-ninth Street, which he occupied between 1890 and June 1893 // F. J. Mather, Jr., *Homer Martin* (1912), p. 55, calls the painting "The Old Manor," says it was completed after 1890; ill. p. 64; pp. 67–69, describes the picture in depth (quoted above) and discusses the melancholy mood; p. 76 // F. F. Sherman, *Art in America* 3 (Feb. 1915), ill. p. 70, discusses it // S. LaFollette, *Art in America* (1929), ill. opp. p. 171; p. 193, notes that Martin "made less use of broken color than of broken tones of the same color, laid on heavily with brush or palette-knife. The result is a pleasing texture and a fine vibrant quality, even in those pictures in such

424

low key as 'Manor House at Criqueboeuf' " // F. J. Mather, Jr., *Estimates in Art* (1931), ill. opp. p. 121; pp. 140–142, discusses the merits of the work // B. Burroughs, *Catalogue of Paintings in the Metropolitan Museum* (1931), p. 232 // H. Cahill and A. H. Barr, *Art in America in Modern Times* (1934), p. 14, notes it as one of the works that marks a major change in Martin's style // P. C. F. Mandel, "Homer Dodge Martin" (Ph.D. diss., New York University Institute of Fine Arts, 1973), p. 106, says this work was anticipated by Martin's Arbury Hall, Cheverell Manor, illustrated in Century Magazine for July 1885 (p. 345); p. 200, notes that the reflections of the house and trees are painted in quick impressionistic strokes.

EXHIBITED: NAD, 1886, Autumn Exhibition, no. 200, as Old Manor of Criquebolerf [*sic*], Normandy // Society of American Artists, New York, 1892, no. 224s, as An Old Manor, lent by Dr. D. M. Stimson // Chicago, 1893, World's Columbian Exposition, no. 693, as Old Manor of Criqueboeuf, lent by Dr. D. M. Stimson // Engineers' Club, New York, 1909, *Loan Exhibition of Paintings by American Artists*, no. 25, as The Haunted House // Century Association, New York, 1932 (no cat. available) // Albany Institute of History and Art, 1936, *Exhibition of American Portraits and Landscapes*, no. 84 // NAD, 1942, *Our Heritage*, no. 246.

EX COLL.: Dr. Daniel M. Stimson, New York, 1892–1922.

Bequest of Daniel M. Stimson, 1922.

22.117.

View on the Seine: Harp of the Winds

Following his return from France in 1886, Martin continued to paint landscapes of Normandy. The best known of these late canvases is undoubtedly *View on the Seine: Harp of the Winds*, which, according to Mrs. Martin (1896), one critic described as the best American picture he had ever seen, better than any Daubigny and equal to any Corot.

Martin sketched the composition in charcoal in his New York studio in 1893 and finished it, despite his failing eyesight, in Saint Paul in the fall of 1895. In a letter to Thomas B. Clarke on October 31, he indicated that the picture was made from a sketch and the scene was "looking down the River Seine towards the little town of Quilleboeuf." Martin appears to have referred to the picture as "Harp of the Winds," but, according to his wife, he thought that title might be considered too sentimental. He was "thinking of music all the while he was painting it." Indeed, she noted, the trees were "so grouped that they

suggested by their very contour the Harp to which he was inwardly listening."

Several of Martin's French landscapes of the mid-1880s prefigure *View of the Seine: Harp of the Winds*. The picture's composition depends on a skillful integration of several earlier motifs: the expressive trees silhouetted on the horizon in *The Sun Worshippers* 1886 (Norfolk Museum of Arts and Sciences, Va.), the reflections on the water that dominate the foreground of his Criqueboeuf scenes, the low horizon line and deep space of *On the Seine*, ca. 1885 (Chicago Art Institute), and the far-off town seen in *A Distant View of Caen*, 1894 (unlocated, ill. in D. H. Carroll, *Fifty-eight Paintings by Homer D. Martin* [1913], no. 56, p. 147).

The success of Martin's synthesis must be credited to his experiments in watercolor, his use of the palette knife, and his interest in impressionism. The loose brushwork suggests a familiarity with the style of contemporary painters like Alfred Sisley and Claude Monet. Martin's brushwork is never quite as free as Monet's; for it follows contours more closely. Contact with these French painters cannot be firmly established, although both Monet and Martin were painting in the same places during the early 1880s. Monet did not begin his poplar scenes until about 1890, but other works by him had made a strong showing in New York where a one-man exhibition was held at Durand-Ruel in 1886, the year Martin returned home.

While Monet's stylistic advances can be considered a primary influence, *View of the Seine: Harp of the Winds* is not an impressionist work. Martin was not concerned with either the immediacy of the image or with the fugitive effects of light. Instead, his composition reflects prolonged contemplation. It is constructed tonally, with the focus on a few silhouetted motifs. Martin's poor eyesight may account for the passages of awkward and undisciplined brushwork as well as the enormous size of the poplars, which, according to Martin's wife, were even taller in an earlier design for the painting.

The picture was exhibited in New York at the Union League Club in 1896, where it received flattering notices. It remained unsold for a year until, at Mrs. Martin's request, a group of her husband's colleagues bought the painting for the Metropolitan Museum with money they had collected in his honor.

Oil on canvas, 28¾ × 40¾ in. (73 × 103.5 cm.).

Signed and dated at lower right: H. D. Martin 1895.

RELATED WORKS: Henry Wolf, *View of the Seine* (*Harp of the Winds*), woodcut, 4 13/16 × 17 3/16 in. (12.5 × 18.3 cm.), 1902, ill. for Century Magazine 43 (Feb. 1902), p. 493.

REFERENCES: H. Martin to T. B. Clarke, Oct. 31, 1895, Thomas B. Clarke Papers, D5, Arch. Am. Art, describes the scene in the painting (quoted above) // *New York Tribune*, Jan. 10, 1896, p. 7, reviews the picture in the Union League Club exhibition and says, "the design has originality, distinction, and in the opalescent sky, in the tawny hues of the bank on the left, in the light which fills the entire canvas, the authority and refinement of Mr. Martin's art declare themselves" // *New York Times*, Jan. 10, 1896, p. 7, refers to the work on exhibition at the Union League Club as "a large river scene, somewhat different from his usual work" // H. Martin to F. F. Du Fais, April 12, 17, 1896, FARL, mentions that the work received flattering reviews in New York // *New York Times*, Nov. 7, 1897, notes that it is a recent acquisition at MMA, it is on view, and it "is thoroughly representative of Martin's later period" // E. Martin (wife of the artist) to Du Fais, Nov. 19–20, 1896, FARL, pp. 4–5, discusses the work and says if money could be found "to buy the Seine picture with the tall trees which was exhibited last winter and so highly praised, would it not be better? George Baise, I remember, . . . said he thought it the best American picture he had ever seen . . . High praise, Eh! To me it was the most satisfactory of his pictures from the time it was first outlined on the canvas, and I said to a friend when those three pictures went to New York, that if he never finished any others, he would go out in a blaze of glory from these" // E. G. Martin, *Homer Martin* (1904), pp. 39–40, says the work was inspired by Martin's nineteen months in Normandy and recalls, "I had asked him what he meant to call it, and, with his characteristic aversion to putting his sentiments into words, he answered that he supposed it would seem too sentimental to call it by the name I have just given [Harp of the Winds]"; ill. opp. p. 40; p. 49, says that in her mind the work in an earlier state was "still more beautiful than it is at present," notes that the trees were originally much larger but Martin felt they looked "about four hundred feet high," and refers to inner music (quoted above); p. 53, indicates that Martin took the preliminary charcoaled canvas to a farm near Saint Paul in the spring of 1894 where he finished it; it was sent to New York the following fall // R. Sturgis, *Appreciation of Pictures* (1905), pl. lxii; pp. 231–233, says the painting is characteristic of Martin's late work // *Brush and Pencil* 15 (Jan. 1905), ill. opp. p. 1 // C. H. Caffin, *Story of American Painting* (1907), ill. p. 208 // A. N. Meyer, *International Studio* 35 (October 1908), ill. p. 256, discusses it; p. 260 // *Bookman* 31 (May 1910), ill. p. 258 // P. Clemens, *Die Kunst für Alle* 25 (May 15, 1910), ill. p. 364 // *L'Art et les Ar-*

tistes 12 (Oct. 1910), ill. p. 20 // C. L. Hind, *International Studio* 61 (Sept. 1910), p. 182, discusses it as Landscape on the Seine and mentions exhibitions in Berlin and Munich // *Selection of Photogravures after Paintings Exhibited at the Royal Academy of Arts, Berlin* [1910], ill. p. 32 // F. J. Mather, Jr., *Homer Martin* (1912), p. 57, says that in June of 1893 Martin took the unfinished work to Saint Paul; p. 58, says it was completed in the summer of 1895 and created a furor when exhibited; pp. 60–61, indicates that Mrs. Martin suggested that testimonial money be used to buy the painting for the museum; p. 63, says such works could be bought for very little money; p. 76, describes the work and says that Wolf's woodcut was "just a shade more fine than the original" // S. Isham, *Mentor* 1 (August 11, 1913), ill. p. 8, discusses Martin's technique // F. J. Mather, Jr., *Mentor* 1 (August 11, 1913), n. p., says it ranks among the artist's best works // F. F. Sherman, *Art in America* 3 (Feb. 1915), ill. p. 70 // J. C. Van Dyke, *American Painting and Its Tradition* (1919), ill. opp. p. 78; p. 79; p. 83, remarks that the picture has the "luminosity" of a watercolor // F. F. Sherman, *Art in America* 7 (Oct. 1919), ill. p. 256 // R. C. Smith, *Life and Works of Henry Wolf* (1927), p. xxxvi; p. 79 // F. J. Mather, Jr., C. R. Morey, and W. J. Henderson, *Pageant of America* 12 (1927), ill. p. 81, no. 122 // R. E. Jackman, *American Arts* (1928), pl. 21 // F. J. Mather, Jr., *Estimates in Art*, series 2 (1931), pp. 142–143, says the work is Martin's most famous picture and describes it // E. Neuhaus, *History and Ideals of American Art* (1931), ill. p. 94 // *New York Herald Tribune*, Nov. 6, 1932, sec. 7, ill. p. 10 // H. Cahill, *Art in America in Modern Times* (1934), p. 14, says it is one of the works that marked Martin's new direction; ill. p. 15 // Macbeth Gallery, New York, *Homer Dodge Martin Centennial* (1936), exhib. cat., n. p., mentions French influence on the work // J. W. Lane, *Parnassus* 8 (March 1936), p. 24 // S. Isham, *History of American Painting* (1942), p. 266, ill. no. 58 // E. P. Richardson, *Painting in America* (1956), p. 305, says the work suffers from overfamiliarity but "deserves the place it held in the affections of the nineties" // J. T. Flexner, *That Wilder Image* (1962), p. 331, fig. 102, says Martin repainted the picture when he realized the trees were too tall; p. 332, calls it his "transcendent masterpiece," says it was painted when Martin could hardly see, and considers it a triumph of the human spirit: "The sky is a glorious radiance that glows again, only slightly dimmed, in land-bound water. The earth is a deeply extending, sculptured panorama, solid and also buoyant with the creativity that pushes high into the multicolored ether thin poplars that respond with sinewy elegance to the music of the spheres" // W. D. Garrett, P. F. Norton, A. Gowans, and J. T. Butler, *Arts in America* (1969), p. 280, pl. 212, says, "a great popular favorite in its own time (1895), this timidly sensitive combination of Impressionistic vision with Barbizon sentiment and color represented the highest flight of American taste ·

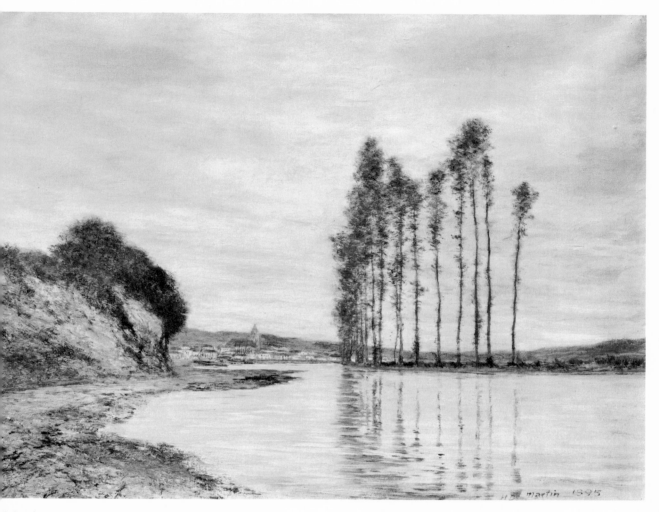

Martin, *View on the Seine: Harp of the Winds*.

in the 1890s" // P. C. F. Mandel, "Homer Dodge Martin" (Ph.D. diss., New York University Institute of Fine Arts, 1973), pp. 190–191, discusses the theme of poplars and Monet's involvement in the subject, calls this Martin's "most Arcadian French landscape," notes letter to Clarke; p. 192, discusses Martin's reworking of the trees and compares to Dutch painting of the seventeenth century; p. 198, says the work has much in common with post–Barbizon painting; p. 249, says Monet's poplar series was probably the inspiration for the work; fig. 106; *Arch. Am. Art Jour.* 13, no. 3 (1973), pp. 7–8, discusses history of the picture.

EXHIBITED: Union League Club, New York, Jan. 1896, no. 33, *Landscape* // Royal Academy of Art, Berlin, and Royal Art Society, Munich, 1910, *Ausstellung Amerikanischer Kunst,* no. 6, pl. 34, *Landschaft an der Seine* // NAD, Corcoran Gallery of Art, Washington, D. C., and Grand Central Art Galleries, New York, 1925–1926, *Commemorative Exhibition by Members of the National Academy of Design,* no. 303 // Museum of Modern Art, New York, 1932–1933, *American Painting and Sculpture, 1862–1932,* no. 73, ill. p. 35 // MMA, 1934, *Landscape Painting,* no. 75 // Carnegie Institute, Pittsburgh, 1940, *Survey of American Painting,* no. 146, pl. 63 // Century Association, New York, 1946–1947, no cat. // Saginaw Museum, Michigan, 1948, *An Exhibition of American Painting from Colonial Times until Today,* no. 40, p. 18 // NAD, 1951, *American Tradition,* no. 99, p. 19 // American Federation of Arts, New York, traveling exhibition, 1952–1953, *20th Century Landscape Painting,* no cat. // Detroit Institute of Arts, 1957, *Painting in America,* no. 130 // Atlanta Art Association, 1962, *Landscape into Art,* no. 41 // Guild Hall, Easthampton, New York, 1964, *A Centennial of American Art, 1864–1964,* ill. p. 4 // MMA, 1965, *Three Centuries of American Painting* (checklist alphabetical) // Los Angeles County Museum of Art and M. H. de Young Memorial Museum, San Francisco, 1966, *American Paintings from the Metropolitan Museum of Art,* no. 95, ill. p. 109 // Hudson River Museum, Yonkers, N.Y., 1970, *American Paintings from the Metropolitan Museum,* no. 30 // MMA, *19th-Century America, Paintings and Sculpture,* exhib. cat. by J. K. Howat and N. Spassky, ill. no. 149 // American Federation of Arts and MMA, traveling exhib., 1975–1977, *The Heritage of American Art,* cat. by M. Davis, no. 62.

EX COLL.: the artist, until 1897.

Gift of Several Gentlemen, 1897.

97.32.

Behind Dunes, Lake Ontario

The area depicted in *Behind Dunes, Lake Ontario* is northeast of Oswego, New York, on the lake between Point Ontario and Sandy Pond. Martin visited the spot in December of 1874.

At that time, he wrote to his friend William C. Brownell of his intense reaction:

The unknowable, free, outside of man, which seems to be the charm of the more serious aspects of landscape, manifests itself to a great degree around this lake (Dec. 28, 1874, Scribner Archives, Firestone Library, Princeton University).

Martin painted five views of the subject between 1874 and 1887, and a sixth one, *Sand Dunes* (unlocated), in 1896, the year before he died. His first attempts were painted on location. The two earliest versions were executed in a detailed style that emphasized the foreground with its barren trees and clumps of grass. The site in *Behind Dunes, Lake Ontario* resembles that of *Sand Dunes, Lake Ontario,* a smaller work Martin painted in 1874 (unlocated, ill. in D. H. Carroll, *Fifty-eight Paintings by Homer D. Martin,* no. 32, p. 8). There is far less detail included, however, in the Metropolitan's painting, which was begun about 1883 while Martin was in Normandy. Initially he intended to exhibit the work at the Paris Salon in 1884, but as his wife later recalled:

before it was completed he got into one of those hobbles, which were not uncommon in his experience, when the more he tried to hurry the less he was in reality accomplishing. It was in no condition to be seen when the last day for sending came, as we both agreed, yet he sent it. Naturally, it was rejected.

He continued to rework the canvas over the next few years and did not finish it until 1887, after he had returned to New York. His final treatment reflects the influence of contemporary French painting, especially in the use of the palette knife, favored by Barbizon artists and proto-impressionists alike. According to John C. Van Dyke (1919), Martin's knife was "trowelled across the canvas, with one tone or color laid over another, flattened down, compressed, blended." The solitary trees and weeds in the foreground are the only brushed elements and were undoubtedly selected by the painter for their evocative, poetic quality.

The contrast between Martin's early, tightly painted treatment of the subject and the scumbled, atmospheric rendering of *Behind Dunes, Lake Ontario* indicates his familiarity with Barbizon art but suggests his additional discovery of the work of the contemporary French painter Eugène Boudin. Boudin's subject matter was most frequently drawn from the landscape surrounding Honfleur and Trouville. He exhibited

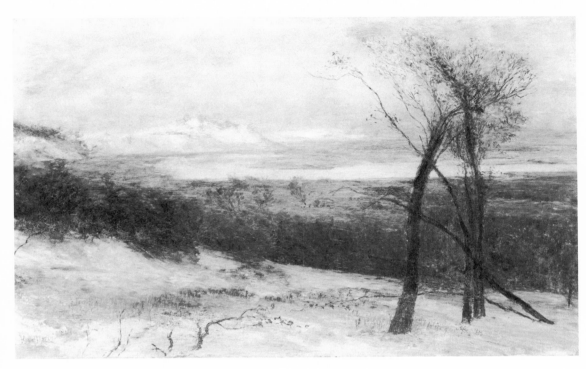

Martin, *Behind Dunes, Lake Ontario*.

regularly in Honfleur, not far from where Martin lived and painted during his years in France. Boudin generally depicted the crowded beaches and ship-filled harbors of the coast, but in the early 1880s he painted a series of dune landscapes, including *Berck. Tempête sur les dunes*, 1880 (private coll., ill. in R. Schmit, *Eugène Boudin* [1973], 2, p. 22, no. 1293), and *Le Havre. Coucher de soleil sur le rivage, marée basse*, 1884 (Musée des Beaux-Arts, Saint-Lo, ill. ibid., p. 223, no. 1880). The latter is similar to Martin's late dune landscapes in both its composition and motif.

Oil on canvas, 36 × 60½ in. (91.4 × 153.7 cm.). Signed and dated at lower left: Homer Martin 1887.

REFERENCES: *New York Daily Tribune*, April 23, 1887, p. 4, says that among the landscapes in the Society of American Artists exhibition, "the largest in respect of feeling is" this picture, "in which facts are not much dwelt upon, but a spacious . . . distance is suggested, and the coloring harmonious" // *New York Times*, April 24, 1887, p. 6, in a review of the Society of American Artists, notes "its exquisite tones in the distant field and poetical cloudwork" // *Art Amateur* 17 (June 1887), p. 5, in a review, calls it a "beautiful, mysterious, unreal-looking landscape" // *Art Interchange* 43 (Oct. 1889), ill. p. 82 // S. Allan, *Camera Work* (July 1903), p. 26 // E. G. Martin, *Homer Martin*

(1904), pp. 41–42, says Martin began the work, called Sand Dunes on Lake Ontario, in Villerville, Normandy, about 1882 with the intention of sending it to the Salon (quoted above) // *MMA Bull.* 1 (Feb. 1906), p. 51, lists the work as a new accession // *The George A. Hearn Gift to the Metropolitan Museum . . .* (1906), p. 174, says the work represents a "desolate area, but is fraught with the impression made by it on the imagination of the painter," ill. 175; (1908), ill. p. 58 // A. N. Meyer, *International Studio* 35 (Oct. 1908), p. 258, ill. as The Sand Dunes of Ontario, p. 260, says he worked on the painting in Normandy, calls it highly characteristic of Martin, and says the picture is "an epitome or summing up of the spirit of wild and waste places where the stormy winds work their own wild will" // F. J. Mather, Jr., *Homer Martin* (1912), ill. opp. p. 48; p. 52, says Martin brought the work back from France in 1886 and indicates he revised it; p. 53, says the painting was reworked and finished in 1887 and "represents the most sublimated phase of Martin's later art"; p. 66, indicates that "four or five" versions of the work were completed between 1874 and 1887, "each one coming a little nearer the light poise of the remote dunes between sky and water, and each working out finer symbols of swart aridity in the forms of the foreground trees" // *George A. Hearn Gift to the Metropolitan Museum . . .* (1913), p. 3; ill. p. 58 // F. F. Sherman, *Art in America* 3 (Feb. 1915), p. 70 // J. C. Van Dyke, *American Painting and Its Tradition* (1919), p. 79, discusses the artists technique in painting this work

(quoted above) // F. J. Mather, Jr., *Estimates in Art* (1931), 2, p. 135, calls it the best work Martin brought back from France; p. 140, mentions that four or five versions of the work were executed between 1874 and 1887 // *DAB* (1933), s. v. Martin, Homer Dodge, refers to the series of sand dune subjects as "grandly spacious and fraught with a noble melancholy" // J. W. Lane, *Parnassus* 8 (March 1936), p. 23, says that Martin did five versions of this subject between 1884 and 1887 // P. C. F. Mandel, "Homer Dodge Martin" (Ph.D. diss., New York University Institute of Fine Arts), 1973, p. 74, quotes letter to Brownell; p. 77, suggests the work was influenced by that of Boudin; p. 136, says it was rejected for inclusion at the Salon of 1884; p. 141, notes it was repainted in 1887; pp. 143–144, discusses in terms of style.

EXHIBITIONS: Society of American Artists, New York, 1887, no. 90, as Behind the Dunes, Lake Ontario // Chicago, 1888, *Catalogue of the Paintings Exhi*-bited by the Inter-State Industrial Exposition of Chicago, no. 260, as Sand Dunes, Lake Ontario // Society of American Artists, New York, 1892, *Retrospective Exhibition*, no. 220n, as Behind Sand Dunes // Chicago, 1893, *World's Columbian Exhibition*, no. 691, as Behind the Dunes, Lake Ontario // Cottier and Co., New York, 1893, as Behind Dunes, Lake Ontario, for sale, $2,500 (according to a label formerly on stretcher) // Macbeth Gallery, New York, 1936 (no cat. available) // Centennial Art Gallery, Salt Lake City, Utah, 1947, *Centennial Exposition, 100 Years of American Painting*, no. 22, ill. p. 9 // National Collection of Fine Arts, Washington, D. C., 1975, *American Art in the Barbizon Mood*, exhib. cat. by P. Bermingham, no. 64.

EX COLL.: with Cottier and Company, New York, by 1893; George A. Hearn, New York, by 1906.

Gift of George A. Hearn, 1906.

06.1287.

WINSLOW HOMER

1836–1910

Homer was born in Boston in 1836 and attended school in nearby Cambridge. His early interest in art was encouraged by both parents. His mother, Henrietta Maria Benson Homer, was a skillful painter in watercolors. Charles Savage Homer, a hardware importer, sent his son sets of lithographs from London to study and copy. At nineteen Winslow Homer became an apprentice at the lithographic firm of J. H. Bufford in Boston. When he completed his apprenticeship in 1857, he was determined to support himself as a freelance illustrator. His first illustrations—scenes of life in Boston and rural New England—appeared that year in *Ballou's Pictorial Drawing-Room Companion*, the noted Boston weekly, and in the newly founded illustrated magazine *Harper's Weekly* in New York. In the fall of 1859, Homer moved to New York. He declined an offer of a staff position at *Harper's* because, as he told his biographer George W. Sheldon: "I had had a taste of freedom. The slavery at Bufford's was too fresh in my recollection to let me care to bind myself again. From the time I took my nose off that lithographic stone, I have had no master, and never shall have any" (New York *Art Journal* 4 [August 1878], p. 226). Homer worked as a freelance illustrator until 1875.

Homer's formal training was limited. In addition to his two-year apprenticeship at Bufford's, he took drawing classes in Brooklyn, attended night school at the National Academy of Design about 1861, and studied painting for a month in New York with the French genre and landscape painter Frederick Rondel (1826–1892).

During the Civil War, Homer served as an artist-correspondent for *Harper's*. Most of his war illustrations show the daily routine of camp life, and are drawn with realistic candor

and at times with humorous overtones. Battle scenes are rare. In 1863 he made a series of six lithographs titled *Campaign Sketches*, which were published by Louis Prang and Company in Boston. The following year Prang issued *Life in Camp*, a set of twenty-four souvenir cards by Homer.

The Civil War provided subjects for Homer's early oil paintings. *A Sharpshooter on Picket Duty*, 1862 (private coll.), painted in his studio in the New York University Building on Washington Square, was described as Homer's "first picture in oils" (R. M. Shurtleff, *American Art News*, 9 [Oct. 29, 1910], p. 4). From 1863 Homer exhibited regularly at the National Academy of Design, and in 1865, at the age of twenty-nine, he was elected an academician. The following year he completed *Prisoners from the Front* (q.v.), his most celebrated war painting. Exhibited at the National Academy in 1866 and the Exposition Universelle in Paris in 1867, it established Homer's reputation.

Late in 1866 Homer made his first trip to Europe and spent ten months in France. Little is known of his activities there. In Paris he shared a studio on Montmartre with Albert W. Kelsey, a friend from Belmont, Massachusetts, and probably also met with his former colleague from Bufford's, J. Foxcroft Cole (1837–1892). Homer visited the Exposition Universelle where *Prisoners from the Front* was on display. He probably also saw the exhibition of the works of Courbet, the leading exponent of realism, and Manet, whose bold approach, original style, and simplified forms made him a controversial figure in Paris art circles of the 1860s. It is doubtful, however, that Homer saw any impressionist works; for these painters did not exhibit as a group until 1874. Similarities between Homer's paintings and the works of Monet and Degas probably are the result of their common approach to painting—based on observation, the direct study of nature, and an interest in the effects of light on form. Homer had in his personal library an 1859 translation of Eugène Chevreul's *The Laws of Contrast of Colour*, a gift from his brother in 1860 and a work he referred to as his Bible (D. Tatham, *American Art Journal* 9 [May 1977], p. 93). Unlike that of many of his controversial French contemporaries, Homer's work conscientiously preserves the integrity of the object. Homer's compositions and strong sense of design, especially evident in his illustrations of the late 1860s and 1870s, have often been attributed to the influence of Japanese prints, which were in vogue among French artists. These effects, particularly noticeable in his early works, were probably achieved independently through his printmaking experience. According to his friend the Boston dealer J. Eastman Chase, "Homer was less influenced by others and by what others had done than any artist—any man, I may as well say—I have ever known" (*Harper's Weekly* 54 [Oct. 22, 1910], p. 14). Homer himself is reported to have remarked to J. Foxcroft Cole, during their apprenticeship at Bufford's: "If a man wants to be an artist, he should never look at pictures" (Goodrich, p. 6). Throughout his life, Homer's artistic development was due more to the direct observation of nature than to any other influence.

Homer returned to the United States in the fall of 1867. In 1872 he moved to a studio in the celebrated Tenth Street Studio Building. JOHN FERGUSON WEIR recalled the period in his reminiscences: "Winslow Homer, E. L. Henry and I were the three youngest men in the Studios. Homer was then drawing for *Harper's Weekly*, and struggling to get out of it to take up more important work. Our relations were intimate; that is, as much so as one could be really intimate with Homer, for he was of reserved manner" (*The Recollections of John Fer-*

guson Weir, ed. T. Sizer [1957], p. 46). Homer was a founding member of the Tile Club, organized in 1877 by a group of artists who met to paint tiles and socialize. He served as host at the club's first annual dinner, which was held in his studio, but with time he dropped out of such activities. Although he lived in the city for some twenty years, it had little place in his paintings and illustrations. He never lost the love for country life acquired in his childhood. He recorded scenes at fashionable resorts, as well as in the country. Summer trips to the White Mountains, Lake George, Saratoga, and Long Branch provided him with subjects. Children were often the focal point of his depictions of rural life, which he presented with an acute eye for truth. Marked by realism, they lack the strong sentimentality that characterizes the works of many contemporary genre painters. His direct approach and broad treatment, which was often misinterpreted as a lack of finish, disconcerted critics accustomed to the accepted mode of academic painting. In a review of Homer's work at the National Academy of Design in 1875, Henry James condemned the choice of subject but gave a perceptive account of Homer's painting style:

> Mr. Homer goes in, as the phrase is, for perfect realism . . . He is a genuine painter; that is, to see, and to reproduce what he sees, is his only care. . . . He is almost barbarously simple, and, to our eye, he is horribly ugly; but there is nevertheless something one likes about him. What is it? For ourselves, it is not his subjects. We frankly confess that we detest his subjects—his barren plank fences, his glaring, bald, blue skies, his big, dreary, vacant lots of meadows, his freckled, straight-haired Yankee urchins, his flat-breasted maidens, suggestive of a dish of rural doughnuts and pie, his calico sun-bonnets, his flannel shirts, his cowhide boots. He has chosen the least pictorial features of the least pictorial range of scenery and civilization; he has resolutely treated them as if they *were* pictorial, as if they were every inch as good as Capri or Tangier; and, to reward his audacity, he has incontestably succeeded. . . . Mr. Homer has the great merit, moreover, that he naturally sees everything at one with its envelope of light and air. He sees not in lines, but in masses, in gross, broad masses. Things come already modelled to his eye (*Galaxy* 20 [July 1875], pp. 93-94).

In 1870 Homer reportedly first visited the Adirondacks, which later became one of his favorite retreats for camping, fishing, and hunting expeditions. The Adirondacks and, later, the Canadian province of Quebec furnished material for oils, watercolors, and illustrations. During the mid-1870s Homer returned to Virginia, where he made studies of blacks, which served as the basis for a group of paintings produced chiefly in 1876 and 1877.

Although he had previously worked in watercolors, it was during the summer of 1873 spent at Gloucester, Massachusetts, that Homer explored that medium extensively. J. Eastman Chase reported that Homer "[took] up his abode on 'Ten-Pound' Island, in Gloucester Harbor . . . and here he painted a large number of water-colors of uniform size, but of a wide range of boldly conceived and vigorously executed subjects" (*Harper's Weekly* 54 [Oct. 22, 1910], p. 14). He first exhibited at the American Society of Painters in Watercolors in the spring of 1874 and became a member in 1877.

Unlike his contemporaries who flocked to Paris during the 1880s, Homer went to England in 1881 and settled at Cullercoats, a village on the North Sea not far from Tynemouth and Newcastle. For nearly two years he devoted himself almost entirely to watercolor painting. Studies of the hazardous life of the North Sea fishermen and their families furnished thematic material for a series of watercolors, oil paintings, and etchings executed after his return. "The

sea, and the lives of those who go down to the sea in ships, became, from this time, his one great theme, and even the earliest and least pretentious of his marine motives had in them the ring of that inalienable veracity . . . which . . . made of his sea pieces the incomparable masterpieces that they are," Downes observed in 1911 (p. 99). A central feature of Homer's English studies are the large, idealized women of Cullercoats and Tynemouth.

In November of 1882 Homer returned to the United States. By 1884 he had settled permanently in Prouts Neck, a rocky peninsula on the coast of Maine, several miles south of Portland. He often went south to escape the harsh northern winters and visited Cuba, Nassau, Bermuda, and Florida. These trips inspired several major paintings and a series of brilliant watercolors, considered by the artist to be his best work in the medium. A self-sufficient man protective of his privacy, Homer realized his desire for solitude in his retreat to Maine. He died at Prouts Neck in 1910.

BIBLIOGRAPHY: William Howe Downes, *The Life and Works of Winslow Homer* (Boston, 1911). A useful, early biography despite the artist's disinclination to cooperate with the author. Contains an exhibition record and a bibliography // Lloyd Goodrich, *Winslow Homer* (New York, 1944). The definitive biography and standard reference on the artist, it contains a chronology and a bibliography. Supplementary material gathered by Lloyd Goodrich in connection with this biography is on microfilm at the Archives of American Art: Lloyd Goodrich's Copies of Winslow Homer Letters, 1860s–1910, microfilm NY/59–12 and 13, Arch. Am. Art // Albert Ten Eyck Gardner, *Winslow Homer, American Artist: His World and His Work* (New York, 1961). Contains a bibliography, chronology, and an index of museums and private collections // Philip C. Beam, *Winslow Homer at Prout's Neck*, foreword by Charles Lowell Homer (Boston, 1966). Contains a selected bibliography // Gordon Hendricks, *The Life and Work of Winslow Homer* (New York, 1979). Contains a chronology, a checklist of works by Homer in public collections in the United States, and a checklist of his published graphics.

The Veteran in a New Field

The Veteran in a New Field was completed in 1865, the year the Civil War ended, and was offered for sale in the sixth annual exhibition of the Artists' Fund Society. In form and content Homer's image contrasts markedly with traditional post-bellum works, such as GEORGE INNESS's idyllic landscape *Peace and Plenty* and THOMAS WATERMAN WOOD's genre group *A Bit of War History* (qq. v.). Homer's solitary harvester is the focal point of a stark, horizontal composition arranged in three successive bands—a carpet of fallen grain, a field of waving wheat that inhibits spatial recession, and a blue, cloudless sky. To complement the austerity of the composition, Homer uses a restricted yet rich palette that adds to the intensity of the image. The high sun creates strong highlights and shadows. This lighting, favored by the artist in his early paintings, gives his figures a pronounced sculptural quality. The broad flat expanse of blue

sky contrasts with the vigorous brushwork of the glistening cut grain. The spare composition and shallow space reinforce the prominence and immediacy of the figure. By showing the figure from the back, John Wilmerding observed (1972), Homer "establishes an anonymous and universal quality that enhances . . . [the] reunion of man and nature." Yet Homer includes a specific reference which identifies the veteran as a Northerner. His canteen, resting on his jacket on the right, bears a red cloverleaf, the insignia of the First Division of the Second Corps of the Sixty-first New York Volunteers, which Homer had joined on his trips to the front. This insignia was one of his favored motifs, probably as much for its personal associations as for its value as a spot of vivid color. It recurs in his war paintings and in the best tradition of realism adds an authentic detail drawn directly from the artist's experience.

Close examination, X rays, and infrared reflectography show that the painting underwent considerable alteration after its exhibition at the

Artists' Fund Society in 1865. A review of the work published in the *Nation* on November 23, 1865, provides a description of its original appearance:

In July we called Mr. Homer our first painter of the human figure in action, and the hasty sketch of "The Veteran in a New Field" is confirmation of that judgment. It is a very insufficient and headlong piece of work, slap-dash execution enough in corn-field and suggested trees; and we do not sympathize with such work *when on public exhibition*. Moreover, we are inclined to quarrel with the veteran for having forgotten in his four years or less of campaigning, that it is with a cradle, and not with a scythe alone, that he should attack standing grain. And such grain! six feet high are its shortest stalks. But the spirit of the single figure takes the eye from the consideration of faults and foibles. The returned soldier's back is turned to the spectator, his right shoulder is dropped, and his right arm brought well around as the scythe has reached the end of its swing and hangs for one instant at rest. Among all the frantic struggles in the big Alhambra picture, noticed last week, there is not so much real human action as in this one man mowing.

The artist subsequently painted over the sky to eliminate the suggestion of trees, decreased the height of the wheat by lowering the sky, and provided the harvester's scythe with a cradle. The jacket and the canteen may also be additions. *The Veteran in a New Field* was the subject of a wood engraving published in *Frank Leslie's Illustrated Newspaper* on July 13, 1867, where it was described as "an illustration of Mr. Homer's excellent and suggestive picture." This engraving seems to represent the painting before the artist made his changes. A tree branch appears at the top right, the wheat is high, the figure wields a scythe without a cradle, and the canteen and jacket are missing. It is a more anonymous image.

The painting was apparently not sold in 1865, for it was included in a sale held at Henry H. Leeds and Miner in New York in November 1866 prior to Homer's departure for Europe. Reporting on the sale, the critic for the *Nation* observed that "the more important" of the paintings were "old friends," including "the admirable 'Veteran in a New Field' which we hope brought a thousand dollars, hasty and slight as it is." He added: "If Mr. Homer learns to finish some of his pictures, so much will be a gain from his studies abroad."

Homer's earliest oils, as John Wilmerding pointed out in an informative study (1975) of this work, include paintings based on both his military experience and civilian life in rural settings. *The Veteran in a New Field* is a synthesis of the two subjects. It is based on a drawing

Homer, *The Veteran in a New Field.*

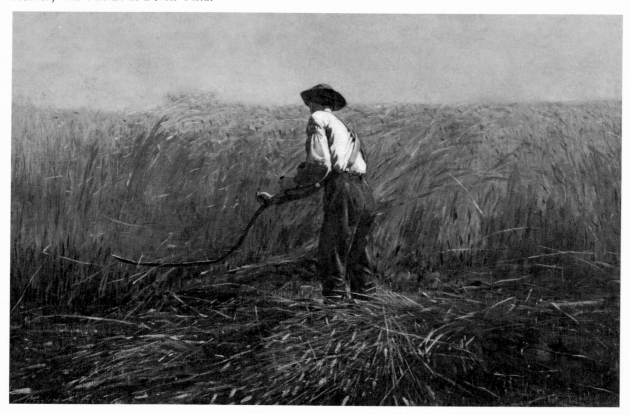

Homer, *Man with a Scythe*, pencil with white gouache. Cooper-Hewitt Museum, New York.

(undoubtedly made from life) called *Man with a Scythe* in the Cooper-Hewitt Museum. Homer made various adjustments: the position of the scythe was altered to suggest more action, and the two additional figures in the drawing were omitted to produce a more austere and powerful composition.

Wilmerding suggests that such works as *Haymaking*, 1864 (Columbus Museum of Art, Ohio), are very much in the native genre tradition exemplified by paintings like WILLIAM SIDNEY MOUNT's *Farmer Whetting His Scythe*, 1848 (Suffolk Museum and Carriage House, Stony Brook, N. Y.). The extent to which European, specifically French, art influenced Homer prior to his first trip abroad is debatable. He was certainly aware of the Barbizon style, which had a decided effect on American painting during the late 1850s and the 1860s. As Peter Bermingham observed (1975), Homer's friends in Boston and New York included the most avid admirers of Barbizon art, and he had ample opportunity to

Engraving of *The Veteran in a New Field* from *Frank Leslie's Illustrated Newspaper*, July 13, 1867.

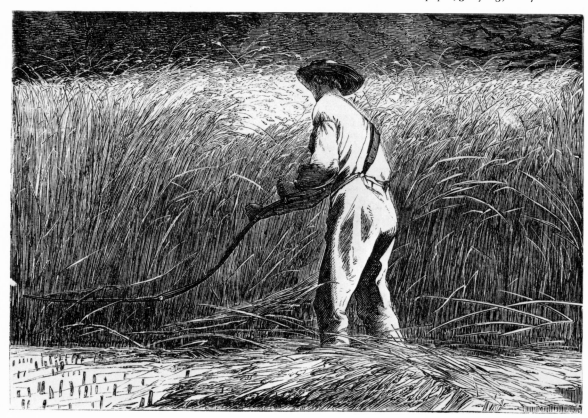

study the subject, although at first chiefly in prints. JOHN LA FARGE reported that Homer's education, like his own, had "been developed from the studies of especially the French masters of whom there were only a very few examples in the country as far as painting went We had to depend on the engravings and especially the very wonderful lithographs, which gave us the synopsis of a great deal of European art" (quoted in L. Goodrich, *Winslow Homer* [1944], p. 36). The subject of *The Veteran in a New Field* and the form it takes—the heroic image of a solitary farmer at work—bear a superficial resemblance to the themes of the rural laborer made famous by Jean François Millet. In both meaning and style, however, they are worlds apart. In contrast to the moral implications and issues of social consciousness implicit in Millet's works, Homer's rural scenes are more objective and dispassionate. Both artists deal with contemporary events and create images rich in meaning. Stylistically, however, Millet's idealized representations are rooted in the classical tradition, while Homer's ingenuous depictions have all the deliberate imperfections of the factual. After his first visit abroad, Homer returned to the subject of the man with the scythe in a wood engraving titled *Making Hay*, published in *Harper's Weekly* on July 6, 1872. Downes reports that Homer made the drawing in Belmont, Massachusetts, where, much to his father's displeasure, Homer had a man pose on the sabbath (*The Life and Works of Winslow Homer* [1911], p. 70). Like *The Veteran in a New Field*, the drawing reflects Homer's dependence on his own observations rather than the work of others. A provocative image rich in symbolic implications, *The Veteran in a New Field* illustrates the powerful originality of Homer's vision, which set him apart from his contemporaries.

Oil on canvas, 24⅛ × 38⅛ in. (61.3 × 96.8 cm.). Signed and dated at lower left: Winslow Homer 65. Signed on canteen at lower right: W. H.

RELATED WORKS: *Man with a Scythe*, pencil with corrections in white gouache, 5 9/16 × 14 1/16 in. (14.1 × 35.7 cm.), ca. 1865, ill. in Cooper-Hewitt Museum, New York, *Winslow Homer 1836–1910* (1972), exhib. cat. by E. E. Dee, no. 22 // *The Veteran in a New Field— from a Painting by Homer*, wood engraving, 4⅛ × 6¼ in. (10.5 × 15.9 cm.), *Frank Leslie's Illustrated Newspaper* 25 (July 13, 1867), p. 268.

REFERENCES: *Nation* 1 (Nov. 23, 1865), p. 663, reviews the painting in 1865 exhibition (quoted above); 3, (Nov. 22, 1866), p. 416, reports on sale of Eugene

Benson's and Winslow Homer's pictures at Henry H. Leeds and Miner, New York, describes sale catalogue and this painting (quoted above) // *Frank Leslie's Illustrated Newspaper* 24 (July 13, 1867), ill. p. 268, shows wood engraving and describes the painting (quoted above) // T. Bolton, *Fine Arts* 18 (Feb. 1932), p. 52, lists it under 1867 in catalogue of Homer's oil paintings and mentions wood engraving // C. S. Hathaway, *Chronicle of the Museum for the Arts of Decoration of Cooper Union* (April 1936), p. 61, no. 11, catalogues drawing of Man with a Scythe in Cooper-Hewitt Museum and notes that it was used for the illustration Making Hay published in *Harper's Weekly*, 16 (July 6, 1872), p. 529 // A. E. Foster, *Bulletin of the New York Public Library* 40 (Oct. 1936), p. 851, no. 216, lists engraving and description from *Leslie's* // H. B. Wehle, *MMA Bull.* 31 (Oct. 1936), p. 210, mentions it among works lent to the MMA for exhibition and calls it Mowing // E. P. Richardson, *American Romantic Painting* (1944), p. 36, no. 212, as The Veteran, discusses it; pl. 212 // Smith College Museum of Art, Northampton, Mass., and Williams College, Williamstown, Mass., *Winslow Homer: Illustrator* (1951), exhib. cat. by M. B. Cowdrey, p. 50, no. 96, lists wood engraving and notes this painting // C. Greenberg, *Art Digest* 28 (Jan. 1, 1954), p. 8, reviews it in exhibition celebrating the founding of Columbia University // A. T. Gardner, *Winslow Homer* (1961), color ill. p. [55]; pp. 251, 254, lists it // J. T. Flexner and the editors of Time-Life Books, *The World of Winslow Homer, 1836–1910* (1966), pp. 72–73, discusses it; p. 82; color ill. p. [83] // *MMA Bull.* 27 (Oct. 1968), ill. p. 70, mentions it among new acquisitions; p. 71, lists it // *Gazette des Beaux-Arts*, suppl. to 73 (Feb. 1969), ill. p. 78, no. 319, as new acquisition // B. Novak, *American Painting of the Nineteenth Century* (1969), p. 165; ill. p. 166, fig. 10–2 // J. Wilmerding, *Winslow Homer* (1972), pp. 47–48, calls it "a perfect image of survival," mentions anonymity (quoted above), analyzes and discusses the painting; ill. 2–22 // W. S. Feldman, "The Life and Work of Jules Bastien-Lepage (1848–1884)," Ph.D. diss., New York University Institute of Fine Arts, 1973, p. 179, contrasts Bastien-Lepage's Les Blès Murs of 1880 with this painting; fig. 72 // J. Grossman, *Echo of a Distant Drum* (1974), color ill. pp. 190–191, pl. 197 // J. Wilmerding, *Antiques* 108 (Nov. 1975), ill. p. 965, fig. 1; pp. 965–971, discusses this painting, preliminary studies, and related works // M. W. Brown, *American Art to 1900* (1977), p. 496, says that Homer "was oblivious of school or manners"; describes this painting as "an original, direct, and irreducible moment of reality, revealing the qualities which would inform his art for the rest of his life—sharpness of observation, elimination of nonessentials, economy and aptness of rendering, a feeling for flat pattern rather than space"; and notes that "few artists have caught a given moment of physical reality with such accuracy"; p. 497, pl. 630 // Museum of Fine Arts, Houston, *Winslow Homer Graphics* (1977), exhib. cat. by M. P. Kelsey with intro.

by D. F. Tatham, p. 31, no. 146, lists engraving after this painting, quotes Wilmerding, and gives bibliography // G. Hendricks, *The Life and Work of Winslow Homer* (1979), p. 72, says it was included in the sale of Eugene Benson's and Winslow Homer's pictures at Leeds and Miner, New York, on Nov. 17, 1866, quotes report on the sale from the *Nation*; p. 316, CL–529, ill. // N. Spassky, *Winslow Homer* (1981), p. 6, discusses; color ill. pl. 1; *MMA Bull.* 39 (Spring 1982), p. 8, discusses; color ill. p. 9, fig. 5 // N. Cikovsky, Jr., "Winslow Homer's Harvest of Death: *The Veteran in a New Field*," National Gallery of Art, Center for Advanced Study in the Visual Arts, Washington, D. C., Colloquium XXVI – Jan. 20, 1983, abstract, reports the painting will be examined as a symbolic picture "by discussing its reference to Cincinnatus and Isaiah; to the harvest as symbol of peace and sign of divine favor; to Death; and to the death of Lincoln" and as an expression of Homer's own feeling // C. Wilson, Middlebury College, Vt., orally, March 7, 1983, said a review of the 1865 exhibition provides a description of the painting before changes were made.

EXHIBITED: Artists' Fund Society, New York, 1865, *Catalogue of the Sixth Annual Exhibition at the National Academy of Design*, p. 18, no. 300, as The Veteran in a new field, for sale by Winslow Homer // Henry H. Leeds and Miner, New York, Nov. 17, 1866, [Pictures by Eugene Benson and Winslow Homer] (no cat. available) // MMA, 1939, *Life in America*, ill. p. 155, no. 205, as The Veteran, lent by Adelaide Milton de Groot // Detroit Institute of Arts, 1944–1945, *The World of the Romantic Artist*, exhib. cat. by E. P. Richardson, ill. p. 14, no. 26; p. 18, no. 26, lists as The Veteran, lent by Adelaide Milton de Groot, by courtesy of the MMA, and discusses it // Perls Galleries, New York, 1958, *Masterpieces from the Collection of Adelaide Milton de Groot*, no. 3, as The Veteran // National Gallery of Art, Washington, D. C., 1958–1959, and MMA, 1959, *Winslow Homer*, intro. by A. T. Gardner, ill. p. 18, no. 6; p. 117, no. 6, as The Veteran in a New Field, also called The Veteran, lent by Adelaide Milton de Groot // Corcoran Gallery of Art, Washington, D. C., 1961, and MFA, Boston, 1962, *The Civil War*, exhib. cat. by H. W. Williams, Jr., ill. p. 251, no. 229; unpaged cat., no. 229, lists it // University of Arizona Art Gallery, Tucson, 1963, *Yankee Painter*, ill. opp. foreword; p. 82, no. 41, lent by Adelaide Milton de Groot // MMA, 1965, *Three Centuries of American Painting* (checklist alphabetical) // Lytton Gallery, Los Angeles County Museum of Art, and M. H. de Young Memorial Museum, San Francisco, 1966, *American Paintings from the Metropolitan Museum of Art*, p. 14, no. 66; p. 77, no. 65, lent by Adelaide Milton de Groot // Osaka, 1970, *United States Pavilion Japan World Exposition*, no cat. // MMA, 1972, *Recent Acquisitions, 1967–1972*, no cat. // MMA and American Federation of Arts, traveling exhibition, 1975–1977, *The Heritage of American Art*, cat. by M. Davis, no. 58, ill. p. 137; rev. ed., 1977, no. 57, ill. p.

135 // Pushkin Museum, Moscow; Hermitage, Leningrad; Palace of Art, Minsk, 1977–1978, *Representations of America*, no cat.

ON DEPOSIT: MMA, 1936–1967, as Mowing, lent by Adelaide Milton de Groot.

EX COLL.: the artist (sale, Henry H. Leeds and Miner, New York, Nov. 17, 1866); Adelaide Milton de Groot, New York, by 1936 until 1967.

Bequest of Miss Adelaide Milton de Groot (1936–1967), 1967.

67.187.131.

Prisoners from the Front

The material that Homer collected as an artist-correspondent during the Civil War provided the subjects for his first oil paintings. In 1866, one year after the war ended and four years after he reputedly began to work in oils, Homer painted *Prisoners from the Front*. This arresting contemporary statement on the nation's tragic conflict established his reputation.

The painting represents three Confederate prisoners facing their captor, a Union officer, identified as Brigadier-General Francis Channing Barlow (1834–1896). The art critic Henry T. Tuckerman (1867) described the work as "an actual scene in the war for the Union," as did an account in the 1899 sale catalogue of the Thomas B. Clarke collection, which Homer accepted "as correct in every respect." In a comprehensive study of the work in 1977, Nicolai Cikovsky concluded that, while it did not represent a specific incident, it was "an entirely plausible and deeply meaningful blend of reality and fiction, of actuality and artifice." Recently, however, D. R. Lauter (1979) proposed that it represents Confederate Colonel John A. Baker of the Third North Carolina Cavalry and two southern soldiers captured on June 21, 1864, by Barlow.

Barlow was commanding officer of the First Division of the Second Corps from April to August 1864. A family friend and a college classmate of Homer's brother Charles, Barlow aided Homer during his visits to the front and mentioned the artist in letters home. In 1938 Barlow's son provided the museum with the following account of Homer's painting of the Union officer:

In 1893, my father Francis C. Barlow, a couple of . . . friends, and several other guests of Nelson A. Miles, then commander-in-chief of the U.S. Army, went on a trip out West with General Miles. General Miles

Homer, *Bust Portrait of an Officer* [*Gen. Francis Channing Barlow*] *and Insignia on Sleeve of Confederate Soldier*, pencil drawing. Cooper-Hewitt Museum.

and my father had served together during the Civil War, General Miles being directly under my father as both of them were successively promoted. He and my father told many stories about each other. One story which my father told got a very amusing rise out of Miles. During the war Winslow Homer had been at the front and had painted pictures of soldiers there.... One of Homer's pictures represented some confederate prisoners being inspected by a Union officer. Miles was a very fine figure of a man, and my father was nothing special in this respect. So Homer got Miles to pose for the officer's figure. Then when the figure was finished, Homer put my father's head on top of Miles's body, apparently merely because my father held higher rank than Miles. At any rate Miles was seriously annoyed.

Infrared reflectography of the area of Barlow's head reveals an earlier depiction, that of a horse, which was painted out. This may account for the awkward appearance of the officer's head. A pencil study for Barlow's portrait is in the Cooper-Hewitt Museum. (A pentimento in the painting suggests that Homer originally intended to show Barlow with his right hand tucked into his jacket as he appears in the drawing.) On the other side of the Barlow study is a drawing of a desolate, war-scarred landscape of tree stumps. Cikovsky identifies it as one of Homer's sketches

Homer, ink drawing, *Escort for a General*, shows background figures and flag. Carnegie Institute.

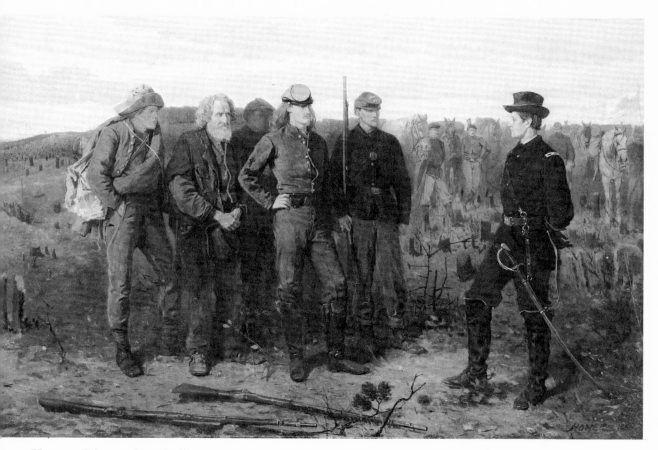

Homer, *Prisoners from the Front*.

Infrared reflectography shows changes on the flag.

made at Petersburg, Virginia, and the model for the landscape in *Defiance: Inviting a Shot before Petersburg*, 1864 (Detroit Institute of Arts), and *Prisoners from the Front*. Beneath the Barlow study is a drawing of the insignia that appears on the sleeve of the Confederate officer's uniform in the painting. Neither the officer (whose hat was originally a broad-brimmed one) nor the insignia has been securely identified. Cikovsky observes, however, that Homer used the same figure and insignia in the frontispiece for John Esten Cooke's novel *Surry of Eagle's Nest: The Memoirs of a Staff Officer Serving in Virginia*, published in New York in 1866, and concludes that the hero of the novel symbolized the chivalrous southern officer, just as Barlow typified the gallant Union hero.

The escort on the right in the painting carries a white flag with a red cloverleaf, the insignia of

Winslow Homer

the First Division of the Second Corps; and the Union soldier in the center wears the same insignia on his cap above the 61, indicating the Sixty-first New York Volunteers. Infrared reflectography shows an earlier flag identical to the forked flag with a clover and 2 that appears in the ink drawing *Escort for a General* (Carnegie Institute, Pittsburgh). According to Michael J. McAfee (1978), this was the headquarters flag of the Second Corps, 1864-1865. Barlow was in command of only the First Division of the Second Corps (Army of the Potomac), and Homer changed the flag to the proper one for that command, demonstrating his commitment to realism.

Barlow and his prisoners are shown in the classically inspired frieze-like arrangement Homer favored in his early works. Demonstrating his skill in delineating character, Homer captures the individual characteristics of the foreground group with particular acuity and creates a series of psychologically penetrating portraits. The polarization of North and South is especially graphic in the confrontation of the Union and Confederate officers, whose respective images are those of puritan and cavalier. The drama of the confrontation is heightened by the isolation of the foreground figures from the dismounted soldiers in the middle distance and by the contrast between the sharp delineation of the main figures and the summary treatment of the others. The desolate setting acts as an effective foil for the figures and adds to the drama. The ravaged scene contrasts sharply with the setting in Homer's *The Veteran in a New Field* (see above) of the previous year with which it shares several compositional features.

While the painting was in progress, the *New York Evening Post*, on February 21, 1866, reported that it "promises to be one of Homer's best works, and it may be made a very powerful picture." It was greeted with enthusiasm at the National Academy of Design in 1866. The critics acclaimed the subject, meaning, and delineation of character in the work, which was variously described as a genre, history, or figure painting. Some, however, found fault with the color and technique. The *New York Independent* described the painting as "Homer's truly Homeric reminiscence of the war," adding, in a nationalistic vein, that it reveals "a true feeling for art, and not a doubtful importation." On April 28 the *New York Evening Post* singled it out for:

integrity of purpose and directness of statement, . . .

force in the rendering of character, and a happy selection of representative, and at the same time local types of men . . . which distinguish it as the most valuable and comprehensive art work that has been painted to express some of the most vital facts of our war It is a genuine example of true historical art—the only kind of historical art which is trustworthy in its facts, free from flimsy rhetoric and barbaric splendor; sensible, vigorous, honest.

Prisoners from the Front was one of two paintings by Homer exhibited in the Exposition Universelle in Paris in 1867, where it was also acclaimed. Reviewing Homer's contributions to the exhibition, the London *Art Journal* reported: "Certainly most capital for touch, character, and vigour, are a couple of little pictures, taken from the recent war, by Mr. Winslow Homer of New York. These works are real: the artist paints what he has seen and known." The critic and painter Eugene Benson (1839–1908) noted:

in spite of its rough execution, and because of its truth and vigor, [it] arrested the attention of polished Parisians and fixed itself in the memory of so many of us as an actual and representative group out of our recent struggle and which alone of all our contemporary paintings has the first claim to a place at Washington as a true bit of history. . . . But historical art in America does not mean such undazzling and unpretending pictures as the "Prisoners from the Front," it means the composed, the invented, the false, the conventional (*Appleton's Journal of Popular Literature, Science and Art* 1 [April 10, 1869], pp. 45–46).

A fellow artist, JOHN FERGUSON WEIR, in a letter to his brother J. ALDEN WEIR, summarized the consensus:

Winslow Homer's *Prisoners from the Front* was in the true sense a contribution to Art, for although the technical execution was immature perhaps, and crude, it was vigorously in keeping with the spirit of the occasion, and the whole characteristic of the struggle between the North and the South, with the typical qualities of the respective officers and men faithfully and astonishingly rendered" (quoted in D. W. Young, [1960], p. 80).

Oil on canvas, 24 × 38 in. (61.0 × 96.5 cm.).
Signed and dated at lower right: HOMER 1866.
RELATED WORKS: *Landscape with Tree Stumps*, pencil and white chalk on brown paper; verso, *Bust Portrait of an Officer* [*Gen. Francis Channing Barlow*] *and Insignia on Sleeve of Confederate Soldier*, pencil, 9½ × 13⅛ in. (24.1 × 33.3 cm.), Cooper-Hewitt Museum, New York, ill. in N. Cikovsky, Jr., *MMA Jour.* 12 (1977), p. 164, figs. 10, 11 // *Cavalry Officer's Boots*; verso, *Supine*

Man, pencil, 6 11/16 × 4 13/16 in. (17 × 12.2 cm.), Cooper-Hewitt Museum, New York, ill. in Cooper-Hewitt Museum of Decorative Arts and Design, Smithsonian Institution, *Winslow Homer 1836–1910* (1972), exhib. cat. by E. E. Dee, no. 11, dates it 1862–1866 // *Six Studies of Soldiers' Heads*, pencil, 9 9/16 × 11 7/16 in. (24.3 × 29.1 cm.), Cooper-Hewitt Museum, New York, ill. in *MMA Jour.* 12 (1977), p. 166, fig. 13 // *Escort for a General*, ink, 9 × 15 in. (22.9 × 38.1 cm.), Carnegie Institute, Pittsburgh, ill. in Corcoran Gallery of Art, Washington, D. C., and MFA, Boston, *The Civil War: The Artists' Record*, (1961), exhib. cat. by H. W. Williams, Jr., p. 92, fig. 69. (N. Cikovsky, Jr., *MMA Jour.* 12 [1977], p. 166, n 43, says that it "was surely made after the painting rather than as a study for it") // *Defiance: Inviting a Shot before Petersburg, Virginia*, oil on wood, 12 × 18 in. (30.5 × 45.7 cm.), 1864, Detroit Institute of Art, ill. in *MMA Jour.* 12 (1977), p. 163, fig. 9 // Frontispiece in John Esten Cooke, *Surry of Eagle's-Nest: or, The Memoirs of a Staff-Officer Serving in Virginia* (New York, 1866), wood engraving, ill. ibid., p. 169, fig. 15.

REFERENCES: *New York Commercial Advertiser*, Feb. 20, 1866, p. 2, reports that "Mr. Homer is at work on a picture representing a group of rebel prisoners brought before a Federal officer to be examined. The subject is well calculated to engage Mr. Homer's talent in the rendering of positive character, and he has already advanced his work far enough to express much of the force of the subject itself. Mr. Homer's walls are crowded with drawings and sketches in o[i]l of incidents and episodes of war, and his work is faithful and varied" // *New York Evening Post*, Feb. 21, 1866, p. 1 (quoted above); April 17, 1866, p. 2, in review of NAD exhibition, notes, "A picture by Homer represents a Union officer—an excellent portrait of General Barlow—receiving a group of rebel prisoners who have evidently just been brought in from the front. The group of prisoners must have been painted from life, for the men are thoroughly characteristic types of their class" // *New York Independent*, April 26, 1866, p. 4, reviews it in the NAD exhibition (quoted above) // Sordello [pseud.], *New York Evening Post*, April 28, 1866, p. 1, reviews it in the NAD exhibition (quoted above): "In our judgement Mr. Homer's picture shows the instinct of genius, for he seems to have selected his material without reflection; but reflection could not have secured a more adequate combination of facts, and they that think more must admit this natural superiority which enabled the painter to make his work at once comprehensive and effective" // *Nation* 2 (May 11, 1866), p. 603, in review of NAD, comments that "Mr. Winslow Homer has two pictures, and the military one, No. 490, 'Prisoners from the Front,' seems to be as popular as it deserves to be. We think Mr. Homer one of our first draughtsmen, in some respects unequalled, but this picture is not wholly in his best manner in execution. In the greater matters of meaning and expression it is hardly to be bettered. Those are real men—the officer with the star on his shoulder, the two soldiers with shouldered muskets, and the three prisoners. The Southern officer and the Northern officer are well contrasted, representing very accurately the widely differing classes to which they belong" // E. B., *Round Table* 3 (May 12, 1866), p. 295, in review of "figure pictures" at the NAD exhibition, says: "Mr. Winslow Homer's work is the most remarkable. The picture called 'Prisoners from the Front' attracts the attention of the public and of amateurs. Painters see in it downright force of hand and uncommon talent to delineate men. For strength of effect, expressive grouping of figures, capacity to paint the subject very much as it appeared in nature, and at the same time freedom from any servile traits, we know of no American figure picture superior to it. We know of pictures more finished in manner, more delicate in gradation of color, but none more sincere, none more vigorous, none more original. . . . [Homer's] methods are direct and plain. We have to warn Mr. Homer against his tendency to blackness and opacity in color, and express a wish that he will soften the harshness of his touch. Happily for him, in this present example of his work the very abruptness of his manner, and the slight gradations of his color, do not mar, but add, to the effect and truth of his rendering of an episode of war" // *Harper's New Monthly Magazine* 33 (June 1866), p. 117, in review of the NAD exhibition, notes that this painting "is to many the most thoroughly pleasing picture in the Exhibition. It is not large, but it is full of character and interest"; pp. 117–118, describes it // W. Homer to T. A. Richards, June 12, 1866, Lloyd Goodrich's Copies of Winslow Homer Letters, 1860s–1910, microfilm NY/59–12, Arch. Am. Art, says, "Please to deliver to Mr. S. P. Avery my picture of '*Prisoners from the Front*'" // *American Art Journal* 5 (June 14, 1866), p. 116, in review of NAD exhibition, notes of this painting: "Mr. Homer's color is still immature. The figures in this picture are good in drawing and excellent in the rendering of expression. In the indication of character, Mr. Homer promises to stand very high among American artists" // *New-York Tribune*, July 4, 1866, p. 5, in a review of the NAD exhibition, says, "In his 'Prisoners From the Front,' Mr. Homer has painted the best picture we have yet seen from his hand; we were not quite prepared for so clever a study of character. We had feared, indeed, that he might degenerate into a mere caricaturist, but this picture reassures us. It is not easy to say how the two soldiers in our late war could have been better epitomized than in this group of three Southern prisoners brought up before a Northern officer"; describes it // *American Art Journal* 5 (July 5, 1866), p. 169, cites a review from the *New York Tribune* which says: "we do not think there are more than three [canvases] which can be called 'excellent'. . . . These three pictures are—Mr. Well's [Weir's] 'Gun Foundery [*sic*],' Eastman Johnson's 'Fiddling His Way,' and Mr. Homer's 'Prisoners from the Front.'

We should like to see these pictures in the great French Exhibition of 1867" // P. Mantz, *Gazette des Beaux-Arts* 23 (Sept. 1867), p. 230, in review of the Paris exposition, notes: "M. Winslow Homer n'aurait pas dû, en bonne justice, passer inaperçu. Il y a de la physionomie et de la finesse dans ses *Prisonniers confédérés* // *Art Journal* [London] 29 (Nov. 1, 1867), p. 248, review of Paris exposition (quoted above) // H. T. Tuckerman, *Book of the Artists* (1967), pp. 18–19, cites unidentified review of Paris exposition which says, "Winslow Homer's strongly defined war-sketches are examined with much curiosity, especially the well-known canvas, 'Prisoners to the Front'. . . . There are not many *genre* pictures in the Exposition that excel these. They have the merit, too, of being true and faithful transcripts of American life, or of a phase of it which, as it has now passed away, can only be recalled by the pencil of the artist"; p. 491, "Homer's 'Prisoners to the Front,' an actual scene in the War for the Union, has attracted more attention, and, with the exception of some inadequacy in color, won more praise than any *genre* picture by a native hand that has appeared of late years"; p. 624, lists it in the collection of John Taylor Johnston // E. Benson, *Appleton's Journal of Popular Literature, Science and Art* 1 (April 10, 1869), pp. 45–46 (quoted above) // *New York Evening Post*, April 27, 1870, p. 1, in a review of 1870 NAD exhibition, compares Homer's contributions unfavorably with this painting "which was remarkable for its truth of character, simplicity of treatment, and a certain dignity of feeling in harmony with the situation"; concludes, "Ability like his is too valuable to the figure department of our national school to be wasted" // *Putnam's Magazine* (July 1870), p. 86, notes, "Most of our New York painters are represented in Mr. Johnston's gallery. First and best of the American figure-pictures is Winslow Homer's 'Prisoners at the Front'"; pp. 86–87, comments that "No gallery in New York offers us any thing more interesting, any thing more genuine and significant, than Mr. Johnston's, in Winslow Homer's 'Prisoners at the Front'—the best record, the most striking characterization in art of the elements in our great struggle with slavery, that has as yet been made by any American painter" // J. F. Weir to J. A. Weir, July 22, 1875, in D. W. Young, *The Life and Letters of J. Alden Weir*, ed. with intro. by L. W. Chisolm (1960), p. 80 (quoted above) // E. Strahan [E. Shinn], ed., *The Art Treasures of America* (1879), 2, p. 128, notes that R. L. Kennedy's collection includes "Winslow Homer's finest work, 'Confederate Prisoners to the Front'"; (1880), 3, p. 86, calls Homer's painting Breezing Up his "greatest hit since the Confederate Prisoners" // J. F. Weir, *United States Centennial Commission, International Exhibition 1876, Reports and Awards, Groups XXI–XXVII*, ed. by F. A. Walker, 7 (1880), p. 635, says: "No recent work of this artist has equaled the remarkable excellence of his celebrated 'Prisoners from the Front,' an incident of the late war, which is a unique work in American art" // A. Stonehouse, *Art Review Miscellany* 1 (Feb. 1887), p. 12, notes, "especially did Prisoners from the Front, . . . make an epoch in his career. The Union officer was a portrait of General Francis C. Barlow and the prisoners were types of Southern swashbucklers, youths and graybeards. At this period Mr. Homer was by no means certain of his drawing of the figure, more especially of the female figure, and in this respect, as well as in the management of color, showed a lack of suppleness of mind" // C. Cook, *Art and Artists of Our Time* (1888), 3, pp. 256–257, says, "No picture has been painted in America in our day that made so deep an appeal to the feelings of the people as his [Homer's] 'Prisoners to the Front'—a young Northern officer examining a squad of Confederate prisoners. Though painted in the heat of the war, and when the bitterest feelings were aroused on both sides, the influence of this picture was strong on the side of brotherly feeling, and of a broad humanity in the way of regarding the great struggle. The scene was intensely dramatic without a touch of exaggeration, and the sympathy it excited had no sentimental flavor. When this picture was shown in France it was universally recognized, apart from its great merit as a work of art, as a distinctively American picture, one of the very few that could be considered worthy of the name" // American Art Galleries, American Art Association, New York, *Catalogue of the Private Art Collection of Thomas B. Clarke, New York, to be sold . . . February 14, 15, 16, 17 . . . (Part I. Paintings)* (1899), sale cat., p. 62, in short biography of the artist, notes: "The subjects he chose were those suggested by the life and scenes around him—scenes of camp and campaign life—the first of them to attract attention being 'Prisoners from the Front.' This actual scene of the war for the Union, appearing at a time when popular excitement was at fever heat, made a profound impression, and established the painter's reputation immediately" // C. H. Caffin, *American Masters of Painting* (1902), p. 75, incorrectly states that it was exhibited at the NAD in 1864 and gives public's reaction to it; pp. 75–76, discusses it // W. Homer, letter in MMA Archives (July 30, 1907), encloses catalogue of the Clarke sale in which this painting is described as an "actual scene of the war for the Union" and notes that in the catalogue "you will find a notice of my life to date—*It is correct in every respect*—(I have crossed out the only objection to it)" // G. Kobbé, *New York Herald*, Dec. 4, 1910, magazine section, p. 11, tribute by John La Farge states, Homer "made a marvellous painting, marvellous in every way, but especially in the grasp of the moment, the painting of the 'Prisoners at the Front' when General Barlow received the surrender of the Confederates" // C. Brinton, *Scribner's Magazine* 49 (Jan. 1911), p. 14, says, "With 'Prisoners from the Front' he sounded a note of pathetic fortitude which found sympathetic response in countless hearts throughout the shattered and disrupted land" // W. H. Downes, *The Life and Works of Winslow Homer* (1911), p. 54, calls it Homer's

"most celebrated war painting," quotes C. H. Caffin; p. 55, gives history of painting, notes it was exhibited at the MMA in 1876 and that its whereabouts is unknown, states that while painting it and other army subjects Homer "had a lay figure, which was alternately dressed up in the blue uniform of the Union soldier and the butternut gray of the Confederate soldier, serving with soulless impartiality, now as a Northerner and now as a Southerner"; p. 56, suggests that it was instrumental in Homer's election to the NAD and quotes La Farge's letter of 1910; p. 57, notes its exhibition in Paris and quotes reviews; p. 58, says that the painting was sent to Brussels and Antwerp; p. 61, notes its exhibition at the NAD in 1868; pp. 82, 90, 258, 262; p. 276, lists its exhibition at the NAD // K. Cox, *Winslow Homer* (1914), p. 18, notes that his election to the NAD "is generally attributed to the reputation of Prisoners from the Front, then under way but not ready for exhibition," mentions its exhibition at the NAD, calls it "one of a series of important pictures that mark off the decades of his life," states that it "may be said to announce the definite conclusion of his prentice years," notes that its present ownership is a mystery and "it does not appear to have been shown in public since the J. T. Johnston sale in 1876" when it "made a deep impression . . . not less upon the artists than upon the critics and the public"; pp. 18–19, quotes Weir and La Farge, notes that in "technical merit" it was "still decidedly primitive," and attributes its success in 1866 to the subject and its illustrative value; pp. 22–23 // Macbeth Gallery, *Art Notes*, no. 78 (Nov. 1923), pp. 1348–1349, reports acquisition, notes exhibition at the NAD and the Paris exposition, and says that it "helped abroad to further knowledge of what American painters were producing" // H. B. W[ehle], *MMA Bull.* 18 (Feb. 1923), ill. p. 38; p. 39, mentions the painting, a gift of Mrs. Rachel Lenox Porter, and notes that it has not been seen by the public since the 1876 Johnston sale; p. 40, discusses its history, speculates that it was made from careful drawings by the artist at the front "for it evidently illustrates an incident in the Peninsular Campaign," and notes that Barlow's portrait, "corresponds closely to a delightful Brady photograph reproduced in Miller's photographs of the Civil War"; p. 41 // L. Goodrich, *Arts* 6 (Oct. 1924), ill. p. 186; p. 192, says that Homer was elected an academician largely because the fame of this picture spread before its exhibition and that the "critics were unanimous in proclaiming it the most successful representation of the Civil War up to that time"; pp. 192–193, notes that "It is undeniably a sincere and strong piece of work, a remarkable production for a man who had been painting only three or four years, but it is rather difficult for us to understand the enthusiasm that it aroused"; p. 193, says: "There is a certain coldness and monotony about it, an over-absorption in detail. In common with all of Homer's Civil War work, it bears unmistakable evidence that he was not interested in what

he was painting. The technical problems which he was painfully working out no doubt interested him, but as far as the rest of it was concerned he was still covering an assignment" // F. J. Mather, Jr., et al., *The Pageant of America* (1927), 12, ill. p. 54, no. 80 // T. Bolton, *Fine Arts* 18 (Feb. 1932), p. 52, lists it in chronological catalogue of the artist's oils as Prisoners from the Front, notes it is called Confederate Prisoners from the Front, notes exhibitions and a reference // R. S. Barlow to A. Tucker, July 21, 1932, letter in Dept. Archives, concerning this picture, notes: "I happened to hear about this picture many years ago, when I was out West shooting in company with my father and General Miles. . . . General Miles was under my father all through the War, and on this occasion my father guyed him about Winslow Homer's picture"; tells story of substituting Barlow's head on Miles's figure // Tucker to B. Burroughs, July 23, 1932, letter in Dept. Archives, encloses Barlow's letter of July 21, 1932 // R. S. Barlow, note in Dept. Archives, April 4, 1938, provides account of this picture (quoted above); adds, "Neither Miles nor my father had any idea what became of the picture and I never expected to see it. . . . the next time I was in New York I went into the Metropolitan Art Museum to look at Homer's works there. Among the latter I came on one of which the face was a striking likeness of my father. It was 'Prisoners at the Front'" // Doll and Richards to L. Goodrich, Feb. 1, 1939, Doll and Richards Letterbooks, microfilm copy Arch. Am. Art 356/111, concerning this painting Mrs. S. V. R. Crosby said the head of the Union officer is that of General Barlow, "In Homer's estimation while Miles had a splendid figure he had an unattractive face. This story was recently told to Mrs. Crosby by Barlow's son" (information courtesy of Beth Treadway) // *Art News* 43 (July 1–31, 1944), ill. p. 16, note for National Gallery of Art exhibition // E. P. Richardson, *American Romantic Painting* (1944), p. 36, no. 211, dates it 1864, says that Homer was attached to the Sixty-first New York Volunteers whose colonel, Francis C. Barlow, is shown in the painting; pl. 211 // L. Goodrich, *Winslow Homer* (1944), p. 21, characterizes this post Civil War painting as Homer's "most famous war picture" and "most mature work up to that time," describes it as "a moving symbol of victory tempered with sympathy for the vanquished"; pp. 21–22, notes its acquisition by Johnston; p. 26, states that despite its success, characteristically, it was one of his last military pictures; p. 39, notes exhibition in Paris and cites reviews; p. 50; p. 51, cites critic in a Brooklyn paper who wrote: "The success which attended 'Prisoners from the Front' seems to have somewhat spoiled a good artist," and reports that such comments made Homer say he was sick of hearing about the picture; p. 72, notes sale and price in 1876; pl. 5 // F. J. Mather, Jr., *Magazine of Art* 39 (Now. 1946), ill. p. 299, describes the composition // O. W. Larkin, *Art and Life in America* (1949), p. 223, discusses it // R. B. Hale, *MMA Bull.*

12 (March 1954), p. 176, discusses it; ill. p. 184 // E. P. Richardson, *Painting in America* (1956), p. 290, fig. 127; pp. 314–315, discusses it // L. Goodrich, *Winslow Homer* (1959), p. 13; p. 114, lists it in chronology // A. T. Gardner, *Winslow Homer* (1961), color ill. p. [38]; p. 44; pp. 47–48, notes it in Johnston sale; p. 57; p. 93, cites review; p. [147]; p. 198, discusses and says Johnston bought it from the NAD exhibition and the sale financed Homer's trip to Paris; calls it "essentially Pre-Raphaelite in character—it is a simple, direct statement of honest fact about modern life"; pp. 237, 238, 249, 254, lists it // J. Gould, *Winslow Homer* (1962), pp. 84–86, describes it; pp. 87, 97–98, lists its exhibitions; pp. 108, 120, notes its reception by critics; p. 209 // J. T. Flexner, *That Wilder Image* (1962), pp. 341–342, discusses the contemporary reaction to the impartialness of the representation of the Civil War and notes that, although Homer "had made for him unusual use of facial expression, he returned at once to his more generalized treatment of mankind," fig. 105 // Bowdoin College Museum of Art, Brunswick, Me., *The Portrayal of the Negro in American Painting* (1964), exhib. cat., unpaged intro. by S. Kaplan, says, "*The Visit of the Old Mistress*, in theme and structure, recalls Homer's best painting of the war days, his *Prisoners from the Front*. The issue of *Prisoners* is a confrontation: like two columns without an architrave, separated by an ocean of air and idea, the officer of the blue faces the officer of the gray. In *The Visit* the columnar figures are black and white—again a tense confrontation without sentimentality" // P. C. Beam, *Winslow Homer at Prout's Neck* (1966), pp. 7, 8; p. 262, lists it // J. T. Flexner and the editors of Time-Life Books, *The World of Winslow Homer, 1836–1910* (1966), pp. 70–71, notes that in this work Homer "came closer to the usual genre style of his compatriots, for he made considerable use of facial expression"; discusses the composition of the foreground frieze of figures as his "customary practice, learned from his struggles with the wood-block"; ill. pp. 80–81, discusses it, noting that the rifle-bearing guard recalls the stereotype Homer developed in his wood engravings; p. 107 // S. Kaplan, *Massachusetts Review* 7 (Winter 1966), p. 106, notes similarity in theme and structure to Homer's The Visit of the Old Mistress and the issue of confrontation in both // B. Novak, *American Painting of the Nineteenth Century* (1969), ill. p. 171, fig. 10–8 // J. D. Prown, *American Painting from Its Beginnings to the Armory Show* (1969), p. 86 // D. F. Hoopes, *Winslow Homer Watercolors* (1969), p. 13, discusses it // W. D. Garrett, P. F. Norton, A. Gowans, J. T. Butler, *The Arts in America, The Nineteenth Century* (1969), p. 246, pl. 184, calls it "a work thoroughly in the broad classical spirit of the 1840's and 1850's" and notes, "it belongs in the great Renaissance-Baroque tradition of self-explanatory and immediately intelligible pictures" // J. T. Flexner, *Nineteenth Century American Painting* (1970), ill. p. 181; p. 183, discusses // J. Wilmerding, *Winslow Homer* (1972), color ill. pl. 4, p. 24;

pp. 43–44, notes that it has "the posed stability so characteristic of photography" and the "rather static quality and posed sobriety" that is "reminiscent of the many photographs by Brady and O'Sullivan of soldiers"; compares the "simple design" and "unpretentious realism" to Gustave Courbet's Interment at Ornans (Musée du Louvre, Paris) and Bonjour Monsieur Courbet (Musée Fabre, Montpellier, France); p. 47, discusses its success; p. 49, notes its exhibition in Paris and quotes reviews // G. Hendricks, *Art News* 72 (May 1973), p. 69, calls it Homer's "first great critical—and popular—success" // P. Hills, *The Painters' America* (1974), p. 68, describes and notes that it has "the same reportorial objectivity as a war photograph"; p. 70, fig. 83 // J. Grossman, *Echo of a Distant Drum* (1974), color ill. pl. 91; color ill. details, pls. 93, 94; p. 114, discusses it; pp. 117–119, calls it "nothing short of a pictorial synopsis of the entire war," describes it and compares with photograph, discusses Barlow and his uniform // E. Parry, *The Image of the Indian and the Black Man in American Art, 1590–1900* (1974), p. 140, discusses the compositional formula for the "theme of confrontation" and suggests that Homer followed a well-established formula, originally military in character and cites as an example Baron Antoine Jean Gros's The Capitulation of Madrid, December 4th, 1808 (Musée du Château de Versailles); describes and says that Homer's picture was "an instant success as an expression of the unbridgeable differences between North and South"; ill. pl. 96 // *MMA Bull.* 33 (Winter 1975–1976), color ill. p. [214], no. 57 // J. Wilmerding, *American Art* (1976), p. 133, discusses it; pl. 158 // M. W. Brown, *American Art to 1900* (1977), pp. 496–497, discusses it and calls it an "illustrator's painting," descriptive "without excessive rhetoric or emotion"; pl. 631, p. 497 // N. Cikovsky, Jr., *MMA Jour.* 12 (1977), pp. 155–172, a comprehensive study of this painting; fig. 1, p. 157 // Museum of Fine Arts, Houston, *Winslow Homer Graphics* (1977), exhib. cat. by M. P. Kelsey with an intro. by D. F. Tatham, p. 9, discusses it // N. Cikovsky, Jr., letter in Dept. Archives, Dec. 10, 1978, supplies additional references to the painting // O. Rodriguez Rogue, MMA, 1978, orally, observed that the features of the old man bear a striking resemblance to those of Homer's father as he appeared at an advanced age in a photograph reproduced in Flexner (1966), p. 169 // M. J. McAfee, West Point Museum, letter in Dept. Archives, Dec. 21, 1978, says he could not identify the insignia worn by the Confederate prisoner and notes: "While it is known that 'devices' of some sort were used by the Confederates late in the war to denote specialities or state origins, no one seems to know their exact form"; identifies the forked flag in a drawing in the Carnegie Museum as the headquarters flag of the Second Corps, 1864–1865, and says, "Not wanting to waste a good study, Homer used the field sketch in his painting, but, realizing Barlow was in command only of the First Division of the

Second Corps (Army of the Potomac), he changed the flag to the proper one for Barlow's command" // G. Hendricks, *The Life and Work of Winslow Homer* (1979), p. [39], color pl. 3; p. 58; p. 60, says that Avery sold it from NAD show to Johnston; p. 64, questions that it represents an actual event; pp. 68, 73, mentions Paris exhibition and reviews; p. 315, CL–520, lists it // D. R. Lauter, letter in Dept. Archives, April 16, 1979, says the painting represents the capture of Colonel John A. Baker of the Third North Carolina Cavalry on June 21, 1864, discusses studies, identifies site, and provides map, discusses flag, says the Latin cross on the Confederate officer's sleeve "represents distinction and is shown as a token of membership in Lee's Loyal Legion—a legion of honor. It is doubtful that Colonel Baker actually had the cross on but there were some photographs of Maryland troops wearing them," supplies copies of Barlow's correspondence and a report of the event // L. Everett, *Richmond-Times Dispatch*, Feb. 3, 1980, reports on Lauter's research on this painting // D. R. Lauter, letter in Dept. Archives, Feb. 16, 1980, provides additional information on the picture // N. Spassky, *Winslow Homer* (1981), color ill. pl. 2; pp. 6–7, discusses; *MMA Bull.* 39 (Spring 1982), pp. 8–11; color ill. fig. 10, pp. 12–13.

EXHIBITED: NAD, 1866, no. 490, as Prisoners from the Front // Paris, 1867, *Exposition Universelle*, no. 26, lent by John Taylor Johnston // Brussels, 1867, *International Exposition* (according to Downes, p. 58) // Antwerp, 1867, *International Exposition* (according to Downes, p. 58, and FARL records) // NAD, 1867–1868, *Winter Exhibition*, no. 662, as Confederate Prisoners at the Front, lent by J. Taylor Johnston // NAD and MMA, 1876, *New York Centennial Loan Exhibition* (according to Downes, p. 55, but not in cat.) // Philadelphia, 1876, *Centennial Loan Exhibition* (according to FARL records) // MMA, April-Oct. 1880, *Loan Collection*, no. 107, as Prisoners at the Front, lent by R. L. Kennedy // MMA, 1939, *Life in America*, no. 196, as Prisoners from the Front // National Gallery of Art, Washington, D. C., and the Museum of Modern Art, New York, 1944, *American Battle Painting, 1776–1918*, exhib. cat. by L. Kirstein, p. 9, notes Homer was "nominally attached to the staff of Colonel Francis C. Barlow, whose portrait he included in 'Prisoners from the Front'"; p. 34, pl. 23; p. 57, lists it // Detroit Institute of Arts, 1944–1945, *The World of the Romantic Artist*, exhib. cat. by E. P. Richardson, no. 24 // Wildenstein, New York, 1947, *A Loan Exhibition of Winslow Homer* (for the benefit of the New York Botanical Garden), cat. by L. Goodrich, ill. p. 14, no. 4; pp. 14–15, discusses it // Columbus Gallery of Fine Arts, 1948, *American Heritage*, no. 20 // Corcoran Gallery of Art, Washington, D. C., 1949, *De Gustibus . . . American Paintings Illustrating a Century of Taste and Criticism*, no. 18 // Detroit Institute of Arts, Art Gallery of Toronto, City Art Museum of St. Louis, and Seattle Art Museum, 1951–1952, *Masterpieces from the Metropolitan Museum of Art*, no cat. // National Gallery of Art,

Washington, D. C., 1958–1959, MMA, and MFA, Boston, 1959, *Winslow Homer: A Retrospective Exhibition*, cat. by A. T. Gardner, pp. 24, 34; p. 117, no. 8 // Corcoran Gallery of Art, Washington, D. C., 1961, and MFA, Boston, 1962, *The Civil War: The Artists' Record*, exhib. cat. by H. W. Williams, Jr., p. 18; ill. p. 194, no. 172; unpaged cat., no. 172, lists it // MMA, 1965, *Three Centuries of American Painting* (checklist alphabetical) // Milwaukee Art Center, 1970, *From Fort Sumter to Appomattox*, no cat. // Hudson River Museum, Yonkers, N.Y., 1970, *American Paintings from the Metropolitan Museum*, no. 23 // Il Museo Civico di Torino, 1973, *Combattimento per un'immagine, fotografi e pittori*, exhib. cat. by D. Palazzoli and L. Carluccio, unpaged // Meredith Long and Company, Houston, 1974, *Tradition and Innovation, American Paintings 1860–1870* (for the benefit of the Houston Museum of Fine Arts), exhib. cat. by L. Curry, ill. p. 27, no. 15 // Los Angeles County Museum of Art, 1974, *American Narrative Painting*, cat. notes by N. W. Moure and essay by D. F. Hoopes, p. 19, says it "deals not with the action of war, but with human interest and psychological penetration"; p. 144, discusses it; ill. p. 145, no. 68 // PAFA, 1976, *In This Academy*, essay by M. Thistlethwaite, p. 101, notes that it typifies a popular mode of historical genre; ill. p. 119, discusses it; p. 290, no. 134, lists it with references // MMA, 1976, *A Bicentennial Treasury* (see *MMA Bull.* 33 above) // Pushkin Museum, Moscow; Hermitage, Leningrad; Palace of Art, Minsk, 1977–1978, *Representations of America*, no cat.

EX COLL.: with Samuel Putnam Avery, New York, 1866; John Taylor Johnston, New York, 1866–1876 (sale, Robert Somerville, New York, Dec. 20, 1876, no. 181, for $1,800); Robert Lenox Kennedy, New York, 1876–d. 1887; his sister, Mary Lenox Kennedy, New York, 1887–d. 1917; her great grandniece, Rachel Lenox Kennedy (Mrs. Frank B.) Porter, New York, until 1922.

Gift of Mrs. Frank B. Porter, 1922.
22.207.

The Studio

This painting, dated 1867, has long been known as *Musical Amateurs* or *Amateur Musicians*. It can, however, be identified as a work called *The Studio*, exhibited at the National Academy of Design in 1868. A critic reviewing the exhibition in the *Round Table* singled out, among "the good things" in the west room, "an exceedingly rough, but able sketch of 'The Studio,' by Winslow Homer, the contents being a brace of violin-players rehearsing." In *Frank Leslie's Illustrated Newspaper*, another critic described it as "almost too sketchy for an Academy picture," adding,

"the subject is one that might have well been worth further development." A cellist and a violinist are shown practicing in an artist's studio. A sheet of music inscribed "W. A. Mozart" rests on the floor to the right, canvases are stacked behind the musicians to the left and against the back wall, and easels have been put to use as music stands.

The painting has a distinctive French character and has often been compared with the work of Edgar Degas. Studio scenes and musical performances were especially popular subjects for French avant-garde artists. The informality of the musicmakers, absorbed in their rehearsal in a studio setting, also suggests bohemian life, which provided a wealth of material for French painters of the period. The strong overhead light that accentuates contours, the technique (pronounced sketchlike by contemporary critics), the bold simplicity of the composition, and the fragmentary nature of the image have counterparts in French art. It has been suggested that Homer painted this work in France. The idea for the painting certainly dates from his visit there in 1866 and 1867. The same cellist appears in a related painting called *The Cellist* (Baltimore Museum of Art). Also dated 1867, it is inscribed "Paris" on the front and "in the old University Building" on the back. The Gothic revival window in the background of the Baltimore painting has been identified as the window in Homer's tower studio in the New York University Building. The window has been described as a later addition to the painting and the New York inscription was probably added at the same time as well.

The Studio could have been painted either in Paris or, later, in New York; but it bears the unmistakable stamp of the artist's French experience. The musicians, undoubtedly modeled from life, have not been identified. The earliest recorded owner of the painting was John H. Converse, a member of the board of directors of the Pennsylvania Academy of the Fine Arts.

Oil on canvas, 18 × 15 in. (45.7 × 38.1 cm.).
Signed and dated at lower center: WINSLOW HOMER N. A. 67.
RELATED WORK: *The Cellist*, oil on canvas, 19 × 13

Homer, *The Studio*.

in. (48.3 × 33 cm.), 1867, Baltimore Museum of Art, ill. in University of Arizona Art Gallery, Tucson, *Yankee Painter* (1963), exhib. cat. by W. E. Steadman, Jr., p. 44, no. 126.

REFERENCES: *Nation* 6 (April 30, 1868), p. 356, refers to it as "a sketch" in review of NAD exhibition // *Round Table* 7 (May 2, 1868), p. 278 (quoted above) // *Nation* 6 (May 7, 1868), p. 377, in a review of NAD exhibition, refers to Homer's contributions here as slight, but they "remind us that he is at home once more, and that good pictures may be expected from him" // *Frank Leslie's Illustrated Newspaper* 26 (May 16, 1868), p. 131 (quoted above) // *Philadelphia Evening Bulletin*, April 28, 1871, p. 1, in review of the Union League of Philadelphia exhibition, notes that "Winslow Homer, of New York, has, in No. 93, 'The Musicians,' a strongly painted picture" // W. H. Downes, *The Life and Works of Winslow Homer* (1911), p. 61, notes, "A small oil painting entitled 'Musical Amateurs' was finished and dated in 1867. It is a picture of two men playing violin and cello in a studio interior. The hands are poorly drawn, and the figures are somewhat lacking in modeling. It is, however, executed with such evident sincerity of purpose as to be thoroughly convincing, despite its shortcomings. 'It has the mark of a man who was in dead earnest,' remarks J. Nilsen Laurvik, 'even though one might not at that time have been able to predict from this canvas the coming master'"; p. 276 // F. F. Sherman, *American Painter of Yesterday and Today* (1919), p. 33, says, "The Musical Amateurs, formerly in the collection of Mr. John H. Converse and now owned by Mr. De Vine, possesses somewhat of the Whistlerian quality that Kenyon Cox has remarked in another early Homer, the New England Country School. . . . The sincerity of the study of the two musicians is sufficient to convey a definite idea of their personalities to anyone interested enough in such a subject to examine the canvas with the attention it deserves. And such an examination will discover in it also a fine tonality and a charming breadth of handling that was not at all common to genre painting of the day in this country // *Creative Art* 9 (July 1931), ill. p. 71, as Musical Amateurs, owned by Babcock Galleries // T. Bolton, *Fine Arts* 18 (Feb. 1932), p. 52, includes it in a catalogue of Homer's oil paintings as Musical Amateurs (Babcock Galleries) // J. L. Allen, *MMA Bull.* 34 (July 1939), p. 183, discusses the acquisition of this painting, gives title as Amateur Musicians, compares with The Cellist, discusses setting, points out French character, and says it is reminiscent of Degas // F. Watson, *Winslow Homer* (1942), ill. p. 100 // E. P. Richardson, *American Romantic Painting* (1944), p. 36, no. 214, conjectures that Degas's influence "may probably be seen here" and suggests that the setting "seems to have been the artist's studio in the old New York University building"; pl. 214; *Art News* 43 (Jan. 15–31, 1945), ill. p. 20, and discusses Detroit exhibition // A. T. Gardner, *Winslow Homer, American Artist*

(1961), ill. p. 97; p. 238, in chronology, lists The Studio exhibited at the 1868 NAD annual exhibition; pp. 245, 254 // J. Gould, *Winslow Homer* (1962), p. 95, notes that two artists posed for this in Paris, calls it Musical Amateurs, says that Homer worked on it after returning to New York but "it was never quite completed; the hands holding the instruments were awkward, clumsily fingering the strings" // P. C. Beam, *Winslow Homer at Prout's Neck* (1966), p. 9, notes that there "is a Degas-like quality to Homer's *Musicians* of 1867"; p. 261, lists it as *Musicians* // J. Wilmerding, *Winslow Homer* (1972), p. 51, discusses it as Amateur Musicians; pp. 51–52, compares it to works by Degas; p. 82, ill. 2–38 // P. Hills, *The Genre Painting of Eastman Johnson* (Ph.D. diss., New York University Institute of Fine Arts, 1973; published 1977), p. 100, discusses Homer's relationship to Johnson and Homer's technique, quotes Goodrich: "The only survival of traditional procedure [used by Homer] was that he underpainted his earliest pictures in brown monochrome and kept the lights thick and the darks thin," cites this painting here called The Musicians as an example of a work painted using this technique, notes that it was also used by Eastman Johnson and "would

Homer, *The Cellist*, oil on canvas. Baltimore Museum of Art.

have been passed along to Homer if there was any such contact between them"; *The Painters' America* (1974), p. 84, discusses it in contrast to William Sidney Mount's pre-Civil War "country fiddlers"; ill. 107, p. 88 // S. Johnston, Baltimore Museum of Art, orally, Dec. 5, 1978, provided information concerning the inscriptions on the Cellist // G. Hendricks, *The Life and Work of Winslow Homer* (1979), pp. 73–74, states "The artist's pictures from this French period are, generally, not the best he produced," and notes that this painting "may be the finest of the lot, although it is less 'finished' than the Baltimore Museum's parallel picture"; p. 289, CL-151, illustrates The Cellist, Baltimore Museum of Art, mentions lefthand figure in MMA painting, and notes that the Baltimore painting was given to Charles de Kay by Homer; p. 314, CL-494, ill. // L. Libin, Musical Instruments, MMA, orally, Jan. 27, 1981, said that the cello is represented before the invention of end pins and shown resting on an ankle // N. Spassky, *Winslow Homer* (1981), color ill. pl. 3; p. 8 discusses; *MMA Bull.* 39 (Spring 1982), ill. p. 14, fig. 11; p. 15, discusses // M. St. Clair, Babcock Galleries, New York, orally, April 15, 1983, provided information on provenance.

EXHIBITED: NAD, 1868, no. 420, as The Studio, for sale // Union League of Philadelphia, 1871, no. 93, as The Musicians // Babcock Galleries, New York, 1931, *Paintings, Watercolors, Etchings by American Artists*, no. 19, as Musical Amateurs // Marie Sterner Galleries, New York, 1937, *19th Century American Painters*, no. 31, as Musical Amateurs // MMA, 1939, *Life in America*, ill. p. 166, no. 219; p. 167, lists it as Amateur Musicians; says that Downes suggested it was painted in Paris but the background of The Cellist suggest that both pictures were done in "Homer's old studio in the New York University building at Washington Square"; notes influence of Degas // Detroit Institute of Arts, 1944, *The World of the Romantic Artist*, exhib. cat. by E. P. Richardson, ill. p. 31; p. 34, no. 92 // Dwight Art Memorial, Mount Holyoke College, South Hadley, Mass., 1950, *The Eye Listens*, no. 49, lists it // MMA, 1965, *Three Centuries of American Painting*, unnumbered cat. // Montreal Museum of Fine Arts, 1967, *The Painter and the New World*, no. 202 // Marlborough-Gerson Gallery, New York, 1967, *The New York Painter (Benefit Exhibition for the New York University Art Collection)*, ill. p. 27; p. 89 // Slater Memorial Museum, Norwich, Conn., 1968, *A Survey of American Art*, no. 11 // Utah Museum of Fine Arts, University of Utah, 1976, *American Painting around 1850*, exhib. cat. by R. S. Olpin, no. 32.

ON DEPOSIT: Utah Museum of Fine Arts, University of Utah, Salt Lake City, 1975–1978.

EX COLL.: John H. Converse, Philadelphia, d. 1910 (sale, American Art Galleries, New York, Jan. 6, 1911, no. 23, as Musical Amateurs $460); Mrs. Stetson, 1911; (sale, American Art Association, New York, Feb. 7, 1918, no. 19, as Musical Amateurs, for $170, "sold to close an Estate"); A. Devine; with Babcock Galleries, New York, 1930–1938; with Marie Sterner, New York, 1938–1939.

Samuel D. Lee Fund, 1939.

39.14.

Study for Eagle Head, Manchester, Massachusetts

This oil sketch is a study for Homer's painting *Eagle Head, Manchester, Massachusetts*, 1870 (see below). For many years it was incorrectly identified as *Surf at Marshfield*. Manchester, a small fishing village eight miles northeast of Salem and twenty-three miles north of Boston, was transformed by the middle of the nineteenth century into a fashionable seaside resort. It was one of several resorts that Homer visited on summer sketching and painting excursions. He was probably in Manchester in the summers of 1868 and 1869. His only contribution to the annual spring exhibition of the National Academy of Design in 1869 was a painting called *Manchester Coast* (unlocated). The Metropolitan's sketch was probably done in the summer of 1869 for the composition of *Eagle Head, Manchester, Massachusetts*, exhibited at the academy in 1870. It is painted directly on an unprimed wood panel. The red-brown ground gives the sand, sea, and headland greater substance. Close examination revealed that the panel had a horizontal split which was splined before the picture was painted. The sky has been extensively overpainted with a thin green-blue paint, probably in an attempt to modify the sketchy character of the work.

It was Homer's practice to use elements from his sketches for his compositions, but a study like this one, adopted virtually unchanged, is rare. In his painting of Eagle Head, Homer gave the incoming wave more definition and replaced the long horizontal format with a more vertical one to accommodate the figures and to enlarge the beach in the foreground.

Oil on wood, $9\frac{1}{2} \times 21\frac{1}{4}$ in. (24.1 × 54 cm.).

RELATED WORKS: (see *Eagle Head, Manchester, Massachusetts* below).

REFERENCES: C. L. Homer to G. Castano, Boston, undated, copy sent to MMA Feb. 14, 1947, Dept. Archives, says, "'The Beach at Marshfield' painted by my uncle Winslow Homer as a sketch from which the Metropolitan's 'On the Beach' [probably means *Eagle Head*] was completed—hung in the studio unframed, with a couple of nails through the board, at the time of Uncle Winslow's death. At which time it became the

Homer, *Study for Eagle Head, Manchester, Massachusetts.*

property of Arthur B. Homer, my father—He had it framed and since that time [it] has been in the possession of the family—upon Dad's death, I hung it in the studio summers when it is opened to the public (possibly this picture) // L. Reiter, MMA, Paintings Conservation, memo in Dept. Archives, August 1979, provides report on painting and support // J.K.Howat, *The Metropolitan Museum of Art, Annual Report for the Year 1978–1979* (1979), p. 18, reports acquisition of this work then called Surf at Marshfield; p. 19, lists it // N. Spassky, *MMA Bull.* 39 (Spring 1982), color ill. p. 16, fig. 12; p. 17, discusses it.

Ex COLL.: Mr. and Mrs. James Fosburgh, New York, 1978.

Bequest of Mary Cushing Fosburgh, 1978.
1979.135.1.

Eagle Head, Manchester, Massachusetts (High Tide)

Dated 1870, this painting was titled *Eagle Head, Manchester, Mass.* when it was exhibited that year at the National Academy of Design's spring and summer exhibitions. It was called *High Tide*, however, in a caption to a wood engraving after the work, published on August 6, 1870, in the short-lived Boston periodical *Every Saturday* and was long known by that title.

The painting, which shows three women bathers and a dog, has been described by Barbara Novak as "one of the most unsettling romantic paintings of the nineteenth century." A distant sailboat, two birds in flight, and small figures on the shore at the left add minute notes of anecdotal interest. The starkness of the scene is heightened by harsh light and long cast shadows. The startled dog, with its tail expressively tucked under, and what Novak describes as the physical proximity, yet psychological estrangement, of the figures contribute to the disquieting effect. Two of the figures are rendered faceless and anonymous. The third figure, according to Homer family tradition, is a portrait of the woman who was Homer's sole romantic interest.

An undated oil (see above) shows the scene without the figures and undoubtedly served as a study for the painting. To date, no studies for the figures are known. Apparently the artist was particularly satisfied with the figure of the woman wringing her skirts; for he used her in several other compositions, such as the painting *By the Shore* (private coll.) and the wood engraving after *The Bathers*, an unlocated painting.

Contemporary critics reviewing the academy exhibition in 1870 found this picture unsatisfactory. With few exceptions its disturbing quality went unnoticed. Attention was focused instead on the subject, Homer's technical shortcomings, and the lack of propriety in the bathers' costumes. Either in reaction to these critics or to satisfy the demands of popular illustration, considerable changes were made in the wood engraving published in *Every Saturday*. The two bare-legged figures were provided with drawers, rendering them more respectable; the face of the seated

High Tide wood engraving from *Every Saturday*, August 6, 1870

Homer's whimsical signature on *Eagle Head*.

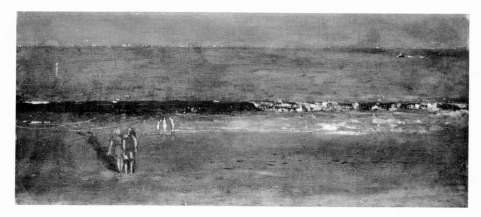

Homer, *The Beach, Late Afternoon*.

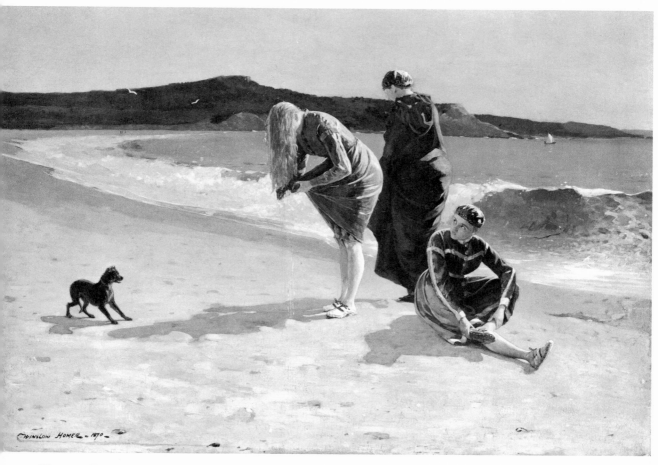

Homer, *Eagle Head, Manchester, Massachusetts (High Tide)*.

figure was given a simpering cupid's-bow mouth that transformed her into a prosaic, conventional type; the dog was replaced by a discarded bathing cap; the headland in the background was made less prominent; the distant beach was made more hospitable by the addition of people and rows of bathhouses; and narrative details—a starfish in the right foreground, a windmill in the left background, two sailboats and a ship billowing smoke along the horizon—were introduced.

The same issue of *Every Saturday* contained a wood engraving after a painting by the artist, entitled *Low Tide*, undoubtedly intended as a companion piece to this work. In the accompanying text, it was described as "the same beach seen in the opposite view, only at low tide . . . surf-bathing . . . over for the day, and the small-fry . . . out in force wading in the shallow water"

(p. 499). When William F. Milton, the owner of *High Tide*, approached Homer to buy *Low Tide*, he was told that the picture had been painted out and the canvas reused.

Oil on canvas, 26 × 38 in. (66 × 96.5 cm.).

Signed and dated at lower left: WINSLOW HOMER 1870.

RELATED WORKS: *Study for Eagle Head, Manchester, Massachusetts* (see above) // *High Tide.—From a Painting by Winslow Homer*, wood engraving, 8 15/16 × 11 13/16 in. (22.7 × 30 cm.), 1870, in *Every Saturday* 1 (August 6, 1870), p. 504 // *By the Shore*, oil on canvas, 9½ × 10 in. (24.1 × 25.4 cm.), 1870s, private coll., ill. in National Gallery of Art, Washington, D.C., 1958–1959, MMA, and MFA, Boston, 1959, *Winslow Homer*, cat. by A. T. Gardner, p. 37, no. 32, p. 118. (Figure shown wringing her skirt in left background is related.) // William H. Redding, *The Bathers.—From a Picture by Winslow Homer*, wood engraving, 13 13/16 × 9 3/16 in. (35.1 × 23.3), 1873, in *Harper's Weekly* 17

(August 2, 1873), p. 668. (Figure shown wringing her skirt in left background is related.)

REFERENCES: *New York World*, April 24, 1870, p. 3, review of the 1870 NAD annual exhibition comments, "It is indeed difficult to find terms in which to speak of this artist's work. Now and then there are gleams of strong, defiant ability reckless all of art rules, but they are apt to be extinguished in smears and splotches of paint," provides description of painting, calls the figures "exceedingly red-legged and ungainly," and observes, "One of them exhibits a bewildered countenance half averted as though the mystery of Eagle Head troubled her as it is supposed to trouble the spectator. It is a well-drawn and atrociously-colored bathing scene" // *New York Evening Post*, April 27, 1870, p. 1, in review of the 1870 NAD annual exhibition, suggests that the painting is "a satire on the fashionable eccentricities of Grecian bands and other modern dress addenda," regrets that the painter of Prisoners from the Front (q. v.) has dealt with "such trifling subjects" but commends Homer's power as a draftsman and his skill in composition, noting that "certain details, like the water and the headland in the bathing scene, show a fine appreciation of external nature" // J. Jones, *Harper's Weekly* 14 (May 14, 1870), p. 307, in review of the 1870 NAD annual exhibition, says Homer's entries "are not wholly pleasing" and the bathing scene "not quite refined. But the pictures show a fresh eye and a wholesome independence of conventions with spirit and vigor. . . . the painter has really seen what he paints, and really tries to represent it. When he fails, it is therefore a hopeful failure" // E. Benson, *Putnam's Magazine* 5 (June 1870), p. 703, in review of the 1870 NAD annual exhibition, notes that the girls on the beach "are not beautiful; their legs are not well drawn, nor are they fine or elegant in form Mr. Homer's three girls are awkward; not very interesting, but very natural" // W. H. Downes, *The Life and Works of Winslow Homer* (1911), p. 64; p. 276, notes exhibition of the painting Eagle Head, Manchester at the 1870 NAD exhibition // H. B. W[ehle], *MMA Bull.* 18 (April 1923), p. 85, discusses its acquisition; states that it "has been called The Bathers but Mrs. Milton [the donor] gives the information that the correct title is High Tide"; notes that Homer painted it on the North Shore at Manchester-by-the-Sea; describes Milton's lack of success in acquiring the painting Low Tide; characterizes this painting as "one of those direct, unsophisticated observations so characteristic of Homer's early work"; ill. p. 86, as High Tide, and discusses style // L. Goodrich, *Arts* 6 (Oct. 1924), ill. p. 189; p. 194, comments that Homer "approached nature with some of the naiveté of a child and yet with all of an unusually unromantic man's grasp of reality. To one who examines a painting like 'High Tide' it is obvious that Homer had no idea what color the sea ought to be in the sun, or how to paint a dog. Everything in the picture was a problem to him, fresh and enthral-

ling" // T. Bolton, *Fine Arts* 18 (Feb. 1932), ill. p. 23, as High Tide or The Bathers; p. 52, lists Eagle Head, Manchester among unidentified works by Homer shown at the NAD in 1870; lists High Tide // L. Goodrich, *Magazine of Art* 37 (Feb. 1944), p. 59; *Winslow Homer* (1944), p. 41, lists it with paintings made two or three years after Homer's return from abroad and states that they "had a gayer and more fashionable note that may have reflected his French experience. They showed an increased awareness of sunlight and atmosphere, and were lighter and cooler than anything he had done before, or in fact was to do for some time, for he soon reverted to a darker key"; observes that Homer's "impressionism was a matter of parallel development rather than influence"; pp. 42–43, includes it among oils reproduced as illustrations and "evidently drawn on the block by" Homer; p. 51, quotes review; p. 57, relates family tradition that girl Homer loved was portrayed seated on the beach in this painting; pl. 8 // T. Bolton, *Art News* 43 (Oct. 15, 1944), p. 17, calls it one of the most extraordinary pictures of its kind // C. L. Homer, copy of letter enclosed with letter from G. Castano, Boston, Mass., Feb. 14, 1947, Dept. Archives, gives information on The Beach at Marshfield, an oil sketch for On the Beach // O. W. Larkin, *Art and Life in America* (1949), p. 222, discusses composition // A. T. Gardner, *MMA Bull.* 17 (Jan. 1959), ill. p. 134 // L. Goodrich, *Winslow Homer* (1959), p. 15, describes contemporary reaction, mentions that girl seated on the beach was reputedly "the object of the young artist's most serious love affair, which ended unhappily because he did not have the income to marry her — an event that was to affect deeply his attitude toward women and society"; pl. 10 // A. T. Gardner, *Winslow Homer* (1961), ill. p. 184, as High Tide: The Bathers; p. 238, lists Eagle Head, Manchester in chronology with works shown at the NAD in 1870; pp. 247, 254 // L. Goodrich, *Winslow Homer's America* (1969), p. 115, discusses bathing costumes; p. 116, discusses model for the girl seated on beach; ill. p. 129, wood engraving of High Tide // B. Novak, *American Painting of the Nineteenth Century* (1969), p. 174, says there are "hints of emotional content suggested by the spatial expressiveness" and that "Homer, like Hopper, achieves mystery through ostensibly prosaic subject matter — three lady bathers and a dog on the beach. As with Hopper, empty space becomes the carrier of wordless feeling;" pp. 174–176, discusses "the use of space as an emotional vehicle suggestive of imminent danger or simply to arouse vague fears of the unknown . . . as part of a romanticism that is frequently tied to some form of realism"; says of the narrative aspects of the painting: "The dog seems unduly disconcerted by the dripping hair of the bending figure, whose face is masked by her falling hair, as is the face of the dark-cloaked figure turned away from us. The seated figure, startled, looks in the general direction of the barking dog, and beyond him, at something we cannot see. Like the

figures of Edvard Munch twenty years later, these women, physically approximated, are psychologically estranged from one another. Like punctuations, they give emotional emphasis to a kind of wordless sentence — the space and silence that they help articulate"; p. 175, ill. 10–11; p. 311, n 17 // J. Wilmerding, *Winslow Homer* (1972), p. 66, color pl. 6; p. 85, discusses stylistic experimentation and comments that it "possesses an unusual tightness and hardness of form, perhaps derived from his style of work in engravings"; pp. 85–86, describes the painting and the "disquieting stillness" of the scene; p. 86, notes the "sculpturesque quality of the figures," the "mood of seriousness," and the ambivalence "between this seriousness and ordinary anecdotal genre" which "is never fully explained," and discusses identity of the seated girl // MMA; Albright-Knox Art Gallery, Buffalo; Albany Institute of History and Art, *Winslow Homer, a Selection of Watercolors, Drawings and Prints from the Metropolitan Museum of Art* (1972), exhib. cat. by N. Spassky, no. 14 // H. W. Williams, Jr., *Mirror to the American Past* (1973), p. 183 // M. W. Brown, *American Art to 1900* (1977), p. 498, mentions "the polished anecdotalism" of High Tide // S. Cochran, Harvard Club Library, orally, Nov. 15, 1978, provided biographical information on the donor's husband, who acquired this painting from Homer's studio // N. Cikovsky, Jr., letter in Dept. Archives, Dec. 10, 1978, supplies references to contemporary reviews of this painting // G. Hendricks, *The Life and Work of Winslow Homer* (1979), pp. 78, 79, 80, discusses Homer's visits to Manchester in 1868 and 1869; p. 80, fig. 119, wood engraving; pp. 80–81, says incorrectly that Manners and Customs "is probably the Metropolitan's" High Tide; ill. p. 315, CL–508 // N. Spassky, *Winslow Homer* (1981), pp. 8–9, discusses; color ill. pl. 4; *MMA Bull.* 39 (Spring 1982), p. 15, discusses; pp. 16–17, color ill. fig. 13.

EXHIBITED: NAD, 1870, no. 172, as Eagle Head, Manchester, Mass., for sale (also included as no. 172 in first summer exhibition) // MMA, 1939, *Life in America*, ill. p. 172, no. 227; p. 174, as High Tide // Whitney Museum of American Art, New York, [*Oils and Watercolors by Winslow Homer*], no cat. // Worcester Art Museum, Mass., 1944, *Winslow Homer*, no. 6 // Newark Museum, 1946, *19th Century French & American Painting from the Collection of the Metropolitan Museum of Art*, no. 19 // Wildenstein, New York, 1947, *A Loan Exhibition of Winslow Homer* (for the benefit of the New York Botanical Garden), exhib. cat. by L. Goodrich, p. 33, no. 12; ill. p. 43 // Smith College Art Gallery, Northampton, Mass., and Williams College, Williamstown, Mass., 1951, *Winslow Homer: Illustrator*, exhib. cat. by M. B. Cowdrey, no. 14, as High Tide; p. 56, no. 149, lists wood engraving // National Gallery of Art, Washington, D. C., 1958–1959, MMA, and MFA, Boston, 1959, *Winslow Homer*, cat. by A. T. Gardner, p. 117, no. 16, as High Tide; Boston ed., 1959, no. 15 // MMA, 1965, *Three Centuries of American Painting*, unnumbered cat., as High Tide // High

Museum of Art, Atlanta, 1971, *The Beckoning Land*, exhib. cat. by G. Vigtel, p. 17, says that in High Tide "there is the same suggestion of clumsiness in the handling of the human figure that we notice in his earlier, and more primitive, illustrations for *Harper's* magazine. This painting tends toward anecdote in the way folk art often does, but it is not sentimental. Beyond the central subjects, the picture is full of the suggestion of bracing air and strong light that points the way to Homer's mature art"; p. 28, no. 62, as High Tide; ill. p. 76.

Ex COLL.: William F. Milton, New York, and Pittsfield, Mass., by 1871–d. 1905; his wife, 1905–1923.

Gift of Mrs. William F. Milton, 1923.
23.77.2.

The Beach, Late Afternoon

This oil study on wood was part of a group of works inherited from the artist's estate in 1910 by Homer's older brother, Charles Savage Homer. In 1918 several of the works, including this one, were donated by Mrs. Charles Savage Homer to the Carnegie Institute in Pittsburgh. At that time a sketch of a white horse was on the back of this wood panel. Sometime after 1941 the panel was cut and the two works were separated. The horse is now in the collection of the Cleveland Museum of Art, where it is titled *White Mare* and dated 1872.

Like *Saddle Horse in Farm Yard* (see below), which has the same provenance, this beach scene was kept in Homer's studio and never intended for exhibition. Three indistinct figures can be seen wading in the surf, and two figures sketched in red and brown are standing on the beach. The study probably dates sometime between 1870 and 1872. It is related to such works as the panel *Study for Eagle Head, Manchester, Mass.* (see above), although that is a more skillful and powerful painting. It is also related to the undated *Sandy Beach with Breakers* (Cooper-Hewitt Museum, New York) and *On the Beach* (Canajoharie [N.Y.] Library and Art Gallery).

Oil on wood, $9\frac{1}{4} \times 21$ in. (23.5 × 53.3 cm.).
REFERENCES: J. K. Howat, *MMA Bull.* 27 (Oct. 1968), p. 71, lists it with new acquisitions as Beach, Late Afternoon // M. St. Clair, Babcock Galleries, New York, orally, Dec. 21, 1978, supplied information on provenance // O. Rodriguez Roque, Museum of Art, Carnegie Institute, Pittsburgh, letter in Dept. Archives, May 12, 1981, supplied information on provenance.

EXHIBITED: Babcock Galleries, New York, 1941, *Exhibition of Paintings by Winslow Homer*, no. 1, as The Beach, Late Afternoon, ca. 1872, in a group of recently acquired paintings never before exhibited.

ON DEPOSIT: Yale University Art Gallery, New Haven, 1946–1952, lent by Adelaide Milton de Groot // MMA, 1952–1967, lent by Adelaide Milton de Groot.

EX COLL.: the artist's brother and executor of his estate, Charles Savage Homer, New York, West Townsend, Mass., and Prouts Neck, Me., 1910–d. 1917; his wife, Mrs. Charles Savage Homer, New York, 1917–1918; Museum of Art, Carnegie Institute, Pittsburgh, 1918–1941; with Downtown Gallery, New York, 1941; with Babcock Galleries and Milch Galleries, New York, 1941–1942; Adelaide Milton de Groot, New York, 1942–1967.

Bequest of Miss Adelaide Milton de Groot (1876–1967), 1967.

67.187.207.

Saddle Horse in Farm Yard *and* Study for Surf and Rocks

Like *The Beach, Late Afternoon* (see above), this small oil study on wood was formerly in the possession of the artist's brother. A farmyard scene, signed H., it bears the distinctive hall-

marks of Homer's style, such as the patchlike application of paint, the luminous quality, and the use of light to define form. Especially characteristic is the backlighting of the horse. Near the chicken to the right is the pentimento of a female figure.

When first exhibited, in 1941, the painting was dated about 1869. That date was probably based on similarities between this painting and *The Bridle Path, White Mountains*, 1868 (Sterling and Francine Clark Institute, Williamstown, Mass.). *The Bridle Path*, however, has the intense luminosity that distinguishes the works Homer did shortly after his first trip abroad; whereas the Metropolitan's painting is considerably lower in key. It bears a closer resemblance to such rural scenes of the 1870s as *Weaning the Calf*, 1875 (North Carolina Museum of Art, Raleigh) and *Milking Time*, 1875 (Delaware Art Museum, Wilmington). The chicken is similar to those in the watercolor *The Sick Chicken* (Colby College Museum of Art, Waterville, Me.), dated 1874. These similarities to paintings of the early 1870s suggest that the Metropolitan's farmyard scene was painted then.

An unfinished study of rocks and breaking surf appears on the upper part of the back of the panel. The predominance of pink colors suggests sunrise or sunset. The bursts of spray and foam are characteristic of the paintings of the sea that Homer made after he settled in Prouts Neck in 1884. The marine paintings of that period, however, appear to have been painted exclusively on white prepared grounds. This study is made directly on the red-brown panel, a ground that gives more weight and substance. Neither of the studies, which date from two different periods of Homer's life, was ever intended for public exhibition. More likely, they served as points of reference for him.

Oil on wood, 12¾ × 15⅞ in. (32.4 × 40.3 cm.). Signed at lower right: H.

REFERENCES: J. K. Howat, *MMA Bull.* 27 (Oct. 1968), p. 71, lists it with new acquisitions as Horse // M. St. Clair, Babcock Galleries, New York, orally, Dec. 21, 1978, supplied information on provenance // G. Hendricks, *The Life and Work of Winslow Homer* (1979), ill. p. 315, CL–509, notes that this is a "rare instance in which Homer signed a painting as he did an engraving" // O. Rodriguez Roque, Museum of Art, Carnegie Institute, Pittsburgh, letter in Dept. Archives, May 12, 1981, supplied information on provenance.

EXHIBITED: Babcock Galleries, New York, 1941,

Homer, *Saddle Horse in Farm Yard* and below on the reverse *Study for Surf and Rocks*.

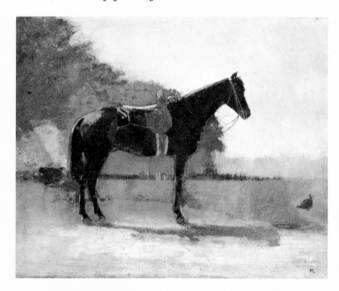

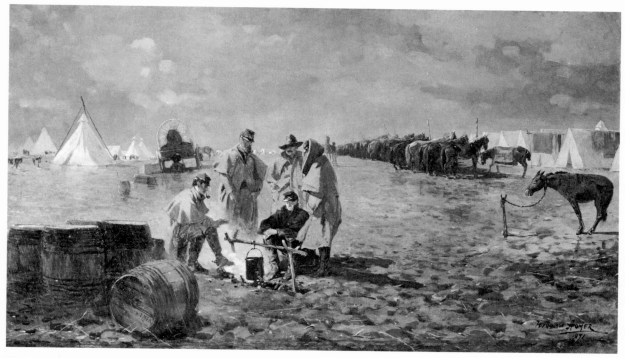

Homer, *Rainy Day in Camp*.

Rainy Day in Camp

Composed from sketches made by Homer in Virginia during the Civil War, *Rainy Day in Camp* epitomizes the bleak discomforts of the day and place. The painting is dated 1871, six years after the war ended. Homer, however, applied the present signature and date over two earlier signatures and at least one other date, indicating that the painting was probably begun earlier. The

Winslow Homer

date that follows the second of the three signatures can no longer be clearly read but appears from remaining traces to have been no earlier than 1870.

Rainy Day in Camp is a composite picture, based on studies from life made while Homer was at the front in 1862. The red cloverleaf on the barrel at the left, above Homer's name, was the insignia of the First Division of the Second Corps of the Sixty-first New York Volunteers, to which he was assigned on his visits to the front.

The sketches for this painting provide insights into Homer's working methods. In his study of

Homer, *Soldiers around a Camp Fire*, pencil and wash on brown paper. Photograph courtesy of Mead Art Museum, Amherst College.

Homer's works dealing with the war, Julian Grossman wrote (1974): "Homer was economical of his pictorial ideas. He would make notes of a typical grouping, or one that was picturesque, and then would use the original pencil sketch to bring veracity to an idealized (or imagined) scene." As an example, Grossman points out that the line of horses, which appears in what is obviously a working study, *Army Encampment*, 1862 (Cooper-Hewitt Museum), is used "exactly as sketched," first in the wood engraving *Thanksgiving in Camp* and again in *A Rainy Day in Camp*. For the central group of figures, Homer used a pencil and wash study, once in the collection of Amherst College. A larger sketch, *An Army Encampment*, also from 1862 and in the Cooper-Hewitt Museum, has some similarities to the central group but is not directly related to the painting. Homer sometimes reused motifs in different works and media. For example, the shrouded standing figure to the right of the fire appears at the right in the wood engraving *Halt of a Wagon Train*, published in *Harper's Weekly* on February 6, 1864; the seated central figure in the group around the campfire is similar to one in the oil painting *In Front of Yorktown*, 1862 (Yale University, New Haven, Conn.); the covered wagon in the middle distance to the left, the figure seated in front of it, and the horse or mule behind it are seen in the lithograph *The Coffee Call*, 1863, from the series *Campaign Sketches*. Combining these disparate components, Homer creates a highly unconventional and calculated composition. The barrels in the foreground echo the grouping of figures around the fire. Placed slightly to the left of the middle of the canvas, the group occupies the center of a sharply converging perspective formed by the line of horses and the tents at the right and by the fallen barrel, covered wagon, and tents at the left. In addition to its deliberate composition, *Rainy Day in Camp* exemplifies Homer's brilliance as a colorist. The glistening effects of emerging sunlight on the rainwashed camp are captured with acuity.

William F. Milton acquired the painting from Homer's studio soon after it was completed and lent it to the National Academy exhibition in 1872. He also owned Homer's *Eagle Head, Manchester, Massachusetts* (q. v.).

Oil on canvas, 20 × 36 in. (50.8 × 91.4 cm.).
Signed and dated at lower right over two former signatures: WINSLOW HOMER / 1871; at left on barrel: HOMER.

RELATED WORKS: *Soldiers around a Camp Fire*, pencil and wash on brown paper, 4⅝ × 6¾ in. (11.8 × 17.1 cm.), formerly Mead Art Museum, Amherst College, Amherst, Mass., ill. in N. Spassky, *MMA Bull.* 39 (Spring 1982), p. 10, fig. 8 // *Army Encampment*, pencil and watercolor, 4⅜ × 9⅞ in. (11.1 × 25.1 cm.), 1862, Cooper-Hewitt Museum, New York, ill. in J. Grossman, *Echo of a Distant Drum* (1974), p. 99, pl. 74.

REFERENCES: W. H. Downes, *The Life and Works of Winslow Homer* (1911), p. 70, lists it among the paintings shown at the NAD in 1872; p. 77 // H. B. W[ehle], *MMA Bull.* 18 (April 1923), ill. p. 85; pp. 86–87, discusses, noting that Milton bought it out of the artist's studio "soon after it was completed"; although dated 1871, it "takes us back again to the Civil War subjects which Homer had apparently not painted since the completion five years earlier of our Prisoners from the Front"; says the beauty of the painting "lies in the sensitive treatment of light and atmosphere, which while casting its spell retains in itself a wonderfully literal and careful notation of facts" // T. Bolton, *Fine Arts* 18 (Feb. 1932), p. 52, includes in catalogue of Homer paintings // Charles D. Childs Gallery, Boston, *Drawings by Remington, Copley and Homer* (Oct. 16–Nov. 20, 1948), no. 13, lists Soldiers around a Camp Fire as a study for the central group of figures in this painting // O. W. Larkin, *Art and Life in America* (1949), p. 272, discusses it // A. T. Gardner, *Winslow Homer* (1961), ill. p. 45; p. 238, includes it in chronology; pp. 249, 254 // P. C. Beam, *Winslow Homer at Prout's Neck* (1966), p. 7, calls it one of Homer's best war paintings and says it illustrates his "determination to finish any project he started; his insistence on tying up the loose ends of a period before he left it for another"; p. 262 // J. Grossman, *Echo of a Distant Drum* (1974), p. 96 (quoted above); pp. 97–98, color pl. 73; p. 99, describes the painting // S. Cochran, Harvard Club Library, orally, Nov. 15, 1978, provided biographical information on the donor's husband // J. A. Barter, Mead Art Museum, Amherst College, Amherst, Mass., letters in Dept. Archives, Dec. 19, 1978, and Jan. 10, 1979, provides information on the Amherst study // G. Hendricks, *The Life and Work of Winslow Homer* (1979), p. 90, lists with works shown at the NAD in 1872; ill. p. 315, CL-521; p. 316, states: "It is difficult to see rain in the blue sky of this picture, or how the fire could be burning so vigorously in the rain" // N. Spassky, *MMA Bull.* 39 (Spring 1982), p. 10, fig. 7, discusses.

EXHIBITED: NAD, 1872, no. 334, as Rainy Day in Camp, lent by Milton // Pennsylvania Museum of Art, Philadelphia, 1936, *Winslow Homer, 1836–1910*, no. 3 // Carnegie Institute, Pittsburgh, 1937, *Centenary Exhibition of the Works of Winslow Homer*, no. 27 // MMA, 1939, *Life in America*, ill. p. 149, no. 197 // NAD, 1942, *Our Heritage*, no. 99 // American Federation of Arts, 1954–1955, *Picture of the Month*, no cat. // MMA, 1965, *Three Centuries of American Painting*, unnumbered cat. // Lehigh University, Bethlehem, Pa.; Reading Public

Museum and Art Gallery, Pa.; Everhart Museum, Scranton, 1971, *Creativity in Crisis, 1871–1971*, ill. no. 2.

ON DEPOSIT: NAD, 1941–1950; Executive Mansion, Albany, N. Y., 1955–1961.

Ex COLL.: William F. Milton, New York and Pittsfield, Mass., 1871–1905; his wife, 1905–1923.

Gift of Mrs. William F. Milton, 1923.

23.77.1.

Snap the Whip

Snap the Whip, showing a group of boys at play in front of a red schoolhouse, is perhaps Homer's best-known genre painting. It offers a striking contrast to early treatments of such idyllic subjects as HENRY INMAN's *Dismissal from School on an October Afternoon*, 1845 (MFA, Boston). The composition is essentially based on a chalk drawing now in the Cooper-Hewitt Museum. Homer painted two versions of *Snap the Whip*, both dated 1872. The other, in the collection of the Butler Institute of American Art, Youngstown, Ohio, is larger and has an additional figure and a mountainous background. Although Homer did not usually paint an oil study first, it appears that for some reason in this case he did and that the Metropolitan's picture is the study. Infrared reflectography shows that he made many changes in it. Originally he had two children standing by the side of the schoolhouse. He also made changes in the trees. What is more significant, however, is that this painting once had a mountainous background like the Youngstown painting.

The Youngstown version, first owned by the New York collector John H. Sherwood, was shown at the Centennial Exhibition in Philadelphia in 1876, the Exposition Universelle in Paris in 1878, and the Homer memorial exhibition at the Metropolitan in 1911. Little is known of the early history of the Metropolitan's picture, which was probably painted shortly before the Youngstown version. A drawing also at the Butler Institute of American Art was probably used, as Lloyd Goodrich noted, for tracing the composition onto a woodblock to make the double-page illustration that appeared in *Harper's Weekly* on September 20, 1873.

Children were popular in nineteenth-century American genre painting, often serving as a reflection of the young nation. American artists explored the subject in compositions celebrating the innocence of childhood, senti-

mental scenes satisfying mid-Victorian taste, humorous representations characterizing the independent, rebellious, high-spirited nature of youth, and works demonstrating youth's self-reliance in adapting to the social realities of an increasingly urbanized society. The proliferation of such imagery following the Civil War has at times been attributed to an optimistic prognosis for the nation's future and a nostalgic exercise in lost innocence. What distinguished Homer's handling of the subject in the 1870s from all but a few was his candid objectivity and lack of sentiment.

The American character of the subject and the power and originality of Homer's style overshadowed what some contemporaries described as his technical shortcomings. In composition, use of light, modeling of form, and painting technique, Homer followed an established formula that characterizes many of his early figure pieces: the placement of figures in the immediate foreground in a frieze-like arrangement derived from classical art, the use of bright light, and the subsequent definition of form in sharp dark and light contrasts.

Homer's inspiration for the subject is not known. In his library he had a children's book called *The Boy's Treasury of Sports, Pastimes, and Recreations* (Philadelphia, 1847), which contained nearly four hundred engravings by Williams and Gilbert. (His copy of the book is now in the Strong Museum, Rochester, N.Y.) Many games are described and illustrated, but, unfortunately, snap the whip is not among them. The illustrations, however, have some similarities to Homer's works featuring children.

The site represented in *Snap the Whip* has not been identified. W. J. Whittemore's "Memorandum of a conversation with Bruce Crane N. A. at the Salmagundi Club, Nov. 17th 1933" (Long Island Collection of the East Hampton Library) states that Homer painted *Snap the Whip* in East Hampton. In a note, dated January 1937, Whittemore adds that Crane did not see Homer paint *Snap the Whip* but the boys who had posed for it told him about it subsequently. Others have suggested that the work was inspired by Homer's visits to Hurley, New York. The drawing at Cooper-Hewitt which served as the model for both paintings represents only the figures with no indication of the setting and could well have been done anywhere. Following what appears to have been his customary practice

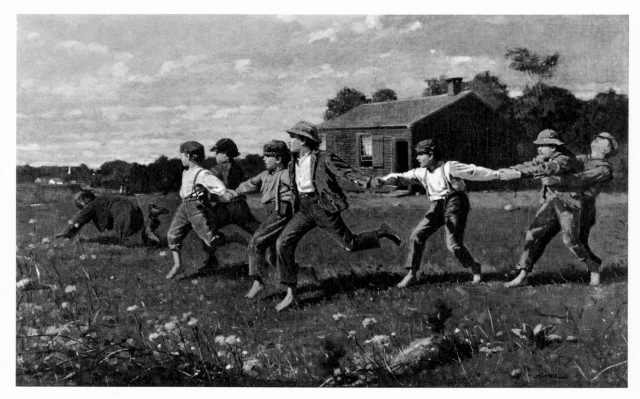

Homer, *Snap the Whip*.

Homer, study for
Snap the Whip, black
chalk on green paper.
Cooper-Hewitt Museum.

Infrared reflectography
of the Metropolitan
painting shows children
that Homer painted out
by the side of the
schoolhouse.

458

Butler Institute of American Art's *Snap the Whip* by Homer.

Homer, study for
Snap the Whip, pencil
on paper. Butler Institute
of American Art.

Wood engraving
by Lagarde for
Harper's Weekly,
September 20, 1873

during the 1860s and 1870s (see *Rainy Day in Camp* and *Eagle Head, Manchester, Massachusetts*), Homer reused certain features in other works, for example, a schoolhouse like the one in both versions of *Snap the Whip* is the subject of an undated painting called *School-Time* (coll. Mr. and Mrs. Paul Mellon).

Snap the Whip provided an exuberant image of rural America that satisfied a taste for works of a national character. In 1879 George W. Sheldon described it and other paintings by Homer as "a chapter in the life of an American boy." JOHN FERGUSON WEIR, in a report on the art section of the Centennial Exhibition, commended Homer for selecting "subjects exclusively from American life and customs, and with marked individuality of treatment" (*United States Centennial Commission, International Exhibition 1876, Reports and Awards, Groups XXI–XXVII*, ed. by F. A. Walker, 7 [1880], p. 630).

Oil on canvas, 12 × 20 in. (30.5 × 50.8 cm.).
Signed and dated at lower right: HOMER 1872.

RELATED WORKS: *Snap the Whip*, black chalk on green paper, 9 3/16 × 16 1/2 in. (23.3 × 41.9 cm.), Cooper-Hewitt Museum, New York, ill. in Cooper-Hewitt Museum of Decorative Arts and Design, *Winslow Homer, 1836–1910* (1972), exhib. cat. by E. E. Dee, no. 31, dates it "probably 1872" // *Snap the Whip*, oil on canvas, 22 × 36 in. (55.7 × 91.4 cm.), 1872, Butler Institute of American Art, Youngstown, Ohio, ill. in L. Goodrich, *Winslow Homer* (1944), pl. 10 // *Snap the Whip*, pencil on paper, 8 11/16 × 19 1/2 in. (22.1 × 49.5 cm.), Butler Institute of American Art, Youngstown, Ohio, ill. in L. Goodrich, *The Graphic Art of Winslow Homer* (1968), p. 11, p. 31, no. 78B, dates it probably 1873 // Lagarde, *Snap-the-Whip*, wood engraving, 13 9/16 × 20 9/16 in. (34.5 × 52.2 cm.), in *Harper's Weekly* 17 (Sept. 20, 1873), pp. 824–825.

REFERENCES: *New York Times*, Dec. 16, 1872, p. 2, in a review of a reception at the Union League Club, reports: "Homer's 'Snapping the Whip,' which represents school-boys at play on the village green, is a great improvement on some of his later works. It is good in composition, drawing and expression, and pleasing, in spite of its crudities and apparent carelessness of execution" // Clarke's Art Rooms, New York, *Catalogue of Modern Paintings...*, Jan. 28, 1915, sale cat., no. 26, Snap the Whip, 20 × 12 (MMA copy annotated $275) // *MMA Bull.* 8 (June 1950), ill. p. 321 // Smith College Museum of Art, Northampton, Mass., and Williams College, Williamstown, Mass., *Winslow Homer: Illustrator* (1951), exhib. cat. by M. B. Cowdrey, p. 22, no. 20; ill. no. 20, lower left (not exhibited) // A. T. Gardner, *Winslow Homer* (1961), color ill. p. 146; p. 204, discusses Snap the Whip, mentions versions, notes that such works "per-

haps contain in themselves just about all that can be said about the simple joys and tribulations of the country schoolboy of 1870 or '80 These are American pictures that make one grateful for the sympathetic genius who was willing to see in them subjects worthy of his brush. Here one is not conscious of Japanese design or French technique or Ruskinian ideas, though perhaps all these influential ideas were by now well assimilated in the artist's work"; pp. 250, 254, lists it // J. Gould, *Winslow Homer* (1962), p. 123, says the painting was done in Hurley, New York; p. 135; pp. 183–184, notes, Homer "had done two versions of the picture, one with a farm background of Hurley, the other against a setting of rugged New England hills, which proved much more successful" // J. Wilmerding, *Winslow Homer* (1972), p. 87, compares composition of drawing, this version and final painting in Youngstown, notes oil study of the schoolhouse and discusses works presumably showing the interior of the same schoolhouse; detail, p. 70, color pl. 10; p. 103, ill. 3–9 // D. Tatum, *American Art Journal* 9 (May 1977), p. 93, discusses Homer's copy of *The Boy's Treasury of Sports, Pastimes, and Recreations* // G. Hendricks, *The Life and Work of Winslow Homer* (1979), p. 94, says that it was inspired by Homer's visits to Hurley, New York, suggests that this painting predates the Youngstown version, discusses drawing, engraving, and related works featuring the schoolhouse; ill. p. 316, CL-526 // N. Spassky, *Winslow Homer* (1981), color ill. pl. 5; p. 9 discusses; *MMA Bull.* 39 (Spring 1982), p. 16, discusses; color ill. p. 20, fig. 17 // A. Wang, Strong Museum, Rochester, N.Y., orally, July 21, 1983, provided information on Homer's copy of *The Boy's Treasury of Sports, Pastimes, and Recreations* // N. Cikovsky, Jr., National Gallery of Art, Washington, D. C., letter in Dept. Archives, March 2, 1984, supplies 1872 review of the picture and says that the reference to the village green seems to indicate that it is the Metropolitan's painting that is discussed.

EXHIBITED: Union League Club, New York, 1872 no cat. available) // MMA, 1950, *20th Century Painters* (not in cat.) // American Federation of Arts, traveling exhibition, 1951–1953, *American Paintings of the Twentieth Century*, no cat. // MMA, 1958–1959, *Fourteen American Masters*, no cat.; 1965, *Three Centuries of American Painting*, unnumbered cat. // Lytton Gallery, Los Angeles County Museum of Art and M. H. de Young Memorial Museum, San Francisco, 1966, *American Paintings from the Metropolitan Museum of Art*, p. 14; color ill. p. 90, no. 66 // MMA, 1970, *19th Century America: Paintings and Sculptures*, exhib. cat. by J. K. Howat and N. Spassky, no. 159 // National Gallery of Art, Washington, D.C., City Art Museum of Saint Louis, and Seattle Art Museum, 1971, *Great American Paintings from the Boston and Metropolitan Museums*, exhib. cat. by T. N. Maytham, no. 54 // Bronx Museum of the Arts, New York, 1972, *Games! ¡Juegos!* no. 131, lists it and, in unpaged text, notes incorrectly that it was painted in the Adirondacks in 1872 // Cooper-Hewitt Museum

of Decorative Arts and Design, New York, held at Wildenstein and Co., New York, 1972, *Winslow Homer, 1836–1910*, exhib. cat. by E. E. Dee (not in cat.) // MMA and American Federation of Arts, traveling exhibition, 1975–1977, *The Heritage of American Art*, exhib. cat. by M. Davis, color ill. p. 138, no. 59; rev. ed., 1977, color ill. p. 136, no. 58.

Ex COLL.: unidentified owner (Clarke's Art Rooms, New York, Jan. 28, 1915, no. 26, for $275); Christian A. Zabriskie, New York, by 1950.

Gift of Christian A. Zabriskie, 1950.

50.41.

Dressing for the Carnival

First exhibited as *Preparing for the Carnival* in Boston in 1878, this painting was retitled *Dressing for the Carnival* when Homer put it up for sale at the Kurtz Gallery in New York in 1879. It was subsequently also called *The Carnival*. The painting is dated 1877 and was presumably based on sketches made in Virginia in 1875. Thomas B. Clarke, one of Homer's major patrons, bought it from him in November 1892.

Homer depicted black people in scenes drawn from the Civil War, Reconstruction, and, after 1884, his travels in the West Indies. The earliest of these representations dates from his visits to Virginia as an artist-correspondent for *Harper's Weekly* during the Civil War. Black people figure prominently not only in Homer's illustrations of camp life but also in such early paintings as *The Bright Side*, 1865 (private coll., New York), which was singled out by the French critic Paul Mantz at the 1867 Exposition Universelle in Paris as a "tight, precise painting in the style of Gérôme, but with less dryness" (*Gazette des Beaux-Arts* 23 [Sept. 1867], p. 230).

In 1875 Homer returned to Petersburg, Virginia, and made studies of life among the blacks that served as the basis for a group of pictures painted over the next two years. Unlike many of his Civil War illustrations, these paintings are free of the caricature and stereotype that often characterized the representation of blacks in American genre painting at the time. For the most part, they give a closely observed record of the life of black people in the South during Reconstruction. These dispassionate representations had counterparts in some of the works of WILLIAM SIDNEY MOUNT and EASTMAN JOHNSON. Homer's realistic approach had earlier precedents, as Barbara Novak observed, citing as an example JOHN SINGLETON COPLEY's *Watson and the Shark*

(q.v. vol. 1). In 1878 George W. Sheldon described Homer's recent studies of black people "in their total freedom from conventionalism and mannerism, in their strong look of life, and in their sensitive feeling for character" as "the most successful things of the kind that this country has yet produced," (*Art Journal* 4 [August 1878], p. 227). They included *The Cotton Pickers*, 1876 (Los Angeles County Museum of Art), an idealized and monumental treatment of two women in a cotton field; *The Watermelon Boys*, 1876 (Cooper-Hewitt Museum, New York); *A Visit from the Old Mistress*, 1876 (National Museum of American Art, Washington, D. C.); *Sunday Morning in Virginia*, 1877 (Cincinnati Art Museum); and this work.

The focal point of this composition is a grave young man, flanked by two women who are solemnly and intently putting finishing touches on his harlequin costume. The fierce-looking, pipe-smoking woman on the right is among the more memorable figures in Homer's works and one of his rare, fully realized character studies. Several children watch the preparations with varied expressions of awe, excitement, and expectancy. Because two of them carry American flags, Harry B. Wehle (1923) conjectured that the carnival might be part of a Fourth of July celebration. Mary Ann Calo (1980) and Jessie J. Poesch (1983) have since suggested that the occasion represented might be a pre-Lenten carnival. In the New York *Art Journal* of November 1878, the painting was described as "a very characteristic and humorous negro sketch." The contrasting attitudes of the adults and children, the somberness of the young man preparing to play the clown, the presence of the flags, and the nature of the forthcoming celebration suggest undercurrents of meaning beyond the simple preparations for a carnival. What perhaps is intended is a comment on the life of blacks in the South during Reconstruction.

The figures in the immediate foreground are arranged in the frieze-like fashion that Homer favored in his early figure compositions. This group is reinforced by the wooden fence that extends the width of the painting in the middle ground. The dense foliage in the background and the frame houses with tall red brick chimneys at the right further inhibit spatial recession. The bright overhead light is another characteristic of Homer's early figure compositions. Light is used to model form and give the figures a sculp-

tural quality. A sensitive use of color also distinguishes this work. In contrast to the muted background, the foreground is painted with a wide range of intensely saturated colors often juxtaposed for maximum contrast. The patchlike application of paint complements the harlequin's brilliantly colored decorative patches and provides an ironic contrast to the utilitarian patches on the clothes of the onlookers.

Oil on canvas, 20 × 30 in. (50.8 × 76.2 cm.).

Signed, inscribed and dated, at lower right: WINSLOW HOMER N. A. / 1877.

RELATED WORK: *Waiting for His Breakfast. From a War-time Sketch*, photographic reproduction in *Battles and Leaders of the Civil War* (New York, 1888), 4, p. 239, ill. in M. A. Calo, *American Art Journal* 12 (Winter 1980), p. 27, fig. 24.

REFERENCES: [New York] *Art Journal* 4 (Nov. 1878), p. 352 (quoted above), mentions as Preparing for the Carnival on exhibition in an unidentified Boston gallery // *New York Herald*, April 3, 1879, p. 6, in a preview of exhibition at the Kurtz Gallery, says, "A Winslow Homer, which contains some remarkably strong work, shows negroes preparing for the carnival" // *New-York Daily Tribune*, April 8, 1879, p. 5, in report on exhibition at the Kurtz Gallery notes, "Mr. Winslow Homer's 'Dressing for the Carnival' is too farcical though there are touches of expression and attitude which allow this clever artist's usual quiet observation" // W. Homer to T. B. Clarke, April 23, 1892, Misc. MSS Homer, Arch. Am. Art, says he will sell Dressing for the Carnival and A Visit from the Old Mistress for $1,000, although he intended the latter for Mr. W. T. Evans because it was a companion to his Sunday Morning in Virginia; adds that Dressing for the Carnival was shown "at the club" and asks $750 for it; states that he would prefer to have both "in some gallery" // Clarke to Homer, Nov. 5, 1892, Lloyd Goodrich's Copies of Winslow Homer Letters, 1860s–1910, microfilm NY/59–12, Arch. Am. Art, writes, "I enclose my check for $1000. in payment of the unframed canvases 'Carnival' 'Visit to the Missus' I had no idea of exhibiting your picture [probably The Camp Fire or this work] except in one room in my residence in 44 St. The display at the NAD was for a week and made a happy hit" // Homer to Clarke, Nov. 9, 1892, Misc. MSS Homer, Arch. Am. Art, acknowleges receipt of $1,000 in payment for two oil paintings, A Visit from the Old Mistress and Dressing for the Carnival // W. H. Downes, *The Life and Works of Winslow Homer* (1911), ill. opp. p. 76; p. 85, discusses Homer's trip to Petersburg in 1876 and the paintings of blacks, including The Carnival of 1877, that resulted from studies made there; p. 87, describes as The Carnival, states that it "is notable for its fine color as well as its capital delineation of character"; pp. 87–88, notes that it was bought by Clarke and included

in his sale in 1899, where it was acquired by Mr. N. C. Matthews of Baltimore for $220; p. [165], lists it as Dressing for the Carnival, lent to the World's Columbian Exposition at Chicago in 1893 by Clarke; p. 203, lists it with Clarke pictures shown at the Union League Club in March 1898 // K. Cox, *Winslow Homer* (1914), p. 25, mentions Homer's trip to Petersburg and calls the paintings based on the visit "sober and excellent genre pictures, but without the 'Homeric' lift of his great successes" // J. C. Van Dyke, *American Painting and Its Tradition* (1919), pp. 97–98, notes: "It was a *genre* interesting only in theme, for Homer's workmanship was still without any great merit or impressiveness" // H. B. W[ehle], *MMA Bull.* 18 (Feb. 1923), ill. p. 39; pp. 40–41, states that several of the paintings based on his return visit to Virginia were sent to the Exposition Universelle of 1878 in Paris; quotes from London *Art Journal* and suggests that it represents a Fourth of July celebration // *Art News* 21 (March 3, 1923), ill. p. 6, reports acquisition and exhibition, says it was painted in Virginia in 1877 and that it "is essentially American and has a 'folksy' charm about it which expresses the same quality found in the songs of Stephen Collins Foster" // L. Goodrich, *Arts* 6 (Oct. 1924), p. 196; ill. p. 198 // *Pageant of America* 3 (1926), ill. p. 161, no. 339, describes the carnival and camp meeting as peaks in the life of the plantation black // T. Bolton, *Fine Arts* 18 (Feb. 1932), p. 28, notes that Homer worked in Virginia during 1876 and 1877 and that some of the pictures, for instance, The Carnival, "retain their original hardness," says the figures recall Vermeer; p. 53, catalogues it // H. Saint-Gaudens, *Carnegie Magazine* 10 (Feb. 1937), ill. p. 262; p. 263, discusses trip to Petersburg in 1876 and the paintings it inspired // A. C. Goodyear, *Parnassus* 10 (April 1938), p. 16; ill. p. 17 // *Magazine of Art* 32 (June 1939), ill. p. 328 // F. Watson, *Winslow Homer* (1942), color ill. p. [97] // E. P. Richardson, *American Romantic Painting* (1944), p. 37, no. 218; pl. 218 // L. Goodrich, *Winslow Homer* (1944), pp. 58–59, discusses trip to Petersburg in 1875 and paintings it inspired; p. 59, notes: "Humor was not absent, but not humor at the negroes' expense so much as sympathy with their primeval gaiety, as in *The Carnival* ..., where two women are solemnly sewing up a young buck in a brilliant pierrot costume. Here was another thing that attracted Homer — negro color, not only in their bodies but in their clothes, garish but instinctively right"; pp. 59–60, adds: "The yellow, scarlet and blue of the man's costume, the women's patched dresses with hues of blue, green and mauve, the mahogany flesh, all under strong sunlight picking out individual tones, revealed a color sense less inhibited than ever before, full of unexpected contrasts and curiously sophisticated harmonies, darker than the impressionist gamut but having much of its quality. It was about this time that we find the critics complaining particularly of the 'queerness' of his color"; p. 129, states that Clarke bought it and the painting A Visit from the Old Mistress in 1892 from the artist

Homer, *Dressing for the Carnival.*

for $1,000; p. 156, discusses Clarke sale of 1899, notes that prices were low only on some of the early works, including *The Carnival* which went for $220, comments that contemporary taste "agrees more with Clarke's than with the public's estimate of these early works"; pl. 17 // L. Goodrich, *Winslow Homer* (1959), p. 29, notes Homer's interest in blacks since Civil War days, adds that in his paintings of the 1870s, he "had been one of the first artists to get away from the old minstrel-show conceptions and to portray them truthfully and understandingly"; color ill. pl. 35; p. 114, lists plate in chronology // A. T. Gardner, *Winslow Homer* (1961), color ill. p. [91], p. 116, suggests that "Perhaps the most subtle effect of the Japanese print masters on Homer's work is to be found in the unconventional use of color that marks both his watercolors and his paintings in oil. This is one of the elements in his work that set him off from his contemporaries in the most conspicuous way. The Japanese sense of color shows plainly in many of his paintings; for instance, the picture of Negro life *The Carnival*, with its rich yet controlled harlequin dapplings of odd tints, is like the kimono design of the Eight Famous Beauties of the Green Houses"; p. 202, lists it among Homer's works

in the Clarke collection; pp. 241, 254, lists it // J. Gould, *Winslow Homer* (1962), p. 161, calls the humor "much more subtle" than in his painting The Watermelon Boys; p. 243, notes Clarke's acquisition of the painting // J. T. Flexner and the editors of Time-Life Books, *The World of Winslow Homer 1836–1910* (1966), color ill. pp. 86–87, says he returned to Virginia several times and mentions that a resulting "half dozen" paintings show "the ex-slave with rare sympathy" // B. Novak, *American Painting of the Nineteenth Century* (1969), ill. p. 181, fig. 10–19; pp. 181–182, states that "By 1877, when Homer painted *The Carnival*..., he was concerning himself primarily with light striking colorfully costumed forms. Both represent, in addition, a genuine attempt to rescue the black from Uncle Tom status in American art"; compares Mount's and Homer's representations of blacks; p. 311, n 19, mentions Copley's representation of a black in Watson and the Shark // J. Wilmerding, *Winslow Homer* (1972), p. 94, discusses Homer's 1875 trip to Petersburg and his oils of "life among the blacks, which may be seen as southern counterparts to his Gloucester scenes"; states that The Carnival and other paintings on the same subject "demonstrated Homer's sympathy for the

color and gaiety in the lives of these individuals"; notes: "These are solidly composed paintings, and the figures are often sculptural and monumental. Homer especially enjoyed the bright patterns made by the dark skin and colorful clothing of these figures. Whether at rest or play, they convey the same sense of enjoyment and self-possession as their northern contemporaries painted by Homer. In deft balance too, are the same comic and serious touches"; p. 120, ill. 3-40; color ill., detail, p. 130, pl. 22 // H. W. Williams, Jr., *Mirror to the American Past* (1973), p. 184, discusses 1875 trip to Virginia and paintings of blacks; p. 185, discusses this painting, which he dates ca. 1877, and notes its authenticity, color, and strong sunlight // H. B. Weinberg, *American Art Journal* 8 (May 1976), p. 75, lists it in checklist of paintings owned by Clarke, notes purchase by Clarke, price, and subsequent sale // M. W. Brown, *American Art to 1900* (1977), pp. 499–500, comments that the paintings Homer did on black themes in the two years following his return trip to Virginia in 1875 are "remarkable in their truth of observation, sympathy for the people, and monumentality of treatment and unusually free of caricature, stereotype (sometimes noticeable in his Civil War illustrations), exoticism, or condescension"; p. 500, notes "color and vitality" of The Carnival and adds that Homer "did not always skirt sentimentality" in his paintings of blacks, "for, with all his reticence, he was obviously moved by their condition and humanity"; p. 500, pl. 635 // M. Quick, *Los Angeles County Museum of Art* 24 (1978), p. 66, says that this painting, "which shows a family dressing the eldest son in a Mardi Gras costume, brings to mind the many village fetes, with young girls in traditional finery, that formed a staple of French painting"; p. 67, fig. 11; p. 69, compares with the work of such contemporaries as Thomas Hovenden and says, "Homer avoided the excessively anecdotal and brought to his subjects a new degree of close observation. The way in which awkward but characteristic poses and gestures are captured by Homer reveals an artistic frankness unusual for the period"; p. 72, observes that "the black figures are arranged in a shallow frieze across the near foreground" // G. Hendricks, *The Life and Work of Winslow Homer* (1979), p. 104, suggests trip to Virginia was made at the end of 1873 as well as 1875 and 1876, discusses this picture and states that a "sketch" called "4th July in Virginia" shown at the Century Association on June 2, 1877, "was evidently a study for *The Carnival*," states that it could have been done no later than July 4, 1876, and concludes that this picture "was based on earlier studies"; p. 130; p. 206, says Thomas B. Clarke bought it in 1892; p. 214, lists it among best works sent to the World's Columbian Exposition in Chicago in 1893; ill. p. 314, CL-500 // M. A. Calo, *American Art Journal* 12 (Winter 1980), p. 10, lists among paintings "traditionally believed to be results of visits by Homer to Virginia during the mid-1870s"; pp. 19–20, describes it, discusses 1898 exhi-

bition at the Union League, and quotes review and anecdote about this painting in the *New York Sun*, March 12, 1898, which said that it was done in Smithtown, Virginia, quotes similar story related in the *Churchman*, July 23, 1898, which suggests that it represents Christmas festivities, conjectures that the story originated with the artist and that the town is Smithfield which was not far from Petersburg, suggests that sketches for the painting may have been done during the Civil War, notes that the little girl on the far left appears in Homer's illustration for *Battles and Leaders of the Civil War* (1884–1888), and observes that the child's "presence in the painting seems arbitrary"; p. 22, fig. 20 // N. Cikovsky, Jr., July 17, 1981, orally, suggested that the festivities might originate in an African festival // N. Spassky, *Winslow Homer* (1981), p. 10, discusses; color ill. pl. 6; *MMA Bull.* 39 (Spring 1982), p. 19, discusses; color ill. p. 21, fig. 19.

EXHIBITED: Boston, 1878, as Preparing for the Carnival // Kurtz Gallery, New York, April 1–7, 1879, *Catalogue of the American Collection of Paintings, Contributed, in Every Instance, by the Artist Represented*, sale cat. (April 8 and 9, 1879), no. 107, under April 9, as Dressing for the Carnival // NAD, Oct. 1892, *Loan Exhibition (New York Columbian Celebration of the Four Hundredth Anniversary of the Discovery of America)*, no. 80, as The Carnival, lent by Thomas B. Clarke // World's Columbian Exposition, Chicago, 1893, no. 566, as Dressing for the Carnival, lent by Thomas B. Clarke // Union League Club, New York, 1898, *The Paintings of Two Americans, George Inness, Winslow Homer*, no. 27, as The Carnival, lent anonymously by T. B. Clarke // Pennsylvania Museum of Art, Philadelphia, 1936, *Winslow Homer, 1836–1910*, no. 10 // Whitney Museum of American Art, New York, 1936–1937, *Winslow Homer Centenary Exhibition*, cat. by L. Goodrich, no. 15 // Carnegie Institute, Pittsburgh, 1937, *Centenary Exhibition of the Works of Winslow Homer*, cat. by H. Saint-Gaudens, p. 7, notes that Homer was in Virginia in 1876; no. 35 // Musée du Jeu de Paume, Paris, 1938, *Trois siècles d'art aux Etats-Unis*, no. 79, and fig. 18 // MMA, 1939, *Life in America*, ill. no. 178 // Robert McDougall Art Gallery, Canterbury, New Zealand, 1951, *Centennial Art Loan Exhibition*, no cat. // Wildenstein, New York, 1947, *A Loan Exhibition of Winslow Homer (for the Benefit of The New York Botanical Garden)*, cat. by L. Goodrich, p. 33, no. 21, ill. p. 52, no. 21 // Munson-Williams-Proctor Institute, Utica, N.Y., 1952, *Painting of the Month* // National Gallery of Art, Washington, D. C., 1958–1959, MMA and MFA, Boston, 1959, *Winslow Homer: A Retrospective Exhibition*, cat. by A. T. Gardner, no. 41; Boston ed., no. 36 // Bowdoin College Museum of Art, Brunswick, Me., 1964, *The Portrayal of the Negro in American Painting*, intro. by S. Kaplan, says that even in this painting "a sad stillness prevades the central group—it is a rather unhilarious carnival, only the children smile, unraucously"; no. 45, quotes *Boston Post*, March 1, 1879: "The Negro boys, girls and women which this

artist produced in oils a year or more ago—their tawny skins, their superbly modelled faces, their full contours, their admirable balance and movement—why, no painter in this or any other country ever so successfully and nobly fixed upon canvas the typical historical American African. A hundred years from now those pictures alone will have kept him famous"; ill. no. 47; intro. reprinted in *Massachusetts Review* 7 (Winter 1966), p. 112 // M. H. de Young Memorial Museum, California Palace of the Legion of Honor, San Francisco Museum of Art, 1964–1965, *Man, Glory, Jest and Riddle*, no. 191 // MMA, 1965, *Three Centuries of American Painting*, unnumbered cat. // Forum Gallery, New York, 1967, *The Portrayal of the Negro in American Painting*, ill. no. 17 // Whitney Museum of American Art, New York; Los Angeles County Museum of Art; and the Art Institute of Chicago, 1973, *Winslow Homer*, exhib. cat. by L. Goodrich, p. 32, discusses 1875 return to Petersburg and Homer's paintings of blacks; color ill. p. 79; p. 135, no. 39 // Virginia Museum, Richmond, traveling exhibition, 1983–1985, *Painting in the South* (shown only at the Virginia Museum, Birmingham Museum of Art, and NAD), essay by J. J. Poesch, pp. 90–91, discusses subject as Catholic pre-Lenten festival; quotes 1898 story; says the costumes were worn by blacks "at Christmas in Virginia" and "the custom was called 'carnival'"; says it may relate to English Boxing Day; exhib. cat. by D. S. Bundy, p. 253, no. 91; ill. p. 254, suggests that it represents Christmas festivities.

Ex COLL.: the artist (sale, Kurtz Gallery, New York, April 9, 1879, no. 107, as Dressing for the Carnival); the artist, by 1892; Thomas B. Clarke, New York, Oct. 1892–1899 (sale, American Art Galleries, New York, Feb. 14, 1899, no. 86, as The Carnival, $220); N. C. Matthews, Baltimore, Feb. 1899–after 1911; with Kraushaar Galleries, New York, 1922.

Amelia B. Lazarus Fund, 1922.
22.220.

Harvest Scene

Early in this century there was some question about the authenticity of this painting, even though it bears Homer's signature. On a card dated March 22, 1908, once attached to the back of the painting, the artist authenticated it: "This picture now submitted to me 'Harvest Scene' I acknowledge as being my work. Winslow Homer."

The painting has also been called *In the Field* and *Harvest*. Undated, it is usually assigned to about 1873, or several years after Homer's first trip to Europe in 1866–1867. Because the ox-drawn haywagon is similar to one in the wood engraving *The Last Load* published in *Appleton's Journal* on August 7, 1869, however, Gordon Hendricks suggested that it dates about 1869. Farm life was the subject of a group of works Homer made during the late 1860s and early 1870s. Most, judging from extant studies, were based on direct observation; and his preoccupation with the subject, his interest in light outdoors, and his technique have their counterparts in the works of the Barbizon painters.

Painted with quick fluent brushstrokes, *Harvest Scene* has the spontaneity of a work done on the spot. The trees, however, silhouetted in an irregular pattern against the light sky, are deliberately calculated and reflect a sense for pictorial design. Homer's use of a direct overhead light to define the middle distance and an asymmetrically placed figure to serve as a focal point is especially effective.

Oil on canvas, 10 × 24 in. (25.4 × 61 cm.).
Signed at lower left: Winslow Homer.

Homer, *Harvest Scene*.

REFERENCES: W. Homer, March 22, 1908, label once on back of the painting, Dept. Archives (quoted above) // *Catalogue of the Collection of Foreign and American Paintings Owned by Mr. George A. Hearn* (1908), p. xii, as In the Field; p. 170, pl. 211 // B. D., *MMA Bull.* 4 March 1909), p. 53, lists it as Harvest among the Hearn fund purchases // C. Brinton, *Scribner's Magazine* 49 (Jan. 1911), ill. p. 12, as Harvest Scene // MMA, *George A. Hearn Gift to the Metropolitan Museum of Art . . .* (1913), p. 3, as In the Field; ill. p. 89 // T. Bolton, *Fine Arts* 18 (Feb. 1932), p. 53, lists it as Harvest and dates it about 1873 // L. Goodrich, *Winslow Homer* (1944), p. 234, as Harvest Scene // A. T. Gardner, *Winslow Homer* (1961), ill. p. 122; pp. 247, 254, lists it // G. Hendricks, *The Life and Work of Winslow Homer* (1979), p. 315, ill. CL–507, suggests it dates about 1869.

EXHIBITED: Depot Museum of the Garrison Landing Association, Garrison, N. Y., 1966, *Hudson River Painters*, no. 13 // American Federation of Arts, traveling exhibition, 1967–1968, *American Masters*, p. 22, no. 24; p. 72, a discussion by S. P. Feld notes titles and dates it about 1873; ill. p. 73 // Queens County Art and Cultural Center, New York; MMA; Memorial Art Gallery of the University of Rochester, N. Y.; Sterling and Francine Clark Art Institute, Williamstown, Mass., 1972–1973, *19th Century American Landscape*, exhib. cat. by M. Davis and J. K. Howat, no. 22 // Lowe Art Museum, University of Miami, 1974–1975, *19th Century American Topographic Painters*, essay by J. Wilmerding, p. 13, no. 68 // Museum of Fine Arts, Saint Petersburg, and the Henry Morrison Flagler Museum, Palm Beach, Fla., 1976, *"The New Vision," American Styles of 1876–1910*, exhib. cat. by M. D. Schwartz, unnumbered // Queens Museum, New York, 1976, *Cows*, no. 31.

ON DEPOSIT: Virginia Museum of Fine Arts, Richmond, 1947–1950.

EX COLL.: George A. Hearn, New York, by 1908.

George A. Hearn Fund, 1909.

09.26.6.

Camp Fire

Homer's first recorded visit to the Adirondacks in upstate New York was in September of 1870. Accompanied by the painters Eliphalet Terry (1826–1896) and John Lee Fitch (1836–1895), he stayed at a farm near Minerva, New York, on the site of what is now the North Woods Club. He returned to the Adirondacks frequently in succeeding years, often in the company of his brother Charles, who shared his love of outdoor life. Both were charter members of the North Woods Club, founded in 1886. According to the club's register, Homer made his last trip to the Adirondacks in June 1908.

Painted in Keene Valley, *Camp Fire* is dated 1880. In 1910, in a letter to the editor of *American Art News*, in which he identified the site, the artist Roswell M. Shurtleff (1838–1915) reported that the painting "was so real, a woodsman could tell what kind of logs were burning by the sparks that rose in long curved lines."

The painting, exhibited at the National Academy of Design in 1880, was discussed by the critic George W. Sheldon in the April issue of the *Art Journal*. While emphasizing Homer's preference for painting outdoors directly from nature, Sheldon reported that Homer nevertheless occasionally improvised to achieve a desired effect:

> He painted it out-of-doors; but the large tree . . . , the line of which answers to the line of one of the poles of the tent, is not in the original scene. He found it elsewhere, built a fire in front of it, observed the effect, and transferred it to the canvas. With this exception, the composition is a general transcript of the surroundings of a fire lighted one night while he was camping in the Adirondacks.

Despite Sheldon's report, it appears that Homer had drawn a similar campfire some six years earlier for a wood engraving titled *Camping Out in the Adirondack Mountains*, published in *Harper's Weekly* on November 7, 1874. Originally the campfire was probably drawn from life, found satisfactory, and subsequently used as a model for the two works, a practice that Homer often followed. The print is essentially a forerunner of the painting and contains many of the same elements. It shows two fishermen seated at a campfire in front of a shelter made of saplings and bark on the bank of a lake or river. The details in the print—canoe, fishing equipment, fish, a dog—reinforce the narrative character of the work. Many of Homer's prints have a more pronounced anecdotal character than their related paintings. In *Camp Fire*, only the tackle basket and net remain to indicate that the men were fishing, and many of the features that characterized the print have been eliminated, making the narrative content less explicit. The shelter has been constructed under a partly uprooted cedar, which functions both as an image of ravaged nature and as a striking feature in the design of the composition. The thrusting diagonal line of the tree counteracts the main diagonal of the shelter. A com-

Homer, *Camp Fire*.

pletely uprooted cedar appears in the print, but it plays a minor role in the design. The fishermen in *Camp Fire*, like the figures in many other works by Homer, appear as separated and noncommunicating. The self-absorbed seated man strongly resembles both the central figure in *Shooting the Rapids, Saguenay River* (q. v.) and two watercolor portraits of the artist's brother Charles (see T. Bolton, *Fine Arts* [April 1932], p. 16, and G. Hendricks, *The Life and Work of Winslow Homer* [1979], p. 137, fig. 214).

Camp Fire brilliantly displays Homer's skill as a colorist and his power as a designer. The shower of sparks shooting from the campfire, the restrained yet decorative berries and foliage, and the dynamic diagonals of the shelter and the cedar create subtle patterns. Albert Ten Eyck Gardner attributed Homer's skill in design to the influence of Japanese prints. He saw *Camp Fire* as a prime example of this and suggested that it showed Homer's familiarity with Japanese prints of fireworks. Equally influential perhaps were Whistler's nocturnes and brilliant fireworks dis-

plays. Artists of the late nineteenth century were interested in depicting night and the special effects of natural and artificial illumination. Homer's treatment of the subject bears the stamp of originality that distinguishes his work. Unfortunately, like other works painted in light pigments on a dark ground, *Camp Fire* has darkened considerably with time.

Oil on canvas, 23¾ × 38⅛ in. (60.3 × 96.8 cm.).
Signed and dated at lower right: HOMER 80.
REFERENCES: [G. W. Sheldon], *Art Journal* 6 (April 1880), p. 107 (quoted above), reprinted in *Hours with Art and Artists* [1882], p. 137–138 // *Art Amateur* 2 (May 1880), p. 112, in review of NAD exhibition, describes this painting: "it is hard, dense, opaque, metallic, but there is an illusion of flying sparks, darting upward in snake-like curves, which has never been painted before and so natural that the eye is imposed on and convinced that the sparks do fly upward" // *Scribner's Monthly* 17 (June 1880), p. 315, in review of NAD exhibition, says that Homer's works include "a fresh, unusual and audacious picture of a camp-fire with men" // *New York Mail and Express*, Oct. 7, 1892,

p. 1, in a review of the Columbian celebration loan exhibition at the NAD, discusses works lent by Thomas B. Clarke and says, "The seven canvases by Homer comprise some of his most admirable works, among them 'The Camp Fire'" // R. M. Shurtleff, *American Art News* 9 (Oct. 29, 1910), p. 4, letter to the editor, dated Oct. 24, 1910 (quoted above) // W. H. Downes, *The Life and Works of Winslow Homer* (1911), pp. 95–96; describes it, notes history of ownership and exhibitions, p. 165, lists with works shown at the World's Columbian Exposition in 1893; p. 203, discusses 1898 exhibition at the Union League Club and lists with paintings by Homer in Clarke's collection; pp. 257, 277, 284, 286 // K. Cox, *Winslow Homer* (1914), p. 43, discusses it // K. Cox, *Scribner's Magazine* 56 (Sept. 1914), p. 378, discusses // B. B[urroughs], *MMA Bull.* 22 (Dec. 1927), p. 314, notes acquisition of the paintings and exhibition history; ill. p. [315] // T. Bolton, *Fine Arts* 18 (Feb. 1932), p. 54, includes it in catalogue of Homer's paintings, gives ownership and references // Macbeth Gallery, New York, *An Introduction to Homer*, (1936), exhib. cat., no. 35, notes that Camp Fire was possibly based on the engraving // L. Goodrich, *Winslow Homer* (1944), pp. 64–65, describes it as a "tour de force and a successful one . . . a vigorous piece of naturalism, with all the utter originality of vision that was Homer's when he was in direct contact with nature"; p. 66; pp. 117–118, notes that it was exhibited at Reichard's in February 1890 and quotes reviews; p. 129 // E. P. Richardson, *Painting in America* (1956), p. 316, says it shows "noteworthy originality not only in its study of firelight and flying sparks, but in its treatment of the masculine world of outdoor life that Homer was to make peculiarly his own" // Adirondack Museum, Blue Mountain Lake, N. Y., *Winslow Homer in the Adirondacks* (1959), exhib. cat., pp. 8, 23; p. 68, pl. 40 // A. T. Gardner, *Winslow Homer* (1961), p. 202; p. 204, discusses the influence of Japanese prints in the color and composition of this work, notes: "The Japanese elements in this picture are not obvious or forced in any way; the picture is entirely American in subject and feeling. It is here that Homer's genius best reveals itself; in his skillful use of oriental concepts of picturemaking unconfused with picturesque Asiatic externalities"; calls it "a tour de force," places it "among Homer's best works," and "among the very best American paintings of the time"; ill. p. 205; pp. 240, 245, 254 // J. Gould, *Winslow Homer* (1962), pp. 174–175, 176, 178; ill. p. 177; p. 239, notes that it was included in an exhibition of Homer's Adirondack oils and watercolors at Reichard's in Feb. 1890; p. 243, lists it in Clarke's collection // J. T. Flexner, *The Wilder Image* (1962), p. 347 // P. C. Beam, *Winslow Homer at Prout's Neck* (1966), pp. 13–14, says, "Discerning critics recognized almost at once the originality and promise of his *Camp Fire*, which may have given him some hint of the road to take"; p. 260 // H. B. Weinberg, *American Art Journal* 8 (May 1976), p. 75, includes it in a list of paintings owned by Clarke //

G. Hendricks, *The Life and Work of Winslow Homer* (1979), p. 138, discusses NAD annual exhibition of 1878, quotes reviews, and incorrectly concludes that The Trappers must be the same picture as the Metropolitan's Camp Fire as well as the painting called A Fresh Morning; p. 214; ill. p. 314, CL–498, says the artist had not been in the Adirondacks for six years, the log lean-to cannot be attributed to Homer's excursions there, and the painting most likely belongs to a fall trip between 1876 and 1879 // N. Spassky, *Winslow Homer* (1981), pp. 10–11, discusses; color ill. pl. 7; *MMA Bull.* 39 (Spring 1982), color ill. detail, inside front cover; pp. 19–21 discusses; ill. fig. 21.

EXHIBITED: NAD, 1880, no. 417, as Camp Fire, for sale // Reichard and Co., New York, Feb. 1890 (no cat. available) // PAFA, 1891, *Thomas B. Clarke Collection of American Pictures*, no. 85 // NAD, Oct. 1892, *Loan Exhibition (New York Columbian Celebration of the Four Hundredth Anniversary of the Discovery of America)*, no. 90, lent by T. B. Clarke // World's Columbian Exposition, Chicago, 1893, no. 568, lent by T. B. Clarke // Union League Club, New York, 1898, *The Paintings of Two Americans: George Inness, Winslow Homer*, no. 30, incorrectly dated 1876, lent anonymously by T. B. Clarke // NAD, 1910, *Winter Exhibition*, no. 213, lent by Mrs. H. K. Pomeroy // MMA, 1911, *Winslow Homer Memorial Exhibition*, no. 4, lent by H. K. Pomeroy // Bowdoin College Museum of Fine Arts, Brunswick, and Colby College, Waterville, Me., 1954, [*The Art of Winslow Homer*], unnumbered // National Gallery of Art, Washington, D.C., 1958–1959, MMA, and MFA, Boston, 1959, *Winslow Homer*, cat. by A. T. Gardner, no. 44; Boston ed., 1959, no. 40 // MMA, 1965, *Three Centuries of American Painting*, unnumbered // National Art Museum of Sport, Madison Square Garden, New York, 1968, *The Artist and the Sportsman*, p. 34, lists it; color ill. p. 35 // Whitney Museum of American Art, New York, Los Angeles County Museum of Art, and Art Institute of Chicago, 1973, *Winslow Homer*, exhib. cat. by L. Goodrich, no. 44, shown only in New York.

EX COLL.: Thomas B. Clarke, New York, 1880–1899 (sale, American Art Galleries, New York, Feb. 16, 1899, no. 239, $700); with Alexander Harrison, as agent, 1899; Henry K. Pomeroy, New York, 1899–1927.

Gift of Henry Keney Pomeroy, 1927.
27.181.

Moonlight, Wood Island Light

After Homer's visit to the English coastal village of Cullercoats in 1881–1882, the sea became his major theme. Initially, he was preoccupied with man's confrontation with the sea. In the mid-1890s, however, Homer began a series of paintings showing only water, coast, and sky.

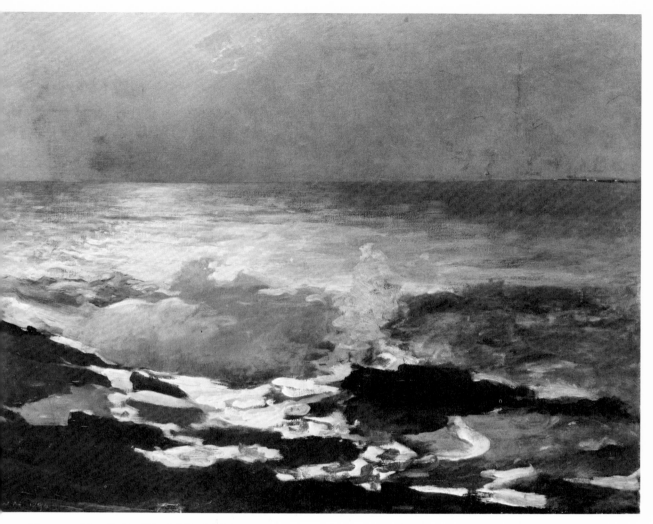

Homer, *Moonlight, Wood Island Light*.

These seascapes, powerful and immediate expressions of nature, established his reputation as America's major marine painter and to some extent overshadowed his early achievements in genre painting.

Dated 1894, *Moonlight, Wood Island Light* is one of this group of major seascapes. William Howe Downes in his 1911 biography of Homer, provides the following account of the painting:

No one who has lived by the seashore can have failed to treasure the memories of those perfect summer nights when the moon sends its beams athwart the wide field of the moving waters in a path of molten silver; and the fascination of watching this glorious spectacle never lost its power over our artist. One night in the summer of 1894, he was sitting on a bench, smoking, with his nephew, in front of the studio. It was a beautiful evening, with quite a sea running, but not much wind. Of a sudden, Winslow Homer rose from his seat, and said: "I've got an idea! Good night, Arthur!" He almost ran into the studio, seized his painting outfit, emerged from the house, and clambered down over the rocks towards the shore. He worked there uninterruptedly until one o'clock in the morning. The picture called "Moonlight—Wood Island Light," was the result of that impulse and four or five hours' work. . . . it was painted wholly in and by the light of the moon, and never again retouched. The very essence of moonlight is in it.

On many occasions and in diverse ways, Homer explored the effects of moonlight. In American painting, the moonlit image, associated with the romantic tradition, harks back to WASHINGTON ALLSTON'S *Moonlight Landscape*, 1819 (MFA, Boston). Homer's treatments of moonlight include the watercolor *Moonlight*, 1874 (Canajoharie Art Gallery, Canajoharie, N. Y.), the oil *A Summer Night*, 1890 (Musée National d'Art Moderne, Paris), often compared with this work for its similarities of composition, the watercolor *A Moonlight Sea*, 1890 (Wadsworth Atheneum, Hartford), and the oils *The Fountains at Night, World's Columbian Exposition*, 1893 (Bowdoin College Museum of Art, New Brunswick, Me.), *Searchlight, Harbor Entrance, Santiago de Cuba* (q. v.), and *Kissing the Moon*, 1904, (Addison Gallery of American Art, Phillips Academy, Andover, Mass.).

A tour de force, *Moonlight, Wood Island Light* is one of Homer's most effective and powerful representations of moonlight, sea, and sky. It was created with exceptional economy of brushwork and a severely restricted palette. The subject of this work is precisely described in its title. The moon is hidden by clouds, but as Downes pointed out, "the very essence of moonlight" is there. The dramatic effects are captured in the barely perceptible lightening of the sky, the light-tinged clouds, and the reflections on the water, so eloquently suggested in broad brushstrokes of heavy white paint. A red light on the horizon, from the lighthouse off Biddeford Pool on Wood Island, provides the vivid note of contrasting color—invariably red—that Homer frequently introduced into his works and gives the picture its name.

Oil on canvas, $30\frac{3}{4} \times 40\frac{1}{4}$ in. (78.1×102.2 cm.).

Signed and dated at lower left: W H 1894. Inscribed on original stretcher (now replaced): Wood Island Light, Winslow Homer.

REFERENCES: W. Homer to T. B. Clarke, Jan. 19, 1896, Misc. MSS Homer, Arch. Am. Art, says, "I wish to thank you for loaning that Moonlight picture to the Penn. Academy" // B. B[urroughs], *MMA Bull.* 3 (May 1908), p. 100, says that Moonlight, Wood's Island Light, on loan from George A. Hearn, has been recently hung and describes it // [W. S. Howard], *Catalogue of the Collection of Foreign and American Paintings Owned by Mr. George A. Hearn* (1908), p. 167, pl. 207, as Wood Island Light // W. H. Downes, *The Life and Works of Winslow Homer* (1911), ill. opp. p. 150; p. 170, includes it as Moonlight, Wood Island Light with works dated 1894; pp. 173–174, relates account of the painting of the work (quoted above), describes the

painting, and provides history of ownership; pp. 179, 181, 205, 258, 282, 284, 286 // *Bulletin of the Brooklyn Institute of Arts and Sciences* 6 (May 13, 1911), p. 384, in discussion of George A. Hearn collection, calls it Wood Island Light // G. A. Hearn to R. de Forest, June 14, 1911, MMA Archives, offers this painting and others to the Metropolitan in memory of his son // *MMA Bull.* 6 (July 1911), ill. p. 145, as Moonlight, Wood's Island Light; p. 146, lists it as Wood's Island Light in Hearn's offer of gift letter // MMA, *George A. Hearn Gift to the Metropolitan Museum of Art . . .* (1913), p. 108, lists it as a gift in memory of Arthur H. Hearn; ill. p. 111, as Wood's Island Light // J. C. Van Dyke, *American Painting and Its Tradition* (1919), p. 109, says, "The crests in the 'Woods Island Light' look like inlays of white marble on lapis lazuli" // T. Bolton, *Fine Arts* 18 (Feb. 1932), p. 54, includes it in catalogue as Moonlight—Wood Island Light, records inscription on back of the stretcher, and provides history of ownership // *Index of Twentieth Century Artists* 1 (Nov. 1933), pp. 2, 11; suppl. to 1, p. ii, lists reproductions // C. S. Hathaway, *Chronicle of the Museum for the Arts of Decoration of Cooper Union* 1 (April 1936), p. 53, states, "Before the War had ended, however, Homer's interests had widened to include the effect on color of variations in light—an interest which culminated so unimpressionistically in such paintings as *Moonlight—Wood Island Light*" // L. Goodrich, *Winslow Homer* (1944), pp. 142, 155, 187, discusses // A. T. Gardner, *Winslow Homer* (1961), ill. p. 220; p. 241, notes PAFA exhibition in 1895; pp. 248, 254 // P. C. Beam, *Winslow Homer at Prout's Neck* (1966), p. 120, fig. 39; p. 120, says it is one of "the most exhilarating and impressive of all his marines" and "shows almost the same view as A Summer Night . . ., but the figures and other distracting elements have been eliminated; even the waves are the gently pulsing ones so characteristic of the summer sea at night"; and says it "is a supremely beautiful culmination of Homer's long study and appreciation of moonlight" // M. D. Davis, *Winslow Homer: An Annotated Bibliography of Periodical Literature* (1975), p. 92, lists reproductions // H. B. Weinberg, *American Art Journal* 8 (May 1976), p. 75, mentions it among paintings owned by Clarke, who acquired it from Reichard and Company in February 1895 and sold it for $3,650 in 1899 // W. B. Bailey, Biddeford Historical Society, Me., letter in Dept. Archives, Feb. 9, 1979, describes the location as follows: "Wood Island is a small island just off Biddeford Pool and looking from Prout's Neck would indeed appear to be connected to the Pool. It does have a lighthouse which was first put into operation in 1808 and thus I feel quite sure that this is the Island and light mentioned" // G. Hendricks, *The Life and Work of Winslow Homer* (1979), pp. 220–221, lists it among best works of its period; pp. 222–223, says it was shown at the Century Association in February and March of 1895, lent by Clarke to the Carnegie Institute the same year with the title Moonlight, Wood's Island Light, Coast

of Maine; says that Carnegie records identify it as "a picture of the lighthouse near Biddeford Pool" and that it was confused with the Corcoran's *A Light on the Sea* in Homer's obituary in *Art News*; notes that it was requested for the PAFA annual of Dec. 1895; ill. p. 315, CL–514 // N. Spassky, *Winslow Homer* (1981), p. 12, discusses; color ill. pl. 10 and detail; *MMA Bull.* 39 (Spring 1982), color ill., pp. [24–25], fig. 22; pp. 26, 30, discusses.

EXHIBITED: Century Association, New York, Feb.-March 1895 (no cat. available) // Carnegie Institute, Pittsburgh, 1895, [*The Dedication Souvenir of the Carnegie Library*], *A Catalogue of Paintings Exhibited at the Carnegie Art Galleries*, no. 143, *Wood's Island Light, Coast of Maine*, lent by Thomas B. Clarke // PAFA, 1895–1896, no. 173, as *Wood's Island Light, Moonlight*, lent by Thomas B. Clarke // Union League Club, New York, 1898, *The Paintings of Two Americans, George Inness, Winslow Homer*, no. 34, as *Moonlight—Wood's Island Light*, lent anonymously by T. B. Clarke // Corcoran Gallery of Art, Washington, D. C., 1907, *First Annual Exhibition, Oil Paintings by Contemporary American Artists*, no. 71, as *Moonlight—Woods Island Light, Maine*, lent by George A. Hearn // MMA, 1911, *Winslow Homer Memorial Exhibition*, no. 15, as *Moonlight—Wood Island Light*, lent by George A. Hearn, records inscription on back of stretcher as *Wood Island Light, Winslow Homer* // XXI International Biennale, Venice, 1938, *Art of the United States*, no. 37 // Corcoran Gallery of Art, Washington, D. C., and Toledo Museum of Art, 1957, *Twenty Fifth Biennial Exhibition of Contemporary American Oil Paintings*, no. 26 // MMA, 1965, *Three Centuries of American Painting*, unnumbered cat. // Bowdoin College, Museum of Art, Brunswick, Me., 1966, *Winslow Homer at Prout's Neck*, exhib. cat. by P. C. Beam, unpaged text, discusses it as "a magnificent tribute to one of his favorite natural spectacles," mentions *A Summer Night* as an earlier work on the same theme, notes that in this work Homer dispensed with all human figures, that he "painted moonlight again, but never reached a higher pitch than this," which "epitomized the natural beauty of Prout's Neck in the summer months"; ill. no. 31 // William A. Farnsworth Library and Art Museum, Rockland, Me., 1970, *Winslow Homer*, no. 19 // High Museum of Art, Atlanta, 1971, *The Beckoning Land*, cat. by G. Vigtel, p. 17, says it "combines the best of the romantic realist vision with that broad handling of paint which in Homer seems as logical and inevitable as his own handwriting"; p. 28, no. 63 // Queens County Art and Cultural Center, New York; MMA; Memorial Art Gallery of the University of Rochester, N. Y., 1972–1973, *19th Century American Landscape*, exhib. cat. by M. Davis and J. K. Howat, ill. no. 23, discusses it (not exhibited in Rochester) // Whitney Museum of American Art, New York, Los Angeles County Museum of Art, and the Art Institute of Chicago, 1973, *Winslow Homer*, exhib. cat. by L. Goodrich, p. 136, no. 58 (exhibited only in New York) //

MMA and American Federation of Arts, traveling exhibition, 1975–1977, *The Heritage of American Art*, exhib. cat. by M. Davis, no. 60, ill. p. 139; rev. ed., 1977, no. 59, ill. p. 137.

ON DEPOSIT: MMA, 1908, lent by George A. Hearn, New York; Gracie Mansion, New York, 1947.

EX COLL.: with Gustav Reichard and Company, New York, until Feb. 1895; Thomas B. Clarke, New York, Feb. 1895—Feb. 17, 1899 (sale, American Art Galleries, New York, Feb. 17, 1899, no. 350, for $3,650); with Boussod, Valadon and Company, New York, Feb. 1899; George A. Hearn, New York, by 1907.

Gift of George A. Hearn, in memory of Arthur Hoppock Hearn, 1911.

11.116.2.

Northeaster

Like *Cannon Rock* (see below), *Northeaster* was painted at Prouts Neck in 1895. It was exhibited that year at M. Knoedler and Company, New York, and sold to Thomas B. Clark, who lent it to the annual exhibition at the Pennsylvania Academy of the Fine Arts from December 1895 to February 1896. Sometime before December 1900 the painting was returned to Homer who reworked it. A comparison of the painting as it now appears and the illustration of it in *Harper's Weekly*, February 15, 1896, shows that he made considerable changes. He painted out two men in sou'westers on the rocks at the left, eliminating the narrative element in the picture. He transformed what had been a relatively realistic work based on close observation into a more calculated design tending to the abstract. This is especially evident in his stylized treatment of the wave right of center, the redefined shape of the burst of spray at the left, and the tracery-like pattern of the foam on the surface of the water.

In December 1900 Homer sent the painting back to Knoedler. At the end of the month, on December 31, he wrote to Clarke, suggesting he substitute *Northeaster* for *Cannon Rock* in a forthcoming exhibition at the Union League Club: "I have today shipped to Knoedler & Co. a larger & better picture.... *Northeaster*. You have seen it before but I have made it much finer." Homer supplied a quick sketch of the painting in his letter. Within a few months the picture was bought by George A. Hearn. It was awarded gold medals at the exhibitions of the Pennsylvania Academy both in 1895 and 1902.

Bryson Burroughs described the painting when Hearn lent it to the museum in 1908:

In the opinion of many people, "Northeaster" is Homer's masterpiece. Certainly one can rarely find so vigorously expressed the dynamic energy and weight of moving water. It is the picture of an oncoming wave just tipped with foam, back of a cloud of spray that is blown to one side. In handling it is hard and uncompromising, and the color—slaty greys, emerald, and the brown black of the rocks—has an austere beauty in accord with the intensity of the idea.

One of Homer's most powerful images of the sea, *Northeaster* demonstrates the artist's superb sense of pictorial design and his gift for grasping the essential character of the turbulent sea. The broadly painted, dynamic composition, the proximity of the rocky shore in the foreground, and the use of a high horizon convey the immediate force of the breaking surf. The leaden sky, the seething white foam, the heaving green-blue water against the slate gray, brown, and mauve-colored rocks demonstrate Homer's skillful use of a limited palette. His virtuoso handling of design is most evident in the ornamental flourish of the cresting wave at right of center and the cloud of spray dominating the left side of the asymmetrical composition.

Oil on canvas, 34½ × 50 in. (87.6 × 127 cm.).
Signed and dated at lower center: HOMER / 1895.
RELATED WORK: Sketch in W. Homer to T. B. Clarke, Dec. 31, 1900, ink on paper, Winslow Homer Misc. MSS 2814, Arch. Am. Art, ill. R. Brown, *Arch. Am. Art Jour.* 16, no. 4 (1976), p. 21.

REFERENCES: A. Hoeber, *Harper's Weekly* 40 (Feb. 15, 1896), ill. p. 149, shows the painting before Homer changed it // W. Homer to M. Knoedler and Co., New York, Dec. 1900, M. Knoedler and Co. MSS microfilm NY 59–5, Arch. Am. Art, says of this painting, "you have already had [it] in your show window five years ago. I have painted on it since & it is better" // Homer to T. B. Clarke, Dec. 31, 1900, Winslow Homer Papers: Misc. MSS 2814, Arch. Am. Art (quoted above) // *MMA Bull.* 1 (Feb. 1906), p. 35, lists it among three works by Homer from which two were to be chosen by MMA as gifts from Hearn // MMA, *The George A. Hearn Gift to the Metropolitan Museum of Art . . .* (1906), p. xii, lists it among three works by Homer of which two were to be chosen by MMA // B. B[urroughs], *MMA Bull.* 3 (May 1908), p. 100 (quoted above), says that it replaced another painting on exhibition as a loan from Mr. Hearn, contrasts with similar themes in Chinese art and notes that its "lack of conventional style, and its extreme individualism are qualities to which perhaps future ages may take exception, but they belong essentially to the nineteenth century and to our own country, of which Homer is so distinctly the product" // [W. S. Howard], *Catalogue of the Collection of Foreign and American Paintings Owned by Mr. George A. Hearn* (1908), ill. p. 168, pl. 208, as A Northeaster; *Harper's Monthly* 120 (March 1910), ill. p. 575, engraving by Henry Wolf // *MMA Bull.* 5 (May 1910), ill. p. 105; p. 108, lists it among works given to MMA by George A. Hearn and notes that this painting by Homer is "considered by many to be his best work" // *Arts and Decoration* 1 (Nov. 1910), ill. p. [24], as The Northeaster // K. Cox, *MMA Bull.* 5 (Nov. 1910), ill. p. 255 // C. Brinton, *Scribner's Magazine* 49 (Jan. 1911), p. 20, lists it among "those marines which constitute Homer's chief title to greatness" // *Bulletin of the Brooklyn Institute of Arts and Sciences* 6 (May

Homer's *Northeaster* as exhibited in Philadelphia and before changes. From *Harper's Weekly*, February 15, 1896.

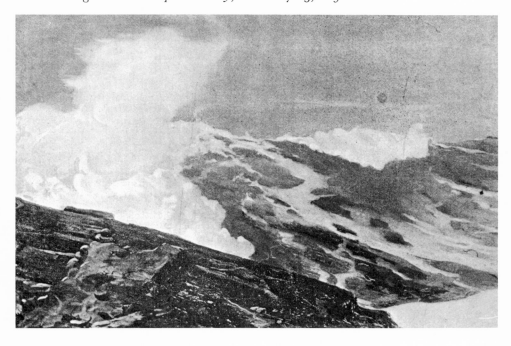

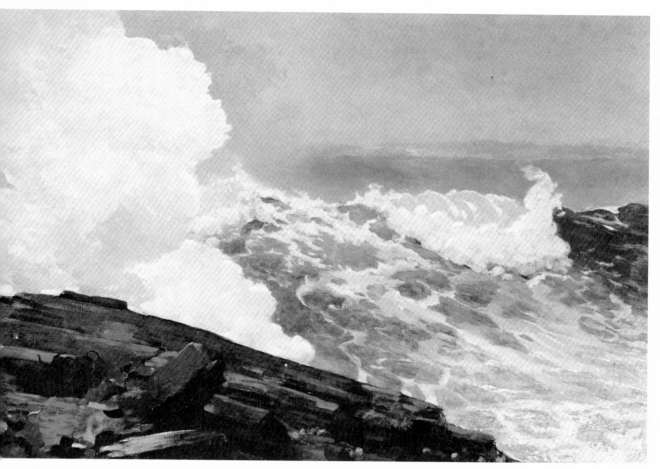

Homer, *Northeaster.*

13, 1911), p. 384, lists it as A Northeaster; ill. p. [391] // W. H. Downes, *The Life and Works of Winslow Homer* (1911), p. 177, comments that it is "one of the most impressive of its author's surf subjects, and by some persons is considered the best of all, but it is not equal to 'The Maine Coast' [q. v.] and 'On a Lee Shore,' which have no rivals"; adds, however, that this "is not only a great piece of work, it is also one of the most exciting of his marines, the weight and movement of the oncoming billow giving the impression of an irresistible and overwhelming force"; observes: "It will be noted that the point of view here is very low, bringing the horizon high in the composition, and giving the onlooker the sense of being below the level of the wave-crest impending to its fall. We are near enough to make out all the shifting and seething patterns of the foam which play upon the immense breast of the coming wave and form an intricate momentary and exquisite diaper-work of milk-white tracery against the blues and greens beneath. The

dark edges of the ledge at the left, and the spouting column of spray beyond it close in this simple and beautiful design"; p. 179, says that it was exhibited in the sixty-fifth exhibition of the PAFA in 1895; p. 201, mentions that it "occupied the place of honor" at the 1907 Lotos Club exhibition arranged by William T. Evans; ill. opp. p. 206; p. 219, says that it received the Temple gold medal at PAFA in 1902; pp. 245-246, notes museum's acquisition of it; p. 282, lists it as a loan to PAFA exhibition from Clarke in 1895-1896; p. 283, lists it in the 1902 exhibition of the Society of American Artists in New York // MMA, *George A. Hearn Gift to the Metropolitan Museum of Art . . .* (1913), p. xi, lists it; ill. p. 60 // K. Cox, *Winslow Homer* (1914), p. 33, lists it among important works in the "series of great pictures of rock and surf, in which the sea is itself the principal subject, the human figure being altogether absent or reduced to a minor role—the series which marks Homer as the greatest of marine painters" // A. T. Van Laer, *Century Magazine* 94

Ink sketch of *Northeaster* that Homer made on a letter to Thomas B. Clarke, December 31, 1900. Courtesy of the Archives of American Art.

(June 1917), color ill. opp. p. 161; p. 314, describes painting and technique // J. C. Van Dyke, *American Painting and Its Tradition* (1919), p. 108, describes it // L. M. Bryant, *American Pictures and Their Painters* (1921), opp. p. 66, fig. 35; p. 67, describes it // R. C. Smith, *Life and Works of Henry Wolf* (1927), p. 90, no. 714, lists Wolf's engraving of it // W. H. Downes, *American Magazine of Art* 23 (Nov. 1931), p. 364; ill. p. 366 // T. Bolton, *Fine Arts* 18 (Feb. 1932), p. 54, lists it as A Northeaster and provides references // *Index of Twentieth Century Artists* 1 (Nov. 1933), p. 2, lists it, p. 11; suppl. to 1, p. ii, lists reproductions // L. Goodrich, *Winslow Homer* (1944), p. 135, lists it in series of seascapes painted in mid–1890s "that were among his greatest works"; p. 171, notes that in December 1900 Homer sent it to Knoedler after reworking it, says that in "a few months it was bought by George A. Hearn for $2,500, netting the painter $2,000"; p. 187, notes that in April 1910 Hearn presented it to the MMA; p. 225, quotes John W. Beatty, who wrote: "Rarely did [Homer] represent in any of his late canvases more than three or four dominant notes. In the *Northeaster*, as in many other paintings, this quality of simplicity is remarkably exemplified. A few massive rock forms combined with onrushing waves are made to give one a tremendous sense of power and reality Standing before the *Northeaster*, one seems to feel the very weight and onrushing of the waves, the very vibration of the earth"; p. [228], lists it in chronology; p. 234, lists it in MMA coll.; pl. 40 // F. J. Mather, Jr., *Magazine of Art* 39 (Nov. 1946), ill. p. 299, discusses "those canvases on the theme of the sea gnawing at the land, his chief subject in his last years," notes that Homer "exploits the theme with infinite variations, like a composition of music. But he rarely admits grace notes. They would impair the austerity of his vision," says

that he "usually ignores such attractions" as "the latent color and iridescence of moving water in the interest of stressing power," concludes that "the echelon of oncoming waves behind the wave that has broken is indicated with a mastery that no other marine painter, not Turner, not Courbet, has equalled" // E. P. Richardson, *Painting in America* (1956), pp. 316–317, lists it in the 1890s "series of pictures in which the theme is the power and loneliness of the sea itself" // A. T. Gardner, *MMA Bull.* 17 (Jan. 1959), p. 132, lists it; ill. p. 136 // A. T. Gardner, *Winslow Homer* (1961), color ill. p. [127]; pp. 207–208, calls it "one of the best known of his late marine pictures" and describes Homer's treatment of the subject; pp. 241, 242, mentions exhibitions; pp. 249, 254, lists it // J. Gould, *Winslow Homer* (1962), pp. 251, 263, 274; p. 283, lists it among the works for which Homer pointed out the sites to John Beatty during his visit to Prouts Neck // P. C. Beam, *Winslow Homer at Prout's Neck* (1966), p. 93; p. [139], fig. 55, mentions it with Cannon Rock and Maine Coast (qq. v.) as three of Homer's "most famous and popular wave and rock pictures" painted during the summer and fall of 1895; p. 140, says, "Not since Turner had there been anything in seascape painting comparable in pure energy to *Northeaster*. Waves like this do beat on the cliffs of Prout's Neck, but they are rare, even in the worst equinoctial storms . . . The rock formation in the painting is no particular spot we could locate, and the matter is unimportant; our whole attention is directed to the surging, creaming sea"; observes that Homer's earlier studies of this type "seem pallid set against the massive, deadly might of the montainous seas For anything comparable we must turn to something like the *Tidal Wave* of the master Japanese sea painter Hokusai"; p. 220 // J. Wilmerding, *Wins-*

low *Homer* (1972), p. 164, color pl. 32; p. 167 // R. Melville, *Architectural Review* 157 (Feb. 1975), ill. p. 118, fig. 10, reviews Homer exhibition at the Victoria and Albert Museum and notes of this work that it "is one of his best known oils" // M. D. Davis, *Winslow Homer: An Annotated Bibliography* (1975), pp. 95–96 // *MMA Bull.* 33 (Winter 1975–1976), color ill. p. 230, no. 79, discusses it // M. W. Brown, *American Art to 1900* (1977), p. 501, pl. 636; p. 561 // G. Hendricks, *The Life and Work of Winslow Homer* (1979), color ill. p. [219], pl. 50; p. 223; p. 246, says that it was sent for exhibition at the Union League Club in 1900 and quotes Homer to Clarke; p. 315, CL–517, lists it // L. B. Reiter, Paintings Conservation, MMA, supplied record of painting examination and treatment, March 1980, states, "As is characteristic of Homer, there are a number of changes in the sky which now appear as dark streaks and the wave at left has a purple pentiment where the shape was altered" // N. Spassky, *Winslow Homer* (1981), p. 12, discusses; color ill. pl. 11; *MMA Bull.* 39 (Spring 1982), color ill. pp. [28–29], fig. 25; pp. 30, 35, discusses.

EXHIBITED: M. Knoedler and Company, New York, 1895 // PAFA, 1895–1896, no. 171, lent by Thomas B. Clarke, ill. shows picture before changes // Union League Club, New York, 1901, *Loan Exhibition, American Paintings*, no. 2, as North-Easter // PAFA, 1902, no. 483, as Northeaster, lent by George A. Hearn // Society of American Artists, New York, 1902, no. 60, as Northeaster, lent by George A. Hearn // Lotos Club, New York, 1907, *Exhibition of Landscapes by American Artists*, lent by George A. Hearn (no cat.) // Century Association, New York, [Centennial Celebration], January 1947 (no cat.) // NAD, March 1949, (no cat. available); 1951, *The American Tradition*, no. 70 // National Gallery of Art, Washington, D.C., 1958–1959, MMA, and MFA, Boston, 1959, *Winslow Homer: A Retrospective Exhibition*, cat. by A. T. Gardner, no. 66; Boston ed., no. 60 // MMA, 1965, *Three Centuries of American Painting*, unnumbered cat.; 1970, *19th-Century America, Paintings and Sculpture*, exhib. cat. by J. K. Howat and N. Spassky, no. 160 // Indianapolis Museum of Art, 1970–1971, *Treasures from the Metropolitan*, ill. p. 15, no. 3, catalogues it // Bronx County Courthouse, New York, 1971, *Paintings from the Metropolitan*, no. 23 // Tokyo National Museum and the Kyoto Municipal Museum, 1972, *Treasured Masterpieces of the Metropolitan Museum of Art*, ill. no. 114 // MMA, 1976, *A Bicentennial Treasury* (see *MMA Bull.* 33 above).

ON DEPOSIT: MMA, 1908, lent by George A. Hearn, New York.

EX COLL.: with M. Knoedler and Company, New York, 1895; with Thomas B. Clarke, New York, 1895–1896; the artist, Prouts Neck, Me.; with M. Knoedler and Company, New York, Dec. 1900; George A. Hearn, New York, 1901–1910.

Gift of George A. Hearn, 1910.

10.64.5.

Cannon Rock

This is one of the seascapes that made Homer's reputation at the turn of the century. The scene, at Prouts Neck in Maine, was described by William H. Downes, Homer's early biographer, in 1911:

Cannon Rock is one of the most easily recognizable landmarks. Looking down from the cliff walk, one sees just the outlines of dark rock against the lighter values of the water that are shown in the picture.... one notices the odd outlines of a projecting rock or segment of rock which bears a semblance of the breech of a cannon. As I stopped to look, I heard a dull, muffled boom, apparently coming from the unseen base of the cliff. This, it was explained, is the report of the cannon. Perhaps it is a little far-fetched. Such ideas are apt to be so. In the middle distance, I saw a wave break repeatedly, as is shown in the painting. That is caused by a sunken reef some little way from the shore.

In a letter dated December 3, 1900, to Knoedler and Company, Homer described the work and his intention of sending it for sale:

The picture now going forward is called "Breaking on the Bar, Cannon Rock." It was painted in *1895* & has been hanging in my studio untouched. I did not put it out or change it in any way as the breaking on the bar part of it looked so broken & so like decanters & crockery, & at the same time looked so fine at a proper distance. I now take the chance of sending it out.

Two days later he reported that he had sent it and instructed Knoedler to charge $2,000 for the painting and frame, which would net him "from $1,200 to $1,500."

Sometime earlier, Homer had been approached by Thomas B. Clarke, one of his major patrons and the chairman of the art committee of the Union League Club of New York, for suggestions as to what works he might contribute to a forthcoming loan exhibition to be held at the club in January 1901. Writing Clarke, on December 11, 1900, Homer agreed to send three paintings, including "one square now at Knoedlers," which he described as "not of much account." In addition to pointing out its square format, he provided a sketch suggesting the best installation of the three marines. It showed this work in the center flanked by *West Point, Prout's Neck* and *Eastern Point, Prout's Neck*, both 1900 (Sterling and Francine Clark Art Institute, Williamstown, Mass.). *Cannon Rock*, however, had been sold to Dr. Frank W. Gunsaulus of Chicago, who ap-

parently owned it only for a short time. Homer informed Clarke on December 31, 1900, that the painting, which he now referred to simply as *Cannon Rock*, was not available, as the Chicago owner had sold it, and suggested *Northeaster* (see above), "a larger & better picture to take its place."

Cannon Rock was exhibited two years later, when it was lent by its new owner, George A. Hearn, to the South Carolina Exposition at Charleston. It received a gold medal. In 1903 the painting was shown at the Society of American Artists in New York, where it was favorably reviewed by the *New York Times*:

As usual, it is Winslow Homer who carries off the palm from all the men who paint the sea, or the surf, the lake, or the rushing stream. It may be presumed that his *Cannon Rock* is exempt from competition, because it is not entered by the artist, but is a loan . . . there is every reason otherwise that it should have won an honor. Seldom has even Homer expressed with greater simplicity and truth the grandeur of the ocean on a day of clear weather, when no storm is on and the power of the sea is merely felt in the big shoreward movement of the water in the outmost comber. He has been able to make us see the rich brown rocks, the inner crunching foam, the swaying, changing levels of the near water, and the surging up of the billow where its foot has touched bottom and its head breaks far out in a crest that runs along some line prescribed by the dynamics of its motion. The fresh, salt air, the imperturbable stolidity of the rocky shore are told with infinite zest and with all the virility of brushwork which makes Homer in some ways the greatest living marine painter of the age.

Downes thought that the arrangement of lines and masses in *Cannon Rock* was less impressive and satisfactory than in most of the artist's offshore marine pieces. KENYON COX also thought that Homer had done better but noted that

"there is yet a vast and dangerous bulk in the sullenly gathering water and great truth of observation in the steady, sweeping onset of the second wave which will be thundering about us in another moment" (1907).

Cannon Rock belongs to the series of major seascapes Homer painted in the mid 1890s. It is a powerful statement of the sheer force of nature reduced to elemental components—the massive rocky shore, pounding surf, and leaden sky. The almost sculptural appearance of the water, and to a lesser extent the rocks, Homer achieved with impasto applied directly to a white ground. The sky is not so thickly painted. Suffused with a rose-lavender tone, it echoes on a less emphatic note the rich lavender and red-brown colors of the rocks. The asymmetrical composition is highly calculated. Among the more intriguing aspects of this work is Homer's conscious choice of a modern square format. In a study, William H. Gerdts suggested that Homer's inital impetus for this came from his work in the Tile Club, where participants painted square tiles. An additional note of modernity in this work, Gerdts observed, was the obliteration of a distinct horizon and the emphatic definition of the wave breaking on the sandbar, inhibiting the illusion of spatial recession.

Oil on canvas, 40 × 40 in. (101.6 × 101.6 cm.).
Signed and dated at lower right: HOMER 1895.
RELATED WORK: Sketch in W. Homer to T. B. Clarke, Dec. 11, 1900, Winslow Homer Papers: Misc. MSS 2814, Arch. Am. Art, ill. in R. Brown, *Arch. Am. Art Jour.* 16, no. 4 (1976), p. 21.
REFERENCES: W. Homer to M. Knoedler and Co., Dec. 3, 1900, M. Knoedler and Co. MSS, New York, microfilm NY 59–5, Arch. Am. Art, and Dec. 5, 1900 (quoted above), and discusses price for two pictures he has sent them, *Fog* (now called *Fisher Girl* at

Homer's ink sketch of three paintings, including *Cannon Rock*, to be hung at a 1901 Union League Club exhibition. Sketch appears in his letter to Thomas B. Clarke, December 11, 1900. Courtesy of the Archives of American Art.

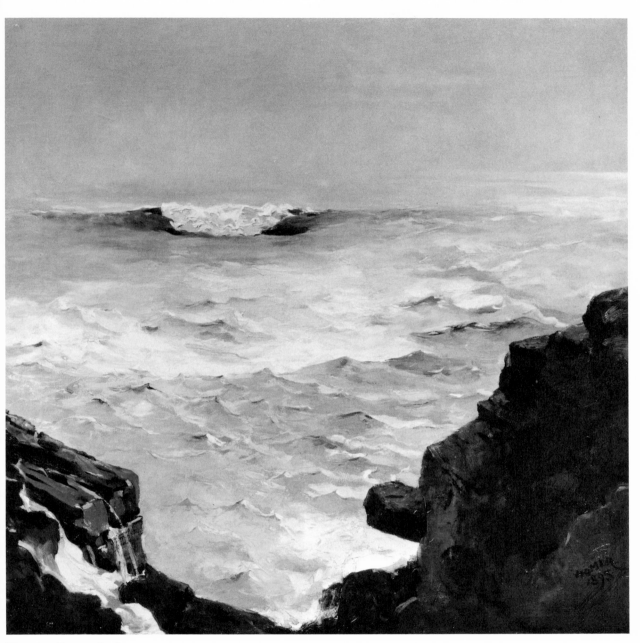

Homer, *Cannon Rock*.

477

Amherst College), 1894, and this painting // Homer to T. B. Clarke, Dec. 11, 1900, Misc. mss Homer, Arch. Am. Art (quoted above), and Dec. 31, 1900, notes that Cannon Rock was sold // Homer to M. Knoedler and Co., New York, March 2 and 21, 1901, M. Knoedler and Co. mss, microfilm NY 59-5, Arch. Am. Art, a receipt for $1,008.45, dated March 21, 1901, indicates his proceeds from the sale // F. W. Morton, *Brush and Pencil* 10 (April 1902), ill. p. 48, as Breaking over the Bar; p. 53 // *New York Times*, Dec. 12, 1902, p. 9, in review of the 1902 Hearn exhibition at the Union League, says of this painting and Maine Coast (q. v.), "Both are masterpieces, strong as ever sea painting has been"; March 29, 1903, p. 7, reviews it in 1903 Society of American Artists exhibition (quoted above) // *Brooklyn Daily Eagle*, April 2, 1903, p. 14, reviews it in Society of American Artists exhibition, commenting that "strength has with him gone to its length and is now mere rudeness," adds that this painting is better—"a big wave rolling in dark and menacing, yet even here we miss the depth, liquidity, power and mystery of the sea" // *MMA Bull.* 1 (Feb. 1906), p. 35, lists it as one of three Homers given by Hearn // W. S. Howard, *MMA Bull.* 1 (March 1906), p. 54, describes it: "Beyond the black rocks, over which the spray trickles in white foam, stretches the pitiless sea. From the grim mass at the right juts the cannon rock which gives title to the work, and adds a note of terror to the uninhabitableness of the scene"; ill. p. 57 // MMA, *The George A. Hearn Gift to the Metropolitan Museum of Art* . . . (1906), p. xii, includes it among three works by Homer of which two were to be chosen by MMA as gift from Hearn; p. 196, describes it; ill. p. [197] // K. Cox, *Burlington Magazine* 12 (Nov. 1907), p. [119], pl. 1; p. 124 (quoted above), reprinted in *MMA Bull.* 5 (Nov. 1910), p. 255 // D. C. Preyer, *The Art of the Metropolitan Museum of New York* (1909), p. 303, says, "Homer's 'Cannon Rock' is one of the greatest works he has painted" // C. L. Hind, *International Studio* 41 (Sept. 1910), p. 189, in a review of the American art exhibition in Berlin and Munich in 1910 calls it Homer's finest picture // [London] *Art Journal* (Oct. 1910), p. 297, quotes Claude Williamson Shaw on the painting: "a vast solemn mood of nature, painted broadly and simply, a sight that he must have absorbed through long years in his far distant lonely home on the coast of Maine"; ill. p. 299 // C. Brinton, *Scribner's Magazine* 49 (Jan. 1911), p. 20, includes it among marines "which constitute Homer's chief title to greatness It is an age-old antagonism which is here depicted. It is that same conflict between rock and water which has been waged for centuries, yet it has never been portrayed with like power or stern simplicity of statement"; ill. p. 22 // W. H. Downes, *The Life and Works of Winslow Homer* (1911), pp. 9, 177; pp. 178–179, describes the site (quoted above) and gives his opinion of the picture; ill. opp. p. 212; p. 220, notes that it received a gold medal in 1902; p. 231, lists it among paintings by Homer shown at

the Carnegie Institute, Pittsburgh, in 1908; p. 247, quotes C. Lewis Hind; pp. 283, 285, includes it in exhibition records // MMA, *George A. Hearn Gift to the Metropolitan Museum of Art* . . . (1913), p. xi; ill. p. 61 // A. Hoeber, *Mentor* 1 (July 7, 1913), ill. opp. p. 12, shows a painting as MMA Cannon Rock, which is another picture (see *American Art News* [1919]) // K. Cox, *Winslow Homer* (1914), p. 33, lists it among "the most important" paintings in the "series of great pictures of rock and surf, in which the sea is itself the principal subject, the human figure being altogether absent or reduced to a minor role—the series which marks Homer as the greatest of marine painters" // *American Art News* 17 (March 22, 1919), p. 6, reports on American Art Association sale, March 14, 1919, cat. no. 192: "The picture that had been expected to bring the highest figure of the sale, a characteristic Maine coast scene and Marine, 'Prout's Head—Maine,' catalogued as having been purchased by the anonymous owner as from a Mr. George Hight, who, in turn, purchased it from the painter, Winslow Homer, was withdrawn, with the announcement by Mr. Kirby that doubt had been cast upon its authenticity by an 'expert' and that the matter awaited thorough investigation. The motif of the picture, a huge foam crested towering billow, rushing in upon a rocky coast, is almost the same as that of one in the Metropolitan Museum, given that institution by the late George A. Hearn, and of another sold in Mr. Hearn's collection last season. The clearing up of the doubt expressed regarding the work offered Mar. 14, will be awaited with interest in American art circles" // J. C. Van Dyke, *American Painting and Its Tradition* (1919), p. 108, discusses as one of the series of Homer's pictures in which "bird and beast and man are left out and only the great sea and its fearsome fret on the shore remain" // A. Ames, Jr., *Art Bulletin* 8 (Sept. 1925), p. 12, fig. 10; p. 13, discusses it // F. J. Mather, Jr., C. R. Morey, and W. J. Henderson, *The Pageant of America* (1927), 12, ill. p. 83, no. 126, notes: "Homer is never greater than in these pictures which represent a pounding sea gnawing at the foot of the cliffs . . . Except for a few canvases by Courbet, which Homer probably knew, there is nothing in modern painting comparable in energy to the series of marines to which this belongs" // W. H. Downes, *American Magazine of Art* 23 (Nov. 1931), p. 364; ill. p. 365 // T. Bolton, *Fine Arts* 18 (Feb. 1932), p. 54, includes it in catalogue of Homer's paintings and provides references // A. C. Goodyear, *Parnassus* 10 (April 1938), p. 16 // L. Goodrich, *Winslow Homer* (1944), p. 135, lists in "series of seascapes that were among his greatest works"; p. 171, quotes Homer's letters to Knoedler and notes painting was bought by Dr. Gunsaulus; pp. 176–177, quotes reviews of 1903 exhibition; pp. 187, 228, 234; pl. 41 // E. P. Richardson, *Painting in America* (1956), pp. 316–317, lists it among the series of pictures Homer began in the nineties "in which the theme is the power and loneliness of the sea itself" // A. T. Gardner, *Winslow*

Homer (1961), ill. p. 35; p. 208, in a discussion of Homer's marine paintings, suggests that perhaps Homer's major interest and "what impressed his contemporaries" was "the powerful tension generated by the opposition of irresistible force meeting immovable body" and lists this picture among works composed of "grim rocks, foaming waves, and stormy skies"; pp. 241, 242, 245, 254 // J. Gould, *Winslow Homer* (1962), p. 251; ill. p. 253; p. 283 // P. C. Beam, *Winslow Homer at Prout's Neck* (1966), p. 137, fig. 53; p. 139, includes it as one of three of Homer's "most famous and popular" seascapes painted during the summer and fall of 1895, describes the spot, notes it could be seen from Homer's "balcony window"; pp. 139–140, describes Homer's "rearrangement of elements for the sake of design" as compared with a photograph of the location; p. 196, says nine of Homer's "greatest marines" were conceived near Cannon Rock; p. 220, notes that it received a gold medal at the South Carolina Exposition // J. T. Flexner and the editors of Time-Life Books, *The World of Winslow Homer 1836–1910* (1966), color ill. p. 156; p. 157, notes in caption that Homer made changes in his painting of the scene "for the sake of design, then patiently waited for the right wave to form before finishing the picture" // J. Wilmerding, *Winslow Homer* (1972), p. 187, ill. 5–1 // W. H. Gerdts, *Arts Magazine* 50 (June 1976), ill. p. 74; p. 75, discusses Homer's infrequent use of the square format and describes Cannon Rock as "the most significant of Homer's square paintings" and "one of Homer's most flattened and design-conscious canvases, with an extremely high horizon"; notes that "the thickest impasto, and the brightest tonal accent, defining the foam of a wave near the horizon, pulls that form to the picture plane, thus effectively negating even the limited spatial distance that appears to exist, illusionistically" // G. Hendricks, *The Life and Work of Winslow Homer* (1979), fig. 270, no. 8, aerial photograph of Prouts Neck with location of Cannon Rock indicated; ill. p. 314, CL–499, says, "Cannon Rock was a short distance from the artist's Prout's Neck studio, but, as Beam points out . . . , the natural topography has been rearranged."

EXHIBITED: South Carolina Interstate and West Indian Exposition, Charleston, 1901–1902, *Exhibition of Fine Arts*, no. 137, as Cannon Rock, lent by George A. Hearn // Union League Club, New York, Dec. 11–13, 1902, *Paintings from the Collection of George A. Hearn, Esq.*, no. 16, as Cannon Rock // Society of American Artists, New York, 1903, no. 308, lent by George A. Hearn // Carnegie Institute, Pittsburgh, 1908, no. 148, as Cannon Rock lent by the MMA; 1908, *Summer Loan Exhibition*, no. 47 // Museum of Modern Art, New York, 1932–1933, *American Painting & Sculpture, 1862–1932*, no. 49 // Musée du Jeu de Paume, Paris, 1938, *Trois Siècles d'Art aux Etats-Unis*, no. 86 // NAD, 1942, *Our Heritage*, no. 239 // Worcester Art Museum, Mass., 1944, *Winslow Homer*, no. 78 // Heckscher Art Museum, Huntington, N.Y., 1947,

European Influence on American Painting of the 19th Century, no. 8 // Robert McDougall Art Gallery, Canterbury, New Zealand, 1950–1951, *Centennial Art Loan Exhibition* (no cat.) // Wildenstein, New York, 1961, *Loan Exhibition of Paintings and Drawings* (benefit of the Citizens' Committee for Children of New York), no. 38 // Mariners Museum, Newport News, Va., and Virginia Museum of Fine Arts, Richmond, 1964, *Homer and the Sea*, essay by L. Goodrich, no. 41 // MMA, 1965, *Three Centuries of American Painting*, unnumbered cat. // Lytton Gallery, Los Angeles County Museum of Art, and M. H. de Young Memorial Museum, San Francisco, 1966, *American Paintings from the Metropolitan Museum of Art*, p. 78, no. 67 // Whitney Museum of American Art, New York, Los Angeles County Museum of Art, and Art Institute of Chicago, 1973, *Winslow Homer*, exhib. cat. by L. Goodrich, ill. p. 110; p. 136, no. 60 // International Exposition, Spokane, 1974, *Our Land, Our Sky, Our Water*, organized by A. Frankenstein, ill. p. 4, no. 6; p. 54, no. 6 // Whitney Museum of American Art, New York, 1975, *Seascape and the American Imagination*, exhib. cat. by R. B. Stein, frontis. ill.; p. 112, discusses it // Pushkin Museum, Moscow; Hermitage, Leningrad; Palace of Art, Minsk, 1977–1978, *Representations of America* (no cat.).

ON DEPOSIT: Virginia Museum of Fine Arts, Richmond, 1954–1958 // Gracie Mansion, New York, 1970–1972.

EX COLL.: with Knoedler and Company, New York, 1900; Dr. Frank W. Gunsaulus, Chicago, from 1900; George A. Hearn, New York, by 1901–1906.

Gift of George A. Hearn, 1906.
06.1281.

Maine Coast

Maine Coast, which Homer first referred to as "A Coast Scene," was painted at Prouts Neck in 1896. Writing to his patron Thomas B. Clarke in March 1897, he reported: "I have another new picture now at the Rhode Island School of Design, Providence. I sent it to them for the opening of their new Gallery You will like it much. 'A Coast Scene.' The same old story only much better." The same month, in response to an invitation from his friend JOHN LA FARGE to show one or more of his pictures at the annual exhibition of the Society of American Artists, Homer sent this picture and two others to New York. Before the exhibition opened to the public, Clarke bought two of the paintings, including this one, for his growing collection of Homer's work. It appeared as *Marine—Coast* in the society's catalogue and Homer corrected the

title in a letter to Clarke: "The coast scene was called when it left me 'Maine Coast.'"

WILLIAM A. COFFIN, writing in 1899, called the painting a masterpiece:

The impression of a wild, squally day is admirably given, and the handling of the subject quite apart from the technical requirements, is comprehensive and lofty. As to the painting, it is this, of course, which makes the picture such a triumph of art. It is virile and broad. The drawing is simple and big, and the color, while veracious, is exceedingly distinguished. The truthful aspect of the work—the result of highly trained artistic powers of observation—and the effect of the picture as a whole, attracting by its pure pictorial quality, are equally remarkable.

William Howe Downes, who had firsthand knowledge of the sea at Prouts Neck, described the subject (1911):

The design is of a rigid simplicity. We are looking seaward from the cliffs at Prout's Neck on a day of storm. At our feet the dark ledges are streaming with milky retreating foam, and just beyond them a monster wave raises its huge bulk as it comes shoreward with an exuberant look of tremendous power. Still further out to sea, in the gray mist, loom the oncoming lines of wave upon wave, until the horizon loses itself in a far turmoil of dimly seen billows.

Oil on canvas, 30 × 40 in. (76.2 × 101.6 cm.).
Signed and dated at lower right: HOMER 1896.
REFERENCES: W. Homer to T. B. Clarke, March 14, 1897, Lloyd Goodrich's Copies of Winslow Homer Letters, 1860s–1910, microfilm NY 59–12, Arch. Am. Art (quoted above); April 2, 1897 (quoted above), and says in response to Clarke's interest in The Lookout and this painting, viewed before the Society of American Artists exhibition: "I am glad that you have found some pleasure in these two pictures. I sent [Maine Coast] to Providence after submitting it to your friend O. H. Darrell at his store in Boston. He did not like it for $750 but they liked it very much at Providence & asked the price which I gave them at $800 making $50 out of O. H. Darrell. . . . Now these profits that I have made out of you on these two pictures, should pay a *commission to the Society* on this sale as they were sold from their Gallery"; April 24, 1897, explains his arrangements for delivering the two pictures and giving the Century Company photographs of them; May 7, 1897, discusses delivery of the two pictures and granting permission for Century Magazine to reproduce them; May 11, 1897, informs Clarke that the pictures arrived at Kurtz without frames and asks advice; May 22, 1897, writes: "Let me know when you receive the two pictures from Kurtz in good order & not *the least hurry about the payment of them*"; Sept. 20, 1897, writes: "Mr. John W. Beatty Director of the Carnegie Art Galleries has written me asking

for one or two pictures extra—as I only have two to send him I have written him that I would try and get from you—the Lookout, & the Maine Coast, and told him to ask you for them. If you could let them go—it would be a good thing"; Homer to J. W. Beatty, Sept. 21, 1897, says he has only a picture he is finishing or trying to finish which he will send: "But two pictures now owned by Mr. T. B. Clarke of New York— (& that have never been exhibited but at the American Society of Art last spring) I will write to him for & you also. Please do it—the titles are 'The Lookout' & 'The Maine Coast'" // American Art Galleries, New York, *Catalogue of the Private Art Collection of Thomas B. Clarke, New York, to be sold . . . Feb. 14, 15, 16, and 17 . . .* (1899), sale cat., part 1, no. 168 (MMA copy annotated, sold to F. A. Bell for $4,400) // W. A. Coffin, *Century Magazine* 58 (Sept. 1899), p. 651, calls Maine Coast "a masterpiece, with a full sense of what the term implies"; ill. p. [652], as Maine Coast; p. 653 (quoted above) // O. Golwin, *Die Kunst für Alle* 16 (March 15, 1901), p. 279, in a review of American paintings at the Exposition Universelle of 1900, describes Homer as a truly American artist; ill. p. 280, as The Maine-Coast // L. Taft, *Chicago Record*, May 28, 1900, Art Institute of Chicago Scrapbook, vol. 12, p. 113, Dec. 1899–July 1900, microfilm roll 2, in review of the American works at the Paris exposition, calls it "one of the strongest things that I have ever seen from him. . . . The picture has a savage zest in it It alone would put Winslow Homer in the front rank of American artists" // C. H. Caffin, *American Masters of Painting* (1902), p. 79, notes that "it is in his marines that he seems to reach the ripest maturity of his genius; the most completely, perhaps, in the 'Maine Coast' . . . This picture involves a drama; but the players are the elements; the text, of universal language; the theme, as old as time. With the enlargement of purpose has come a corresponding grandeur of style; they realize, as no other marines with which I am acquainted, the majesty, isolation, immensity, ponderous movement and mystery of the ocean" // F. W. Morton, *Brush and Pencil* 10 (April 1902), p. 48, says, "His 'Maine Coast,' for instance, is a masterpiece which carries conviction; p. 49, notes, "every technical requirement necessary to convey what the artist wishes to express is met. The simplicity of the drawing and the fidelity of the coloring to nature impart to the picture a truth and a power that make it impressive" // *New York Times*, Dec. 12, 1902, p. 9, in review of the 1902 Hearn exhibition at the Union League Club, says of this painting and Cannon Rock (q. v.) : "Both are masterpieces, strong as ever sea painting has been" // C. H. Caffin, *Critic* 43 (Dec. 1903), ill. p. 548; pp. 551–552, comments that Homer's "vision does not look toward far horizons; the passion of the subject is hemmed around by sullenness; its violence concentrated upon some focal point, immediately near. Yet contracted though it is in scope, the impression of such masterpieces as 'Maine Coast' and

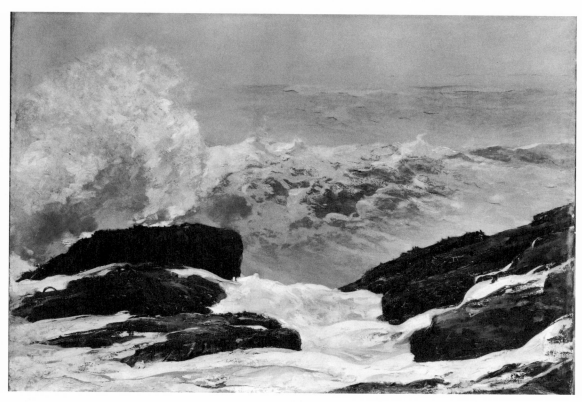

Homer, *Maine Coast.*

'Eastern Point' is one of extraordinary breadth" // [W. S. Howard], *Catalogue of the Collection of Foreign and American Paintings Owned by Mr. George A. Hearn* (1908), ill. p. 169, pl. 209, as The Maine Coast // C. Brinton, *Scribner's Magazine* 49 (Jan. 1911), p. 20, includes it as one of "those marines which constitute Homer's chief title to greatness. . . . Temperamentally they demonstrate to the full his ability to confront nature in her mightiest moods and extract from her the highest measure of pictorial possibility. Continued study and practice taught him how to convey an incomparable sense the of rhythm of wave and the exact impact and buoyancy of great masses of water, while profound contemplation and close intimacy with his subject gave him in the end the magic secret of elevating the merely local to the plane of universality" // W. H. Downes, *The Life and Works of Winslow Homer* (1911), p. 9; p. 177, says it is unrivaled; p. 181, lists it among "five exceptionally important pictures" Homer painted in 1896; pp. 185–186, describes it (quoted above); p. 187, provides history of ownership, noting that it was bought by Clarke and sold in the 1899 sale of his collection, when it was purchased for $4,400 by F. A. Bell, who subsequently sold it to Hearn; pp. 190, 205, 206, 207, 219, ill. opp. p. 228; p. 232, notes confusion with Coast in Winter lent by Mr. C. J. Blair of Chicago to

the Carnegie Institute in 1908; pp. 258, 286 // *MMA Bull.* 6 (July 1911), p. 146, includes it in Hearn's offer of gift of June 14, 1911; ill. p. [147] // MMA, *George A. Hearn Gift to the Metropolitan Museum of Art* . . . (1913), p. 108, lists it with works given to the MMA in memory of Arthur Hoppock Hearn; ill. p. 110 // K. Cox, *Winslow Homer* (1914), p. 33, lists it with important works in the "series of great pictures of rock and surf, . . . which marks Homer as the greatest of marine painters" // J. C. Van Dyke, *American Painting and Its Tradition* (1919), p. 108, describes it // W. H. Downes, *American Magazine of Art* 23 (Nov. 1931), p. 364 // T. Bolton, *Fine Arts* 18 (Feb. 1932), p. 55, lists Maine Coast, 1896, describes it, and gives references // *Index of Twentieth Century Artists* 1 (Nov. 1933), p. 2, includes it; suppl. to 1, p. ii, lists reproductions // L. Goodrich, *Winslow Homer* (1944), p. 135, includes with seascapes and characterizes it as among Homer's greatest works; pp. 143–144, discusses Clarke's interest in it and previous history; p. 155, includes it among works sold at the 1899 Clarke collection sale and gives price; p. 156, notes that Clarke paid $800 for it; pp. 187, 228 // A. T. Gardner, *Winslow Homer* (1961), p. 202, mentions it in Clarke collection; ill. p. 203, as Maine Coast; p. 208, mentions it in a discussion of Homer's marines; pp. 241, 242, notes various exhibitions; pp.

248, 254 // J. Gould, *Winslow Homer* (1962), pp. 251, 274; p. 283, says that Homer pointed out the site to John W. Beatty, when he visited Prouts Neck // P. C. Beam, *Winslow Homer at Prout's Neck* (1966), p. 139, cites it as one of Homer's three "most famous and popular wave and rock pictures"; pp. 211–212, discusses it; p. 220, notes that in 1902 Homer received the Temple Gold Medal from the Pennsylvania Academy for Northeaster and Maine Coast; p. 261 // M. D. Davis, *Winslow Homer* (1975), p. 91, lists bibliography // D. B. Kuspit, *Art in America* 64 (Jan.-Feb. 1976), pp. 69–71, discusses late seascapes and Homer's approach to nature; ill. p. 70 // H. B. Weinberg, *American Art Journal* 8 (May 1976), p. 75, includes it in checklist of paintings owned by Clarke, notes that Clarke acquired it and The Lookout—All's Well from the artist in April 1897 for $1,500 and sold Maine Coast for $4,400 in 1899; p. 76 // S. Nunemaker, Art Institute of Chicago, letter in Dept. Archives, Dec. 11, 1979, supplied information from the Art Institute of Chicago Scrapbook // G. Hendricks, *The Life and Work of Winslow Homer* (1979), p. 241, notes price at the Clarke sale in 1899; ill. p. 315, CL–513.

EXHIBITED: Union League Club, New York, Jan. 1896, *Loan Collection of Paintings by American Artists*, no. 26, as Coast of Maine, lent by the artist (possibly this painting) // Rhode Island School of Design, Providence, 1897, *Catalogue of Paintings and Engravings on View at the Rhode Island School of Design at the Opening of the New Galleries*, no. 43, as Maine Coast, lent by the artist // Society of American Artists, New York, 1897, no. 120, as Marine-Coast // Carnegie Institute, Pittsburgh, 1897–1898, no. 119, as Maine Coast // Union League Club, New York, 1898, *The Paintings of Two Americans: George Inness, Winslow Homer*, no. 40, as Maine Coast, lent anonymously by T. B. Clarke // Exposition Universelle, Paris, 1889–1900, *Catalogue Général Officiel*, groupe 2, classe 7, no. 153, as La Côte de Maine // Paris Exposition of 1900, *Official Illustrated Catalogue, Fine Arts Exhibit, United States of America*, no. 58, as The Maine Coast, lent by F. A. Bell // Union League Club, New York, 1902, *Paintings from the Collection of George A. Hearn, Esq.*, no. 14, as Maine Coast // Galleries of the American Fine Arts Society, New York, 1904, *Comparative Exhibition of Native and Foreign Art under the Auspices of the Society of Art Collectors*, no. 71, as Maine Coast, lent by Mr. George A. Hearn // MMA, 1911, *Winslow Homer Memorial Exhibition*, no. 19, lent by George A. Hearn // Akron Art Institute, Ohio, Dec. 1945, *40 American Painters*, no. 14a // Newark Museum, N. J., 1946, *19th Century French and American Paintings from the Collection of the Metropolitan Museum of Art*, no. 18 // Munson-Williams-Proctor Museum, Utica, N. Y., 1946–1947, *Paintings by Winslow Homer and Thomas Eakins*, unnumbered cat. // Centennial Art Gallery, Centennial Exposition, Salt Lake City, 1947, *One Hundred Years of American Painting . . . from the Collections of the MMA and the Whitney Museum of American Art* [assembled and arranged by the Amer-

ican Federation of Arts], ill. p. 10, no. 24 // Los Angeles, National Construction Industries Home Show Exposition, June 14-Aug. 31, 1951 (no cat. available) // Mariners Museum, Newport News, and Virginia Museum of Fine Arts, Richmond, 1964, *Homer and the Sea*, essay by L. Goodrich, no. 42, as The Maine Coast, 1895 // MMA, 1965, *Three Centuries of American Painting*, unnumbered cat. // Andrew Dickson White Museum of Art, Cornell University, Ithaca, N. Y., 1967, *Painting in America until the Civil War* (no cat.) // Brooklyn Museum, Virginia Museum of Fine Arts, Richmond, and California Palace of the Legion of Honor, San Francisco, 1967–1968, *Triumph of Realism*, p. 79, no. 77, misdates it; ill. p. [160], no. 77.

ON DEPOSIT: Virginia Museum of Fine Arts, Richmond, 1948–1949 // United States Mission to the United Nations, New York, 1968–1971 // White House, Washington, D. C., 1971–1977 // MFA, Boston, 1980-present.

EX COLL.: Thomas B. Clarke, New York, April 1897—Feb. 15, 1899 (sale, American Art Galleries, New York, Feb. 15, 1899, no. 168, New York, $4,400); F. A. Bell. New York, Feb. 15, 1899—after 1900; George A. Hearn, New York, by 1902–1911.

Gift of George A. Hearn, in memory of Arthur Hoppock Hearn, 1911.

11.116.1.

The Gulf Stream

Dated 1899, *The Gulf Stream* was based on studies made during Homer's two winter trips to the Bahamas in 1884–1885 and 1898–1899. In the painting Homer returned to the theme of the confrontation of man and nature, which found its chief expression in his works dealing with the sea. He shows a black man adrift on a dismasted sloop encircled by sharks and threatened by a distant waterspout. The subject is presented with a wealth of narrative detail that recalls Homer's early work as an illustrator. The sun-drenched brilliance of an otherwise idyllic tropical setting and the man's stoic resignation to his fate heighten the pathos of the impending tragedy.

The picture was first exhibited at the Pennsylvania Academy of the Fine Arts in Philadelphia in 1900. After two unsuccessful attempts to persuade Homer to lend it, Harrison S. Morris, then secretary and managing director of the academy, telegraphed him: "The greatest American Art Exhibition can not open without an example from the greatest American artist." Homer sent the canvas together with a note instructing Morris not to "let the public poke its

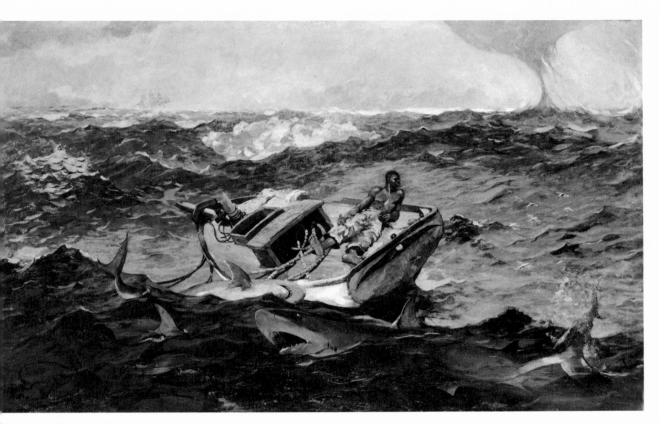

Homer, *The Gulf Stream.*

nose into my picture." Reviewing the work in *Brush and Pencil*, one critic reported that a "novelist could not have conceived a more dramatic situation" and observed that, although "the painting strikes one somewhat as too hard in outline, one cannot deny its power."

In September 1900, several months after the exhibition closed, Homer wrote John W. Beatty, his friend and the first director of the Department of Fine Arts at the Carnegie Institute: "I have painted on the picture since it was in Philadelphia & improved it very much (more of the Deep Sea water than before)." A comparison of the picture as it now appears with an illustration of it before reworking shows that Homer's changes were not solely confined to the sea. The waves in the trough at the upper left have been modified to make the design more subtle; the starboard gunwale, shown intact in the early version, is now broken, and a sail has been added over the gunwale; the waterline, formerly continuous and probably delineated in black paint, has been replaced by a dash of vivid red, which,

intersected with a broad stroke of white, attracted the comment of critics and artists; the name of the vessel now clearly appears on the stern; and a ship has been introduced on the distant horizon. These changes intensify the pronounced narrative character of the work.

In this final state the painting was shown at the Carnegie Institute in Pittsburgh in 1900–1901 and then at Knoedler's in New York, with the record-asking price of $4,000. The critic Sadakichi Hartmann (1901) mentioned the New York exhibition and called *The Gulf Stream* "one of the greatest pictures ever painted in America." Yet, as Lloyd Goodrich pointed out, the painting did not sell, either because of the price or the nature of the subject. Goodrich reports that the Worcester Museum had it under consideration for a time, but its acquisition was blocked by two women on the board who objected to the "unpleasantness" of the subject. A request for an explanation of the work provoked a characteristic response from Homer, who on February 17, 1902, wrote to Knoedler's:

You ask me for a full description of my picture of the 'Gulf Stream'. I regret very much that I have painted a picture that requires any description. The subject of this picture is comprised in *its title* & I will refer these inquisitive schoolma'ms to Lieut. Maury [presumably Matthew Fontaine Maury (1806–1873), an oceanographer, whose classic studies on navigation and wind and ocean currents earned him an international reputation]. I have crossed the Gulf Stream *ten* times & I should know something about it. The boat & sharks are outside matters of very little consequence. *They have been blown out to sea by a hurricane.* You can tell these ladies that the unfortunate negro who now is so dazed & parboiled, will be rescued & returned to his friends and home, & ever after live happily.

On another occasion, Homer responded in a similar vein:

The criticisms of The Gulf Stream by old women and others are noted. You may inform these people that the Negro did not starve to death. He was not eaten by the sharks. The waterspout did not hit him. And he was rescued by a passing ship which is not shown in the picture (quoted in P. C. Beam [1966], p. 172).

At some point, probably after the Philadelphia exhibition in 1900, Homer added a large, fully rigged ship on the horizon. This vessel, which he later replaced with a smaller version, was obviously out of scale. The old outline is almost visible to the naked eye and is clearly visible under infrared reflectography. Homer's reworking of the ship may explain the peculiar inscription on the canvas, "At 12 feet you can see it."

Following its exhibition in New York, *The Gulf Stream* was shown in Venice and then sent to the Chicago art dealers M. O'Brien and Son. Homer wrote them on March 20, 1902, suggesting that

Homer, watercolor, *Study for the Gulf Stream*. Cooper-Hewitt Museum.

they try to sell it to a public gallery; for, "No one would expect to have it in a private house" (quoted in W. H. Downes [1911], p. 149). The painting remained unsold until it was exhibited in 1906 at the National Academy of Design in New York. "When the canvas came before the jury," the *American Art News* reported on De-

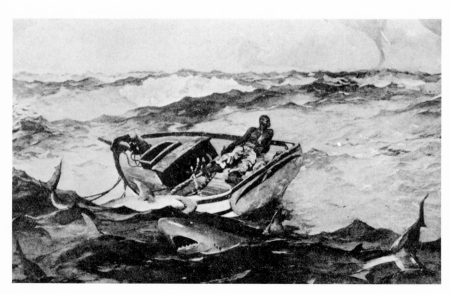

Photograph of *The Gulf Stream* in 1900, before Homer made changes on it. From the Pennsylvania Academy of the Fine Arts, *Catalogue of the Sixty-ninth Annual Exhibition, January 15 to February 24, 1900* (2nd ed.).

cember 29, "there was a murmur of admiration, and then one artist called out 'Boys that ought to be in the Metropolitan.'" The museum had considered acquiring the painting two months earlier, but turned it down. A petition to the museum, however, urging "the acquisition of this picture as a most notable achievement of American art" was drawn up on December 12 and signed by all the members of the jury. Two days later, the museum bought the painting. The same day, the curator of paintings, Roger Fry, wrote to Louis Loeb of the jury and informed him of the decision: "I need not tell you how delighted I am personally. I regard the Gulf Stream as one of the most typical and central creations of American art. It belongs to this country in every way It is a great masterpiece and counts among the very finest that Winslow Homer has created."

Reviews of the academy exhibition were mixed. Some critics devoted as much attention to the museum's role as an arbiter of contemporary taste as they did to the painting. The *New York Sun*, condemning the mediocrity of the show, characterized *The Gulf Stream* as "by no means the best picture" but "the most popular" and concluded that the museum had "consecrated that popularity by purchasing the canvas." The *New York Herald* reported: "The selection and purchase of The Gulf Stream, artists believe, is an indication that the Metropolitan Museum realizes its duty toward contemporary American art, or to be exact, toward what is best in contemporary American art." Among the most disparaging remarks was one made by the critic for the *Philadelphia Item*, who called the work a "unique burlesque on a repulsive subject" and

Homer, pencil on paper, *Study for the Gulf Stream*. Photograph courtesy of Steven Straw.

renamed it "Smiling Sharks" (quoted in W. H. Downes [1911], p. 135). Most contemporary critics, however, were struck by the drama and power of the work. The *New York Herald* called it "an unusually strong canvas, even for a Winslow Homer," and noted: "It should, so artistic opinion runs, eventually bear the same relation to marine subjects painted by this American that Turner's famous 'Slave Ship' does to that artist's works." "Sharks," it added, "are neither pretty nor artistic looking creatures, but their presence in this canvas gives it a touch of grotesque hideousness that adds immeasurably to the sense of impending tragedy." The *New York Press* described it "as a piece of wonderful craftsmanship" and singled out the "note of brilliant red" on the sloop as "a masterly stroke that kept a crowd of artists before the canvas all day long . . . in open admiration of Homer's genius

Homer, watercolor, *The Gulf Stream*. Art Institute of Chicago.

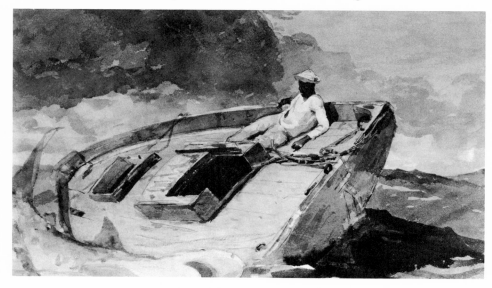

for color." In a December 1906 issue of the *Nation*, the artist and critic KENYON COX praised the museum for acting on the academy's recommendation and wrote, "'The Gulf Stream' is, in spite of evident crudities, a masterpiece of extraordinary power; perhaps the greatest work of our most original painter." Although he was chairman of the academy jury and one of the petitioners who recommended the museum's purchase, Cox subsequently enumerated the painting's shortcomings in an article published in the *Burlington Magazine* in 1907:

The Gulf Stream is not without certain obvious faults; the tubby boat has been objected to by experts in marine architecture, and the figure of the negro is by no means faultless in its draughtsmanship, while there is a certain hardness of manner in the painting of the whole canvas. But these things scarcely obscure the dramatic force of the composition, which renders it one of the most powerful pictures Homer ever painted.

The Gulf Stream, a work rooted in the romantic tradition, looks back to such celebrated epic treatments of maritime disasters as JOHN SINGLETON COPLEY's *Watson and the Shark*, 1778 (National Gallery of Art, Washington, D.C.; also see vol. 1), Théodore Géricault's *The Raft of the Medusa*, 1818–1819 (Louvre, Paris), and J. M. W. Turner's *The Slave Ship*, first exhibited 1840 (MFA, Boston), all of which Homer must have known. *Watson and the Shark* was based on an incident in the life of an English merchant, Brooke Watson, who fell overboard during a voyage to the West Indies in 1747 and lost his leg to a shark. This painting and *The Gulf Stream* share a realistic approach, romanticism comprised in the horror of the subject, an expressive baroque composition, and a Caribbean setting. Even the shark is similar to one in the same position in Homer's work.

The Raft of the Medusa, a masterpiece of French romantic painting and a political statement, was inspired by the shipwreck of the *Méduse* off the west coast of Africa in 1816 and the long ordeal of the few survivors. *The Gulf Stream* was aptly characterized by the critic Royal Cortissoz (1923) as "Homer's 'Raft of the Medusa,' . . . his equivalent for the drama of a Gericault or a Delacroix." Yet as Cortissoz observed, "for them the tragic motive was necessarily surcharged with a certain romantic fervor," but "Homer is almost passionless in his delineation of a lurid scene. He stands aside and leaves his facts to speak for themselves. *His expression corresponds with the thing's essential reality.*"

In discussions of *The Gulf Stream*, contemporary critics also found parallels with *The Slave Ship*, acquired by the Museum of Fine Arts, Boston, the same year Homer painted *The Gulf Stream*. Among Turner's sources were a passage describing sharks following a slave ship during a typhoon in James Thomson's poem *The Seasons* and the case of the slave ship *Zong*, whose captain had the slaves thrown overboard when an epidemic broke out in 1783 (because insurance covered losses at sea but not deaths by disease). Differences in style notwithstanding, *The Gulf Stream* and *The Slave Ship* both contrast beautiful settings (the sunset and approaching storm in *The Slave Ship* and the lush tropical brilliance of *The Gulf Stream*) with the horror of the subject. Also, Turner's retreating slaver and Homer's ship on the horizon provide "a suggestion of hope receding which put, in Kipling's phrase, 'the gilded roof on the horror'" (quoted in W. H. Downes [1911], p. 135).

The fact that several of Homer's works were inspired by contemporary events raises the question whether *The Gulf Stream* was based on an actual incident (as yet undisclosed). The name ANN[IE] KEY WEST on the stern of the sloop might appear to suggest this, yet the boats in his Caribbean watercolors, if identified at all, are named either Annie or Lizzie. What is more intriguing, as Ellwood Parry (1974) observed, is that although the studies for *The Gulf Stream* were made in the West Indies, Homer suggests that the man's home port is the United States by designating the boat's origin as Key West. Despite Homer's insistence that the subject of his picture "is comprised in *its title*," Sidney Kaplan (1964) described it as a "masterpiece of the black image—the deathless Negro waiting stoically, Homerically, for his end between waterspout and white-bellied shark." The image and its analogies to such abolitionist works as Turner's *The Slave Ship* suggest undercurrents of meaning beyond the prosaic representation of an ocean current.

An intentionally enigmatic work, *The Gulf Stream*, as Bryson Burroughs observed in 1907, "assumes the proportion of a great allegory if one chooses." Curiously reactionary in its romantic character and excessive narrative concerns, it is nevertheless an audacious work of intense colors, unrestrained energy of execution, and elemental power.

Oil on canvas, 28⅛ × 49⅛ in. (71.4 × 124.8 cm.). Signed and dated at lower left: HOMER/1899.

Inscribed at lower left (partly painted over): At 12 feet you can see it.

RELATED WORKS: *Derelict and Sharks*, watercolor on paper, 1885, private coll., ill. in T. Bolton, *Fine Arts* 18 (April 1932), p. 17 // *Study for the Gulf Stream*, watercolor on paper, 14½ × 10 1/16 in. (36.8 × 25.6 cm.), Cooper-Hewitt Museum, New York, 1912-12-36, ill. in C. S. Hathaway, *Chronicle of the Museum for the Arts of Decoration of Cooper Union* 1 (April 1936), p. [60], fig. 6 // *Study for the Gulf Stream*, pencil on paper, sight size 4 3/16 × 6 7/16 in. (10.6 × 16.4 cm.), New York art market, 1981 // *The Gulf Stream*, watercolor on paper, 11⅜ × 20 1/16 in. (28.9 × 51 cm.), 1889, Art Institute of Chicago, ill. in P. C. Beam, *Winslow Homer at Prout's Neck* (1966), p. 168, fig. 70.

REFERENCES: W. Homer to T. B. Clarke, Feb. 25, 1899, Lloyd Goodrich's Copies of Winslow Homer Letters, 1860s–1910, microfilm NY 59-12, Arch. Am. Art, writes, "I have had a most successful winter at Nassau. I found what I wanted & have many things to work up into *two paintings* that I have in mind. I shall not go North until it is warmer but I am through work for the winter & desire to report myself *very well*" // Homer to J. W. Beatty, Sept. 1899, ibid., Arch. Am. Art, says: "I painted in water colors three months last winter at Nassau, & have now just commenced arranging a picture from some of the studies" // H. S. Morris to Homer, telegram [before Jan. 1900], and Homer's reply (quoted above from Morris, *Confessions in Art* [1930], p. 63) // W. P. Lockington, *Collector and Art Critic* 2 (Feb. 1, 1900), p. 121, describes at PAFA exhibition and notes: "The abject fear at the near approach of the sharks is well interpreted, but all else is theatrical and unpleasant" // F. Ziegler, *Brush and Pencil* 5 (March 1900), p. 264 (quoted above); ill. p. 265, before reworking // Homer to Beatty, Sept. 1900, Lloyd Goodrich's Copies of Winslow Homer Letters, 1860s–1910, microfilm NY 59-12, Arch. Am. Art (quoted above) // Homer to M. Knoedler and Co., New York, Sept. 21, 1900, M. Knoedler and Co. MSS, microfilm NY 59-5, Arch. Am. Art, offers to send Gulf Stream after Pittsburgh show and says, "I had rather have a picture in your show window than any place"; Oct. 5, 1900, discusses price and commission // Homer to Clarke, Oct. 24, and Dec. 11, 1900, Misc. MSS Homer, Arch. Am. Art., mentions possible exhibition of Gulf Stream at the Union League Club in January, says it has never been shown in New York and will be returned from Pittsburgh to Knoedler // Homer to M. O'Brien and Son, Chicago, Dec. 3, 1901, quoted in W. H. Downes [1911], p. 214, writes: "It is about time that I received my picture the 'Gulf Stream' back from Venice, and the beautiful frame on it will go on [another] . . . picture" // S. Hartmann, *A History of American Art* 1 (1901), p. 200 (quoted above) and says it was exhibited at Knoedler's in 1901 // Homer to M. Knoedler and Co., New York,

Feb. 17 1902, M. Knoedler and Co. MSS, microfilm NY 59-5, Arch. Am. Art (quoted above) // Homer to M. O'Brien and Son, Chicago, March 15, 1902, says he is sending the Gulf Stream, just back from Venice, and offers it at a net price to him of $3,000, and March 20, 1902, writes, "Why do you not try and sell the 'Gulf Stream' to the Layton Art Gallery, or some other public gallery? No one would expect to have it in a private house," quoted in W. H. Downes [1911], pp. 215 and 149 // F. W. Morton, *Brush and Pencil* 10 (April 1902), ill. p. 40, before reworking; p. 54, notes that "with its boat and fish in the foreground [it] is but another mute witness of the force of nature" // W. Homer to M. O'Brien and Son, Chicago, Nov. 6, 1902, quoted in W. H. Downes (1911), p. 218, asks them to take it out of the frame, pack it, and send it to him // Minutes of Committee on Purchases, MMA, Oct. 15, 1906, MMA Archives, declines to buy the painting // W. H. Low to R. W. de Forest, Dec. 12, 1906, MMA Archives, encloses request of NAD jury that MMA acquire Gulf Stream // Request [Dec. 12, 1906] stamped rec'd Dec. 14, 1906, MMA Archives, signed by Kenyon Cox (chairman of the NAD jury), Francis C. Jones, Frederick G. R. Roth, Louis Loeb, Will H. Low, Leonard Ochtman, Robert Henri, Ben Foster, H. Bolton Jones, Wm. T. Smedley, Samuel Isham, Wm. H. Howe, Emil Carlsen, Carlton T. Chapman, Elliott Daingerfield, Geo. W. Maynard, F. D. Millet, Louis Paul Dressar, Edw. H. Potthast, Frederick Dielman, expresses their admiration for Gulf Stream and urges museum's trustees to acquire the painting (quoted above) // R. E. Fry to L. Loeb, Dec. 14, 1906, copy in MMA Archives, describes his delight with the committee's decision to buy the painting (quoted above) // *New York Herald*, Dec. 21, 1906, p. 12 (quoted above) // *New York Times*, Dec. 22, 1906, p. 2, describes painting and reports its purchase // *New York Evening Post*, Dec. 22, 1906, p. 2 // *New York Press*, Dec. 23, 1906, p. 8, reviews it at NAD (quoted above) // *New York World*, Dec. 23, 1906, p. 2w (p. 14), in review of NAD exhibition, says it "was naturally the center of attraction, but it was by no means the best painting on view" // *New York Sun*, Dec. 27, 1906, p. 6, says the "treatment is broad, flowing, virile, Mr. Homer is a veteran, but he can fence with any of the younger men in rugged force and graphic fidelity. Yet is his picture not a great one. It is only popular. It contains more shudders than the 'Raft of the Medusa.' It is too crowded, with naturalistic melodrama. It is less fantastic than cruel, and the quality of the paint is neither pleasant nor translucent. Mr. Homer imagined that sea" (quoted above) // K. Cox, *Nation* 83 (Dec. 27, 1906), pp. 564–565, says it is the first American picture to be bought from the Wolfe fund and discusses (quoted above) // *New York Evening Post*, Dec. 29, 1906, p. 5, cites the painting's "blunt directness" and force, says it recalls Homer's early days as an illustrator, calls it "a great dramatic picture" // *American Art News* 5 (Dec. 29,

1906), p. [4], calls it "one of his strongest and most representative works" and relates events leading to its purchase by the museum (quoted above) // B. B[urroughs], *MMA Bull.* 2 (Jan. 1907), p. 14, announces acquisition of the painting and describes it (quoted above) // *American Art News* 5 (Jan. 5, 1907), p. [4], reprints notice from *New York Sun* // A. Hoeber, *International Studio* 30 (Feb. 1907), ill. p. [xcvii]; p. cii, says: "It is a daring performance entirely personal, painted with the certainty of a master—which Mr. Homer is—and the colour is to the last degree original....There is not a dull square inch to the canvas" // *International Studio* 30 (Feb. 1907), p. cxii // W. C. Arensberg, *Burlington Magazine* 10 (Feb. 1907), p. 336 // Homer to de Forest, April 11, 1907, MMA Library, acknowledges with thanks the proof of a color reproduction of the painting // K. Cox, *Burlington Magazine* 12 (Nov. 1907), p. [122], pl. ii; pp. 123, 124 (quoted above); reprinted in *MMA Bull.* 5 (Nov. 1910), pp. 255–256 // L. Mechlin, *International Studio* 34 (June 1908), p. cxxv; ill. p. [cxxxii], top // F. V. Du Mond, *Palette and Bench* 1 (April 1909), ill. p. 157 // W. Pach, *Gazette des Beaux-Arts* 51 (Oct. 1909), p. 330 // *Masterpieces of American Painting, a Selection of Photogravures after Paintings Exhibited at the Royal Academy of Arts, Berlin, 1910*, intro. by C. Brinton, no. 24 // P. Clemen, *Die Kunst für Alle* 25 (May 15, 1910), p. 372; ill. p. 373 // C. L. Hind, *International Studio* 41 (Sept. 1910), ill. p. 189, as The Castaway // C. Brinton, *L'Art et les Artistes* 12 (Oct. 1910), ill. p. 13; pp. 15–16 // J. E. Chase, *Harper's Weekly* 54 (Oct. 22, 1910), ill. p. 13, as The Castaway // C. Brinton, *Scribner's Magazine* 49 (Jan. 1911), ill. p. [21]; p. 23, notes that the painting was "the last of the series" of marine masterpieces and "stirring as it is, already displays a certain diffusion of interest seldom seen in the canvases of his best manner" // A. Hoeber, *World's Work* 21 (Feb. 1911), ill. p. 14012 // W. H. Downes, *The Life and Works of Winslow Homer* (1911), opp. p. 20, reproduces photograph of Homer in front of The Gulf Stream; ill. opp. p. 126; p. 132; pp. 133–135, comments on composition and theme (quoted above), discusses exhibitions, and quotes from reviews; pp. 149, 204, 213–214, 215, 218, 225, 229; pp. 231, 247, 258, 278, 282, 285, gives information on exhibitions // W. Pach, *L'Art et les Artistes* 16 (Nov. 1912), ill. p. 73; p. 76 // A. Hoeber, *Mentor* 1 (July 7, 1913), p. 2, discusses it; ill. p. 3 // K. Cox, *Winslow Homer* (1914), color frontis., p. 32, notes that Homer's first voyage to Nassau and Cuba was in the winter of 1885–1886 and the Gulf Stream was not finished until 1899; p. 33; p. 35, says the brilliant light intensified the tragic character of the subject; praises the composition and color; p. 51; p. 52, suggests that Homer's addition of a scarlet note on the boat was a sign that he was growing color-blind; p. 57, suggests that "the greatest test of a designer is his use of little things to produce unexpectedly great effects, and a remarkable instance of this is to be found in 'The Gulf Stream.' Remove the trailing

ropes from the bow of the tubby boat and its helpless sliding into the trough of the sea will be checked, the ghastly gliding of the sharks will be arrested, and the fine wave drawing will not avail to keep the picture alive and moving" // J. C. Van Dyke, *American Painting and Its Tradition* (1919), p. 104, thinks the color is not integral but an "afterthought" added to the design // *Arts and Decoration* 12 (March 25, 1920), ill. p. 306 // R. Cortissoz, *American Artists* (1923), p. 122 (quoted above) // W. Starkweather, *Mentor* 13 (July 1925), ill. p. 46 // W. Pach, *Gaceta de Bellas Artes* 18 (March 1, 1927), ill. p. 11, discusses // I. Hoopes, *Mentor* 17 (August 1929), ill. p. 34; pp. 34–35, discusses; ill. p. 35, reproduction of Homer in front of this painting // H. S. Morris, *Confessions in Art* (1930), p. 63 (quoted above) // E. Neuhaus, *The History and Ideals of American Art* (1931), ill. p. [288], top; p. 298, says it is "almost melodramatic in its story, but told in a bold and decorative manner" // W. H. Downes, *American Magazine of Art* 23 (Nov. 1931), p. 364; ill. p. 365 // T. Bolton, *Fine Arts* 18 (Feb. 1932), p. 52, discusses Homer's use of color; p. 55, includes it in catalogue // C. H. Hathaway, *Chronicle of the Museum for the Arts of Decoration of Cooper Union* 1 (April 1936), pp. 55–57, discusses related works // J. W. Lane, *Apollo* 24 (Oct. 1936), ill. p. 236; p. 237 // F. Watson, *American Magazine of Art* 29 (Oct. 1936), ill. p. 636 with watercolor study, notes incorrectly that the Gulf Stream was acquired from the Chicago World's Fair in 1893 // L. Goodrich, *Winslow Homer* (1944), p. 90, notes that the theme dates from the 1885 trip to the West Indies and that a "sketch of sharks hovering around a dismasted sailboat was the germ of *The Gulf Stream* of 1899"; p. [158]; p. 161, says that it is "the last and finest variation of his favorite theme of the perils of the sea, less heroic and more realistic than the earlier ones, with an added touch of irony in the warm tropical sunlight and the blue southern sea," adds its color is "the most brilliant in any oil so far," and although it is "without true glazing, the variety and power of its brushwork made it one of his greatest technical achievements; pp. 161–162, discusses the painting and studies, cites letters to Beatty, Knoedler, and correspondence with Morris (quoted above); p. 186; p. 187, discusses its exhibition at the NAD in 1906 and acquisition by MMA; p. [228], in chronology, notes that Homer began it in Sept. 1899; p. 234; pl. 52 // A. Winchester, *Antiques* 51 (Feb. 1947), pp. 100–101, 108, and 127, discusses it in review of American paintings exhibit at the Tate Gallery, London; fig. 69, p. 107 // *MMA Bull.* 6 (April 1948), color ill. detail on cover; ill. opp. p. 213 // O. W. Larkin, *Art and Life in America* (1949), p. 274, notes that "compared with the swift terror of a Ryder shipwreck," Gulf Stream "is no more than a vigorous dramatic anecdote superbly told" // A. T. Gardner, *MMA Bull.* 16 (Summer 1957), p. 1; ill. p. 8; *MMA Bull.* 17 (Jan. 1959), ill. pp. 132–133; p. 135–137, discusses source of composition, exhibitions, artist's

comments, and quotes reviews of picture // L. Katz, *Arts* 33 (Feb. 1959), ill. p. 27, and quotes Homer // L. Goodrich, *Winslow Homer* (1959), pp. 30, 31; color pl. 86 // A. T. Gardner, *Winslow Homer* (1961), ills. pp. 34, 100, shows related works; p. 211, discusses Homer's selection of "a particularly enigmatic and tantalizing episode" and says it is "story-suggesting rather than storytelling"; pp. 212–213, says on purely artistic grounds it is "a triumph," points out its few oriental characteristics, including "the detached point of view of the spectator," discusses 1885 studies, says that it was shown in an unfinished state at the PAFA, was subsequently improved and sent to Homer's dealer priced at $4,000, notes that it was rejected by the Worcester Museum in 1902 because of its subject matter, gives information on MMA acquisition; color ill. p. [218]; p. 242, in chronology, lists it at the PAFA and the Carnegie Institute, Pittsburgh, in 1899; p. 243, in chronology, lists it at the NAD in 1906 and in Berlin and Munich in 1910; pp. 247, 254 // J. Gould, *Winslow Homer* (1962), pp. 272–273, mentions related watercolor and discusses picture; pp. 277–279, 286, 288 // J. T. Flexner, *That Wilder Image* (1962), ill. p. 353, fig. 109; p. 354, discusses and says that with a few exceptions "the Native School had avoided the darker sides of life— pain and death—that had so fascinated European romantics," but with this work "Homer revived subject matter Copley had pioneered more than a century before in *Brook Watson and the Shark* (1778), and which Géricault had carried on in *The Raft of the Medusa* (1819)," and compares the works // Bowdoin College Museum of Art, Brunswick, Me., *The Portrayal of the Negro in American Painting* (1964), intro. by S. Kaplan (quoted above); reprinted in *Massachusetts Review* 7 (Winter 1966), p. 112 // A. T. Gardner, *Antiques* 87 (April 1965), ill. p. 437 // W. Andrews and G. McCoy, *Art in America* 53 (August-Sept. 1965), color ill. p. 56; p. 58, quote Homer's 1902 letter to Knoedler // P. C. Beam, *Winslow Homer at Prout's Neck* (1966), p. [169], fig. 71; pp. 169–171, discusses studies and mentions exhibitions and reviews; pp. 172–173, gives Homer's description of the painting (quoted above) and in a letter in Dept. Archives, April 12, 1984, says the source for this quote was Homer's nephew Charles Lowell Homer; p. 179, mentions that the "only photo of Homer at work shows him painting on *The Gulf Stream* . . . in the dead of winter"; p. 241, notes that in 1906 it was purchased by the MMA for $4,500, "the highest price" Homer had ever received // J. T. Flexner and the editors of Time-Life Books, *The World of Winslow Homer, 1836–1910* (1966), p. 163, calls it "the most disturbing picture" Homer ever painted; p. 172, discusses; color ill. of detail. p. 173 // H. Honour, *Apollo* 84 (July 1966), p. 23, fig. 10, and mentions in discussion of 1901 Venice Biennale // B. Novak, *American Painting of the Nineteenth Century* (1969), ill. 10–28, p. 186; p. 187 // D. F. Hoopes, *Winslow Homer Watercolors* (1969), p. 9, lists it under 1899 in chronology; pp. 17, 19, 48, 56 // J. D. Prown,

American Painting from Its Beginnings to the Armory Show (1970), color ill. p. 89; p. 90, discusses it at length // M. S. Young, *Apollo* 91 (April 1970), p. 291; color pl. ii, p. 292 // J. Wilmerding, *Winslow Homer* (1972), pp. 136, 170, 174–175, discusses related works; compares the picture to Copley's *Watson and the Shark* and Bellows's *Both Members of This Club*; draws parallels between Homer's art and Melville's writing; and says the painting is "as much about the belief in survival as about the acceptance of death"; color pl. 44, p. 200; ill. 5–13, p. 212, shows related watercolor // J. Seelye, *New Republic* (Jan 20, 1973), p. 28, discusses in review of Wilmerding book // G. Hendricks, *Art News* 72 (May 1973), ill. p. 69, notes price; p. 71, discusses acquisition // M. S. Young, *Apollo* 98 (Sept. 1973), ill. p. 229, fig. 8, and mentions // H. W. Williams, Jr., *Mirror to the American Past* (1973), p. 190 // E. Parry, *The Image of the Indian and the Black Man in American Art, 1590–1900* (1974), p. 128, says, "the turbulent, shark-infested waters . . . demonstrate that even the finest American 'realists' of the period were not immune to Romantic impulses"; pp. 169–170, describes it as "the most pessimistic and compelling of his West Indian sea-pieces," speculates on significance of inscription on the stern of the boat, notes exhibition in 1900, and quotes from contemporary reviews that compare the painting to Géricault's Raft of the Medusa and Turner's Slave Ship // M. D. Davis, *Winslow Homer: An Annotated Bibliography of Periodical Literature* (1975), pp. 82–83, provides a bibliography of this painting // Whitney Museum of American Art, New York, *Seascape and the American Imagination* (1975), exhib. cat. by R. B. Stein, p. 112, says that Gulf Stream is "poorly painted, harsh in color, melodramatically overstated and terribly derivative in both its symbolism and its structure . . . a curious pessimistic melange of Watson and the Shark . . . and [Allston's] the Rising of a Thunderstorm at Sea"; p. 113, fig. 120 // *MMA Bull.* 33 (Winter 1975–1976), ill. p. 242 // G. Eager, *Art Journal* 35 (Spring 1976), p. 228; ill. p. 229, fig. 9; p. 230 // M. W. Brown, *American Art to 1900* (1977), p. 502 // W. D. Wilkinson, Mariners Museum, Newport News, Va., to D. K. Herrick, MMA, letter in Dept. Archives, August 17, 1979, notes that terms smack and sloop are used interchangeably, but a smack has a live fish well whereas a sloop does not, concludes that the boat in this painting is not large enough to have a fish well, "there is no structural evidence to suggest that there was a fish well," and suggests in view of this that it would be more appropriate to call the boat a sloop // G. Hendricks, *The Life and Work of Winslow Homer* (1979), p. 196, fig. 299, shows sketch; p. 196, fig. 300, shows watercolor; p. 237, notes 1906 NAD exhibit; p. 240; p. 242, mentions photograph of artist with this painting; p. 243, fig. 346, reproduces photograph of artist with painting; color pl. 62, p. 248; color detail, pl. 63, p. 249; pp. 250, 251, 253, 265, 275, discusses studies and history of the painting; p. 315, CL–506, lists it // N.

Spassky, *Winslow Homer* (1981), pp. 13–15, discusses; color ill. pl. 14; *MMA Bull.* 39 (Spring 1982), color ill. pp. 36–37; fig. 30; pp. 35, 37, 39, 41, 42, discusses.

EXHIBITED: PAFA, 1900, no. 3, as The Gulf Stream; ill. opp. p. 9 (in 2nd ed. of cat.), shows painting before reworking // Carnegie Institute, Pittsburgh, 1900–1901, no. 121 // M. Knoedler and Company, New York, 1901 // Venice, 1901, *Esposizione Internazionale d'Arte*, no. 57, as La corrente del golfo // NAD, 1906–1907, *Winter Exhibition*, no. 286 // Carnegie Institute, Pittsburgh, 1908, no. 146 // Art Society, Munich, and Royal Academy of Art, Berlin, 1910, *Ausstellung Amerikanischer Kunst*, ill. p. 11; no. 183, as Golfstrom // Museum of Modern Art, New York, 1932–1933, *American Painting & Sculpture, 1862–1932*, p. 14; no. 48, p. 32 // MMA, 1934, *Landscape Paintings*, no. 73 // Pennsylvania [Philadelphia] Museum of Art, 1936, *Winslow Homer, 1836–1910*, no. 26 // Whitney Museum of American Art, New York, 1936–1937, *Winslow Homer Centenary Exhibition*, cat. by L. Goodrich, no. 32 // Carnegie Institute, Pittsburgh, 1937, *Centenary Exhibition of Works of Winslow Homer*, exhib. cat. by H. Saint-Gaudens, p. 11; p. 22, no. 46; ill. opp. p. 23 // NAD, 1939, *Special Exhibition*, no. 250 // Museum of Modern Art, New York, 1943–1944, *Romantic Painting in America*, exhib. cat. by J. T. Soby and D. C. Miller, p. 33, say that in comparison to Géricault's Raft of the Medusa this painting "from one viewpoint is more Romantic in that it emphasizes the elemental struggle between nature and man, while Géricault's picture is above all a studio manifesto on a political issue"; ill. p. 79; p. 136, no. 104 // Tate Gallery, London, 1946, *American Painting from the Eighteenth Century to the Present Day*, no. 110 // MMA, 1950, *20th Century Painters*, p. 7; *100 American Painters of the 20th Century*, intro. by R. B. Hale, p. xvi; color ill. p. xviii // National Gallery of Art, Washington, D. C., MMA, and MFA, Boston, 1958–1959, *Winslow Homer, a Retrospective Exhibition*, cat. by A. T. Gardner, pp. 72, 73, 121, no. 71; Boston ed., 1959, pp. 57, 97, no. 65 // MMA, 1965, *Three Centuries of American Painting*, unnumbered cat.; 1970, *19th Century America, Paintings and Sculpture*, exhib. cat. by J. K. Howat, and N. Spassky, no. 161 // MFA, Boston, 1970, *Masterpieces of Painting in the Metropolitan Museum of Art*, cat. by E. A. Standen and T. M. Folds, color ill. p. 111, discusses it // MMA, 1970, *Masterpieces of Fifty Centuries*, intro. by K. Clark, no. 369 // [Wildenstein and Co., New York], Cooper-Hewitt Museum of Decorative Arts and Design, New York, 1972, *Winslow Homer, 1836–1910*, exhib cat. by E. E. Dee (not in cat.) // Whitney Museum of American Art, New York, Los Angeles County Museum of Art, Art Institute of Chicago, 1973, *Winslow Homer*, exhib. cat. by L. Goodrich, p. 46; color ill. p. 123; p. 137, no. 65, lists it (shown only in New York) // Pushkin Museum, Moscow, and Hermitage, Leningrad, 1975, *100 kartin iz muzeya Metropoliten, Soedinenie Shtati Ameriki* [100 Paintings from the Metropolitan Museum, United States of America], color ill. p. 250; no. 92, pp. 250–251, catalogues this painting.

EX COLL.: the artist, 1899–1906; with M. Knoedler and Co., New York, 1906.

Wolfe Fund, Catharine Lorillard Wolfe Collection, 1906.

06.1234.

Searchlight on Harbor Entrance, Santiago de Cuba

During Homer's visit to Cuba in February and March 1885, he made several studies of Morro Castle, the late sixteenth-century fort built by the Spanish at the entrance to the harbor of Santiago de Cuba. In 1901 Homer returned to the subject. Relying on his studies, he depicted the fort at Santiago during the United States blockade of the harbor at the end of the Spanish-American War in 1898.

The painting was first alluded to in a letter Homer wrote from Prouts Neck on December 7, 1901, to M. Knoedler and Company in New York: "At present I am in a most happy state of mind as I am hard at work on a *fine subject* that I can paint without any trouble right here in my studio. I have been free here for four days, the last tenderfoot having been frozen out, & now out of gun shot of any soul & surrounded by snow drifts, I again take up my brush after *nine months* of loafing." At the end of the month he wrote to Knoedler's that he was about to ship the painting and that this was "just the time to show that picture as the subject is now before the people." The events of the successful blockade were being widely publicized; for a controversy had arisen over which United States commander should have received credit for the victory. A court of inquiry was convened to investigate charges of improper conduct made against Winfield Scott Schley, one of the naval commanders of the blockade. The court, presided over by Admiral George Dewey, heard testimony from September 12 to December 12, 1901. It decided against Schley, and President Roosevelt stated that "technically [William Thomas] Sampson commanded"; however, no action was recommended.

In a letter postmarked December 30, 1901, to Thomas B. Clarke, one of his major patrons and chairman of the art committee of the Union League Club in New York, Homer reported finishing the painting and gave its title as "Search

Light on Harbor Entrance, Santiago de Cuba."
In a postscript he added: "If you think that this
is too much of a title—you may call it—'Harbor
Entrance Santiago de Cuba.'" He enclosed a
sketch, illustrated here, that shows ships, includ-
ing one with a searchlight, deployed around the
harbor entrance of Santiago; a full moon; and
Morro Castle, part of which is framed and in-
scribed, "Point of view of Picture." In what was
a rare instance for Homer, this sketch provided
a literal key to the painting but, characteris-
tically, in no way prepared Clarke for such an
unconventional representation. A diagram illus-
trating the blockade appeared in 1899 in an ar-
ticle titled "The Atlantic Fleet in the Spanish
War" by Rear Admiral William T. Sampson.
About the searchlight, which was an intrinsic
part of Homer's painting, Sampson wrote:

The search-light, as will be seen, was a very important
factor of the blockade. At first everybody felt that it
was desirable to explore the coast on each side of the
harbor, and every ship acted for herself, and began
in the same way, moving the search-light up and
down the coast. But we found, after one or two trials,
that where the beam of one light was intersected by
the beam of the next we could see nothing. Moreover,
the slightest movement of the pivot of the light made
the beam change so rapidly that little could be made
out. We therefore restricted the service to a single
light at any one time, keeping it stationary and point-
ed exactly up the harbor, which it illuminated per-
fectly The scene on a moderately dark night was
a very impressive one, the path of the search-light
having a certain massiveness, and the slopes and
crown of the Morro cliff being lighted up with the
brilliancy of silver (*Century Magazine* 57, n.s. 35 [April
1899], p. 901).

Sampson reported an unexpected result:

A search-light shining direct in one's eyes prevents
him absolutely from seeing anything else; it is as
though he were looking at the sun: and it was that
effect upon them [the officers of the Spanish fleet],
taken in connection with the necessity of seeing their
way out of the channel, that made them hesitate. This
feeling was in itself a compliment to the efficiency of
the blockade, but we did not attach so much impor-
tance to the dazzling of the enemy as to the illumina-
tion of the channel so that we could see everything
that was going on. It was a continual wonder to us
why they did not fire at our search-light, which was
always within range. To be sure, it would have re-
quired pretty good marksmanship to knock it out, but
it would have made the man who was manipulating
it quite uneasy to know that he was the center of the
enemy's fire (ibid., p. 910).

Homer's painting shows a section of the para-
pet of Morro Castle with its obsolete cannons
and a watchtower illuminated by the light of the
moon and the glare of the searchlight represent-
ing the blockade. Examination with infrared re-
flectography indicates that Homer rejected an
earlier plan of placing a cannon at the left of
the composition. The severely limited palette of
black, gray, slate blue, and white, the austerity
of the pared-down forms, and the asymmetrical
composition contribute to the strength of the
work. The composition and the abrupt cropping
of one cannon imply familiarity with a format
introduced by the impressionists. This painting—
a stark image of ominous solitude in the romantic
tradition—is one of Homer's most abstract com-
positions.

Shown at the Union League Club in New
York from January 9 to 11, 1902, the work at-
tracted the attention of the critics. "It was an
impossible subject," the *New York Evening Sun*
reported,

and we will not say that Mr. Homer, with all his
genius, has made it beautiful, for beauty is hardly the
word to describe the rude force that is in this silent
old fort above which the searchlight sweeps. But if it
is not at all beautiful within the meaning of the word
it is almost everything else.

The critic for the *New York Tribune* wrote,
"there is something which repels. It is a good
study in lighting, it is a good piece of technique,
but we cannot say that it is beautiful." In a let-
ter to Knoedler's, dated January 14, 1902, Ho-
mer replied:

That Santiago de Cuba picture *is not intended to be
"beautiful."* There are certain things (unfortunately
for critics) that are stern facts but are worth recording
as a matter of history as in this case. This is a small
part of Morro Castle & immediately over the Harbor
entrance which is only about 400 feet wide—& from
this point were seen all the stirring sights of June &
July 1898. *I find it interesting.*

In a telegram to Knoedler's recorded in his
daybook on January 9, 1902, Homer requested
$2,200 for the work "with regret, as I should
have more money." The painting was sold on
January 31 to George A. Hearn, who presented
it to the Metropolitan Museum in 1906.

In this unusual depiction of contemporary his-
tory, the juxtaposition of the ineffectual yet im-
posing remnants of an old colonial power and the
modern technology of a new nation on the in-

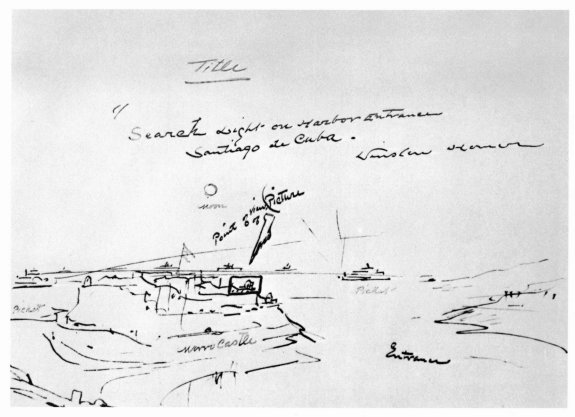

Homer's ink sketch of the painting in his letter to Thomas B. Clarke,
December 30, 1901. Courtesy of the Archives of American Art.

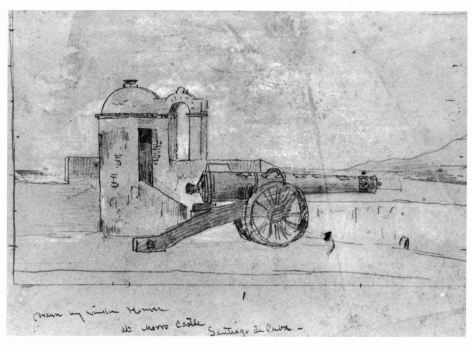

Homer, *Ramparts of Morro Castle, Santiago de Cuba*, pencil
and white chalk on gray paper. Cooper-Hewitt Museum.

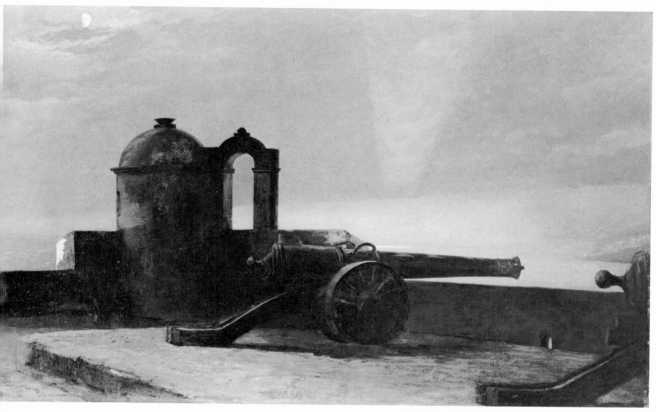

Homer, *Searchlight on Harbor Entrance, Santiago de Cuba.*

ternational scene may have been intended to suggest more than the mere facts of the blockade of Santiago. The art critic Frank Jewett Mather, Jr., speculated about this possibility in the *Magazine of Art* (1946):

The strange beauty of *Searchlight, Santiago* pretty well defies analysis For me this is one of the most fascinating pictures painted in my time. Most of Homer's work has a wholesome, often a heroic obviousness, and overtones are generally absent. Here there may be overtones, and even symbolism, in the contrast of the handsome old guns which are no longer weapons, but which are museum pieces, with the sharp beam of the searchlight which tells of the sinister efficiency of modern scientific warfare. While such a thought may not have been in Homer's mind as he planned this masterpiece, it does not seem alien to his thinking.

Oil on canvas, 30½ × 50½ in. (77.5 × 128.3 cm.). Signed at lower right: W. HOMER.

RELATED WORKS: *Morro Castle*, watercolor on paper, 13 × 19 in. (33 × 48.3 cm.), 1885, United States Military Academy, West Point, N. Y., ill. in the University of Arizona Art Gallery, Tucson, *Yankee Painter: A Retrospective Exhibition of Oils, Water Colors and Graphics by Winslow Homer* (1963), cat. by W. E. Steadman, Jr., p. 67, no. 135 // *Ramparts of Morro Castle, Santiago de Cuba*, pencil and white chalk on gray paper, 11 × 18⅝ in. (27.9 × 47.3 cm.), 1885, Cooper-Hewitt Museum, New York, 1912-12-1, ill. in J. Wilmerding, *Winslow Homer* (1972), p. 214, ill. 5–26 // *Ramparts of Morro Castle, Santiago de Cuba*, pencil on paper, 4⅞ × 7⅞ in. (12.4 × 20 cm.), Cooper-Hewitt Museum, New York, 1912-12-86, ill. in J. Wilmerding, *Winslow Homer* (1972), p. 214, ill. 5–25 // "Searchlight on Harbor Entrance, Santiago de Cuba," ink on paper, W. Homer to T. B. Clarke, postmarked Dec. 30, 1901, Misc. MSS Homer, Arch. Am. Art, ill. in G. Hendricks, *The Life and Work of Winslow Homer* (1979), p. 251, fig. 351.

REFERENCES: W. Homer to M. Knoedler and Co., New York, Dec. 7, 1901, M. Knoedler and Co. MSS, microfilm NY 59–5, Arch. Am. Art (quoted above); Dec. 19, 1901, in response to Knoedler's invitation to show a new painting, notes, "The only thing that I have got is the one I commenced the other day, &

Winslow Homer

as I may finish it in time I now beg to order a frame for it, to be done on Jan. *5th at noon*. If I find, *in about a week from now* that I cannot finish the picture, I will write to you"; Dec. 30, 1901 (quoted above) // Homer to T. B. Clarke, postmarked Dec. 30, 1901, Misc. MSS Homer, Arch. Am. Art, says painting is finished and arrangements for framing have been made, gives title as "Search Light on Harbor Entrance / Santiago de Cuba" and encloses sketch that indicates point of view of picture // Homer, daybook entry for Jan. 7, 1902, Winslow Homer Collection, Bowdoin College, Brunswick, Me., says, "Wrote M. Knoedler net price $2,200 for (Santiago)"; Jan. 9, 1902, notes that as he has not heard anything he has sent a telegram asking $2,200 net (quoted above) // *New York Evening Sun*, Jan. 11, 1902, p. 9 (quoted above) // *New York Tribune*, Jan. 11, 1902, p. 7 (quoted above) // Homer to M. Knoedler and Co., New York, Jan. 14, 1902, M. Knoedler and Co. MSS, microfilm NY 59–5, Arch. Am. Art (quoted above) // *MMA Bull.* 1 (Feb. 1906), p. 35, lists it in group of three paintings by Homer, two of which were to be chosen by MMA as gift from Hearn // W. S. Howard, *MMA Bull.* 1 (March 1906), pp. 54–55, discusses Hearn's gift to the MMA and describes this work: "Here, in spite of the grim reminders of war, all is peaceful and a Southern calm prevails Everything shows this picture to be the product of an accomplished hand and trained observation, and it must ever remain an interesting interlude in this artist's series of studies of storm-tossed seas" // MMA, *The George A. Hearn Gift to the Metropolitan Museum of Art* . . . (1906), p. xii; p. 192, ill. p. [193] // K. Cox, *Burlington Magazine* 12 (Nov. 1907), p. [122], pl. ii; p. 124, writes that it "is one of those odd pieces of observation that no one but Homer would have made—apparently a simple and almost bald representation of ordinary enough facts, yet with a strange impressiveness that the reproduction does not altogether render. A great part of its effectiveness is in its gray, moonlight tone, very accurately and perfectly rendered with the utmost directness of method" [reprinted in *MMA Bull.* 5 (Nov. 1910), p. 255]; *Nation* 86 (Jan. 23, 1908), p. 88, mentions it in the PAFA exhibition // L. Mechlin, *International Studio* 34 (June 1908), ill. p. [cxxxii]; p. cxxxv // W. H. Downes, *The Life and Works of Winslow Homer* (1911), pp. 132–133, notes that the painting was based on studies made during Homer's trip in 1885–1886, was first shown at the Union League Club, was painted at different times "in the intervals of other work"; states that as "the painter was not at Santiago in 1898, the effect of the searchlight introduced in this composition must have been studied elsewhere and adapted to the subject"; p. 231, lists it among Homer's works shown at the Carnegie Institute in 1908; p. 282, lists it in the PAFA exhibition of 1908–1909; p. 285, lists it at the Carnegie Institute in 1908 // W. Pach, *L'Art et les Artistes* 16 (Nov. 1912), p. 76; ill. p. 78 // MMA, *George A. Hearn Gift to the*

Metropolitan Museum of Art . . . (1913), p. xi; ill. p. 59 // K. Cox, *Winslow Homer* (1914), p. 32, notes that Homer's first voyage to Cuba took place in the winter of 1885–1886 and assumes that the painting was done in 1899; p. 56, says: "It is almost totally without color, and has not even that approach to unity of tone which moonlight sometimes enabled Homer to attain. In handling it is poor and harsh, and there are no objects in it which require more of the draughtsman than a fairly correct eye for the sizes and shapes of things. Yet the picture is grandly impressive a great picture is created out of nothing and with almost no aid from any other element of the art of painting than this all-important one of design" // J. C. Van Dyke, *American Painting and Its Tradition* (1919), p. 106, misdates it about 1899 and comments: "The canvas comes precious near being a great affair of form, light, and air. It is as sharp in drawing and as flat and dull in its surface painting as his other works. The naïve simplicity of the brush-work is astonishing. Homer knows no tricks of handling, and will resort to no glazes, scumbles, or stipples. He makes his statement so unadorned that it seems almost crude or immature. And yet with these shortcomings we still have an unusual quality of light, a rare night sky, and a suggestion, at least, of fine color" // T. Bolton, FARL Mount 119–3/C, Jan. 1932, notes: "According to a letter dated Dec. 3, 1901, Homer wrote to T. B. Clarke that this picture was just finished (see Downes). As a matter of fact, 1902 in red, is seen faintly below the signature"; *Fine Arts* 18 (Feb. 1932), p. 52, refutes Cox's assertion that "after 1900 Homer's powers may be said to have been on the decline," citing *The Searchlight, Santiago*, "which Mr. Howard Giles considers the most significant American painting in the latter part of the nineteenth century"; p. 55, lists it, gives references, and says it was finished in 1902 // C. S. Hathaway, *Chronicle of the Museum for the Arts of Decoration of Cooper Union* 1 (April 1936), p. 57, discusses two drawings used for the composition of this painting, notes that one must date from Homer's trip to Cuba in 1886 and concludes that the other "was probably made in immediate preparation for the painting, since it shows on the parapet the bright spot of light, cast by a searchlight, which is so important an element in the finished work; although it differs in showing no second cannon to the right"; p. 61, lists two studies // F. Watson, *Winslow Homer* (1942), color ill. p. [58] // L. Goodrich, *Winslow Homer* (1944), p. 90, says it is based on a drawing of Morro Castle at Santiago made during Homer's trip to Cuba in 1885; pp. 172–173, quotes Homer's letters to Knoedler of Dec. 7, 19, and 30, 1901; calls it "one of Homer's most impressive works"; quotes from his daybook entry concerning price and says that Hearn offered Knoedler $2,000 for the painting; p. 187, notes that Hearn presented it to the MMA in 1906; p. 229, lists it in chronology, Dec. 1901; p. 234, lists it in MMA coll.; pl. 53 // T. Bolton, *Art News* 43 (Oct. 15–31, 1944), color ill. p.

19, in review of L. Goodrich monograph and exhibit at the Whitney Museum of American Art, discusses Homer's Cuban trip of 1885–1886 and his studies of Morro Castle, mentions letter to Clarke of Dec. 30, 1901, with sketch; suggests that "as Homer was not in Santiago in 1898 the effect of the searchlight must have been explored elsewhere and then incorporated with the watercolor studies"; notes that "Homer's interest in military objects dates from the succinct, objective recordings of army life which he made during the Civil War"; calls the painting "unsurpassed in his work as a formal impressive statement" // F. J. Mather, Jr., *Magazine of Art* 39 (Nov. 1946), p. 298, dates it 1901 and discusses (quoted above) // A. T. Gardner, *MMA Bull.* 17 (Jan. 1959), cover ill.; p. 136, notes it as Hearn's gift // L. Goodrich, *Winslow Homer* (1959), pl. 87; p. 114 // A. T. Gardner, *Winslow Homer* (1961), ill. p. 193; p. 206, says, "the Japanese elements of design are particularly strong" and the "picture is a subtle study in refined monochrome patterns that were enhanced at the time it was painted by a timely emotional value"; p. 243, in chronology, notes that it was exhibited at the PAFA in 1908; pp. 249, 254, lists it // J. Gould, *Winslow Homer* (1962), p. 219, mentions Homer's arrival in Cuba at the end of Feb. 1885 and the drawing of Morro Castle that "resulted in a painting many years later"; p. 277, describes the painting, notes that Homer finished it by Jan. 5, 1902, quotes his letter to M. Knoedler and Company of Jan. 14, 1902 // W. Andrews and G. McCoy, *Art in America* 53 (Aug.-Sept. 1965), p. 58, quotes Homer's letter to M. Knoedler and Company of Jan. 14, 1902 // P. C. Beam, *Winslow Homer at Prout's Neck* (1966), p. [219], fig. 76, calls it a "superbly simple design" painted in 1901 but conceived in 1885 when Homer first visited Cuba; pp. [219]–220, notes he began work on the composition in 1899 and finished it in 1901; p. 220, calls it perhaps "the only really great painting" to come out of the Spanish-American War, comments that "it is almost Mondrian-like in its strong interplay of straight lines and right angles," states that it was Homer's "last experiment with moonlight and electric illumination and is quite haunting," discusses contemporary criticism of the work, and quotes Homer's daybook entries for Jan. 7 and 9, 1902, concerning price // J. T. Flexner and the editors of Time-Life Books, *The World of Winslow Homer, 1836–1910* (1966), p. 163, says that the painting "communicates only idyllic moonlight gleaming on an old fort" // B. Novak, *American Painting of the Nineteenth Century* (1969), p. 187, ill. 10–30; p. 188 // D. F. Hoopes, *Winslow Homer Watercolors* (1969), p. 19 // J. Wilmerding, *Winslow Homer* (1972), p. 141, discusses Homer's trips to the Bahamas and Cuba; p. 170; p. 172, notes "purely abstract quality" in this and other works; p. 177, says that it is based on several pencil and charcoal drawings Homer made during a visit to Cuba in 1885 but that "it was not until the attention brought to Cuba by the Spanish-American War in 1899 that Homer

thought of doing an oil painting of the subject"; describes it and calls it "a strong abstraction in its own right, with little narrative content or personal feeling. It is a final statement of almost pure form for Homer"; p. [215], ill. 5–27 // R. Brown, *Arch. Am. Art Journ.* 16, No. 4 (1976), p. 21 // MFA, Boston, *Winslow Homer* (1977), exhib. cat. by S. L. Stepanek, p. 23, no. 102, includes Homer's letter of Dec. 30, 1901, to Clarke concerning this painting // G. Hendricks, *The Life and Work of Winslow Homer* (1979), p. 251, fig. 351, reproduces Homer's sketch of the picture in letter to Thomas B. Clarke; ill. p. 316, CL-522, mentions 1885 studies in the Cooper-Hewitt Museum // L. B. Reiter, Paintings Conservation, MMA, supplied record of painting examination and treatment, Jan. 1980, noting discoloration prior to conservation from varnish applied in 1948; states: "As is characteristic of Homer, there are numerous changes in the sky which now appear as streaks. The vertical beam emerging from the horizon was altered in width by the artist, and these changes have discolored and darkened"; says, "Judging from the 1906 photograph, the area to the left, where the horizontal searchlight beam enters, the picture has sunk so that the initial diffusion of light intended by the artist has been lost and the beam appears as a solid shape," observes that the fortress "is painted in thin glazes and scumbles"; and says this "glazing technique is somewhat unusual for Homer" // N. Spassky, *Winslow Homer* (1981), color ill. pl. 15; pp. 15–16, discusses; *MMA Bull.* 39 (Spring 1982), color ill. p. 40, fig. 34; pp. 42, 44, 47, discusses // V. Shetley, M. Knoedler and Co., New York, letter in Dept. Archives, August 9, 1983, says Hearn bought the painting on Jan. 31, 1902, and there is no record it was exhibited at Knoedler in 1902 // D. Dwyer, Paintings Conservation, MMA, Jan. 31, 1984, orally, reported that examination under infrared light shows that Homer originally left a vertical section to the left of the watchtower in reserve but later painted it over.

EXHIBITED: Union League Club, New York, 1902, *A Group of Pictures by Living American Artists*, no. 24, as Search Light, Entrance to Harbor, Santiago, Cuba // PAFA, 1908, no. 28, as The Search Light, Harbor Entrance // Carnegie Institute, Pittsburgh, 1908, no. 147, as Searchlight; Harbor Entrance, Santiago de Cuba // Pennsylvania Museum of Art, Philadelphia, 1936, *Winslow Homer, 1836–1910*, no. 27, as Searchlight, Harbor Entrance, Santiago de Cuba, 1899 // Carnegie Institute, Pittsburgh, 1940, *Survey of American Painting*, no. 168 // Worcester Art Museum, 1944, *Winslow Homer*, no. 81 // Wildenstein, New York, 1947, *A Loan Exhibition of Winslow Homer [for the Benefit of the New York Botanical Garden]*, exhib. cat. by L. Goodrich, ill. p. 30, no. 36; p. [31], notes that although in his old age "Homer was generally considered the foremost living American painter . . . critics still frequently condemned his new pictures for their supposed ugliness, as they did both *Early Morning* and *Searchlight, Harbor Entrance, Santiago de Cuba*"; p. 34, no. 36,

as Searchlight, Harbor Entrance, Santiago, Cuba, 1901 // Centennial Art Gallery, Centennial Exposition, Utah State Fair Grounds, Salt Lake City, 1947, *One Hundred Years of American Painting* (arranged by the American Federation of Arts, Washington, D. C.), no. 25 // MMA, 1950, *20th Century Painters*, p. 7 // Winnipeg Art Gallery, Manitoba, 1951, *Exhibition of European and American Paintings* (no cat.) // National Gallery of Art, Washington, D. C., 1958–59, MMA and MFA, Boston, 1959, *Winslow Homer: A Retrospective Exhibition*, cat. by A. T. Gardner, p. 71, notes, it "is particularly Japanese in its refined monochrome patterns, enhanced by the timely emotional value of the subject"; ill. p. 103, no. 73; p. 121, no. 73, lists it; Boston ed., pp. 56–57; ill. p. 86, no. 67; p. 98, lists it // MMA, 1965, *Three Centuries of American Painting*, unnumbered cat. // National Gallery of Art, Washington, D. C., City Art Museum of Saint Louis, and Seattle Art Museum, 1971, *Great American Paintings from the Boston and Metropolitan Museums*, exhib. cat. by T. N Maytham, no. 55 // Whitney Museum of American Art, New York, Los Angeles County Museum of Art, and the Art Institute of Chicago, 1973, *Winslow Homer*, exhib. cat. by L. Goodrich, ill. p. 125; p. 137, no. 68.

Ex COLL.: with M. Knoedler and Company, New York, Jan. 1902 – Jan. 31, 1902; George A. Hearn, New York, Jan. 31, 1902 – 1906.

Gift of George A. Hearn, 1906.

06.1282.

Shooting the Rapids, Saguenay River

In 1893 Homer and his brother Charles made the first of many visits to the province of Quebec. Drawn by the excellent fishing and a wilderness more isolated than the Adirondacks, they joined the Tourilli Fish and Game Club, a sportsman's haven near Saint Raymond on the shores of Lake Tourilli, several miles northwest of Quebec City. On a subsequent excursion to the Canadian province, Homer discovered Roberval, on the south shore of Lake Saint John some 120 miles north of Quebec City. Accessible by canoe up the Saguenay River, it became another favorite haunt.

Homer's first trip in 1893 was apparently confined to fishing. Subsequent visits, however, were devoted to painting as well as the pursuit of trout and the elusive ouananiche, or landlocked salmon, which provided a challenge to the most expert angler. The Canadian wilderness, anglers playing fish, canoes shooting turbulent rapids, and the French-Canadian woodsmen and Montagnais Indians were the subject of a series of

watercolors dating from 1895, 1897, and 1902. In these works Homer demonstrated his comprehensive command of the medium and captured the characteristic qualities of light, color, and atmosphere of the Canadian wilds with the same veracity he had used to characterize the north woods and the tropics.

During his last known trip to Canada in August 1902, Homer painted watercolors at Lake Saint John and on the Saguenay River. Several of these were used as the basis for *Shooting the Rapids, Saguenay River*, which is one of his last oils. In July 1904 he sent two watercolors of the Saguenay River to his dealers Doll and Richards in Boston. Requesting acknowledgement of their arrival, he wrote on July 10: "I value them highly—as I could make a fine picture by combining the two in an oil painting." He enclosed a sketch of the two watercolors. One, showing two canoes on the rapids, has been identified as *Shooting the Rapids* now in the Brooklyn Museum. A month later, encouraged by the sale of a painting, he wrote again to Doll and Richards:

Having sold a picture after waiting a year & a half, I now propose painting another, & as that subject of the Rapids Upper Saguenay River is the most easy thing, as I have many studies of the subject & even a trip up there at this time of year is not a bad thing— I will ask you to send me the three drawings, lately submitted to you.

The proposed painting was not mentioned again until the summer of 1905 when Homer wrote to M. Knoedler and Company, in New York, requesting the return of another Saguenay watercolor, noting: "I wish to refer to it in a picture that I have now on hand & propose to paint." The work was delayed until October, when in a letter to his friend the lithographer and wood engraver Louis Prang, Homer explained:

I have been waiting for the summer people to leave here . . . thinking I would do more work, although I am the only one interested in the matter Just now I have commenced a picture the first since last October. I find one a year is enough to fill the market.

At the time of Homer's death five years later, the painting remained unfinished in his studio. According to William Howe Downes, Homer had not wanted to complete it without returning to the Saguenay River. Lloyd Goodrich suggests, however, that Homer gave up creative work for other reasons. A nephew, Charles Lowell Homer, according to Philip C. Beam, believed the artist

considered the work finished, visual evidence notwithstanding. Shown for the first time at the memorial exhibition of the artist's work in 1911, it was presented to the Metropolitan Museum by Homer's brother Charles.

Man's struggle with nature was a theme that preoccupied Homer starting in the 1880s. It found expression in various guises chiefly connected with the sea or inland waters. In his biography of the artist, Lloyd Goodrich tells how Homer paid a guide ten dollars to make the journey down the rapids while he waited down river to observe from the shore. After a long wait, Homer returned to camp to see what had happened and learned that his brother Charles had paid the same guide ten dollars not to make the trip. Philip C. Beam notes that, according to Homer's nephew Charles, *Shooting the Rapids, Saguenay River* had its origin in an incident that occurred on the first visit of Winslow and Charles S. Homer to Lake Saint John. Before making the trip home, the brothers gave each of their four guides a pint of whiskey in appreciation of their work. To prevent breakage on the rough trip down river the guides promptly drank the whiskey, before setting out. From his canoe,

Homer could see his brother clinging in terror to his canoe while his imperturbable guides navigated the treacherous rapids with wild abandon. The resemblance of the facial features of the central figure to those of Charles as he appears in photographs and a watercolor by the artist (ill. in T. Bolton, *Fine Arts* 18 [April 1932], p. 16) gives the story some credence.

Homer made a series of black chalk drawings and watercolors of men on the rapids of the Saguenay River in 1895, 1897, and 1902. *Shooting the Rapids, Saguenay River* is most closely related to *Shooting the Rapids*, the watercolor of 1902 now in the Brooklyn Museum. In contrast to the spontaneous quality and immediacy of the watercolor, which is due in part to the demands of the medium, the oil appears more calculated. The unfinished painting, with contemplated revisions indicated in chalk, provides a rare opportunity to study Homer's methods. He established the major structural elements of the composition and chose a palette restricted primarily to earth colors, black, brown, gray, ocher, and white with a few notes of red and blue. The arrangement of contrasting values of light and dark with the lights concentrated in the middle ground serves

Homer, *Shooting the Rapids, Saguenay River.*

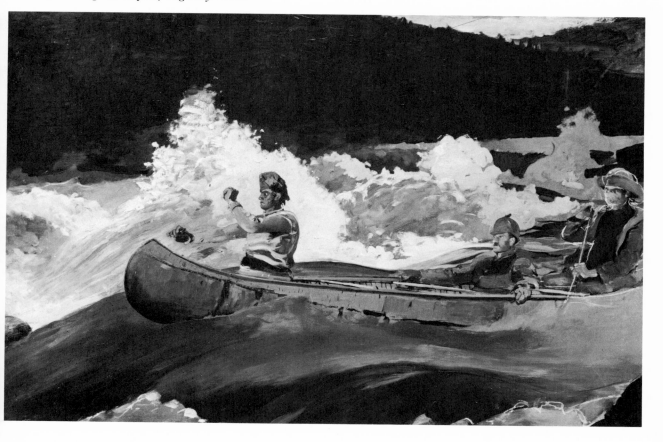

as a foil for the figures. The mountainous background and the rushing river are blocked out in broad masses, some given highly stylized decorative forms. The shooting spray is topped with white crests and indicated with quick brushwork. It is a decorative composition characterized by strong design. Despite the calculated quality of the work, Homer manages to convey the unrestrained force of the sweeping rapids with quick brushstrokes and diagonals. It is the unbridled energy of this dynamic composition that impressed the critic Frank Jewett Mather, Jr., who wrote: "The whole thing is gaunt, powerful, emphatic. . . . What the artist wanted was clearly the assertion of the heave and rush of the rapids, of the strain of the figures."

Oil on canvas with chalk, 30 × 48¼ in. (76.2 × 122.6 cm.).

RELATED WORKS: *Shooting the Rapids*, watercolor on paper, 13⅞ × 21¾ in. (35.2 × 55.2 cm.), 1902, Brooklyn Museum, 11.540, ill. in L. Goodrich, *Winslow Homer* (1944), pl. 59 // W. Homer to Doll and Richards, Boston, July 10, 1904, Misc. MSS Homer, Arch. Am. Art, pen and ink sketch, combines view in two watercolors.

REFERENCES: W. Homer to Doll and Richards, Boston, July 10, 1904, and August [?], 1904, Misc. MSS Homer, Arch. Am. Art (quoted above); August 30, 1904, Homer again requests the "three watercolors lately submitted to you for the purpose of showing Dr. Warren what could be done in the way of a [sporting] picture. . . . I told you how particular I was about them & you promised not to show them to these rapacious bea[s]ts—I will ask you to return that watercolor to me immediately—as it was not for sale" // Homer to M. Knoedler and Co., New York, Sept. 31, 1905, M. Knoedler and Co. MSS, microfilm NY 59–5, ibid., requested return of another Saguenay watercolor (quoted above) // Homer to L. Prang, Oct.

1905, Lloyd Goodrich's Copies of Winslow Homer Letters, 1860s–1910, microfilm NY 59–12, ibid. (quoted above) // W. H. Downes, *The Life and Works of Winslow Homer* (1911), pp. 224–225, quotes 1904 letters to Doll and Richards concerning the watercolors that served as models for this painting and says it remained unfinished in Homer's studio for several years because he "did not wish to complete it without going to the Upper Saguenay once more"; p. 258, lists it in 1911 exhibition as unfinished picture of 1910; p. 265; ill. opp. p. 270; p. 286, lists it in memorial exhibition, lent by Charles S. Homer // B. B[urroughs], *MMA Bull.* 6 (March 1911), ill. p. 66; pp. 66–67, reports its acquisition and describes: "The first staining of the canvas shows in places, and proposed changes in the composition are indicated by bold chalk lines. Though none of the figures are complete in all details, the expression of the whole picture loses nothing on this account" // F. J. Mather, Jr., *Nation* 92 (March 2, 1911), p. 225, reprinted in *Estimates in Art* (1931), pp. 186–187 (quoted above) // W. Pach, *L'Art et les Artistes* 16 (Nov. 1912), pp. 76–77, says it is unfinished only from the point of view of execution, notes the admiration of tumultuous movement, great space, severe definition of form, an art which reflects force, integrity and the poetry of a frontier race; ill. p. 79 // K. Cox, *Winslow Homer* (1914), p. 46, "'Shooting the Rapids,' . . . was begun in 1904, and Homer expected to complete it easily, as he had made many studies for it; but he could not satisfy himself without another trip to the Upper Saguenay to restudy it from nature, and it remained unfinished at the time of his death" // J. C. Van Dyke, *American Painting and Its Tradition* (1919), p. 94, notes it as an example of Homer's objective observation // T. Bolton, *Fine Arts* 18 (Feb. 1932), p. 52, disputes Cox's assertion that Homer's powers declined after 1900, citing such paintings as Shooting the Rapids: "The latter contains all the elements of design that make Homer a great artist. Three of the most astounding figures appear in the canoe, which are veritable masterpieces of portraiture and reveal Homer's powers

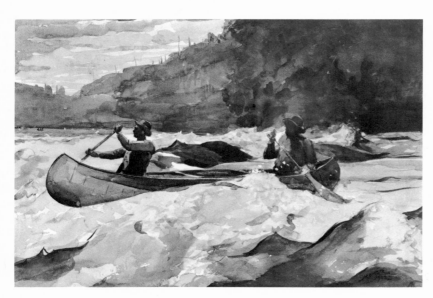

Homer, watercolor, *Shooting the Rapids*. Brooklyn Museum.

as undiminished until the end"; p. 55, includes it in checklist of Homer's paintings, describes it and notes watercolor studies, one of the background of trees and the other a work in the Brooklyn Museum, provides references // F. Watson, *American Magazine of Art* 28 (Feb. 1935), ill. p. 115 // L. Goodrich, *Winslow Homer* (1944), pp. 184–185, notes that Homer returned from his last trip to Canada in August 1902 with a group of watercolors painted at Lake Saint John and on the Saguenay, which inspired this painting; quotes Homer's letters to Doll and Richards, Knoedler, and Prang; discusses Brooklyn Museum watercolor and says of the painting: "Even in its unfinished state it is impressive. To the qualities of his earlier north woods oils it adds greater movement in the rushing water bearing the canoe forward and the muscular tension of the men. Its undiminished energy makes one wonder why it was not completed"; says there must have been deep causes that "made him give up all creative work at this time"; p. 229; pl. 59 // J. G. Smith, *American Artist* 19 (Feb. 1955), ill. p. 20; pp. 20–21, notes in contrast to the watercolor the unfinished oil "is heavy-handed and labored, revealing how much more at ease Homer was in watercolor than in oil" // A. T. Gardner, *MMA Bull.* 17 (Jan. 1959), ill. p. 137 // L. Goodrich, *Winslow Homer* (1959), pl. 93 // A. T. Gardner, *Winslow Homer* (1961), color ill. p. [163]; p. 254, lists it // P. C. Beam, *Winslow Homer at Prout's Neck* (1966), p. 252, mentions Homer's photography of 1895 and watercolors on the subject; notes that in July 1904 Homer asked Doll and Richards to return his watercolors "as he proposed painting another picture" and apparently "wanted to review them in preparation" for this oil; p. 253, fig. 91; pp. 253–254, relates story of painting's conception as told to him by Charles Lowell Homer; says that Homer "recorded the scene in the oil which critics call an unfinished work" but agrees with the opinion of Homer's nephew "that the painter considered it completed"; notes, Homer "could have 'finished' it at any time from 1905 on, and had he wished to do so . . . he would have by 1907, when he was doing just that to other partly painted works" // D. F. Hoopes, *Winslow Homer Watercolors* (1969), p. 72, discusses 1902 watercolor for it, quotes letter to Doll and Richards, and writes: "he sketched in the leaping white water of the rapids more powerfully than he had in the watercolor," but "the watercolor remains a more accurate statement for, unlike the oil painting, it shows the canoe slipping quickly in the current, its course guided by hands sure of their task" // J. Wilmerding, *Winslow Homer* (1972), p. 178, identifies figure in center of canoe as Charles, writes that "Man's struggle with the elements is still a personal one for Homer, though the uncompleted canvas gave poignant testimony to the artist's failing reserves"; p. 216, ill. 5–28 // Brooklyn Museum, *Homer Watercolors from the Brooklyn Museum* (1972), exhib. cat. by L. Sundberg, no. 64 // G. Hendricks, *The Life and Work of Winslow Homer* (1979), p. 263, says Homer began this painting in October 1905, never finished it, and wrote Louis Prang of this; ill. p. 316, CL-523 // N. Spassky, *MMA Bull.* 39 (Spring 1982), pp. 46–47, fig. 39; p. 47, discusses.

EXHIBITED: MMA, 1911, *Winslow Homer Memorial Exhibition*, no. 23, as Shooting the Rapids, Saguenay River (unfinished), lent by Charles S. Homer, says it was in Homer's studio at the time of his death; 1937, *Exhibition of Sporting Prints and Paintings*, no. 44; 1965, *Three Centuries of American Painting*, unnumbered cat.; 1966–1978, *The Artist's Workshop* (no cat.).

EX COLL.: the artist's brother Charles Savage Homer, New York, 1910–1911.

Gift of Charles S. Homer, 1911.

11.57.

ELIHU VEDDER

1836–1923

Frequently cited by critics as the main proponent of the Pre-Raphaelite style and a precursor of the symbolist movement in the United States, Elihu Vedder is best remembered for his early visionary paintings and his mystical illustrations for the *Rubáiyát of Omar Khayyám*. An expatriate, he spent over sixty years of his career in Italy. He is noted for his inventiveness and extraordinary ability to assimilate diverse stylistic sources, both literary and visual. His work reflects the international scope of his contacts and the power of his imagination.

Vedder was born in New York City. His father worked as a dentist in Cuba, and young

Vedder visited there often but attended boarding schools in New York. He spent many summers on his grandfather's farm in Schenectady, New York. At the age of eighteen Vedder began to study art, receiving his first formal instruction from Tompkins Harrison Matteson (1813–1884), a historical, genre, and portrait painter in Sherburne, New York. Vedder's significant development began in 1856, when he went abroad to study, beginning a lifelong dialogue with European art.

His first destination was Paris, where he enrolled in the popular atelier of François Edouard Picot. Although Vedder soon tired of the daily drawing from classical casts, the experience proved valuable. Disappointed in French academicism, which seemed to him merely an imitation of the classical, he decided to go to Italy, where he could see more classical art firsthand and live less expensively.

In Florence, Vedder sought the academic guidance of Raffaello Bonaiuti, who instructed him in drawing. But Vedder's strongest response to Italian painting came from his contact with a group of young, predominantly Tuscan painters with whom he frequented the Caffè Michelangiolo. The Macchiaioli, as the group was called, eschewed the Accademia and drew their inspiration instead from the French plein-air works of Gustave Courbet and the Barbizon painters. Using *macchiae*, or splashes of color, and chiaroscuro, they produced romantic landscapes. A leader of the group, Giovanni (Nino) Costa, an admirer of the works of Corot, guided Vedder and introduced him to the rugged landscape of the Tyrrhenian coast and the stark cliffs of Etruscan Volterra. Vedder's earliest paintings date from this association and show a fascination for the Italian countryside that continued throughout his career.

It was during this initial stay in Florence that Vedder became a charter member of a circle of expatriate English and American artists and writers. One of them was James Jackson Jarves, an American theorist and collector, whose major essay, *The Art-Idea* (1864), placed Vedder in the pantheon of successful American artists. Together they discussed theory and roamed the hill towns in search of obscure Renaissance frescoes. Through Jarves, who formed a remarkable collection of early Italian paintings (Yale University), Vedder began to observe closely the styles of the primitive and Renaissance Florentine painters. In *The Art-Idea*, Jarves pointed to what would be Vedder's career-long debt to that tradition: "A close, indefatigable student, he never became a mere copyist, but, making notes of ideas and technical details, assimilated to himself much of the lofty feeling and strong manner of the world's masters in painting . . . The men, women, and animals are solid projections, having the strong relief of nature, standing out of the canvas, indicating absolute substance and weight" (p. 198).

In 1860 Vedder went to Cuba by way of Spain. His father, who was still living in Cuba, was reluctant to support his art career any longer. Vedder arrived in the United States at the outbreak of the Civil War. An arm injury exempted him from military service, and he attempted to support himself in New York, doing woodcuts for *Vanity Fair* and *Frank Leslie's Illustrated Newspaper*. His interest in illustration prompted him to examine the work of various European artists, especially that of Gustave Doré, who was popular with Vedder's literary and artistic companions.

In New York Vedder often found himself in the company of the bohemian literati, Walt Whitman, Herman Melville, Fitz Hugh Ludlow, Fitz-James O'Brien, and Thomas Bailey

Aldrich. Their influence spurred him to infuse a series of landscape paintings with literary symbolism. He was instinctively drawn to the mystical and grotesque. Works from this period include *The Questioner of the Sphinx*, 1863 (MFA, Boston), and *The Lair of the Sea Serpent*, 1864 (MFA, Boston, and q.v.), which were among the paintings he showed at the National Academy of Design, where in 1864 he was made an associate. A year later he became an academician. Vedder left New York about this time and joined his friends WILLIAM MORRIS HUNT and JOHN LA FARGE in Boston.

Returning to Europe in 1866, Vedder spent several months in Paris and then the summer in Brittany with Hunt. At the end of the year, he settled in Rome, where he remained, with the exception of brief visits to the United States and England, until his death. During one trip home, in 1869, he married Caroline Rosekrans from Glens Falls, New York. They had met in Paris in 1866, while she was on a study tour. Caroline Vedder devoted herself to the advancement of her husband's career, arranging exhibitions, corresponding with customers, and handling the sale of his works. In May of 1870 the Vedders went to London to await the birth of their first child, and Vedder took a studio in George Street, where he spent several months painting and acquainting himself with Pre-Raphaelite painters and critics.

Between 1871 and 1875 the Vedders spent their summers and autumns in the Perugian countryside. They made the acquaintance of several English artists, Walter Crane, Edwin Ellis, and William Davies, whose contact with the Pre-Raphaelite movement provided Vedder with a new direction. Ellis was a student of oriental philosophy and a disciple of eastern mysticism. His study of the visual symbolism of William Blake, which culminated in a book coauthored with William Butler Yeats in 1893, provided Vedder with a new stylistic source. Vedder accompanied Davies on a trip to London in 1876 and viewed the large Blake exhibition at the Burlington Fine Arts Club. In his *Digressions of V.*, he contrasted himself to Blake: "The ease with which I conjure up visions if cultivated would soon enable me to see as realities most delightful things, but the reaction would be beyond my control and would inevitably follow and be sure to create images of horror indescribable and so, while I have rendered my Heaven somewhat tame, at least my Hell remains quite endurable. Thus it comes that Blake can wander with delight and retain his mental health in an atmosphere which would prove fatal to me" (pp. 408-409).

The most obvious influence of Blake on Vedder was his powerful visions. Vedder was interested in the work of other artists as well. Regina Soria has pointed out that "upon his return from London, there began to appear, quite consciously . . . a softening in the color of his nudes, a search for the beautiful effect where before there was a search for the tragic, the horrible, the awesome" (p. 112). This was a result of Vedder's interest in the paintings of Frederic Leighton, Lawrence Alma-Tadema, and George Watts, whose recent works he had seen on his trip. Their adaptation of classical style and interest in idealized subjects encouraged Vedder to pursue a classical decorative manner. His mature work, done after 1876, reveals the extent of their influence.

Central to this development was Edwin Ellis's gift to Vedder of Edward FitzGerald's 1859 translation of the *Rubáiyát of Omar Khayyám*, composed by an astronomer-poet of the eleventh century. FitzGerald's version of the text included 101 quatrains dealing with meditation and speculation on the mysteries of existence and the joys of wine and love. There is reason to

believe that Vedder also had an opportunity to see a copy of the manuscript illustrated by Edward Burne-Jones, with whom he shared some stylistic traits. In Vedder, who had illustrated epic poetry, contributing drawings to Alfred Tennyson's *Enoch Arden* in 1865 and to an edition of the *Arabian Nights*, "the seed of Omar" was "planted in a soil peculiarly adapted to its growth, and it grew and took to itself all of sorrow and of mirth that it could assimilate, and blossomed out in the drawings" (Vedder, *Digressions of V.*, p. 404).

In 1879 Vedder exhibited his work at the Williams and Everett Gallery in Boston. The success of the show brought him both fame and financial security. In May of 1883 he began work on fifty-five illustrations for a deluxe edition of the *Rubáiyát*, which Houghton, Mifflin and Company published in Boston on November 8, 1884. The English edition was published by Bernard Quaritch. The *Rubáiyát* illustrations marked a new phase in Vedder's work, providing him with thematic material for subsequent large-scale works.

The popularity of Vedder's illustrations sent the publication into several printings and placed his other work in great demand. His studio in Rome soon became a favourite haunt of wealthy traveling Americans. Financial stability allowed Vedder to experiment in other media. Designs by him exist for Tiffany glass objects, bas-reliefs, bronze statuettes, and mosaics. He was invited in 1892 to execute murals for the Walker Art Gallery building designed by Charles McKim for Bowdoin College in Brunswick, Maine. The success of that commission insured many others, including decorations for Collis P. Huntington's dining room in New York in 1893 and a series of murals for the Library of Congress in Washington in 1895. In those projects Vedder was able to draw on his years of observing the frescoes of the Italian masters and his own highly developed decorative style.

He was happiest working in Italy, where he found the pace of life to his liking. In 1900 Vedder began to build his dream home on the Island of Capri, and there he spent his summers. The rest of the year he lived in Rome. He continued to paint and write until his death in 1923. Besides paintings and drawings by Vedder, the Metropolitan Museum has a bronze bust of the artist by Charles Keck.

BIBLIOGRAPHY: James Jackson Jarves, *The Art-Idea* (Boston, 1864). Revised ed. by Benjamin Rowland, Jr., Cambridge, Mass.; Harvard University Press, 1960. In chapter fifteen Vedder is discussed as a member of the new school of American painting // Elihu Vedder, *The Digressions of V.* (Boston, 1910). Vedder's autobiography // Regina Soria, *Elihu Vedder: American Visionary Artist in Rome (1836–1923)* (Rutherford, N. J., 1970). An account of Vedder's life and works based on many letters and manuscripts (now in the Archives of American Art), it includes a catalogue of works and an extensive bibliography // Marjorie Reich, "The Imagination of Elihu Vedder—As Revealed in His Book Illustrations," *American Art Journal* (May 1971), pp. 39–53. An examination of some of Vedder's sources and his symbolism // National Collection of Fine Arts, Washington, D. C., and Brooklyn Museum, *Perceptions and Evocations: The Art of Elihu Vedder* (Washington, D. C., 1979). The catalogue for a major exhibition of the artist's work, it includes an introduction by Regina Soria, essays by Joshua C. Taylor, Jane Dillenberger, and Richard Murray. (A separate checklist with the same title was published in 1978.)

The Lost Mind

The Lost Mind was painted in New York in 1864 and 1865, a transitional period for Vedder. The picture harks back to the pure landscape painting he did in Italy under the influence of the Macchiaioli. There are elements as well of the classicizing style of his mature work, in which his visionary ideas contain specific literary references. The product of Vedder's imagination, *The Lost Mind* was described by a critic for the *Magazine of Art* in 1885:

Through some desolate Umbrian country, straight, limestone mountain-walls ridged up behind her, a young girl walks in a quasi-religious dress. The aimless hand, the vague glance, the irresolute gesture, reveal that from that beautiful face the informing sense has fled. Having wandered away on some fancied quest, she seeks among the desolate rocks her lost mind. The barren, stony landscape, the bewildered, innocent face are full of poetic suggestion.

The painting appears to be a composite of two works Vedder executed in Italy: *Monks Walking in a Garden near Florence—Fiesole*, ca. 1863 (unlocated, known through the oil study in the Fine Arts Museums of San Francisco), and *Le Balze-*

Vedder, *Study for The Lost Mind*. Spencer Museum of Art, University of Kansas.

Vedder, *The Lost Mind*.

Volterra (*Cliffs of Volterra*), 1860 (Butler Institute of American Art, Youngstown, Ohio). The central motif of a robed figure was suggested by the first picture, which the artist described (1910) as "a sketch I made on a dark, stormy day, of Fiesole with the road and cypresses coming down from it, into the foreground of which I had painted three Dominican friars, whose black and white garments carried out the feeling seen in hillside and sky."

To obtain the dramatic effect of *The Lost Mind*, Vedder chose a solitary female figure, clad in the heavy clothing of a friar. The result was slightly peculiar and prompted some criticism. The artist's friends, among them the painter HOMER DODGE MARTIN, jokingly referred to the

503

painting as "The Idiot and the Bath-Towel," forcing Vedder to admit in his 1910 autobiography that "in fact the drapery was a little thick about the neck." The critic Kate Field thought the picture had shortcomings both in the drawing of the figure and in the title; nevertheless, she admired it.

'A Lost Mind' is another name for a lost love embodied in a woman more fascinating through her magnetism than her beauty.... She ... has loved with body, heart, and soul, and has waked to find the lover lost. The mind is not gone, it is simply eclipsed by hopeless grief; therefore we seriously object to the name of this picture.... The greatness of 'Lost Mind' consists in suggestion. It shows that Vedder is rich in ideas.

The background of the painting was universally admired, having been drawn from *Le Balze-Volterra*. It depicts the striking terrain of the "badlands" of Volterra, first introduced to the artist by his colleague Giovanni Costa. The white limestone cliffs and ravines, composed of rock from the Pliocene era, give the countryside an eerie aspect well suited to the subject of human suffering and the loss of reason.

Vedder's choice of this theme and his treatment of the figure in a landscape reveal the extent to which he was influenced by contemporary English painting, especially the landscapes of Pre-Raphaelites like William Dyce and John William Inchbold with whom he sometimes painted in Florence. Both Dyce and Vedder spent considerable time studying the masters of the Renaissance as well as the frescoes of the German Nazarene painters. *The Lost Mind* bears noteworthy resemblance to Dyce's *The Man of Sorrows*, ca. 1859 (private coll., ill. A. Staley, *The Pre-Raphaelite Landscape* [1973], pl. 94b), which depicts a seated robed figure meditating in a barren, rocky landscape. Although Vedder eschewed what he felt was the pretentious detail of the Pre-Raphaelites, their preference for subjects expressing intense human and religious feelings provided him with the initial direction for his own symbolic expression.

Oil on canvas, $39\frac{1}{8} \times 23\frac{1}{4}$ in. (99.4 × 59.1 cm.). Initialed and dated at lower right: 18 V 64–5.
RELATED WORKS: Study for *The Lost Mind*, oil on wood, $12\frac{1}{2} \times 7\frac{3}{4}$ in. (31.8 × 19.7 cm.), 1865, University of Kansas Museum of Art, Lawrence, ill. in National Collection of Fine Arts, Washington, D. C., and Brooklyn Museum, *Perceptions and Evocations*, p. 70 // Two sketches, pencil on paper, mounted on cardboard, $2\frac{1}{4} \times 2\frac{3}{8}$ in. (5.7 × 6 cm.), 1866, and $2\frac{9}{16} \times 2\frac{1}{4}$ in. (6.5 × 5.7 cm.), ca. 1866, coll. Harold O. Love family, ill. ibid., p. 71.

REFERENCES: *New York World*, May 16, 1865, p. 4, reviews it at NAD exhibition // *Nation* 1 (July 13, 1865), p. 59, reviews it in NAD exhibition, noting that the landscape is "the best part of the picture" and the subject is "devoid of any real meaning" // *New York Evening Post* (May 3, 1865), p. 1, in a review of NAD, calls it dramatic and says woman appears more grief-stricken than mad; yet "Mr. Vedder has given us a work that has power to act on us, he has again suggested something outside our everyday life, and he has again asserted his peculiar and emphatic genius // K. Field, 1865, comments on the picture at the NAD, quoted in L. Whiting, *Kate Field* (1899), p. 161 (quoted above) // H. Tuckerman, *Book of the Artists* (1867), p. 451 // C. Clement and L. Hutton, *Artists of the Nineteenth Century* (1879), p. 313 // S. G. W. Benjamin, *Art in America* (1880), p. 94 // W. H. Bishop, *American Art Review* 1 (1880), p. 50, describes the work, reprinted in *American Artists and Their Work* (1890), p. 152, and W. Montgomery, ed., *American Art and American Art Collections* (1899), p. 162 // C. de Kay, *Scribner's Monthly* (Nov. 1880), p. 114, says it is an amplification of The Shadow of the Cypress and may well rank among the finest paintings by Americans during the present century; p. 115, says the landscape adds to the severity and gloom; ill. p. 116 // A. M. F. Robinson, *Magazine of Art* 7 (1885), p. 122 (quoted above) // S. R. Koehler, *American Art* (1886), p. 42 // E. Radford, *Magazine of Art* 23 (July 1899), p. 365, calls it "the highest poetical work ... which may rank amongst the finest paintings the Americans have produced during the century" // S. Isham, *History of American Painting* (1905), p. 302 // E. Vedder, *Digressions of V.* (1910), p. 166, says Laura Curtis Bullard bought the picture; p. 194 (quoted above); p. 241 (quoted above); p. 464, lists it as sold in 1865 to Jeremiah Curtis, New York, for $575 // J. M. Lansing, *MMA Bull.* 16 (Dec. 1921), cover ill.; pp. 246–247, announces its acquisition // F. J. Mather, *Scribner's Magazine* 74 (July 1923), pp. 124–125, illustrates it and discusses its critical acclaim; *Estimates in Art* (1931), p. 77, calls it one of the "dozen most impressive pictures" at the Metropolitan Museum of Art; *Magazine of Art* 39 (Nov. 1946), ill. p. 269, discusses it // E. Richardson, *Painting in America* (1956), p. 352 // R. Soria, *Elihu Vedder* (1970), p. 38, mentions its exhibition at NAD; p. 44, says that when the work was exhibited "there was outspoken advice to go to Paris to improve his style"; p. 58, mentions the painting; p. 286, no. 57, catalogues it // University of Kansas Museum of Art, Lawrence, 1972, *The Arcadian Landscape*, n. p., mentions that The Cliffs of Volterra was used as the background.

EXHIBITED: NAD, 1865, no. 601, as A Lost Mind, lent by Mrs. J. Curtis // Brooklyn Art Association, Dec. 1869, no. 201, lent by Jeremiah Curtis // NAD;

Corcoran Gallery of Art, Washington, D. C.; Grand Central Art Gallery, New York, 1925–1926, *Commemorative Exhibition by Members of the National Academy of Design*, no. 267 // Am. Acad. Arts and Letters, 1937–1938, *Elihu Vedder Exhibition*, no. 101 // Utah Centennial Exhibition, Salt Lake City, 1947, *100 Years of American Painting*, no. 26 // Detroit Institute of Arts; Toledo Museum of Art, 1951, *Travelers in Arcadia*, no. 90 // Am. Acad. Arts and Letters, 1954, *The Great Decade in American Writing, 1850–1860*, no. 135 // Montreal Museum of Fine Arts, 1967, *The Painter and the New World*, no. 224 // Hyde Collection, Glens Falls, N. Y., 1975, *Elihu Vedder*, ill. no. 4, p. 27 // National Collection of Fine Arts, Washington, D. C., and Brooklyn Museum, 1978–1979, *Perceptions and Evocations*, ill. p. 70; p. 71, J. C. Taylor, describes it as the "juxtaposition of a hypnotic face with a directionless landscape; no. 36, in separately published checklist.

Ex COLL.: Jeremiah Curtis, New York 1865—d. 1881; his daughter, Laura Curtis Bullard, Brooklyn, d. 1912; her daughter-in-law, Helen Lister (Mrs Harold Curtis) Bullard, New York, to 1921.

Bequest of Helen L. Bullard in memory of Laura Curtis Bullard, 1921.

21.132.1.

Vedder, *The African Sentinel.*

The African Sentinel

Painted in 1865, a few years after Vedder's first residence in Italy, *The African Sentinel* illustrates his mastery of the stylistic conventions of the Macchiaioli, a group of contemporary Italian plein-air painters. Applying their technique of juxtaposing patches of color, accented with chiaroscuro, to produce a mosaic effect, Vedder drew this landscape of the rugged Tuscan countryside, which often appeared as a background in his early works. Whereas the Macchiaioli were content to deal with landscape alone, emphasizing its romantic melancholy aspects or limiting the size of their figures, Vedder preferred to include more subject matter. He noted this difference in approach in describing a sketching excursion he had made with his Italian companion Giovanni Costa:

Once Costa and I were painting in Velletri. We stopped at the same house and shared the same subject. This was an old church and a road leading up to it It was a midday effect and simple to a degree. I went at it in that spirit and painted as directly as I knew how; afterwards I put in a contadino with jacket thrown over his shoulder, pausing to light his pipe. Costa approached the subject by parallels,—prepared it with red one day, and on another inserted greys, and again went over it, then took it to

Rome and painted on it from time to time for several years; that was his way. I took it by assault; he, by siege. I don't think he saw more in nature than I did; but he saw more in Nature to paint than I did (Vedder, *Digressions of V.*, pp. 373–374).

Vedder has employed the dark-skinned sentinel, armed and watchful, to invest the scene with a mood of uneasy expectation. The figure is in marked contrast to the surrounding hills. The dull metallic tones of the landscape—reminiscent of the Macchiaioli—appear frequently in Vedder's landscapes from this period.

The theme of the painting remains unclear, but its date of 1865 suggests a tie to the American Civil War. Vedder apparently painted this subject more than once, for he listed a work entitled *The Sentinel—"Who Goes There?"*, sold to Charles Siedler of New York for thirty dollars, among his wartime sales (Vedder, *Digressions of V.*, p. 460). During the same period he first painted *Jane Jackson—formerly a Slave*, 1865 (NAD), the model for which was an old black woman who had been a slave.

Oil on canvas, 14¼ × 8 9/16 in. (36.2 × 21.8 cm.). Initialed and dated at lower right: 18 V 65.
REFERENCES: E. L. Cary, *International Studio* 35

(Sept. 1908), suppl. 95, ill. p. xciv, describes it // E. Vedder, *Digressions of V.* (1910), p. 463, lists it as "The Sentinel—variation," under sales of 1861 to 1865, and indicates it was sold to "G. Whitney, New York: Phoenix" for $200 // *A Concise Catalogue of Paintings in the Metropolitan Museum of Art* (1957), no. 23 // R. Soria, *Elihu Vedder* (1970), p. 286, catalogues the work as no. 56, The Arab Sentinel or The African Sentinel // National Collection of Fine Arts, Washington, D. C., and Brooklyn Museum, *Perceptions and Evocations* (1979), exhib. cat., pp. 71–73, J. C. Taylor describes and compares it to The Lost Mind, ill. no. 64 (not exhibited).

EXHIBITED: Summer Street Art Rooms, Boston, 1896 // Am. Acad. of Arts and Letters, 1937–1938, *Elihu Vedder Exhibition*, no. 130.

Ex COLL.: Stephen Whitney Phoenix, New York, probably by 1865 to 1881.

Bequest of Stephen Whitney Phoenix, 1881.
81.1.651.

Greek Girls Bathing

On February 1, 1875, Vedder wrote to J. P. Morgan in New York, concerning a work Morgan had commissioned in March of 1872. Vedder was experiencing difficulties with the painting, which he called "Carnival of Colors," and he told Morgan that he preferred to begin a new canvas:

For your interest and my own I have made a careful sketch of a new subject—which I submit to you in hopes you will approve of it, and in approving will let me know at once so I can make the necessary drawing before I leave for the country where models are hard to get. Everyone admires the sketch, *Greek Girls Bathing* and I know I can make a good picture of it. I think of putting another figure in the left hand lower corner, a girl reclining with a basket of clothes.

In any case I shall commence on the drawings at once and prepare the canvass so that there may be no further delay . . . The sketch is in color and of course the photograph gives but a poor idea of the capabilities of the subject.

Vedder was also having a difficult time financially. Although commissions continued to come his way, he had no assurance that once a work was finished the patron would find it acceptable and pay him. His wife Carrie wrote to her mother in March of 1875, indicating that the family was counting on $2,500 from the Morgan commission and that Vedder would not actually begin to paint until he received final confirmation. Morgan, however, was apparently in no rush to answer the artist who had disappointed him once before, and it was not until December 31, 1875, that he responded: "I am quite willing to take the picture of which you sent me the photograph. It is so long since I have heard of the order that I had given up any expectations of getting it."

On January 25, 1876, Vedder wrote to Morgan: "In regards to the delay all I can say is that had you answered my first letter of February 1875 the picture would have been well under way by this time. As it is, I cannot promise to give it to you under 18 months."

Greek Girls Bathing was finished and delivered to Morgan a year later, on February 18, 1877, when he visited Vedder's studio. The critic W. H. Bishop aptly described the picture in 1881:

He is not contented with simple rest; generally his characters must move, and that quite actively. A kind of movement to which he is peculiarly given is that of fluttering drapery. This . . . seems almost the mo-

Vedder's 1904 version, *Greek Girls Bathing at the Seashore*. Coll. Wentworth Vedder.

Vedder, *Greek Girls Bathing*.

tive of the picture. They are all muffled up close in their garments, and bearing up against a stiff breeze. They have come down to the shore rather for a promenade and romp than bathing. The line of vision is low down, so that they are outlined boldly against the sky. A gleam of light strikes into the picture, upon the figure at the point of the spit of sand, in the middle distance, while sober shade falls angularly across the whole foreground.

Several preparatory sketches exist for *Greek Girls Bathing*. They show that Vedder first considered including only a few figures in his composition, none of them seated and all dressed in conventional peasant garments, indicating that the seashore scene was probably based on one that Vedder had witnessed. In an oil sketch for the work (private coll.), the standing woman just to the left of center in the museum's painting appears to have originally held a basket of clothes on her head. Vedder's letter to Morgan of February 1, 1875, indicates that he was thinking about adding a reclining figure with a basket of clothes. In the end he placed the basket on the ground and added two figures, one sitting and one reclining. He also changed the dress of all the women to conform to his idealized and poetic vision of classical life.

The changes in composition and intent were very likely the result of Vedder's trip to London in June of 1876. At that time, when he was probably in the midst of painting this work, he had the opportunity to see what the current style in English art was. In addition to visiting the studios of the Pre-Raphaelite painters George Watts and Edward Burne-Jones, he saw works by other painters that incorporated a somewhat

mannered version of classical Greek style and the idealized subjects of mythology. Vedder was already under the influence of James Jackson Jarves, the American critic who espoused the idealism of Greek art. That, and his exposure to contemporary English painting, encouraged him to follow this new, distinctly classical phase in his work. There is speculation that the primary source for the subject and composition of this painting was Frederic Leighton's *Greek Girls Picking up Pebbles by the Sea*, ca. 1871 (unlocated, ill. in L. and R. Ormond, *Lord Leighton*, no. 116). According to Leonée and Richard Ormond, at least one of Leighton's four figures was based on *Hippomenes and Atalanta* by Guido Reni. The heavy swirling drapery of Vedder's figures and their horizontal placement on a barren shore, with a low horizon line behind them, is markedly similar to Leighton's. Vedder, however, included seventeen figures in his composition, revealing the influence of antique friezes, such as those of the Parthenon.

Using individual cutout figures (Corcoran Gallery of Art, Washington, D. C.), Vedder apparently arranged and rearranged them across the canvas before choosing the final composition. The clarity of color and linear crispness in the painting are characteristic of his later work and indicate his developing skill and sophistication.

Oil on canvas, 18¼ × 58¾ in. (46.4 × 149.2 cm.). Signed and dated at lower left: Elihu Vedder 1877. RELATED WORKS: Study for *Greek Girls Bathing*, oil on board, 6¾ × 20 in. (sight), (17.1 × 50.8 cm.), ca. 1876, private coll., noted in Soria, p. 312, no. 286 // *Greek Girls Bathing*, oil on canvas, 19½ × 72 in. (49.5 × 182.9 cm.), 1878, formerly coll. Frank R. Cham-

bers, New York, until March 1906, unlocated // There are thirteen cutout figures for *Greek Girls Bathing* in the Corcoran Gallery of Art, Washington, D. C.; all are oil on gray-primed cream paper, various sizes, catalogued and ill. L. C. Simmons, *American Drawings, Watercolors, Pastels, and Collages in the Collection of the Corcoran Gallery of Art*, nos. 482–494 // *Standing Draped Female Figure*, verso *Female Head and Shoulders*, red chalk, pastel, and pencil on beige paper, 10⅝ × 4¹⁵⁄₁₆ in. (271 × 12.5 cm.), ibid., ill. no. 495 // *Seated Female Figure*, pencil heightened with white chalk on lavender paper, 8⅜ × 10¾ in. (21.3 × 27.5 cm.), ibid., no. 497 // *Standing Figure*, red chalk heightened with white on lavender paper, 10½ × 7 in. (26.6 × 17.7 cm.), ibid., no. 498 // *Greek Girls Bathing on the Seashore*, 1904, oil on canvas, 9 × 26¼ in. (22.9 × 66.7 cm.), coll. Wentworth D. Vedder, ill. no. 39 in Soria.

REFERENCES: E. Vedder to J. P. Morgan, Feb. 1, 1875 (quoted above), Morgan to Vedder, Dec. 31, 1875 (quoted above), and Vedder to Morgan, Jan. 25, 1876 (quoted above), Vedder Papers, 517, Arch. Am. Art // A. Brewster, *New York World*, Oct. 23, 1876, p. 5, reports seeing the painting on an easel in Vedder's studio during a visit: "There is a certain classic character in the draperies, in the idea, and yet the treatment, which is of course original, is not at all classical // E. Strahan [E. Shinn], ed., *The Art Treasures of America* (1879), 3, p. 22, says, "Mr. Vedder has made of this Homeric group a decorative panel. He extends the line of playful maidens in long sequence, varying as much as possible their playful attitudes and the daring flutter of their draperies. His style is partly inspired by the friezes of Greek marbles, partly by the more opulent variety afforded by Renaissance painters. This troubador variation, played on the plain Greek air, is a very popular thing just now,

particularly in England; and Mr. Vedder's Greek draperies, just beginning to lose their holy simplicity in the torments of Bandinelli and Bernini, have an air of vexed innocence that would appeal to Mr. Burne Jones, to Mr. Albert Moore, or to Mr. Rosetti" // W. H. Bishop, *American Art Review* 1 (1881), ill. p. 32; p. 329, calls it Roman Girls on the Sea-Shore (quoted above); reprinted in *American Artists and Their Works* (1889), 1, ill. p. 151; p. 158; and *American Art and American Art Collections* (1889), W. Montgomery, ed., ill. p. 161; p. 167 // E. Radford, *Magazine of Art* 23 (July 1899), p. 368, notes the painting in a discussion of Vedder's "classical manner" // E. Vedder, *The Digressions of V.* (1910), p. 475, lists the painting as commissioned by J. P. Morgan in 1876 // S. Drexel, letter in MMA Archives, Jan. 23, 1958, says painting was formerly owned by Morgan, who, according to Anita Vedder, paid $2,500 for it // R. Soria, *Elihu Vedder* (1970), p. 89, notes Mrs. Vedder's letter about the picture in March 1885; p. 117, discusses commission; p. 238, reports that in 1904 thieves stole a version of the painting from Vedder's studio; p. 312, catalogues the painting as no. 285, Greek Girls Bathing or Greek Girls on Seashore or Roman Girls on the Seashore or Nausicaa and Companions on Seashore, notes related oil study; no. 286, catalogues related oil study.

EXHIBITIONS: Am. Acad. of Arts and Letters, 1960, *A Change of Sky*, no. 24 // MMA, 1965, *Three Centuries of American Painting*, unnumbered checklist // Los Angeles County Museum of Art and M. H. de Young Memorial Museum, San Francisco, 1966, *American Paintings from the Metropolitan Museum of Art*, ill. p. 88, no. 74 // Hudson River Museum, Yonkers, N. Y., 1970, *American Paintings from the Metropolitan Museum of Art*, no. 48 // MMA and American Federation of Art, traveling exhibition, 1975–1977, *The*

Vedder, two charcoal studies for one of the Pleiades. MMA, 50.50.2 (left) and 50.50.1 (right).

Vedder, pastel drawing for one of the Pleiades. Kennedy Galleries, New York.

Vedder, *The Pleiades*.

Heritage of American Art, ill. p. 141, discusses the work //
National Collection of Fine Arts, Washington, D. C.,
and Brooklyn Museum, 1978–1979, *Perceptions and
Evocations*, pp. 131–132, J. Dillenberger discusses, ill.
no. 161; no. 159 in separately published checklist.

Ex coll.: J. Pierpont Morgan, New York, 1877–
d. 1914; Sophia (Mrs. Maximilian) Drexel, New
York, by 1938–1958.

Arthur Hoppock Hearn Fund, 1958.

58.28.

The Pleiades

According to Greek mythology, the Pleiades
were the seven daughters of Atlas and the nymph
Pleioné: Alcyone, Celoeno, Electra, Maia, Me-
rope, Sterope, and Taygete. In one legend, the
gods transformed the Pleiades into doves to save
them from Orion, after which their images were
placed among the stars. Another myth recounted
that the Pleiades killed themselves in grief after
the death of their sisters, the Hyades, and Zeus
then placed them as stars in the sky. Only six
are visible in the constellation Taurus; the miss-
ing or invisible seventh star, "the lost Pleiad,"
is considered by some to be Merope, who was
said to have hidden herself in shame for falling
in love with a mortal. Still another account ex-
plains that this star is Electra, who withdrew

from sight to avoid witnessing the destruction of
Troy, founded by her son Dardanus.

Vedder first used the Pleiades in his illus-
trations for Edward FitzGerald's translation of
the *Rubáiyát of Omar Khayyám*, published by
Houghton Mifflin and Company of Boston in
1884. Illustrating quatrains thirty-seven to thir-
ty-nine, the group of seven female figures rep-
resents the astronomer-poet Omar Khayyám's
horoscope. The two influences of Jupiter and the
Pleiades, connected by the pleasure of the vine,
are symbolized by the thread that entwines them.
The central figure, who looks with apprehension
at her broken thread, is "the Lost Pleiad." Ved-
der subsequently developed this figure in several
sketches and an oil.

Vedder painted *The Pleiades* in 1885, following
a classical linear style. The picture mimics his
earlier *Rubáiyát* illustrations and in its decorative
aspects shows that he was strongly under the in-
fluence of the Pre-Raphaelites. Central to that
influence was the work of Edward Burne-Jones,
with which Vedder had become familiar during
a trip to London in 1876. Through his associa-
tion with the English illustrator Walter Crane,
who had used the subject of the *Rubáiyát* in his
decorations for the home of Alexander Ionides
in Rome in 1880, Vedder had occasion to see an
edition of the *Rubáiyát* designed by William Mor-

Elihu Vedder

ris and Burne-Jones in 1872. A comparison of Vedder's *Pleiades* with works by Burne-Jones from the 1870s, such as *The Apple Gatherers*, 1876 (Tate Gallery, London), reveals stylistic similarities particularly in gesture and costume. Vedder's vine motif was most likely adapted from Pre-Raphaelite sources as well, probably from the decorative designs of William Morris and Company.

The almost monochromatic coloring of the painting may reflect Vedder's direct borrowing from his earlier *Rubáiyát* illustrations, although, when questioned about the pale tonalities by a critic from the *Philadelphia Bulletin* in 1885, he indicated that "the coloring of the picture was suggested to me by a group of Japanese chrysanthemums."

Critical response to the painting was apparently excellent. Color reproductions at various prices were published by Curtis and Cameron of Boston in 1900 and were extremely popular. Vedder colored some himself and they were included in his 1899 and 1900 exhibitions. In addition, the painting inspired the poet Edwin Markham to pen the ode "On Seeing Vedder's *Pleiades*":

I hear a burst of music on the night!
 Look at the white whirl of their bodies, see
 The sweep of arms seraphical and free.
And over their heads a rush of circling light,
That draws them on with mystery and might:
 But O the wild dance and the deathless song
 And O the lifted faces glad and strong—
Eternal passion burning still and white.

But she that glances downward, who is she,
 Her face stilled with the shadow of pain?
 The one who let all go for that mad chance?
And does the sudden gust of memory,
 Bringing the earth, sweep back into the brain!
 But O wild white whirl of the wild dance!

Oil on canvas, 24⅛ × 37⅝ in. (61.3 × 95.6 cm.). Signed, inscribed, and dated at lower left: Elihu Vedder / Roma 1885.

RELATED WORKS: *The Pleiades*, pastel, formerly in the collection of Mrs. M. H. Simpson (in 1886), unlocated // Study for *The Pleiades*, charcoal on gray paper, heightened with white, 19 1/16 × 12 13/16 in. (48.5 × 32.5 cm.), MMA, 55.50.1 // Study for *The Pleiades*, charcoal on gray paper, heightened with white, 16⅞ × 13¼ in. (42.9 × 33.7 cm.), MMA, 55.50.2 // Sketch for the First and Second Pleiades, crayon and white chalk on green paper, 9 × 20 in. (22.9 × 50.8 cm.), Kennedy Galleries, New York // *Sketch for the First and*

Second Pleiades, colored crayons on brown paper, 17 × 22½ in. (43.2 × 57.2 cm.), private coll. // Nymph, ca. 1885, pastel, 20¾ × 16 in. (52.7 × 40.6 cm.), private coll., ill. in Kennedy Galleries, New York, *Drawings by Elihu Vedder* (1979), no. 26.

REFERENCES: C. Vedder to C. A. Whittier, Jan. 26, 1884, Vedder Papers, 518, Arch. Am. Art, describes the picture and includes a photograph of it unfinished and a photograph of the drawing "from which you ordered the picture," noting, "Each figure has been carefully worked up from life // Whittier to C. Vedder, July 3, 1884, ibid., says he did not choose the composition for all its figures, "I did particularly like the subject"; says he wishes to see the picture before committing himself and discusses terms // C. Vedder to Whittier, July 6, 1884, ibid., sends another photograph // Whittier to C. Vedder, Oct. 4, 1884, ibid., asks about progress on the painting; Nov. 2, 1884, inquires about the painting and says that Stanford White wrote him an enthusiastic letter about it; Dec. 19, 1884, discusses shipping the painting to him in England or the United States; May 1, 1885 (ibid., 519), acknowledges receipt of the painting and "the delight I take in it. I am much more than satisfied, and I wonder that Vedder should be willing to part with such beautiful girls. I, who have just sent them to the Art Museum here for the spring exhibition, feel quite lonely and melancholy in the prospect of a separation of three or four weeks"; says he wishes to own more pictures by Vedder // Whittier to W. Davies, July 22, 1885, ibid., acknowledges letter about recent Vedder painting and says he was pleased with the Pleiades // M. Taylor, *Philadelphia Bulletin*, Feb. 9, 1885, p. 1, describes the work (quoted above) // A. M. F. Robinson, *Magazine of Art* 8 (1885), pl. 305, engraved by Joumard; p. 122, discusses the relationship of the painting to the Rubáiyát // S. R. Koehler, *American Art* (1886), p. 42; pl. 23, opp. p. 50, engraved by F. G. Fillebrown // T. Tracy, *Chicago Sunday Inter-Ocean*, August 21, 1892, p. 4, lists the work // E. Radford, *Magazine of Art* 33 (1899), pp. 364–369, discusses the painting; reprinted in *Art Journal* 51 (April 1899), pp. 97–103 // E. Markham, *Scribner's Magazine* 27 (May 1900), p. 616 (quoted above) // S. Hartmann, *History of American Art* (1902) 2, p. 210 // E. L. Cary, *International Studio* 35 (Sept. 1908), p. xciv, discusses the painting // E. Vedder, *Digressions of V.* (1910), p. 485, lists the work as sold to General C. A. Whittier in 1885 // *Mentor* 2 (Sept. 15, 1914), ill. n. p., as an intaglio-gravure, discusses it in the context of an illustrated series entitled "American Mural Painters" // C. B. Ely, *Modern Tendencies in American Painting* (1925), ill. opp. p. 4 // R. Cortissoz, *New York Herald Tribune*, Dec. 5, 1937, sec. 7, ill. p. 8, notes: "It is into the most gracious pattern that he weaves the undulating forms of 'The Pleiades'" // R. Soria, *Elihu Vedder* (1970), pp. 192–193, discusses commission; p. 229, mentions poem about the picture; p. 330, catalogues the painting as no. 420, The Pleiades (Rubáiyát,

Quatrains 34–36, Omar's Horoscope), 1884–1885; p. 367, catalogues related works.

EXHIBITIONS: MFA, Boston, 1885, *Spring Exhibition*, lent by Gen. Charles A. Whittier // Boston, St. Botolph Club, 1887, *Catalogue for Loan Exhibition*, no. 31, lent by C. A. Whittier // Dowdeswell Galleries, London, 1899, *Exhibition of Oil Painting, Sketches and Drawings by Elihu Vedder* // Carnegie Institute, Pittsburgh, 1901, *Exhibition of Works by Elihu Vedder*, no. 22 // Art Institute of Chicago, 1901, *Works of Elihu Vedder*, no. 30 // Am. Acad. of Arts and Letters, 1937–1938, *Elihu Vedder Exhibition*, no. 132 // University Gallery, University of Minnesota, Minneapolis, 1939, *American Paintings*, no. 40 // MMA, 1950, *20th Century Painters*, checklist // Hyde Collection, Glens Falls, N. Y., 1975, *Elihu Vedder (1836–1923)*, ill. no. 30 // Delaware Art Museum, 1976, *The Pre-Raphaelite Era*, ill. no. 7–13 // National Collection of Fine Arts, Washington, D. C., and Brooklyn Museum, 1978–1979, *Perceptions and Evocations*, exhib. cat., ill. no. 162; no. 215 in separately published checklist.

EX COLL.: Charles A. Whittier, Boston, 1885–d. 1908; George A. Hearn, New York, by 1910.

Gift of George A. Hearn, 1910.

10.64.13.

The Cup of Love

The popularity of Vedder's work reached a peak in 1887. His illustrations for the *Rubáiyát of Omar Khayyám* (1884) were selling extremely well, and the publisher was eager to have him promote the work in the United States. In addition, a major exhibition of paintings had been organized by his dealers, Doll and Richards of Boston. Vedder consented to make a special trip to attend the opening on March 18, 1887.

Among the most faithful of Vedder's American customers was Agnes Ethel Tracy. A former actress who had married a wealthy businessman, she was anxious at this time to buy several of Vedder's large-scale oils. Vedder was now asking $2,500 for his major oil paintings. Following the death of her husband, Frank Tracy, his estate was tied up in probate, and Mrs. Tracy was unable to afford a large major work by Vedder. At this point Vedder was ready to lower his prices, but Mrs. Tracy wouldn't hear of it. In the end she managed to buy a drawing, *Tito*, a *Delilah*, both ca. 1886, and *The Cup of Love*, 1887. Vedder, with her encouragement, kept his prices and sold all the large works. He also sold hand-colored reproductions of his paintings, among them, *The Cup of Love*. These works were

included in the exhibition and sold for seventy-five dollars a piece.

The Cup of Love is one of at least four paintings based directly on Vedder's designs for the *Rubáiyát of Omar Khayyám* (1884), specifically on quatrains forty-six through forty-eight. The painting from 1887 differs somewhat from the 1884 illustration. For one thing, it is considerably more detailed. The *Atlantic Monthly* in 1887 described it:

On a sculptured sarcophagus, in which lies buried the Past, sits a handsome brown youth, wearing a Greek costume of red and blue cloth and a crown of vine leaves. To him comes the woman in fine figure, with a mass of auburn hair, whose back is alone visible,—holding aloft in her right hand the enchanted cup, through whose crystal side we see the magic red wine gleam. At the right, Dan Cupid looks on, approving,—a pretty blonde boy, with a charming pair of red wings, his bow and arrows at his side, and, upheld in his hand, a shining globe, to show the lovers that the whole earth is theirs.

The additions of background and foreground landscape, elaborate carving on the sarcophagus, as well as the figure of cupid on the right, filling space formerly occupied by the lines of text from the *Rubáiyát*, are all painted in Vedder's late style, combining inspiration from both classical antiquity and the Renaissance. The painting's vivid coloration, linear style, and small format are reminiscent of paintings by the German Nazarenes, who worked in Rome at the beginning of the nineteenth century. Vedder was undoubtedly familiar with their frescoes at the Casino Massimo. Here his emphasis on the details of foreground flora and background landscape parallel the concern of the Nazarenes in transporting the viewer to a higher, more idealized realm through nature. Their aim was to reconcile the ideal and the real by emulating the masters of the Renaissance.

Vedder's interest in themes suggested by the *Rubáiyát* reflects his lifelong preoccupation with man's quest for the meaning of existence and the transitory nature of life. His development of *The Cup of Love* into a fully realized painting suggests his reaction to the forty-eighth quatrain:

And if the Wine you drink, the Lip you press, End in what All begins and ends in—Yes; Think then you are To-day what Yesterday You were—To-morrow you shall be not less.

Oil on wood, 12 × 10 in. (25.4 × 30.5 cm.).

Signed and dated on stone at lower right: 18 V 87.

RELATED WORKS: *The Cup of Love*, 1883–1884, chalk and pencil on paper, 17¾ × 13 15⁄16 in. (45.1 × 35.4 cm.), National Museum of American Art, Washington, D. C., ill. in National Collection of Fine Arts, Washington, D. C., and Brooklyn Museum, *Perceptions and Evocations*, p. 140, no. 174. This is the original drawing which was photographically reproduced for quatrain 46 of Vedder's *Rubáiyát* // *Figure Study*, charcoal and white chalk on paper, 12 3⁄16 × 9 1⁄16 in. (31 × 23 cm.), 1883?, Davison Art Center, Wesleyan University, Middletown, Conn., 55.7.1 (2) // Study for *The Cup of Love*, charcoal and white chalk on gray-green paper, 9 / 11⅛ × 14 15⁄16 in. (22.9 / 28.2 × 38 cm.), 1887, Davison Art Center, 55.7.1 (3) // *Cupid—Study for the Cup of Love*, charcoal and white chalk on gray-green paper, 12 5⁄16 × 8 11⁄16 in. (31.2 × 22 cm.), 1887, Davison Art Center, 55.7.1 (4) // Preliminary compositional study for *The Cup of Love*, charcoal and white chalk on gray paper, 14 15⁄16 × 12 9⁄16 in. (37.9 × 32 cm.), 1887, Davison Art Center, 55.7.1 (5), ill. in National Collection of Fine Arts, Washington, D. C., and Brooklyn Museum, *Perceptions and Evocations*, p. 140, no. 173 // Cartoon for transfer, *The Cup of Love*, pencil on tracing paper, 13 × 10⅝ in. (33 × 27 cm.), 1887, Davison Art Center, 55.7.1 (6) // *The Cup of Love*, black chalk and opaque watercolor, heightened with gold, on paper, 10⅞ × 8 15⁄16 in. (27.7 × 22.8 cm.), 1887, coll. Dr. and Mrs. E. P. Richardson, Philadelphia, ill. in National Collection of Fine Arts, Washington, D. C., and Brooklyn Museum, *Perceptions and Evocations*, p. 141, no. 175.

REFERENCES: [Houghton, Mifflin and Company], *Catalogue of Vedder's Phototypes* (1887), no. 20 // C. Vedder, sales book, Vedder Papers, 528, Arch. Am. Art, indicates the work was bought by Mrs. Agnes E. Tracy on May 24, 1887, for $800 // W. H. Downes, *Atlantic Monthly* 59 (June 1887), pp. 844–845, says the painting was inspired by the Rubáiyát drawings and describes it (quoted above) // E. Vedder, *Digressions of V.* (1910), p. 485, records the sale of the work to Mrs. Agnes E. Tracy in 1887 // R. Soria, *Elihu Vedder* (1970), p. 193, mentions that the work was painted between 1885 and 1887, inspired by the Rubáiyát; p. 195, says the work was purchased by Agnes E. Tracy along with two others, *Tito* and *Delilah*, for a total of $1,100; p. 229, notes that W. D. Partridge wrote a poem inspired by the painting; pp. 332–333, catalogues the painting as no. 437 // National Collection of Fine Arts, Washington, D. C., and Brooklyn Museum, *Perceptions and Evocations* (1979), exhib. cat., pp. 140–141, J. Dillenberger, describes it (not exhibited).

EXHIBITION: Doll and Richards, Boston, 1887, *Elihu Vedder* (according to C. Vedder, sale book; no cat. available) // Carnegie Institute, Pittsburgh, 1901, *Exhibition of Works by Elihu Vedder*, no. 23 // Am. Acad. Arts and Letters, 1937–1938, no. 13, lent by Mrs. H. G. Henderson.

EX COLL.: Agnes Tracy Roudebush, New York, 1887—d. 1903, her husband's niece, Agnes Roudebush (Mrs. Harold G. Henderson), New York, 1903—d. 1955; her son, Harold G. Henderson, New York, 1955—d. 1974; his wife, Mary Benjamin Henderson, New York, 1974–1976.

Gift of Mrs. Harold G. Henderson, 1976. 1976.106.2.

Vedder, study for *The Cup of Love*, 1857, black chalk, watercolor, heightened with gold. Coll. Mr. and Mrs. E. P. Richardson.

Vedder, *Study: Cup of Love*, charcoal and white chalk. Davison Art Center. 55–7–1 (5).

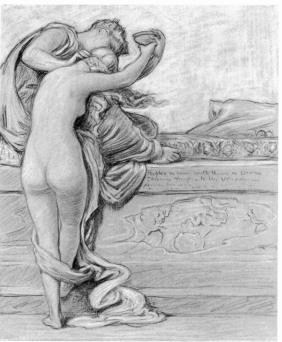

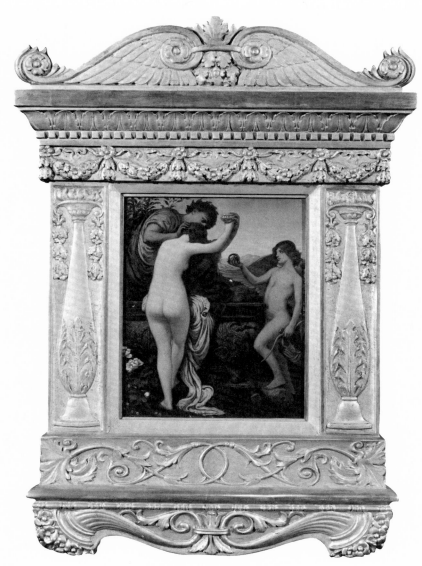

Vedder, *The Cup of Love.*

Lair of the Sea Serpent

In his 1910 autobiography, Elihu Vedder recorded that this painting started as the original sketch for *Lair of the Sea Serpent* of 1864 (MFA, Boston). It was not until many years later that he went back and finished it, making it a second version of the subject. The decision to develop the early oil sketch into another fully realized picture was prompted by plans for a major exhibition of his work at the Dowdeswell Galleries in London in April of 1899. His illustrations had been extremely popular in England due to the wide circulation of the Quaritch edition of the *Rubáiyát of Omar Khayyám*, published in 1884. A few of Vedder's paintings had been exhibited in

London in 1870, and he was anxious to see if he could develop a stronger following among the British since the interest in the Rubáiyát. Confident that the show would be a success and provide him with the necessary funds to build a house he planned on the island of Capri, Vedder prepared a survey of his work. He included paintings and sketches from the 1860s and revamped some of the more popular subjects for immediate sale. According to Regina Soria: "Most of these sketches his friends in London had seen, there and around his studio walls for the last thirty years" (p. 222). The Metropolitan's *Lair of the Sea Serpent* was such a work. The illustrator Walter Crane mentioned seeing a version of the painting on an easel in Vedder's studio in Rome

in 1871 (*An Artist's Reminiscences* [1907], p. 129).

The exhibition was far from a success. Very few sales resulted, and fewer commissions. Vedder's staunch supporter Agnes Ethel Tracy, who had previously purchased *The Cup of Love* (q.v.) and all of the drawings for *The Rubáiyát*, arrived in London in time to buy *Lair of the Sea Serpent*, thus providing Vedder with enough money to cover his exhibition expenses. He was encouraged enough, however, to send an exhibition to Boston the following year. Besides the Boston show, exhibitions of his work were held in New York, Washington, Pittsburgh, and Chicago from 1900 to 1901.

This 1899 version of the sea serpent subject differs only slightly from Vedder's 1864 one, which he painted after a prolonged stay in Florence and his first exposure to European painting. Both versions of the work reflect his early style of landscape painting. Influenced by the Macchiaioli painters, he emulated their muted palette and the way they wove small spots and splashes of color into a uniform fabric. Vedder, however, added his own visionary element, incongruously placing a serpent in a tranquil scene. The picture is one of the first in a long series of mystical themes that characterized his painting. The 1864 picture was exhibited at the National Academy of Design in New York and was Vedder's first public success. One critic described it as depicting:

A huge monster, motionless, torpid, yet self-conscious, overlooking the fair expanse of nature like an incarnate evil, waiting and defiant in its very calm We take this picture to be a symbol of the serene purity of the soul threatened or subjected to a horrible evil. The serpent lying there with its sleepless eye is like an affront to faith, to virtue, to love. It is the evil of a man's life . . . To be haunted by such an image, what suffering! To express it, what relief! We fancy Mr. Vedder must have felt as if a nightmare had been dissipated when he completed that picture (*Round Table* 1 [April 23, 1864], p. 296).

The appearance of this fantastical strain in Vedder's work coincided with his study of the graphic works of Gustave Doré and Francisco Goya. In his autobiography he recalled that the initial inspiration for *Lair of the Sea Serpent* was a volume of Goya's *Los Caprichos* (1799). Goya's *The Sleep of Reason Produces Monsters* from that series and accompanying demons undoubtedly encouraged Vedder to express his own nightmare scene.

Oil on canvas, 12 × 30 in. (30.5 × 76.2 cm.).

Signed, inscribed, and dated at lower left: Elihu Vedder (along left edge) / copyright 1899.

RELATED WORKS: *Lair of the Sea Serpent*, oil on canvas, 21 × 36 in. (53.3 × 91.4 cm.), 1864, MFA, Boston, color ill. in MFA, Boston, *American Paintings in the Museum of Fine Arts, Boston* (1969), 2, p. 201, fig. 401 // *The Tail of the Sea Serpent*, drawing, unlocated, noted in Avery Art Galleries, New York, Feb. 1900, *Exhibition of Works by Elihu Vedder*, no. 32 // *Lair of the Sea Serpent*, black and white chalk on paper, 7⅝ × 12⅜ in. (19.4 × 31.4 cm.), 1899, unlocated, noted in Soria, no. D508.

REFERENCES: C. Vedder, sales book, Vedder Pa-

Vedder, *Lair of the Sea Serpent*.

Vedder, *Lair of the Sea Serpent*, 1864. MFA, Boston.

pers, 528, Arch. Am. Art, lists the work as sold in May 1899 to Agnes E. Tracy for $750 (also notes drawing, Tail of the Sea Serpent, sold Feb. 1900) // E. Radford, *Magazine of Art* 23 (July 1899), p. 368, reviews this picture in the Dowdeswell Gallery exhibition and mentions the fame of the 1864 version // *Glasgow Herald*, April 10, 1899, describes the painting as "a charming seascape" // *London Athenaeum*, April 10, 1899, recommends the picture // *London Daily Telegraph*, April 15, 1899, refers to the work as the "most noticeable" in the Dowdeswell exhibition // W. Crane, *An Artist's Reminiscences* (1907), p. 129, mentions having seen a version of the painting in Vedder's studio while visiting Rome in 1871 (probably this picture) // E. Vedder, *Digressions of V.* (1910), p. 495, records the sale of the work to Agnes Tracy in 1899 and notes that it was a later completion of the sketch for the first version // MFA, Boston, *American Paintings in the Museum of Fine Arts, Boston* (1969) 1, p. 275, no. 992, catalogues 1864 painting and notes that the "Sketch bought from Vedder by Mrs. Agnes E. Tracy in 1899, was owned in 1938 by Mrs. Harold G. Henderson" // R. Soria, *Elihu Vedder* (1970), p. 16, says that the theme of the painting is traceable to

Vedder's childhood experiences and dreams; p. 37, notes that the work is in the spirit of Melville; p. 222, mentions the exhibition of this painting in the 1899 Dowdeswell Galleries show; p. 225, notes that Agnes [Tracy] Roudebush bought the painting at the Dowdeswell exhibition of 1899; p. 335, no. 448, catalogues the work, dating it about 1899.

EXHIBITIONS: Dowdeswell Galleries, London, 1899, *Exhibitions of Oil Paintings, Sketches and Drawings by Elihu Vedder*, no. 105 // Am. Acad. Arts and Letters, 1937–1938, *Catalogue of the Exhibition of the Works of Elihu Vedder*, no. 7 // National Collection of Fine Arts, Washington, D. C., and Brooklyn Museum, 1978–1979, *Perceptions and Evocations*, exhib. cat., p. 65, ill. no. 58; no. 34 in separately published checklist.

EX COLL.: Agnes Ethel Tracy Roudebush, New York, 1899—d. 1903; her second husband's niece, Agnes Roudebush (Mrs. Harold G. Henderson), New York, 1903—d. 1955; her son Harold G. Henderson, New York, 1955—d. 1974; his wife, Mary Benjamin Henderson, New York, 1974–1976.

Gift of Mrs. Harold G. Henderson, 1976.
1976.106.1.

ALFRED COPESTICK

ca. 1837–1859

Not a great deal is known about Copestick's short life. His career had just begun when he died in 1859. Copestick was listed as a landscape painter at 52 John Street in the New York City business directory for 1859–1860. He exhibited four marine paintings at the National Academy of Design in 1859: *The Abandoned Ship, Coast of Cuba* and *On the Coast*, lent by Dr. Morehead; *Coast Scene, Afternoon*, lent by S. M. Wood; and *Headwaters of the Juniata*, lent by N. Orr. In June 1859, the *Cosmopolitan Art Journal* reported that Copestick was one of several artists chosen to provide illustrations to be engraved by N. Orr and Company for an elaborate edition of Nathaniel Parker Willis's *Sacred Poems*. The project was discussed in the September issue of the journal, which noted that "Alfred Copestick of New-York, who promises great excellence in his profession," chose to illustrate the poet's "Thoughts while making the Grave of a New-Born Child." A small engraving after Copestick's design, illustrating an excerpt from the poem, was reproduced.

In its December issue, the *Cosmopolitan Art Journal* belatedly reported the death of the artist: "Alfred Copestick, the marine and landscape painter, met with an untimely death on the 28th of August last, while out on his summer sketching tour. He shot himself by accident, and died within a few moments of receiving the charge of shot in his breast. Mr. Copestick was a young man of rare promise in his profession, having given proofs of genius which have not failed to attract attention. He was but twenty-two years of age at the time of his decease." *Sacred Poems* by Willis with four illustrations by Copestick, engraved on wood by N. Orr and Company, was published in New York by Clark, Austin and Smith in 1860.

BIBLIOGRAPHY: *Cosmopolitan Art Journal* 3 (June 1859), p. 138; (Sept. 1859), pp. 156–157. Mentions and discusses Copestick's illustrations for *Sacred Poems*; (Dec. 1859), p. 236. Supplies Copestick's obituary // Sinclair Hamilton, *Early American Book Illustrators and Wood Engravers, 1670–1870*, (Princeton, 1958), p. 95. Notes Copestick's four illustrations for *Sacred Poems*.

Copestick, *New York from the Harbor Showing the Battery and Castle Garden.*

New York from the Harbor Showing the Battery and Castle Garden

The distinctive form of Castle Garden identifies this marine painting as a view of New York from the southwest. The structure was built as a fortification in 1808 and named Castle Clinton in 1815. The walls of the fort were used in the construction of Castle Garden, which opened as a theater and recreation spot in 1824. In 1855, three years before Copestick painted this work, Castle Garden became an immigration depot. The steeple of Trinity Church is faintly visible above the skyline to the left of Castle Garden. The fishermen in the left middle ground, occupied with their nets, are probably fishing for shad, which ascended the rivers along the Atlantic coast to spawn in early spring.

In this work, painted when the artist was twenty-one, Copestick foregoes a literal description in favor of an interest in atmospheric effects and mood. Using a subdued, almost monochromatic palette of blue, gray, and white, he presents an indistinct, barely defined impression of the New York shoreline.

Oil on canvas, 13⅞ × 21 in. (35.2 × 53.3 cm.).
Signed, dated, and inscribed at lower left: [A.] Copestick / NY 1858.
ON DEPOSIT: Museum of the City of New York, 1935–1963; U.S. Senator from New York, Senate Office Building, Washington, D. C., 1973–1976.
EX COLL.: Edward W. C. Arnold, New York, by 1935–1954.
The Edward W. C. Arnold Collection of New York Prints, Maps, and Pictures. Bequest of Edward W. C. Arnold, 1954.
54.90.89.

ALFRED THOMPSON BRICHER

1837–1908

The rugged cliffs of Grand Manan Island, New Brunswick, with the dramatic tides of the Bay of Fundy and the quiet coastal inlets at low tide were favorite subjects of Alfred Thompson Bricher. His works appeared in the major exhibitions of the late nineteenth century and were known through illustrations for *Harper's New Monthly Magazine* and the popular chromo-lithographs of Louis Prang.

Throughout his career, Bricher remained a conservative painter. He was particularly influenced by such artists as JOHN F. KENSETT, a Hudson River school painter who inspired his interest in capturing effects of light and atmosphere. The looser handling of paint in his later work shows the influence of the Barbizon painters.

Bricher was born in Portsmouth, New Hampshire, in 1837 and spent his childhood in Newburyport, Massachusetts, where he attended school. Later, he worked as a clerk in a Boston drygoods store and painted in his spare time. He may have studied art at the Lowell Institute in Boston during the mid-fifties; although an 1875 article in the *Art Journal* states that during his early years in Boston, Bricher had little contact with other artists and was "entirely self-taught" (p. 340). The same article says that WILLIAM STANLEY HASELTINE and Charles Temple Dix (1840–1873), whom Bricher met in 1858 while sketching on Mount Desert Island, Maine, had a decisive influence on his style. Haseltine's paintings of sunstruck, fissured rocks on the New England coast may have prompted Bricher to turn from landscapes to marine paintings in which large rocks dominate the foreground. He probably also knew

Bricher, *Marine Landscape*.

the marine and still-life painter MARTIN JOHNSON HEADE, who worked in Newburyport during the early 1860s. In addition to painting on the New England coast, Bricher went on sketching trips to the White Mountains and the Catskills and in 1866 to the upper Mississippi River and Minnesota.

Bricher moved to New York in 1868. During the 1870s, he occupied a studio in the YMCA Building. He was a member of the American Society of Painters in Water Colors and an associate of the National Academy of Design. In 1882, while maintaining a studio in New York, he built a summer home in Southampton, Long Island, to be closer to the sea. From 1890 until his death in 1908, he lived in New Dorp, Staten Island.

BIBLIOGRAPHY: "American Painters—Alfred T. Bricher," *Art Journal* 38 (Nov. 1875), pp. 340–341. First published biography of Bricher, says he "has already assumed a leading position as . . . a marine painter . . . and in the delineation of landscape," notes influence of Haseltine and Dix; reprinted with minor changes in *Art Journal* 39 (June 1877), pp. 174–175 // George W. Sheldon, *American Painters* (New York, 1879), pp. 144–146 // John Duncan Preston, "Alfred Thompson Bricher, 1837–1908," *Art Quarterly* 25 (Summer 1962), pp. 149–157. Quotes from artist's letters to family and friends and says he studied at Lowell Institute, Boston // Indianapolis Museum of Art and George Walter Vincent Smith Art Museum, Springfield, Mass., *Alfred Thompson Bricher* (1973), exhib. cat. by Jeffrey R. Brown, assisted by Ellen W. Lee. First monograph and exhibition catalogue of Bricher's work, includes chronological list of early exhibitions and activities // Rena Neumann Coen, "Alfred Thompson Bricher's Early Minnesota Scenes," *Minnesota History* 46 (Summer 1979), pp. 233–236. Traces Bricher's course up the Mississippi in 1866 through his sketches and oil paintings.

Marine Landscape

Throughout his career, Bricher painted the parabolic coastline, a scene which was popularized in America by such artists as JOHN F. KENSETT and present as well in the work of the English painter John Constable. In *Marine Landscape*, painted about 1895, Bricher abbreviated his characteristic curve and cut the arc at the far right, telescoping the relationship of the rocks and the peninsula.

Typical of his seascapes, expanses of placid water are carefully balanced by massive land forms, and impasto paint emphasizes light and dark in such areas as the white sail and black seaweed. The sail echoes the shape of the hill, strengthening the connection between the two sides of the painting. This connection is also suggested by the emphatic horizon line. Reflections of the boat and land in the water add to the illusion of volume. Strong foreground elements, especially rocks covered with seaweed, were characteristic of Bricher's paintings in the 1890s.

Oil on canvas, 25 × 52 in. (63.5 × 132.1 cm.).

Signed at lower right: ATBRICHER (initials in monogram).

REFERENCES: *MMA Bull.* 4 (1909), p. 10 // J. R. Brown, Indianapolis Museum of Art, June 19, 1973, note in Dept. Archives, dates it about 1895.

EXHIBITED: Washington Irving High School, New York, 1914 [Loan Exhibition of Paintings from the MMA] (no cat.) // Bronx Society of Arts and Sciences, Lorillard Mansion, Bronx Park, New York, 1915, [Loan Exhibition of Paintings from the MMA] (no cat.) // American Federation of Arts, traveling exhibition, 1926–1927, *Exhibition of 39 Paintings Lent by the Metropolitan Museum of Art* (no cat.) // Heckscher Museum, Huntington, N. Y., 1958, *Marine Paintings by American Artists*, unnumbered cat. // Phoenix Art Museum, 1967–1968, *The River and the Sea*, no. 1 // Colby College Art Museum, Waterville, Me.; Bowdoin College Museum of Art, Brunswick, Me.; Carnegie Gallery, University of Maine, Orono, 1970, *Landscape in Maine, 1820–1970* (not in cat.).

ON DEPOSIT: United States Mission to the United Nations, New York, 1968–1969 // New York City Department of Parks, 1974–1976 // Gracie Mansion, New York, 1981–1984.

EX COLL.: William Wheeler Smith, New York, d. 1907; his wife, New York, 1908.

Gift of Mrs. William Wheeler Smith, 1908.
09.237.3.

THOMAS MORAN

1837–1926

In the late nineteenth century, the paintings, lithographs, and etchings of Thomas Moran were largely responsible for publicizing the natural wonders of the American West. Employing the coloristic style of the English painter J. M. W. Turner, Moran sought to capture the spiritual essence rather than the literal truth of what were to become eight national parks and monuments. To Moran, as to others, the landscape of the West was uniquely American.

Thomas Moran was born in Bolton, Lancashire, England, in 1837. His family came to the United States in 1844 and settled in Philadelphia. At the age of sixteen, Moran was apprenticed to the wood-engraving firm of Scattergood and Telfer. Through his employers, he sold many of the drawings and watercolors that he produced in his spare time. He exchanged others for books on poetry and art. A severe attack of rheumatic fever caused him to leave the firm in 1856, after only three years. Following his recovery, Moran made his debut as a professional artist by exhibiting six watercolors at the Pennsylvania Academy of the Fine Arts. He shared the first of several studios with his older brother, the marine painter EDWARD MORAN. Later, they were joined by their younger brother Peter (1841–1914).

Although he had no formal training as a painter, Thomas Moran benefited during the formative stages of his career from the advice of the marine painter JAMES HAMILTON. Under his influence Moran studied the work of the popular British landscape and marine painter J. M. W. Turner. Moran, who owned copies of Turner's *Liber Studiorum* and the *Rivers of France*, became an enthusiastic admirer and painted many watercolors based on Turner's prints. Most of Moran's early works, however, were romantic, imaginative illustrations for such works as Longfellow's *The Song of Hiawatha*, which remained one of his favorite poems throughout his life.

Thomas Moran

On July 23, 1860, Moran made the first of many trips to the American frontier, traveling to Lake Superior with another artist, Isaac L. Williams (1817–1895). Moran's drawings and impressions of this trip were made into wood engravings for the periodical the *Aldine*, illustrations for *The Song of Hiawatha*, lithographs, and oil paintings. Like his later studies, they served him again and again throughout his career.

By the time Thomas and Edward Moran left Philadelphia for England in 1861, Thomas Moran had attained a local reputation as an artist. In London, while his brother studied at the Royal Academy, Moran made a careful study of Turner's paintings and watercolors in the National Gallery. He was fascinated by Turner's dynamic effects and luminous colors. Although thoroughly familiar with Turner's black and white engravings, he was "stunned by the radiance" of color in the paintings themselves, "which he had not imagined but which he, himself, found literally glowing in the Yellowstone country, later on in his life" (R. Moran, *American Magazine of Art* 17 [Dec. 1926], p. 645). In order to master the techniques, he copied several of Turner's oils and watercolors. Moran was also impressed by the compositional strength in the paintings of Claude Lorrain. During the summer, he studied at the new South Kensington Museum (now the Victoria and Albert Museum) and made sketching trips into the English countryside, often choosing the same subjects that Turner had painted.

Moran returned to Philadelphia in the summer of 1862 and married Mary Nimmo (1842–1899), a former student of his, who later became a successful etcher. During the following years, he continued to provide illustrations for major periodicals and to exhibit at the Pennsylvania Academy and at James S. Earle's gallery. Most of his work was based on sketches from his trips to Lake Superior and England, although occasionally he used sketches by other artists. He also taught during the 1860s at the Philadelphia School of Design for Women.

In 1866 Moran returned to Europe with his family for a year. After a brief visit to London to show his wife the paintings by Turner, they traveled to Paris, where he studied the paintings in the Louvre and the Luxembourg and sketched in the countryside near Dieppe and Fontainebleau. His reaction to contemporary French painting, however, was contemptuous: "French art . . . scarcely rises to the dignity of landscape—a swamp and a tree constitute its sum total" (Sheldon, p. 127). Moran also studied the old masters in Italy, where he found a special kinship with the romantic feeling, beauty, and warmth of color in Italian art.

During the years following their return from Europe, Moran worked as an illustrator for several periodicals in New York. After the Civil War, magazines such as the *Aldine* and *Scribner's Monthly* eagerly reported on the trips of United States government survey teams to the western frontier. In 1871 *Scribner's* published Nathaniel P. Langford's "Wonders of the Yellowstone" with illustrations by Moran, based on the crude sketches of an anonymous soldier. The same year, Moran joined Dr. Ferdinand Hayden's expedition to the Yellowstone region. Also on the expedition was the photographer William H. Jackson. Jackson and Moran became good friends, each offering professional advice to the other. During this trip, Moran recorded the breathtaking sights in a spectacular series of delicate pencil drawings, often washed with color and carefully annotated. He later used these to illustrate Hayden's reports and articles for *Scribner's*, as well as to compose his own oil paintings. The largest of these, *The Grand Canyon of the Yellowstone*, was purchased in 1872 by the United States Congress for $10,000 and hung in the Capitol. This painting established Moran's reputation as the

preeminent artist of the American West and gave him the nickname Tom "Yellowstone" Moran.

Moran made a number of other trips west. In 1872 he visited Yosemite Valley in California, and the next year he accompanied Major John Wesley Powell's geographical and geological survey of the Rocky Mountain region, traveling through the brilliantly colored mountains of Utah and visiting the Grand Canyon. In 1874 he joined the Hayden party in Colorado. In 1879 he traveled to the region of the Donner Pass in the Sierra Nevada and to Lake Tahoe; then, with a military escort, he explored the Teton Mountains of Wyoming, visiting the peak that Dr. Hayden had named Mount Moran in his honor.

Moran also occasionally traveled abroad, to England and Scotland in 1882 and 1910, Mexico in 1883, and Italy in 1886 and 1890. The Morans moved to New York in 1872. In 1884 they built a summer studio at East Hampton on Long Island. Beginning in 1916, however, Moran spent his winters in Santa Barbara, California, moving there permanently in 1922. He died four years later in his Santa Barbara home.

Many of Moran's later paintings depict Venice and show the strong influence of Turner in their luminous color and vibrant brushstrokes. Others that Moran painted while he was living on Long Island recall the marshes of the Barbizon painters, but newly infused with brilliantly colored skies.

Moran's watercolors and oil paintings were widely exhibited in the United States and England. In 1884 he was named an academician at the National Academy of Design. He also exhibited at and was a member of the American Watercolor Society and the New York Etching Club. The two major repositories of his papers are the East Hampton Free Library and the Gilcrease Foundation in Tulsa, Oklahoma.

BIBLIOGRAPHY: George W. Sheldon, *American Painters* (New York, 1879), pp. 122–128. Provides information about early career and painting style, discusses Moran in relation to contemporary artists, and quotes conversation with him // Fritiof Fryxell, ed., *Thomas Moran: Explorer in Search of Beauty* (East Hampton, N. Y., 1958). Good summary of career // William H. Gerdts, "The Painting of Thomas Moran: Sources and Style," *Antiques* 85 (Feb. 1964), pp. 202–205 // Thurman Wilkins, *Thomas Moran, Artist of the Mountains* (Norman, Okla., 1966). Most complete account of artist's life and work // Carol Clark, *Thomas Moran: Watercolors of the American West* (Austin, 1980). A catalogue raisonné of close to 300 watercolors from Moran's western trips.

Lake Como

The spectacular scenery of Lake Como in northern Italy has been famous since ancient times. By the nineteenth century, a visit to its shores was almost obligatory for tourists, especially artists. Thomas Moran painted this view in 1867 during his second trip to Italy.

The heavy earth tones used to describe the foreground of the painting are characteristic of Moran's early works. His brushstroke is broad and mutes the forms so there is no clear definition of detail. The luminosity of the distant mountains suggests Moran's later translations of Turner's style in depicting the mountains of the American West. The linear outline that defines the otherwise ethereal mountains also recalls Moran's delicate, washed pencil drawings, which served as preliminary studies for many of his compositions.

Moran was apparently satisfied with his painting of *Lake Como*, for after inscribing it with the location, his signature, and the date, he assigned it an opus number, reserved for only his important works between 1863 and 1868. This painting is believed to have been one that

Moran, *Lake Como*.

Moran's elder brother, EDWARD MORAN, owned and sold in 1877.

Oil on canvas, 40 × 34½ in. (103.5 × 87.6 cm.).
Signed, dated, and inscribed on well at lower left: COMO / Thos. Moran 1867 / Op. 27.
REFERENCES: *New York Times*, May 18, 1877, p. 5, notes Lake Como by Thomas Moran in list of Edward Moran collection of paintings sold at Association Hall, New York, and gives price as $100 // T. Wilkins, *Thomas Moran, Artist of the Mountains* (Norman, Okla., 1966), p. 51, says that this painting was not one of the artist's better works; p. 245, lists it among works by Moran at the Metropolitan.
EXHIBITED: American Federation of Arts, traveling exhibition, 1965–1966, *Romantic Art, 1750–1900*, no. 19 // University of Kansas Museum of Art, Lawrence, 1972, *The Arcadian Landscape*, pl. 31, and discusses // Whatcomb Museum of History and Art, Bellingham, Wash., 1976–1977, *5,000 Years of Art*, no. 64, ill. p. 87.
ON DEPOSIT: United States Mission to the United Nations, 1973–1974.

EX COLL.: possibly the artist's brother, Edward Moran (sale, Association Hall, New York, May 17, 1877, as Lake Como [probably this painting]); Emily Buch, New York, and Ridgefield, Conn., by 1933.
Bequest of Emily Buch, 1963.
64.198.5.

The Teton Range

Moran considered the Teton Mountains to be "perhaps the finest pictorial range in the United States and even in North America" (F. Fryxell, *Annals of Wyoming* 15 [Jan. 1943], p. 75). *The Teton Range*, painted in 1897, is one of a series based on observations he made on an expedition to the Tetons in 1879. In his diary of this trip, Moran described the approach to the great range:

The Tetons are now plainly visible but not well defined owing to the mistyness (*sic*) of the atmosphere.

They loom grandly above all the other mountains. An intervening ridge dividing us from the Teton Basin stretches for miles to the north, of a beautiful pinkish yellow with delicate shades of pale cobalt, while the distant range is of an exquisite blue with but little definition of forms on their surface (ibid., p. 77).

A dramatic contrast of brilliant sunlight and dark shadow dominates Moran's painting. The sun highlights the monumental salmon-pink rock on the right and the snow-covered mountains in the distance. The light weaves in and out of the middle ground, breaking the shadows cast by unseen mountains. The luminous colors of the landscape and the daylight moon reflect the artist's continuing fascination with Turner. The sharp silhouette of the mountains against the sky and the precise definition of forms, however, reveal a persistent linear quality characteristic of all Moran's work.

Although it captures a mood, the scene in *The Teton Range* is not topographically accurate and could not be identified by the National Park Service. Rather, it is what Moran called an "idealization of the scene which consists in the combination and arrangement of the various objects in it" (G. W. Sheldon, *American Painters*, [1879], p. 126). Using the numerous sketches he had made of the region, plus photographs by William H. Jackson who had accompanied the expedition, Thomas Moran composed this painting in his studio.

Many of Moran's sketches were carefully detailed studies, such as *From New Inspiration Point, Yellowstone Canyon, July 1892* (National Museum of American Art, Washington, D. C.). He may have used this drawing to define the form of the prominent rock in the right middle ground and the distant cliff in the painting. The precision of the drawing shows Moran's attempt to draw rocks so carefully "that a geologist could determine their precise nature" (Sheldon, p. 126).

Oil on canvas, 30 × 45 in. (76.2 × 114.3 cm.).
Signed and dated at lower right: TMORAN (initials in monogram), 1897.

REFERENCES: "In the Studio, Feb. 14, 1898," Thomas Moran Papers, Long Island Collection, East Hampton Free Library, as no. 8, "In the Teton Range, Idaho 30 × 45" // C. M. Bartlett, *Masterpieces of the World's Art Galleries* (1904), pl. 7, as The Teton Range, Idaho, calls it "one of the most picturesque and impressive" of Moran's compositions and compares it to the two Moran paintings purchased by the U. S. Congress // M. Tanenbaum, July 27, 1934, letter in MMA Archives, includes it in a list of paintings which he wishes to bequeath to MMA // L. Burroughs, *MMA Bull.* 34 (June 1939), pp. 137–138, discusses acquisition // L. Kirstein, *The Latin American Collection of the Museum of Modern Art* (1943), ill. p. 18, for a comparison of Mexican landscape painter Jose Maria Velarco and Moran // F. C. Fagergren, superintendent, Unites States Department of the Interior, National Park Service, letter in Dept. Archives, Feb. 1964, notes: "Our rangers who know the Teton high country well

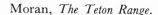
Moran, *The Teton Range*.

cannot identify the spot, nor can the staff of the Targhee National Forest . . . The Mountain mass on the left does have the general appearance of the Grand Teton with Mt. Owen centered in the high saddle. The sharp peak in the center, seen in the lower saddle, would then be South Teton. The peaks do have this approximate relation when viewed from Hurricane Pass on the boundary between Grand Teton National Park and Targhee National Forest. However, the foreground does not fit this location at all. The existence of such a stream flowing in the direction indicated is simply not known to us" // T. Wilkins, *Thomas Moran, Artist of the Mountains* (1966), p. 130, discusses this painting as In The Teton Range, Idaho, and notes that Moran never knew where the line ran that placed the peaks in Wyoming; pp. 245–246, lists it as The Teton Range // University of Notre Dame, Notre Dame, Ind., *The Drawings and Watercolors of Thomas Moran (1837–1926)*, exhib. cat. by T. S. Fern, colorpl. 5 (not exhibited), p. 64, suggests that this painting resulted from sketches Moran made on August 27, 1879, when he and his companions went about six miles up the Teton Canyon and climbed to the top of a granite cliff for a better view; quotes from artist's diary that the three Tetons were not visible but a number of others were; notes that Moran spent three hours on the cliff sketching and that the peaks in the painting are not identified; p. 68, compares this painting to the composition of an undated mezzotint of the Teton Range from the west.

EXHIBITED: NAD, 1898, no. 111, as The Teton Range, Idaho // Heckscher Museum, Huntington, N. Y., 1965, *The Moran Family*, no. 51 // Los Angeles County Museum of Art and M. H. de Young Museum, San Francisco, 1966, *American Paintings from the Metropolitan Museum of Art*, ill. no. 36 // Hudson River Museum, Yonkers, N. Y., 1970, *American Paintings from the Metropolitan Museum of Art*, ill. no. 31 // Lehigh University, Bethlehem, Pa., Reading Public Museum and Art Gallery, Pa., and Everhart Museum, Scranton, Pa., 1971, *Creativity in Crisis, 1871–1971* (Loan Exhibition in Honor of Episcopal Diocese of Bethlehem Centennial), ill. no. 3 // Museum of Fine Arts, Houston, 1972, *Days on the Range*, exhib. cat. by D. Harrington, frontis. ill.; no. 19 // University of Colorado, Fort Collins, 1972, *Thomas Moran in Yellowstone*, ill. p. 15, no. 53 // MMA and American Federation of Arts, cat. by M. Davis, color ill. no. 63, p. 145; rev. ed., 1977, color ill. no. 62, p. 143, discusses it.

EX COLL.: the artist, until 1898, Moses Tanenbaum, New York and Irvington, N. Y., by 1934—d. 1937.

Bequest of Moses Tanenbaum, 1937.
39.47.2.

EDWARD GAY

1837–1928

Edward Gay was born near Mullingar, County Westmeath, Ireland. His father, a mason and stonecutter, fled the country for political reasons during the famine in 1848 and settled in Albany, New York, where he became a successful builder. As a youth, Edward held various jobs, including one in a wine cellar, where the proprietor found him making charcoal drawings, recognized his talent, and introduced him to some local artists. Gay was befriended by JAMES M. HART and accompanied him and other painters on a sketching trip to Lake George. Among the Albany artists that Gay knew well were the sculptor Erastus Dow Palmer and the young painters George Boughton (1833–1905) and HOMER DODGE MARTIN. In order to support himself, Gay taught at the Albany Female Academy. In 1858 he began to exhibit at the National Academy of Design, where he remained a regular contributor throughout his career.

Gay left for Europe in 1862 and, perhaps at Hart's suggestion, enrolled in the art academy at Karlsruhe, Germany. Founded in 1854, this school, which emphasized landscape painting, had close ties to the art academy at Düsseldorf, where Hart had studied a decade earlier. Both of Gay's teachers, Johann Wilhelm Schirmer and Carl Friedrich Lessing, had taught

previously at that popular school. In the spring of 1864, when Gay had completed his studies, he made a brief visit to his native Ireland. On his return to Albany, he married Martha Fearey, whom he had met at the Albany Female Academy. He was an active participant in the city's art community.

Gay took a studio in the Dodsworth Building in New York in 1868. He achieved some success, being elected an associate member of the National Academy in 1869. The following year he moved his growing family out of the city to then-rural Mount Vernon, New York, which became one of his favorite landscape settings. His friendship with the wealthy art patron William J. Arkell, a manufacturer and newspaper publisher from Canajoharie, New York, was initiated when Gay and two of his sons made a walking tour of the Hudson valley. In 1880, when Arkell sponsored an excursion of members of the Artists' Fund Society up the Hudson River and along the Erie Canal, Gay led the group.

Two shows of Gay's work were held in 1881—an exhibition at Townsend and Evans, followed by an exhibition and auction of eighty-two paintings and eighteen watercolors at Barker and Company. Soon afterward, Gay and his wife went to Europe. Gay visited his old friend Boughton, who was living in London. He then went to Norway and France.

In England Gay became enthusiastic about the work of John Constable. His study of Constable and his familiarity with Barbizon painting inspired his art over the next two decades. The critic Sadakichi Hartmann considered Gay one of the few old-school landscapists who had been able to pick up the new progressive spirit in that genre. In 1883 Gay went to Europe again and stopped in Ireland on his way home. For a proposed magazine article, he went to Egypt in 1890 with M. de Forest Bolmer (1854–1910).

Gay achieved critical success during the eighties, winning, for example, a medal in San Francisco in 1885. Two years later, his painting *Broad Acres* (see below) took second place in the Prize Fund Exhibition and was presented to the Metropolitan Museum of Art. This exhibition, held at the American Art Association, was organized for the purpose of presenting important contemporary paintings to major American institutions. Wealthy subscribers contributed money, and the prize-winning pictures were bought and donated to various institutions. Sales of Gay's paintings remained irregular, however, until the 1890s, when William Macbeth became his representative. It was not until 1907 that Gay was elected an academician at the National Academy.

After the turn of the century, Gay often went to Florida during the winter, sometimes stopping in South Carolina. In 1905 he built a summer house at Cragsmoor, New York, an artists' colony that included such painters as EDWARD LAMSON HENRY and George Inness, Jr. (1854–1926). One-man shows of Gay's work were held in New York at the Clausen Art Rooms in 1908 and the McDonough Art Gallery in 1914.

Throughout his later years, Gay's style remained unchanged. He produced large landscapes, loose in structure and painted in atmospheric tones.

BIBLIOGRAPHY: Edward Gay Papers, D30, Archives of American Art. Include correspondence, clippings, and biographical material // *American Art Annual* 20 (1928), p. 369. Obituary notice // *National Cyclopaedia of American Biography* 10 (1900), pp. 375–376 // Groce and Wallace, p. 252 // Richard G. Coker, *Portrait of an American Painter: Edward Gay, 1837–1928* (New York, 1973). An appreciative biography written by the artist's grandson.

Broad Acres

Dated 1887, *Broad Acres* represents a panoramic view in which much of the canvas is devoted to a cloudy sky above a field of ripened wheat. The choice of subject was so typical of the artist that one critic described him as "the painter of the wheatfield" (*American Art News* 7 [Dec. 19, 1908], p. 6). Except for the middle ground, where he added a horse-drawn carriage, a line of telegraph poles, and a distant farmhouse, there is little action or detail. Gay's quiet scene invites contemplation, not of the grandeur of nature but of its everyday beauty. The choice of subject, the composition, in which the sky plays so prominent a role, and the emphasis on light and climatic conditions reflect Gay's admiration for the work of John Constable, whose landscapes he had studied in London six years earlier.

In 1887 *Broad Acres* received second place in the third annual Prize Fund competition in New York, which elicited some reproof from the critic for the *New York Times*: "If one looks to second prize for one of the best pictures in the exhibition the result is to cause one to admire the courage of the jury of award rather than their strict adhesion to select the best."

Gay, *Field Sketch at "Broad Acres,"* watercolor. Coll. Ross Rowland.

Oil on canvas, 47¾ × 71¼ in. (121.9 × 181 cm.). Signed and dated at lower right: EDWARD GAY. 87.

RELATED WORK: *Field Sketch at "Broad Acres,"* watercolor on paper, 6 × 9¾ in. (15.2 × 24.8 cm.), coll. Ross Rowland, Great Falls, Va.

REFERENCES: *New York Times*, May 2, 1887, p. 4, in a review of the Prize Fund Exhibition, notes that it has been awarded second prize: "it is a fine open landscape painted with earnestness, but more remark-

able for promise than fulfillment"; "it would conduce to sweetness and light if the public could know on what principle the Awards at the Art Association Galleries are given" (quoted above) // Montezuma [pseud.], *Art Amateur* 17 (June 1887), p. 3, in a discussion of the Prize Fund Exhibition, mentions that the picture is being presented to the MMA // *Art Amateur* 17 (June 1887), p. 9, in a review of the Prize Fund Exhibition, notes that it and Charles H. Davis's Late Afternoon have received awards; says, "this award is understood to be the result of a compromise between that section of the jury which favored the French school in art, represented by Mr. Davis, and the one which believed strictly in American methods, as supposed to be exemplified in Mr. Gay's painting"; notes that "the simple, horizontal order of the composition—a large field of yellow grain comes down to the little stream that straggles through the meadow, in the distance are some low hills, a long stretch of trees, and some tall telegraph poles. At first glance the color strikes the spectator as somewhat crude and hard" // L. B. di Cesnola to A. Elliott, American Art Association, Oct. 5, 1887, acknowledges his letter of Oct. 4 and says that the picture has not yet arrived at the museum // Board of trustees, MMA, Minutes, MMA Archives, Nov. 14, 1887, acknowledges it as a gift of the American Art Association // S. Hartmann, *A History of American Art* (1902), 1, p. 65 // *National Cyclopaedia of American Biography* 10 (1900), p. 375 // E. Gay, letter in Dept. Archives, June 1928, in response to a request to reproduce the picture, says that "'Broad Acres' has been copied so often I have now no desire to interfere with the arrangement of the Museum in this matter" // *Antiques* 64 (Nov. 1953), p. 400 // R. G. Coker, *Portrait of an American Painter* (1973), pp. 70–71, quotes 1887 letters congratulating Gay on his Prize Fund award; p. 82; p. 99, notes prize and presentation to the MMA, mistakenly attributes this gift to the instigation of Gay's friends Arkell and J. H. Johnston, and notes that it was reproduced in the New York Daily Graphic.

EXHIBITED: American Art Association, New York, 1887, *The Third Prize Fund Exhibition for the Promotion and Encouragement of American Art*, no. 86, as Broad Acres, lists subscribers to the fund // MMA, 1887–1888, *Collection of Paintings and Sculpture in the West Galleries and the Grand Hall*, no. 64.

EX COLL.: subscribers to the Third Prize Fund Exhibition, New York (William T. Walters, Henry G. Marquand, Cornelius Vanderbilt, Morris K. Jesup, Thomas B. Clarke, H. C. Fahnestock, William K. Vanderbilt, W. M. Rockefeller, Andrew Carnegie, Henry M. Flagler, Joseph J. Little, E. Dwight Church, Benjamin Altman, James J. Raymond, A. W. Kingman, George I. Seney, Jerome B. Wheeler, James F. Sutton, W. H. Fuller, Edward C. Moore, Thomas E. Kirby, and L. Crist Delmonico).

Gift of Several Gentlemen, 1887.
87.18.

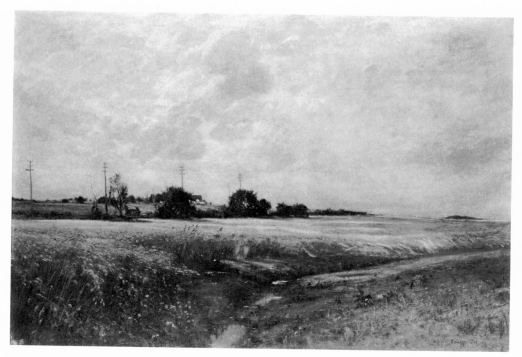

Gay, *Broad Acres.*

CLINTON OGILVIE

1838–1900

The landscape painter Clinton Ogilvie was born into a wealthy family that had lived in New York since 1745, when William Ogilvie arrived from Scotland.

Clinton Ogilvie studied with JAMES M. HART, a painter trained in the Düsseldorf tradition. The careful observation and minute detail of Ogilvie's early paintings undoubtedly derived from Hart and JOHN F. KENSETT, whose studio Ogilvie often visited. Ogilvie began exhibiting at the National Academy of Design in 1861 and was elected an associate in 1864. During the 1860s, his landscapes of New York, New Jersey, and Connecticut were also exhibited at the Pennsylvania Academy of the Fine Arts and the Boston Athenaeum. In 1866 Ogilvie made the first of several long trips to Paris, where he is said to have studied with several different artists. He returned for a year following his marriage in 1872. Then in 1879, he and his wife and child spent four years abroad. In the winters they settled in Nice or Mentone, where Ogilvie made outdoor studies. His later paintings were mainly of European scenes; he did not, however, adopt the Barbizon style that was popular at the time but retained instead his meticulous finish and detailed treatment. The titles of his paintings suggest that among Ogilvie's favorite places to paint were Ireland, Italy, and Switzerland.

He returned to New York in about 1883 and remained there until his death in 1900. He was survived by his wife, Helen Slade Ogilvie (1851–1935), who was a painter and a well-known collector of oriental rugs, and by his daughter, Ida Helen Ogilvie, who became a

prominent geologist and teacher. The deanery of Saint John the Divine in New York was built in his memory.

A portrait bust of Clinton Ogilvie by Paul Wayland Bartlett is in the collection of the Metropolitan Museum.

BIBLIOGRAPHY: Clara Erskine Clement and Laurence Hutton, *Artists of the Nineteenth Century* (Boston, 1880), 2, p. 154 // *Appleton's Cyclopedia of American Biography* 4 (New York, 1900), p. 563 // *American Art Annual* 4 (1903–1904), p. 143. Obituary notice // Francklyn W. Paris, *Personalities in American Art* (New York, 1930), pp. 70–82. Discusses the artist's family and his relationship to Hart and Kensett and describes the development and characteristics of his style // *The National Cyclopaedia of American Biography* 16 (New York, 1937), p. 440.

Near Jackson, White Mountains

With the completion of the Portland and Ogdensburg Railroad in the early 1870s, the White Mountains became easily accessible from the major eastern cities. During the 1880s and 1890s, Jackson, New Hampshire, at the foot of the White Mountains, was a center for writers, scientists, and artists. The community of artists that gathered in Jackson and North Conway produced careful studies in the tradition of the Hudson River school. Advertisements in contemporary guidebooks suggest that many of these works were souvenirs for the tourist trade.

Near Jackson, White Mountains, signed and dated 1885, is typical of Clinton Ogilvie's work. Painted in subdued colors, this tranquil landscape focuses on the impressive peak of Mount Washington in the distance. A small red farmhouse and lines of drying laundry provide a human element. This may have been the view from the road between Jackson and Goodrich Falls that was the point preferred by artists for "studies of the massiveness and sublimity of the Imperial ridge" (S. C. Eastman, *The White Mountain Guide Book*, [16th ed., Concord, N. H., 1881] p. 70).

Oil on canvas, 16¼ × 26¼ in. (41.3 × 66.7 cm.).

Signed and dated at lower left: Clinton Ogilvie / 1885. Inscribed on the back: Clinton Ogilvie / N. Y. 1885.

ON DEPOSIT: Federal Reserve Bank, New York, 1972–1973.

REFERENCES: H. S. Ogilvie, Jan. 31, 1919, letter in MMA Archives, offers museum a painting from a selection of her husband's works // W. F. Paris, *Personalities in American Art* (1930), 1, p. 77, mentions this picture among the artist's best works, calling it Near Jackson in the White Mountains.

EXHIBITED: NAD, 1885, Autumn Exhibition, no. 192, as Morning near Jackson, N. H., $200 (possibly this picture) // Currier Gallery of Art, Manchester, N. H., 1955, *Artists in the White Mountains*, no. 23.

EX COLL.: the artist, d. 1900; his wife, Helen S. Ogilvie, until 1919.

Gift of Mrs. Clinton Ogilvie, 1919.

19.120.

Ogilvie,
*Near Jackson,
White Mountains.*

WALTER SHIRLAW

1838–1909

Born in Paisley, Scotland, Shirlaw came to New York with his parents around 1841. His father was an inventor and maker of handlooms. As a child, Shirlaw began to draw, model in clay, and carve in wood. About the age of twelve, he left school and within a few years was apprenticed at the American Bank Note Company to become an engraver. He attended drawing classes in the evenings. Shirlaw first exhibited at the National Academy of Design and the Pennsylvania Academy of the Fine Arts in 1861. Financial difficulties, however, forced him to accept a lucrative position as an engraver with the Western Bank Note Company in Chicago.

For several years, he lived and prospered in the Midwest and was instrumental in the founding of the Chicago Art Institute. In 1870 he resigned from his job and took a six-month sketching trip to the Rockies. Determined to further his artistic education, he embarked for Europe soon after. En route, he stopped in London where he was advised to avoid Paris because of the Franco-Prussian War. Instead he went to Munich. In over seven years there, Shirlaw studied drawing with George Raab, painting with Alexander von Wagner, and composition with Arthur George von Ramberg and Wilhelm von Lindenschmit. He acquired the fluid style that characterized the Munich school. His most famous works of this period were *Toning the Bell*, 1874 (Art Institute of Chicago), and *Sheep Shearing in the Bavarian Highlands* (formerly Saint Louis Art Museum), which was exhibited at the National Academy of Design in 1877 and won an honorable mention at the Paris Exposition the following year.

Throughout his life, Shirlaw experimented with various types of compositions. Primarily he painted figural groups, generally rustic genre scenes and landscapes with animals. In 1889 he was sent by the United States government to the Crow and Cheyenne reservations to record Indian life. He described this experience in an article in the *Century Magazine*. He also painted murals for public and private buildings, including a frieze, *Peace and Plenty*, for Darius Ogden Mills's home in New York, a ceiling decoration representing eight sciences for the Library of Congress, and one of the domes of the Liberal Arts Building at the World's Fair in Chicago in 1893. He executed designs for stained-glass windows, painted in watercolor, and made skillful charcoal drawings, many of which were published in the *Century* and *Harper's Monthly*.

Shirlaw was a member of the Society of American Artists and the American Watercolor Society. In 1888 he was elected an academician at the National Academy of Design. He died in Madrid on his second trip to Spain. Memorial exhibitions of his work were held in Saint Louis, Buffalo, Chicago, Washington, and New York.

BIBLIOGRAPHY: T. H. Bartlett, "Walter Shirlaw," in *American Artists and Their Works*, ed. by Walter Montgomery (Boston, 1889), 1, pp. 19–32. Good early treatment of the artist's life // W. Shirlaw, "Artists' Adventures: The Rush to Death," *Century Magazine* 47, n.s. 25 (Nov. 1893), pp. 41–45 // City Art Museum, Saint Louis, *A Memorial Collection of Paintings, in Oil and Water Color, Pastels, Cartoons, Decorative Designs, Drawings and Studies by the Late Mr. Walter Shirlaw, N. A.*, (1910).

Includes a listing of Shirlaw's works and a biographical sketch by his wife, Florence M. Shirlaw; reprinted in [Hackley Art Gallery, Muskegon, Mich.] *Aesthetics* 1 (Oct. 1912 – July 1913), pp. 64–67 // D. A. Dreier, "Walter Shirlaw," *Art in America* 7 (Autumn 1919), pp. 206–216. Most complete discussion of Shirlaw's life and work, with a chronology.

In Mischief

It was exceedingly popular at the end of the nineteenth century to paint portraits depicting beautiful, elegantly dressed young women in attractive interiors. These scenes often included exotic accessories that augmented the air of refinement. The major exponents of this genre were JAMES MC NEILL WHISTLER and WILLIAM MERRITT CHASE, who, like Shirlaw, had been primarily schooled to paint in Europe. Shirlaw, however, rarely dabbled in this idiom.

Here, he represents an attractive woman in a red gown. A mirror and an oriental-looking plate decorate the background wall. Communicating almost no emotion, the woman sits primly on a high-backed chair: she holds a fan of peacock feathers and rests her feet on a pillow. A cat reclines comfortably on a long shawl that has fallen to the floor. Coquettishly, the woman teases or admonishes the pet with her finger. Apparently the title, *In Mischief*, is derived from this playful interchange. At this stage of his career Shirlaw had abandoned the tight linear style of his engraving years. Influenced by his studies in Munich, he used a warm, rich palette and broad, fluid brushwork. As in Whistler's works, *In Mischief* is more an abstract study of form and color than a penetrating portrait.

There is a London canvas stamp on the back of the picture, and according to the donor, Katherine S. Dreier (1877–1952), one of Shirlaw's students and an early collector of his works, the picture was painted in London.

Oil on canvas, 21 × 13½ in. (55.3 × 34.3 cm.).
Signed and inscribed at lower left: W. Shirlaw. Inscribed on the back by a later hand: K. S. D. Canvas stamp: PREPARED BY / WINSOR & NEWTON / 38, RATHBONE PLACE, / LONDON.
 Label on stretcher stamped: K. S. DREIER'S COLLECTION.
 REFERENCES: D. A. Dreier, *Art in America* 7 (August 1919), p. 211, suggests this picture was painted in London; ill. p. 213 as The Red Dress owned by Miss Katherine Dreier, New York.
 EXHIBITED: Saint Louis Exposition and Music Hall Association, 1898, no. 414, p. 113, as In Mischief // Minneapolis Society of Fine Arts, 1904, no. 81 // PAFA, 1904, *Catalogue of the 100th Anniversary Exhibition*, no. 477 // Brooklyn Museum, 1929–1930, *Catalogue of an Exhibition of Paintings and Drawings by the Late Walter Shirlaw and a Group of His Pupils*, no. 18 // Lyman Allyn Museum, New London, Conn., 1958, *Painters of the Munich School*, no. 63 // MMA, 1965, *Three Centuries of American Paintings*, unnumbered cat.
 EX COLL : Katherine S. Dreier, 1919–1952.
 Bequest of Katherine S. Dreier, 1952.
 53.45.7.

WILLIAM MAGRATH

1838–1918

William Magrath was born in Cork, Ireland, in 1838. After studying at the Cork School of Design, he came to the United States in 1855 and established himself as a sign painter in New York. By 1868 he had opened a studio, where he painted sentimental genre scenes of Irish rural life, which he exhibited at the National Academy of Design and the American Society of Painters in Water Colors. He was elected an associate of the National Academy in 1874 and an academician in 1876. From 1879 to 1883, Magrath lived in England, where he exhibited at the Royal Academy, the Royal Institute of Painters in Watercolors, and the

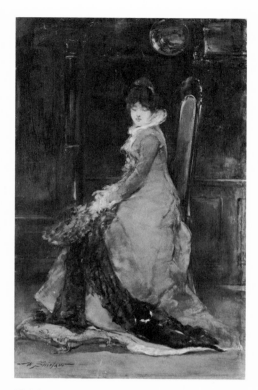

Shirlaw, *In Mischief*.

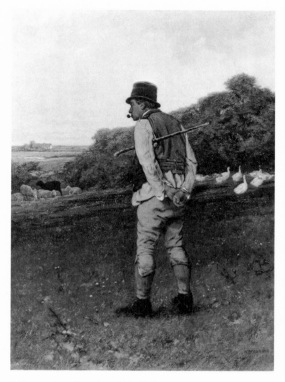

Magrath, *On the Old Sod*.

Manchester City Art Gallery, among others. He returned to the United States in 1883. In 1891–1892, according to the records of the National Academy, he was living in Washington, D. C. For a short time in 1893, Magrath was back in his native Cork; but by 1894 he was again in New York. In 1909, he moved to Staten Island, then later to New Jersey, first to Towaco and then East Orange. After 1914 Magrath made his home in England, where he had relatives. He died at Harlesden near London.

In the United States, Magrath's best-known work was *On the Old Sod* (see below). His masterpiece, however, was said to be a painting called *The Harp that Once thro' Tara's Halls* (unlocated), exhibited in Ireland in 1904. The artist and critic Samuel G. W. Benjamin (1837–1914) called Magrath "one of the strongest artists in *genre* on this side of the Atlantic" and noted that "he occasionally suggests the inimitable humanity which is the crowning excellence of the paintings of Jean François Millet" (pp. 117–118). The sentimental subjects, the palette restricted to brown tones, and the calligraphic treatment also relate him to a school of genre painting then popular in Ireland. In addition to genre subjects, Magrath also painted portraits, including one of his friend the painter WILLIAM HART.

BIBLIOGRAPHY: Clara E. Clement and Laurence Hutton, *Artists of the Nineteenth Century and Their Works* (Boston, 1879), 2, p. 86. Provides information on Magrath's early career // Samuel G. W. Benjamin, "Fifty Years of American Art, 1828–1878," *Harper's New Monthly Magazine* 59 (Oct. 1879), pp. 686–687; reprinted in his *Art in America* (New York, 1880), pp. 117–118. Discusses Magrath's style // *Appleton's Cyclopedia of American Biography* 4, p. 175. Gives details of early career // Cork Art Galleries, *Crawford Municipal School of Art* (Cork, 1953), p. 46. Discusses work and studies in Ireland and England // Certified copy of death certificate, General Register Office, London, June 4, 1981. Notes that William Magrath, age 79, died on Feb. 13, 1918, at 19 Park Road, Harlesden, County of Middlesex.

William Magrath

On the Old Sod

When the painting was exhibited at the National Academy of Design in 1879, Magrath was praised for his sentiment as well as his technique. A wood engraving of the picture was published the same year in *Harper's New Monthly Magazine*.

The title of this painting and another by Magrath, *Son of the Soil* (Cork Art Galleries), suggest a longing for one's native land and rural life common to many immigrants of the late nineteenth century. This represented a reaction to the displacement brought about by both industrialization and emigration. The sentiment may have been particularly meaningful for Magrath, who in 1879 returned to the British Isles for the first time since his departure fourteen years earlier.

The single standing figure, silhouetted against the landscape and sky, recalls the compositions of the Barbizon painter Jean François Millet.

Oil on canvas, 38⅜ × 28 in. (97.5 × 71.1 cm.).
Signed at lower right: w. MAGRATH.
RELATED WORK: Richard Alexander Müller, *On the Old Sod*, engraving 5¾ × 4¼ in. (14.1 × 10.8 cm.), in *Harper's New Monthly Magazine* 59 (Oct. 1879), p. 686.

REFERENCES: S. G. W. Benjamin, *Harper's New Monthly Magazine* 59 (Oct. 1879), ill. p. 686, reproduces engraving of it by Richard Alexander Müller // [New York] *Art Journal* 5 (1879), p. 159, describes this picture at NAD exhibition as "a harmonious study, in browns" // *Art Interchange* 2 (April 16, 1879), p. 58, calls it a "good piece of figure painting" // *Nation* 28 (May 15, 1879), p. 341, in a review of the academy exhibition, describes it as Magrath's "master-piece, thoughtful, whimsical, and tender" // S. G. W. Benjamin, *Art in America* (1880), ill. p. 127, shows engraving of the picture // W. J. Linton, *American Art Review* 1 (1881), ill. p. 52, shows engraving of it; p. 520, discusses the engraving; reprinted in W. Montgomery, ed., *American Art and American Art Collections* (1889), pp. 524, 526 // *Appleton's Cyclopaedia of American Biography* 4 (1900), p. 17, says the painting attracted much attention for its technical qualities // S. Hartmann, *A History of American Art* (1902), 1, p. 162, notes that it is one of his best paintings, mistakenly says it is at PAFA // F. Weitenkampf, *American Graphic Art*, p. 131, notes engraving of the picture // U. Thieme and F. Becker, *Allgemeines Lexikon der Bildenden Künstler* 23 (Leipzig, 1929), p. 565 // E. Clark, *History of the National Academy of Design, 1825–1953* (1954), p. 172.

EXHIBITED: NAD, 1879, no. 380, $800 // Bronx Society of Arts and Science, Lorillard Mansion, New York, 1915 (no cat.).

Ex COLL.: William Carr.

Gift of William Carr, 1887.

87.3.

WILLIAM KEITH

1839–1911

William Keith was born in Scotland and came to the United States as a child. He was apprenticed at the age of sixteen to a wood engraver in New York. Shortly thereafter, he was employed by Harper and Brothers and in 1858 was given an assignment in California. Fascinated by its beautiful scenery, he returned a year later, after a brief trip to Scotland and England, and settled in San Francisco. There he worked in Harrison Eastman's engraving shop and then in partnership with Durbin Van Vleck. By 1868, when he opened his own studio, Keith had begun to paint. In that same year, the August issue of the *Overland Monthly* said of him: "William Keith, a Scotchman by birth, a good wood engraver and one of our best water-colorists in landscapes, has lately given evidence of astonishing capacity in oil. His studies of San Mateo scenery—in twilight and in storm—show remarkable power,

fidelity and sentiment. His atmospheres are luminous. His woods have depth and richness. His coloring is full of the finest feeling. He imbues his pictures with poetry."

In 1869, with the profits from the sale of thirty of his paintings, Keith traveled to Europe. He stayed about a year in Düsseldorf, studying with Andreas Achenbach, and visited Dresden and Paris. In 1872 he established a studio in Boston. In late 1873 he explored the mountains of Utah with Carleton E. Watkins, the famous photographer, who was a close friend. Keith stayed for a while in New Orleans during the 1880s, and from 1883 to 1885 he was in Europe, studying in Munich with the American-born painter Carl Marr (1858–1936). Keith traveled widely in southern Europe. He was especially impressed by the paintings of Velázquez in Spain and the landscapes of Ruysdael, Hobbema, and the Barbizon painters. (Keith's few portraits reveal his fascination with both Velázquez and Rembrandt.) He later made sketching trips to Alaska in 1886 and the West in 1887 and two more visits to Europe, in 1893 and 1899.

Like his contemporaries ALBERT BIERSTADT, THOMAS MORAN, and THOMAS HILL, Keith explored the western wilderness with naturalists such as John Muir and John Burroughs. An early conservationist, Keith was a founding member of the Sierra Club. His careful drawings of the landscape became the source of many large studio paintings. Often his compositions give evidence of his openly acknowledged reliance on the landscape photographs of Watkins.

GEORGE INNESS visited California in 1870 and spent six weeks at Keith's San Francisco studio. Inness's influence was partly responsible for Keith's deepening mystical attitude toward nature and his preference for poetic landscapes, often dominated by live oaks and sunlit meadows. His paintings became richer and softer in color and less detailed in treatment. He had begun his painting career by depicting specific geographical locations. Under the influence of Inness and the Barbizon painters, however, he gradually became more interested in creating an atmosphere than reproducing a scene. Nevertheless, he maintained his own individual style.

Keith was a major figure in the artistic community and was elected a director of the San Francisco Art Association in 1880 and again in 1895. The *San Francisco News-Letter* of September 30, 1882, noted:

> Keith does not suffer from limitations of artistic power, which impel many painters to be interpreters of gray-dawns, but not of glowing sunsets, of moist Springs, but not of burning Autumns. He is satisfied with nothing less than a rich chord of harmony—chosen from the whole gamut of nature's notes. It is his unerring power of sounding the rich chord which has given Keith's pictures a place in all the galleries of our millionaires, side by side with the works (chosen by connoisseurs) of eminent European masters (quoted in *California Art Research* 2 [Jan. 1937], p. 52).

From the mid–1890s, Keith's work became increasingly well-known in the East, where the Macbeth Gallery had the exclusive right to sell his paintings. Unfortunately, the 1906 earthquake and fire in San Francisco destroyed his studio and over two thousand paintings and drawings. Though almost seventy, Keith did not allow the loss to interfere with his work, and he continued to paint nearly until his death in 1911. Many of his pictures were exhibited at the Panama-Pacific International Exposition in 1915.

Keith was married twice: in 1865 to Elizabeth Emerson, an artist who died in 1882, and in 1883 to Mary McHenry, the first woman graduate of the Hastings College of Law. For

many years Keith lived in Berkeley near the campus of the University of California, and his home was a gathering place for professors, writers, and artists.

BIBLIOGRAPHY: Benjamin Avery, "Art Beginnings on the Pacific," *Overland Monthly* (August 1868), p. 118. Describes Keith's style, notes he is in Oregon and recently designed and engraved illustrations for two volumes of poetry // Robert Walker Macbeth, "William Keith, Artist and Man," in *Thirty Paintings by the Late William Keith*, sale cat., Anderson Galleries, New York, April 22, 1916. Good summary of his career // Hutton Webster, *DAB* (1933, 1961), s.v. "William Keith." The best summary of the artist's career // Eugen Neuhaus, *William Keith: The Man and the Artist* (Berkeley, 1938). A biography and discussion of Keith documented with quotes from letters and contemporary reviews // Brother Cornelius, *Keith, Old Master of California*, 2 vols. (New York, 1942, and Fresno, Calif., 1956). The major work on Keith, of which the second volume is an updated supplement.

Yosemite Falls, from Glacier Point

Yosemite Valley in central California was discovered during a military expedition in 1851. Its fantastic waterfalls and cliffs soon were a favorite subject of American artists. Keith visited Yosemite for the first time in 1872 and met the naturalist John Muir, who was living in the re-

Keith, *Yosemite Falls, from Glacier Point.*

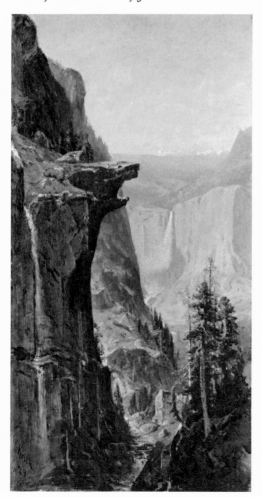

gion. Muir became a good friend and guided Keith then and on subsequent trips in 1873 and 1875. Despite the earlier paintings by ALBERT BIERSTADT and THOMAS HILL, Keith wrote in the August 1875 issue of the *Overland Monthly*:

Yosemite has yet to be painted; painters' visits of a month or so have not done it. Time is required to take it in, and digest it. The cliffs are neither red nor yellow, but an indescribable shifting gray, changing and shifting even as you look. The lightness and evanescence of the morning gray, and the burnished light of evening, can not be gotten by a lucky hit. A French painter of the first rank, like Corot..., would rejoice in this richness of gray (pp. 198–199).

At the Fourteenth Annual Exhibition of the San Francisco Art Association in 1879, Keith exhibited a painting titled *Yosemite, from Glacier Point*. It was probably this painting, which is signed and dated that year. The identification of the scene in the Metropolitan Museum's painting can be verified by comparing it with a photograph by Keith's friend Carleton E. Watkins titled *Yosemite Falls from Glacier Point* (no. 99, published by I. Taber about 1866, ill. in Weston Naef and James N. Wood, *Era of Exploration* [1975], pl. 17). Keith's painting is an example of his early, linear style, which reflects his training as an engraver.

Oil on canvas, 26 × 13 in. (66 × 33 cm.).
Signed and dated at lower left: W. Keith / 79.
REFERENCES: Brother F. Cornelius, *Keith, Old Master of California*, 2 (1957), pp. 10, 11, 153, 236, 242, note 2, mentions this picture as Yosemite Falls // Mrs. S. Scammell to R. B. Hale, letter in MMA Archives, July 15, 1951, says painting was given by Keith to her father, James D. Bruce, his first cousin; calls it "a small painting, which was said to be one of the artist's great favorites, 'The Falls of the Yosemite.'"

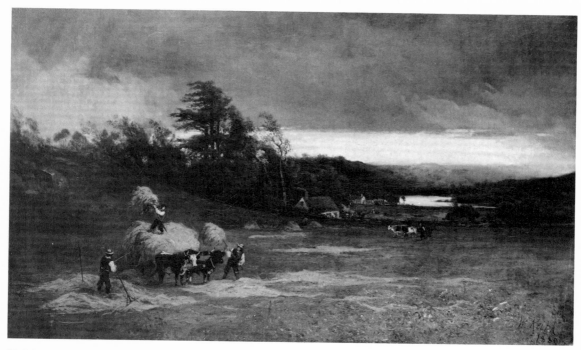

Keith, *Approaching Storm.*

EXHIBITED: San Francisco Art Association, 1879, no. 139, as Yosemite, from Glacier Point, for sale $200 // Museum of Art, Fort Wayne Art Institute, 1960, *American Landscape*, as The Falls of Yosemite.

Ex COLL.: the artist's cousin, James D. Bruce, Brooklyn; his daughter, Maysie Bruce (Mrs. Scott Scammell).

Gift of Mrs. Scott Scammell, 1952.

52.45.

Approaching Storm

This unidentified view of a thunderstorm passing over hills, lake, and mountains is one of many studies in which Keith explored the effects of changing weather. Signed and dated 1880, *Approaching Storm* shows his growing interest in the work of GEORGE INNESS and the Barbizon painters, who also were concerned with the transitory moods of nature rather than the exact record of a landscape.

The gusting wind shows in bent trees and scudding clouds, and the thickly painted dark green ground and leaden sky increase the sense of foreboding. Broadly applied color is used rather than line, marking a departure from Keith's earlier canvases. Hints of the earlier style can still be seen, however, in the delicate trees in the middle ground and the narrative detail of the figures loading hay.

Approaching Storm may have been painted while Keith was visiting New England during the summer of 1880 and given at that time to his cousin James Daniels Bruce. Bruce's daughter, Mrs. Scott Scammell, who gave the painting to the Metropolitan Museum in 1951, said that it had been presented by the artist to her father.

Oil on canvas, 30 × 50 in. (76.2 × 127 cm.).

Signed and dated at lower right: W. Keith. / .1880.

REFERENCES: Brother F. Cornelius, *Keith, Old Master of California* (1957), 2, pp. 10–11, 153, 236, 242 // Mrs. S. Scammell, letter in MMA Archives, July 15, 1951, discusses provenance.

EXHIBITED: Los Angeles County Museum of Art; M. H. de Young Memorial Museum, San Francisco, 1966, *American Paintings from the Metropolitan Museum of Art*, ill. p. 63, no. 47.

Ex COLL.: the artist's cousin, James D. Bruce, Brooklyn; his daughter, Maysie (Mrs. Scott) Scammell.

Gift of Mrs. Scott Scammell, 1951.

51.144.

William Keith

EDGAR MELVILLE WARD

1839–1915

Edgar Melville Ward was born in Urbana, Ohio, and graduated from Miami University in Oxford, Ohio. From 1865 to 1870 he attended classes at the National Academy of Design in New York. In 1872 he began to study in Paris at the Ecole des Beaux-Arts, where he worked in the studio of Alexandre Cabanel. He often spent summers in Brittany, where a fellow American painter, J. ALDEN WEIR, joined him in 1874. Ward spent about six years studying in Paris. One of his most acclaimed European works was *The Sabot Maker*, which received a medal at the Paris Salon and was bought by the French government.

Ward was elected an associate at the National Academy in 1875 and was made an academician in 1883 after his return from Europe. That same winter he began teaching painting at the academy as the assistant to Lemuel Wilmarth. When Wilmarth resigned in 1889, Ward was promoted to director, a position he held for twenty years. A great many American painters studied with him at one time or another. He was a popular genre painter who often depicted tradesmen and craftsmen. As a landscape painter he was also competent. He had a warm relationship with his older brother, the sculptor John Quincy Adams Ward.

BIBLIOGRAPHY: Clara E. Erskine and Laurence Hutton, *Artists of the Nineteenth Century and Their Works* (Boston, 1880), 2 // Obituaries: *American Art News* (June 12, 1915), p. 5; *American Art Annual* 12 (1915), p. 263 // National Collection of Fine Arts, Washington, D. C., *Academy: The Academic Tradition in American Art*, exhib. cat. by L. M. Fink and J. C. Taylor (1975), pp. op. 116–119. Lists positions and years taught at the National Academy of Design.

Ward, *The Coppersmith*.

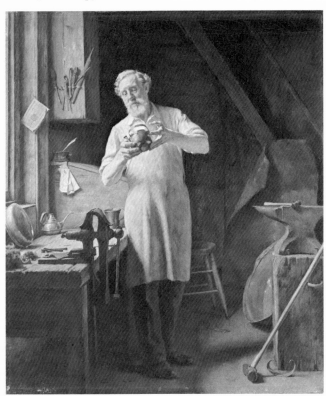

The Coppersmith

Sympathetic portraits of craftsmen at work were very popular during the latter part of the nineteenth century. This popularity grew out of a nostalgia for the past and its beautiful handicrafts, as more mass-produced goods became available.

Ward depicted a dignified coppersmith, surrounded by his tools and copper vessels. The objects are precisely rendered in a manner that reflects Ward's academic training. The strong light falling on the man's face, on his large, graceful hands, and on the various objects in the shop lends an air of nobility to the man and his trade. When *The Coppersmith* was exhibited at the National Academy of Design in 1898, a reviewer in *Brush and Pencil* noted: "Mr. Ward's 'Coppersmith' . . . is another good picture in its solid, careful painting and general completeness" (p. 83).

Oil on canvas, 23⅞ × 21 in. (60.5 × 53.3 cm.).
Signed at lower left: Edgar M. Ward.

REFERENCES: O. Lowell, *Brush and Pencil* 2 (May 1898), p. 83 (quoted above) // *American Art Annual* 10 (1913), p. 370 // *American Art News* 13 (June 13, 1915), p. 5, notes that friends of the artist presented the picture to MMA // *Literary Digest* 94 (Sept. 3, 1927), cover ill.; p. 28.

EXHIBITED: NAD, New York, 1898, ill. no. 235, *Coppersmith* // Corcoran Gallery of Art, Washington, D. C.; Grand Central Art Galleries, New York, 1925–1926, *Commemorative Exhibition by Members of the Na-tional Academy of Design, 1825–1925*, no. 153 // MMA, 1965, *Three Centuries of American Painting*, unnumbered cat. // Marlborough-Gerson Gallery, New York, 1967, *The New York Painter* (benefit exhibition for the New York University Art Collection), ill. p. 30; cat. p. 98.

EX COLL.: friends of the artist (Hon. Nicholas Muller, Hon. William N. Cohen, Joseph M. Lichten-eaur, Samuel P. Avery, anonymous contributor, William T. Evans, George Inness, Jr., Hon. Whitelaw Reid, Collin Armstrong), 1900.

Gift of Several Gentlemen, 1900.
00.6.

JOHN HENRY HILL

1839–1922

Hill was born at Nyack Turnpike (now West Nyack), New York, into a family of artists. His grandfather was the English-born engraver John Hill (1770–1850), who was well known for his engravings of Joshua Shaw's *Picturesque Views of American Scenery* (1820) and the aquatints for William Guy Wall's *Hudson River Portfolio* (1828). His father, from whom he received his training, was the engraver and landscape painter John William Hill (1812–1879). Both he and his father were members of a small group of American artists who were strongly influenced by John Ruskin and the Pre-Raphaelites and advocated following nature as closely as possible. John Henry Hill first exhibited at the National Academy of Design in 1856.

In 1867 Hill published *Sketches from Nature*, a folio volume of etchings based on drawings and sketches, exemplifying his beliefs. In the accompanying text he stated:

> The best instruction for beginners in landscape art is to be found in the 'Elements of Drawing' and 'Modern Painters,' both by John Ruskin, which contain all the information necessary for those who have sufficient industry and love of nature to persevere as artists in the right track.
>
> I have reason to hope that the illustrations in this book will not only give pleasure to those who admire nature, but may, in a number of instances, fall into the hands of those who are working in the green fields, among the tender grass and lovely flowers, and who seek to impress upon their fellow men the infinite beauty of God's handiwork in this world of ours. To all such I would say, drawing a single flower, leaf, or bit of rock thoroughly well is something better worth doing than conjuring up pictures in the studio without a bit of accurate drawing to account for their evident pretentions.

Hill traveled and sketched in New England, the Catskills, and along the Hudson in the region near Nyack. He studied J. M. W. Turner's work in 1864 and 1865, when he spent eight months in England. In 1868 he accompanied Clarence King on the United States government expedition to survey the Cordilleran ranges from eastern Colorado to California. In 1878 he again visited England and then in the spring of 1879 made a tour of the Continent.

He was a frequent exhibitor at the National Academy of Design, where he was elected an associate in 1858. He died at West Nyack.

BIBLIOGRAPHY: *Nyack Evening Star*, March 23, 1905, p. 2. Gives a brief account of his career // Edward Cary, "Some American Pre-Raphaelites: A Reminiscence," *Scrip* 2 (Oct. 1906). Discusses the ideas of the group and the association of John Henry Hill and his father // David Howard Dickason, *The Daring Young Men: The Story of the American Pre-Raphaelites* (Bloomington, Ind., 1953), pp. 259–267. Includes discussion of John William Hill and John Henry Hill.

A Study of Trap Rock (Buttermilk Falls)

This picture, painted in 1863, was given to the Metropolitan Museum by the artist, who described it as "a study from nature." In 1911 in a letter to the museum, Hill wrote that the work was "the most elaborately literal study from nature I ever made. It was done in July and oc[c]upied me nearly every afternoon in the month while our civil war was going on." There is an etching showing the central portion of the painting in reverse in Hill's book *Sketches from Nature* (1867). In the accompanying text he describes the scene as "a pleasant rocky dell, in the rear of the Palisades, at Nyack." The painting was exhibited at the National Academy of Design in 1882. Charles Herbert Moore (1840–1930), a leading spokesman for the American Pre-Raphaelites, described the work in a review in the *New York Evening Post*:

"Study of Trap Rock," by J. Henry Hill . . . contains more good painting than any other picture in the galleries. It represents a passage of rocky ravine, with light cascades leaping from ledge to ledge. The picture is quiet and true in all respects. Everything in it is perfectly and felicitously characterized, yet it is broad and true in total effect. Such sincere and affectionate rendering of simple nature is the best outcome of all our artistic activities thus far.

Hill, *A Study of Trap Rock. (Buttermilk Falls)*.

Painted with meticulous attention to detail, this work is an essay in the application of Ruskin's principles of landscape painting and of special interest as an example by a member of the American group of Pre-Raphaelite followers.

In 1904 Hill made a replica of the painting which he presented to his local library the following year. At that time the site was properly identified as Buttermilk Falls. Hill's original title loosely refers to the geological formation he depicted and not to the specific area known locally as Trap Rock. Buttermilk Falls is a well-known feature on a rivulet that descends the western slope of Clausland Mountain near Central Nyack and makes its way through a picturesque glen to the Hackensack River. It can be seen in Buttermilk Falls Park on the high, precipitous declivity east of Old Greenbush Road.

Hill, etching of *A Study of Trap Rock*.

Oil on canvas, 20 × 24 in. (50.8 × 61 cm.).

Signed and dated at lower left: J. H. Hill 1863.

RELATED WORKS: etching, plate size 5½ × 6¼ in. (14 × 15.9 cm.), in *Sketches from Nature* (1867), pl. 4 // *Buttermilk Falls*, oil on canvas, 30 × 36 in. (76.2 × 91.4 cm.), 1904, Nyack Free Library.

REFERENCES: C. H. Moore, *New York Evening Post*, April 27, 1882, p. 3, reviews the picture at the NAD (quoted above) // J. H. Hill, letters in MMA Archives, May 8, Dec. 4, 1882, discusses giving the picture (annotated by chairman of art committee that Frederic E. Church spoke well of Hill's work) // G. H. Story to J. H. Hill, March 24, 1904, gives him permission to copy the picture // *Nyack [N. Y.] Evening Star*, March 23, 1905, p. 2, says that a picture by J. Henry Hill will be unveiled on Saturday, March 25: "The picture is a copy by Mr. Hill from his original painting made about 1863 and now in the Metropolitan Museum of Art in New York. It represents the well known Buttermilk Falls of West Nyack (seen in summer) when the volume of water, reduced to a small cascade, combines with the rugged rocks and overhanging foliage in producing a most picturesque and pleasing effect" // J. H. Hill, letter in MMA Archives, May 14, 1911, discusses the picture (quoted above) // R. Koke, NYHS, letter in Dept. Archives, Oct. 6, 1984, discusses the title and provides the description of the location.

ON DEPOSIT: New York City Department of Parks, 1974–1976 // Staten Island Institute of Arts and Science, 1977–1978.

EXHIBITED: NAD, 1882, no. 664, as Study of Trap Rock, $125 // Rockland Center for the Arts, West Nyack, N. Y., April 21 – May 8, 1974, "*In touch with our past*" (no cat.).

EX COLL.: the artist, until 1882.

Gift of the artist, 1882.

82.9.7.

THOMAS HOVENDEN

1840–1895

Hovenden was born in Dunmanway, county Cork, Ireland. When he was still a child, his parents died and he was raised in an orphanage. At the age of fourteen, he was apprenticed to a carver and gilder who recognized his ability to draw and encouraged him to take evening classes at the Cork School of Design. In 1863 Hovenden came to the United States and sup-

ported himself by coloring photographs and by making, gilding, and selling picture frames. He continued art lessons at the National Academy of Design in New York. In 1868 he moved to Baltimore and painted in a studio in the home of H. BOLTON JONES. In 1874 he went to Paris where he studied for a short time with Jules Breton and with the celebrated figure and portrait painter Alexandre Cabanel at the Ecole des Beaux-Arts. He spent most of his time, however, in Brittany where he joined the artists' colony at Pont-Aven, which included his longtime friend H. Bolton Jones, WILLIAM PICKNELL, and Robert Wylie (1839–1877). He painted several Breton subjects, the most famous of which was *Breton Interior: Vendean Volunteer, 1793* (coll. Dr. and Mrs. Robert M. Carroll) exhibited at the Paris Exposition in 1878.

Hovenden was back in New York by 1880, and the following year he married Helen Corson (1846–1935), a painter he had met at Pont-Aven. They settled in the town of Plymouth Meeting near Philadelphia where Mrs. Hovenden's family had a farm. Ardent Quakers, the Corsons had been well known for their staunch abolitionist sympathies during the Civil War, when their home was used as a station on the "underground railroad." This association may well have stimulated the artist's interest in black people whom he so often and sensitively portrayed.

Hovenden became an academician at the National Academy in 1882. In 1886 he succeeded Thomas Eakins as instructor at the Pennsylvania Academy of the Fine Arts where Robert Henri (1865–1929) was one of his pupils. Hovenden was a member of the American Watercolor Society, the Society of American Artists, the Philadelphia Society of Artists, and the New York Etching Club. Of his genre pictures illustrating simple scenes of American life, *Breaking Home Ties*, 1890 (Philadelphia Museum of Art), exhibited in 1893 at the World's Columbian Exposition in Chicago, was his most famous. It depicted a young man leaving his rural home to make his fame and fortune in the city. The picture was widely praised, and an engraving of it had great popular appeal. Although Hovenden was primarily known as a genre painter, he also exhibited several highly acclaimed landscapes in the early 1890s. His career was cut short when he was killed in a railroad accident while trying to save a child. His daughter Martha Hovenden (1884–1941) became a well-known sculptor.

BIBLIOGRAPHY: E. Pfatteicher, "Thomas Hovenden: The Painter of 'Breaking Home Ties' and 'Bringing Home the Bride,'" *Book News Monthly*, 25 (Jan. 1907), pp. 301–305. First complete biography of Hovenden // Helen Corson Livezey, "The Life and Works of Thomas Hovenden, N. A.," paper read before the Plymouth Meeting Historical Society, February 22, 1955, Thomas Hovenden Papers, PAFA, microfilm P52, Arch. Am. Art, published in the *Germantown Crier* 8 (May 1956) // Scrapbook of Thomas Hovenden, 1866–1895, private coll., microfilm P13, Arch. Am. Art. Contains clippings from newspapers, periodicals, and miscellaneous letters // Rudolf Wunderlich, "Thomas Hovenden and the American Genre Painters," *Kennedy Quarterly* 3 (April 1962), pp. 2–11. Illustrates several early paintings and drawings, as well as later landscapes // Hermann Warner Williams, Jr., *Mirror to the American Past: A Survey of American Genre Painting, 1750–1900* (Greenwich, Conn., 1973), pp. 214–216. Places Hovenden in the genre tradition.

The Last Moments of John Brown

The fanatic abolitionist John Brown (1800–1859) unquestionably played a vital role in precipitating the Civil War. His final act of rebellion, the raid on Harper's Ferry, Virginia, was an attempt to establish a base of operations from which he could liberate the Southern slaves. Harper's Ferry was one of the largest federal arsenals in the country. His confused and ill-conceived plan failed and Brown was captured. He was tried in Charleston, Virginia (now West Virginia), found guilty of conspiring to incite insurrection and treason, and hanged on December 2, 1859. Three days later, the *New York Tribune* published an emotionally charged and totally fictional account of the execution, believed to have been written by a reporter named Edwin H. House. Clearly meant to fire northern abolitionist sentiments, it stated:

On leaving the jail, John Brown had on his face an expression of calmness and serenity characteristic of the patriot who is about to die with a living consciousness that he is laying down his life for the good of his fellow creatures ... As he stepped out of the door a black woman, with her little child in her arms, stood near his way. The twain were of the despised race, for whose emancipation and elevation to the dignity of children of God, he was about to lay down his life.... He stopped for a moment in his course, stooped over, and with the tenderness of one whose love is as broad as the brotherhood of man, kissed [the child] affectionately (p. 8).

This story in turn inspired the stanza in John Greenleaf Whittier's "Brown of Ossawattomie," which appeared in the *New York Independent* on December 22, 1859:

John Brown of Ossawattomie, they led him out to die:
And lo! A Poor slave mother with her child pressed nigh:
Then the broad blue eye grew tender and the old harsh face grew mild
As he stopped between the crowding ranks and kissed the Negro's child.

According to one of Brown's biographers, this scene would in fact have been impossible because all civilians were kept out of the area by the soldiers, and Brown was too tightly surrounded by the guards to allow anyone to get close to him (Jules Abels, *Man on Fire*, 1971, pp. 367–368).

Nevertheless, such propagandistic myths were clearly popular in the pre-Civil War North and provided inspiration for history painters. *John Brown on His Way to Execution*, 1860 (Oberlin College), by Louis Ransom (1831–1926/27) was reproduced and widely circulated by Currier and Ives in 1863 as *John Brown — The Martyr*, and in 1867 *John Brown's Blessing* (NYHS) was painted by Thomas S. Noble (1835–1907). Both of these works were in the traditional romantic style of nineteenth-century academic history painting.

Over twenty years after Brown's death, a New York manufacturer, Robbins Battell, commissioned Thomas Hovenden to commemorate Brown's last moments in this same traditional manner. In a letter on June 10, 1882, Battell outlined the scene as he envisioned it and later sent Hovenden the *Tribune* article. According to Gebbie's pamphlet about the development of this picture, Hovenden read numerous contemporary articles describing the execution. Nevertheless, he stuck with the interpretation based on the *Tribune*'s account that Battell prescribed. It is not clear whether Hovenden, who was still a youth in Ireland in 1859 when Brown was executed, ever realized that the scene was imaginary. He went to some efforts to render as realistically as possible details of costume and location and is said to have visited Charleston, where he interviewed Brown's jailor and local residents. He spoke to one of the former guards who told him that the Jefferson County guards wore a uniform of the United States Artillery—dark blue coats and light blue trousers, with the insignia of the state of Virginia on their belts and hats. Although the court house at Charleston had been destroyed during the war, Hovenden found similar red brick buildings for models and even seems to have learned the number of steps Brown probably descended. For the likeness of Brown, Hovenden relied on several photographs, particularly one in the collection of Horace Howard Furness, a noted Unitarian minister in Philadelphia, and found out that on the day of his execution, Brown was wearing carpet slippers made by an admirer.

In general, Hovenden depended on well-established pictorial principles. In portraying Brown, he ignored the man's gruff, crazed, and haggard appearance and presented a natural and sympathetic likeness that is both noble and gentle. It should also be pointed out that, according to Abels, Brown's beard was only about one and one-half inches long at the time of his death. He

had cut it short the spring of that year. Whether Hovenden knew this or not is unknown, but certainly the long beard gave Brown a more grandfatherly image, which enhanced his appeal.

In order to attach greater significance to the scene, Hovenden used a classically inspired triangular composition with all movement oriented toward the central subject in perhaps too studious an imitation of the grand manner of history and religious painting. What sets it apart from the romantic historical works of the 1860s, however, is its realism and sense of drama. Each of the characters has a distinctive personality that adds a narrative or symbolic significance to the picture. The guard at the left, for example, sternly eyes an advancing black man whom he elbows from Brown's path. The sheriff with the death warrant in his hand, standing behind Brown, gazes at him disdainfully. The young white girl who holds the black woman in a gesture echoing that of the baby serves to remind one of Brown's antislavery message.

Hovenden worked on this picture for almost two years, completing it in 1884. It was widely exhibited and acclaimed in national periodicals and newspapers. Battell was so pleased with the results that he paid the artist $6,000—$2,000 more than the agreed price—and allowed him to copyright it. Hovenden made a replica two-thirds the size (Fine Arts Museums of San Francisco) from which he could make reproductions. A woodcut by Frederick Juengling appeared in *Harper's Weekly*, and Hovenden himself made a large etching which was published by George Gebbie of Philadelphia in 1885 in an edition of one thousand. It was accompanied by Whittier's poem.

Oil on canvas, 77⅜ × 66¼ in. (196.5 × 168.3 cm.).
Signed, dated, and inscribed at lower left: Copyright / T. Hovenden 1884.
RELATED WORKS: Study for "John Brown," pencil and wash on paper, about 13 × 17 in. (33 × 43.2 cm.), unlocated, ill. in *Kennedy Quarterly* 3 (April 1962), p. 11 // *Last Moments of John Brown*, replica, oil on canvas, 48 × 38 in. (121.9 × 96.5 cm.), ca. 1884, Fine Arts Museums of San Francisco, ill. in *American Art*, exhib. cat. by E. P. Richardson, no. 76, p. 181 // *Last Moments of John Brown*, copper etching, 31½ × 25¾ in. (80 × 65.4 cm.), 1885, PAFA // Frederick Juengling, woodcut, 1884, *Harper's Weekly* 29 (Jan. 31, 1885), pp. 72–73.
REFERENCES: R. Battell to T. Hovenden, June 10, 1882, photocopy in Dept. Archives, says he is "satisfied with what you have done, and the ideas you have in regard to the picture. The incident of the kissing of the child must have occurred as stated and published at the time. You are familiar I suppose with Whittier's beautiful allusion to it. . . . I will look for the correspondent's account in the New York Tribune. . . . It has probably occurred to you that you might represent the child in its mother's arms, extending one or both of its little hands toward the man, with a wistful look, which he pleasingly recognizes, and is about to bend to kiss it. But I remember that in spite of this and whatever you may decide to represent in the picture it will be most satisfactory if you consult your judgment and that of your artists friends and especially that of your accomplished wife" // W. Garrison to Parsons at the *Nation*, March 2, 1883, copy in Dept. Archives, says Hovenden came to him regarding Brown's "last costume," encloses a letter for him from Rebecca B. Spring, describing Brown's clothes // *New York Herald*, May 16, 1884, p. 4, discusses the picture on view at Knoedler and Company: "The canvas he has produced is a masterly one and presents the scene in a homely, natural manner, probably just as it occurred. Except in the case of the principal figure no portraiture has been attempted. Great attention has been paid to the details of military costume, architecture, &c., the artist making two visits to the locality and conversing with participants. . . . the work is a decided success, . . . and the artist can be congratulated on his first American historical canvas" // *New York Evening Post*, May 16, 1884, p. 3, discusses the picture then on exhibition: "We are still too near John Brown to write or paint his history well. . . . Unless the rope was actually worn to the scaffold as is here represented, this is a license not needed and too great in a realistic picture such as this is. . . . The *ensemble* is well conceived and the details well studied. . . . The arm and hand by which [the little white child] holds on to the skirts of the woman are the weak point in the painting, . . . which is in general honestly and solidly painted. The picture is a real addition to our limited gallery of historical art" (T. Hovenden, letter, May 19, 1894, in *New York Evening Post*, says in response: "Perhaps it is as well to have it on record that the rope was worn to the scaffold and placed on John Brown's neck before he left the jail"; discusses his interview with Captain John Avis, Brown's jailor) // *New York Times*, May 18, 1884, p. 6, discusses the picture: "John Brown seems to have taken strong hold on the mind of the artist as this is the crowning work of several essays on the same subject. If Mr. Battell will allow the picture to be exhibited in various cities throughout the country he will not only help the artist but will be doing good service in American art. Certainly, it is the most significant and striking historical work of art ever executed in the Republic // R. Green, letter, in *Baltimore Sun*, May 21, 1884, clipping in Dept. Archives, writes that he was a member of the Richmond Howitzers and was on duty at Charlestown at the time and

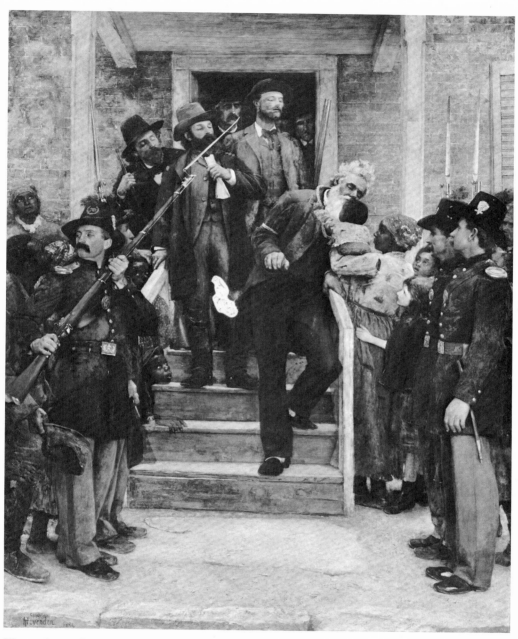

Hovenden, *The Last Moments of John Brown.*

that there was no so-called kissing scene. To this the editor replied: "It should be stated in justice to Mr. Hovenden, that the subject of the picture, it is understood, was suggested by the gentleman who gave the order for it, and the work was executed as a matter of business by the artist, in accordance with the purchaser's suggestion, the historical accuracy of which the artist probably knew nothing about" // *Magazine of Art* (July 1884), p. 9, calls it "an American picture of real importance" // G. Gebbie, *The "Last Moments of John Brown"* (1885), includes several reviews of the picture // S. P. Avery to H. S. Morris, PAFA, Oct. 27, 30, 1896, PAFA, says that he has it for sale and it was recently reframed // S. P. Avery, letter in MMA Archives, undated (ca. 1897), states that Daniel Huntington most strongly advises acceptance of the picture, one of the most important and successful productions of the artist; cites its popularity // S. Hartmann, *A History of American Art* (1902), 1, pp. 281–282 // S. Isham, *History of American Painting* (1905), p. 502, discusses it // C. Caffin, *Story of American Painting* (1907), p. 185, mentions it as representing French influence // J. C. Malin, *Kansas Historical Quarterly* 8 (Nov. 1939), pp. 340–341, ill. p. 342 // O. Larkin, *Art and Life in America* (1949), p. 237.

EXHIBITED: Earles' Galleries, Philadelphia, 1884 // Knoedler and Co., New York, 1884 // Union League Club, New York, 1884 // Chicago, Inter-State Industrial Exposition, 1884, no. 34 // Exposition Universelle, Paris, 1889, *Catalogue Illustré des Beaux Arts*, p. 81, no. 168, John Brown quittant la prison le matin de son exécution // Corcoran Gallery of Art, Washington, D. C., 1890 // MMA, 1939, *Life in America*, no. 183, ill. p. 137 // Corcoran Gallery of Art, Washington, D. C., 1950, *American Processional*, no. 208 // MMA, 1965, *Three Centuries of American Painting*, unnumbered cat. // Lytton Gallery, Los Angeles County Museum of Art; M. H. de Young Memorial Museum, 1966, *American Paintings from the Metropolitan Museum of Art*, p. 14; no. 63, ill. p. 75 // National Portrait Gallery, Washington, D. C., 1968, *This New Man*, ed. by Benjamin Townsend, p. 212.

EX COLL.: Robbins Battell, 1884, New York and Norwalk, Conn.; his daughter and son-in-law, Mr. and Mrs. Carl Stoeckel, Norwalk, Conn., until 1897.

Gift of Mr. and Mrs. Carl Stoeckel, 1897.
97.5.

Jerusalem the Golden

After a trip abroad in 1890 and 1891, Hovenden spent a winter in Washington, D. C., where he painted this unusual picture. One of his last major works, it was included in the annual exhibition at the Pennsylvania Academy of the Fine Arts in 1894–1895 and received favorable notice in the *Philadelphia Bulletin*. The pale, reclining woman seems to be an invalid. Next to her sits her young man. The woman at the organ or piano is presumably playing the hymn "Jerusalem the Golden." Written by John Mason Neale in 1851 and set to music by Alexander Ewing in 1853, it was derived from passages of *De Contemptu Mundi* (On Contempt of the World), a twelfth-century poem by Bernard of Cluny. By the latter part of the nineteenth century, the hymn had become a favorite of Protestant congregations. It was clearly meant to comfort the faithful in the face of death by promising salvation and peace in the afterlife:

> 1. Jerusalem the golden, With milk and honey blest,
> Beneath thy contemplation Sink heart and voice oppressed:
> I know not, O I know not, What joys await us there,
> What radiancy of glory, What bliss beyond compare! . . .
> 4. O sweet and blessed country, the home of God's elect!
> O sweet and blessed country That eager heart's expect!
> Jesus, in mercy bring us To that dear land of rest,
> Who art, with God the Father And Spirit, ever blest!

Relying on this musical analogy, Hovenden tried to explore human relations and express the feelings of his subjects in a realistic style. Relaxed, the frail woman looks out in almost blissful resignation, seeming to accept the vision the hymn suggests. The man, however, appears anxious, his body taut, his intense gaze suggesting inner turmoil; or as the reviewer for the *Philadelphia Bulletin* wrote, his "face betrays solicitude mingled with admiration."

Hovenden, *Jerusalem the Golden.*

Hovenden presents the American counterpart of the many late nineteenth century European pictures that have a brooding atmosphere of claustrophobia and the sick room. Indeed, themes of this type were so prevalent that the Norwegian artist Edvard Munch—himself a painter of many death and sickroom compositions—coined the expressions "pillow era" or "sick bed era."

Oil on canvas, 30 × 40 in. (76.2 × 101.6 cm.).
REFERENCES: *Philadelphia Evening Bulletin*, Dec. 15, 1894, p. 6, says the painting "will have careful examination, and will command approval, not only because of the reputation which the artist won . . . but also by reason of its own distinct merits the play of firelight on the two prominent figures, and especially on the face and figure of the woman, brings out the expression of contentment and peaceful happiness on the faces in a fashion which is the keynote of the whole conception the effect of the hymn . . . lends such a peaceful atmosphere to the room and imparts tranquillity to its occupants // *Washington Post*, April 24, 1894, discusses it as the New Jerusalem, clipping in Hovenden Scrapbook, private coll., microfilm P13, Arch. Am. Art // F. Mather, *The Pageant of America* (1927), p. 56, ill. no. 83 // E. Pfatteicher, *Book News Monthly* 25 (Jan. 1907), p. 304, says the picture was painted in a studio in the Corcoran Building in Washington, D. C., where Hovenden spent the winter following a trip to Europe.
EXHIBITED: PAFA, 1894–1895, no. 168, as Jerusalem the Golden; ill. [p. 7] // Fine Arts Galleries, New York, April 1895.
EX COLL.: the artist's wife, Helen Corson Hovenden, 1895.
Gift of Helen C. Hovenden, in memory of her husband, Thomas Hovenden, 1895.
95.5.

ALFRED WORDSWORTH THOMPSON

1840–1896

Wordsworth Thompson, as he was known, was born and educated in Baltimore. He studied law in his father's office for two years at the urging of his family but then took up art. He opened a studio in Baltimore about 1861 and worked as an illustrator, preparing many sketches for engravings in *Harper's Weekly* and the *Illustrated London News* during the early stages of the Civil War. He soon determined to further his training, however, and left for Paris in 1861. There he worked successively with Charles Gleyre, Emile Lambinet, Alberto Pasini, and Adolphe Yvon. He also studied the anatomy of the horse under the sculptor Antoine Barye. Of all these teachers, Thompson's favorite was Pasini, with whom he studied in 1864. He was impressed by his delicate drawing and coloring. In 1864 Thompson enrolled in the Ecole des Beaux-Arts and entered a picture in the Paris Salon a year later.

During his years abroad, from 1861 to 1868, Thompson traveled widely, walking through the Eifelwald, along the banks of the Rhine and the Danube, through the rugged regions of Bohemia and the Tyrol. He spent six months enroute from Heidelberg to Italy, where he visited Sicily and climbed Mount Etna. During his wanderings he made numerous sketches, some of which he later worked up into finished compositions. On his return to the United States, he settled in New York. In 1873 he was elected an associate of the National Academy of Design, and two years later he became an academician. In 1878 he joined the Society of American Artists. A diary kept by Thompson's wife, now in the New-York Historical Society, records a trip they made to Europe and North Africa in 1882 and 1883. In the same collection are five of the artist's sketchbooks.

Although Thompson painted a number of pictures based on his travels abroad, he was best known for his patriotic scenes from early American history, among them *The Parting Guests, 1775*, painted in 1889 (NYHS). These were often elaborate scenes with landscape, architecture, and figures. Thompson was especially praised for his ability to render horses. His paintings have a finished, rather dry appearance and are characterized by a broad handling of paint.

He died at his home Stonewood in Summit, New Jersey, at the age of fifty-six.

BIBLIOGRAPHY: S. G. W. Benjamin, *Our American Artists* (Boston, 1879), unpaged // Clara Erskine Clement and Laurence Hutton, *Artists of the Nineteenth Century and Their Works* (Boston, 1889), 2, pp. 291–292 // G. W. Sheldon, *Recent Ideals of American Art* (1888), pp. 54–56. Discusses his use of colonial subjects // William Howe Downes, *DAB* (1935; 1963), s. v. Thompson, Alfred Wordsworth.

Old Bruton Church, Williamsburg, Virginia, in the Time of Lord Dunmore

Inspired by the one-hundredth anniversary of American independence, Thompson painted a number of subjects depicting the period of the American Revolution. Over the years, his interest in colonial and revolutionary scenes contin-

Thompson, *Old Bruton Church, Williamsburg, Virginia, in the Time of Lord Dunmore.*

ued. This picture was intended to show Bruton Church in Williamsburg during the years 1771–1775, when John Murray, earl of Dunmore, was governor of Virginia. The work was painted in 1893 and exhibited at the National Academy of Design that year.

Bruton Parish was founded in 1674 by merging two older parishes, one established as early as 1633. It was named for a parish in Somerset, England. The original church was a small, buttressed Jacobean building, erected in the years from 1677 to 1683, but the removal of the capital of Virginia from Jamestown to Williamsburg in 1700 resulted in the need for a more commodious building. The present church was built in the years 1711–1715 to satisfy that need. In 1752 the chancel was enlarged by twenty-five feet to accommodate an organ, and the brick wall seen in the picture was constructed in 1754.

Thompson's view of Bruton Church shows it very much as it appears today; for the exterior of the building changed very little during the nineteenth century. About 1837 or 1838, however, the interior of the church was extensively altered: the high pews were cut down, the old pulpit discarded, and the west end was partitioned off as a Sunday school. The interior was partially restored in 1905, but in 1938 a more ambitious program of restoration brought the building back to its eighteenth-century appearance.

Both Thompson and his wife were concerned with the restoration of the church. After her husband's death, Mrs. Thompson sent reproductions of the painting to Williamsburg to be sold for the benefit of the restoration.

Thompson's pictures of colonial subjects resemble the works of EDWARD LAMSON HENRY, who was a fellow pupil in the studio of Charles Gleyre. Like Henry, Thompson undoubtedly based certain details on photographs. The picture is painted in the rather dry, academic manner that characterizes the work of Thompson's French mentors.

The picture was selected for the museum by Samuel P. Avery.

Oil on canvas, 18 × 27⅛ in. (45.7 × 68.9 cm.).

Signed at lower right: *Wordsworth Thompson*. Inscribed at lower right below Dunmore coat of arms: DUNMORE.

REFERENCES: M. Thompson (artist's wife), letters in MMA Archives, July 25, 1900, requests permission for church to sell engravings to raise money; Sept. 4, 1907, and May 23, 1913 // *American Art New* 6 (Nov. 30, 1907), ill. p. 3, says picture was painted on the site in 1893 // W. H. Downes, *DAB* (1935; 1963), s.v. Thompson, Alfred Wordsworth, mentions it.

ON DEPOSIT: Colonial Williamsburg, Williamsburg, Va., 1943–1946.

EXHIBITED: NAD, 1896, no. 326, Old Bruton Church, Williamsburg, Virginia, in Time of Lord Dunmore, the Last Royal Governor of Virginia, for sale.

EX COLL.: Mrs. A. Wordsworth Thompson, 1896–1899.

Gift of Mrs. A. Wordsworth Thompson, 1899.
99.28.

HARVEY O. YOUNG

1840–1901

Like several other nineteenth-century painters of the American West, Harvey Otis Young was first attracted to the region by the lure of gold. He became one of the leading figures in the Denver art community, yet throughout his life, his financial and sometimes artistic success was determined largely by his mining speculations.

Young was born in Lyndon, Vermont, in 1840. Within a year of his birth, his father, Otis Jarvis Young, died, and his mother, Wealthy Anne Young, went to work in Somerville, Massachusetts, leaving her two young sons in the care of relatives. Young spent his childhood in Saint Johnsbury, Vermont, but he may have studied painting in Boston and Worcester, Massachusetts. He stopped in Boston briefly before moving to New York, where he is listed in the city directory for 1859–1860. In 1859 Young took a steamer to California in search of gold and for the next six years panned for gold in the Salmon River country. In 1866, however, he moved to San Francisco and worked as a wagon painter, establishing his own studio as a fine artist the following year. His early efforts reveal his artistic immaturity and dependence on picturesque compositional formulas from instruction books. Hudson River school precedents, especially the work of ASHER B. DURAND and JAMES M. HART were influential. Young was actively involved in the developing artistic community of San Francisco and would have known other painters and photographers active there at that time—WILLIAM KEITH, THOMAS HILL, Carleton Watkins, and William H. Jackson.

In the fall of 1869, Young returned to New York. The following year, he married Josephine Bowyer. Accompanied by her, he made the first of six trips to Europe. Although he may have spent at least part of this trip studying, no records of his travels are known. For ten years beginning in 1871, Young maintained a studio in New York and participated in the city's art associations. Under the influence of changing tastes and his exposure to the avant-garde styles in New York and Europe, his interest gradually turned away from his early topographical paintings, with their hard modeling and lack of atmosphere, to the increasingly popular, broader mode of the Barbizon painters. The first suggestion of his new interest came after his return from Europe in 1872 and matured during his 1875 trip when he undertook

informal studies in Munich. It is also likely that he saw the retrospective exhibition of Corot's work in Paris at this time.

Young opened a studio in San Francisco in 1876 and painted portraits, landscapes, and marines. From 1877 to 1878 he was again in Paris, where he attended the Académie Julian, drew from nude models, and joined other Americans on sketching trips to Barbizon and Grez. It was probably during this period too that he studied with the portraitist Emile Auguste Carolus-Duran. Young exhibited two paintings at the Paris Salon of 1878.

He came back in 1879 and lived briefly in New York. His work was shown at the National Academy of Design, the Brooklyn Art Association, and the Pennsylvania Academy of the Fine Arts. Soon he moved to Colorado, where he established temporary residence at the Cliff House in Manitou Springs. His return west in 1879 was probably precipitated by his mining interests, which overshadowed his artistic activity in the early 1880s.

Young was in Paris with his family in both 1886 and 1887. Under the influence of the Barbizon school, he began to paint again. He returned to the United States in 1888 because of persistent legal and financial problems and his wife's ill health. After settling his family in Washington, D. C., Young traveled extensively in the West and during the summers in New England. He became increasingly active in Denver art associations and in 1889 was elected the first president of the Denver Paint and Clay Club. That year he shifted to painting in watercolors, with which he was able to approach the "depth and brilliance of oils" by constantly experimenting with the combination of opaque washes, body color, and varnishes. In his mature works of 1897 to 1901, he achieved subtle tonal and atmospheric effects suggesting a delicate hazy distance and a more prominent foreground.

Young's last years were burdened with financial problems. In March 1899, the sheriff of Denver seized his entire stock of paintings and sketches because of an outstanding debt. Young and his family moved to Colorado Springs, where former business associates helped him to reestablish himself. The presentation of his painting *La Sal Mountains* to Colorado College by prominent businessmen in 1900 was a major factor in his renewed success. Other exhibitions of his paintings at O'Brien's Gallery in Chicago and at the Antlers Hotel in Colorado Springs followed in 1901.

BIBLIOGRAPHY: Benjamin Avery, "Art Beginnings on the Pacific," *Overland Monthly* 1 (August 1868), p. 119. Mentions Young's early beginnings in art // Clara E. Clement and Laurence Hutton, *Artists of the Nineteenth Century* (Boston, 1879), p. 368. A brief note on his early career // *American Art Annual* 4 (1903–1904), p. 147. Obituary mentions that he studied in Munich and in Paris with Carolus-Duran // Groce and Wallace, p. 710 // Patricia Trenton, *Harvey Otis Young, the Lost Genius, 1840–1901* (Denver, 1975). The most complete treatment of his work, it includes full bibliography and exhibition record.

Sunset

Sunset reveals Harvey O. Young's interest in the popular Barbizon painters. The low horizon and broad, flat landscape, intersected by a quiet stream; the feathery trees in the middle distance, silhouetted against an orange sunset; the low farm buildings; and the cattle returning from the fields particularly recall paintings by Charles François Daubigny. Over a dark undercoat, Young has applied his paint with a broad, soft, wet brush. He defined the water with a flat, dry brush to suggest the flickering reflections of light.

Young, *Sunset.*

The picture is not dated. The busy composition, however, reveals the immaturity of Young's style. The picture lacks the simplified forms of his later paintings and of his French predecessors. There is a New York canvas stamp on the back that indicates that Young probably painted the picture during the 1870s, when he maintained a New York studio. Moreover, the strong influence of Barbizon painting is a characteristic of his style during these years. A comparison of the painting with *Summer in Sacramento, California,* 1876 (Oakland Museum), further supports the dating.

Oil on canvas: 20 × 30 in. (50.8 × 76.2 cm.).
Signed at lower left: H. Young.
Canvas stamp: JOHN SNEDECOR / Picture Frames / AND / Artist Materials / NEW YORK.

Ex COLL.: Emily Buch, New York and Ridgefield, Conn., by 1933.
Bequest of Emily Buch, 1963.
63.198.7.

ROBERT SWAIN GIFFORD

1840–1905

Swain Gifford, as he was known, was the son of a fisherman and boatman. He was born on the small island of Nonamesset, one of the Elizabeth Islands, which lie between Massachusetts's Buzzard's Bay and Vineyard Sound. He spent his childhood in New Bedford and nearby Fairhaven, Massachusetts, working on the docks and sketching the ships in the harbor in his spare time. In his mid-teens he met the Dutch-American marine painter Albert Van Beest, known for his large-scale coastal scenes and whaling views. Van Beest recognized young Gifford's potential and introduced him to the rudiments of art. Gifford collaborated with Van Beest and the marine painter WILLIAM BRADFORD on pictures depicting New Bedford whaling ships for the lithographic firm of Charles Taber and Company.

Encouraged by his early success, Gifford opened a studio in Boston in 1864. Two years later, he moved to New York where he shared a studio for a while with SAMUEL COLMAN. Gifford quickly established himself as a leading landscape painter, becoming an associate of the National Academy of Design in 1867 and an academician in 1878. From sketches made on a trip to California and Oregon in 1869, he contributed scenes to the two-volume *Picturesque America*, edited by William Cullen Bryant. Stimulated by what he heard of Colman's trip to the Near East in the 1860s and intent on sketching picturesque views, Gifford accompanied LOUIS COMFORT TIFFANY as his guest on a trip through Europe and North Africa from 1870 to 1871. Although the tour was cut short by Tiffany's poor health, Gifford returned with many sketches of North Africa, and for these subjects he became well known. He returned to Europe on several occasions, a year after his marriage to Frances Eliot in

1873 and then in 1882, when he visited northern Germany, the Netherlands, and Scandinavia. In 1885 he went to Quebec and in 1899 he traveled to Alaska on the E. H. Harriman expedition.

In 1877 Gifford began a long association with Cooper Union. He began as an instructor of oil painting, became director of its Woman's Art School, and in 1896 was appointed director of all the art schools. Known for his wood engravings and fine etchings, he was a founding member in 1878 of the New York Etching Club. He was a leading member of the Society of American Artists and the American Society of Painters in Water Colors. He also belonged to the Century Association and the Tile Club. Although Gifford maintained a studio in New York for many years, he often worked at his summer home at Nonquitt, a small seaside resort in Massachusetts. The landscapes he painted in this region established the high reputation he held in his later years. They are distinguished from his earlier, literally detailed works by a broad handling of paint that shows the influence of the Barbizon painters.

BIBLIOGRAPHY: George W. Sheldon, *American Painters: with Eighty-three Examples of Their Work Engraved on Wood* (New York, 1879), pp. 93–96; reprinted in Walter Montgomery, ed. *American Art and American Art Collections* (Boston, 1889), pp. 251–256 // Cooper Gaw, "Robert Swain Gifford, Landscape-Painter," *Brush and Pencil* 15 (April 1905), pp. 201–211 // American Art Galleries, New York, *Oil Paintings and Water Colors of the Late R. Swain Gifford, N. A.* (1906). Includes an introduction by Frank D. Millet // William Howe Downes, *DAB* (1931; 1959), s. v. "Gifford, Robert Swain" // Robert Swain Ross, Jr., "The Life and Art of Robert Swain Gifford," paper written for the Department of Art, Princeton University, May 3, 1966. Based on original letters and family papers // Whaling Museum, Old Dartmouth Historical Society, New Bedford, Mass., and Hudson River Museum, Yonkers, N. Y., *R. Swain Gifford, 1840–1905* (1974), introduction by Elton W. Hall. A comprehensive catalogue of Gifford's work with many fine illustrations.

Near the Coast

This painting was voted one of the best three pictures in the Prize Fund Exhibition held in New York in 1885 by the American Art Association. Gifford was awarded a $2,500 cash prize and the painting was given to the Metropolitan Museum. It was later included among several Gifford paintings exhibited at the Exposition Universelle in Paris.

The picture is typical of Gifford's mature style, reflecting the strong influence of the Barbizon school on his work—a result of his European trip in the 1870s and of the earlier influence of WILLIAM MORRIS HUNT in Boston. Like works by such French artists as Henri Joseph Harpignies and Charles François Daubigny, it is restrained in scale, general in description, broad in treatment, and romantic in feeling.

The bleak coastal scene was apparently inspired by the area near New Bedford where Gifford had his summer studio. To evoke the somber mood, he has carefully selected simple but poignant imagery, which he depicts under dreary weather conditions. Gray clouds overhead culminate in a threatening black line at the horizon and suggest an approaching storm. The barren landscape with its russet, wiry grass is broken only by a few stunted shrubs and spindly trees that bend in the autumn winds. As George Sheldon once observed, an ordinary landscape seen through Gifford's eyes, "becomes full of mystery and of meaning; 'the meanest flower that blows' can, when he has placed it on the canvas, 'give thoughts that often lie too deep for tears.' Mr. Gifford will paint a barren moor under a leaden sky so that it shall almost palpitate with emotion" (*American Painters* [1879], p. 95).

Oil on canvas, 31¼ × 51 in. (79.4 × 129.5 cm.). Signed at lower right: R. Swain Gifford.
RELATED WORKS: *Near the Coast*, watercolor and gouache, 6⅞ × 10⅞ in. (sight) (17.5 × 27.6 cm.), Century Association, New York // *Near the Coast*,

Gifford, *Near the Coast.*

etching, $6\frac{7}{8} \times 10\frac{5}{8}$ (17.5 × 27 cm.), in S. R. Koehler, *American Art* (1886), pl. 24.

REFERENCES: S. Koehler, *American Art* (1886), pp. 24, 25 // W. D. Garrett, *MMA Journ.* 3 (1970), p. 331, fig. 24, discusses it; p. 332.

EXHIBITED: American Art Association, New York, First Prize Fund Exhibition, 1885, no. 120, Near the Coast // Exposition Universelle, Paris, 1889, *Catalogue Illustré des Beaux-Arts*, p. 78, no. 125, Près de la côte // MMA, 1965, *Three Centuries of American Painting*, unnumbered cat. // Queens County Art and Cultural Center; MMA; Memorial Art Gallery of the University of Rochester; Sterling and Francine Clark Art Institute, Williamstown, Mass., 1972–1973, *19th Century American Landscape*, exhib. cat. by M. Davis and J. K. Howat, no. 20 // Whaling Museum, New Bedford, Mass., and Hudson River Museum, Yonkers, N. Y., 1974, *R. Swain Gifford, 1840–1905*, exhib. cat. by E. W. Hall, p. xvi; ill. no. 23, p. 24 // National Collection of Fine Arts, Washington, D. C., 1975, *American Art in the Barbizon Mood*, exhib. cat. by P. Bermingham, pp. 141–143, no. 40, discusses it; ill. p. 143.

EX COLL.: subscribers to the Prize Fund Exhibition. Gift of an Association of Gentlemen, 1885.
85.7.

WILLIAM GEDNEY BUNCE

1840–1916

Primarily a colorist, Gedney Bunce was famous for his numerous repetitions of a single theme—Venetian fishing boats at sunset. Like many of his contemporaries, Bunce was more concerned with creating a poetic impression than an accurate visual description. He worked

in a broad manner: in his later paintings he used a palette knife and his fingers to make a thick impasto. He favored transparent, often tinted glazes over a warm red mahogany panel.

Bunce was born in Hartford, Connecticut, September 19, 1840, the son of James M. Bunce, the owner of a wool and cotton concern, and his second wife, Elizabeth Chester Bunce. He took his first drawing lessons in Hartford in 1856 with the popular Dresden-born teacher Julius Busch (1821–1858). Little is known about Bunce's early career before 1861 when he began service as a sergeant in the Union Army. After a medical discharge in 1863, he moved to New York. During the next four years he was a student at Cooper Union. He studied landscape painting with WILLIAM HART and sketched with him in Maine during the summer of 1864.

Bunce spent much of his career in Europe. In 1867 he began a twelve-year residence abroad, settling first in Paris. Later he studied for a year with Andreas Achenbach in Düsseldorf and then walked through Switzerland with Charles E. Du Bois (1847–1885), spending some time in Davos. For six years Bunce lived in Rome and made numerous excursions through Italy. Around 1870 he was apparently seriously ill, for when the American sculptor Augustus Saint-Gaudens arrived in Rome, he was told that he could soon expect to occupy the studio of a dying American—Bunce. Bunce survived, however, and became a close friend of Saint-Gaudens, sharing a corner of the sculptor's studio in Paris during the winter of 1877. It was then that Saint-Gaudens modeled a portrait relief of Bunce (Wadsworth Atheneum, Hartford), which was exhibited at the Paris Salon of 1879. Bunce loved Paris and explained:

> I stay in Paris because I think I can learn more here than anywhere else in the world . . . I think the Paris *salon* the best and hardest place to work for in the world. I want to live in my native land and I hope I yet may; but older countries, like older men, can teach me the most as yet (French, pp. 148–149).

Bunce studied in Antwerp with the marine painter Paul Jena Clays, whose paintings had an important influence on him. It was Felix Ziem, however, who first inspired him to paint Venetian harbor scenes, and it was Ziem to whom he was often compared by his contemporaries.

In 1879 Bunce returned to New York, where he maintained a studio for many years. During this time he was an active member of the Tile Club, joining his old friends Saint-Gaudens and Stanford White, as well as WILLIAM MERRITT CHASE, ELIHU VEDDER, and FRANK D. MILLET. Bunce's nickname among this group was "The Bishop." Like most of these men, he exhibited both at the National Academy of Design and at the Society of American Artists.

Bunce often traveled to Europe during his later years. He had first exhibited at the Paris Salon in 1876, and he showed works there again in 1878 and 1879. He won a bronze medal at the Paris Exposition of 1900 and was elected an academician at the National Academy of Design in 1907. He was a member of the National Institute of Arts and Letters and the Lotos Club. Toward the end of his life, he spent half of each year in Hartford, Connecticut, where he lived with his sister, and the other half in Italy, either in Venice or at Lake Como. Gedney Bunce died in 1916 in Hartford, after being struck by an automobile.

BIBLIOGRAPHY: H. W. French, *Art and Artists in Connecticut* (New York, 1879), pp. 148–149. Bunce was in Paris at the time and provided information on his early career // "The Younger Painters of America, III," *Scribner's Monthly* 22 (July 1881), pp. 321–323. Discusses characteristics of his style // Samuel Isham, *The History of American Paintings* (New York, 1905), pp. 448–449. Discusses him as a colorist in context of contemporaries // James Trimbell Marshall, Jr., *DAB* (1929; 1958), s. v. "Bunce, William Gedney." Best summary of his career // "William Gedney Bunce," *American Art News* 15 (Nov. 11, 1916), p. 4. Obituary with good summary of his life.

Early Morning—Venice

Gedney Bunce, like many of his contemporaries, was fascinated by Venice. He painted there often. By the late 1870s, the rich, moisture laden atmosphere that diffuses color and light became his favorite theme. Unlike Felix Ziem and others whose paintings first interested him in Venice, Bunce did not include the city's distinctive skyline in *Early Morning—Venice*. Instead, the location is only suggested by the title and the Venetian fishing boats. The title further implies Bunce's interest in depicting a specific time of day. In this poetic evocation he reflects the romantic attitudes of the Barbizon painters.

Bunce was primarily interested in the decorative, poetic effect of a painting. He used pictorial facts to elaborate his subtle color schemes. In *Early Morning—Venice*, the geometric shapes of the sailboats and their reflections create space and structure. The textural contrast of the scumble that highlights the reflection of the sun on the sails and the thin glaze over the mahogany panel that suggests the transparency of sky and water is particularly noteworthy. As in many of his paintings, the dominant tone is vibrant yellow, a color also used by Ziem, but one which received at least the early criticism of Bunce's friends. An anecdote recorded by Mrs. Oliver Emerson tells how in Paris during the winter of 1877, Augustus Saint-Gaudens, his brother Louis, and Stanford White returned home one day covered with yellow paint. They explained their condition:

Bunce had a yellow day . . . He started to smear that color over one of his Venetian sketches, so we got rid of him while we smeared it off—over everything."
[H. Saint-Gaudens, ed., *The Reminiscences of Augustus Saint-Gaudens* ([1913], 1, p. 260).

Early Morning—Venice is not dated. It is likely, however, that Bunce painted it late in his career. It was acquired by his dealer James Inglis, owner of Cottier and Company. Inglis died in 1907, and two years later the painting was sold at auction to George A. Hearn. In the sale catalogue the location of the scene is given as in front of the Public Gardens in Venice.

Bunce, *Early Morning—Venice*.

Oil on wood, 12½ × 16¼ in. (31.7 × 41.3 cm.).
REFERENCES: American Art Association, New York, *De Luxe Illustrated Catalogue of Paintings and Water Colors . . . of the Late James S. Inglis of Cottier and Company New York*, sale cat. (1909), ill. no. 56, as Early Morning—Venice, says purchased from the artist (annotated copy, MMA Library, says sold to Hearn for $280) // *MMA Bull.* 4 (July 1909), p. 113, lists the painting as part of George A. Hearn gift; ill. p. 116 // *American Art Annual* 14 (1917), p. 320 // *DAB* (1929; 1958), says it is one of his more important works.

EX COLL.: James S. Inglis of Cottier and Company, New York, d. 1907; his estate, 1907–1909 (sale, American Art Association, New York, March 12, 1909, no. 56); George A. Hearn, New York, 1909.

Gift of George A. Hearn, 1909.
09.72.1.

GEORGE H. SMILLIE

1840–1921

George Henry Smillie was born in New York, the second son of James Smillie (1807–1885), an eminent engraver of Scottish descent whose production included engraved versions of major works by THOMAS COLE, ASHER B. DURAND, and ALBERT BIERSTADT. George received his first instruction in drawing from his father and in 1861 studied briefly with JAMES M. HART. The following year he opened a studio in New York and began exhibiting landscapes at the National Academy of Design, where he was elected an associate in 1864.

Exposure to his father's work undoubtedly influenced Smillie's first canvases, which were traditional Hudson River school landscapes based on sketches made during summer excursions to the White Mountains and Adirondacks. By the 1870s he began to seek subject matter elsewhere. A trip to Yosemite and the Rockies in 1871 inspired a series of western landscapes, including *Cathedral Rocks, Yosemite* (unlocated), exhibited in 1873 at the National Academy of Design. In 1874 he went south to Florida. In the early 1880s his subjects were drawn from visits to the New England coast, which remained a favorite place to paint.

During the 1870s Smillie worked in watercolor and became one of the first members of the American Watercolor Society. In 1881 he married the watercolorist Nellie Sheldon Jacobs (1854–1926), who had been a student of his older brother, the engraver, etcher, and painter James D. Smillie (1883–1909). Shortly thereafter, he was elected an academician at the National Academy of Design.

In 1885 Smillie and his wife made an extended trip through Europe. He subsequently produced views of rural France and is sometimes considered a follower of the Barbizon painters. His favorite subject matter, however rural, remained American, and in several respects he must be seen as a conservative member of the second generation of Hudson River school painters. He later wrote that he had "purposely deferred his trip until he felt himself thoroughly established as an American painter of American subjects, developed in America" (G. H. Smillie, pp. 1–2).

In the 1880s Smillie's summers were spent on Long Island, in East Hampton, already an artistic center. There he sketched the coastal landscape, which became a favorite theme in his later years. In 1889 WILLIAM A. COFFIN summed up his attributes:

> His pictures combine artistic skill and poetic feeling in a high degree, and are marked by an agreeable cheerfulness of color and brightness of effect. His landscapes and coast subjects are completely national in character, and are among the most satisfactory representations we have of the many pleasing phases of our gentler rural scenery (*Catalogue of the Private Art Collection of Thomas B. Clarke* [New York, 1889], p. 102).

Smillie remained active in New York art circles, exhibiting regularly at the National Academy of Design, where he was recording secretary from 1892 until 1902. He was also a member of the Century Association and the Lotos Club. He received medals at the Louisiana Purchase Exposition of 1904 in Saint Louis and from the Society of American Artists in 1907. He died in Bronxville, New York, at the age of eighty-one.

BIBLIOGRAPHY: George Henry Smillie, autobiographical statement, Nov. 17, 1907, in Dept. Archives. Gives details of his career // William Howe Downes, *DAB* (1936; 1952), s. v. Smillie, George Henry, pp. 231–232. Discusses his life and important works // National Collection of Fine Art, Washington, D. C., *American Art in the Barbizon Mood* (Washington, D. C., 1975), exhib. cat. by Peter Bermingham, p. 166, includes stylistic discussion.

East Hampton Meadows

In the late 1870s and 1880s the eastern tip of Long Island became a popular sketching ground for American artists. In April of 1883, the same year Smillie painted this canvas, an article on American Barbizon paintings noted:

East Hampton, which we have ventured to call the American Barbison [*sic*], is a village of Puritan origin, situated at the southeastern extremity of Long Island, in a little oasis of meadows and wheatfields, that owes some portion of its attractiveness to its surroundings of sand and scrub (*Lippincott's Magazine* 5 [April 1883], p. 321).

Smillie began to spend his summers in East Hampton in the early 1880s. By 1885 he was considered a primary member of the local art colony, which included H. BOLTON JONES, Bruce Crane (1857–1937), and THOMAS MORAN. A contemporary magazine article on "The Summer Haunts of American Artists" discussed the painter's fascination with the variety of landscape the area offered, and reported:

Mr. Smillie finds here a likeness both to England and Holland. The gardens and orchards, the lanes, barns and shrubbery, are all English; while the meadows stretching to low horizons, the windmills "with their delicate white vanes outlined against the sky," are Dutch (L. Champney, *Century Magazine* 30 [Oct. 1885], p. 850).

East Hampton Meadows was the first Long Island landscape exhibited by the artist at the National Academy of Design. Its muted palette of browns, greens, and yellows, loose brushwork, and horizontal construction are typical of Smillie's late coastal subjects. Painted before his first trip abroad, the canvas displays a direct approach to nature comparable to that of earlier French *plein-air* painting but which may have been due largely to Smillie's extensive work in watercolor.

Oil on canvas, 15 × 23¾ in. (38.1 × 60.3 cm.).

Signed and dated at lower left: Geo. H. Smillie–1883.

REFERENCE: Fifth Avenue Art Galleries, New York, *Catalogue of Paintings by George H. Smillie, N. A., and J. Wells Champney, A. N. A.*, sale cat. (1892), no. 5, At East Hampton, L. I., 15 × 23½ (possibly this picture).

EXHIBITED: NAD, 1883, no. 329, as East Hampton Meadows, for sale, $200 (possibly this picture) // Lotos Club, New York, 1907, *Exhibition of Paintings by Artist Members of the Lotos Club*, no. 41, as East Hampton, L. I. // Guild Hall, East Hampton, New York, 1969, *East Hampton, the American Barbizon, 1850–1900*, ill. no. 95, as East Hampton Meadows // Lowe Art Museum, Miami, 1974–1975, *19th Century American Topographic Painting* (no cat. available) // Heckscher Museum, Huntington, N. Y., 1976, *Artists of Suffolk County*, no. 62 // Guild Hall, East Hampton, N. Y., 1976, *East Hampton Artists: 1850–1976* (no cat. available).

ON DEPOSIT: YMCA, New York, 1947.

EX COLL.: Dr. Everett Herrick, New York, d. 1919 (according to a label on the back); James Ford, New York, until 1920.

Gift of James B. Ford, 1920.

20.87.

Smillie, *East Hampton Meadows.*

VINCENT G. STIEPEVICH

1841—at least 1910

Relatively little is known about Vincenzo (later Vincent) G. Stiepevich, who immigrated to the United States in 1872. He was born in Italy, probably in Florence, and, although his birthdate is variously reported as 1855 and 1861, the United States census for 1900 records it as 1841, which seems more accurate when one looks at the details of his career. He studied at the Royal Academy in Venice under the Austrian historical painter Karl von Blaas, and, in the early years of his career, painted mainly in watercolor, receiving a prize for his work in this medium from the academy in 1865. After studying decorative painting, Stiepevich went to Milan around 1868 and did frescos for private and public buildings. He married in 1867 or 1868, and his first child was born in 1871.

The following year he came to the United States, reportedly to do decorations in Saint Louis, where his second child was born in 1877. In 1878, when he settled in the New York area, he exhibited at the National Academy of Design and the Brooklyn Art Association. Until at least 1894, he maintained a studio at 1193 Broadway in New York, which was also the business address of V. G. Stiepevich and Company, mural decorators. His partner was apparently the Brooklyn artist Robert J. Pattison (1838–1903). Stiepevich is known to have decorated a number of buildings, and in 1880 he prepared a study for a mural in the Metropolitan Museum (see below). He conducted classes in ornamental design and wall decoration at the museum's school in 1885–1886 and 1891–1892. A group of his watercolor designs, which demonstrate his awareness of the latest trends in European decoration, are in the Metropolitan's collection.

The few known examples of Stiepevich's easel paintings are primarily Arab subjects. Works like *The Conjuror* and *The Harem*, n. d. (Toronto art market, 1977), are richly painted interior scenes with dramatic lighting. As Alfred Trumble wrote about the artist's genre subjects:

> The graceful composition and picturesque character of his subjects, their strong, rich color, and conscientiously complete execution render his cabinet and larger pictures equally adaptable to the gallery or to the embellishment of the home. Without making any pretension to mere story-telling, his works have the quality of suggesting a story, which the observer may adapt according to his own moods and fancies, a distinction which the public is never slow to recognize (p. 266).

Stiepevich served as secretary to the Artists' Fund Society of New York in 1903–1904. He continued to work and reside in Brooklyn until at least 1910, after which no further record of him has been discovered.

BIBLIOGRAPHY: Alfred Trumble, "The School of Venice (with original illustrations by Vincent G. Stiepevich)," *Monthly Illustrator* 5 (Sept. 1895), pp. 258–266 // Twelfth Census of the United States, schedule 1, 1900, New York, Enumeration District No. 356, sheet no. 2.

Stiepevich, *The Parthenon.*

The Parthenon

Dated 1880, this painting is believed to be a study for an unexecuted mural for one of the lunettes in Wing A of the Metropolitan Museum of Art, which opened to the public at the end of March 1880. As late as February 16, the executive committee of the board of trustees discussed a proposal "to have the two ends of the mainhall decorated." Stiepevich was mentioned as an artist who could complete this decoration "satisfactorily for the sum of $2,000." A special committee composed of the architect Richard Morris Hunt, the sculptor John Quincy Adams Ward, and the art dealer Samuel P. Avery investigated the question and after a week reported that time did not permit an elaborate decorative scheme. Instead, the executive committee decided to explore the possibility of "simple coloring" for this area. Most likely, Stiepevich did this study for the committee while it was still considering the commission.

The Parthenon, a popular subject with such American landscape painters as SANFORD ROBINSON GIFFORD and FREDERIC E. CHURCH, was probably selected to associate the museum with great cultural achievements of the past. It may have also been inspired by the revival of interest in classical art and life in the early 1880s. In the typical nineteenth-century romantic tradition, Stiepevich represents the ruins of the Parthenon with figures in picturesque attire and immerses the building and landscape in a luminous light.

The painting was donated to the museum at the request of William Loring Andrews who was a member of the executive committee and may have first suggested the mural commission.

Oil on canvas, 21⅜ × 50 in. (54.3 × 127 cm.).
Signed and dated at lower left: V. G. Stiepevich 1880. Signed and dated at lower right: V. G. Stiepevich/ 1880.

REFERENCES: Minutes of the executive committee of the board of trustees, MMA, MMA Archives, Feb. 16, 1880, discusses proposal to have the two lunettes in the main hall decorated, notes that Stiepevich could do it for $2,000, and refers the issue to a special committee (quoted above); Feb. 23, 1880, discusses the possible decoration of the lunettes with a landscape and reports final decision // Council minutes, Grolier Club, New York, March 4, 1890, records the "gift of an oil painting by President Andrews" (probably this painting) // W. Gillies, secretary, Grolier Club, letter in MMA Archives, June 4, 1912, says that the Grolier Club is presenting to the museum a painting "originally made as a lunette" for the Metropolitan's building // R. Nikirk, librarian, Grolier Club, letter in Dept. Archives, Oct. 1977, provides reference from council minutes.

EXHIBITED: Fifth Avenue Art Galleries, New York, 1887–1888, *Catalogue of the Third Annual Exhibition of the Architectural League of New York*, no. 426, as The Parthenon, lent by W. L. Andrews.

EX COLL.: William Loring Andrews, New York, by 1887–probably 1890; Grolier Club, New York, probably 1890–1912.

Gift of the Grolier Club, 1912.
12.113.

Vincent G. Stiepevich

EDWARD LAMSON HENRY

1841–1919

Henry was born in Charleston, but little is known of his youth. Orphaned at a young age, he was brought to New York to live with cousins, the Stows, in 1848. According to his own account, he studied painting briefly in 1855 with Walter M. Oddie (1808–1865) in New York. Three years later he went to Philadelphia, where he attended the Pennsylvania Academy of the Fine Arts and sketched from nature. He may also have studied painting with the German-born landscapist Paul Weber (1823-1916). Within a year, when he was just eighteen, a barnyard scene that he painted was exhibited at the National Academy of Design. That picture won him critical acclaim as "a young and most talented artist" and was said to foreshadow "great excellence" (quoted in McCausland, p. 26).

In 1860 Henry went abroad to continue his studies. He worked in Paris with Charles Gleyre and Gustave Courbet and then took the traditional grand tour, visiting Rome, Florence, the Italian lakes, Germany, the Low Countries, England, and Ireland. In the course of these travels he made many sketches, which inspired his first works after he returned to the United States in 1862. Once at home he also began to paint the American views for which he is best known today, and in 1864 he exhibited the first of his famous railroad pictures, *Station on Morris and Essex Railroad* (unlocated). That year Henry served in the Union army as a captain's clerk. He drew a number of wartime sketches, several of which were later worked up into paintings. The best-known of these is one he painted in 1868, *A Presentation of Colors to the First Colored Regiment of New York by the Ladies of the City in Front of the Old Union League Club, Union Square, New York City in 1864* (Union League Club, New York). Meanwhile his European and domestic scenes became popular with collectors. From the beginning, Henry found a ready market for his work. His pictures were shown annually at the National Academy, of which he was elected an associate in 1867 and an academician in 1869. It was said that later in his career his paintings always sold on varnishing day at the academy.

Henry married Frances Livingston Wells in 1875 and spent a year's honeymoon in Europe. Mrs. Henry was an amateur artist, who, in 1885, exhibited a flower painting at the National Academy of Design.

Except for three trips to Europe (1871, 1875, and 1881-1882), Henry spent most of his time in New York. For many years he occupied a studio in the Tenth Street Studio Building. After 1885 he moved to larger quarters on Washington Square North. In 1883 he built a house at Cragsmoor, near Ellenville, New York. This small community in the Shawangunk Mountains became a summer art colony. Henry generally stayed at Cragsmoor from early spring to late fall. In 1887 he made it his legal address but continued to spend the winters in the city. He specialized in depicting rural scenes and ways of life that were quickly disappearing. Although he occasionally took liberties with the subject matter, his pictures have a certain documentary value. In many of them he used his Cragsmoor neighbors as models. One of his chief hobbies was photography, and he frequently photographed people and objects for his paintings. He often based his views of historical buildings on one or more photographs. Occasionally he even painted over photographs and prints.

Coupled with his interest in recording a vanishing way of life was his intense interest in preserving early buildings and old woodwork. In a sense he was one of the founders of the colonial revival. He collected antique furniture and was considered an authority on the subject, often acting as agent for such collectors as Joseph W. Drexel and J. W. Pinchot. Henry had a strong interest in architecture; he photographed and sketched old buildings and became involved in efforts to save some of them. He also assembled collections of carriages and costumes. Part of his costume collection is now in the Brooklyn Museum.

By the time Henry died, his paintings were considered old-fashioned. But their former popularity is indicated by the many reproductions of them made during his lifetime. He and his wife handcolored some of these prints, which often have the appearance of original paintings. Henry won numerous awards in his long career, including medals at the world expositions in Chicago, 1893, Buffalo, 1901, Charleston, 1902, and Saint Louis, 1904. He was a member of the American Watercolor Society and the Century Association.

BIBLIOGRAPHY: *The National Cyclopaedia of American Biography* 5 (New York, 1894), pp. 315–316 // Katharine A. Amend, *DAB* (1932; 1960), s.v. Henry, Edward Lamson. Concise summary of his career // Elizabeth McCausland, *The Life and Work of Edward Lamson Henry, N. A., 1841–1919*, New York State Museum Bulletin, no. 339 (Albany, 1945). A discussion of his life and work, based on the large Henry collection at the New York State Museum. Includes an important catalogue of 345 works, a list of unlocated items, a chronology, and bibliography // Maureen Radl and Jan P. Christman, *E. L. Henry's Country Life: An Exhibition* (1981–1982). Catalogue for a traveling exhibition presented by the Cragsmoor Free Library and the New York State Museum.

The 9:45 Accommodation

Henry was much interested in modes of transportation, past and present. He painted a number of pictures dealing with carriages, horses, wagons, ships, and trains. His first railroad picture, now lost, *Station on Morris and Essex Railroad* (ill. McCausland, 1945, p. 263, fig. 108), was painted in 1864. Its popularity led him to paint many others, the largest of which is *The First Railway Train on the Mohawk and Hudson Road*, 1892–1893 (Albany Institute of History and Art), which commemorates the opening of the route from Albany to Schenectady, New York, in 1831.

The 9:45 Accommodation was painted in 1867 for John Taylor Johnston, president of the New Jersey Central Railroad and first president of the Metropolitan Museum. Mrs. Henry mentioned the commission in a memorial sketch she wrote after her husband's death:

Mr. John Taylor Johnston . . . gave him one of his first large orders, for one of the early R. R. paintings . . . and paid him $500, an almost unheard-of price at that time even by a man of reputation . . . It was placed on an easel at one of Mr. Johnson's noted artist receptions, attracting a good deal of atten-

tion, as also [did] the young artist. It was here he was introduced to Mr. S. P. Avery, who at that time was dealing only in American paintings, and who became one of his earliest patrons (see McCausland, 1945).

This picture, which is among Henry's best works, is painted in his usual precise, detailed manner. Elements of it may be based on photographs. He has effectively recorded the bustling activity before the train pulls out of the station. At the left a family is rushing to the train, while at the right a number of arriving carriages cause a traffic jam. There are other carefully chosen narrative details, among them two men reading newspapers on the platform, a barking dog, and rearing horses. Signs announcing a sheriff's sale, an agricultural fair, and a trotting race add reality to the scene.

A photograph in the Henry collection (New York State Museum, Albany) illustrates what appears to be an unlocated version or a study for the painting. It may, however, simply show this picture at an earlier stage. It differs from the painting in the museum in some details and appears to be less precisely painted.

For many years the site of this scene was considered to be Stratford, Connecticut. This identi-

Henry, *The 9:45 Accomodation.*

fication, however, was not made until 1934. There is little evidence to support it. In fact, it has recently been discovered that when the painting was sold from the John Taylor Johnston collection in 1876, the title was given as *The Railway Station, Westchester.* Since Johnston commissioned the painting and was still living in 1876, this is more likely the correct identity. What particular station is shown has not been discovered. Henry very often combined various elements in his pictures and could easily have taken a railroad station from one town and the geography from another. Moreover, stations on a particular railroad line were often built on the same model and varied little. In those years, there were several lines in Westchester, like the Boston and Maine, which no longer exist today.

Oil on canvas, 16 × 30⅝ in. (40.6 × 77.8 cm.).
Signed and dated at lower right: E. L. HENRY, / P. 1867.
REFERENCES: "Photographs of Paintings by E. L. Henry, 1864–1868, album of photographs, E. L. Henry Collection, New York State Museum, Albany, N. Y., includes this or related painting // R. Somerville,

New York, *The Collection of Paintings, Drawings, and Statuary, the Property of John Taylor Johnston . . .*, sale cat., Dec. 19, 20, 22, 1876, title page, notes that collection will be exhibited at NAD from Nov. 29 to Dec. 19; p. 16, no. 41, as The Railway Station, Westchester, 16 × 30 (annotated copies in NYPL and MMA give Garret[t] as buyer and price as $530) // E. Strahan [E. Shinn], ed., *The Art Treasures of America* (1880), 2, p. 82, as Railway Station, West Chester, N. Y., coll. Mr. John W. Garrett, Baltimore // C. Cook, *Art and Artists of Our Time* (1888), 3, p. 267, as The Railway Station of a New England Road // C. E. Clement and L. Hutton, *Artists of the Nineteenth Century and Their Works* (1889), 1, p. 346, calls it The Railway Station of a New England Road // American Art Galleries, New York, *Catalogue of Modern Paintings by Artists of the American and Foreign Schools . . . to be Sold . . . by Direction of . . . the Late Miss Mary E. Garrett of Baltimore,* sale cat., Feb. 15 and 17, 1919, no. 57, lists as The 9:45 Accommodation, 16 × 30½, from Garrett estate and describes the scene (MMA copy annotated M. Knoedler Co. $480) // J. M. Lansing, MMA, 1934, note in MMA Archives, says she examined the painting: "It is a view of the station at Stratford, Connecticut, in 1867, very lively with bustle of arrivals and departures // Moses Tanenbaum's will, New York, Jan. 12, 1937, copy in MMA Archives, calls it "9:45 Accommodation" // L. Burroughs, *MMA Bull.* 34 (1939), pp.

Photograph of a similar painting by Henry. Albany Institute of History and Art.

137–138, as The 9:45 Accommodation, Stratford, Connecticut // *Magazine of Art* (June 1939), p. 332 // E. McCausland, *The Life and Work of Edward Lamson Henry, N. A.* (1945), p. 87, calls it "undoubtedly one of Henry's best paintings"; p. 112, discusses it; p. 158, no. 65, catalogues it and mentions photograph of what may be another version of the subject // K. Moore, M. Knoedler and Co., New York, May 15, 1981, letter in Dept. Archives, notes that Knoedler's acquired the painting at the Garrett sale in Feb. 1919 and sold it to Moses Tanenbaum in March 1919.

EXHIBITED: NAD, 1876 [Collection of John Taylor Johnston] // MMA, 1939, *Life in America*, p. 160, no. 212, as The 9:45 Accommodation, Stratford, Connecticut // NAD, 1942, *Our Heritage*, no. 179 // Century Association, New York, 1942, *An Exhibition of Oils and Water Colors by Edward Lamson Henry, N.A. (1841–1919)*, no. 32 // Columbus Gallery of Fine Arts, Ohio, 1948, *American Heritage*, no. 19 // Dayton Art Institute, 1949, *The Railroad in Painting*, no. 28.

EX COLL.: John Taylor Johnston, New York, 1867–1876 (sale, Chickering Hall, New York, Dec. 20, 1876, no. 41, $530); John Work Garrett, Baltimore, 1876–d. 1884; his daughter, Mary E. Garrett, Baltimore, 1884–d. 1915; her estate, 1915–1919 (sale, American Art Galleries, New York, Feb. 17, 1919, no. $480); with M. Knoedler and Co., New York, Feb. 1919–

March 1919; Moses Tanenbaum, New York and Irvington, N. Y., March 1919–d. 1937.

Bequest of Moses Tanenbaum, 1937.

37.47.1.

The North Dutch Church, Fulton and William Streets, New York

The North Reformed Dutch Church was built especially for English language services. It was designed by Andrew Breested, Jr., in 1767 and dedicated in 1769. During the Revolution the building was stripped of its original pews and pulpit and used by the British as a hospital and a storehouse. The elaborate steeple was added in 1820, and in 1842 the interior was remodeled. In 1866 the consistory decided to demolish the building, but action was delayed, and in October of 1869 the tower and steeple burned. Demolition of the church was completed in 1875.

Henry painted this scene in 1869, probably to commemorate the centennial of the church's dedication, which was celebrated on May 25. He may have based the picture on a photograph or the engraving of the building in Valentine's

Manual of 1855. Compared to his other paintings of churches, this is an especially lively scene with street vendors, dogs, carriages, and a street car.

The donor of the painting, Maria DeWitt Jesup, specified in her bequest that all paintings from both her collection and that of her husband be listed in the museum as from her husband's collection. It is very likely, however, that this was one of her paintings and had belonged to her father, Dr. Thomas De Witt, who served as minister at the old North Dutch Church from 1827 to 1874.

Oil on academy board, 18 × 14 in. (45.7 × 35.6 cm.).

Signed and dated: *E. L. Henry* 1869.

REFERENCES: *New York Evening Post*, Nov. 8, 1869, p. 2, calls it The North Dutch Church on view at the Century Association // H. C. Brown, ed., *Valentine Manual of the City of New York from 1916–7* (1916), ill. p. 173 // E. McCausland, *The Life and Work of Edward Lamson Henry, N. A.* (1945), p. 162, no. 83, as Old Dutch Church, New York; p. 264, fig. 110 // B. Burroughs, *MMA Bull.* 10 (April 1915), p. 67.

EXHIBITED: Century Association, New York, Nov. 1869, as The North Dutch Church // NAD, 1869, no. 383, mistakenly as Middle Dutch Church, Fulton

Henry, *The North Dutch Church, Fulton and William Streets, New York.*

Street, lent by S. P. Avery // MMA, 1939, *Life in America*, no. 213 // Century Association, New York, 1942, *An Exhibition of Oils and Water Colors by Edward Lamson Henry, N. A. (1841–1919)*, no. 37.

EX COLL.: Samuel P. Avery, New York, by 1869; probably Thomas De Witt, New York, d. 1874; his daughter, Mrs. Morris K. Jesup, New York, d. 1914.

Bequest of Maria DeWitt Jesup, from the collection of her husband, Morris K. Jesup, 1914.

15.30.66.

Saint George's Church, New York

Saint George's Chapel, built from 1749 to 1752 at the corner of Beekman and Cliff streets in New York, was originally part of the parish of Trinity Church. In 1811 the congregation separated from Trinity and became Saint George's Church. In 1814, the original church was destroyed by fire, but the following year the building shown in Henry's painting was constructed on the same site. In 1848 the congregation abandoned the building and moved to a new church at Rutherford Place and Sixteenth Street, where it remains today.

In 1851 the old church was taken over by the Church of the Holy Evangelist and called the Free Church of Saint George's Chapel. In 1868 it was torn down and the property sold. The painting, dated 1875, appears to be based on Charles Burton's view, published by Bourne in 1831. The houses in the painting are the same as those in the engraving except for the doorways and stoops. Henry's keen interest in transportation is indicated here by the three horse-drawn carriages that give the scene an old-time atmosphere.

Henry revealed his estimate of this painting in a letter he wrote on March 3, 1875, to the bibliophile William Loring Andrews, who seems to have commissioned the picture:

As your leaving for Europe in May precludes the possibility of my exhibiting your little painting at the Academy, I should be extremely obliged if you could loan it to me for the Century Saturday night. I should like to have it seen a little in New York as I consider it one of my best so far.

The same year that he painted this picture, Henry also did *The Library of William Loring Andrews* (Century Association, New York). As founder of the Society of Iconophiles, Andrews commissioned the copying of many old views of New York.

Henry, *Saint George's Church, New York.*

Saint George's Church, ca. 1831, drawn
by Charles Burton and engraved by George
W. Hatch and James Smillie. NYHS.

Oil on wood, 10 × 8½ in. (25.4 × 21.6 cm.).
Signed and dated at lower left: E. L. Henry, 75.
REFERENCES: E. L. Henry to W. L. Andrews,
March 3, 1875, MMA Archives (quoted above) //
American Art Galleries, New York, *Oil Paintings from
the Estates of the Late . . . Jane E. Andrews . . .*, March
25 and 26, 1931, p. 2, no. 5, Street Scene, from the
estate of Jane E. Andrews (MMA copy annotated
$400) // M. C. Hurlbut's will, New York, June 22,
1933, bequeaths to MMA all oil paintings "purchased
from the estate of my aunt, Jane E. Andrews" // E.
McCausland, *The Life and Work of Edward Lamson
Henry N. A.* (1945), p. 169, no. 119, as St. Geor-
ge's Chapel, Beekman and Cliff Street, New York.
EXHIBITED: Century Association, New York, 1875
(no cat.); 1942, *An Exhibition of Oils and Water Colors by
Edward Lamson Henry, N. A. (1841–1919)*, no. 48 // Mu-
seum of the City of New York, *Paintings of New York,
1850–1950*, 1958 (no cat.).
EX COLL.: William Loring Andrews, New York,
1875–d. 1920; his wife, Jane E. Andrews, d. 1930
(sale, American Art Galleries, New York, March 25,
1931, no. 5, $400); Margaret Crane Hurlbut (Mrs.
Andrews's niece), New York, 1931–d. 1933.
Bequest of Margaret Crane Hurlbut, 1933.
33.136.2.

HENRY MOSLER

1841–1920

Born in New York, Mosler was the son of a cigar maker who had been a lithographer before
emigrating from Germany. In 1851 the family moved to Cincinnati where Mosler was
introduced to oil painting by George Kerr, a hatter by profession and an amateur artist. It was
Mosler's father who encouraged him to make his first engravings, which soon led to brief

Henry Mosler

employment with a wood engraver in Richmond, Indiana. His first teacher of prominence was the portrait and genre painter James H. Beard (1812–1893) in Cincinnati.

Mosler began his artistic career by illustrating a comic weekly entitled *Omnibus*. At the outbreak of the Civil War, he worked for about a year as a war correspondent and artist for *Harper's Weekly*. He left the United States in 1863, after recuperating from a bout of camp fever, and went to Düsseldorf. At the academy there, he studied drawing under Heinrich Mücke and painting under Albert Kindler. Before returning home, he went to Paris and studied for six months under Ernest Hébert. He was back in Cincinnati in 1866 painting portraits and genre pictures. *The Lost Cause*, his most well-known work of this period, established his reputation. Exhibited at the National Academy of Design in 1868 and subsequently chromolithographed, it showed a Confederate soldier returning to his deserted home.

In 1874 Mosler studied with Alexander Wagner and Karl Piloty in Munich. After three years, he settled in Paris, where he remained for almost fifteen years, regularly contributing to the annual salons. Many of his pictures of this period depicted Breton peasant life. His most important painting, *The Return of the Prodigal Son* (*Le Retour*), was exhibited at the Salon of 1879 and sold to the French government. It is now in the Musée Departemental Breton-Quimper.

In 1886 Mosler was commissioned by H. H. Warner of Rochester, New York, to paint large canvases of the life and customs of the American Indians. He traveled to New Mexico to make studies of the Apache, their customs, tools, and utensils. At least two paintings are documented: *The White Captive*, which depicted a young white girl being burned at the stake (exhibited at the Paris Salon of 1886), and *Abandoned*, which depicted an old squaw left to die alone (exhibited at the Paris Salon of 1887).

In 1894 Mosler returned to New York, and except for excursions to Paris from time to time, he lived there the rest of his life. In the winters he taught painting and composition in his Carnegie Hall studio, and in the summers he ran a school for advanced art students at his home at Margaretville, New York, in the Catskills.

During his career, Mosler received many honors in Europe, including the French Legion of Honor and election to the French Academy. He was one of the four winners of the Prize Fund Exhibition at the Society of American Artists in 1885 (for his painting *The Last Sacrament*, now in the Polytechnic Institute, Louisville, Ky.). Elected an associate at the National Academy of Design in 1895, he resigned his membership in 1906. After 1914, he was plagued by poor health, which greatly reduced his output. One of his sons, Gustave Henry Mosler (1875–1906), also became a painter.

BIBLIOGRAPHY: "Henry Mosler," *Art Amateur* 13 (Nov. 1885), pp. 113–115 // Spencer H. Coon, "Philip Martiny and Henry Mosler," *Metropolitan Magazine* 7 (March 1898), pp. 245–247. Good discussion of early career // Avery Galleries, New York, *A Collection of Choice Paintings by Henry Mosler*, exhib. cat. (1896). Contains biographical sketch and list of honors and medals received // *New York Times*, April 22, 1920, p. 11. Lengthy and informative obituary notice // "Album of Pictures by Henry Mosler" in private coll., New York.

Mosler, *Just Moved*.

Just Moved

Sentimental vignettes of this kind, with a high degree of finish and technical precision, were very popular in America in the second half of the nineteenth century. The carefully painted objects scattered about the room—a dismantled cast-iron stove, rolled mattress, wash tub, scrubbing board, basket of dishes, and Gothic-revival clock—make a fascinating record of the contents of a modest household of the late 1870s.

As the "breadwinner" and pivotal figure of the family, the father is placed at the apex of the triangular group of figures and is shown slicing a loaf of bread. The family's loving and playful interest in the baby further unites the composition.

Painted in the United States after Mosler had completed his studies in Europe, *Just Moved* has

the rich, glowing palette and the unifying interaction of light and shadow that characterizes Düsseldorf genre painting.

Oil on canvas, 29 × 36½ in. (73.7 × 92.7 cm.). Signed and dated at lower right: HMosler./1870.
REFERENCES: Kennedy Galleries, New York, *Kennedy Quarterly* 3 (1962), p. 33, ill. no. 50 // S. P. Feld, *Antiques* 87 (April 1965), ill. p. 442, discusses it.

EXHIBITIONS: MMA, 1965, *Three Centuries of American Painting*, unnumbered cat. // Lytton Gallery, Los Angeles County Museum of Art and M. H. de Young Memorial Museum, San Francisco, 1966, *American Paintings from the Metropolitan Museum of Art*, ill. p. 71, no. 57.

EX COLL.: with Kennedy Galleries, New York, by 1962.

Arthur Hoppock Hearn Fund, 1962.
62.80.

JOHN FERGUSON WEIR

1841–1926

John Ferguson Weir was born at West Point, New York, the son of ROBERT W. WEIR, who was the drawing instructor at the United States Military Academy. He received an elementary education in local schools and was tutored by some of the instructors at the academy. At a young age he began art studies with his father, who maintained a large collection of books, prints, casts, and studio accessories useful for an aspiring painter. An early list of his works (coll. Rev. DeWolf Perry) shows that he first painted copies, some after his father's pictures, and small landscape views of West Point, which he sold to tourists and cadets. Many artists— THOMAS COLE, ASHER B. DURAND, and EMANUEL LEUTZE among them—visited his father. So too did such local residents as the writers John Bigelow, Gulian Crommelin Verplanck, and Nathaniel Parker Willis. It is often stated that John Ferguson Weir continued his studies at the National Academy of Design, but his name does not appear in the school's student register. In 1861, shortly after the outbreak of the Civil War, he enlisted in the New York Seventh Regiment but only served for three months before returning home to begin his artistic career in earnest.

He settled in New York in 1862, taking a studio in the new Tenth Street Studio Building, where his neighbors included SANFORD ROBINSON GIFFORD, JERVIS MC ENTEE, and WINSLOW HOMER. Through General Winfield Scott, a family friend, he sold *View of the Highlands from West Point*, 1862 (NYPL, on deposit at NYHS), to the philanthropist Robert L. Stuart. Weir then began a series of paintings, which would establish him as one of the most promising young artists of his generation. Many were drawn from his youthful experiences at West Point. The first of these, *An Artist's Studio*, 1864 (coll. Jo Ann and Julian Ganz, Los Angeles), is of his father surrounded by some of his best known works. Exhibited at the National Academy of Design in 1864, the picture secured his election as an associate there. Two years later, he exhibited *The Gun Foundry*, 1866 (Putnam County Historical Society, Cold Spring, N. Y.), and became a full member of the academy. This industrial scene and *Forging the Shaft* (q.v.) were exceptional not only for their subject and scale but also for their complex groupings of figures. In 1867, *The Gun Foundry* was exhibited at the Exposition Universelle in Paris, and Henry T. Tuckerman wrote: "We know of no picture which so deftly elaborates our industrial economy as this clever and effective picture of the West Point Foundry" (*Book of the Artists* [1867], p. 488). This was undoubtedly the high point of Weir's career.

During the 1860s Weir also worked on a smaller scale, exploring a wide range of subjects. He made a specialty of interior scenes such as *Sunny Moments*, 1864 (Yale University, New Haven), and *The Morning Paper*, 1868 (q.v.); these show people engaged in quiet domestic activities. Occasionally, he undertook highly imaginative subjects like *Christmas Eve*, 1865 (coll. Theodore Stebbins, Jr., Boston), in which a legion of fairies, illuminated by moonlight, ring a bell. Whatever his subject, Weir believed that painting was an intellectual art, one that required great education and knowledge. "An artist is necessarily as much of a poet as any writer of poems," he wrote to his fiancée about 1862. "A poet expresses his ideas and sentiments in verse and a painter with colour and form. One uses the language of lines and col-

our. . . . There is no profession which requires more general knowledge than painting" (John F. Weir Papers, Sterling Memorial Library, Yale University).

Weir married his childhood sweetheart, Mary French, in 1866. Sales of his paintings soon enabled him to make his first European trip. He was abroad from December 1868 to August 1869, when he was asked to become director of the Yale School of Fine Arts, a post he accepted upon his return. This marked a major turning point in Weir's career. For the next forty-four years, until 1913, he devoted his energies to developing the curriculum and the collection of the art school. He enlarged the academic program to include the study of sculpture, architecture, and art history. He was influential in the university's acquisition of the celebrated Jarves collection of early Italian paintings in 1871. Weir also wrote extensively on art, publishing articles in *New Englander, Princeton Review*, and *Harper's New Monthly Magazine*. These efforts left little time for his own painting. He continued to exhibit but attempted few ambitious works, concentrating instead on portraits (often of his colleagues), landscapes done around New Haven or on summer excursions, and later, floral still-life paintings. He gave up his New York studio within a few years of accepting the post at Yale, but through his younger half-brother, J. ALDEN WEIR, a cosmopolitan painter trained in Paris in the 1870s, he remained in touch with developments in the art world. With him he made a second trip to Europe in 1881 and later, under his influence, began to paint in an impressionist style. He also experimented with sculpture, modeling statues of Benjamin Silliman and Theodore Dwight Woolsey for the Yale campus, as well as a fountain for the New Haven green and a plaque for the Pinchot Building in Milford, Pennsylvania. Always a religious man, he became increasingly absorbed in the subject, publishing two books, *The Way: The Nature and Means of Revelation* (1899) and *Human Destiny in the Light of Revelation* (1903).

He made another trip to Europe in 1901. Following his retirement from Yale in 1913, he settled in Providence, Rhode Island, where he compiled his autobiography, parts of which were published posthumously in 1957.

BIBLIOGRAPHY: John Ferguson Weir Papers, Sterling Memorial Library, Yale University, New Haven. The richest source of information on the artist, it includes an account book (1858–1871), a diary of his European trip (1868–1869), several lists of his paintings, drafts of his autobiography, and copies of lectures and articles // Theodore Sizer, ed., *The Recollections of John Ferguson Weir, Director of the Yale School of the Fine Arts, 1869–1913* (New York, 1957). Published version of the autobiography, reprinted from the *New-York Historical Society Quarterly* 41 (April, July, and Oct., 1957) // Theodore Sizer, ed., "Memories of a Yale Professor," *Yale University Library Gazette* 32 (Jan. 1958), pp. 93–98 // Betsy Fahlman, "John Ferguson Weir: Painter of Romantic and Industrial Icons," *Archives of Am. Art Jour.* 20, no. 2 (1980), pp. 2–9.

The Morning Paper

Dated 1868, this painting is one of several interior scenes that Weir painted in the West Point studio of his father, ROBERT W. WEIR. The first of this group is the ambitious *An Artist's Studio*, 1864 (coll. Jo Ann and Julian Ganz, Jr., Los Angeles), which shows Weir's father surrounded by his paintings and studio props. The scene takes a more intimate direction in *Sunny Moments*, 1864 (Yale University, New Haven), in which a woman and child sit in a sunlit interior. These three paintings are characteristic of the early style that Weir developed under his father's guidance: dark colors, often warm reds and browns, are richly applied, and firm draftsmanship is maintained.

For a long time the museum's picture was

called *Portrait of the Artist's Father*, but it now appears to be the genre subject that Weir recorded as "The Morning Paper—studio of R. W. Weir 22 × 24 J. A. Dean 1868 400.00." Joseph A. Dean lent the work to the 1876 spring exhibition at the National Academy of Design. The description given by the reviewer for the *Art Journal* matches the museum's picture:

One of the latest works from the easel of Prof. John F. Weir represents the interior of a library, with the figure of an old gentleman seated at a window reading. There are a palette and brushes on a table, and other evidences of the artistic taste of its occupant scattered around the room The figure is not a portrait in a strict sense, but it suggests the idea that the artist when putting it on the canvas had in his mind the form of his venerable father, Prof. Robert W. Weir, of West Point, and the likeness is carefully painted If this may be called a portrait-picture, we feel assured that it will be admired as such, not only on account of the interesting character of the subject, but also for its conservative and thoughtful treatment.

The painting dates from 1868, not 1876, the year of the exhibition. It differs slightly from the description of the picture in the review, which noted that a palette was lying on the table rather than on the bookcase, where it can be seen in the Metropolitan painting. Nevertheless, it seems fairly certain that the museum's picture is *The Morning Paper*. The eight-year delay between its creation in 1868 and its exhibition in 1876 can be explained by the events of Weir's career. This was the period when he was absorbed in his work at the Yale School of the Fine Arts and generating few new works. Lacking new paintings, he might well have chosen an older picture for the show. Furthermore, the manuscript list of Weir's paintings, which seems fairly complete, includes no other work that corresponds to this picture in size, subject, or date.

The owner of *The Morning Paper*, Joseph A. Dean, was a New York merchant who was friendly with the artist in the 1860s.

Oil on canvas, 24 × 20 in. (61 × 50.8 cm.).
Signed and dated at lower left: Jno. F. Weir / 1868.
REFERENCES: [New York] *Art Journal* 2 (1876), p. 64 (quoted above) // "List of Pictures painted by Jno. F. Weir," n.d. [after 1902], coll. Rev. DeWolf Perry, includes it as no. 72 (quoted above); attached list, "Selections for the Centennial," no. 7, dates it 1868, gives size as 34 × 38 (probably in frame) // G. Paget, orally, May 26, 1981, recalls that he purchased it from some member of the Weir family in New England.
EXHIBITED: NAD, 1876, no. 489, as The Morning Paper, lent by J. A. Dean.
EX COLL.: Joseph A. Dean, New York, 1868–at least 1876 (died 1902); probably a member of the Weir family; Gerald Paget, New York, 1960.
Purchase, Bertram F. and Susie Brummer Foundation, Inc., Gift, 1960.
60.72.

Weir, *The Morning Paper*.

Forging the Shaft

Forging the Shaft shows the interior of the West Point Iron and Cannon Foundry in Cold Spring, New York, where workers are casting the shaft for the propeller of an ocean liner. Weir has chosen the moment when the shaft has reached a welding heat. The industrial scene, unusual in American art of the period, Weir knew well from his youth. He grew up in nearby West Point and often visited the foundry. Gouverneur Kemble, who established the factory in 1818, and his brother-in-law Robert Parker Parrott, his successor and the inventor of the Parrott gun, were well known to the Weir family.

The museum's painting is the second version of *Forging the Shaft*. The first version, painted between June 1867 and March 1868, was destroyed in a fire in 1869. Based on the earlier work, this painting was begun in 1874 and com-

pleted by 1877, when it was exhibited at the Williams and Everett Gallery in Boston. Weir had originally intended to exhibit it beside *The Gun Foundry* at the Centennial Exhibition in Philadelphia in 1876 but, given his teaching responsibilities at Yale, was unable to finish it in time. The earlier version had been shown in Paris at the Exposition Universelle in 1867, establishing something of an international reputation for Weir. The appearance of this lost work is best recorded in a crude line engraving (coll. Rev. DeWolf Perry), signed simply "Speer". The accuracy of the engraving, however, is confirmed by a photograph of the artist and his wife which shows the painting in full view on an easel (John F. Weir Papers, Sterling Memorial Library, Yale University, New Haven).

While both paintings represented the same activity and setting, they were significantly different in composition and intention. The earlier version simply recorded an industrial process; the later one dramatized and ennobled it. In the first painting Weir followed the conventions of mid-nineteenth century genre painting. Within a clearly defined, stage-like setting, figures were arranged singly or in loosely joined groups, their poses and gestures anecdotal. In composing the second version, he chose a vantage point farther back from the action so that the figures are shown on a smaller scale. He also doubled the number of figures and arranged them in a more unified manner. They are gathered around and behind the shaft, parallel to the picture plane, forming a tightly integrated frieze. With every gesture, gaze, and pose the figures enhance the unity of the whole. This effect is perhaps most noticeable in the group of men who strain to move the shaft. A figure has been added in front of the shaft, between the man who raises a cloth to protect his face from the heat and the one who leans backward and raises his left arm to direct his fellow workers. The poses of the first three figures no longer seem random. Instead, they are carefully orchestrated, with each straining leg parallel to the other. On the right, there are five instead of two men pulling a rope and manipulating the pulley that moves the shaft; their poses echo those of the men surrounding the shaft. Additional figures have been placed in the left and right foreground of the picture to frame the principal action of the scene better. Weir also exaggerated the glowing light of the furnace, not only to unite the composition but also

to heighten its drama and mystery. The molten shaft is surrounded by an aureole of light that illuminates the interior, creating strong patterns. Some of these changes may have been made after the painting was exhibited in 1877. As Weir noted in a letter to William MacLeod, curator of the Corcoran Gallery of Art, in 1881: "Since you saw the picture in Boston I have repainted a large portion of it, and I think greatly enriched it—I have also added more figures."

Weir's other ambitious view of the Cold Spring Foundry, *The Gun Foundry*, 1864–1866 (Putnam County Historical Society, Cold Spring, N. Y.), depicted the casting of a Parrott gun, a weapon widely used during the Civil War. *Forging the Shaft* must be seen in relation to this earlier industrial subject. Neither version of *Forging the Shaft* seems to have been exhibited with *The Gun Foundry* during the artist's lifetime, but the two subjects were often linked in the critical literature of the period. In 1879 a pamphlet was published incorporating the notices on both pictures. In subject and treatment, if not in size, the two works can be seen as companion pieces celebrating the country's industrial achievement. *The Gun Foundry*, painted during the Civil War, may allude to the industrial superiority of the North, and *Forging the Shaft*, painted shortly after the close of the war, refers to the peacetime uses of industry. As Weir himself wrote of the museum's painting in 1881: "It is designed to illustrate a great *labor* theme— characteristic of a prominent national industry. It thus lays claim to historic interest." Of all the published reviews, Weir favored Edmund C. Stedman's interpretation of the first version of the subject:

In these days of painting for mere art's sake, the elevated purpose of Weir's picture is of unusual significance to the observer. This artist has recognized that, after all, art is chiefly noble for that which it expresses, and has herein made a presentation of that foremost American idea—the strength and majesty of human labor. He could have found no more powerful illustrations of this thought than in the operations of the immense foundry near which he had, formerly, the good fortune to make his home.

In the "Gun Foundry" and "Forging of the Shaft" he has produced a counterpart, in color, to the poetical work of Schiller in the immortal "Casting of the Bell," and of Longfellow in "The Building of the Ship." His theme is the subjugation of matter to mind. The diverse after-uses of the gigantic engines which so command our awe suggest a truly heroic contrast of ideas.

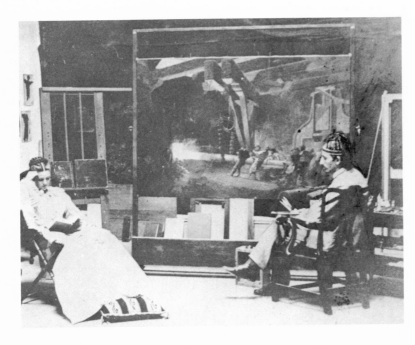

Left: Detail of photograph showing the first version of *Forging the Shaft* in Weir's studio. Below: Engraving of the first version.

All have seen engravings of Landseer's famous pictures, "War" and "Peace," the one mournful with the ruin of the battle-field, the other giving the repose of the pastoral hill-sides, and the spider weaving his "web across the cannon's throat." But Weir's paintings have a still more suggestive imaginative quality. "The Gun Foundry" is the prophet of destructive war; "The Forging of the Shaft" is a higher tribute to human labor as the companion and promoter of enriching and enduring peace (*New York Evening Post*, May 7, 1868, p. 2).

Oil on canvas, 52 × 73¼ in. (132.1 × 191.7 cm.).
Signed at lower left: John F. Weir.
RELATED WORKS: *Forging the Shaft*, 1866–1867, oil on canvas, destroyed in 1869.

REFERENCES: J. A. Weir to J. F. Weir, Jan. 11, 1874, says, "I have been thinking lately what a grand thing it would be if you would send your *Forging of the Shaft* or rather come over [to Paris] with it and spend two months or so"; and March [21], 1875, says, "I am sorry you have not yet got your *Forging of the Shaft* finished," quoted in D. W. Young, *The Life and Letters of J. Alden Weir* (1960), p. 28 and p. 71 // T. G. Appleton to J. F. Weir, April 24, 1877, John F. Weir Papers, D129, Arch. Am. Art, says that Williams and Everett have just sent it to him: "I have seen the same scenes, and it brought it to mind most vividly. I congratulate you that after the loss of your first-born, this second furnace should have so the likeness of his elder brother" // J. W. Pinchot to J. F. Weir, Feb. 21, 1878, ibid., says that he has received his letter of the 19th; "I think the committee [of the Exposition Universelle]

Weir, *Forging the Shaft*.

will be likely to carry out your wishes without even a suggestion The preliminary hanging will not take place until next week, and not therefore until after the arrival of your picture. Now that this important work is off your hands, what about the small figure piece for me?" // *L'Illustration* 71 (June 15, 1878), p. 399, in a review of the American section of the Exposition Universelle notes, "citons encore la *Forge* de M. Weir, d'un aspect très-puissant" // J. F. Weir to J. G. Brown, March 17, 1879, John F. Weir Papers, D129, Arch. Am. Art, says that he hopes that it will arrive in time and that "it may be placed in a better position than it was in Paris"; // *New York Evening Post*, March 29, 1879, p. 4, in a review of the NAD, calls it "glowing" // *New York Daily Graphic*, March 29, 1879, p. 207, in a review of the NAD exhibition, says that Weir "has skillfully arranged a very difficult subject"; ill. p. 209, says that the "deep shadows" throw "a

wild and pictorial mystery over the composition" // *New-York Daily Tribune*, April 1, 1879, p. 5, in a review of the NAD, says it is "a striking p[i]ece of realism no doubt, but with details the layman is puzzled to understand" // *New York Herald*, April 7, 1879, p. 8, in a review of the NAD, praises the skillful drawing of "complicated detail" and the management of light // *Art Interchange* 2 (April 16, 1879), p. 58, in a review of the NAD, says it "improves upon acquaintance" // *New York Times*, May 24, 1879, p. 9, in a review of the NAD, says it "has the advantage of attaining what it set out to say It merely relates the fact that in a cyclopean forge stalwart men, with the aid of derricks, hooks, trip hammers, and enormous furnaces, prepare the iron beams that turn the wheels of our floating hotels"; says that it replaces "a larger and more dramatic canvas of similar nature" // S. G. W. Benjamin, *Harper's New Monthly Magazine* 59 (Oct.

1879), p. 682 // L. Whiting, *Art Amateur* I (Nov. 1879), p. 119, in a review of the Cincinnati Exposition, mistakenly says that it represents the casting of a huge Parrott gun // *"The Gun Foundry." A Painting by John F. Weir, N. A. "Forging the Shaft." A Painting by John F. Weir, N. A., Director of the Yale School of Fine Arts. Notices and Criticisms from the Newspaper Press* [1879], pp. 15–16, quotes reviews from the Hartford and New York newspapers for the Exposition Universelle and NAD exhibition, includes an editorial note that it was completed in 1878 and was "superior to the first picture, it having been entirely re-studied, and re-composed with many additional figures" // G. W Sheldon, *American Painters* (1879), p. 175; ill. opp. p. 176, shows engraving after it by W. McCracken entitled Casting the Shaft // C. E. Clement and L. Hutton, *Artists of the Nineteenth Century and Their Works* (1879; 1884 ed.), p. 343 // S. G. W. Benjamin, *Art in America* (1880), p. 114 // "Journal of the Official Proceedings of the Trustees of the Corcoran Gallery of Art," Archives, Corcoran Gallery of Art, Washington, D. C., Oct. 10, 1881, p. 154, says that Weir's request for space in the exhibition gallery was granted; Jan. 9, 1882, p. 157, says that Weir offered to sell the picture to the Corcoran // J. F. Weir to W. MacLeod, curator, Corcoran Gallery of Art, ibid., Oct. 4, 1881, says that the MMA is willing to send it to the Corcoran after their summer exhibition closes; mentions that it is for sale; notes "a collection of notices that were reprinted with a view to their use in connection with a proposed engraving to be published of the picture"; says that the sculptor Henry Kirke Brown has "very kindly interested himself in my picture"; Oct. 10, 1881, notes that it has been repainted (quoted above) and he made studies for it "in several places"; discusses theme (quoted above); says that he considers Stedman's interpretation "a satisfactory one" and that Longfellow has written to him about it, "calling attention to several poems inspired by similar themes"; discusses price, noting that he has never asked less than $4,000 for it, but in order to have it "permanently placed" in the Corcoran, he would make a deduction of $500; mentions that he worked for "more than two years on the picture, and the models and other ways it has cost me a good deal of money"; notes that the dealer Derby paid him $4,000 for the first version; says that he wants to retain the copyright, as he has considered publishing "a large engraving from it"; Oct. 12, 1881, says that should it require a *"thin coat of varnish"* due to being exhibited in the summer heat in New York, "have you any reliable person who could be entrusted to varnish it"; Oct. 13, 1881, says that he has asked Mr. Pratt of the MMA to prepay shipping charges for it; Oct. 14, 1881, confirms that the price is $3,500; Oct. 14, 1881, recommends the use of "a thin coat of Mastic varnish" on it // W. J. Pratt to J. F. Weir, ibid., Oct. 15, 1881, describes shipping arrangements for it // J. F. Weir to W. MacLeod, ibid., Oct. 17, 1881, encloses Pratt's letter of Oct. 15 and reiterates in-

structions about varnishing; Oct. 19, 1881, encloses check to pay bills for varnishing and labor; says, "Thank you very much for attending to the varnishing"; Nov. 14, 1881, asks what action about its purchase has been taken by the Board of Trustees, says, "I had hoped that it might receive their favorable consideration in view of the offer I made"; Jan. 26, 1882, says that the Southern Art Union of New Orleans has asked for it for their exhibition, which would open on Feb. 15; asks him whether it could arrive by Feb. 10; says that he had received MacLeod's note that the committee had declined to purchase it; inquires whether "the Committee would care to make an offer for it" because he would be "willing to make some considerable sacrifice" in order to sell it to the Corcoran; Jan. 27, 1882, acknowledges receiving MacLeod's telegram; agrees that it would be too expensive to send it by express to New Orleans; asks him to retain it until he can decide whether to send it to Philadelphia; telegram, Jan. 30, 1882, says that MacLeod should ship it express to PAFA, "Need not insure"; Jan. 31, 1882, asks MacLeod to let him know if and when it has been shipped // W. MacLeod, "Curator's Journal," 1881, Archives, Corcoran Gallery of Art, Washington, D.C., Oct. 10, 11, 18, 19, 24, 1881, pp. 194–195, 202, 204, 205; "Curator's Journal," 1882, Jan. 16, 27, 31, and Feb. 1, 1882, pp. 3, 27, 31, 32, includes his answers to Weir's letters noted above and decisions regarding the exhibition and possible purchase of the painting // H. K. Brown to J. F. Weir, Feb 24, 1882, John F. Weir Papers, D129, Arch. Am. Art, says, he is sorry that the Corcoran did not accept it, but "Do not let it trouble you—a more worthy purchaser for the work will yet appear" // *Collector* 3 (Dec. 15, 1891), p. 55, says that it is on view at Knoedler's // J. N. Paulding to J. F. Weir, July 29, 1893, Yale University Art Gallery, discusses the "Exposition . . . , with the idea that some one might see and wish to purchase that painting" // J. F. Weir to L. P. di Cesnola, June 19, 1901, MMA Archives, says that he must dispose of it in spite of his intention to bequeath it to Yale; asks if the MMA could purchase it at a "moderate" cost; encloses pamphlet, which he says was prepared for Goupil and Co. // L. G. Bloomingdale to Cesnola, June 25, 1901, John F. Weir Papers, Sterling Memorial Library, Yale University, says that S. P. Avery has advised him that the MMA is considering purchasing it; offers to give $300 in addition to the $1,700 previously donated; and says, "I am delighted to have been given the opportunity to acquire this painting for the Museum" // G. H. Story to J. F. Weir, June 26, 1901, ibid., informs him that the museum has purchased it for $2,000 // J. F. Weir to J. A. Weir, July 29, 1901, ibid., says that the MMA has purchased it; that "Cesnola was the means of their doing this, and he certainly did it handsomely and in a most friendly way. It was through his influence that all the Trustees became interested in buying the picture,

which was bought by a Mr. B . . . and presented to the Museum. This has nearly wiped out all my debts and lifted a load from my back, and I know that you will be glad to know this" // "List of Pictures painted by Jno. F. Weir," n.d. [after 1902], coll. Rev. DeWolf Perry, no. 94, lists it as a "duplicate of [no.] 68 destroyed"; gives size as 51 × 72 in.; notes its exhibitions at the NAD, in Paris, Philadelphia, Washington, Cincinnati, "N. Ham.," Boston, and Chicago; unnumbered entry, says it is 48 × 72 in. and it was sold to the MMA for $2,000; attached list, "Selections for the Centennial," no. 8, dates it 1876, gives size as 76 × 99 in. (probably including frame) // S. Isham, *The History of American Painting* (1905; rev. ed. 1915), p. 346, mentions its completion in 1868; ill. p. 351 // *Art News* 24 (April 17, 1926), p. 6, mentions its sale to the museum in obituary of the artist // J. H. N., *Bulletin of the Associates in Fine Arts at Yale University* 1 (June 1926), p. 27 // T. Sizer, *New-York Historical Society Quarterly* 41 (July 1957), pp. 369; (Oct. 1957), p. 460, notes the important role it played in Weir's career; pp. 473, 475, discusses it; ill. p. 474; reprinted as *The Recollections of John Ferguson Weir* (1957), pp. 59, 68, 81–83; ill. opp. p. 83 // J. F. Kasson, *Civilizing the Machine* (1976), p. 168, discusses it and The Gun Foundry as examples in which "the technological sublime was at once stimulated and fused with a progressive vision" // B. Fahlman, *Abstracts of Papers . . . 67th Annual Meeting: College Art Association of America* (1979), p. 71, discusses it // D. A. Noverr, *American Examiner* (Michigan State University) 7 (Spring 1980), pp. 43–44, says that it is "a more tightly constricted view" than The Gun Foundry; that its subject is the casting of an engine drive shaft for an ocean steamer; and describes composition; p. 45, says that Weir is one of the pioneers of "a new realism in American art"; calls it a symbol of "America's coming of age in the late 1860's" // B. Fahlman, *Arch. Am. Art Journ.* 20, no. 2 (1980), p. 2, says that it was his last major work; ill. p. 3; pp. 5–8, discusses its subject and its parallels in literature; compares it to Adolph von Menzel's Iron Foundry; says that Weir had difficulty in finding a buyer and planned to bequeath it to Yale but pressing debts then forced him to sell it; says that it shows "that the machinery for wartime production had now been converted to peaceful purposes"; mentions works by Weir similar in theme; and discusses other American works of such subjects; letter in Dept. Archives, MMA, Oct. 10, 1983, provides archival information from the Corcoran Gallery of Art // D. B. Burke, *J. Alden Weir* (1983), ill. p. 30; p. 31, discusses it in relationship to The Gun Foundry // M. Bushnell, orally, Jan. 12, 1984, said that there is no record of its being exhibited at PAFA in 1882.

EXHIBITED: Williams and Everett Gallery, Boston, 1877 (no cat. available) // Paris, 1878, Exposition Universelle, United States section, no. 116, as Forgeant un Arbre de Couche // NAD, 1879, no. 322, as Forging the Shaft // Cincinnati Industrial Exposition, 1879,

no. 53, as Forging the Shaft, for sale, $5,000 // MMA, 1881, *Loan Collection of Paintings*, no. 265, as Forging the Shaft: A Welding Heat, lent by the artist // Art Institute of Chicago, 1888, no. 44, Forging the Shaft, $3,500 // M. Knoedler and Co., New York, 1891 (no cat. available) // World's Columbian Exposition, Chicago, 1893, *Official Catalogue: Fine Arts*, United States, no. 1096, as Forging the Shaft // Panama-Pacific International Exposition, San Francisco, 1915, *Official Catalogue*, no. 2966 // Whitney Museum of American Art, New York, *American Genre*, no. 102 // Carnegie Institute, Pittsburgh, *An Exhibition of American Genre Paintings*, no. 91 // MMA, 1970, *19th-Century America*, cat. by J. K. Howat and N. Spassky, no. 134, says original version painted in 1867; this version, 1877.

ON DEPOSIT: Corcoran Gallery of Art, Washington, D. C., 1881–1882, lent by John F. Weir // Yale University Art Gallery, New Haven, 1932–1957.

EX COLL.: the artist, New Haven, Conn., until 1901.

Purchase, Lyman G. Bloomingdale Gift, 1901.
01.7.1.

The Alhambra, Granada, Spain

On a trip to Europe in 1901 Weir visited the Alhambra, the Moorish palace and citadel erected between 1248 and 1354. While there, he wrote to his half-brother J. ALDEN WEIR, who had visited the same site on a student trip to Spain in 1876.

In all my rambles in the Alhambra . . . I am somewhat reminded of your sojourn in Granada—as I have heard you tell of it . . . the Alhambra itself does not tempt me—it is wholly a matter of charm of *ornament*. The architectural forms are very slight and not particularly interesting for painting . . . The charm is in what lies outside—the views: these are delectable, Granada is lovely (Nov. 24, 1901, John F. Weir Papers, Sterling Memorial Library, Yale University, New Haven).

In this view, the Alhambra is shown at a distance. The emphasis on the surrounding landscape rather than the building probably reflects Weir's immediate reaction to the site.

The picture is not dated. Although its earliest known exhibition was in 1914, it seems likely that it was executed on or shortly after Weir's visit in 1901. He shows a strong interest in the effects of light and atmosphere and uses some broken brushwork, but his style is only loosely tied to impressionism. As in his earlier work, the draftsmanship remains very much in evidence, particularly the firm contours of the

Weir, *The Alhambra, Granada, Spain.*

architecture. His palette has a strong brown cast, creating earthy tones alien to the pure, light colors of the impressionists.

Oil on canvas, 36¼ × 46½ in. (92.1 × 118.1 cm.). Signed at lower right: John F. Weir.

REFERENCES: J. F. Weir to M. F. Weir, n.d., coll. Rev. De Wolf Perry, discusses offer of $1,000 from Mansfield // "List of Mr. Weir's pictures to be sent to Providence," [1915], includes it as the property of Mansfield, on Elm Street; "Pictures Collected on April 5th for Mr. Weir," [1915], includes it; "List of Paintings Taken by Fry on March 31, 1915," includes it, John F. Weir Papers, Sterling Memorial Library, Yale University // D. T. Owsley, letter in Dept. Archives, June 28, 1983, says that he bought it in a New York antique shop between 1955 and 1960.

EXHIBITED: Providence Art Club, 1915, *Catalogue of Paintings by John F. Weir, N. A.,* no. 2, as The Al-hambra, Grenada [*sic*], Spain, lent by Burton Mansfield // Carnegie Institute, 1920, no. 358 // MMA, 1965, *Three Centuries of American Painting,* checklist alphabetical // American Federation of Art, traveling exhibition, 1977, *The Heritage of American Art,* exhib. cat. by M. Davis, p. 144, no. 63, as The Alhambra; dates it about 1919 and says that it shows that Weir was influenced by impressionism // Cadet Fine Arts Forum of the United States Corps of Cadets, United States Military Academy, West Point, New York, 1976, *Robert Weir,* exhib. cat. by W. H. Gerdts, J. T. Callow, and M. Moss, p. 43, no. 88; ill. p. 84 // Nassau County Museum of Fine Art, Roslyn, N. Y., 1983, *William Cullen Bryant, the Weirs and American Impressionism,* exhib. cat. by H. J. Pinto, p. 13, p. 23, no. 23; ill. p. 45.

Ex COLL.: Burton Mansfield, New Haven, by 1914; David T. Owsley, New York, ca. 1955–1964.

Gift of David T. Owsley, 1964.

64.119.

FRANK WALLER

1842–1923

The artist and architect Frank Waller was born in New York in 1842. He was the son of Martha Brookes Waller and Joseph Fernando Waller, a drygoods merchant who died before his son was five years old. During the years from about 1857 to 1861, young Waller attended the New York Free Academy, the future City College of New York, where he studied drawing. "Between the years 1863 and '68," according to Clement and Hutton (p. 331), "he was in business in his native city, drawing with pen and ink, and painting in oil in his leisure hours." It is unclear whether the drawing they speak of was architectural or fine-art drawing. Throughout his career, Waller apparently pursued both painting and architectural design, with alternating emphasis on one or the other. He entered the annual exhibition of the National Academy of Design in 1870. The same year, he went to Europe and studied in Rome with the well-known American artist JOHN GADSBY CHAPMAN. Having returned to New York in 1871, Waller left again the following year to tour Egypt with EDWIN WHITE. Waller's interest in Egypt continued. He became known for his Egyptian paintings, especially romantic scenes of the Nile, and he was made a local honorary secretary of the Egypt Exploration Society, from 1897 to 1902, and of the Ur Exploration Society.

Waller studied at the National Academy of Design with Lemuel Wilmarth (1835–1918) and at the Art Students League of New York, which he helped to found in 1875. Waller served as its first president, was treasurer in 1876, corresponding secretary in 1879, and president for a second time in 1881. He visited several major art academies in Europe in 1878, and his *Report on Art Schools*, published the following year by the Art Students League, assisted in establishing guidelines for the teaching program there. He also wrote the *First Report of the Art Students' League of New York* in 1886.

In 1885 Frank Waller opened an architectural office in New York and joined the New York Architectural League. His interest in the interiors of building is evident in his paintings of the Metropolitan Museum (below). He designed the First National Bank in Cooperstown, New York, and many country houses. In 1902 he gave up architecture and returned to painting, apparently working in Morristown, New Jersey, where he had lived since 1895. He died there in 1923.

BIBLIOGRAPHY: Clara Erskine Clement and Laurence Hutton, *Artists of the Nineteenth Century and Their Works* (Boston, 1889), 2, p. 331. Gives biographical information on his early years // *Who's Who in America* 12 (Chicago, 1922–1923), p. 3187 // *New York Times*, March 10, 1923, p. 13, contains obituary notice // *The National Cyclopaedia of American Biography* 23 (New York, 1933), p. 146.

Entrance Hall of the Metropolitan Museum of Art when in Fourteenth Street

From 1873 to 1879, the Metropolitan Museum of Art occupied the Douglas Mansion, the former home of Harriet Douglas Cruger, at 128 West Fourteenth Street, New York. This was the second building to house the museum's collections. Later owned by the Salvation Army, the mansion was destroyed by fire in 1918.

During the fiftieth anniversary of the founding of the Metropolitan Museum in 1920, Frank Waller wrote that he was too ill to join in the festivities, but he wanted to know if the museum would like to have several drawings, an etching, and this oil study of the old building on Fourteenth Street. One of the drawings is dated February 14, 1879, the day of the final reception held in the Douglas Mansion. Several others are also from 1879, and one is dated 1880. Presumably the oil study was made about the same time. Waller noted: "It has ever been my purpose to perfect the view, of which I have a good oil study, of the entrance hall of the building . . . and let the Museum become its owner if it were desired as a part of its history I cannot carry my work further now and probably never will be able to do so."

He obviously, however, considered the oil study an accurate record of the museum at that time: "The entrance hall as I have painted it is properly drawn in perspective, the several statues have their own places, the draperies their proper color & paintings as well . . . it may be depended upon as accurate and therefor *historical.*" The heroic-sized bust of the poet and editor William Cullen Bryant at the top of the stairs is by Launt Thompson. Originally intended for Bryant Park, it was lent to the Metropolitan Museum by the New York City Parks Department in 1874 and is now on deposit in the museum. As a sketch, Waller's study lacks the sharp definition of his painting of the interior (see below), but it shows his interest in the reflections of light on hard surfaces.

The woman standing in the foreground may be consulting one of the museum's early guidebooks, or she may be sketching. As part of a traditional art education, students used the gal-

Waller, pencil study for the statue at right in *Entrance Hall.* MMA, 20.78.2.

leries to make copies of old master paintings and sketches of sculpture and casts. Waller noted the value of the museum's collection for students in the *First Report on the Art Students' League of New York* (1886), in which he lamented the museum's move from Fourteenth Street so far uptown to its present location in Central Park (p. 42).

Oil on wood, 12 × 16 in. (30.5 × 40.6 cm.).
RELATED WORK: *In the Entrance Hall of the Metropolitan Museum of Art in Fourteenth Street,* a study of statue at right in painting, pencil on gray paper, 13½ × 9¾ in. (34.3 × 24.8 cm.), MMA, 20.78.2.

Waller, *Entrance Hall of the Metropolitan Museum of Art when in Fourteenth Street.*

REFERENCES: F. Waller, letters in MMA Archives, Oct. 16, 1912, mentions a 12 × 16 painting he once started of the main entrance hall, which he would like to finish; April 26, 1920, discusses oil sketch in a letter in which he sends regrets that he cannot attend museum's 50th anniversary celebration (quoted above) // H. W. Kent to Waller, May 24, 1920, ibid., says the museum will purchase the painting.

EXHIBITED: MMA, 1939, *Life in America* (not in cat.) // Museum of the City of New York, 1958, *Paintings of New York, 1850–1950*, unnumbered checklist // Corcoran Gallery of Art, Washington, D. C., 1959, *The American Muse*, no. 105.

EX COLL.: the artist, New York and Morristown, N. J., until 1920.

Purchase, 1920.

20.77.

Interior View of the Metropolitan Museum of Art when in Fourteenth Street

This painting is intended to be a historical record of two galleries on the second floor of the Metropolitan Museum when it was housed in the Douglas Mansion on Fourteenth Street. Based on drawings made in 1879 and 1880, the painting was executed in 1881 and exhibited at the National Academy of Design, where it was offered for sale.

In 1884, the museum began discussing with Waller the possible purchase of the painting and was granted first refusal. In his correspondence Waller emphasized the accuracy of his description of the galleries. To Luigi P. di Cesnola, the president of the museum, he wrote:

I took much interest in painting the picture and as far as the perspective is concerned it is absolutely correct for I drew it from a ground plan and height made on actual measurement of the rooms themselves and several of the pictures represented are owned by the Museum today.

Three years later, the painting was still in Waller's possession when he wrote to the museum's trustees:

Of its merits . . . as a work of art, of course I am not a competent judge; but I may say, that as far as accuracy goes it is absolute, the original sketch having been made in the old building in 14th St. and corrected by subsequent measurements laid out in perspective. This was done as I deemed it of some value connected with the history of the Museum.

The trustees finally voted to buy the painting in 1895.

In this interior view of the museum, Waller carefully depicted paintings that were actually on exhibition in 1879. *The Wages of War* (q.v.) by HENRY PETERS GRAY hangs over the door frame; *Saint Rosalie Borne up to Heaven by Angels* by Anthony Van Dyck and *Portrait of a Young Lady* attributed to Cornelis de Vos are on the left. The portrait seen through the doorway is probably the *Portrait of a Woman* attributed to Leonardo when it was lent to the museum in 1879 by Mrs. G. Talbot Olyphant.

The view is from Gallery H through a doorway into Gallery G. Gallery H, at the core of the building, was used for both the modern paintings in the permanent collection and the annual loan exhibition. Gallery G, at the center front of the second floor, exhibited the loan collection, paintings by the old masters, photographs, and various other objects of art.

Waller's accurate description of a gallery of paintings and art objects continues the tradition of seventeenth-century gallery painting, especially the work of the Flemish court painter David Teniers. The stool and cloak, seen on the left, are part of the tradition and are meant to suggest the artist's presence. Seventeenth-century gallery paintings often show a visitor closely examining an object or painting; the visitor is usually a proud collector being guided through a private gallery. Waller's painting, on the other hand, illustrates the popular late nineteenth century concept of public collections that are open for everyone's enjoyment and education.

Oil on canvas, 24 × 20 in. (60.9 × 50.8 cm.).

Signed and dated at lower right: Frank Waller. / 1881. / COPYRIGHT.

RELATED WORKS: Perspective sketch of gallery, pencil and ink on paper, 27 × 20¼ in. (68.6 × 50.8 cm.), 1879, MMA, 12.191.6 // Details of doorways, railings, etc., pencil and chalk on paper, 13⅜ × 9¾ in. (34.0 × 24.8 cm.), March 1879, MMA, 12.191.3 // Details of art objects, pencil, touched with watercolor and Chinese white, on gray paper, 13¼ × 9¾ in. (33.7 × 24.8 cm.), July 1879, MMA, 12.191.8 // Ground plan of gallery, pen and pencil on paper, 22 × 14⅛ in. (55.9 × 35.9 cm.), 1879, MMA, 12.191.7 // *Interior of the Metropolitan Museum when in Fourteenth St.*, etching, 15¾ × 11⅜ in. (40 × 29 cm.), copyright 1883, MMA, ill. in W. L. Andrews, *MMA Bull.* 2 (Jan. 1907), p. 1.

REFERENCES: F. Waller, letters in MMA Archives, April 13, 1887, offers the picture to MMA (quoted

Frank Waller

above), says that it is "of some value connected with the history of the Museum" and he is willing to accept a lower price because he is opening an office as an architect. The painting, he says, has already been on exhibition at the MMA [in 1883]; May 17, 1884, says he will not send it "away from the city, even for exhibition, as long as the museum has the refusal which, at your request, I gave you the day of our conversation [May 5]. I would so much rather have the Museum own the picture, than any one else" (quoted above); Jan. 26, 1895, sends the picture to the museum, noting that Samuel P. Avery recommends its purchase; Jan. 30, 1895, refers to note from Cesnola acknowledging that the painting had been received by the museum (annotated that committee recommended purchase) // W. E. Howe, *A History of the Metropolitan Museum* 1 (1913), ill., p. 165 // *MMA Bull.* 4 (April 1920), frontis. ill. // F. Waller, letters in MMA Archives, Oct. 16, 1912, mentions drawings that show details of the painting and notes that the museum already has two proofs of the etching; April 26, 1920, says he regrets he will not be able to attend the 50th anniversary celebration, mentions that he has other views of the building, and notes: "I recognize your satisfaction with my painting of the old 14th St. home by the reproduction again in your April bulletin" // *MMA Bull.* 10 (June 1950), color ill. on cover // W.

Waller, an 1879 perspective study for *Interior View*. MMA, 12.191.6.

Waller, *Interior View of the Metropolitan Museum of Art when in Fourteenth Street.*

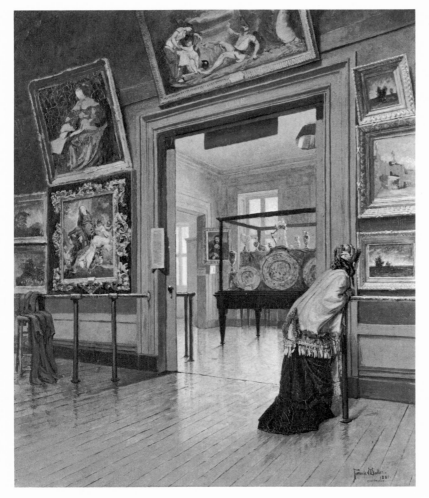

Garrett, *MMA Journ.* 3 (1970), p. 315, ill. 7, notes in caption that The Wages of War by Henry Peters Gray is above the doorway.

EXHIBITED: NAD, 1881, no. 230, as In the Metropolitan Museum, Cruger Mansion, $350 // PAFA, 1881, *Exhibition of American Artists at Home and Abroad*, no. 339, as In the Metropolitan Museum (Kruger [*sic*] Mansion, 1879), lent by the artist // MMA, May – Oct. 1883, *Loan Collection of Paintings and Sculpture in the West Galleries and the Grand Hall*, no. 90, as Interior of the Metropolitan Museum of Art, Kruger Mansion, Fourteenth St., New York, 1879, lent by the artist // MMA, 1939, *Life in America*, no. 252, ill. p. 192, as Interior of the Metropolitan Museum when in Fourteenth Street, New York // MMA, 1946, *Taste of the Seventies*, no. 161 // Wadsworth Athenaeum, Hartford, Conn., Addison Gallery, Phillips Academy, Andover, Mass., Boston Symphony, 1949-1950, *Pictures within Pictures*, no. 47, as Interior of the Metropolitan Museum when in Fourteenth Street // MMA, 1950, *20th Century Painters*, checklist, p. 12; 1966, *Three Centuries of American Paintings*, checklist alphabetical // Cranbrook Academy of Art Museum, Bloomfield Hills, Mich., 1973, *Genre, Portrait, and Still Life Painting in America*, no. 22, ill. p. 21 // Whitney Museum of American Art, New York, Oakland Museum, Calif., Museum of Fine Arts, Houston, 1974–1975, *The Painter's America*, p. xxii, no. 114; ill. p. 91, no. 113; p. 92, notes that it is evidence of a "newly awakened self-consciousness of art and art history" // Museum of the City of New York, 1975–1976, *New York by Artists of the Art Students League of New York*, p. 22, no. 44; ill. p. 69.

EX COLL.: the artist, New York, until 1895.
Purchase, 1895.
95.29.

GEORGE WILLOUGHBY MAYNARD

1843–1923

A native of Washington, D. C., Maynard came to New York about 1866 to study drawing and modeling with the sculptor Henry Kirke Brown. Subsequently he became a pupil in the schools of the National Academy of Design and then studied with the figure painter EDWIN WHITE. In 1869 he went abroad with White to visit the major art centers of Europe. He was particularly drawn to Antwerp where he settled and studied at the academy under Joseph H. F. van Lerius, a painter of genre and historical subjects. In 1873, he traveled in southeastern Europe with a fellow American artist and friend, FRANK D. MILLET. After the winter of 1873–1874, which he spent in Rome, Maynard returned to New York. He became a regular exhibitor at the National Academy of Design in 1875, was elected an associate in 1881, and an academician in 1885.

In 1876, under the direction of JOHN LA FARGE, Maynard was among the ten to fifteen artists who did the decorative work on Trinity Church, Boston, a masterpiece of Romanesque revival architecture in the United States. Apparently, this experience encouraged him to study mural painting in Italy and England. He also had a studio in Paris for a short time. It was there that his friend the American sculptor Augustus Saint-Gaudens executed a bronze portrait relief of him (Century Association, New York). Upon his return to the United States, Maynard was awarded numerous commissions for mural decorations in hotels, theaters, churches, and various public buildings, including the Library of Congress. His murals for the Agriculture Building at the 1893 World's Columbian Exposition in Chicago were considered among the best of their type and earned him a special medal.

Although not many works by Maynard have been located, he is known to have painted

genre scenes and portraits. His special interest, however, was the depiction of mermaids. He was a member of the Society of American Artists, the American Watercolor Society, the Tile Club (where he was nicknamed the "Eagle"), the Players Club, the Century Association, and the Salmagundi Club, of which he was president.

BIBLIOGRAPHY: William A. Coffin, "The Artist Maynard," *Century Magazine* 61 (Dec. 1890), p. 316. Most complete treatment of the artist's life at that time // National Portrait Gallery, Washington, D. C., *Augustus Saint-Gaudens: The Portrait Reliefs*, exhib. cat. (1969), no. 6. Discusses Maynard and the bronze portrait plaque of him // NAD, New York, *Artists by Themselves* (1983), p. 128.

In Strange Seas

Mermaids have captured the imagination of writers and artists ever since man ventured seaward. During the last half of the nineteenth century this ancient fascination with mermaids had a revival, perhaps in response to the scientific interest in the undersea world. There was a vogue for aquatic themes in such fanciful literary works as Charles Kingsley's juvenile book *Water Babies* (1863) and Jules Verne's futuristic romance *Twenty Thousand Leagues under the Sea* (1870).

Such potentially rich subject matter did not escape painters. In the United States, EDWARD MORAN in his *The Valley in the Sea*, 1862 (Indianapolis Museum of Art), and Frederick Stuart Church (1842–1923) in his *Mermaids*, 1887 (private coll.), each explored the mythological theme of mermaids in his own manner. *In Strange Seas* is the best known of Maynard's excursions into this subject. The painting represents five mermaids who have just seen an approaching ship on the horizon. The subject is a traditional one and alludes to ancient legends like the *Odyssey*, in which mermaids or sirens charm unwitting, sea-weary sailors to unsafe seas where they abandon them to a watery death. These are the strange seas with which Maynard is concerned.

The picture has much in common with, and may well have been inspired by, *Im Spiel der Wellen* (Neue Pinakothek, Bayerische Staatsgemäldesammlungen, Munich) executed in 1883 by the Swiss symbolist Arnold Böcklin. In both canvases, the sea occupies three-quarters of the picture. Similarly, several figures appear in the foreground. Where Böcklin has a husky sea centaur on the horizon, however, Maynard has a ship. Böcklin creates an erotic scene in which mermaids disport in a variety of revealing poses before a lusty triton; whereas Maynard presents a traditional mythological subject.

Maynard's mermaids are more concealed than revealed by the waves. They are idealistically conceived and, with sweet and innocent expressions, seem remarkably chaste in comparison to Böcklin's voluptuous creatures or the femmes fatales found in European pictures of the period. This lack of eroticism may well be a result of Maynard's American propriety. It may also be due to his technical shortcomings. The figures are in fact unconvincingly posed, and naturalistic details of anatomy are weakly and awkwardly delineated. Maynard's abilities to capture the subtleties of the female form were just not up to the standards of his European contemporaries, and the result is a diluted kind of drama and eroticism. He was able to handle his medium fluidly, however, and the paint surface is rich. He created a marvelous effect of moving, foamy water.

Oil on canvas, $36\frac{1}{4} \times 50\frac{5}{16}$ in. (91.8 × 127.8 cm.). Signed and dated at lower right: Maynard / 89.
REFERENCES: *New York Times*, April 7, 1890, p. 4, in a review of the NAD, says that the waves are "more alive and natural" than his earlier depictions of this theme // *Art Interchange* 24 (May 1890), in a review of NAD, says, "Mr. Maynard sends another version of his mermaid story" // W. A. Coffin, *Century Magazine* 41 (Dec. 1890), p. 316, in a biographical article, calls it "Mermaids and Marines," says that among his easel paintings it is "perhaps his most important work," and it attracted a lot of attention at the NAD in 1890 // *Catalogue of the Valuable Collection . . . Belonging to Wm. F. Havemeyer*, Fifth Avenue Art Galleries, New York, sale cat., Feb. 17 to 23, 1899, no. 74, p. 27 (annotated copy MMA indicates that it was sold for $500 // *New York Commercial Advertiser Illustrated Supplement*, Feb. 18, 1899, ill. p. 7, says it is in the Havemeyer sale // *New York Times*, Feb. 24, 1899, p. 6, says that it brought $500 in the Havemeyer sale // O. Golwin, *Die Kunst für Alle* 16 (March 1901), p. 274, in a review of the Exposition Universelle, discusses; ill. p. 285 // W. F. Havemeyer, letter in MMA Archives, May 4, 1901, says it was included in the Paris Ex-

Maynard, *In Strange Seas*.

position in 1900 // G. Maynard to C. P. Clarke, ibid., May 7, 1908, says that Mr. Havemeyer has drawn his attention to some discolored areas in the picture, requests permission to examine it in order to see if something can be done to correct the problem // B. Burroughs to C. P. Clarke, n. d., ibid., recommends "that Mr. Maynard be permitted to paint over the discolorations" // C. P. Clarke to G. Maynard, May 12, 1908, ibid., agrees to allow him to have the painting back for restoration // G. Maynard to B. Burroughs, June 21, 1908, ibid., says he has completed work on the picture and it is ready to be returned // W. H. Gerdts, *The Great American Nude* (New York, 1974), ill. p. 106, p. 107.

EXHIBITED: NAD, 1890, no. 560 // Paris, *Exposition Universelle*, 1900, no. 167, lent by William Havemeyer //
NAD, Corcoran Gallery of Art, Washington, D. C., and Grand Central Art Galleries, New York, 1925–1926, *Commemorative Exhibition by Members of the National Academy of Design, 1825–1925*, no. 210 // Grey Art Gallery and Study Center, New York University, New York, and Helen Foresman Spencer Museum of Art, University of Kansas, Lawrence, *American Imagination and Symbolist Painting*, 1979–1980, exhib. cat. by C. C. Eldredge, p. 64, discusses it; ill. p. 65.

EX COLL.: William F. Havemeyer, New York, by 1899 (sale, Fifth Avenue Art Galleries, New York, Feb. 17-23, 1899, $500, but probably bought in) until 1901.

Gift of William F. Havemeyer, 1901.
01.22.

HENRY O. WALKER

1843–1929

A native of Boston, Henry Oliver Walker began his professional life in business. Then in 1879, he went to Paris, enrolled in the atelier of the academician Léon Bonnat, and remained there for three years. He spent the summers painting in Brittany. Bonnat taught him a reverence for the classical ideal that was crucial to his stylistic development. Walker's mature work also

reflected the strong influence of the contemporary French mural painter Pierre Puvis de Chavannes.

Walker returned to Boston in 1882 and opened a studio. In 1883 the successful exhibition of two of his works at the National Academy of Design in New York placed him in great demand as a portraitist. He continued to follow an idealized style in his work and produced many decorative figure paintings. In 1888 he married and settled in Lakewood, New Jersey, and also established a studio in New York. His paintings, which dealt more and more frequently with elevated themes, were well received. In 1893 he won a gold medal at the World's Columbian Exposition in Chicago, the first of many such honors. From 1889 to 1895 Walker exhibited regularly at the National Academy of Design. He was elected an associate member in 1894 and eight years later an academician.

Walker's later years were devoted to large-scale works—murals for public buildings, which are among his most notable achievements. The best known of these is *Wisdom Attended by Learning* in the lobby of the Appellate Court House, New York, but he also completed a series of lunettes entitled *Lyric Poetry* for the Library of Congress, Washington, D. C., and two murals for the Massachusetts State House in Boston, *Pilgrims on the Mayflower* and *John Eliot Preaching to the Indians*. Walker maintained summer homes in Belmont, Massachusetts, and in Cornish, New Hampshire, where his neighbors included the sculptor Augustus Saint-Gaudens and the painter and architect Charles Adams Platt (1861–1933). ABBOTT THAYER and GEORGE DE FOREST BRUSH, two artists who pursued a similar mode of figure painting, lived in nearby Dublin. Walker's final years were spent in Boston. He died in Belmont.

BIBLIOGRAPHY: Obituaries: *New York Times*, Jan. 15, 1929, p. 29; *New York Herald-Tribune*, Jan. 20, 1929, p. 11 // William H. Downes, *DAB* (1936; 1964), s. v. Walker, Henry Oliver.

A Morning Vision

Dated 1895, *A Morning Vision* shows the realistic approach to portraiture and the idealized classicism that Walker learned from Léon Bonnat. Pierre Puvis de Chavannes's ethereal and pastoral ideas are also evident in the muted pastel tones, sketchy brushstrokes, and scant detail. Walker used a high horizon and a flattened background, designed to accentuate the foreground figures, as in Puvis's *L'Esperance*, 1872 (Walters Art Gallery, Baltimore). The delicate flora surrounding Walker's figures are also similar to the decorative motifs Puvis frequently used. Walker would have been especially conscious of Puvis's work in 1895, for the French artist was engaged in an important American commission, a series of murals for the Boston Public Library. Walker's own efforts as a muralist began at this time. His work, however, lacked the solidity of Puvis's and remained considerably more saccharine.

A Morning Vision was well received at the National Academy of Design in 1895 and won Walker the Thomas B. Clarke Prize for excellence in figure painting. In a review of the academy exhibition, Royal Cortissoz noted: "The point of view is exalted, the style is sensitive, imbued with the influence of imagination, and the effect is one of fragile beauty throughout."

The painting's provenance is slightly confusing. At William T. Evans's sale in 1900, *A Morning Vision* was reported as sold to William Clausen, a New York dealer from whom Evans often bought paintings. In this instance, Clausen may have been acting as Evans's agent, buying the painting back for him when it did not fetch the expected price. In any event, the work was again in Evans's possession by 1901, when he lent it to the Pan-American Exposition.

Oil on canvas, 28⅛ × 30⅛ in. (71.4 × 76.5 cm.).
Signed and dated at lower right: H. O. WALKER / 1895.
REFERENCES: *New York Times*, March 29, 1895, p. 5, in a review of the NAD exhibition, says that it is "conceived in a spirit of delicious sentiment, and carried out with good taste and refinement of color";

Walker, *A Morning Vision*.

predicts that Walker will win a prize; March 30, 1895, p. 8, says that a rumor has begun to circulate that Walker is to receive the Clarke prize // R. Cortissoz, *Harper's Weekly* 39 (April 16, 1895), p. 318, in a review of the NAD exhibition, praises it (quoted above) // *New York Times*, April 7, 1895, p. 13, says that it has been awarded the Clarke Prize and notes that it "is a most satisfactory effort, certainly the best of a series of compositions in the same vein that has long attracted the painter"; p. 25 // W. A. Coffin, *The Collection of William T. Evans* (1900), no. 261, describes the work // *International Studio* 30 (Dec. 1906), p. xlix, mentions its exhibition in November at the National Arts Club and says that it was also exhibited the winter before at the Lotos Club, New York // W. A. Coffin, *American Paintings Belonging to William T. Evans* (1913), no. 127, describes the work // *American Art News* 11 (March 29, 1913), p. 7, says that it is included in an auction of Evans's collection and notes that it is one of several paintings offered for sale in 1901 but did not sell; (April 3, 1913), p. 6, says that it was sold to George A. Hearn for $1,550 // MMA, *George A. Hearn Gift to the Metropolitan Museum . . .* (1913), ill. p. 116 // *New York Times*, Jan. 15, 1929, p. 29, mentions it in the artist's obituary // W. H. Low, *New York Herald Tribune*, Jan. 20, 1929, p. 11 // *DAB* 10 (1936), p. 345, notes that the painting is in the collection of the MMA // W. H. Truettner, *American Art Journal* 3 (Fall 1971), p. 62, shows it on view in a photograph of Evans's picture gallery; p. 78, includes it in a list of works belonging to

Evans and notes that it was acquired by 1896 and then by 1901; orally, Jan. 3, 1984, said that it is probably not possible to determine the provenance with certainty but Evans did repurchase some of the works he sold in the 1900 sale and that Clausen, with whom Evans often dealt, bought some works at the 1900 sale.

EXHIBITED: NAD, 1895, no. 325 // Brooklyn Institute of Arts and Sciences, 1897, *Opening Exhibition*, no. 355, lent by William T. Evans // Pan-American Exposition, Buffalo, N. Y., 1901, no. 514, lent by Wm. T. Evans // Lotos Club, New York, *Exhibition of Paintings Selected from the Pan-American Exposition*, 1901–1902, no. 23, lent by William T. Evans; 1906, *American Paintings from the Collection of William T. Evans*, no. 70 // National Arts Club, New York, 1906, *Opening Exhibition—Paintings from the Collection of William T. Evans*, no. 54 // Newark Museum Association, 1910, *Exhibition of American Paintings Lent by William T. Evans*, no. 39 // Union League Club, New York, 1935, *Paintings by American Artists*, no. 26.

EX COLL.: William T. Evans, New York and Montclair, N. J., by 1896 (sale, American Art Galleries, New York, Feb. 2, 1900, no. 261, as A Morning Vision, $900); with William Clausen, New York, 1900; William T. Evans, New York and Montclair, N. J., by 1901–1913 (sale, American Art Galleries, New York, April 1, 1913, no. 127, as A Morning Vision, $1,550); George A. Hearn, New York, 1913.

George A. Hearn Fund, 1913.

13.74.1.

Henry O. Walker

THOMAS EAKINS

1844–1916

Son of Caroline Cowperthwait Eakins and Benjamin Eakins, a calligrapher and writing master, Thomas Cowperthwait Eakins was born in Philadelphia, where he spent most of his life. In 1861 he graduated from Central High School, where he had excelled in his studies. He registered for the antique class at the Pennsylvania Academy of the Fine Arts in 1862 and for the life class in 1863. He also attended anatomy lectures at the academy and demonstrations at Jefferson Medical College before going to Paris in the fall of 1866. After some difficulty prompted by the reluctance of the Ecole des Beaux-Arts to admit foreign students, he was accepted and entered the celebrated atelier of Jean Léon Gérôme. Gérôme, who placed great emphasis on drawing, had considerable influence on Eakins's development. When Eakins visited the Exposition Universelle in 1867, he was chiefly attracted by the machinery exhibit; it is not known whether he saw the works of Manet and Courbet that were independently exhibited outside the fair. That summer Eakins traveled in Switzerland with his old school friends William Crowell and William Sartain (1843–1924). He also visited Christian Schussele (1824–1879) in Strasbourg. The following summer he toured Italy, Germany, and Belgium with his father and his sister Frances. In the summer of 1869, he studied with the portraitist Léon Bonnat, whose emphasis on broad handling of paint was in distinct contrast to Gérôme's preference for contour, line, and draftsmanship. Eakins briefly studied clay modeling with the sculptor Augustin Alexandre Dumont.

Ill health sent Eakins to Spain in the fall of 1869. In Madrid he visited the Prado, and his letters home report his admiration for the paintings of Velázquez and Ribera, which, together with those of Rembrandt, were to have a fundamental influence on his development. He settled in Seville for a few months, returned briefly to Madrid and Paris in the summer of 1870, and left for home shortly before the outbreak of the Franco-Prussian War. In Philadelphia, he established a studio in his family home at 1729 Mount Vernon Street and began to paint portraits and domestic genre and outdoor sports scenes. Eakins exhibited for the first time at the Union League of Philadelphia in 1871. He also sent several works to Gérôme for criticism and continued his anatomical studies at Jefferson Medical College. From 1874 to 1876 he taught life classes at the Philadelphia Sketch Club. He is thought to have assisted Christian Schussele in private classes while the academy schools were closed during construction of a new building.

In 1875 Eakins painted his most important work of these years, a portrait of Dr. Samuel Gross, better known as *The Gross Clinic* (Medical College of Thomas Jefferson University, Philadelphia). Like *The Agnew Clinic*, 1889 (University of Pennsylvania), it has antecedents in the two seventeenth-century Dutch paintings of anatomy lessons by Rembrandt. As Goodrich points out, however, it differs in showing an operation in progress rather than the dissection of a cadaver. Criticized by contemporaries for its uncompromising realism, *The Gross Clinic* was relegated to the United States Hospital Building at the Centennial Exhibition in 1876. Dating from the same period are two paintings both entitled *William Rush Carving His Allegorical Figure of the Schuylkill River*, 1876 (Yale University, New Haven), and 1877 (Philadelphia

Museum of Art), which reflected Eakins's admiration for the early Philadelphia sculptor and the importance to Eakins of working from the nude. Eakins returned to the subject some thirty years later in a work of the same title, 1908 (Brooklyn Museum), and in *William Rush and His Model*, ca. 1908 (Honolulu Academy of Arts).

With the resumption of classes at the academy in the fall of 1876, Eakins volunteered his services as assistant to Schussele for a year. Then, in 1877, Eakins served as instructor at the newly founded Art-Students' Union and also assisted Dr. William W. Keen in his anatomy lectures. Reinstated as Schussele's assistant in 1878, Eakins was appointed professor of drawing and painting after Schussele died the following year. In a teaching program that emphasized modeling, perspective, and working from nature, Eakins particularly stressed the study of anatomy and painting from the nude. About 1880, he began to experiment with photography, using it as a tool in his work and for its own sake. In 1884 and 1885 he collaborated with the English photographer Eadweard Muybridge in experiments with motion photography. The 1880s also witnessed his renewed interest in landscape painting and sketching outdoors. During this period he explored an arcadian theme in a series of works based on his plein-air studies and photographs. In January of 1884, Eakins married Susan Hannah Macdowell (1851–1938), his former pupil. Her sustained efforts in support of his work were instrumental in bringing it to public notice.

Eakins was made director of the Pennsylvania Academy school in 1882. He continued to teach there until 1886, when growing opposition to his methods, especially his insistence on the study of the nude in mixed classes, forced his resignation. He still taught, however, at the Art Students' League of Philadelphia, which was founded by his students. Subsequently, he lectured in New York at the Art Students League, Cooper Union, and the National Academy of Design. He also lectured at the Academy of Natural Sciences and Drexel Institute in Philadelphia and at the Art Students' League of Washington, among others.

After a visit to the North Dakota Badlands in 1887, Eakins began his celebrated portrait of Walt Whitman, 1887–1888 (PAFA). In the mid-1880s, Eakins had started to devote most of his time to portraiture. His probing, dispassionate character studies are among the most memorable and compelling portraits in American art. During the early 1890s, Eakins also was active as a sculptor. He received commissions to sculpt the life-size horses for the Brooklyn Memorial Arch in 1891 and two historical relief panels for the Trenton Battle Monument in 1892. He resigned from the Society of American Artists in New York in 1892 because his works had been rejected for three successive years. His lecturing career was jeopardized in 1895, when he was dismissed from the Drexel Institute in Philadelphia, again over the use of a nude model in mixed classes. Portraiture dominated his last productive years; although in 1898, he turned to a series on boxing and wrestling, which occupied him for two years. In 1908 he returned to the subject of William Rush and his model. Eakins was elected to the National Academy of Design in 1902. Two years later he was awarded the coveted Temple Gold Medal by the Pennsylvania Academy. He also won a gold medal for *The Gross Clinic* at the 1904 Universal Exposition in Saint Louis.

Following Eakins's death in 1916, the Metropolitan Museum mounted a memorial exhibition of his work. Under considerable pressure, another memorial exhibition was assembled at the Pennsylvania Academy of the Fine Arts. Except for a small circle of admirers, Eakins

had been criticized and neglected during his most productive years. His place as one of the country's major artists was not securely established until after his death.

One obituary notice described Eakins as the "dean of American painters" and said that "his difficulties in life arose from an adherence to ideals that brooked no compromise" (*Arts and Decoration* 6 [Aug. 1916], p. 477). As teacher to an entire generation of American artists, he encouraged traditions of American realism. In an interview two years before his death, Eakins singled out Winslow Homer as the greatest American painter. He dismissed impressionism, futurism, and cubism as "nonsense," noting: "no serious student should occupy his time with them. He who would succeed must work along the beaten path first and then gradually, as he progresses, try to add something new but sane, something which arises out of the new realities of life." At the same time, he observed:

> If America . . . is to produce great painters and if young art students wish to assume a place in the history of the art of their country, their first desire should be to remain in America, to peer deeper into the heart of American life, rather than to spend their time abroad obtaining a superficial view of the art of the Old World. . . . It would be far better for American art students and painters to study their own country and portray its life and types. . . . Of course, it is well to go abroad and see the works of the old masters, but Americans must branch out into their own fields, as they are doing. They must strike out for themselves, and only by doing this will we create a great and distinctly American art" (*Philadelphia Press*, Feb. 22, 1914, p. 8).

BIBLIOGRAPHY: Lloyd Goodrich, *Thomas Eakins: His Life and Work* (New York, 1933). The first definitive biography and standard reference on the artist. Contains a catalogue of Eakins's works arranged chronologically and a bibliography // Gordon Hendricks, *The Life and Works of Thomas Eakins* (New York, 1974). A biography with extensive quotations from primary source material, it contains a bibliography and an illustrated checklist of the artist's works in public collections in the United States // Phyllis D. Rosenzweig, *The Thomas Eakins Collection of the Hirshhorn Museum and Sculpture Garden* (Washington, D. C., 1977). The catalogue of the collection with a chronology and a list of works // Theodor Siegl, *The Thomas Eakins Collection* [Handbooks in American Art, No. 1, Philadelphia Museum of Art] (Philadelphia, 1978). A comprehensive catalogue of the Thomas Eakins Collection at the Philadelphia Museum of Art. Contains a preface by Evan H. Turner, biographical introduction, chronology, catalogue entries, and two appendices with other works by and relating to the artist and comparative illustrations // Lloyd Goodrich, *Thomas Eakins* (Ailsa Mellon Bruce Studies in American Art), published for the National Gallery of Art, Washington, D. C. (Cambridge, Mass., and London, 1982), 2 vols. A biography by the foremost scholar on the artist, containing extensive quotations from the artist's letters, a chronology, and a bibliography.

Carmelita Requeña

After completing his studies in Paris, Eakins traveled to Spain in the fall of 1869. He spent several days in Madrid visiting the Prado, where he studied the works of Velázquez and Ribera. He then went to Seville, where on Christmas he wrote to his sister that he was painting Carmelita Requeña, the seven-year-old daughter of a family of street performers. He had posed her, he reported, looking down at some candy he had given her. This portrait of Carmelita Requeña is one of Eakins's earliest paintings and the earliest work by him in the Metropolitan Museum.

The child also posed outdoors for Eakins's first major composition, *A Street Scene in Seville*, 1870 (New York art market, 1983). Regarding that work, Eakins wrote to his father on March 29, 1870, "Picture making is new to me, there is the sun & gay colors & a hundred things you never see in a studio light" (Goodrich [1982], 1, p. 57). While that painting may have presented many difficulties for Eakins, the portrait of Carmelita was less complex. To some extent, it reflects the culmination of his studies with Léon Bonnat and

Jean Léon Gérôme as well as his more recent independent study of the Spanish masters. Executed with remarkable virtuosity, *Carmelita Requeña* shows the distance Eakins had traveled. His *Study of a Young Girl*, about 1868 (Philadelphia Museum of Art), is a carefully drawn and modeled work that bears the stamp of Gérôme's influence, whereas his *Study of a Girl's Head*, 1868–1869 (Hirshhorn Museum and Sculpture Garden, Washington, D. C.), is a bold, quickly painted work that shows the influence of Bonnat. Compared to those studies done in Paris, the bust portrait of Carmelita Requeña is vigorously painted, unusually rich in color, and firmly modeled with the strong dark and light contrasts that distinguish the best of Eakins's oil sketches.

Oil on canvas, 21 × 17 in. (53.3 × 43.2 cm.).

REFERENCES: A. Burroughs, *Arts* 5 (June 1924), p. 328, lists it in catalogue of the artist's works under "1870?" as Portrait Carmencita Requera [*sic*] owned by Mrs. Eakins // S. M. Eakins to B. Burroughs, June 29, 1926, letter in MMA Archives, says the artist David Wilson Jordan, New York, "has an interesting collection of paintings by my husband," including "a portrait head of the little Spanish dancer *Angeleta Requena*," asks if the museum would be interested in exhibiting the works, noting that they "have never been exhibited publicly in New York," and adds, "The pictures are very interesting examples of Mr. Eakins' work, the head of the dancer—low in tone I believe you would be charmed with. I remember you liked the quiet tone of 'Retrospection'" // H. G. Marceau, G. S. Parker, and L. Goodrich, *Pennsylvania Museum Bulletin* 25 (March 1930), p. 18, no. 6, list in catalogue of the artist's works as Carmencita Requera, owned by Babcock Gallery // *Parnassus* 3 (Jan. 1931), ill. p. 26, as Carmencita Requera with a note that it was shown in an important exhibition of the artist's paintings at Babcock Galleries // L. Goodrich, *Thomas Eakins* (1933), p. 162, no. 32, catalogues as Carmalita Requena; cites 1869 letter from Eakins in Seville to his sister concerning this painting: "Some candy given me, I ate a little and then gave the rest to a dear little girl, Carmalita, whom I am painting. . . . She is only seven years old and has to dance in the street every day. But she likes better to stand still and be painted. She looks down at a little card on the floor so as to keep her head still and in the right place, and when we give her the goodies she eats some and puts the nicest ones down on the card so she would be looking at them all the time she poses"; describes the picture,

Eakins, *Carmelita Requeña*.

notes the canvas has been lined, gives owner as E. C. Babcock Art Galleries, New York // M. McHenry, *Thomas Eakins Who Painted* (1946), p. 20, states that about "Christmas in Spain he had painted head and bust of seven year old Carmalita Requena" and adds that the girl and her parents posed for his Street Scene in Seville // G. M. Ackerman, *Gazette des Beaux-Arts* 73 (April 1969), ill. p. 238, fig. 3, as Carmelita Requena, 1870, whereabouts unknown; p. 239, discusses as a work influenced by Léon Bonnat, says it is similar to Bonnat's Portrait of a Young Girl, 1865, in the Louvre and the "strong contrast of light and dark reveal the structure of the girl's face" // G. Hendricks, *The Life and Work of Thomas Eakins* (1974), p. 61, describes the painting of this work from a letter to the artist's sister; color ill. pl. 5, between pp. 64–65, as Carmelita Requena, 1870, coll. Mr. and Mrs. James Fosburgh, New York // L. Goodrich, *Thomas Eakins* (1982), 1, p. 55, discusses Eakins's "first complete composition," an oil of the Requeña family, Augustín, Angelita, and their seven-year-old daughter Carmelita, street performers in Seville; ill. p. 56, fig. 14; p. 57, quotes the artist's letter to his father, March 29, 1870 (quoted above) // J. K. Howat, *The Metropolitan Museum of Art, Annual Report for the Year 1978–1979* (1979), p. 18, reports acquisition; p. 19, lists it.

Exhibited: PAFA, 1917–1918, *Memorial Exhibition of the Works of the Late Thomas Eakins*, no. 76, as Carmencita Requira [*sic*] lent by Mrs. Thomas Eakins // Babcock Galleries, New York, Summer 1928, *Exhibition by American Artists*, no. 7, as Carmencita // Babcock Galleries, New York, Summer 1929, *Paintings, Water Colors, Etchings by American Artists*, no. 13, as Carmencita Requera // Babcock Gallery, New York, March 1936, *Opening Exhibition at the New Galleries, Paintings by American Masters*, no. 4, as Carmencita // National Gallery of Art, Washington, D. C., Art Institute of Chicago, and Philadelphia Museum of Art, 1961–1962, *Thomas Eakins, a Retrospective Exhibition*, cat. by L. Goodrich, ill. p. 38, no. 4, as Carmalita Requena, 1869–1870, lent by Mr. T. Edward Hanley, quotes Eakins's 1869 letter to his sister concerning this painting and notes that the subject was one of the models for A Street Scene in Seville // Philadelphia Museum of Art, MFA, Boston, 1982, *Thomas Eakins, Artist of Philadelphia*, exhib. cat. by D. Sewell, color ill. p. 2, no. 1; p. 5, suggests that the picture is a preliminary study for A Street Scene in Seville, says the technique is similar to that in The Strong Man (Philadelphia Museum of Art) but freer and perhaps reflects the artist's studies with Bonnat.

Ex coll.: the artist's widow, Susan Eakins, Philadelphia, from 1916; possibly David Wilson Jordan, New York, by 1926–1928; with Babcock Galleries, New York, by 1928–at least 1936; Mr. T. Edward Hanley, Bradford, Pa., 1961–1962; Mr. and Mrs. James Fosburgh, New York, by 1974–1978.

Bequest of Mary Cushing Fosburgh, 1978.

1979.135.2.

Max Schmitt in a Single Scull (The Champion Single Sculls)

Eakins's early works were largely autobiographical. They depicted his family, friends, and favorite outdoor sports—rowing, sailing, and hunting. Shortly after his return to the United States in July 1870, he began the first of a series of rowing pictures. Painted between 1870 and 1874, they are an impressive demonstration of Eakins's commitment to realism—the accurate and objective representation of the three-dimensional, based on close observation, a painstaking study of perspective, and the use of light to define form. *Max Schmitt in a Single Scull*, dated 1871, is perhaps the most celebrated of these works. It shows Eakins's boyhood friend Max Schmitt (1843–1900), a champion oarsman, in a shell on the Schuylkill River in Philadelphia. Schmitt served as Eakins's model on other occasions: in the oil *Sketch of Max Schmitt in a Single Scull*, ca. 1870–1871 (Philadelphia Museum of Art), which is a preparatory study for the second figure from the right in the oil painting *Oarsmen on the Schuylkill*, ca. 1871 (coll. Hirschl and Adler Galleries, New York), and as the musician in the watercolor *The Zither Player*, 1876 (Art Institute of Chicago).

Eakins, who spent many hours sailing on the Delaware and rowing on the Schuylkill, put himself in this painting in the distant boat, inscribed with his name and the date. Schmitt's scull is inscribed Josie and was named after his sister. The other craft shown on the river bear witness to the popularity of rowing as a sport in nineteenth-century Philadelphia. A flock of ducks swim on the left, and a steamboat appears in the distance beyond two bridges identified as the Girard Avenue Bridge and the Connecting Railroad Bridge. The leafless trees along the left bank and the austere autumnal colors of the landscape led Gordon Hendricks (1974) to suggest that the painting was started in the fall of 1870. Elizabeth Johns (1983) later found that the work probably commemorates Schmitt's victory in a single scull competition on October 5, 1870.

Eakins's practice during this period was to make extensive studies for his paintings. These included elaborate perspective drawings, such as those for *The Pair-oared Shell*, 1872 (Philadelphia Museum of Art), and more immediate, broadly painted impressions to record basic forms in dark and light, such as his sketch of Max Schmitt

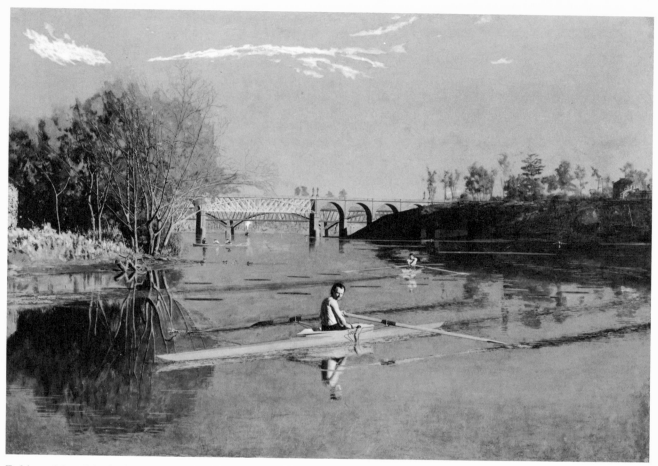

Eakins, *Max Schmitt in a Single Scull* (*The Champion Single Sculls*).

(Philadelphia Museum of Art). Without doubt Eakins followed the same procedure for this work, which is one of his most ambitious and complex early compositions. *Max Schmitt* is essentially a traditional studio piece, a carefully premeditated work based not only on precise perspective drawings but also on quick plein-air studies. Yet, except for *Drawing of the Girard Avenue Bridge with Sketch of an Oar on the Verso*, ca. 1871 (Hirshhorn Museum and Sculpture Garden), no studies are known.

This is one of Eakins's most elaborate treatments of an American subject drawn from his own experience. It is an extraordinarily accomplished work for an artist in his late twenties. The technique and style demonstrate Eakins's highly individual construction of a painting and reflect his formal training with Gérôme. The foreground figures, the trees, and the bridges are drawn with the detailed precision of a master draftsman; in contrast, the peripheral setting, especially the foliage in the left foreground and right distance, is suggested by scumbling rather than defined. Although as a teacher Eakins later advocated drawing with a brush, this early composition shows his dependence on the pencil. Traces of pencil are especially evident in the foreground scull. Linear elements predominate, reflecting the emphasis on drawing in the curriculum of the Ecole des Beaux-Arts as well as the exacting finish that characterized the work of Gérôme, Eakins's chief mentor in Paris. The composition has a strong geometric structure, which gives it much of its classical character. One suspects that Eakins composed this work and others of the same period by drawing a vertical line down the center of the canvas and intersecting it by a horizontal line on which he established the correct vanishing point as a guide in placing objects as they appear in space. Positioning Max Schmitt on that central vertical axis and in direct confrontation with the spectator makes him the focal point of the composition and provides an underlying symmetry. His importance and, to a lesser extent, that of Eakins in the distant boat are reinforced by the extreme realism and detail with which they are painted. The calculation and geometry are evident in a series of corresponding motifs; for example, a slender, diagonal cloud echoes the diagonal of Schmitt's scull, and the irregular grid of the tree branches corresponds to the grid of the bridges. Eakins's palette became increasingly austere

and restricted, influenced perhaps by his study of the works of such Dutch and Spanish masters as Rembrandt and Velázquez. Here the palette is still somewhat varied. Although earth colors like gray and brown predominate, they are relieved by the intense blue of the heavily painted sky and scattered touches of red, in the artist's belt, the inscription on his shell, the boat on the left, and the bridge in the distance. These touches of red also help to unify the composition.

Long known as *Max Schmitt in a Single Scull*, this painting was identified by Gordon Hendricks (1968) as *The Champion Single Sculls*. It was one of two works shown in what Hendricks discovered was Eakins's first public exhibition, which opened on April 26, 1871, at the Union League of Philadelphia. The other work, *Portrait* lent by M. H. Messhert, is now unlocated. Reviews of Eakins's debut were mixed. The *Philadelphia Evening Bulletin* reported that Eakins,

lately returned from Europe and the influence of Gérôme, has also a picture, entitled "The Champion Single Sculls" (No. 137), which, though peculiar, has more than ordinary interest. The artist, in dealing so boldly and broadly with the commonplace in nature, is working upon well-supported theories, and, despite a somewhat scattered effect, gives promise of a conspicuous future.

The critic added, "A walnut frame would greatly improve the present work." The *Philadelphia Inquirer* said:

Thomas Eakins shows . . . a portrait and a river scene, entitled "The Champion Sculls." While manifesting a marked ability, especially in the painting of the rower in the foreground, the whole effect is scarcely satisfactory. The light on the water, on the rower and on the trees lining the bank indicate that the sun is blazing fiercely, but on looking upward one perceives a curiously dull leaden sky.

The intensity of the blue sky in the painting and the restriction of this heightened blue area to the center of the work suggest that Eakins may have reworked it at some point after this exhibition.

The painting belonged to Max Schmitt and, following his death in 1900, to his widow. She lent it to the Pennsylvania Museum of Art in 1930 where it was exhibited as *On the Schuylkill above Girard Bridge*. It was acquired by Mrs. Eakins that same year and bought from her by the Metropolitan Museum in 1934.

Oil on canvas, 32¼ × 46¼ in. (81.9 × 117.5 cm.).
Signed and dated on scull in background: EAKINS / 1871.

Eakins,
Drawing of the Girard Avenue Bridge, ca. 1871. Hirshhorn Museum and Sculpture Garden.

RELATED WORK: *Drawing of the Girard Avenue Bridge with Sketch of an Oar on the Verso (Studies for Max Schmitt in a Single Scull)*, pencil on paper, 4⅛ × 6⅞ in. (10.4 × 17.3 cm.), ca. 1871, Hirshhorn Museum and Sculpture Garden, Smithsonian Institution, Washington, D. C., ill. in P. D. Rosenzweig, *The Thomas Eakins Collection of the Hirshhorn Museum and Sculpture Garden* (1977), p. 49, no. 17.

REFERENCES: *Philadelphia Inquirer*, April 27, 1871, p. 4, reviews it in the exhibition at the Union League of Philadelphia, which opened April 26, 1871 (quoted above) // *Philadelphia Evening Bulletin*, April 28, 1871, p. 1 (quoted above) // *Philadelphia Daily Evening Telegraph*, April 29, 1876, p. 7, calls Eakins "a thoroughly accomplished artist who has, during the four or five years that have elapsed since he first exhibited in Philadelphia at one of the Union League art receptions, been steadily growing" // A. Burroughs, *Arts* 5 (June 1924), p. 329, lists it under 1873? as Max Schmidt [*sic*] in a Single Scull, owned by Mrs. Max Schmidt [*sic*] // H. G. Marceau, G. S. Parker, and L. Goodrich, *Pennsylvania Museum Bulletin* 25 (March 1930), p. 18, no. 12, lists it as On the Schuylkill above Girard Bridge, lent by Mrs. Louise S. M. Nache to the Thomas Eakins exhibition at the Pennsylvania Museum of Art // L. Mumford, *The Brown Decades* (1931), pp. 214–215, notes, "Eakins admired the oarsmen in their shells on the Schuylkill; and he went back again and again to the prize ring. He seized the moment of pause, the return of the fighter to his corner, the oarsman resting on his oars, and he communicated, in these resting figures, a deeper sense of actuality than any snapshot of fleeting and combative moments" // L. Goodrich, *Thomas Eakins* (1933), p. 39, says, "Rowing was one of the most popular sports of the time; the Schuylkill, lined with boat clubs, was always alive with shells. Eakins himself rowed, and was friendly with the champion oarsmen; and many of his early pictures were of rowers. One of the first shows his boyhood friend Max Schmitt resting on his oars in

his shell *Josie*, while in the distance the artist himself is seen rowing; it is a still, sunny afternoon, with glassy water, and one can almost feel the heat"; p. 163, no. 44, catalogues it as Max Schmitt in a Single Scull, describes it, notes that it is also called On the Schuylkill above Girard Bridge, says that it was given by the artist to Max Schmitt and purchased in 1930 from his widow by Mrs. Eakins, who is given as the owner; pl. 5 // *Index of Twentieth Century Artists* 1 (Jan. 1934), suppl. to 1, no. 4, p. i, lists it and reproductions; suppl. to 1, nos. 4 and 12, p. iii, lists reproductions // B. Burroughs, *MMA Bull.* 29 (Sept. 1934), ill. cover; pp. 151–152, describes it and identifies the figure in the background as Eakins; ill. p. 152, detail of Eakins's portrait; p. 153, compares with other paintings by Eakins and notes that "the variety and lustiness of this youthful work give it a particular and perhaps more general appeal"; p. 155 // *Art Digest* 9 (Oct. 1934), ill. p. 13, announces acquisition // A. Burroughs, *Limners and Likenesses* (1936), p. 199, calls it "the first and most stunning" of Eakins's rowing pictures and says it recalls the work of the Hudson River school artists; fig. 179 // F. A. W[hiting], Jr., *Magazine of Art* 33 (Jan. 1940), ill. p. 50 // H. Saint-Gaudens, *Carnegie Magazine* 14 (Oct. 1940), ill. p. 139 // R. McKinney, *Thomas Eakins* (1942), p. 14, says, "Greatly intrigued by the play of light on objects he went so far as to prepare miniature models of forms to be used in his arrangements so that he might study them in natural light in order to achieve the correct tones. This method was first used in the preparation of his famed rowing pictures, painted between 1871 and 1874. These productions were created in his studio but the preliminary work was done on location. Possessed of the 'reporter's eye,' Eakins quickly registered details in countless sketches"; ill. p. 65 // M. Varga, *Studio* 125 (April-May 1943), ill. p. 116 // L. Goodrich and H. Marceau, *Philadelphia Museum Bulletin* 39 (May 1944), ill p. 123; p. 134, no. 13, lists it in checklist of the *Thomas Eakins Centennial Exhibition* // *Antiques* 45

Thomas Eakins

(June 1944), ill. p. 316, and describes this painting as an example from the group of boating pictures in which Eakins's "preoccupation with problems of perspective, reflection, and refraction are handled masterfully" // M. McHenry, *Thomas Eakins Who Painted* (1946), p. 23, discusses Eakins's interest in perspective and boating // O. W. Larkin, *Art and Life in America* (1949), p. 272 // V. Barker, *American Painting* (1950), pp. 653–654, says that in this work "the human incident is only a subordinate device for a painting of the level light of a late afternoon sun conferring a timeless majesty upon this familiar space of river and sky"; p. [655], pl. 98 // P. Tyler, *American Artist* 16 (March 1952), ill. p. 42, discusses it // R. B. Hale, *MMA Bull.* 12 (March 1954), color ill. on cover p. 176, notes that the work reveals Eakins's "firm belief that nature cannot be adequately expressed unless intellectually comprehended"; ill. p. 185 // P. Tyler, *Art News* 56 (March 1957), ill. p. 41, detail of Max Schmitt, and discusses // A. T. Gardner, *MMA Bull.* 16 (Summer 1957), ill. p. 8 // M. D. Schwartz, *Apollo* 66 (Dec. 1957), ill. p. 193 // F. Porter, *Thomas Eakins* (1959), p. 27, notes, "The light in his paintings is hardly pervasive; even in *Max Schmitt* [*sic*] *in a Single Scull* . . . the dark accents win out"; color pl. 8 // Mrs. A. F. Carey, July 13, 1960, letter in MMA Archives, notes, "Max Schmitt was my father and the above painting hung in our parlor until my Mother came West, when I think she returned it to Mrs. Eakins" // L. E. Scanlon, *College Art Journal* 19 (Summer 1960), ill. p. 323, fig. 1; pp. 323–324, discusses its formal aspects and Eakins as "a functionalist" // D. L. Smith, *American Artist* 24 (Nov. 1960), ill. p. 28; p. 71, discusses it // G. Byrd, *Art Journal* 23 (Fall 1963), p. 133, records Charles Bregler's quoting Eakins: "When I came back from Paris, I painted those rowing pictures. I made a little boat out of a cigar box and rag figures, with the red and white shirts, blue ribbons around the head, and I put them out into the sunlight on the roof and painted them, and tried to get the true tones" // S. Schendler, *Eakins* (1967), p. 33, discusses Gérôme's influence on Eakins's technique and calls this painting an "early masterpiece"; p. [34], fig. 11; p. 35, notes that it "is a melancholy painting, asserting the impossible contraries of existence in time" // G. Hendricks, *MMA Bull.* 26 (March 1968), pp. 306–307, identifies the painting as the work called The Champion Single Sculls, shown with a now unlocated portrait lent by M. H. Messhert at the third and final exhibition of the Union League, Philadelphia, in April 1871; notes that this was Eakins's first public exhibition; cites contemporary reviews from the *Philadelphia Evening Bulletin* and the *Inquirer*; says that it was painted in late fall or early spring and suggests that, while dated 1871, it might have been begun in the autumn of 1870; p. 307, fig. 3, detail of Eakins's self-portrait // J. Wilmerding, *A History of Marine Painting* (1968), p. 225, fig. 150; p. 226, says that Eakins's "interests in the functioning of

anatomy, the properties of photography, and the application of mathematics to the construction of a picture conjoined in his well-known series of scullers and boaters around Philadelphia. Of these one of the most familiar and popular is *Max Schmitt in a Single Scull.* . . . Rendering every detail of figures, objects, and landscape, Eakins comes close to the optical precision of photography"; discusses the construction of the work, Eakins's use of reflections, grids, and perspective; notes that it "has a deceptive organization around a wide variety of angles and curves integrated both as a design on the surface and also locked together in space" // G. Hendricks, *Art Bulletin* 51 (March 1969), p. 57 // B. Novak, *American Painting of the Nineteenth Century* (1969), p. 191, discusses Eakins's boating pictures and his methods and notes that "direct observation, secondary re-creation through the model, and mathematical (sometimes mechanical drawing) aids were all brought to bear on a single picture"; color ill. II–1, p. 192; p. 193, discusses Eakins's "combining *process*" and notes that "in his early masterpiece, *Max Schmitt in a Single Scull* (1871) . . ., one can isolate sections that seem to have drawn on immediate plein-air response, that were probably painted on the spot, as, for example, the trees at the left, where the stroke is lighter and more spontaneous. But the figure of Schmitt himself is so sharply focused that it is more likely a studio portrait, too heavy in its plastic assertiveness for the fragile, ideographic boat. One senses that boat, man and water were not all apprehended and painted simultaneously but put together out of different aspects of the painter's experience and sensibility. The burnished portions of the painting, the quiet detail near the boat in the left background, and the studied still-life observation of the oars in the foreground recall that particular conjugation of memory and knowledge peculiar to luminism"; p. 200 // J. D. Prown, *American Painting from Its Beginnings to the Armory Show* (1969), p. 92 // Whitney Museum of American Art, New York, *Thomas Eakins, Retrospective Exhibition* (1970), cat. by L. Goodrich, p. 14 // J. T. Flexner, *Nineteenth Century American Painting* (1970), p. 229; ill. pp. [230–231] // D. F. Hoopes, *Eakins Watercolors* (1971), p. 16, says, "In 1871, he began work on a picture of a boyhood friend rowing on the Schuylkill River: *Max Schmitt in a Single Scull.* . . . Such a subject had never appeared before in American painting. At twenty-seven, Eakins already showed a prodigious mastery; he had successfully established a bridge between his own heritage of luminism and the clarity of color and precision of drawing of his European teachers. He surpassed Gérôme in this picture precisely because he understood that light is transparent and must be rendered transparently. Moreover, his sense of spatial relationships is refined in the Schmitt picture to a point which vindicates his scientific realism in both a pictorial and a mathematical way"; p. 58 // D. Dwyer, Paintings Conservation, MMA, Fall 1974, reported that there was a section of old restora-

tion along the bottom of the picture // G. Hendricks, *The Life and Work of Thomas Eakins* (1974), between pp. 64 and 65, color pl. 10, detail of the painting shows Schmitt and Eakins; between pp. 64 and 65, color pl. 11, detail of the painting shows Schmitt; pp. 70–71, notes that portrait by Eakins lent by M. H. Messhert (identified as Mr. Messchert) and this picture of Schmitt and Eakins, then called *The Champion Single Sculls*, were included in an exhibition at the Union League of Philadelphia from April 26 to 29, 1871, which was Eakins's first public exhibition of his work; notes that "Schmitt's daughter thinks she remembers her father saying he posed for the painting on the roof outside Eakins's studio. But she may be confusing this memory with another story with which she was familiar—that the model for Eakins's *Crucifixion* . . . was posed on the roof outside the studio. In any case we know that the artist could not have painted Schmitt from where he is shown in the picture, at a considerable distance from the left bank of the Schuylkill, upstream from the Girard and Connecting Railroad bridges; quotes from reviews; and says that "*The Champion Single Sculls* is primarily a portrait and only secondarily a genre or anecdotal picture"; p. 333, CL–175, lists it // D. Sellin, *Bulletin, Philadelphia Museum of Art* 70 (Spring 1975), p. 37, discusses Eakins's exhibition of this work at the Union League of Philadelphia in 1871 and quotes reviews from the *Bulletin* and the *Inquirer* // *MMA Bull.* 33 (Winter 1975–1976), color ill. no. 56, p. 242 // J. Wilmerding, *American Art* (1976), pp. 137–138, discusses it and notes that the inclusion of a self-portrait was "a symbolic signature, both referring to first-hand experience, and signifying the artist's literal embodiment of self in his art"; says that Eakins "made careful perspective drawings to place his friend Max Schmitt explicitly in space, but implicitly as well in a coherent metaphysical structure"; pl. 164 // Museum of Fine Arts, Houston, and the Brooklyn Museum, *Gustave Caillebotte, a Retrospective Exhibition* (1976–1977), cat. by J. K. T. Varnedoe and T. P. Lee, p. 49, fig. 3, compares to Caillebotte's work // B. Dunstan, *American Artist* 41 (Jan. 1977), ill. p. 78, and analyzes the painting; color ill. p. 79 // M. W. Brown, *American Art to 1900* (1977), color pl. 71, p. [573], pp. 503–504, calls it "a striking innovation in the history of Realism as well as American genre painting"; suggests possible affinities to impressionism and "luminism" but observes that "it projects a new kind of vision, photographic in inspiration or influence, concerned with objective recording without reference to theory, memory or sentiment"; notes that, "except for Degas, Eakins was the first to grapple with the aesthetic of photographic vision, the stop-action moment of eternity"; says that it is "modern in the unquestioning acceptance of the mechanical elegance of the bridges, American in its cool, limpid light. But the contradiction between the sharp focus of studied detail and the immediate im-

pression of visual experience creates an aesthetic ambivalence—a kind of frozen animation—and a poetic quietude that Barbara Novak feels to be peculiarly American"; compares with Homer's work // Slack Hall, North Cross School, Roanoke, Va., *Thomas Eakins, Susan Macdowell Eakins, Elizabeth Macdowell Kenton* (1977), exhib. cat. by D. Sellin, p. 15 // P. D. Rosenzweig, *The Thomas Eakins Collection of the Hirshhorn Museum and Sculpture Garden* (1977), p. 32, no. 9; p. 49, no. 17, illustrates and catalogues drawing for this painting; p. 49, n 2, discusses the painting; p. 235, no. 17, lists studies // T. Siegl, *The Thomas Eakins Collection [Philadelphia Museum of Art]*, (1978), intro. by E. M. Turner, p. 53, no. 8, illustrates and catalogues Sketch of Max Schmitt in a Single Scull, about 1870–71, notes that it was probably used for Eakins's painting Oarsmen on the Schuylkill, ca. 1871, says that Eakins "probably abandoned the picture, turning instead to *Max Schmitt in a Single Scull* . . ., his most successful and best-known rowing picture," comments that the "unresolved problems of representing reflections in water suggest that Eakins painted Oarsmen on the Schuylkill before either *Max Schmitt in a Single Scull*, dated 1871, or *The Pair-Oared Shell*, dated 1872" (Philadelphia Museum of Art), notes that the sketch "may be the very first rowing picture Eakins painted" and that all of his "rowing pictures were created in less than four years, between the second half of 1870 and 1874" // J. Wilmerding, *Arts Magazine* 53 (May 1979), pp. 108, 111 // R. Onorato, *Arts Magazine* 53 (May 1979), p. 126 // E. Johns, *Arts Magazine* 53 (May 1979), p. 131, reevaluates Eakins's realism with this painting as an example // L. Goodrich, *Thomas Eakins* (1982), 1, p. 7; p. 81, describes it and says, "This was a scene completely familiar to the artist, observed firsthand, and recorded with fidelity to reality"; p. [82], color pl. 26; p. 83, states that there "was no trace of a derived style" in the work and that for such a young artist "the absolute sureness was remarkable"; p. 94, says, "Max Schmitt was so precisely pictured that the painting was in one sense an outdoor portrait"; p. 100, discusses perspective drawings, suggests that some were not preserved and that "a painting as finely designed in three dimensions . . . would almost certainly have been constructed in this way"; p. 107, lists with early paintings that "exhibit a technical command remarkable in so young a painter"; p. 120, records its exhibition at the Union League of Philadelphia in 1871 as The Champion Single Sculls and quotes review; p. 165, notes that Eakins gave away some of his best oils, including this one; p. 287, says that "nothing stood between him [Eakins] and the motif in nature" and cites this work, "his first outdoor painting in America," as an example // E. Johns, *Thomas Eakins* (1983), pp. 19–22, discusses this work, preparatory drawings, technique, and style; p. 22, n 7, discusses condition of the painting and observes that the color of the sky, criticized in 1871, today "does not seem inharmonious with the rest of

the work"; pp. 23–37, discusses the history of rowing in America, Max Schmitt, and Eakins's rowing pictures; pp. 37–39, records Schmitt's victory in a race held on October 5, 1870, suggests that this painting commemorates that victory, that Eakins included himself as a witness, and that he faithfully portrayed the autumn day; p. 40, analyzes composition; pp. 41–45, discusses artist's rowing pictures and the changes in the sport; between pp. 42 and 43, color pl. 1, detail.

EXHIBITED: Union League, Philadelphia, 1871, no. 137, as The Champion Single Sculls // Pennsylvania Museum of Art, Philadelphia, 1930, *Thomas Eakins, 1844–1916*, no. 12, as On the Schuylkill above Girard Bridge, lent by Mrs. Louise S. M. Nache (see *Pennsylvania Museum Bulletin* [March 1930]) // Babcock Galleries, New York, 1930–1931, *Thomas Eakins*, no. 2, as Oarsman // M. H. de Young Memorial Museum, San Francisco, 1935, *Exhibition of American Painting*, no. 107 // Musée du Jeu de Paume, Paris, 1938, *Trois Siècles d'art aux Etats-Unis*, no. 50 // MMA, 1939, *Life in America*, no. 229 // Carnegie Institute, Pittsburgh, 1940, *Survey of American Painting*, no. 182 // MFA, Boston, 1944, *Sport in American Art*, no. 25 // Philadelphia Museum, 1944, *Thomas Eakins Centennial Exhibition*, ill. p. 123; p. 134, no. 13 (see checklist in *Philadelphia Museum Bulletin* [May 1944]) // MMA, 1950, *20th Century Painters*, p. 5 // Century Association, New York, 1951, *Eakins-Homer Exhibition*, no. 3 // Albright Art Gallery, Buffalo, 1952, *Expressionism in American Painting*, p. 15, no. 6 // PAFA, Philadelphia, 1955, *150th Anniversary Exhibition*, no. 56 // MMA, 1958–1959, *Fourteen American Masters*, no cat. // National Gallery of Art, Washington, D. C., Art Institute of Chicago, and Philadelphia Museum of Art, 1961–1962, *Thomas Eakins, a Retrospective Exhibition*, cat. by L. Goodrich, pp. 14–15, 18, 40, no. 6 // MMA, 1965, *Three Centuries of American Painting*, unnumbered cat. // Brooklyn Museum, Virginia Museum of Fine Arts, Richmond, and California Palace of the Legion of Honor, San Francisco, 1967–1968, *Triumph of Realism*, exhib. cat. by A. von Saldern, pp. 48, 79, no. 79; ill. p. [161], no. 79 // MMA, 1970, *19th-Century America, Paintings and Sculpture*, exhib. cat. by J. K. Howat and N. Spassky, no. 154 // MFA, Boston, 1970, *Masterpieces of Painting in the Metropolitan Museum of Art*, cat. by E. A. Standen and T. M. Folds, color ill. p. 108, and discusses it // National Gallery of Art, Washington, D. C., City Art Museum of Saint Louis, and Seattle Art Museum, 1970–1971, *Great American Paintings from the Boston and Metropolitan Museums*, exhib. cat. by T. N. Maytham, p. 97, no. 59; ill. p. 98, no. 58 // Pushkin Museum, Moscow, and Hermitage, Leningrad, 1975, *100 Kartin iz Muzeya Metropoliten, Soedinennie Shtati Ameriki* [*100 Paintings from the Metropolitan Museum, United States of America*], color ill. no. 91; pp. 248–249, catalogues it // MMA, 1976, *A Bicentennial Treasury* (see *MMA Bull.* 33) // Philadelphia Museum of Art and MFA, Boston, 1982, *Thomas Eakins, Artist of Philadelphia*, exhib. cat. by D. Sewell, color ill. p. 14, no. 12;

p. 15, says Eakins's concentration on the subject of rowing in the series of oils and watercolors done between 1870 and 1874 "indicates that he used the subject to master a whole range of new artistic problems"; p. 16, states that some "paintings appear to commemorate specific events, such as Max Schmitt's victories on the Schuylkill in the summer of 1870," says, "there is something of a private joke in the way that Eakins rows rapidly into the distance, ... while his friend turns to look out of the picture," notes that Eakins "re-created the scene, assembling it in his studio from various studies, which he made before he began the final painting—a process of 'combination' in the literal sense," a method he would have learned from Gérôme, suggests oil sketch of Max Schmitt in a Single Scull was done out of doors; pp. 17–18, calls the painting ambitious and states, "the artist's difficulties with resolving his various studies into a pictorial whole are apparent. Every aspect of the scene seems to have been not only studied separately but also painted with an individual technique, so that men, water, trees, bridges each have their own material quality," quotes review from 1871 exhibition; compares with The Pair-oared Shell, 1872, and other rowing pictures // MFA, Boston, Corcoran Gallery of Art, Washington, D. C., and Grand Palais, Paris, 1984, *A New World*, intro. by T. E. Stebbins, Jr., p. 11; essay by H. B. Weinberg, pp. 27–28, states that Eakins's rowing pictures of the 1870s, especially this one, "may be considered domestications of Gérôme's exotic river scenes, and they retain some of the basic characteristics of Gérôme's works: careful arrangements of forms and their interrelationships, meticulously observed and recorded anatomical and costume detail, overall focus, and glowing light emanating from the horizon"; color ill. detail p. 116, no. 57; color ill. p. 117, no. 57; cat. entry by C. Troyen, ill. p. 266, no. 57, notes inconsistency of technique.

EX COLL.: Max Schmitt, Philadelphia; his widow, Mrs. Louise S. M. Nache, until 1930; Mrs. Thomas Eakins, Philadelphia, 1930–1933 (consigned to Babcock Galleries, New York, 1930–1931); with Milch Galleries, New York, 1934.

Purchase, Alfred N. Punnett Endowment Fund and George D. Pratt Gift, 1934.

34.92.

Pushing for Rail

Eakins's father and his friends George Morris and William R. Hallowell owned a boathouse on the Cohansey River west of Fairton in Cumberland County, New Jersey. Eakins made regular trips with them there and along the marshes of the Delaware River to hunt rail. The sport, long popular with Philadelphians, was the theme

of a series of paintings that he did during the 1870s. *Pushing for Rail*, one of his most extensive treatments, was painted in 1874, four years after he returned from Europe. According to his custom at that time, Eakins sent the work and two others to his former teacher, Jean Léon Gérôme, for criticism. Gérôme, in turn, was to pass them on to his father-in-law, the dealer Goupil. In a long letter, written in May 1874, Eakins explained the sport to Gérôme:

I am sending you two little paintings and one water color. The first represents a delightful hunt in my country, a hunt arranged so that one arrives at the edge of the marsh two or three hours before the height of the tide. As soon as the water is high enough for the boat to be floated on the marsh, the men get up and begin the hunt. The pusher gets up on the deck and the hunter takes a position in the middle of the boat (so as not to have his head buried), the left foot forward a little. The pusher pushes the boat among the reeds. The hunter kills the birds which take wing. I show in my first boat the movement when a bird starts to rise. The pusher cries, "Mark," and being on the pusher's deck, stiffens up and tries to stop the boat or at least to hold it firmer. . . . I have chosen to show my old codgers in the season when the nights are fresh with autumn, and the falling stars come and the reeds dry out.

Gérôme, in a letter to Eakins dated September 18, 1874, acknowledged receipt of the pictures, commended his progress, and, although doubting the commercial potential of the works, noted that he was delighted to have a student in the new world who was such a credit to him.

As *Une Chasse aux Etats-Unis*, this painting is said to have been exhibited at the Paris Salon in 1875 with another work by Eakins that was given the same title in the catalogue and is identified by Lloyd Goodrich as *Starting Out after Rail*, 1874 (MFA, Boston).

In a letter dated June 1, 1875, Eakins's lifelong friend William Sartain (1843–1924) noted that Eakins's works attracted "a good deal of attention" at the Salon. Judging from two contemporary reviews, however, the reception was mixed. One of the more favorable notices was Paul Leroi's in *L'Art*:

Mr. Thomas Eakins, a disciple of Mr. Gérôme's . . . has sent from Philadelphia a very strange painting; it is, however, far from being without merit. *Une Chasse aux Etats-Unis* (no. 757) is a true work of precision; it is rendered like a photograph. There is a veracity of movement and details that is truly great and singular. This exotic product teaches you something, and

its author is not one to be forgotten. We are dealing with a seeker with a will; it is necessary to wait and see what he finds and if his discoveries may be worthwhile and better still.

F. de Lagenevais in the *Revue des Deux Mondes* gave a description that raises the question of whether *Pushing for Rail* was one of the works shown in Paris in 1875.

These two canvases [which Mr. Eakins has sent us from Philadelphia], each containing two hunters in a boat, resemble photographic prints covered with a light watercolor wash to such a degree that one asks oneself whether these are not specimens of a still secret industrial process, and that the inventor may have maliciously sent them to Paris to upset Mr. Detaille and frighten the French school.

The museum's painting has more than two hunters but still they are paired off two hunters to a boat. Although it remains uncertain which Eakins paintings were shown at the Salon, it is likely that *Pushing for Rail* was one of them.

Eakins submitted the painting to the annual exhibition of the National Academy of Design in 1877, where it was shown as *Rail Shooting on the Delaware* and offered for sale at three hundred dollars.

Several years later, *Pushing for Rail* provided the inspiration for what apparently were to be Eakins's last illustrations, *A Pusher* and *Rail-Shooting*. During the late summer of 1880, Joseph Pennell (1857–1926), one of Eakins's students, conceived the idea for an illustrated article about the area known as "The Neck," between the Schuylkill and Delaware rivers, south of Philadelphia. The idea was accepted by Alexander W. Drake, art editor of *Scribner's Monthly*, and the story, "A Day in the Ma'sh" by Maurice F. Egan, appeared in July 1881 with illustrations by Pennell, Henry R. Poore (1859–1940), and Eakins. *A Pusher* was based on the black poleman at the far left of *Pushing for Rail*. *Rail-Shooting* was based on the painting called *Will Schuster and Blackman Going Shooting for Rail*, 1876 (Yale University, New Haven). The poleman and hunter in that picture are closely related to the two figures in the boat at the far right of *Pushing for Rail*, which is dated two years earlier. In preparation for the wood engravings, Eakins made monochrome wash drawings *The Poleman in the Ma'sh*, ca. 1881 (National Gallery of Art, Washington, D. C.), and *Rail Shooting*, ca. 1881 (Yale University, New Haven).

In May 1896, *Pushing for Rail* was exhibited

Detail of poleman in Eakins, *Pushing for Rail*.

Eakins, *The Poleman in the Ma'sh*,
ca. 1881, wash drawing in sepia and white
over pencil. National Gallery of Art.

at Earles' Galleries in Philadelphia. Evan H. Turner (1979), who reconstructed the exhibition through contemporary reviews, noted that the painting was called *Shooting at the Rope Ferry* in the *Philadelphia Daily Evening Telegraph* for May 16, 1896. In the spring of 1916, the work was included in the annual exhibition of the Pennsylvania Academy. There it was seen by J. ALDEN WEIR, who recommended its purchase to the Metropolitan Museum as an addition to the Hearn collection. In an undated letter to Bryson Burroughs, the curator of painting, Weir referred to it as "hunting the rice birds" and noted that it was a work "painted some thirty or more *years* ago *but* one of great beauty." One of Weir's pupils, Joseph T. Pearson, Jr. (1876–1951), reported to Weir's daughter:

your father . . . came over to Philadelphia to see the . . . exhibition of that very great man Eakins. We saw the pictures together, and as we passed along the line we came upon a small and until that moment very little known picture. . . . One who knew your father may readily understand the appeal that picture would have for him. It has the interest of a Currier and Ives print; the detail and finish of a great Dutch picture; an integrity and unaffected charm seldom equalled. So easily might its worth be unsuspected that even today it may have remained unknown had it not been for your father's ready realization of its charm (see D. W. Young, 1960).

Informed of the museum's purchase of *Pushing for Rail*, Eakins wrote Burroughs on April 23, 1916: "I thank you very much for the kindly interest you have taken in my work. I sincerely wish the Museum had chosen a larger and more important picture, such as 'The writing master.'" *Pushing for Rail* is, nonetheless, one of the most satisfactory of Eakins's early figure and genre

Eakins, *Rail Shooting from a Punt*, ca. 1881, wash drawing. Mabel Brady Garvan Collection, Yale University.

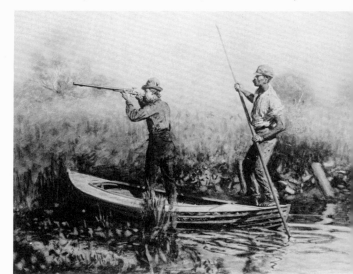

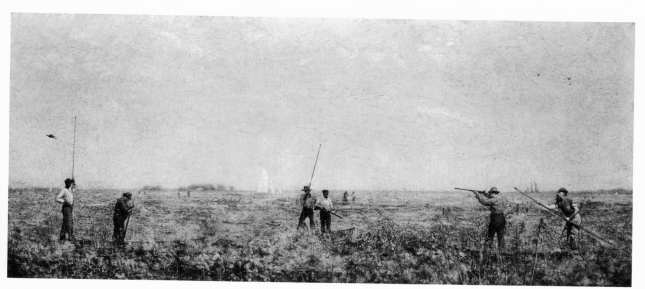

Eakins, *Pushing for Rail*.

compositions. Like *The Artist and His Father Hunting Reed-Birds* (coll. Mr. and Mrs. Paul Mellon), believed to have been painted in the same year, it is based on Eakins's own experience and observations. Although none of the figures have been identified, a few give the impression of having been done from life. Ellwood C. Parry III and Maria Chamberlin-Hellman (1973) suggested pictorial precedents for the pair of figures in the boat on the right. They cited as an example the compositional similarity to *Rail Shooting on the Delaware*, a chromolithograph published by John Smith in Philadelphia in 1866. They also noted the strong narrative element in the painting, which serves to unify the three pairs of figures. The figures in the foreground are arranged in frieze-like fashion, reminiscent of the continuous narrative in classical art, although here the protagonists do not reappear in successive episodes within the same frame or share a ground line. The figures, guns, and poles not only tell the story but also punctuate the horizontal composition with strong vertical elements. The three-inch figures, described with the precision of a miniature painter, are in sharp focus in contrast to the scumbled, undifferentiated reeds. Indistinct figures and vessels in the background reinforce the illusion of depth.

Oil on canvas, 13 × 30 1/16 in. (33 × 76.4 cm.).
Signed and dated at lower right: EAKINS 74.

RELATED WORKS: *Will Schuster and Blackman Going Shooting for Rail*, oil on canvas, 22 1/8 × 30 1/4 in. (56.2 × 76.8 cm.), 1876 (Yale University, New Haven, ill. in E. C. Parry III and M. Chamberlin-Hellman, *American Art Journal* 5 (May 1973), p. 41, fig. 24 // *Rail Shooting*, wash drawing, 8 7/8 × 12 3/16 in. (22.5 × 31 cm.), ca. 1881, Yale University, New Haven, ill. ibid., p. 43, fig. 28 // *The Poleman in the Ma'sh*, wash drawing in sepia and white over pencil sketch, 11 × 5 7/8 in. (27.9 × 14.9 cm.), ca. 1881, National Gallery of Art, Washington, D. C., ill. ibid., p. 44, fig. 29 // Elbridge Kingsley, *Rail Shooting*, wood engraving, 3 1/2 × 5 in. (8.9 × 12.7 cm.), 1881, in *Scribner's Monthly* 22 (July 1881), p. 345 // Unidentified engraver, *A Pusher*, wood engraving, 4 5/16 × 3 3/8 in. (11 × 8.6 cm.), 1881, ibid., p. 348.

REFERENCES: T. Eakins to E. Shinn, April 2, 1874, Richard T. Cadbury Papers, Friends Historical Library, Swarthmore College, Swarthmore, Pa., says, "I will soon have my rail shooting picture done, and maybe it would be a good thing for me to bring it to New York and show it to two or three dealers before I send it away. I send it to Paris with my other things in May" // T. Eakins to J. L. Gérôme [May 1874], formerly coll. Charles Bregler now unlocated (quoted above as translated in M. McHenry, *Thomas Eakins Who Painted* [1946], pp. 39–40) // J. L. Gérôme to Eakins, Sept. 18, 1874, quoted in L. Goodrich, *Thomas Eakins* (1982), 1, p. 116: "J'ai reçu vos tableaux et j'ai trouvé un progrès très grand; je vous fais mes compliments. . . . vous avez maintenant en main, le côté d'exécution, ce n'est plus qu'une question de choix et de goût. Votre aquarelle est entièrement bien, et [je] suis bien content d'avoir dans le Nouveau

Thomas Eakins

Monde un élève tel que vous qui me fasse honneur. . . . Je ne sais . . . si cette espèce de peinture est commerciale, il me suffit de constater qu'elle est dans la bonne voie et l'avenir est la" // Eakins to Shinn, Jan. 30, 1875, Cadbury Papers, Friends Historical Library, Swarthmore College, Swarthmore, Pa., writes that within a week or two he wants to show four of his oil paintings "to the three or four principal N. Y. dealers & then ship them to Gérôme from there"; he also quotes from Gérôme's 1874 letter; April 13, 1875, discusses delayed arrival of pictures, Gérôme's decision to submit the "old ones" from the 1874 shipment to the Salon after retrieving them from Goupil, then the last minute arrival of the 1875 shipment, Gérôme's reaction to the pictures, and his subsequent decision to submit the "old ones" to the Salon // P. Leroi, L'Art 2 (1875), p. 276, in review of the Paris Salon of 1875, says, "Il y a une foule de noms des Etats-Unis au catalogue; ce ne sont encore que des élèves, mais pleins de bonnes promesses. Parmi les hommes arrivés, je ne vois que M. May, le portraitiste bien connu qui habite depuis longtemps Paris, et M. Thomas Eakins, un disciple de M. Gérôme, qui envoie de Philadelphie un bien étrange tableau; c'est loin toutefois d'être sans mérite. Une Chasse aux Etats-Unis (no. 757) est un véritable ouvrage de précision; c'est rendu comme une photographie; il y a là une vérité de mouvement et de détails vraiment grande et singulière. Ce produit exotique vous apprend quelque chose, et son auteur n'est pas à oublier; on a affaire à un chercheur à une volonté; il faut s'attendre à ce qu'il trouve, et ses trouvailles peuvent être interessantes et mieux encore" (quoted above in translation) // W. Sartain, June 1, 1875, mentions Eakins work at Salon (quoted above from G. Hendricks [1974], p. 81) // F. de Lagenevais, Revue des Deux Mondes 9 (June 15, 1875), p. 927, in a review of the Salon of 1875, notes: "Les produits que M. Eakins nous expédie de Philadelphie sont d'un bon enseignement. Vous les avez vus sans doute? Ces deux toiles, contenant chacune deux chasseurs dans un bateau, ressemblent tellement à des épreuves photographiques recouvertes d'une légère teinte locale à l'aquarelle, que l'on se demande si ce ne sont pas là les spécimens d'un procédé industriel encore inconnu, et que l'inventeur aurait malicieusement envoyés à Paris pour troubler M. Detaille et effrayer l'école française" (translation in E. C. Parry III, Arts Magazine 51 [June 1977], p. 113, quoted above) // Eakins to Shinn, n. d. (dated March 1875 by Goodrich and ca. March 15, 1876, by Hendricks), Cadbury Papers, Friends Historical Library, Swarthmore College, Swarthmore, Pa., discusses a painting rejected by the NAD and reports the following on what is possibly this picture: "A gentleman & lady came to see me Tuesday. They told me they were commissioned to buy one of my pictures. It must have 2 or 3 or more figures in it and so large as not to need a magnifying glass. I had none such but showed them what I had at their request. I showed them the oil picture I had intended for the

N. Y. exhibition. They liked it but feared the distant figures might fall in the magnifying glass limits. I feared it too & showed them their best plan would be to wait till our fall exhibition when I would likely have something larger" // Philadelphia Daily Evening Telegraph, May 16, 1896, p. 7, calls it Rail Shooting at the Rope Ferry in review of Eakins's exhibition at Earles' Galleries, Philadelphia // J. A. Weir to B. Burroughs, undated but after Feb. 6, 1916, the opening of the PAFA annual exhibition, MMA Archives (quoted above) and Feb. 17 [1916], urges purchase of the painting // T. Eakins per S. M. E[akins] to B. Burroughs, April 23, 1916, MMA Archives (quoted above) and May 7, 1916, acquisition form, MMA Archives, describes scene: "A gunning skiff is pushed over the marsh at high water, and the birds springing in the air are shot down" // B. B[urroughs], MMA Bull. 11 (June 1916), p. 132, describes: "It is a small picture and the figures are at most three inches high, yet no detail of their appearance has been slighted; each peculiarity of person or costume has been scrupulously recorded. . . . He has set down each fact of the scene in the most certain way and his success is remarkable. One cannot fail to be impressed by the straightforwardness of his workmanship and the keenness of his observation"; says the picture "in its sincerity and impersonality recalls certain of the little masters of Holland of the seventeenth century" // J. A. Weir to S. M. Eakins, Dec. 15, 1917, quoted in Goodrich [1982], 2, p. 271, says he recognized the painting as having been exhibited in the Salon in the 1870s from a description provided by Dagnon-Bouveret and notes: "The remarkable character of the figures made me realize it was the one he spoke of. I told Eakins this, which pleased him very much" // B. B[urroughs], MMA Bull. 13 (Jan. 1918), p. 25, n 1; 18 (Dec. 1923), p. 282, writes: "Thirty-five years after the reception of The Chess Players, Pushing for Rail was bought from the artist. . . . The outdoor subject was hardly so favorable a vehicle for his talents—luminosity was never his strong point—and the lack of light, as sunlight is attempted in the picture, is noticeable. Pushing for Rail, despite its very remarkable qualities, is sombre and hard to see. It would have been better in water-color, as some of his water-colors of this time prove. The modern method of oil painting does not lend itself to the expression of such tiny facts as the folds and the checkered pattern of a shirt on a figure scarcely three inches high. To appreciate Pushing for Rail, one should hold the picture in a strong light as one would a miniature. Only then can one enter into the vigor and enthusiasm of the painting—the hunters then are seen as real people in real clothes, their boats float on the grass-clogged streams of the marsh, and one enters into the spirit of the scene" // A. Burroughs, Arts 5 (June 1924), p. 329 // L. Goodrich, Thomas Eakins (1933), p. 49, says that in 1874 Eakins sent Gérôme through William Sartain a watercolor and two oils of hunting scenes to submit to the

Salon, quotes Gérôme's letter to Eakins concerning the works and notes that the "two oils were accepted by the Salon, the height of a young artist's ambition in those days"; p. 166, no. 70, describes and mentions that this work was exhibited at the Salon in 1875 as Une chasse aux Etats-Unis; p. 166, no. 72; p. 174, no. 151, lists A Pusher and says that it is a drawing of the black man at the left in Pushing for Rail // *Index of Twentieth Century Artists* 1 (Jan. 1934), p. 50, includes it as Pushing the Rail // C. Bregler, letters in Dept. Archives, April 12, 1942, encloses "copy of notes written in French by Thomas Eakins which were fastened to his perspective drawing. It is in reference to the painting which the Museum owns 'Pushing for Rail.' I have the original notes which Miss Margaret McHenry translated for me. To me it is most interesting as it gives one a more intelligent understanding of the painting, aside from its artistic merits. And it further reveals the infinite care and knowledge of Eakins in the creation of his painting"; May 4, 1942, discusses translation and says, "Have search[ed] among my papers and have been unable to find Eakins notes—do not recall if they were returned to me. When they are found will gladly let you make a photostat of them"; June 24, 1942; August 8, 1945 // M. McHenry, *Thomas Eakins Who Painted* (1946), pp. 38–40, discusses illustrations Eakins supplied for Scribner's article and says that he "wrote in French an account of rail shooting in America," provides translation (quoted above); p. 56, describes Eakins's original notes about rail shooting, then in the collection of Charles Bregler; p. 131, describes the Fish House as a shack Eakins used in Fairton on the Cohansey River in New Jersey; pp. 153–154, in bibliography lists letters from Gérôme to Eakins, May 10, 1873, and Sept. 18, 1874 // D. W. Young, *The Life & Letters of J. Alden Weir* (1960), pp. 193–194, includes letter from Joseph Pearson concerning Weir's reaction to the picture (quoted above) // S. Schendler, *Eakins* (1967), p. 41, notes that it dates from the same year as The Artist and His Father Hunting Reed Birds (coll. Mr. and Mrs. Paul Mellon); fig. 16, p. [43]; p. 48, says, "In lesser hands either scene would have slipped over into the competence of illustration or the banalities of anecdote" // G. M. Ackerman, *Gazette des Beaux-Arts* 73 (April 1969), pp. 241–243, quotes 1875 letters from Eakins to Shinn; p. 253, identifies the picture as one of the four paintings Eakins intended to ship to Gérôme; p. 255, n 34, says that this was one of two paintings titled Une Chasse aux Etats-Unis by Eakins exhibited at the Salon in 1875 // University Art Gallery, State University of New York at Binghamton, *Loan Exhibition, Selections from the Drawing Collection of Mr. and Mrs. Julius S. Held* (1970), p. 10, no. 5, catalogues The Poleman and notes that the figure is the same as in this painting // E. C. Parry III and M. Chamberlin-Hellman, *American Art Journal* 5 (May 1973), detail ill. on cover; p. 37, discuss article for Scribner's

in which Joseph Pennell's "*first* magazine illustrations and Eakins's *last*" appeared together; p. 39, note that "hunting rail birds was probably a favorite sport and certainly a favorite pictorial theme for Eakins, a theme he turned to several times in the 1870's"; pp. 39–40, discuss picture and call it the "key composition" of the subject; ill. p. 40, fig. 23; p. 41, cite an 1866 chromolithograph of Rail Shooting on the Delaware as a closely related "pictorial precedent" for the work at Yale and the figure group on the right in this painting; pp. 42–43; p. 45, say that for the last two illustrations "he turned to his own 'Pushing for Rail' paintings" // G. Hendricks, *The Life and Work of Thomas Eakins* (1974), color pl. 14, between pp. 64 and 65; pp. 75–78, discusses the "fish house" near Tindall's Landing on the south bank of the Cohansey that the Eakinses, father and son, used as a retreat during the early 1870s and notes that the picture could have been painted "within a block of where the Williams fish house stood"; p. 79, says it is likely that it was finished in the studio late in the spring "from studies made in the fall of 1873"; pp. 80–81, says that the paintings Eakins sent to Gérôme in May 1874 included this one which was shown in the 1875 Salon, includes review from *L'Art* (1875); p. 82, notes that, after the painting was returned from Europe, Eakins submitted it to the 1876 annual of the NAD but it was rejected; quotes Eakins's letter to E. Shinn; p. 83, notes it was at NAD in 1877; p. 297, n 24; p. 333, CL–177 // E. Parry, *The Image of the Indian and the Black Man in American Art, 1500–1900* (1974), pp. 150–152, states that the image of the black man on the left of Pushing for Rail "is the portrait of a real man whom Eakins knew in 1874," but he is not identified; *Arts Magazine* 51 (June 1977), p. 113, quotes review of Eakins's paintings from the *Revue des Deux Mondes* 9 (1875) // T. Siegl, *The Thomas Eakins Collection [Philadelphia Museum of Art]* (1978), intro. by E. H. Turner, p. 24, mentions exhibitions at the Paris Salon; p. 42, in chronology, mentions exhibition of two paintings in the Salon of 1875; p. 45, notes acquisition by MMA; p. 57, no. 12, mentions works sent to Gérôme and exhibition at the Paris Salon; p. 58, no. 12, quotes Eakins's letter to Shinn, April 13, 1875, and identifies the rail shooting painting as possibly Starting Out after Rail, MFA, Boston; p. 63, no. 20, discusses works sent to Gérôme // Frank S. Schwarz and Son, Philadelphia, *Artists of the 19th Century* (1978), no. 1, under 1876 portrait of Abbie Williams [Mrs. Samuel Hall Williams] by Eakins, states that the artist rented a "fishhouse" from the Williams family "and painted a number of major paintings from the immediate area, including 'Pushing for Rail'" // E. H. Turner, *Arts Magazine* 53 (May 1979), p. 101, identifies it as one of the "subject" paintings included in Eakins's one-man exhibition at Earles' Galleries in Philadelphia in 1896 and says it was the work which Gérôme had admired when Eakins sent it to Paris in 1874; it was one of two works sent to be offered for sale by Gé-

rôme's father-in-law, the dealer Goupil; and when four other works sent for the Salon exhibition in 1875 were delayed, Gérôme sent instead two works each entitled Une Chasse aux Etats-Unis; p. 107, n 11, says the unusual title, Rail Shooting at the Rope Ferry, was given in an account of the one-man exhibition in the *Philadelphia Daily Evening Telegraph* for May 16, 1896 // R. Onorato, *Arts Magazine* 53 (May 1979), p. 129, no. 41, says in 1874 Eakins sent this picture to Paris; p. 129, n 43, notes that it received a favorable review in *L'Art*, 1875, 2, p. 276 // L. Goodrich, *Thomas Eakins* (1982), 1, p. 92, color pl. 35; p. 93, notes the figures are "exactly characterized as in a full-size portrait," contrasts with works by A. F. Tait and William T. Ranney, says that this was probably the painting Eakins wrote to Gérôme about in 1874 and quotes; says that two years later the artist used the hunter on the right in the same position and the same shirt and the black pusher on the left in a different position in Will Schuster and Blackman Going Shooting; p. 94; p. 107, observes that in small paintings like this one "the handling is very delicate and fine, almost a miniature technique"; p. 108: p. 118, suggests that this painting was one of two works Eakins sent to Paris in May 1874 for consideration by Goupil, quotes Eakins's letters discussing paintings sent to Paris Salon and quotes review from *Revue des Deux Mondes*, suggests in footnote that the critics did not accurately remember the painting; pp. 199–200, discusses illustrations for Scribner's;

Eakins, *Perspective Drawing for "The Chess Players,"* 1876, pencil and ink on paper. MMA, 42.35.315

p. 207, compares frieze-like arrangement of figures to those in Mending the Net, 1881, Philadelphia Museum of Art; 2, p. 163, lists this work among those shown in Eakins's first and only one-man exhibition at Earles' Galleries in Philadelphia in May 1896; p. 199, says the rail-shooting scene Eakins exhibited at the first international held at the Carnegie Institute in Pittsburgh in 1896 was probably this picture; p. 265; p. 270, says that when it was shown at the PAFA in 1916, Eakins asked $800 for it and that it was acquired by the MMA; pp. 270–271, quotes Weir's letters concerning this picture and Eakins's letter about the museum's acquisition of it; p. 274.

EXHIBITED: Paris, Salon, 1875, no. 757 or 758, Une chasse aux Etats-Unis // NAD, 1877, no. 150, as Rail Shooting on the Delaware, for sale $300 // Earles' Galleries, Philadelphia, May 1896 (no cat.), as Rail Shooting at the Rope Ferry // PAFA, 1916, no. 274, as Pushing for Rail // Musée du Jeu de Paume, Paris, 1938, *Trois siècles d'art aux Etats-Unis*, no. 51, as Chasse aux Râles (Pushing for Rail) // MMA, 1939, *Life in America*, no. 242, p. 184; ill. p. 185 // MFA, Boston, 1944, *Sport in American Art*, no. 30, p. 11 // Milwaukee Art Institute, 1947, *Sports and Adventure in American Art*, no. 27 // MMA, 1950, *Twentieth Century Painters*, p. 5 // Detroit Institute of Arts, Art Gallery of Toronto, City Art Museum of Saint Louis, and Seattle Art Museum, 1951–1952, *Masterpieces from the Metropolitan Museum of Art* (no cat.) // MMA, 1958–1959, *Fourteen American Masters* (no cat.); 1965, *Three Centuries of American Painting*, unnumbered cat. // Los Angeles County Museum of Art and M. H. de Young Memorial Museum, San Francisco, 1966, *American Paintings from the Metropolitan Museum*, p. 14; color ill. p. 91, no. 68 // National Art Museum of Sport, Madison Square Garden Center, New York, 1968, *The Artist and the Sportsman*, color ill. p. 18; p. 19 // MMA and American Federation of Arts, traveling exhibition, 1975–1977, *The Heritage of American Art*, cat. by M. Davis, detail ill. on cover; no. 64, p. 147; rev. ed., 1977 // William Rockhill Nelson Gallery of Art, Mary Atkins Museum of Fine Arts, Kansas City, Mo., 1977–1978, *Kaleidoscope of American Painting, Eighteenth and Nineteenth Centuries*, ill. p. 62, no. 75.

ON DEPOSIT: Executive Mansion, Albany, N.Y., 1955–1958.

EX COLL.: the artist, until 1916.

Arthur Hoppock Hearn Fund, 1916.

16.65.

The Chess Players

This small, precisely rendered composition is painted on wood and dated 1876. It shows the artist's father, Benjamin Eakins (1818–1899), watching a chess game between his friends Bertrand Gardel (ca. 1808–1885), a French teacher,

Eakins, *Bertrand Bardel* (*Study for "The Chess Players"*), oil on paper, ca. 1875, Philadelphia Museum of Art.

on the left, and George W. Holmes (ca. 1812–1895), a painter and art teacher, on the right. Thomas Eakins inscribed the painting in Latin on the drawer of the central table: painted by the son of Benjamin Eakins 76. Benjamin Eakins is also the subject of the *Writing Master* (q. v.) and other works. Holmes posed on several occasions as well. The elaborately detailed setting of *The Chess Players*, with its Renaissance revival furniture, has been identified as the parlor of Eakins's home at 1729 Mount Vernon Street, Philadelphia. A comparison between the painting in its present state and an early photograph taken after it entered the museum reveals that some detail has been lost in the background—a common condition in dark paintings.

Eakins undoubtedly made several studies for this intricate painting, but only two are known: an elaborate perspective drawing in the Metropolitan and a broadly painted oil study of Bertrand Gardel in the Philadelphia Museum. These works demonstrate Eakins's dual approach – the precise scientific investigation of three-dimensional space and the quickly seized impression rendered in dark and light.

The subject and composition were influenced by the genre paintings of the seventeenth-century Dutch little masters, contemporary French art-

Eakins, *The Chess Players*.

ists like Meissonier, and Eakins's studies with Jean Léon Gérôme. Eakins had a collection of photographs of Gérôme's paintings for study and reference. Observing the similarity between Eakins's *The Chess Players* and an 1859 painting with the same title by Gérôme in the Wallace Collection, London, Gerald M. Ackerman (1969) pointed out the common use of a pyramidal composition. Eakins chose the same figural arrangement in his celebrated portrait of Dr. Samuel Gross, *The Gross Clinic*, 1875 (Medical College of Thomas Jefferson University, Philadelphia). Despite formal similarities, however, the Eakins and the Gérôme paintings are entirely different in character. Gérôme's has an exotic setting, while Eakins's portrays the familiar self-contained world of his home.

Exhibited by Eakins at the Centennial Exhibition in Philadelphia in 1876, together with the controversial *Gross Clinic* and other works, *The Chess Players* was favorably received. The critic for the *Philadelphia Evening Bulletin* described the work as, "In modern genre, quite the best" and added, "The very rich color, powerful light and shade, and admirable still life details combine with the expressive characterization of figures to make the picture one of the most unusual excellence." When the work was exhibited in the spring of 1877 at the Pennsylvania Academy, the *Art Journal* called it "a capital little picture . . . the admirable manipulation of which has but one fault—a tendency to blackness." Another critic writing for the *Art Journal* described the painting at the National Academy of Design in 1878 as "a rich, juicy piece of colour. The little heads in this painting are admirably made, and in the future we expect this artist to take an important position as a colourist." When the painting entered the museum's collection as a gift from the artist in 1881, the *Art Amateur* reported that nothing Eakins "has done has been so unreservedly admired by artists":

It requires a special lighting, being painted in a mistakenly low key; but treated fairly, and well-flooded with light, it is found to equal in quality the very best Meissoniers; it is a great pity that this picture has never been sent to a Paris Salon, for our public believe in nothing that has not been consecrated by a French imposition of hands.

Oil on wood, 11¾ × 16¾ in. (29.8 × 42.6 cm.). Signed, inscribed, and dated on drawer of central table: Benjamini. Eakins. Filius. Pinxit. 76.

RELATED WORKS: *Bertrand Gardel (Study for "The Chess Players")*, oil on paper mounted on cardboard, 12⅛ × 9¾ in. (30.8 × 24.8 cm.), ca. 1875, Philadelphia Museum of Art, ill. in T. Siegl, *The Thomas Eakins Collection [Philadelphia Museum of Art]* (1978), p. 66, no. 24 // *Perspective Drawing for "The Chess Players,"* pencil and ink on paper mounted on pulpboard, 24 × 19 in. (60.9 × 48.2 cm.), 1876, MMA // Alice Barber, *The Chess Players*, wood engraving, 3⁷⁄₁₆ × 4⁷⁄₁₆ in. (8.7 × 11.3 cm.), in *Scribner's Monthly* 20 (May 1880), p. 8.

REFERENCES: *Philadelphia Evening Bulletin*, June 24, 1876, p. 1, reviews it in the Centennial Exhibition in Philadelphia (quoted above) // D. C. M., *Art Journal*, n. s. 3 (June 1877), p. 190, reviews it in the 1877 spring exhibition at the PAFA (quoted above) // *Nation* 26 (April 4, 1878), p. 229, lists it in PAFA exhibition // *New York Times*, April 21, 1878, p. 6, in a review of the NAD exhibition, notes that Eakins's "'Chessplayers' will be found to repay examination. . . . The best specimen of his craft which New-York has yet seen. . . . [It] shows that Mr. Eakins is remarkable for skill in composition, drawing, and the ability to give shades of character delicately. The party gathered about the chessboard is recognized at once as a truthful home scene, the gradations of light falling from a lamp are well preserved, and the subtle distinctions of character in the players are adequately, but not obtrusively, rendered" // S. N. Carter, *Art Journal*, n. s. 4 (May 1878), p. 159, reviews it in NAD exhibition (quoted above) // *Nation* 26 (May 30, 1878), p. 364, in a review of the NAD exhibition, notes, "Mr. Eakins has a group of ancient professors forgetting college hours in a game of chess that has lasted well into the twilight. It is wholly admirable, and equally so for unity of composition and discrimination of character" // *Art Interchange* 1 (Dec. 11, 1878), p. 51, notes it in the exhibition of the Brooklyn Art Association // [W. C. Brownell], *Scribner's Monthly* 20 (May 1880), ill. p. 8, shows wood engraving of it by Alice Barber // C. E. Clement and L. Hutton, *Artists of the Nineteenth Century and Their Works* (1880 ed.), 1, p. 232 // T. Eakins to W. S. Pratt, March 17, 1881, MMA Archives, says, "It would give me great pleasure to have my picture of the Chess players in your beautiful galleries. If agreeable to the Directory, I should present it to the Museum" // *Art Amateur* 5 (July 1881), p. 24 (quoted above) // *Art Journal* (New York) 7 (July 1881), pp. 221–222, discusses // C. de Kay, *Magazine of Art* 10 (1887), p. 39, says, "Eakins made his mark at the Centennial Exhibition with 'Chess-players,' a broadly and severely painted interior, very dark, very realistic, very sober" // *American Art News* 14 (July 15, 1916), p. 4, in Eakins's obituary, mentions this work "among the paintings of Mr. Eakins, which are marked by strong structural qualities and great sobriety and strength of technique" // *MMA Bull.* 12 (Oct. 1917), cover ill., shows detail // J. M. Hamilton and H. S. Morris, *MMA Bull.* 12 (Nov. 1917), pp. 218–

219, Hamilton says that in this work Eakins "followed the traditions of the Dutch school" and "rivaled in this masterpiece the best works of Meissonier or Menzel"; p. 222 // *Outlook* 117 (Nov. 21, 1917), p. 452, in a review of the MMA memorial exhibition, lists it among paintings exemplifying "Eakins's integrity and sincerity" // B. B[urroughs], *MMA Bull.* 13 (Jan. 1918), p. 25, n 1 // *Art World and Arts and Decoration* 9 (August 1918), frontis.; p. 196; p. 201, discusses it at length, commenting that had Eakins "painted nothing else than his 'Chess Players,' it would place him in the rank of great artists"; says the "pyramidal mass of forms" gives the work "a monumental quality and carrying power"; notes, "its color is not captivating. Eakins was not a great colorist. . . . He was first of all a realist. . . . When he chose a fine subject the result was always full of poetic suggestion, like this 'Chess Players'. . . . It is all so true, so spontaneous; there is such a harmony between the movements of the body, hands, feet; and the expression of emotion and intellectual activity on the faces is so profound that we feel ourselves in the presence of life itself. . . . Many artists have handled this subject, but none has done it with more masterful skill and power of expression and in so small a compass. The work is an honor to American art, and it will increase our affection for Eakins as the years roll by" // A. Burroughs, *Arts* 4 (Dec. 1923), ill. p. 308 // B. B[urroughs], *MMA Bull.* 18 (Dec. 1923), pp. 281–282, notes that it was the first painting by Eakins to enter the collection, compares to Gérôme and Meissonier, and comments, "Owing to its small size, perhaps, or to its superficial resemblance to a tiresome sort of genre subject, turned out in great numbers at the time, its merits have failed to win general popular recognition, but some appreciate it at its worth and find that its solidity and its strength of characterization place it among the best of its sort, whether from the seventeenth century, by a Metsu or a Jan Steen, or from the nineteenth, like an early Degas or a Menzel" // A. Burroughs, *Arts* 5 (June 1924), p. 329 // *Art and Archaeology* 20 (Oct. 1925), ill. p. 197 // *The Pageant of America*, ed. R. H. Gabriel (1927), 12, p. 51 // S. LaFollette, *Art in America* (1929), pp. 185–186, says that in this picture Eakins's "statement was complete and exhaustive," that in the hands of a weaker man it would have become merely photographic, and that "He knows how to keep the interest of the picture safely centered upon the three figures grouped under the light around the chess board, their fine old faces intent upon the hazards of the game. He can do this because he does not start from detail in building up his composition. He works the other way around, first reducing the problem to the essential relations of space, light, and mass, and adding the details only after these have been firmly established" // *Bulletin of the Pennsylvania Museum* 25 (March 1930), p. 20, no. 53 // F. J. Mather, Jr., *Estimates in Art* 2 (1931), p. 222, says that Eakins's lack of recognition in the field of genre painting is amazing, "these little pictures offer no obstacle to appreciation. Yet he sold few. . . . The only one that was publicly visible during his lifetime, the admirable 'Chess-Players,' in the Metropolitan Museum, was his gift"; pp. 224–225, discusses Eakins's "formula," consisting of "a carefully chosen form strongly illuminated in foreground amid a barely penetrable obscurity" and lists this among his masterpieces constructed in this way // L. Goodrich, *Thomas Eakins* (1933), p. 60, calls it a work "tending toward genre"; p. 61, says it is the best known of his works of family or friends and describes it as "a document of the period, as exquisite in its handling as one of the Dutch little masters"; p. 132; p. 169, no. 96, says that he first lent and then presented it to the MMA; p. 169, nos. 97 and 98, lists related works; pl. 15 // *Index of Twentieth Century Artists* 1 (Jan. 1934), p. 50, lists it; p. 56, lists reproductions; suppl. to 1, p. i, lists reproduction // A. Burroughs, *Limners and Likenesses* (1936), p. 200, compares with Eastman Johnson's The Funding Bill (q. v.), notes that Johnson's and Eakins's "pictures with similar points of view and technique" are "one of the clearest bits of evidence of a national trend in American art" // R. McKinney, *Thomas Eakins* (1942), color ill. p. 108 // M. McHenry, *Thomas Eakins Who Painted* (1946), pp. 24–26, discusses Eakins's method of perspective drawing and uses Chess Players as example; p. 28; p. 51, discusses George Holmes // F. J. Mather, Jr., *Magazine of Art* 39 (Nov. 1946), ill. p. 300, writes: "*The Chess Players* is easily comparable to the best of the Dutch little masters, greatly superior to contemporary French and English genre painting of the time, and for me a peg above similar works of Eastman Johnson and Winslow Homer. The mere indication of the fantastic accessories, their half vanishing as the incoming light fails, is quietly exquisite. That blend of good fellowship with unrelenting watchfulness and suspicion is perfectly expressed. Nothing could be changed without loss. The handling has an elegance less marked in Eakins' larger pictures and portraits. This derives from a sort of affectionate interest in the objects themselves, or there may be some lingering flavor of kindred elegances observed in Zurburan" // F. Porter, *Thomas Eakins* (1959), pl. 22 // C. S. Kessler, *Arts Magazine* 36 (Jan. 1962), ill. p. 20, comments, "The compelling mood in intimacy in *The Chess Players* is the result of Eakins' characteristic avoidance of professional models. . . . It is remarkable to what lengths of rational analysis Eakins went in a preparatory drawing for this picture, drawing all the furniture in the room in mathematically correct perspective in an effort to bring all things into absolutely coherent spatial relationship with each other. But in spite of the elaborateness of his preparations and the precision of the final execution, the painting has a warm emotional appeal and breathes a deeply felt atmosphere of sociability and intellectual concentration" // A. T. Gardner, *MMA Bull.* 23 (April 1965), p. [268], fig. 7; pp. 271–272, considers it perhaps the most impor-

tant of the modern pictures added to the MMA collection in the eighties // J. T. Flexner and the editors of Time-Life Books, *The World of Winslow Homer, 1835–1910* (1966), ill. p. 148, shows and discusses perspective drawing for *Chess Players*; ill. p. 149 // E. C. Parry III, *Jefferson Medical College Alumni Bulletin* 16 (Summer 1967), p. 12 // S. Schendler, *Eakins* (1967), p. 60; p. 65, compares with The Gross Clinic and notes pyramid arrangement of figures; ill. p. 68; p. 69, comments, "The teacher of French, the painter and the writing master are older men, the two seated men almost fragile in the late-afternoon sunlight. The themes of fragility and time underlie the more obvious ones. On the small table are half-filled decanters and glasses; on the mantel, an ornate clock. Solidity and order are set against time, and the small circle of this room against the world outside, marked by the water pipe, the landscape above the mantel, and the globe. Through this concentrated yet undemonstrative mastery of subject, of atmosphere and of mood, Eakins communicates his sense of deep affection for this world"; pp. 69–70; p. 86 // G. M. Ackerman, *Gazette des Beaux-Arts* 73 (April 1969), p. 242, fig. 9; p. 243, discusses influence of Gérôme on Chess Players and compares to his picture of that title in the Wallace Collection: "Both works contain cleverly foreshortened furniture, the reed bench in one, the wine table in the other. The motif of an observer looking up from business in the middle background was a favorite of Gérôme's, who may have taken it from Steen or Brouwer. Eakins sometimes used it in portraits"; p. 255, n 35, says that Eakins owned a photograph of a similar version of Chess Players by Gérôme, dated 1867, which is illustrated in E. Strahan [E. Shinn], *Gérôme* (1887) // B. Novak, *American Painting of the Nineteenth Century* (1969), p. 204, ill. 11–15 // PAFA, *Thomas Eakins, His Photographic Works* (1969), exhib. cat. by G. Hendricks, p. 46, fig. 52, no. 109, shows Eakins's photograph of George W. Holmes; p. 50 // G. Hendricks, *Art Bulletin* 51 (March 1969), p. 61 // W. D. Garrett, *MMA Jour.* 3 (1970), p. 330, fig. 23; p. 332 // G. Hendricks, *The Photographs of Thomas Eakins* (1972), pp. 9, 207, no. 197 // E. C. Parry III and M. Chamberlin-Hellman, *American Art Journal* 5 (May 1973), p. 24, say it is "a painting directly based on personal experience and observation" and note similarities of mood and composition in one of Eakins's first wood engravings, "Thar's a New Game Down in Frisco," in *Scribner's Monthly* 17 (Nov. 1878); p. 27, discuss "imprecise effects that Eakins usually gave to the background of even his most carefully constructed pictures" and mention perspective drawing for this painting as an example of his mathematical precision; pp. 31–32, discuss the picture as a prototype for the illustration "Thar's such a thing as Calls in the world," in *Scribner's Monthly* 18 (June 1879); p. 32, say that "it is tempting to think that Eakins used The Chess Players composition as a kind of formula . . . one that assured effective results"; pp. 33–35, discuss

illustration of it // G. Hendricks, *The Life and Work of Thomas Eakins* (1974), pp. 96, 108, 111; color pl. 21, printed in reverse; color pls. 22, 23, show details; p. 280, discusses review; pp. 333–334, CL–180 // J. Wilmerding, *American Art* (1976), p. 139, discusses it; pl. 166 // Slack Hall, North Cross School, Roanoke, Va., *Thomas Eakins, Susan Macdowell Eakins, Elizabeth Macdowell Kenton* (1977), exhib. cat. by D. Sellin, p. 14 // P. D. Rosenzweig, *The Thomas Eakins Collection of the Hirshhorn Museum and Sculpture Garden* (1977), p. 62, n 1 // T. Siegl, *The Thomas Eakins Collection [Philadelphia Museum of Art]* (1978), intro. by E. H. Turner, p. 22, fig. 2; p. 27, says that the "family setting that had been shown in his early pictures remained largely unchanged throughout his life. The Mount Vernon Street parlor, painted in *The Chess Players* . . . with a precision suggesting great affection, was a characteristic middle-class room of the period. It was comfortable and formal, by no means as cluttered as many interiors of the day; its furnishings had largely been acquired when the house was new"; p. 43; ill. p. 66, no. 24, catalogues study of Gardel, says that, in addition to the Gross Clinic, "Eakins decided that he would also paint a small and very precise interior scene in the Dutch manner . . . to demonstrate his skill on very different scales" and suggests that by inscribing it in the manner he did, "Eakins publicly acknowledged his affection and respect for his father"; pp. 102, 107 // E. Johns, *Arts Magazine* 53 (May 1979), p. 130, fig. 3; p. 131, discusses it // M. Chamberlin-Hellman, *Arts Magazine* 53 (May 1979), p. 136 // L. Goodrich, *Thomas Eakins* (1982), 1, p. 67, describes it and observes that the inscription "is a testimony to the artist's relation with his father"; color ill. p. [71], pl. 19; pp. 100–102, discusses perspective drawing for it; p. 107, observes that in such small pictures as this work and Pushing for Rail (q. v.) "the handling is very delicate and fine, almost a miniature technique"; p. 111, says that "a good many of his early oils" such as this work were "small compared to his later paintings, and were marked by refinement as well as strength"; pp. 130, 200; p. 280, notes that it was among the artist's favorite early paintings as it was "intimately connected with his father and two old friends" and was frequently exhibited; 2, p. 106, discusses Holmes as one of the figures in this work; p. 196, discusses Eakins's use of Latin inscriptions on this and other works; p. 265, quotes Burroughs to H. Morris, Jan. 6, 1910; p. 287, notes that this and other multi-figure compositions "had produced designs much more complex than single-figure portraits"; p. 326, n 165, quotes Eakins's Record Book 2, p. 174, "Scribner for use of Chess Players 1879" $10 and "Getting negatives of Chess Players 1879" $5 // Philadelphia Museum of Art and MFA, Boston, 1982, *Thomas Eakins*, exhib. cat. by D. Sewell, p. 47.

EXHIBITED: Philadelphia, 1876, *Centennial Exposition*, no. 49, lent by the artist // PAFA, 1877, no. 225, lent by Benjamin Eakins // NAD, 1878, no. 612, lent

by Benjamin Eakins // Brooklyn Art Association, Dec. 1878, *Catalogue of Pictures Exhibited at Their Fall Exhibition*, no. 222, lent by Benjamin Eakins // MMA, 1880, *Loan Collection of Paintings*, no. 14, lent by the artist // Union League Club, New York, 1880 // MMA, 1896, *Loan Collection and Recent Gifts to the Museum*, no. 194 // Detroit Institute of Arts, 1937, no. 4; 1944-1945, *The World of the Romantic Artist*, no. 18 // Philadelphia Museum, 1944, *Thomas Eakins Centennial Exhibition*, no. 32 (see *Philadelphia Museum Bulletin* 39 above) // Carnegie Institute, Pittsburgh, 1945, *Thomas Eakins Centennial Exhibition*, no. 58 // MMA, 1946, *The Taste of the Seventies*, no. 94 // Centennial Art Gallery, Centennial Exposition, Utah State Fair Grounds, Salt Lake City, 1947, *One Hundred Years of American Painting* (American Federation of Art, Washington, D. C.), no. 29 // Slater Memorial Museum, Norwich Free Academy, Norwich, Conn., 1947, *Painting by Thomas Eakins* (no cat.) // American Federation of Arts, traveling exhibition, 1951-1953, *The Metropolitan Museum of Art Series* (no cat.) // Slater Memorial Museum, Norwich Free Academy, Norwich, Conn., 1954, *Representational Painting in America* (no cat.) // MMA, 1958-1959, *Fourteen American Masters* (no cat.) // National Gallery of Art, Washington, D. C., Art Institute of Chicago, and Philadelphia Museum of Art, 1961-1962, *Thomas Eakins: A Retrospective Exhibition*, exhib. cat. by L. Goodrich, p. 15, no. 23 // MMA, 1965, *Three Centuries of American Painting*, unnumbered cat. // Whitney Museum of American Art, New York, 1970, *Thomas Eakins, Retrospective Exhibition*, exhib. cat. by L. Goodrich, p. 12; ill. p. 40; no. 24 // Bronx Museum of the Arts, Bronx County Courthouse, New York, 1972, *Games! ¡Juegos!* no. 35.

Ex COLL.: the artist, until 1881.

Gift of the artist, 1881.

81.14.

The Writing Master

The subject of this portrait is the artist's father, Benjamin Eakins (1818-1899). He was the son of Alexander Eakins, who had emigrated from Ireland with his wife Frances and established himself as a weaver. Benjamin Eakins was born on a farm in what is now Schuylkill Township, near Valley Forge, Pennsylvania. As a young man he went to Philadelphia and became a writing master, teaching the old copperplate style of calligraphy in the city's schools and engrossing deeds, diplomas, and other documents. In 1843 he married Caroline Cowperthwait, daughter of a Quaker cobbler, and in 1857 they moved to what subsequently became 1729 Mount Vernon Street, where he spent the rest

of his life. Benjamin Eakins encouraged his son's wish to become an artist and served as his model on several occasions. Besides this portrait of 1882, he appears in *The Artist and His Father Hunting Reed-Birds*, ca. 1874 (coll. Mr. and Mrs. Paul Mellon), and *The Chess Players*, 1876 (see above); as William Rush in *William Rush Carving His Allegorical Figure of the Schuylkill River*, 1876 (Yale University, New Haven), according to Evan H. Turner; and in a portrait dating about 1894 (Philadelphia Museum of Art).

In 1882, following his customary practice, Eakins began this portrait by making a quick, broadly painted oil sketch (Philadelphia Museum of Art), which established the general dark and light values of the composition. The finished painting, a sensitive portrayal of his father absorbed in work, is both an eloquent portrait and a tour de force of chiaroscuro, which reflects Eakins's study of Rembrandt.

Shown at the Sixth Annual Exhibition of the Society of American Artists in New York in 1883, the painting received mixed reviews. The critic for the *New York Times* wrote on March 25, 1883, "Mr. Thomas Eakins has a 'Writing Master' in his careful, just, and hard style—he has several styles and this is not his best." The *New York Herald* observed in a review on April 1, "the pose is admirable and the hands are finely painted; but the color of the expressive and well modelled head is made too decidedly the color of brick by the light on the forehead being a most pure white." The *Art Amateur* for May reported that the expression was "well-seized, but the picture is mainly a pair of well-drawn and well-colored hands."

After Eakins's death, when the portrait was acquired by the museum, Mrs. Eakins wrote (1917) to Bryson Burroughs, the curator of paintings, to express her "happiness in the knowledge that the most treasured for all reasons, of the pictures—the portrait of my husband's father 'The Writing Master' has found a safe and honored position among the works of other painters, whom Eakins respected and admired."

Oil on canvas, 30 × 34¼ in. (76.2 × 87 cm.).

Signed and dated on edge of table at lower right: EAKINS 82.

RELATED WORK: *Sketch for "The Writing Master,"* oil on wood, 8¼ × 10⅛ in. (20.9 × 25.7 cm.), 1882, Philadelphia Museum of Art, ill. in T. Siegl, *The Thomas Eakins Collection* [*The Philadelphia Museum of Art*] (1978), p. 103, no. 50.

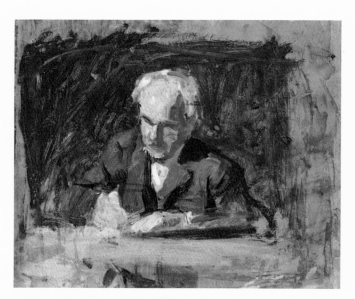

Eakins, *Sketch for "The Writing Master,"* 1882, oil on wood, Philadelphia Museum of Art.

REFERENCES: *New York Times*, March 25, 1883, p. 14, reviews it in Society of American Artists exhibition (quoted above) // *New York Herald*, April 1, 1883, p. 10 (quoted above) // *Art Amateur* 8 (May 1883), p. 124 (quoted above) // T. Eakins to B. Burroughs, April 23, 1916, MMA Archives, writes that he wished "the Museum had chosen a larger and more important picture such as 'The writing master'" rather than Pushing for Rail (q. v.) // *Outlook* 117 (Nov 21, 1917), p. 452, reviews it in MMA memorial exhibition // J. M. Hamilton and H. S. Morris, *MMA Bull.* 12 (Nov. 1917), ill. p. 221 // S. M. Eakins to Burroughs, Dec. 21, 1917, MMA Archives, (quoted above); Jan. 11, 1918, expresses gratitude to Burroughs for recommending acquisition of the work // B. B[urroughs], *MMA Bull.* 13 (Jan. 1918), p. 25, reports purchase and says that the work "shows the leaning toward Rembrandtesque effects of light and shade which marks his earlier work, of which The Gross Clinic is the most important example. The light is from above and falls on the sitter's bald forehead and on his strong and sensitive hands as he sits at a table filling out a parchment diploma, the tenderly painted old face being in half-shadow. Every inch of the work has been dwelt upon with reverent care, bespeaking the preciousness to the painter of each detail of likeness and character, but his enthusiasm was at its height in the portrayal of the hands. Outside of a few pictures by the same artist, it is difficult to recall in the whole course of American art hands of such solidity and expression. Their structure and flexibility are what is evident at first sight. They seem alive; one almost expects that at a second look they will have moved to another position. Then one notices details

to the minutest, how each wrinkle about the knuckles and each unevenness of the skin has been set down. But the expression of the sure and delicate strength and the kindliness that these fingers are capable of is more astounding than the form. The Writing Master might have for a second title, The Portrait of a Pair of Hands. On leaving the picture one wonders if the hands one sees in life have really such possibilities of revelation" // N. N., *Nation* 106 (Feb. 21, 1918), p. 218, in review of PAFA memorial exhibition, observes, "No less excellent is The Writing Master, the portrait of his father; the expression of the old man looking down absorbed in his task and the carefully studied hands are as true as anything Eakins ever did, though he all but spoiled the canvas by the inevitable highlight on the lofty forehead. That this should be one of the pictures selected for purchase by the Metropolitan Museum can be understood, but it is not easy to account for the choice of The Thinker" (q. v.) // A. Burroughs, *Arts* 4 (Dec. 1923), p. 312, notes, "Portraits of people in his family, like . . . the sensitive portrait of his father, The Writing Master, glow with a peaceful, natural sentiment—totally removed from science in the abstract, yet curiously thoughtful and exact in the actual working out"; ill. p. 319 // B. B[urroughs], *MMA Bull.* 18 (Dec. 1923), p. 282, discusses: "It is one of his most ambitious single portraits and the doing of it must have given him great satisfaction"; compares with The Thinker // A. Burroughs, *Arts* 5 (June 1924), p. 330 // S. LaFollette, *Art in America* (1929), p. 188 // L. Goodrich, *Thomas Eakins* (1933), p. 176, no. 188, catalogues it, no. 189, catalogues sketch for it; pl. 27 // *Index of Twentieth Century Artists* 1 (Jan. 1934), p. 50, lists it; pp. 58–59, lists reproductions // R. McKinney, *Thomas Eakins* (1942), ill. p. 90 // M. M. Henry, *Thomas Eakins Who Painted* (1946), pp. 61–62, notes the challenges that the artist successfully overcame in rendering this subject; p. 111, compares Eakins's portraits of his wife and his father; notes, "Eakins's pupil Tommy Eagan remembered that when the hands in the painting had already been finished, Benjamin Eakins went fishing and consequently got sunburned, so that the face and hands in the portrait don't at all match" // *American Artist* 11 (Jan. 1947), ill. p. 8 // E. P. Richardson, *Painting in America* (1956), p. 319, says that "the Rembrandtesque gravity and intensity of his portraits" may be seen in The Writing Master // T. B. Hess, *Art News* 56 (Nov. 1957), p. 28, fig. 5, shows detail // E. Hoffmann, *Burlington Magazine* 100 (Dec. 1958), p. 452, fig. 46; p. 454, in review of MMA exhibition, comments that Eakins's "best work in this gallery is the portrait of his father at the writing desk, which shows something of the absorption of a figure by Chardin" // National Gallery of Art, Washington, D. C., traveling exhibition, *Thomas Eakins, a Retrospective Exhibition* (1961), intro. by L. Goodrich, p. 9, says, "In *The Writing Master* his son has recorded his strong, kindly face, and his hands used to years of fine, precise work" // S.

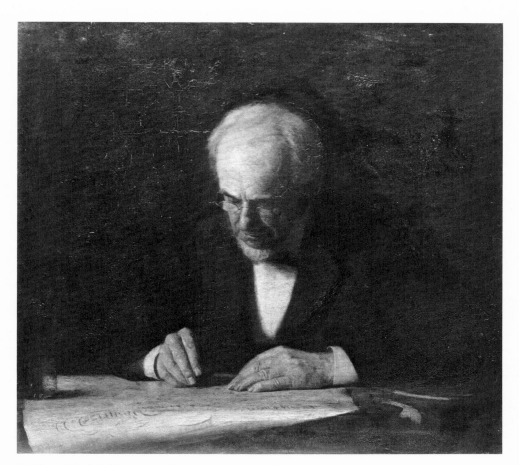

Eakins, *The Writing Master.*

Schendler, *Eakins* (1967), p. 165, compares it with Eakins's 1899 portrait of his father and discusses; p. [167], fig. 76; p. 269 // G. Hendricks, *The Life and Work of Thomas Eakins* (1974), p. 169, says that it was Eakins's first portrait of his father since The Chess Players of 1876 and quotes review of it; p. 170, fig. 157; p. 280, lists it among the works by Eakins shown at the MMA memorial exhibition and praised by the critic of *Outlook*; p. 282, notes that the PAFA requested it for a memorial exhibition; p. 284, quotes Mrs. Eakins's letter to Burroughs concerning its sale; p. 334, CL–185 // T. Siegl, *The Thomas Eakins Collection [Philadelphia Museum of Art]* (1978), intro. by E. H. Turner, p. 27, discusses Benjamin Eakins; pp. 102–103, no. 50, discusses under oil sketch; p. 140, no. 89, mentions under Portrait of Benjamin Eakins, ca. 1894 // E. H. Turner, *Arts Magazine* 53 (May 1979), p. 103, concerning 1896 exhibition at Earles' Galleries in Philadelphia, says: "The *Benjamin Eakins* mentioned in the newspapers must be the head now belonging to the Philadelphia Museum of Art rather than the frequently exhibited 1882 portrait of his father known as *The Writing Master.* Certainly the later portrait is a far more incisive likeness of the strong personality of the man who had been the artist's constant support; the earlier picture is less a por-

trait than a statement of a professional person deeply involved in his work" // J. Wilmerding, *Arts Magazine* 53 (May 1979), pp. 110–111, compares this painting with later portrait in the Philadelphia Museum of Art // L. Goodrich, *Thomas Eakins* (1982), 1, ill. p. 2, fig. 1; p. 3, describes; p. 201, describes and says: "A human document without idealization or sentimentality, it is one of Eakins' most sympathetic and mellow portraits"; 2, pp. 161–162, discusses its exhibition at the Paris Salon of 1890 and quotes Eakins's letter to the secretary of the treasury, requesting information to ensure the return of the portrait; p. 163, notes its exhibition in the 1893 World's Columbian Exposition in Chicago and in 1896 at Earles' Galleries in Philadelphia; p. 199, notes its acceptance for the Carnegie Institute exhibition of 1896 but says that it was not hung; p. 271, quotes 1916 letter from Eakins to Burroughs; p. 277, states that the Metropolitan bought the work from Mrs. Eakins after the memorial exhibition.

EXHIBITED: Society of American Artists, New York, 1883, no. 40 // PAFA, 1883, no. 116 // Inter-State Industrial Exposition, Chicago, 1885, no. 122 // Paris Salon, 1890, no. 2283, as Le calligraphe // Society of American Artists, New York, 1892, *Retrospective Exhibition,* no. 119s, as The Writing Master, lent

by Mrs. Wm. J. Crowell (probably this picture) ‖ PAFA, 1893, *Catalogue of Works of Art to Be Exhibited at the World's Columbian Exposition, Chicago, 1893*, no. 25 ‖ World's Columbian Exposition, Chicago, 1893, no. 382 ‖ Earles' Galleries, Philadelphia, May 1896 (no cat., possibly exhibited) ‖ Carnegie Institute, Pittsburgh, 1896–1897, no. 95, lent by the artist ‖ MMA, 1917, *Loan Exhibition of the Works of Thomas Eakins*, no. 23, lent by Mrs. Eakins ‖ PAFA, 1917, no. 340; 1917–1918, *Memorial Exhibition of the Works of the Late Thomas Eakins*, no. 127 ‖ Detroit Institute of Arts, *Eighteenth Annual Exhibition of American Art*, 1937, p. 4, no. 7 ‖ Philadelphia Museum of Art, 1944, *Thomas Eakins Centennial Exhibition*, no. 47 ‖ Carnegie Institute, Pittsburgh, 1945, *Thomas Eakins Centennial Exhibition*, no. 80 ‖ Newark Museum, N. J., 1946, *19th Century French and American Paintings from the Collection of the Metropolitan Museum of Art*, no. 16 ‖ MMA, 1958–1959, *Fourteen American Masters* (no cat.); 1965, *Three Centuries of American Art*, unnumbered cat. ‖ Osaka, 1970, *United States Pavilion, Japan World Exposition* (no cat.) ‖ Hudson River Museum, Yonkers, N. Y., 1970, *American Paintings from the Metropolitan Museum*, no. 16 ‖ Detroit Institute of Arts, 1983, *The Quest for Unity*, cat. entry by K. Pyne, ill. p. 110, no. 45; pp. 110–111, no. 45, discusses.

EX COLL.: the artist, Philadelphia, until 1916; his wife, Susan M. Eakins, Philadelphia, 1916–1917.

John Stewart Kennedy Fund, 1917.

17.173.

Arcadia

This painting dates from 1883, when Eakins began a series of figure studies with idyllic pastoral scenes inspired by his visits to the farm of his sister Frances and her husband, William J. Crowell, in Avondale, Pennsylvania, near Philadelphia. These studies, both oil paintings and sculpture reliefs, were long thought to be based on the classical theme of Arcadia, celebrated in Western art and literature. An isolated area in the central Pelopponesus, Arcadia was reputed to be the haunt of the god Pan, fabled inventor of the syrinx, or panpipe. His cult had a strong following, and the Arcadians were noted for a love of music. It was the Roman poets, especially Virgil, who created the legendary Arcadia. According to Lloyd Goodrich, however, Eakins never referred to any of this group of works as Arcadia. The title was first used by Mrs. Eakins after the artist's death, and it is by this title that these works have been known ever since.

Eakins's *Arcadia* provided the opportunity, within a traditional framework, to make a realistic study of nudes outdoors. The painting grew out of Eakins's pronounced interest in the human figure and his short-lived interest in plein-air landscapes. "To draw the human figure," he asserted, "it is necessary to know as much as possible about it, about its structure and its movements, its bones and muscles, how they are made, and how they act" (W. C. Brownell, *Scribner's Monthly* 18 [Sept. 1879], pp. 744–745). While Eakins was a staunch admirer of classical art, he doubted the value of prolonged copying from the antique, reasoning convincingly that the accomplishments of the classical masters stemmed from their careful studies from life.

Eakins's *Arcadia* was based on plein-air photographs and broadly painted studies of his students and family, who assumed "classical" poses that, with the possible exception of the standing piper, have no exact parallel in classical art. Three nude figures are shown in a landscape

Below: Eakins, photographic study for reclining boy in *Arcadia*. Bottom: Eakins, *Boy Reclining* (*Study for Arcadia*), ca. 1883, oil on wood. Both Hirshhorn Museum and Sculpture Garden.

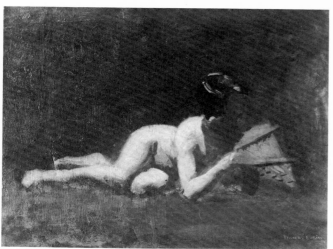

inspired by the farm in Avondale, where Eakins spent much time. The same landscape serves as the setting for the unfinished painting called *An Arcadian*, 1883 (coll. Lloyd Goodrich, New York). It represents at the left a draped seated figure shown from the back. Originally there were traces of chalk marks indicating Eakins's intention of introducing a nude youth playing pipes at the right. The standing piper in *Arcadia* is closely modeled after a photograph and an oil study (coll. Maurice Horwitz) of a figure identified as Eakins's student and assistant John Laurie Wallace (1864–1953), who served as a model for a number of paintings, including *The Crucifixion*, 1880 (Philadelphia Museum of Art). The reclining piper is closely related to a photograph and an oil study (Hirshhorn Museum and Sculpture Garden, Washington, D. C.) of a youth who has been identified as Ben Crowell (b. 1877), Eakins's nephew. The reclining woman is related to a series of studio photographs by Eakins. None of them, however, resembles any of the figures in the painting as closely as

the preparatory studies and photographs for the two youths resemble those figures. The photographs provided Eakins with reference material while painting, and the rapid oil sketches served as studies of the effects of outdoor light on form. In color and sharpness of focus, the white nudes in *Arcadia* stand out in stark contrast against the bright green landscape, represented in rather cursory fashion. The painting, as Lloyd Goodrich notes, was left unfinished. The earth-colored palette is characteristic of Eakins's work. If this painting had been completed, one suspects that the harshness of unmodulated green would have been toned down and the color relationships made less strident – as in Eakins's celebrated painting *The Swimming Hole*, 1884–1885 (Fort Worth Art Center), done shortly thereafter and also representing nude figures outdoors. The unfinished *Arcadia* was given by Eakins to WILLIAM MERRITT CHASE, who served as head of the schools of the Pennsylvania Academy from 1897 to 1909, Eakins's relationship with Chase is not well documented, but he painted Chase's portrait about

Eakins, *Arcadia*.

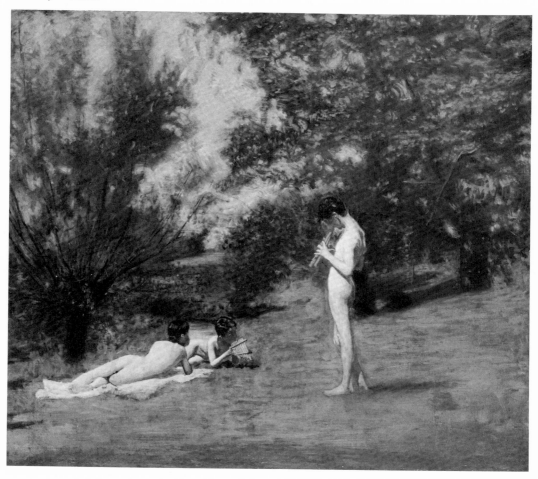

1899 (Hirshhorn Museum and Sculpture Garden, Washington, D. C.) and also gave him the painting *Sailing*, ca. 1875 (Philadelphia Museum of Art). After Chase's death, *Arcadia*, then titled *Idyl*, was sold in his estate sale to Eakins's friend LeRoy Ireland (1889–1910), the artist, collector, and author.

Apparently, *Arcadia* was never exhibited during Eakins's lifetime. The fact that he left it unfinished suggests that it was an experiment. "Almost his only excursion into the fanciful," Goodrich notes (1933), "it probably represented, a temporary inclination toward a more pagan, imaginative type of subject, which in the end proved not natural to him, being too far removed from the life around him. . . . He was too much the portraitist of his surroundings to paint such subjects with much conviction" (p. 62). Contemporary critics chiefly objected to the dichotomy presented by the blunt realism of the unidealized figures and the traditional classicism of the subject. *Arcadia*, nevertheless, offers a candid image of the nude outdoors without the mannered conceits that characterized the treatment of the nude by most American painters of the period. It celebrates a remote, ideal, pagan world free of the strictures of the Victorian society in which Eakins lived.

Oil on canvas, $38\frac{5}{8} \times 45$ in. (98.1 × 114.3 cm.).
Signed on back of lining canvas by another hand: T. Eakins Pinxit.

RELATED WORKS: *Sketch*, oil on wood, $5\frac{5}{8} \times 7\frac{3}{4}$ in. (14.3 × 19.7 cm.), ca. 1883, unlocated, listed in L. Goodrich, *Thomas Eakins* (1933), p. 177, no. 197, notes, "Same general arrangement, except that the woman at the left is seated" // *Youth Playing Pipes* [*Study*], oil on wood, $14\frac{1}{2} \times 10\frac{1}{4}$ in. (36.8 × 26 cm.), coll. Maurice Horwitz, ill. in Corcoran Gallery of Art, *The Sculpture of Thomas Eakins*, exhib. cat. by M. M. Domit (1969), p. 48, no. 16 // *Boy Reclining* (Study for *Arcadia*), oil on wood, $10\frac{3}{8} \times 14\frac{5}{8}$ in. (26.1 × 36.9 cm.) (mounted on second wood panel, $11\frac{5}{8} \times 16\frac{1}{8}$ in. [29.9 × 40.8 cm.]), ca. 1883, Hirshhorn Museum and Sculpture Garden, Washington, D. C., ill. in P. D. Rosenzweig, *The Thomas Eakins Collection of the Hirshhorn Museum and Sculpture Garden* (1977), p. 107, no. 49 // *Ben Crowell* (Study for *Arcadia*), ca. 1883, sepia photograph, irreg. $4\frac{1}{4} \times 6$ in. (10.7 × 14.7 cm.), Hirshhorn Museum and Sculpture Garden, ill. ibid., p. 108, no. 50 // *Standing Piper* (Study for "*Arcadia*"), sepia photograph, irreg. $3\frac{1}{2} \times 3\frac{9}{16}$ in. (8.5 × 8.7 cm.), ca. 1883, Hirshhorn Museum and Sculpture Garden, ill. ibid., p. 109, no. 51.

REFERENCES: American Art Galleries, New York, *The Private Collection of William Merritt Chase*, sale cat.

(May 17, 1917), no. 335, as Idyl, describes it, sold to LeRoy Ireland for $170, according to annotated copy in the MMA Library // *American Art News* 15 (May 19, 1917), p. 7, reports Chase sale // American Art Galleries, New York, *Illustrated Catalogue of Foreign and American Oil Paintings Forming the Collections of John M. Greene of Philadelphia . . .*, sale cat. (Nov. 14, 1923), no. 88, as Idyl: Music, describes it, says that it comes from the collection of the late William Merritt Chase and is the property of Mr. John M. Greene, sold for $250 // A. Burroughs, *Arts* 5 (June 1924), p. 330, includes it under "1886?" as Arcadia and notes that it was given to Chase // H. G. Marceau, *Pennsylvania Museum Bulletin* 25 (March 1930), p. 27, no. 195, includes it in catalogue of Eakins's work as Arcadia, coll. Thomas Finger // L. Goodrich, *Thomas Eakins* (1933), p. 109, mentions "the unfinished Arcadia" in a discussion of Eakins's paintings of nudes; p. 177, no. 196, describes it as "One of Eakins' few excursions into the idyllic; not entirely finished." He also did three reliefs of similar subjects," dates it about 1883, notes it was given by Eakins to Chase; nos. 197–199, describes related works // H. B. Wehle, *MMA Bull.* 31 (Oct. 1936), p. 210, reports its exhibition at MMA // M. McHenry, *Thomas Eakins Who Painted* (1946), p. 54, says, "In 'Arcadia,' a pastoral scene in the classical manner, Wallace had posed for the youth playing the pipes" // V. D. Coke, *The Painter and the Photograph from Delacroix to Warhol* (1964), ill. p. 85, fig. 190; p. 85, observes that this painting "is somewhat out of keeping with Eakins' usual subject matter"; says that Eakins "posed his models to conform to the idea that he had in mind for the painting, then he photographed them instead of making sketches. But his models seem uneasy in the poses. His photograph of the boy lying on the ground playing pipes is especially stiff and artificial"; and concludes that the "general theme of the canvas, while an homage to antiquity, was in truth an excuse for Eakins to paint the nude figure but it is overly contrived. This is due in part to the inconsistent treatment of the figures copied from photographs and the trees painted from life or imagination, as well as the stilted poses of the models"; p. 86, calls it "a staged event" // S. Schendler, *Eakins* (1967), p. 81, says, "*Arcadia* . . ., painted in 1883, has a poignant effect which his photographs of nudes in similar positions do not suggest. . . . Behind his failure to finish this painting or any of the other arcadian studies is the repressive force of a civilization which could approve this use of the imagination no more than it might the Whitmanesque, or the Michelangelesque, for that matter"; p. 83, fig. 36, as coll. Adelaide Milton de Groot // *MMA Bull.* 27 (Oct. 1968), p. 70, in acquisitions report, calls it a "moody figure study"; ill. p. 71 // G. Hendricks, *The Photographs of Thomas Eakins* (1972), p. 3, says, "In 1883, when Eakins was working on his *Arcadia* pictures, he posed his young nephews and nieces in the nude amidst the grass and water, and succeeded varyingly in making them lose

their self-consciousness"; pp. 6, 11, 12, discusses Eakins's use of photographs taken in Avondale and the New Jersey tidelands for his Arcadian works of 1883; pp. 41, 43, figs. 45, 46, 48, reproduces photographic studies for *Arcadia* // W. H. Gerdts, *The Great American Nude* (1974), pp. 121–122, ill. 6-17, notes that photographs served as reference material for the painting, which shows Eakins's sister's children on their farm in Avondale, Pennsylvania; states that the painting has been criticized "for the peculiar dichotomy between the sharply realistic and unidealized figures and the classically pastoral setting and the arcadian tradition they reflect. Undoubtedly, the contrast was partly intentional, Eakins thus presenting his own answer to the coy idylls of Shirlaw and others. In part, too, it must have been intended to reflect an ideal, more pagan world in which the social and moral restraints under which Eakins labored did not exist, and this quality is underlined by the dreamlike yearning that is the picture's essential mood" // G. Hendricks, *The Life and Work of Thomas Eakins* (1974), pp. 150–151, discusses related photographs and attributes Eakins's failure to the fact that he "was working with imaginary situations"; ill. p. 153, fig. 128 // P. D. Rosenzweig, *The Thomas Eakins Collection of the Hirshhorn Museum and Sculpture Garden* (1977), pp. 106, 107, 108, 110, 111, illustrates and catalogues studies and photographs; p. 171, no. 4, mentions as Idyll, purchased at the Chase sale by LeRoy Ireland, who also bought Eakins's portrait of Chase; p. 236, nos. 49, 50, 51, lists studies for Arcadia // T. Siegl, *The Thomas Eakins Collection [Philadelphia Museum of Art]* (1978), intro. by E. H. Turner,

p. 35, notes that although the extent of their friendship cannot be established, Eakins painted Chase's portrait and gave him the painting Sailing, and one of the Arcadian paintings, p. 40, n 109; pp. 106–108, nos. 53–55, discusses works on the Arcadian theme // R. M. Peck, *Arts Magazine* 53 (May 1979), p. 114, fig. 7; p. 115, discusses it among works on the Arcadian theme, says that "though his subjects were timeless, idealized, and 'n the spirit of the Greek sculpture he admired, Eakins insisted on depicting them factually from life," and notes that "By working from life in the open air, Eakins hoped to interpret anew the spirit of ancient Greece. Ironically, he did so with the aid of a tool that was very much a product of the modern world—the camera" // W. I. Homer, *Arts Magazine* 54 (Feb. 1980), p. 150, states that several "paintings that are most untypical of Eakins resulted from his Avondale experience," including the Arcadian pictures that "were conceived and possibly executed at the farm," discusses photographs; ill. p. 151, fig. 4 // Brandywine River Museum, Chadds Ford, Pa., *Eakins at Avondale and Thomas Eakins, a Personal Collection* (1980), exhib. cat., essay by W. I. Homer, p. 11, states this picture was "conceived and possibly executed" at the farm of Eakins's brother-in-law at Avondale, mentions photograph of Eakins's nephew Ben holding panpipes that served as a model, and suggests that the Arcadian subjects were inspired by his Avondale experience, essay by J. G. Lamb, Jr., p. 18, mentions photographs and sketches for this unfinished work, discusses Eakins's interest in classical art, suggests that Eakins, "in choosing the Arcadian

Eakins, *Standing Piper (Study for Arcadia)*, 1883, sepia photograph. Hirshhorn Museum and Sculpture Garden.

Eakins, *Youth Playing Pipes*, oil on wood, coll. Maurice Horwitz.

theme, may have been voicing an unconscious protest against the complexity and pressure of his life in Philadelphia and may have been influenced, either consciously or unconsciously, by the example of the Barbizon School"; p. 19, fig. 4; p. 19, discusses Eakins's attitude to the nude, observes that when nude figures appear in his work "they are usually treated in the distancing context of historical painting . . ., religious paintings . . ., and classical subject matter" // L. Goodrich, *Thomas Eakins* (1982), 1, p. 230, says both this painting and An Arcadian were painted or conceived "probably in the summer of 1883" at his brother-in-law's farm at Avondale, Pa., that the "settings of both were near the stream and the pool, and Eakins used outdoor sketches and his photographs"; says that there is "a purely idyllic context that was new in his work, revealing the strong influence of Avondale's pastoral life"; discusses Eakins's Arcadian works, "two paintings and four oil sketches for them, three sculpture reliefs, and a number of photographs," which were "created probably in 1883 and 1884"; discusses meaning of the theme for the artist; color ill. p. 231, pl. 102; p. 233, says that these works have no literary or mythological connotations; instead "Eakins was trying to express the essential spirit of paganism, of bodily freedom in harmony with nature"; calls this work his "most ambitious essay in this mode"; observes that the "painting is not entirely finished"; notes that photographs were used for both An Arcadian and this painting, that John Wallace, the standing pipe player, "posed outdoors, naked," and that the boy was "probably one of Eakins' Crowell nephews"; pp. 233–234, discusses Arcadian reliefs and photographs; p. 235, says that Mrs. Eakins told the author that the woman who was the model for this painting appears in various photographs and reliefs; p. 236, observes that in all the Arcadian works, only one of the women is nude, "and she has her back to us"; notes that to the best of his knowledge the artist never exhibited any of his Arcadian works, that he gave this one to William M. Chase, and that he never seemed to have called his works Arcadia or Arcadian, titles first used by Mrs. Eakins in 1929; p. 237, says this work, which was the most ambitious of the idyllic subjects, "has its quality of poetic beauty, but is not one of his strongest works" and contrasts it with The Swimming Hole, described as "a subject as idyllic as *Arcadia*, but straight out of reality"; p. 251, discusses Eakins's use of photography; 2, p. 83, says Eakins's interest in music extended to his work and mentions the youths playing pipes in this work and the Arcadian reliefs; p. 90, discusses rarity of female nudes in Eakins's work and mentions this picture; p. 220, says that Eakins gave this unfinished picture to Chase; p. 247 // M. St. Clair, Babcock Galleries, New York, orally, June 6, 1984, gave information on provenance.

EXHIBITED: Babcock Art Galleries, New York, 1929, *Paintings by Thomas Eakins*, no. 13 // Perls Galleries, New York, 1958, *Masterpieces from the Collection of Adelaide Milton de Groot*, ill. no. 8, as Arcadia, dates it about 1885 // MMA, 1965, *Three Centuries of American Painting*, unnumbered cat., lent by Adelaide Milton de Groot // Lytton Gallery, Los Angeles County Museum of Art, and M. H. de Young Memorial Museum, San Francisco, 1966, *American Paintings from the Metropolitan Museum of Art*, p. 14, ill. p. 79, no. 69, dates it ca. 1883, lent by Adelaide Milton de Groot // Corcoran Gallery of Art, Washington, D. C., 1969, *The Sculpture of Thomas Eakins*, exhib. cat. by M. Domit, p. 9, notes that Eakins's Arcadian paintings and reliefs "appear to illustrate his inability to cope with imaginary themes. Neither the landscape nor the figures in the Metropolitan's canvas, *Arcadia* . . . seem to be far removed from Eakins' immediate environment. Even in its unfinished state, the painting has a stark naturalism that is reminiscent of Manet's *Luncheon on the Grass*. In particular, a comparison can be drawn between the three nudes in the Eakins and the nude figure in the foreground of the Manet composition"; p. 22, no. 13; ill. p. 46, no. 13 // PAFA, 1969, *Thomas Eakins, His Photographic Works*, exhib. cat. by G. Hendricks, ill. p. 58, fig. 69, no. 94; p. [60], says, "The standing figure at the right is taken directly from a photograph . . . the reclining boy in the center also directly from a photograph, possibly of his nephew Ben Crowell, . . . the reclining female possibly from more than one photograph. . . . The trees are reminiscent of trees along the brook in Avondale"; p. 71, no. 94 // High Museum of Art, Atlanta, 1971, *The Beckoning Land*, pp. 17–18, comments: "*Arcadia* defies easy classification; it is not really a landscape, nor is it genre painting. But by taking a studio subject such as these nude figures out into the light of day, Eakins achieved a heightened sense of realism. He has reunited the human being with nature within the context of a truly luminist painting. It is pleasant to surmise that Eakins, with all of his earnestness and his complete honesty, was wishing that society could be unchained from stultifying conventions"; no. 71; ill. p. 91, no. 71 // MMA and American Federation of Arts, traveling exhibition, 1975–1977, *The Heritage of American Art*, exhib. cat. by M. Davis, p. 148, no. 65; ill. p. [149].

ON DEPOSIT: MMA, 1936–1967, lent by Adelaide Milton de Groot.

EX COLL.: William Merritt Chase, New York, by at least 1916; his estate, 1916–1917 (sale, American Art Galleries, New York, May 17, 1917, no. 335, as Idyl, for $170); LeRoy Ireland, New York, May 1917; John M. Greene, Philadelphia, by 1923 (sale, American Art Galleries, New York, Nov. 14, 1923, no. 88, as Idyl: Music, for $250); Thomas E. Finger, New York, by 1929–1933 (consigned to Babcock Galleries, New York, 1929–1930); Adelaide Milton de Groot, New York, by 1936–1967.

Bequest of Miss Adelaide Milton de Groot (1876–1967), 1967.

67.187.125.

The Artist's Wife and His Setter Dog

Susan Eakins (1851–1938), the former Susan Hannah Macdowell, was the daughter of Hannah Trimble Gardner Macdowell and William H. Macdowell, a noted Philadelphia engraver. He encouraged the artistic interests of his daughters Susan and Elizabeth (later Mrs. Louis N. Kenton, 1858–1953). Susan is said to have first seen Eakins in 1876 at the exhibition at Haseltine's Galleries of *The Gross Clinic*, 1875 (Jefferson Medical College of Thomas Jefferson University, Philadelphia). She resolved to study with him and entered the Pennsylvania Academy of the Fine Arts the same year. Eakins described her as one of his most talented pupils. She exhibited her works intermittently at the academy from 1876 to 1882. Her painting *The Rehearsal* (unlocated) was awarded the Mary Smith Prize in 1879 as the best picture submitted by a Philadelphia woman artist in the Pennsylvania Academy's annual that year. In 1882 *The Old Clock on the Stairs* (unlocated) received the Charles Toppan Prize for accurate drawing. She and Eakins were married on January 19, 1884, and, although she continued to paint, family life took precedence over her work.

In addition to *The Artist's Wife and His Setter Dog*, Susan Eakins posed on two other occasions: once before their marriage, as the pianist accompanying the singer Margaret Alexina Harrison in *The Pathetic Song*, 1881 (Corcoran Gallery of Art, Washington, D.C.), and again about 1899 for a portrait titled *Mrs. Thomas Eakins* (Hirshhorn Museum and Sculpture Garden, Smithsonian Institution, Washington, D. C.). *The Artist's Wife and His Setter Dog*, traditionally dated 1885, was probably begun in 1884 shortly after the Eakinses' marriage. X-rays show that Eakins reused a canvas with a discarded study of a woman's head. Autoradiographs prove that the head is not a study of Margaret A. Harrison, as several art historians have suggested.

Mrs. Eakins is wearing an old-fashioned, light-blue silk dress in the empire style that Eakins favored in several of his post-Centennial works focusing on early America. Red stockings and black slippers complete her costume. She is seated in a Philadelphia Queen Anne style chair that the artist used in other works. Her hand rests on an open Japanese book, suggesting that the Eakinses shared the interest in Japanese art that was in vogue during the second half of the nineteenth century. While the pages are not legible, Ellwood Parry in a comprehensive study (1979) tentatively identified the book as Hiroshige's *Sohitsu Gafu* of 1848, an inexpensive sketchbook for artists, printed in black with pink and blue added. The setter dog Harry figures in several of Eakins's works. He inherited the dog from his sister Margaret, who died in 1882 at the age of twenty-eight. The setting has been identified by Parry as Eakins's studio at 1330 Chestnut Street, to which he moved early in 1884 soon after his marriage. Eakins's relief *Arcadia*, dating from about 1883, appears on the wall to the right. Of three paintings shown on the left, only a small one of a woman knitting or crocheting is clearly visible. Although Eakins painted several pictures of women knitting, sewing, and spinning, this painting has not been identified.

The Artist's Wife and His Setter Dog is one of Eakins's most powerful portraits. Seated in three-quarter view with her head slightly inclined, Mrs. Eakins is shown under a merciless overhead light that emphasizes her worn features with stark highlights and deep shadows. She looks at the viewer with disconcerting directness. Such confrontation, an effective device that Eakins used on other occasions, establishes a relationship between the painted figure and the viewer that reinforces the realism of the image. The portrait is also one of Eakins's most vividly colored works. The predominately warm earth tones—the russet coat of the dog, the rich ruby tones of the oriental carpet, the red-flecked ocher in the hanging, and the brown wood of the furniture—are relieved by the cool contrasts of Mrs. Eakins's blue dress and the delicate pink and blue of the Japanese book. It is a highly personal and intimate image. It is also an uncompromisingly realistic portrait of his wife.

Parry has cited several early portraits that led to this one of Mrs. Eakins: *Elizabeth Crowell and Her Dog*, ca. 1871–1872 (San Diego Museum of Art); *Kathrin*, 1872 (Yale University, New Haven), showing Kathrin Crowell with a kitten in her lap; and the most closely related work, an oil sketch called *In the Studio*, 1884 (Hyde Collection, Glens Falls, N. Y.), showing a woman identified by Lloyd Goodrich as one of Eakins's pupils with the setter Harry, and also the unfinished watercolor of it in the Philadelphia Museum of Art. More interesting, however, is the similarity between *The Artist's Wife and His Setter Dog* and a portrait painted by Susan Eakins before her

marriage, representing her father with a dog at his feet. Called *Portrait of Gentleman and Dog*, ca. 1878 (coll. Mary Macdowell Walters, Roanoke, Va., ill. in PAFA, *Susan Macdowell Eakins, 1851–1938*, p. 9), it was shown at the Fiftieth Annual Exhibition of the Pennsylvania Academy of the Fine Arts in 1879 and reproduced as a wood engraving by Alice Barber in William C. Brownell's article "The Art Schools of Philadelphia" in *Scribner's Monthly* (18 [Sept. 1879], p. 745).

Parry speculated that James McNeill Whistler's *Arrangement in Grey and Black No. 1, Portrait of the Artist's Mother*, 1871 (Louvre, Paris), which was included in an exhibition at the Pennsylvania Academy of the Fine Arts from November 7 until December 26, 1881, inspired Eakins to depict female figures in studio settings. Eakins had already dealt with such a figure, however, in his *William Rush Carving His Allegorical Figure of the Schuylkill River*, the first version completed in 1876 (Yale University, New Haven).

In this portrait, Eakins combines two themes that have immediate precedents in nineteenth-century French painting and were popular with a younger generation of American artists trained abroad or subject to European influence. The theme of the artist's studio was most completely realized in Gustave Courbet's *L'Atelier du peintre, Allégorie réelle déterminant une phase de sept années de ma vie artistique*, 1855 (Louvre, Paris), reflecting the emergence of the artist as an individual and celebrating his world. The theme of a pensive woman with an open book in hand recurs in the figure paintings of Jean Baptiste Camille Corot from the 1860s and 1870s. It became increasingly popular in the late decades of the century.

The Artist's Wife and His Setter Dog was the subject of a photogravure reproduction titled "A Portrait," which appeared in *The Book of American Figure Painters*, with an introduction by Mariana Griswold Van Rensselaer, published by J. B. Lippincott Company, Philadelphia, in Oc-

A Photogravure of the painting from M. G. Van Rensselaer, *The Book of American Figure Painters* (1886), shows the painting before Eakins's reworked it.

Eakins, *The Artist's Wife and His Setter Dog*.

tober 1886. In an explanatory note, the publisher stated that the pictures "include reproductions both of drawings that were made especially for the purpose, and of paintings that have been independently conceived." The considerable differences between the reproduction and the painting as it now appears raised the question whether in 1886 Eakins copied the painting in wash specifically for reproduction. Recent evidence makes this seem very unlikely. An entry in Eakins's account book for September 10, 1886, records a one-hundred-dollar payment from Lippincott "for privilege of photographing" the "Portrait of Sue & Harry." Since Eakins had the portrait, it seems unlikely that he would go to the trouble of making a copy for an illustration. Furthermore, autoradiographs of the painting show that the painting was considerably reworked both before and after the representation in the photogravure published in October 1886. In her interpretation of the autoradiographs, Maryan Ainsworth of the museum's Department of Paintings Conservation reported that the "arrangement of objects in the studio was altered several times. . . . A curtain originally covered the top of the painting, pulled from the right and fastened at the left. . . . There was a larger picture in the central position of those at the right and a portrait featured below it." She adds that Eakins painted over Mrs. Eakins's face and scraped away paint layers in other areas above and to the left of the head. He may also, she noted, "have applied paint with a palette knife or spatula to cover a previous design." The painting was always available for Eakins to work on, and it appears that he continued to make changes on it, giving his wife, for example, an older appearance.

The painting was exhibited with four of Eakins's other works from April 25 to May 21, 1887, at the Ninth Exhibition of the Society of American Artists in New York, as *Portrait of Lady and Dog*. A review of the work in the June issue of the *Art Amateur* was unfavorable:

Mr. Thos. Eakins, of Philadelphia, who is always interesting—and sometimes aggravating—sends five contributions to the exhibition. . . . In his portrait of a lady, with a dog lying at her feet, he has followed various theories of painting in different parts of the work, a very good one in rendering the dog, and an unfortunate one—of much consideration given to details and none to the general effect—when he came to the painting of the lady.

Charles de Kay, poet, art critic, and early champion of HOMER DODGE MARTIN and ALBERT P. RYDER, was kinder in his review: "Thomas Eakins, of Philadelphia, shows three portraits, that of a lady being the best for its wonderfully painted hands."

When the painting was purchased by the museum in 1923, Mrs. Eakins wrote to the curator of paintings, Bryson Burroughs:

I am glad, indeed, that you care for the picture. I had intended never to part with it & had it hidden away. Now it seems best, that I should accept always an opportunity to place my husband's pictures, and what better place could be than the Met. Museum, and what greater pleasure, than to have had you interested to have it there My husband and I had the entire care of Harry after his mistress, my husband's sister, died. He was a magnificent dog & lived to be 16 years old.

The picture belonging to the museum, they may entitle it as they please. I would like as a title "The artist's wife & his setter dog"—If it cannot be so entitled now, I hope it will be so catalogued after I am dead.

Oil on canvas, 30 × 23 in. (76.2 × 58.4 cm.).
REFERENCES: T. Eakins's account book [1883–1888], p. 108, Sept. 10, 1886, coll. Mr. and Mrs. Daniel W. Dietrich II, notes, "Cash 100– to Portrait of Sue & Harry from J. B. Lippincott for privilege of photographing 100" // *The Book of American Figure Painters* (1886), intro. by M. G. Van Rensselaer, n. p., pl. [24], as A Portrait // C. de Kay, *Art Review* 1 (April 1887), p. 11, review of Ninth Exhibition of the Society of American Artists (quoted above) // *Art Age* 5 (June 1887), p. 68, in review of the Ninth Exhibition of the Society of American Artists, writes, "Mr. Thomas Eakins, of Philadelphia, who used to be one of the most prominent of the irreconcilables, is falling into comparative obscurity. . . . his portrait of a lady and dog, pushed into a corner is a striking example of the disastrous effects that may attend the importation of a scientific theory into the art of the painter" // [T. Child], *Art Amateur* 17 (June 1887), p. 5, review of Ninth Exhibition of the Society of American Artists (quoted above) // S. M. Eakins to B. Burroughs, Sept. 6, 1917, MMA Archives, refuses to have this portrait in the memorial exhibition at the MMA: "I prefer that my portrait would not be in the exhibition"; June 3, 1923, MMA Archives (quoted above) // B. Burroughs, *MMA Bull.* 18 (Dec. 1923), ill. p. 281, as Portrait of a Lady; p. 282, reports purchase and describes work, noting its "close relationship in point of view to The Writing Master; the same reverence and love for the likeness, both physical and spiritual, the same love for every personal trait of the sitter are found in both," says that "it was done at the time

of his greatest enthusiasm and energy, and his interest in the sitter brought out the best that was in him; it is surely one of his finest works" // A. Burroughs, *Arts* 5 (June 1924), p. 329, under 1881? lists it as The Artist's Wife and Her Setter Dog—24 × 20—Mrs. Eakins; under 1881? lists The Artist's Wife and Her Setter Dog (watercolor on paper), MMA // H. G. Marceau, G. S. Parker, and L. Goodrich, *Pennsylvania Museum Bulletin* 25 (March 1930), p. 22, no. 86, lists it as Portrait of a Lady with a Setter Dog, The Artist's Wife, not signed or dated, MMA // L. Goodrich, *Thomas Eakins* (1933), p. 96, discusses sitter; p. 101; p. 178, no. 213, lists it as A Lady with a Setter Dog, describes it, notes that it is "one of Eakins' most brilliant works in color," dates it 1885; pl. 30 // *Index of Twentieth Century Artists* 1 (Jan. 1934), p. 50, lists it as Lady with a Setter Dog; p. 57, lists reproductions of it under Lady with a Setter Dog, Portrait, and Portrait of a Lady // B. Burroughs, *MMA Bull.* 29 (Sept. 1934), p. 152 // L. Goodrich and H. Marceau, *Philadelphia Museum Bulletin* 39 (May 1944), p. 134, no. 52, lists it in checklist of the Thomas Eakins Centennial Exhibition at the Philadelphia Museum // J. O'Connor, Jr., *Carnegie Magazine* 19 (May 1945), ill. p. 38 // M. McHenry, *Thomas Eakins Who Painted* (1946), p. 41, describes the painting, says that it was painted shortly after Eakins's marriage in 1884, notes that Eakins "named the portrait 'A Lady with a Setter Dog'"; mentions lighting; pp. 58–59, 70, 111 // W. S. Baldinger, *Art Quarterly* 9 (Summer 1946), p. 212, fig. 1, reproduces plate from Lippincott's *Book of American Figure Painters* (1886) and identifies it as "Original version, painted in 1885"; p. 212, fig. 2, reproduces this painting and identifies it as the "final state, middle 1890's"; p. 218, discusses; pp. 221, 223–224, says that in the 1890s "Eakins' continued adherence to portrait painting and his exclusive concern with the minute analysis of character were not practices calculated to gratify current demands that painting provide imaginative relief from the frustrations of actual life. It must be recognized, nevertheless, that Eakins could not wholly escape the current transmutation. Witness, for example, the changes made in the final state of his first portrait of his wife. . . . Judging by her appearance in the present painting, some ten years after completion of the original portrait in 1885, Mrs. Eakins posed again for her husband in the same chair and the same dress. Illness during the interim may account for her pinched features and her careworn expression, the droop to her head and her thinner hair, but it is the new demands of the state of mind of the middle nineties that explain the transformation in the form of the picture: the alterations in the folds of the dress and the border of the curtain to unite with the greater inclination of the head in converting what was predominantly a static, rectilinear compo-

Autoradiograph, XD 9, of Eakins's *The Artist's Wife and His Setter Dog* shows several changes. Brookhaven National Laboratories.

X-ray of Eakins's *The Artist's Wife and His Setter Dog*. Brookhaven National Laboratories.

sition into one with continuous curves of action"; p. 225 // C. Greenberg, *Art Digest* 28 (Jan. 1, 1954), ill. p. 8 // H. Rosenberg, *Art News* 52 (Jan. 1954), ill. p. 62; p. 75 // L. Katz, *Arts* 30 (Sept. 1956), pp. 21–22, describes; ill. p. 22 // F. Porter, *Thomas Eakins* [*The Great American Artists Series*], (1959), p. 28, notes, "His conscience wins in the portrait of his wife, *The Lady with the Setter Dog . . .*, a repainting after ten years of the first version, which was a much larger spirited and less severe painting"; p. 32, n 31, mentions illustration in *Book of American Figure Painters* (1886) as the "first version"; pl. 36 // J. T. Flexner and editors of Time-Life Books, *The World of Winslow Homer, 1836–1910* (1966), p. 150, notes that Eakins's "gift was to catch people at the moment they lapsed into themselves. . . . His wife . . ., wilting into her chair, appears defenseless and resigned"; color ill. p. 151 // S. Schendler, *Eakins* (1967), p. 87, discusses painting and compares with Eakins's portrait of Kathrin Crowell, 1872 (Yale University, New Haven); p. [88], fig. 39; p. 89, describes the work, identifies the relief as *Arcadia*, and says, "No other American artist of the time was capable of psychological effects such as this, and none could bring color and light like this to the service of a vision so profound, so compassionate and so lacking in the sentimental": pp. 120, 172 // Whitney Museum of American Art, New York, *Thomas Eakins, Retrospective Exhibition* [1970], exhib. cat. by L. Goodrich, p. 16, mentions color; color ill. p. [30]; p. 70, no. 45, lists it // S. B. Sherrill, *Antiques* 98 (Oct. 1970), ill. p. 480 // D. F. Hoopes, *Eakins Watercolors* (1971), p. 19; p. 54, notes, "About 1885, a year after he married Susan Macdowell, he painted her in nearly an identical pose; except for minor details, the 1885 portrait is a reworking of the *Retrospection* theme" // M. H. de Young Memorial Museum, San Francisco, and California Palace of the Legion of Honor, San Francisco, *The Color of Mood* (1972), exhib. cat. by Wanda M. Corn, p. 22, n 3 // G. Hendricks, *The Life and Work of Thomas Eakins* (1974), between pp. 128 and 129, pl. 32, color detail of Mrs. Eakins, printed in reverse; p. 168, says Eakins made a wash copy in 1886 for reproduction in Lippincott's *Book of American Figure Painters*; p. 174, notes that the oil was shown in 1887 at the Society of American Artists' exhibition in New York and discusses reviews; p. 284, notes that it was included in the 1923 Eakins's exhibition at the Joseph Brummer Galleries in New York and that the MMA bought it from the exhibition; p. 332, CL–166, lists and illustrates *In the Studio*, 1884?, Hyde Collection, Glens Falls, and notes that it is "possibly a study for *Lady with a Setter Dog*"; p. 334, CL–187, lists *Lady with a Setter Dog*, 1885? // *MMA Bull.* 33 (Winter 1975–1976), p. 222, no. 70, discusses it; ill. p. [223] // J. Wilmerding, *American Art* (1976), p. 140, pl. 169 // L. Goodrich, Feb. 23 and April 5, 1977, orally, said that the painting under the *Lady with a Setter Dog*, visible in X-rays, looks like a preliminary study for The Pathetic Song; that Eakins's notes mention lending the painting for reproduction to Lippincott; that the painting may have been cut down in the past, possibly by the artist, because the Lippincott reproduction (1886) shows not only a younger woman but also more painted surface; that the identity of the painting shown at the top left in the picture is not known; and that the label on the stretcher is from Haseltine's Gallery, Philadelphia // M. W. Brown, *American Art to 1900* (1977), pp. 524-525, notes, "No American portraitist has ever approached . . . the total revelation of what may be his greatest portrait, that of his wife and their dog Harry in *Lady with a Setter Dog*. . . . The last is exceptional in the relationship of the figure to its setting, the high-keyed color, the almost miniaturist yet broad treatment of surface, and the skillful handling of interior light and atmosphere. The vulnerable and appealingly fragile lady remains one of the unforgettable images in American art"; p. 526, pl. 649 // P. D. Rosenzweig, *The Thomas Eakins Collection of the Hirshhorn Museum and Sculpture Garden* (1977), pp. 94, 95, 96, 111, 168 // MFA, Boston, *Richard Estes* (1978), essay by J. Canaday, exhib. cat. and interview by J. Arthur, pp. 26–27 // T. Siegl, *The Thomas Eakins Collection* [*Philadelphia Museum of Art*] (1978), intro. by E. H. Turner, p. 27; p. 107; p. 113, mentions Susan Eakins's 1878 portrait of her father with a dog at his feet; p. 137, discusses Lippincott's reproduction of the portrait and the artist's account book concerning the reproduction; pp. 156–157 // J. Wilmerding, *Arts Magazine* 53 (May 1979), p. 108; ill. p. 109; pp. 111, 112 // M. Chamberlin-Hellman, *Arts Magazine* 53 (May 1979), p. 137 // L. Dinnerstein, *Arts Magazine* 53 (May 1979), p. 142 // E. C. Parry III, *Arts Magazine* 53 (May 1979), p. 146, fig. 1; p. 147, fig. 2, shows the 1886 reproduction; pp. 146–149, discusses differences between portrait and reproduction; concludes that Eakins repainted the canvas and that the traditional dating of ca. 1885 is inadequate; discusses and dismisses W. B. Baldinger's explanation for the changes and G. Hendricks's proposal that a copy was made for reproduction; cites Eakins's account book entry of Sept. 10, 1886; discusses similar early works, *Kathrin* 1872 (Yale University, New Haven), *Elizabeth Crowell and Her Dog*, ca. 1871–72 (San Diego Museum of Art), his wife's painting of her father, ca. 1878 (coll. Mary Macdowell Walters, Roanoke, Va.), and works by others; notes that the setting for this portrait is his new studio at 1330 Chestnut Street; speculates that Eakins was influenced by Whistler's portrait of his mother, which was exhibited at the PAFA in 1881; suggests that Eakins's oil sketch *In the Studio*, 1884 (Hyde Collection, Glens Falls, N. Y.), "may have been a first working out in paint of the ideas that culminated in *The Lady with the Setter Dog*"; mentions Eakins's unfinished watercolor "after it" (Philadelphia Museum of Art) and notes that although the oil sketch is dated, the lack of background details makes it impossible to determine whether it was painted in the new studio or in the studio at his

father's; discusses dating and early changes now visible as pentimenti; p. 149, figs. 11 and 12, show details of painting and photogravure; pp. 149–150, discusses changes after photogravure of 1886, the major ones being in Mrs. Eakins's face and dress; p. 151, figs. 14, 17, color details; discusses works shown in the portrait; p. 152, fig. 20, shows composite X-ray photograph and notes that MMA X-rays of the painting show the head of a woman underneath the dog's face, identifies it as Margaret A. Harrison; discusses Japanese book held by Mrs. Eakins; and concludes that the first work on the canvas took place in 1880 or 1881; p. 153, fig. 21, shows inverted detail of X-ray and notes that Eakins reused the canvas for this painting between 1884 and 1886 and finished reworking it by 1889 when it was lent to the Art Institute of Chicago; suggests dating of 1884–1888 // M. Ainsworth, Paintings Conservation, MMA, report, Jan. 15, 1980, Dept. Archives, gives results of X-rays and autoradiographs // L. Goodrich, *Thomas Eakins* (1982), 1, p. 224, says it was probably painted in 1886 or two years after the artist's marriage to Susan Macdowell, compares with 1886 photogravure reproduction and concludes that "after the painting was photographed for reproduction Eakins worked further on it, in the process making his wife look somewhat older," says that it is not known when he did this and suggests that it may have been before "its first recorded exhibition, in May 1887, or the next one, in May 1889," describes findings from X-rays, says that Eakins made many changes before arriving at the version reproduced in 1886, calls it "one of his most richly painted works"; p. [225], color pl. 98; p. 226, figs. 99, 100, details illustrating head and hands; p. 235, says that the artist's inclusion of the Arcadia relief suggests his feelings for that work; pp. 330–331, n 224; 2, p. 165, states several pictures such as this "came in for captious and supercilious comments" from the critics; p. 166, says that J. B. Lippincott Company paid Eakins $100 in 1886 "for photographing and illustrating" this work; p. 167, lists it among the artist's strongest works; p. 256, says that "Almost all his finest portraits were uncommissioned" including this work; p. 274, notes that Bryson Burroughs wanted to include this portrait in the 1917 exhibition of Eakins's works but Mrs. Eakins refused, and quotes Mrs. Eakins's letter; p. 278, says that this picture was not lent to the exhibition at the PAFA; p. 279, notes acquisition by the MMA and quotes Mrs. Eakins's letter.

EXHIBITED: Society of American Artists, New York, 1887, no. 53, as Portrait of Lady and Dog, lent by William G. McDowell [sic] // Art Institute of Chicago, 1889, *Catalogue of the Second Annual Exhibition, American Oil Paintings*, no. 112, as Portrait of a Lady and her Dog // Society of American Artists, New York, 1892, *Catalogue of the Retrospective Exhibition*, no. 115s, as Portrait of a Lady and a Dog // Brooklyn Museum, 1915, *Contemporary American Painting*, no. 34, as Por-

trait // MMA, 1939, *Life in America*, no. 256 // Art Institute of Chicago, 1939–1940, *Half a Century of American Art*, p. 16, no. 52, notes that it was shown there in 1889; pl. xi, no. 52 // Philadelphia Museum, 1944, *Thomas Eakins Centennial Exhibition*, p. 134, no. 52 [see *Philadelphia Museum Bulletin* 39 above] // M. Knoedler and Company, New York, 1944, *A Loan Exhibition of the Works of Thomas Eakins*, exhib. cat. by L. Goodrich, p. 13, no. 38 // Carnegie Institute, Pittsburgh, 1945, *Thomas Eakins Centennial Exhibition, 1844–1944*, exhib. cat. by L. Goodrich, no. 17 // Newark Museum, N. J., 1946, *19th Century French and American Paintings from the Collection of the Metropolitan Museum of Art*, no. 17 // MMA, 1953–1954, *American Painting, 1754–1954* (no cat.) // PAFA, 1955, *150th Anniversary Exhibition*, no. 82 // MMA, 1958–1959, *Fourteen American Masters* (no cat.); 1965, *Three Centuries of American Painting*, unnumbered cat. // Corcoran Gallery of Art, Washington, D. C., 1969, *The Sculpture of Thomas Eakins*, exhib. cat. by M. Domit, no. 14 // Whitney Museum of American Art, New York, 1970, *Thomas Eakins, Retrospective Exhibition*, exhib. cat. by L. Goodrich, p. 16; color ill. p. [30]; p. 70, no. 45, lists it // National Gallery of Art, Washington, D. C., City Art Museum of Saint Louis, and Seattle Art Museum, 1971, *Great American Paintings from the Boston and Metropolitan Museums*, exhib. cat. by T. N. Maytham, p. 97, no. 60; ill. p. 100, no. 60 // MMA, 1976, *A Bicentennial Treasury* (see *MMA Bull.* 33 above) // Pushkin Museum, Moscow; Hermitage, Leningrad; Palace of Art, Minsk, 1977–1978, *Representation of America* (no cat.) // Philadelphia Museum of Art and MFA, Boston, 1982, *Thomas Eakins*, cat. by D. Sewell, p. 121, says it "is a reworking in Eakins's own terms of another popular subject of the day, the studio interior, as it was being painted by William Merritt Chase and others"; describes the subject's expression and hands, observing, "the realism and physicality are so pronounced that they seem an embodiment of an artistic belief directly opposed to Whistler's painting, which both Eakins and his wife would have upheld"; color ill. p. 124, no. 134.

EX COLL.: the subject's father, William H. Macdowell, Philadelphia, 1887–d. 1906; the subject, Mrs. Thomas Eakins, Philadelphia; with Joseph Brummer, New York, as agent, 1923.

Fletcher Fund, 1923.

23.139.

James MacAlister (Sketch)

Formerly called "Man with a Red Tie," this sketch has been identified by Lloyd Goodrich as a study for a portrait of James MacAlister (1840–1913). Born in Glasgow, where he received his early schooling, MacAlister immigrated with his family to Wisconsin in 1850. He graduated from

Brown University in 1856 and from the Albany Law School in 1864. After his appointment as superintendent of public schools in Milwaukee in 1873, he devoted himself to education with such success that he was chosen to reorganize the Philadelphia public school system in 1883. In 1890 he resigned to become president of the newly founded Drexel Institute of Art, Science and Industry.

This sketch is usually dated about 1895 when Eakins lectured briefly on anatomy at the Drexel Institute before being dismissed. Following his customary practice, Eakins squared off the sketch for enlarging. It was evidently a study for the life-size portrait of MacAlister exhibited at Eakins's only retrospective during his lifetime, held at Earles' Galleries in Philadelphia in May 1896. Riter Fitzgerald in the *Philadelphia Evening Item* of May 12 noted that it was fashionable "to say that Eakins is 'brutally frank'; that he has too high a regard for Art to idealize or etherealize his subjects"; that "he paints his subjects as he finds them, imperfections, blemishes and all'; that "people demand idealization"; and "the portrait painter, the same as everyone else, must trim his craft to the trade winds" (quoted in G. Hendricks [1974], p. 233). The life-size portrait of MacAlister has been lost since at least 1933. Apparently this sketch is now the sole record of the portrait.

When Goodrich first saw this sketch in Mrs. Eakins's collection in 1930, the canvas was mounted on composition board with two additional sketches by the artist on the back. They were removed from the back of the MacAlister study sometime before 1939, when it was shown at Babcock Galleries in New York.

In this three-quarter view, MacAlister's left side is illuminated by intense light from an undisclosed source on the right, and the other side is in shadow. The red tie provides a note of vivid color in the otherwise characteristically somber palette. The figure is quickly and broadly painted and defined primarily by the contrast of light and dark values. Besides being an example of Eakins's method of preparing a portrait study, the painting's chief interest is as the record of a lost portrait.

Oil on canvas, 14¼ × 10¼ in. (36.8 × 26 cm.).
RELATED WORK: *James MacAlister*, oil on canvas, life-size, about 1895, unlocated, recorded in L. Goodrich, *Thomas Eakins* (1933), pp. 206–207, no. 481.
REFERENCES: D. A. Robertson, *DAB* (1933; 1961),

s. v. "MacAlister, James," gives biographical information on the subject // L. Goodrich, *Thomas Eakins* (1933), pp. 185–186, no. 276, lists it in Mrs. Eakins's collection as James MacAlister (Sketch), says that the portrait for which it is a study has disappeared, notes that it is squared off for enlarging, describes two figure sketches on the back, and states that it is canvas mounted on cardboard; pp. 206–207, no. 481, discusses life-size portrait of James MacAlister, dates it probably 1895 // M. McHenry, *Thomas Eakins Who Painted* (1946), p. 99, notes that there was a portrait on the back of it // L. Goodrich, letter in Dept. Archives, Feb. 13, 1970, identifies this portrait study, discusses sketches that were once on verso and says that when last seen in 1939 at the Babcock Galleries exhibition, the study had been separated from the back // G. Hendricks, *The Life and Works of Thomas Eakins* (1974), p. 232, notes that Eakins's life-size portrait of MacAlister was one of twenty-eight works by the artist shown at Earles' Galleries, Philadelphia, in May 1896; ill. p. 334, no. CL–189, as Sketch for Portrait of James MacAlister [Man with a Red Tie], ca. 1895 // E. H. Turner, *Arts Magazine* 53 (May 1979), pp. 104–105, fig. 10, and discusses Eakins's widely publicized break with the Drexel Institute, speculates that the fact that MacAlister agreed to sit for him attracted attention to the life-size portrait in the 1896 exhibition // L. Goodrich, *Thomas Eakins* (1982), 2, p. 163, lists portrait of James MacAlister, dated about 1895, with works exhibited at Earles' Galleries in Philadelphia in May 1896 // M.

Eakins, *James MacAlister* (Sketch).

St. Clair, Babcock Galleries, New York, orally, Feb. 1, 1984, provided history of ownership.

EXHIBITED: Babcock Galleries, New York, 1939, *Exhibition of Sketches, Studies and Intimate Paintings by Thomas Eakins* (not in cat.).

ON DEPOSIT: Yale University, New Haven, 1946–1952, lent by Adelaide Milton de Groot // MMA, 1952–1967, lent by Adelaide Milton de Groot.

EX COLL.: Mrs. Thomas Eakins, Philadelphia, d. 1938; her estate, consigned to Babcock Galleries, New York, 1939–1941; with Babcock Galleries, New York (acquired from the estate), 1941–1944; Adelaide Milton de Groot, 1944–1967.

Bequest of Miss Adelaide Milton de Groot (1876–1967), 1967.

67.187.206.

Eakins, *Mrs. Mary Arthur.*

Mrs. Mary Arthur

Eakins painted this portrait in 1900, according to an inscription on the back of the canvas. The sitter, Mrs. Robert Arthur (1824–1911), was the mother of Eakins's friend Robert Arthur (1850–1914), an artist.

As Lloyd Goodrich and others have observed, Eakins's preoccupation with the theme of women knitting, sewing, or spinning was probably inspired by the Centennial in 1876 when many artists turned their attention to early America and sometimes, in reaction to growing industrialization, to a special appreciation of handicrafts. The first instance in Eakins's work was probably the chaperon knitting in *William Rush Carving His Allegorical Figure of the Schuylkill River*, 1877 (Philadelphia Museum of Art). It was followed, as Goodrich notes, by a historically inspired series of oils, watercolors, and reliefs of women in early nineteenth-century dress engaged in similar handwork.

By representing Mrs. Arthur engaged in a commonplace domestic task Eakins adds to the description of her character. The concentration of light on the face and hands, which emerge from the dark ground produces a sculptural effect and recalls his study of the seventeenth-century Dutch masters, especially Rembrandt, and Spanish artists like Ribera and Velázquez, In Eakins's portrait of his father, *The Writing Master* (q. v,), similar lighting is used for maximum dramatic effect, whereas in this portrait the contrast is modified by a lighter background. It is a sensitive, probing portrait of an elderly woman whose distinctive character is captured in the description of her face, dress, and occupation.

Oil on canvas, 24 × 20 in. (61 × 50.8 cm.).

Inscribed, signed, and dated on the back: to his dear / friend / Robert Arthur / Thomas Eakins. / 1900.

REFERENCES: A. Burroughs, *Arts* 5 (June 1924), p. 332, lists it as Mrs. Arthur, coll. Miss Arthur, dates it "1905?" // H. G. Marceau, *Pennsylvania Museum Bulletin* 25 (March 1930), p. 31, no. 295, lists it as Portrait of Mrs. Arthur, coll. Miss Arthur // L. Goodrich, *Thomas Eakins* (1933), p. 191, no. 334, lists it as Mrs. Mary Arthur, identifies her as the mother of the painter Robert Arthur, describes the portrait, and identifies owner as the subject's granddaughter, Miss Mary Arthur Bates, Englewood, N. J. // M. A. Bates, letters in MMA Archives, Feb. 22, 1937, Aug. 11, 1950, March 1, 1965, discusses the painting and its loan to the museum // G. Hendricks, *The Life and Works of Thomas Eakins* (1974), ill. p. 334, no. 191, as Portrait of Mary Arthur and lists it // L. Dinnerstein, *Arts Magazine* 55 (April 1981), ill. p. 113, fig. 5; p. 114, discusses.

EXHIBITED: MMA, 1965, *Three Centuries of American Painting*, unnumbered cat. // Kennedy Galleries, New York, 1975, *Hundredth Anniversary Exhibition of Paintings and Sculptures by 100 Artists Associated with the Art Students League of New York*, p. 28, no. 30, mistakenly says that it is undated; ill. p. 101.

ON DEPOSIT: MMA, 1937–1965, lent by Miss Mary Arthur Bates // Hyde Collection, Glens Falls, N. Y., 1969–1970.

EX COLL.: Robert Arthur, 1900–d. 1914; his sister,

by 1924; her daughter, Mary Arthur Bates, Englewood, N. J., by 1933–1965.

Gift of Mary Arthur Bates, 1965.

65.83.

The Thinker: Portrait of Louis N. Kenton

Painted in 1900, this picture was exhibited as Portrait of Mr. Louis N. Kenton until it was purchased by the museum in 1917. The title was then changed to *The Thinker* to conform to an inscription on the stretcher, probably in Mrs. Eakins's hand. The subject is Eakins's brother-in-law Louis N. Kenton (1865–1947). In 1899 he married Elizabeth Macdowell (1858–1953), sister of Eakin's wife, Susan. Elizabeth Macdowell Kenton studied at the Pennsylvania Academy of the Fine Arts, exhibited professionally, and traveled widely. Her marriage to Kenton was described by Gordon Hendricks as "a brief, storm-ridden period" and, according to David Sellin, "barely outlasted the honeymoon." Little is known of Kenton, whose portrait by Eakins suggests a studious, introspective personality. When asked to identify the subject in 1916, Mrs. Eakins described him as "a friend of Mr. Eakins's."

The Thinker is part of a late series of life-size, standing male portraits, which includes *Portrait of John McClure Hamilton*, 1895 (Wadsworth Atheneum, Hartford), *The Dean's Roll Call*, 1899 (MFA, Boston), and *Portrait of Leslie W. Miller*, 1901 (Philadelphia Museum of Art). The dark figure against a light neutral ground derives from Velázquez. Both Jean Léon Gérôme and Léon Bonnat urged Eakins to study Velázquez, which he did on a visit to Madrid in December of 1869 and in May of the following year. The profound influence of this Spanish painter on Eakins, JOHN SINGER SARGENT, JAMES MC NEILL WHISTLER, and Edouard Manet produced a diverse group of works. In *The Thinker*, Eakins adopted an essentially restricted palette but avoided the decorative effects, the emphasis on formal qualities, and the subtle adjustments of color, tone, and pattern that distinguish other Velázquez-inspired works, such as Whistler's portrait of Théodore Duret (q. v.). Quickly executed with uncharacteristic facility reminiscent of Sargent, *The Thinker* nevertheless differs from Sargent's work, which often lacks the profound probing of the subject's character that Eakins achieved. Eakins

Eakins, *Study for the Thinker*, 1900, oil on wood, William A. Farnsworth Library and Art Museum.

grasps essentials as forcefully as Manet, yet executes them in a more conventional manner. In *The Thinker*, Eakins captures the preoccupation and isolation we sometimes associate with his own nature—the work is an archetypical Eakins portrait. The only contrived note in this remarkably penetrating portrait is the artist's prominent signature. An exercise in perspective used by the artist in other works, it reaffirms the three-dimensional illusion of depth, but its stylized, curving calligraphy injects a decorative element that is inconsistent with the overall effect of the painting.

Widely exhibited before it entered the museum's collection, *The Thinker* was generally recognized as a work outside the mainstream of fashion. Its lack of the customary embellishments was seen as a deficiency, yet it was deemed worthy of attention. M. E. Wright, reviewing the annual exhibition of the Pennsylvania Academy of the Fine Arts for the *Brush and Pencil* in 1901, singled out the painting for its "simplicity and vigor." Calling it "a masterpiece of correct

Eakins,
*The Thinker: Portrait
of Louis N. Kenton.*

portraiture, devoid of all flattery, but instinct with the strong individuality of the subject," he observed, it "is a pictorial expression of character which could only result from the closest communion between painter and subject."

Charles H. Caffin, writing of the portrait in the Pan-American Exhibition in 1901 for *International Studio*, astutely observed, "We may find it ungainly in composition, certainly without any superficial qualities of beauty; but its intense realism and the grasp which it suggests of the subject's personality render the picture one of notable fascination." In a review of the exhibition of the National Academy of Design in 1902 for the same journal, he noted:

The figure is represented without any of the usual aids to artistic effect. Seen in cold, clear light, the hands thrust in the pockets, the head bent down in absorbed meditation, as if the gentleman had been caught pacing the room in the solution of some problem and were unconscious of anybody's presence.

Caffin further remarked in a study of American painting in 1907:

It is a picture that in its matter-of-factness and in its disregard of the elegancies of line, and of the persuasiveness of colour and tone, might be charged with ugliness, but as a record of a human individual is extraordinarily arresting and satisfactory.

The critic for the *Nation*, reviewing the museum's acquisition then on view in the 1917 memorial exhibition at the Pennsylvania Academy of the Fine Arts, grouped it with Eakins's other life-size portraits and complained:

nearly all have the same crease in the trousers, the same clodhopper boots, nearly all stand in the same attitude reminiscent of the Prado but scarcely of Velasquez. How utterly untrue they are not only to art, but to life.

Suzanne LaFollette wrote in 1929:

The pose of "The Thinker" may have struck the man who stood for it as unconventional and awkward; but the figure stands on its feet with a firmness that Whistler would have envied, and the pose perfectly repeats and emphasizes the intense concentration of the face. If Eakins does not beautify his sitters, it can never be said that he renders them inexpressively.

About Eakins's portraits, Frank J. Mather observed:

Style they have abundantly, but it is scrupulously subordinated to character, and has to be looked for. . . . In a generation that sorely overvalued brilliant handling, Eakins simply offered nothing that could be talked about or written about, and was naturally ne-

glected. Today, I trust, we are more interested in what is expressed than in the rhetoric of expression, and Eakins is coming into his own, for no portrait painter of his age, whether in America or Europe, has left a more various and speaking gallery of thinking and feeling fellow mortals.

Oil on canvas, 82 × 42 in. (208.3 × 106.7 cm.).
Signed and dated at lower right: Eakins 1900.
Inscribed on stretcher, probably by Mrs. Eakins: "Thinker" T. Eakins.

RELATED WORK: *Study for the Thinker*, oil on wood, 14 × 10¼ in. (35.6 × 26 cm.), squared for enlargement, William A. Farnsworth Library and Art Museum, Rockland, Maine.

REFERENCES: M. E. Wright, *Brush and Pencil* 7 (Feb. 1901), p. 264, discusses it in review of the PAFA exhibition (quoted above) // C. H. Caffin, *International Studio* 14 (Oct. 1901), p. xxxii, reviews it in Pan-American Exposition (quoted above); 15 (Feb. 1902), p. lxi, in a review of the NAD exhibition, calls the portrait "at first, distasteful by reason of its frank realism, but gradually growing upon one's interest, and with further intimacy becoming extraordinarily fascinating" (quoted above) // H. N. Howard, *Brush and Pencil* 9 (Feb. 1902), p. 286, in review of the NAD exhibition, notes, "Among other examples of excellent portraiture one may find much to praise in . . . Thomas Eakins's 'Louis N. Kenton.'" // H. S. Morris, *Century*, n. s. 47 (March 1905), ill. p. 718 // C. H. Caffin, *The Story of American Painting* (1907), p. 232, says: "Equally objective are the portraits of men by Eakins, which represent a similarly impersonal point of view toward the sitter, and in his best ones an extraordinary display of the artist's own personality in his grip of the technical problems of the picture. One of the most remarkable examples is the *Portrait of Louis N. Kenton*; a lean, shambling figure, with the hands thrust into the waist-pockets of the trousers; the strong, intellectual head bowed in meditation. It suggests that the man has been pacing up and down the room, thinking out some matter, and has suddenly halted, all alert, as he finds himself near to its solution" (quoted above) // S. Eakins, letter in MMA Archives, 1916, identifies several subjects of Eakins portraits, including Kenton (quoted above) // H. McBride, *New York Sun*, Nov. 11, 1917, p. 12, lists with works "in which the characterization and finish have been carried to a degree unprecedented in the history of American art," and says it "is the most restrained, most classic of all of the Eakins canvases. It is so restrained that it is almost more like sculpture than painting. . . . It is indeed a memorable, unforgettable picture. . . . In great art the means are concealed in the end, so it is said. In 'The Thinker' they certainly are. In it Eakins hides all his effort and withdraws from the scene utterly" // J. M. Hamilton and H. S. Morris, *MMA Bull.* 12 (Nov. 1917), ill. p. 220 // *Arts and Decoration* 8 (Nov. 1917), ill. p. 26 // *Outlook* 117

(Nov. 21, 1917), p. 452, in review of the MMA memorial exhibition, calls it "perhaps the most distinctive of all the painter's achievements" // B. B[urroughs], *MMA Bull.* 13 (Jan. 1918), p. 25, reports purchase of the painting, notes that it is "executed impersonally, in the way that Velázquez or Piero della Francesca approached their subjects, and in the more austere lighting of Eakins's later period," and calls it "a distinctly American type" // N. N., *Nation* 106 (Feb. 21, 1918), p. 218, reviews it in PAFA memorial (quoted above) // B. B[urroughs], *MMA Bull.* 18 (Dec. 1923), p. 282, discusses it in relation to The Writing Master, "painted in rich and dark colors in a sort of Rembrandt-like effect. The other portrait, The Thinker . . . has an aspect of bleakness. The figure is lit by a cold light as he stands in his carelessly worn black clothes against a plain gray wall. . . . in the years between The Writing Master and this, the painter's style has become broader, more austere, and less sensuous. He had lost his interest in accessories; his effort was concentrated on statements of aspect and character, particularly character. No one can mistake the nervous, absent-minded, theoretical, almost fanatical temperament of the subject. It is hard to say whether the impersonality of this work or the warmth and affection of The Writing Master display the greater art. They are both extraordinary, and in them Eakins shows himself the best of our portrait painters" // A. Burroughs, *Arts* 4 (Dec. 1923), ill. p. 312; 5 (June 1924), p. 332, lists it // *The Pageant of America*, ed. by R. H. Gabriel, 12 (1927), ill. p. 96, no. 149, says that the intensity of Eakins's "vision and insight are beyond the average observer's powers to imitate or even to grasp, hence his portraiture has never been popular, and is not likely to be so. But his fame has steadily risen among his fellow-painters and the critics. *The Thinker*, painted in 1900, is a study of contemporary life reflecting an age when the man in the office is the dominant figure" // E. A. Abbott, *The Great Painters* (1927), pl. 87A, p. 389, notes, "The picture lacks beauty of colour, form, and execution, but the force of the artist's mind intent upon creating a certain type—just this ungainly type—surmounts all difficulties," describes it as "an expression of the American spirit" // R. E. Jackman, *American Arts* (1928), pl. xlvii // S. LaFollette, *Art in America* (1929), p. 189 (quoted above) // F. J. Mather, Jr., *Estimates in Art* 2 (1931), pp. 219–220 (quoted above) // L. Mumford, *The Brown Decades* (1931), pp. 213–214, discusses it and The Gross Clinic: "The mild unflinching butchery of the surgeon, the abstract calculations of the physicist, the tense, dry, somewhat bleak faces of the scientific men of his period, crystallized once for all in his portrait of The Thinker—these subjects attracted Eakins and he interpreted them, not as a romantic visitor, but as a colleague or disciple" // L. Goodrich, *Thomas Eakins* (1933), p. 137; p. 139, notes that when the MMA bought another work, Eakins was disappointed and asked why they hadn't bought the Thinker; pp. 190–

191, no. 331, describes it, no. 332, notes oil sketch // *Index of Twentieth Century Artists* 1 (Jan. 1934), p. 50 lists it; p. 58, lists reproductions of it // R. McKinney, *Thomas Eakins* (1942), ill. p. 43 // M. McHenry, *Thomas Eakins Who Painted* (1946), p. 70, mentions that it was shown in a Brooklyn exhibition with the old masters and that Eakins's pupil Thomas J. Eagan was thrilled that Eakins "held his own" among them // R. B. Hale, *MMA Bull.* 12 (March 1954), p. 176 // S. Schendler, *Eakins* (1967), ill. p. 191; p. 192, discusses it; p. 294, discusses Kenton and his short-lived marriage to Elizabeth Macdowell, "a painter of some talent, a contentious woman of great spirit"; p. 296, notes that it was shown at the Carnegie Institute // B. Novak, *American Painting of the Nineteenth Century* (1969) p. 208, ill. 11–21; p. 209, says, "Eakins learned, as had Manet, from Velázquez, to use the limbo of empty space around a figure, making it function as surface and depth. In their full-length portraits Sargent and Whistler, too, were aware of this spatial potential. But, more than they, Eakins could utilize the gestural attitude of the entire body as a psychological comment. Thus, in *The Thinker* . . . it is the arabesque of the suit against the surrounding space, rather than the face, that reveals the mood of the man" // J. D. Prown, *American Painting from Its Beginnings to the Armory Show* (1969), color ill. p. 114; p. 117, compares with Whistler's portrait of Théodore Duret (q. v.) and analyzes, concluding that Eakins's "primary interest is not in art for its own sake but for its relevance to man and his existence" // W. D. Garrett, P. F. Norton, A. Gowans, and J. T. Butler, *The Arts in America* (1969), p. 254, pl. 191, and notes, "Its theme evokes the typical loneliness of creative individuals of the post-Civil War decades. And like so many of Eakins' works, it ultimately recalls that lost America of individual independence and self-sufficiency in the 1840's and 1850's, to which Eakins always spiritually belonged" // G. M. Ackerman, *Gazette des Beaux-Arts* 73 (April 1969), p. 247, makes reference to "the Whistler-like outline of Louis Kenton, *The Thinker*" // C. Ratcliff, *Art International* 14 (Christmas 1970), ill. p. 64 // G. Hendricks, *The Life and Work of Thomas Eakins* (1974), p. 246, fig. 264 (quoted above); p. 280, mentions favorable notice of it in the *Outlook*'s review of the MMA memorial exhibition; p. 282; p. 283, mentions critical notice of it in the *Nation*'s review of the PAFA exhibition; p. 334, CL-190 // *MMA Bull.* 33 (Winter 1975–1976), ill. p. 242 // Museum of Fine Arts, Houston, and the Brooklyn Museum, *Gustave Caillebotte, a Retrospective Exhibition* (1976–1977), cat. by J. K. T. Varnedoe and T. P. Lee, p. 49, fig. 5, compares to Caillebotte's work // M. W. Brown, *American Art to 1900* (1977), p. 523, pl. 645, notes that it "can stand comparison with the suave aestheticism of Whistler's *Théodore Duret* . . . or Manet's brilliant paraphrase of Velázquez in his *Philosopher with a Hat.* . . . Although they are remarkably similar in many respects, the Eakins appears almost provincial

in its primary concern with the sturdy honesty and warm humanity of the subject" // Slack Hall, North Cross School, Roanoke, Va., *Thomas Eakins, Susan Macdowell Eakins, Elizabeth Macdowell Kenton* (1977), exhib. cat. by D. Sellin, pp. 29–30, says, "Elizabeth Macdowell Kenton has been an unknown quantity. The same ingredients went into her upbringing and art instruction, and she had the same independence of spirit as Susan [Eakins]. . . . Elizabeth didn't let marriage stand in her way; hers to Louis Kenton, whom Eakins portrayed in his large 1900 picture called *The Thinker*, barely outlasted the honeymoon" // P. D. Rosenzweig, *The Thomas Eakins Collection of the Hirshhorn Museum and Sculpture Garden* (1977), p. 226, no. 129, n 2, states that Harrison Morris, managing director of the PAFA from 1892 to 1905, "confused Will Crowell with Louis Kenton, . . . as the subject of Eakins's portrait *The Thinker*" // T. Siegl, *The Thomas Eakins Collection* [*Philadelphia Museum of Art*] (1978), intro. by E. H. Turner, p. 30, fig. 8, says, "Certain works were painted with an awesome facility. These, for the most part, were likenesses of those with whom he felt a considerable sense of ease or identification, for example, some of the portraits of his father-in-law; his portraits of Leslie Miller . . . and of Louis Kenton, called *The Thinker*"; notes, "There can be no question that his justified pride in a portrait as understated as *The Thinker* was based upon the recognition that he had successfully conveyed a sense of time suspended; p. 39, n 82, cites Goodrich, who notes that Eakins hoped the MMA would purchase this painting // J. Wilmerding, *Arts Magazine* 53 (May 1979), p. 110, says this work is the culmination of the portrait in an evocatively empty setting and shows the influence of Velázquez's paintings "wherein we feel equally the palpability of flesh and thought" // L. Goodrich, *Thomas Eakins* (1982), 2, pp. 179–182, discusses and observes: "Eakins' full-length portraits of standing men have many parallels with those of Velázquez: complete realism, concentrations on character, naturalistic depiction of light, fundamental austerity of style. The Kenton portrait is especially close to Velázquez"; includes color pl. 231, fig. 232 (detail); and says that Eakins showed it at least thirteen times; p. 205, lists with the best of Eakins's larger portraits; p. 256.

Exhibited: Carnegie Institute, Pittsburgh, 1900–1901, no. 70, as Portrait of Mr. Louis Kenton // PAFA, 1901, no. 11, Portrait of Louis N. Kenton, lent by Mrs. Louis N. Kenton // Buffalo, 1901, *Pan-American Exposition*, no. 310, as Portrait of Louis N. Kenton, Esq. // NAD, 1902, no. 309, as Portrait, Louis N. Kenton, lent by Mrs. Louis N. Kenton // Worcester Art Museum, summer 1902, no. 363, as Portrait of Louis Henton [*sic*], Esq. // Copley Society, Copley Hall, Boston, 1902, *The Copley Society Second Annual Exhibition of Contemporary Art*, p. 9, as Portrait of Louis N. Kenton, Esq.; p. 33, no. 81 // Universal Exhibition, Saint Louis, 1904, *Official Catalogue of Exhibitors* (rev.

ed.), p. 27, no. 220, as Portrait of Mr. Louis Kenton // Detroit Museum of Art, 1906, *Annual Exhibition of American Artists* (no cat. available) // Corcoran Gallery of Art, Washington, D. C., 1907, *First Annual Exhibition, Oil Paintings by Contemporary American Artists*, no. 150, as Portrait of Mr. Louis N. Kenton, lent by Mr. Louis N. Kenton // MMA, 1917, *Loan Exhibition of the Works of Thomas Eakins*, no. 48, as The Thinker, Portrait of Louis N. Kenton, lent by Mrs. Louis N. Kenton // PAFA, 1917–1918, *Memorial Exhibition of the Works of the Late Thomas Eakins*, no. 68, as The Thinker, Portrait: Louis N. Kenton, lent by the MMA // NAD, Corcoran Gallery of Art, Washington, D. C., and the Grand Central Art Galleries, New York, 1925–1926, *Commemorative Exhibition by Members of the National Academy of Design*, no. 315 // MMA, 1939, *Life in America*, no. 263 // Philadelphia Museum, 1944, *Thomas Eakins Centennial Exhibition*, no. 90 (see *Philadelphia Museum Bulletin* 39 above) // MMA, 1950, *Twentieth Century Painters*, p. 5 // Century Association, New York, 1951, *Eakins-Homer Exhibition*, no. 5 // Los Angeles County Fair, Art Building, Pomona, Calif., 1951, *One World of Art*, unnumbered cat., ill. // PAFA, 1955, *150th Anniversary Exhibition*, no. 88 // MMA, 1958–1959, *Fourteen American Masters* (no cat.) // National Gallery of Art, Washington, D. C., Art Institute of Chicago, and Philadelphia Museum of Art, 1961–1962, *Thomas Eakins, a Retrospective Exhibition*, cat. by L. Goodrich, p. 29, lists it among his "finest works"; no. 77 // MMA, 1965, *Three Centuries of American Painting*, unnumbered cat.; 1970, *19th-Century America, Paintings and Sculpture*, exhib. cat. by J. K. Howat and N. Spassky (not in cat.) // Whitney Museum of American Art, New York, 1970, *Thomas Eakins, Retrospective Exhibition*, cat. by L. Goodrich, p. 17, notes that it "is close to the portrait of Pablo de Valladolid [by Velázquez] in the Prado, not only in its whole concept but in its actual color harmony" and says: "Whistler . . . adapted the master's decorative qualities but not his naturalism. With Eakins the affinity was deeper: a direct relation to the realities of their respective times and centuries, a grasp of character, a command of three-dimensional space, and a monumental sense of design"; p. 29, lists with his "strongest works"; ill. p. 58; no. 76 // M. Knoedler and Co., New York, 1971, *What Is American in American Art?* [An Exhibition in Memory of Joseph B. Martinson for the Benefit of the Museum of American Folk Art], intro. by L. Goodrich, cat. by M. Black, p. 37, no. 87, discusses it; ill. p. 67, no. 87 // MMA, 1976, *A Bicentennial Treasury* (see *MMA Bull.* 33 above) // MFA, Boston, Corcoran Gallery of Art, Washington, D. C., Grand Palais, Paris, 1983–1984, *A New World*, p. 175; color ill. p. 182, no. 102; pp. 329–330, no. 102, entry by C. Troyon, discusses it.

Ex coll.: Elizabeth Macdowell Kenton, Philadelphia, 1900–1917.

John Stewart Kennedy Fund, 1917.

17.172.

Eakins, *Signora Gomez d'Arza.*

Signora Gomez d'Arza

Signora Gomez d'Arza was an Italian actress. Her husband, Enrico Gomez d'Arza, was the impresario of a small theater in the Italian quarter of Philadelphia. Eakins and his wife visited the theater and became friends with the Arza family. Although this portrait is inscribed 1902, it was painted in the winter of 1901 according to a letter from Mrs. Eakins (1927). In a subsequent letter, she added:

The portrait was painted in 1901. The year previous a party of us went often to the Italian quarters (Little Italy of Phila.) to see the marionettes perform in classic Plays, and hear the beautiful Italian spoken . . ., also interesting performances at the Italian Theatre. There we saw Signor & Signora Gomez act and through this association Mr. Eakins painted the portrait. They were very poor, depending on their acting and Signora's teaching young actors, for a living. They could

not speak English. Mr. Eakins spoke Italian and learned from her that she had had tragic experiences in her early life. She was about thirty years old when the portrait was painted.

During the period of the posings for the portrait, Miss [Mary Adeline] Williams and I cooked and served a noon dinner for them and their two children, a boy "Mario," and a baby "Immaculata," marvel of happiness and comfort, always smiling. The baby was swathed in white wrappings, we were curious, so different from the American way. Signora unwrapped the cloths to show us the custom, and we also noted the exquisite care and cleanliness, altho. so poor.

Signora showed us how to cook spaghetti & kidney the finest way, she said "I know how, but cannot afford it myself." The dish became famous in our house. Soon after the portrait was finished they left Philadelphia. We heard only once from them.

Signora Gomez d'Arza is one of Eakins's strongest and most compelling character studies. Dark-

haired, dressed in an elaborate lace-trimmed costume with dark blue sleeves, and wearing a red earring, Signora Gomez d'Arza is shown seated in three-quarter view. The intensity of her character is reflected in her tense posture and disquieting preoccupied expression. The drama is heightened by her theatrical dress and the stark, raking light on her face and hand.

Oil on canvas, 30 × 24 in. (76.2 × 61 cm.).

Signed and dated on back by another hand: T. E. 1902.

REFERENCES: A. Burroughs, *Arts* 5 (June 1924), p. 332, calls it Signora Gomez d'Artza [*sic*], 1901?, coll. Mrs. Eakins // L. Goodrich, *Arts* 8 (Dec. 1925), pp. 345, 347, in a review of the Sargent exhibition at Knoedler's and the Eakins exhibition at the Brummer Galleries, compares the work of the two artists; ill. p. 346 // L. Kalonyme, *Arts and Decoration* 24 (Jan. 1926), p. 53, calls sitter Signora Gomez d'Artza [*sic*], speculates how Sargent would represent her, and concludes that "he *would not* have painted her"; notes, "The long, strong dark face is unparalleled in American classical painting for structural strength. It seems incredible that an American, and a Philadelphian at that, could have painted it"; ill. p. 54 // H. McBride, *Dial* 80 (Jan. 1926), p. 78, in a review of the Eakins exhibition at the Brummer Galleries, New York, lists it with "two or three portraits . . . which would, and someday will, hold their own comfortably in any European collection of masterpieces" // E. C. Babcock to B. Burroughs, Nov. 11, 1927, MMA Archives, as Mrs. Eakins's agent, arranges to send the painting to the MMA, says the picture is number 8 in the current exhibition of Eakins's work, and quotes an article by McBride who called the painting "a masterpiece that should be gobbled up instantly by one of our museums" // S. M. Eakins to Burroughs, Nov. 27, 1927, MMA Archives, says: "With much pleasure, I receive your note today, announcing the purchase by the Museum of the portrait of the Italian actress Signora Gomez d'Artza [*sic*]. I will write you about the portrait soon" // S. M. Eakins to MMA, Nov. 30, 1927, MMA Archives, supplies information on exhibitions in 1925 and 1927 // S. M. Eakins to H. W. Kent, Dec. 1, 1927, MMA Archives, says: "Thinking it over, I think I may have neglected to give the date of the painting of the portrait. Signora Gomez d'Artza was painted the winter of 1901"; Dec. 10, 1927, adds, "I must now confess to an error in the record, regarding the portrait of Signora Gomez d'Arza. There is not a *t* in the name. Looking through my papers I found the card of Signor Gomez d'Arza—his full name, Enrico Gomez d'Arza, he was an actor, of Spanish ancestry, but born and raised in Italy. Signora Gomez d'Arza [was] of Italian ancestry" // S. M. Eakins to Burroughs, Dec. 12, 1927, MMA Archives, notes correction of name; says that the "only other informa-tion I can give you is to describe the period during which the Signora posed for the portrait" (quoted above) // J. M. L[ansing], *MMA Bull.* 23 (Jan. 1928), ill. pp. 29–30, announces acquisition, discusses, and calls it "a powerful rendering of a sad, rather plain woman who shows the effect of tragic experiences in her early life, which make her look older than her thirty years" // S. LaFollette, *Art in America* (1929), ill. opp. p. 155; p. 188, says, "The portrait of Signora Gomez d'Arza may have offended the actress herself; but the disinterested person sees that unlike El Greco as it is in every other way, it has his grand austerity" // L. Mumford, *The Brown Decades* (1931), p. 216, observes, "no degree of refinement or sensitiveness was beyond Eakins' reach: his portrait of Señora Gomez or that of Arthur B. Frost discloses the inner drama" // L. Goodrich, *Thomas Eakins* (1933), p. 104, calls it "one of his most intense portraits of women, showing a deep affinity for the Latin temperament"; p. 137; pp. 193–194, no. 360, catalogues it; ill. pl. 58 // *Index of Twentieth Century Artists* 1 (Jan. 1934), p. 50, lists it; p. 56, lists reproductions; suppl. to 1, p. iii, lists reproductions // F. Watson, *American Magazine of Art* 28 (Feb. 1935), ill. p. 114 // R. McKinney, *Thomas Eakins* (1942), p. 15, lists it as one of his four greatest portraits, "brilliant transcriptions of character that have seldom been surpassed in American painting," calls it "an example of the great respect for the elements of design and form which Eakins possessed from his student days," notes that some compared him to Goya, but "there is no resemblance between the two artists except perhaps in the intelligent consideration of character in which both Goya and Eakins excelled"; p. 19, says that "the assertive portrait of Signora Gomez d'Arza" was executed in 1902 and calls it a milestone "in the development of our native art"; color ill. p. [97] // F. Watkins, *Art News* 43 (April 15–30, 1944), ill. p. 13 // F. J. Mather, Jr., *Magazine of Art* 39 (Nov. 1946), ill. p. 300, calls it "a superb portrait" and notes, "He has made an artistic asset of positive uncomeliness in a character in which tragic resignation and hesitant dignity oddly blend. The picture's few attractive and charming features are limited to the touching in of the costume and of the fine, awkwardly held hand. But in a larger way the spotting of the economized light passages is highly effective compositionally, as always with Eakins. His apparent disregard of decoration finds compensation in his sensitive rightness in those aspects of fine arrangement, which somehow transcend the merely decorative" // M. McHenry, *Thomas Eakins Who Painted* (1946), pp. 106–107, describes visits with the family, describes this portrait, and says, "Signora Gomez D'Arza looks entirely aristocratic. . . . Eakins has hinted nowhere her harsh life of penury, unless in the slightly brooding look and the slight frown of the forehead" // V. Barker, *American Painting* (1950), p. 661 // H. McBride, *Art News* 49 (June, July, August 1950), ill. p. 36; pp. 36–37, notes that it "is a masterpiece that would hold

its own in any exhibition of portraits anywhere on earth" // D. Brian, *Art Digest* 24 (July 1950), ill. p. 7; p. 9, says that it "can stand up to almost any thing in the Metropolitan's old master collections" // R. B. Hale, *MMA Bull.* 12 (March 1954), p. 176 // F. Porter, *Thomas Eakins* (1959), color pl. 65 // S. Schendler, *Eakins* (1967), p. 164, mentions it and notes that "though the late work may evoke the tragic sense . . ., the underlying sense of human loss is frequently in tension with qualities of character that imply endurance . . . or with an understanding that includes some absolute sense of mortality"; pp. 222–226, calls it "a classic portrait whose intimations of the tragic are handled with the greatest restraint. . . . The painting reminds one of the great Spanish masters and yet, I think, only a profound modern consciousness could have painted it. Despair has been encompassed not by faith but by a mysterious and astonishing art"; p. [223], fig. 111; p. 282, notes, "When he came upon the portrait of *Signora D'Arza* . . . hung as a pendant to the *Pygmalion and Galatea* of Gérôme in the recent-accessions room of the Metropolitan, Walter Pach felt the confrontation instructive 'because it showed how a powerful personality remained untouched by bad influences'" // R. Moynihan, *Art News* 69 (Jan. 1971), p. 51, notes that Eakins's "best work is in his portraits where he is confronted by the moral reality of the subject, and which he could render 'without frills or affectation,'" and mentions this painting among examples; ill. p. 52 // G. Hendricks, *The Life and Works of Thomas Eakins* (1974), fig. 277, p. [254]; p. 255, dates it 1902; pp. 334–335, no. CL–192, in checklist, dates it "1902?" // M. W. Brown, *American Art to 1900* (1977), p. 524, says, "No American artist has ever approached the . . . romantic intensity of Signora Gomez D'Arza" // P. D. Rosenzweig, *The Thomas Eakins Collection of the Hirshhorn Museum and Sculpture Garden* (1977), p. 221, no. 124, quotes letter from Charles Bregler to Samuel Murray, postmarked April 2, 1941, in the Hirshhorn Museum Archives, which mentions condition of Murray portrait and this painting // J. Wilmerding, *Arts Magazine* 53 (May 1979), p. 109; p. 110, says, "Ordinarily Eakins' later three-quarter views of individuals painted bust length are without much color, and rely instead on carefully modulated contrasts of tonal values within a restricted or near-monochromatic palette," includes this painting with "the strongest and most familiar in this group," states that "the actress's harsh features seem to carry a transcendent serenity of stoic thought," and observes that the "embroidered dress sets off the strong head" // L. Goodrich, *Thomas Eakins* (1982), 2,

color ill. p. [210], fig. 246; detail p. 211, fig. 247, and lists it among the artist's "outstanding portraits" of women painted between 1900 and 1910; p. 280.

EXHIBITED: Brummer Galleries, New York, 1925, *Paintings and Drawings by Thomas Eakins*, no. 4 // Albright Art Gallery, Buffalo, 1926, *Catalog of a Collection of Paintings and Drawings by Thomas Eakins (1844–1916)*, no. 4, as Signora Gomez d'Artza // Babcock Galleries, New York, 1927 [no cat. available; no. 8 in exhibition according to E. C. Babcock to B. Burroughs, Nov. 11, 1927, MMA Archives] // Portland, San Francisco, and Los Angeles, 1927 [according to Mrs. Eakins] // Baltimore Museum of Art, 1936–1937, *Thomas Eakins, 1844–1916, a Retrospective Exhibition of His Paintings*, no. 33 // Philadelphia Museum of Art, 1944, *Centennial Exhibition of Thomas Eakins*, no. 98 // Centennial Art Gallery, Centennial Exposition, Utah State Fair Grounds, Salt Lake City, 1947, *One Hundred Years of American Painting* (American Federation of Arts, Washington, D. C.), no. 30 // NAD, March 1949, unnumbered cat. // MMA, 1950, *American Painters of the 20th Century*, alphabetical checklist; 1950, *20th Century Painters*, checklist, p. 5 // Century Association, New York, 1951, *Eakins-Homer Exhibition*, no. 4 // NAD and American Federation of Arts, traveling exhibition, 1951–1952, *The American Tradition*, no. 50 // MMA, 1958–1959, *Fourteen American Masters* (no cat.) // National Gallery of Art, Washington, D. C., Art Institute of Chicago, and Philadelphia Museum of Art, 1961–1962, *Thomas Eakins, a Retrospective Exhibition*, intro. essay by L. Goodrich, no. 87 // MMA, 1965, *Three Centuries of American Painting*, unnumbered cat. // Los Angeles County Museum of Art and M. H. de Young Memorial Museum, San Francisco, 1966, *American Paintings from the Metropolitan Museum of Art*, no. 70 // Brooklyn Museum, Virginia Museum of Fine Arts, Richmond, and California Palace of the Legion of Honor, San Francisco, 1967–1968, *Triumph of Realism*, intro. by A. von Saldern, no. 85 // Whitney Museum of American Art, New York, 1970, *Thomas Eakins, Retrospective Exhibition*, cat. by L. Goodrich, ill. p. 61; p. 71, no. 85 // MMA and American Federation of Arts, traveling exhibition, 1975–1977, *The Heritage of American Art*, cat. by M. Davis, ill. p. [150]; p. 151, no. 66.

EX COLL.: the artist, Philadelphia, until 1916; his wife, Susan M. Eakins, Philadelphia, 1916–1927, with E. C. Babcock Art Galleries, New York, as agent, 1927.

George A. Hearn Fund, 1927.

27.220.

MARY CASSATT

1844–1926

Mary Stevenson Cassatt was born in Allegheny City (now part of Pittsburgh), Pennsylvania. In 1851, when she was seven, her father took the family to Europe, and she spent her early years in France and Germany. Late in 1855 the Cassatts returned to the United States. From 1861 to 1865 Mary Cassatt studied at the Pennsylvania Academy of the Fine Arts. She drew from casts and copied paintings in the academy's collection. Afterward, she convinced her parents to let her study abroad. Late in 1865 she went to Paris. She took private lessons from Jean Léon Gérôme, copied works of the old masters, and went sketching. She later credited her mastery of painting techniques to copying and advised other aspiring artists to do the same. She stayed in Courances and in Ecouen and studied with Edouard Frère and Paul Soyer. She also visited Saint-Valery-sur-Somme and Barbizon. In 1868, Cassatt's painting *La Mandoline* (private coll.) was accepted at the Paris Salon, the first time her work was represented there. Following the exhibition, she settled in Villiers-le-Bel, presumably to study with Thomas Couture. Shortly thereafter she made a sketching trip through the French and Italian Alps. The Franco-Prussian War interrupted her studies, and she returned to Philadelphia in 1870.

In 1871 she sailed for Italy with Emily Sartain (1841–1927), the daughter of the Philadelphia artist John Sartain (1808–1897). They spent eight months in Parma in 1872, where Mary Cassatt studied the paintings of Correggio and Parmigianino and benefited from the encouragement of Carlo Raimondi, head of the department of engraving at the Parma Academy. In 1873 she visited Spain, Belgium, and Holland to study the works of Velázquez, Rubens, and Hals. Several of the copies she made are extant, including Frans Hals's 1633 painting *Meeting of the Officers of the Cluveniers-Coelen* (Cassatt's 1873 copy, coll. Mrs. Percy C. Madeira, Jr., Berwyn, Pa.). She sent *Torero and Young Girl*, 1873 (Sterling and Francine Clark Art Institute, Williamstown, Mass.) to the Salon in 1873 and returned to Paris.

In 1877 Mary Cassatt's parents and her sister Lydia joined her in Paris. The same year Edgar Degas invited her to join the group of independent artists later known as the impressionists. "I accepted with joy," she later told her biographer Achille Segard. "At last, I could work with absolute independence without considering the opinion of a jury. I had already recognized who were my true masters. I admired Manet, Courbet and Degas. I hated conventional art" (p. 8). The only American officially associated with the impressionists, Mary Cassatt exhibited in four of their eight exhibitions: 1879, 1880, 1881, and 1886. Her admiration for these artists had manifested itself earlier in a change in style. Mary Cassatt's technique, composition, and use of color and light reflected the influence of the French avant-garde, particularly Degas and Manet. Degas, her chief mentor, provided criticism of her work, offered advice on technique, and encouraged her experiments in printmaking. Like Degas, she was chiefly interested in figure compositions. During the late 1870s and early 1880s, the subjects of her works were her family (especially her sister Lydia), the theater, and the opera. Later she made a specialty of the mother and child theme, which she treated with warmth and naturalness in paintings, pastels, and prints. In

1878 J. ALDEN WEIR invited her to exhibit at the newly founded Society of American Artists in New York. Commitments in Paris prevented her from participating in the first exhibition, but her work was represented in the second exhibition in 1879. Although she was a member from 1880 to 1894 and admired the independence of the group and its aims, she exhibited with them only once more, in 1892.

Mary Cassatt made over two hundred prints. According to Segard, one of her major reasons for concentrating on printmaking was to perfect her draftsmanship. The exacting discipline of drypoint especially presented a formidable challenge. In addition to drypoint, she explored tonal effects in soft-ground and aquatint and sometimes combined all three techniques. None of the graphics she produced as a student in Parma survive, but about 1879 she began a more intensive exploration of the medium. That year Degas made plans for a new art publication titled *Le Jour et La Nuit*. Various artists, including Mary Cassatt, were asked to contribute. In a letter to Pissarro, Degas reported: "Miss Cassatt is making some delightful graphic experiments." Although the journal was never published, it served to encourage her experiments in printmaking. In 1890 she visited the great exhibition of Japanese art at the Ecole des Beaux-Arts. Although Japanese art had influenced French and American artists considerably before 1890, this exhibition, which included over seven hundred prints, had a profound effect. Mary Cassatt, who shared Degas's enthusiasm for Japanese prints, acquired a small collection of landscapes by Hiroshige and Hokusai and figure prints by Kiyonga, Shunjo, Utamaro, and others. During 1890 and 1891 she made ten color prints that are a unique contribution to graphic art. "The set of ten plates was done with the intention of attempting an imitation of Japanese methods," she wrote to Frank Weitenkampf, curator of prints at the New York Public Library in 1908. "Of course I abandoned that somewhat after the first plate and tried more for atmosphere." These innovative prints were included in her first one-woman exhibition held at Galerie Durand-Ruel in Paris in 1891. Subsequently she made eight additional color prints, notable for their rich colors and decorative qualities. The influence of Japanese art also had an effect on her painting style, evident in such works as *The Bath*, 1892 (Art Institute of Chicago). Line, silhouette, decorative pattern, and perspective were given greater attention.

In 1892 the Chicago collector Mrs. Potter Palmer commissioned Mary Cassatt to paint a mural for the south tympanum of the Women's Building at the World's Columbian Exposition in 1893. This gave her an opportunity to work on a larger scale than usual. The mural *Modern Women*, which was painted on canvas, has since disappeared and is known only through reproductions.

Following a second, large, well-received exhibition of her work at the Galerie Durand-Ruel in Paris in 1893, Mary Cassatt purchased the Château de Beaufresne at Mesnil-Théribus, Oise. The seventeenth-century manor house, twenty-seven miles north of Paris, became her country home. In 1898 she returned on a visit to the United States for the first time since 1875.

Mary Cassatt's role as an advisor to collectors benefited many public and private collections in the United States. From her early days in Paris she encouraged the collection of old masters and the French avant-garde. In 1901 she accompanied Mr. and Mrs. Horace Havemeyer on a collecting trip to Italy and Spain. "I call her the fairy godmother of my

collection," Mrs. Havemeyer wrote, "for the best things I own have been bought upon her judgment and advice." Mary Cassatt had known Mrs. Havemeyer before her marriage. In 1873 she had encouraged the then seventeen-year-old Louisine Elder to buy a pastel by Degas, and the two women became close friends. Mary Cassatt was eventually instrumental in shaping the Havemeyer collection, most of which is now in the Metropolitan Museum. Mrs. Havemeyer recalled: "Some of the happiest moments of my life were spent with her and Mr. Havemeyer in Europe, where she was sure to have a clue which led to some acquisition that has made our collection what it is. One of her earliest bits of advice was 'Never omit the modern note,' and we collected Courbets, Monets, Degas, and the Impressionists. Another time, she said 'We must collect old moderns also' and in our gallery were added Veronese, Grecos, Goyas, etc." (*Pennsylvania Museum Bulletin* 22 [May 1927], p. 373).

In 1903 an exhibition of Mary Cassatt's work was held at Durand-Ruel in New York. She visited the United States in 1904 and again, for the last time, in 1908. Failing eyesight severely curtailed her work, and in 1910 she gave up printmaking, and in 1914 she stopped painting. She spent most of the war years in Grasse and died in 1926 at the Château de Beaufresne.

BIBLIOGRAPHY: Achille Segard, *Un Peintre des enfants et des mères, Mary Cassatt* (Paris, 1913). A contemporary biography of the artist, containing a list of exhibitions, public and private collections in which her work is represented, and a bibliography // Frederick A. Sweet, *Miss Mary Cassatt: Impressionist from Pennsylvania* (Norman, Okla., 1966). An excellent biography of the artist with extensive quotes from a large number of unpublished letters and family documents. Contains a list of unpublished letters, a bibliography, and a list of exhibition catalogues // Adelyn Dohme Breeskin, *Mary Cassatt: A Catalogue Raisonné of the Oils, Pastels, Watercolors, and Drawings* (Washington, D. C., 1970). This indispensable publication for Cassatt's work contains a biographical essay, a chronology, an illustrated catalogue of the artist's known work (except graphics), a selective bibliography, and indexes of owners, titles, and sitters // Adelyn D. Breeskin, *Mary Cassatt: A Catalogue Raisonné of the Graphic Work* (Washington, D. C., 1979). An updated and revised edition of the author's 1948 publication, it includes a biography, a chronology, a discussion of Cassatt's printmaking techniques, and an illustrated catalogue raisonné // Nancy Mowll Mathews, ed., *Cassatt and Her Circle: Selected Letters* (New York, 1984).

The Cup of Tea

Painted about 1879, two years after Degas invited Mary Cassatt to join the group of independent artists subsequently known as impressionists, *The Cup of Tea* shows the extent of her commitment to impressionism. This picture marks a departure from such works as *Mrs. Duffee Seated on a Striped Sofa Reading*, 1876 (MFA, Boston). *The Cup of Tea* is closely related in both style and composition to *Lydia Reading the Morning Paper*, 1878 (two versions: Joslyn Art Museum, Omaha, and Norton Simon Foundation, Fullerton, Calif.). Although it represents the artist's sister, Lydia Simpson Cassatt (1837–1882),

The Cup of Tea is, as the title suggests, less a specific portrait than a representation of a popular social ritual—one of the activities of contemporary life that became the mainstay of impressionist imagery. The high vantage point, the asymmetrical placement and arbitrary cropping of the figure, the fluent brushwork, the luminous and high-key palette are very much part of the impressionist idiom. Mary Cassatt's brushwork creates a rich, scintillating surface texture. She avoids the loss of form that is characteristic of the more extreme forms of impressionism and relies on local color and contrasting values for structure, thus aligning herself with Degas, her principal mentor.

Cassatt, *The Cup of Tea*

The Cup of Tea is also a fine example of Mary Cassatt's skill as a colorist. In the impressionist manner, she invariably uses contrasting colors for shadows. The pink dress and white gloves are flecked with blue shadows, while measured strokes of local color are used to accentuate form. Attention is also devoted to the effects of reflected color. The luminous quality of the pink dress is reinforced by pink on the arm of the chair, the underside of the saucer, the white glove, and the woman's face. The blue stripes of the armchair, the vivid green of the flower stand, and the dark green foliage contrast with the high-key intensity of the pink dress and white gloves and the light green background. The last is sketch-like, with the primed canvas visible in peripheral areas. This use of the canvas as part of the composition contributes to the spontaneity of the image. It was, however, one of the avant-garde innovations that invariably met with criticism from the establishment, who viewed it as lack of finish. The rapid progression from dark foreground to light background within the shallow space circumscribed by the arm of the chair and the flower stand also is a departure from academic traditions.

According to Achille Segard, (1913) *The Cup of Tea* was included in the impressionist exhibition of 1879. Subsequent biographers, presumably following Segard, have also stated that *The Cup of Tea* was included in the 1879 exhibition, but this cannot be confirmed. A preliminary list of twelve works by Mary Cassatt appears in a notebook kept by Degas in 1878–1879 (T. Reff, *The Notebooks of Edgar Degas* [1976], 1, pp. 137–138, notebook 31, p. 66). This is apparently a working list of possible contributions by Mary Cassatt to the 1879 exhibition; but only six of those works are listed among eleven Cassatts in the 1879 catalogue. *The Cup of Tea*, however, is not among them, unless it was one of the few that remain unidentified; nor was it mentioned by the reviewers who discussed some of her works but confined their remarks largely to her debut with the group. This work might have been the painting *Le Thé* shown in 1880. *The Cup of Tea* was included, together with *Lydia Crocheting in the Garden at Marly* (q. v.), in the impressionist exhibition of 1881. In an extensive review of Mary Cassatt's contributions to this exhibition, the banker, collector, and art historian Charles Ephrussi praised the varied visual effects of color and light and noted that in this painting, "harmonies of neutral, subtle and exquisite tones" replaced the more emphatic palette she used in other works. Joris Karl Huysmans in his review of the 1881 exhibition, singled out *The Cup of Tea* for its "fine sense of Parisian elegance" and said that Mary Cassatt achieved "something which none of our painters knows how to express, the joyful quietude, the tranquil comfort of an interior."

Oil on canvas, 36⅜ × 25¾ in. (92.4 × 65.4 cm.). Signed at lower left: Mary Cassatt.

REFERENCES: C E[phrussi], *La Chronique des Arts et de la Curiosité*, suppl. to *La Gazette des Beaux-Arts* 17 (April 23, 1881), p. 135, reviews it in the sixth impressionist exhibition, 1881: "la femme en rose buvant du thé fait succéder à ces grands cris de couleurs des harmonies de tons neutres, fines et exquises, d'où sont bannies les matières luisantes" (quoted above in translation) // J. K. Huysmans, *L'Exposition des Indépendants en 1881*, reprinted in *L'Art Moderne* (1883), pp. 233–234, reviews it in the sixth impressionist exhibition, 1881, together with Lydia Crocheting in the Garden at Marly (q. v.): "Deux autres tableaux,—l'un appelé *le Jardin* . . . et l'autre intitulé *le Thé*, où une dame, vêtue de rose, sourit, dans un fauteuil, tenant de ses mains gantées une petite tasse,—ajoutent encore à cette note tendre et recueillie une fine odeur d'élégances parisiennes. Et c'est là une marque inhérente spéciale à son talent, Mˡˡᵉ Cassatt qui est Américaine, je crois, nous peint des Françaises; mais, dans ses habitations si parisiennes, elle met le bienveillant sourire du *at home*; elle dégage, à Paris, ce qu'aucun de nos peintres ne saurait exprimer, la joyeuse quiétude, la bonhomie tranquille d'un intérieur" (quoted above in translation) // M. Utrillo, *Forma* 2 (1907), ill. p. [345], as La Taza de Té // A. Segard, *Un Peintre des enfants et des mères, Mary Cassatt* (1913), ill. opp. p. 4, dated 1879; pp. 59–60, compares this painting to Manet's *Le Printemps* (Jeanne Demarsy), exhibited at the Salon of 1882; pp. 62–63, discusses the possible relation of this painting to the work of Morisot; p. 64, says that the accents of vigor characteristic of Cassatt's work distinguish it from Manet's and Morisot's works and cites as an example the vigor of the dark and light stripes of the chair and its modeling, which is unique to Cassatt; n 1, describes the weak sections of the work, including the modeling of the flower stand, its inadequacy as a background for the face, and the summary treatment of the still life; comments that the tones of the clothing are more delicate than vigorous and do not sufficiently indicate the realities of the body, particularly the limbs; p. 167; p. 203, lists it as Portrait de la soeur de l'artiste dans un intérieur and states that it was shown at the impressionist exhibition of 1879 // B. B[urroughs], *MMA Bull.* 17 (March 1922), p. 55, reports acquisition and describes painting; ill. p. [56] // C. B. Ely, *The Modern Tendency*

in American Painting (1925), ill. opp. p. 4 // Index of Twentieth Century Artists 2 (Oct. 1934), p. 2, lists it; pp. 5, 6, lists reproductions; suppl. to 2 (1935), p. i, lists reproductions // Vogue 123 (Feb. 15, 1954), ill. p. 102 // A. T. Gardner, MMA Bull. 16 (Summer 1957), ill. p. 11 // J. M. H. Carson, Mary Cassatt (1966), pp. 27, 30, says that Cassatt showed La Loge and this painting at the fourth impressionist exhibition in 1879; p. 30, notes 1881 reviews // F. A. Sweet, Miss Mary Cassatt (1966), p. 40, dates it about 1879, says that it was exhibited in the sixth impressionist exhibition of 1881, describes it and says that the "creating of a specific portrait is avoided in favor of an over-all conception of a relaxed figure which merely plays its part in an exquisite tonal study," notes provenance; p. 61, quotes Huysmans's 1881 review; pl. 10 between pp. 108 and 109; p. 137, states that it was included in Cassatt's second exhibition at Durand-Ruel, Paris, in Nov. and Dec. 1893 // D. Sutton, Apollo 54 (March 1967), ill. p. 219, fig. 12; p. 220 // A. D. Breeskin, Mary Cassatt (1970), ill. p. 51, no. 65, catalogues it and notes it is Durand-Ruel 511-L1283 and was shown at the fourth and sixth impressionist exhibitions in 1879 and 1881 // W. Wells, Apollo 95 (Feb. 1972), p. 133; ill. 134, fig. 11 // D. Lowe, American Heritage 25 (Dec. 1973), color ill. p. 17, and says that it was exhibited in the fourth and sixth impressionist exhibitions // N. Hale, Mary Cassatt (1975), p. 166 // J. Roudebush, Mary Cassatt (1979), color ill. p. [26]; p. 33, notes that it is "stylistically reminiscent of Woman Reading" and that the "soft colors and fluid brushwork show further development of the Impressionist influence"; p. 39, quotes Huysmans's 1881 review of this painting // F. Daguet, Durand-Ruel et Cie, Paris, letter in Dept. Archives, July 30, 1984, provides information on provenance and lists as "St 1283 (Paris) et no 3383. PH 511. St 1382 (New York)" from firm's records.

EXHIBITED: possibly shown at 28 Avenue de l'Opéra, Paris 1879, La 4e Exposition de Peinture (Fourth Impressionist Exhibition), according to A. Segard // 35 Boulevard des Capucines, Paris, 1881, 6e Exposition de Peinture (Sixth Impressionist Exhibition), as Le Thé // Galeries Durand-Ruel, Paris, 1893, Exposition de Tableaux, Pastels et Gravures de Mary Cassatt, no. 8, as La Tasse de thé // Barcelona, 1907, Exposición Internacional de Arte (no cat. available) // Galeries Durand-Ruel, Paris, 1908, Tableaux et Pastels par Mary Cassatt, no. 12, as La Tasse de thé // Art Institute of Chicago, 1926–1927, Catalogue of a Memorial Collection of the Works of Mary Cassatt, no. 27, as The Cup of Tea // Philadelphia Museum, 1927, Memorial Exhibition of the Works of Mary Cassatt [catalogue in Pennsylvania Museum Bulletin 22 (May 1927), p. 374], no. 5 // Baltimore Museum of Art, 1941–1942, Mary Cassatt, no. 4 // Utah Centennial Exposition, Salt Lake City, 1947, 100 Years of American Painting, no. 32 // Pasadena Art Institute, 1951, Mary Cassatt and Her Parisian Friends [catalogue in J. P. Leeper, Bulletin of the Pasadena Art Institute, 2 (Oct.

1951), p. 5], no. 13 // Munson-Williams-Proctor Institute, Utica, N. Y., 1953, Expatriates: Whistler, Cassatt, Sargent, no. 26 // Art Institute of Chicago and MMA, 1954, Sargent, Whistler and Mary Cassatt, exhib. cat. by F. A. Sweet, ill. p. 16, no. 5, says that this was the first picture she exhibited with the impressionists in 1879 // PAFA, 1955, The One Hundred and Fiftieth Anniversary Exhibition, no. 116; part of same exhibition included in United States Information Service traveling exhibition, 1955, no. 44 in Italy and Germany; no. 40 in Belgium // MMA, 1958–1959, Fourteen American Masters (no cat.); 1965, Three Centuries of American Painting, unnumbered cat. // Parrish Art Museum, Southampton, N. Y., 1967, Miss Mary Cassatt, no. 9 // MMA, 1970, 19th-Century America, Paintings and Sculpture, exhib. cat. by J. K. Howat and N. Spassky, no. 167 // MFA, Boston, 1970, Masterpieces of Painting in the Metropolitan Museum of Art, intro. by C. Virch, cat. by E. A. Standen and T. M. Folds, color ill. p. 110, discusses it // Meredith Long and Company, Houston, 1971, Americans at Home and Abroad, 1870–1920 (Loan Exhibition for the Benefit of the American Association of Museums), no. 3 // Tokyo National Museum and Kyoto Municipal Museum, 1972, Treasured Masterpieces of the Metropolitan Museum of Art, no. 113 // MMA, 1973, Mary Cassatt (no cat.) // Staten Island Institute of Arts and Sciences, 1974, Mary Cassatt (no cat.) // Pushkin Museum, Moscow, and Hermitage, Leningrad, 1975, 100 kartin iz muzeya Metropoliten, Soedinennie Shtati Ameriki [100 Paintings from the Metropolitan Museum, United States of America], color ill. p. 256, no. 95; no. 95, p. 257, catalogues it // MMA and American Federation of Arts, traveling exhibition, 1977, The Heritage of American Art, cat. by M. Davis, ill. p. [152], no. 67; rev. ed. 1977 [Australian tour], p. 153, no. 67, discusses it // MFA, Boston, 1978, Mary Cassatt at Home, cat. by B. S. Shapiro, no. 5.

ON DEPOSIT: White House, Washington, D. C., 1961–1963.

EX COLL.: with Durand-Ruel, Paris, 1891–1895; with Durand-Ruel, New York, 1895; with Durand-Ruel, Paris, 1895-1911; James Stillman, Paris and New York, 1911-1918; his son, Dr. Ernest G. Stillman, 1918-1922.

From the Collection of James Stillman, Gift of Dr. Ernest G. Stillman, 1922.

22.16.17.

Lydia Crocheting in the Garden at Marly

The artist's sister, Lydia Simpson Cassatt (1837–1882), posed for this painting at Marly-le-Roi, some forty miles west of Paris, where the Cassatt family spent the summer of 1880. The painting has also been called En Brodant and

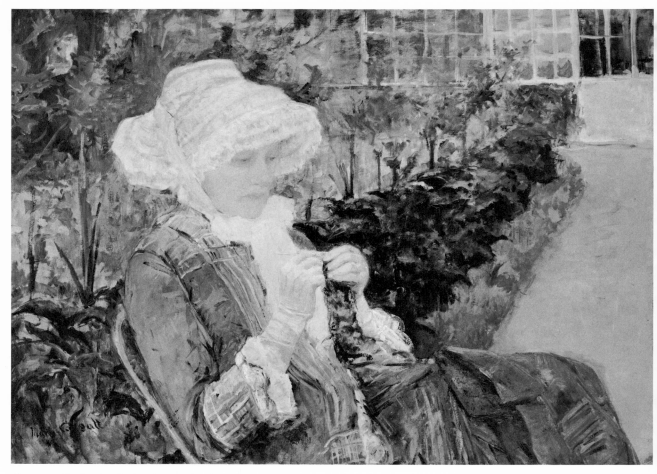

Cassatt, *Lydia Crocheting in the Garden at Marly.*

Lydia Knitting in the Garden at Marly. In subject, conception, palette, and technique, this work demonstrates Mary Cassatt's assimilation of impressionism. Through rapid brushwork and a rich, wide-ranging palette, she skillfully captured the vibrant shimmering effects of outdoor light. This is particularly evident in her treatment of the white hat, which is made iridescent with pink, yellow, and blue. The high-keyed, luminous colors contrast with the intense crimson and purple of the coleus plants that act as a foil for the sitter and reinforce the dramatic perspective.

This is one of Mary Cassatt's boldest compositions. The oblique vantage point and the asymmetrical placement of the cropped figure are an intrinsic part of the impressionist's vision. The closest parallels are late works by Edouard Manet, such as *Portrait de M^{me} Manet à Bellevue*, 1880 (private coll., New York), *M^{me} Manet, Mère, en Plein Air*, 1880 (private coll., Paris), and *Le Banc*, or *The Artist's Garden, Versailles*, 1881 (private coll., New York), and works by Manet's sister-in-law Berthe Morisot, like *Jeune femme cousant dans un jardin*, 1881 (Musée des Beaux-Arts, Pau).

Lydia Crocheting in the Garden at Marly attracted favorable attention at the impressionist exhibition of 1881. The effusive review in *La Chronique des Arts et de la Curiosité* led the editors to append a disclaimer that the opinions expressed were those of the writer. He provided one of the most perceptive accounts of Cassatt's contributions:

The eye has been refined, sharpened in a way so as to perceive nuances of the same color in its most fugitive gradations, so that the wide range has been enlarged by an infinite number of tones, half tones, quarter tones. The slightest spot affects the eye, which translates with extreme delicacy not contour, but the small luminous movement which creates color; all becomes value, covering and mass. This system, which requires a very special development and education of the visual faculties has been applied to the *Young Woman in a Garden*, shown knitting, wearing a hat . . . the brim of which casts a soft shadow on the face which is modelled in half-tints with astonishing skill . . . the artist has mastered the relation and opposition of tones, their logical inferences, the penetration of one color by another. . . . [and] has a very sure sense of local scene and character.

Oil on canvas, 26 × 37 in. (66 × 94 cm.).
Signed at lower left: Mary Cassatt.

REFERENCES: C. E[phrussi], *La Chronique des Arts et de la Curiosité*, suppl. to *La Gazette des Beaux-Arts* 17 (April 23, 1881), p. 134, reviews it in the sixth impressionist exhibition, 1881, and says, "La rétine a été affinée, aiguisée de façon à percevoir les nuances d'une même couleur dans ses dégradations les plus fugitives, si bien que les diverses gammes ont été augmentées d'un nombre infini de tons, de demi-tons, de quarts de ton. La plus légère tache effecte l'oeil, lui traduit avec une extrême délicatesse, non plus de contour, mais le petit mouvement lumineux qui fait couleur; tout devient valeur, enveloppe et masse. Ce système, qui exige une conformation et une éducation toutes spéciales des facultés visuelles, est appliqué à la *Jeune femme au jardin*, tricotant, coiffée d'un chapeau de tulle rose dont le rebord projette une ombre douce sur le visage modelé en demi-teinte, d'une étonnante finesse La même figure nous montre à quel l'artiste possède la relation et l'opposition des tons, leurs déductions logiques, la pénétration d'une couleur par l'autre. . . . sûre de l'effet et du caractère local" (quoted above in translation) // *L'Année Artistique* 4 (1881–1882), p. 168, a reviewer of the sixth impressionist exhibition praises this painting, which he calls *Jardin*, for its delicacy of modeling, likens it to fifteenth century primitives, and calls it a work of rare merit // J. K. Huysmans, *L'Exposition des Indépendants en 1881*, reprinted in *L'Art Moderne* (1883), p. 233, reviews it // J. M. Bowles, ed., *Modern Art* 3 (Winter 1895), p. 4, reviews Cassatt's exhibition at the Galeries Durand-Ruel, Paris, in 1893 and comments that "the best to me was a lady in a lace hat, in a garden, working, with gloves on, at knitting. The face was so exquisite in tone, with the outdoor light, and so refined in sentiment—she looked *thinking*. They are all so beautiful in their impression of light and color! The French were wild over her, and half the pictures were sold when I visited the gallery" // A. Mellerio, *L'Art et les artistes* 12 (Nov. 1910), ill. p. 69, as La

Liseuse // A. Segard, *Un Peintre des enfants et des mères, Mary Cassatt* (1913), ill. between pp. 16 and 17, dated 1881; p. 65; p. 66, describes this painting, says that the border of green plants and red flowers which cuts the canvas almost diagonally was considered bold in its time, states that the portraits bear witness to considerable progress and the formation of her personality; p. 203, lists it as La soeur de l'artiste dans son jardin and notes that it was shown at the impressionist exhibition in 1881 // C. O. Lublin, *Town and Country* 71 (Feb. 20, 1916), ill. p. 35, as Woman Knitting in a Garden, calls it "a very sensitive expression of impressionistic ideals. The face is painted smoothly in a low key and the flesh tones are given a marked individuality by the contrast of the stipple method used in the white cap, the gloves and the garden accessories" // F. Watson, *Arts* 11 (June 1927), ill. p. 296, as The Artist's Sister in a Garden (1881), lent by Mr. Robert Cassatt to the Philadelphia exhibition // E. Valerio, *Mary Cassatt* (1930), p. 7, describes and says, "C'est, à notre avis, un des plus jolis portraits peints par Mary Cassatt, qui révèle toute la distinction de son art" // *Index of Twentieth Century Artists* 2 (Oct. 1934), p. 5, lists reproductions under Artist's Sister in the Garden // F. A. Sweet, *Miss Mary Cassatt* (1966), p. 57, quotes Degas's letter to the painter and collector Henri Rouart, dated Oct. 26, 1880, in which Degas comments favorably on Cassatt's summer work at Marly and notes that Degas was perhaps referring to this painting; p. 61, quotes Huysmans's 1881 review and in a note says that although Huysmans described the subject as a woman reading, it was "probably the portrait of Lydia knitting or crocheting in the garden, painted at Marly in 1880; p. 173, quotes letter from Cassatt to Mrs. Robert K. Cassatt, Feb. 26, 1907, saying she is glad Mrs. Cassatt has this painting // E. C. B[aker], *Art News* 64 (Feb. 1966), ill. p. 13; p. 14, lists Cassatt exhibition at Knoedler Galleries // A. D. Breeskin, *Mary Cassatt: A Catalogue Raisonné of the Oils, Pastels, Watercolors, and Drawings* (1970), p. 11, quotes Degas's letter to Rouart; p. 12, says, "The works that gained such praise from this most severe critic certainly included the painting of 'Lydia Crocheting in the Garden at Marly' . . ., one of her strongest works of these early years. The color is especially distinguished, with the soft blues of the gown contrasted with the rich dark crimson of the coleuses in the flower bed behind Lydia and the handsome white accents of her bonnet. It is indeed an outstanding example of Miss Cassatt's kind of Impressionism, which never fractured the form nor used color in dots and dashes in the manner of some of her fellow artists"; p. 23, lists it in chronology under 1881 when it was included in the Sixth Impressionist Exhibition; ill. p. 62, no. 98, catalogues it; color ill. p. [63] // N. Hale, *Mary Cassatt* (1975), pp. 134, 149 // *The Metropolitan Museum of Art, Notable Acquisitions, 1965–1975* (1975), ill. p. 15, and discusses it // *One Hundred Eighth Annual Report of the Trustees, the Metro-*

politan Museum of Art for the Fiscal Year July 1, 1977, through June 30, 1978 (1978), ill. p. 30, J. K. Howat reports gift of final interest in the painting // [*Metropolitan Museum of Art*] *Notable Acquisitions, 1975–1979* (1979), ill. p. 66, entry by M. M. Salinger, describes it and notes strong influence of Manet // F. Daguet, Durand-Ruel et Cie, Paris, letter in Dept. Archives, July 30, 1984, provides early provenance and lists as "St 2574 (Paris). PH 435 'Femme dans un jardin'" in firm's records.

EXHIBITED: 35 Boulevard des Capucines, Paris, 1881, *6ᵉ Exposition de Peinture* (Sixth Impressionist Exhibition), no. 2, as Le Jardin // Galeries Durand-Ruel, Paris, 1893, *Exposition de Tableaux, Pastels et Gravures de Mary Cassatt*, no. 7, as Dame Tricotant // Durand-Ruel, New York, 1895, *Exposition of Paintings, Pastels and Etchings by Mary Cassatt*, no. 18, as Dame Tricotant // PAFA, 1916, ill. between pp. [16]–17, p. 32, no. 134, as Woman Sitting in a Garden // Philadelphia Museum of Art, 1927, *Memorial Exhibition of the Works of Mary Cassatt* (catalogue in *Pennsylvania Museum Bulletin* 22 [May 1927], p. 374, no. 27, as Portrait of the Artist's Sister, Miss Lydia Cassatt, in a Garden, 1881 // City Art Museum of Saint Louis, 1933–1934, no. 2 // Union, Haverford College, Pa., 1939, *Mary Cassatt Exhibition*, no. 4, as Miss Lydia Cassatt in the Garden at Marly, lent by Mr. Robert K. Cassatt // Department of Fine Arts, Carnegie Institute, Pittsburgh, 1940, *Survey of American Painting*, no. 202, as Miss Lydia Cassatt in Garden at Marly-le-Roi, dates it about 1879 or 1880, lent by Robert Kelso Cassatt; pl. 50 // Baltimore Museum of Art, 1941–1942, *Mary Cassatt*,

Cassatt, sketch for *Lady at the Tea Table*, coll. Lauren Poplack.

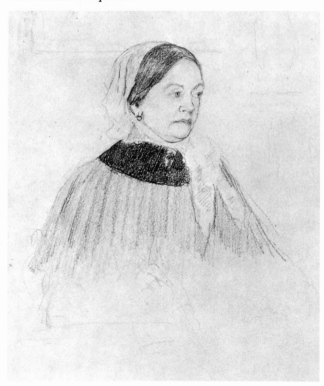

no. 9, as Lydia Knitting in the Garden, 1881, lent by Mr. Robert Kelso Cassatt // Portraits, Inc., New York, 1945, *Portraits of American Women* (for the Benefit of the Home For Incurables), no. 14, as Miss Lydia Cassatt in the Garden at Marly Le Roi, 1880, lent by Mrs. Robert Kelso Cassatt // Wildenstein, New York, 1947, *A Loan Exhibition of Mary Cassatt* (for the Benefit of the Goddard Neighborhood Center), essay by A. D. Breeskin, ill. p. 24, no. 8; p. 33, no. 8, lists it as Lydia Knitting in the Garden, 1881, lent by Mrs. Robert K. Cassatt // PAFA, Philadelphia, Peale House Gallery, 1955, no. 12 // Philadelphia Museum of Art, 1960, *Checklist of Mary Cassatt Exhibition* (typed copy in FARL), p. 3, lists it as Lydia Cassatt in the Garden at Marly, lent by Mrs. Gardner Cassatt // Baltimore Museum of Art, 1962, *Paintings, Drawings and Graphic Works by Manet, Degas, Berthe Morisot, and Mary Cassatt*, ill. p. 44, no. 105, as Lydia in the Garden; p. 59, no. 105, lists it as Lydia in the Garden (The artist's sister), ca. 1881, lent by Mrs. Gardner Cassatt // Knoedler Galleries, New York, 1966, *The Paintings of Mary Cassatt* (a Benefit Exhibition for the Development of the National Collection of Fine Arts, Smithsonian Institution, Washington, D. C.), cat. by A. D. Breeskin, ill. no. 10, as Lydia Cassatt Knitting in the Garden at Marly (The artist's sister), 1880, lent by Mrs. Gardner Cassatt // National Gallery of Art, Washington, D. C., 1970, *Mary Cassatt, 1844–1926*, cat. by A. D. Breeskin, p. 23, no. 23, as Lydia Crocheting in the Garden at Marly, 1880, lent by Mrs. Gardner Cassatt, Villanova, Pa., discusses and gives alternate titles En brodant and Lydia Knitting in the Garden at Marly; pl. no. 23 // MMA, 1973, *Mary Cassatt* (no cat.) // MFA, Boston, 1978, *Mary Cassatt at Home*, cat. by B. S. Shapiro, no. 11, as Lydia Crocheting in the Garden at Marly, 1880, lent by the MMA.

EX COLL.: with Durand-Ruel, Paris, 1893; P. A. B. Widener, Philadelphia, 1894; the artist's brother, Alexander J. Cassatt, Philadelphia, d. 1906; his son, Robert Kelso Cassatt, Rosemont, Pa., by 1907–until d. 1944, and his wife, Mrs. Robert Kelso Cassatt, Rosemont, Pa., 1944; their nephew, Gardner Cassatt, and his wife, Mrs. Gardner Cassatt, Villanova, Pa., until 1965.

Gift of Mrs. Gardner Cassatt, 1965.
65.184.

Lady at the Tea Table

The subject of this painting is Mrs. Robert Moore Riddle (d. 1892), the former Mary Johnston Dickinson, a first cousin of the artist's mother, Mrs. Robert S. Cassatt. Mary Cassatt began the portrait in 1883 and finished it two years later. On November 30, 1883, her mother wrote to Alexander J. Cassatt, the artist's brother:

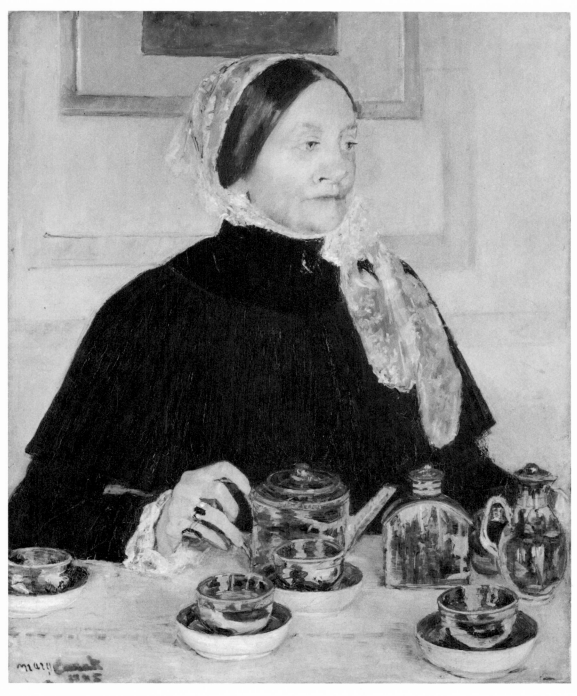

Cassatt, *Lady at the Tea Table*.

I don't know if your Father or Mary told you of the presents of porcelain Mrs. [Thomas Alexander] Scott [Mrs. Riddle's daughter Annie] sent us after we got home from England, and you know she insisted on our being her guests at the Hotel in London. When they came Mary asked Mrs. Riddle to sit for her portrait thinking it was the only way she could return their kindness and she consented at once and Annie seemed very much pleased. The picture is nearly done but Mary is waiting for a very handsome Louis Seize [frame] to be cut down to suit before showing it to them. As they are not very artistic in their likes and dislikes of pictures and as a likeness is a hard thing to make to please the nearest friends, I don't know what the results will be. Annie ought to like it in one respect for both Degas and Raffaëlli said it was "La distinction même" and Annie goes in for that kind of thing (quoted in F. A. Sweet [1966]).

Alexander Cassatt in a letter to his wife in January 1885 reported:

Mary has done an excellent portrait of Mrs. Riddle quite as good in its way as the one we have of Mother, but I don't think Mrs. Scott quite likes it (quoted in F. A. Sweet [1966]).

Annie Riddle Scott objected to the size of her mother's nose in the picture, and the portrait was put away and forgotten until 1914 when it was shown to Louisine W. Havemeyer. "The family did not like it, and I was so disappointed," Mary Cassatt told her. "I felt that I never wanted to see it again. I did it so carefully and you may be sure it was like her—but—no one cared for it" (L. W. Havemeyer, quoted in *Pennsylvania Museum Bulletin* [1927]). When the painting was exhibited later that year at Durand-Ruel in Paris, Mrs. Havemeyer reported, "It was the sensation of the exhibition. . . . With the result . . . that both the Luxembourg and the Petit Palais were anxious to have it" (ibid). In April 1915, it was included in an exhibition of works by Degas, Cassatt, and others at Knoedler and Company, New York, organized by Mrs. Havemeyer for the benefit of women's suffrage. In 1918 the painting was lent to the Metropolitan, and in 1923 Mary Cassatt gave it to the museum. In a note to Bryson Burroughs, dated March 12, 1923, she wrote:

I have just heard that you wish a letter from me giving my picture the Lady with the tea cups to the Metropolitan Museum. I give it with great pleasure & wish at the same time to thank you for the trouble you have taken. About the frame, I would like the picture to remain in the same frame for the color of the gold suits it I think.

Wearing a lace cap tied under her chin, a blue cape, and a dark blue dress, Mrs. Riddle is seated at a table set with a blue and white, gilded porcelain tea service, which her daughter had given to the Cassatt family. The wall in the background, almost indistinguishable in color from the foreground, is defined by strips of molding and a portion of a gold-framed picture. The cropped, framed picture was a recurring motif in the works of Edgar Degas. He, however, used identifiable pictures to extend the meaning of the work, while Mary Cassatt, like JAMES MCNEILL WHISTLER, used the device chiefly as an element of design. With the exception of the flesh tones, the dark brown hair, and the green of the background picture, Cassatt restricted her palette in *Lady at the Tea Table* to blue, yellow, and white. The bold design, which is a major distinguishing feature of the work, is reinforced by color, for example, the blue in the tea set, Mrs. Riddle's eyes, and her dress, and the gold of the tea set and the frame on the wall. Color also serves to unify the composition. Traditional relationships of depth are reduced, and the silhouette becomes prominent. This marks a departure from conventional methods of representing space and aligns Mary Cassatt with both Manet and Degas.

Lady at the Tea Table resembles Cassatt's *Young Woman in Black* of 1883 (Peabody Institute, Baltimore) in its restricted palette as well as in several compositional features. It was begun in 1883, the same year that JAMES MC NEILL WHISTLER'S *Arrangement in Grey and Black No. 1, Portrait of the Artist's Mother*, 1871 (Louvre, Paris), was awarded a medal at the Paris Salon. Mary Cassatt may have been influenced by this work. In *Lady at the Tea Table*, the emphasis on the silhouette and the simplicity of the composition document her interest in Japanese prints and oriental design. This interest, which was shared by Degas and Manet, anticipated the Japanism of her color prints and paintings of 1890 and 1891.

Oil on canvas, 29 × 24 in. (73.4 × 61 cm.).
Signed and dated at lower left: Mary Cassatt / 1885.
RELATED WORKS: *Mrs. Robert Moore Riddle*, watercolor on paper, 1½ × 1½ in. (3.8 × 3.8 cm.), ca. 1883, Mrs. George A. Robbins, Ambler, Pa., ill. in A. D. Breeskin, *Mary Cassatt: A Catalogue Raisonné of the Oils, Pastels, Watercolors, and Drawings* (1970), p. 222, no. 621 ∥ *Sketch of Mrs. Riddle*, pencil on paper, 9½ × 8

in. (24.2 × 20.3 cm.), 1885, coll. Lauren Poplack, ill. ibid., p. 265, no. 774 // Probably by Cassatt, *Mrs. Riddle*, watercolor on ivory in red leather case, 5 × 5¼ in. (12.7 × 13.3 cm.), ca. 1883–1885, private coll., listed in MFA, Boston, *Mary Cassatt at Home* (1978), exhib. cat. by B. S. Shapiro, no. 68.

REFERENCES: Mrs. R. S. Cassatt to A. J. Cassatt, Nov. 30, 1883, quoted in F. A. Sweet, *Miss Mary Cassatt, Impressionist from Pennsylvania* (1966), pp. 85–86 (quoted above) // A. J. Cassatt to Mrs. A. J. Cassatt, Jan. 1885, quoted in ibid., p. 92 (quoted above) // M. Cassatt to L. W. Havemeyer, Nov. 24, [1914?], MMA Archives, writes, "As to the portrait (Mrs. R's) Duret wants me to give it to Petit Palais. Bessie Fisher sent me through Jennie such very disagreeable messages about it that I have no desire that the family possess it"; Feb. 4, [1915], MMA Archives, says: "George D. R has just written to me about Mrs R's portrait. My dear I would give it to you at once (of course to be left to a Museum) only I have more than half promised it to the Petit Palais. On no account shall Bessie Fisher ever own it. She sent me the most decided messages regretting that there was so little likeness to her Mother! The line of the back & the hand & that is all. Even the worm will turn, & I see no excuse for her too evident desire to snub me. Well let her rejoice in Miss Beaux['s] portraits & leave me alone. Jennie wrote that she was told Edgar Scott was crazy to get the picture. He or Mother[']s children are the only ones who could have even the shadow of a claim to it. I wonder if any one will care for it at the Exhibition. I doubt it, its home ought to be in Paris where I painted it" // *New York Evening Post*, Saturday Magazine, April 3, 1915, ill. p. 6 // *New York Times Magazine*, April 4, 1915, ill. p. 14, discusses it in Knoedler exhibition // *Town and Country* 70 (April 10, 1915), ill. p. 31 // *Arts and Decoration* 5 (May 1915), ill. p. 282, as Portrait // M. Cassatt to L. W. Havemeyer, August 24, [1918], writes: "Did I write to you that they told me my portrait of Mrs R was in the room with a Sargent! They thought I ought to be very proud" // B. B[urroughs], *MMA Bull.* 17 (March 1922), p. 55, notes that the painting has been lent to the MMA for the past four years // M. Cassatt to E. Robinson, Nov. 24, 1922, MMA Archives, discusses distribution of her works, including this painting; Jan. 19, 1923, MMA Archives, mentions framing (quoted above) // M. Cassatt to B. Burroughs, March 12, 1923, MMA Archives (quoted above) // *Literary Digest* 90 (July 10, 1926), ill. p. 29 // G. Biddle, *Arts* 10 (August 1926), pp. 108, 110–111; ill. p. [109] // E. R. Abbott, *The Great Painters* (1927), ill. opp. p. 389 // *Pennsylvania Museum Bulletin* 22 (May 1927), p. 373, quotes letter from Mrs. Havemeyer to the Pennsylvania Museum, which mentions this painting; p. 374, no. 11, lists it; pp. 381–382, Mrs. Havemeyer tells how the neglected painting came to be exhibited in 1914 (quoted above) // *Art News* 25 (May 7, 1927), p. 2, quotes Mrs. Havemeyer and supplies list of exhibited works in

which this painting appears as no. 11 // *Arts* 15 (Jan. 1929), cover ill. // *H. O. Havemeyer Collection* (1931), p. 294, as Woman at the Tea Table, records exhibition history, noting that it was shown at the PAFA in 1920, says that it was a gift of the artist to the MMA in 1923 // *Index of Twentieth Century Artists* 2 (Oct. 1934), p. 2, lists it in MMA; p. 6, lists reproductions // J. Walker and M. James, *Great American Paintings, from Smibert to Bellows, 1729–1924* (1943), p. 14, say that Cassatt's paintings such as the Lady at the Tea Table "evoke the elaborate refinement of the society described in the novels of her fellow expatriate, Henry James"; p. 21, lists it; pl. 74 // E. A. Jewell and A. Crane, *French Impressionists* (1944), color ill. p. 105 // M. Breunig, *Mary Cassatt* (1944), p. 9, discusses it and notes that the artist presented it to the MMA "wondering deprecatingly if such a gift were worthwhile when she 'was so little known at home'"; color ill. p. [14] // F. J. Mather, Jr., *Magazine of Art* 39 (Nov. 1946), ill. p. 306 // A. D. Breeskin, *The Graphic Work of Mary Cassatt* (1948), p. 18, relates remark made by Mrs. Havemeyer in 1914 // A. T. Gardner, *MMA Bull.* 7 (Dec. 1948), ill. p. 117 // R. B. Hale, *MMA Bull.* 12 (March 1954), p. 176; ill. p. 183 // *Life* (March 28, 1955), color ill. p. 74 // J. N. Rosenberg, *Arts* 31 (May 1957), ill. p. 12 // C. McCurdy, *Modern Art* (1958), ill. p. 150 // M. G. Eberhart, *Art in America* 47 (Nov. 2, 1959), ill. p. 49, discusses it // W. Andrews and G. McCoy, *Art in America* 53 (August–Sept. 1965), color ill. p. 64 // J. M. H. Carson, *Mary Cassatt* (1966), pp. 59–60, discusses Mrs. Havemeyer's discovery of the portrait // F. A. Sweet, *Miss Mary Cassatt, Impressionist from Pennsylvania* (1966), pp. 85–86, discusses it and quotes Mrs. R. S. Cassatt's letter (quoted above); p. 92, quotes A. Cassatt's letter to his wife (quoted above); p. 102; pl. 13 // A. D. Breeskin, *Mary Cassatt: A Catalogue Raisonné of the Oils, Pastels, Watercolors, and Drawings* (1970), p. 13, discusses influence of Japanese art on Lady at the Tea Table "in the flattening of planes and emphasis on strongly linear contours" and says, "The simply described dark shape of her gown is contrasted with the brilliantly sparkling blue Canton china across the foreground. The long-fingered hand holding the teapot is balanced by the lace ends of her cap and the strong line of her dark hair. The features are delicately suggested with very little three-dimensional form. Nevertheless, the individual character is set down with a directness and simplicity which marks the portrait as a 'speaking likeness' as well as a powerful figure study"; color ill. p. [80]; ill. p. 81 and no. 139, catalogues it // E. Wilson, *American Painter in Paris*, (1971), pp. 119–123, discusses it; ill. p. [121]; pp. 126, 138, 178 // N. Hale, *Mary Cassatt* (1975), ill. p. 120; pp. 130–131, says both Mrs. Scott and Mrs. Riddle rejected the portrait, which upset Mary Cassatt greatly; calls it a "child's eye view" and says it shows a basic animosity; pp. 165, 177, 258, 283 // *MMA Bull.* 33 (Winter 1975–1976), color ill. no. 63 // J. Wilmerding, *American Art* (1976), p. 155, calls it

one of her strongest portraits; pp. 155–156, suggests that Cassatt's "insight into the settled habits and fragile toughness of age" led to the family's rejection of the work; ill. pl. 189 // J. Withers, *Art Journal* 35 (Summer 1976), pp. 335–336, discusses it; p. 336, fig. 8 // J. Roudebush, *Mary Cassatt* (1979), color ill. p. [28]; p. 53, discusses it // N. M. Matthews, ed., *Cassatt and Her Circle* (1984), pp. 174–175, reprints letter from Mrs. Cassatt to A. J. Cassatt, Nov. 30, [1883]; p. 175, fig. 21; p. 176, n 2, discusses tea set; pp. 320–321, includes letters from Mary Cassatt to Louisine Havemeyer, Feb. 4, 1915, concerning this portrait; p. 321, n 1, provides history of the painting.

EXHIBITED: Galeries Durand-Ruel, Paris, 1914, *Tableaux, Pastels, Dessins, et Pointes-sèches par Mary Cassatt*, no. 8, as Portrait // M. Knoedler and Co., New York, 1915, *Loan Exhibition of Masterpieces by Old and Modern Painters*, no. 44, as Lady at the Tea Table // MMA, 1919–1922 (see *MMA Bull.* [March 1922] above) // Art Institute of Chicago, 1926–1927, *Catalogue of a Memorial Collection of the Works of Mary Cassatt*, no. 10 // Philadelphia Museum, 1927, *Memorial Exhibition of the Works of Mary Cassatt* (see *Pennsylvania Museum Bulletin* 22 [May 1927]) // Carnegie Institute, Pittsburgh, 1928, *Memorial Exhibition of the Works of Mary Cassatt*, no. 13 // Baltimore Museum of Art, 1941–1942, *Mary Cassatt*, unpaged ill.; no. 16 // Tate Gallery, London, 1946, *American Painting*, no. 38 // Heckscher Art Museum, Huntington, N. Y., 1947, *European Influence on American Painting of the 19th Century*, exhib. cat. by A. D. Smith, ill. p. [14], no. 10, as Lady at Table // Wildenstein, New York, 1947, *Loan Exhibition of Mary Cassatt* [for the Benefit of the Goddard Neighborhood Center], essay by A. D. Breeskin, ill. p. 28, no. 15; p. 35, lists it // MMA, 1950, *20th Century Painters*, exhib. cat., p. 4 // Art Institute of Chicago and MMA, New York, 1954, *Sargent, Whistler and Mary Cassatt*, cat. by F. A. Sweet, pp. 26–27, ill. no. 14, and says it was begun in 1883, finished two years later, and marked a turning point in Cassatt's career // PAFA, Philadelphia, 1955, *The One Hundred and Fiftieth Anniversary Exhibition*, no. 111 (also included in traveling exhibition to Europe organized by the United States Information Service) no. 45 (in Italy and Germany) and no. 41 (in Belgium) // Baltimore Museum of Art, 1962, *Paintings, Drawings and Graphic Works by Manet, Degas, Berthe Morisot and Mary Cassatt*, ill. p. 34, no. 110; p. 60, no. 110, lists it // MMA, 1965, *Three Centuries of American Painting*, unnumbered cat. // Joslyn Art Museum, Omaha, 1969, *Mary Cassatt among the Impressionists*, cat. and intro. by W. A. McGonagle, essay by A. D. Breeskin, ill. p. 8, no. 9; p. 70, no. 9, lists it // National Gallery of Art, Washington, D. C., 1970, *Mary Cassatt, 1844–1926*, cat. by A. D. Breeskin, p. 15, discusses Japanese influence; p. 25, no. 34; ill. between pp. 34 and 117, no. 34 // MMA, 1973, *Mary Cassatt* (no cat.) // Staten Island Institute of Arts and Sciences, 1974, *Mary Cassatt* (no cat.) // MMA, 1976, *A Bicentennial Treasury*

(see *MMA Bull.* 33 above) // MFA, Boston, 1978, *Mary Cassatt at Home*, cat. by B. S. Shapiro, p. 6, discusses; color ill. p. [8], no. 17; p. 11, no. 17, lists it; p. 15, no. 55, lists blue and white Chinese export tea service shown in the painting.

ON DEPOSIT: MMA, New York, 1918–1923, lent by Mrs. H. O. Havemeyer for Mary Cassatt.

EX COLL.: the artist, until 1923.

Gift of the artist, 1923.

23.101.

Portrait of a Young Girl

Also called *Young Girl in a Park Landscape* (*Jeune fille dans un parc*) and *Jeune fille assise sur l'herbe*, this work was described by Achille Segard as a "subject rather than a portrait." He dated it 1899. The identity of the pensive, fashionably dressed young girl is unknown.

The composition has several features that are fundamental to impressionism and suggest the fragmentary nature of the visual experience: the high vantage point and the extension of the ground almost to the top of the canvas, the placement of the cropped figure in the immediate foreground, and the bold juxtaposition of the figure and the expansive background. Winding paths, which suggest recession, serve also as decorative elements in the subtly modulated green field and echo the contours of the girl's hat and extravagant sleeves.

Oil on canvas, 29 × 24⅛ in. (73.7 × 61.3 cm.).
Signed at lower left: Mary Cassatt.

REFERENCES: G. Geffroy, *Les Modes* 4 (Feb. 1904), p. 8; ill. p. 10, as Portrait de Fillette // M. Utrillo, *Forma* 2 (1907), ill. p. 342, as Niña en un Parque (Girl in a Park), Gallery 11, no. 5, in an article on the paintings section of the Exposición Internacional de Arte de Barcelona // A. Mellerio, *L'Art et les artistes* 12 (Nov. 1910), ill. p. 70, as Jeune fille dans un parc // A. Segard, *Un Peintre des enfants et des mères, Mary Cassatt* (1913), ill. between pp. 92 and 93, dated 1899; pp. 170–171, says, "Est-ce ou non un portrait cette jeune fille qui mord le bout d'une paille? Elle est représentée assise dans l'herbe qui, par un effet de perspective monte jusqu'au bord supérieur du tableau sans qu'on aperçoive le ciel. Elle peut avoir dix-sept ou dix-huit ans. Elle est vêtue d'un corsage clair en forme de blouse sur laquelle se développe une énorme manche de tissu moins léger. Elle est coiffée d'une sorte de charlotte blanche surmontée d'un noeud de velours et tout en suçant sa paille regarde dans le vide avec une vague expression d'innocence. C'est un sujet plutôt qu'un portrait. Bien qu'un peu méticuleux, cela est joli et séduisant. Le sentiment en est un peu factice

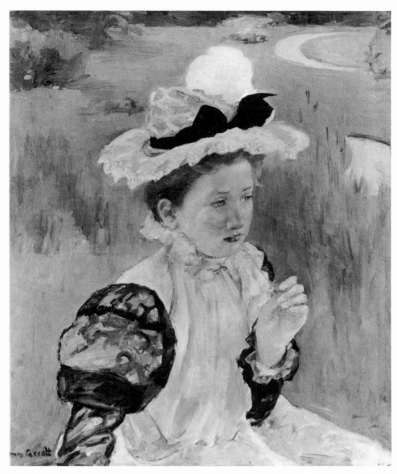

Cassatt, *Portrait of a Young Girl*.

et particulier. Ce n'est pas une oeuvre importante";
p. 204, lists it as Jeune fille assise sur l'herbe, dates it
1899, coll. Stillman // B. B[urroughs], *MMA Bull.* 17
(March 1922), p. 55, reports its acquisition, calls it
Portrait of a Young Girl, suggests it dates about
twenty years after The Cup of Tea; ill. p. [57] //
Index of Twentieth Century Artists 2 (Oct. 1934), p. 2,
lists it as Portrait of a Young Girl; p. 8, lists repro-
ductions of it under Young Girl Seated on Ground //
H. McBride, *Art News* 49 (Summer 1950), ill. p. 36 //
A. D. Breeskin, *Mary Cassatt: A Catalogue Raisonné
of the Oils, Pastels, Watercolors, and Drawings* (1970),
ill. p. 137, no. 309, catalogues it as Young Girl in a
Park Landscape, 1899, with alternate titles as Jeune
fille dans un parc and Portrait of a Young Girl,
Durand-Ruel no. 1631 // F. Daguet, Durand-Ruel
et Cie, Paris, letter in Dept. Archives, July 30,
1984, gives provenance and notes it is listed in firm's
records as: "Jeune fille dans un parc. St 6195. PH
1631."

EXHIBITED: Barcelona, 1907, Exposición Interna-
cional de Arte de Barcelona, no. 5, as Girl in a Park //
Smith College Museum of Art, Northampton, Mass.,
1928, *Memorial Exhibition of the Works of Mary Cassatt,
1845–1926*, no. 5, as Portrait of a young girl // New
York, Bloomingdale's 75th Anniversary Exhibition,
1947, *A Woman of Fashion* (not in cat.) // MMA, 1950,
20th Century Painters, p. 4; 1954, *American Painting,
1754–1954* (no cat.) // Society of the Four Arts, Palm
Beach, 1959, *Loan Exhibition of Works by John Singer
Sargent (1856–1925) and Mary Cassatt (1845–1926)*, no.
46 // International Business Machines Gallery of Arts
and Sciences, New York, 1963, *Realism: An American
Heritage*, no. 9 // University of Iowa Gallery of Art,
Iowa City, 1964, *Impressionism and Its Roots*, p. 5, F.
Seiberling in a guide to the exhibition notes influence
of Manet; ill. p. 14, no. 18, dates it ca. 1901 // MMA,
1965, *Three Centuries of American Painting*, unnumbered
cat. // Knoedler Galleries, New York, 1966, *The Paint-
ings of Mary Cassatt* (Benefit Exhibition for the Devel-
opment of the National Collection of Fine Arts, Smith-
sonian Institution, Washington, D. C.), cat. by A. D.

Breeskin, ill. no. 30, dates it 1900 // Lytton Gallery, Los Angeles County Museum of Art and M. H. de Young Memorial Museum, San Francisco, 1966, *American Paintings from the Metropolitan Museum of Art*, color ill., p. 121, no. 101, lists it and dates it about 1900 // Parrish Art Museum, Southampton, N. Y., 1967, *Miss Mary Cassatt* (no cat.) // Staten Island Institute of Arts and Sciences, 1974, *Mary Cassatt* (no cat.) // Coe Kerr Gallery, New York, 1976, *Masters of American Impressionism* (Benefit for the Presbyterian Hospital in the City of New York), essay by R. J. Boyle, color ill. no. 3, lists it and dates it ca. 1900 // Galerie des Beaux-Arts, Bordeaux, 1981, *Profil du Metropolitan Museum of Art de New York de Ramsès Picasso*, color ill. detail on cover, pp. 148–149, no. 188, ill. and catalogues.

ON DEPOSIT: White House, Washington, D.C., 1969–1973; U. S. Mission to the United Nations, New York, 1976–1977.

EX COLL.: with Durand-Ruel, Paris, 1901–1912; James Stillman, Paris and New York, 1912–1918; his son, Dr. Ernest G. Stillman, New York, 1918–1922.

From the Collection of James Stillman, Gift of Dr. Ernest G. Stillman, 1922.

22.16.18.

Mother and Child (Baby Getting Up from His Nap)

Known by a variety of titles, including *Baby Arises (Le Lever de Bébé)* and *Morning Bath*, this painting was completed by 1899 when it was bought by Durand-Ruel. One of Mary Cassatt's most ambitious compositions, it centers on the domestic intimacy of mother and child that she made her specialty. A blonde woman, drying her child's feet, is shown in a white-topped orange dressing gown. She is seated on a green chair upholstered in rose and green fabric. The blonde, blue-eyed child (said to be Jules who also posed for *Mother and Child* [*The Oval Mirror*] below) is seated on the edge of a bed with a green headboard set against a light blue wall. A silver sugar bowl and creamer, a plate, a gilded teacup and saucer, and a dish with two red fruits rest on a round gilded tray on the green table in the foreground. The furniture and service belonged to Mary Cassatt and appear in other works by her. Barbara S. Shapiro has observed (1978) that the French provincial bed and table were used earlier in *Breakfast in Bed*, 1897 (coll. Virginia Steele Scott Foundation, Pasadena, Calif.), and the English silver creamer of 1795 was used in the colorprint *Afternoon Tea Party*, 1891.

In composition and execution, the picture has a modernity that grew out of Mary Cassatt's commitment to impressionism in the 1870s. The brushwork is vigorous and spontaneous, particularly in the figures, the decorative arabesques of the upholstery, and in the background. Mary Cassatt's interest in paint texture is also evident. She skillfully conveys the transitory quality of the moment. The still life, which is tilted upward for pictorial purposes and slightly cropped by the canvas edge, adds to the immediacy. This is a device employed also by Manet and Degas. In contrast to the abruptly receding perspective in *Lydia Crocheting in the Garden at Marly* (q. v.), the space in this painting is shallow. Mary Cassatt is indebted to the impressionists for both of these unconventional treatments of space. Here, the lack of depth is less extreme than in such works as *Lady at the Tea Table* (q. v.) and her Japanese-inspired colorprints. It is underscored, however, by the geometric structure and the emphasis on decorative pattern. This work is a successful synthesis of realistic form and surface design.

Oil on canvas, $36\frac{1}{2} \times 29$ in. (92.7 × 73.7 cm.). Signed at lower left: *Mary Cassatt*.

REFERENCES: M. E. Wright, *Brush and Pencil* 7 (Feb. 1901), ill. p. 260, as Baby Arises, in review of PAFA exhibition // C. Mauclair, *L'Art décoratif* 4 (August 1902), ill. p. 184, as Le Lever de Bébé // S. Isham, *The History of American Painting* (1905), p. [413], fig. 89, as Mother and Child, owned by Durand-Ruel and Sons // *International Studio* 29 (Oct. 1906), ill. p. liv, as Le Lever de Bébé in review of the Cincinnati Museum's annual exhibition // *MMA Bull.* 4 (March 1909), p. 53, lists it as Mother and Child among new acquisitions; ill. p. 54, as Mother and Child; p. 56 // C. Mauclair, *The French Impressionists (1860–1900)* (1911), ill. p. 155, as Getting Up Baby // C. L. Borgmeyer, *The Master Impressionists* (1913), ill. p. 158, as Mother and Child // MMA, *George A. Hearn Gift to the Metropolitan Museum of Art . . .* (1913), ill. p. 79 // *Mentor* 2 (March 16, 1914), ill. following p. 208 // L. M. Bryant, *American Pictures and Their Painters* (1917; 1921 ed.), ill. opp. p. 208, fig. 161, as Morning Bath; p. 210, discusses and compares with Mother and Child [Reine Lefebvre and Margot before a Window], 1902 (Breeskin, no. 408); pp. 210–211, notes, "Fortunately, time is toning the vivid green background and rather cold surroundings into a delightful cosy corner of the nursery where centres the life of the mother and her child" // *Literary Digest* 90 (July 10, 1926), ill. p. 26 // *American Review of Reviews* 75 (Jan. 1927), ill. p. 92 // *New York Sun*, Jan. 6, [1928], ill. in review of the American Art Association exhibition [unpaged clipping in MMA library, artist's files] // E. Neuhaus, *The*

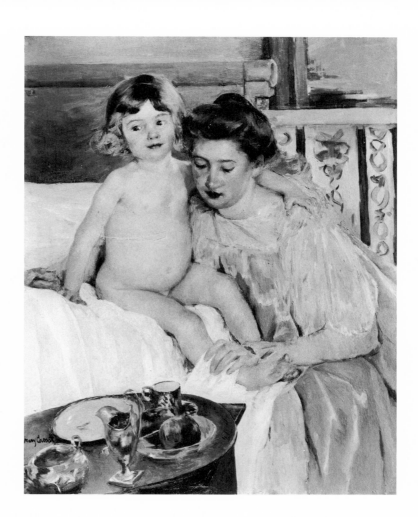

Cassatt, *Mother and Child*
(*Baby Getting Up from His Nap*).

History and Ideals of American Art (1931), ill. p. [168] //
Index of Twentieth Century Artists 2 (Oct. 1934), p. 2,
lists it as Mother and Child in MMA; p. 5, lists re-
productions of it under After the Bath; p. 6, lists some
reproductions under Getting Up Baby; p. 7, lists some
reproductions under Mother and Child; suppl. to 2,
p. i, lists some reproductions under Baby's Toilet and
Mother and Child // *Life* 12 (Jan. 19, 1942), color
ill. p. 56 // A. D. Breeskin, *Mary Cassatt: A Catalogue
Raisonné of the Oils, Pastels, Watercolors, and Drawings*
(1970), ill. p. 146, no. 342, catalogues it as Baby Get-
ting Up from His Nap, 1901; gives alternate titles,
notes that it is Durand-Ruel 1422–L5510, and gives
incorrect acquisition date // B. S. Shapiro, MFA,
Boston, March 16, 1978, copy of letter in Dept. Ar-
chives, gives information on Cassatt's furniture and
says that one can "trace her tastes in interior furnish-
ings" through her paintings // F. Daguet, Durand-
Ruel et Cie, Paris, July 30, 1984, letter in Dept.
Archives, provides provenance and says it is listed in
firm's records as "Le lever de bébé. St 5510. PH 1422.
ST NY 2306."

EXHIBITED: Carnegie Institute, Pittsburgh, 1900,
ill. no. 33, as Baby Arises // PAFA, 1901, no. 124, as
Baby Arises // Durand-Ruel, New York, 1903, no. 7 //

Cincinnati Museum, 1906, ill. opp. p. 8; p. 13, no. 91,
lists it as Le Lever de Bébé, lent by Messrs. Durand-
Ruel, New York // Carnegie Institute, Pittsburgh,
1908, *Exhibition of Paintings by the French Impressionists*,
ill. no. 19, as Morning Cares // Baltimore Museum of
Art, 1941–1942, *Mary Cassatt*, no. 48, as Mother and
Child, about 1905 // Berkshire Museum, Pittsfield,
Mass., 1946, *French Impressionist Painting*, no. 30, as
Mother and Child // Saginaw Museum, Mich., 1948,
*An Exhibition of American Painting from Colonial Times
until Today*, no. 7, as Mother and Child // Swope Art
Gallery, Terre Haute, Ind., 1948 (no cat. available) //
Lyman Allyn Museum, New London, Conn., 1950,
Paintings from Delacroix to the Neo-Impressionists (no
cat.) // Barnard College, New York, 1951 (no cat.) //
Detroit Institute of Arts, Art Gallery of Toronto, City
Art Museum of Saint Louis, and Seattle Art Museum,
1951–1952, *Masterpieces from the Metropolitan Museum
of Art* (no cat.) // MMA, 1958–1959, *Fourteen American
Masters* (no cat.) // Parrish Art Museum, Southamp-
ton, N. Y., 1967, *Miss Mary Cassatt*, ill. no. 8, as
Mother and Child // National Gallery of Art, Wash-
ington, D. C., 1970, *Mary Cassatt, 1844–1926*, exhib.
cat. by A. D. Breeskin, p. 29, no. 63, lists it as Baby
Getting Up from His Nap, 1901, mentions Cassatt's

use of still life in her figure compositions and gives alternate titles; ill. after p. 34, no. 34 // MMA, 1973, *Mary Cassatt* (no cat.) // Staten Island Institute of Arts and Sciences, 1974, *Mary Cassatt* (no cat.) // Whitney Museum of American Art, New York; Saint Louis Art Museum; Seattle Art Museum; and the Oakland Museum, 1977–1978, *Turn-of-the-Century America*, exhib. cat. by P. Hills, ill. p. 22, fig. 10; p. 183, lists it in checklist as Baby Getting Up from His Nap, 1901 // MFA, Boston, 1978, *Mary Cassatt at Home*, exhib. cat. by B. S. Shapiro, ill. p. 7, no. 27; p. 7, discusses Cassatt's use of furniture and accessories; p. 14, no. 27, lists it; p. 16, no. 61, lists English silver creamer, 1795, which appears in this painting and in Cassatt's colorprint Afternoon Tea.

ON DEPOSIT: Virginia Museum of Fine Arts, Richmond, 1954–1956 // Springfield Art Museum, Mo., 1976.

Ex COLL.: with Durand-Ruel, Paris, Nov. 1899–1900; with Durand-Ruel, New York, 1900–1909 George A. Hearn, New York, 1909.

George A. Hearn Fund, 1909.

09.27.

Mother and Child (The Oval Mirror)

As Mary Cassatt once told Mrs. Havemeyer, months would pass when she and Edgar Degas "just could not see each other, and then something I painted would bring us together again and he would go to Durand-Ruel's and say something nice about me, or come to see me himself." When he saw this painting, Degas asked Durand-Ruel:

"Where is she? I must see her at once. It is the greatest picture of the century." When I saw him he went over all the details of the picture with me and expressed great admiration for it, and then, as if regretting what he had said, he relentlessly added: "It has all your qualities and all your faults—it is the Infant Jesus and his English nurse" (Havemeyer, *Sixteen to Sixty* [1930]).

Mrs. Havemeyer noted that the painting, which she acquired from Durand-Ruel, became known in her family as *The Florentine Madonna*. The child's contrapposto pose does recall the Infant in various Italian Renaissance paintings of the Madonna and Child; and as Richard Boyle observed, this image is reinforced by the mirror that frames the child's head like a nimbus. The date of the painting is not certain, but it was acquired by Durand-Ruel in April 1899. Adelyn D. Breeskin identified the child as Jules, who probably also posed for *Mother and Child*

(*Baby Getting Up from His Nap*) (q. v.), which we now know was also painted by 1899. The age of the child is similar in both pictures, and presumably they were painted about the same time.

The intimacy between mother and child is portrayed with eloquent simplicity. The nude blonde boy stands with his left arm around the woman's neck; his right hand grasps her thumb. The mother, in a white gown and a blue wrapper with white stripes, holds him and rests her face against his cheek. The oval mirror frames the two heads in the background.

The rich yet restricted palette shows Cassatt's skill as a colorist. The cool blues of the woman's wrapper, the mirror, and the marble set off the glowing colors of the hair and flesh, the russet wood, and the warm green background wall. In the impressionist manner, contrasting complementary colors are introduced throughout. The work is broadly painted. The forms are firmly modeled, and the figures are defined by strong, calligraphic contour lines. The boy's pose is the only reference to the past in this painting. Otherwise it is entirely modern, and the cropping of the mirror and figures by the canvas edge is very much in the impressionistic mode. Cassatt also made a drypoint of the composition, which Breeskin dates about 1909. The focus there is on the figure of the child, the mother's head, and the mirror.

Cassatt, drypoint, *The Oval Mirror*.
Cleveland Museum of Art.

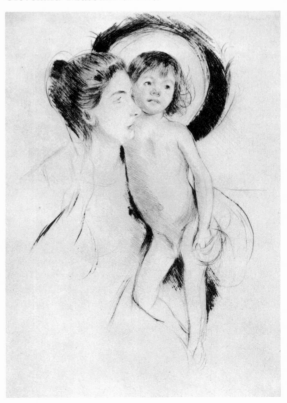

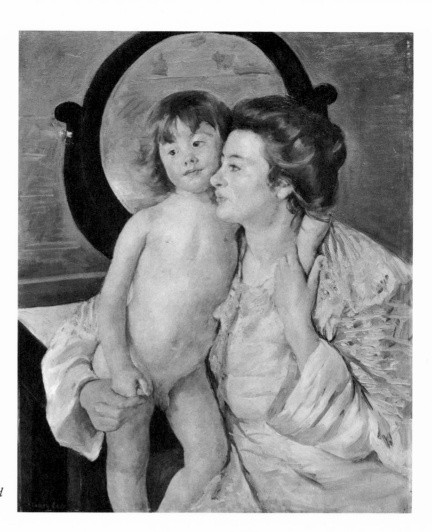

Cassatt, *Mother and Child*
(*The Oval Mirror*).

Oil on canvas, $32\frac{1}{8} \times 25\frac{7}{8}$ in. (81.6 × 65.7 cm.).
Signed at lower left: Mary Cassatt.

Canvas stamps: F. DUPRE / 144, Faubourg Saint-Honoré, 144 / coin de la Rue de Berri, PARIS (also appears on the stretcher); COLLECTION / Mr and Mrs / H. O. HAVEMEYER / 1875–1925 / NEW YORK CITY.

Labels on stretcher (probably Durand-Ruel): 7522 Cassatt / Mère et / Enfant; 7553 / Cassatt.

RELATED WORK: *The Oval Mirror*, drypoint, $16\frac{1}{16}$ × $11\frac{5}{16}$ in. (40.8 × 28.7 cm.), ill. in A. D. Breeskin, *The Graphic Work of Mary Cassatt* (1948), p. 81, no. 205.

REFERENCES: V. Pica, *Emporium* 26 (July 1907), ill. p. 16 // L. W. Havemeyer, "Mary Cassatt" [n. d., before 1929], typed copy in MMA Archives, p. 12, says painting was bought from Durand-Ruel and explains why the Havemeyers called it the Florentine Madonna; *Pennsylvania Museum Bulletin* 22 (May 1927), p. 378, relates Degas's reaction to the painting // *Art News* 25 (May 7, 1927), p. 2, provides checklist in which this is one of the paintings called Mother and Child, nos. 15–21 // L. W. Havemeyer, *Sixteen to Sixty* (1930; 1961), p. 244 (quoted above) // H. O.

Havemeyer Collection (1931), ill. p. [172]; p. 173, catalogues it as Mother and Child, says it was painted about 1898, supplies exhibition history // *Index of Twentieth Century Artists* 2 (Oct. 1934), p. 2, lists it in MMA as Mother and Child // R. L. Benjamin, *Gazette des Beaux-Arts*, series 6, 25 (May 1944) detail ill. on cover; p. 303, fig. 2, as Mother and Boy // MMA, *The H. O. Havemeyer Collection* (2nd rev. ed., 1958), p. 4, no. 7, lists it as Mother and Boy // J. M. H. Carson, *Mary Cassatt* (1966), p. 35 // F. A. Sweet, *Miss Mary Cassatt, Impressionist from Pennsylvania* (1966), p. 183 // A. D. Breeskin, *Mary Cassatt: A Catalogue Raisonné of the Oils, Pastels, Watercolors, and Drawings* (1970), p. 17, identifies model as Jules, "a young boy of six or seven years"; ill. p. 145, no. 338, catalogues it as The Oval Mirror, dates it 1901, notes alternate titles as The Florentine Madonna and Mother and Boy, notes related drypoint, quotes Degas, says that the painting is Durand-Ruel 1284–L5155 // E. Wilson, *American Painter in Paris* (1971), pp. 166, 169, quotes Degas's remarks // E. J. Bullard, *Mary Cassatt, Oils and Pastels* (1972), p. 70 // R. J. Boyle, *American Impressionism* (1974), pp. 110–111, ill. as Mother and Boy, says it

was also called The Florentine Madonna, "suggested no doubt by the oval mirror which creates a kind of nimbus behind the boy's head"; notes, "The boy himself, in his classical stance, is wonderfully done, and alive, yet even here the viewer might be as aware of the largeness of the drawing, the superb technique, and the monumental quality akin to the schema of early Italian painting—as well as of the feelings generally evoked by the subject," suggests the Italian-inspired pose might be ascribed to Cassatt's trip to Italy in 1901 with the Havemeyers // J. Roudebush, *Mary Cassatt* (1979), p. 16; color ill. p. [83], as Mother and Boy (The Oval Mirror), 1901 // F. Daguet, Durand-Ruel et Cie, Paris, July 30, 1984, letter in Dept. Archives, provides provenance and says it is listed in firm's records as "Mère et enfant. ST 5155. PH 1284. ST NY 2257."

EXHIBITED: St. Botolph's Club, Boston, 1909, no. 17 // M. Knoedler and Co., New York, 1915, *Loan Exhibition of Masterpieces by Old and Modern Painters*, no. 46, as Mother and Son with Mirror, 1898 // Art Institute of Chicago, 1926–1927, *Catalogue of a Memorial Collection of the Works of Mary Cassatt*, no. 31 or 32, as Woman and Child // Philadelphia Museum, 1927, *Memorial Exhibition of the Works of Mary Cassatt* (see *Pennsylvania Museum Bulletin* above) // MMA, 1930, *The H. O. Havemeyer Collection*, ill. and no. 2, as Mother and Boy // Pierson College, Yale University, New Haven, 1935 (no cat.) // Society of the Four Arts, Palm Beach, 1950, *From Plymouth Rock to the Armory*, no. 39, as Mother and Boy // Pasadena Art Institute, 1951,

Mary Cassatt and Her Parisian Friends (not in cat.) // Vancouver Art Gallery, 1955, *Two Hundred Years of American Painting*, ill. and no. 26, as Mother and Boy // MMA, 1958–1959, *Fourteen American Masters* (no cat.) // Society of the Four Arts, Palm Beach, 1959, *Loan Exhibition of Works by John Singer Sargent (1856–1925) and Mary Cassatt (1845–1926)*, no. 45, as Mother and Boy // Los Angeles County Museum of Art and M. H. de Young Memorial Museum, San Francisco, 1966, *American Paintings from the Metropolitan Museum of Art*, ill. p. 114, no. 102 // Birmingham Museum of Art, Ala., 1972, *American Masters, 1871–1972* [*Birmingham Museum of Art Bulletin*, 1972 Festival of Arts, cover ill.; no. 9, as Mother and Boy (or The Oval Mirror), 1901] // MMA, 1973, *Mary Cassatt* (no cat.) // Staten Island Institute of Arts and Sciences, 1974, *Mary Cassatt* (no cat.) // San Jose Museum of Art, 1975–1976, *Americans Abroad*, ill. unnumbered cat. // Dixon Gallery and Gardens, Memphis, 1976, *Mary Cassatt and the American Impressionists*, p. 12, no. 2, entry by D. S. C[onway], notes that the "surface patterning ... reveals Cassatt's indebtedness to the Japanese print"; ill. p. 13 // Whatcomb Museum of History and Art, Bellingham, Wash., 1976–1977, *5000 Years of Art*, exhib. cat. by T. Schlotterback, ill. p. 92; p. 93, no. 68, catalogues it, discusses the subject, the influence of Japanese woodcuts, and the related drypoint // Grey Art Gallery and Study Center, New York University, New York, 1978, *Changes in Perspective, 1880–1925*, exhib. cat., p. 42.

EX COLL.: with Durand-Ruel, Paris, April 1899; with Durand-Ruel, New York, July 1899; H. O. Havemeyer, New York, July 1899–d. 1907; his wife, Mrs. H. O. Havemeyer, New York, until 1929.

Bequest of Mrs. H. O. Havemeyer, 1929, H. O. Havemeyer Collection.

29.100.47.

Young Mother Sewing

Margot Lux, a dark-haired vivacious child, posed for Mary Cassatt on many occasions. Here she joined Reine Lefebvre (later Madame Pinault), a woman from the village near the Château de Beaufresne, the seventeenth-century manor house at Mesnil-Théribus, Oise, that Cassatt bought in 1894. The models were identified by Adelyn D. Breeskin. Reine Lefebvre, according to Frederick A. Sweet (1966), recalled posing for the artist "from 1901 to 1903, when she was sixteen and seventeen." The setting in this work was probably the conservatory remembered by Mrs. Ernest Stillman, the daughter-in-law of Cassatt's friend James Stillman, as a "sort of long, glassed room like a sun porch" in the Château de Beaufresne (quoted in Sweet, p. 183). Ac-

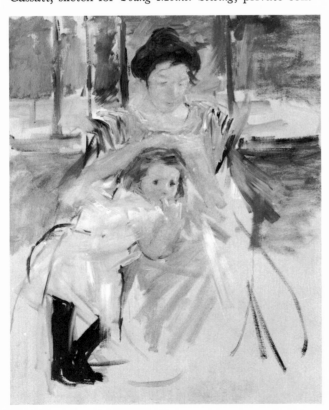

Cassatt, sketch for *Young Mother Sewing*, private coll.

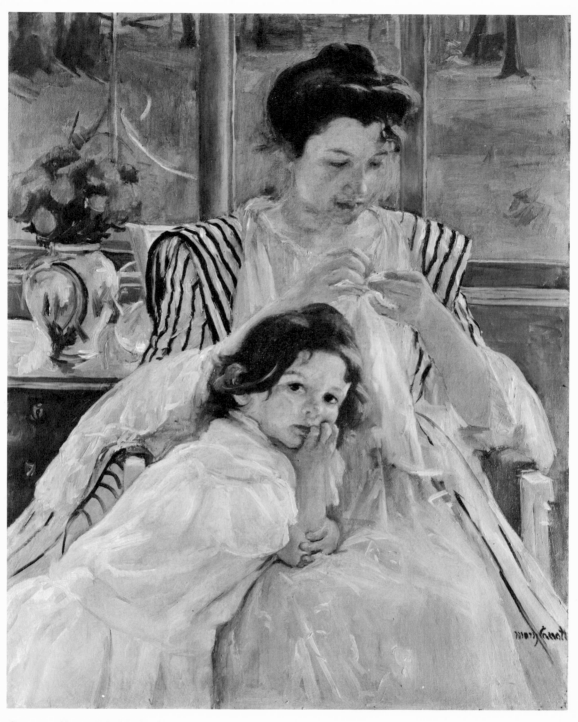

Cassatt, *Young Mother Sewing*.

cording to the records of Durand-Ruel, Mary Cassatt sold them the picture on January 3, 1901, so it was most likely completed in 1900.

Wearing a green chiffon dress or breakfast gown with a black and white striped wrapper, Reine Lefebvre is shown seated, wholly engrossed in sewing. Her dark hair is arranged in a disheveled yet fashionable pompadour style. The window behind her opens onto a view of lawn and trees. Margot Lux, chin in hand, leans against the preoccupied woman and looks intently toward the viewer. There is a blue and white porcelain vase with orange flowers, probably chrysanthemums, on a chest of drawers. The wide-ranging palette of green, orange, brown, blue, and white is skillfully handled, and the forms are firmly modeled with broad brushstrokes to give an illusion of concrete weight.

Studies related to this work include five pencil drawings of the figures alone, of which two show the woman sewing; an oil sketch of the entire composition (except the flower arrangement), which shows the child full-length; and a similar pastel with both figures cropped to three-quarter length and positioned much as they appear in the painting. Mary Cassatt made a closely related drypoint in which the child appears as a full-length figure in dark stockings and the woman is shown looking down at her. While the sequence of these related works has not been established, one suspects that Cassatt concentrated on varied arrangements of the two figures and subsequently worked with the figures and the background, playing the curving forms against the straight lines of the windows. The studies show the painstaking development of her complex composition.

Young Mother Sewing is an elaborate example of a type of composition that Mary Cassatt explored extensively during the first decade of the twentieth century. It consists of one, two, or more figures (most often a woman absorbed in a domestic task and a child or children) shown in an interior in front of a window or a row of windows with a view onto a landscape. In addition to this painting, examples include *Reine Lefebvre and Margot before a Window*, 1902 (private coll., Houston, ill. in Breeskin [1970], p. 164, no. 408), and *Augusta Sewing before a Window* (q.v.). The image of the window, which has a long and varied history as a symbol in western art, became a popular theme with the impressionists. Gustave Caillebotte, one of the supporters of the

group, used it in his own work to juxtapose the private world of the domestic interior with the public world of the city. In contrast, Mary Cassatt invariably shows an uninhabited landscape beyond the window.

The world of nature functions chiefly as an element in the composition. The harmonious intimacy of the domestic interior and its figures are the primary concern. Cropped three-quarter-length figures are placed at the center of the immediate foreground. The high horizon line and barely modulated expanse of lawn inhibit the illusion of depth and give the landscape a two-dimensional character. The child's gaze, directed toward the viewer, contributes to the emphasis on the foreground and establishes a relationship with the viewer. This concentration on the space immediately behind the surface plane and the references outside the picture give the painting its contemporary character and anticipate twentieth-century concerns with the painted surface.

Young Mother Sewing is one of Cassatt's most successful representations of the unaffected relationship between a mother and child. This aspect was discussed at length by Mrs. Havemeyer (1927), the former owner of the painting:

Look at that little child that has just thrown herself against her mother's knee, regardless of the result and oblivious to the fact that she could disturb "her mamma." And she is quite right, she does not disturb her mother. Mamma simply draws back a bit and continues to sew, while little daughter rests her elbows upon mamma's knee. Such a movement never could have been except just between mother and little daughter, and Miss Cassatt has caught and expressed it with all the beautiful accessories of flowers and of colour and of light. How often have friends said to me: "Won't you ask Miss Cassatt to paint my little girl? I would like to have her painted just like that." Well, the "just like that" means years of study and observation and a large proportion of artistic insight added to the recipe.

Oil on canvas, 36⅜ × 29 in. (92.4 × 73.7 cm.).
Signed at lower right: Mary Cassatt. Canvas stamps: F. DUPRE / 144, Faubourg Saint-Honoré, 144 / coin de la Rue de Berri, PARIS (also stamped on stretcher); COLLECTION / Mr. and Mrs. H. O. HAVEMEYER / 1875–1925 / NEW YORK CITY.
Labels on stretcher: Durand-Ruel / Paris, 16 Rue Laffitte / NEW YORK, 389 FIFTH AVENUE / Cassatt No. 2628 / Jeune Mere; [same but torn] Cassatt No. 6188 / . . . mere / . . . cousant; 7523 / Cassatt / Jeune Mère.
RELATED WORKS: *Sketch for "Young Mother Sewing,"* oil on canvas, 17½ × 14¾ in. (44.5 × 37.5 cm.), 1902,

private coll., Philadelphia, ill. in A. D. Breeskin, *Mary Cassatt: A Catalogue Raisonné of the Oils, Pastels, Watercolors, and Drawings* (1970), p. 166, no. 413 // *Study for "Young Mother Sewing,"* pastel on tan board, 36¼ × 29⅛ in. (92.1 × 74 cm.), 1902, private coll., Paris, ill. ibid., p. 166, no. 414 // *Margot Leaning against Reine's Knee (No. 1)*, pencil on cream paper folded to 14⅝ × 10⅜ in. (37.2 × 26.4 cm.), ca. 1902, private coll., Paris, ill. ibid., p. 286, no. 862 // *Margot Leaning against Reine's Knee (No. 2)*, pencil on paper folded to 14¾ × 10⅜ in. (37.5 × 26.4 cm.), ca. 1902, private coll., Paris, ill. ibid., p. 286, no. 863 // *Margot Leaning against Reine's Knee (No. 3)*, pencil on cream paper folded to 16¼ × 11½ in. (41.3 × 29.2 cm.), ca. 1902, private coll., ill. ibid., p. 286, no. 864 // *Margot Leaning against Reine's Knee (No. 4)*, pencil on paper folded to 15 × 10½ in. (38.1 × 26.7 cm.), ca. 1902, private coll., ill. ibid., p. 287, no. 865 // *Margot Leaning against Reine's Knee (No. 5)*, pencil on paper, 15 × 11½ in. (38.1 × 29.2 cm.), ca. 1902, coll. Gloria and Richard Manney, ill. ibid., p. 306, no. 942 // *In the Conservatory*, drypoint, 11⅝ × 8 3/16 in. (29.5 × 20.8 cm.), ca. 1901, ill. in A. D. Breeskin, *The Graphic Work of Mary Cassatt* (1948), p. 78, no. 174 (possibly related) // *Jeanette Leaning against Her Mother*, drypoint, 9 13/16 × 7 in. (24.9 × 17.8 cm.), ca. 1901, ill. ibid., p. 78, no. 175 (possibly related) // *The Crocheting Lesson*, drypoint, 17 5/16 × 10½ in. (44 × 26.7 cm.), ca. 1901, ill. ibid., p. 79, no. 178 (possibly related).

REFERENCES: G. Geffroy, *Les Modes* 4 (Feb. 1904), ill. p. 10, as *Mère et Enfant* // L. W. Havemeyer, *Pennsylvania Museum Bulletin* 22 (May 1927), pp. 378, 381 (quoted above) // *Art News* 25 (May 7, 1927), p. 2 // A. Alexandre, *La Renaissance* 13 (Feb. 1930), ill. p. 56, as *Jeune Mère Cousant* // F. J. Mather, Jr., *Arts* 16 (March 1930), ill. p. [476] // *Arts and Decoration* 33 (May 1930), ill. p. 55 // *H. O. Havemeyer Collection* (1931), ill. p. 172; p. 173, describes it, notes that it was painted about 1900, gives exhibitions and bibliography // *Literary Digest* 112 (March 26, 1932), cover ill.; p. 40, calls it "one of the most brilliant specimens of the delightful art of Mary Cassatt" // F. Watson, *Mary Cassatt* (1932), ill. p. 31 // *Index of Twentieth Century Artists* 2 (Oct. 1934), p. 2; p. 8, lists reproductions of it // M. Breunig, *Mary Cassatt* (1944), ill. p. 31 // MMA, *The H. O. Havemeyer Collection* (2nd rev. ed., 1958), p. 4, no. 8, as *Young Mother Sewing* // F. A. Sweet, *Miss Mary Cassatt* (1966), p. ix, says Mme. Pinault (Reine Lefebvre) recalled posing when young; p. 139, mentions painting as *Mother Sewing*; p. 148, says Mme. Pinault (Reine Lefebvre), recalled "posing for Mary Cassatt from 1901 to 1903, when she was sixteen and seventeen. '*Notre Mademoiselle*,' as they all called her, 'always wore a white blouse while painting. She was serious but not severe, though I must say at times she was difficult. It was hard to pose at first but became easier when I got used to it'" // A. D. Breeskin, *Mary Cassatt: A Catalogue Raisonné of the Oils, Pastels,*

Watercolors, and Drawings (1970), p. 18, says, "Reine Lefebvre . . . figured in many compositions both in oil and pastel during 1902 and 1903 Of many renderings of a little dark-haired girl, Margot Lux, the best is in 'Young Mother Sewing' . . ., a sunny painting in which the artist seems to recall the approach that she used in painting her mural"; pp. 166, 287, 306, catalogues related works // S. F. Yeh, *Art Journal* 35 (Summer 1976), p. 362, fig. 4 // J. Roudebush, *Mary Cassatt* (1979), color ill. p. 82, discusses.

EXHIBITED: St. Botolph's Club, Boston, 1909, no. 13 // M. Knoedler and Co., New York, 1915, *Loan Exhibition of Masterpieces by Old and Modern Painters*, no. 47, as *Little Girl Leaning Upon Her Mother's Knee*, 1900 // MMA, 1930, *The H. O. Havemeyer Collection*, no. 3, as *Young Mother Sewing* // Baltimore Museum of Art, 1941–1942, *Mary Cassatt*, no. 41, dates it 1903 // Museum of Modern Art, New York, 1942–1943, *Second Children's Festival of Modern Art* (no cat.) // Newark Museum, N.J., 1946, *19th Century French and American Paintings from the Collection of the Metropolitan Museum of Art*, no. 1, as *Woman Sewing* // Mint Museum of Art, Charlotte, N. C., 1946, *10th Anniversary Exhibition* // MMA, 1958–1959, *Fourteen American Masters* (no cat.) // MMA, 1965, *Three Centuries of American Painting*, unnumbered cat. // Parrish Art Museum, Southampton, N. Y., 1967, *Miss Mary Cassatt, Paintings and the Graphic Arts*, color frontis.; no. 11 // National Gallery of Art, Washington, D. C., 1970, *Mary Cassatt, 1844–1926*, exhib. cat. by A. D. Breeskin, p. 30, no. 69 // MMA, 1973, *Mary Cassatt* (no cat.) // Newport Harbor Art Museum, Newport Beach, Calif., and Santa Barbara Museum of Art, 1974, *Mary Cassatt, 1844–1926*, intro. by B. Turnbull, mentions it, color ill. on cover, no. 11 // Staten Island Institute of Arts and Sciences, N. Y., 1974, *Mary Cassatt* (no cat.) // MMA, 1974–1975, *The Impressionist Epoch*, not in cat. // MMA and American Federation of Arts, traveling exhibition, 1975–1977, *The Heritage of American Art*, exhib. cat. by M. Davis, ill. p. 152; p. 153, no. 67, discusses // F. Daguet, Durand-Ruel et Cie, Paris, July 30, 1984, letter in Dept. Archives, supplies provenance, says it is listed in firms records as "ST 6188. PH 1753. ST NY 2628. Dépôt NY no. 7523. Jeune mère," and indicates that Mrs. Havemeyer probably bought it in Paris even though it was sent to Durand-Ruel in New York.

ON DEPOSIT: Gracie Mansion, New York, 1947–1956, 1956–1958; U. S. Ambassador to the United Nations, New York, 1971–1973.

EX COLL.: with Galeries Durand-Ruel, Paris, Jan. 3, 1901–April 23, 1901; Mr. and Mrs. Henry O. Havemeyer, New York, 1901–1907; Mrs. Henry O. Havemeyer, New York, 1901–d. 1929.

Bequest of Mrs. H. O. Havemeyer, 1929, H. O. Havemeyer Collection.

29.100.48.

Mother and Child with a Rose Scarf

Usually dated 1908, *Mother and Child with a Rose Scarf* was painted near the end of Mary Cassatt's career. Studies and related works reveal the painstaking method by which she composed the painting. These include three watercolors and two pencil studies for the position and interaction of the figures, an oil sketch of the child's head, and two oils of the mother and child as half-length figures. The seated woman, wearing a pale green dress with a rose scarf, embraces a blue-eyed child. The back of the woman's head is reflected in an oval mirror above a marble-topped mahogany console. A gilded blue and white vase with pink, crimson, and yellow flowers rests on the white marble top. Mary Cassatt used many of these same features in a different composition called *The Mauve Dressing Gown*, ca. 1908 (coll. Mr. and Mrs. Sidney Zlotnick, Washington, D. C.).

The figures, although posed asymmetrically, form a pyramid in the classical manner; and the interplay of vertical and horizontal lines in the background maintains the symmetry. This subtle arrangement is underscored by the curving forms of the figures and the cropped oval mirror.

Mother and Child with a Rose Scarf is not alto-gether successful. It displays weaknesses characteristic of Mary Cassatt's late works. The seated figure is ponderous, and the unconvincing form and foreshortening of the lower body make it appear abruptly truncated. The paint, applied with a heavy hand, lacks the vigor that distinguishes the best of Mary Cassatt's paintings.

Oil on canvas, 46 × 35¼ in. (116.8 × 89.5 cm.).
Signed at lower right: *Mary Cassatt*.

RELATED WORKS: *Sketch of Mother Jeanne Nursing Her Baby*, oil on canvas, 33½ × 28 in. (85.1 × 71.1 cm.), ca. 1908, private coll., ill. in A. D. Breeskin, *Mary Cassatt: A Catalogue Raisonné of the Oils, Pastels, Watercolors, and Drawings* (1970), p. 188, no. 503 // *Mother Nursing Her Baby*, oil on canvas, 39⅝ × 32⅛ in. (100.6 × 81.6 cm.), ca. 1908, Art Institute of Chicago, ill. ibid., p. 188, no. 504 // *Sketch of Pose Related to "Mother and Child Smiling at Each Other,"* watercolor on paper, 12½ × 9 in. (31.8 × 22.9 cm.), ca. 1908, London art market, 1967, ill. ibid., p. 229, no. 649 // *Sketch for "Mother and Child Smiling at Each Other" (No. 1)*, watercolor on paper, 17¼ × 11⅜ in. (43.8 × 28.9 cm.), ca. 1908, unlocated, ill. ibid., p. 229, no. 650 // *Sketch for "Mother and Child Smiling at Each Other" (No. 2)*, watercolor on paper, 13 × 9½ in. (33 × 24.1 cm.), ca. 1908, London art market, 1964, ill. ibid., p. 229, no. 651 // *Standing Nude Child Reaching Up to Caress His Mother*, pencil on paper, 19¼ × 13¼ in. (48.9 × 33.7 cm.), ca. 1908, Paris art market, 1966, ill. ibid., p. 301, no. 925 // *Study of the Child for "Mother and Child Smiling at Each Other,"* oil on canvas, 1908, private coll., France, ill. ibid., p. 189, no. 506 // *Mother and Child Smiling at Each Other (No. 1)*, oil on canvas, 36½ × 29 in. (92.7 × 73.7 cm.), 1908, private coll., ill. ibid., p. 189, no. 507 // *Mother and Child Smiling at Each Other (No. 2)*, oil on canvas, 31¼ × 23¾ in. (79.4 × 60.3 cm.), 1908, Philadelphia Museum of Art, ill. ibid. p. 190, no. 508 // *The Mauve Dressing Gown*, oil on canvas, 37 × 28¾ in. (94 × 73 cm.), 1908, coll. Mr. and Mrs. Sidney Zlotnick, Washington, D. C., ill. ibid., p. 190, no. 510 // *Mother Looking Down at Her Sleeping Child*, watercolor on paper, 13⅜ × 11⅜ in. (34 × 28.9 cm.), ca. 1908, Paris art market, 1966, ill. ibid., p. 228, no. 648.

REFERENCES: E. Neuhaus, *The Galleries of the [Panama-Pacific International] Exposition* (1915), ill. after p. 10, as Woman and Child: Rose Scarf // C. H. B[urroughs], *Bulletin of the Detroit Museum of Art* 13 (April 1919), ill. p. 52, as Woman and Child in review of the fifth exhibition of American paintings // E. Valerio, *Mary Cassatt* (1930), pl. 14, as Femme et enfant avec écharpe rose // H. G. Marceau, *Pennsylvania Museum of Art Bulletin* 25 (May 1930), ill. p. 20, as Mother and Child in John F. Braun Collection // *Index of Twentieth Century Artists* 2 (Oct. 1934), p. 8, lists reproductions of Woman and Child with Rose Scarf // A. D.

Cassatt, *Mother and Child with a Rose Scarf.*

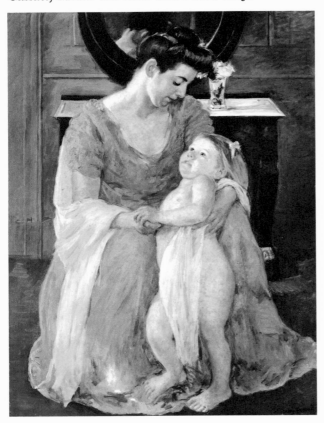

Breeskin, *Mary Cassatt: A Catalogue Raisonné of the Oils, Pastels, Watercolors, and Drawings* (1970), p. 190, ill. no. 509, catalogues this painting as Mother and Child with a Rose Scarf, dates it 1908, mentions studies for the work and notes it is Durand-Ruel 6678–L9218 // C. Durand-Ruel to Art Institute of Chicago, Jan. 30, 1979, copy in Dept. Archives, says that the painting called The Bath and shown as no. 14 at Durand-Ruel, New York, in Feb.-March 1935 was lent by Miss Adelaide de Groot and identifies it as this painting rather than one in Chicago // A. Alexander, Philadelphia Museum of Art to Art Institute of Chicago, June 28, 1979, copy of letter in Dept. Archives, notes that the painting called The Bath and listed as no. 2 in the Cassatt memorial exhibition at the Philadelphia Museum of Art in 1927 was lent by John F. Braun of Philadelphia // L. Hardenburgh, Art Institute of Chicago, July 16, 1979, letter in Dept. Archives, supplies information on exhibition history and provenance and copies of letters from A. Alexander and Durand-Ruel // F. Daguet, Durand-Ruel et Cie, Paris, July 30, 1984, letter in Dept. Archives, gives early provenance and says it is listed in firms records as "ST 9218. PH 6678. ST NY 3399. Femme et enfant avec écharpe rose."

EXHIBITED: PAFA, 1911, *Catalogue of the 106th Annual Exhibition* (2nd ed.), ill. between pp. 12 and 13, as Mother and Child; p. 43, no. 471, as Woman and Child // Albright Art Gallery, Buffalo Fine Arts Academy, 1912, p. 13, no. 14, as Femme et Enfant, 1910, lent by Messrs. Durand-Ruel and Son, New York; ill. p. 40 // Carnegie Institute, Pittsburgh, 1914, ill. and no. 48, as Woman and Child with Pink Scarf // *Panama Pacific International Exposition*, San Francisco, 1915, p. 61, no. 3008, as Woman and Child: Rose Scarf; p. 297, no. 3008 in *Catalogue Deluxe of the Department of Fine Arts, Panama-Pacific International Exposition* 2, ed. by J. E. D. Trask and J. N. Laurvik // Detroit Museum of Art, 1919, ill. p. 10; p. 13, no. 104, as Woman and Child // Durand-Ruel, New York, 1920, no. 14 // Philadelphia Museum, 1927, *Memorial Exhibition of the Works of Mary Cassatt* (see *Pennsylvania Museum Bulletin* 22 above) // Pennsylvania Museum of Art, 1930, *John F. Braun Collection* // McClees Gallery, Philadelphia, 1931, as no. 8 // Durand-Ruel, New York, 1935, *Exhibition of Paintings and Pastels by Mary Cassatt*, no. 14, as The Bath // MMA, 1973, *Mary Cassatt* (no cat.) // Staten Island Institute of Arts and Sciences, 1974, *Mary Cassatt* (no cat.) // Portland Museum of Art, Me., 1979, *Miss Mary Cassatt, Impressionist from Pennsylvania*.

ON DEPOSIT: MMA, 1936–1939, lent by Adelaide Milton de Groot // Yale University Art Gallery, New Haven, 1939–1952, lent by Adelaide Milton de Groot // MMA, 1952–1967, lent by Adelaide Milton de Groot // White House, Washington, D. C., 1969–1973.

EX COLL.: with Durand-Ruel, Paris, Jan. 1910–Dec. 1910; with Durand-Ruel, New York, Dec. 1910–

Mary Cassatt

1922; New York Association of Women Painters and Sculptors, 1922; John F. Braun, Philadelphia, by 1927–until at least 1930; Adelaide Milton de Groot, Paris and New York, by 1935–1967.

Bequest of Miss Adelaide Milton de Groot (1876–1967), 1967.

67.187.122.

Augusta Sewing before a Window

One of Mary Cassatt's frequent compositions during the first decade of the twentieth century consisted of a figure or two in an interior with a window view. The most elaborate composition of this type among her paintings in the museum's collection is *Young Mother Sewing* (q. v.). *Augusta Sewing before a Window*, once called *Woman Sewing*, is a late example, which Adelyn D. Breeskin dates 1910. The closest parallel to this work is the pastel *Sewing in the Conservatory*, ca. 1905 (private coll., ill. in Breeskin [1970], p. 177, no. 461).

Augusta, shown here in a blue gown trimmed with white lace, posed for Mary Cassatt on several occasions (Breeskin [1970], nos. 571, 573, 574, 676, 677), yet has not been further identified. The setting in this and related examples

Cassatt, *Augusta Sewing before a Window*.

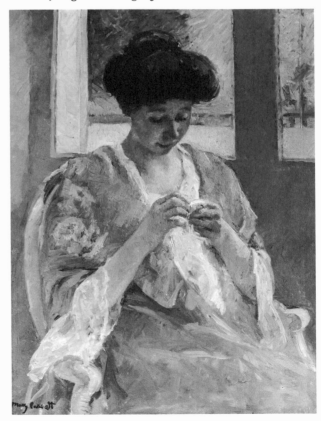

was probably the conservatory described in the discussion of *Young Mother Sewing*. The three-quarter pose of the figure and the wall at the left provide an asymmetrical note in what is otherwise a symmetrical composition with the figure framed by the central windowpane. The rectilinear framework of the windows and the emphasized horizon line act as foils for the contours of the figure. The work is broadly painted and lacks the firm modeling and underlying structure of Mary Cassatt's earlier compositions. These weaknesses may be attributed to her failing eyesight.

Oil on canvas, 31¾ × 23¾ in. (80.6 × 60.3 cm.). Signed at lower left: *Mary Cassatt.*

Canvas stamp: F. DUPRÉ / 144 Faubourg Sᵗ Bonace / coin de la Rue de Berri PARIS (also stamped on stretcher).

Label on back (Durand-Ruel): Cassatt (M.) N° 9458 / Femme cousant / ibdc.

REFERENCES: *Index of Twentieth Century Artists* 2 (Oct. 1934), p. 2, lists it in the MMA // A. D. Breeskin, *Mary Cassatt: A Catalogue Raisonné of the Oils, Pastels, Watercolors, and Drawings* (1970), ill. p. 206, no. 572, calls it Augusta Sewing before a Window, dates it 1910, provides alternate title Woman Sewing, Durand-Ruel 6899-L9458, and catalogues it.

EXHIBITED: Centennial Art Gallery, Centennial Exposition, Utah State Fair Ground, Salt Lake City, 1947, *One Hundred Years of American Painting*, no. 31 // Pasadena Art Institute, 1951, *Mary Cassatt and Her Parisian Friends* (catalogued by J. P. Leeper in *Bulletin of the Pasadena Art Institute* 2 [Oct. 1951]), p. 5, no. 6, as Young Woman Sewing, about 1906 // Mount Holyoke College, South Hadley, Mass., 1956, *French and American Impressionism*, no. 29 // MMA, 1958–1959, *Fourteen American Masters* (no cat.) // Kalamazoo Art Center, Kalamazoo Institute of Arts, Mich., 1966, *Paintings by American Masters (Fifth Anniversary Exhibition, Bulletin* 18 [Sept. 1966], ill. p. 12, as Woman Sewing) // Staten Island Institute of Arts and Sciences, 1974, *Mary Cassatt* (no cat.) // F. Daguet, Durand-Ruel et Cie, Paris, July 30, 1984, letter in Dept. Archives, gives provenance and lists as "ST 9458. PH 6899. Femme cousant" in firm's records.

ON DEPOSIT: College Art Association, New York, 1931–1932, 1935–1936 // Teachers College Library, Columbia University, New York, 1933, 1934, and 1935 // Gracie Mansion, New York, 1959–1966 // Office of the Governor of the State of New York, New York City, 1975–1976.

EX COLL.: with Galeries Durand-Ruel, Paris, Sept. 1910– August 1912; James Stillman, Paris and New York, August 1912–1918; his son, Dr. Ernest G. Stillman, New York, 1918–1922.

From the Collection of James Stillman, Gift of Dr. Ernest G. Stillman, 1922.

22.16.19.

INDEX OF FORMER COLLECTIONS

A

Adams, Edward D., as subscriber, 250
Adams, Muriel Vanderbilt, estate of, 134
Agnew, Thomas, and Sons, 373
Allis, Mary, 131
Altman, Benjamin, 247; as subscriber, 526
American Art-Union, 104
Amory, Marion Renée (Mrs. George S.), 99
Armstrong, Collin, as subscriber, 537
Andrews, Jane E. *See* Andrews, Mrs. William Loring
Andrews, William Loring, 143, 557, 563; as subscriber, 250
Andrews, Mrs. William Loring, 563; probably, 143
Arnold, Benjamin G., as subscriber, 104
Arnold, Edward W. C., 5, 12, 13, 28, 30, 51, 96, 517
Arthur, Robert, 622
Avery, Samuel P., 56, 146, 242, 319, 445, 562; as agent, 262; as subscriber, 537
Avery, Samuel P., Sr., 56

B

Babcock Galleries (also E. C. Babcock Art Galleries), 396, 448, 454, 455, 588, 594, 612, 621; as agent, 629
Babcock, H. D., 35
Babcock, Samuel D., 35
Baker, George F., as subscriber, 250
Bancroft, John C., 396
Bancroft, Mrs. John C., 396
Barlow, Thomas Oldham, 65
Batcheller, Katherine, 80, 81
Bates, Mary Arthur, 622
Battell, Robbins, 544
Beard, Caroline (Mrs. William H.), 100
Bell, F. A., 482
Bernet, Otto, as agent, 210
Bierstadt, Edward, 326
Bierstadt, Mary (Mrs. Albert), 326
Bierstadt, Mary Adeline, 326
Bishop, Heber R., as subscriber, 250
Blakeslee Galleries, 385
Bliss, Susan Dwight, 332
Block, Mrs. Bates, 337
Blodgett, William T., 275; as subscriber, 104, 116
Bloomingdale, Lyman G., 262
Bonner, Frederick, 266
Borden, Matthew Chaloner Durfee, 139, 303
Boussod, Valadon and Company, 471
Braun, John F., 653
Brereton, Mrs. Denny, 67

Brewster, Mrs. William T. (née Anna Richards), 359
Brown, John George, estate of, 341
Bruce, James D., 535
Bruce, Maysie. *See* Scammell, Mrs. Scott
Brummer, Joseph, as agent, 619
Bryant, William Cullen, as subscriber, 104
Buch, Emily, 310, 522, 549
Buckstone, J., probably, 118
Bullard, Mrs. Harold Curtis (Helen Lister), 505
Bullard, Laura Curtis, 505
Burkhardt, Robert, 305
Butler, Richard, 233
Butterworth, Mrs. Emily, 361

C

Carfax and Company, 378
Carnegie, Andrew, as subscriber, 526
Carnegie Institute, 454, 455
Carpenter, S. H., 291
Carr, William, 532
Carroll, John R., 134
Carter, Amy Jane, 159, 160, 161
Cassatt, Alexander J., 638
Cassatt, Gardner, 638
Cassatt, Mrs. Gardner, 638
Cassatt, Robert Kelso, 638
Cassatt, Mrs. Robert Kelso, 638
Cesnola, Luigi Palma di, descendants of, 77
Chapman, Gertrude Perry, 159, 160, 161
Chapman, Helen (Mrs. William H.), 122
Chapman, Niles, 122
Chapman, William H., 122
Chase, William Merritt, 612
Childs Gallery, 354
Chittenden, S. B., as subscriber, 104
Church, E. Dwight, as subscriber, 526
Clark, Mrs. Alfred Corning, as subscriber, 250
Clark, Edward, as subscriber, 116
Clark, Stephen C., 337
Clark, Susan Vanderpoel, 337
Clarke, Thomas B., 247, 250, 465, 468, 471, 475, 482; as subscriber, 250, 526
Clausen, William, 583
Coddington, Dave Hennen, 60
Coddington, Eleanor (Mrs. Dave Hennen), 60
Cohen, William N., as subscriber, 537
Colgate, J. B., as subscriber, 104
Collord, Mrs. George Whitfield. *See* Fiske, Martha T.
Converse, John H., 448
Cook, Henry H., 141
Cook, Mrs. James Bradley, 77

Cornell, Mrs. Birdsall, descendants of, 66
Cornell, Kate Lyon. *See* Diggs, Mrs. Dabney William
Cottier and Company, 430, 553
Courtright, Milton, 192
Courtright, Mrs. Milton, probably, 192
Cowl, Clarkson, 342
Cozzens, Abraham M., 102
Cram, Ethel, 159, 160, 161
Cumerford, Mrs. Frederick T. *See* Möen, Yvonne
Curtis, Jeremiah, 505

D

Davis, Edmund, 373
Dean, Joseph A., 568
Decker, Jane Elizabeth, 143
de Forest, Emily (Mrs. Robert W.), 242
DeFrate, Mrs. Marjorie Lowrie, 315
de Groot, Adelaide Milton, 396, 437, 454, 455, 612, 621, 653
de Kay, Charles, 405
de Kay, Mrs. Charles, 405
Delmonico, L. Christ, as subscriber, 526
Dering, Sylvester, 69, 70
Devine, A., 448
De Witt, Thomas, probably, 562
Dickinson, E. Everett, 341
Dickinson, E. Everett, Jr., 341
Diggs, Dabney William, 286
Diggs, Mrs. Dabney William, 286
Dodge, William E., as subscriber, 250
Dodge, William E., Jr., as subscriber, 104
Doig, John, 104
Doll and Richards, 259, 262
Doverdale, Lady (née Elizabeth Leslie Cornell)
Downtown Gallery, 454, 455
Dows, David, 275
Dows, Mrs. David, 275
Draper, Mrs. Henry, as subscriber, 116
Dreier, Katherine S., 530
Drexel, Mr. and Mrs. Joseph W., 156
Drexel, Sophia (Mrs. Maximilian), 509
Durand-Ruel (also Galeries Durand-Ruel), 635, 638, 644, 646, 648, 651, 653, 654
Duret, Théodore, 373, 392
Durup, Helene (Mrs. Johan), 403

E

Eakins, Susan (Mrs. Thomas), 588, 594, 608, 619, 621, 629
Eighth Company, Seventh Regiment, National Guard, 5
Einstein, Caroline E., 237
Einstein, David Lewis, 237
Einstein, Lewis, 237
Evans, Silas C., 242
Evans, William T., 423, 583; as subscriber, 537

F

Fagnani, Charles, as subscriber, 116
Fagnani, Emma, as subscriber, 116
Fagnani, Joseph, estate of, 112–116
Fahnestock, Harris C., 373; as subscriber, 526
Field, Benjamin H., as subscriber, 104
Field, Cyrus W., 71
Finger, Thomas E., 612
Fiske, Josiah M., 205, 206
Fiske, Martha T. (Mrs. Josiah M.), 205, 206
Flagler, Henry M., as subscriber, 526
Fleischer, David N., 122
Fleischer, Helen W., 122
Fleischer, Thomas, 122
Fleischman, Lawrence A., 85
Floyd-Jones, Louise. *See* Thorn, Mrs. Condé Raguet
Forbes, George, 284
Ford, James, 555
Fosburgh, Mr. and Mrs. James, 449, 588
Fowler, Charles A., 138, 178, 308, 340
Freer, Charles Lang, as agent, 385
French, Daniel Chester, as agent, 407
Fridenberg, Robert, 12, 28
Friedsam, Michael, 247
Fuller, George, estate of, 151, 154
Fuller, W. H., as subscriber, 526

G

Gandy, Shepherd, 35
Garbisch, Edgar William and Bernice Chrysler, 8, 131, 305, 315, 334
Garrett, John Work, 561
Garrett, Mary E., 561
Garvan, Francis P., 396
Gay, Walter, 373
Gifford, Sanford R., as subscriber, 104
Gifford, Mrs. Sanford Robinson, 233
Glickman, Mr. and Mrs. Maurice, 326
Goddard, J. Warren, as subscriber, 116
Gordon, Robert, 177, 417; as subscriber, 104
Goupil, Vibert and Company, 24
Graham, James, and Sons, 194
Grand, Charles, 348
Grant, Mrs. Delancey Thorn, 329
Graves, Henry, and Company, 385
Gray, Henry Peters, 104
Gray, Horace, 358
Gray, Mrs. Horace, 358
Greene, John M., 612
Gregg, Eleanor Merritt (Mrs. Louis D.), 287, 288
Grolier Club, 557
Grossman, Daniel B., Inc., 346
Gunsaulus, Frank W., 479

H

Hamel, Paul, 354
Hanley, Edward T., 588

Hannay, Alexander Arnold, 370
Harriot, Samuel J., 352
Harrison, Alexander, as agent, 468
Hart, James M., 184
Hart, William W., 184
Haseltine, Helen. *See* Plowden, Helen Haseltine
Hatch, Alfrederick Smith, 225
Hatch, Frederic H., 225
Havemeyer, Mr. and Mrs. H. O., 648, 651
Havemeyer, Henry O. (H. O.), 355; as subscriber, 250
Havemeyer, William F., 581
Haven, H. C., 126
Healy, Aaron, 56
Hearn, George A., 153, 256, 259, 266, 378, 414, 418, 419, 420, 430, 466, 471, 475, 479, 482, 496, 511, 553, 583, 646
Heaton, John, 8
Heinemann, William, 373
Heinemann, Mrs. William, 373
Heinigke, Otto, 407
Henderson, Harold G., 512, 515
Henderson, Mrs. Harold G. (née Agnes Roudebush), 512, 515
Henderson, Mary Benjamin (Mrs. Harold G.), 512, 515
Hering, Adelaide Heriot Arms (Mrs. Oswald C.), 352
Herrick, Everett, 555
Hewitt, Edwin, Gallery, 348
Hicks, Angelina D. King (Mrs. Thomas), 181
Higginson, Henry Lee, 403
Homer, Charles Savage, 454, 455, 499
Homer, Mrs. Charles Savage, 454, 455
Hopkins, John G., 284
Hovenden, Helen Corson (Mrs. Thomas), 545
Howell, Charles Augustus, 385
Humphreys, Alexander C., 210
Hunt, Jane, 203, 213
Hunt, Louisa D. (Mrs. William Morris), 208, 213
Hunt, William Morris, estate of, 203, 208, 210, 213
Huntington, Archer M., 37, 68, 190, 193, 232, 242, 292, 357
Huntington, Collis P., 37, 68, 190, 193, 232, 242, 292, 357; as subscriber, 250
Huntington, Mrs. Collis P. (later Mrs. Henry E.), 37, 68, 190, 193, 232, 242, 292, 357
Huntington, Mrs. Henry E. *See* Huntington, Mrs. Collis P.
Huntington, William H., 300
Hurlbut, Margaret Crane, 563

I

Inglis, James S. (Cottier and Company), 553
Inness, George, estate of, 266
Inness, George, Jr., as subscriber, 537
Ireland, LeRoy, 612
Irving, Henry, 385

Iselin, Adrian, as subscriber, 104
Isham, William B., as subscriber, 116

J

Jaffray, Edward S., as subscriber, 116
Jesup, Maria DeWitt (Mrs. Morris K.), 36, 173, 279, 292, 562
Jesup, Morris K., 36, 173, 279, 292; as subscriber, 104, 250, 526
Johnson, Eastman, estate of, 229
Johnson, Mrs. Eastman, 239
Johnson, Fry and Co., 300
Johnston, Henry Mortimer, 292
Johnston, John Taylor, 242, 445, 561; as subscriber, 104
Jones, John Divine, 329
Jones, Mrs. John Divine, 329
Jordan, David Wilson, possibly, 588

K

Kennedy, Edward G., 394; as agent, 392
Kennedy, John Stewart, 24; as subscriber, 250
Kennedy, Mary Lenox, 445
Kennedy, Rachel Lenox. *See* Porter, Mrs. Frank B.
Kennedy, Robert Lenox, 445
Kennedy Galleries, 128, 257, 565
Kensett, Thomas, 38–50
Kenton, Elizabeth Macdowell, 626
Kingman, A. W., as subscriber, 526
Kirby, Thomas E., as subscriber, 526
Knoedler and Company, M., 126, 378, 409, 475, 479, 490, 496, 561
Koeniger, Mrs. Karl W., 330
Kraushaar Galleries, 465

L

Labouchere, Henry, 378
Lazarus, Amelia B. (Mrs. Jacob H.), 155, 156
Lazarus, Frank, 156
Leeds, Henry H., 190, 193
Lenz, John, 194
Lichteneaur, Joseph M., as subscriber, 537
Lieutaud, Albert, 8
Little, Joseph J., as subscriber, 526
Lewison, Florence, Gallery, 326
Lincoln, L. J. B., 153
Lord, Thomas, as subscriber, 116
Lovell, Harold W., 313
Lowrie, Mrs. Ada Read, 315
Ludlum, Nicholas, 188
Ludlum, Sarah Ann (Mrs. Nicholas), 188
Lyons, Louis C., 8

M

Macbeth Gallery (also William Macbeth and Macbeth Galleries), 203, 210, 361, 396, 418

Macdowell, William H., 619
Macfarlan, Mr. and Mrs. Daniel T., 287, 288
Macfarlan, Helen Rutherfurd Stuyvesant, 287, 288
Mansfield, Burton, 574
Marquand, Henry G., as subscriber, 526
Mather, Frank Jewett, Jr., 405
Mathey, P., 373
Matthews, N. C., 465
Matthews, Thomas S , 358
McCarten, Clara F., 184
McHenry, James, 326
McKearin, George, 315
McLaren, Sir Charles (later Lord Aberconway), possibly, 373
Middendorf, J. William, II, 409
Milch Galleries, 454, 455, 594
Milton, William F., 453, 457
Milton, Mrs. William F., 453, 457
Möen, Mrs. Edward C. *See* Cram, Ethel
Möen, Yvonne, 159, 160, 161
Miles, Mrs. Emily Winthrop, 128
Mills, Darius O., as subscriber, 250
Moore, Edward C., as subscriber, 526
Moran, Edward, possibly, 522
Morgan, J. Pierpont, 407, 509
Morgan, Henry T., as subscriber, 104
Morrill, William A., Jr., 315
Morse, Mrs. Darwin, 128
Morton, Josephine Ames (Mrs. Asa), 53
Muller, Nicholas, as subscriber, 537

N

Nache, Mrs. Louise S. M., 594
Nash, Evette and Stanley, 306
Nathan, Benjamin, 37
Nathan, Mrs. Benjamin, 37
National Guard. *See* Eighth Company, Seventh Regiment, National Guard
Nelson, William, 91
Nesmith family, 346
Newhouse Galleries, 124, 337
Newington, Mrs. John C., 192
North, Paul, Jr., 85
Northrup, William B., 178

O

Oberwalder, A., probably as agent, 291
O'Brien, Morgan, 257
Oehme, Julius, 292
Ogilvie, Helen S. (Mrs. Clinton), 528
Old Print Shop, 134, 348, 354
Olyphant, Robert M., as subscriber, 104
Osborn, William Church, 103, 106
Osborn, William Henry, 106, 281
Osborn, Mrs. William H., 281
Otis, Fessenden N., 423
Owsley, David T., 574

P

Paget, Gerald, 568
Palmer, Charles P., as subscriber, 116
Palmer, Courtlandt, Jr., as subscriber, 116
Paton, David, 183, 328
Paton, Stewart, 183, 328
Paton, William, 183, 328
Paton, William Agnew, 183, 328
Patterson, Daniel W., 337
Perry, Mrs. Stuart. *See* Carter, Amy Jane
Peters, Howard J., 192
Philip, C. S., 259
Phoenix, Stephen Whitney, 506
Plowden, Helen Haseltine, 399
Polignac, Princess Edmond de, 373
Pomeroy, Henry K., 468
Porter, Mrs. Frank B. (née Rachel Lenox Kennedy), 445
Post Road Antiques, 167
Pyne, Percy R., 2d, 28

R

Randall, Blanchard, 284
Rawle, Mary Cadwalader, 317
Raymond, James J., as subscriber, 526
Read, Charles, 315
Reichard, Gustav, and Company, 471
Reichard, possibly Gustav, 128
Reid, Whitelaw, as subscriber, 537
Rhinelander, Frederick W., as subscriber, 250
Richards, Anna. *See* Brewster, Mrs. William T.
Riker, Samuel, Jr., 156
Ritter, A. Howard, 385
Roberts, Marshall O., 24, 65
Rockefeller, W. M., as subscriber, 526
Rohlfs, H. D. G., Jr., 326
Rosenthal, Albert, 239
Ross, Robert (Carfax and Company), 378
Rossiter, Mary S. (Mrs. Thomas P.), as administratrix, 91
Roudebush, Agnes Tracy, 512, 515
Russell, S. Howland, 363

S

St. George's School, 164
Samuels, Mr. and Mrs. Harold, 134
Sandor, H. and R., 110
Sartain, John, 118
Sartain, William, 118
Sawyer, Mrs. Wallace, 296, 297, 298
Scammell, Mrs. Scott (née Maysie Bruce), 535
Schanck, Mrs. George E., 414
Schell, Robert, as subscriber, 104
Schmitt, Max, 594
Schmitt, Mrs. Max. *See* Nache, Mrs. Louise S. M.
Seitz, Emil (Seitz and Noelle Gallery), 326

Seney, George I., 149, 151, 154, 262, 416; as subscriber, 526
Sherwood, John H., 242
Singer, Alexander, 409
Slater, Enid Hunt (executrix for William Morris Hunt estate), 208, 213
Smith, Charles Stewart, 199; as subscriber, 250
Smith, William Wheeler, 519
Smith, Mrs. William Wheeler, 519
Solway, Carl, Gallery, 84
Somerville Art Gallery, 116, 352
Spark, Victor, 126, 134, 194
Spencer, Milliard, 346
Spiegel, Lou, 85
Spring, Edward, probably, 256
Spring, Marcus, 256
Stebbins, Henry G., as subscriber, 104
Sterner, Marie, 448
Stetson, Mrs., 448
Stickney, Albert, 403
Stickney, Mrs. Albert, 403
Stevens, B. F., and Brown, as agents, 385
Stillman, Ernest G., 635, 644, 654
Stillman, James, 635, 644, 654
Stimson, Daniel M., 425
Stoeckel, Mr. and Mrs. Carl, 544
Stone, Harry, Gallery (also Harry Stone), 8, 239
Story, Mrs. George H., 411
Stuart, Anna Watson, descendants of, 67
Sturges, Jonathan, as subscriber, 104
Sturges, Mrs. Jonathan, 102
Sturges, Walter Knight, 257
Sussel, Eugene, 109
Sutton, James F., as subscriber, 526

T

Tanenbaum, Moses, 524, 561
Tarbell, Mrs. (née Nesmith), 346
Taylor, Bayard, 332
Thomas, George C., 385
Thompson, Mrs. A. Wordsworth, 547
Thorn, Mrs. Condé Raguet (née Louise Floyd-Jones), 329
Tilden, Samuel J., as subscriber, 104
Tracy, Agnes Ethel. See Roudebush, Agnes Tracy
Travers, William R., as subscriber, 104

Trevor, John B., as subscriber, 104
Tuckerman, Lucius, as subscriber, 104
Turner, Percy M., 370

V

Vanderbilt, Cornelius, as subscriber, 250, 526
Vanderbilt, William K., as subscriber, 526

W

Walker, Maynard, Gallery, 409
Walters, Henry, 407
Walters, William T., as subscriber, 526
Ward, George Cabot, as subscriber, 104
Warren, Samuel D., 259
Warren, Mr. and Mrs. Samuel D., 153
Warren, Mrs. Samuel D. (née Susan Cornelia Clark), 259
Way, Thomas, 370
Way, Thomas R., 370
Weems, Louise A., 8
Welcher, Fanny (Mrs. Manfred P.), 319
Weld, Francis M., 210
Wetherbee, Martha, 217, 218
Wetherbee, Winthrop, 217, 218
Wheeler, Jerome B., as subscriber, 526
Wheelock, Charles D., as agent, 213
White, A. M., 210
White, Jessie, 184
White, Mrs. Edwin, 75
Whittier, Charles A., 511
Whittredge, Worthington, 26
Widener, P. A. B., 638
Wilkinson, Mr., 378
Williams and Everett, probably, 247
Williams, Margaret, 85
Wolf, Erving, Foundation, 122
Wolf, Erving and Joyce, 122, 346
Wolfe, Catharine Lorillard, 68; as subscriber, 104
Wood, Clarence W., 247
Worsham, Mrs. Arabella Duval (Yarrington). See Huntington, Mrs. Collis P., 37

Z

Zabriskie, Christian A., 461

INDEX OF ARTISTS AND TITLES

A

Aegean Sea, The, by Church, 279–281
African Sentinel, The, by Vedder, 505–506
Alhambra, Granada, Spain, The, by Weir, 573–574
Amateur Musicians, by Homer. See *Studio, The*
Ames, Joseph Alexander, 51–53
Anahita: A Study for The Flight of Night, by Hunt, 213–217
Andrews, Mrs. William Loring, by Baker, 142–143
And She Was a Witch, by Fuller, 149–151
Antiquary, The, by White, 74–75
Approaching Storm, by Keith, 535
Arcadia, by Eakins, 608–612
Arrangement in Black: Girl Reading, by Whistler, 394–396
Arrangement in Black: No. 3: Sir Henry Irving as Philip II of Spain, by Whistler, 378–385
Arrangement in Flesh Colour and Black: Portrait of Théodore Duret, by Whistler, 385–392
Arthur, Mrs. Mary, by Eakins, 621–622
Artist's Wife and His Setter Dog, The, by Eakins, 613–619
Augusta Sewing before a Window, by Cassatt, 653–654
Autumn Landscape, Mount Chocorua, New Hampshire, by Cropsey, 193–194
Autumn Landscape with Figures, by McEntee. See *Saturday Afternoon*
Autumn Meadows, by Inness, 256–257
Autumn Oaks, by Inness, 262–263

B

Baby Getting Up from His Nap, by Cassatt. See *Mother and Child*
Baker, George A., Jr., 141–144
Barlow, Mrs. Francis Channing. See *Polyhymnia,* by Fagnani
Bath, The, by Cassatt. See *Mother and Child with a Rose Scarf*
Bathers, The, by Hunt, 210–213
Bay and Harbor of New York from Bedlow's Island, by Coates, 10–11; attributed to Coates, 11–12
Bayside, New Rochelle, New York, by D. Johnson, 292–293
Beach, Late Afternoon, The, by Homer, 453–454
Behind Dunes, Lake Ontario, by Martin, 428–430
Berks County Almshouse, 1880, by Rasmussen, 304–305
Bierstadt, Albert, 319–330
Bishop Berkeley's Rock, Newport, by La Farge, 403–405
Bit of a War History, A: The Contraband, The Recruit, and The Veteran, by Wood, 197–199
Blodgett, Josephine. See *Urania,* by Fagnani

Blondel, Jacob D., 75–77
Boetticher, Otto, 3–5
Bradford, William, 164–167
Brady, James Topham, by Ames, 53
Bricher, Alfred Thompson, 517–519
Broad Acres, by Gay, 526–527
Broad, Silent Valley, by Wyant, 417–418
Brown, John George, 337–342
Bryant, William Cullen, by Le Clear, 99–100
Bummers, The, attributed to Perry. See *True American, The*
Bunce, William Gedney, 551–553
Burning of the Sidewheeler Henry Clay, by unidentified artist, 12–13
Buttermilk Falls, by J. H. Hill. See *Study of Trap Rock, A*

C

Cafferty, James H., 93–96
Calliope, by Fagnani, 113
Camp Fire, by Homer, 466–468
Camp Meeting, The, by Whittredge, 138–139
Cannon Rock, by Homer, 475–479
Carhart, Amory Sibley, by Le Clear, 98–99
Carter, Amy Jane, by unidentified artist, 161
Carter, Charles Henry Augustus, by Kittell, 157–159; by unidentified artist, 161
Carter, Henry, by unidentified artist, 159, 160
Carter, Mrs. Henry, by unidentified artist, 160
Cassatt, Lydia. See *Lydia Crocheting in the Garden at Marly,* by Cassatt
Cassatt, Mary, 630–654
Cesnola, Luigi Palma di, by Blondel, 76–77
Champion Single Sculls, The, by Eakins. See *Max Schmitt in a Single Scull*
Chappel, Alonzo, 298–300
Chess Players, The, by Eakins, 600–605
Church, Frederic E., 266–281
Circus Is Coming, The, by C. C. Ward. See *Coming Events Cast Their Shadows Before*
Claremont, The, by unidentified artist, 26–28
Clearing Off, by Coman, 360–361
Cleveland, Grover, by E. Johnson, 237–239
Clio, by Fagnani, 112–113
Coates, Edmund C., 8–12
Colman, Samuel, 349–355
Coman, Charlotte Buell, 359–361
Coming Events Cast Their Shadows Before, by C. C. Ward, 335–337
Coming Storm, The, by Heade, 121–122, 123
Contraband, The, by Wood. See *Bit of War History, A*
Convent near Rome, by Yewell, 331–332

Cook, James Merrill, by Cook, 78–80
Cook, Mrs. James Merrill, by Cook, 80–81
Cook, Nelson, 78–81
Copestick, Alfred, 516–517
Coppersmith, The, by E. M. Ward, 536–537
Cornell, Kate Lyon, by Pine, 286
Cornell, Mrs. Birdsall, by Huntington, 65–66
Corn Husking at Nantucket, by E. Johnson, 227–229
Cremorne Gardens, No. 2, by Whistler, 367–370
Cropsey, Jasper F., 185–194
Crossing Sweeper, The, by Guy, 242
Culverhouse, Johan Mengels, 131–134
Cup of Love, The, by Vedder, 511–512
Cup of Tea, The, by Cassatt, 632–635

D

Dana, William P. W., 361–363
Daughters of Daniel T. Macfarlan, The, by Pine, 286–287
Day, Sallie. See Clio
Deer – Sketch from Nature, by Tait, 128
Delaware Valley, The, by Inness, 247–250
Delaware Water Gap, by Inness, 245–247
Dering, Nicoll Havens, by Huntington, 68–69
Dering, Mrs. Sylvester, by Huntington, 69–70
Discoverer, The, by Hunt. See Fortune
Doe and Two Fawns, by Tait, 128
Dressing for the Carnival, by Homer, 461–465
Drexel, Joseph W., by Lazarus, 156
Duncanson, Robert S., 81–85
Duret, Théodore. See Arrangement in Flesh Colour and Black

E

Eagle Head, Manchester, Massachusetts (High Tide), by Homer, 449–453
Eakins, Benjamin. See Chess Players, The, and Writing Master, The
Eakins, Susan Macdowell. See Artist's Wife and His Setter Dog
Eakins, Thomas, 584–629
Early Morning – Venice, by Bunce, 553
East Hampton Meadows, by Smillie, 555
Eaton's Neck, Long Island, by Kensett, 46
Einstein, Lewis, by E. Johnson, 236–237
Elliott, Charles Loring, by Guy, 240–242
Entrance Hall of the Metropolitan Museum of Art when in Fourteenth Street, by Waller, 575–577
Erato, by Fagnani, 115–116
Euterpe, by Fagnani, 113, 114
Evans, James Guy, 5–8
Evening at Medfield, Massachusetts, by Inness, 257–259
Evening in the Woods, by Whittredge, 139–141

F

Fagnani, Joseph, 110–116
Field, Cyrus W., by Huntington, 70–71

Finish – First International Race for America's Cup, August, 8, 1870, by Colman, 352–354
Flight of Night, The, by Hunt. See Anahita
Foggy Sky, A, by Kensett, 40–41
Forging the Shaft, by Weir, 568–573
Fortune: A Study for The Discoverer, by Hunt, 217–219
Fortune Teller, The, by Newman, 295–296
Franklin, Maude. See Arrangement in Black: Girl Reading
Fruit with Blue-footed Bowl, by Raleigh, 334
Fuller, George, 147–154
Fuller, George Spencer. See Ideal Head of a Boy
Funding Bill, The, by E. Johnson, 233–236

G

Gardel, Bertrand. See Chess Players, The
Gathering Storm on Long Island Sound, by Kensett, 49–50
Gay, Edward, 524–526
George Washington: Design for an Engraving, by Chappel, 299–300
Gifford, Robert Swain, 549–551
Gifford, Sanford Robinson, 168–179; portrait by E. Johnson, 232–233
Gilchrist, Connie. See Harmony in Yellow and Gold
Gillett, Mrs. Joseph Allston. See Urania
Girl at the Fountain, by Hunt, 201–203
Glimpse of the Sea, by Wyant, 418–419
Godesberg, by Hart, 306
Gomez d'Arza, Signora, by Eakins, 627–629
Gray, Henry Peters, 100–106
Greek Girls Bathing, by Vedder, 506–509
Greek Lovers, The, by Gray, 101–103
Gulf Stream, The, by Homer, 482–490
Guy, Seymour Joseph, 239–242

H

Hagar and Ishmael, by Newman, 297–298
Hamilton, James, 116–118
Harmony in Yellow and Gold: The Gold Girl – Connie Gilchrist, by Whistler, 373–378
Hart, James M., 305–308
Hart, William, 181–184
Harvest Scene, by Homer, 465–466
Haseltine, William Stanley, 397–399
Hatch Family, The, by E. Johnson, 223–225
Heade, Martin Johnson, 119–126
Heart of the Andes, by Church, 269–275
Heart's Ease, by Dana, 362–363
Henry, Edward Lamson, 558–563
Hicks, Thomas, 180–181
Hicks, Mrs. Thomas, by Hicks, 181
Hidley, Joseph H., 313–315
High Tide, by Homer. See Eagle Head, Manchester, Massachusetts
Hill, John Henry, 537–539
Hill, Thomas, 311–313

Hill of the Alhambra, Granada, The, by Colman, 350–352

Hofmann, Charles C., 129–131

Holmes, George W. See *Chess Players, The*

Homer, Winslow, 430–499

Hovenden, Thomas, 539–545

Hubbard, Richard William, 54–56

Hudson River Scene, by Kensett, 33, 35

Hummingbird and Passionflowers, by Heade, 122, 124

Hunt, William Morris, 199–219

Huntington, Daniel, 56–73

I

Ideal Head of a Boy (George Spencer Fuller), by Fuller, 149

Indian Summer, by Richards, 357

Inman, Henry, by Lazarus, 155

Inman, Mary, by Huntington, 58–60

In Mischief, by Shirlaw, 530

Inness, George, 243–266

In Strange Seas, by Maynard, 580–581

Interior View of the Metropolitan Museum of Art when in Fourteenth Street, by Waller, 577–579

Irving, Sir Henry. See *Arrangement in Black, No. 3*

Isola Bella in Lago Maggiore, by S. R. Gifford, 177–179

Italian Boy, by Hunt, 204–205

Italian Girl, by Hunt, 205–206

J

Jaffray, Mrs. William P. See *Thalia*

Jersey Meadows, by Heade, 124–126

Jerusalem the Golden, by Hovenden, 544–545

Johnson, David, 289–293

Johnson, Eastman, 220–239

Johnson, Mrs. William M. See *Clio*

Just Moved, by Mosler, 565

K

Kauterskill Clove, by S. R. Gifford, 170–173

Kauterskill Falls, by S. R. Gifford. See *Kauterskill Clove*

Keith, William, 532–535

Kennedy, Edward G., by Whistler, 392–394

Kensett, John F., 31–50; portrait by Baker, 143–144

Kenton, Louis N. See *Thinker, The*

Kittell, Nicholas Biddle, 157–159

L

Lady at the Tea Table, by Cassatt, 638–642

La Farge, John, 400–409

Lair of the Sea Serpent, by Vedder, 513–515

Lake Como, by T. Moran, 521–522

Lake George, by Kensett, 34, 35–36

Lake George, a Reminiscence, by Kensett, 41–42

Lake George, 1872, by Kensett, 42

Lake George, Free Study, by Kensett, 42, 43

Lake George, New York, by Kensett, 40

Lambdin, George Cochran, 317–319

Landscape, by Hunt, 203

Landscape in the Adirondacks, by Wyant, 419–420

Landscape with Cows Watering in a Stream, by Duncanson, 84–85

Landscape with Shepherd, by Duncanson, 83–84

Landscape with Waterfall and Figures, by Sonntag, 163–164

Last Moments of John Brown, The, by Hovenden, 541–544

Last Summer's Work, The, 19 paintings by Kensett, 37–50

Lazarus, Jacob Hart, 154–156

Le Clear, Thomas, 96–100

Leutze, Emanuel, 13–26

Lost Mind, The, by Vedder, 503–505

Luca, Mrs. Ferdinand de. See *Melpomene*

Lydia Crocheting in the Garden at Marly, by Cassatt, 635–638

M

MacAlister, James, (Sketch), by Eakins, 619–621

Macfarlan, Mr. and Mrs. Daniel T., by Pine, 287–288

Macomb's Dam Hotel, by Sullivan, 50–51

Madonna and Child and Little Saint John, by Newman, 296–297

Magrath, William, 530–532

Maine Coast, by Homer, 479–482

Marine, by E. Moran, 310

Marine Landscape, by Bricher, 518–519

Martin, Homer Dodge, 420–430

Max Schmitt in a Single Scull (The Champion Single Sculls), by Eakins, 588–594

Mayer, Francis Blackwell, 282–284

Maynard, George Willoughby, 579–581

McEntee, Jervis, 300–303

Meditation, by Brown, 341–342

Melpomene, by Fagnani, 112

Merced River, Yosemite Valley, by Bierstadt, 326–328

Mercy's Dream, by Huntington, 60–65

Mignot, Louis Remy, 87–91

Mohawk Valley, by Wyant. See *Tennessee*

Moonlight, Wood Island Light, by Homer, 468–471

Moran, Edward, 308–310

Moran, Thomas, 519–524

Morning on the Mountain, by Hubbard, 54–56

Morning Paper, The, by Weir, 567–568

Morning Vision, A, by Walker, 582–583

Mosler, Henry, 563–565

Mother and Child (Baby Getting Up from His Nap), by Cassatt, 644–646

Mother and Child (The Oval Mirror), by Cassatt, 646–648

Mother and Child with a Rose Scarf, by Cassatt, 652–653

Mountain Range, by J. M. Hart, 306–307

Murray, Alexander Stuart, by Story, 410
Muse of Painting, The, by La Farge, 406–407
Musical Amateurs, by Homer. See *Studio, The*
Music Lesson, The, by Brown, 339–340

N

Near Jackson, White Mountains, by Ogilvie, 528
Near Land's End, Cornwall, by Richards, 357–358
Near Squam Lake, New Hampshire, by D. Johnson, 290–291
Near the Coast, by R. S. Gifford, 550–551
New Bonnet, The, by E. Johnson, 229–232
New Jersey Beach, by Richards, 359
Newman, Robert Loftin, 294–298
Newport Rocks, by Kensett, 39–40
New York from the Harbor Showing the Battery and Castle Garden, by Copestick, 517
9:45 Accommodation, The, by Henry, 559–561
Nine Muses, The (American Beauty Personified as The Nine Muses), 9 paintings, by Fagnani, 111–116
Nocturne in Green and Gold, by Whistler, 370–373
North Dutch Church, Fulton and William Streets, New York, The, by Henry, 561–562
Northeaster, by Homer, 471–475
Nydia, by Fuller, 153–154

O

October in the Marshes, by Kensett, 44
Ogilvie, Clinton, 527–528
Old Annapolis, Francis Street, by Mayer, 283–284
Old Bruton Church, Williamsburg, Virginia, in the Time of Lord Dunmore, by Thompson, 546–547
Old Clearing, An, by Wyant, 416–417
Old Dutch Church, by Henry. See *North Dutch Church, Fulton and Williams Streets, New York*
Old Manor of Criqueboeuf, by Martin, 423–425
Old Pine, Darien, Connecticut, The, by Kensett, 48–49
On Hampstead Heath, by Hamilton, 118
On the Old Sod, by Magrath, 531, 532
On the Unadilla, New York, by D. Johnson, 291–292
Orange Branch, formerly attributed to La Farge, 407–409
Oranges of Seville, by La Farge. See *Orange Branch*
Oval Mirror, The, by Cassatt. See *Mother and Child (The Oval Mirror)*

P

Parker, Minnie. See *Euterpe*
Parthenon, The, by Church, 275–279; by Stiepevich, 557
Passing Off of the Storm, by Kensett, 44–45
Pasture Scene, by Hart, 307–308
Peace and Plenty, by Inness, 250–256
Perry, Enoch Wood, 342–348
Phoenix, Stephen Whitney, by Ryder, 146
Pine, Theodore, 284–288

Pine Grove of the Barberini Villa, by Inness, 259–262
Pleiades, The, by Vedder, 509–511
Polyhymnia, by Fagnani, 113, 114
Pompton Plains, New Jersey, by Cropsey, 192–193
Portrait of a Young Girl, by Cassatt, 642–644
Portrait of the Artist, by La Farge, 402–403; by Story, 410–411. See also *Self-portrait*, by Lazarus
Portrait of the Artist's Father, by Weir. See *Morning Paper, The*
Pride of the Village, The, by Gray, 104–106
Prime, William C., by Huntington, 71–73
Prisoners from the Front, by Homer, 437–445
Pulpit in Saint Mark's, Venice, by Yewell, 332–333
Pushing for Rail, by Eakins, 594–600
Putnam, George P., by Ryder, 145–146

Q

Quadroon, The, by Fuller, 151–153

R

Rainy Day in Camp, by Homer, 455–457
Raleigh, Charles Sidney, 333–334
Rasmussen, John, 303–305
Rawle, Mary Cadwalader, by Stone, 316–317
Recruit, The, by Wood. See *Bit of War History, A*
Requeña, Carmelita, by Eakins, 586–588
Richards, William Trost, 355–359
Riddle, Mrs. Robert Moore. See *Lady at the Tea Table*
River Scene, by Kensett. See *Summer Day on Conesus Lake*
Rocky Mountain Goats, by Bierstadt, 328–329
Rocky Mountains, Lander's Peak, The, by Bierstadt, 321–326
Roesen, Severin, 107–110
Roman Girls on the Seashore, by Vedder. See *Greek Girls Bathing*
Ronalds, Mrs. George Lorillard. See *Terpsichore*
Roses, by Lambdin, 318–319
Rosenberg, Charles G., 92–93, 94–96
Rossiter, Thomas P., 85–87, 88–91
Ryder, Platt Powell, 144–146

S

Saddle Horse in Farm Yard, by Homer, 454–455
Saint George's Church, New York, by Henry, 562–563
Saint John the Baptist, by Newman. See *Madonna and Child and Little Saint John*
Salt Meadow in October, by Kensett, 45
Sand Bank with Willows, Magnolia, by Hunt, 208–210
Santa Maria della Salute, Sunset, by Haseltine, 399
Saturday Afternoon, by McEntee, 301–303
Scene at Napanoch, by W. Hart, 184
Schenck, William H., 28–30
Schmitt, Max. See *Max Schmitt in a Single Scull*, by Eakins
Sea, The, by Kensett, 47

Searchlight on Harbor Entrance, Santiago de Cuba, by Homer, 490–496

Seascape, by Richards. See *Near Land's End, Cornwall*

Seashore, Morning, by Hart, 183

Self-portrait, by Lazarus, 155–156. See also *Portrait of the Artist*, by La Farge and by Story

Seventh Regiment on Review, Washington Square, New York, by Boetticher, 3–5

Shaw, Ellen. See *Polyhymnia*

Shipwreck off Nantucket (Wreck off Nantucket, after a Storm), by Bradford, 166–167

Shirlaw, Walter, 529–530

Shooting the Rapids, Saguenay River, by Homer, 496–499

Skating on the Wissahickon, by Culverhouse, 132–134

Signora Gomez d'Arza, by Eakins. See *Gomez d'Arza, Signora*

Smillie, George H., 554–555

Smythe, Nellie. See *Thalia*

Snap the Whip, by Homer, 457–461

Sonntag, William L., 162–164

Spanish Peaks, Southern Colorado, Late Afternoon, by Colman, 354–355

Spring Blossoms, Montclair, New Jersey, by Inness, 265–266

Stiepevich, Vincent G., 556–557

Still Life: Flowers and Fruit, by Roesen, 108–109

Still Life: Fruit, by Roesen, 109–110

Stone, William Oliver, 316–317

Story, George Henry, 409–411

Stuart, Anna Watson, by Huntington, 66–67

Studio, The, by Homer, 445–448

Study for Eagle Head, Manchester, Massachusetts, by Homer, 448–449

Study for Surf and Rocks, by Homer, 454–455

Study in a Wood, by Huntington, 67–68

Study of a Tree, by Bierstadt, 326

Study of Beeches, by Kensett, 42–43

Study of Trap Rock, A, (Buttermilk Falls), by J. H. Hill, 538–539

Sullivan, M. A., 50–51

Sullivant, Kate. See *Erato*

Summer Day on Conesus Lake, by Kensett, 36–37

Sumner, Charles, by Hunt, 206–208

Sunrise, by Inness, 264

Sunrise on the Matterhorn, by Bierstadt, 329–330

Sunset, by Kensett, 47; by Young, 548–549

Sunset on the Sea, by Kensett, 38–39

Sunset Sky, by Kensett, 46–47

Surf at Marshfield, by Homer. See *Study for Eagle Head, Manchester, Massachusetts*

Surf on Rocks, by Richards, 358–359

T

Tait, Arthur Fitzwilliam, 126–128

Talking It Over, by Perry, 345–346

Tennessee, by Wyant, 412–415

Terpsichore, by Fagnani, 113

Teton Range, The, by T. Moran, 522–524

Thompson, Alfred Wordsworth, 545–547

Thalia, by Fagnani, 114, 115

Thinker, The: Portrait of Louis N. Kenton, by Eakins, 622–626

Third Avenue Railroad Depot, The, by Schenck, 29–30

Tivoli, by S. R. Gifford, 173–177

To Decide the Question, by Brown, 340–341

Tow Boat Conqueror, The, by Evans, 7–8

Townsend, Mrs. Edward. See *Clio*

Trout Pool, The, by Whittredge, 136–138

True American, The, attributed to Perry, 346–348

Twilight in the Cedars at Darien, Connecticut, by Kensett, 38, 39

Twilight on the Sound, Darien, Connecticut, by Kensett, 43, 44

U

Unidentified artist, 12–13, 26–28, 159–162

Urania, by Fagnani, 114, 115

V

Valley of Wyoming, The, by Cropsey, 190–192

Vedder, Elihu, 499–515

Veteran, The, by Wood. See *Bit of War History, A*

Veteran in a New Field, The, by Homer, 433–437

View in County Kerry, by Wyant, 415–416

View near Sherburne, Chenango County, New York, by Cropsey, 187–188

View of Poestenkill, New York, by Hidley, 314–315

View of the Schuylkill County Almshouse Property, by Hofmann, 129–131

View on the Seine: Harp of the Winds, by Martin, 425–428

View of Yosemite Valley, by T. Hill, 312–313

W

Wadsworth, Lizzie. See *Calliope*

Wages of War, The, by Gray, 103–104

Wall Street, Half Past Two, October 13, 1857, by Rosenberg and Cafferty, 94–96

Walker, Henry O., 581–583

Waller, Frank, 575–579

Ward, Charles Caleb, 335–337

Ward, Edgar Melville, 536–537

Washington and Lafayette at Mount Vernon, 1784 (The Home of Washington after the War), by Rossiter and Mignot, 88–91

Washington Crossing the Delaware, by Leutze, 16–24

Watts, George. See *Erato*

Weir, John Ferguson, 566–574

Weir, Robert Walter. See *Morning Paper, The*, by Weir

Whistler, James McNeill, 363–396

White, Edwin, 73–75
White Mountains, from Randolph Hill, The, by Martin, 422–423
Whittredge, Worthington, 134–141; portrait by Leutze, 25–26
Wolfe, John David, by Huntington, 68
Woman Sewing, by Cassatt. See *Augusta Sewing before a Window*
Wood, Thomas Waterman, 195–199
Wreck off Nantucket, after a Storm, by Bradford. See *Shipwreck off Nantucket*
Writing Master, The, by Eakins, 605–608

Wyant, Alexander H., 411–420
Wyoming Valley, Pennsylvania, by Cropsey, 188–190. See also *Valley of Wyoming*

Y

Yewell, George Henry, 330–333
Yosemite Falls, from Glacier Point, by Keith, 534–535
Young, Harvey O., 547–549
Young Girl in a Park Landscape, by Cassatt. See *Portrait of a Young Girl*
Young Mother Sewing, by Cassatt, 648–651

INDEX OF AUTHORS

Ames, Joseph Alexander	Natalie Spassky	Kittell, Nicholas Biddle	Natalie Spassky
Baker, George A., Jr.	Natalie Spassky	La Farge, John	Meg Perlman
Bierstadt, Albert	Meg Perlman	Formerly La Farge	Kathleen Luhrs
Blondel, Jacob D.	Natalie Spassky	Lambdin, George Cochran	Linda Bantel
Boetticher, Otto	Natalie Spassky	Lazarus, Jacob Hart	Natalie Spassky
Bradford, William	Natalie Spassky	Le Clear, Thomas	Natalie Spassky
Bricher, Alfred Thompson	Amy Walsh	Leutze, Emanuel	Natalie Spassky
Brown, John George	Meg Perlman	Magrath, William	Amy Walsh
Bunce, William Gedney	Amy Walsh	Martin, Homer Dodge	Meg Perlman
Cafferty, James H.	Natalie Spassky	Mayer, Francis Blackwell	Doreen Bolger Burke
Cassatt, Mary	Natalie Spassky	Maynard, George Willoughby	Linda Bantel
Chappel, Alonzo	Amy Walsh	McEntee, Jervis	Linda Bantel
Church, Frederic E.	Meg Perlman	Mignot, Louis Remy	Natalie Spassky
Coates, Edmund C.	Natalie Spassky	Moran, Edward	Linda Bantel
Colman, Samuel	Meg Perlman	Moran, Thomas	Amy Walsh
Coman, Charlotte Buell	Meg Perlman	Mosler, Henry	Linda Bantel
Cook, Nelson	Natalie Spassky	Newman, Robert Loftin	Linda Bantel
Copestick, Alfred	Natalie Spassky	Ogilvie, Clinton	Amy Walsh
Cropsey, Jasper F.	Natalie Spassky	Perry, Enoch Wood	Natalie Spassky
Culverhouse, Johan Mengels	Natalie Spassky	Pine, Theodore	Amy Walsh
Dana, William P. W.	Meg Perlman	Raleigh, Charles Sidney	Meg Perlman
Duncanson, Robert S.	Natalie Spassky	Rasmussen, John	Natalie Spassky
Eakins, Thomas	Natalie Spassky	Richards, William Trost	Amy Walsh
Evans, James Guy	Natalie Spassky	Roesen, Severin	Natalie Spassky
Fagnani, Joseph	Natalie Spassky	Rosenberg, Charles G.	Natalie Spassky
Fuller, George	Natalie Spassky	Rossiter, Thomas P.	Natalie Spassky
Gay, Edward	Doreen Bolger Burke	Ryder, Platt Powell	Natalie Spassky
Gifford, Robert Swain	Linda Bantel	Schenck, William H.	Natalie Spassky
Gifford, Sanford Robinson	Natalie Spassky	Shirlaw, Walter	Linda Bantel
Gray, Henry Peters	Natalie Spassky	Smillie, George Henry	Meg Perlman
Guy, Seymour Joseph	Doreen Bolger Burke	Sonntag, William L.	Natalie Spassky
Hamilton, James	Doreen Bolger Burke	Stiepevich, Vincent G.	Doreen Bolger Burke
Hart, James M.	Linda Bantel	Stone, William Oliver	Meg Perlman
Hart, William	Natalie Spassky	Story, George Henry	Kathleen Luhrs
Haseltine, William Stanley	Meg Perlman	Sullivan, M. A.	Natalie Spassky
Heade, Martin Johnson	Natalie Spassky	Tait, Arthur Fitzwilliam	Natalie Spassky
Henry, Edward Lamson	Kathleen Luhrs	Thompson, Alfred Wordsworth	Amy Walsh
Hicks, Thomas	Natalie Spassky	Vedder, Elihu	Meg Perlman
Hidley, Joseph H.	Amy Walsh	Walker, Henry O.	Doreen Bolger Burke
Hill John Henry	Kathleen Luhrs	Waller, Frank	Amy Walsh
Hill, Thomas	Linda Bantel	Ward, Charles Caleb	Linda Bantel
Hofmann, Charles C.	Natalie Spassky	Ward, Edgar Melville	Linda Bantel
Homer, Winslow	Natalie Spassky	Weir, John Ferguson	Doreen Bolger Burke
Hovenden, Thomas	Linda Bantel	Whistler, James McNeill	Natalie Spassky
Hubbard, Richard William	Natalie Spassky	White, Edwin	Natalie Spassky
Hunt, William Morris	Doreen Bolger Burke	Whittredge, Worthington	Natalie Spassky
Huntington, Daniel	Natalie Spassky	Wood, Thomas Waterman	Natalie Spassky
Inness, George	Doreen Bolger Burke	Wyant, Alexander H.	Amy Walsh
Johnson, David	Linda Bantel	Yewell, George Henry	Amy Walsh
Johnson, Eastman	Natalie Spassky	Young, Harvey O.	Amy Walsh
Keith, William	Amy Walsh	Unidentified artists	Natalie Spassky
Kensett, John F.	Natalie Spassky		

CUMULATIVE LIST OF ARTISTS
FOR VOLUMES I, II, & III

Edwin Austin Abbey, III
Francis Alexander, I
Henry Alexander, III
John White Alexander, III
Washington Allston, I
Ezra Ames, I
Joseph Alexander Ames, II
Thomas Anshutz, III
John Woodhouse Audubon, I
Joseph Badger, I
George A. Baker, Jr., II
Cecilia Beaux, III
J. Carroll Beckwith, III
Henry Benbridge, I
Frank W. Benson, III
Albert Bierstadt, II
George Caleb Bingham, I
Joseph Blackburn, I
Ralph Blakelock, III
Edwin H. Blashfield, III
Jacob D. Blondel, II
Robert Blum, III
David Gilmour Blythe, I
Otto Boetticher, II
George H. Bogert, III
Frank Boggs, III
William Bradford, II
John Bradley, I
John Brewster, I
Alfred Thompson Bricher, II
George Loring Brown, I
John G. Brown, II
Mather Brown, I
W. H. Browne, I
George de Forest Brush, III
William Gedney Bunce, II
Dennis Miller Bunker, III
Howard Russel Butler, III
Theodore Earl Butler, III
James H. Cafferty, II
John Carlin, I
Emil Carlsen, III
John W. Casilear, I
Mary Cassatt, II
Jefferson D. Chalfant, III
Thomas Chambers, I
John Gasdby Chapman, I
Alonzo Chappel, II
William P. Chappel, I
William Merritt Chase, III
Frederic E. Church, II

Edmund C. Coates, II
William Coffin, III
Thomas Cole, I
Alfred Q. Collins, III
Samuel Colman, II
Charlotte Buell Coman, II
Nelson Cook, II
Colin Campbell Cooper, III
Alfred Copestick, II
John Singleton Copley, I
Kenyon Cox, III
Caroline Cranch, III
Bruce Crane, III
Jasper F. Cropsey, II
Johan Mengels Culverhouse, II
Elliott Daingerfield, III
William P. W. Dana, II
William Dannat, III
Arthur B. Davies, III
Charles H. Davis, III
Charles Melville Dewey, III
Thomas Dewing, III
Ruger Donoho, III
Thomas Doughty, I
Robert S. Duncanson, II
William Dunlap, I
Asher B. Durand, I
John Durand, I
Frank Duveneck, III
Gerrit Duyckinck, I
Thomas Eakins, II
Ralph Earl, I
Oliver Tarbell Eddy, I
Francis W. Edmonds, I
Jacob Eichholtz, I
Louis Michel Eilshemius, III
Carnig Eksergian, III
Charles Loring Elliott, I
James Guy Evans, II
Joseph Fagnani, II
Robert Feke, I
Erastus Salisbury Field, I
Charles Noël Flagg, III
Ben Foster, III
August R. Franzén, III
James Frothingham, I
George Fuller, II
Ignaz Marcel Gaugengigl, III
Edward Gay, II
Walter Gay, III
Robert Swain Gifford, II

Sanford Robinson Gifford, II
Henry Peters Gray, II
Seymour Joseph Guy, II
John Haberle, III
James Hamilton, II
Chester Harding, I
William Michael Harnett, III
Alexander Harrison, III
James M. Hart, II
William Hart, II
William Stanley Haseltine, II
Childe Hassam, III
Rufus Hathaway, I
Robert Havell, Jr., I
Martin Johnson Heade, II
George P. A. Healy, I
Edward Lamson Henry, II
John Hesselius, I
Edward Hicks, I
Thomas Hicks, II
Joseph H. Hidley, II
John Henry Hill, II
Thomas Hill, II
Thomas Hewes Hinckley, I
George Hitchcock, III
Charles C. Hofmann, II
Winslow Homer, II
Thomas Hovenden, II
William James Hubard, I
Richard William Hubbard, II
William Morris Hunt, II
Daniel Huntington, II
Charles Cromwell Ingham, I
Henry Inman, I
George Inness, II
Charles Wesley Jarvis, I
John Wesley Jarvis, I
William Jennys, I
William Jewett, I
David Johnson, II
Eastman Johnson, II
Joshua Johnston, I
William Johnston, I
Francis Coates Jones, III
H. Bolton Jones, III
Matthew Harris Jouett, I
John Kane, III
William Keith, II
Frederic Kemmelmeyer, I
John F. Kensett, II
Nicholas Biddle Kittell, II

Anna Elizabeth Klumpke, III
Joseph Kyle, I
John La Farge, II
George Cochran Lambdin, II
Fitz Hugh Lane, I
Louis Lang, I
William L. Lathrop, III
Jacob Hart Lazarus, II
Thomas Le Clear, II
Emanuel Leutze, II
George Linen, I
Wilton Lockwood, III
Will H. Low, III
Frederick MacMonnies, III
William Magrath, II
John Mare, I
Homer Dodge Martin, II
Arthur Frank Mathews, III
Francis Blackwell Mayer, II
George Willoughby Maynard, II
Jervis McEntee, II
Gari Merlchers, III
Willard Metcalf, III
Louis Remy Mignot, II
Frank Millet, III
Louis Moeller, III
Theodore Sydney Moise, I
Edward Moran, II
Thomas Moran, II
Samuel F. B. Morse, I
Anna Mary Robertson (Grandma)
 Moses, III
Henry Mosler, II
Reuben Moulthrop, I
Shepard Alonzo Mount, I
William Sidney Mount, I
H. Siddons Mowbray, III
J. Francis Murphy, III
John Neagle, I
Robert Loftin Newman, II
Clinton Ogilvie, II
William Page, I
Walter Launt Palmer, III
John Paradise, I
DeWitt Parshall, III
Charles Willson Peale, I
James Peale, I
Raphaelle Peale, I

Rembrandt Peale, I
Charles Sprague Pearce, III
Robert Peckham, I
Enoch Wood Perry, II
John F. Peto, III
Ammi Phillips, I
William Picknell, III
Theodore E. Pine, II
Charles Peale Polk, I
Alexander Pope, III
Matthew Pratt, I
Maurice Prendergast, III
John Quidor, I
Charles S. Raleigh, II
Henry Ward Ranger, III
John Rasmussen, II
Robert Reid, III
Frederic Remington, III
William Trost Richards, II
Theodore Robinson, III
Severin Roesen, II
Charles G. Rosenberg, II
Thomas P. Rossiter, II
Albert Pinkham Ryder, II
Platt Powell Ryder, II
John Singer Sargent, III
William H. Schenck, II
Charles Schreyvogel, III
Schuyler Limner, I
Samuel H. Sexton, I
James J. Shannon, III
Joshua Shaw, I
Alexander Shilling, III
Walter Shirlaw, II
John Smibert, I
George H. Smillie, II
William L. Sonntag, II
Frederick R. Spencer, I
Albert Sterner, III
William Oliver Stone, II
George H. Story, II
Gilbert Stuart, I
M. A. Sullivan, II
Thomas Sully, I
Thomas Wilcocks Sully, I
Gardner Symons, III
Edward Martin Taber, III
Arthur Fitzwilliam Tait, II

Edmund C. Tarbell, III
Abbott H. Thayer, III
Jeremiah Theüs, I
Alfred Wordsworth Thompson, II
Cephas Giovanni Thompson, I
Jerome B. Thompson, I
Thomas Thompson, I
Louis Comfort Tiffany, III
Stacy Tolman, III
John Trumbull, I
Dwight W. Tryon, III
John H. Twachtman, III
Charles Ulrich, III
John Vanderlyn, I
Pieter Vanderlyn, I
Elihu Vedder, II
Douglas Volk, III
Robert Vonnoh, III
Hubert Vos, III
Samuel L. Waldo, I
Henry O. Walker, II
Horatio Walker, III
Frank Waller, II
Charles Caleb Ward, II
Edgar Melville Ward, II
Harry W. Watrous, III
Frederick J. Waugh, III
Edwin Lord Weeks, III
John Ferguson Weir, II
J. Alden Weir, III
Robert W. Weir, I
Adolph Ulrik Wertmüller, I
Benjamin West, I
James McNeill Whistler, II
Edwin White, II
Worthington Whittredge, II
Irving R. Wiles, III
William Williams, I
John Wollaston, I
Joseph Wood, I
Thomas Waterman Wood, II
John A. Woodside, I
Alexander H. Wyant, II
George Henry Yewell, II
Harvey O. Young, II

American Paintings
in the Metropolitan Museum of Art

was designed by Klaus Gemming, New Haven, Connecticut.
It was set in Monotype Baskerville, named for
the English printer and typefounder John Baskerville (1706–1775),
by Stamperia Valdonega, Verona. The book was
printed by Meriden-Stinehour Press, Meriden, Connecticut,
on Creme Blanc, a text paper made by the
French Paper Company, Niles, Michigan, and bound
by Publisher's Book Bindery, Long Island City, New York.

The Metropolitan Museum of Art